ART AND LOVE IN
RENAISSANCE ITALY

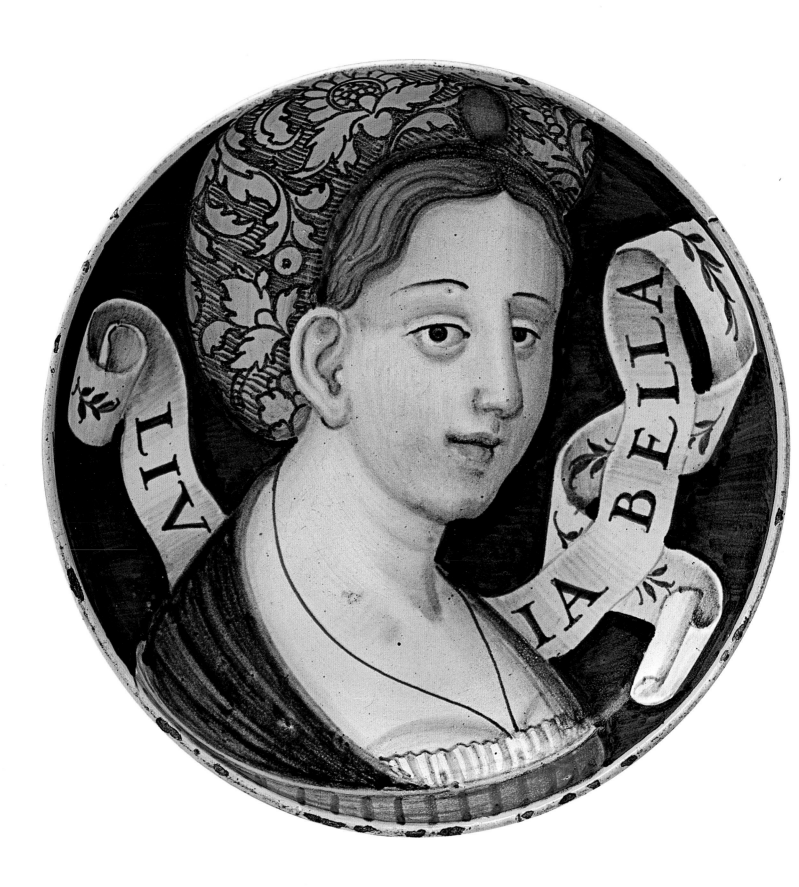

ART AND LOVE IN RENAISSANCE ITALY

EDITED BY ANDREA BAYER

Andrea Bayer, Beverly Louise Brown, Nancy Edwards, Everett Fahy, Deborah L. Krohn,
Jacqueline Marie Musacchio, Luke Syson, Dora Thornton,
James Grantham Turner, and Linda Wolk-Simon

*With contributions by Sarah Cartwright, Andreas Henning, Jessie McNab, J. Kenneth Moore,
Eve Straussman-Pflanzer, Wendy Thompson, and Jeremy Warren*

The Metropolitan Museum of Art, New York

Yale University Press, New Haven and London

This volume is published in conjunction with the exhibition "Art and Love in Renaissance Italy," held at The Metropolitan Museum of Art, New York, from November 11, 2008, to February 16, 2009, and at the Kimbell Art Museum, Fort Worth, from March 15 to June 14, 2009.

The catalogue is made possible by The Andrew W. Mellon Foundation.

Additional support is provided by the Charles Bloom Foundation.

The exhibition is made possible by the Gail and Parker Gilbert Fund and the Samuel H. Kress Foundation.

Additional support is provided by The Horace W. Goldsmith Foundation.

The exhibition was organized by The Metropolitan Museum of Art, New York, and the Kimbell Art Museum, Fort Worth.

It is supported by an indemnity from the Federal Council on the Arts and the Humanities.

Published by The Metropolitan Museum of Art, New York

John P. O'Neill, Publisher and Editor in Chief
Gwen Roginsky, General Manager of Publications
Margaret Rennolds Chace, Managing Editor
Jane Bobko, Cynthia Clark, Margaret Donovan, Editors
Bruce Campbell, Designer
Peter Antony, Bonnie Laessig, Christopher Zichello, Production
Robert Weisberg, Assistant Managing Editor
Jayne Kuchna, Bibliographic Editor
Marilyn Anderson, Indexer

New photography of works in the Metropolitan Museum collection by Carmel Wilson, Joseph Coscia, Jr., Mark Morosse, and Juan Trujillo, The Photograph Studio, The Metropolitan Museum of Art. A complete list of photograph credits is printed at the back of this volume.

Typeset in Adobe Garamond Pro and Poetica Std
Printed on R-400 matte, 130 gsm
Separations by Professional Graphics, Inc., Rockford, Illinois
Printed and bound by Mondadori Printing S.p.A., Verona, Italy

Jacket/cover illustration: Antonio del Pollaiuolo (Florentine, 1431–1498), *Apollo and Daphne* (detail of cat. no. 135)

Frontispiece: Low-Footed Bowl with Bust of a Woman, Urbino or Castel Durante, ca. 1530 (cat. no. 12)

Endpapers: Velvet Fragment with Medici Arms, Florence or Venice, 1440–1500 (detail of cat. no. 51)

Cataloging-in-Publication Data is available from the Library of Congress.

ISBN 978-1-58839-300-5 (hc: The Metropolitan Museum of Art)
ISBN 978-1-58839-301-2 (pbk: The Metropolitan Museum of Art)
ISBN 978-0-300-12411-8 (hc: Yale University Press)

To Philippe de Montebello

in gratitude and admiration

CONTENTS

DIRECTORS' FOREWORD

American collectors have long been attracted to the secular, domestic arts of the Italian Renaissance. Maiolica, glassware, cassone panels, furniture, and portraits—all were acquired, in depth, by some of the nation's first patrons of the arts. In 1851 Thomas Jefferson Bryan bought the impressive *Triumph of Fame* (cat. no. 70), then thought to be by Giotto and now known to be the tray painted to commemorate the birth of Lorenzo de' Medici, the Magnificent, making it one of the first early Italian paintings to arrive in New York City. The monumental bridal chest decorated with the narrative of the *Conquest of Trebizond* (cat. no. 56) was purchased for the Metropolitan Museum from the Florentine antiquarian and art dealer Stefano Bardini in 1913. Elia Volpi, another important presence among dealers in Florence, played a key role in encouraging American collecting through the decoration of the Palazzo Davanzati (now a museum dedicated to Florentine domestic life and one of the important lenders to this exhibition). Archival photographs of its rooms between 1910 and 1916 show tables, tapestries, sculptures, and other works that are now dispersed among the Metropolitan Museum and the Frick Collection in New York and collections in Boston, Richmond, and Los Angeles. One of Volpi's best clients about 1910 was J. Pierpont Morgan, and following Volpi's sales in New York in 1916 other objects from the dealer's cache of Renaissance domestic objects entered the Metropolitan's collection.

As early as 1880 the American sense of attachment to the culture of the Renaissance was so widely diffused that in a review of a book by Jacob Burckhardt the *New York Herald* could proclaim: "We are Children of the Renaissance." Beyond their intrinsic beauty, the works of art and decorative objects offered for sale by Volpi and Bardini may have had the attraction of skirting the deeply devotional imagery that made much Italian Baroque painting, for example, difficult for some of the North American public to admire. Wealthy Americans' desire to collect Renaissance domestic objects grew, above all, from their wish to emulate the Florentine merchants and bankers for whom the objects had been made (chief among them the Medici), who were seen as predecessors of the titans of American commerce. The architect Charles Follen McKim, who designed J. Pierpont Morgan's grand library on Madison Avenue between 1902 and 1906, called his client "Lorenzo the Magnificent."

The taste for beautiful domestic art of the Renaissance was abiding. Gifts to the Metropolitan Museum by Henry Marquand, J. Pierpont Morgan, Jules Bache, and Robert Lehman, among others, made numerous departments—Medieval Art, European Sculpture and Decorative Arts, European Paintings, the Lehman Collection, and Drawings and Prints—important repositories of remarkable paintings and objects that once graced the Renaissance home. More than sixty of these works are presented in this exhibition and catalogue.

The exhibition was inspired by the desire to look afresh at these works of art, some of them quite familiar, others less so, in an effort to understand more fully their original functions and contexts and thus to better appreciate them. The curators aspired to provide an assessment of them "in the round," having considered them from both an aesthetic and a contextual point of view. Investigation revealed that many were commissioned or purchased by their original owners to mark the great ritual moments of family life: betrothal, marriage, and the birth of a child. They could have been given as gifts during the many ceremonies accompanying a wedding; or commissioned by the bridegroom for the bride's arrival at her new home; or presented to the new mother. When a bridegroom in Florence wrote in his diary that he was preparing to dress his bride and decorate their *camera*, or bedroom, he would have had numerous things in mind: fabrics, jewels, tableware to set on a credenza at a festive meal, carved and painted beds and benches, and exquisite paintings designed for the specific site. Recently, the historian Christiane Klapisch-Zuber, whose work on the Florentine traditions of matrimony has helped to establish this field of scholarship, asked rhetorically what a Renaissance artist painting a fresco of the Marriage of the Virgin, or *Sposalizio,* would have hoped to convey to his audience. Would viewers have recognized the trappings of a real marriage or something idealized, sanctified, and removed from daily life? She wondered how close scholars like herself could come to a faithful interpretation of the reactions of a fifteenth-century viewer. Our exhibition pursues comparable questions. Here we present these magnificent objects and ask: What did they convey to those who received them, and how close to a verifiable interpretation can we come?

In some cases, such as that of the double-handled cups often known as *coppe amatorie,* an association with nuptial rituals seems unequivocal, but in other cases ritual significance has had to be teased from works of far greater ambiguity. This is most apparent in the final section of the exhibition. The great paintings gathered there are not defined by a precise function; these paintings of love and marriage carry many meanings and have provoked a wide range of often contradictory responses.

We present them in a spirit of inquiry, but the close relations among them will, we trust, show that they are being presented in the appropriate context. From Giorgione's *Laura* (cat. no. 145) to Titian's *Venus Blindfolding Cupid* (cat. no. 153), they are the aesthetic and poetic pinnacles of a tradition that extolled love and marriage.

Along the way we are taking one important detour from the licit path of marriage and family to explore the sphere of profane love, the secret world of Renaissance erotica. Largely originating in the crucible of Raphael's workshop in Rome about 1520, and nourished by a satirical spirit and deep appreciation of the ancient world, the erotic art of the first decades of the sixteenth century gives us a unique glimpse into a lesser-known side of Renaissance art and life. Some of the finest artists active at that moment—Giulio Romano, Parmigianino, Perino del Vaga—contributed inventively to this genre, as did ceramists and sculptors. Besides offering titillation, these works could be enormously witty and subversive of authority, and we believe that they will be a revelation for our public.

In order to plot this narrative completely we have requested almost one hundred loans from collections throughout the United States and Europe that complement the core group of works from the Metropolitan Museum. We wish to thank all of our lenders, both institutional and private, for their enormous generosity and sustained interest in this project. Our colleagues the directors at the British Museum and the Victoria and Albert Museum in London, and at the Ashmolean Museum in Oxford, were especially generous. Their various departments are rich in works of art relevant to our theme, and without them we could not have assembled a selection of this depth and quality. For other extraordinary, often multiple, loans we thank the directors of the Museo Nacional del Prado, Madrid; the Borghese Gallery, Rome; the Kunsthistorisches Museum, Vienna; the Museums of the Polo Museale di Firenze; the Musée du Louvre, Paris; the National Gallery, London; the Detroit Institute of Arts; the Frick Collection, New York; the Pierpont Morgan Library, New York; the Philadephia Museum of Art; and the Walters Art Museum, Baltimore.

The exhibition was organized by Andrea Bayer at the Metropolitan Museum and Nancy Edwards at the Kimbell Art Museum. It has been a complex task, and we are grateful for the energy and dedication that these capable curators brought to it, not least in coordinating the equally complex catalogue.

The generous funding of the exhibition and the catalogue cannot go unmentioned. Our deepest thanks go to the Gail and Parker Gilbert Fund and The Horace W. Goldsmith Foundation. We are grateful to the Samuel H. Kress Foundation for once again offering their support of a scholarly endeavor in the field of European art. The catalogue has been made possible by The Andrew W. Mellon Foundation and the Charles Bloom Foundation. We express our most sincere appreciation to all.

Philippe de Montebello
Director
The Metropolitan Museum of Art

Malcolm Warner
Acting Director
Kimbell Art Museum

ACKNOWLEDGMENTS

This exhibition and its catalogue have been the result of a team effort, and the curators have been fortunate to have had the opportunity to work with a remarkable group of scholars from the moment of the exhibition's conception. We thank all those who wrote for the catalogue and above all our core group of fellow travelers, Deborah L. Krohn, Jacqueline Marie Musacchio, and Dora Thornton, who gave shape to the first section of the exhibition, and Linda Wolk-Simon and James Grantham Turner, who did the same for the second. The other authors of essays, Everett Fahy, Beverly Brown, and Luke Syson, have made invaluable contributions to the contents of the catalogue. It would have been impossible to ask for a more dedicated, and inspiring, group of contributors.

We have consulted a wide variety of professional colleagues during our research and planning, and have worked closely with the lenders who have responded so generously to our requests. Although we cannot hope to thank them all individually, we wish to particularly acknowledge Cristina Acidini, Marta Ajmar-Wollheim, the late Tracey Albainy, Denise Allen, Christopher Apostle, Colin B. Bailey, Costanza Baldini, Alex Bayer, Luigi Bellini, Shelley Bennett, Jadranka Bentini, Monica Bietti, Monique Blanc, Edgar Peters Bowron, Mark Brady, Millie Bratton, Bill Brown, Christopher Brown, David Alan Brown, Andrea Buzzoni, the late Ellen Callmann, Pietro Cammarota, Francesca Cappelletti, Patricia Cavazzini, Janis Chan, Richard Charlton-Jones, Peter Cherry, Rachel Church, Andrea Ciaroni, Evelyn Cohen, Anna Coliva, Cristiano Collari, the Earl of Crawford and Balcarres, Anthony Crichton-Stuart, Alan Darr, David DeMuzio, Flora Dennis, Hester Diamond, Moroello Diaz della Vittoria Pallavicini, Richard Edgcumbe, Elizabeth Eisenberg, Rhoda Eitel-Porter, Seth Fagen, Miguel Falomir, Sylvia Ferino-Pagden, Sarah Fisher, Carmela Franklin and the staff of the American Academy in Rome, Alison Frazier, Adelheid Gealt, Antony Griffiths, Andreas Henning, Jack Hinton, Gretchen Hirschhauer, Mark Jones, Laurence B. Kanter, Dedo von Kerssenbrock-Krosigk, Sally Kilbridge, Armin Kunz, Elizabeth Lane, Donald Leichter, Nat and Jackie Leichter, Mario Luccarelli, John Marciari, Felix de Marez Oyens, Harald Marx, Giuliano Masciarri, Susannah Mauer, Ian McClure, Melinda McCurdy, Massimo Medica, Melissa Meighan, Liz Miller, Peter N. Miller, Mr. and Mrs. R. Miller, Peta Motture, Victoria and Samuel I. Newhouse Jr., Elke Oberthaler, Federica Olivares, Inna Orn, Jutta-Annette Page, Beatrice Paolozzi Strozzi, Daniela Parenti, Rosanna Caterina Proto Pisani, Marchesa Cristina Pucci, Anthony J. Ratyna,

Guido Rossi, David Salmond, Elisa Sani, Diana Scarisbrick, Kurt and Regine Schäfer, David Scrase, Stephanie Seavers, Silvana Seidel-Menchi, Joseph Simon, Marcello Simonetta, Gert Jan van der Sman, Sonia Solicari, Joaneath Spicer, David Steel, Gerald Stiebel, Carl Brandon Strehlke, Caitline Sweeney, Angelo Tartuferi, Dominique Thiébaut, William Voelkle, George Wachter, Raymond Waddington, Jørgen Wadum, Adriaan E. Waiboer, Jeremy Warren, Kathleen Weil-Garris Brandt, the Countess of Wemyss and March, Stefan Weppelman, Aidan Weston-Lewis, Eric M. White, Timothy Wilson, Matthias Winkler, James Yorke, and Timothy Young.

As this exhibition has drawn on nine curatorial and four conservation departments at the Metropolitan Museum, the curators and authors have many colleagues to thank. Everett Fahy and Keith Christiansen in the Department of European Paintings and George R. Goldner in the Department of Drawings and Prints were always available for advice and support. We have benefitted greatly from the expertise of Stijn Alsteens, Verrinia Amatulli, Dita Amory, Martin Bansbach, Peter Barnet, Mechthild Baumeister, George Bisacca, Barbara Drake Boehm, Christine E. Brennan, Thomas P. Campbell, Cristina B. Carr, Silvia Centeno, Kathrin Colburn, David del Gaizo, Manus Gallagher, Michael Gallagher, Charlotte Hale, Catherine Jenkins, Theresa King-Dickinson, Harold Koda, Wolfram Koeppe, Gary Kopp, Donald J. LaRocca, Margaret Lawson, Marco Leona, Kent Lydecker, Dorothy Mahon, John McKanna, Joan R. Mertens, J. Kenneth Moore, Marina Nudel, Pascale Patris, Carlos A. Picón, Lisa Pilosi, Marjorie Shelley, Jack Soultanian Jr., Mary Sprinson de Jesús, Denny Stone, Wendy Thompson, Clare Vincent, Thomas C. Vinton, Jenna Wainwright, Ian Wardropper, Melinda Watt, Mark Wypyski, Akiko Yamazaki-Kleps, and Elizabeth Zanis.

For the production of the complex catalogue we are indebted to our editors, Jane Bobko, Cynthia Clark, and Margaret Donovan, as well as to Ellyn Childs Allison and Margaret Aspinwall, who provided substantial assistance; our managing editor, Margaret Rennolds Chace, and assistant managing editor, Robert Weisberg; our designer, Bruce Campbell; our bibliographer, Jayne Kuchna; and Gwen Roginsky, general manager of publications, who was helped in production by Peter Antony, Bonnie Laessig, and Christopher Zichello, under the direction of publisher John P. O'Neill. Expert photography for the catalogue was done by Carmel Wilson, Joseph Coscia, Jr., Mark Morosse, and Juan Trujillo. The exhibition's inspired designers were Michael Langley and

Connie Norkin. Clint Ross Collier and Richard Lichte were responsible for the lighting. We also thank Linda Sylling for overseeing the design and installation.

We are grateful for substantial assistance from other departments at the Metropolitan as well. We would like to thank Kirstie Howard and Rebecca L. Murray in the Office of the Senior Vice President, Secretary and Counsel; Christine S. Begley, Nina McN. Diefenbach, Andrea Kann, and Thomas Reynolds in Development; Kent Lydecker, Joseph Loh, Michael Norris, and Stella Paul in Education; Doralynn Pines and Emily Vanderpool in the Office of the Director; Aileen Chuk in the Registrar's Office; and Mary Flanagan and Elyse Topalian in Communications.

Andrea Bayer wishes to thank four outstanding graduate students who worked with her over the course of the exhibition's preparation, Andaleeb Badiee Banta, Sarah Cartwright, Christopher Platts, and, above all, Eve Straussman-Pflanzer. Thanks as well to Beata Foremna, a talented student visiting from Poland.

At the Kimbell Art Museum, Nancy Edwards and Andrea Bayer would like to thank Samantha Sizemore, curatorial coordinator, for her indispensable role organizing the loan requests and other aspects of the exhibition with proficiency and aplomb. Nancy Edwards would also like to express her gratitude to librarians Chia-Chun Shih, Stephen Gassett, and Pat Oestricher for their efficient and invaluable help, and the following colleagues for their collaboration: Claire Barry, Jessica Brandup, Patty Decoster, Bart J. C. Devolder, C. D. Dickerson, Larry Eubank, Wendy P. Gottlieb, Stefanie Ball Piwetz, Ruth Wilkins Sullivan, and Patty Virasin. The able assistance of graduate-student interns Lindsay Dunn, Sarah Hamilton, Lauren Hughes, and Sarah Wilson was greatly appreciated. Both curators would like to extend their gratitude to Timothy Potts, director of the Fitzwilliam Museum, Cambridge, who was director of the Kimbell Art Museum when this exhibition was initiated, for his commitment to this project, and Malcolm Warner, acting director of the Kimbell Art Museum, who assisted us at every stage.

Andrea Bayer and Nancy Edwards

LENDERS TO THE EXHIBITION

CONTRIBUTORS TO THE CATALOGUE

AB Andrea Bayer
Curator, Department of European Paintings
The Metropolitan Museum of Art, New York

Beverly Louise Brown
Independent scholar
London

SC Sarah Cartwright
Mellon Fellow, Columbia University
New York

NE Nancy Edwards
Curator of European Art / Head of Academic Services
Kimbell Art Museum, Fort Worth

Everett Fahy
John Pope-Hennessy Chairman, Department of European
 Paintings
The Metropolitan Museum of Art, New York

AH Andreas Henning
Curator of Italian Paintings
Gemäldegalerie Alte Meister, Staatliche Kunstsammlungen,
 Dresden

DLK Deborah L. Krohn
Associate Professor, The Bard Graduate Center for Studies in
 the Decorative Arts, Design, and Culture
New York

JMM Jacqueline Marie Musacchio
Associate Professor, Department of Art
Wellesley College, Massachusetts

JMcN Jessie McNab
Associate Curator, Department of European Sculpture and
 Decorative Arts
The Metropolitan Museum of Art, New York

KM J. Kenneth Moore
Frederick P. Rose Curator in Charge, Department of Musical
 Instruments
The Metropolitan Museum of Art, New York

ES-P Eve Straussman-Pflanzer
Research Assistant, Department of European Paintings
The Metropolitan Museum of Art, New York

Luke Syson
Curator, Italian Painting, 1460–1500
The National Gallery, London

WT Wendy Thompson
Independent scholar
Vermont

DT Dora Thornton
Curator, Renaissance Collections and the Waddesdon
 Bequest, Department of Prehistory and Europe
The British Museum, London

JGT James Grantham Turner
Professor, Department of English
University of California, Berkeley

JW Jeremy Warren
Head of Collections
Wallace Collection, London

LW-S Linda Wolk-Simon
Curator, Department of Drawings and Prints
The Metropolitan Museum of Art, New York

ART AND LOVE IN
RENAISSANCE ITALY

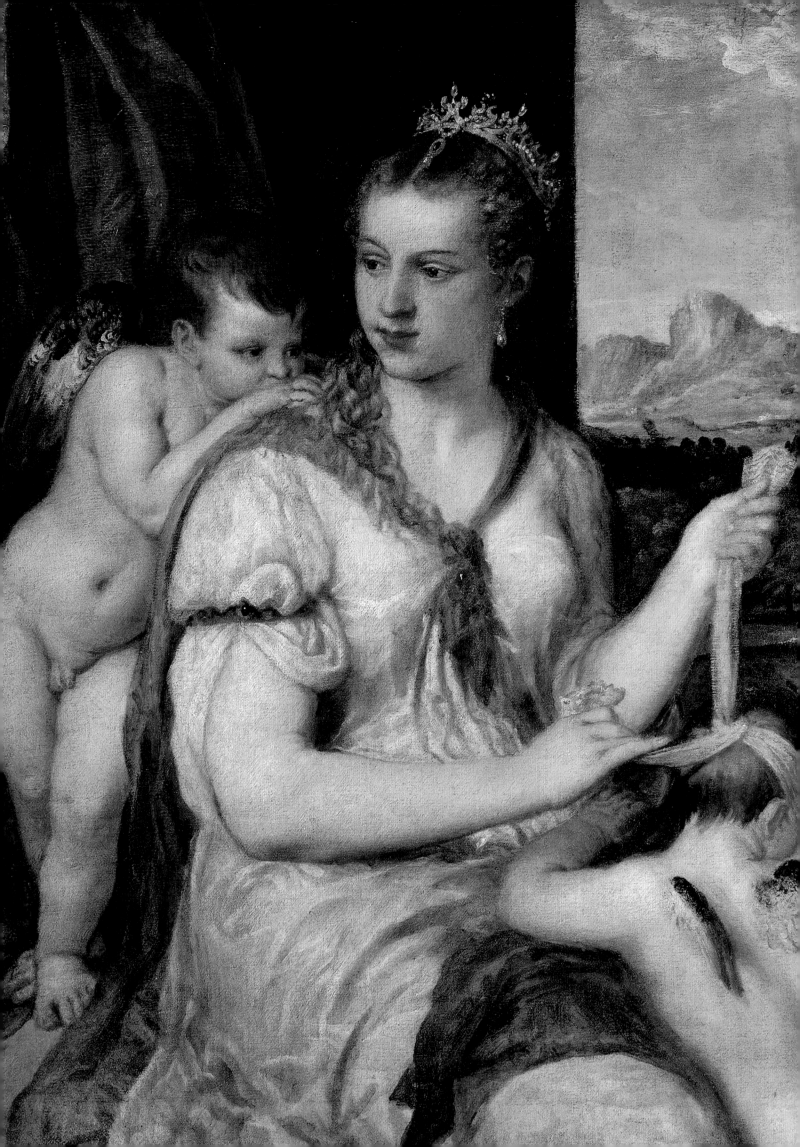

Introduction: Art and Love in Renaissance Italy

Andrea Bayer

Clasped hands; couples in facing profile; garlands of myrtle; the words *fede* (faith) and *volo* (I wish to): these are graphic declarations of love and fidelity that grace Renaissance art. Conjuring up elements of contemporary marriage ritual and tokens of amorous exchange, they afford an unparalleled insight into private life in Renaissance Italy. At the same time, knowledge of the rituals of Renaissance love and marriage in all their variety can inform our understanding of the maiolica, glassware, paintings, and the objects in a multitude of other media on which such imagery appears. In this exhibition we have attempted to gather the broadest possible array of artwork designed to commemorate betrothals, marriages, and the arrival of children, as well as the celebration of less official ardent attachments. The range is impressive—extending from birth trays painted at the beginning of the fifteenth century through large canvases on mythological themes by Titian in the mid-sixteenth century—but each work of art would have been recognized by contemporary viewers for its function within the private, domestic domain.

Most of the objects exhibited here are associated in some way with marriage and the family that followed from it. It should be emphasized that marriage itself in this period was chaotic, without uniform boundaries or legal consistency. The scholars Silvana Seidel Menchi and Diego Quaglioni, who directed an impressive research project carried out through investigation of documents involving matrimonial litigation housed in the ecclesiastical archives of Italy, provide startling information demonstrating just how informal the act of marriage could be and how it could take place in almost any location. "People got married in stables or in a tavern, in the kitchen or in the vegetable garden, in the pasture or in the attic, in a wood or in a blacksmith's shop, under the portico of one's house or near the public fountain." This suggests that many weddings were extraordinarily spontaneous, and the fact that they often took place on a balcony or at a window bears this out: "With the assistance of a ladder, the groom, flanked by witnesses, reached the bride, and facing each other they pronounced the formula of the ritual, balanced in an equilibrium as unstable as the tie that thus bound them."[1] Indeed, before the edicts of the Council of Trent systematized the requirements of a proper wedding in 1563, only mutual consent was an absolute necessity for marriage. People did not need to be married in church or by priests; they did not need to post banns or to appear before a notary; they did not need to exchange rings; nor were witnesses required (although most weddings were public acts). Clandestine marriages, undertaken to outwit disapproving parents, were common.

The confusion that could result has been expressed best in Gene Brucker's classic *Giovanni and Lusanna,* a story that unfolded in the courtroom of Saint Antoninus, the archbishop of Florence, in 1455.[2] In this tale, a determined and beautiful tailor's widow, abetted by her brother, tries to prove the legality of her marriage to a gentleman of a significantly higher level in society, bringing forward witnesses who say that they had heard his promises, seen the exchange of rings, and certainly were aware of the couple's cohabitation.[3] Giovanni denies that he was married to Lusanna (albeit admitting that he had had a relationship with her)—and quite essentially so, as he had just publicly betrothed a young girl of the prestigious Rucellai family. The archiepiscopal court decides in Lusanna's favor, but its ruling is soon reversed by the Roman curia, where Giovanni's family had more influence. The Roman court deemed Lusanna's evidence questionable and may have been influenced by the marked absence of a dowry (for more on this case, see Deborah L. Krohn's essay "Marriage as a Key to Understanding the Past" in this volume). This one story can now be multiplied by the dozens thanks to the previously mentioned archival research, which has focused on separations, controversial and clandestine marriages, concubinage, adultery, and bigamy. Other specialized studies have centered on quirky domestic arrangements in Verona, Venice, and elsewhere.[4]

It was the very fluidity of the marriage vows that made the traditional rituals and their public manifestations so important for weddings sanctioned by society. This was true at all social levels but was especially vital for the wealthy. Indeed, public wedding ceremonies and the material objects generated for them provided the physical demonstration of the marriage's legitimacy. The gifts and paraphernalia that formed the cornerstones of wedding celebrations were discussed at length and in great specificity in the abundant contemporary texts that recorded particular weddings and inventoried couples' belongings, as well as in more generalized writings on marriage. Some of the most significant moments

Opposite: Fig. 1. Titian (Tiziano Vecellio) (ca. 1488–1576), *Venus Blindfolding Cupid* (detail of cat. no. 153)

of these orchestrated ceremonies will be rehearsed here, as they provide the armature upon which the exhibition has, in part, been developed (for further analysis of these rituals, see Krohn, "Marriage as a Key to Understanding the Past").

Marco Antonio Altieri's treatise *Li nuptiali* (Nuptials), written in Rome between 1506 and 1513 and prompted by a wedding that took place in 1504, records the mores of Roman society, harking back to a time when, the author felt, more attention was paid to a family's honor and less to the value of a bride's dowry.[5] Nonetheless, Altieri maps out a lengthy and lavish series of ceremonies that began with an agreement including a ratified list of the *dote*, or dowry. Each of the following rituals involved an exchange of particular gifts. The most legally binding ritual took place next; this was the so-called *arraglia*, during which the bride and groom were asked to pledge themselves to each other while a sword was held over their heads. The bride was then presented with three rings, one of which bore the arms of the groom's family (see cat. nos. 32a–e). Throughout Italy the giving of rings could bear more weight than even a private pledge in a dispute about a marriage. Other gifts exchanged during the *arraglia* were a silver dish and a *boccale*, or jug, displaying the arms of both families (see cat. no. 1).

A Mass was usually planned as one of the final group of elaborate ceremonies that concluded with the bride's arrival in her new home, where her husband's family lived. In the days leading up to the Mass, feasts were arranged and the bride's home was decorated with tapestries and sideboards laden with the kind of plates and glassware that are shown in the first section of the exhibition. The bridegroom, accompanied by music, presented the bride with her clothes and ornaments, which included a chain and a diadem. On the Sunday morning of the Mass she wore these along with earrings and a necklace with a jeweled pendant (see cat. no. 118), as well as a belt her father placed around her waist (see cat. nos. 36a,b). She then rode astride a white horse to church—where myrtle hung and incense burned (see cat. no. 148). Following the Mass, the bridegroom took his bride by the hand and led her home to another great feast; grain and vegetables were thrown from the windows and guests shouted out lascivious jibes. During this banquet and on the following days epithalamia, or marriage orations and poems, might be read (see cat. no. 61) and comedies and dances were performed. In a culminating moment, on the third day, the bride's mother visited and opened the cassoni, or bridal chests, to confirm that they held the linen and other items that had been agreed upon (see cat. no. 56).

If we move to Florence and Venice, we find different sequences of events but many of the same exchanges. Historians have culled details from disparate sources to put together a clear picture of marriage rituals in those cities.[6] In Florence, great weight was given to the moment when hands were clasped at the signing of a contract, a moment called the *impalmamento* (see cat. no. 16). On that occasion, the bride was given rings, often in a small chest, or *forzerino* (cat. nos. 38–40). However, the actual "ring day" (the *anellamento*)—when a ring was placed on her finger and the couple exchanged verbal vows—took place at a separate moment and in the home of the bride, with her father or guardian in attendance.[7] Then the bride was brought to her husband's house in a public and festive manner (the so-called *menare a casa*); early on

in the period under discussion, she often brought her great wedding chests with her. It was the husband's responsibility not only to bring his wife home but also to organize the bedchamber, the decoration of which will be discussed throughout the following pages. The church itself had a very small role in these proceedings until the Council of Trent, although people often chose to be married on the steps of churches.

Thanks to the Florentine habit of keeping scrupulous records and inventories, we know a good deal about the contents of both the *donora*—the trousseau that was part of the dowry—and the so-called countertrousseau of gifts and clothing provided by the husband. Indeed, in Florence the contents of the trousseau were examined by two independent dealers. These luxury goods, with which the women in Florentine nuptial portraits are bedecked, belonged to the husband and were sometimes pawned or sold pitilessly some years after the marriage. As Christiane Klapisch-Zuber has remarked, the groom's gifts to the bride were considered an outward symbol of her integration into his family; once they had served this purpose he could use them for his own purposes.[8]

In some ways, the weddings of Venetian nobility were the most sumptuous and elaborate in Italy. The signing of a contract of engagement called *le nozze* was followed by a round of activities during which the bride was presented by a master of ceremonies and dancing master called the *ballerino* (see cat. no. 65), and the engagement was announced to both families (*fermare il parentado*); then the bride received her ring (*l'anellamento*). After this, there was a public declaration of vows; and after much feasting the bride was brought home (*menare a casa*). Two aspects of the Venetian rituals are striking: the public nature of the drawn-out ceremonies and the centrality of organized giving and display of gifts. For example, brides were not only ceremonially introduced to society but also circulated in a flotilla of gondolas, visiting their relatives in convents (see cat. no. 65).[9] Various *compari*, or sponsors, offered gifts to the couple, as did the principal ring-sponsor (*compare dell'anello*), whose gifts might include silver tableware and furs. Marin Sanudo (1466–1535), who kept a diary that is critical to our understanding of life in Venice during the period, elaborated on the indulgence of incredible display: thousands of gold and silver ducats heaped in basins to represent the dowry; dozens of women dressed in velvets, their necks and waists hung with pearls and heavy gold chains; the exquisite quality, huge quantity, and extreme rarity of the food and drink—and of the vessels in which they were served (see cat. nos. 26–29); entertainments that included the composing of epithalamia; the importance and number of the guests and their gifts to the couple.[10]

And then there were the weddings of the ruling families throughout Italy. These were spectacles that are almost impossible for us to imagine, lasting for days and for which innumerable artifacts, many of them ephemeral, were created. When Annibale Bentivoglio, the eldest son of Giovanni Bentivoglio II, ruler of Bologna (see cat. no. 120) married Lucrezia d'Este (the natural daughter of Duke Ercole d'Este of Ferrara) in 1487, it was necessary to destroy houses and shops along the path of the triumphal procession through the streets to accommodate the crowds of spectators. At the Palazzo Bentivoglio theatrical events were held in the *sala maggiore*, whose decorations inspired the awe of contemporaries: benches topped by *spalliere*, tapestries, great fronds

of myrtle and juniper, and a grand credenza covered with precious vessels of silver and gold—all the trappings of weddings that appear in objects and paintings throughout this exhibition.[11] The elaborate festivities for the marriage of Costanzo Sforza, Lord of Pesaro and Gradara, and Camilla of Aragon, in Pesaro in 1475 were described in a famous manuscript now in the Vatican Library (Urb. Lat 899). The text and its illustrations captured for posterity a seemingly endless sequence of courtly and antiquarian tableaux, featuring Hymen (see fig. 63) and many other gods and allegorical figures, mounted for the couple and the wedding guests during the procession to Pesaro and the following festivities, which included an important marriage oration by the humanist Pandolfo Collenuccio.[12]

Following the festivities came the serious concerns of marriage and the establishment of a family, which were, of course, fundamental to the continuation of civic society. Many authors wrote in praise of the state of marriage, and a stream of literature, increasing steadily through the sixteenth century, defined the nature of a good wife and a properly run household. One of the earliest of these texts is the Venetian Francesco Barbaro's *De Re Uxoria* (On Wifely Duties) of about 1415–16, which was translated into Italian and published in 1548 as *Prudentissimi et gravi documenti circa la elettion della moglie*. At about the same time, at least six other books were published in Venice dealing specifically with issues of marriage, the duties of wives, and the raising of children. Most of these maintained that marriage was valuable in that it created a "perpetual union of man and woman for the procreation of children [that] is natural, socially useful, and, if well ordered, emotionally satisfying."[13]

Yet not all voices were raised in praise of marriage or wives, and the occasional naysayers based their opinions on longstanding traditions. One example is the sharp, ironic voice in Leon Battista Alberti's *Intercenales* (Dinner Pieces), short pieces meant to be read convivially over dinner. Alberti seems to have written many of them in the 1430s, and they must have circulated in manuscript, as their influence is perceptible in both poetry and painting. These texts are satirical and meant to expose folly but nonetheless represent recognizable types and situations. Above all, they present the reverse of the virtuous wife evoked over and over in the iconography of marriage gifts, in which "Onesta passa ogni bellezza" (Integrity [that is, virtue] surpasses all beauty) (see cat. no. 10). In the acid set piece called "The Husband," the narrator relates how he silently and coldly torments his unfaithful wife, managing to "kill her without her death causing a scandal." Thus he could congratulate himself on his tolerance, while achieving his revenge; it was an outcome that he felt obliged to share with his readers because "Woman is a fickle creature and given to pleasure" and "naturally lustful." In a longer piece entitled "Marriage," two brothers discuss their difficult marriages. The first touches on the impossibility of keeping a wife virtuous: "Before my eyes passed hosts of lovers, and I saw suitors in continual succession both day and night courting and tempting my wife, and besieging her chastity like veteran soldiers." The second claims, "Every woman is wanton, inconstant, troublesome, proud, querulous, shameless, and stubborn." Finally, a third brother explains that his brothers' struggles have inspired him to avoid "the blight of matrimony" and thus devote his talents to more "important matters." Even

the eponymous heroine of the piece called "The Widow" does not emerge virtuous in Alberti's view.[14]

Alberti's barbed remarks, even taken in the appropriate spirit of irony, indicate a suspicion of marriage and suggest a concurrent embrace of the ideal of celibacy, understandable given that Alberti not only moved in clerical circles but also worked for the papal curia. In the context of this study, their misogynistic edge and the anxieties they express about marriage help us understand the mindset that deemed certain extremely ambivalent subjects appropriate for the decoration of the bedrooms of newlyweds. These include Boccaccio's violent story about Nastagio degli Onesti (cat. no. 139), in which a young girl is abundantly punished for her pride and aloofness, and the tale of Jason and Medea, despite the disastrous fate of their marriage (cat. no. 140).[15] Similarly, the cruelty of love, bringing with it possibilities for betrayal, pain, and disillusionment, often seen from the point of view of the woman, informs the imagery of a startling group of maiolica dishes and vessels (cat. nos. 21–25).

The primary functions of the institution of marriage centered on the family and society, and love rarely entered into the equation. Yet the subjects of love, beauty, and attraction mesmerized Renaissance men and women. They were discussed—even dissected—endlessly in poems, dialogues, and treatises from perspectives ranging from the most base to the most elevated. The pleasures and pain of love could be weighed against each other, even within a single poem (see Krohn, "Rites of Passage: Art Objects to Celebrate Betrothal, Marriage, and the Family," in this volume). The same dichotomy was rehearsed in prose, for example in Pietro Bembo's widely read *Gli Asolani* of 1505. In this dialogue three men and three women discuss the meaning of love during three days of wedding festivities held at Queen Caterina Cornaro's villa at Asolo. Each man offers a different viewpoint. Book I presents the opening salvo with an argument against love: in a deluge of metaphors, love is termed the greatest possible turbulence, bringing the "most certain unhappiness and misery." It is compared to fire—as fire is beautiful for its splendor and yet terribly painful to touch, so love is beautiful at its first appearance but later torments us beyond measure. Shifting metaphors, we are described as the victims of Love's arrows, shot by a marksman who never tires and never shows mercy, even when we are wounded by arrow after arrow.[16] Such passages prepare us for the theme of "amor crudel" found in abundance on the maiolica of the period, such as the brilliant plate from Gubbio with a depiction of *A Love Argument*, in which a woman holding a knife advances on her lover, whom she has tied to a tree (cat. no. 24).

In the second book, love is instead praised and women lauded for their beauty, acknowledging the tug of sensuality (ruby lips feeding the desire for kisses; breasts like sweet apples resisting the soft drape of fabric) (see cat. no. 146).[17] Finally, in Book III love without carnality is extolled. Spiritual and pure love is seen to bring out the best in man, wherein his soul is "liberated from the appetites" and reaches a state in which "the intellect guides the senses."[18]

Bembo's popular text is one of many that fueled debates about the nature and legitimate goals of love and beauty. One section of the Mantuan humanist Mario Equicola's influential *Libro di natura d'amore* (On the Nature of Love), published in 1526, presents

an overview of Greek, Latin, Provençal, Italian, and French love poetry through the ages. Equicola artfully demonstrates his understanding of different attitudes when he compares Provençal and Latin poetry: "Their [the Provençal] way of describing their love was new and different from the ancient Latin; these are without respect, without reverence, without fear of defaming the woman by writing their opinions openly. . . . Provençal [poets] courteously feign to hide any lasciviousness of feeling . . . saying: Love wants chastity (or 'honesty'), and is kind to chastity, without this it is not love."[19] In the fourth book of his treatise, Equicola himself urges his readers to choose a middle way between love that is purely carnal and love that rejects all sensuality, given his belief that "the soul and the body are united together in marvelous harmony."[20]

The Bembo *Gli Asolani* and the Equicola *Libro di natura d'amore* are just two of the many and various texts on the subject of love and desire, expressed in either philosophical, religious, or poetic terms. It was commonly believed that love would be brought about by the apprehension of beauty; according to one author, when he sees beauty, the viewer's "limbs shudder, his hair curls, he sweats and shivers at the same time, not unlike one who, unexpectedly seeing something divine, is possessed by divine frenzy." Yet the same writer, despite his belief in the uncontrollable physical response to beauty, did not think it was incongruous to claim that it is through beauty that "we direct our souls to contemplation, and through contemplation to the desire for heavenly things."[21]

The great Renaissance paintings on the themes of love and marriage owe their rich complexity, and often ambiguity, of meaning to the coexistence of this broad range of contemporary thought on the subject. Love can bring pleasure or pain; beauty can inspire lascivious thoughts or bring us closer to the divine; marriage makes it impossible to live a spiritual life or provides us with an ideal companion who brings us harmony. Again and again we will grapple with issues of this kind in discussions of individual paintings: Is the woman a courtesan or a wife? Was the work painted to commemorate a marriage or as an erotic pinup? What happens to the meaning of the images when they are no longer rather straightforward elements of nuptial furniture (the inner lids of cassone panels, for example [cat. no. 58]), but have migrated to the wall and become highly expressive independent works (as in cat. no. 148)?

One example illustrates the problems of interpretation we face. Late in his career Titian painted five related works showing Venus reclining in bed accompanied by a male musician—sometimes an organist and sometimes a lute player—who gazes at her intently (see cat. no. 152). Not only the kind of musician but other details vary as well: Cupid comes and goes, and the landscape backgrounds differ significantly. Technical examination has shown that the principal figure of Venus was in most cases transferred mechanically from canvas to canvas through use of a cartoon and that Titian was personally involved in the production of each work to varying degrees.[22] We can assume, therefore, that at least some of these paintings were produced for the open market, rather than invented for a specific client, and that their imagery evolved as a result of the popularity of the composition. What then did this image mean to the various owners of the paintings, and in what way was that meaning inflected by the changes? Interpretations have drawn upon the contemporary attitudes we have outlined here.[23] To be sure, Titian's paintings are narratives about love, music, and the suitor's gaze, but do they illustrate Neoplatonic philosophical ideas about the hierarchy of the senses, comparing sight and hearing in the apprehension of beauty, as Erwin Panofsky suggested and Otto Brendel expansively articulated?[24] Or do their replicability and relative "vulgarity" indicate, as Ulrich Middeldorf responded, that they were merely "ornamental furniture" meant to decorate bedrooms? Does the suitor employ his music and gaze, and Venus her beauty, for a goal that is sacred or profane? Perhaps if we follow Equicola, we can arrive at a middle way that does not reject either alternative exclusively. As the Prado's *Venus with an Organist and a Dog* was most likely painted in a marital context, this version was probably perceived as a sensual image that fell within the accepted norms of married life. Titian's paintings seem to embody the multiplicity of interpretations found in contemporary poetry and prose and therefore bring these writings alive in visual terms.

This exhibition could not have been undertaken without its underpinning in several decades of important historical and art-historical research on elements of Italian society, ranging from dowries, marriage, and the family through costume history. Its organizers hope, above all, that the results of these flourishing research fields have informed our descriptions of the impressive variety of objects on view. While we can highlight groundbreaking work, such as Klapisch-Zuber's on Florentine marriage rituals, it is now well-nigh impossible even to cite the many recent studies that have scrutinized erotic relationships, marriage, the institution of the family, and the roles of women and children within it in the Renaissance. There has been a parallel explosion in the study of both the function and the imagery of the art created in tandem with these historical contexts; the authors of the present catalogue are among the most important contributors to these ongoing fields of study. Thus, the exhibition offers a unique, illuminating view of these fundamental aspects of Renaissance society through the investigation of the works of art that are most intimately tied to them.

1. Seidel Menchi 2001, pp. 18–19, in a section entitled "Anarchia coniugale?" For courtships at windows and doors, see as well Lombardi 2001, pp. 183–84. They also loom large in the romantic literature of the time.

2. Brucker 1986; Kuehn 1989 has pointed out the limits of this kind of microhistory as well as some lacunae and misjudgments in Brucker's analysis of the story.

3. Kuehn 1989, p. 520, points out that these were the three elements that the preacher Saint Bernardino da Siena considered as constituting an indissoluble marriage.

4. See, for example, Ferraro 2001 and Eisenach 2004.

5. Altieri, *Li nuptiali*, 1995 (ed.). See also Krohn, "Marriage as a Key to Understanding the Past," for further discussion of marriage rituals throughout Italy.

6. These include Klapisch-Zuber 1979/1985; Klapisch-Zuber 1982/1985; Witthoft 1982; various essays in Dean and Lowe 1998; Labalme and Sanguineti White 1999; Fortini Brown 2004, pp. 141–45; and an excellent essay by Matthews Grieco (2006).

7. Klapisch-Zuber 1982/1985, p. 231, has pointed out how many rings were exchanged at these events. Research on the Rucellai family, for example, has shown that when Bernardo Rucellai married Nannina de' Medici in 1466, she received twenty rings from eighteen people, including her mother-in-law and ten other members of her husband's family.

8. Klapisch-Zuber 1982/1985, p. 225. The symbolic significance of these gifts was clear to everyone. Thus, in 1549, when Maria da Reggio, a young woman of modest birth in Bologna was unhappy with her betrothal, she expressed her feelings by refusing to wear to church the coral necklace, white bonnet, and black velvet belt that her fiancé, Andrea, had given her. When asked why she had decided not to wear these items, she responded, "Because I don't want Andrea!"; see Matthews Grieco 2006, p. 105.

9. The contemporary Francesco Sansovino remarked that this was how the bride "shows herself in the household and throughout the city almost as if to so many witnesses to the contracted marriage"; see Labalme and Sanguineti White 1999, pp. 44–45.

10. The Venetian government tried to limit these excesses with sumptuary laws, which were enacted in many other cities as well. The huge scale of the entertainments they proscribe gives us an idea of the flood of ostentatious display the laws were meant to control; see Labalme and Sanguineti White 1999, pp. 62–64; and Fortini Brown 2004, pp. 150–51.

11. Cazzola 1979.

12. Hankins 1993, pp. 62–63, pl. 56. A monographic treatment of the manuscript, *A Renaissance Wedding: The Celebrations at Pesaro for Costanzo Sforza and Camilla Marzano d'Aragona*, including a translation of the contemporary account of 1475, introduced and edited by Jane Bridgeman, is forthcoming (2009). These events were not always characterized by undiluted splendor. When Felice della Rovere, Pope Julius II's natural daughter, married the Roman nobleman Gian Giordano Orsini in 1506, despite the fact that the ceremony took place in the prestigious Roman palace of the Cancelleria, whose rooms were filled with cardinals, the bride was greatly embarrassed by her husband's maladroit attentions, and the guests left early because of the lack of food and silverware. See Murphy 2005, pp. 82–85. For Felice's armorial maiolica, see cat. no. 8.

13. Rogers 1993, pp. 385ff. (quotation on p. 386).

14. See Alberti, *Dinner Pieces*, 1987 (ed.), pp. 132, 133 ("The Husband"), 141, 143, 147 ("Marriage"), 190–97 ("The Widow"), and also p. 5 (introduction by David Marsh).

15. Various authors have attempted to understand the context of such works, including Olsen 1992 and Baskins 1994 on the *Nastagio degli Onesti* panels, and more generally Tinaglia 1997, chap. 1, esp. pp. 32–35 on Boccaccio's difficult tale of Griselda, and Baskins 1998.

16. Bembo, *Gli Asolani*, 1808 (ed.), pp. 28, 48–49.

17. Ibid., pp. 158–59.

18. Bonora 1966/1979, pp. 134–35.

19. Ibid., p. 469.

20. Equicola, *Libro di natura d'amore*, 1989 (ed.), p. 47. One of the participants in Castiglione's *Courtier* expresses a similar view, maintaining that in love the body cannot be separated from the soul; see Rosand 1980, p. 378.

21. Firenzuola, *On the Beauty of Women*, 1992 (ed.), p. 11 ("First Dialogue").

22. See Falomir 2003a, p. 250, fig. 136, and see cat. 152.

23. For summaries, see Miguel Falomir in Falomir 2003a, pp. 248–51, 394–96, nos. 41, 42; Bayer 2005, pp. 15–17; and Keith Christiansen in Ferino-Pagden 2008, pp. 211–15, no. 2.4.

24. See cat. 152. Both Equicola and Castiglione express similar views on sight and hearing as the means of gaining knowledge of beauty and harmony.

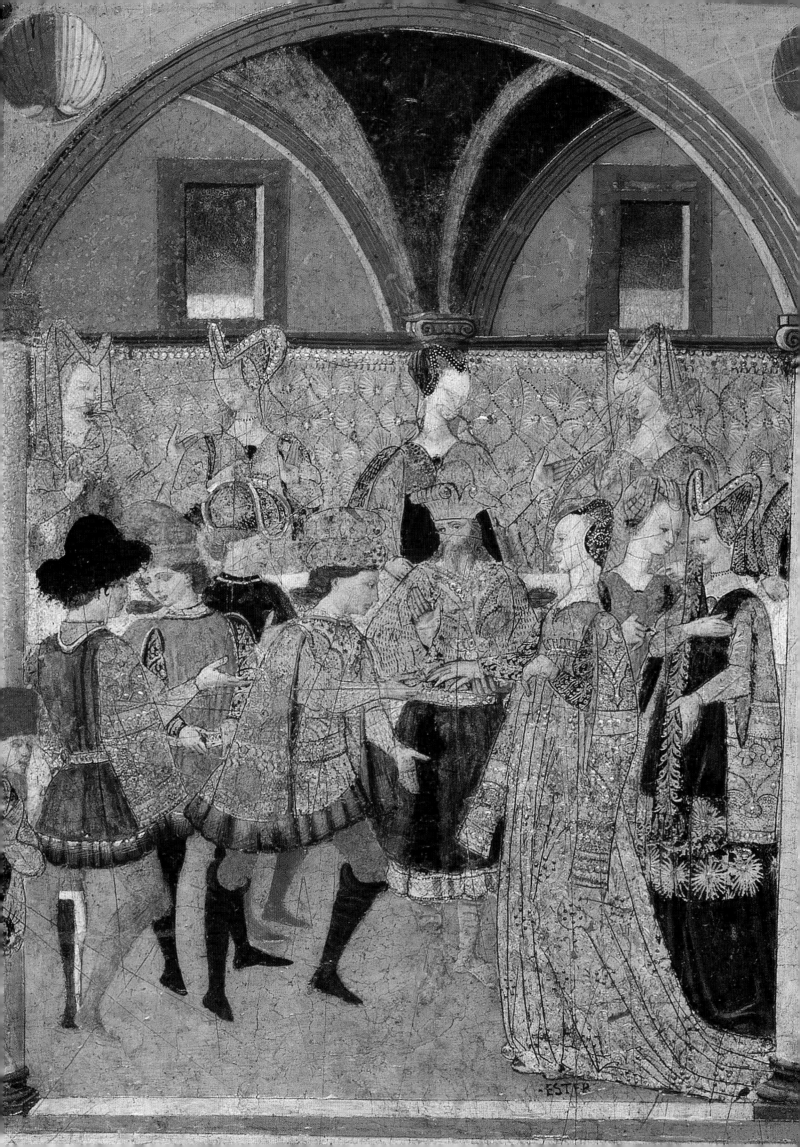

Marriage as a Key to Understanding the Past

Deborah L. Krohn

In 1447 a wealthy Florentine widow prepared for the wedding of her daughter, Caterina Strozzi. Writing to her son, she described clothing that the future husband, Marco Parenti, had ordered for his bride, using the dowry provided by her family:

When she was betrothed he ordered a gown of crimson velvet for her made of silk and a surcoat of the same fabric, which is the most beautiful cloth in Florence. He had it made in his workshop. And he had a hat of feathers and pearls made for her [that] cost eighty florins, the cap underneath has two strings of pearls costing sixty florins or more. When she goes out, she'll have more than four hundred florins on her back. And he ordered some crimson velvet to be made up into long sleeves lined with marten, for her to wear when she goes to her husband's house. And he's having a rose-colored gown made, embroidered with pearls. He feels he can't do enough having things made, because she's so beautiful and he wants her to look even more so.

This letter, penned by Alessandra Macinghi Strozzi (1407/8–1471), affords a vivid picture of the material world of the Italian Renaissance marriage.[1] But it also reveals many things about the relationships between mothers and sons, mothers and daughters, and husbands and wives. For the mother, the monetary significance of her daughter's wardrobe must have satisfied a desire to maintain her social standing and reflect well on the family's generous dowry. Alessandra was obliged to write to her son for approval of the details of the wedding, since she did not remarry and was not in control of her own finances. Finally, the letter manifests the groom's desire to show off his bride publicly by ordering articles of expensive clothing made especially for the occasion.

Three textile pieces decorated with heraldic devices of prominent families, the Medici, the Strozzi, and possibly the Peruzzi, are featured in this volume (cat. nos. 51, 53, 54), examples of fabrics that were perhaps custom-woven for nuptial events. A detail from Filippo Lippi's double portrait (cat. no. 118; fig. 4) illustrates a sleeve lavishly embroidered with the word *lealta* (loyalty), alluding to the quality most desired in a wife. This bride, if she is one, literally wears her heart on her sleeve.

Alessandra Strozzi's letter and art objects such as these demonstrate why historians study the institution of marriage. The rituals and ceremonies that inspired much of the art discussed in this volume, from courtship to consummation, provide a unique frame through which to view the social and economic history of early modern Italy.

APPROACHES

When did historians begin to look at marriage, and what kinds of sources did they employ? Fifteenth- and sixteenth-century chroniclers already reflect an awareness of the deep significance of marriage, which they recognized was necessary to secure dynastic unions for the maintenance of social and political continuity. One way or another, family was perpetuated by marriage, for the nobility and middle classes alike. A survey of the sources used for understanding Renaissance marriage follows.

Prescriptive Sources

For Leon Battista Alberti (1404–1472), author of the mid-fifteenth-century treatise *Della famiglia* (On the Family), the institution of marriage was the foundation upon which a strong and prosperous society must be built. "Marriage," he wrote, "was instituted by nature, our most excellent and divine teacher of all things, with the provision that there should be one constant life's companion for a man, and one only."[2] Aware of the tendency of Florentine men to delay marriage, he emphasizes the criteria that ought to inform their choice of a bride. "They say that in choosing a wife one looks for beauty, parentage, and riches." He further advises, "Even a wild, prodigal, greasy, drunken woman may be beautiful of feature, but no one would call her a beautiful wife." Beyond beauty, the ability to bear children is stressed. "In her body he must seek not only loveliness, grace, and charm but must also choose a woman who is well made for bearing children, the kind of constitution that promises to make them strong and big. There's an old proverb, 'When you pick your wife, you choose your children.'" But in choosing a wife, a man was also choosing her kinsmen and extended family. "To sum up this whole subject in a few words, for I want above all to be brief on this point, let a man get himself new kinsmen of better than plebeian blood, of a fortune more than diminutive, of a decent occupation, and of modest and respectable habits."

Documentary Sources

Prescriptive sources such as Alberti tell us how contemporary people were supposed to behave. Documentary materials, on the other hand, describe how people actually behaved. An example is Alessandra Strozzi's letter cited above. A shift in the historiography not only of marriage but of all aspects of social life came in 1929 with the founding of the journal *Annales d'histoire économique et sociale*, and of a related school of historical research that emphasized the study of long-term historical structures, such as marriage, over events such as wars or famines.[3] The *Annales* School, as it has come to be called, includes the work of Fernand Braudel (1902–1985), whose study of Mediterranean culture in the age of Philip II, among other works, helped shape current perspectives on the Renaissance.[4] Combining sociology and geography with the more traditional historical questions, scholars such as Emmanuel Le Roy Ladurie and Carlo Ginzburg created a new template for historical research that challenged historians to embed their objects of study into the psychological, as well as the material and environmental, context of the period.[5] Microhistories, which look at society through the lens of a small town or a particular person, are also an important tool for understanding works of art. It is due to this revolution in historiography that demographic and sociological information, such as that presented by David Herlihy and Christiane Klapisch-Zuber in their groundbreaking study of the *catasto*, discussed below, could in turn shed light on works of art from early modern Europe. Thus, the study of the arts of love and marriage has benefited from the formulation of new questions beginning in the 1960s.

A fundamental source for understanding marriage and how it structured Italian Renaissance society is the survey, or *catasto*, conducted in Florence and its territories to serve as the basis for taxation between 1427 and 1430. Among the most complete documentation of the composition of the household for any early modern city, these records were brilliantly and comprehensively analyzed by Herlihy and Klapisch-Zuber beginning in the late 1960s; they yield insights into every aspect of society, from agriculture to infant mortality.[6] How did the *catasto* work? Every citizen liable to pay the *monte*, or mandatory loan, to the government had to complete an official questionnaire, the *portata*, describing his possessions and the number of mouths, or *bocche*, in his household. From this, officials made a fair copy, called the *campione*, which indicated the amount of tax that had been assessed. Clergy and guilds also had to submit questionnaires, completing the picture of property and population that the *catasto* painted. There was no real census again in Florence until 1552. The database that Herlihy and Klapisch-Zuber created to sort the information from transcriptions of the *catasto* (one of the earliest uses of quantitative, computer-assisted research in the humanities) and the many articles and books spawned by this research lie at the heart of discussions of marriage and the history of the family in the Italian Renaissance to the present day.[7]

General conclusions from this body of research have enabled us to situate Tuscan marriage customs within the larger context of European marriage models. Tuscan marriage followed the Mediterranean model rather than that of northwestern Europe. One characteristic of this model was a significant age differential between spouses. Women were between eight and fifteen years younger than their husbands on average, with the largest gap found among the wealthy.[8] It is easy to speculate that this age difference reinforced women's dependent role within the family. These insights, based on quantitative research, continue to govern interpretations of the complex and often puzzling imagery found on marriage objects such as cassoni (wedding chests), as I explore further in my essay "Rites of Passage," preceding the first catalogue section in this volume.

Klapisch-Zuber was also among the first to exploit a unique source for early modern Italy: the family memoirs, or *ricordanze*, kept by Florentine men. These are manuscripts in which heads of households recorded marriages, births, and deaths, as well as other significant information. The narrative form of these memoirs often yields much information not only about what happened in a family but also about how people felt about it. Like the letters of Alessandra Strozzi, the *ricordanze* afford a glimpse of the social rituals that structured the lives of Renaissance men and women.

Looking at the past through the lens of social life, rather than seeing history as a succession of battles, dynastic alliances, or technological advances, has its roots in antiquarian studies of the sixteenth century. An example is the important dialogue *Li nuptiali* (Nuptials) by the Roman nobleman Marco Antonio Altieri (1450–1532), which contrasted contemporary and ancient nuptial customs. Written on the occasion of the wedding of one of Altieri's noble friends, the dialogue offers advice and information on the way to celebrate marriage based on the customs of the ancient Romans, considered to be the ancestors of Altieri and members of his social milieu. Through performing nuptial rites in the proper ways, contemporary Romans would be able to resuscitate the moral order and political power that were their due.[9] The descriptions of weddings from the period starting about one hundred years before his time are the most useful part of the book for us. His colorful explanations of medieval customs, such as the placing of a sword over the heads of a couple as they took their vows, explore a variety of themes in the tradition of humanist scholarship that flourished during the fifteenth century, when historical precedent was invoked as authority for proper behavior of many sorts.

The vivid descriptions of upper-class marriages in Renaissance Venice found in the diaries of Marin Sanudo (1466–1536) provide another important source, adding a personal perspective to the more moralizing work of Altieri.[10] Both Altieri's and Sanudo's narratives of noble marriages can be compared with the genre of festival books, frequently illustrated, which circulated throughout Europe beginning in the mid-sixteenth century to document royal marriages, entries, and funerals, among other ceremonies. These festival books must have satisfied a voyeuristic interest in the lives of the powerful, but they were also a form of political propaganda designed to publicize the tremendous expense spent on royal marriages and other types of official celebrations. An example of this type of book is included in this volume (cat. no. 126b). Raffaello Gualterotti, a Medici courtier, provided lavish verbal descriptions and illustrations of the marriage of Francesco de' Medici and Bianca Cappello in 1579.

The interesting tradition of writing about marriage and then presenting the product as a wedding gift, as Altieri did, is traceable as far back as the advent of printing at the end of the fifteenth century, and links Renaissance sources to more recent

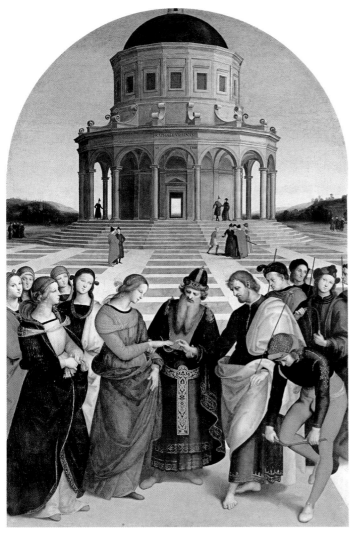

Fig. 3. Raphael (Raffaello Sanzio) (1483–1520), *The Marriage of the Virgin*
(*"Sposalizio"*), 1504. Oil on panel, 66⅞ × 46½ in. (170 × 118 cm). Pinacoteca
di Brera, Milan

historical explorations of marriage. Marking the occasion of mar-
riage through a publication on the subject, often of literary or
historical value, frequently of strictly local relevance, and gener-
ally printed in small quantities, continued into the early twentieth
century and may still occur now and then in Italy.[11] A pamphlet
published in an edition of two hundred for a marriage that took
place in 1907 provided information about the gift of a marriage
casket (perhaps similar to the casket in this volume [cat. no. 39])
originally made for Lodovico il Moro and Beatrice d'Este when
they married in 1499, implicitly linking its twentieth-century
recipients to their illustrious Renaissance precursors.[12]

Another type of descriptive evidence is provided by contem-
porary legal documents, which provide a glimpse into behaviors
that went against prescribed codes of conduct. When marriages
failed or adulterers were caught, when love blossomed between
the wrong people, the law intervened and often left detailed court
records for historians to mine. Gene Brucker's masterful analysis
of a complex judicial process involving a dubious marriage that
began in mid-fifteenth century Florence illuminates not only the
various legal institutions that existed at the time but also other
aspects of Florentine social experience. The lawsuit was brought by
a beautiful widowed tailor's daughter, Lusanna, who claimed that
her upper-class lover, Giovanni, had married her soon after her

husband had died. Later, Giovanni became publicly engaged to a
young woman of the Rucellai family, one of Florence's wealthiest
and most distinguished. When Lusanna protested that they had
been wed in secret, he denied the marriage. Lusanna attempted to
set the record straight and reclaim her honor, which Giovanni did
his best to defame, accusing her of having multiple lovers while
her husband was still alive, and even of poisoning her husband to
get him out of the way. Though Giovanni did not deny the sexual
relationship he had had with Lusanna, he did not acknowledge a
legal union between them. As the story unfolds through the court
documents, a fascinating picture of the meanings and mechanics
of marriage emerges. The central question was whether the two,
Giovanni and Lusanna, were actually married or not, and if so, in
the eyes of whom.[13]

It may be surprising to some that there could be so much
uncertainty concerning what appears to be a straightforward
question of legal status. The story of Giovanni and Lusanna raises
the issue of the definition of marriage in Renaissance Italy, and
who had the authority to establish its legality. Scholars such as
Brucker, Guido Ruggiero,[14] and a group of Italian historians
led by Silvana Seidel Menchi have used legal records to tell love
stories that ended in marriage and others that deviated from the
norms established by society for relationships between men and
women. As Seidel Menchi has asserted, legal cases can tell us a
great deal not only about marital conflicts but also about marriage
in general.[15] Among the topics these judicial records illuminate
are the status of marriage at the opening of the Council of Trent
(1545–63), the ascertaining of consent, the coercion exerted upon
women—including the existence of "child brides" and "invol-
untary bigamy"—and their resistance.[16] Other topics that these
particular sources shed light on should be familiar to students of
Italian social history: neighbors and neighborhoods, confession,
the dowry, the female body, love, modesty, illegitimacy, decep-
tion, and magic. The confessional nature of small ecclesiastical
tribunals in which there were generally two members, vicar and
chancellor, opens up a window on the lived lives of many men and
women who were not otherwise noteworthy.[17]

While nuptial customs and traditions were localized and varied
throughout the Italian peninsula, to say nothing of the broader
European context, the period covered by this volume, roughly
1400 to 1600, witnessed transformations in the ways marriage
was celebrated and regulated. Before we look more closely at these
changes, a description of an actual wedding is in order.

WHAT CONSTITUTED MARRIAGE IN THE ITALIAN
RENAISSANCE?

What did it mean to marry in the Italian Renaissance? Klapisch-
Zuber approaches the subject by remarking on the popularity of
a theme in Italian paintings between 1300 and 1500: the marriage
of the Virgin, or *sposalizio*, as it was called (fig. 3). From a his-
torical perspective going back to the Roman period, the mutual
consent of the couple and of those who had authority over them
remains constant.[18] Personal memoirs, or *ricordanze*, and descrip-
tions such as that recorded by the above-mentioned Venetian
diarist and statesman Marin Sanudo detail the stages of the mar-
riage process. Though there are variations according to region,

especially in the elapsed time between the ring day and the public procession/consummation, the ceremony generally followed some basic guidelines.

In Florence, it went generally like this: at first, a marriage broker might propose a good match, after which family members from both sides would come together to negotiate. Once an agreement was made, the terms would be recorded in a sealed document that might remain secret until the couple was old enough to marry or a suitable dowry had been prepared. This ceremony was called the *impalmamento* or the *toccamano*.[19] At the appointed time, the groom would hasten to the home of his future bride for dinner, bearing gifts.

A large gathering would follow, attended by the male members only of both the bride's and the groom's families. At this stage, the specific terms of the union would be hammered out, including the amount of the dowry, a schedule for its payment, and the date of the festivities. This was called the *giuramento grande* or the *sponsalia*.[20] Since this ceremony was public, objections could be raised by members of the clan or outsiders. Before the Council of Trent, there was no formal posting of the banns or public vows of the couple.

The next stage finally involved the bride, since her finger was needed for the placement upon it of a ring that symbolized the union. This ring ceremony took place at the home of the bride in the presence of both male and female members of her family, as well as those of the groom's. The groom's family brought gifts, while the bride's provided a festive meal. This ring ceremony, or *anellamento*,[21] is portrayed in painted panels such as Apollonio di Giovanni and Marco del Buono's *Story of Esther* (cat. no. 57; fig. 2) or Jacopo del Sellaio's *Cupid and Psyche* (cat. no. 136), where the focus of the narrative is the moment when the ring is placed on the bride's finger. The legitimization of the marriage in the eyes of the public, or *nozze*,[22] took place after a procession through the streets of the city. The bride moved from the home of her father to that of her husband, thus enacting the union both physically and symbolically. The festivities could take several days, but at the end, the union between the two was to be clear to all. In Rome, the procession included a stop at a church, but in Florence there was no ecclesiastical intervention and the ceremony was what we might call civil.

Venetian patrician marriages followed roughly the same trajectory. A formal engagement, which included the stipulation of dowry arrangements, was followed by the announcement of the engagement in front of the families involved and Venetian officials, the display of the bride (see cat. no. 65), and then the exchanging of public vows between the bride and groom. A feast, often featuring exotic and lavish dishes presented as gifts to the couple, preceded the bride's arrival at the groom's family home and the consummation. Details that were particular to Venice's unique topography included travel through the city in open gondolas (see cat. no. 65) and other public festivities that could last a week. These festivities served to underscore the couple's ties to the city and thus had enormous diplomatic value.[23] Sanudo, whose diaries cover the period between 1496 and 1533, records details such as the size of dowries, the spectacles enacted at wedding parties, the clothing worn by the bride and her retinue, and the food served. Sanudo reports on the wedding of the granddaughter of

Doge Andrea Gritti in 1525. The betrothal was announced at a dinner, and festivities followed the next day. This party took place in the Ducal Palace, in a room usually reserved for meetings of the Venetian Senate. A supper party after dancing was especially noteworthy, to judge from Sanudo's description: "It was a most elegant dinner with pine-nut cakes, partridges, pheasants, baby pigeons, and other dishes. And although more guests appeared than were expected, each one had enough to eat." Eight days later, after a procession through the square with torches and trumpets, the wedding took place in the Basilica of San Marco. At an official dinner afterward, members of the Venetian government dined with the doge on "an excellent meal of duck, pheasant, partridge and many other dishes. For dessert there was whipped cream, marzipan, and sweetmeats followed by performances by the buffoon Zuan Polo and other virtuosi." But this was not the end of the celebrations. There was a meal for the women, then a sunset cruise on the Bucintoro, the doge's personal ship, from the Ducal Palace down the Grand Canal to the home of the groom, where another feast followed before the couple was permitted to consummate their union.[24]

Wedding feasts were among the most lavish of meals, featuring entertainment as well as many courses of specialty foods, including different types of fowl, and a variety of sweet dishes. In contemporary handbooks for stewards, specific instructions are provided for menu planning and proper table service for weddings. Domenico Romoli's 1560 *Singolare dottrina* contained a section that instructed the steward to lay the tables and included mention of embroidered tablecloths.[25]

Sumptuary laws, which regulated anything from the amount of fabric that could be used in a wedding gown to the quantities and types of foods that could be served at a wedding feast, survive as mute testimony to the excesses of celebration that civic governments in most Italian cities struggled to contain. Regulations pertaining to clothing were among the most persistent.[26] As in the case of other types of prescriptive strictures, one can assume that they were frequently violated, since otherwise they would not have been repeated year after year.

By the mid-sixteenth century, the church exercised greater influence over the institution of marriage than it had in the past. Responding in part to the Protestant Reformation, which had proclaimed marriage to be a civil contract rather than a sacrament and therefore outside the purview of the church, the bishops at the Council of Trent decreed that public notice of weddings be given for a specified time before they were to take place, and that all marriages be celebrated by a priest in the presence of witnesses. This was to avoid the situation in which Giovanni and Lusanna (and Florence's Archbishop Antoninus, who was eventually called in to adjudicate that case) found themselves: having celebrated a clandestine marriage, they had no hard and fast evidence with which to claim either that they were married (Lusanna's allegation) or not (Giovanni's counterclaim). Both Protestant and Catholic authorities condemned the notion that mutual agreement between bride and groom was the only requirement for marriage, mandating parental consent, as well as the posting of the banns.[27] Protestant theologians, led by Martin Luther and John Calvin, also recognized that marriages could fail, paving the way for legally sanctioned divorce and subsequent remarriage. As copious

legal documents make clear, establishing grounds for terminating a marriage was fraught with difficulties.

Central to the institution of marriage in the Renaissance was the exchange of wealth that accompanied the joining of two families. When contracting a marriage, the cash, property, and goods changing hands played an important role. Men entering into marriage expected to receive a dowry from their betrothed. The amount and form of the dowry was established contractually prior to the consummation, as discussed above. Florentine girls' destinies were determined from birth through the state-mandated dowry funds into which their prudent fathers invested. Interest accrued to the initial investment, while the government had use of the cash for at least fifteen years.[28] But the dowry was not the only material transaction to take place. The trousseaux that women brought into their married lives often consisted of household linens, lengths of fabric for clothing, and personal items such as underwear, caps, handkerchiefs, spinning and embroidery tools, or small devotional books. The clothing and jewelry, including rings (see cat. nos. 32a–e, 33), that grooms gave to their brides were considered the countertrousseau, a throwback to earlier medieval customs in which the groom gave the bride a gift on the morning following the consummation of the marriage. In Florence, this *morgincap*, or *donatio propter nuptias*, as it was called, was limited to fifty lire, so the countertrousseau of the Renaissance made up for this negligible sum.[29]

Venetian dowries could be very lavish, as Sanudo's accounts make clear. In one case, presentation of the dowry was part of the entertainment. Describing a wedding in 1507, Sanudo wrote: "It should be noted that at the dinner hour, when I was present, about 4000 ducats, part of the bride's dowry, was brought in six basins. The first one contained gold [coins], the rest silver [coins]. Well done, for those who can afford it!"[30]

Nothing was more revealing of women's unstable status than the fate of widows in early modern Italy. Legal statutes varied regionally. In Florence, widows were assured their dowry after the death of their husbands, but they were not entitled to anything else, lest they cut into the inheritance of the husband's heirs, who were not required to care for their mother by law. When a widow remarried, she generally left her children with the extended family of her deceased husband, rather than bringing them along to her new husband's home. When she took her dowry with her, as often happened, she might leave her children effectively orphaned and struggling to come up with the funds to survive.[31] In Venice, too, the legal system theoretically protected the dowry for return to the wife in the case of the husband's death, but in practice this was hard to enforce. Since women were entitled to the husband's money and property for only a year after his death, the loss of the dowry often sent women and children into the care of the state once they no longer had access to funds. Dowry litigation was common in Renaissance Venice, providing historians with a great deal of information about when and how marriages failed.[32] The widow was a common figure, often of derision, in Renaissance literature, from the merry widow in Giovanni Boccaccio's *Corbaccio* (1354–55) to the title character of the comedy *La vedova* (The Widow) by Giovani Battista Cini, first performed in Florence in 1569.[33] But she was also a threat to the very fabric of society. Women were discouraged from remaining independent; if

they did not remarry quickly, they were sent back to their father's home, where they could be more easily controlled.[34]

Like their Christian compatriots, Italian Jews tended to marry in private homes rather than houses of worship. The search for an appropriate match could be lengthy, sometimes involving extended travel and residence in another city in order to observe a marriage candidate firsthand.[35] Following the customs established by Jewish law, a formal legal writ called the *tenaim* was drawn up between families of the bride and groom in advance, sometimes by several months or years, of the wedding. The *tenaim* recorded the terms of the marriage, including the amount and nature of the dowry and counter-dowry, a date for the wedding, provisions for dissolution of the union in terms of property, and pledges to honor the terms as set out in the writ.[36] During the period between agreement and marriage, the fiancé would visit the future bride, bringing valuable gifts such as a basket of silver or porcelain filled with fruit.[37] When bride and groom were from different cities, preparations for the wedding were carried out through correspondence, which has provided useful evidence for historians. In particular, the many letters of invitation testify to elaborate customs of letter writing and etiquette.[38] The lavishness of some Jewish weddings led Christian lawmakers to formulate sumptuary laws relating to the number of mounted escorts an arriving Jewish bride might have, the number of guests who could attend the nuptial banquet, and so forth.[39] Public celebrations assured community recognition of the marriage,[40] and these would have included the ring giving and breaking of a glass at the conclusion of the formal vows. The marriage ceremony might also have featured the reading of a second, more formulaic legal document, the marriage contract (*kettubah*), many of which were beautifully illuminated by leading scribes.[41]

WOMEN'S ROLES IN THE HISTORIOGRAPHY OF
RENAISSANCE MARRIAGE

Inevitably, the focus on social structures that has supplemented more traditional forms of historical inquiry has led to the reevaluation of women's roles. Economic and social historians approach the question of gender roles through documentary sources that tell us about women's economic status: whether they were allowed to own property, inherit wealth, or pass it along to their offspring. Looking at history through the frame of the family unit demands that gender, or "the social organization of sexual difference," be defined and examined with new eyes.[42] Though it is dangerous to generalize about gender, the significant role played by Renaissance women in the literary and material culture of the period—as patrons of artists, as subjects of portraits, or, less commonly, as artists themselves—yields a complex answer to the question: Did women have a Renaissance?

That question is the title of an important essay by Joan Kelly published in 1977.[43] Contrasting the cultural involvement of women in the Middle Ages, as troubadour singers, for example, Kelly found that women's roles contracted during the fifteenth century with the revival of classical models that were explicitly patriarchal. Contemporary prescriptive sources, written almost exclusively by men, set out the dominant expectations for women's behavior. For Alberti in his treatise *On the Family*, discussed

above, the most important qualities of women were virtue and fertility. In his fiery sermons, delivered to crowds all over the Italian peninsula in the mid-fifteenth century, Saint Bernardino of Siena (1380–1444) addressed the failings of both men and women in his exhortations to marriage. According to him, marriage should be based on honesty, pleasure, and profit. As he describes these values in action, a vivid picture of Renaissance marriage emerges; highlighting points of friction that must have occurred frequently between spouses, the picture flatters neither wife nor husband.

Women in courtly settings were expected to be educated and articulate, but in ways that differed from their male counterparts. Baldassare Castiglione's sixteenth-century treatise on the ideal life of the courtier unfolds as a series of conversations that supposedly took place at the Ducal Palace in Urbino in 1507. A small number of women are part of these gatherings, among them the Duchess of Urbino, Elisabetta Gonzaga (1471–1527), wife of Duke Guidobaldo da Montefeltro (1472–1508). Elisabetta is praised by the author for her beauty, good humor, wit, modesty, and nobility. But as the first soirée begins, the duchess relinquishes any authority she might have had over the choice of "games," as the conversations were termed, delegating the decision instead to Gaspare Pallavicino. The duchess then proceeds to release all women present from the task of thinking up "games." Castiglione effectively has the noblewomen in attendance literally write themselves out of the conversations, although they appear now and again uttering banal interlocutions.

Despite the generally subservient role played by women in Italian Renaissance society, there were a number of extraordinary women whose words and actions have endured. A recent biography of Felice della Rovere (1483?–1536), illegitimate daughter of Pope Julius II (r. 1503–13), details the way in which she used her family connections, both by birth and through marriage, to consolidate power in Renaissance Rome.[44] Isabella d'Este (1474–1539), daughter of Duke Ercole I d'Este, of Ferrara, and Eleonara of Aragon, was a humanist and shared leadership of Mantua with her husband, Francesco Gonzaga (1466–1519). She was also one of the most important art collectors of the Renaissance, using her wealth to fashion and furnish her palaces, selecting everything from ceramic dishes and floor tiles to monumental wall paintings and sculpture. But she is still a controversial figure, both revered and reviled by contemporary scholars seeking to characterize her contribution as a patron of both arts and letters.[45] Patricia Fortini

Brown, in her study of Venetian domestic art, architecture, and social history, includes an extended discussion of the lavish material world of Venetian courtesans, whose business acumen was notable since they were more in control of their finances.[46]

Treatises that describe the responsibilities and conduct of gentlewomen, parallel to those for men, proliferated throughout the sixteenth century, reinforcing traditional roles. Among the most widely read of these was Juan Luis Vives's book *De l'istituzione de la femina christiana* (The Education of a Christian Woman), which included sections on virgins, married women, and widows.[47] This book described the various attitudes that women needed to cultivate based on the stages of their lives. Scholars of literature use a variety of texts, from lyric poetry to ribald *novelle*, or short stories, to understand the construction of women's roles. Many of the surviving objects featured in the present volume, from maiolica dishes to painted panels of cassoni, reflect these literary or prescriptive tropes.

CONCLUSION

After this brief overview of marriage, Italian-style, during the Renaissance, we can return to Marco Parenti, whose gifts to his prospective bride Caterina Strozzi began this essay. The lavish gown of crimson velvet and the cap embellished with feathers and pearls that he had made for Caterina reappear in the documentary record forty-three years after the marriage, when Marco sold them, together with other used clothing, to recoup some of his initial investment. Whether or not he had any sentimental attachment to the clothing cannot be inferred from the documents. However, he waited nine years after Caterina's death, suggesting that he had held back before parting with them. We can reflect on many aspects of marriage in the Italian Renaissance thanks to the survival of these records, allowing us to reconstruct the life cycle of a suite of wedding clothes, created with the hope of a prosperous union and passed along after it had ended.[48] The importance of marriage as a moment for material display, the complementary roles of men and women, and the significance of family and posterity are all part of the story told by Caterina's clothing. It is through sources and documents such as these that new perspectives on early modern social life have emerged and continue to enrich our understanding of the visual culture of marriage in the Italian Renaissance.

1. Macinghi Strozzi, *Letters*, 1997 (ed.), pp. 29–33 (quotation on p. 31, modified by author). For an extended discussion of Alessandra Strozzi, see Crabb 2000.
2. L. B. Alberti, *Family in Renaissance Florence*, 1969 (ed.), p. 112. The remaining quotes in this paragraph are on pp. 115–17.
3. See Hunt and Revel 1995.
4. Braudel 1949.
5. Le Roy Ladurie's most noted book is *Montaillou: Village occitan de 1294 à 1324* (1975), which examines a group of Inquisition records from supposedly heretical shepherds in a remote village in the Pyrénées. Carlo Ginzburg wrote *The Cheese and the Worms*, first published in Italian as *Il formaggio e i vermi* in 1976, about the philosophical writings of an uneducated miller in Central Italy whose creation myth, concerning a ball of cheese that spawned worms that eventually became men, was considered heretical, leading to his persecution and thereby a series of excellent records. See Le Roy Ladurie 1975; and Ginzburg 1976.
6. Herlihy and Klapisch-Zuber 1978.
7. Many of the applications of the *catasto* research are summarized in Klapisch-Zuber 1980/1985.
8. Ibid., p. 20.
9. Klapisch-Zuber 1981/1985, p. 250.
10. Labalme and Sanguineti White 1999.
11. On this custom, see Pinto 1971; and Di Domenico 2003.
12. See Beltrami 1907. It was created "Per le fauste nozze Alessandro

Sormani, Andreani Verri Augusta Vanotti, 9 mar., 1907," as we are told on the title page. There were only two hundred copies of this printed. Beltrami was an important historian of the Renaissance in Milan.

13. Brucker 1986.
14. Ruggiero 1993.
15. Silvana Seidel Menchi has led a team of scholars in a project to document archival research on marriage trials carried out between 1997 and 2001 in several ecclesiastical archives in Italy: Verona, Feltre, Naples, Trento, and Venice. For a summary of this research and extensive bibliography, see Seidel Menchi and Quaglioni 2006, pp. 15–42.
16. Ibid., p. 29.
17. Ibid., pp. 30–31, 35.
18. Klapisch-Zuber 1979/1985, pp. 178–80. The author provides copious notes for a history of Tuscan marriage. See also Matthews Grieco 1996; and Witthoft 1996.
19. Klapisch-Zuber 1979/1985.
20. Ibid., p. 184.
21. Ibid., p. 186.
22. Ibid.
23. Labalme and Sanguineti White 1999, p. 45.
24. Ibid., p. 55ff.
25. *La singolare dottrina di M. Domenico Romoli* 1560, p. 18. The table-cloths were described as "lavorate e imbizzarate à suo modo."
26. See Allerston 1998.
27. For a succinct discussion of the role of the church in marriage customs, see Barbargli and Kertzer 2001, pp. xxiii–xvii.
28. See the masterful study by Anthony Molho (1994) of the Florentine marriage market.
29. Frick 2002, p. 129.
30. Labalme and Sanguineti White 1999, p. 48.
31. Klapisch-Zuber 1983a/1985, pp. 125–27.
32. Ferraro 2001, p. 126ff.
33. See Levy 2003a, p. 211.
34. Klapisch-Zuber 1983a/1985, p. 123ff.
35. For an exhaustive explication of Jewish marriage practices in this period and their context, researched through fascinating and voluminous primary sources, see Weinstein 2004, p. 52ff.
36. Ibid., p. 125ff. The *tenaim* were also translated into Italian and filed by Christian notaries in appropriate archives, since they would be upheld by Christian civic authorities in the event of conflicts.
37. Bonfil 1994, p. 261.
38. Weinstein 2004, p. 81ff.
39. Bonfil 1994, p. 262; and the more extensive description of these processions in Weinstein 2004, p. 358ff.
40. Muir 2005, p. 41.
41. Weinstein 2004, p. 125. There are many studies of illuminated *kettuboth*. See, for example, Sabar 1986–87, pp. 96–98.
42. Scott 1988, p. 2.
43. Kelly 1977.
44. Murphy 2005.
45. See the discussion of the Isabella literature in S. J. Campbell 2004, pp. 2–4.
46. Fortini Brown 2004, p. 159ff.
47. First published in Latin in 1524, an Italian version appeared in 1546: *De l'istituzione de la femina christiana, vergine, maritata, ò vedova. . . .* See Vives, *De l'istituzione de la femina christiana*, 1546.
48. Frick 2002, p. 131.

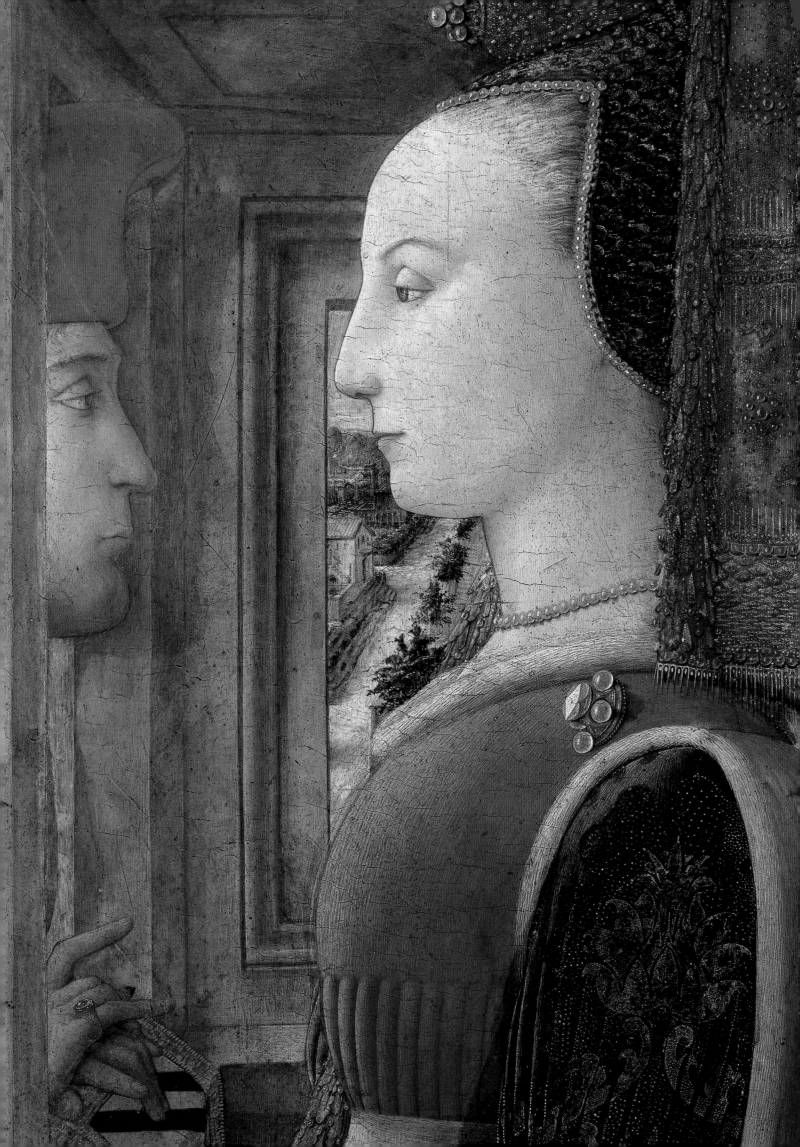

The Marriage Portrait in the Renaissance,
or
Some Women Named Ginevra

Everett Fahy

What exactly is a marriage portrait? The term, frequently used by art historians to describe fifteenth- and early sixteenth-century paintings, medals, and even sculpted busts, is difficult to pin down because we know so little about the sitters and the circumstances that led to the making of their portraits. With Italian paintings, the subject of this short essay, the term embraces several different types of portraiture: likenesses of potential brides or bridegrooms for parents and other interested parties to inspect, portraits celebrating betrothals or the births of male heirs, paintings commemorating long unions, and posthumous records of deceased spouses. The desire to portray married couples is a deeply human impulse going back to ancient times; it thrives in our digital age with images of newlyweds smiling at us weekly from the Sunday papers.

None of the early sources mentions marriage portraits as such, and account books and inventories are no help in clarifying the purpose of various portraits.[1] Only rarely do the works of art themselves provide clues, such as coats of arms or inscriptions, to the identities of the sitters, and we seldom are helped in establishing their names by comparisons with medals and tomb effigies of known personalities. Traditional identifications can be unreliable. Take the example of Pisanello's charming profile portrait of a young girl in the Louvre (fig. 5), long believed to commemorate the marriage in 1434 of Ginevra d'Este (1419–1440), the fifteen-year-old illegitimate daughter of Niccolò III d'Este (1383–1441), Marquess of Ferrara, to Sigismondo Pandolfo Malatesta of Rimini (1417–1468). The identification is based on the sprig of juniper tucked into the piping at her shoulder, the Italian for "juniper," *ginepro*, being a pun on the name Ginevra. But in recent Pisanello exhibitions, a case has been made for identifying the sitter as Margherita Gonzaga (d. 1439), because her husband, Lionello d'Este (1407–1450), whom she married on February 6, 1435, used juniper as one of his emblems.[2]

For most presumed marriage portraits we can only speculate about the matrimonial status of the subjects portrayed. Take the sitter in Parmigianino's lovely portrait of the early 1530s in the Museo di Capodimonte, in Naples, known as "Antea." A

beautiful, anonymous young woman of marriageable age, she has received wildly divergent identifications: for example, she has been called the artist's daughter, his mistress, a Roman courtesan, a noblewoman bride, an ideal beauty, and even a hermaphrodite.[3] Another example is Francesco del Cossa's portrait of a young man in the Thyssen-Bornemisza Collection, in Madrid (fig. 6). Standing before a landscape with fantastic outcroppings by a lake, he

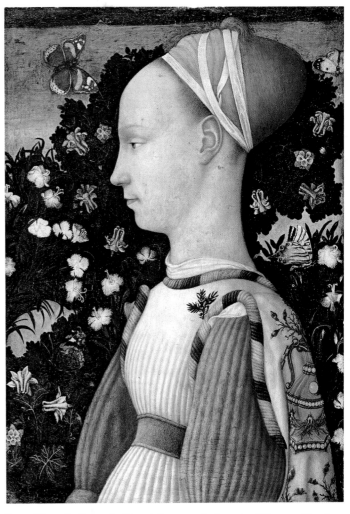

Fig. 5. Pisanello (Antonio Pisano) (1395–1455), *Portrait of Ginevra d'Este (or Margherita Gonzaga?)*, ca. 1434–36. Tempera on panel, 16⅞ × 11¾ in. (43 × 30 cm). Musée du Louvre, Paris

Opposite: Fig. 4. Fra Filippo Lippi (ca. 1406–1469), *Portrait of a Woman and a Man at a Casement* (detail of cat. no. 118)

extends a powerfully foreshortened hand over the balustrade at the bottom of the painting to show us a ring. During the four centuries the portrait was assumed to be the self-portrait of Francesco Raibolini (ca. 1447–1517), the Bolognese painter and goldsmith known as Francia, the ring was believed to be an example of the sitter's handicraft. In the early twentieth century, when the portrait was recognized as the work of the Ferrarese painter Francesco del Cossa (ca. 1436–1478), Roberto Longhi asked if the ring might not allude to the sitter's engagement. More recently the ring has been called a prize for a tournament victory, like the ring in Rogier van der Weyden's portrait (ca. 1460; Metropolitan Museum of Art, New York) of Francesco d'Este (ca. 1430–after 1475).[4]

The double portrait by Fra Filippo Lippi in the Metropolitan Museum (cat. no. 118; fig. 4) would seem to be a straightforward marriage portrait, with the bride ensconced in her marriage chamber and decked out in her nuptial finery—luxurious garments and a profusion of jewelry, including what appear to be wedding rings[5]—while her young husband looks in from the world outside. To judge from the size of her abdomen, she appears to be pregnant (though Joseph Breck has called her protruding stomach "a matter of fashion in dress and carriage of the body").[6] Breck, the first scholar to identify the painting as the work of Fra Filippo Lippi, assumed that the "two portraits represent a betrothed or newly married couple," an assumption often repeated in the literature on the painting.[7] Breck also identified the coat of arms, depicted at the base of the window, as that of the Scolari family and suggested that the man is Lorenzo di Ranieri Scolari (1407–1478), who married Angiola di Bernardo Sapiti in 1436.[8] But the evidence of the coat of arms is disputed,[9] and conflicting interpretations have been made of the enigmatic relationship between the sitters. For Joanna Woods-Marsden, the woman displays the sumptuous fabrics and jewels that she, "no longer a virgin," received as wedding presents from her husband.[10] For Jeffrey Ruda, the portrait of the woman may be posthumous and the sitters are unlikely to be "an ordinary married or betrothed couple" because they are separated spatially and psychologically.[11] For David Alan Brown, the painting may commemorate the birth of the couple's son in 1444.[12] For Luke Syson, it was painted in 1436 for the Scolari–Sapiti nuptials, and the format of the painting might allude to Gabriel's annunciation to the Virgin Mary.[13] For Christina Neilson, it portrays a knight and his lady "who is most certainly therefore not his wife."[14]

Many marriage portraits appear to have been made about the time of the marriage ceremonies. A classic example is Lorenzo Lotto's double portrait in the Museo Nacional del Prado, Madrid (fig. 7).[15] The canvas shows Marsilio Cassotti about to slip a wedding band onto the third finger of the left hand of his bride, presumably Faustina Assonica, as an airborne "Cupidineto," as Lotto called him, lays a yoke on their shoulders, literally joining them together. Signed and dated 1523, the canvas commemorates the couple's marriage in March of that year, when Marsilio was twenty years old, an unusually young age for a man to marry. The painting was commissioned by the bridegroom's father, Zanin Cassotti, who had an appetite for portraits of members of his family. According to an account drawn up by the artist, of the five pictures that Lotto painted for Zanin, at least three were portraits or religious paintings that included portraits—of Zanin's wife, his children, his deceased father and mother, and Zanin himself.[16]

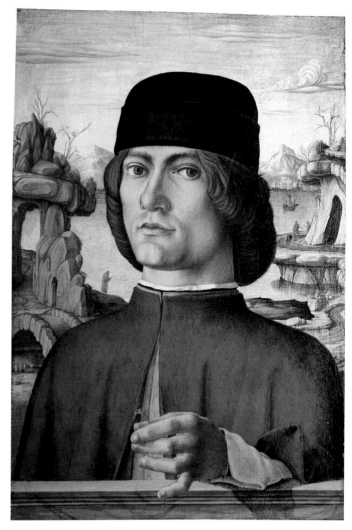

Fig. 6. Francesco del Cossa (ca. 1436–1478), *Portrait of a Man Holding a Ring*, ca. 1472. Tempera on panel, 15⅛ × 10⅞ in. (38.5 × 27.5 cm). Fundación Colección Thyssen-Bornemisza, Madrid

Without symbols to denote a marriage portrait, it is difficult to be sure if a picture actually was painted to mark the occasion of a wedding. The debate goes on about the status of Leonardo da Vinci's *Ginevra de' Benci* (fig. 8). Ginevra was married on January 15, 1474, to the widower Luigi di Bernardo Niccolini, probably in her family's palace in the Via de' Benci, Florence. Scholars argue whether the portrait was painted for a member of the Benci family; for Ginevra's husband, Luigi; or for her Platonic lover, Bernardo Bembo, whose *impresa,* or personal device, is painted on the verso.[17] The three possible recipients of the portrait require different datings for the execution of the portrait, from 1473 to 1480, a surprisingly wide range for an artist whose career has been so well studied.

No pairs of Italian portraits from this period survive in their original frames. To judge from the shape and comparatively small size of paired portraits, however, they were probably encased in molding to form portable folding diptychs, such as the example listed in an inventory of Este possessions at Ferrara, drawn up in 1494, which describes such a portrait diptych as "a painting that opens in two parts with gilded frames, in which is the duke of Milan [Francesco Sforza (1401–1466)] and M. Bianca [Madonna Bianca Maria Visconti (1423–1468)]."[18] Like donor portraits in

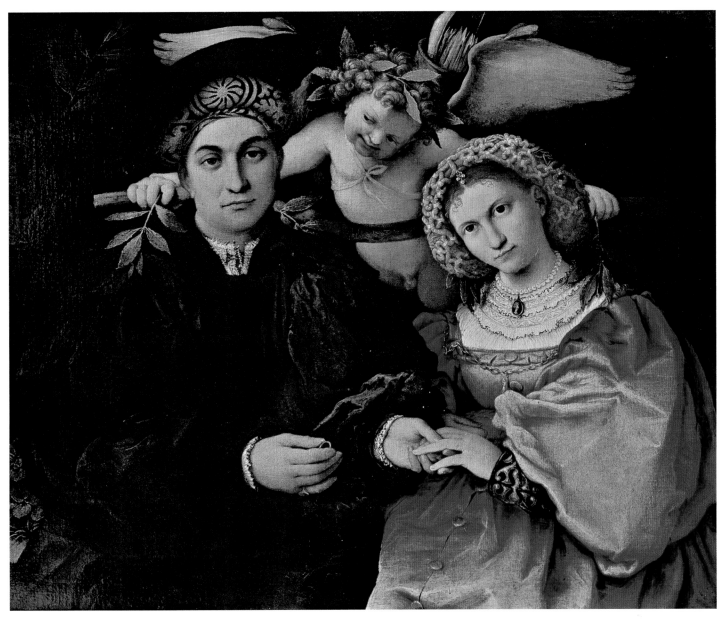

Fig. 7. Lorenzo Lotto (1480–1556), *Portrait of Messer Marsilio Cassotti and His Wife, Faustina*, 1523. Oil on canvas, 28 × 33⅛ in. (71 × 84 cm). Museo Nacional del Prado, Madrid

altarpieces, portraits in diptychs show husbands and wives facing each other in profile; only later in the century do they portray the sitters in three-quarter views (see cat. no. 122a). These portable diptychs often depict powerful rulers with their spouses, such as the cultivated condottiere Federigo da Montefeltro (1422–1482) and his second wife, Battista Sforza (1446–1472), whom Piero della Francesca painted some ten years after they married, on February 10, 1460, in his celebrated diptych (Galleria degli Uffizi, Florence) or the tyrant Giovanni II Bentivoglio (1443–1508) and his slightly older wife, Ginevra Sforza (ca. 1440–1507), whom Ercole de' Roberti portrayed in a pair of panels (cat. nos. 120a, b). In 1463 Bentivoglio had seized control of Bologna, of which partial views appear behind the sitters. Ginevra Sforza was an illegitimate daughter of Alessandro Sforza, Lord of Pesaro, and the half-sister of Battista Sforza. Before marrying Giovanni II Bentivoglio, Ginevra was betrothed at the age of about twelve to Sante I, the ruler of Bologna, and was married to him in 1454. Sante died in

1463, and the following year Ginevra married Bentivoglio, with whom she had sixteen children, of whom eleven survived childhood. The couple probably sat for these portraits about ten or fifteen years after their wedding.

Two slightly later pictures painted in Bologna and originally forming a diptych may celebrate a betrothal. In contrast to the bristling power of the Bentivoglio diptych, the Gozzadini panels (cat. nos. 121a, b) in the Robert Lehman Collection of the Metropolitan Museum promise marital harmony. They are by a late fifteenth-century Emilian painter, strongly influenced by Francesco del Cossa, known as the Maestro dei Storie di Pane. Both panels bear the coat of arms of the Gozzadini, a prominent Bolognese family; the woman's coat of arms, normally placed on the wife's portrait, is not depicted. One panel shows a man in profile facing right, perhaps Matteo Gozzadini (b. 1473) at the age of twenty-one; the woman on the other panel, presumably his future wife, Ginevra d'Antonio Lupari (d. 1557), faces left. He

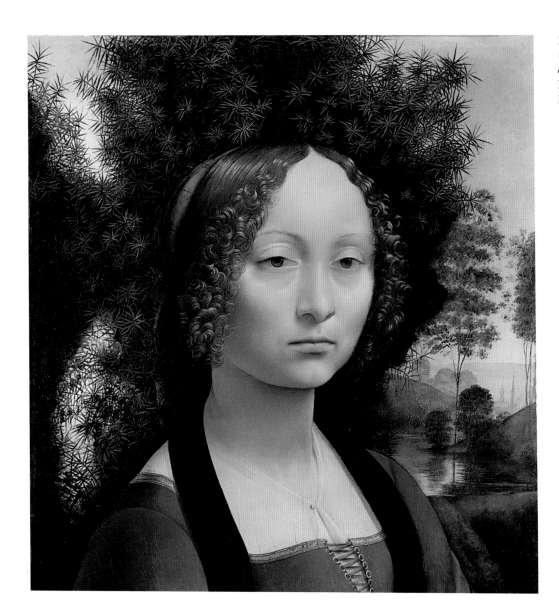

Fig. 8. Leonardo da Vinci (1452–1519), *Ginevra de' Benci*, ca. 1474–78. Oil on panel, 15 × 14⅝ in. (38.1 × 37 cm). National Gallery of Art, Washington, D.C., Ailsa Mellon Bruce Fund

displays a spray of pinks, a popular symbol of engagement seen, incidentally, in Hans Memling's *Young Woman with a Pink* of about 1490 and Rembrandt's *Woman with a Pink* of about 1662, both in the Metropolitan Museum, while she holds up an apple or a peach, which may be a marriage symbol. In the landscape behind them are additional symbols: a pelican piercing its breast to feed its young (a common symbol of charity or self-sacrifice), a phoenix (resurrection), two rabbits (fecundity), and a unicorn (chastity). The inscription running across the entablature of the building behind the sitters—*VT SIT NOSTRA FORMA SVPERSTES* (In order that our features may survive)—expresses a universal rationale for commissioning portraits.

The marriage-portrait diptych reached its apogee in Raphael's paintings of Agnolo Doni (1474–1539; fig. 9) and his noblewoman wife, Maddalena Strozzi (baptized February 20, 1489; fig. 10). Doni was a Florentine textile merchant, art patron, and collector; he commissioned Michelangelo's *Holy Family* tondo of about 1506 (Galleria degli Uffizi, Florence), and he was an early owner of Donatello's marvelous bronze statue *Amor Atys* (ca. 1435–40; Museo Nazionale del Bargello, Florence). Raphael portrayed

husband and wife as three-quarter-length figures seated before a continuous landscape in poses reminiscent of Leonardo's *Mona Lisa* and conspicuously displaying their matching wedding rings. The couple married on January 31, 1504, when Maddalena was almost fifteen years old. Given her matronly appearance, the portraits must have been painted at least two or three years later. On the backs of the panels another artist, the Serumido Master, painted scenes in grisaille of the gods of Olympus and of the Greek myth of Deucalion and Pyrrha, progenitors of a new human race, symbolizing fecundity.[19] The myth had significance for the couple, since they had suffered several miscarriages before the birth of their first child, a daughter, Maria, baptized on September 8, 1507, which was quickly followed by that of a son, Francesco, baptized on November 21, 1508. Conforming to the Tuscan practice of preparing a *camera nuziale*, or bridal chamber, for his wife, Agnolo employed the woodworker Francesco del Tasso to decorate it with elaborate wood furnishings. Another Florentine, Lodovico de' Nobili, commissioned Tasso to decorate a similar *camera nuziale* on January 3, 1506—two years after his marriage sometime before December 3, 1503—specifying that the work

be as good as or better than Agnolo Doni's,[20] thus providing a terminus ad quem for the Doni–Strozzi bridal chamber. The portrait diptych probably was kept there, along with Michelangelo's great tondo.

In the sixteenth century the marriage diptych was superseded by pairs of large independent portraits, such as Parmigianino's three-quarter-length, lifesize portraits of about 1533–35 (Museo Nacional del Prado, Madrid).[21] They portray Pier Maria de' Rossi (d. 1547) and his wife, Camilla Gonzaga, Count and Countess of San Secondo, she with their three sons. They are comparable to Veronese's full-length portrait of about 1555 of Giuseppe da Porto with his eldest son, Adriano (Contini Bonacossi Collection, Galleria degli Uffizi, Florence) and its pendant, a portrait of Countess Livia da Porto Thiene with her daughter Porzia (Walters Art Museum, Baltimore).[22] The presence of children signals a shift in emphasis from the married couple to their family, from the marriage portrait to the family portrait. In medieval altarpieces entire families sometimes were portrayed as donors kneeling in profile; in the fifteenth century the family emerges as the principal subject of murals such as Andrea Mantegna's decoration of the Camera Picta, or painted room, an audience chamber that occasionally served as a bedroom in the Ducal Palace, Mantua. Commissioned by Ludovico Gonzaga (1412–1478), second Marquis of Mantua, the murals depict Gonzaga and his wife, Barbara of Brandenburg (1422–1481), seated on faldstools and attended by their sons and daughters, grandchildren, and retinue of courtiers and servants.[23] Barbara of Brandenburg had been brought to Mantua from Prussia as a child in 1432. The marriage contract was signed in 1433, and the couple married in 1437.[24] The murals were painted much later, between 1465 and 1474, so the popular name of the room, the Camera degli Sposi, or "room of the newlyweds," is a misnomer.

We get a glimpse of the role portraits played in arranged marriages in a report written on September 1, 1492, by Marchesino Stanga, a confidant of Ludovico il Moro (1452–1508), ruler of Milan. Stanga reported that "uno Todesco," a German working for the duke of Saxony, had come to Milan to take stock of Ludovico's niece Bianca Maria Sforza (1472–1510) as a possible bride for the king, later Holy Roman Emperor, Maximilian I (1459–1519), who had lost his first wife in 1482. The German observed her in church and took away a drawing of her by Ambrogio Preda (ca. 1455–after 1508). Returning to Milan, he pressed Stanga for information about Bianca Maria's dowry and lineage,

Fig. 9. Raphael (Raffaello Sanzio) (1483–1520), *Portrait of Agnolo Doni*, 1505–6. Oil on panel, 24¾ × 17¾ in. (63 × 45 cm). Galleria Palatina, Palazzo Pitti, Florence

Fig. 10. Raphael (Raffaello Sanzio) (1483–1520), *Portrait of Maddalena Doni*, ca. 1505–6. Oil on panel, 24¾ × 17¾ in. (63 × 45 cm). Galleria Palatina, Palazzo Pitti, Florence

Fig. 11. Giovanni Ambrogio Preda (ca. 1455–after 1508), *Bianca Maria Sforza*, probably 1493. Oil on panel, 20⅛ × 12¾ in. (51 × 32.5 cm). National Gallery of Art, Washington, D.C., Widener Collection

Right: Fig. 12. Raphael (Raffaello Sanzio) (1483–1520), *Lorenzo II de' Medici*, 1518. Oil on canvas. Private collection, Greenwich, Conn.

and asked for "uno retracto colorito" (colored portrait). Stanga refused to reveal anything about the dowry, but said that Preda had some portraits of her that would satisfy his needs. The half-length, profile portrait of Bianca Maria in the National Gallery of Art, Washington, D.C. (fig. 11), probably dates from after this report, because the red carnation tucked in her belt is a symbol of betrothal. On November 30, 1493, she was married by proxy in an elaborate ceremony in Milan. She eventually met her husband for the first time in Innsbruck, where they married on March 16, 1494, and began a miserable conjugal life.[25]

The best-documented marriage portraits are images of potential spouses, exchanged in diplomatic negotiations for arranged marriages, such as Raphael's majestic portrait (fig. 12) of a bridegroom-to-be, Lorenzo II de' Medici (1492–1519), the Duke of Urbino, nephew of Pope Leo X (r. 1513–21), and grandson of Lorenzo the Magnificent (1449–1492).[26] Leo was eager to form a marital alliance with France in order to protect the papacy from the Holy Roman Empire. Raphael, then at the height of his powers, had already portrayed the pope's younger brother, Giuliano de' Medici, Duke of Nemours (1479–1516), at the time of his engagement to Philiberte of Savoy (1498–1524), an aunt of Francis I of France. That portrait, now lost, is known from an old copy in the Metropolitan Museum (fig. 13). When Giuliano died a year later without legitimate issue, the pope encouraged Lorenzo II to marry Madeleine de la Tour d'Auvergne (1502–1519), one of

Fig. 13. Raphael (Raffaello Sanzio) (1483–1520), copy after, *Giuliano de' Medici (1479–1516), Duke of Nemours*, 16th century. Tempera and oil on canvas, 32¾ × 26 in. (83.2 × 66 cm). The Metropolitan Museum of Art, New York, The Jules Bache Collection, 1949 (49.7.12)

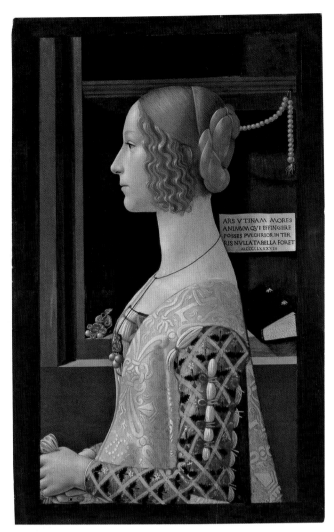

Fig. 14. Domenico Ghirlandaio (1449–1494), *Portrait of Giovanna degli Albizzi Tornabuoni*, 1488. Tempera and oil on panel, 30¼ × 19¼ in. (77 × 49 cm). Museo Thyssen-Bornemisza, Madrid

Francis I's cousins. A portrait of Madeleine was dispatched on or before January 29, 1518, from the château of Amboise (close to the château of Cloux, where Leonardo spent his last years and died in 1519). At the same time Raphael was busy making a lifesize, three-quarter-length portrait of Lorenzo. From letters exchanged by the pope's agents, we know Raphael had finished painting it by February 3, but was waiting for a dry sunny day to varnish it. Finally, on February 10, the picture was "finito del tutto" (entirely finished) and ready to be sent to France. Lorenzo II reached Paris on April 15, accompanied by thirty-six horses carrying wedding presents. The ceremony took place on April 28, 1518, at Amboise. Sadly, neither spouse lived long: Madeleine died in Italy on April 28, 1519, shortly after the birth of her only child with Lorenzo, Catherine de' Medici (1519–1589); six days after his wife's death, Lorenzo passed away at the age of twenty-seven.

Domenico Ghirlandaio (1449–1494) created another type of marriage portrait, that of a deceased spouse. Bernardino Licinio's painting (cat. no. 125) of a seated young woman displaying a framed portrait of a bearded man may belong to this category, but there is no evidence of how the woman was related to the man. We have plenty of information, however, about Ghirlandaio's portrait of Giovanna degli Albizzi (1468–1488), in the Museo Thyssen-Bornemisza (fig. 14).[27] For centuries this lifesize profile portrait was thought to represent Laura, Petrarch's Platonic love; the correct identification was made in 1813 by Leopoldo Cicognara, who recognized the woman's features in a medal attributed to Niccolò Spinelli (1430–1514) commemorating Giovanna's marriage to Lorenzo Tornabuoni (1468–1497) on June 15, 1486.[28] Three panels from the couple's bridal chamber are discussed elsewhere in this

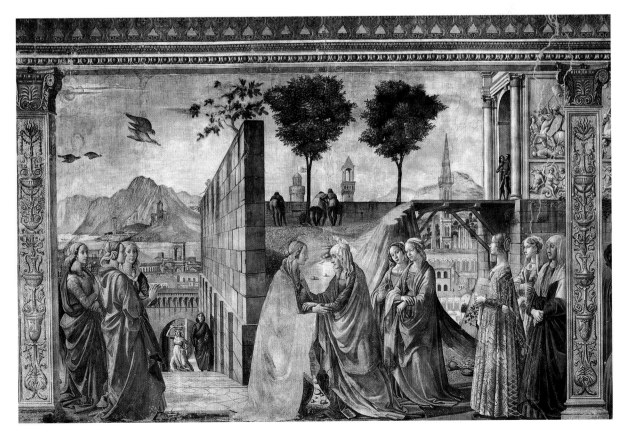

Fig. 15. Domenico Ghirlandaio (1449–1494), *The Visitation*, 1490. Fresco. Capella Maggiore, church of Santa Maria Novella, Florence

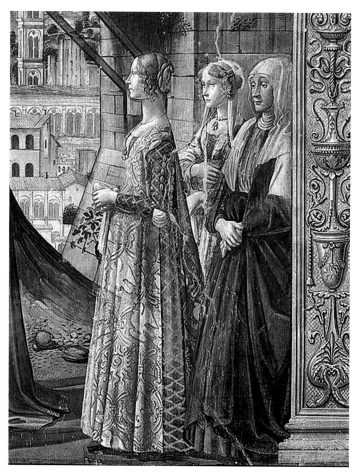

Fig. 16. Domenico Ghirlandaio (1449–1494), *The Visitation* (detail), 1490. Fresco. Capella Maggiore, church of Santa Maria Novella, Florence

volume (cat. nos. 140a–c). The bride and bridegroom were both seventeen years old. Their only child, a boy named Giovanni, was born on October 11, 1487. The groom's father was Giovanni Tornabuoni, whose sister Lucrezia was the wife of Piero de' Medici (1414–1469) and the mother of Lorenzo the Magnificent. A partner of the Medici Bank, Giovanni Tornabuoni is best remembered for employing Ghirlandaio to decorate the choir of the church of Santa Maria Novella, in Florence, with scenes from the lives of the Virgin and of Saint John the Baptist. The scenes include portraits of the extended Tornabuoni family and their friends as spectators of the religious narratives—they wear modern dress, whereas the protagonists of the murals are in period attire.

Except for its background with its still life and inscription, the portrait of Giovanna degli Albizzi is almost identical to the portrayal of her in the scene of the *Visitation* in the Tornabuoni murals (fig. 15); the two images must have been painted from the same cartoon.[29] The *Visitation* dates from 1490, as it was one of the last scenes to be painted—the murals were commissioned on September 1, 1485, and unveiled on December 22, 1490. But Giovanna died while pregnant (not in childbirth, as some writers say) on October 7, 1488, so the date 1488 inscribed on the panel records the year of her death rather than the year the panel was executed.[30] Nine years later, an inventory of the contents of the Tornabuoni palace identified Giovanna's portrait as located next to her husband's room.[31] Having produced an heir to satisfy the family's dynastic hopes, Giovanna was remembered by her father-in-law, who provided a marble sepulcher for her in front of the high altar of Santa Maria Novella, and by her husband, who included her

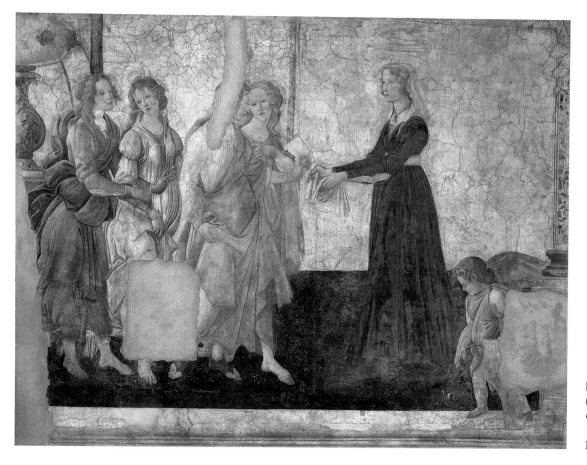

Fig. 17. Sandro Botticelli (1445–1510), *Venus and the Graces Offering Presents to a Young Girl*, ca. 1490. Fresco. Musée du Louvre, Paris

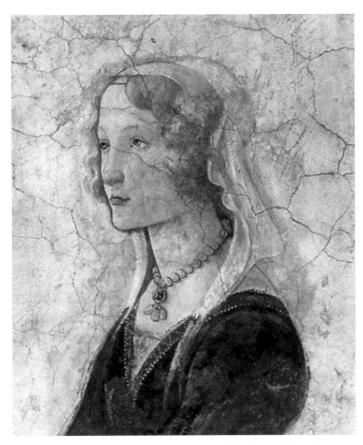

Fig. 18. Sandro Botticelli (1445–1510), *Venus and the Graces Offering Presents to a Young Girl* (detail), ca. 1490. Fresco. Musée du Louvre, Paris

coat of arms in the chapel he purchased in the church of Cestello almost two years after her death, when he was evidently planning to remarry.

In 1550 Vasari wrote that Ghirlandaio's mural of the Visitation depicted "the Virgin Mary and Saint Elizabeth, accompanied by many women dressed in the fashions of the day; and among them is portrayed Ginevra de' Benci, then a most beautiful young woman."[32] For centuries people thought the woman standing in profile in the scene of the *Visitation* (fig. 16) was this Ginevra, the subject of Leonardo's portrait mentioned above.[33] Only in 1889 did Frances Sitwell recognize that the woman in the *Visitation* was the same as the sitter in the Thyssen-Bornemisza portrait.[34] Vasari's statement, however, was not entirely incorrect, since the young woman with blond hair standing behind Giovanna is yet another Ginevra, Ginevra Gianfigliazzi (b. 1473), Lorenzo Tornabuoni's second wife.[35] Ginevra's dowry was delivered on October 13, 1491, nine months after the frescoes were unveiled, suggesting that the marriage had recently been consummated. She gave birth to a son, Leonardo, on September 29, 1492. Five years later her husband met a tragic end. With Gianozzo Pucci, whose bridal chamber Botticelli helped decorate (cat. no. 139; fig. 48), and three other Florentines, he entered into a plot to overthrow the government and restore the Medici to power. The young men were arrested by Savonarola's henchmen and beheaded on August 21, 1497.

Ginevra Gianfigliazzi's distinctive features reappear in Botticelli's murals in the Louvre. They originally formed part of the decoration of a room in the Villa Lemmi, the Tornabuoni villa at Chiasso Macerelli, near the Medici villa at Careggi. One of

them shows a young man presented by Grammar to Wisdom and the Liberal Arts. As scholars long ago recognized by comparing the man's features with medals and the likeness of Lorenzo Tornabuoni in the Tornabuoni chapel, he is the same person. The other mural (fig. 17) depicts a young woman extending her handkerchief to catch flowers dropped into it by Venus, who is accompanied by the Three Graces. In most books on Botticelli, the woman is identified as Giovanna degli Albizzi.[36] But a comparison of her features (fig. 18) with those of the bystanders in *The Visitation* (fig. 16) leaves no doubt that she is the woman standing immediately behind Giovanna, her head turned slightly toward the viewer, her right hand on her breast, wearing a pearl necklace with a jeweled pendant quite similar to Giovanna's. In 1882 Charles Ephrussi noted this similarity, but saw her as Giovanna degli Albizzi. More than one hundred years later, Patricia Simons identified the woman as Lorenzo Tornabuoni's second wife and explained the significance of the Albizzi coat of arms in the room.[37] Ginevra's presence in the Villa Lemmi murals not only gives us an example of portraits of successive spouses but also provides a terminus a quo for Botticelli's chronology. Previously, the murals had been dated as early as 1480.[38] Her marriage firmly dates them to 1490–91.

The phenomenon of portraying successive spouses or prospective bridegrooms might explain why there are marriage diptychs by Ghirlandaio and his workshop in San Marino, California (cat. nos. 122a, b), Berlin (Gemäldegalerie), and Montpellier (Musée des Beaux-Arts)—all three of them showing the same woman paired with different young men.[39] Not knowing who the sitters were, we cannot say why the different youths were paired with the same young woman. She is depicted in profile facing left before a loggia with dark brown marble columns—like those in Ghirlandaio's *Madonna and Child*, known as the Rothschild *Madonna* (ca. 1477–80; Musée du Louvre, Paris)—and an alcove in which are placed a coral necklace, an open book, a ring, a fantastic jeweled brooch, and a wooden box—like the still life in the background of Ghirlandaio's *Giovanna degli Albizzi,* in the Museo Thyssen-Bornemisza (fig. 14). The youths are seen in three-quarter view, dressed in similar red caps and tunics. They differ in the color of their hair: dark brown in San Marino and blond in Berlin and Montpellier; in their countenances: the man in San Marino smiles slightly and gazes at his wife (or was she still his fiancée?), whereas the youths in Berlin and Montpellier stare with blank expressions; and in the landscape backgrounds: that in San Marino has the clarity of Ghirlandaio's mural of the *Calling of Saints Peter and Andrew,* in the Sistine Chapel, whereas those in Berlin and Montpellier are cluttered with tall towers in the Flemish style. In terms of the quality of execution, the paintings in San Marino are the best, worthy of Domenico Ghirlandaio; the clumsy handling of the pair in Berlin betrays his less talented brother, Davide; and the works in Montpellier are simply poor contemporary copies.

The most recently recognized type of marriage portraits is that of spouses disguised as mythological figures. In the Museo Nacional del Prado are two versions of Titian's celebrated painting *Venus and the Organist* (ca. 1550 and ca. 1555), both essentially the same composition of a reclining female nude attended by a musician. But as Miguel Falomir has observed, one of them—the

primary version (cat. no. 152)—does not include Cupid, the traditional attribute of the goddess of love. In this version, the nude wears a wedding ring on her right hand and she looks down not at Cupid but at a dog, a symbol of marital fidelity.[40] Moreover, both the musician and the reclining woman have highly individualized features, and this led Falomir to suspect that the figures are portraits, perhaps of a married couple. His suspicion gains support from the fact that of all the replicas of the composition, this is the only one for which we know the name of the original owner, the lawyer Francesco Assonica.

Lorenzo Lotto's *Venus and Cupid* in the Metropolitan Museum (cat. no. 148; fig. 50) may be another example of a disguised marriage portrait. As Keith Christiansen established in a fundamental study of the painting published in 1986, when Mr. and Mrs. Charles Wrightsman presented it to the Metropolitan Museum,

its recondite iconography links it to marriage. The startling motif of Cupid urinating on Venus's lap, the *strophion* that Venus wears beneath her breasts, the pink and white rose petals scattered on her thighs, the conch shell hanging over her head, the elaborate gold crown and veil, the grass snake emerging from beneath the blue cloth, and the myrtle wreath and incense burner all allude to the literary tradition of ancient Roman epithalamia, or marriage poems. The distinctive features of Venus's face raise the possibility that the artist portrayed an actual bride.[41] She certainly lacks the idealized beauty of Lotto's other painting of Venus, based on an antique statue, in his *Allegory of Chastity* (ca. 1526; Rospigliosi Pallavicini Collection, Rome). Who is portrayed in the Wrightsman *Venus and Cupid* remains one of many unanswered questions about this most intriguing of marriage paintings.

Unless otherwise noted, all translations are the author's.

1. As Lydecker (1987a, pp. 159–60) observed, the little surviving documentary evidence for portraits in Renaissance Florence concerns posthumous ones of family members.
2. Cordellier 1996, pp. 15–20; Syson and Gordon 2001, pp. 102–5.
3. Neilson 2008, pp. 9–10, 23–37; see fig. 1 for an illustration of the painting.
4. Longhi 1934, p. 164, n. 74; Bacchi 1991, pp. 44–45, no. 3. See also Cecilia Cavalca in Natale 2007, pp. 412–13, no. 127. For the portrait of Francesco d'Este in the Metropolitan, see Mary Sprinson de Jesús in Ainsworth and Christiansen 1998, pp. 154–55, no. 23.
5. In Renaissance Italy, a woman might receive multiple rings, some set with stones, when she married. The rings might be given by different members of the husband's family or at different stages in the betrothal and marriage rituals. See Klapisch-Zuber 1982/1985.
6. Breck 1914, p. 173.
7. Breck 1913, p. 48.
8. Ibid., pp. 48–49. Initially, Breck (1913, pp. 50–55) dated the painting to about 1440. Subsequently, Breck (1914, p. 171) dated it to 1436, the date of the Scolari–Sapiti nuptials.
9. Keith Christiansen in Christiansen 2005, p. 150.
10. Woods-Marsden 2001, pp. 65–67.
11. Ruda 1993, pp. 85, 88, 385.
12. David Alan Brown in D. A. Brown et al. 2001, pp. 106–9, no. 3. Brown's opinion was seconded by Keith Christiansen in Christiansen 2005, p. 150, no. 4.
13. Syson 2006, pp. 97–98.
14. Neilson 2008, p. 44.
15. Mauro Lucco in D. A. Brown, Humfrey, and Lucco 1997, pp. 134–37, no. 21.
16. Locatelli 1867, pp. 463–64.
17. David Alan Brown in Boskovits and D. A. Brown 2003, pp. 360–64; Garrard 2006, p. 26.
18. Campori 1870, p. 30: "uno Quadro che si apre in due parte cum le cornise dorate, in sul quale è il Duca di Milano et M. Biancha." Venturi (1885, pp. 225–26) identified the diptych as one presented to Borso d'Este in 1455 by the little-known painter Niccolò Teutonico. See also Warnke 1998, pp. 213–14, n. 12.
19. Padovani 2005. For illustrations of the grisaille scenes on the backs of Raphael's portraits, see Serena Padovani in Meijer 2008, p. 195.
20. Aquino 2005.
21. For the Parmigianino portraits, see Ekserdjian 2006, figs. 162, 163.

22. For illustrations of Veronese's two portraits, see Pignatti and Pedrocco 1995, vol. 1, pp. 58–59, no. 29.
23. Lightbown 1986, pl. 85.
24. Ibid., pp. 82–83. For illustrations of the portion of the Camera Picta under discussion, see ibid., pls. 85, 87.
25. Stanga's report was published by Malaguzzi Valeri 1902. David Alan Brown (in Boskovits and D. A. Brown 2003, p. 599) believed the duke of Saxony was a rival suitor; for the correct reading of the report, see Welch 1995, p. 249.
26. Oberhuber 1971; Shearman 2003, vol. 1, pp. 316–17, 319–23. The portrait was sold at Christie's, London, July 5, 2007, lot 91.
27. For a recent survey of the literature on the painting, see David Alan Brown in D. A. Brown et al. 2001, pp. 190–93, no. 30.
28. Cicognara 1813–18, vol. 1, p. 411.
29. Hendy 1964, p. 45.
30. For a source about Giovanna, see the epigraph that Angelo Poliziano composed for her tomb (Poliziano 1867, pp. 154–55, no. LXXXIV).
31. Lydecker 1987a, p. 63, n. 84.
32. Vasari, *Le vite*, 1550/1986 (ed.), p. 465: "la Visitazione di Nostra Donna a Santa Elisabetta; nella quale sono molte donne che la accompagnano con portature di que' tempi, e fra loro fu ritratta la Ginevra de' Benci, allora bellissima fanciulla."
33. In a note to Vasari's fleeting mention of Leonardo da Vinci's portrait of Ginevra de' Benci, Gaetano Milanesi (in Vasari, *Le vite*, 1568/1878–85 [ed.], vol. 4, p. 39, n. 2) wrote, "È la stessa Ginevra de' Benci ritratta di profilo dal Ghirlandajo nel coro di Santa Maria Novella."
34. Sitwell 1889, p. 9.
35. Simons 1985, vol. 1, pp. 171–73, vol. 2, pp. 136–39, nn. 75–79. Simons's identification of Ginevra Gianfigliazzi was accepted by Dale Kent (2001, p. 40). Without citing her source, Rubin (1996, p. 102) alludes to Giovanna degli Albizzi and Ginevra Gianfigliazzi as Lorenzo Tornabuoni's "successive wives" in the *Visitation* and (2007, p. 241) refers to the depiction of Ginevra Gianfigliazzi as Lorenzo Tornabuoni's second wife. The exact dates of Giovanna degli Albizzi's death and the delivery of Ginevra Gianfigliazzi's dowry were discovered by Rab Hatfield and reported by Luchs 1977, p. 160, n. 16.
36. In the recent Botticelli monographs by Alessandro Cecchi (2005, pp. 236–42) and Hans Körner (2006, pp. 246–49), the Louvre murals are associated with Lorenzo and Giovanna's wedding in 1486, and despite the obvious similarity of the young woman in the Louvre fresco to the one standing behind Giovanna degli Albizzi in the *Visitation*, Gert Jan van der Sman (2007, p. 179, nn. 2, 3) claims that

she is Giovanna degli Albizzi, not Ginevra Gianfigliazzi, implausibly maintaining that "the facial features of the young woman conform more to a type than an individual." Helen Ettlinger (1976) made a misguided attempt to identify the young woman as Nanna di Niccolò Tornabuoni and the young man as Matteo d'Andrea Albizzi, a mistake repeated by Zöllner (2005, pp. 120–24, 225–26).

37. Ephrussi 1882, pp. 478–81. Thieme 1898, pp. 199–200, also observed the similarity but thought that she was an unknown woman. See also Simons 1985, vol. 1, pp. 171–73, vol. 2, pp. 136–39, nn. 75–79.

38. U. Baldini 1988, pp. 274–75.

39. Fahy 2007, p. 45. David Alan Brown (in D. A. Brown et al. 2001, p. 194) wonders if the woman had two husbands or if one of the portraits represents a relative "or even her lover."

40. Miguel Falomir in Falomir 2003a, pp. 248–51, 394–96, nos. 41, 42; Falomir 2003b, pp. 88–89, 330.

41. Christiansen 1986. He observes that the Venus was "was based on an actual model" (p. 169) and has the "compelling personality of a real person" (p. 173), but stops short of calling it a portrait.

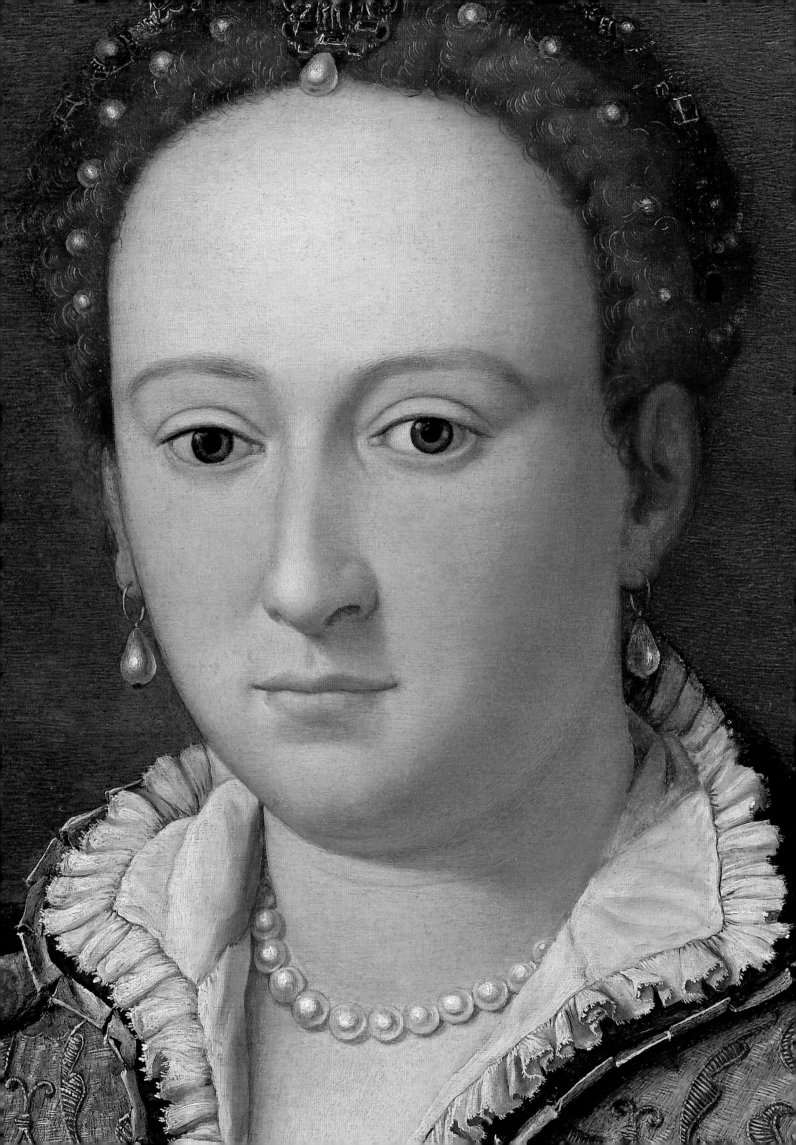

Wives, Lovers, and Art in Italian Renaissance Courts

Jacqueline Marie Musacchio

The marriage chests and dowry goods in this volume are typical of the objects associated with the middle and upper classes in urban centers on the Italian peninsula during the Renaissance. In most cases, these objects marked women as either wives or future wives and provided them with a recognizable but idealized identity to the outside world. But the complex realities of love and marriage at court incorporated the arts—visual, literary, musical, or some combination of the three—in a greater variety of ways. Most rulers came to power either by hereditary claim or by force, and the arts were crucial in fashioning their public image; through the assembly of elite collections, the construction and ornamentation of public buildings and spaces, or the institution of extravagant celebrations and theatrics, art enforced and legitimized their power.[1] Marriage—or, in some cases, an affair—was another method of enforcing and legitimizing power. In that context, art bolstered public approval and represented love and affection, even when it was absent, or, in the case of arranged matches, when it had not yet had time to develop. Art was especially useful when a wife or lover confounded political alliances; it then justified the woman to the court or constituents and made licit otherwise illicit affairs. But much like the women of the middle and upper classes, the women in these alliances were often little more than facades, with no opportunity to fashion a public image for themselves.[2] Despite serving as subjects and recipients of works of art, only a few wives or lovers were able to use art to craft an image of themselves in the same way their princes did, and even then what they were able to accomplish was often fleeting.[3] Though few court women were able to exploit the arts to represent themselves to the outside world, they were not completely invisible. But there was a great difference between idealization and reality, and, in the end, between a representation determined by a husband or lover and one determined by the woman herself.

THE CHIVALRIC TRADITION IN REPUBLICAN FLORENCE

Continuing in the tradition of medieval courtly romance, chivalric affairs were primarily intellectual exercises that enjoyed great favor among elite and educated young men. These affairs did not damage reputations because they were platonic rather than physical. Republican Florence was not an actual court, but its emphasis on the arts and its interest in reconfiguring medieval courtly love practices from across the Alps made it an important site for this activity, in part because of the relationship between the city's de facto ruler, Lorenzo de' Medici, and Lucrezia Donati. Lucrezia's reputation was impeccable; the chronicler Marco Parenti cited her as a paradigm of virtue when looking for the perfect wife for his exiled brother-in-law Filippo Strozzi.[4] In their poetry Lorenzo and members of his circle celebrated Lucrezia's virtues and alluded to her role as the revered object of their affections.[5] Her husband, Niccolò Ardinghelli, understood the rules of chivalric love and the political benefits he received for going along with it. The astute Alessandra Strozzi, Niccolò's distant relation as well as the mother-in-law of Marco Parenti, commented on such advantages in her letters to her exiled sons; she wryly stated that beautiful wives, who might attract similarly chivalric admirers, might be more useful in her sons' quest to reenter the city than any political alliances they secured.[6] In another letter, describing a dance Lorenzo held in Lucrezia's honor, Alessandra acknowledged that the dance was both a carefully staged, richly costumed event—a work of art in itself—and a political event, too.[7] The same was true of the extravagant joust, more theatrical performance than athletic feat, in the Piazza Santa Croce organized by Lorenzo de' Medici in 1469 and dedicated to Lucrezia.[8] There was no mistaking her role in it: according to contemporary accounts, Lorenzo rode under a standard painted by Andrea del Verrocchio with a representation of Lorenzo's symbolic laurel tree and Lucrezia herself.[9] But the innocent nature of this chivalric devotion was essential. After all, the joust took place a mere four months before Lorenzo's long-negotiated and carefully planned marriage to the Roman noblewoman Clarice Orsini.

One of the so-called Otto Prints, a group of fine-manner engravings often attributed to the Florentine artist Baccio Baldini, has been associated with Lorenzo, Lucrezia, and the joust of 1469 (fig. 20).[10] This engraving represents a young man in a cape decorated with the Medici device of a diamond ring and three feathers and a nymphlike woman in classicizing dress with a jeweled brooch on her head; they clasp hands in the center at an armillary sphere. A scroll winding between them reads, in translation, "Love needs faith, and where there is no faith there can be no love." A variation

Fig. 20. Attributed to Baccio Baldini (1436–ca. 1487), *Youth and Nymph Holding an Armillary Sphere*, ca. 1470. Engraving, Diam. 5⅝ in. (14.4 cm). Bibliothèque Nationale de France, Paris

Lorenzo failed to pay for this portrait, and Verrocchio's brother tried to claim the money owed for it in 1496, after the death of both artist and patron and the Medici exile.[13] That exile, brought on by the inept rule of Lorenzo's son Piero, led to the confiscation of Medici property by the newly established Republican government and the sale of particular objects, at auction or otherwise, to satisfy claims such as Verrocchio's.[14] In October 1495 Lucrezia Donati's adult son Niccolò bought her portrait from the estate for twenty-three large gold florins.[15] This sizable sum indicates that the painting must have been particularly impressive. Lucrezia was then forty-six years old and would die a few years later, in 1501. Perhaps she wanted the portrait as a reminder of the earlier Laurentian golden age and her inspiring role in it. Though the subject of Lorenzo's affection, or at least his professed affection, Lucrezia had no control over the verses written about her or the images made of her, but she could reclaim at least one of her images years later by acquiring this portrait. Of course, since the Medici were in exile at the time, few others would have wanted it.

Lorenzo's devotion to Lucrezia Donati must have motivated other men in his circle to engage in similar chivalric affairs. One was the Venetian ambassador Bernardo Bembo, who was devoted

of this sentiment, included in Luigi Pulci's poem about the joust, likewise appears as a niello inscription on a contemporary ring (cat. no. 32c), indicating its popularity and recognizability at this time. The couple does not literally represent the chivalric pair, but the details link the print to the Medici circle. Such a print might have decorated a love token, such as a betrothal casket, similar to the more elaborate painted and gilt examples in this volume (cat. nos. 38a, b). It was via such easily circulated and inexpensive prints, whether pasted to the lid of a casket or displayed in some other manner, that Medicean chivalric ideals filtered down to less elite levels. The blank circular panel in the center of the engraving allowed the owner to personalize it with the addition of his own coat of arms, thereby claiming a connection to the chivalric tradition and to the Medici as well.

Although the woman in this print is not a literal depiction of Lucrezia, Lorenzo did apparently commission Verrocchio to paint her portrait, presumably sometime between the start of their relationship in 1465 and Lorenzo's marriage to Clarice in 1469; it was in the Medici estate at Lorenzo's death in 1492.[11] The evidence is limited, but portraits of women seemed to remain with the men who commissioned them, perhaps substituting for the absent sitters—the daughters who left to marry, the wives who died young—they represented.[12] The painting of Lucrezia, now lost or at least unidentified, may have been Lorenzo's substitute for his unobtainable love interest. This relatively innocuous substitute, like their relatively innocuous affair, did not threaten their respective marriages. In Lorenzo's Florence, the portrait of Lucrezia would have celebrated—and undoubtedly idealized—her beauty, following the Neoplatonic idea that contemplating beauty drew one closer to God.

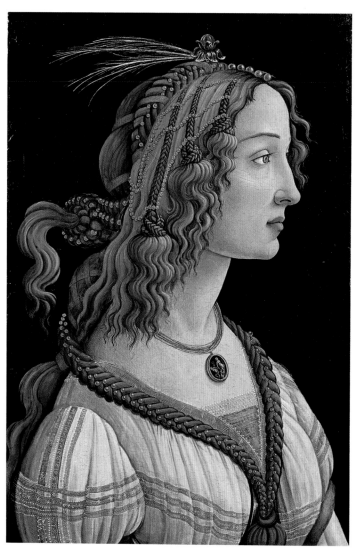

Fig. 21. Sandro Botticelli (1445–1510), *Ideal Portrait of a Woman (Portrait of Simonetta Vespucci)*, 1480–85. Tempera and oil on panel, 32¼ × 21¼ in. (82 × 54 cm). Städelsches Kunstinstitut, Frankfurt am Main

to the Florentine poet Ginevra de' Benci, the wife of Luigi Niccolini and the subject, and perhaps even the patron, of Leonardo da Vinci's earliest known painted portrait.[16] Another was Lorenzo's younger brother Giuliano, who held his own joust in 1475 and dedicated it to Simonetta Cattaneo, the wife of Medici partisan Marco Vespucci. Giuliano's joust was as extravagant as Lorenzo's, and his chivalric devotion to the beautiful Simonetta was a major part of the pageantry surrounding it. Simonetta's sudden death a year later was thus all the more tragic, inspiring commemorative odes from Lorenzo, Agnolo Poliziano, and other members of the Medici circle and creating what became a veritable cult in her honor.[17] Additional evidence of this cult may be Botticelli's fantastic painting of a woman, often identified as an idealized portrait of Simonetta because of the cast of an ancient carnelian from the Medici collection around her neck and the pearl net, called a *vespaio*, or wasp nest, in her hair, etymologically identifying her as a Vespucci (fig. 21).[18] As was the case with the Otto Print of Lucrezia Donati, this painting probably bore little resemblance to the real Simonetta. Whether on a popular level with prints or on a more elite level with paintings, images such as these celebrated chivalric love, representing the women as idealized objects of men's affections. Multiple versions of Botticelli's painting survive, perhaps an indication of the demand for a way to memorialize Simonetta. At least one was probably in Giuliano's possession after her death; her family sent it to him, together with some of her clothing, as a memento.[19]

LOVERS VERSUS WIVES IN RIMINI, FERRARA, AND MILAN

Although these chivalric affairs were chaste, other relationships were not. Since princely marriages tended to be more about politics, geography, or economics than about love, both extramarital affairs and the artistic celebration of the women involved in them were relatively common. For example, Sigismondo Malatesta, lord of Rimini, Fano, and Cesena, fell in love with thirteen-year-old Isotta degli Atti in 1446, while he was still married to his second

wife, Polissena Sforza, an unhappy but politically expedient union that ended when Polissena died in a plague outbreak in 1449. Although she was only a merchant's daughter with no political influence, Isotta remained with Sigismondo, and courtiers sought her favor. For example, Basinius of Parma, one of Sigismondo's court humanists, dedicated a book of poems to her.[20] This somewhat scandalous arrangement continued until 1456, when Sigismondo chose love over politics and married Isotta; by that time, she had given birth to at least two sons. Even before their marriage, however, he made extensive use of the newly revived art of the portrait medal to celebrate their love. Sigismondo commissioned Matteo de' Pasti to strike medals with Isotta's undoubtedly idealized profile on the obverse. On the reverse was an elephant, an animal with various meanings in Malatesta iconography and, as a tribute to Isotta and a statement on the sanctity of her relationship with Sigismondo, a traditional symbol of chastity (fig. 22).[21] Many of these medals were placed in the foundations of buildings Sigismondo commissioned, a permanent and romantic attestation of his love for Isotta.[22] He also commissioned the reconstruction of the church of San Francesco in Rimini (now known as the Tempio Malatestiano) from Leon Battista Alberti as a mausoleum and monument to himself and Isotta. Like Lucrezia Donati and Simonetta Cattaneo in Florence, Isotta was the recipient of Sigismondo's affections and the benefits that accompanied them, but she did not arrange any of this herself. She did, however, leave some small mark of her own—perhaps as part of the rehabilitation of her reputation as she transformed from lover to wife—as patron of a funerary chapel dedicated to the angels in San Francesco.[23]

Both wives and lovers, however, could have more direct connections to the arts at the courts of their respective princes. In the late fifteenth century, the Este family of Ferrara provides a telling, if complicated, case study, not least because the family had been ruled through much of the fourteenth and fifteenth centuries by bastards, who needed all the authority that arts patronage could provide.[24] For example, Borso d'Este, the illegitimate son of Niccolò III d'Este, became marchese in 1450, then duke in 1452. While his hereditary claim on these positions was fragile,

Fig. 22. Matteo di Andrea de' Pasti (act. 1441–67), *Portrait Medal of Isotta da Rimini Wearing a Veil* (obverse) and *Elephant* (reverse), ca. 1450. Bronze. Museo Nazionale del Bargello, Florence

his patronage—paintings, illuminations, and tapestries, as well as fine costumes and furnishings—was extensive, creating an identifiable court style that promoted his rule. In the case of the unmarried Borso, some of this patronage must also be seen as a way to distract attention from what modern scholars have categorized as his homosexual behavior, which was considered a crime in Ferrara and elsewhere. Borso's arts patronage thus became a useful subterfuge.[25]

Borso was succeeded as duke by his legitimate brother, Ercole, who was probably keen to continue his line with his own legitimate heirs. Nevertheless, in 1473 Ercole sent his betrothed, Eleonora of Naples, a now-lost portrait of himself by Cosmè Tura, in which he posed with his daughter Lucrezia, born of his mistress Lodovica Condomieri.[26] The little girl was a symbol of his virility—Eleonora's family need not worry that they were sending their daughter into a sterile union—but the painting also helped legitimize Lucrezia to all who saw it. Certainly knowledge of Lucrezia, and presumably her mother, did nothing to lessen the splendor of Ercole and Eleonora's marriage; it was a two-month extravaganza that began in Eleonora's home in Naples and ended in Ferrara. Along the route the participants made celebratory stops for elaborate entries, banquets, dances, and jousts that harnessed the visual and

performing arts to demonstrate the power of the Este dynasty.[27] Like a work of art herself, Eleonora was displayed to the crowds in each city in her costly costumes and precious jewels. Therefore it is not surprising that the marriages of the two legitimate Este daughters of this union, Beatrice and Isabella, were of such concern. Even more than their half-sister Lucrezia, who was married into the prominent Bolognese Bentivoglio family, these girls were valuable pawns in political matches designed to elevate the Este, and no time was wasted in making arrangements: in 1480 five-year-old Beatrice was betrothed to the then regent and later duke of Milan, Lodovico Sforza, and six-year-old Isabella was betrothed to the marchese of Mantua, Francesco Gonzaga.

The marriage contract between Beatrice and Lodovico was executed in 1489, but Lodovico insisted on several delays before they finally wed in January 1491. The long betrothal, and then the delays leading up to the nuptials, provided time to plan the extravagant events necessary to commemorate this auspicious union. Artists were called on to furnish the couple's apartment in the Milan Castello, but the greatest efforts went into the public ceremonies, which proclaimed the union both to the Milanese and to the representatives of the neighboring cities in attendance. Beatrice and her court entered the city in a great procession accompanied by

local nobility, citizens, and musicians, and she was honored with street pageants, lavish dances, and a three-day joust.[28]

These celebrations were, however, an elaborate pretense. There are indications that Lodovico grew fond of his wife as the years passed, and he both appreciated and needed the political advantages that his marriage to her provided.[29] But the real reason behind his repeated requests to delay their union was an open secret: Lodovico had been having an affair with a Milanese woman named Cecilia Gallerani since at least early 1489, and in November 1490, the Ferrarese ambassador to the Sforza court reported that Cecilia was in fact pregnant.[30] She was also, apparently, a very impressive woman. Described as both learned and beautiful by many of Milan's humanists, Cecilia was a poet and orator who delighted those around her—including Lodovico—with her wit and charming manners.[31] Unfortunately, but not surprisingly, none of her literary efforts seems to survive. Instead, the best evidence for her role at the Milanese court, besides the flattering praise penned by her contemporaries, is her painted portrait by Leonardo da Vinci in which she holds a weasel, often described as an ermine because of its white coat (fig. 23).

Leonardo had arrived in Milan about 1482. The monumental paintings he produced there—*The Last Supper* in Santa Maria delle Grazie and the two versions of *The Madonna of the Rocks*—are now some of his best-known works, but he also executed several smaller-scale portraits of the men and women connected to the Sforza court. Unfortunately, his work for Lodovico is poorly documented, and there is no known commission for Cecilia's portrait. Nor is there an inscription, or a secure provenance, to identify the sitter of the painting as Cecilia; we must rely instead on a confluence of historical and iconographic evidence. The poet Bernardo Bellincioni, for instance, wrote a sonnet stating that Nature herself envied Leonardo's representation of Cecilia, which he described as seeming "to listen, but not to speak," an accurate analysis of the alert pose of both woman and ermine in this painting.[32] But a carnivorous, sharp-clawed ermine was an inappropriate pet for such a well-dressed lady; its inclusion here must be understood as symbolic.[33] Cecilia's surname, Gallerani, is similar to the ancient Greek term for cat or weasel, *galée* (γαλέη), making the animal's presence a reference to her family.[34] Furthermore, King Ferrante of Naples invested Lodovico with the prestigious Order of the Ermine in 1488; following his investiture, Lodovico was sometimes called "L'Ermellino" (the ermine). The painting might therefore be read as a double portrait, which is underscored by Cecilia's caressing gesture and the proprietary posture of the ermine.[35] Contemporary bestiaries, as well as one of the childbirth trays in this volume (cat. no. 72 recto), include the ermine as a symbol of purity and chastity, making it an appropriate companion for Cecilia, who, like Isotta degli Atti, was lauded for these virtues.[36] These same bestiaries also identified ermines, or weasels in general, as talismanic animals in connection with pregnancy and childbirth; this too is reinforced by a maiolica childbirth tray representing the Birth of Hercules, where a weasel plays a key role in the narrative (cat. no. 77).[37] This confluence of details helps date the painting to late 1490 or early 1491, when Cecilia was pregnant with Lodovico's son Cesare, who was born in May 1491.

In this reading, the painting of Cecilia becomes a love image encoded for the sake of propriety. It seems unlikely that Lodovico would have commissioned what was, in effect, a double portrait with his pregnant lover while he was either making marriage preparations with the Este family or was recently married. Cecilia's pregnancy made it obvious that theirs was not a chivalric romance, and there was the risk of offending the Este, who were already dismayed by his delaying tactics. Their lenient attitude toward the offspring of such alliances in their own family would not extend to condoning Lodovico's behavior at the expense of their honor.

Of course, Lodovico may have commissioned Leonardo to execute the painting as a gift to Cecilia. But Cecilia was an intelligent woman who had control of the funds provided by Lodovico to take care of her household expenses.[38] She could have commissioned this very personal work herself, to keep in her home as a substitute for Lodovico after he married Beatrice and to announce to all, in an encoded but nevertheless understandable manner, her status as mother to his son. This then is similar to the way that so many portraits of women remained with their original male patrons, as noted earlier regarding Lorenzo de' Medici and Lucrezia Donati. Cecilia's probable acquaintance with Leonardo himself is further reason to believe she was the patron. She knew Leonardo through his association with the Sforza court and could have taken advantage of that connection when she sought a portraitist.[39] Leonardo, in turn, needed private commissions; in late 1490, about the date of this painting, he wrote a letter to Lodovico explaining how he had to take on additional projects to make money.[40] He may also have been intrigued by the prospect of painting Cecilia, who was so much like his earlier sitter, the equally intellectual and perhaps equally demanding Ginevra de' Benci.[41] Leonardo's great empathy for female sitters—five of his six known portraits are of women, and each one is notably inventive in composition and mood—may well have extended to female patrons, too, if indeed Cecilia and Ginevra commissioned their own portraits.[42]

Identifying the learned Cecilia as the patron of this painting helps explain the preponderance of clever symbols; together she and Leonardo could have devised this complex iconography for her unique situation. The painting would have hung in the apartment in the ducal residence where Cecilia continued to live for more than a year and a half after Beatrice's arrival. But the painting, and the relationship it commemorated, was no guarantee of future peace. Beatrice soon learned of Cecilia's relationship with Lodovico and was perhaps reminded of her father's affairs and the presence of his illegitimate daughter Lucrezia at the Ferrarese court. The young bride probably did not want a similar arrangement in her own life. In a surprisingly bold move, she enlisted the help of the Ferrarese ambassador to force Lodovico to end the relationship.[43] Her efforts were not immediately successful; however, in 1492 Lodovico—whether in deference to Beatrice's wishes or because of his own flagging ardor—made arrangements for Cecilia to marry a faithful courtier, Lodovico Carminati de Brambilla, the Conte Bergamini.

This arrangement was a particularly good one for the count, since the duke provided Cecilia with a substantial dowry and properties in Milan and Saronno.[44] Leonardo's portrait would have accompanied Cecilia to those new homes. As the Contessa Bergamina Cecilia retained a permanent role in the Milanese social scene, hosting various events and enjoying the company of

Fig. 24. Giovanni Ambrogio Preda (ca. 1455–after 1508), attributed to, *Profile Portrait of a Lady*, probably ca. 1500. Oil on panel, 20½ × 14½ in. (52.1 × 36.8 cm). National Gallery, London

the city's intellectuals, artists, and authors; the fame of Leonardo's portrait would have increased through continual viewing by this elite and appreciative audience.[45] In fact, shortly after Beatrice's unexpected death during childbirth in 1497, Isabella d'Este, who had long hoped to commission a portrait of herself by Leonardo (and only succeeded, it seems, in obtaining a preparatory charcoal drawing), wrote to Cecilia and asked her sister's former rival to lend the portrait to her. Cecilia did so, although she lamented to Isabella that she no longer resembled it.[46] Isabella must have met Cecilia during one of her earlier journeys to Milan to visit her sister, and their relationship remained amicable despite the seemingly awkward circumstances. After the fall of the Sforza in 1499, Cecilia and her son fled to Mantua and were housed for a time by Isabella, who also helped her obtain the favor of the invading French king, Louis XII.[47]

Isabella was practical, and her cordial acquaintance with Cecilia indicates she accepted her brother-in-law's lover as a consequence of court life. Besides the infidelities of her father, those of Isabella's own husband, Francesco Gonzaga, no doubt offered perspective. In 1480, when Isabella and Francesco were betrothed, a painted portrait by Cosmè Tura, now lost, was sent to Mantua to show her youthful beauty to her future husband.[48] Their marriage ten years later seemed to start well, but Isabella must have known of Francesco's many affairs, including one with Teodora Suardi,

which produced three children; another with Isabella's own sister-in-law, the papal bastard Lucrezia Borgia; and several less well-documented relationships with young boys.[49] These many affairs proved Francesco's undoing: he died of syphilis in 1519, and the widowed Isabella outlived him by twenty years.

Francesco's behavior did not stifle Isabella's expression of her own public image, however. Both before and after his death, she occupied herself with the arts. She came to her marriage with an abiding interest in music, dance, art, and antiquities, and a love for luxury goods ranging from precious textiles to perfumed gloves.[50] Francesco too had a great interest in arts patronage, encompassing villas, cathedral furnishings, coin and manuscript collections, and theatrical events, and Isabella's efforts might be seen as a response to Francesco's patronage.[51] But her efforts might also be regarded as a dignified response to his infidelity; patronage gave her a purpose and role in which she excelled, and with which she established her own public image. Her extensive correspondence provides a sense of her as both performer and patron and reveals her zeal for novelty, rarity, and beauty, all of which helped her express herself apart from her marriage.[52]

Fortunately for her sister Beatrice, Lodovico Sforza does not seem to have been as reckless as Francesco Gonzaga in his extramarital affairs. Yet Beatrice's brief life as his wife could not have been an easy one, even after the departure of Cecilia from the ducal residence. Lodovico continued to stray; by 1495 or 1496, he had replaced Cecilia with Lucrezia Crivelli, a member of Beatrice's own court. When Beatrice died, she must have known Lucrezia too was pregnant, in her case, with Lodovico's son Gianpaolo.

Leonardo also painted Lucrezia's portrait; an epigram in his Codex Atlanticus refers to the portrait's intense naturalism and to Lodovico's possession of Lucrezia's soul.[53] Lucrezia has been identified as the sitter in various Leonardo or Leonardo-circle portraits, including the so-called *Belle Ferronnière*.[54] But the best case might be made for a painting attributed to Leonardo's collaborator Ambrogio Preda, perhaps executed on the basis of Leonardo's own designs (fig. 24).[55] Leonardo's extensive work for the Milanese duke and his court resulted in a distinctive Sforza style that was adopted by many artists at this time.[56] As was the case with Cecilia's portrait, this painting has neither an inscription nor a secure provenance, but the sitter wears a girdle ornamented with what seems to be niello or enamel bearing Lodovico's initials and his Moor's-head device. The role of Renaissance girdles as love tokens is demonstrated elsewhere in this volume (cat. nos. 36, 55), although known examples are not as precise in their details as this girdle is. The ornament was surely meant to be recognized, since it identified the girdle as a gift from Lodovico to the sitter. With it, Ludovico made the sitter his, possessing her soul in the language of Leonardo's epigram, while the girdle intimately possessed her body. The girdle was therefore a symbol of Lodovico akin to the ermine in Cecilia's portrait. It is not unlikely, in the small world of the Sforza court, that Lucrezia knew both Cecilia as well as Leonardo's portrait of her. In fact, during the French invasion, while pregnant with Lodovico's second child, Lucrezia fled to Mantua and, like Cecilia, was housed by Isabella d'Este.[57] If Cecilia Gallerani and Ginevra de' Benci were indeed patrons of their portraits, Lucrezia may have been emulating them by commissioning a painting with specific references to Lodovico and

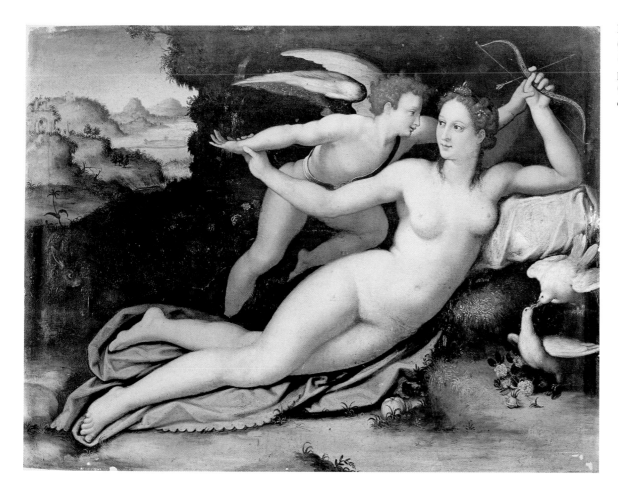

Fig. 25. Alessandro Allori (1535–1607), *Venus and Cupid*, ca. 1570. Oil on panel, 11⅜ × 15⅛ in. (29 × 38.5 cm). Galleria degli Uffizi, Florence

then keeping it in her own home as a reminder to herself, and to all who saw it, of their relationship.

Although Beatrice was aware of the many women with claims on Lodovico's affections, there was little she could do about it. Instead, like her sister Isabella, she diverted some of her attention to the arts. She was involved in musical entertainments and poetry, but primarily as a somewhat passive subject for the artists around her, in the manner of the chivalric Medici mistresses discussed earlier in this essay rather than in the more active role Isabella took.[58] In fact, the poet Ludovico Ariosto, who served the Este family, described Beatrice in his *Orlando Furioso* (1516 and 1532) only in relation to her husband; in contrast, he celebrated Isabella for her many individual accomplishments.[59] Most tellingly, there is no evidence that Leonardo ever painted a portrait of Beatrice. Despite Leonardo's ubiquitous presence at the Milanese court, as well as Isabella's great interest in him at Ferrara, Beatrice may herself have decided against a portrait by the painter because of his work with her husband's lovers.

THE STRATEGIC USE OF THE ARTS IN LATE RENAISSANCE FLORENCE

The ability of the women discussed thus far, whether lovers or wives—Lucrezia Donati and Simonetta Vespucci, Isotta degli Atti, Cecilia Gallerani, and Lucrezia Crivelli, or Isabella and Beatrice d'Este—to take advantage of the arts to shape their public image varied considerably. Among the most deliberate, and well-documented, examples of a Renaissance woman who used the arts

in this manner was that of the Venetian Bianca Cappello. Bianca eloped to Florence with a penniless clerk in 1563 but, within a year, met the ducal heir Francesco I de' Medici and began what became a fourteen-year affair. It continued throughout Francesco's marriage to Giovanna of Austria, a daughter and sister of Hapsburg emperors, which was celebrated in 1565 and 1566 with a series of minutely planned and thoroughly learned events devised by the ducal impresario Vincenzo Borghini and documented in letters, memoirs, literary descriptions, and nearly three hundred drawings for costumes and carts by Giorgio Vasari and his workshop.[60] These events culminated with a performance of Boccaccio's *Genealogia degli Dei*, involving twenty-one triumphal carts containing the Olympian gods who had descended from the heavens to honor the marriage. Yet even the blessings of this pantheon could not make the marriage happy; Giovanna dutifully gave birth to eight children while Bianca and Francesco continued their affair. Bianca's first husband was murdered in 1572, almost certainly with the approval of Francesco, who succeeded his father, Cosimo I, in 1574. As a widow and the grand duke's lover, Bianca had a great deal of freedom, and she gave birth to Francesco's son Antonio in 1576. Two years later, Giovanna died in childbirth, and within two months Francesco and Bianca married. When they celebrated the union publicly in 1579, Bianca became grand duchess.

Bianca's transformation from lover to consort was one few women were able to undertake with success, particularly on the ducal scale. Isotta degli Atti and Sigismondo Malatesta lived on a much smaller stage; the Medici grand dukes played a role in European politics, which made their status more complicated

and, in many ways, more public than that of the Rimini lord and his lover-turned-wife. To many Florentines and also, it seems, to Bianca herself, she never lost the stigma associated with being Francesco's lover. Their long and public affair angered the Florentines, who distrusted her Venetian heritage, questioned her morality, condemned her as syphilitic, mocked her cuckolded husband, and blamed her for almost anything that went wrong in the city.[61] A verse sung in the streets capitalized on the rhyme between *veneziana*, or Venetian woman, and *puttana*, or whore.[62] Francesco only exacerbated this ill will; he preferred to spend time working in his laboratories rather than governing, and his reign was marked by an unhappy populace, economic decline, and strained political relationships. Other than the imperial-scale celebrations surrounding his marriage to Giovanna, Francesco's commissions tended to be costly but small and experimental, like his porcelain and crystal workshops, or relatively private, like his *studiolo* in the Palazzo Vecchio. These were very different from the larger, more public monuments of his father, Cosimo, and, as a result, his artistic patronage did little to improve his reputation with the citizens of Florence. He also had trouble within his own family. His younger brother, the ambitious Cardinal Ferdinando, hoped to become duke at Francesco's death; Ferdinando never took his final vows, a calculated decision that allowed him to abandon his cardinalate when he inherited the ducal throne in 1587.[63] Bianca was not a humanist or scholar in the tradition of Ginevra de' Benci or Cecilia Gallerani—although she could read and write, she was not formally schooled and she certainly never wrote verse—but she was as ambitious as Ferdinando and very aware of the negative assessments of others. As a result, she concentrated her efforts on boosting her image through the arts, taking as her model the activities of male rulers, rather than those of their wives or mistresses.

In fact, Bianca's privileged upbringing in a noble household, the privations of her first marriage, and the model of Francesco's extensive patronage may have encouraged her in this pursuit even further. From her residence in a palace on the Via Maggio Francesco provided for her and her husband (to whom Francesco granted a minor court position), she witnessed the money he lavished on the arts and sciences firsthand. As Francesco's lover, Bianca was the recipient of some of that largesse herself, the palace being just one example of his efforts to maintain her in the style appropriate to a princely mistress. In about 1570 Francesco commissioned from Alessandro Allori a painting of Venus and Cupid as a gift to Bianca, representing the nude goddess reclining on rich textiles in a landscape (fig. 25).[64] The composition was based, in part, on Venetian models, perhaps in tribute to Bianca's Venetian heritage, and the goddess was painted with the same red hair Bianca herself had. The painting also relied on a famous drawing by Michelangelo, best known through multiple painted versions by Jacopo Pontormo and his circle. Francesco, like Cosimo before him, admired Michelangelo and tried to bring the aged artist back to Florence.[65] Allori's reference to Michelangelo therefore helps associate the painting with Medici taste.

Even though the painting was essentially a love token between the ducal heir and his mistress, it was well known; Allori painted at least four additional versions for other patrons. About this same time Allori also executed a small oil on copper with a portrait on the recto of the red-haired and jewel-bedecked Bianca; she wears a head brooch representing Venus and Cupid, a reference to Bianca as Francesco's lover and probably also to the earlier painting, suggesting an intimate vocabulary of symbols between the couple (cat. no. 126a recto; fig. 19).[66] The verso, however, has a version of an allegorical drawing by Michelangelo, often referred to as *The Dream of Human Life*. Again, the reference to Michelangelo—here in a notably restrained version of a fairly erotic original—makes a statement about Francesco's patronage as well as, according to some scholars, about the purifying force of love, a worthy sentiment for his much-maligned lover.[67] Although both paintings by Allori were Francesco's commissions, reflecting his love for Bianca and his own taste, Bianca must have approved of her representation in them; she soon began to commission paintings from Allori, and their relationship was close enough that she later stood as godmother to his son.[68]

Bianca used her palace as an alternative court to the official one presided over by Francesco's wife, Giovanna, a pious woman who spent neither time nor money on the arts. Of course, Giovanna's status as imperial daughter and sister, and as grand duchess of Tuscany, required no further burnishing. Bianca did not have a similar background, so she instead used her patronage of the arts as a defense against her detractors. In her role first as lover, then as

Fig. 26. Raffaello Gualterotti (1543–1639), Engraving of Palazzo Pitti courtyard, frontispiece to *Feste nelle nozze del serenissimo Don Francesco Medici Gran Duca di Toscana; et della sereniss. sua consorte la sig. Bianca Cappello* (detail of cat. no. 126b)

wife of the duke of Florence, certain artists came to her for favors; poets wrote her sonnets, and authors like Francesco Sansovino, Moderata Fonte, and Sperone Speroni dedicated books to her. She also took an active and deliberate role, even before her marriage to Francesco, by using Medici connections and money to employ architects, painters, sculptors, weavers, and musicians. She was at least partly responsible for the villa at Pratolino, designed as a retreat for herself and Francesco by Bernardo Buontalenti beginning in 1569.[69] In 1572 she acquired a set of tapestries from the Florentine tapestry workshops, which was paid for with Medici funds.[70] And in 1577 she hired the court musician Alessandro Striggio to compose madrigals for the extravagant and essentially Medici-sponsored wedding of her daughter into the Bentivoglio family of Bologna, the same family into which Ercole d'Este married his illegitimate daughter Lucrezia almost a century earlier.[71] In this case, the Bentivoglio acknowledged Bianca as Francesco's lover and knew that marriage to her daughter gave them access to the Medici.

Bianca also used her own marriage celebrations of 1579 to legitimize herself in the eyes of the city and beyond. But this marriage did not celebrate two powerful families in a new political alliance. Like Sigismondo Malatesta, Francesco married the second time for love; Bianca had little else to offer. Therefore, rather than an alliance, the complex celebrations promoted Medici power and, by extension, attempted to polish Bianca's public image. Although the program was the collaborative product of Francesco's court artists, there is little doubt that Bianca oversaw most of the details. The ten days of events were commemorated in several festival books describing the ceremonial entrance, tournaments, coronation, hunt, and theatrical performances that took place (cat. no. 126b; fig. 47).[72] The culmination was the pageant in the Pitti courtyard on October 14. As the frontispiece of the festival book by Raffaello Gualterotti illustrates, the performance in the tented courtyard was illuminated by candelabra carried by seventy suspended putti (fig. 26). Ten ornate carts, accompanied by actors, musicians, and automatons representing mythological and allegorical figures, passed through the courtyard to narrate a complex story of an imprisoned Dalmatian knight. According to the tale, the knight could only escape when the crown worn by the fire-breathing dragon who guarded him was placed on the head of the most worthy princess in the world. And, indeed, at the culmination of the drama an actor dressed as the god Apollo retrieved the crown and placed it on Bianca's head, signifying her new status as grand duchess and symbolically replicating her actual coronation, which had taken place a few days earlier in the Duomo. Alessandro Striggio and Piero Strozzi composed words and music for the complex pageant, and the singer Giulio Caccini was one of the performers.[73] The day ended with an elaborate joust, continuing the same chivalric traditions so popular during the time of Francesco's fifteenth-century forebear Lorenzo de' Medici.

Bianca's marriage to Francesco gave her greater access to the funds, and the people, necessary to continue the rehabilitation of her image. Some of her activities must have been unselfish: Pope Sixtus V presented her with a Golden Rose for her charitable work, and she apparently supported several prominent holy women. She also advocated for the Jewish population during the formation of Florence's ghetto.[74] Still, much more is known about her efforts in the arts, such as her support of musicians like Cosimo Bottegari, who dedicated one of the compositions in his celebrated songbook to her, and the dancing master Fabritio Caroso, who did the same with his manual *Il ballarino* (1581).[75] This illustrated manual, one of the first of its kind, describes seventy-seven different dances, many of which would have animated Bianca's own chambers during the many gatherings she hosted.

Invitations to attend these gatherings and view the precious contents of these chambers, surely understood as an extension of Bianca's public image, were offered to visiting dignitaries. In 1584 the agent for the Duke of Urbino described how the Marchese of Mantua and others were taken to see "the little chambers of the Grand Duchess, where there are the most delicious things, full of paintings and sculpture."[76] Clearly these chambers were meant to impress and influence her visitors, and their diplomatic role cannot be underestimated. Although she could do little to appease her Florentine subjects, she did have better luck with her reputation on the larger European stage. In fact, many of the objects in her chambers were gifts from prominent figures in politics and religion. Pope Gregory XIII gave her a mother-of-pearl goblet, King Philip II of Spain an elaborate mirror, Cardinal Luigi d'Este a crystal and gold sculpture of Christ and the Virgin, and Cardinal Dolfino an Annunciation by Raphael.[77] Even her brother-in-law, Cardinal Ferdinando, sent a gold goblet by Benvenuto Cellini and two prized feather mosaics from Mexico.[78] Her native city of Venice, despite earlier attempts to extradite and prosecute her for marrying her first husband without parental consent, named her a True and Particular Daughter of the Republic—an honor bestowed on only one other woman, Caterina Cornaro—and presented her with a diamond necklace upon her marriage.[79] Both dealers and courtiers provided her with antiquities and other collectibles; she received ancient statuettes of Hercules and Bacchus, Egyptian idols and carved stones with portraits of Nero and Petrarch, and a pair of Judith panels by Botticelli.[80] Bianca acquired other objects via commission or direct purchase; her private chapel had a painting of the Annunciation by Francesco Morandini and a crucifix by the goldsmiths Jacques Bijlivert and Giovanni Paolo Lomazzi, all artists popular at the Medici court at that time.[81]

Although most of these objects were prestigious items that helped shape Bianca's image as an elite collector and connoisseur, they did not form a carefully composed collection meant to display a comprehensive ideal. Francesco did that in his *studiolo*, as did Rudolf II, further afield, in his *Kunstkammer* in Prague. Bianca had neither the means, nor the interest, to do the same.[82] Instead, she seemed most concerned with accumulating objects that reflected well on her, and those listed above certainly did that. One gift, however, was more problematic. In 1582 the composer Emilio de' Cavalieri gave her a painting of Clelia Farnese, the illegitimate daughter of Cardinal Alessandro Farnese (fig. 27).[83] Married to Giovan Giorgio Cesarini in 1570, Clelia was praised by both Michel de Montaigne and Torquato Tasso and sought after by many admirers, among them Bianca's own brother-in-law, Cardinal Ferdinando. In fact, Clelia apparently gave birth to Ferdinando's son in 1586, a year after Cesarini died. The relationship between Clelia and Ferdinando was public knowledge; a popular pasquinade referred to it in less than flattering terms.[84] Apparently Ferdinando's duplicitous secretary, Pietro Usimbardi, devised a

Fig. 27. Jacopo Zucchi (1540–1596), *Portrait of Clelia Farnese*, possibly 1582. Oil on panel, 19⅝ × 14⅞ in. (49.7 × 37.8 cm). Galleria Nazionale d'Arte Antica, Palazzo Barberini, Rome

plan to guarantee succession through Ferdinando's bloodline if Francesco and Bianca died without a proper heir by having Ferdinando marry Clelia; the fact that she had already borne his son was, of course, especially fortuitous.[85] Many versions of Clelia's portrait, by Jacopo Zucchi and his circle, were circulated, and these can be dated between her marriage in 1570 and her widowhood in 1585 because of the inclusion of Farnese and Cesarini arms on the elaborate necklace she wears. In all likelihood the painting presented to Bianca was one of these.[86] The number of these portraits suggests considerable demand among a certain elite group, rather like the case of Simonetta Vespucci. It is doubtful, however, that Bianca, by this time married to Francesco, would have wanted a painting representing a Medici mistress, which could only serve as a reminder of her own former status, after all the effort she had put into expunging it. Nor would she wish to celebrate Ferdinando's lover, since she and her brother-in-law had such a problematic relationship.

Indeed, Bianca must have perceived Ferdinando as a threat. She knew that the best way to secure her place at court was to arrange for Antonio to succeed Francesco as grand duke of Florence. In preparation for that, the boy had been legitimized; after the 1582 death of Francesco and Giovanna's only son, Filippo, Antonio was his only male offspring and therefore the rightful heir. Francesco enforced this succession visually by hiring Allori to paint a double portrait of Bianca and Antonio for the so-called *serie aulica*, the series of Medici portraits that lined the corridors

of the Uffizi, then used as a residence and a governing center; one version of this composition is known today (fig. 28).[87] The painting was a statement about succession, similar, in that way, to Agnolo Bronzino's earlier dynastic double portraits of Francesco's mother, Eleonora of Toledo, with Francesco and his brother Giovanni.[88] Such images were key to public perception; as both Francesco and Bianca knew (and as Ercole d'Este earlier realized, with the portrait of himself and his illegitimate daughter Lucrezia), an artist could invest an illegitimate offspring with just as much prestige as a legitimate one. Allori's painting reinforced Francesco's lineage via Antonio as well as Bianca's rights as the mother of the Medici heir. Certainly Bianca understood the importance of this painting and the others like it that Allori executed of her; indeed, one version, known only through documentary references, represented her and Antonio with Filippo, thus including Francesco's legitimate son to elevate the perception of both Bianca and Antonio. Bianca had copies of these portraits sent to her allies outside of Florence, perhaps as a form of insurance against Ferdinando's machinations.[89]

In the end Bianca's efforts failed. In 1587 Francesco and Bianca died unexpectedly, less than a day apart, at the Medici villa of Poggio a Caiano outside Florence. The cause of their deaths remains a mystery. Neither of them was in good health, and they may have contracted a particularly deadly virus that weakened them further. Or, according to a number of contemporary sources

Fig. 28. Alessandro Allori (1535–1607) (currently catalogued as Lavinia Fontana), *Portrait of Grand Duchess Bianca Cappello de' Medici and Her Son*, after 1582, before 1587. Oil on canvas, 50½ × 39⅝ in. (128.4 × 100.5 cm). Dallas Museum of Art, The Karl and Esther Hoblitzelle Collection, Gift of the Hoblitzelle Foundation

Fig. 29. Ring with the conjoined Medici and Cappello arms, second half of 16th century. Coral, Diam. 1⅛ in. (2.7 cm). Museo degli Argenti, Palazzo Pitti, Florence

and recently discovered physical evidence, they may have been poisoned. Biological material containing levels of arsenic consistent with acute poisoning found under the floor of the church of Santa Maria a Bonistallo near Poggio has been identified via documentary references and DNA profiling as that of Francesco and quite possibly Bianca.[90] If indeed they were murdered, the likely perpetrator was Cardinal Ferdinando, who had the most to gain from their deaths. He was at Poggio when they fell ill, and he took charge of events immediately. He promptly set aside his eleven-year-old nephew, Antonio, and became grand duke himself; he relinquished his cardinal's hat to marry Cristina of Lorraine, with whom he went on to have nine children. But Bianca's construction of a public image via the arts obviously worried Ferdinando. In his efforts to counter it, he removed her heraldry wherever he could, replacing it with the Medici *palle* or the Hapsburg device of Francesco's first wife, Giovanna.[91] Among the few places it remains are on the portal of her palace and on several small personal objects, including a red coral ring with conjoined Cappello and Medici arms (fig. 29). A posthumous portrait of Giovanna of Austria and her son Filippo was placed in the position that should have been granted to Allori's portrait of Bianca and Antonio in the Uffizi series. It seems that Ferdinando sent Allori's painting, and several others representing Bianca, to the Casino at San Marco, the original site of Francesco's laboratories and the future residence of Antonio; when Antonio died in 1621 the Casino contained at least nine portraits of his mother, as well as

many of her possessions.[92] Two of these portraits were described as box lids, one of which may have been the two-sided painting by Allori cited earlier (cat. no. 126a recto; fig. 19).[93] The Casino never became a celebrated ducal residence like the Pitti or the Palazzo Vecchio; by relegating these portraits, and Antonio himself, to the Casino, Ferdinando made it clear that neither Bianca nor Antonio were part of the grand ducal family. In a similar manner, several texts about the Medici published during the reign of Ferdinando and his immediate heirs omitted reference to Bianca altogether. Indeed, within two months of her death the Urbino ambassador observed that Ferdinando had extinguished all memory of the former grand duchess.[94]

Since Ferdinando also needed to ensure that later Florentines would not fault his succession, he fabricated a documentary cache based around an alleged deathbed confession from one of Bianca's associates; these documents discredited Antonio's claim to the throne by describing him as neither Bianca's nor Francesco's son but instead a baby Bianca obtained after faking a pregnancy in her desperation to produce an heir.[95] However, with Antonio removed from succession, both in the present and, with these documents, in the future, the relationship between uncle and nephew apparently grew close; Antonio remained at court and often acted on Ferdinando's behalf. Like his mother before him, Antonio was a generous patron, in his case particularly of theater and science, and he used his patronage to legitimize and solidify his public image. He was so successful at this, and apparently posed so little threat to Ferdinando's heirs, that he was buried with honor in the Medici tombs.[96]

Ferdinando's extreme efforts to erase Bianca from history indicate just how successful she was at creating a positive public image. Through her arts patronage Bianca transcended her original status as Francesco's lover and established herself as his consort. But her premature death, the lingering animosity of the Florentine population, and the efforts of Ferdinando all prevented her from maintaining this image for posterity. In the end, she is almost as invisible as the other wives and lovers at Italian Renaissance courts. Their greatest achievements often involved the careful crafting of their public images, but little evidence of these efforts remains today.

1. For key studies, see T. D. Kaufmann 1978; Strong 1984; and Starn and Partridge 1992.
2. H. S. Ettlinger 1994; for analysis of the concept of Renaissance self-fashioning, see Greenblatt 1980.
3. As Joan Kelly demonstrated in her canonical study of women in the Renaissance, the transition from a medieval feudal society created new and often stifling limitations on women; see Kelly 1977.
4. Parenti, *Lettere*, 1996 (ed.), p. 95.
5. Del Lungo 1923, pp. 44–45; and Dempsey 1992, pp. 79–113.
6. Macinghi Strozzi, *Lettere*, 1877 (ed.), p. 385.
7. Ibid., p. 575; for analysis of this text, see Dempsey 1992, pp. 86–87.
8. Pulci 1500. See also Ventrone 1992, pp. 167–87; and Carew-Reid 1995.
9. For a possible reconstruction of the now-lost banner, see Mario Scalini in Ventrone 1992, pp. 182–83, no. 3.17.
10. On this print, see Warburg 1905; Dempsey 1992, p. 111; and Alison Wright in Rubin and Wright 1999, p. 339, no. 89.
11. Spallanzani and Gaeta Bertelà 1992, p. 124, "Uno quadro di legname, dipintovi la 'mpromta di madonna Lucretia." Of course, this notoriously vague reference might refer instead to a painting of Lorenzo's mother, Lucrezia Tornabuoni, or his daughter, Lucrezia (who married Jacopo Salviati in 1486 and was therefore entitled to the honorific "madonna" by the date of this inventory). But the fact that Lucrezia Donati's son later bought a portrait of his mother from the estate (see n. 15) is strong evidence that this was a painting of Lorenzo's chivalric love interest.
12. Garrard 2006, p. 37.
13. For a transcription of this claim, see Covi 2005, p. 287, "Per uno quadro di legname, drentovi la fighura della testa della Luchretia de' Donati." According to this, Verrocchio also made—and was not compensated for—standards for the Medici jousts.
14. On these sales, see Merisalo 1999; Musacchio 2003b; and L. Fusco and Corti 2006, pp. 159–77.

15. Merisalo 1999, pp. 75–76, "Prefati officiales etc. seruatis seruandis absente Nicolao de Nobilibus deliberauerunt quod filius Nicolai de Ardinghellis si uult figuram si[ue] immaginem et pituram eius matris soluat florinos 23. largos de auro in aurum"; and F. W. Kent 2004, p. 76. This painting, together with "un altro quadro, dipintovi 6 meze fighure, picholo" and "dua coppe dorate, entrovi dua palle tonde, dipintovi drento 2 spere," was valued at 60 florins in the 1492 inventory; see Spallanzani and Gaeta Bertelà 1992, pp. 124–25.

16. Garrard 2006.

17. Dempsey 1992, pp. 114–39; and Schmitter 1995.

18. Most recently, see Schmitter 1995; David Alan Brown in D. A. Brown et al. 2001, pp. 182–85, no. 28; and, for this gem, L. Fusco and Corti 2006, p. 124.

19. Schmitter 1995, p. 41. In 1478, exactly two years after Simonetta's death, Giuliano was assassinated in the Pazzi conspiracy and his estate was absorbed into that of his brother Lorenzo. No painting of Simonetta, however, was cited in Lorenzo's inventory of 1492.

20. H. S. Ettlinger 1994, p. 775.

21. On Isotta's medals, see Alison Luchs in Scher 1994, pp. 62–64, nos. 12, 12a, 13.

22. Pasini 1983, pp. 140–47.

23. H. S. Ettlinger 1990, p. 135.

24. Bestor 1996.

25. Syson 2007b.

26. Venturi 1887–88, p. 355. For Lucrezia, see also Salimbeni, *Epitalamio*, 1487; and Gruyer 1897, vol. 1, p. 82.

27. For a summary of these events, see Olivi 1887; and Sparti 1996, pp. 58–61.

28. Cartwright 1903, pp. 65–74; and Lopez 1976.

29. See, for example, the emotional letter Lodovico wrote announcing Beatrice's death in Luzio and Renier 1890, p. 125.

30. Malaguzzi Valeri 1913–23, vol. 1, pp. 503–4.

31. For biographical information, see Uzielli 1896, pp. 266–304; Shell and Sirani 1992, pp. 56–58; and Shell 1998.

32. For the sonnet in Italian, with English translation, see Shell and Sirani 1992, pp. 48–49, "La fa che par che ascolti, e non favella."

33. Ferrets, another member of the weasel family, were domesticated for use in hunting or gamekeeping; see Topsell, *Foure-Footed Beastes*, 1967 (ed.), p. 171. There is no evidence, however, that any of these animals were household pets in the Renaissance.

34. Hewett 1907, p. 310. For other examples of female portraits with similar symbols, see Leonardo's portrait of Ginevra de' Benci with juniper (*ginepro*), Giorgione's Laura with laurel (*lauro*), and Lorenzo Lotto's Lucina Brembati with the letters "ci" inside a moon (*luna*).

35. Ochenkowski 1919; and Pedretti 1990, p. 167.

36. The ermine's desire for cleanliness—and thus the metaphorical link to chastity—was represented by Leonardo in a drawing of an ermine submitting to a hunter rather than dirty its fur in an escape attempt. This drawing may have been the model for the verso of a medal to commemorate Lodovico's investiture; see Möller 1916; Pedretti 1990, p. 167; and Fabjan 1998.

37. Moczulska 1995, pp. 81–85; and Musacchio 2001.

38. Welch 1995, p. 256.

39. For the relationship between Leonardo and Cecilia, see Pedretti 1997, p. 234.

40. Welch 1995, pp. 255–56.

41. For Ginevra's possible role in the execution of her portrait, see Garrard 2006.

42. Earlier scholars somewhat implausibly professed that a repentant Leonardo, on his deathbed, regretted having painted Lodovico's mistresses; see Rio 1856, p. 45.

43. Cartwright 1903, pp. 89–90. Cecilia certainly had a presence at court. In February 1492, Bellincioni recorded visiting her there for dinner and, about the same time, Beatrice demanded that Cecilia stop wearing a certain dress, identical to one that Lodovico had presented to her; see Ghinzoni 1889.

44. Pini 1999.

45. For information on Cecilia's life as the Contessa Bergamina, see Bandello, *Novelle*, 1990 (ed.), p. 138; Shell and Sirani 1992, p. 58; and Shell 1998, pp. 55–63.

46. For a transcription of both letters, see Ferrari 2003, p. 76.

47. Luzio 1901, pp. 153–54; and Cartwright 1915, vol. 1, p. 154.

48. Venturi 1887–88, p. 364; and Cartwright 1915, vol. 1, p. 4.

49. On Francesco's affairs, see Luzio 1915, pp. 119–67; Bellonci 2000, pp. 289–93, 302–3, 347–50; and Bradford 2004, pp. 216–26. Despite her affair with Francesco, Lucrezia Borgia kept up a correspondence with her sister-in-law Isabella, on one occasion asking her to send some fashionable Milanese fans; see Luzio and Renier 1896, p. 686.

50. On Isabella's habits, see Welch 2005, pp. 245–73.

51. On Francesco's patronage activities in relation to Isabella's, see Bourne 2000.

52. Although her collecting interests were similar to those of her male contemporaries, some scholars persist in analyzing Isabella's collecting as a distinctly "feminine" habit; for a refutation, see San Juan 2002.

53. Marinoni and Pedretti 2000, vol. 2, pp. 854–55, "[U]t bene respondet nature[a]e ars docta . . . Possidet illius Maurus amans animam"; and, in translation, Marani 2000, p. 177.

54. See, for example, Cook 1904, pp. 201–2.

55. Hewett 1907; Davies 1951, pp. 349–50, no. 5752; and Syson 2004, p. 123. The tiny heart-shaped details of the sitter's hairnet may be mulberry leaves, the mulberry, or *moro*, also referring to Lodovico; see Hewett 1907, p. 308.

56. Syson 2004.

57. Luzio 1901, p. 154.

58. Cartwright 1903, pp. 141–44; and Shell 1998, p. 54.

59. Ariosto, *Orlando Furioso*, 1999 (ed.), p. 134.

60. For information on the program, see Lapini 1900, pp. 142–43; Petrioli 1966, p. 5; and Scorza 1981.

61. See, among others, Arditi, *Diario*, 1970 (ed.), pp. 34, 177–79; Lapini 1900, p. 197, n. 1; Pardi 1916, p. 197; and Mariotti Masi 1986, p. 97.

62. Hove 1797, vol. 2, p. 510.

63. Ferdinando was a complex figure in Medicean politics; for further information, see Butters 2002.

64. Lecchini Giovannoni 1991, pp. 225–26, no. 24; and Philippe Costamagna in Falletti and Nelson 2002, p. 226, no. 43.

65. In fact, an image of Michelangelo was included in Francesco's marriage celebrations a year after the artist's death; see Scorza 2003.

66. Lecchini Giovannoni 1991, pp. 305–6, no. 191; and Jonathan Katz Nelson in Falletti and J. K. Nelson 2002, pp. 221–23, no. 41.

67. Marabottini 1956.

68. Lecchini Giovannoni 1991, p. 11.

69. Zangheri 1987, p. 46. Various poets, authors, and musicians published works to celebrate the villa and Bianca; see W. Smith 1961, pp. 165–66; and Kirkendale 1993, p. 107.

70. The set was bought on behalf of "uno amico," probably because items for Bianca had to be masked while Giovanna was alive. After Giovanna's death, however, an additional tapestry was commissioned and charged to "Carissima Signora Biancha Chapello"; see Adelson 1984, pp. 54–55. For the Florentine tapestry workshops, see Gavitt 2001; and T. P. Campbell 2002, pp. 493–94. After she became grand duchess, Bianca purchased her own tapestries outright; see C. Conti 1875, p. 55; Meoni 1998, p. 81; and Gavitt 2001, p. 216.

71. Kirkendale 1993, p. 75.

72. For the *sbarra*, see Gaci, *Sbarra*, 1579 and Gualterotti, *Feste delle nozze*, 1579; see also Schrade 1956 and Nagler 1964, pp. 49–57. The god Apollo played a major role in this and other Medici theatricals; his association with medicine had real resonance for the Medici, who had long associated themselves with Saints Cosmas and Damian, the early doctors and Christian martyrs; see Hanning 1979, pp. 502–3.

73. Kirkendale 1993, pp. 94, 123.

74. L. Berti 2002, p. 381.

75. Kirkendale 1993, p. 255; MacClintock 1956; and Caroso, *Il ballarino*, 1581. Caroso dedicated individual dances in the manual to other court women, including Clelia Farnese.

76. Barocchi and Gaeta Bertelà 1993, p. 256, "i camerini della Gran Duchessa dove sono cose deliziosissime, massime di pittura e scultura." For visits by Venetian ambassadors and a Gonzaga cardinal, see Segarizzi 1916, p. 249; and Barocchi and Gaeta Bertelà 1993, p. 287.

77. Saltini 1898, p. 340; Barocchi and Gaeta Bertelà 1993, p. 239; and L. Berti 2002, pp. 48–49.

78. Saltini 1898, p. 340; and Heikamp 1972, p. 16.

79. Saltini 1898, p. 341.

80. Barocchi and Gaeta Bertelà 1993, pp. 208–9, 225–26; and Borghini, *Il riposo*, 1584, p. 353.

81. Borghini, *Il riposo*, 1584, p. 643; and Fock 1980, p. 328.

82. T. D. Kaufmann 1978; and L. Berti 2002.

83. Barocchi and Gaeta Bertelà 1993, pp. 229–30; and Philippe Morel in Hochmann 1999, p. 304, no. 87.

84. Winspeare 1961, p. 162, "Il medico cavalca la mula del Farnese."

85. Morel 1991, pp. 159–62.

86. Pillsbury 1980, pp. 204–7.

87. Lecchini Giovannoni 1991, p. 75; see also Langedijk 1981–87, vol. 1, pp. 317–19, no. 12, 11, vol. 3, pp. 1524–25, no. 12,11. The condition of the version in Dallas (see fig. 28) is problematic; the original appearance of the child's face, in particular, is not clear.

88. Janet Cox-Rearick in Acidini Luchinat et al. 2002, pp. 145–46, nos. 8, 9; and Langedijk 1981–87, vol. 1, pp. 695–97, nos. 10 and 12.

89. Allori, *I ricordi*, 1908 (ed.).

90. Mari et al. 2006.

91. The removal of Cappello heraldry is particularly evident on tapestries; see Meoni 1998, pp. 230, 252.

92. Musacchio 2007, pp. 490–92.

93. Covoni 1892, pp. 237, 243.

94. Mariotti Masi 1986, p. 297.

95. These documents were first exploited in an official ducal history; see Galluzzi 1781.

96. Musacchio 2007.

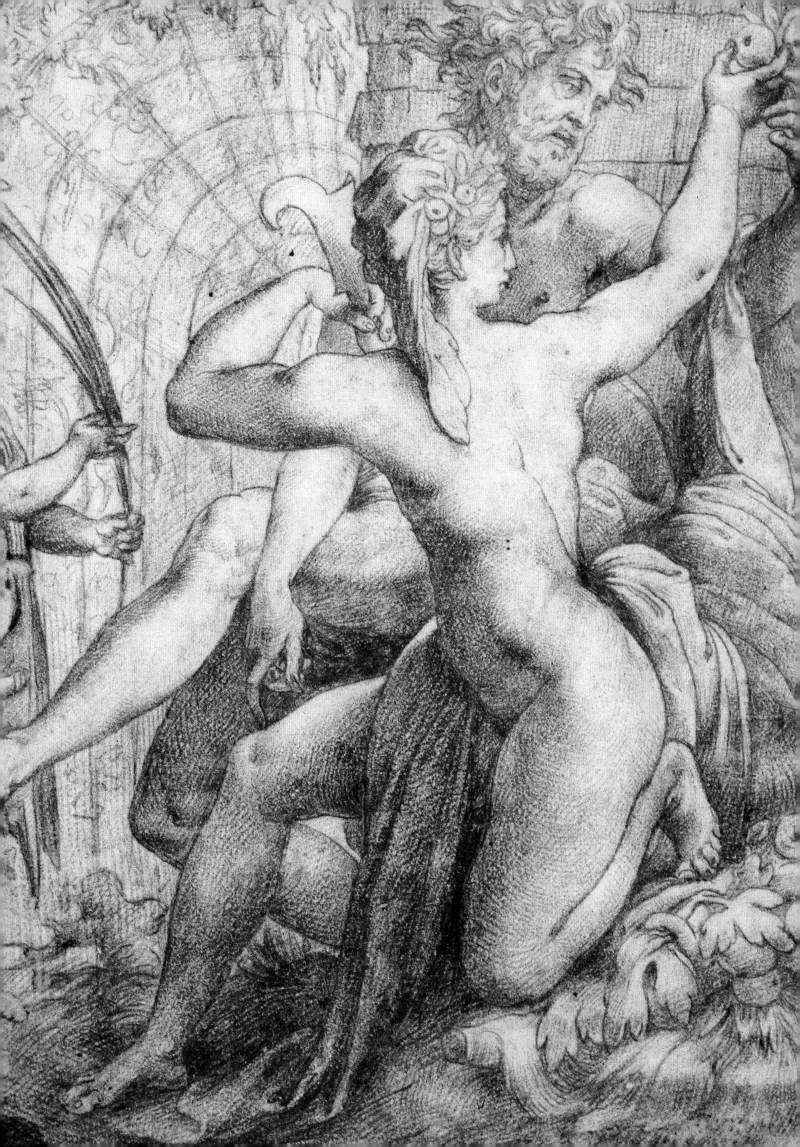

"Rapture to the Greedy Eyes": Profane Love in the Renaissance

Linda Wolk-Simon

Raphael of Urbino, most excellent and singular painter, painted in Rome the loggia in the garden of Augustine Chisio. And in the painting there appeared many figures of gods and graces, and among the others a large Polyphemus and a Mercury as a boy of thirteen or so.

There entered there one morning a lady who, wishing to appear a person of culture and intelligence, admired and praised the paintings very much. And she said: "Certainly, all these figures are most excellent, but I could have wished, Signor Raphael, for the sake of your reputation, that you had painted a nice rose or a figleaf over the shame of Mercury."

Then said Raphael, smiling: "Pardon me, madonna, that I did not think of this." And then he added: "But why did you not suggest that I should do the same thing for Polyphemus, whom you praised so much, and whose shame is so much larger." (Paolo Giovio, *Lettere volgari*, 1560)

This amusing anecdote related by the sixteenth-century humanist and historian Paolo Giovio, though full of inaccuracies and perhaps apocryphal, affords a glimpse of the avowedly secular side of Renaissance culture.[1] The locus of Giovio's narrative is the glorious suburban villa of the papal banker Agostino Chigi (1465–1520) on the west bank of the Tiber, known since 1579 as the Villa Farnesina. Built by the wealthiest man in Rome as a pleasurable retreat for himself and the courtesan who would eventually become his wife, site of extravagent banquets, festive gatherings, and frivolous dalliances, as well as the occasional more sober discourse, Chigi's villa is the consummate icon of that halcyon epoch and a monument to the Renaissance ethos of profane, erotic love.[2]

Of principal interest for this discussion is the vault of the garden loggia, where Raphael's pupils Giulio Romano, Gianfrancesco Penni, and Giovanni da Udine, working from his drawings, portrayed the legend of Cupid, god of love, and the nymph Psyche (fig. 31). Based on *The Golden Ass* by the second-century Roman poet Apuleius, the decoration recounts the story of Cupid and Psyche's illicit love, which withstood a series of trials and culminated in a joyous marriage celebration attended by the Olympian deities. Monumental, sensuous nudes populate the frescoes, their erotic aspect judged exceptional even to an audience schooled in such subjects, as Giovio's account attests. Effulgent garlands of vegetation abound with a seemingly endless variety of suggestively shaped fruits and vegetables, reiterating the narrative scenes' profane content.[3] In one conspicuous passage, a sexual encounter is parodied by a lush, yielding fig and a swollen zucchini or "cucumber fully ripe"[4] (fig. 32)—a playfully lewd detail highlighted by the expansively gesturing Mercury below. The birds that appear throughout the ceiling have no part in the narrative; undoubtedly admired for their impressive naturalism and realistic aspect, they may also have been appreciated as visual puns, *uccello* (bird), then as now, being slang for penis.

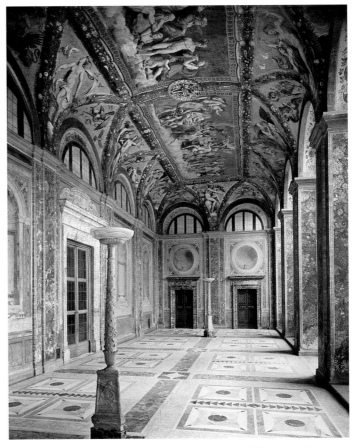

Opposite: Fig. 30. Perino del Vaga (1501–1547), *Vertumnus and Pomona* (detail of cat. no. 94)

Fig. 31. Raphael (Raffaello Sanzio) (1483–1520), View of the Psyche Loggia, ca. 1511–13. Villa Farnesina, Rome

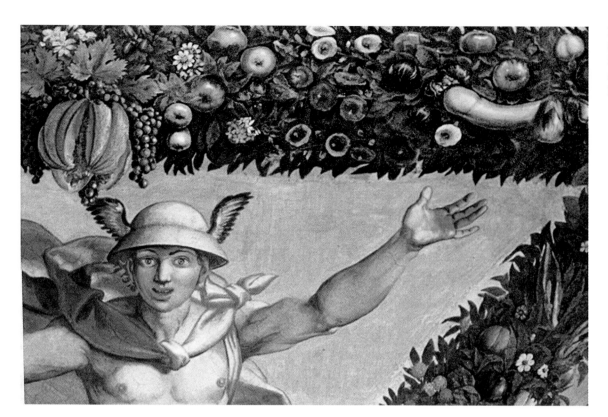

Fig. 32. Raphael (Raffaello Sanzio) (1483–1520), Psyche Loggia (detail), ca. 1511–13. Villa Farnesina, Rome

Agostino Chigi's villa was a "sexy place."[5] Love was in the air, not just literally in the vault of the Psyche Loggia but also on the walls and in the gardens: in a fresco by Sodoma in Chigi's bedroom, Alexander the Great meets his beautiful mistress Roxanne; in the Loggia of Galatea, the giant Polyphemus gazes with longing across the room at the comely sea nymph; and in the garden, there stood sculptures of Cupid and Psyche and a satyr seducing a boy. The doings of the villa's inhabitants mirrored the amorous theme of its decorations. It was here, in 1519, that Agostino Chigi wed his considerably younger Venetian mistress, Francesca Ordeaschi (then pregnant with their fifth child), with whom he had taken up after the death of a prior paramour, the courtesan Imperia. The lavish marriage ceremony was attended by a retinue of cardinals and conducted by the epicurean Pope Leo X (an occasional, if rather dull, guest at Chigi's legendary banquets), who had insisted on the nuptials. Here, too, according to the biographer Giorgio Vasari, the amorous Raphael whiled away languorous hours with his own *innamorata*, his impatient but indulgent patron having expediently installed her at the villa to entice the painter to report for work. And taking in the entire spectacle was a recent addition to Chigi's household, an ambitious but as yet unknown newcomer to Rome named Pietro Aretino (1492–1556), who would come to personify the erotic pulse of the sixteenth century.[6]

Ancient and modern Rome; Raphael, Giulio Romano, Giovanni da Udine, and Pietro Aretino; mistresses and courtesans; humanists, poets, and prelates; lascivious satyrs and amorous gods; pleasant gatherings with learned and amusing friends; salacious images intended for private rather than public consumption; the racy poetry of classical antiquity; refined erudition; illicit love, homoeroticism, and other carnal pleasures; abundant wit and bawdy humor; erotic puns and metaphors (with a particular preference for birds, fruits, vegetables, and gardens): in microcosm at the Villa Farnesina is the matrix of personalities and themes that defined the profane culture of the Renaissance.

VENUS IN THE VATICAN: THE RENAISSANCE *STUFETTA* AS PROLOGUE

The *stufetta* (bath), an intimate space self-evidently intended for the use and pleasure of a very select few, provided a private sanctuary that lent itself to the presentation of erotic imagery. The two most important *stufette* among the few surviving examples, commissioned by a pope and a high-ranking cardinal, both house such decoration. A light-hearted evocation of the ancient world, the *stufetta* of Clement VII in the papal fortress Castel Sant'Angelo, designed by Giovanni da Udine, shows the thrones of the Olympian deities littered with their discarded clothing and attributes. More coy than salacious, the witty conceit suggests that the gods and the goddesses have disrobed and descended nude into the papal bath.[7] The upper walls are embellished with four scenes featuring a voluptuous Venus. The diminutive narratives are culled from Ovid, the same ancient literary source that provided the subject matter for the earlier Vatican *stufetta* of Cardinal Bernardo Dovizi da Bibbiena. Executed about 1516 by Giulio Romano and other members of the Raphael workshop, its now-damaged frescoes are more provocative in portraying the nude Venus in a variety of alluring poses. Adumbrated here are the spirit and subject matter of the more expansive decorations of the Psyche Loggia.

If the choice of subject imagery "such as would agitate the celibate"[8] seems rather surprising for a pope and a cardinal, not to mention indecorous (in the case of the *stufetta* of Bibbiena) for a room within the sacred precinct of the Vatican, it must be acknowledged that in Renaissance Rome, spiritual pursuits were not always the first calling of Princes of the Church, who frequently lived in a splendor rivaling or surpassing that of their secular counterparts. Moreover, like a mistress portrait concealed behind a shutter or an erotic drawing, the decorations of this private space were accessible only to a restricted audience. And finally, the dichotomy between sacred and erotic was not as pronounced

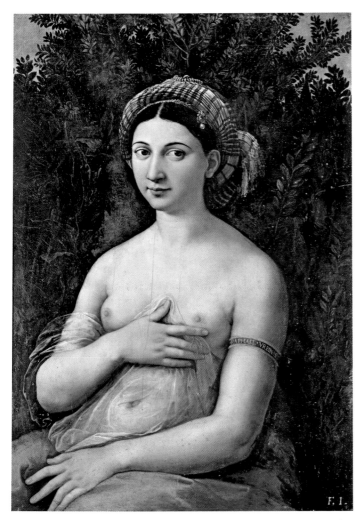

Fig. 33. Raphael (Raffaello Sanzio) (1483–1520), *La Fornarina*, ca. 1520. Oil on panel, 33½ × 23⅝ in. (85 × 60 cm). Galleria Nazionale d'Arte Antica, Palazzo Barberini, Rome

Fig. 34. Agnolo di Cosimo di Mariano Bronzino (1503–1572), *Ludovico Capponi*, 1550–55. Oil on panel, 45⅞ × 33¾ in. (116.5 × 85.7 cm). The Frick Collection, New York

as it would come to be following the implementation in Rome of the decrees of the Council of Trent (1545–63). Indeed, the two were often a seamless continuum, as a number of incongruously erotic and sensual religious images produced by artists who had experienced the licentious and libertine culture of Rome before the Sack in 1527 attest—works such as Rosso Fiorentino's *Dead Christ with Angels* and Parmigianino's *Madonna of the Rose*.[9]

MISTRESSES, LOVERS, COURTESANS, AND PROSTITUTES

Although the socially ambitious Raphael was betrothed to the niece of the powerful Cardinal Bibbiena, he managed to elude the bonds of matrimony.[10] A sensuous nude portrait is believed to represent his *innamorata*, known as the Fornarina (fig. 33; see also cat. no. 88). This is both a depiction of the artist's mistress and an image of idealized, Platonic beauty. Raphael signaled his proprietary "ownership" of the woman by inscribing his name on her armband, and an erstwhile shutter that concealed the painting from all but its intended audience was a measure of its private and therefore implicitly erotic nature.[11] Such concealment was a convention in the display of mistress portraits: Pietro Aretino referred to a portrait of a *donna amata* by Titian that her protective lover installed in his private chamber and kept behind a silk curtain "like a reliquary";[12] Ludovico Capponi, in a portrait by

Bronzino, conceals a miniature—by inference a portrait of his mistress or beloved (fig. 34); and the secret shutter of a sixteenth-century Florentine mirror surely hid an illicit image of forbidden love (cat. no. 115). The lover's fevered yearning for that which is hidden is also a literary trope: inflamed by lust, Apollo in Ovid's *Metamorphoses* is not content to gaze at Daphne's lovely features and imagines the nymph's flesh beneath her dress: "what is hid he deems still lovelier" (si qua latent, meliora putat).[13]

The *Fornarina* is not only a portrayal of a real sitter, it is also an image that probes the abstract idea of beauty. The foliate screen backdrop contains branches of laurel[14]—a tree that, by its etymology, invokes Laura, the beloved of the fourteenth-century poet Petrarch and the archetype of the ideal woman or mistress.[15] Laurel is also a symbol of chastity—a virtue Petrarch extolled in Laura and one that Raphael, through the pictorial device of the painted laurel, imputes to his mistress. Through the artistic act of conjuring his own chaste and virtuous Laura, Raphael is equated with Petrarch: the painter is a poet, the portrait an analogue of his poetic formulation of ideal beauty—what Raphael described as a "certain idea . . . which comes into my head." That "certa Iddea"—a cerebral synthesis of the best features of many rather than a literal likeness of a single individual—the painter explained, was the necessary construct for painting a *bella donna*.[16]

Raphael's friend the poet Pietro Bembo cast the poetics of

beauty in a Platonic mode in his widely circulated and influential dialogues on love, *Gli Asolani* (1505). Physical beauty, one of his interlocutors explains, "may lift us to [virtuous love] provided we regard [it] in the proper way."[17] The transcendental power of beauty—an idea anticipated in Petrarch's veneration of his ideal Laura—would have resonated in Raphael's portrait of a *bella donna* as an exhortation to regard the image "in the proper way," that is, with pure rather than lascivious desire. Chaste and erotic, ideal and real, the *Fornarina* partakes of the polarity that informs many mistress portraits of the period.[18]

Giulio Romano's painting of a woman with a mirror (cat. no. 87) patently derives from Raphael's *Fornarina* (fig. 33), but a number of subtle changes transform the image from Petrarchan icon to Renaissance centerfold. Raphael's symbolically charged foliage is replaced by a quotidian, topographical view of the courtyard of a Renaissance palazzo with an attendant in the distance, a tableau reminiscent of the background of Titian's *Venus of Urbino* (fig. 87). No praiseworthy virtues are ascribed to this nude woman, and the poetic ambiguity of Raphael's sitter is absent. Neither a Platonic formulation of ideal, perfect beauty, nor Campaspe to Giulio's Apelles or Laura to his Petrarch, she is without doubt a courtesan. That status is unequivocally communicated by her "semi-undress, inviting body language, [and] suggestive accessories"—all textbook attributes of the "overtly erotic aspects" of Renaissance depictions of courtesans.[19]

Fig. 35. Domenico Puligo (1492–1527), *Portrait of a Woman (perhaps Barbara Raffacani Salutati)*, ca. 1525. Oil on panel, 38 × 31 in. (96.5 × 78.8 cm). Private collection

Fixtures in sixteenth-century Italy, courtesans were essentially high-class prostitutes, as distinguished from the more ordinary, and cheaper though equally ubiquitous, *puttane* (common prostitutes).[20] A significant population of courtesans and prostitutes is documented in the 1518 census of Rome, where the institutionalized clerical and nominally celibate culture made for a more open tolerance of such women than in most other Italian cities, at least in the period before the Counter-Reformation.[21] The later years of the sixteenth century saw a shift in attitude, however.[22] A censorious, if perhaps somewhat disingenuous, post-Tridentine view is offered in an account of the Eternal City written in 1581: "in Rome it is a thing much wished and desired that there were none of these common wemen [*sic*], which they call Harlots or Courtisans."[23] In the very wish for their absence lies confirmation of their intractable presence. A series of prints dating from roughly this time illustrating the modes of dress of Roman women includes the courtesan, together with the betrothed, the bride, the wife, and the widow (cat. no. 104). Such popular imagery corroborates the testimony of contemporary written sources: prostitutes and courtesans were as much a part of the fabric of Roman society as honest women.

Indeed, to all outward appearances the two were often indistinguishable, as vouched by lamentations on the practice of many courtesans of dressing in the garb of respectable matrons. In Venice, decrees forbidding the imposters to wear veils was but one attempt on the part of civic authorities to end this deception.[24] That city was positively swarming with "many thousands of ordinary less than honest [women]," according to the report of an English traveler, who accounted for their sizeable number by explaining that Venetian gentlemen "keep courtesans to the intent they may have no lawful children."[25] These illegitimate offspring typically became monks or nuns—abbots or priors if they had family connections. If no other city could "compare with Venice for the number of gorgeous dames," the fact that none was "unpainted" meant that this foreign observer, though dazzled, "will not highly commend them." The Venetian state shared the Englishman's ambiguous attitude: periodically condemned, courtesans were at other times protected and even enlisted as officially sanctioned deterrents to the greater scourge of sodomy, the hope being that the display of their ample charms to passersby on the descriptively names Bridge of Tits (Ponte delle Tette) would distract those tempted to stray.[26]

Famed for their beauty, wit, refinement, or conversational skills, and often learned, cultured, and well spoken, many courtesans were also accomplished musicians or poets (or least they contrived to appear so: Aretino's *puttana* Nanna urges the would-be *cortigiana onesta* Pippa to "play a little tune you've learnt for fun, hammer at the clavichord, strum the lute, pretend to be reading *Furioso*, Petrarch, and the *Centonovelle*"[27]). The home of the "lovely, kind and generous Maria da Prato" in Florence provided a venue for literary gatherings, including the premiere of the poet Antonfrancesco Grazzini's comic farce *Il frate*.[28] Machiavelli's mistress Barbara Raffacani Salutati, the probable subject of a portrait by the Florentine painter Domenico Puligo (fig. 35), was acclaimed for her exceptional musical ability (alluded to by the music book in front of her) and her enchanting voice. In Vasari's characterization of her as "a famous and beautiful courtesan of

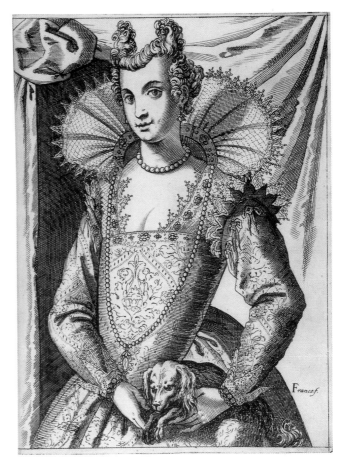

Fig. 36. Cesare Vecellio (ca. 1521–1601), "Meretrici de' luoghi publici/Prostituées des maisons publiques," from *Costumes anciens et modernes/Habiti antichi e moderni di tutto il mondo,* Paris, 1860 (first Italian edition, 1590), illustration on page 120. Thomas J. Watson Library, The Metropolitan Museum of Art, New York

Fig. 37. Giacomo Franco (1550–1620), engraving from *Habiti delle donne venetiane* (detail of cat. no. 65)

the time, beloved of many not less for her beauty than for her fine manners, and especially because she was a good musician and sang divinely," Barbara emerges as nothing less than the female equivalent of Baldassare Castiglione's ideal courtier.[29] The Venetian Lucia Trivixan, eulogized as "the consummate *cortigiana* of her day" by the diarist Marin Sanudo, was similarly famed for her lyrical voice, and her home, too, offered a gathering place for musical virtuosi.[30] Later in the sixteenth century, the dazzling Veronica Franco, a Venetian *cortigiana onesta* as renowned for her grace and beauty as for her keen intellect and poetry, not only wrote Petrarchan verses but also famously inspired such paeans.[31]

Certain kinds of luxury objects, and jewels in particular, were expressly associated with courtesans. That English observer of Venetian customs remarked with wonderment that such women were "so rich that . . . you shall see them decked with jewels as [if] they were queens."[32] Documents of the period record that such jewelry, especially pearls, was frequently given as a form of payment for "carnal commerce."[33] The courtesans of Cesare Vecellio and Giacomo Franco both display strands of pearls with their revealing décolletages (figs. 36, 37),[34] as does the veiled Roman courtesan in the series of prints mentioned above (cat. no. 104). Veronica Franco was accused before the court of the Holy Office of the Inquisition in Venice of pretending to be married as a ruse "to recover the pearls, golden bracelets, and other jewels that she used to wear,"[35] and her courtesan compatriot Amabilia Antongnetta offered strands of pearls as collateral for a loan.[36] No

wonder, then, that pearls were the jewels most specifically targeted by Venetian sumptuary laws.[37] One such law forbade all but courtesans and recently married women to wear them in public, much to the dismay of respectable pearl-owning matrons; that decree contradicted an earlier one that expressly proscribed the wearing of pearls by prostitutes.[38]

Both Raphael's and Giulio's sitters are adorned with pearls (fig. 33; cat. nos. 87, 88), but they convey very different messages in the two paintings. The single pearl worn by Raphael's mistress is, like the laurel branch behind her, a symbolic attribute—an emblem of her perfect beauty. Like Dante's beloved Beatrice, "a mortal thing . . . adorned and pure," she has the "color of pearl" and is, in his eyes, "whate'er of good Nature can make."[39] By contrast, the strand worn by Giulio's woman must be one of those gifts that courtesans and prostitutes of a certain caste in Rome and elsewhere were routinely given. The trinkets arrayed on the table beside her are similarly the kind of luxury items bestowed on such women as gifts (cat. no. 87).

Another erotic painting by Giulio Romano is the monumental *Two Lovers* (fig. 38), executed about 1524.[40] The amorous nature of the protagonists' encounter is iterated in the carved relief on the bedpost showing a satyr, symbol of unbridled physical lust, and parodied by the crone, who has unlocked the door and burst into the bedchamber. *Chiavare* (to turn the key or to lock) has long been slang for sexual intercourse, and keys themselves, an assortment of which dangles at the woman's waist, carry a similar

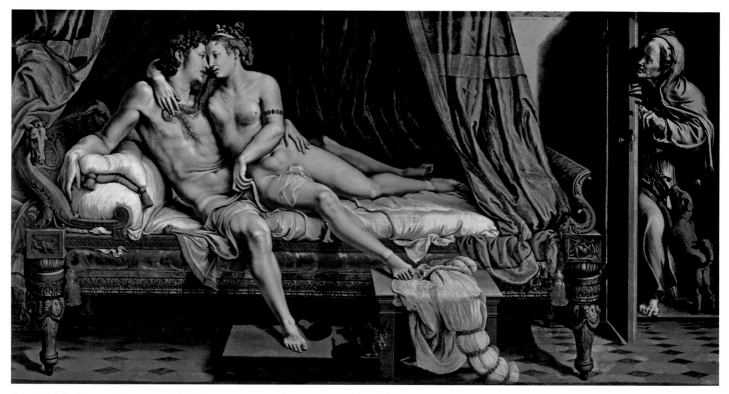

Fig. 38. Giulio Romano (1499–1546), *Two Lovers*, ca. 1524. Oil on canvas transferred from panel, 64⅛ × 10 ft. 11⅝ in. (163 × 337 cm). State Hermitage Museum, Saint Petersburg

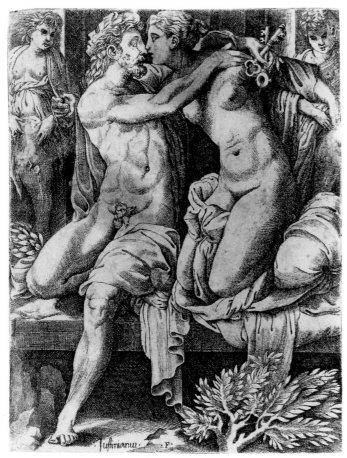

Fig. 39. Giovanni Jacopo Caraglio (ca. 1500/5–1565), *The Love of Janus*, from *The Loves of the Gods* (detail of cat. no. 101)

sexual connotation.[41] Sixteenth-century poets took up the theme with relish. Antonfrancesco Doni dedicated an entire parodic treatise to the variegated sexual etymology and associations of the *chiave*, and Pietro Aretino and Cardinal Bibbiena both employed the key-in-lock metaphor as a literary analogue for fornication.[42] When keys appear in erotic paintings and prints (fig. 39), their punning and lewd meaning is unquestionable.[43]

The presence of a voyeur in the *Two Lovers* and others of Giulio's inventions exploring the theme of carnal love (see cat. nos. 91, 100) signals the erotic, illicit nature of the espied liaison and heightens its titillation by implicating the spying viewer as co-voyeur. The inflamed passion of the unseen observer is a topos in Renaissance love poetry as well. Petrarch, in his *Canzoniere*, related that the sight of his beloved Laura, who was unaware of his gaze, caused him to "shake and shiver with a chill of love" despite the heat of the day. But he made a clear distinction between his virtuous love and the base lust—"the rapture to the greedy eyes"—that the vision of a naked goddess had the power to incite.[44] This distinction is lost in Giulio's compositions: unlike Petrarch the voyeur, whose pure heart burns at the sight of his chaste love, Giulio's voyeurs are seized by lascivious thoughts, as their obscene gestures frequently imply (see cat. no. 91). Parallels lie not with Petrarch or Bembo, but with Aretino, for whom lewd voyeurism—the vicarious pleasure of the unseen observer—was a concomitant element of erotic experience.

Aretino's *puttana* Nanna colorfully describes the orgiastic antics she observed through cracks in the walls of the nuns' cells: "I put my ear to one of the cracks . . . and fixed my right eye to the space between one brick and the next, and what did I see: . . . ha! ha! ha!"[45] In the anonymous, Aretino-inspired dialogue *La puttana errante* (The Errant Whore), the courtesan Madalena similarly

engages in a host of lewd voyeuristic activities.[46] Nor was this the pastime only of lowly types like whores. Nanna recounts that "the big fish in the monasteries and the priesthood hire courtesans just to watch them being screwed by their rent boys . . . and it whets their appetites to see them penetrated *per alia via* (as the Epistle says)."[47]

Giulio's *Two Lovers* is devoid of any discernible literary or mythological content. The absence of a classical overlay is what distinguishes this invention from the no less erotic, if more rhetorically elevated, frescoes that Raphael designed for Agostino Chigi's suburban villa (fig. 31). There, an antique literary source, whose dramatis personae are Olympian gods and goddesses, provided the pretext for painting a cast of sensual nudes. In *Two Lovers*, in contrast, Giulio removes the gossamer veil of decorum accorded Raphael's art by Ovid and Apuleius, much as Perino del Vaga's lewd satyrs and lascivious gods lift the draperies to expose the nudity of sleeping nymphs.

PEACHES AND FIGS: BURLESQUE POETRY AND THE FRUITS OF THE GARDEN

The most vocal, and arguably the most vulgar, proponent of the burgeoning literary genre of the burlesque (and often regarded as the first modern pornographer) was Pietro Aretino, who penned some of the most salacious verses of the sixteenth century.[48] Self-anointed "Secretary to the World," Aretino wielded a scurrilous pen that earned him the epithet, coined by the poet Ludovico Ariosto, "Scourge of Princes." Cuckolds, lechers, and prostitutes were among his favorite characters, and priests and other clerics—greedy, debauched, morally corrupt, forever surrendering to the temptations of the flesh—were the frequent targets of his satirical wit. Loud defender of the sexual act, Aretino adopted the satyr, a base creature consumed by carnal appetites, as one of his personal devices. The satyr (*satiro* in Italian) was considered (through flawed philology) the etymological progenitor of the satirist—the purveyor of satire (*satira*)—a genre at which none was more supremely adept than Aretino.[49]

That literary calling is alluded to in the goatlike profile head of a satyr rendered of phalli on the reverse of a portrait medal of Aretino (cat. no. 113a).[50] As an object, the medal recalls the hat badge worn by Aretino in an engraved portrait by Marcantonio Raimondi (cat. no. 113b), a personal ornament invoking the poet's apotheosis of the penis as worthy of such veneration that it should be displayed "as a medal in one's hat."[51] If the motto on the medal, TOTVS . IN . TOTO . ET . TOTVS . IN . QVALIB[ET] . PARTE (All in all and all in every part), is an exegesis, Aretino, like the satyr head, is pure *cazzo* (prick)—a phallic hero in the mode of Francesco Salviati's priapic triumphator (cat. no. 102). But, although the phallus is a symbol of carnality, it is also the very embodiment and generative source of Aretino's creative powers, the unrivaled penchant for satire and slander that made him both revered and feared, imitated and reviled, in Rome. It is therefore a uniquely eloquent and even learned symbol of his particular genius[52]—his satirical *terribilità*. "Care only that Aretino is your friend," the poet himself admonished the world, "because he is a terrible enemy to acquire. . . . God keep everyone safe from his tongue."[53]

A self-styled "anti-Petrarch," Aretino authored subversive verses that challenged the lyric mode of the great Tuscan poet's adherents, particularly Pietro Bembo.[54] The thinly coded metaphors he employed in his dialogues and sonnets to communicate obscene or erotic meaning—birds, fruits, vegetables, gardens, keys—were part of a shared lexicon of the vulgar and profane that many literary wits of the period adopted in their mock-humanist poems, dialogues, and tracts, and that artists had free recourse to as well. The very ubiquity of these metaphors confirms that the scabrous allusions can have eluded almost no one in the sixteenth century. Of the many fruits and vegetables accorded an erotic alter ego, none had more overt sexual connotations, and accordingly none enjoyed greater popularity, than the fig and the peach. Aretino's *puttana* Nanna recounts her erotic adventures while seated under the fig tree in her garden. One of Poggio Bracciolini's *Facetiae* concerns a tight-fisted client who awarded his lawyer a peach and a fig, only to regret the predictably risible results of the lewd insult.[55] The sixteenth-century poets Francesco Maria Molza, Antonfranceso Grazzini, Niccolò Franco, and Annibale Caro each penned verses extolling the fig's myriad virtues. Caro's mock-humanist excursus probes the gender of the word ("i fichi o le fiche") and the fruit's fetishistic mysteries, employing language rife with bawdy, erotic double entendres, while Molza announced that the fig was to be prized above the rival peaches and apples.[56]

The poet and curial secretary Francesco Berni, whose formulation of the paradoxical encomium—excessive praise of the exceedingly banal—profoundly influenced burlesque poetry,[57] would have contested this apotheosis of the fig, instead commending the peach (the favorite food of prelates, he wryly observes) as the most perfect creation: "O fruit blessed above all others / Good before, in the middle and after the / meal, but good before and perfect behind!"[58] Like other literary trifles that take up the relentless theme, the coded homoerotic meaning of this seemingly innocuous eulogy to a favorite fruit was understood by one and all in Berni's day; indeed, the poem may well have provided fodder for the accusation of sodomy that was leveled against him. A note of creative independence is sounded in the burlesque poetry of the painter Agnolo Bronzino, who was evidently unmoved by figs or peaches but did pen an ode in praise of his frying pan—like the peach, a coded symbol for the male buttocks.[59] And for the obtuse few who may have been deaf to the subtle (and not so subtle) language of poetry, instruction in the erotic double entendres of the fruits of the garden was always available in the form of popular music. A well-known Florentine carnival song, "Canto de' cardoni," rhapsodizes about the cardoon: "Ladies, we are master growers of cardoons, / which in our gardens grow big and good. . . . / [We] shall give you this recipe of ours, besides which we have no greater gift to give. / . . . / The cardoon should be in size / a span or a little more, for nature / cannot digest anything so big and hard, / even though we always like the big mouthfuls. . . ."[60] Sometimes a peach is just a peach. But as the abundant literary puns and linguistic jests attest, in many learned (and not so learned) circles in the Renaissance, fruits and vegetables were much more than they might seem to the uninitiated. In the visual arts, as in burlesque poetry and salacious epistles, novellas, and epigrams, their humorous and erotic connotations are often inescapable (see fig. 32).

Their serious and learned literary undertakings notwithstanding, the many academies, sodalities, and more irrevent *cene*, or supper clubs, that sprang up in Rome and elsewhere in Italy beginning in the later fifteenth century in loose emulation of ancient symposia—"evening companies which constitute themselves and have those most delightful discussions," in the words of one participant[61]—were incubators for such prose, which relied on teasing and suggestive, erotically charged language.[62] These gatherings also offered a haven for sodomitic encounters. Pomponio Leto's humanist academy, founded in Rome in the late 1460s and later known as the Accademia Romana, was dedicated to "the restoration of beautiful Latin."[63] Modeled after Plato's Academy in Athens, it fostered "intense male friendships." Some of its most celebrated members, Leto himself and the papal librarian Tomasso Inghirami among them, were known to practice "aggressive homosexuality," a crime punishable by burning at the stake.[64] Later members included some of the most brilliant poets, scholars, and humanists—men like Paolo Giovio, Baldassare Castiglione, and Angelo Colucci—who sought advancement in Rome during the pontificates of Julius II and Leo X. Their prodigious literary output reflected a rigorous grounding in the study of ancient texts, Latin models they emulated flawlessly and with great erudition.[65] That sodomy was rampant in it was no secret: a friend in Rome recounted in a letter to Machiavelli the travails of a young poet who was always to be found in the protective company of four prostitutes: "he said to me that he worries that because he has a certain reputation for being a poet, and that the Roman Academy wants to induct him, he does not want to run any risk of being molested."[66]

An offshoot of the Accademia Romana, the Accademia dei Vignaiuoli (Vintners), to which Francesco Berni and Francesco Maria Molza (known to his fellows as il Fico, the Fig) belonged, could dubiously boast of having produced more "learned erotica" than any other humanist sodality of the day.[67] Their favorite poetic theme was the fruits and vegetables of the garden—an erotic Eden to which Berni's reveries frequently led him. In a playful letter to absent friends, he offered the expansive benediction: "May god grant you his blessing in giving you for your garden a big 'thing,' with a pitchfork as long as a beam between your legs . . . and that you might have beans and pods and peaches and carrots all year round, in the way I desire for my small garden."[68] The poet's predilection was shared by members of the unsubtly named Accademia degli Ortolani (Gardeners) in Piacenza, to which the literary gadabout Antonfrancesco Doni for a time belonged, adopting the fitting tag il Semenza (Seed).[69]

The Accademia degli Ortolani was dedicated to Priapus, ancient god of gardens, orchards, and harvests. This rapacious, ithyphallic deity (cat. no. 62) was another favorite subject for lewd literary trifles by the likes of the Florentine poet Benedetto Varchi and Aretino's follower Niccolò Franco. Fusing rude, unpolished language with a mock-erudite, pseudo-classical literary style, Franco's *Priapea* is loosely modeled on a widely popular collection of obscene epigrams, the *Carmina Priapea*, ascribed to Ovid and his followers (though their authorship was then hotly debated).[70]

Franco adopted both the profane tone of the ancient Latin verses (the Ovidian rustic deity threatens violators of his sacred space with heterosexual and homosexual acts of retribution) and the conceit of the garden as a locus of carnal excess. In Florence, the Accademia degli Umidi (Academy of the Damp) was committed to perpetuating the *volgare* in the Tuscan vernacular and to opposing stultifying humanist pedantry. Petrarch and the imitators of his style were the targets of their literary invectives. Their ethos and nomenclature was more crude than vulgar, as reflected in its members' choice of nicknames suggestive of primordial slime: Grazzini, one of the founders, was known as il Lasca (Roach), while his fellows included l'Humoroso (Damp), il Frigido (Cold), and lo Suposo (Foamy).[71]

The Accademia degli Intronati (Deaf) in Siena was similarly concerned with language, particularly Tuscan, but also Latin and Greek.[72] Its name signaled an avowed determination "to pay no attention and give no care to any other thing in the world."[73] Like similar sodalities, its members engaged in witty, mock-pedantic parodies of humanist literary models, none more vulgar than *La cazzaria* by its preeminent personality, Antonio Vignali (il Arsiccio, the Singed). A Platonic dialogue in the manner of Castiglione's *Il cortegiano* and Bembo's *Gli Asolani*, *La cazzaria* (its allusions to the political strife between Florence and Siena notwithstanding) is a lengthy discourse on the manifold pleasures and primacy of sodomy. In its appropriation of an elevated literary mode to explore a lewd subject, *La cazzaria* shares the essence of Berni's paradoxical encomium, taking up Aretino's apotheosis of the phallus and according that burlesque paradox an entire dialogue.[74]

The very title of Vignali's dialogue, its coarse language, the lengthy and open exploration of sodomy and homoeroticism, the apparent lack of irony with which that subject is addressed, and the anthropomorphizing of the male sexual organ all call to mind a sixteenth-century Italian maiolica plate decorated with a profile head of man made up entirely of phalli (cat. no. 110).[75] In a quintessential burlesque parody, a stock motif from the maiolica painter's repertoire—the male head (see cat. nos. 13a, 14a)—is here utterly transformed. The banderole, which typically bears an inscription explicating the painted subject, expresses, with the same mock erudition and lack of irony as the protagonists of Vignali's sodomitic dialogue, this eroticized Arcimboldo's *moti mentali*[76]—his wonderment that "everybody looks at me as though I were a dickhead."

We can only guess at the circumstances that led to the production of this plate, but it is not difficult to imagine its amusing presence at raucous *cene* such as those memorialized by Poggio Bracciolini, Pomponio Leto, and other satirical wits. Poggio described the Bugiale, his supper club in Rome, as a "laboratory for fibs." Its habitués—papal secretaries and other well-placed functionaries of the Roman Curia—gathered for their own amusement and "freely attacked whomever or whatever met with our disapproval; . . . many attended our gatherings, lest, in their absence, they be the object of the first chapter."[77] His *Facetiae*, Boccaccio's *Decameron*, and Aretino's *Dialogues* abound with tales of clever trickery and seduction. A consummate satiric jest was the tableau staged by Benvenuto Cellini, who took a neighborhood boy disguised as a girl to a *cena* of painters, sculptors, and goldsmiths.

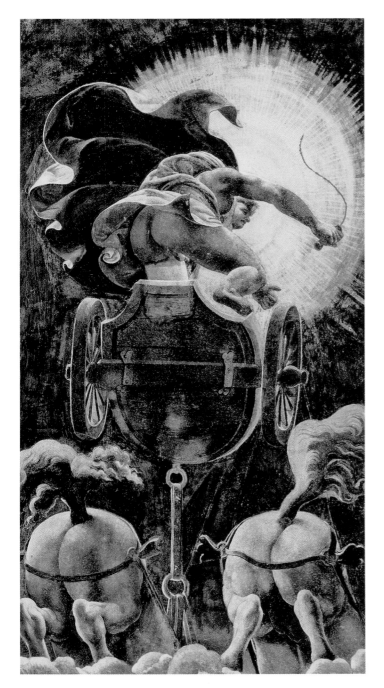

Fig. 41. Francesco Salviati (1510–1563), *Study of Three Nude Men*, ca. 1545–47. Pen and brown ink, brown wash on beige paper, 6¾ × 6⅛ in. (17 × 15.5 cm). École Nationale Supérieure des Beaux-Arts, Paris

Left: Fig. 40. Giulio Romano (1499–1546), Ceiling of the Camera del Sole e della Luna: *Apollo on His Chariot* (detail), 1527. Fresco. Palazzo Te', Mantua

Christened Pomona for the occasion, the youth's true identity was revealed when a courtesan in attendance reached under the imposter's skirts.[78]

Cellini recounted that his prank was roundly applauded by Giulio Romano, whose ceiling fresco of Apollo—or rather, Apollo's buttocks and genitalia—embodies the same bawdy, erotic humor (fig. 40).[79] More overtly homoerotic, if also more refined than

Fig. 42. Perino del Vaga (1501–1547), *The Fall of the Giants*, ca. 1531–32. Fresco. Palazzo Doria del Principe, Genoa

Giulio's unencumbered deity, are the posturing male nudes in the *Fall of the Giants* (fig. 42), painted for the Genoese admiral-prince Andrea Doria, whose portrait by Agnolo Bronzino (Pinacoteca di Brera, Milan) shares the same sensibility. The fresco is by Perino del Vaga, like Giulio a member of Raphael's *bottega* and the author of erotic and homoerotic drawings. It is tempting to posit that the original audience for their works in this vein (cat. nos. 91–94), like similar drawings by Francesco Salviati (fig. 41) and Parmigianino (cat. nos. 96, 97), was to be found in fellowships and sodalities like the Accademia Romana and its many kin in Rome, Florence, and elsewhere, whose members all shared a quintessentially burlesque taste for the "priapic but erudite."[80]

There is no more "priapic but erudite" invention than Salviati's *Triumph of the Phallus* (cat. no. 102). In this mock-heroic composition, an attenuated, monumental phallus occupies the triumphal chariot reserved for gods and heroes in Renaissance *trionfi*. Accompanied by a lively retinue bearing banners emblazoned with the deified phallus, the chariot makes its way toward a triumphal arch that assumes the aspect of female pudenda. Aretino declared that male and female genitalia should be celebrated in public festivals, a satirical tableau literally envisioned here.[81] The conceit is a prurient but learned parody of the artistic conventions of Petrarch's *Triumphs*, just as Renaissance burlesque poetry parodies, with mock erudition, Petrarchan poetics. Whether or not they ever saw it, the likes of Grazzini, Berni, Franco, Aretino, and their many cohorts would surely have lauded such an invention as an admirable recasting, in the language of Ovid, of Horace's dictum "Ut pictura poesis" (As is poetry, so is painting).

PARSNIPS AND BIRDS: EROTIC EARTHENWARE OF THE RENAISSANCE

Profane, erotic subjects frequently appear on Italian maiolica.[82] A singular example is the phallic-head plate discussed above (cat. no. 110). On another plate, a leering satyr face reminiscent of an *all'antica* grotesque mask is formed not of phalli but of succulent fruits and vegetables, familiar signifiers of lewd, sexual meaning (cat. no. 111). Its reverse (the plate's hidden, private side) reveals a sketch of a woman, possibly a courtesan, in contemporary dress,

Fig. 44. Sebastiano del Piombo (ca. 1485–1547). *Portrait of a Woman ("Dorothea")*, ca. 1513. Oil on panel, 30¾ × 24 in. (78 × 61 cm). Gemäldegalerie, Staatliche Museen zu Berlin

the secret object of the satyr's—and the owner's—libidinous and presumably illicit desire.[83] A woman seated with a basket is depicted on a more or less contemporary piece of maiolica (cat. no. 106). Baskets brimming with ripe fruit often appear as subtle erotic metaphors in portraits of courtesans or *belle donne* (fig. 44); here, however, the basket is piled high not with peaches or figs, but with phalli. Was the patron or recipient of this plate too literal-minded to appreciate the salacious innuendo of fleshy fruits and vegetables, opting for a portrayal of the real thing? Or is the woman possibly a witch? The *Malleus Maleficarum*, an influential fifteenth-century treatise on witchcraft published in fourteen editions before the year 1520, recounts that witches were capable of performing "diabolic operations with regard to the male organ," and could "with the help of devils really and actually remove the member," or at least could seem to do so through some magical, "prestidigitatory illusion."[84] There is nothing sinister about the woman on the plate, however, so that interpretation does not seem particularly pertinent. More relevant is a rarely illustrated but widely dispersed late-medieval iconographic tradition showing women plucking phallus-shaped fruits from trees (fig. 43). This peculiar subject has been plausibly interpreted as a visualization of female sexual desire.[85] The fruit-phalli in the basket presumably connote that general meaning, though a more specific identification can perhaps be assigned to them.

In Aretino's *Ragionamento*, the courtesan Nanna describes the delivery to a convent of precisely such a basket of fruit, much to the thrill of the assembled company of friars, priests, novices, and nuns as well as their abbot and abbess.[86] "Hardly had they set eyes on those fruits of paradise," she vividly recalls, "than the hands of the men and the women (already starting to explore each other's thighs and tits and cheeks and piccolos and pussies with the same dexterity as thieves explore the pockets of the stupid wankers whose wallets they snaffle) shot out towards those fruits just as people rush to pick up the candles that are thrown down from the Loggia on Candlemas Day."[87] Asking "what were those fruits, exactly?" her protégé Antonia learns that "they were those glass fruits made in Murano . . . shaped like a man's testimonials," in other words, the glass dildoes known as *pastinache muranese* (parsnips of Murano), one of which is undoubtedly being put to use by the absorbed nude woman in an erotic print by Marcantonio Raimondi (fig. 45).[88] The parsnip was a metaphor for phalli of flesh as well: in a lewd turn of phrase, Nanna elsewhere disparages an errant wife as "the insatiable Swallower-of-Parsnips."[89] "Parsnips," as they were understood in the Renaissance, are the contents of the woman's basket.

Another maiolica plate shows an enigmatic image of a woman baring her breast with a bird (cat. no. 107). Birds, like fruits, resonated with lewd, carnal, and preeminently homoerotic associations. In Renaissance burlesque poetry, "*uccello* (bird) could signify variously the penis, the anus, or an accessible boy,"[90] universally understood references that spilled over into the visual arts. Vasari related that Giovanni da Udine created a sketchbook of birds that was the much-prized *trastullo* (amusement) of Raphael. This description suggests that the drawings, surely of unquestionable artistic merit,[91] were also entertaining in some way. Possibly they were viewed by Raphael, Giovanni, and their fellows as erotic puns in the mode of Berni's peaches and Bronzino's frying pan.

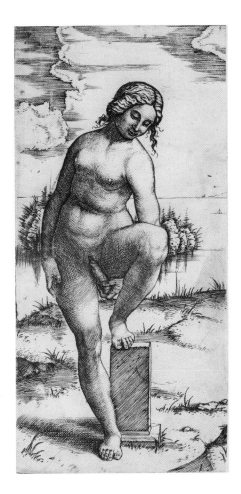

Fig. 45. Marcantonio Raimondi (ca. 1470/82–1527/34), *Woman with a Dildo*. Engraving, 5½ × 2¾ in. (14.1 × 7 cm). Nationalmuseum, Stockholm

Machiavelli, in an epistolary novella, employed the bird metaphor to describe the sodomitic appetites of one Giuliano Brancacci, who, "believing that every bird was waiting," went in search of quarry. Enticing a little bird into an alley, "he kissed it repeatedly, straightened two feathers of its tail and . . . put the bird in the basket behind him."[92] The protagonist is supposedly a literary invention who just happens to have the same name as the real Giuliano Brancacci, who figures in the letters written to Machiavelli by his friend Francesco Vettori.[93] Machiavelli makes it clear that anyone from a long list of names could be substituted for his "fictional" bird-loving Brancacci,[94] confirming that "bird hunting," or sodomy, was common practice in Renaissance Florence, as elsewhere.[95]

It is hard to avoid the conclusion that the bird on the maiolica plate is a metaphor for sodomy, an alternative to the carnal pleasures offered by the woman who displays her breast (itself a profane gesture of offering, which contemporaries would have associated with a courtesan or prostitute).[96] Indeed, the decoration of this plate seems best interpreted as, in essence, an epigram of the tableau that was played out on the Bridge of Tits in Venice, the conflicting temptations of sodomy and heterosexual sex. Or perhaps the pairing is meant to signal not a choice, but rather the full menu of carnal options, sodomitic and heterosexual. Given the nature of their imagery, these plates and vessels would seem to have been created as private gifts intended for the pleasure and amusement of a select individual or a private sodality. Earthenware *trastulli* (amusements), they are, like the erotic drawings and burlesque literary trifles referred to throughout this essay, loquacious pieces of the profane side of Renaissance culture.

Fig. 46. Anonymous northeastern Italian artist, *Allegory of Copulation* (verso), last quarter of the 15th century. Copper engraving plate, 5⅞ × 8⅞ in. (15 × 22.4 cm). National Gallery, Washington, D.C.

I MODI

About 1524, Giulio Romano and Marcantonio Raimondi collaborated on the most famous—indeed, infamous—erotic images of the Renaissance, a series of sixteen prints known as *I modi*, usually translated into English as *Ways* or *Positions*, both in reference to sexual acts, showing couples copulating with impressive *varietà* (cat. nos. 99, 100).[97] Given his salacious imagination and provocative wit, it may well be that Pietro Aretino proposed or encouraged the venture. The acrobatics performed by Giulio's figures are suggestively close to the sexual positions enumerated by Aretino's *puttana* Nanna in the *Dialogo*: "One likes his meat rare and another likes it well done, and they come up with the 'horizontal shuffle', 'legs in the air', 'side-saddle', the 'crane', the 'tortoise', the 'church steeple', the 'relay', the 'grazing sheep' and other postures stranger than the gestures of a mime."[98] Moreover, Aretino's *Sonnetti lussuriosi sopra i XVI modi*, written as a literary pendant to the prints, were in circulation in Rome in manuscript form in the summer of 1524,[99] that is, about the time the engravings appeared, a chronology suggesting that the sonnets were not a delayed homage, as their author retrospectively recalled, but rather a simultaneous production. Aretino himself professed that he was moved to compose his verses by the same spirit that prompted Giulio to create the designs; certainly, he remained the loud champion and defender of Giulio's enterprise, announcing some years later in defense of the *Modi*, "I reject the furtive attitude and filthy custom which forbids the eyes what delights them most."[100] The prim and unamused Vasari professed himself unable to decide which was more offensive, Giulio's drawings or Aretino's words, indicating that he, at least, regarded the painter and the poet, a disgraceful Apelles and Apollo, as equally culpable miscreants in this tasteless foible.[101]

Immediately upon their publication, the engravings were suppressed and the plates destroyed by agents of the outraged Pope Clement VII. Heading the censorship campaign was the austere

Papal Datary Gian Matteo Giberti, bishop of Verona. Giulio Romano and Pietro Aretino escaped official punishment, but Marcantonio Raimondi was imprisoned, and an attempt made on Aretino's life was probably ordered by Giberti. Yet, despite the swiftness of his action, some impressions of the *Modi* evaded obliteration. The compositions were immediately disseminated and copied, individual figures from Giulio's pairings were widely appropriated in various media, and other series of engravings of a similar tenor were produced in Rome and elsewhere, beginning with Gian Giacomo Caraglio's *Loves of the Gods*, designed by Perino del Vaga and Rosso Fiorentino (cat. no. 101a–g).

The *Modi* were reissued in a woodcut edition, accompanied in print for the first time by the *Sonnetti lussoriosi*, some time after 1527 (see cat. no. 100). Aretino must have been emboldened to engage in this provocative act of publishing bravado because he had by then removed to Venice, which offered a safe haven from the punitive reach of Rome, and a "freedom and democracy of the printing press that Rome did not."[102] Crude, vulgar, utterly without artifice, and at least borderline pornographic, his language, like Giulio's images, avoided coded metaphors: no birds or peaches here.[103] And like the *Modi* in the visual arts, the *Sonnetti lussoriosi* heralded a new literary genre of obscene, graphically erotic prose—none more influential than the Aretino-inspired dialogue *La puttana errante*, which described dozens of "different positions for enjoying sexual intercourse"—far more than the meager sixteen that Giulio and Aretino envisioned.[104]

The salacious subject matter of the *Modi* was not new. Erotic prints had been circulating throughout Europe since the mid-fifteenth century (fig. 46).[105] Archaeological and literary models from classical antiquity, too, were abundant and could be adduced to legitimize this risqué enterprise as yet another revival of the *maniera all'antica*.[106] Certainly, the *Modi* found a ready audience among Roman cognoscenti including, Vasari implies, the improbable hands of high-ranking clerics and curial dignitaries.[107] Their enthusiastic reception is unsurprising, for the erotic

was an indelible part of Renaissance culture, as much a defining characteristic of the age as the erudite humanist paradigm *instauratio Romae* (the renewal of Rome to the glorious splendor of its ancient past) that animated so much of the period's artistic, cultural, and philological endeavors.[108] The same artists and patrons, and the same network of secretaries, courtiers, prelates, diplomats, poets, and intellectuals—and not just in Rome—navigated both waters. Why, then, were the frescoes in the Psyche Loggia of the Chigi villa considered sufficiently decorous, while the *Modi*, a product of the same culture and judged by the same audience, were not?

The absence of a veneer of respectability that an obvious mythological subject would have conferred made the *Modi* irredeemably offensive: no double entendres or hidden meanings lurking behind a classical excursus are to be found in these images, only the profane, erotic, sixteenth-century reality. Moreover, unlike the salacious frescoes, the homoerotic drawings, the lewd maiolica, and the burlesque poems penned by and for closed sodalities, the *Modi*, by virtue of being prints, could be mass produced and widely dispersed beyond the protective walls of a *studiolo*, villa, or private academy. In the calculation of an ascetic and reform-minded cleric such as Giberti (like Cardinal Gabriele Paleotti some decades later),[109] the harm these degenerate images could inflict in a Rome already reeling from vituperative Protestant rants against the Church's licentiousness, corruption, and moral turpitude was incalculable. To appropriate that tireless poetic metaphor of the garden, the erotic weed needed to be uprooted. Therein, perhaps, lies part of the explanation for the fact that, of the three perpetrators, only the engraver, Marcantonio Raimondi, was punished.[110] It was through his efforts that what should have remained private—that which was capable of "bringing rapture to the greedy eye"—became public and therefore transgressive.

"No Petrarchan subtleties," Aretino's worldly-wise Nanna proclaims by way of explaining the preferences of her Venetian clientele, announcing therein a shifting paradigm of love and the essence of the erotic ethos of the Renaissance.[111] Just as the language of burlesque poetry constitutes an explicit renunciation of Petrarchan poetics and its concomitant notions of love and beauty,[112] so too does erotic imagery of the period forsake the Petrarchan ideal for the carnal real. Nanna and her lusty kind inhabit the world of Boccaccio rather than of Petrarch; of Berni rather than of Bembo; of Giulio Romano rather than of Raphael.[113] If this was a world that rejected Horace's dictum that the noble purpose of literature (and, by extension, of painting) was to edify and instruct, a new maxim for the sister arts that Ovid could have formulated—"recar piacere et diletto alle genti (to bring pleasure and delight to people)"—never held more true.[114]

The epigraph is from Paolo Giovio, *Lettere volgari*, edited by Lodovico Domenichi (Venice, 1560), pp. 14v–15r, cited in Jones and Penny 1983, pp. 185, 253, n. 42; quoted in translation from *Facetiae* 1928, Facetia CXXXIII (there ascribed to Lodovico Domenichi), pp. 159–60.

1. The inaccuracies are numerous: the Polyphemus was painted not by Raphael but by Sebastiano del Piombo; it is not in the Psyche Loggia but in the adjacent Loggia of Galatea; and, unlike Mercury, that monumental figure is not nude, so the size of his "shame" could only be imagined rather than expressly gauged.

2. This despite contemporary panegyrics lauding the villa's gardens as a place for stoic reflection and learned discourse, for which see Rowland 2005, p. 21.

3. According to the humanist and poet Blosio Palladio, the encyclopedic botanical presentation included exotic specimens from the Orient and the New World, in addition to varieties mentioned in Pliny the Elder's *Natural History*; Rowland 2005, pp. 23, 29.

4. Aretino, *School of Whoredom*, 2003 (ed.), p. 12.

5. Rowland 2005, p. 37.

6. Aretino probably arrived in Rome about 1517. Rowland (2005, p. 29) characterized Aretino at this time as Agostino Chigi's newly hired "houseboy." Roger Jones and Nicholas Penny (1983, p. 183) suggest that Aretino may have been the literary advisor behind the decorations of the Psyche Loggia.

7. For these damaged decorations, painted about 1524 by Giovanni da Udine and assistants, see *Quando gli dei si spogliano* 1984. Documentary evidence supporting the traditional attribution, which has been questioned in the literature, was recently published in Wolk-Simon 2005, p. 269. For the *stufetta* of Cardinal Bibbiena, see Jones and Penny 1983, pp. 192–93.

8. Jones and Penny 1983, p. 193. Edifying here is Aretino's remark that an image of Venus had the power "to fill with lust the thought of anyone who gazes at it"; letter to Federigo Gonzaga, 1527, in Aretino, *Lettere*, 1957–60 (ed.), vol. 1, p. 17, no. 11. Cardinal Bibbiena's bawdy theatrical comedy, *La calandria*, had recently been performed to considerable acclaim; Dovizi da Bibbiena, *La calandria*, 1978 (ed.). The third Vatican *stufetta*, not discussed here, was commissioned by Bishop Gian Matteo Giberti, Datary to Pope Clement VII. See *Quando gli dei si spogliano* 1984, pp. 18, 33, and fig. 31.

9. For a discussion of this aspect of sixteenth-century Roman art, see Nova 2001; Nagel 2005; and Burke 2006.

10. Maria Bibbiena achieved in death what she was unable to accomplish in life: dying within days of the painter, she was interred near him in the Pantheon, remaining at his side for all eternity.

11. This possessive "branding" of the sitter makes it unlikely, in the opinion of this author, that she is Francesca Ordeaschi, mistress and then wife of Agostino Chigi, as has recently been suggested by Claudio Strinati (2004, p. [13]), rather than Raphael's mistress as she has traditionally been identified. That the painting was covered by a shutter at least by the seventeenth century, and conceivably from its inception, is noted in D. A. Brown and Oberhuber 1978, p. 48.

12. Letter to Don Diego Mendoza, in Aretino, *Lettere*, 1957–60 (ed.), vol. 1, p. 26, no. CLIII.

13. Ovid, *Metamorphoses*, 1994 (ed.), vol. 1, pp. 36, 37 (bk. 1, l. 502).

14. The plants, which in addition to laurel include myrtle and quince, were identified by D. A. Brown and Oberhuber (1978, pp. 47–48), who interpret the branches as symbols of eternal love, virtue, and fidelity. The plants have been discussed more recently by Anna Lucia Francesconi, "Notazioni botaniche sul dipinto," in Mochi Onori 2000, pp. 19–20. The background originally showed an open landscape behind the seated figure, as a recent technical examination has revealed; see Mochi Onori 2000, pp. 6–7; and Strinati 2004, pp. [9, 10].

15. On the pictorial motif of laurel as a visual metaphor resonant with literary, specifically Petrarchan, associations, see Vaccaro 2000, p. 108.

16. Quoted in translation by Jones and Penny (1983, p. 97), who note the widely accepted suggestion that the letter was composed for Raphael by Aretino. More recently, John Shearman (2003, vol. 1, pp. 734–41, transcription of letter, p. 735) proposed that it was written by Baldassare Castiglione about 1522.

17. Bembo, *Gli Asolani*, 1954 (ed.), p. 182.
18. The thematic polarity implicit in mistress portraits is discussed in Rogers 2000, p. 96.
19. Ibid., pp. 92–93. The "suggestive accessories" include cosmetics and fragrances in addition to the mirror on the table beside her, as well as the pearls she wears (discussed below in this essay). Leonardo's observations on the power of an image to "arouse desire in the beholder" (for which see D. A. Brown and Oberhuber 1978, p. 34), which anticipate the similar observations of Aretino (see note 8 above), are apposite here.
20. On courtesans in the Renaissance, see Masson 1976; and Lawner 1987.
21. Prostitutes and courtesans in Renaissance Rome are discussed in Witcombe 2002. For the 1518 census, see Armellini 1882. The division of courtesans into three categories: "courtesana onesta" (honest courtesan), "cortesana da lume" or "da candela" (lantern courtesan), and "courtesana puttana" (whore) is discussed in Witcombe 2002, pp. 274–75.
22. This shift resulted in an "ongoing iconographic, literary, and social campaign for the suppression of prostitution and the conversion of whores"; Matthews Grieco 1997, p. 79.
23. Martin, *Roma Sancta*, 1969 (ed.), p. 145. On prostitutes and courtesans in Renaissance Venice, see Fortini Brown 2004, pp. 159–87.
24. Roman women donned a veil, symbolizing their status as matrons, after the birth of their first child, a practice reported by a Mantuan emissary in a letter of 1526, transcribed in D. A. Brown and Oberhuber 1978, p. 84, n. 186. The courtesan in the series of prints discussed here wears a veil similar to that of the matron. The protest against courtesans wearing veils occurs in an account of 1598, quoted in Fortini Brown 2004, p. 185.
25. Thomas, *History of Italy*, 1963 (ed.), pp. 82–83.
26. On this subject, see Ruggiero 1985, esp. chap. 6, "Sodom and Venice," pp. 109–45. A few enterprising women dressed in men's clothing and enticed youths into the closed cabins of gondolas, where sodomy and other illicit practices could be engaged in unobserved; see Fortini Brown 2004, p. 185.
27. Aretino, *School of Whoredom*, 2003 (ed.), p. 83. *Furioso* is Ludovico Ariosto's *Orlando Furioso*, and the *Centonovelle* is Boccaccio's *Decameron*.
28. Maria da Prato was so described by Grazzini himself in his prologue to the play, quoted in Rodini 1970, pp. 15–16, 203, n. 57.
29. On Barbara Raffacani Salutati and the identification of her as the sitter in Puligo's portrait of a courtesan, see Rogers 2000; passage from Vasari's *Life of Puligo*, quoted in ibid., pp. 92, 101, n. 9. (Interestingly, Vasari reports that the morally lax Puligo preferred the company of women and musicians and that his promiscuous behavior led to his early demise after having contracted the plague in the house of one of his mistresses; Vasari, *Le vite*, 1568/1906 [ed.], vol. 4, p. 467.) On the portrait, see also Elena Capretti in *Domenico Puligo* 2002, pp. 122–23, no. 27. For the ideal courtier, the subject of much of the first and second books' dialogues, see Castiglione, *Book of the Courtier*, 1959/2002 (ed.), pp. 20–82.
30. Sanudo, *I diarii*, 1879–1903 (ed.), vol. 19, col. 138, on the occasion of her death in 1514; quoted in Fortini Brown 2004, pp. 163, 279, n. 14.
31. Veronica Franco's work was published as *Terze rime* (Venice, 1575) and *Lettere familiare a diversi* (Venice, 1580); see Rosenthal 1992, and Rosenthal 1993.
32. Thomas, *History of Italy*, 1963 (ed.), p. 82.
33. This practice is well documented in contemporary legal records, which also enumerate jewel-related altercations, givers' attempts to reclaim them, and recipients' efforts to hang onto them or demand their return; see Storey 2006, pp. 71–77. Matthews Grieco (2006, p. 110) notes that the "opalescent sheen" of pearls was regarded as the gemological equivalent of the fairest type of female beauty.
34. Vecellio's illustrations (see cat. nos. 64, 65) include the *Cortigiana fuor di casa*, the *Meretrice publiche*, and the *Cortigiane venetiane per casa*. Another example is Paolo Tozzi (?), *Lament of the Courtesan Anzola*, ca. 1600, ill. in Matthews Grieco 1997, p. 84, fig. 3.9.
35. "[P]er ricuperare li perli, le maniglie d'oro, et altre gioie, ch'ella portava"; testimony of Redolfo Vannitelli, 1580, quoted in Rosenthal 1992, p. 157. Franco wears pearls in the engraved portrait frontispiece of her volume of poems, *Terze rime*, ill. in Rosenthal 1993, p. 111, fig. 21.
36. "[A] string of pearls . . . interspersed with gold leaves and another string of ninety-nine baroque pearls"; notarial document registering the debt (Archivio di Stato, Rome), quoted in Storey 2006, p. 77. See ibid., p. 71, for a document recording the purchase of an expensive strand of pearls by the courtesan Orinthia Focari in 1606.
37. Killerby 2002, p. 45.
38. The sumptuary law of 1543 is transcribed in Chambers and Pullan 2004, p. 127. See also Knauer 2002, pp. 100–101, n. 29; and Fortini Brown 2004, pp. 182–83.
39. Dante, *The New Life*, 1896 (ed.), p. 36.
40. Gombrich et al. 1989, pp. 274–75 (entry by Sylvia Ferino-Pagden). The work was probably painted for Federigo Gonzaga, duke of Mantua, perhaps while the artist was still in Rome.
41. See Barolsky 1978, pp. 132–33; see also Frantz 1989, pp. 27–29. In Aretino's *Ragionamento* (*Secret Life of Nuns*, 2004 [ed.], p. 25), Nanna employs a similar pun to describe an abbot having his way with a young nun: "what he did was pop his paintbrush in her little paint pot." The phallic alter ego of this seemingly innocuous object is the subject of Bronzino's poem "Del pennello" (On the Paintbrush), for which see Parker 1997, pp. 1024–26. In a letter of 1520, Cardinal Giulio de' Medici refers to the quarreling Giulio Romano and Giovanni da Udine, then at work at his villa (the Villa Madama), as "quei due scopettini" (those two little paintbrushes; see Wolk-Simon 2005, p. 259). Aretino's use of the same phrase in a context that makes the vulgar overtones unambiguous suggests that Cardinal Giulio's patronizing name-calling, while invoking the artists' profession, also carried a lewd connotation that was an intentional (if hitherto unnoticed) and therefore particularly witty double entendre.
42. On these literary occurrences of the erotic key metaphor, see Barolsky 1978, pp. 132–33. See also Frantz 1989, p. 97, for its occurence in the erotic dialogue *La puttana errante*, further discussed in note 46 below. In Bibbiena's *La calandria*, voyeurs refer to "keyholes" that are "full," thereby linking the voyeur with the sexual metaphor of the key. On Doni in particular, see Frantz 1989, p. 27; Thompson 2007, for his activity as a publisher; and also Bing 1938.
43. The print illustrated in fig. 39 has been associated with the Perino-Caraglio *Loves of the Gods*, but it is either a later interpolation or a late-stage addition designed by an anonymous artist imitating the Perino-Rosso format. See Archer (1995, p. 109), who suggests that this composition was separated from the series before the accompanying verses were composed (a conjecture rejected by Talvacchia 1999, pp. 255–56, and Turner 2007a, p. 370); and cat. no. 101a–g.
44. "Diana, naked in the shadowy pool, / Brought no more rapture to the greedy eyes / Of him who watched her splashing in the cool / Than did my glimpse of a maiden unaware / Washing a snood, the gossamer garment of / My lady's wild and lovely golden hair; / Wherefore, although the sky burn hot above, / I shake and shiver with a chill of love"; Petrarch, *Canzoniere*, no. LII, in Petrarch, *Love Rimes*, 1932 (ed.), reprinted in Petrarch, *Sonnets*, 1966 (ed.), p. 35.
45. And again: "the cracks in the wall were so badly plastered that even if you just put the corner of your eye to one of the chinks, you could see everything going on in every nun's little cell." Aretino, *Secret Life of Nuns*, 2004 (ed.), pp. 21, 23. On voyeurism, both visual (espied) and auditory (overheard) in Giulio's compositions, see *I modi* 1988 (ed.), pp. 39–42. That erotic pleasure attached to voyeurism is implicit in Pietro Bertelli's flap print of a courtesan, which engages and implicates the viewer as voyeur—not just as passive spectator but as active participant (see cat. no. 103).
46. On the anonymous, mid-sixteenth-century obscene dialogue *La puttana errante* (distinct from the far less influential lewd epic poem of the same title by Aretino's follower Lorenzo Venerio, published in Venice in ca. 1529 or 1531), see Frantz 1972, p. 164; Frantz 1989, pp. 92–95 (in both wrongly ascribed to Aretino's secretary Niccolò Franco); and Moulton 2000, pp. 148–152. A modern edition is Aretino 1987, kindly brought to my attention by James Grantham Turner.
47. Aretino, *School of Whoredom*, 2003 (ed.), p. 76.

48. On Aretino, see Waddington 2004. For portraits of Aretino, as well as an extensive discussion of him, see Woods-Marsden 1994. Aretino's literary output was not exclusively satirical and salacious; for another aspect, see Land 1986.

49. See Waddington 1989, pp. 661–64; and Waddington 2004, chap. 4, "Satyr and Satirist," pp. 91–116. On the false etymology, which was first exposed in 1605, see Waddington 1989, pp. 661–62; and Waddington 2004, 94–95.

50. See Waddington 1989, pp. 678–81; and Waddington (2004, pp. 109–11), who suggests (p. 111) that the satyr's mouth "ejaculates" his words, which are employed in "innocent truth-telling and satiric exposure of vice."

51. In a letter to Battista Zatti of December 1537, Aretino wrote: "It would seem to me that the thing which is given to us by nature to preserve the race, should be worn around the neck as a pendant or pinned on to the cap like a broach [i.e., hat badge]"; Aretino, *Lettere*, 1957–60 (ed.), vol. I, pp. 110–11, no. LXVIII, quoted in translation in Waddington 2004, p. 115.

52. As discussed in Waddington 2004, pp. 113–16. Aretino's "propensity to slander" and satire are discussed in Reynolds 1997, pp. 120–21.

53. "Fa sol che lo Aretino ti sia amico, perché gli e mal nemico ad chi lo acquiste. . . . Dio ne guarde ciascun da la sua lingua"; Aretino, *Farza*, vv. 223–24, 232, as quoted and translated in Reynolds 1997, p. 120.

54. Aretino as "Counter-Petrarch" is discussed in Waddington 2004, pp. 20–30. The conflicting and increasingly hostile attitudes of contemporary poets in Rome toward Aretino are discussed in Reynolds 1997, pp. 119–42.

55. Bracciolini, *Facetiae*, 1968 (ed.), Facetia CVII, pp. 99–100.

56. Grazzini's now-lost ode to figs is listed in an early index of the poet's work; see Rodini 1970, p. 167. Molza's and Caro's literary confections praising figs are discussed in Frantz 1989, pp. 33–37; also mentioned in Frantz 1972, p. 163.

57. Parker 1997. The paradigmatic formulation is Berni's encomium to a urinal.

58. "O frutto sopra gli altri benedetto, / buono inanzi, nel mezzo e dietro pasto; / ma inanzi buono e di dietro perfetto"; Berni, *Rime facete*, 1959 (ed.), p. 32, quoted and translated in Frantz 1989, p. 30. Frantz notes that the peach "was understood to suggest the ass or more particularly asshole—especially of a boy"; while "fig is slang for the female pudenda" (Rowland 2005, p. 29). In addition to the peach and fig, other fruits and vegetables eroticized in burlesque poetry included melons and apples (buttocks) and string beans (vulgar for cocks); Frantz 1989, pp. 29–30.

59. On Bronzino's poem "La padella del Bronzino pittore" (The Frying Pan of Bronzino the Painter) and the eroticizing of this mundane object, see Parker 1997, pp. 1027–28.

60. Transcribed and translated in Orlando Consort 2001, p. 44, where it is noted that the cardoon in the song stands for the male organ and "nature" for the female sexual organ.

61. Description of Giulio Sadoleto, secretary of Cardinal Bibbiena, written in 1517, is quoted in Reynolds 1997, p. 2, n. 5.

62. See Samuels 1976; D'Amico 1983; Yates 1983; Gaisser 1995; and Rowland 1998. On artists and academies, in addition to Parker 1997 (for Bronzino), see Perini 1995; Quiviger 1995; and Scorza 1995.

63. Rowland 1998, pp. 14, 22.

64. Ibid., p. 24.

65. Samuels 1976, p. 606; Rowland 1998.

66. Quoted and translated in Rowland 1998, pp. 24–25.

67. Franz 1989, pp. 25–27; see also Samuels 1976, p. 606. An offspring of Angelo Colocci's Accademia Romana, the Vignaiuoli had as its mission the translation of antique poetry into the vernacular and the composing of original verse. On the Accademia Romana, see Samuels 1976, pp. 606–7; D'Amico 1983; and Rowland 1998.

68. Written in 1534; Berni, *Opere*, 1864 (ed.), vol. 2, p. 112; Frantz 1989, pp. 25–27.

69. Frantz 1972, p. 163, n. 10. Another member was known as il Carota (the Carrot)—a phallic favorite of Berni.

70. On the *Carmina Priapea*, which many Renaissance humanists believed were by Virgil rather than by Ovid, see Reynolds 1997, pp. 289–90, n. 220; Waddington 2004, pp. 11–12; and Frantz 1989, pp. 105–7.

71. For Grazzini, see Rodini 1970. Founded in 1540, the Accademia degli Umidi was a forerunner of the Accademia Fiorentina, whose members included, in addition to Grazzini (expelled but later readmitted), the poet Benedetto Varchi, the Medici agent Luca Martini, the woodworker Giovanni Battista del Tasso, Ugolino Martelli, a perfume maker named Ciano, Michelangelo, and Agnolo Bronzino; see Rodini 1970, pp. 7–15, 25–27; Samuels 1976, pp. 625–27; and Parker 1997, pp. 1013–14.

72. Samuels 1976, pp. 607–10, esp. p. 608.

73. Stated in the mid-sixteenth-century prologue to the constitution of the Intronati, which was founded in 1525; see Vignali, *La cazzaria*, 2003 (ed.), pp. 14–15.

74. On Aretino's "epiphany of the penis" as a burlesque paradox, see Waddington 2004, pp. 3–4.

75. See T. Wilson 2005a. The image calls to mind the phallic-head satyr on the reverse of the Aretino portrait medal, discussed in this essay and in cat. no. 113a, but no direct connection between the medal and the plate has been established.

76. Leonardo's term for the "movements of the mind," or inner thoughts that motivate the movements of the body. The inscription reads from right to left in emulation of Hebrew (as an inscription on the reverse explains)—requiring mock rather than authentic erudition to read it.

77. Bracciolini, *Facetiae*, 1968 (ed.), p. 18, quoted in Frantz 1989, p. 13.

78. Cellini, *Autobiography*, 1998 (ed.), pp. 47–50.

79. Andrea Mantegna, Giulio's predecessor as court artist to the Gonzaga in Mantua, had painted anatomically descriptive nude cherubs seen *sotto in su* in the more intellectually elevated decorations of the Camera degli Sposi in the nearby Palazzo Ducale, whose seriousness Giulio's foreshortened and shamelessly exposed Apollo playfully mocks. Mantegna himself demonstrated flashes of humor and irony in his work, as discussed in Christiansen 1992, pp. 35–36.

80. Turner (2007c, p. 285) formulated this phrase to describe the *Triumph of the Phallus* (cat. no. 102).

81. The parallels between Salviati's image and Aretino's words are noted in ibid., p. 286.

82. Two recent, important contributions on this subject are Hess 2003; and T. Wilson 2005a. See also G. Conti 1992.

83. Such painting on the reverse of maiolica plates is rare, and the examples that do exist are more often decorative than figurative. According to Timothy Wilson (written communication to the author), the painted back of cat. no. III is original.

84. Kramer and Sprenger, *Malleus Maleficarum*, 1928/1951 (ed.), p. 58.

85. Camille 1998, pp. 109–10, with reference to a wood casket on which the subject is represented. An enigmatic mural in Massa Marittima shows an expanded version of the tableau; see Ferzoco 2005, citing other examples of the subject in various media. In an effort to explain the presence of such lewd imagery in a public space, Bagnoli (2002) proposed that the subject of the mural is fertility.

86. In the Renaissance, convents were hotbeds of unbridled sexual activity, as contemporary denouncements reflect. In a sermon delivered before the doge in the Basilica of San Marco on Christmas Day 1497, Timoteo da Lucca, a Franciscan friar, denounced the existence in Venice of "convents of nuns, not convents so much as whorehouses and public bordellos"; Sanudo, *I diarii*, 1879–1903 (ed.), vol. I, cols. 836–37, quoted in translation in Ruggiero 1985, p. 113.

87. Aretino, *Secret Life of Nuns*, 2004 (ed.), p. 16.

88. This print is known in a single surviving impression in the Nationalmuseum, Stockholm, for which see Landau and Parshall 1994, p. 298. Its rarity is presumably owing to effective censorship efforts. No such glass dildoes from the sixteenth century are known to survive, but fragments of seventeenth-century English examples have been excavated; see Telfer 2006, p. 194. I am grateful to Dora Thornton for this reference.

89. Aretino, *Secret Life of Wives*, 2006 (ed.), p. 58.

90. Rocke 1995, p. 151.

91. At least some of the sheets from the dismembered sketchbook survive, the best examples being those in the Nationalmuseum, Stockholm, for which see Wolk-Simon in Bayer 2004, pp. 86–87, no. 13; and Wolk-Simon 2004, p. 49.

92. Machiavelli's text is quoted in translation in Najemy 1993, p. 273.

93. Ibid., pp. 261–62.

94. Ibid., p. 272.

95. On sodomy in Florence, see Rocke 1995. In Renaissance Venice, sodomy was equally widespread though far more harshly punished; see Ruggiero 1985, esp. pp. 109–45.

96. Knauer (2002, p. 100, n. 26) identified the sitter in the portrait by Bugiardini as a prostitute.

97. See James Grantham Turner, "Profane Love: The Challenge of Sexuality" in this volume; *I modi* 1988 (ed.), passim; and Talvacchia 1999.

98. Aretino, *School of Whoredom*, 2003 (ed.), p. 39.

99. Reynolds 1997, p. 125; Waddington 2000, p. 886.

100. Aretino, letter to Battista Zatti, December 18, 1537; Aretino, *Lettere*, 1957–60, vol. 1, pp. 110–11, no. LXVIII, quoted in translation in Waddington 2004, p. 26, and cited above in note 51. In further praise, Aretino went on to point out that it was the sexual act that produced, among others, "the Bembos, Molzas, Varchis, Sebastiano del Piombos, Sansovinos, Titians and Michelangelos" of the world.

101. Vasari, *Le vite*, 1568/1906 (ed.), vol. 5, p. 418 (*Vita* of Marcantonio).

102. Waddington 2004, p. 6.

103. English translations are found in *I modi* 1988 (ed.).

104. Frantz 1989, pp. 92–100, esp. p. 99. Moulton 2000, p. 150, describes the work as "the single most influential piece of early modern erotic writing." According to James Grantham Turner (written communication), the dialogue initially enumerated fifty-two different postures, which were reduced to thirty-five in the first printed version.

105. See Landau and Parshall 1994, p. 298.

106. Antique sources of the *Modi* are explored at length in Talvacchia 1999, esp. chap. 3, "*I modi* and Their Antique Paradigms," pp. 49–69. The authenticity of the *spintriae* discussed there has been questioned.

107. Vasari, *Le vite*, 1568/1906 (ed.), vol. 5, p. 418 (*Vita* of Marcantonio): ". . . ne furono trovati di questi disegni in luoghi dove meno si sarebbe pensato."

108. The literature on this subject is vast, but see, inter alia, D'Amico 1983; Grafton 1993; and Rowland 1998, all with ample bibliography.

109. Deeply attuned to the matter of audience, Paleotti (*Discorso intorno alle imagini sacre e profane*, 1582) opined that pagan and erotic images, though best eschewed altogether, should at the very least be locked away in private rooms, thereby rendered inaccessible to all but an intended and select few. A similar idea is expressed slightly later by the early seventeenth-century Sienese physician-turned-theorist Giulio Mancini, who wrote that lascivious images should be covered and seen only by a privileged audience; see M. Bury 2003, p. 81. Woods-Marsden (1994, p. 298) suggests that the audience for medals, like other precious objects kept in a private *studiolo*, could also be strictly controlled, thus giving artists and patrons considerable freedom from inhibiting rules of decorum when commissioning or collecting such works. An object like the Aretino portrait medal with the phallic head reverse (cat. no. 113a), accordingly, was not meant for widespread circulation, but rather for a special, private, and privileged audience.

110. That Giulio Romano and Pietro Aretino both skipped town shortly after the publication of *I modi* helped protect them from a similar fate, though neither ran away immediately after the prints appeared, and they must have felt reasonably safe or protected from Giberti's (and by extension the pope's) wrath, although Giberti was probably behind the near-fatal attack on Aretino's life that occurred at this time, as noted above.

111. Aretino, *School of Whoredom*, 2003 (ed.), p. 44.

112. Parker 1997, p. 1019.

113. Berni's disdain for Bembo (which was surpassed by his antipathy for Aretino) and his formulation of a paradigm of grotesque beauty as a counterpoint to Bembo's Platonic/Petrarchan, idealized beauty have been analyzed and discussed at length in Reynolds 1983; and Reynolds 2000. The paradoxical encomium, a specialty of Berni, is discussed in Frantz 1989, pp. 29–31; and Parker 1997.

114. Written by the publisher Filippo Giunti, in the preface to *Il secondo libro dell'opere burlesche* (Florence, 1555), quoted and translated in Parker 1997, p. 1018.

Commemorating Betrothal, Marriage, and Childbirth

Rites of Passage: Art Objects to Celebrate Betrothal, Marriage, and the Family

Deborah L. Krohn

I have not just spent money on my marriage but almost entirely used up my patrimony on one wedding. It is unbelievable how much is spent on these new weddings; habits have become so disgusting.

—Leonardo Bruni, writing to Poggio Bracciolini on the occasion of his marriage, 1412

Social and economic historians have long recognized the importance of marriage and family to understanding early modern Italy. Art historians, too, have used rituals and customs surrounding love and marriage as a filter to sift the many kinds of art objects created during the Italian Renaissance. Looking at what are often called "decorative" or "minor arts" sharpens the focus, while at the same time broadening the angle of vision to embrace the social and cultural resonances of these things. The following section of the catalogue presents an array of objects created to celebrate betrothal, marriage, and the family. This essay will supply a context to situate them within the social worlds that they both reflected and influenced. The selection gathered here represents some of the most spectacular examples, including ceramics, jewelry, boxes, textiles, glass, and panel paintings. Many share a common visual language; all were created to mark love, desire, betrothal, marriage, or childbirth.

Traditional studies of the Italian Renaissance stress the theme of the revival of antiquity manifest in the arts, letters, music, politics, science, and philosophy of the period, but it was Jacob Burckhardt, the great Swiss art historian writing in the mid-nineteenth century, who first recognized the importance of secular festivals and public display for the Renaissance citizen. As Burckhardt noted, "The Italian festivals in their best form mark the point of transition from real life into the world of art."[1] The luxury objects assembled here reveal the resources spent on commemorating betrothals, marriages, and baptisms, and their survival enables essential pieces of the historical puzzle to fall into place.

Yet it is only by examining these celebratory events themselves that we can complete the puzzle. From many of these all that remains is ephemera, works that were not intended to survive and do so only in secondary forms such as verbal descriptions, drawings, or musical intermezzi written to accompany multiday celebrations, often performed between courses of festive meals. Before discussing the objects, it is worth exploring some of these celebrations.

WEDDINGS

Many official descriptions of weddings between wealthy or important people survive. Wedding celebrations could go on for several days, involving a succession of parades, processions, spectacles, performances, games, and meals. Beginning in the fifteenth century, the ancient Roman practice of declaiming custom-written poems celebrating the union was revived. Wedding poems, called epithalamia (see cat. no. 61), are full of references to the purpose of marriage: to perpetuate the civic and political institutions that maintain a stable society. The humanist writers of the wedding poems generally shared the "family values" expressed by Leon Battista Alberti and others who extolled the civic virtues of marriage, but even philosophers apparently needed reassurance. Pandolfo Collenuccio's oration for the 1475 wedding of Costanzo Sforza and Camilla of Aragon makes the assumption that marriage needed to be justified, at least to some:

> Wives have not stolen prudence from great statesmen, nor battle glory from great generals, nor fame and zeal from those philosophers whose writings we admire and whose learning we follow. What impious detractor of marriage then should be tolerated who dares to accuse and criticize petulantly the holiest pact? God established marriage; nature beckons us to use and enjoy it; peoples agree upon it; and individual cities have founded rites and solemn ceremonies for it. Kings, warriors, and philosophers have all embraced marriage and approved of it, so that the entire world accepts it.[2]

Of course, orations such as the one excerpted above, often delivered in Latin, made up only one small part of the festive schedule. The wedding procession was the most public part of the marriage, and provided an opportunity for the entire community to share in the celebration and thus ratify the marriage. The ritual actions of the father handing the daughter to the husband, expressed in the Latin phrase "tradere filiam suam" (to hand over his daughter), and of the husband taking the woman into his house, "uxorem ducere" (to lead a woman), were the essence of the ceremony, as Nicole Belmont and others have pointed out. Like the many gifts exchanged before and after the ceremony, the bride herself was an object handed from one owner to another.[3]

Wedding processions became more elaborate during the Renaissance period, according to scholars who have studied the phenomenon as a whole. Marriages, which were also mergers, were potentially explosive moments, and lavish festivities may have diffused some of the tensions that might arise between families over

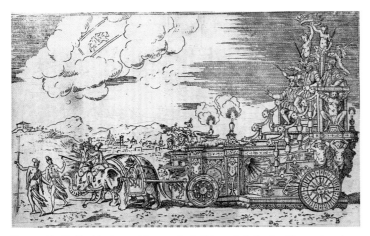

Fig. 47. Raffaello Gualterotti (1543–1639), Triumphal chariot illustrating the entry of the three Persian knights. Engraving from *Feste nelle nozze* (detail of cat. no. 126b, illustration between pp. 40 and 41)

dowry arrangements and other touchy subjects.[4] The bridal procession might even face dangers from hostile mobs or individuals, as suggested by a Florentine statute from 1415, which forbade the throwing of stones or garbage at the home of the couple.[5] Wedding processions were often compared to ancient triumphal processions.[6] The idea of the wedding as a triumph is reflected in the imagery on cassoni (marriage-chest) panels such as Apollonio di Giovanni's *Triumph of Scipio Africanus*, known in several versions.[7]

Descriptions of fabulous scenery and floats for the great Medici weddings of the sixteenth century are well known through Giorgio Vasari's *Lives* and other sources (see fig. 47). In his account of the life of the versatile designer Il Tribolo, Vasari describes the 1539 wedding, in Florence, of Cosimo I de' Medici and Eleonora di Toledo:

> Tribolo was given the charge of constructing a triumphal arch at the Porta al Prato, through which the bride, coming from Poggio, was to enter; which arch he made a thing of beauty, very ornate with columns, pilasters, architraves, great cornices, and pediments. The arch was to be all covered with figures and scenes, in addition to the statues by the hand of Tribolo.[8]

Vasari continues, cataloguing the allegorical figures on this arch as well as the decorations in the Medici palace, in the Piazza San Marco, and the scenery for theatrical events staged during the wedding festivities. Other descriptions of entire cities being transformed into stage sets for the performances of great court weddings tantalize the imagination, yet little visual evidence remains.

Wedding feasts were among the most lavish of meals, featuring entertainment as well as many courses of specialty foods for both eating and beholding. When Eleanor of Aragon arrived in Ferrara in 1473 for her multiday wedding, she was greeted by a parade of allegorical floats, followed on subsequent days by a fifty-six-course feast, and dances and jousts, during which sugar sculptures were displayed.[9] The humanist Filippo Beroaldo reported that the 1487 wedding of Lucrezia d'Este and Giovanni Bentivoglio in Bologna featured giant sugar sculptures of castles, ships, people,

and animals, and a flaming wheel of fireworks that accidentally ignited some of the wedding guests.[10] Contemporary handbooks provide specific instructions on wedding planning and menus, such as Domenico Romoli's 1560 *Singolare dottrina*, which contains a section instructing the steward on how to lay the tables with embroidered tablecloths.[11] In his *spalliera* painting *The Banquet in the Pinewoods*, one of four grand panels for a wedding chamber based on Giovanni Boccaccio's dark moralizing tale, in *The Decameron,* of Nastagio degli Onesti, Botticelli illustrated a feast gone awry (cat. no. 139; fig. 48). The potential bride being wooed by the hapless Nastagio has been invited to a banquet, where she bears witness to a spectral reluctant bride pursued to the death by her spurned lover—a knight—and his dogs. As the naked woman is nipped by dogs in the foreground prior to being eviscerated at the hands of the knight, the carefully laid table is thrown into disorder by the agitated guests, overturned glasses staining the tablecloths and gleaming vessels clattering to the ground. In its remarkable detail and psychological poignancy, this image conveys both the highest aspirations and the greatest fears of any bride on her wedding day.

With the sounds and smells of the great weddings of the Renaissance still fresh in our minds, we can now look at the group of art objects assembled here. Many share imagery as well as purpose, drawing on literary and visual traditions that would have been well known to their possessors but may be obscure to contemporary viewers. These beautiful things often began as gifts, both the offering and the receiving of which were integral parts of love and marriage in the Renaissance. Gifts were exchanged between lovers, between brides and grooms, and between parents

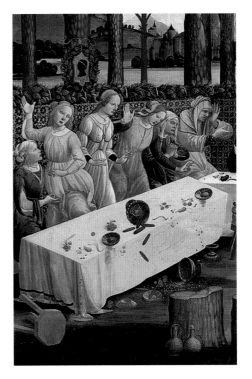

Fig. 48. Sandro Botticelli (1444/45–1510) and workshop, probably Bartolomeo di Giovanni (act. ca. 1475–ca. 1500/1505), *The Banquet in the Pinewoods: Scene Three of the Story of Nastagio degli Onesti* (detail of cat. no. 139)

and children, the last in the form of the dowry. Glittering jewels, delicate or lavish textiles, and personal items such as belts or combs were treasured articles that carried symbolic as well as real value. For many, marriage signaled an opportunity to create a new household, leading to the commissioning or purchase of furnishings, from beds and chests to colorful painted panels for wall decoration. Many of the objects speak for themselves, using language that is clear even now, but others demand background knowledge to situate them within the social worlds they inhabited.

LOVE TOKENS: COURTSHIP AND BETROTHAL

In the Italian Renaissance, as now, lovers exchanged gifts. The physical embodiment of desire, these objects often display literary or symbolic representations of the pursuit or attainment of the lover. Couched in the ancient metaphor of the phoenix, the mythical bird that burns yet emerges unscathed from the embers, the explicit language of desire winds along the length of a woven belt (cat. no. 55; fig. 49): *I WILL SMOULDER EVEN AS A PHOENIX/ WITH THE FIRE OF YOUR KISSES,/ AND I WILL DIE.* Though its author has eluded identification, the verse echoes chivalric love poetry from the late Middle Ages by Petrarch or Dante, texts well known among a broad range of social classes by the middle of the sixteenth century through musical contexts such as madrigals as well as in written form. Belts or girdles (cat. no. 36a) were associated with fertility as well as marriage, since the touch of a particular relic of the Virgin's girdle was said to aid women in childbirth. The front of a niello plaque (cat. no. 36b) that cinched this belt features a profile portrait of an amorous couple, the woman's arm provocatively encircling the shoulders of her lover. The woman wears a head brooch and a pearl necklace, both characteristic bridal ornaments;[12] a lady holding a carnation, traditional symbol of love, betrothal, and marriage, is on the reverse. Mentioned in literary and documentary contexts, belts had a practical function as well, and were probably worn by women high above the waist with the weighted ends dangling suggestively. Marco Parenti commissioned a belt of crimson silk with silver-gilt embroidery and a buckle and tip of gilded silver as part of the wedding ensemble for his bride, Caterina Strozzi, in 1447. They kept their value: he was able to sell the metal ornaments separately eleven years later.[13]

Love can also be painful. The notion of "sweet suffering" was diffused through sources such as the *Canzoniere* of Petrarch, which provided rich descriptive vocabulary such as this from the sixty-first sonnet:

Oh blessèd be the day, the month, the year,
the season and the time, the hour, the instant,
the gracious countryside, the place where I
was struck by those two lovely eyes that bound me;

and blessèd be the first sweet agony
I felt when I found myself bound to Love,
the bow and all the arrows that have pierced me,
the wounds that reach the bottom of my heart.[14]

In this passage, the poet praises the moment when he first saw the eyes of his beloved but elusive Laura, and was bound to her by love, which led to his heart's being pierced by wounding arrows. This

Fig. 49. Belt or Girdle with a Woven Love Poem, 16th century (detail of cat. no. 55)

imagery of piercing and binding is ubiquitous on a group of maiolica dishes from Deruta, Faenza, and Gubbio. The textual inspiration for these images is evident from the fragmentary but evocative inscriptions that animate the line drawings on the ceramics, words that bespeak a familiarity with this currency of expression.

A tin-glazed earthenware, or maiolica, plate from Deruta features the inscription *EL MIO CORE É FERITO P[ER] VOE* (my heart is wounded by you; cat. no. 22b). On it, a barefoot woman seen in profile carries a footed dish in which a heart, pierced by two arrows, rests. She is framed by two oversized ears of millet, perhaps an allusion to fertility. Spurned love is also the theme represented on a plate from Gubbio (cat. no. 24). The inscription *ME DOL L'INFAMIA TUA: PIU CHE [I]L MORIRE* (your infamy hurts me more than death) appears on a sign in the foreground of a landscape in which a woman points an accusatory finger—and a dagger—at a man whose arms are bound to a tree. A *crespina,* or fluted bowl, from Faenza (cat. no. 25) features a scene of *amor crudel* (cruel love): seated in a landscape, a woman wields a dagger in one hand, and in the other she holds a heart she is about to pierce with her weapon. On a dish from Deruta (cat. no. 22a), a woman draws back a bow strung with an arrow, her target a man whose arms are bound behind his back. A banderole winds behind him bearing the inscription *O Q[U]ANTA CRUDELTA* (O what a cruel fate). Between the archer and her mark, a heart, pierced by two arrows, rests on a footed dish.

But the symbol of the heart pierced by an arrow—understood metonymically as the weapon generally deployed by Cupid, son of Venus, to ensnare his victims—is also one of hope. It appears at the center of an ivory comb (cat. no. 37), once perhaps part of a dowry ensemble, a reminder of the one for whom the hair is being dressed. On a two-handled cup from Deruta (cat. no. 2), winged Cupid holds a footed dish that contains a heart pierced by an arrow. Two inscriptions on the cup leave no doubt about its meaning: *QUISTA TE DONO P[ER] AMORE BELLA* (I give you this, beautiful one, as a token of my love) and *P[ER] AMORE TE PORTO IN QUISSTA COPA BELLA* (for the love I bear thee in this fine cup).[15] Cupid himself appears as a feisty and plump toddler

in the magnificent allegory of marriage by Lorenzo Lotto, the painting *Venus and Cupid* (cat. no. 148; fig. 50), wounding arrows stashed in his quiver to shift the focus from the pains of love to the joys of marriage and hopes for fecundity.

Petrarchan messages are conveyed on other objects connected with courtship and betrothal. A wood casket decorated with reliefs inspired by chivalric romance (cat. no. 40; fig. 51) has the inscription *ONESTÀ FA BELLA DONNA* (integrity makes a beautiful woman), written in Gothic letters, on its cover. The casket may have been created to store small personal effects such as the ivory comb (cat. no. 37), spindle whorls (cat. nos. 42, 43), or needle case (cat. no. 44), which could have made up a trousseau. The inscription alludes to the central idea that beauty is the outward manifestation of inner virtue, which also informs the inscription on a *tondino* from Gubbio (cat. no. 10): *.ONESTA.PASSA. ONE. BE[LLE]ZA* (integrity surpasses all beauty). As Luke Syson writes elsewhere in this volume (see his essay "*Belle*"), beauty was both admired and suspected in the moral economy of Renaissance men and women.

The many ceramic plates that feature images of beautiful women, with inscriptions that generally give a name followed by the word *bella,* also fall into this category of art objects tied to the rituals of courtship and betrothal. The plate from Urbino or Castel Durante with the bust of a woman and a *cartellino* indicating that she is *LIVIA BELLA* (cat. no. 12) is a prime example of *coppe amatorie,* or "love gifts," made until at least the eighteenth century.[16] Though the question of whether these beauties represent portraits of actual women has not been resolved, Marta Ajmar-Wollheim and Dora Thornton suggest convincingly that they are linked to a literary genre of catalogues of illustrious men and women that flourished in Renaissance cities like Florence, Bologna, Venice, and Naples after being revived from classical antiquity by Petrarch and Boccaccio.[17] These plates were most likely commissioned by male suitors as gifts for their intended brides. A well-known example in the Victoria and Albert Museum (fig. 52) depicts a craftsman in a pottery workshop painting a *bella donna* on a plate. Sitting before him is a young couple. The man is following the work of the painter carefully, whereas the woman appears still, perhaps because she is posing for the painter. Like the couple who look on eagle-eyed as the craftsman weighs a ring in Petrus Christus's painting of a goldsmith, probably the patron of goldsmiths Saint Eligius (fig. 53), the well-dressed couple in the pottery studio prepares for an upcoming nuptial union through a commercial transaction. The commissioning of a commemorative plate or a ring then played an important role in cementing the union between a man and woman.

What might the ring that the goldsmith created in Christus's painting have looked like? The painting provides its own answers: in it a number of gold cabochon rings and simple bands can be seen displayed in a small box. A gold ring from the British Museum set with a faceted diamond features enameled blackletter script with the inscription *LORENSO*ALENALENA* (Lorenzo to Lena Lena), presumably the names of a couple who are united in matrimony (cat. no. 32a). A silver hoop with niello decoration is inscribed *AMORE VOLE FE* (love needs faith; cat. no. 32c).

Rings also took the ancient form of two clasped hands, known in the Renaissance as the *fede,* or faith, motif. This motif may refer to a specific moment in contemporary marriage rituals when representatives of the couple met to conclude a contractual agreement, shaking hands afterward (cat. no. 18). The symbol of clasped hands appears on a variety of objects besides rings. A ceramic inkstand (cat. no. 16) features images of a man and woman facing each other, with a pair of clasped hands in a roundel between them. The inscription reads *IO. TE DO.LA.MANE / DAME. LA.FEDE* (I give you my hand, give me your faith [i.e., the ring]), a concise description of the marriage ceremony.[18] Two plates (cat. nos. 17, 18) also feature the clasped hands.

Rings played a seminal role at various points in the process of marrying, as Christiane Klapisch-Zuber and others have shown.[19] As discussed in my essay "Marriage as a Key to Understanding the Past" elsewhere in this volume, the *anellamento,* or ring day, marked the passage of the couple from betrothed to married. The placing of the ring on the bride's finger is illustrated in cassone and *spalliera* paintings, such as Apollonio di Giovanni's *Story of Esther* (cat. no. 57; fig. 2) and Jacopo del Sellaio's *Story of Cupid and Psyche* (cat. no. 136), suggesting the ring's strong symbolic power. Rings made a marriage. When the beautiful widow Lusanna attempted to argue that her boyfriend Giovanni had actually married her, she stated that he gave her a ring, and when she explained through her lawyer that Giovanni later turned around and married another woman, the proof of his marriage to this other woman was that it took place "in a public ceremony with an exchange of vows and rings and with other customary solemnities."[20] Rings were also an important part of Jewish marriage customs. A Jewish betrothal ring fashioned of gold filigree and brightly colored enamel (cat. no. 33) features the characteristic rooflike shape that represents the shelter that marriage and family were intended to provide.

FURNISHING THE NUPTIAL SUITE

The language of love and desire that radiates from the group of objects surveyed above parallels the rituals of betrothal and

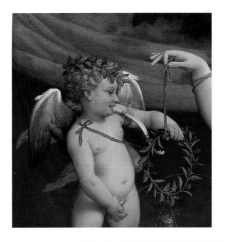

Fig. 50. Lorenzo Lotto (ca. 1480–1556), *Venus and Cupid* (detail of cat. no. 148)

Fig. 51. Top of wood coffret inscribed *ONESTÀ FA BELLA DONNA* (detail of cat. no. 40)

marriage described by anthropologists and historians.[21] No one knows how many gift objects achieved the desired goals, but marriages engendered the creation of new furnishings and decoration that expressed the dynastic and political aspirations of the families that purchased or commissioned them. Though marriage, as Kent Lydecker and others have suggested, "was the most important social occasion for the purchase of art and furnishings,"[22] furniture and decorative objects were purchased at other points during the life cycle as well.[23]

After the terms of the marriage had been agreed upon publicly by members of both the bride's and the groom's family in the *giuramento*, a series of celebrations took place.[24] The time between the contractual arrangement and the wedding itself allowed for the provision of the material trappings of marriage. Chief among these was the cassone or *forziere*—two terms found in contemporary documents for a large storage chest—often ornamented with panels painted with lively narratives such as the *Conquest of Trebizond* by Apollonio di Giovanni (cat. no. 56). Although chests associated with marriage are now commonly described as cassoni, recent archival research has suggested that inventories from the fifteenth century used the term *forzieri da sposa*, or betrothal chests, to refer to the chests commissioned in pairs for the dowry goods of the bride. The term *cassone* may refer to a subset of *forzieri*, specifically, to those shaped like antique sarcophagi.[25] There were often three to six months between the *giuramento* and the *anellamento* and consummation, when the couple went to live on their own. During this interval, a pair of cassoni and other painted or carved furnishings for the nuptial chamber, including *spalliere* (wainscoting panels), *lettucci* (daybeds), and *lettiere* (beds), sometimes hung with specially woven fine textiles, might be created.

As the wonderful Strozzi cassone (cat. no. 56) demonstrates, marriage chests could be elaborate creations that demanded the coordination of several different craftsmen: carpenters, gilders, painters, and perhaps locksmiths to provide the hardware. Ellen Callmann, whose pioneering studies from the 1970s on cassoni still

inform current scholarship, estimated that it took about a month to paint a cassone front, thus two months for two. Callmann's interpretation of the most important source for our knowledge of wedding chests—an account book known from a 1670 copy documenting an eighteen-year period in the workshop of Apollonio di Giovanni—has confirmed that they were indeed commissioned in pairs.[26] Since so few cassoni have survived with their carpentry and gilding intact, it is difficult to draw conclusions about the process of construction, but we know from Vasari's life of Dello Delli that painters such as Apollonio di Giovanni probably specialized in the creation of these panels. Vasari indicates that Dello was well suited to painting cassone panels:

> *[H]e resolved, being a good draughtsman, to give his attention to painting; and in this he succeeded with ease, for the reason that he soon acquired a good mastery in colouring, as many pictures demonstrate that he made in his own city [Florence], and above all those with little figures, wherein he showed better grace than in the large.*[27]

Vasari continues to describe cassoni in the following manner:

> *[C]itizens of those times used to have in their apartments great wooden chests in the form of a sarcophagus, with the covers shaped in various fashions, and there were none that did not have the said chests painted; and besides the stories that were wrought on the front and on the ends, they used to have the arms, or rather, insignia of their houses painted on the corners, and sometimes elsewhere. And the stories that were wrought on the front were for the most part fables taken from Ovid and from other poets, or rather, stories related by the Greek and Latin historians, and likewise chases, jousts, tales of love, and other similar subjects, according to each man's particular pleasure. Then the inside was lined with cloth or with silk, according to the rank and means of those who had them made, for the better preservation of silk garments and other precious things.*[28]

Fig. 52. Plate with a Scene of a Maiolica Painter at Work, Cafaggiolo, ca. 1510. Tin-glazed earthenware (maiolica), Diam. 9¼ in. (23.5 cm). Victoria and Albert Museum, London

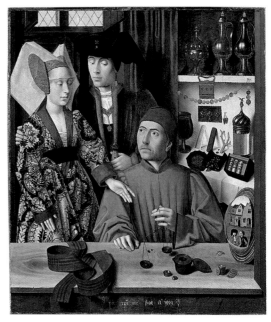

Fig. 53. Petrus Christus (act. by 1444–1475/76), *A Goldsmith in His Shop (Saint Eligius?)*, 1449. Oil on panel, 39⅜ × 33¾ in. (100.1 × 85.8 cm). The Metropolitan Museum of Art, New York, Robert Lehman Collection, 1975 (1975.1.110)

Vasari tells us that many people owned cassoni, and not just the wealthiest. He reports that in addition to cassoni having the form of a sarcophagus, like the Strozzi chest, there were examples with various other types of covers. He also confirms what can be deduced from the panels known today: the subject matter for the painted fronts was secular rather than religious, with stories taken from classical or chivalric sources.

Vasari also connects the creation of cassoni with the making of other furnishings, suggesting that they were viewed in the same light. Continuing his account of Dello's life, he informs us:

> And what is more, it was not only the chests that were painted in such a manner, but also the couches, the chair-backs, the mould-ings that went right round, and other similar magnificent orna-ments for apartments which were used in those times, whereof an infinite number may be seen throughout the whole city. And for many years this fashion was so much in use that even the most excellent painters exercised themselves in such labours, without being ashamed, as many would be to-day, to paint and gild such things.[29]

By the mid-sixteenth century, the fashion for interiors had evidently changed. Vasari speaks of the decoration on cassoni and other household objects as a thing of the past:

> And that this is true can be seen up to our own day from some chests, chair-backs, and mouldings, besides many other things, in the apartments of the Magnificent Lorenze de' Medici, the Elder, whereon there were painted—by the hand, not of common paint-ers, but of excellent masters, and with judgment, invention, and marvellous art—all the jousts, tournaments, chases, festivals, and other spectacles that took place in his times. Of such things rel-ics are still seen, not only in the palace and the old houses of the Medici, but in all the most noble houses in Florence; and there are men who, out of attachment to these ancient usages, truly magnificent and most honourable, have not displaced these things in favour of modern ornaments and usages.[30]

What of these other things, the *lettucci*, *spalliere*, and *cornici*? *Let-tucci* were daybeds, precursors of modern-day couches, and may have included storage areas to hang clothing.[31] Together with cas-soni and *spalliere*, they would have been made for the *camera*, or nuptial chamber, often furnished about the time that a man married.[32] Marco Parenti, whose elaborate sartorial gifts for his bride, Caterina Strozzi, are discussed elsewhere in this volume (see my essay "Marriage as a Key"), not only redecorated his bedroom at the time of their marriage, in 1448, but also bought two *for-zieri*, a *lettuccio*, decorative capitals for the bed, and a relief of the Madonna, among other things.[33]

We turn again to Vasari for the resonance that wedding fur-nishings could have for their owners. In his *Lives*, he describes in vivid detail an ensemble of paintings, some mounted on pieces of furniture designed by Baccio d'Agnolo, commissioned by Salvi Borgherini on the occasion of the marriage of his son Pierfran-cesco (1480–1558) to Margherita Accaiuoli in 1515. (The paintings are discussed at length by Andrea Bayer in her essay "From Cassone to *Poesia*" in this volume.) Vasari's praise of the different elements in the ensemble reads like a manual of interior decoration and has allowed scholars to attempt reconstructions of the layout of the actual room, recently identified by Brenda Preyer.[34] In his life of

Pontormo, who executed several of the paintings, Vasari recounts Margherita's supposed passionate reaction when the room was about to be broken up and the furnishings shipped off as a gift from the Florentine Republic to Francis I, king of France, in 1529:

> This bed, which you would seize for your own private inter-est and for greed of gain, although you keep your evil purpose cloaked with a veil of righteousness, this is the bed of my nuptials, in honour of which my husband's father, Salvi, made all these magnificent and regal decorations, which I revere in memory of him and from love for my husband, and mean to defend with my very blood and with life itself.[35]

Although the veracity of this anecdote cannot be confirmed, it demonstrates the aura that wedding furniture retained over time.

When Vasari refers to *spalliere*, he is probably referring to wain-scoting or moldings. *Cornici* were presumably wall-mounted deco-rations that were placed above eye level. Both cassone and *spalliere* panels are horizontal in format, but Anne Barriault has argued that a clear distinction between the two can be made based on size as well as on stylistic grounds. She suggests further that *spalliera* panels, after the Italian term *spalla* (shoulder), are the ancestors of modern easel paintings created for domestic display.[36] Scholars agree that *spalliera* panels, such the *Story of Cupid and Psyche* by Jacopo del Sellaio (cat. no. 136) or the *Story of Joseph* by Biagio d'Antonio (cat. no. 138), were not intended to be placed close to the floor on great chests or cassoni, but there is no consensus on just how high *spalliere* were to hang. Barriault has maintained that *spalliere* were to be placed in the middle register of the wall, at eye or shoulder level, but Jonathan Nelson has pointed to "internal evidence," together with the absence of interior views with paint-ings hung in this manner, that suggests otherwise.[37] Nelson posits that many *spalliere* panels may have been intended to be seen from below, and were therefore mounted higher up on a wall. Although there are no conclusive answers to these questions, since no works from this period remain in situ, the painted panels that viewers now experience in museums as individual works of art once func-tioned as elements in complex and dazzling interior ensembles that would have been fitting monuments to lasting dynastic alli-ances created through marriage.

WELCOMING THE NEXT GENERATION

Another group of objects belong to the rituals attending the arrival of children and are found across the social spectrum. Prescriptive literature emphasized the importance of family and, specifically, children for maintaining the health of the civic body. In Book Two of Leon Battista Alberti's *I libri della famiglia*, the author's interlocutor Lionardo discusses fatherhood:

> It will serve our purpose, also, to remind the young of the dignity conferred on the father in the ancient world. Fathers of families wore precious jewels and were given other tokens of dignity for-bidden to any who had not added by his progeny to the popula-tion of the republic. It may also help to recall to young men how often profligates and hopeless prodigals have been restored to a better life by the presence of a wife in the house.[38]

Fig. 54. Bartolomeo di Fruosino (1366/69–1441), *Urinating Putto* (detail of cat. no. 69)

The dialogue also addresses issues concerning the mother's pre- and postnatal care. After admitting that it is best to leave specific instructions to the doctors, Lionardo tells Battista:

> *The woman, then, who thinks she is pregnant should live discreetly, contentedly, and chastely—light nourishing foods, no hard, excessive labor, no sleepy or lazy days in idle solitude. She should give birth in her husband's house and not elsewhere. Once she is delivered, she must not go out into the cold and the wind until her health is fully restored and all her limbs have fully regained their strength.*[39]

Doctors were probably less in evidence in the birthing room than midwives, whose knowledge comprised superstition as well as an intuitive understanding of childbirth greater than most male doctors would have had at the time. Many contemporary objects manifest the attendant risks and potential joys of bearing offspring.

Responsible parenting began even before the moment of conception. As Jacqueline Marie Musacchio has pointed out, a variety of talismans, amulets, and herbal remedies were employed by women who desired children.[40] Many people believed that gazing on certain images would ensure the birth of a perfect male child.[41] The eroticizing imagery of nudes painted on the inner lids of cassoni (see cat. no. 58b) presumably helped in this process, as did images of young boys cavorting on the reverse of painted wood *deschi da parto*, or birth trays. An example of the latter is the reverse of the tray by Bartolomeo da Fruosino, with the chunky toddler wearing a coral amulet and holding a pinwheel (fig. 54). Like Lorenzo Lotto's Cupid, he urinates in a shower of good wishes, as recounted on the inscription that runs around the rim of the tray: MAY GOD GIVE HEALTH TO EVERY WOMAN WHO GIVES BIRTH AND TO THE CHILD'S FATHER . . . MAY [THE CHILD] BE BORN WITHOUT FATIGUE OR DANGER. I AM A BABY WHO LIVES . . . AND I MAKE URINE OF SILVER AND GOLD. On another *desco*, a group of boys play a well-known game, the *civettino*, in a public square (cat. no. 71).

Once a child was born, *deschi da parto* and other objects helped to smooth his (and probably only rarely *her*) entrance into the world. Painted wood trays such as that created in 1448–49 by Giovanni di Ser Giovanni (Lo Scheggia) to commemorate the

birth of Lorenzo de' Medici might be cherished by their owners throughout their lives, as we know from research into Medici family inventories that list Lorenzo's birth tray in his rooms at his death in 1492.[42] The imagery on this tray, the *Triumph of Fame*, alludes to a theme made popular by Petrarch's literary descriptions of various kinds of triumphal processions that took place in antiquity.[43] Birth trays may have been used initially to serve celebratory delicacies to the new mother as she recovered in bed, where she might stay for an extended period. The image on the front of the Fruosino tray (cat. no. 69) displays a group of women gathered around a bed while the mother recuperates, her baby being serenaded by attendants in the foreground. Resting on the bed in front of the mother is what appears to be a polygonal tray covered with a cloth, perhaps to protect its painted surface.

The custom of creating brilliantly painted souvenir birth trays flourished in the fifteenth century but was short-lived. By the early sixteenth century, flat *deschi da parto* were superceded by round wood bowls, called *tafferie da parto*, like the outstanding example by Jacopo Pontormo from about 1525 (cat. no. 74). Unlike the flat trays, *tafferie* generally featured religious imagery such as the Naming of John the Baptist, which depicts John's father, Zacharias, writing down the baby's name, a favorite scene for the literate Florentines of the Renaissance prone to keeping track of their own families through memoirs or *ricordi*. Musaschio has suggested that the form of the wood *tafferie* developed in response to the many ceramic birth bowls, called *accouchement* or *impagliata* sets, that became popular beginning in the early sixteenth century.[44] The bowls—probably created in ensembles, as documented in a drawing in Cipriano Piccolpasso's treatise *Three Books of the Potter's Art* from the second half of the sixteenth century

Fig. 55. Cipriano Piccolpasso (1524–1579), Illustration from his manuscript *The Three Books of the Potter's Art*, fol. 11r. Castel Durante, 1557. Pen and ink. National Art Library, Victoria and Albert Museum, London

(fig. 55)—may have been designed to serve a special meal to the recovering mother. The confinement imagery on a set consisting of a *scodella* and a *tagliere* from Castel Durante reflects its function (cat. nos. 78a, b). On the curved interior of the bowl, a woman sits comfortably in a fashionable *lettiera* with a canopy, a teal-colored coverlet draped over her legs. She holds a cup to her mouth and appears to be drinking. At a fireplace in the room, attendants prepare other food, some of which is being conveyed to the bed, where a cloth-covered tray awaits its charge. The baby sleeps peacefully in a cradle beside the bed. The *tagliere*, whose exterior is decorated with a matching landscape vista, would have cradled the bowl, which may once have had a cover to keep its contents warm. Just what was on the menu? Musacchio has discovered that poultry, a standard food for convalescents, was served frequently to women during both pregnancy and confinement.[45] A restorative chicken soup may very well have arrived at bedside in a beautiful maiolica covered bowl like that painted by Baldassare Manara (cat. no. 80a). This bowl represents stories from ancient sources—that of Aeneas and Hercules, examples of filial piety and strength, who are featured in images and inscriptions that wind around the bowl and cover, as well as that of the star-crossed lovers Pyramus and Thisbe, whose true love led to their destruction.

Another object that rounds out our picture of family life is the cradle or crib. In confinement images such as those visible on maiolica birth wares, cradles frequently appear, bearing their new occupants swaddled in fine linens. The example here, richly carved and emblazoned with family escutcheons, is testimony to the deep regard in which children were held (cat. no. 86). The cradle depicted on a wood childbirth platter from the circle of Battista Franco holds a large infant labeled on the front, in gold, *HERCULES*, who is unmistakable as he strangles the serpents sent by jealous Juno to destroy him (cat. no. 75). Lavinia Fontana celebrates the life of an anonymous infant in her portrait that depicts the child in a marquetry crib under an elaborate canopy of lace, which is used for his coverlet as well (cat. no. 129). Baptisms, like marriages, were also occasions to exchange gifts and cement family and kinship ties. As we know from descriptions and even from sumptuary regulations, babies were decked out in velvets and fine linens for the trip to the baptismal font while their mothers usually rested at home. Gifts for baby and mother were presented by the godparents and other important members of the extended family, and could include sweetmeats, wax, and even forks.[46]

Together, these objects—from furniture to jewelry to boxes and maiolica or wood birth wares—reflect the aspirations of generations of men and women during the Italian Renaissance. All were created to commemorate important moments in lives that have long since run their course. The infants for whom the cradles were fashioned may have flourished, married, had their own children, and died. The life cycle was punctuated by occasions to celebrate: here is the material evidence of the events that marked the lives and loves of Renaissance people.

The epigraph to this essay is taken from Bruni, *Epistolario,* vol. 1, p. 93, quoted in D'Elia 2002, p. 382. D'Elia gives the Latin: "Ego enim non matrimonium dumtaxat sed patrimonium insuper unis nuptiis consumpsi. Incredibile est quam multa impendantur his novis et iam ad fastidium usque deductis moribus."

1. Burckhardt 1990, p. 256.
2. D'Elia 2004, p. 84.
3. See Belmont 1982, p. 2.
4. See Witthoft 1982, p. 47.
5. For this and other examples, see ibid., p. 48.
6. Ibid., p. 49.
7. Callmann 1974, pls. 51, 55, and 57.
8. Vasari, *Lives*, 1568/1912–14 (ed.), vol. 7, p. 28.
9. D'Elia 2004, p. 46.
10. Ibid.
11. *La singolare dottrina di M. Domenico Romoli*, 1560, p. 18. The tablecloths were described as "lavorate e imbizzarate à suo modo."
12. Syson and D. Thornton 2001, pp. 55–56.
13. Frick 2002, p. 127. For the market in second-hand goods, see A. Matchette in Ajmar-Wollheim, Dennis, and Matchette 2007, p. 81, n. 6.
14. Petrarch, *Canzoniere*, 1985 (ed.), p. 35.
15. Syson and D. Thornton 2001, p. 69.
16. For the most thorough discussion of these plates, see Ajmar-Wollheim and D. Thornton 1998.
17. Ibid., 1998, pp. 140–41.
18. Syson and D. Thornton 2001, p. 63; Matthews Grieco 2006, p. 107. In this context the word *fede* can mean "ring" as well as "faith" since, as Thornton explains, the marriage ring "stood for a pledge of faith in the legal and moral covenant of marriage" (see cat. no. 16, n. 4).
19. Klapisch-Zuber 1979/1985, p. 186.
20. Brucker 1986, pp. 13–14.
21. See my essay "Marriage as a Key to Understanding the Past" in this volume.
22. Lydecker 1987a, p. 145.
23. For a critique of the standard view that focuses on marriage as the fulcrum for interior decoration, see Lindow 2007, p. 145ff.
24. See my essay "Marriage as a Key" in this volume.
25. For a recent discussion of terminology based on extensive archival research, see Lindow 2007, p. 147.
26. Callmann 1974, p. 25ff.
27. Vasari, *Lives*, 1585/1912–14 (ed.), vol. 2, p. 107.
28. Ibid., pp. 107–8.
29. Ibid., p. 108.
30. Ibid.
31. Calderai and Chiarugi 2006, p. 122.
32. Preyer 2006, p. 40. See also Lydecker 1987b, p. 213ff.
33. Lydecker 1987b, pp. 214–15.
34. Preyer 2006, pp. 42–43.
35. Vasari, *Lives*, 1585/1912–14 (ed.), vol. 7, p. 161.
36. Barriault 1994, p. 5.
37. J. K. Nelson 2007, pp. 53–54.
38. L. B. Alberti, *Family in Renaissance Florence*, 1969, p. 113.
39. Ibid., p. 122.
40. Musacchio 1997a, p. 43.
41. Musacchio (ibid., p. 48ff.) traces this idea back to the book of Genesis (30:25–43), which recounts how Jacob placed mottled tree boughs in the watering troughs of his animals so that they would produce offspring with speckled coats.
42. Spallanzani and Gaeta Bertelà 1992, p. 27.
43. Callmann (1974, pls. 103–6, 110) illustrates a number of birth trays with triumphal themes.
44. Musacchio 1999, p. 87. Musacchio has counted more than a hundred ceramic childbirth wares in museums and private collections today. She explains (ibid., p. 97) the probable meaning of the term *impagliata*.
45. Musacchio 1997b, p. 7.
46. Musacchio 1999, pp. 49–50.

1. Two-Handled Vase with the Arms of Medici Impaling Orsini

Florentine region (perhaps Montelupo), 1470–80
Tin-glazed earthenware (maiolica), H. 15¼ in.
(38.7 cm), foot damaged and repaired
Detroit Institute of Arts, Gift of the Women's
Committee with additional funds from Robert H.
Tannahill, 1937 (37.74)

The vase has distinctive wing handles of flattened section. The entire body, except for a central garland on the front, is painted with a diaper pattern of stylized leaves in blue and yellow with tendrils in manganese brown. Within the garland are the arms of Medici impaling Orsini, representing a marriage alliance between the two families. The arms could refer to one of two marriages: that of Lorenzo de' Medici to Clarice Orsini in 1469, or that of Piero de' Medici to Alfonsina Orsini in 1487.[1] The "jar with two handles and the arms of Medici and Orsini" that is listed among the contents of the Medici villa at Poggio a Caiano in 1494[2] must be this vase.

Both the Islamic-inspired form and the leaf decoration, known to Tuscans as *fioralixi* (fleur-de-lis), derive from Spanish lustered pottery imported from Valencia.[3] Fifteenth-century Italians imported their luxury pottery through banking houses active in the western Mediterranean. Muslim and Christian potters working in and around the southern Spanish port of Valencia produced pottery in a modified Islamic tradition for special commissions, including complete dining services, as well as standard pieces

for the export market. Valencian lustered pottery was admired for its brilliant metallic sheen, with highlights ranging in tone from pale silvery gold to deep red. Firing the vessels to achieve this spectacular effect was a difficult and expensive procedure demanding consummate craftsmanship. The delicate painted decoration of Valencian lustered pottery, often incorporating arms or devices, won it great prestige as a luxury product among Italian consumers, not least in Florence, throughout the fifteenth century.[4] Letters and account books document the commissioning or arrival of Valencian wares, and inventories record their placement in the domestic interior and occasionally estimate their monetary value. These sources, and the surviving pieces themselves, are valuable indicators of mid-fifteenth-century demand, particularly among the Florentine urban elite.[5] A famous wing-handled lustered vase in the British Museum, with the arms of Piero de' Medici (d. 1469) or of his son Lorenzo (d. 1492), is the best-known example of a luxury commission that can be dated by the arms, in this case to 1465–92.[6] The use of the lustered "ivy leaf" motif on the British Museum vase may narrow the dating to approximately 1465–70, since it was about 1470 that this design superceded the leaf design in blue that from the 1420s had dominated Tuscan taste.[7]

The form of the smaller vase here is copied from that of a Spanish lustered flower vase (*teràs*), down to the wing handles with their frilled outlines and mysterious piercings. Tuscan paintings depict Spanish flower vases

or pots for plants in fine detail as luxury objects. We know from surviving Valencian pieces that some examples were carefully designed for potted plants, such as the *alfabeguer* for growing basil.[8] A sophisticated cassone panel of the Florentine school painted with Cupid and Psyche, perhaps made in 1444 for the marriage of Lucrezia Tornabuoni to Piero de' Medici, shows Valencian vases on a balcony, painted with minute fleur-de-lis designs in blue. They are being used to grow evergreens that have been pruned into elaborate shapes, the central one in the form of the Medici *impresa*, or device, of the diamond ring and feathers (fig. 56).[9] This is the kind of Spanish import that inspired the present vase. Like its Spanish prototypes, this vase may have served as a flower vase or pot for plants at the Medici villa at Poggio a Caiano. There is a variety of evidence to suggest that luxury maiolica was thought particularly suitable for use within the refined but rural setting of the villa, rather than in the urban palace.[10]

Of the two marriages between the Medici and the Orsini, it is likely that the first, between Lorenzo de' Medici and Clarice Orsini in 1469, is the one referred to on this vase. The fleur-de-lis design was fashionable among the Tuscan elite into the early 1470s, and the rather awkward air of the vase suggests that it is an early example of the efforts of Italian potters, beginning about 1450, to imitate Spanish prototypes. It was certainly made in Tuscany, most probably in Montelupo, where potters experimented in imitating Spanish lustered imports.[11] A vase such as this one may have appealed to Lorenzo, whose ownership of ceramics of all kinds is well documented, from ancient Aretine wares and Chinese porcelains to contemporary maiolica.[12]

In the late fifteenth century Italian potters had not yet mastered the demanding luster technique and could only imitate gold-luster effects in manganese brown, as seen here. Luster was successfully achieved in several Italian pottery centers by 1500, the date by which Italian potters had driven Spanish imports from the local markets and dominated the luxury ceramics trade in Europe.[13] The vase is a key piece in this story and has justifiably been described as "a milestone in the conquest by Italian potters of the highest levels of patronage among Italian clients."[14]

DT

Fig. 56. Anonymous Florentine painter (mid-15th century), cassone panel with *Scenes from the Legend of Cupid and Psyche* (detail), ca. 1444. Oil on panel, 15⅛ × 51 in. (38.5 × 129.5 cm). Gemäldegalerie, Staatliche Museen zu Berlin

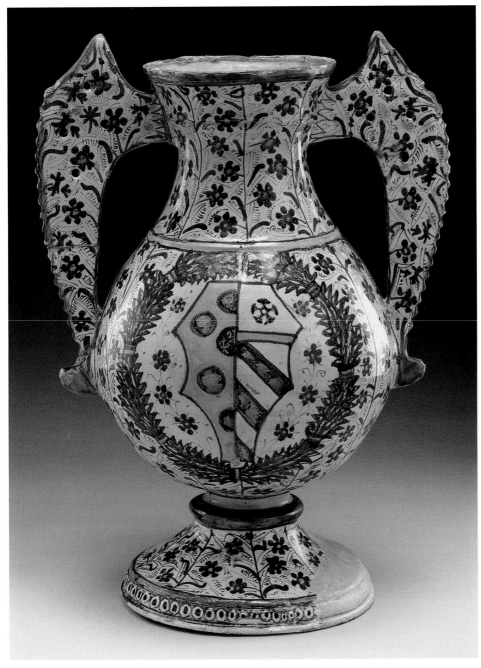

Cat. 1

1. Middeldorf 1937; Spallanzani 1974; T. Wilson 1989b, pp. 132–33; Syson and D. Thornton 2001, pp. 205–6; Spallanzani 2006, pp. 139–40; T. Wilson and Sani 2006–7, vol. 2, p. 318.

2. Spallanzani and Gaeta Bertelà 1992, pp. 141, 151.

3. Spallanzani 1986, p. 166.

4. Ravanelli Guidotti 1992; Ray 2000a; Spallanzani 2006.

5. Spallanzani 1978, p. 152; Spallanzani 1986; T. Wilson 1989b; D. Thornton 1997, p. 78; Spallanzani 2006.

6. The form of the Medici arms painted on the front and the device on the reverse were used by both Piero and Lorenzo. T. Wilson 1987, no. 16; T. Wilson 1989b, pp. 129–30;

Rubin and Wright 1999, no. 81; Syson and D. Thornton 2001, pp. 204–5, fig. 165; Spallanzani 2006, p. 201; T. Wilson and Sani 2006–7, vol. 2, p. 317.

7. Spallanzani 2006, pp. 134–35, 139.

8. Ray 2000a.

9. Syson and D. Thornton 2001, pp. 202–3, fig. 163; Spallanzani 2006, pp. 126–27, fig. 14.

10. Palvarini Gobio Casali 1987, p. 211; Syson and D. Thornton 2001, pp. 222–23; T. Wilson 2003a, p. 181; T. Wilson and Sani 2006–7, vol. 2, pp. 319–20.

11. F. Berti 1997–2003, vol. 1, pp. 319–24.

12. Syson and D. Thornton 2001, pp. 214–15; L. Fusco and Corti 2006, pp. 78–80; T. Wilson and Sani 2006–7, vol. 2, p. 318.

13. T. Wilson 1996a.

14. T. Wilson and Sani 2006–7, vol. 2, p. 318.

SELECTED REFERENCES: Middeldorf 1937; Spallanzani 1974; Spallanzani 1986; T. Wilson 1989b, pp. 132–33; Ravanelli Guidotti 1992, p. 50; Spallanzani and Gaeta Bertelà 1992, pp. 145, 151; T. Wilson 1996a, p. XIV, fig. 21; F. Berti 1997–2003, vol. 1, pp. 312–24; Rubin and Wright 1999, under no. 81; Ray 2000a; Ray 2000b; Syson and D. Thornton 2001, p. 206, fig. 166; Spallanzani 2006, pp. 139–40; T. Wilson and Sani 2006–7, vol. 2, p. 318

2. Two-Handled Vase with an Amorous Inscription

Deruta, ca. 1470–80
Tin-glazed earthenware (maiolica), H. 9⅝ in. (24.5 cm)
Inscribed: QUISTA TE DONO P[ER] AMORE BELLA; P[ER] AMORE TE PORTO IN QUISSTA COPA BELLA
Victoria and Albert Museum, London (525–1865)

The vase has two handles in the form of winged dragons. A laurel wreath is painted on each side of the body; within the wreath is a cupid carrying a goblet that holds a heart pierced by an arrow. Around the cupid flutters a scroll inscribed: QUISTA TE DONO P[ER] AMORE BELLA (I give you this, beautiful one, as a token of my love) and P[ER] AMORE TE PORTO IN QUISSTA COPA BELLA (for the love I bear thee in this fine cup).[1]

This form of two-handled cup, a *coppa amatoria* (wedding vessel), is a well-known type associated with the Umbrian pottery town of Deruta. These wares are traditionally known as *gamelii* or *nuziali*, reputedly made for presentation as betrothal gifts and for use at marriage feasts.[2] This one bears a courtly inscription perhaps referring to the moment when a fiancé would drink from a cup and then hand it to his betrothed; their drinking from the same cup signified their new status as a couple. The inscription on another example refers to apparent romantic frustration on the part of the male giver: EL NON PODER ME FINE (not being able to is putting an end to me).[3]

Judging by the form of the lip, this vase apparently had a lid originally, as found on lustered equivalents also made in Deruta. Its complex dragon handles suggest that the form copies, crudely, a lost silver prototype that was likely designed to decorate a tiered buffet, or *credenza*, set out for wedding feasts, as is often shown in contemporary depictions

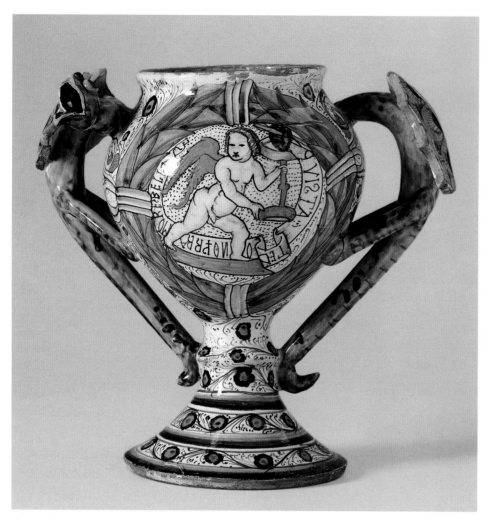

Cat. 2, view 1

3. Dish with an Allegory of Chastity and the Arms of Matthias Corvinus and Beatrice of Aragon

Probably Pesaro, 1476–ca. 1490
Tin-glazed earthenware (maiolica), Diam. 18⅞ in.
(47.9 cm)
The Metropolitan Museum of Art, New York, Fletcher
Fund, 1946 (46.85.30)
New York only

At the center is a young woman seated in a landscape, combing the mane of a unicorn—a white, horselike creature with a single horn in the middle of its forehead— that lies in her lap. According to legend, derived from late-antique bestiaries, the fierce unicorn could be tamed only by a virgin, after which it could be captured; the deer in the background of this scene allude to the hunt which is to come.[1] During the Middle Ages this legend took on Christian connotations, so that the unicorn, associated with purity and self-sacrifice, could be seen as a Christ-like figure. The maiden, who exemplifies chastity, could be compared with the Virgin Mary. Leonardo da Vinci (1452–1519) illustrated the theme twice in drawings of the 1470s.[2] Recounting the story in his notebooks, he brought out instead the erotic and sexual elements in the image: "The unicorn through its lack of temperance, and because it does not know how to control itself for the delight it has for young maidens, forgets its ferocity and wildness, and laying aside all fear it goes up to the seated maiden and goes to sleep in her lap, and in this way the hunters take it."[3] The way in which secular and religious elements of the legend blended into the tradition of courtly love is best seen in two superb series of late fifteenth-century tapestries, *The Hunt of the Unicorn,* at The Cloisters, The Metropolitan Museum of Art, and *The Lady and the Unicorn,* in the Musée National du Moyen Âge–Thermes et Hôtel de Cluny, Paris.[4]

On this dish, the story of the maiden and the unicorn is presented as an allegory of feminine chastity, a virtue promoted in association with betrothal and marriage.[5] A late fifteenth-century Florentine engraving in the British Museum likewise links the unicorn theme with marriage (fig. 57). It shows the young woman caressing the unicorn in her lap as it gazes up at her, enraptured. She holds in her other hand the collar and chain from which she has released the animal. Two shields flanking her have been left blank, to hold the arms of the families united by marriage. The woman wears northern European dress with decorative sleeves, one of which is embroidered with her name, Marietta—a

on cassoni.[4] Later lustered examples of this two-handled form, made with shining golden decoration in imitation of silver-gilt vessels, must have served as relatively inexpensive versions of dining silver. These pieces bear the arms of ruling families or popes, crowned monograms or names,[5] paired busts of a couple, or the familiar *fede* (faith) motif associated with betrothal and marriage (see cat. nos. 16–18). An example in the Victoria and Albert Museum is painted with the fede motif accompanied by the motto CO[N] PURA FE (with pure faith).[6]

DT

Cat. 2, view 2

1. Rackham 1940, no. 162.
2. Ballardini 1929; De Mauri 1924, p. 39; Poole 1995, no. 244.
3. Syson and D. Thornton 2001, p. 69.
4. Ibid.
5. Poole 1995, no. 244; Rackham 1940, no. 488.
6. Rackham 1940, no. 460.

SELECTED REFERENCES: De Mauri 1924, p. 39; Ballardini 1929; Rackham 1940, no. 162; Syson and D. Thornton 2001, p. 69, fig. 50

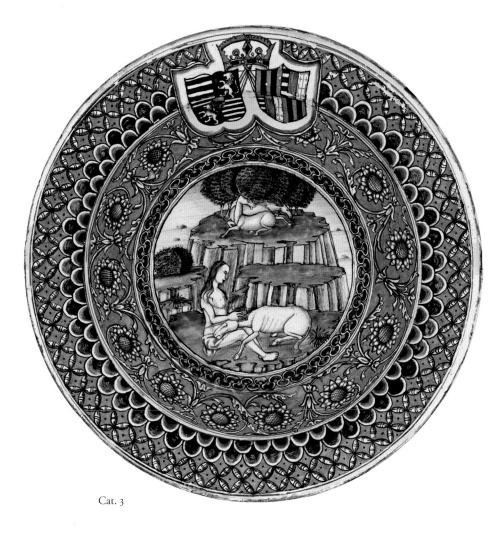

Cat. 3

and elsewhere."[13] Beatrice of Aragon was the cousin of Camilla of Aragon, who married Costanzo Sforza, Lord of Pesaro, in 1475. An illustrated manuscript commissioned to mark their wedding shows the same figurative style as the two surviving narrative scenes on the set made for Matthias and Beatrice.[14] The set constitutes one of the most astonishing achievements of fifteenth-century Italian maiolica.
DT

1. Shepard 1930, pp. 46, 48, 70, 283, n. 1; Einhorn 1976, pp. 29, 182; Syson and Gordon 2001, p. 117.
2. For the drawings, see Bambach 2003, p. 307, no. 23 (Ashmolean Museum, Oxford), and p. 308, fig. 135 (British Museum, London).
3. MacCurdy 1939, vol. 2, p. 473.
4. Clark 1977, pp. 143–46; Young 1979, pp. 65–75.
5. Syson and D. Thornton 2001, p. 57.
6. Rubin and Wright 1999, no. 92; Syson and D. Thornton 2001, p. 61.
7. Syson and Gordon 2001, p. 116, figs. 3.31a, b, and p. 117.
8. Bettini 1997; *Matthias Corvinus* 1982, pp. 296–301; T. Wilson 1996b, pp. xiv–xv, fig. 3; T. Wilson 1999, p. 6; Ciaroni 2004, pp. 74–80, 152, figs. 21a, b.
9. Rackham 1940, nos. 150, 151; Ricci 1927, no. 25 (for the present dish) and no. 26; Ciaroni 2004, p. 75.
10. Rackham 1940, no. 150; Ravanelli Guidotti 1985b; Barbe and Ravanelli Guidotti 2006, no. 1.
11. Berardi 1984; Bettini 1997; T. Wilson 2005b.
12. Bettini 1997; Ciaroni 2004, pp. 75–77.
13. Bettini 1997, p. 173; T. Wilson 1999, p. 6.
14. Biblioteca Apostolica Vaticana, Urb. lat. 899; Berardi 2000, p. 55; Ciaroni 2004, pp. 74, 78.

SELECTED REFERENCES: Ricci 1927, no. 25; Rackham 1940, under nos. 150, 151; *Matthias Corvinus* 1982, pp. 296–301; T. Wilson 1996b, pp. XIV–XV, fig. 3; T. Wilson 1999, p. 6; Bettini 1997; Ciaroni 2004, pp. 74–80, 152, figs. 21a, b; Balla 2008, pp. 33–38, ill. nos. 15, 20; Gabriella Balla in Balla and Jékely 2008, pp. 144–46, no. 3.1.

reference to Marietta Strozzi, of Florence, who was courted by Bartolomeo Benci in 1464.[6] A rather different connection between the unicorn theme and marriage is provided by Pisanello's medal of Cecilia Gonzaga, dating from 1447, which features the lady and the unicorn in tribute to Cecilia's chastity as a nun and "bride of Christ."[7]

This dish is one of four surviving pieces from a remarkable set of dining wares made for Matthias Corvinus, king of Hungary (r. 1458–90), and his second wife, Beatrice of Aragon (d. 1508).[8] There are two pieces in the Victoria and Albert Museum, London, and one in the Phoebe A. Hearst Museum of Anthropology, at the University of California, Berkeley.[9] Two of the four—the present dish and one of those in London—are painted with narrative scenes at the center; the London dish shows boys gathering fruit as an allegory of Abundance, a theme associated with marriage and fertility and found in prints and medieval ivories as well as maiolica.[10] All four dishes have broad, brightly colored borders on the front incorporating the paired arms of Matthias Corvinus, on the left, and those of his wife, surmounted by a crown. The couple were married in 1476, but it cannot be proven that the set was ordered to commemorate that event. It is likely to have been created before Matthias's death in 1490.

Fig. 57. Baccio Baldini (1436–ca. 1487), attributed to, *Emblem of Chastity,* ca. 1465–80. Engraving, Diam. 6 in. (15.3 cm). The British Museum, London

The set was probably made in Pesaro, in the Italian Marches, where maiolica of superb quality was produced in the last quarter of the fifteenth century.[11] Maiolica sherds with comparable geometric and stylized plant designs have been found there.[12] A document of May 1488 also supports a link between the Corvinus set and Pesaro, in that it mentions that an Italian potter from Pesaro called Francesco di Angelo Benedetti was then working "in distant parts of Hungary

4. Plate with an Allegory of Love

Origin uncertain, perhaps Tuscan, dated 1513 on the reverse
Tin-glazed earthenware (maiolica), Diam. 16½ in. (42 cm)
Inscribed: *1513 ADI 3 AVEZ[T?]O* [or *MAZO*]
Musei Civici d'Arte Antica, Bologna (1122)

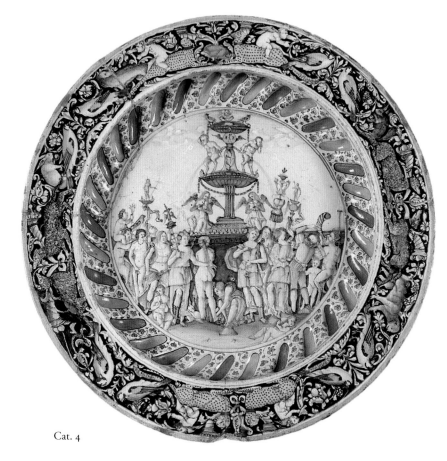

Cat. 4

This damaged but delightful plate is painted at the center with an encounter of a young man and woman, with their retinues, at an elaborate, symbolic fountain. The subject has been interpreted as the Fountain of Youth,[1] which was created when the nymph Juventas was transformed by Jupiter into a youth-giving fountain. According to this legend, elderly men and women arrived at the fountain and threw off their clothes to bathe, only to emerge rejuvenated, dancing and embracing under the eye of Cupid. If this is indeed the theme portrayed here, it is so heavily condensed into a single scene that it is almost unrecognizable. Like similar scenes of triumphs on contemporary maiolica painted in various pottery centers, the ambitious composition (including naked figures boldly viewed from behind) may depend on a woodcut, niello, or other print source that remains to be identified.[2]

The fountain has a high base, on which sit two angels playing musical instruments. They flank a central pedestal on which a bowl rests, hung with a garland; at the rim of the bowl, standing back to back, two satyrs urinate, as part of the play of the fountain. The pedestal between them, with a knop on which is a gemlike image of a satyr, supports two *all'antica* dishes with garlands, two birds resembling goldfinches, and a central seated figure. The youths and maidens at the foot of the fountain are dressed *all'antica* or are nude, except for one youth in contemporary dress on the right, who is viewed from the back and is apparently dancing to the music of the angels. Putti lie on the ground, and a satyr blows a conch. Both retinues carry *all'antica* standards. On the outer border of the plate, putti are shown riding leopards amid twisting foliage, accompanied by the same birds as seen atop the fountain and by hares, hunting dogs, a fox, a monkey, and cornucopias bursting with fruit and flowers.[3]

The central scene demonstrates the Renaissance fascination with table fountains and perpetual fountains, which is explored in the dream-romance *Hypnerotomachia Poliphili* (Venice, 1499), where elaborate examples (including a fountain with a urinating Cupid) are illustrated and described (cat. no. 62).[4] Urinating putti or cupids are featured as emblems of fertility on a range of art objects associated with betrothal and

marriage, including glass cups, birth trays, and marriage chests (see cat. nos. 69, 72; fig. 54).[5] The same imagery appears even more explicitly in Lorenzo Lotto's *Venus and Cupid* of the late 1520s (cat. no. 148), in which Cupid directs a stream of urine through a myrtle wreath into the lap of the naked Venus reclining at his feet. Why satyrs—associated with lust and sexual license—appear on this plate in the place of putti is not clear, but they make the sexual allusion more explicit. The iconography of a meeting at a fountain is also explicitly associated with marriage and fertility on the famous Barovier Cup (Museo dell'Arte Vetrario, Murano), a glass "betrothal cup" of about 1460–70 on which are painted a cavalcade of women and the Fountain of Youth—and of Love—in which they bathe.[6] Young women bathing are painted on a sumptuous Gubbio lustered plate (Wallace Collection, London), dated 1525: sensuous nude women wearing coral charms associated with fertility enjoy an open pool in a landscape.[7] The Wallace plate also features cornucopias, emblematic of fertility and fruitfulness, on the border and on the reverse.

This plate is precisely dated on the reverse, although the month given is not easy to read: *1513 ADI 3 AVEZ[T?]O*, or *MAZO*, which could denote the third day of August, March, or even May. The plate resists attribution. On stylistic grounds it has long been deemed a product of Cafaggiolo, in Tuscany,[8] but recent excavations at the workshop there indicate that Cafaggiolo wares were marked,

and thus it is no longer possible to assign pieces to this center simply because they cannot easily be placed elsewhere.[9] In form and in the foliate design on the back, this plate bears a slight resemblance to a plate with Lapiths and Centaurs (Fitzwilliam Museum, Cambridge)[10] which is attributed to the Vulcan Painter, so called after a plate of that subject in the Victoria and Albert Museum, London. He is traditionally thought to have worked in Cafaggiolo in the first decades of the sixteenth century, although none of his pieces are marked for the workshop there.[11] On balance, however, the Bolognese plate cannot be given to this painter, and its attribution remains uncertain.

DT

1. Ravanelli Guidotti 1985a, no. 33.
2. Ravanelli Guidotti 1989, no. 92; Busti and Cocchi 2004, p. 42, fig. 10.
3. Ravanelli Guidotti 1985a, no. 33.
4. Colonna, *Hypnerotomachia Poliphili*, 1999 (ed.), pp. 85, 90, 112.
5. Barovier Mentasti et al. 1982, no. 71; Musacchio 1999, pp. 130–34, fig. 125.
6. Barovier Mentasti et al. 1982, no. 65. A woodcut of the Fountain of Love appears in the *Hypnerotomachia Poliphili*; see Colonna, *Hypnerotomachia Poliphili*, 1999 (ed.), p. 378.
7. Norman 1976, no. C66; Mallet 2007, no. 10.
8. Cora and Fanfani 1982, no. 8.
9. I am grateful to Marino Marini and Sandro Alinari for their comments on the attribution of this plate and the finds from their recent excavations at Cafaggiolo, which remain to

be published in full. For preliminary find-
ings, see Alinari 2002.

10. Poole 1995, no. 191.

11. Rackham 1940, pp. 109–10; Cora and Fanfani
1982, no. 78; Alinari 1991; Moore Valeri 2003,
pp. 43–44; D. Thornton and T. Wilson 2009,
no. 124.

SELECTED REFERENCE: Ravanelli Guidotti
1985a, no. 33

5. Bowl with the Arms and Devices of Pope Leo X and of Families Allied by Marriage with the Medici

Tuscany, Montelupo, possibly Sartori workshop,
1513–21

Tin-glazed earthenware (maiolica), H. 8⅛ in.
(20.5 cm), Diam. 14½ in. (36.8 cm)

Inscribed: SENPUR; SUAVE; DIVINA PONTETIA; SUMUS
VIVIMUS; RENOVABITUR

The British Museum, London (1855.1201.76)

This impressive bowl is painted with the arms and devices of the Medici pope Leo X, who ruled from 1513 to 1521. In the well are the Medici arms with a lion's mask at the top, referring to Leo, as well as the papal tiara and crossed keys (the latter are symbolic of the powers granted by Christ to Saint Peter and his successors). Four of Leo's devices, or *imprese*, are painted on the inside. These are a diamond ring and three ostrich feathers with the inscription SENPER (always); a yoke with a scroll reading SUAVE (gentle) and DIVINA PONTETIA (perhaps a mistranscription by the maiolica painter, with a play on the pope's Latin title, *Pontifex maximus*, and the Latin *potentia*, "power"); a wheel with a nail through it and the words SUMUS VIVIMUS (we are, we live); and a spread eagle with the phrase RENOVABITUR (it will be renewed).[1] The first two of these mottoes were widely used as Leo's personal devices, whereas the last two, with their bib-lical quotations, emphasized Leo's authority and power as pope, as well as his standing within the revived Medici family following their return to Florence in 1512. The bowl combines these devices with Leo's arms in a way that suggests the bowl was likely to have been a personal commission, perhaps from or for Leo himself.

The theme of the decoration on the outside of the bowl is marriage. Here the Medici arms appear three times, supported by putti who bear flaming torches, emblem of Hymen, the ancient Roman god of mar-riage. The Medici arms alternate with those of the three principal Roman and Florentine families with which the Medici allied them-selves by marriage. The Orsini arms recall the marriage of Leo's mother, Clarice Orsini, to Lorenzo de' Medici (the Magnificent) in 1469 and that of Leo's brother Piero to Alfonsina Orsini in 1487. The Strozzi arms point to the marriage of Leo's niece, Clarice, to Filippo Strozzi in 1508. The Salviati arms recall the marriage of Leo's sister, Lucrezia, to Jacopo Salviati in 1488 and that of their daughter, Maria Salviati, to Giovanni dalle Bande Nere in 1516. It was through this last-mentioned marriage that the two branches of the Medici were finally reunited; from 1537, Maria and Giovanni's son was to rule Florence as Cosimo I de' Medici. Given that the marriage of Maria Salviati and Giovanni dalle Bande Nere is the only one of those referred to on the bowl which occurred dur-ing Leo's pontificate, that alliance is likely the one that the bowl commemorated. The marriage carried special significance in the revival of Medici family fortunes: the ico-nography of the bowl makes this clear in situating the marriage within the network of Medici power in Rome and Florence.

Bowls of similar form are sometimes painted with designs or inscriptions associ-ated with betrothal and marriage. Two in the Fitzwilliam Museum, Cambridge, are painted with women's heads and inscriptions in tribute of named women: DIAMANTTE BELLA (beautiful Diamantte) and VI[N]CEN-ZIA BELLA (beautiful Vincenzia). Another bowl, also in the Fitzwilliam Museum, bears the Medici arms surrounded by paired cornucopias—emblems of fruitfulness and procreation.[3]

The bowl is not marked for a particular town or workshop, but has formerly been attributed to a workshop attached to the Medici villa at Cafaggiolo, in Tuscany.[4] However, the form, known as a *rinfresca-toio* (the bowl was used for washing fruit or cooling wine flasks or glasses), is typical of the Tuscan pottery town of Montelupo.[5] Documents and local finds demonstrate that Montelupo workshops supplied dining wares for Florentine patricians and members of the papal curia during Leo X's pontificate, such as Cardinal Lorenzo Pucci, from about 1513 to 1520.[6] Foremost among these workshops was that of Lorenzo di Pietro Sartori,[7] who supplied dining wares for Clarice Strozzi de' Medici in 1518.[8] The present bowl was almost certainly made in Montelupo, possi-bly in the Sartori workshop. DT

1. T. Wilson 1984; D. Thornton and T. Wilson
2009, no. 130.
2. T. Wilson 1984; D. Thornton and T. Wilson
2009, no. 130.
3. Poole 1995, nos. 176, 190.
4. Fortnum 1873, p. 93; Rackham 1940, p. 105;
Cora and Fanfani 1982, no. 24; T. Wilson
1984, pp. 433–36.
5. Poole 1995, p. 131; F. Berti 1997–2003, vol. 2,
forms 87, 88.
6. Spallanzani 1999; F. Berti 2002, no. 48.
7. F. Berti 1997–2003, vol. 4, pp. 537–57.
8. Spallanzani 1984; F. Berti 2002, p. 202.

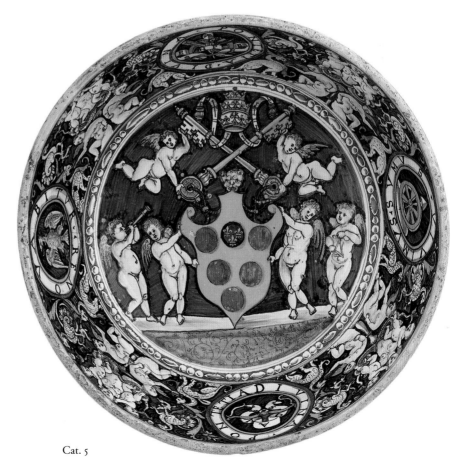

Cat. 5

SELECTED REFERENCES: Fortnum 1873, p. 93; Rackham 1940, p. 105; Cora and Fanfani 1982, no. 24; T. Wilson 1984; D. Thornton and T. Wilson 2009, no. 130

6. Roundel with Mock Triumph of Love

Perhaps Castel Durante or elsewhere in the Marches, ca. 1510–20
Tin-glazed earthenware (maiolica), Diam. 8¾ in. (22.2 cm)
The Metropolitan Museum of Art, New York, Robert Lehman Collection, 1975 (1975.1.1025)

The curious scene is arranged as a grotesque composition in which the elements are linked by cornucopias and looped strings of beads. At the center a young woman, taken captive by putti, sits in a triumphal car. Her arms are bound and her hair is being pulled by another young woman standing on the back of the car. On the front of the car is a classical column with a bound male figure in *all'antica* armor. Projecting forward from the column, as if from the prow of a ship, is a blindfolded Cupid with his bow. Behind the car walk a dwarf and a satyr holding a jester's staff, which has a mask at one end. In the foreground are a snail, a snake, a tortoise, a toad, and a swan.[1]

Triumphal imagery was an integral part of celebrating dynastic marriages: the marriage of Lucrezia d'Este to Annibale Bentivoglio, in Bologna in 1487, was accompanied by a staging of the Battle between Chastity and Matrimony, featuring specially designed and decorated triumphal cars.[2] (For a depiction of the Combat of Love and Chastity, see cat. no. 137a.) The caricature-like style and comic, grotesque details on this plaque suggest that it is intended to be read as a mock triumph of love, showing the young couple as victims of carnal passion. The mood is one of playful burlesque, reminiscent of the comedies and spectacles put on at contemporary carnivals.[3]

The painter of this roundel is probably also the painter of two plates in the Victoria and Albert Museum, London, with closely comparable imagery arranged as symmetrical grotesque compositions.[4] He has in the past been identified with the painter known as Giovanni Maria of Castel Durante, who signed a superb and sophisticated plate of 1508 bearing the arms of Pope Julius II (r. 1503–13)[5] and to whom were formerly attributed works sharing this roundel's use of grotesques incorporating putti. The latter now appear unrelated to the signed Julius II plate. Moreover, their great variation in quality suggests that they are the work of several hands, making it hazardous to attribute them to Castel Durante, let alone to the same workshop there.[6]

DT

1. Rasmussen 1989, pp. 106–9, no. 64.
2. Syson and D. Thornton 2001, p. 66.
3. Raggio 1956, p. 189; Rasmussen 1989, p. 106, no. 64; Chambers and Pullan 1992, pp. 380–82.
4. Rackham 1940, nos. 525, 526.
5. Rasmussen 1989, pp. 100–104, no. 62.
6. Poole 1995, no. 364.

SELECTED REFERENCES: Rackham 1940, under nos. 525, 526; Raggio 1956, p. 189; Rasmussen 1989, pp. 106–9, no. 64; Poole 1995, under no. 364

7. Low-Footed Dish with Lovers Embracing in a Pastoral Landscape

Gubbio, workshop of Maestro Giorgio Andreoli, ca. 1524–27
Tin-glazed earthenware (maiolica) with luster, Diam. 10 in. (25.3 cm)
The Metropolitan Museum of Art, New York, Robert Lehman Collection, 1975 (1975.1.1088)
New York only

The subject of this delightful bowl (*coppa*), with its central erotic scene, remains mysterious. It has plausibly been suggested that the composition represents an episode from Ariosto's epic poem, *Orlando Furioso* (1516), in which the lovers Angelica and Medoro consummate their marriage in a month-long "honeymoon."[1] An alternative, less likely hypothesis is that the bowl depicts the love of Paris, in the guise of a cowherd, and Oenone, from Ovid's *Heroides*, though the smartly attired youth is overdressed for the part.[2] In either case, the other figures, a woman washing clothes in a stream and another woman following a prancing horse, appear incidental to the story.

The lyrical painting style is close to the manner of the greatest of all maiolica painters, Nicola da Urbino, as seen in his work of the mid-1520s (the luster would have been added in the workshop of Maestro Giorgio Andreoli in Gubbio). However, this dish seems to be the work of another painter, probably working in Maestro Giorgio's workshop, to whom a number of other lustered pieces dated between 1524 and 1527 have recently been attributed.[3] Closest to this piece is a

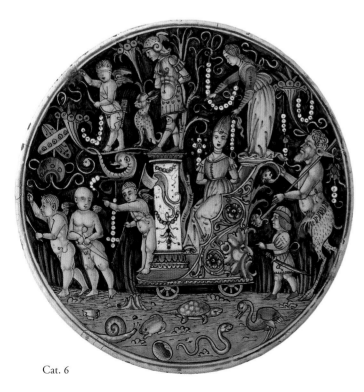

Cat. 6

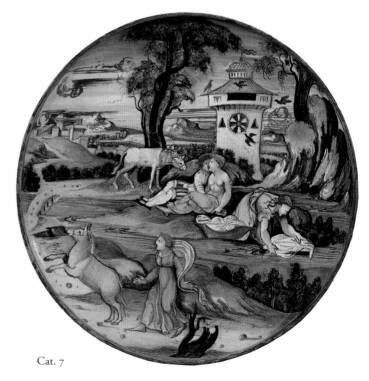

Cat. 7

plate with the Rape of Europa (Fitzwilliam Museum, Cambridge), which is dated 1524 in luster on the reverse and may have been both painted and lustered in Gubbio.[4] Also closely comparable is a lustered *coppa* (Ashmolean Museum, Oxford) with the Beheading of Saint John the Baptist and a grotesque border; it is inscribed for Maestro Giorgio's workshop and dated 1526 in luster on the reverse.[5] The present bowl offers the painter's most beautiful and atmospheric landscape, viewed at sunset. DT

1. Rasmussen 1989, p. 116, no. 69; Ariosto, *Orlando Furioso*, 1976 (ed.), vol. 1, p. 460 (book 19, vv. 33–34).
2. Rasmussen 1989, p. 116.
3. Poole 1995, p. 311; T. Wilson 1996b, pp. 317–18; D. Thornton and T. Wilson 2009, no. 315.
4. Poole 1995, no. 378.
5. T. Wilson 1989a, no. 11.

SELECTED REFERENCES: Rasmussen 1989, pp. 116–18; no. 69; T. Wilson 1989a, under no. 11; Poole 1995, p. 311; T. Wilson 1996b, pp. 317–18; D. Thornton and T. Wilson 2009, under no. 315

8. Dish with Scene of Christ at Supper with Simon the Pharisee and with the Arms of Orsini Impaling della Rovere

Urbino, circle of Nicola da Urbino, lustered in the workshop of Maestro Giorgio Andreoli in Gubbio, inscribed and dated 1528 on the reverse
Tin-glazed earthenware (maiolica) with luster, Diam. 18¼ in. (46.5 cm)
The Metropolitan Museum of Art, New York, Robert Lehman Collection, 1975 (1975.1.1103)

In the biblical scene depicted here, Mary Magdalen dries Christ's feet at supper with her hair, prior to anointing them (Luke 7:36–50). The composition is adapted from Marcantonio Raimondi's engraving of the subject,[1] which was well known to and frequently employed by Renaissance maiolica painters. The beautiful grotesque border with interlaced dolphins, tritons, and dragons, and with putti scrambling up cornucopias, incorporates on either side the arms of Orsini impaling della Rovere. These record the marriage in 1506 of Felice della Rovere (ca. 1483–1536), the illegitimate daughter of the della Rovere pope Julius II (r. 1503–13), to Giangiordano Orsini, Lord of Bracciano, who died in 1517. Felice used these arms as a widow until her death, and this beautiful plate may have been a present in her widowhood from her cousin in Urbino, Francesco Maria I della Rovere.[2]

In the 1520s sets of maiolica dining wares seem to have been considered appropriate presents for noble widows; a marvelous set was made by Nicola da Urbino in 1524–55 for the widowed Isabella d'Este

(1474–1539), Marchioness of Mantua.[3] Such maiolica wares were thought suitable for a widow, at least in some circles, even earlier, at the beginning of the sixteenth century. A fascinating letter of 1501 describes how the widowed Lucrezia Borgia (1480–1519) was abandoning her mourning for her second husband, Alfonso, Duke of Bisceglie: "Up to now Donna Lucretia, according to Spanish usage, has eaten from earthenware and maiolica [i.e., lustered pottery]. Now she has begun to eat from silver as if almost no longer a widow."[4]

This dish—particularly in the style of the grotesque border—is closely related to one depicting Mary Magdalen and Martha (Wallace Collection, London) and to another with Apollo and Marsyas (British Museum, London). Both are unlustered and have similar grotesque borders; though neither is inscribed, they can be attributed to Urbino, to a close follower of Nicola da Urbino, and dated about 1525–30.[5] DT

1. Bartsch XIV.23.
2. G. C. Carli, "Sulle pitture in majolica," 1988–89 (ed.), pp. 619–20, n. 26; Rasmussen 1989, p. 206, no. 124; Mattei and Cecchetti 1995, p. 102, pl. IX; Busti and Cocchi 2004, no. 62.
3. Mallet 1981, p. 165; Palvarini Gobio Casali 1987, pp. 180–92, nn. 27, 29, for documents of 1523 and 1524; Rasmussen 1989, pp. 110–14, nos. 66, 67; Ravanelli Guidotti 1991; T. Wilson 1993, p. 192; Syson and D. Thornton 2001, pp. 223–28.
4. Quoted in Bradford 2005, p. 108.
5. Norman 1976, no. C41; D. Thornton and T. Wilson 2009, no. 150.

SELECTED REFERENCES: Rasmussen 1989, pp. 204–6, no. 124; Busti and Cocchi 2004, no. 62; D. Thornton and T. Wilson 2009, under no. 150

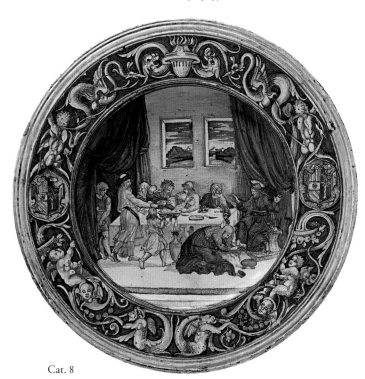

Cat. 8

9. Bowl with Bust of a Woman and Trophy Ornament

Gubbio, workshop of Maestro Giorgio Andreoli,
ca. 1519
Tin-glazed earthenware (maiolica) with luster,
Diam. 10⅛ in. (25.8 cm)
Inscribed: *PULISENA.B.[ELLA]*
The Metropolitan Museum of Art, New York, Robert
Lehman Collection, 1975 (1975.1.1085)

Cat. 9

This bowl is the earliest in a group of pieces in this publication which are traditionally known as *belle donne* (beautiful women). The group comprises a category of maiolica dishes bearing female heads, accompanied by a label with a name and an epithet, such as *bella* (beautiful), *diva* (divine), *unica* (unique), or *pulita* (chaste). More rarely, a woman's name is accompanied by a man's, as on a Deruta plate (Museo Regionale della Ceramica di Deruta) inscribed *ORELIA B[ELLA] E MOMOLO SUO SERVO* (beautiful Orelia and Momolo her servant) and a Deruta plate (Musée National de la Renaissance, Écouen) inscribed *LA GIOVANNA BELLA DI BELARDINO BEL[L]O* (beautiful Giovanna the beloved of handsome Belardino).[1] These pieces were made in a number of pottery-producing centers and have been classed since the eighteenth century as *coppe amatorie*, or love gifts, presented by a man to his betrothed.[2] Their interpretation continues to intrigue collectors and scholars. The heads are usually stereotyped and stylized so as to make it hazardous to view them as portraits, but the names are thought to be those of real women to whom the pieces were given as flattering tributes. A poem written by Andreano da Concole in 1557, addressed to a potter of Deruta, praises the women of his native city of Todi, making explicit the link between living women and female heads on maiolica, and suggesting that *belle donne* should be viewed within the literary tradition of extolling local beauties, which was well established in different regions of Italy from the late fifteenth century.[3] The names featured on *belle donne* often appear fancifully classical or literary, recalling those in contemporary sonnets.[4] High-flown classicizing names derived from the names of heroes and heroines of antiquity were, however, fashionable in the late fifteenth and early sixteenth centuries at a certain level of society. A famous Roman courtesan was called Imperia, and noblewomen named in

the antique manner are listed in poems of the 1530s in praise of Neapolitan beauties: Lucrezia Carafa, Cornelia Marramau, and Faustina Scaglione.[5]

The name Pulisena, in the inscription *PULISENA.B.[ELLA]* (beautiful Pulisena) encircling the profile of the young woman in this beautifully lustered bowl, is a good example of a classicizing name on *belle donne* maiolica. It is an Italian version of Polyxena, the name of the daughter of King Priam of Troy who was sacrificed to appease the ghost of Achilles, as related in Ovid's *Metamorphoses*.[6] The name suggests a certain level of literary and classical culture within a social elite. Famous women from the Veneto with this name, for example, include the daughter of the well-known mercenary captain Erasmo Gattamelata of Padua, who is commemorated on a fifteenth-century medal, hailing her as *LA BELA PULIZENA* (beautiful Pulisena) in the manner of the inscription on a *bella donna* maiolica dish.[7] Another illustrious woman of this name in the Veneto was the singer Pulisena Pecorina,

who was a leading figure in the musical life of Venice in the 1530s.[8]

On the border, painted in blue with touches of green and heightened with red and golden luster, are four grotesque monsters whose wings support roundels containing military trophies. Around the well is a spiraling pattern in golden luster, in imitation of embossed designs known as gadroons in the well of silver dishes.

The bowl is not marked on the reverse. It has been identified, however, as one of a group of bowls with busts and trophies in the antique manner, most of which are dated 1519 and one of which is inscribed for Maestro Giorgio Andreoli's workshop in Gubbio.[9]

DT

1. Busti and Cocchi 2001, no. 8, for the plate in Deruta; Giacomotti 1974, no. 518, for the plate in Écouen.
2. Passeri 1853, pp. 62–63; F. Briganti 1903; Ballardini 1925; Ballardini 1928; T. Wilson 1989a, pp. 50–51; Gardelli (Giovanna) 1992; Ajmar-Wollheim and D. Thornton 1998;

Ravanelli Guidotti 2000; Busti and Cocchi
2001.

3. F. Briganti 1903; Ajmar-Wollheim and
D. Thornton 1998, p. 140; Ravanelli Guidotti
2000, pp. 14–33; Busti and Cocchi 2001,
pp. 16–17.
4. T. Wilson 1989a, pp. 50–51.
5. Masson 1975; Ajmar-Wollheim and
D. Thornton 1998, p. 141 and n. 13.
6. Rasmussen 1989, pp. 185–86, no. 112.
7. Pollard 1984–85, vol. 3, p. 1467, no. 866;
Ajmar-Wollheim and D. Thornton 1998,
p. 147; Ravanelli Guidotti 2000, p. 312;
Toderi and Vannel 2000, vol. 2, p. 89,
no. 2747.
8. Chambers and Pullan 1992, pp. 382–83, doc.
no. 20.
9. Rasmussen 1989, p. 186; D. Thornton and
T. Wilson 2009, no. 295. One of the related
pieces is also in the Metropolitan Museum
(Rasmussen 1989, p. 184, no. 111). Until
1945 nine bowls from the series were in the
Schlossmuseum, Berlin. Only three sur-
vived the Second World War; today they are
in the Kunstgewerbemuseum, Berlin. See
Hausmann 1972, nos. 162–64.

Selected references: Rasmussen 1989,
pp. 185–86, no. 112; D. Thornton and T. Wilson
2009, under no. 295

10. Bowl with Bust of a Woman and Trophy Ornament

Gubbio, workshop of Maestro Giorgio Andreoli,
ca. 1518–20
Tin-glazed earthenware (maiolica) with luster, Diam.
10¼ in. (26.1 cm)
Inscribed: *ONESTA.PASSA.ONE.BE[LLE]ZA*
The Metropolitan Museum of Art, New York, Robert
Lehman Collection, 1975 (1975.1.1077)

This *bella donna* bowl (see cat. no. 9) is
decorated at the center with the profile
bust of a woman painted in blue and green
and in golden luster on a red-lustered ground.
Above her head is a scroll with the moraliz-
ing inscription *ONESTA.PASSA.ONE.BE[LLE]ZA*
(integrity surpasses all beauty). Here, in com-
bination with a woman's profile, the phrase
alludes to chastity, the only virtue it was
thought a woman could truly attain[1] and the
feminine attribute that was most often cele-
brated in art objects associated with betrothal
and marriage. The inscription can be com-
pared with that on another dish with the bust
of a woman (Musée National de la Céramique,
Sèvres), inscribed *ONESTA FA BELLEZZA,* or
"integrity makes beauty," in which the woman

is presented as exemplifying the virtue of
onestà.[2] It is also comparable to the inscrip-
tion *ONESSTÀ FA BELLA DONNA* (integrity
makes a beautiful woman) on a wood coffret
(cat. no. 40; fig. 51). According to Neoplatonic
theory, beauty was a mirror or sign of good-
ness within, so that in praising a woman's
beauty one by implication paid tribute to the
virtue which it made visible.[3]

The border combines cornucopias, as
emblems of abundance and fertility, with
masks and trophies in golden and red luster.
This combination of motifs is often found
on *belle donne* bowls produced in Maestro
Giorgio Andreoli's workshop in Gubbio and
dated 1518 and 1519.[4] DT

1. D. Thornton 1997, p. 97.
2. Giacomotti 1974, no. 801; Ajmar-Wollheim
and D. Thornton 1998, p. 145.
3. Busti and Cocchi 2001, pp. 30, 114, no. 41;
Syson and D. Thornton 2001, p. 51.
4. Rasmussen 1989, pp. 186–88, no. 113; D.
Thornton and T. Wilson 2009, no. 295.

Selected reference: Rasmussen 1989,
pp. 186–88, no. 113

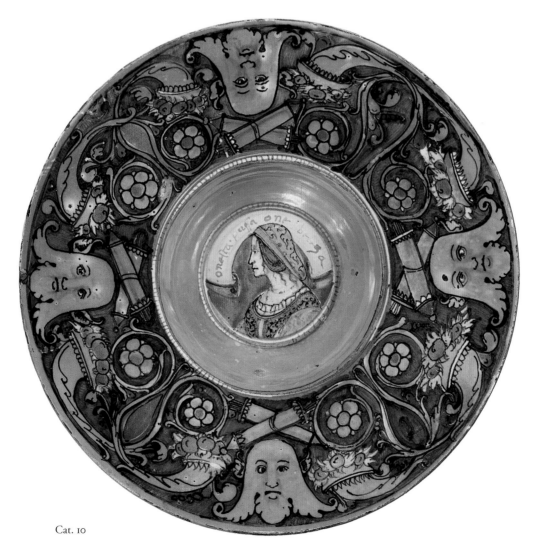

Cat. 10

Cat. 11

11. Bowl with Bust of a Woman and Trophy Ornament

Gubbio, workshop of Maestro Giorgio Andreoli, here attributed to the Painter of the Judgment of Paris, dated 1522

Tin-glazed earthenware (maiolica) with luster, Diam. 8¼ in. (20.9 cm)

Inscribed on back: *1522*

The Metropolitan Museum of Art, New York, Robert Lehman Collection, 1975 (1975.1.1104)

At the center, framed by curving, golden-lustered dolphins, is the three-quarter-profile bust of a young woman. She wears a low-cut dress with detached sleeves over an undershirt; a coral necklace; and, covering her hair, a soft, silk hat with a central jewel. She is painted against a deep-red-lustered ground, the red being picked up again in plant tendrils, beads, and fluttering ribbons in the trophy ornament on the border. The bowl is inscribed *1522* on the back, in luster.[1] It is a *bella donna* (beautiful woman) dish (see cat. no. 9).

This delicate bowl is outstanding for its thinness and brilliant use of luster, making it appear to be made of precious metal. It is also notable for its sinuous, sensuous design and fine drawing. It can be compared with lustered bowls with busts of saints outlined and shaded in blue and framed by grotesques: three such bowls (Ashmolean Museum, Oxford; Wernher Collection, Ranger's House, London; private collection, Paris) are dated 1520 on the reverse and a fourth, in the Metropolitan Museum, is undated.[2] The painter can be identified as the painter of a famous plate with the Judgment of Paris (Collection Dutuit, Musée du Petit Palais, Paris), which is inscribed on the back, in blue, *MO GIORGIO 1520 A DI 2 DE OCTO-BRE B.D.S.R INGUBIO* (Maestro Giorgio, October 2, 1520, BDSR in Gubbio), proving that the piece was both painted and lustered in Maestro Giorgio Andreoli's workshop in Gubbio.[3]

Maestro Giorgio Andreoli was one of the most successful Renaissance potters.[4] His workshop specialized in the application of golden- or red-luster finishes to twice-fired maiolica pieces, which required a third firing (see also cat. nos. 7–10, 15a, 24, 79). The importance of his business to the Gubbio economy was recognised by a grant of citizenship and exemption from taxes by Guidobaldo I, Duke of Urbino. In 1519 a papal brief described Maestro Giorgio as "an excellent master without rival in the art of lustred pottery, whose work brings honour to the city, lord and people of Gubbio in all the nations to which the pottery of his workshop is exported, as well as the great income it brings in customs dues."[5] The Judgment of Paris painter seems to have been the most important painter in the workshop between about 1518 and 1522, judging by pieces attributed to him. For the work of this painter, see also catalogue number 24.

DT

1. Rasmussen 1989, pp. 192–94, no. 117.
2. T. Wilson 1989a, no. 7; T. Wilson 2002a, p. 36, fig. 5; T. Wilson 2002b, pls. XIV, XV (undated), XVI.
3. Join-Diéterle 1984, p. 167; T. Wilson 2002b, pp. 113–14; Barbe and Ravanelli Guidotti 2006, no. 4; D. Thornton and T. Wilson 2009, no. 296.
4. See papers by various authors and bibliography in Bojani 2002.
5. Vanzolini 1879, vol. 2, p. 245, trans. in T. Wilson 1987, p. 103; Syson and D. Thornton 2001, p. 247.

SELECTED REFERENCES: Rasmussen 1989, pp. 192–94, no. 117; T. Wilson 2002a, p. 36

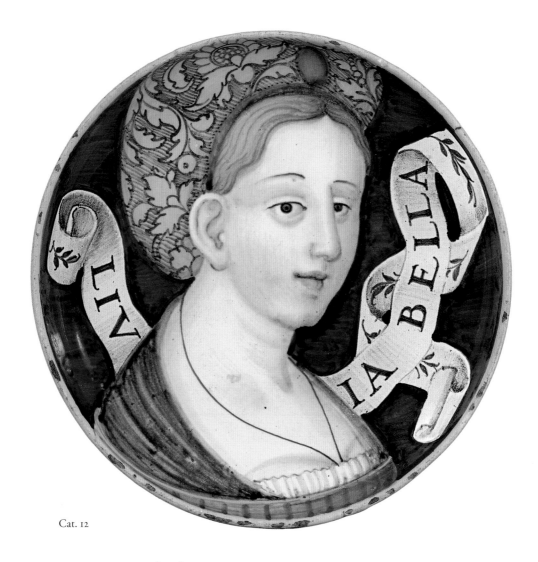

Cat. 12

12. Low-Footed Bowl with Bust of a Woman

Urbino or Castel Durante, ca. 1530
Tin-glazed earthenware (maiolica), Diam. 8½ in.
(21.5 cm)
Inscribed: *LIVIA BELLA*
The Metropolitan Museum of Art, New York, Robert
Lehman Collection, 1975 (1975.1.1084)

This footed bowl (*coppa*) belongs to a category of maiolica dishes known as *belle donne* (beautiful women). The dishes are painted with women's heads and names and with admiring epithets (see the essay by Luke Syson in this volume; see also cat. nos. 9–11). The *bella donna* bowl here is painted with a three-quarter bust of a young woman, who looks out at the viewer with an animated expression. This and the way in which her hat is truncated by the edge of the bowl add to the sense of freshness and immediacy.[1] Around her head is a fluttering scroll inscribed *LIVIA BELLA* (beautiful Livia).[2] She wears a *scufia,* or cap, with a jewel centered above the forehead, of a type fashionable between about 1515 and 1545.[3] Livia's cap appears to be made of silk velvet. A necklace of black cord, which probably holds a pendant, is stuffed into her bodice.

This *coppa* is one of a group of *belle donne* bowls probably painted in Urbino or Castel Durante, including one inscribed *ELISABETTA BELLA* (Kunstgewerbemuseum, Frankfurt), another inscribed *CATERINA BELL[A]* (formerly Adda collection, Paris; present location

unknown), and a third inscribed *LUCHINA* (Museo Civico, Arezzo).[4] They can be compared to a larger group of ten lustered bowls with *belle,* including one inscribed *AURA BELLA* (British Museum, London), dated 1531, and marked for Maestro Giorgio Andreoli's workshop in Gubbio. The British Museum *coppa,* which shows Aura wearing a cap identical to the one depicted here, provides useful confirmation of the dating for this bowl.[5]

DT

1. Ajmar-Wollheim and D. Thornton 1998, p. 145, fig. 7.
2. Rasmussen 1989, pp. 120–21, no. 71.
3. Penny 2004, pp. 87–88.
4. Poole 1995, p. 298 (Frankfurt); Rackham 1959, no. 399 (formerly Paris); Fuchs 1993, no. 211 (Arezzo).
5. D. Thornton and T. Wilson 2009, no. 318.

SELECTED REFERENCE: Rasmussen 1989, pp. 120–21, no. 71

Cat. 13a

Cat. 13b

13a, b. Pair of Low-Footed Bowls with Profile Busts of a Couple

Urbino or Castel Durante, dated 1524
Tin-glazed earthenware (maiolica), Silvia:
Diam. 8¼ in. (21 cm); Lutio: Diam. 8⅜ in. (21.3 cm);
Inscribed: *SILVIA DIVA 1524; LUTIO 1524*
(Silvia) Private collection, Germany
(Lutio) The British Museum, London (AF 3318)

On one footed bowl (*coppa*) is the profile bust of a young man facing left. He has an embroidered shirt collar and wears a broad hat over a separate cap, of a kind seen on contemporary medals.[1] The bust is accompanied by a scroll reading *LUTIO 1524*. On the other bowl is the profile bust of a young woman facing right, with the legend *SILVIA DIVA* [divine Silvia] *1524*. The woman's shirt, like the man's, has a smocked collar, and the two pieces share the same script and date. It has therefore been suggested that the images were intended to be viewed as a couple facing each other, as they would when the bowls were displayed on a buffet.[2] The bowls in the maiolica tradition to which these two belong usually feature medal-like busts of famous heroes and heroines, or characters from history and romance (compare cat. no. 14a, b). The meticulously represented contemporary dress, the contemporary names, and the identical date make this pair stand out. These variations from the rule suggest that the figures may have been intended as representations of a living couple.

There is only one surviving *coppa* (Victoria and Albert Museum, London), depicting a man and inscribed *RAMAZOTTA*, which is comparable to the Lutio and Silvia bowls in its departure from the norm. Here, too, the man is shown in contemporary dress rather than as a classical or literary hero. On the border, the name of a woman, Camilla, is written as if on a sheet of music. The portrait on the bowl is considered to be the portrait of an actual person, either Armaciotto Ramazotto or Melchiorre Ramazotto, Bolognese mercenary soldiers who served in the papal forces in the sixteenth century.[3] The likelihood that the "Ramazotta" on the bowl was indeed a real person, and "Camilla" his lover or betrothed, strengthens the hypothesis that Luzio and Silvia were a real rather than a mythical couple.[4] DT

1. Hill 1930, no. 626.
2. D. Thornton and T. Wilson 2009, no. 203.
3. Rackham 1940, no. 557.
4. D. Thornton and T. Wilson 2009, no. 203.

SELECTED REFERENCE: D. Thornton and T. Wilson 2009, no. 203

Cat. 14a

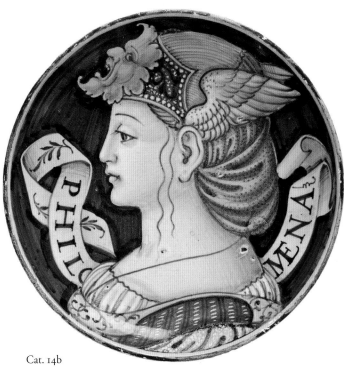

Cat. 14b

14a, b. Pair of Low-Footed Bowls with Busts of Ruggieri and Filomena

Urbino or Castel Durante, ca. 1520–25
Tin-glazed earthenware (maiolica), Ruggieri: Diam.
8¼ in. (21 cm); Filomena: Diam. 8⅜ in. (21.3 cm)
Inscribed: *RUGIERI; PHILOMENA*
The Metropolitan Museum of Art, New York,
J. Pierpont Morgan Gift, by exchange, 1965 (65.6.7);
Gift of J. Pierpont Morgan, 1965 (65.6.8)

The pair of bowls are part of a large series of footed bowls (*coppe*), made for an as yet unidentified patron, which have beautifully painted busts of illustrious heroes and heroines, both ancient and modern. The series forms one of the most striking sets of maiolica to have survived from the early 1520s. All the busts are presented in the same way, with helmets in the classical style, reminiscent of busts on ancient coin portraits or contemporary medals *all'antica* (in the ancient manner). It has recently been proposed that six other *coppe* with women's heads, and eleven with men's heads, are part of this series.[1] Formerly, in the early twentieth century, the Metropolitan's pair were together in the same collection, in Berlin.[2]

The quality of the painting on all the pieces has long been admired. The set has been attributed to the greatest of all Renaissance maiolica painters, Nicola da Urbino, or to the excellent painter known as Giovanni Maria from his inscription on a 1508 Castel Durante bowl in the Lehman Collection, at the Metropolitan Museum.[3]

Neither of these attributions now appears to hold, which makes it difficult to narrow down the place of production to either Urbino or Castel Durante.[4] The bowl can be dated by comparison of the busts with similar busts on closely related maiolica dishes, such as the pair in catalogue numbers 13a, b, which are dated 1524. DT

1. For a list of all the pieces in the series and their locations, see D. Thornton and T. Wilson 2009, no. 204.
2. Falke 1925, pl. XVIII, nos. 82, 83; Rasmussen 1989, p. 105, n. 5.
3. For these attributions and comments, see Falke 1917, cols. 13–15; Rackham 1940, p. 182; Hausmann 1972, p. 259; Rasmussen 1989, pp. 100–104, no. 62.
4. T. Wilson 2003b; D. Thornton and T. Wilson 2009, no. 204.

SELECTED REFERENCES: Falke 1925, pl. XVIII, nos. 82, 83; Rasmussen 1989, pp. 104, 105, n. 5, App. I, p. 245, nos. 63.5, 63.6; D. Thornton and T. Wilson 2009, under no. 204

15a. Ewer with Profile Busts of a Man and a Woman

Gubbio, possibly workshop of Maestro Giorgio Andreoli, ca. 1520
Tin-glazed earthenware (maiolica) with luster,
H. 7¼ in. (18.4 cm)
The Metropolitan Museum of Art, New York, Gift of V. Everit Macy, in memory of his wife, Edith Carpenter Macy, 1927 (27.97.39)

15b. Basin with Profile Busts of a Man and a Woman

Deruta, ca. 1500
Tin-glazed earthenware (maiolica) with luster, Diam. 12 in. (30.5 cm)
Inscribed: *FIDES O[M]NIA; LORE[NZO]; CESERA*
The Metropolitan Museum of Art, New York, The Friedsam Collection, Bequest of Michael Friedsam, 1931 (32.100.364)

E wers and basins would have been used for hand washing after meals as a polite ceremonial. Writing in 1465, the architect Filarete (ca. 1400–ca. 1469) described life in an ideal town, where the lord in his ideal palace "ordered water to be brought for our hands. Three young unmarried girls came in with three youths; they looked like angels. The girls were dressed in white with garlands of different flowers on their heads. Each had over her arm a white towel so that it floated in

the breeze when the arm moved a little. Each had a silver basin and a ewer in the other."[1] The water might be scented with rose petals or other additions, and the cloths for drying the hands were made of fine linen, worn over the shoulder by a servant. Early ewers and basins, made in matching sets, were of silver or bronze, but maiolica versions known as *bacili da acquareccia* came into use in the late fifteenth century, though the basins were often (like the one here) too shallow to be practical, and the sets must have had symbolic value.

The ewer (cat. no. 15a) is painted in luster with two shields beneath the spout: the shield on the left contains the profile bust of a young man, wearing a cap over an underhat fitting close to his head (compare cat. no. 13b), and the shield on the right contains the profile bust of a young woman wearing a *coazzone,* or snood, to cover her hair (compare cat. no. 16). The shields are surrounded by dolphin-headed grotesques on a blue ground, and the designs and busts are heightened with touches of red luster.[2] The ewer was made to accompany a ewer stand or dish, which, like catalogue number 15b, would have had a central ring to hold the foot of the ewer in place. Although ewers were more liable than basins to breakage and rarely survive, in the case of catalogue number 15a, it is the matching basin that is now lost. Two golden-lustered ewers in the British Museum, London, and four other examples in the Louvre, Paris, can

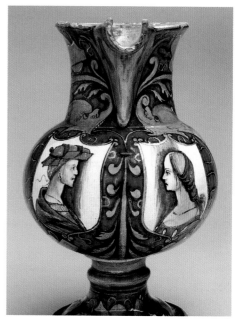

Cat. 15a, view 1

all be dated about 1500–40 and attributed, on account of the their form and similar lustered decoration, to Deruta.[3]

This ewer may be an early piece from the workshop of Maestro Giorgio Andreoli in Gubbio, made at a time when Derutese forms and designs were strongly influential there (for Maestro Giorgio, see cat. nos. 7–11, 15a, 24, 79). Giorgio Andreoli and his brother Salimbene contracted with a Gubbio master potter, Giacomo di Paoluccio, in 1495 to produce 2,500 pieces of pottery—including

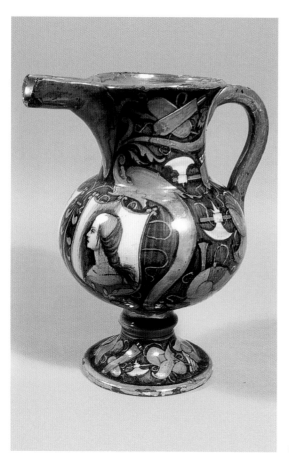

Cat. 15a, view 2

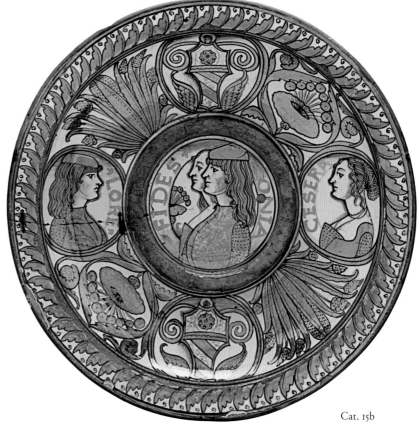

Cat. 15b

luster—in collaboration.[4] Their early pieces probably resembled Deruta types, except for being finished in the rich red luster that came to characterize Gubbio wares.[5] Giorgio Andreoli quickly took over Giacomo di Paoluccio's role as the leading potter in Gubbio. Documents prove that potters from Deruta and, from the 1520s, Castel Durante and Urbino worked for the Andreoli.[6]

The dolphin-headed grotesques on a bright blue ground, the use of golden-luster painting with touches of bright red luster, and the finely detailed figurative painting all recall products dated and/or inscribed for Maestro Giorgio's workshop in the period between 1518 and 1522. A good comparison for the grotesques, palette, and use of luster is a plate in the Louvre dated 1518/1519, which is among the first pieces marked for Maestro Giorgio's workshop.[7] The paired heads of the couple in matching shields, and their mutual gaze, are typical of objects which, through their imagery, can be tentatively associated with betrothal and marriage. They recall the paired portraits painted on panel that are discussed later in this volume (see cat. nos. 120–122).

This basin (cat. no. 15b) is decorated in golden luster, so as to imitate silver-gilt vessels in a relatively inexpensive way. Luster was a particular specialty of the pottery-producing town of Deruta, a few miles south of Perugia: this type of basin and ewer, finished in luster, was a characteristic Deruta product in the early sixteenth century.[8]

Many such Deruta lustered basins feature a woman's profile at the center, which is indicative of their original role as suitable gifts between women. Margherita, the wife of Francesco Datini of Prato (d. 1410), planned to take "a bowl and ewer, such as is customary to give to girls" to the birthday party of one of her friend's daughters. The Datini version was likely to have been made of silver or brass, given the date, but the later maiolica versions may also have been exchanged as gifts.[9]

The inscriptions and iconography on this basin indicate that it was probably made (with its now missing ewer) in association with a betrothal or wedding. In the central roundel are the half-length busts of a young couple seen in profile. Around them is the inscription, written in luster, FIDES O[M]NIA, for Fides omnia vincit, or "Faith conquers all." Here the word fides refers to the moral contract entered into at betrothal and marriage. In the well are four roundels: two with arms that have been associated with the Orsini family of Perugia; one, on the left, with the young man again in profile, inscribed in luster LORE[NZO]; and one, on the right, with the young woman, labeled CESERA. The names are probably those of a real couple, though the idealized profiles

cannot be regarded as portraits. Between the roundels are stylized flowers and leaf sprays; on the rim is a repeating leaf pattern. The placement of the profiles on the border, together with the family arms, makes it more likely that the basin was a presentation piece. In the case of an intimate gift, the foot of the ewer would have covered a central "portrait" on the basin, which would have been revealed only to the recipient.

An unlustered Deruta basin of similar type and date (Corcoran Gallery of Art, Washington, D.C.) lacks the busts and names of this example, but has in two of the roundels on its rim a dog, a traditional symbol of fidelity. It also has an inscription around the central ring reading SOGIE TOVESERO PERFIHIVIVO EPOLAMORTE (I will be subject to you as long as I live and even after death). The inscriptions on such pieces often contain misspellings, suggesting that the maiolica painter or lusterer was probably functionally illiterate.[10] DT

1. Quoted in P. Thornton 1991, p. 244.
2. Poole 1995, p. 168.
3. D. Thornton and T. Wilson 2009, nos. 283, 284; Giacomotti 1974, nos. 620–29.
4. Biganti 1987, p. 213; Fiocco and Gherardi 1996; Biganti 2002, pp. 32–33.
5. Sannipoli 2004, pp. 55–63.
6. Fiocco and Gherardi 1995, pp. 35–40; Fiocco and Gherardi 1996; Fiocco and Gherardi 1998; Fiocco and Gherardi 2002; T. Wilson 2002b.
7. Giacomotti 1974, no. 751.
8. T. Wilson 1987, nos. 142, 143; Ajmar-Wollheim and D. Thornton 1998, p. 143, fig. 3; S. Cavallo 2006, p. 184, pl. 13.13.
9. Poole 1995, p. 168, citing Origo 1988, p. 188.
10. W. M. Watson 1986, no. 28.

SELECTED REFERENCE: 15a. Poole 1995, p. 168

16. Inkstand with Busts of a Couple and Fede Motif and Inscription

Probably Faenza, ca. 1500
Tin-glazed earthenware (maiolica), 3¼ × 7⅞ × 11 in. (8.2 × 20 × 27.9 cm)
Inscribed: IO.TE.DO.LA.MANE / DAME.LA.FEDE
Museum of Fine Arts, Boston, John H. and Ernestine A. Payne Fund (56.310)

The inkstand is divided into three compartments: a long, rectangular tray, at the left, to hold quill pens; a smaller, squarish container with a circular opening, at the top right, to hold ink; and another rectangular tray, at the lower right, perhaps intended to hold the sand that was scattered over a document to absorb excess ink.[1] A band at one end of the inkstand is painted on the outer

edges with the profile busts of a man and a woman, facing each another. Both wear dress that was typical of the northern courts (Milan, Ferrara, Bologna, Mantua) in the period between 1490 and 1506. His cap, shoulder-length hair, and tunic open at the front over a fine shirt are known from medals and painted portraits as well as from busts on maiolica dishes. She wears a shift with a dress over it, to which are tied attachable sleeves. Around her neck is a tight necklace, and encircling her head is a black textile band known as a lenza, tied at the side, of a type that often held a pendant or significant betrothal jewel on the forehead or over one ear.[2] The woman also wears her hair in a coazzone, or snood, at the back.[3] Her appearance closely resembles that of the amorous young woman on a Faentine jug dated 1499 (cat. no. 15a).

Between the lovers is painted the fede (faith) motif of clasped hands, referring to the moral covenant signified by the handclasp at a crucial moment in the marriage ritual (see below).[4] The motif is often found on maiolica dishes, bowls, and tiles, sometimes together with the word fede itself. In ancient Roman law, a handclasp denoted a contract, and in Europe during the Middle Ages it came to serve as a symbol of betrothal or devotion, appearing on the hoop of late medieval rings and on belt fittings, necklaces, and brooches.[5] The concept of faithful love was elaborated upon in mottoes playing on the word fede. The phrase amor vol fe (love needs faith) is found on a late fifteenth-century Venetian glass in the British Museum with facing busts of a man and woman, of a type associated with betrothal.[6] This inscription is expanded in two late fifteenth-century Florentine engravings, one showing a couple and the other a reclining nymph, which include the legend Amor vol fe e dove fe none amor non puo (Love needs faith and where there is no faith there can be no love).[7]

The motif of joined hands, in the context of Renaissance marriage, signified an agreement that was legally and morally binding. Here, it evokes a specific moment in the carefully orchestrated marriage rituals, when representatives of the couple would meet and sign a written contract. This was accompanied by shaking right hands, referred to in Latin as the dextrarum junctio and in Italian as the impalmamento or toccamano.[8] In Florentine custom, the couple themselves would join hands before a notary and state individually their wish to marry through the vow Volo (I wish to), after which the notary would declare them married.[9]

On this inkstand, the fede motif is surrounded by fluttering ribbons and the legend IO.TE.DO.LA.MANE / DAME.LA.FEDE (I give you my hand, give me the ring).[10] The

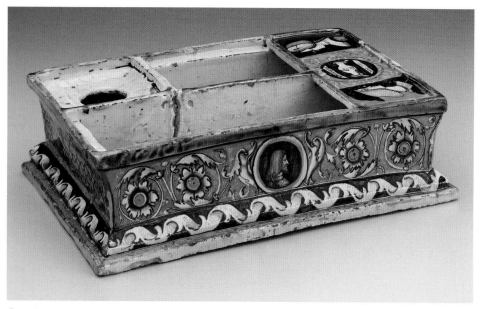

Cat. 16

6. Syson and D. Thornton 2001, p. 53, fig. 33.
7. Rubin and Wright 1999, nos. 89, 93.
8. Matthews Grieco 2006, p. 107.
9. Witthoft 1982, p. 45; Syson and D. Thornton 2001, p. 63.
10. Matthews Grieco 2006, p. 108. The word *fede* came to be used for the marriage ring, inasmuch as it stood for a pledge of faith in the legal and moral covenant of marriage.
11. Altieri, *Li nupitali*, 1995 (ed.), p. 9; Syson and D. Thornton 2001, p. 63.
12. Syson and D. Thornton 2001, p. 63.
13. Lightbown 1986, p. 122; D. Thornton 1997, p. 95.
14. Syson and D. Thornton 2001, p. 63; Matthews Grieco 2006, p. 108.
15. Mallet 1976; Ravanelli Guidotti 2000, pp. 51–52, 91, 240.

SELECTED REFERENCES: Mallet 1976; Ravanelli Guidotti 2000, pp. 51–52, 91, 240; Syson and D. Thornton 2001, p. 63, fig. 44; Matthews Grieco 2006, p. 108

paired profiles of the couple, gazing toward each other, echo paired nuptial portraits on panel (see cat. nos. 120–122). The *fede* motif and the inscription, referring to the marriage vow and the gift of a ring to signify it, make the iconography explicit.

The signing of the contract (*scritta*) between two families was the key element in elite marriage rituals. This was done in the presence of a notary, and could be accompanied by an exchange of vows by the couple as they joined hands. This, in turn (according to treatise on marriage written about 1504 by the Roman humanist Marco Antonio Altieri), could be accompanied by a ring ceremony, as referred to on the inkstand, in which a chosen ring would be placed by the groom on the bride's finger.[11]

We know that the act of signing the contract, if not the exchange of vows or the giving of rings, sometimes took place in the study of the head of a household where notarial documents concerning the family were signed and kept for reference.[12] Laura Mantegna, the daughter of the Mantuan court painter Andrea Mantegna (1431–1506), was married in her father's study in Mantua on August 31, 1486.[13] The practice appears to have been common in Northern and Southern Europe in the fifteenth and sixteenth centuries. It is a plausible hypothesis that this inkstand might have been intended to be used at the signing of a marriage contract or the exchange of vows before a notary.[14] This is the only maiolica inkstand that has thus far been tentatively linked, through both its iconography and its inscription, to the marriage ceremony.

In formal presentation, the busts of the lovers resemble those on contemporary medals. Similar busts appear singly on maiolica dishes and jugs made in Faenza, in Emilia-Romagna, and this, as well as the painting style, suggests that the inkstand was made there, about 1500.[15] The lack of initials or

arms makes it impossible to link the inkstand with a particular marriage. Moreover, the couple's appearance is so standardized in the representation of courtly dress and style of the period as to suggest that these are not portraits as such but, rather, evocations of a young elite couple, whose status would be immediately recognizable to the viewer.

DT

1. Mallet 1976.
2. Syson and D. Thornton 2001, p. 49, fig. 29.
3. Whitaker and Clayton 2007, no. 30.
4. Matthews Grieco 2006, p. 107.
5. Syson and D. Thornton 2001, p. 47, fig. 26; T. Wilson and Sani 2006–7, vol. 1, no. 20; Descatoire 2007, nos. 35, 36, 42; D. Thornton and T. Wilson 2009, no. 40.

17. Footed Bowl with Fede Motif and Inscription

Tuscany, Montelupo, ca. 1500–1510
Tin-glazed earthenware (maiolica), H. 8 in. (20.2 cm), Diam. 11⅛ in. (28.4 cm)
Inscribed: FEDE
International Museum of Ceramics in Faenza—Foundation (21934/c)

The bowl is painted on the inside with the *fede* motif of clasped hands and with the inscription *fede* (faith) (see cat. no 16).

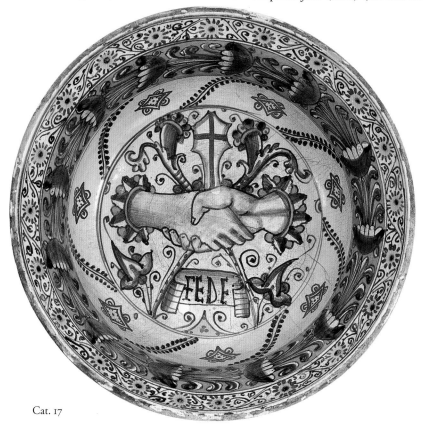

Cat. 17

What seem to be the arms of the Capitano del Popolo of Florence appear above, flanked by cornucopias which, with their connotations of abundance and fertility, reinforce the theme of betrothal and marriage.[1] Judging by its decoration, the bowl may have been designed to serve a commemorative function in connection with nuptial festivities and can be compared in this respect with the British Museum bowl recording Medici marriage alliances (cat. no. 5). It is possible that standing bowls of this type not only were commissioned or given as part of betrothal and marriage rituals but also were part of large dining sets for use at marriage feasts.

Like the British Museum bowl, this example can be attributed to Montelupo, in Tuscany, by reason of its form, which is well known from pieces found in the subsoil of the city, and its painted decoration, such as the flower motif on the border. Montelupo workshops supplied the Florentine market with fine maiolica in the late fifteenth and early sixteenth centuries, including special commissions for elite clients. This bowl can be dated about 1500–1510.[2] To judge from a detail of Francesco di Simone's 1504 painting *The Annunciation* (Accademia Carrara, Bergamo), standing bowls of this form, made from metal or ceramic, seem to have been used for the display of topiary on windowsills and balconies.[3] DT

1. Bojani, Ravanelli Guidotti, and Fanfani 1985, p. 206, no. 514.
2. F. Berti 1997–2003, vol. 2, p. 284, no. 111.
3. P. Thornton 1991, pl. 48; Poole 1995, p. 131.

SELECTED REFERENCES: Bojani, Ravanelli Guidotti, and Fanfani 1985, p. 206, no. 514; Poole 1995, p. 131; F. Berti 1997–2003, vol. 2, p. 284, no. 111.

18. Plate with Fede Motif

Emilia-Romagna, Faenza, ca. 1490–1510
Tin-glazed earthenware (maiolica), Diam. 11¼ in. (28.5 cm)
Fondazione Cassa di Risparmio di Perugia (Wilson-Sani 20)

Given the clasped hands at its center, known as the *fede* (faith) motif (see cat. no. 16), this plate has been described as "probably a gift of homage to the beloved or a betrothal gift."[1] The *fede* motif appears within a bold decorative framework typical of Faentine maiolica of this date.[2] The stylized plant motif on the border, known as a "Persian palmette," is derived from Near Eastern prototypes. It was commonly used in Faenza in the late fifteenth century as a framing device for amorous motifs, heads of men and women, and hunting themes on maiolica. The plate can be more precisely dated according to the form of the palmettes, which is closely comparable to designs on Faentine tiles in the Vaselli Chapel pavement in the Cathedral of San Petronio, Bologna, of about 1487–90. The *fede* motif also appears seven times on tiles in the same pavement, once accompanied by an inscription.[3] DT

1. Wilson and Sani 2006–7, vol. 1, p. 66.
2. D. Thornton and T. Wilson 2009, no. 10.
3. Ravanelli Guidotti 1988, nos. 152–56 (no. 152 for *fede*), nos. 121–32 for the Persian palmette.

SELECTED REFERENCE: T. Wilson and Sani 2006–7, vol. 1, no. 27

19. Pharmacy Jar with Heads of Young Boys

Attributed to Pesaro, the Marches, ca. 1470–80
Tin-glazed earthenware (maiolica), H. 10½ in. (26.8 cm), Diam. 8 in. (20.3 cm)
Fitzwilliam Museum, Cambridge (C.60-1927)

This jar is an example of a type known as an albarello. The form was adapted from Islamic prototypes by Italian potters in the fifteenth century. About 1500 the jars came to be inscribed with the names of drugs, herbs, or spices, indicating that they were often used by hospital pharmacies, spice stores, or herbalists.

The sculptural half-length busts on this pharmacy jar are typical of late fifteenth-century maiolica attributed to Pesaro; similar elements appear on many fragments found there[1] as well as on a famous pavement in Parma (formerly Convent of San Paolo, now in the Galleria Nazionale) that is thought to have been made by potters from Pesaro.[2] The busts presented here are differentiated from one another. The way in which they are represented resembles the manner in which identified individuals are portrayed on late fifteenth-century medals and coins.[3] It is not clear, however, whether these busts are intended to be viewed as portraits of specific individuals. It has been claimed that this albarello came from "the Bentivoglio pharmacy in Bologna" and that the busts were intended either to represent Giovanni II Bentivoglio (1443–1508), Lord of Bologna, and three of his many children or, more specifically, to depict Giovanni's four legitimate sons, Annibale II, Antongaleazzo, Alessandro, and Ermes, who appear in the 1488 fresco by Lorenzo Costa (ca. 1460–1535) in the Bentivoglio Chapel in San Giacomo Maggiore, Bologna.[4] Julia Poole has explained that both theories can be discounted, as the boys on the jar are shown as being much the same age, and there was a thirteen-year gap between the oldest and the youngest of Giovanni's sons.[5] Nonetheless, the busts are still thought to represent a family group.

The albarello closely resembles another, perhaps from the same set, which is also in Cambridge (fig. 58). This jar shows a young couple facing each other, separated by a

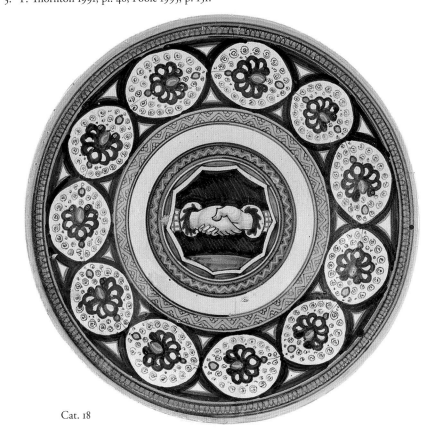

Cat. 18

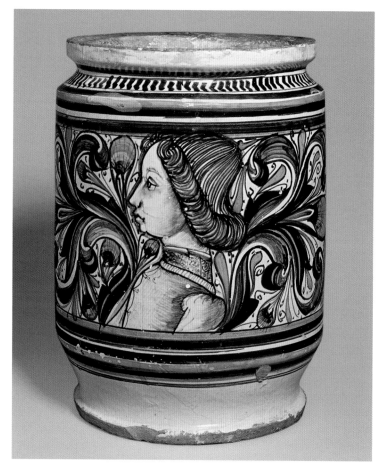

Cat. 19

8. Bettini 1991, p. 15; Poole 1995, p. 278.
9. Albarelli 1986, pp. 555–58; Ciaroni 2004, pp. 109, 212, doc. no. 217.
10. Berardi 1984, p. 40; Albarelli 1986, doc. no. 561.

SELECTED REFERENCES: Poole 1995, no. 353 (no. 352, for albarello perhaps from same set); Ravanelli Guidotti 2000, pp. 51, 52, 53, figs. 61, 64; Ciaroni 2004, pp. 56–59

20. Spouted Pharmacy Jar with Embracing Couple

Castelli (?), 1548
Tin-glazed earthenware (maiolica), H. 12⅜ in. (31.4 cm), Diam. 9⅞ in. (25.1 cm)
Inscribed on front: *ISOEPIU / FELICE OMO / DEQUESTA / TERRA 1548; AD.FARFARA;* on reverse, under handle: *P.P.A. / 1.5.4.8.;* on underside, incised: [cursive L-shaped] *1* [and] *8½ 8½* .
Philadelphia Museum of Art, The Dr. Francis W. Lewis Collection, 1903 (1903-28)

On one side of this pharmacy jar, a man and woman are captured in a moment of intimacy. Their faces almost touch, and one of his hands rests possessively on her chest, calling attention to her revealingly low neckline and beaded necklace. His other hand curls around her neck, while his legs drape suggestively over her knees, locking her in his embrace. A banderole floats above the couple, framing them with the message *ISOEPIU / FELICE OMO / DEQUESTA / TERRA 1548* (I am the happiest man on earth 1548). Though seated on separate stools, the figures project an aura of unity. The assumption must be that his happiness is due to possession of her. The diagonal grid pattern in the background suggests a tile floor and thus a domestic setting.

A second inscription, this in Roman capitals, is found below the pictorial roundel. It tells us that the contents of the jar was acqua di farfara, or a distillation of coltsfoot. Coltsfoot (*Tussilago farfara*) is a common plant from which various medicinal products were created. The ancient medical authorities Dioscurides, Pliny, and Galen recommended smoking the leaves to relieve respiratory symptoms such as coughs and catarrh. An emollient for topical use was also made from the plant as a remedy for skin irritations. Today, coltsfoot is used for treating bronchitis and asthma, though recently it has been associated with deleterious effects such as liver damage and cancer if consumed in large doses. Though no aphrodisiacal powers have been attributed to coltsfoot, contemporaries may have associated a healthy heart with achievement of romantic goals. At the very

vase of pinks or carnations, which serve as emblems of love and betrothal.[6] The imagery picks up that on contemporary nielli in belt fittings (see cat. nos. 36a, b) and in nielli prints.[7]

There is a strong Ferrarese character to the busts on both jars, which is unsurprising given that Ferrarese painters are documented as having worked in Pesaro in the late fifteenth century.[8] One member of a local pottery family, Almerico Fedeli di Ventura da Siena, who was a painter as well as a potter, associated with Ferrarese painters and was involved in litigation with one of them, Ranaldo da Ferrara, in 1481.[9] The high quality of maiolica made in Pesaro was recognized in a 1486 protective edict of Giovanni Sforza d'Aragona, in which it was stated that these pieces were "praised by anyone of understanding throughout Italy and beyond Italy."[10] DT

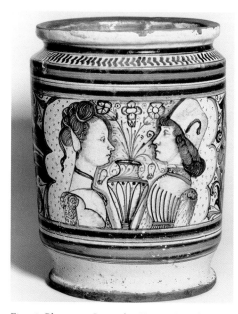

Fig. 58. Pharmacy Jar with a Young Couple, probably Pesaro, or elsewhere in the Marches, or Emilia-Romagna, ca. 1470–80. Tin-glazed earthenware (maiolica), H. 10⅝ in. (26.9 cm). Fitzwilliam Museum, Cambridge

1. Bettini 1991, p. 12; Poole 1995, p. 278; Ciaroni 2004, pp. 56–59.
2. Fornari Schianchi 1988.
3. Corradini 1998; Syson 1998.
4. Borenius 1931, p. 5 and pl. VII.
5. Poole 1995, no. 353.
6. Ibid., no. 352.
7. Hind 1936, p. 56, no. 247; Ravanelli Guidotti 2000, p. 52, figs. 61, 64; Syson and D. Thornton 2001, p. 55, fig. 36.

least, the suggestion of such a connection might have been a good advertising strategy.

The body of the jar is covered in a bold pattern of alternating yellow and green rosettes dotted with orange, with the remaining white space filled by calligraphic blue flourishes and green butterfly-like shapes. A pale green spout appears to grow from the upper body of the vessel, anchored to the body by dainty leaves. A series of bands featuring dashes, zigzags, and half-circles below the pharmaceutical inscription draws the eye to the vessel's foot. Figures indicating the volume of the jar are found on the bottom, suggesting that its contents had some commercial relevance.

A handle springs from the reverse of the jar, rising out of a white panel on which is figured a double cross that terminates in the letter *P*, most likely the emblem of a particular pharmacy, flanked by the personal initials *P* and *A*. Several design elements on this jar suggest an especially close relationship between it and at least three other vessels with similar initials and surface decoration. The same double cross and central *P* flanked by *P* and *A* are found on two albarelli illustrated by Carola Fiocco and Gabriella Gherardi.[1] The latter also have what appear to be identical decorative banding and patterning on the body, and use Roman capital lettering to describe the contents rather than Gothic, which is more common. A third related example, with initials *E* and *F*, is discussed by Timothy Wilson, who hypothesizes the existence of two series of pots made for "different monasteries or patrons, but for the same ecclesiastical organization."[2] The double cross can be compared to the emblem of the hospital of Santo Spirito, in Sulmona, though that monogram features the letter *S* rather than *P*.[3]

This jar belongs to a larger group of vessels, also dated 1548, that share characteristics of decoration and have been termed "colored porcelain" (*porcellana colorata*).[4] These are stylistically related in turn to several other groups of pots marked with a *T, B,* or *B°,* and possibly as well to a vast set generally referred to as the Orsini–Colonna series, after a well-known example in the British Museum, London.[5] The attribution of the Orsini–Colonna group, once thought to have been made in Faenza, to Castelli, was first suggested by Fiocco and Gherardi in the mid-1980s, and is now generally accepted.[6] But the attribution of the related groups, of which the Philadelphia jar is part, to Castelli, while attractive, is inconclusive on both technical and archaeological grounds.[7] The Abruzzo region of Italy, southeast of Rome, where Castelli is located, was a noted source of saffron since antiquity, and was also known for producing a large volume of pharmaceutical pottery during the sixteenth century.[8] With the appearance of pharmacopoeias and books of secrets in the late Middle Ages, tin-glazed earthenware emerged as an economical and expedient means of storage for the growing number of medicinal compounds available, stimulating the foundation and flourishing of potteries all over the Italian peninsula.[9]

DLK

1. Fiocco and Gherardi 1992, pls. XXVIII, XXIX.
2. D. Thornton and T. Wilson 2009, no. 337. I am grateful to Timothy Wilson and Dora Thornton for making this material available to me in manuscript.
3. Ibid. This monogram is tentatively identified in Poole 1995, p. 228.
4. Fiocco and Gherardi 1992, p. 162.
5. On the B° group, see Hess 2002, pp. 118–27. She maintains that these are from Deruta or Montelupo. Although she accepts the Orsini–Colonna attribution to Castelli, she disputes the B° and related groups' attribution to this center. On the British Museum jar which gives the series its name, see D. Thornton and T. Wilson 2009, no. 337.
6. Fiocco and Gherardi 1985.
7. Most recently, Hess (2002) disputes the attribution of the related B° group to Castelli, citing neutron-activation analyses, aimed at providing a specific origin for the clay, executed by Michael Hughes, who found that the group was not from Castelli. According to Timothy Wilson, however, Hughes also tested the albarello at the British Museum thought to be part of the Orsini–Colonna set and found it to be convincingly from Castelli, disputing Hess and her team's finding about the related B° series as well (D. Thornton and T. Wilson 2009, no. 337).
8. Fiocco and Gherardi 1992, p. 165.
9. On this, see Drey 1978, pp. 22–23; Goldthwaite 1989.

SELECTED REFERENCES: Fiocco and Gherardi 1992; W. M. Watson 2001, p. 201, no. 59, ill. p. 137; D. Thornton and T. Wilson 2009, under no. 337

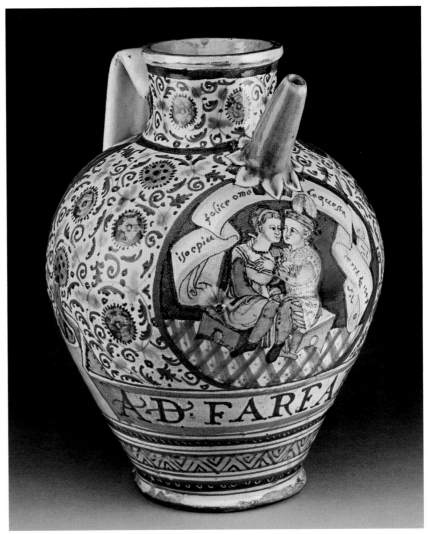

Cat. 20

21. Dish with a Young Man Blinded by Love

Umbria, probably Deruta, ca. 1460–75
Tin-glazed earthenware (maiolica), Diam. 13⅜ in. (34 cm)
Inscribed: *CALUIE CHE ENAMORATO QUISTO CREDE CHE ALTER SI CHIEDO E ESO POCHO VEDE*
Private collection, Siena

This large dish is painted in the well with the figure of an elegantly dressed young man. In one hand he holds a scroll, which swirls around him and on which is written: *CALUIE CHE ENAMORATO QUISTO CREDE CHE ALTER SI CHIEDO E ESO POCHO VEDE*, roughly translated as "The lover thinks that everyone else is blind, but really it is he who sees little." This ironic and popular motto points to the young man as someone who has been blinded by Love, while the lively drawing presents him almost as a figure of fun, in spite of his formal elegance.[1] The conceit is that of the cruelty of love (*amor crudel*).

The carefully recorded details of his dress help to date the dish fairly closely. He wears a tabardlike tunic (*giornea*) made of silk velvet with a contrasting border. The pleats of this tunic, which would have been open-sided, would have been held in place on the inside by stitches into the lining or by tapes, and, as shown here, the tunic would have been secured on the outside by a wide belt.[2] Underneath this the figure wears a high-necked doublet with separate, richly patterned silk sleeves. He also wears a dark flat-topped cap on his curling hair. On his legs are woolen particolored hose—each leg is a different color. He appears to wear flat shoes that, like his hose, match the contrasting colors on the border of his tunic. His dress can be compared to that of the adolescent Tobias in Andrea Verrocchio's *Tobias and the Angel* (National Gallery, London), which dates from about 1470–80, and to that of young men and boys in two of Perugino's panels with the Miracles of San Bernardino: *The Healing of Giovanni Rieti's Daughter*, which is dated 1473, and *The Healing of a Mute*, also dating from the early 1470s (Galleria Nazionale dell'Umbria, Perugia).

The form is typical of Deruta and can be compared with that of two Deruta dishes in the Victoria and Albert Museum, London (cat. nos. 22a, b). Both of those dishes feature moralizing inscriptions, like the one here, on the power of love. Both here and in catalogue number 22a, the figurative scene is surrounded by stylized Gothic leaves. The border is decorated with a motif of winding leaves scratched through purple into the creamy ground of the tin glaze. The figure is separated from the densely decorated border by a line, or contour panel, with clusters of small blue dots within it. All these features appear on fragments found in Deruta.[3] They also characterize a famous group of large presentation dishes (*piatti da pompa*) which were formerly attributed to Faenza but which have now been attributed to late fifteenth-century Deruta.[4]

This delightful dish represents the moment at which Deruta maiolica painters began to experiment with boldly drawn figures and with allegories and histories, just as maiolica painters in other centers, such as Pesaro and Faenza, were also starting to develop a narrative style (*istoriato*).[5] In the drawing of his profile as well as in the details of his costume and hairstyle, the young man here resembles a man on a large Deruta dish of about 1460–70 excavated in Foligno. It has recently been suggested that the portraitlike profile on the Foligno dish, which is much more fluently drawn than the figure on this dish, recalls the work of local artists such as the Foligno painter Nicolo di Liberatore l'Alunno.[6] One Deruta dish in the British Museum, London, is painted with the full-length figure of an armed young man which can be related to an early Florentine engraving.[7] It is possible that the figure on this dish may derive from a similar engraved source, as yet unidentified.　　DT

1. T. Wilson 2004, p. 40, fig. 1.
2. Birbari 1975, pp. 85, 88, figs. 90, 91.
3. Fiocco and Gherardi 1988–89, vol. 1, pls. va, b, and via, b.
4. Ibid., pp. 52–53; T. Wilson 2004, p. 40.
5. T. Wilson 2004.
6. Busti and Cocchi 2004, no. 4.
7. D. Thornton and T. Wilson 2009, no. 45; Hind 1938–48, pt. 1, p. 46, no. 52, and vol. 2, pl. 51, A.I.52.

SELECTED REFERENCE: T. Wilson 2004, p. 40, fig. 1

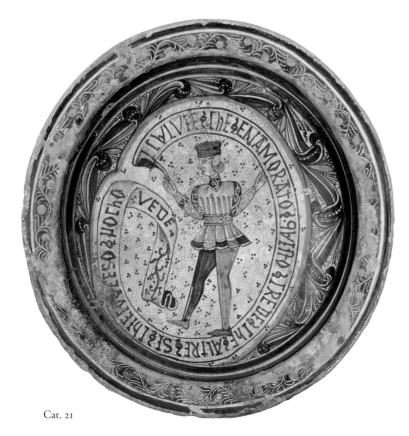

Cat. 21

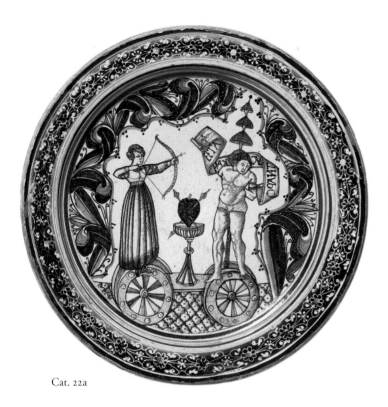

Cat. 22a

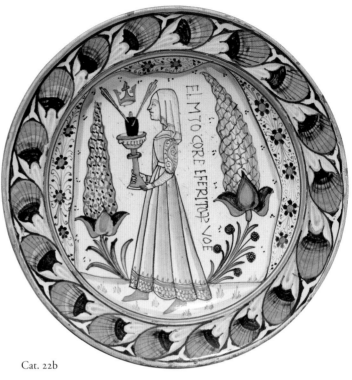

Cat. 22b

22a. Dish with an Allegory of Cruel Love

Deruta, ca. 1470–90
Tin-glazed earthenware (maiolica), Diam. 16½ in.
(42 cm)
Inscribed: *O Q[U]ANTACRUDELTA*
Victoria and Albert Museum, London (1806–1855)

22b. Dish with an Allegory of Cruel Love

Deruta, ca. 1470–90
Tin-glazed earthenware (maiolica), Diam. 15 in.
(38.5 cm)
Inscribed: *EL MIO CORE E FERITO P[ER] VOE*
Victoria and Albert Museum, London (2558-1856)
Not exhibited

At the center of catalogue number 22a, framed by a contour panel and Gothic foliage, is a young woman in northern Italian court dress of the late fifteenth century. She draws her bow to aim an arrow at a young man who is bound, naked, to a column. His figure is copied from an early Italian engraving illustrating Petrarch's *Triumph of Fame*, and the float on which the man and woman stand also recalls the imagery of Petrarch's *Triumphs*, which was closely associated with wedding feasts and spectacle in Renaissance Italy.[1] The two figures flank a standing cup

supporting a heart pierced by two arrows (see cat. no. 22b). A scroll flutters around the young man's head, inscribed *O Q[U]ANTA-CRUDELTA* (O what a cruel fate).

The young woman at the center of catalogue number 22b also wears northern Italian court dress of the late fifteenth century. She holds as a trophy a standing cup containing a heart pierced by two arrows, surmounted by a crown. She is flanked by two large, stylized plant stems, and an inscription running vertically behind her figure reads, *EL MIO CORE E FERITO P[ER] VOE* (my heart is wounded by you).[2] The words are intended to be those of the male lover, whose heart has been pierced by the woman's glances as if by arrows.

The idea that the beloved's gaze wounds the heart of the lover has a long history: in the biblical Song of Songs (4:9) the poet addresses his lover: "Thou hast ravished my heart, my sister, my spouse; thou hast ravished my heart with one of thine eyes."[3] The portrayal of the young women here as archers who unleash arrows into the heart of the beloved, both inflicting pain and inflaming desire, is essentially a literary conceit, echoing late-medieval love poetry in the vernacular, such as a poem by Dante Alighieri (1265–1321) in which the poet promises to avenge himself on the stony-hearted woman who has pierced him to the heart with her glance: "To such a woman, O my song, go straight / to her who wounded me and still conceals / what I most

hunger for: / her heart (oh, now!) with a fast arrow cleave, / for in revenge great honor we achieve."[4] The beloved as archer appears on two plates dated between 1440 and 1460 and attributed to the Tuscan pottery-producing town of Montelupo. On one of these (Museo Archeologico, Montelupo) a female archer strides with her bow and arrow before a scroll inscribed *IMENSO [A]MORE[E]* (immense love), whereas on the second (Musée National de la Renaissance—Château d'Écouen) an archer bears a bow in one hand and points with her other hand to a scroll reading *DIANA BELLA* (beautiful Diana), perhaps in reference to the ancient Roman goddess and virgin huntress.[5]

Large presentation dishes of this type are known as *piatti da pompa* and were designed to be displayed on a buffet rather than used.[6] Some later examples are pierced through the foot for a cord to be threaded through, allowing the piece to be hung on the wall in the manner of a print. The careful drawing on these dishes and their moralizing inscriptions reflect their role as presentation and display pieces.

These two dishes were long believed to be products of Faenza. Both, however, can now be firmly attributed to the Umbrian town of Deruta. Catalogue number 22a is comparable in form, decoration, and facture with pottery fragments found locally.[7] The scale, shape, and transparent lead glaze on the reverse of catalogue number 22b, as well as its

decorative elements and manner of drawing, are also typical of Deruta. Close parallels can be found in locally discovered fragments in public collections.[8]

DT

1. Rackham 1940, no. 112; Syson and D. Thornton 2001, p. 66.
2. Rackham 1940, no. 113.
3. Busti and Cocchi 2001, p. 22.
4. Dante, *Rime per la donna pietra*, 1969 (ed.), p. 577 (ll. 79–83): "Canzon, vattene dritto a quella donna / che m'ha ferito il core e che m'invola / quello ond'io ho più gola, / e dille per lo cor d'una saetta; / chè bell'onor s'acquista in far vendetta."
5. F. Berti 2002, nos. 7, 8.
6. Busti and Cochi 2001, p. 90.
7. Fiocco and Gherardi 1988–89, vol. 1, p. 53, fig. 11; T. Wilson 2004, p. 40.
8. Fiocco and Gherardi 1988–89, vol. 1, pp. 52–53, fig. 12; T. Wilson 2004, p. 40; D. Thornton and T. Wilson 2009, no. 45. Many fragments are in the collection of the Museo Regionale della Ceramica, Deruta.

SELECTED REFERENCES: Rackham 1940, nos. 112, 113; Fiocco and Gherardi 1988–89, vol. 1, pp. 52–53, figs. 11, 12; Busti and Cocchi 2001, no. 29; F. Berti 2002, nos. 7, 8; T. Wilson 2004, p. 40; D. Thornton and T. Wilson 2009, under no. 45

(Ludovica) and *GABRIIELLA BE[LLA]* (beautiful Gabriella).[2] The vase in Faenza and the Metropolitan's vase are of almost identical form and facture and may be attributed to the same workshop.

The purpose of this type of vase is still uncertain, though similar vases could be used for growing herbs or topiary on a balcony or terrace. A mid-fifteenth-century Florentine cassone (wedding-chest) panel painted with the story of Cupid and Psyche (Gemäldegalerie, Staatliche Museen zu Berlin) shows fashionable young women, one of whom holds a carnation as an emblem of betrothal. They stand in a roof garden, where a row of two-handled maiolica vases, apparently of a type imported from southern Spain, has been arranged on a ledge. The vases are being used to grow evergreens, one of which has been pruned to form the Medici device of a diamond ring and three feathers.[3] If tending potted plants was a pastime traditionally associated with women in the Italian household, as literary and pictorial evidence suggests, this might explain the presence of the two women's names on the vase in Faenza.[4] It appears that vases of this type made suitable gifts for young women: a contemporary Deruta jar, also with two rope handles, is inscribed *AT[E]LV[CIA]BE[LLA]*,

or "For you, beautiful Lucia."[5] The inscription links it to dishes with idealized female heads and inscriptions in praise of individual women (see cat. nos. 9–12) and to other pieces traditionally associated with betrothal (see cat. nos. 13–15).

DT

1. Fiocco and Gherardi 1988–89, vol. 1, p. 33, fig. a, pp. 53–55; Busti and Cocchi 2001, p. 66.
2. Ravanelli Guidotti 1990, no. 88; Busti and Cocchi 2001, no. 17; Busti and Cocchi 2004, p. 19, fig. 3.
3. Syson and D. Thornton 2001, p. 202, fig. 163; Spallanzani 2006, pp. 126, 127, fig. 14.
4. Ravanelli Guidotti 1990, p. 156, figs. 88e, f.
5. Gardelli (Giuliana) 1999, no. 181.

SELECTED REFERENCE: Busti and Cocchi 2001, under no. 17

23. Vase with an Amorous Inscription

Deruta, second half of 15th century
Tin-glazed earthenware (maiolica), H. 10⅛ in. (25.7 cm)
Inscribed: *NON TE POSSO LASSARE*
The Metropolitan Museum of Art, New York, J. Pierpont Morgan Gift, 1965 (65.6.3)
New York only

On one side a bird holds in its beak a scroll with the amorous inscription *NON TE POSSO LASSARE* (I cannot leave you). The theme of love and longing is continued in the imagery on the other side, which shows a heart, pierced by an arrow, with drops of blood and with leaves and acorns sprouting from the severed aorta. Catalogue numbers 22a, 22b, and 25 show comparable imagery.

The form and decoration of the vase are typical of the small Umbrian pottery town of Deruta. The rope handles are of a kind found as kiln wasters in Deruta, and also appear on a drawing of a vase on a Deruta tax document of 1489.[1] The decoration can be matched to that of other double-handled vases attributed to the city, such as an example now in the Museo Internazionale delle Ceramiche, Faenza, bearing an inscription, in Gothic script, in tribute to two women, *LUDIVICHA*

Cat. 23

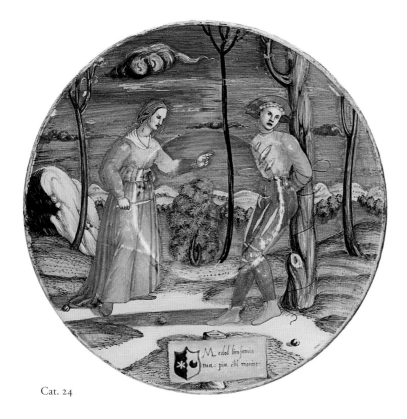

Cat. 24

and another, with Dido, dated 1522.[8] A group of small bowls with saints can also be attributed to this painter (see cat. no. 11). His identity is unknown, but his narrative wares are outstanding for their quality and grace, making him one of the earliest and finest of all painters in this style working in the duchy of Urbino. His pieces are also striking for their dazzling and highly successful golden and red luster finishes, as evident here.

DT

1. Falke 1925, p. 9, no. 88, pl. xx; Ballardini 1933–38, vol. 1, p. 44, no. 119, fig. 114; Rackham 1958, p. 149, ill. no. 1.
2. T. Wilson 1996b, no. 50.
3. Kube 1976, no. 90; Poole 1995, no. 296; Ivanova 2003, no. 117.
4. Poole 1995, p. 222; Mallet and Dreier 1998, p. 226; D. Thornton and T. Wilson 2009, no. 296. Rasmussen 1989, no. 116, attributed the Metropolitan's Saint Ubaldus plate to the Saint Ubaldus Painter.
5. Join-Diéterle 1984, p. 167; Fiocco and Gherardi 1988–89, vol. 2, pp. 421–22; Mallet and Dreier 1998, no. 11; T. Wilson 2002b, pp. 113–14; Barbe and Ravanelli Guidotti 2006, no. 4; D. Thornton and T. Wilson 2009, no. 296.
6. Rackham 1940, no. 666.
7. Fiocco and Gherardi 1988–89, vol. 2, p. 424, fig. 125; T. Wilson 1993, pp. 169–72.
8. T. Wilson and Sani 2006–7, vol. 2, no. 58 and p. 349, n. 2.

SELECTED REFERENCES: Falke 1925, p. 9, no. 88, pl. xx; Ballardini 1933–38, vol. 1, p. 44, no. 119, fig. 114; Rackham 1958, p. 149, ill. no. 1; Poole 1995, p. 222

24. Plate with a Love Argument

Gubbio, workshop of Maestro Giorgio Andreoli, the Painter of the Judgment of Paris, dated 1522
Tin-glazed earthenware (maiolica) with luster, Diam. 10½ in. (26.7 cm)
Inscribed: ME DOL L'INFAMIA TUA: PIU CHE [I]L MORIRE
The Metropolitan Museum of Art, New York, J. Pierpont Morgan Gift, 1965 (65.6.10)

The scene, set in a landscape, shows a heated argument between a well-dressed young couple. The woman holds a knife in her right hand; with her left, she points at her lover, whom she has tied to a tree. She appears to address him in her fury as she advances toward him. He looks away, in the direction of the viewer. A cartouche in the foreground is painted with the arms of a patron and the inscription ME DOL L'INFAMIA TUA: PIU CHE [I]L MORIRE (your infamy hurts me more than death).[1] The meaning of the scene remains elusive. In some of its elements the scene resembles that in an early Florentine engraving in which a woman has tied her lover to a tree and has just plucked his heart from his breast, signifying the cruelty of love and the vulnerability of the lover (fig. 59). Here, the inscription adds complexity: since it is the young man who is threatened at the hand of his lover, it must be he who is speaking, in which case the "infamy" must be that of the woman. The scene and inscription might be based on a contemporary print, yet to be identified, or on a *novella*, or romance,

as has been suggested in the case of other, less complex representations of love arguments on maiolica.[2] The arms—which have been tentatively identified as those of the Turamini family of Siena—also appear on two other lustered pieces, one with Mercury, Herse, and Aglauros (Fitzwilliam Museum, Cambridge) and the other with the Fall of Phaeton (State Hermitage Museum, Saint Petersburg); both are dated 1522.[3] The presence of the arms indicates that all three plates belonged to the same set of dining wares.

These three armorial pieces have been convincingly attributed to the Painter of the Judgment of Paris, named after a famous lustered plate of that subject (Collection Dutuit, Musée du Petit Palais, Paris).[4] The Paris plate is inscribed on the back, in blue, *MO GIORGIO 1520 A DI 2 DE OCTOBRE B.D.S.R INGUBIO* (Maestro Giorgio, October 2, 1520, B.D.S.R. in Gubbio), proving that the piece was both painted and lustered in Maestro Giorgio Andreoli's workshop in Gubbio.[5] The earliest piece attributed to the Painter of the Judgment of Paris, on stylistic grounds, is a bowl with Saint Francis, dated both 1518 and 1519 (Victoria and Albert Museum, London).[6] A plate of 1520 attributed to him, with Hercules and Antaeus, is in the National Gallery of Art, Washington, D.C.; two others, also dated 1520, one with Peleus and Thetis and the other with Adonis and Myrra, were destroyed during World War II.[7] To these can be added a plate in the Fondazione Cassa di Risparmio, Perugia, with Venus and Cupid, dating from 1520–25,

25. Fluted Bowl (Crespina) with an Allegory of Unrequited Love

Faenza, possibly workshop of Virgiliotto Calamelli, dated 1538 twice on the border
Tin-glazed earthenware (maiolica), Diam. 10⅞ in. (27.5 cm)
Fondazione Cassa di Risparmio di Perugia (Wilson-Sani 27)

This form of molded dish, made in imitation of embossed silver prototypes, is known as a *crespina,* after the word *crespa,* "wrinkle."[1] Allegories of love or female exemplars of virtue, such as Lucretia, the legendary heroine of ancient Rome, are often painted on this type of dish. The woman seated at the center here smiles in cruel triumph as she regards the heart of her lover, held in one hand like a fruit, which she prepares to pierce or cut with a dagger.[2]

The theme of cruel, one-sided love (*amor crudel*) which is portrayed here is a literary

one, taken up in early niello prints, wood-cuts, and engravings. An early Florentine engraving from the series known as the Otto Prints (British Museum, London), which dates from about 1465–80, shows a young woman before her lover, whose arms she has bound behind a tree (fig. 59). She triumphantly presents his heart, which she has just plucked from his chest.[3] A shorthand variant on the theme shows a woman holding a spear or arrow, in readiness to inflict pain.[4] Sixteenth-century engravings (such as one by Sebald Beham dating from about 1539) show Venus as the goddess of love, holding a flaming heart in one hand and an arrow in the other, indicating her capacity both to inspire longing and to inflict pain in the heart of a lover.[5] Flaming, bleeding, or pierced hearts are often found on their own as decorative motifs on Faentine maiolica and tiles from the late fifteenth century.[6]

The *crespina* form was made in a number of workshops in the pottery-producing town of Faenza from the 1530s, and decorated in a variety of ways: with a dark blue base color (*berettino*), as here; with brilliantly contrasting fields in the swirling panels; or with a plain white ground and small, sketchy motifs. The form might have been used as a fruit bowl. Some examples are pierced, presumably to allow air to circulate; others are decorative and filled with maiolica imitation fruit, perhaps in a playful reference to the real fruit the *crespina* might have held in the Renaissance household.[7] A 1587 conduct book for brides recommended offering sweetmeats and fruit to guests as a key element in welcoming visitors to the home.[8] A dish like the *crespina* was well suited in both form and decoration for such a function.

This *crespina*, which is twice dated 1538 on the border, can possibly be attributed to

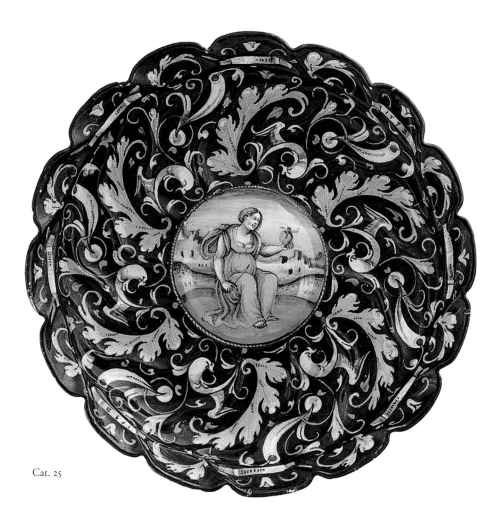

Cat. 25

the workshop of Virgiliotto Calamelli, who is documented in Faenza from 1531 and who died before 1570. The huge scale of his business is indicated by a workshop inventory of 1556.[9] Comparison with one of Calamelli's marked pieces showing Saint Jerome (present location unknown) suggests that the present bowl, although unmarked, is likely a product of his workshop.[10] DT

1. Hess 1988, no. 27.
2. T. Wilson and Sani 2006–7, vol. 1, no. 27.
3. Hind 1938–48, pt. 1, vol. 2, pl. 144, A. IV.15; Hess 1988, p. 88.
4. D. Thornton and T. Wilson 2009, no. 97.
5. Bartsch VIII.162.118. For an impression in the British Museum, see Department of Prints and Drawings, 1931,5-11,14.
6. Ravanelli Guidotti 1988, nos. 170–75; Ravanelli Guidotti 2000, pp. 346–47.
7. T. Wilson 1987, no. 115.
8. Ajmar-Wollheim 2006b, p. 209.
9. Ballardini 1916; Ballardini 1918; Grigioni 1934; Ravanelli Guidotti 1996b, pp. 78–91.
10. Rackham 1959, no. 317; T. Wilson and Sani 2006–7, vol. 1, p. 303.

SELECTED REFERENCE: T. Wilson and Sani 2006–7, vol. 1, no. 27

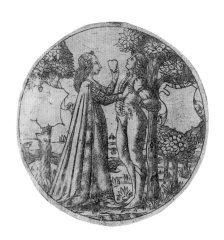

Fig. 59. Baccio Baldini (1436–ca. 1487), attributed to, *The Cruelty of Love,* ca. 1465–80. Engraving, Diam. 4 in. (10.1 cm). The British Museum, London

26. Wineglass or Sweetmeat Cup (Confittiera) with Scenes of Virgil and Febilla

Venice, ca. 1475–1500
Glass, enameled and gilded, H. 8½ in. (21.6 cm),
W. 4⅞ in. (12.4 cm)
Inscribed: *VERBLIO; VENITE*
The Metropolitan Museum of Art, New York, Gift of
J. Pierpont Morgan, 1917 (17.190.730a, b)
New York only

Three vignettes arranged clockwise around the bowl of this glass goblet illustrate the folk tale of Virgil the Sorcerer and Febilla, daughter of the emperor of Rome. Virgil (70–19 B.C.), the great poet of Rome's Augustan age, was revered by early Christians for what they perceived to be a foretelling, in the *Eclogues* (4.4–52), of the coming of Christ. In the popular imagination, the pre-Christian seer came to be regarded as a magician with amazing powers to outwit wrongdoers and to reverse the acts of evil powers. However, the story of Virgil the Sorcerer and the emperor's daughter shows him in a very different light.[1]

On this cup, the story begins at the white, blue-domed tower with a closed door at ground level and a single open window at the top. Virgil, crammed into a basket, dangles in midair from a rope held by a woman standing at the window embrasure. It is morning, and Virgil is observed by a crowd of Romans. They know that he was frustrated in a presumptuous attempt at a romantic nighttime rendezvous with Febilla in her own father's house in his absence. Townsmen assembled by the tower exhibit various reactions: one shrugs, one scowls, one wrings his hands, and one, smirking, clasps his stomach with both hands, suppressing a guffaw. Their eloquent expressions are delineated with a minimum of small, deft touches of black enamel. The men exhibit the four humors—phlegmatic, choleric, melancholic, and sanguine—that in the Middle Ages and well into the seventeenth century were believed to represent the four basic human personality types.

The breadth of the next vignette suggests the lapse of some time and distance. A messenger rides to tell the emperor,[2] away on campaign, what has befallen Rome. As revenge on Febilla, Virgil has caused all the fires in Rome to go out—the worst calamity that could befall the city—and has offered the emperor only one remedy. All the women in Rome must relight their fires from a live coal that Virgil had set within Febilla's body. The largest scene on the glass illustrates the horrific finale. From the doorway of his tower,

the emperor fixes his dread-filled gaze on his daughter. Virgil, looming above Febilla from the city wall, gloats as he holds his immense book of spells. (The enameler has drawn the wall as a medieval town wall, with a variety of towers at intervals along its length.) Febilla stands on a low pedestal inscribed *VENITE* (come here), and heaves up her skirt to prepare for her punishment. Shrinking but stoic, and already bleeding, she awaits her ordeal: to be repeatedly ravished by Virgil's surrogates—the large tapers held by long lines of girls, the unwilling instruments of Virgil's lust and fury. They must draw fire from the live coal concealed within Febilla's body so that the domestic fires throughout Rome can be rekindled, saving the hearths, which were considered to ensoul the life forces of the city.

This sumptuous and rare example of the glassmaker's and the enameler's art appears to be unrelated to themes of marriage and love. However, among the girls is a small rabbit, which was a commonly understood symbol of lust, the opposite of love. The presence of the rabbit is a contemporary comment on the old story. Italians deplored Virgil's implacable revenge. Febilla, who preserved her virginity, saved Rome by accepting her fate, becoming a heroic figure, whereas Virgil, isolated and impotent to inflict further harm,

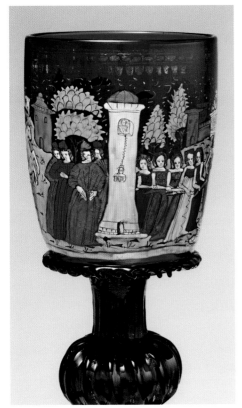

Cat. 26, view 1

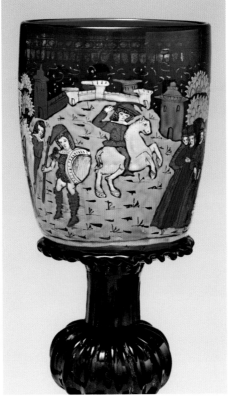

Cat. 26, view 2

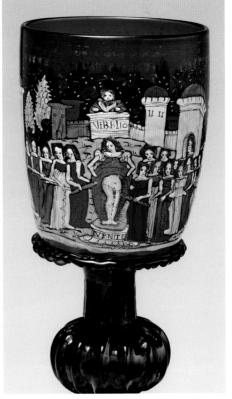

Cat. 26, view 3

derived no benefit from his humiliation of the princess.

In ancient Rome a vestal virgin was flogged to the point of shredding the skin if she allowed the sacred fire of Vesta in the vestals' care to go out. Unchastity was punished by live burial. A confused, faint memory of the vestals appears to have colored the Virgil and Febilla folk tale. A contemporary, late fifteenth-century social viewpoint is expressed in the postures and dolorous expressions of the girls depicted on the glass. Although they do not approve of Virgil's frustrated scheme, there lingers among them a superstitious belief in the power of sorcery.

This fine goblet is undoubtedly Venetian. In its original form, it had a gently barreled side and a ruff around the base, raised on a vertically fluted columnar pedestal with a spreading trumpet foot.[3] The minute scale, the plentiful use of gold leaf—for the top border, details of the sky, all the heads of hair—and the simple brilliant colors suggest that the designer had had training in illuminated manuscripts. The lovely blue, red, green, purple, and white enamels rise slightly from the surface, giving a jeweled effect. Details were added in black and red. The enamels are separated from each other by narrow reserves of the blue glass, becoming demarcation lines of a sort for the enameler. They may have been necessary to separate the colors in order to avoid their running into each other when heated. This enameling technique survives in a few scattered examples from the late fifteenth century, all of which exhibit themes where women are the active protagonists and all of which were clearly made in the same glasshouse.[4]

The goblet is without doubt meant to be examined and appreciated and to elicit comment. It was most likely made as part of a service for a dessert of sweet wine or as a *confittiera*, a container for sweets such as sugared almonds and candied dried fruits. These were invariably offered as the relaxed final course of a feast, banquet, or wedding celebration, for the guests of a host of high status and ample resources.

JMCN

1. For the medieval story of Virgil and Febilla, and variations on it, see *Wonderful History of Virgilius* 1893, pp. 33–35, 50, 77; and Comparetti 1895, pp. 326–27.
2. The emperor is accoutered as a Roman officer, except for his high concertina-sided knee boots.
3. The original shape of the foot and stem was probably like that of a goblet with a very similar vertically ridged stem and slightly barrel-sided body, with a pincered trail around the lower edge, That goblet, in the Museo Nazionale del Bargello, Florence, is

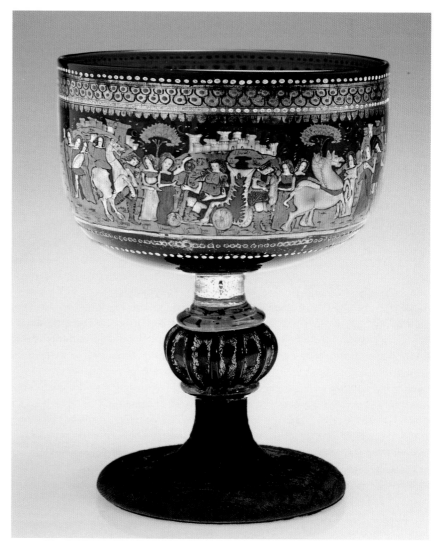

Cat. 27

illustrated in Barovier Mentasti 1988, p. 32, no. 52, where it is dated to the second half of the fifteenth century.
4. New research indicates the enameling was fired in a glass furnace, so that the Beroviero family's glass furnace on Murano can again be considered a probable origin. The family was the leading owner of glasshouses, and the leading maker of glass, in Murano. See R. Schmidt 1911, pp. 249–51; and Gudenrath 2006, pp. 47–58.

SELECTED REFERENCES: *Catalogue des objets d'art . . . Alessandro Castellani* 1884, pt. 2, lot 405; Christie's, London, sale cat., May 6, 1890, lot 96, ill.; R. Schmidt 1911, pp. 257–58, fig. 4; R. Schmidt 1912, p. 89; McNab 2001, p. 46, ill.

27. Footed Glass with a Cavalcade of Young Men and Women

Venice (Murano), late 15th century
Dark blue and colorless glass, blown, mold-blown, enameled, and gilded (original foot missing and replaced with wood covered in velvet), H. 7½ in. (19.1 cm), Diam. of rim 5⅞ in. (14.9 cm)
Lent by the Toledo Museum of Art; Purchased with Funds from the Libbey Endowment, Gift of Edward Drummond Libbey (1940.119)

A narrative frieze, painted in enamel with gold highlights, stretches all around the middle of the bowl and would have been viewed as a continuous scene as one turned the glass in one's hand. The decoration shows young men, some armed and holding shields and some riding prancing white horses, and groups of young women in *all'antica* dress, gesturing obscurely to one another. In a triumphal car apparently drawn by two white horses sits an armed and crowned man, who touches the hand of one of the women. The scene is set in a landscape punctuated by stylized trees and towns on distant grassy hilltops.[1]

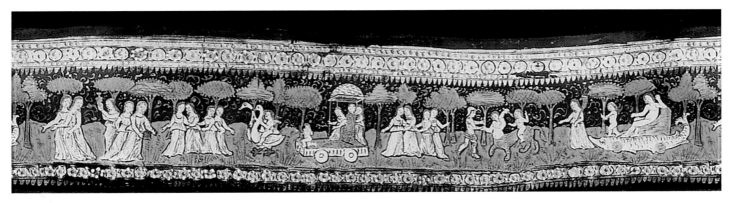

Fig. 60. Standing cup with *The Triumph of Hymen* (detail), Venice (Murano), mid-15th century. Blue glass with enameled and gilded decoration. The British Museum, London

With its repeated elements, the scene lacks coherence as a narrative, but may be intended as an illustration of a contemporary *novella,* or romance. It resists precise interpretation, as the significance of the particular elements and their arrangement is unclear. It includes the kinds of details (elaborate *all'antica* costumes and armor and a triumphal car) that would have been familiar to contemporary viewers from the cavalcades, morality plays, and processions accompanying dynastic marriages and civic celebrations.[2] The iconography is closely related to that of contemporary woodcuts and literary descriptions in editions of Petrarch's *Triumphs* and the dream-romance *Hypnerotomachia Poliphili* (Venice, 1499; cat. no. 63). (For such imagery on maiolica, see cat. no. 4.)

The narrative on the Toledo glass has been interpreted as a Triumph of Fame.[3] There are various problems with this interpretation, not least that Fame is generally personified as a woman, accompanied by trumpets that broadcast her influence through the world, as seen on the Florentine birth tray commissioned from Scheggia about 1448 or 1449 to mark the birth of Lorenzo de' Medici (cat. no. 70). We cannot be certain about the subject of the enameled decoration on this glass.

The decoration has several distinctive features: the landscape with its trees and towns; the palette with its curious violet tones and touches of red; and, above all, the sketchy style of the drawing in dark brown, which comes close to scribbling. The same features are found in the decoration of a glass in the Metropolitan Museum (cat. no. 26). This glass belongs to a group of glasses that are enameled (though not by the same artist) with similarly lively but inept imagery, including one with the Triumph of Hymen, the Roman god of marriage, in the British Museum, London (fig. 60).[4]

It is possible that the imagery here is related to betrothal and marriage rituals. Glasses decorated with triumphs or cavalcades, or with playful putti or the paired heads of a man and a woman, have traditionally been called *coppe nuziali* (marriage cups).[5] They are thought to have been commissioned or bought for the couple to drink from as a symbolic gesture at a particular moment at a marriage feast.[6] There is no documentary evidence for this assumption, which is based almost entirely on the interpretation of the decoration of such glasses and on what little we know about mainly Florentine and Roman marriage rituals. Large covered cups in silver and in glass were used in formal dining and were valued as commemorative display pieces to mark a particular event within a family or community, particularly in northern Europe, where the tradition is well documented.[7] Surviving pieces demonstrate the point. For example, a tall Venetian glass covered cup in the British Museum, which copies silver prototypes, is inscribed on its foot with a drinking toast in Czech, suggesting that it came to be used, sometime after its making, as a welcome cup in the castle of Deblín, in Bohemia.[8]

It has recently been proposed, however, that the large size of the Toledo glass, with its unusually shaped and heavy bowl, might signal an alternative function, that of presenting sugared almonds, or *confetti,* at a particular occasion in marriage or birth rituals.[9] Fifteenth-century written and visual evidence indicates that *confetti* were bought and even given in birth rituals in special boxes made from wood shavings and lined with paper or skin to keep the contents fresh.[10] Containers or dishes (*confettiere*) for presenting *confetti* were part of specially designed silver dining sets in the late fifteenth century, like the one designed by the Ferrarese court painter Cosmè Tura (1430?–1495) for Ercole d'Este.[11] In a 1444 fresco (cathedral of Monza, near Milan) depicting in a Renaissance setting the sixth-century wedding of the Lombards Theodelinda and Agilulf, servants offer the diners what appear to be silver-gilt cuplike vessels filled with *confetti*.[12] Shallow silver-gilt bowls on low feet are shown with what appears to be *confetti* at a wedding banquet on a *spalliera* panel in the National Gallery,

London, one of a set of three made by the Griselda Master to commemorate a double wedding in the Spannochi family of Siena in 1494.[13] It is possible that early sixteenth-century colorless glass dishes of the same form, generally known as *tazze*, were used for this function. *Confetti* were also served on other social occasions: a well-brought-up married woman was expected to offer them to guests in her home, according to a late sixteenth-century manual for young brides.[14]

DT

1. Jutta-Annette Page in Page 2006, no. 29.
2. Syson and D. Thornton 2001, p. 66.
3. Page in Page 2006, no. 29.
4. Syson and D. Thornton 2001, pp. 66–67.
5. Tait 1991, p. 160, fig. 203; Syson and D. Thornton 2001, p. 66.
6. Matthews Grieco 2006, p. 117.
7. Tait 1981, p. 71.
8. Tait 1979, no. 23; Tait 1981, p. 35; Syson and D. Thornton 2001, p. 189, fig. 153.
9. Page in Page 2006, p. 81.
10. Musacchio 1999, p. 41.
11. Syson and D. Thornton 2001, p. 139. The set is known only from a description in a 1473 inventory of silver belonging to Ercole d'Este.
12. P. Thornton 1991, p. 238.
13. Luke Syson in Syson et al. 2007, pp. 230–33, no. 64.
14. Ajmar-Wollheim 2006b, p. 209.

SELECTED REFERENCE: Jutta-Annette Page in Page 2006, pp. 78–81, no. 29

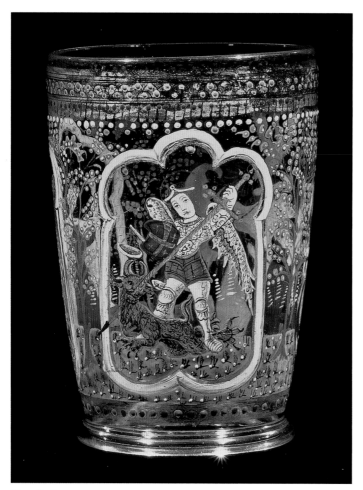

Cat. 28, view 1

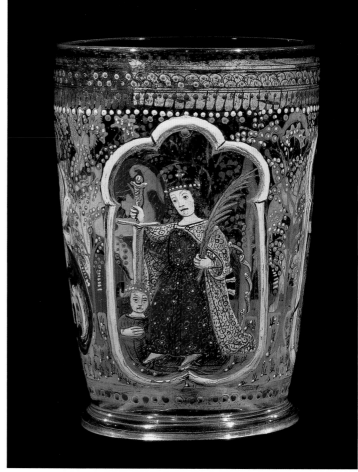

Cat. 28, view 2

Fig. 61. Behaim Beaker (one of a pair), 1495 (?). Colorless glass, enameled and gilded, H. 4½ in. (11.5 cm). Private collection

28. Behaim Beaker

Venice (Murano), ca. 1495
Colorless glass *(cristallo)*, blown, enameled, and gilded,
H. 4¼ in. (10.7 cm), Diam. 3⅛ in. (7.9 cm)
Lent by the Corning Museum of Glass, New York.
Purchased with funds from the Houghton Endowment Fund (84.3.24)

As early as the thirteenth century, Venetian glassmakers had successfully produced colorless glass *(cristallo)*, but it was only from the fifteenth century that the glass commanded the attention of patrons across Europe. From about 1450, Venetian craftsmen made large, standing, covered cups in *cristallo,* and "betrothal goblets" in blue, green, and turquoise glass, to which gold and enamels were richly applied. Pieces could be customized by the addition of arms or suitable figurative decoration, such as the paired heads of a couple or a triumphal procession, and this heightened their appeal.[1]

This beaker is enameled with the arms of the Behaim family, one of the twenty families that belonged to the old patriciate of Nuremberg. The glass must therefore have been commissioned by a member of the Behaim family.[2] Several small details show that the Venetian enameler, who was probably working from a pattern provided by the

client, was not familiar with Nuremberg heraldry. He has changed the eagle on the crest into a white bird with a pointed beak, and the targe, or special shield used for jousting, is lacking its cutout (bouche), which serves as an armrest. Finally, the helm lacks the breathing holes on the sides that are always featured in Nuremberg renditions of these arms. In two panels on the glass, figures are enameled: in one panel, the archangel Michael slaying a dragon, and in the other, the martyr Saint Catherine of Alexandria holding her attributes, a palm and the sword with which she was beheaded. At her feet is the Roman emperor who had tried to force her to relinquish her faith. (Catherine is said to have been martyred in the early fourth century, so the emperor is either Maxentius or Maximinus.) The wheel at her right side, which is now scarcely visible owing to loss of gilding, alludes to the intended instrument of her execution, a machine of spiked wheels, which shattered before it could be used. The figures and the arms are set against a background of blossoming trees in a green meadow; the blossoms are formed from densely painted enamel drops in green, white, and blue.[3]

Until 1978 this beaker was kept as a pair with another, which is now in a private collection in Bremen (fig. 61). The Bremen beaker

is slightly larger, at 4½ inches (11.5 cm) in height, and the Behaim arms are enameled on it twice, though in the same way as on the Corning beaker. There are no figures on the Bremen beaker, but it is decorated with the same trees and meadow as appear on the Corning beaker, rendered in the same manner. All these features indicate that the beakers were made as a pair.[4] The iconography of the Corning beaker—the archangel Michael and Saint Catherine, an unusual combination, are likely the name saints of the couple celebrated—suggests that the beakers were commissioned for Michael IV Behaim (1473–1522) and Katharina Lochnerin (d. 1527), who married in Nuremberg on July 7, 1495.[5] Michael was a knight and civic official in Nuremberg.[6] His wife, Katharina, was the daughter of a rich merchant in the city who controlled the trade between Nuremberg and Venice, which may explain how the commission for the beakers came to be placed with a Venetian glasshouse. Nuremberg patrician families such as the Imhoff are documented in the early sixteenth century as having discerning tastes for Venetian sculpture and maiolica, as much as for the art of their native city.[7] The Behaim beakers are the first documents of a taste among the Nuremberg elite for Venetian glass. Their commissioning represents a new aesthetic among the urban elite of northern Europe.

The marriage of Michael IV Behaim and Katharina Lochnerin proved childless, but from 1511 they acted as guardians to their orphaned nephew Michael V Behaim, bringing up the boy in their home until his apprenticeship in Milan, from 1523.[8] He is likely to have inherited the beakers. Nuremberg patricians, to judge by the evidence of their silver, guarded family heirlooms carefully. A good example is the three silver-gilt double cups commissioned by various generations of the Tucher family, which document family marriages and deaths in the early to mid-sixteenth century (Schroder collection, London).[9] There is no reason to think that the delightful Behaim beakers would have been regarded as any less important in the family history, despite their being made of glass rather than silver.

The beakers could have been commissioned from Venice in 1495, or at some point before Michael's death in 1522. Apart from being the name saint of Michael's wife, Saint Catherine of Alexandria, on the Corning beaker, may indicate an association with marriage of a different kind. This saint, although she was a holy virgin, was promoted in the literary hagiographies as a model for Christian wives on account of her mystical marriage to Christ. The fifteenth-century preacher Saint Vincent Ferrer counseled wives and unmarried virgins to emulate her in her special relationship with Christ.[10] Her presence on the Corning beaker may therefore have a double significance. If the beakers were commissioned upon the marriage of the couple in 1495, it is puzzling that the Lochner arms do not appear on the glasses, either impaled by the Behaim arms or paired with them in some way. Other beakers of this type—in blue, turquoise, and milk-white opaque glass—are rare and difficult to date.[11] Comparison of the enameled figures on the Corning beaker with those on milk-white glasses associated with betrothal and marriage suggests that a date of about 1495–1500 is likely to be correct.[12] The Behaim beakers therefore appear to bridge the gap between the taste for enameling on strongly colored glasses and that for enameling on colorless *cristallo*, which was to supercede it in the early years of the sixteenth century. DT

1. Tait 1979, nos. 17, 21, 22; Barovier Mentasti et al. 1982, nos. 72, 81, 82, 98–101; Tait 1991, pp. 158–60, figs. 199–203; Syson and D. Thornton 2001, pp. 189–93, figs. 152–155.
2. Franz Adrian Dreier in *Glaskunst* 1981, no. 645; Barovier Mentasti et al. 1982, nos. 82a, b; Battie and Cottle 1991, p. 64; Mallet and Dreier 1998, p. 274; Page 2004, p. 25; Whitehouse 2004, pp. ii–iv, fig. 1.
3. These details concerning the way in which the Behaim arms are enameled on the glass were kindly provided by Dedo von Kerssenbrock-Krosigk, at the Corning Museum, to whom I am grateful.
4. Mallet and Dreier 1998, no. 31.
5. Franz Adrian Dreier in *Glaskunst* 1981, no. 645.

6. Ozment 1990, pp. 12, 17.
7. *Spiegel der Seligkeit* 2000, pp. 49–53; Lessmann 2004, p. 238, n. 21, citing Pohl 1992, p. 89.
8. Ozment 1990, pp. 15–17.
9. Schroder 2007, no. 8.
10. Ajmar-Wollheim and D. Thornton 1998, p. 142.
11. Barovier Mentasti et al. 1982, nos. 72, 98; Tait 1991, p. 159, fig. 199.
12. T. H. Clarke 1974.

SELECTED REFERENCES: Franz Adrian Dreier in *Glaskunst* 1981, no. 645; Barovier Mentasti et al. 1982, no. 82; Mallet and Dreier 1998, p. 274; Page 2004, p. 25; Whitehouse 2004, pp ii–iv, fig. 1

29. High-Footed Cup with the Arms of France Impaling Brittany

Probably Venetian (Murano), 1498–1514
Colorless glass (*cristallo*), blown, pattern molded, enameled, and gilded, H. 8¾ in. (22.1 cm), Diam. of rim 10⅞ in. (27.6 cm)
The Metropolitan Museum of Art, New York, Robert Lehman Collection, 1975 (1975.1.1194)

The cup is enameled twice on the foot with the royal arms of France impaling those of Brittany, surmounted by a crown and surrounded with flying ribbons. The arms could be those either of Anne of Brittany (1477–1514) or of her daughter Claude de France (r. 1499–1515), each of whom held the title of Duchess of Brittany and Queen of France. This glass, and the three others

Cat. 29

extant that formed a set with it, has generally been described as having been made for Anne of Brittany's marriage to Louis XII of France, in Nantes in 1499, though this cannot be proven.[1]

The three other pieces that survive from what was probably a large armorial set, designed for the French royal court, are a cup closely similar to this one (Musée National de la Renaissance, Château d'Écouen);[2] a *tazza,* or cup on a low foot (Toledo Museum of Art);[3] and a plate in the Victoria and Albert Museum, London.[4] Their form, heavy gilding, and enameled arms suggest that they emulate silver-gilt prototypes. They were therefore suitable for display on a tiered buffet, or *credenza,* or for sophisticated formal dining among guests who could appreciate their lightness and transparency and the lack of any metallic taste or odor. Thierry Crépin-Leblond has noted Anne of Brittany's liking for glass, confirmed by the presence in her collections of covered cups, a ewer, and a set of *tazze,* all of which were gilded and enameled but which are not described as being decorated with her arms.[5] Two of the four surviving pieces from the French royal set, including this glass, show symptoms of deterioration known as crizzling, which occurs when there is insufficient lime in the glass formula. The Lehman cup is rather thick, with bubbled glass and a bowl that leans to one side. It is awkwardly joined together from several separate elements. These characteristics have prompted some scholars to propose that the set may have been made not in Murano, near Venice, but by an Italian glassmaker working in France.[6] A number of other features suggest, however, that the set was more likely made in Murano. First, the Toledo *tazza* is made from the same mold as a *tazza* in the British Museum, London, which is enameled with a typically Venetian scene of a man slaying a water monster.[7] Second, Dwight P. Lanmon and David B. Whitehouse point out that large cups made from a forty-rib mold are typically Venetian, and these include cups in the Rijksmuseum, Amsterdam, and Kynžvart Castle, in the Czech Republic, which have been attributed to the same glasshouse as the Écouen and Lehman cups.[8] On balance, it seems more likely that the pieces are Venetian rather than French, and this view is reflected in recent scholarship. Future archival discoveries will perhaps clarify the origin and importance of this extraordinary set of glasses, which document the French court's taste for Venetian *cristallo* wares.[9] DT

1. Lanmon and Whitehouse 1993, pp. 8–12, no. 1; Crépin-Leblond and Ennès 1995, pp. 87–88; Jutta-Annette Page in Page 2006, p. 76.
2. Lanmon and Whitehouse 1993, p. 10, fig. 1.2;

Crépin-Leblond and Ennès 1995, no. 45.
3. Crépin-Leblond and Ennès 1995, no. 46; Page in Page 2006, no. 28c.
4. Honey 1946, p. 67; Lanmon and Whitehouse 1993, p. 10, fig. 1.35.
5. Crépin-Leblond and Ennès 1995, p. 88.
6. Honey 1946, p. 67; Lanmon and Whitehouse 1993, p. 11, no. 1; Rochebrune 2004, pp. 143–45.
7. Tait 1979, no. 14.
8. Lanmon and Whitehouse 1993, p. 11, figs. 1.5, 1.6.
9. Crépin-Leblond and Ennès 1995, pp. 85–86; Rochebrune 2004, p. 143.

SELECTED REFERENCES: Lanmon and Whitehouse 1993, pp. 8–12, no. 1; Crépin-Leblond and Ennès 1995, pp. 87–88; Rochebrune 2004, p. 143, fig. 4, ill. p. 144 (detail)

30. *Pilgrim Flask*

Venice (Murano), ca. 1460–1500
Colorless glass, blown, enameled, and gilded,
H. 13⅝ in. (34.6 cm)
Lent by the Toledo Museum of Art; Purchased with funds from the Libbey Endowment, Gift of Edward Drummond Libbey (1948.225)

From the late fifteenth century, pilgrim flasks were a common form in metal, glass, and maiolica; their prototypes were in silver. The flasks made good display pieces: a pair of silver examples appears among a display of silver on a *credenza,* or tiered buffet, frescoed in the Roman palace of Girolamo Riario and his wife, Caterina Sforza, between about 1477 and 1481.[1] The paired ring handles on the sides of the silver prototypes were originally intended to be threaded with a cord or chain so that the flasks could be carried. Flasks made of glass were clearly not portable, and they must have been meant to hold wine or water in formal dining—the liquid would have set off the enameled and gilded decoration—or for display. Glass was preferable for serving vessels in that, unlike silver or pewter, it does not retain odors or leave a taste.

This flask is decorated with enameled and gilded rosettes, typical of late fifteenth-century Venetian production.[2] It can be dated by comparison with a pair of flasks in Bologna, one of which is enameled with the Bentivoglio arms and the other with the Sforza arms. These arms record the marriage in 1464 of Giovanni II Bentivoglio (1443–1508) and his consort, Ginevra Sforza, though the flasks do not necessarily date from their wedding. A pair of flasks with the arms of each member of a couple would, however, seem to be an appropriate commission to mark an important dynastic alliance. The flasks must have been made before 1489, when the paly of Aragon, which do not appear on the pair, were added to the Bentivoglio arms.[3]

Other armorial pilgrim flasks of clear glass (*cristallo*) enameled with arms and gilded are later in date than the Bentivoglio-Sforza pair. One of the earliest of these is a flask in the Musée du Louvre, Paris, with the arms of Catherine de Foix, queen of Navarre (r. 1483–1517), which was probably made in Venice before 1517.[4]

From about 1500, slightly smaller armorial examples were made in blue, green, opaque turquoise, or opaque white glass. A turquoise flask in the 1510 postmortem inventory of Andrea Mantegna's son, in Mantua, was described as having "the device of the sun upon it." The flask must have belonged to Andrea Mantegna (1431–1506) himself, as the sun was his personal device, granted to him by his patron at the Mantuan court, Ludovico Gonzaga (1412–1478).[5] According to the inventory, Mantegna's flask had an upended beaker suspended from its neck, indicating that it was used for water or wine. A blue flask with a portrait of Henry VII of England (r. 1485–1509) and the royal arms enameled on it is listed in Henry VIII's inventory of 1542.[6] A white flask, made in Venice about 1500 as a diplomatic gift or special commission for Henry VII, survives in the British Museum, London. This flask is enameled, in a manner similar to that of the blue flask in the 1542 inventory, with Henry VII's portrait and his personal device of the Tudor portcullis.[7] DT

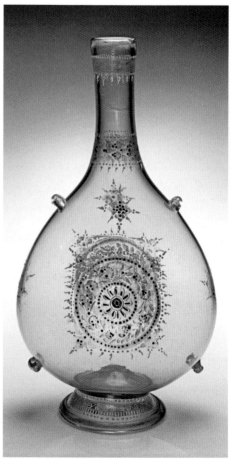

Cat. 30

1. P. Thornton 1991, p. 103, fig. 101.
2. Jutta-Annette Page in Page 2006, no. 30.
3. Barovier Mentasti et al. 1982, no. 81 (for another flask with arms of Bentivoglio, in a private collection) and p. 87; Fortunati 2003, p. 43.
4. Crépin-Leblond and Ennès 1995, no. 49.
5. Signorini 1996, p. 112; Syson and D. Thornton 2001, p. 195.
6. Tait 1991, p. 159.
7. Tait 1979, no. 204; Tait 1991, p. 160, fig. 202.

SELECTED REFERENCE: Jutta-Annette Page in Page 2006, p. 82, no. 30

31. Plate with the Arms of Orsini Impaling Medici

Venice, between 1558 and 1576, probably 1560–65
Grayish colorless glass, blown with applied foot ring, diamond-point–engraved, Diam. 9½ in. (24.1 cm)
The Metropolitan Museum of Art, New York, Gift of Estate of Marie A. Main, 1901 (01.12.10)
New York only

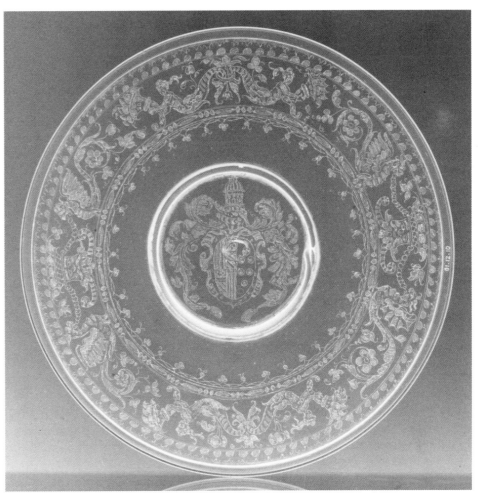

Cat. 31

The plate is blown from a special type of colorless glass (*cristallo*) with a grayish tint that has myriad tiny bubbles within it. When cool, the plate was engraved using the point of a diamond. The arms engraved at the center are those of Orsini impaling Medici beneath the Orsini crest. They record the marriage of Isabella de' Medici, daughter of Cosimo I de' Medici, Duke of Florence (r. 1537–74), and Paolo Giordano Orsini, great-grandson of Ferdinand I of Aragon, king of Naples (r. 1458–94). They married in 1558, but the marriage was unhappy and Paolo Giordano strangled his wife in 1576. This plate and another, slightly smaller one with the same arms and decoration, which is now in the Corning Museum of Glass, are all that remains of a set of plates that can be dated by the arms to 1558–76.[1] It has been suggested that the set was probably made in association with the marriage of the couple in 1558, but there is no evidence for this, and the arms could have been used until Isabella's murder eighteen years later.[2]

The plates have been more narrowly dated, to about 1560–65, by comparison with a similar set of engraved plates made for the Medici pope Pius IV (r. 1559–65). These can be dated between January 1560, when his election to the papacy was confirmed, and 1565, the year of his death. Three plates with his arms survive.[3] Another nine plates, and a jug, appear to belong to the same set, since although they lack arms, they are engraved with papal devices such as the crossed keys and the *ombrellino*.[4]

What unites all these glasswares is the extraordinary delicacy of the diamond-point engraving, with complex grotesques—on this plate, dragons supporting *mascherone*, and mermaids carrying cornucopias—of the latest design. The designs on the Orsini–Medici plates recall the scheme by the papal architect Pirro Ligorio (ca. 1513–1583) for the fresco decoration of the Casino of Pius IV, in the Vatican, executed in the 1560s.[5] Here, the transparency of *cristallo* is used to great advantage, giving the intricate design on the rim the appearance of contemporary lace, cut linens, and embroidery.[6] Glass of this kind was an elite and short-lived taste in Italy, however, and it is worth noting that the two major commissions for glass of this type are both associated with the Medici family. In Italian heraldry, impaled arms like those on the Orsini–Medici plates can stand for a married couple or for the wife alone. There is tantalizing evidence that maiolica *credenze* (sets of dining wares) with impaled arms might have been commissioned by or given to the wife in a particular couple. All the evidence suggests that women were arbiters of taste in the making of maiolica *credenze*, and there is much to recommend Timothy Wilson's hypothesis that women were likely to have been "prime movers" in their making in the mid-1520s.[7] Given the evidence of the plates made for Pope Pius IV, engraved glass plates of this kind were to Medici taste—to which Isabella de' Medici, rather than her husband, aspired.

It was only when Venetian craftsmen took the diamond-point engraving technique to northern Europe—first to Antwerp, then to London and the Tyrol—that it became a popular fashion.[8] Engraved glass in the Venetian style was familiar enough in Silesia in 1562 for the Lutheran pastor Johannes Mathesius to refer to it in one of his sermons to local miners: "All sort of festooning and handsome lines are engraved by diamond-point on the nice and bright Venetian glasses. . . . glasses decorated with scrolls scratched upon them."[9] DT

1. Whitehouse 2004, p. vi, fig. 4.
2. Page 2006, p. 88; Heikamp 1986, p. 319, no. 86; Buckley 1932, pl. IIA and p. 160.
3. Page 2006, p. 88, no. 34; Tait 1991, p. 174, fig. 222; Engels-de-Lange and Engels 1995.
4. Engels-de-Lange and Engels 1995; Tait 1979, nos. 223, 224; Tait 1991, p. 174, fig. 222; Newby 2000, no. 34.
5. P. Thornton 1998, pl. 27.
6. Currie 2006, p. 345, pl. 24.7.
7. T. Wilson 2003a, p. 180.
8. Tait 1991, p. 174.
9. Whistler 1992, p. 23; Jutta-Annette Page in Page 2006, p. 88.

SELECTED REFERENCES: Buckley 1932; Heikamp 1986, p. 319, no. 86; Jutta-Annette Page in Page 2006, p. 88, under no. 34

32a. Ring with Names (Wedding Ring)

Northern Italy, 15th century
Gold set with faceted diamond, black enameled script on shoulders, Diam. ¾ in. (1.9 cm)
Inscribed: *LORENSO A LENA LENA*
The British Museum, London (AF 1090)

32b. Ring with Couple

Umbria, 15th century
Silver with niello, Diam. ¾ in. (2 cm)
The Ashmolean Museum, Oxford (WA1899.CDEF.F414)

32c. Ring with Inscription

Umbria, 15th century
Silver with niello, Diam. ¾ in. (1.8 cm)
Inscribed: *AMORE VOLE FE*
The Ashmolean Museum, Oxford (WA1899.CDEF.F420)

32d. Ring with Clasped Hands

Northern Italy, 15th century
Silver with niello, Diam. 1⅛ in. (2.4 cm)
The Victoria and Albert Museum, London (835.1871)

32e. Ring with Clasped Hands

Italy (?), 1500–1650
Gold, Diam. 3/4 in. (1.9 cm)
The Walters Art Museum, Baltimore (57.1636)

These five rings, all love tokens, belong to a tradition dating back at least as far as ancient Rome. Rings were evoked as signs of devotion in such texts as Ovid's first-century-B.C. *Amores*, in which the poet speaks to the ring he plans to give to his beloved: "Go, happy ring, who are about to bind the fair one's finger; may the fair be kind" (*Amores* 2.15.1–2). The earliest identification of rings as specifically marriage objects perhaps occurred in the fifth century, when the playwright Macrobius in his *Saturnalia* stated that the ring went on the fourth finger of the left hand because it was from there that a vein flowed directly to the heart (*Saturnalia* 7.13). Comments by influential church figures such as Bishop Augustine of Hippo indicate that this belief, as well as the practice of gifting rings at marriage, was adopted by medieval Christians. And both surviving rings and textual evidence demonstrate that Renaissance Italians continued the tradition. The Franciscan Saint Bernardino of Siena and the humanist politician Lorenzo

de' Medici, among others, described it in some detail.[1] Certainly the many paintings of the Mystic Marriage of Saint Catherine of Alexandria or the Marriage of the Virgin, in which disproportionately large rings are visible, attest to the ring's importance as a symbol of marriage during this period (fig. 62). And, of course, the belief that the fourth finger had an immediate connection to the heart survives to the present day in the Western practice of placing engagement and marriage rings on that finger.

Prior to the Council of Trent (1545–63), Italian Renaissance marriage was relatively simple: a couple agreed to be husband and wife and sealed the agreement by a handclasp in front of witnesses. This practice was often referred to as the *anellamento*, or "giving of the ring," because the bride also accepted a ring from her groom at the same time (see Deborah L. Krohn's essay "Marriage as a Key to Understanding the Past" in this volume). These rings became increasingly ornate over time, with the addition of gems, enamel, or niello, and many of the gems used on them were thought to have miraculous powers. The most precious stone was the diamond, mined during this period almost exclusively on the present-day subcontinent of India. Ancient, medieval, and Renaissance texts stated that the great strength of the diamond—from the Greek *adamas* (source of the English *adamantine*)—made it a symbol of fidelity and, by extension, of marital fidelity. In the illuminated album celebrating the marriage in 1475 of Costanzo Sforza of Pesaro and Camilla of Aragon, Hymen, the Greek god of marriage, is shown wearing a costume patterned with diamond rings and standing before an altar crowned by an enormous diamond ring pierced by a pair of joined flaming torches (fig. 63). The accompanying text describes how "Two wills, two hearts, two passions, / Are bonded in marriage by a diamond."[2]

In light of this connection, the faceted diamond on the ring from the British Museum (cat. no. 32a) at least tentatively links it to marriage, while the inscription, enameled in black into the shoulders, offers further evidence. The text, "Lorenzo to Lena Lena," reveals that the ring was originally presented to a woman named Maddalena or Elena by a Lorenzo. The repetition of the familiar form of her name may have been a way to balance it with Lorenzo's name on the other side. Or, less practically but more romantically, it may have been Lorenzo's nickname for her. The addition of names to rings may have been relatively

common; another example has the names Catarina and Nicola surrounding an octagonal bezel bearing an unidentified device.[3]

Jeweled rings could be part of an elaborate exchange when a woman married. Her new

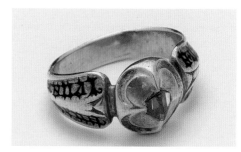

Cat. 32a

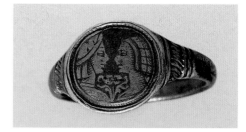

Cat. 32b

Cat. 32c

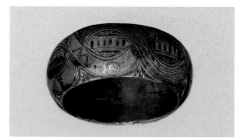

Cat. 32d

Cat. 32e

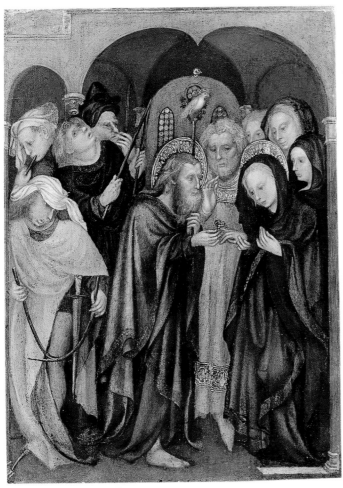

Fig. 62. Michelino da Besozzo (act. 1388–1450), *The Marriage of the Virgin*, ca. 1430. Tempera and gold on panel, 25⅝ × 18¾ in. (65.1 × 47.6 cm). The Metropolitan Museum of Art, New York, Maitland F. Griggs Collection, Bequest of Maitland F. Griggs, 1943 (43.98.7)

Fig. 63. *Hymen*, from *Le nozze di Costanzo Sforza e Camilla d'Aragona celebrate a Pesaro nel maggio 1475*, Codice Urb. Lat. 899, fol. 56v. © Biblioteca Apostolica Vaticana

relations presented her with these precious objects, which they had received upon similar occasions, and she was expected to pass them on to the next new family member at the appropriate time.[4] Other rings were less formal love tokens. A popular type, judging from the number of surviving examples, had a niello representation of a couple in profile on the bezel. Such rings seem to derive from the medieval Byzantine tradition, and ultimately from ancient Rome, where they were regarded as talismans to ensure successful marriages.[5] The Renaissance example here (cat. no. 32b) depicts a fashionable couple, the man with a cap on his long hair, the

woman with a snood, facing each other over a blooming flower, their stark profiles visible even on this small scale because of the clarity of the niello technique. The motif of facing profiles enjoyed great popularity among love and marriage objects, as witnessed in this volume by pendants (cat. nos. 35a, b), maiolica wares (cat. nos. 13–16), and glass; paired male and female painted portraits ultimately represent the same idea but in a more individual, elaborate manner (cat. nos. 120–122).

Rings nielloed on the exterior (or, on occasion, the interior) with short romantic phrases were popular as well, not only on the Italian peninsula and elsewhere in Europe

but also, particularly later, in England, where they were known as "posey rings."[6] One early Italian example has an intricately ornamented niello hoop with the words *AMORE VOLE FE*, or "Love needs fidelity," weaving in and out of the design (cat. no. 32c). Lorenzo de' Medici adopted an extended version of this phrase as his personal motto for his famous joust of 1465, and Luigi Pulci's poem about the joust describes it as an "old saying."[7] It can in fact be traced back at least as far as Boccaccio, who used it in his *Rime*, written about 1374.[8] The adage was common enough to appear not only on this ring but also on several of the so-called Otto Prints, a group of small fine-manner engravings produced in late fifteenth-century Florence and often attributed to the printmaker Baccio Baldini (fig. 64; the inscription can be translated as "Love desires loyalty, and where no loyalty is, neither is there love"). These engravings, which illustrate romantic subjects with great charm and vivacity, may have been used to decorate inexpensive betrothal chests that could serve as containers for rings and other tokens.

A second example of an inscribed ring is a substantial object with a convex profile, the diameter indicating that it might have been

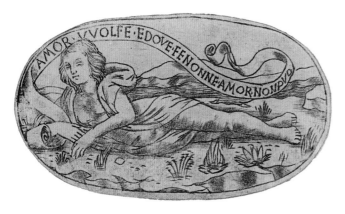

Fig. 64. Baccio Baldini (1436–ca. 1487), attributed to, *Reclining Woman Holding a Scroll Inscribed AMOR VUOLFE EDOVE FENONNE AMOR NON PUO*, ca. 1465–80. Engraving, 2⅛ × 3⅞ in. (5.4 × 9.8 cm). The British Museum, London

worn on the thumb or perhaps by a man (Victoria and Albert Museum, London). The undulating niello script, set within a ribbed scroll, is the last six words from the Gospel of Matthew's much-quoted section on marriage: "For this reason a man shall leave his father and mother and be joined to his wife, and the two shall become one flesh" (Matt. 19:5). This direct statement leaves no doubt as to the original role of this particular ring in the rituals of love and marriage.

Similarly obvious are the so-called *fede* rings, identified by the motif of clasped hands across the front or, sometimes, the back. The analogy between the clasped hands as a contractual gesture and the businesslike aspects of Renaissance marriage made this an appropriate motif for objects associated with this ritual, as seen elsewhere in this volume on maiolica plates (cat. nos. 17, 18), an inkwell (cat. no. 16), and the two rings shown here (cat. nos. 32d, e). The gold ring reinforces this with the addition of tiny hearts below the cuff of each sleeve, while the finely nielloed silver ring is a particularly legible example of the motif JMM

1. Bernardino of Siena, *Le prediche volgari*, 1936 (ed.), p. 402; Medici, *Autobiography*, 1995 (ed.), pp. 95, 133.
2. Scarisbrick 1998, p. 164.
3. Oman 1930, p. 103, no. 638, pl. XXVII; Musacchio 2008, p. 25, fig. 15,
4. Klapisch-Zuber 1982/1985, pp. 231–37.
5. A. Walker 2002, pp. 59–66.
6. Evans 1931.
7. Rubin and Wright 1999, p. 339.
8. P. F. Watson 1979, pp. 88–89.

SELECTED REFERENCES: *32a.* Dalton 1912, p. 157, no. 984, pl. XVI; Scarisbrick 1998, p. 164; Syson and D. Thornton 2001, p. 65, fig. 45; Ajmar-Wollheim and Dennis 2006, p. 361, no. 148; Matthews Grieco 2006, p. 110, pl. 7.7; Musacchio 2008, p. 25, fig. 14

32b. Scarisbrick and Henig 2003, pp. 48–49, pl. 15, no. 1

32c. Scarisbrick and Henig 2003, pp. 48–49, pl. 15, no. 2

32d. Oman 1930, p. 104, no. 656; Musacchio 2008, p. 25, fig. 16

33. Jewish Betrothal Ring

Venice or eastern Europe, ca. 17th–19th century
Gold, enamel, 1¾ × ⅞ in. (4.4 × 2.2 cm)
Inscribed: מ ת [*mem* and *tav*, the Hebrew initials for *Mazel Tov*]
The Metropolitan Museum of Art, New York, Gift of J. Pierpont Morgan, 1917 (17.190.996)

A significant number of large, finely ornamented Jewish betrothal rings are known and form a distinct, albeit problematic, group with no clear attribution or dating. In this case, the intricately executed filigree may indicate an eastern European origin, but scholars have noted that stylistically these rings seem to cross both geographic and chronological boundaries.[1] As portable objects, they could be carried from one Jewish community to another, thereby influencing artisans in many locales. And as ritual objects, they were preserved and used for several generations. These factors make attribution extremely difficult today.

In this case, a simple band is overlaid with filigree and colored enamel ornament. The gabled roof, which could represent the Temple of Jerusalem, the local synagogue, or the new couple's home, is common to this type. It hinges open to reveal the Hebrew initials מ and ת , abbreviating "Mazel Tov," or "Good Luck," an appropriate wish for a newly married couple. The use of rings in Jewish betrothals seems to have developed in post-Talmudic Mediterranean communities. According to traditional Jewish law, marriage was formalized through the *kiddushin*, during which bride and groom agreed to marry in front of witnesses and the groom presented the bride with a *kesef*, or coin. Eventually a ring replaced the coin as the token that marked the transfer of the bride from her father to her husband.[2] On occasion grooms

Cat. 33, view 1

Cat. 33, view 2

also received rings; Shakespeare's Shylock bemoans the loss of the turquoise ring presented to him by his wife at their betrothal years earlier (*Merchant of Venice* 3.1).

There is ample evidence that many rings, including complex and large examples such as this one, were exchanged during Italian Jewish weddings.[3] They would have been placed by the groom on the bride's finger during the ceremony, but then removed and kept as a prized memento by either the family or sometimes the temple itself. Some of the most elaborate rings were owned by the temple rather than by any individual and were reused as necessary.[4] Unlike the other, smaller rings in this volume, this example is too large, and the projecting bosses and delicate filigree too fragile, for daily wear. Some sources state that rings such as these were also used to hold bunches of myrtle.[5] One of the four plants of the Sukkot feast, myrtle was also sacred to the goddess Venus and therefore part of ancient Roman marriage rituals. It may have been a combination of these two traditions that made the plant popular within the Renaissance Jewish community. JMM

1. Seidmann 1989.
2. Marcus 2004, pp. 145–48.
3. Weinstein 2004, pp. 202–6.
4. Keen 1991, p. 77.
5. See, for example, Kunz 1917, p. 214.

SELECTED REFERENCES: Hoving and Gómez-Moreno 1972–73, p. 98, ill. p. 99; Hackenbroch 1979, p. 50, fig. 105

34. Jewel with Gold Letters Spelling "Amor"

Franco-Flemish, mid-15th century
Gold, pearls, diamond, emerald paste, 1⅛ × 15⁄16 in. (2.9 × 2.4 cm)
The Metropolitan Museum of Art, New York, The Cloisters Collection, 1957 (57.26.1)

This cluster jewel of gold set with five pearls features an emerald at its center, from which small leaves and tendrils issue. At the top is a pyramidal setting on which a diamond is mounted. Four Gothic letters of gold dangle from loops across the bottom of the jewel, spelling the Latin word *amor* (love). A small loop of gold wire soldered to the jewel, behind the diamond, was probably meant to serve as a point of suspension. The jewel could have functioned as either a pendant or a brooch, though the pin now attached to the reverse was added by the owner of the piece in the twentieth century and is entirely new.

Women's ornaments of this type became popular in the mid-fifteenth century as more

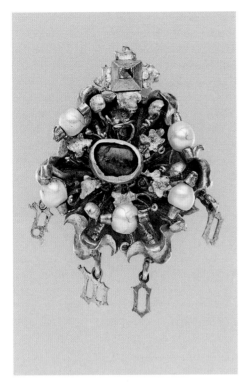

Cat. 34

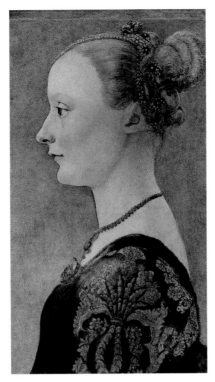

Fig. 65. Piero del Pollaiuolo (ca. 1441–not later than 1496), *Portrait of a Woman,* ca. 1470. Tempera on panel, 19¼ × 13⅞ in. (48.9 × 35.2 cm). The Metropolitan Museum of Art, New York, Bequest of Edward S. Harkness, 1940 (50.135.3)

and more sartorial attention was focused on the neckline.[1] Heavy cluster jewels could be worn suspended from a chain or cord around the neck, as can be seen in Piero del Pollaiuolo's *Portrait of a Woman,* at the Metropolitan Museum, from about 1470 (fig. 65). Similar ornaments were also worn as brooches, at the shoulder or in the hair, as shown in the Pollaiuolo painting mentioned above as well as in Fra Filippo Lippi's depiction of a finely adorned young woman, possibly Agnola di Bernardo Sapiti, in *Portrait of a Man and a Woman at a Casement* (cat. no. 118). A group of three comparable cluster jewels appears in Petrus Christus's painting of a goldsmith's shop, in the Robert Lehman Collection at the Metropolitan (fig. 53). The painting depicts a couple, presumably about to marry, who have come to the goldsmith's shop to select appropriate jewelry. The three cluster ornaments, set among rings, earrings, loose pearls, a purse, and other items, are mounted on a black background on the wall, to the right of the goldsmith's head. Perhaps these three were meant to be worn together as a set, as has been conjectured about three related jewels in the British Museum, London, from the 1440s.[2] The British Museum set, found in the river Meuse in the nineteenth century, are related in technique as well as appearance to the Cloisters jewel.[3]

Expensive and elaborate jewelry played an important role in betrothal and marriage. Brooches were among the gifts typically given by the groom to the bride as a personal token of love before or just after marriage, when jewelry with amorous inscriptions was

still appropriate.[4] An example is the jewelry that was part of the counter-dowry provided by Marco Parenti, whose marriage to Caterina Strozzi in 1447 is discussed in my essay "Marriage as a Key to Understanding the Past" in this volume. Parenti ordered for his bride a golden brooch set with two sapphires and three pearls, which was to be worn on her shoulder.[5] The great expense of jewelry led many Florentine men to rent or borrow appropriate jewels for their brides—a solution that was socially acceptable.[6] Since sumptuary laws stipulated that women were allowed to wear jewelry associated with betrothal or marriage for only a limited time following the wedding, there must have been a particular, clearly recognizable form of jewel for such use.[7] Jewelry with any obvious amorous content, such as the brooch under discussion here, would certainly fall into this category. Documents support the theory that borrowing or lending jewelry was also a form of consolidating familial and dynastic bonds, for they record the serial use of the same piece, perhaps somewhat altered to disguise the fact, by different men for their brides.[8]

The word *amor* on this jewel calls to mind the fictive brooch of gold inscribed with the letter *A* and the phrase *amor vincit omnia* that is worn by the prioress Eglantine in Geoffrey Chaucer's *Canterbury Tales.*[9] Like the Latin inscription *LEALTA* (loyalty) in Gothic letters on the sleeve of the woman's cloak in

the Filippo Lippi double portrait mentioned above (cat. no. 118), the glittering letters spelling *amor* which dangle from this jewel allude to the culture of courtly love which flourished in late medieval and Renaissance Europe.[10]

DLK

1. Frick (2002, pp. 189–90) describes a dizzying array of terminology referring to distinct types of neckline ornaments, including buttons and studs and metallic decorations of gilded, silvered, or enameled copper in the form of leaves, flowers, or stars.
2. These are illustrated and discussed in Syson and D. Thornton 2001, p. 44, fig. 23. Like the Cloisters piece, they are believed to be Franco-Burgundian in origin.
3. Katharine Reynolds Brown (1992, p. 417) discusses the British Museum Meuse find and the Cloisters jewel as well as several other related pieces.
4. Lightbown 1992, p. 72.
5. Frick 2002, p. 127.
6. Syson and D. Thornton 2001, p. 42.
7. Frick 2002, p. 129.
8. Syson and D. Thornton 2001, pp. 42–43.
9. Chaucer, *Canterbury Tales,* 1957 (ed.), p. 18 (General Prologue, ll. 160–62): "And theron heng a brooch of gold ful sheene, / On which ther was first write a crowned A, / And after *Amor vincit omnia.*"
10. For a general introduction to courtly love, see Boase 1977. For the arts of love in the Middle Ages, see Camille 1998.

SELECTED REFERENCES: *Secular Spirit* 1975, p. 89, no. 96, pl. 4; K. R. Brown 1992, pp. 414–19, figs. 10a, 10b

35a. Pendant with Facing Couple (obverse) and Sacred Monogram (reverse)

Italy, 15th century
Silver gilt, niello, Diam. 1⅛ in. (2.9 cm)
Inscribed: *IHS*
The Metropolitan Museum of Art, New York, Gift of J. Pierpont Morgan, 1917 (17.190.965)

35b. Pendant with Facing Couple (obverse) and Sacred Monogram (reverse)

Italy, 15th century
Silver gilt, niello, Diam. 1½ in. (3.8 cm)
Inscribed: *IHS*
The Metropolitan Museum of Art, New York, Gift of J. Pierpont Morgan, 1917 (17.190.968)
New York only

Pendants such as these must have been relatively common, since many examples are housed in museums in the United

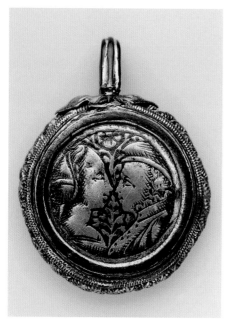

Cat. 35a, obverse

Cat. 35a, reverse

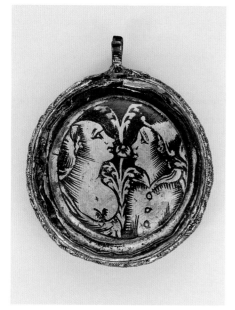

Cat. 35b, obverse

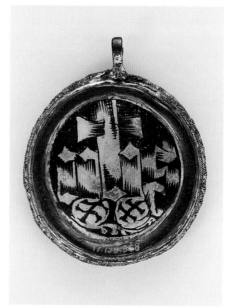

Cat. 35b, reverse

engraved lines were then covered with a black powder made from sulphur, lead, and various other metals. When heated, this powder liquefied and flowed into the engraved lines; after it cooled, the surfaces were polished flat. This technique resulted in the stark contrasts visible here. The interest in ornament, evident in the addition of space-filling floral motifs on one side—notice in particular the blooming pinks slotted between the couples—and the calligraphic letters on the other, comes through especially well in niello.

JMM

1. Cherry 2001, pp. 157–60; Musacchio 2005, pp. 143–51.
2. Vasari, *Technique*, 1568/1907 (ed.), pp. 273–74.

36a. Girdle

Venice (?), late 14th century
Basse taille enamel and silver-gilt plaques, mounted on a woven band, L. 63 in. (160 cm), W. ⅜ in. (1.1 cm)
The Metropolitan Museum of Art, New York, Gift of J. Pierpont Morgan, 1917 (17.190.936)
New York only

36b. Girdle End with a Profile Couple (front) and a Woman Holding a Pink (back)

Northern Italy (?), mid-15th century
Silver gilt with niello plaques, overall 2¼ × 1¾ in. (5.8 × 4.3 cm), each plaque 1⅜ × 1¼ in. (3.4 × 3.1 cm)
The British Museum, London (2004, U.4)

Renaissance clothing was often made from great quantities of textile, so girdles to cinch in the fabric were practical accessories for both men and women. Many were made of metal links or a combination of fabric and applied metal fittings with niello or enamel ornament.[1] Like much portable goldsmith work, these girdles were stylistically similar across geographical boundaries, which makes it difficult to provide secure attributions for the surviving examples. The Flemish painter Petrus Christus included a girdle in his representation of the shop of a goldsmith, often identified as Saint Elegius (fig. 53). As the goldsmith tends to a couple buying a ring, which was a common love or marriage token, a striped textile girdle lies on his worktable; its buckle is perhaps hanging by a nail on the shelf behind him. Such a shop, where objects were displayed both ready for purchase and partially completed, allowed prospective buyers to customize their orders. For example, the shop of the Florentine goldsmith Nanni di Jacopo Braccesi, inventoried at his death in 1427,

States and Europe. The representation of a facing couple on one side indicates that they were originally love tokens, but the sacred monogram on the other—*IHS*, a transliteration of the first three letters of the Greek name of Jesus Christ, or *IHΣ*—is an important reminder of the role of the sacred in daily life during the Renaissance. Even something as blatantly secular as a love token could accommodate less worldly concerns. And, in this case, the wearer, presumably a woman, could decide which side should be visible. As she went about her everyday routine, the facing couple might be appropriate and might identify her as a betrothed or married woman. For similar reasons, comparable representations of facing couples appeared on contemporary rings (cat. no. 32b), maiolica (cat. nos. 13–16), and glass. But when the wearer attended church services, she could

flip the pendant by its attached loop to expose the sacred monogram as a symbol of her piety. Other pendants were strictly sacred and probably served as cases for *Agnus Dei* waxes, valuable talismans that protected the wearer from various dangers. The front of those pendants usually had a representation of the Lamb of God.[1]

Whether secular, sacred, or a combination of both, these pendants were made from two metal plates decorated with niello and set into a circular, cabled surround with an attached loop for hanging. Giorgio Vasari devoted a section of his introduction to the second edition of *Lives of the Artists* (1568) to a discussion of the niello technique, citing its history and outlining the process for his readers.[2] Vasari's text and close examination of surviving objects indicate that the metal plates were first engraved with a sharp tool, and the

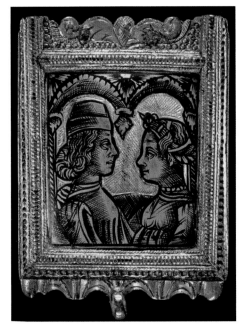

Cat. 36b, front

Cat. 36b, back

account books regularly cited expenses associated with marriage-related girdles. They were often referred to by the evocative term *chiavacuora*, or "heart key," which the goldsmith Benvenuto Cellini described as a bridal item.[5]

It is relatively rare to have a complete, or near complete, girdle from this period. One example, attributed to late fourteenth-century Siena, is more than seven feet long and made of woven silver with applied silver and enamel plaques representing musical figures and beasts; it is surprisingly lightweight, given its size and materials.[6] A girdle this long wrapped under the breasts and cinched at the buckle, leaving the long tongue to fall to the ground. As the woman walked, the dangling end would move with her, its gilt details and bright enamels catching the light. The girdle shown here (cat. no. 36a), although slightly shorter, would have been worn in the same way. The buckle is formed by a curving figure, probably the victim of the archer who is attached further along the girdle; the pin of the buckle may be meant as one of the archer's arrows. The band in tablet weave has a repeating geometric pattern studded with metal plaques attached via silver rivets that strengthen it and give it weight. Its colors—red, green, yellow, pink, and purple, as well as a neutral undyed silk thread—have

included thirty-seven girdles as well as various buttons and attachments.[2]

Particularly extravagant girdles were often part of betrothal gifts, dowries, or counter-dowries. As marriage items, they can be associated with the girdle of the goddess Venus, said to make its wearer irresistible (*Iliad* 14). They also are connected to fertility, in part because of the belief that threads that touched the relic of the Virgin's girdle in Prato aided women in labor.[3] Indeed, a Florentine inventory of 1471 included a girdle made of relics and ribbons specifically for a woman to wear during childbirth.[4] In the *Decameron* (9.10), Boccaccio included girdles, along with a ring, as gifts for a new bride. And contemporary

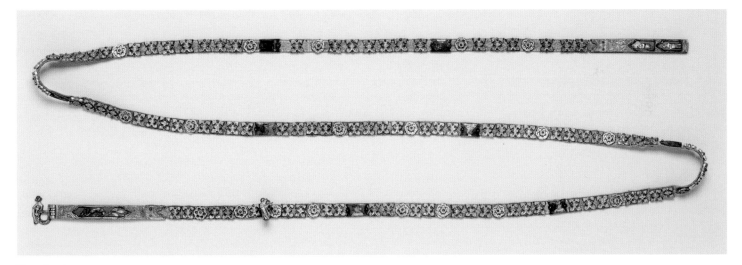

Cat. 36a, view 1

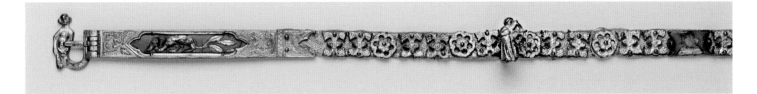

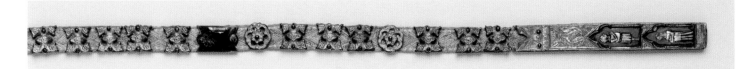

Cat. 36a, view 2

faded from a brighter palette, which would have best set off the enamels and gilding; the reverse gives a better sense of the original, vibrant dyes. The plaques alternate between X-shaped flourishes, rosettes, and enamels set into an engraved silver ground. This enamel technique, known as *basse taille*, allows the silver to shine through the translucent enamel. The placement of these enamels on the girdle was dictated by their iconography: the couple standing under archways needed to hang vertically, while the busts (some sadly damaged but others retaining their original brilliance) and especially the fantastic bird-men, who seem to crawl through narrow passages with their backs arched and tails trailing behind, needed to be horizontal.

The metal casing for the fabric at the end of a girdle was known as a chape. Examples of these, along with various bits and pieces of metal fittings, survive in greater numbers than whole girdles. The one shown here (cat. no. 32b) has inset niello plaques depicting a couple in profile on one side and a woman holding a pink on the other. It, too, would have had to hang vertically to be seen properly; its inherent weight and the loop at the lower edge, to secure a chain or pendant, would have ensured that it fell as required. The niello plaques illustrate motifs common to Renaissance love and marriage objects. The couple, with contemporary costume and hairstyles, face each other in the same manner seen on rings (cat. no. 32b), paintings (cat. nos. 120–122), and maiolica (cat. nos. 13–16). In this case, however, further intimacy is implied by the woman's hand resting on her lover's shoulders. The dresses of the women on both sides of this chape are cinched under their breasts, probably by a girdle similar to the one that originally carried this plaque.

JMM

1. Fingerlin 1971.
2. Cantini Guidotti 1994, vol. 2, pp. 12–14.
3. Cassidy 1991.
4. Musacchio 1999, p. 144.
5. Cellini, *Autobiography,* 1983 (ed.), p. 22.
6. Milliken 1930.

Selected references: *36a.* Fingerlin 1971, pp. 412–14, no. 335, ill.; Lightbown 1992, pp. 329–30, fig. 183

36b. Hind 1936, p. 34, nos. 87, 88, pl. XIII; Syson and D. Thornton 2001, p. 56, fig. 36; Musacchio 2008, pp. 168–69, fig. 171

37. Woman's Comb

France or Italy, 15th or 16th century
Ivory, polychromy, gilding, 3½ × 5⅛ × ⅛ in. (8.8 × 12.9 × 0.4 cm)
The Metropolitan Museum of Art, New York, Gift of J. Pierpont Morgan, 1917 (17.190.245)

This double-toothed ivory comb is decorated with golden trophy animals: hounds, a hare, and a stag on one side, and various birds on the other. The animals are outlined in black and are accompanied by floral shrubbery in red and green. A flowering vine with vivid green blossoms fills the border on both sides. In the center of one side is a flaming heart, suggesting an amorous context for the comb. An insect, perhaps a louse or a bee, is painted directly on the smaller set of teeth on one side; the winged creature on the other side has partially flaked off, but was either an insect or a bird. One of the comb's functions may have been to aid in the removal of lice, hence the smaller set of teeth. Handbooks for making cosmetics in late medieval and early modern Europe include recipes for scents and perfumes, as well as remedies for lice, that were to be dispersed in the hair through combing.[1]

Personal grooming implements such as combs were frequently included in bridal trousseaux during the fifteenth and sixteenth centuries in Italy. For example, the 1474 trousseau of Caterina Pico of Carpi lists seven ivory combs, one of which is in a case together with a mirror inlaid with bone.[2] Late medieval French ivory combs of similar design are also documented as gifts to women and would have nested together in a leather case with a mirror and a long hairpin for parting the hair.[3] (For three late sixteenth-century ornamental hairpins, see cat. nos. 116a–c.) Ivory or boxwood combs

were preferable to lead, which was believed to darken the hair.[4]

Double-toothed combs appear in painted images of ladies at their toilette such as Paris Bordon's *Venetian Women* (National Galleries of Scotland, Edinburgh; 1540s) and Tintoretto's *Susanna after Her Bath* (Kunsthistorisches Museum, Vienna; 1560–62). The combs and, often, mirrors that are present in such artworks put the agents of female beauty on display. Cultivation of physical beauty was not a path to true virtue, but it was nonetheless an important part of Renaissance culture. In his fiery sermons, Saint Bernardino of Siena (1380–1444) rails against the use of cosmetics, hair dyes, and related customs, such as bleaching the skin with sulphur, that were popular among Sienese and Florentine women.[5] Elizabeth Cropper and others have written on the pervasive influence of lyric poetry by Petrarch (1304–1374) and Giovanni Boccaccio (1313–1375), and their followers, on the aesthetic and philosophical conceptions of female beauty during the Renaissance.[6] In poetry from this tradition, the comb appears as a privileged article capable of experiencing intimacy with the object of desire, a metonymic representation of the beholder.[7] The best-known example of this trope is found in a poem by the Neapolitan Giambattista Marino (1569–1625) entitled "Mentre la sua donna si pettina," which can be roughly translated as "While your beloved combs her hair," where the comb is imagined as an ivory ship which parts the golden waves of the subject's hair.[8] The whimsical decoration on the Metropolitan's comb, including the flaming heart also found on other objects associated with courtship and love, conjures the desires of women (or at least of their lovers) to embody the aesthetic values of the age, which evidently could be cultivated with the help of combs, mirrors, and cosmetics.

DLK

Cat. 37

1. For hair-care recipes, see Marinelli, *Gli ornamenti delle donne*, 1562; and Green 2001, esp. pp. 113–24.

2. Morselli 1956, p. 98. Another mention of an ivory comb in a trousseau, that of the Florentine Maria di Piero Bini who married in 1493, is cited by Blake 2006, p. 340.

3. Camille 1998, pp. 55–56.

4. *Secular Spirit* 1975, p. 94, under no. 107.

5. Origo 1962, pp. 49–50.

6. Cropper (1976) uses texts such as Agnolo Firenzuola's *Dialogo delle bellezze delle donne* to provide an interpretive key to Parmigianino's *Madonna of the Long Neck* and other images of the sixteenth and seventeenth centuries.

7. See Goodman-Soellner 1983, p. 432, where the author cites Pierre de la Ronsard's *Les Amours* of 1552, in which "a comb was a precious relic to be envied and worshipped because it enjoys the intimacy with the lady that they desire to have." Goodman-Soellner illustrates several School of Fontainebleau paintings of women where combs appear.

8. See Forster 1969, p. 31–32, "Onde dorate, e l'onde eran capelli, / Navicella d'avorio un di fendea; / Una man pur d'avorio la reggea / Per questi errori preziosi e quelli; / E, mentre i flutti tremolanti e belli / Con drittissimo solco dividea, / L'or de le rotte fila Amor cogliea, / Per formarne catene a'suoi rubelli. / Per l'aureo mar, che rincrespando apria / Il procelloso suo biondo tesoro, / Agitato il mio core a morte gia. / Ricco, naufragio, in cui commerso io moro, / Poich' almen fûr, ne la tempesta mia, / Di diamante lo scoglio e 'l golfo d'oro!"

38a. Betrothal Chest with Female Busts and Rosettes

Florence, early 15th century
Wood with gilt and polychrome stucco, H. 5¾ in. (14.6 cm), Diam. 13 in. (33 cm)
Victoria and Albert Museum, London (487-1899)

38b. Betrothal Chest with Stags and Pinks

Florence, early 15th century
Wood with gilt and polychrome stucco, H. 5¾ in. (14.6 cm), Diam. 13¼ in. (33.6 cm)
Victoria and Albert Museum, London (5757 [1:2]-1859)
New York only

After marriage negotiations were concluded, many Renaissance men of the middle and upper classes gave their future brides *forzerini*, or small chests filled with various objects associated with their betrothal. In 1432, for example, Francesco de' Medici sent his intended, Ghostanza, a chest holding a silver basin, a headdress and collar decorated with pearls, a skein of wool, and two silver girdles.[1] This was a common, and expected, practice. The Franciscan preacher Bernardino of Siena cited the *forzerino* in a sermon to Sienese women he delivered in 1425; he described it as "the [chest] in which you keep your ring and pearls and jewels, and other similar things."[2] But many contemporaries, including Bernardino, did not agree with this sometimes ostentatious practice. The value of betrothal chests and their contents was limited by Florentine sumptuary legislation throughout the fourteenth and fifteenth centuries, although those who could afford to do so paid a fee to subvert the legislation and present whatever sort of chest, filled with whatever sort of objects, they wished.[3] Apparently, these chests were often delivered with the assistance of small children, who were understood as talismans

for future fecundity.[4] In an attempt to control this delivery ritual, the involvement of children was outlawed—perhaps one reason why representations of them appeared on the sides of marriage chests and the backs of childbirth trays with increasing frequency during this time (cat. nos. 71, 72).

Some betrothal chests were assembled from small pieces of bone or ivory carved with relevant literary or mythological scenes. Others were made of wood, such as the very simple example that appears in the background of the portrait of an unidentified woman attributed to Domenico Ghirlandaio (cat. no. 122b). It is displayed alongside the many betrothal objects that fit inside it. Although no simple chests such as this seem to survive, those in this volume, and others like them, were constructed similarly. A piece of shaved wood was curved around a base to form the body and then topped with a lid, after which the whole was decorated with painting, gilding, and stucco relief representing romantic themes such as pairs of lovers, dancers, putti, and hunts.[5] Both of the chests shown here have an allover vine pattern that provides texture to their surfaces; the gilding, now much abraded, would have shone in the candlelit interiors of their original palaces. One chest is further ornamented on both body and lid with rosettes and roundels bearing female busts (cat. no. 38a). The fashionable clothing of these figures, with its bright colors and patterns, is complemented by the women's finely painted facial features. Each of these vibrant little heads is shown in three-quarters view, their pink cheeks tinted to give an even greater semblance of reality. The second chest is decorated with blooming pinks, or carnations, and roundels with seated stags on the body and lid (cat. no. 38b). Both pinks and stags were associated with the ideals of courtly love, and pinks, in particular, appear on other betrothal and marriage objects (cat. no. 36b). The hole in the center of this lid may have been used to attach a pommel or handle. The two shields

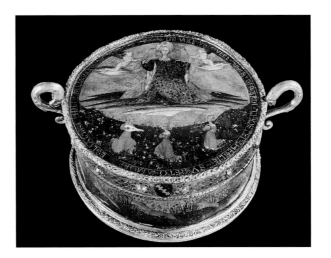

Fig. 66. Giovanni di Paolo (ca. 1403–ca. 1482), Marriage Casket, 1421. Musée du Louvre, Paris

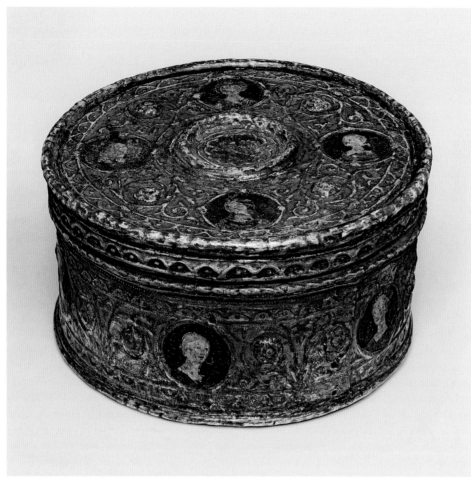

Cat. 38a

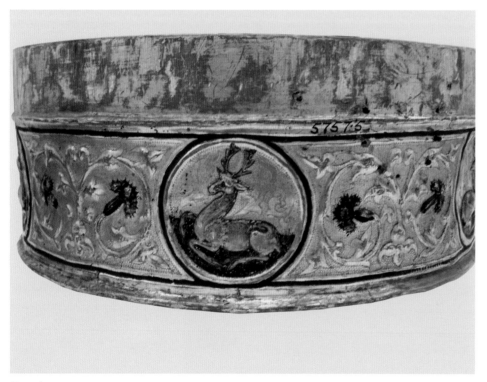

Cat. 38b

of the Triumph of Venus on the lid, that chest has inscriptions celebrating the bride's virtues and beauty.[7] Regardless of the artist responsible for their production, all these chests would have been lined in a soft fabric, both to complement the painting and gilding on the exterior and to cushion the precious objects stored inside. JMM

1. P. F. Watson 1970, p. 30.
2. Bernardino of Siena, *Le prediche volgari*, 1935 (ed.), p. 413.
3. Rainey 1985, pp. 648–56.
4. Niccolini di Camugliano 1933, p. 64; Klapisch-Zuber 1983b/1985, p. 319.
5. Toesca 1920; Swarzenski 1947.
6. Pollen 1874, p. 3.
7. Mather 1922.

REFERENCES: *38a. Catalogue des objets d'art . . . Bardini* 1899, p. 39, no. 215, ill. pl. 14; Pommeranz 1995, p. 120, no. 11, p. 255, fig. 25

38b. Pollen 1874, pp. 29–30; Lorenzelli and Veca 1984, p. 112, fig. 119; Pommeranz 1995, p. 123, no. 21; Ajmar-Wollheim and Dennis 2006, p. 359, no. 119; Bellavitis and Chabot 2006, p. 78, pl. 5.2

39. Casket (Cassetta)

Ferrara or Venice, 1500–1530
Gesso on wood (*pastiglia*), 7¼ × 8½ × 10¼ in. (18.4 × 21.6 × 26 cm)
The Metropolitan Museum of Art, New York, Rogers Fund, 1910 (10.141.1)

This wood casket is decorated with *pastiglia*, a relief technique used in northern Italy between the late fourteenth and mid-sixteenth centuries. Called *pasta di muschio* (musk paste) in contemporary documents, the relief medium was made from ground white lead. To make white-lead paste, lead shavings were exposed to vinegar vapor in a sealed jar, forming a powder that was scraped off and then mixed with egg white, which served as a binder.[1] The paste, which was scented with musk or civet, was then molded in metal matrices before being applied with rabbit-skin glue to the wood support, which had been covered with punched and gilded gesso or rice-flour paste.

The decorative forms on this casket recall classicizing grotesque decoration, suggesting an early sixteenth-century date, since these motifs appear only after the rediscovery at the end of the fifteenth century of the frescoes in the Domus Aurea, one of the residences in Rome of the emperor Nero. Three panels on each long side of the casket, and two panels on the short sides, are divided by pilasters. Putti and tritonlike figures animate these main panels. A series of antique vases

are abraded, but one may be identified as the arms of the Florentine Buondelmonte and the other presumably is that of a family with whom the Buondelmonte entered into a marriage alliance in the early fifteenth century.[6]

Such small chests were almost certainly made in advance and then personalized when purchased by painting arms on the reserved shields. Most of the known examples were workshop productions and cannot be associated with particular artists. One exception is an elaborate handled example dated 1421 that is attributed to the Sienese artist Giovanni di Paolo (fig. 66). Painted with a representation

and female figures holding what may be allegorical symbols, such as torches and musical instruments, decorate the base. A metal lock has been inserted into the middle front panel. The top is of truncated pyramidal shape, and the grotesque decoration, as well as the vases and allegorical female figures, continues on it.

Similarities in decorative motifs on *pastiglia* caskets suggest that a small group of workshops produced them and perhaps shared the molds, which were recombined in different ways on each individual casket, much as typographers used the same metal type for printing different combinations of letters.[2] This casket has been attributed by Patrick de Winter to the workshop of the Main Berlin Casket.[3] However, Johannes Pommeranz does not share the view that this type of casket can be grouped according to workshop, since the molds were interchangeable and were probably not proprietary.[4] Besides grotesques, *pastiglia* caskets featured narratives from Roman history and mythology and from the Bible—subjects parallel to those which decorated the larger cassoni of the period (see cat. nos. 57, 59, 136, 138, 140). Visual sources for the caskets included a variety of media, among them bronze plaquettes and prints. *Pastiglia*

casket makers may even have used some of the same molds as the plaquette makers.[5]

De Winter argues that most caskets were probably made in Venice, but Pommeranz, citing archival sources, more recently suggests that they may also have been made in Naples, another city with a notable court culture of luxury.[6] A Gallic origin has been proposed for the form, based on the documented presence in Ferrara of Carlo di Monlione, an artisan from Brittany, who created *pastiglia* caskets there starting in 1430.[7] Under the Este dukes Leonello (r. 1441–50) and Borso (r. 1450–71), Ferrara was known for its refined humanistic culture and patronage of the arts. Cosmè Tura (1430?–1495), one of the foremost artists active at the Este court, was paid for work decorating *pastiglia* caskets, in association with Monlione and other craftsmen, in 1452 and 1453.[8] By the sixteenth century, though casket making was certainly still localized in northeastern Italy, the center of production may have shifted to Venice. Venice had a monopoly on the production of *bianco di Venezia*, the white-lead paste that was a key ingredient for *pastiglia* caskets. Lead shavings were a byproduct of metallurgical processes such as the

engraving and niello decoration of armor and cannon for which Venice was famous. Lead was not indigenous to Italy, and Venice's pre-eminence in trade assured a ready supply for many uses, including the making of movable type, essential for the printing industry, as well as of the pigment used on the decoration of the boxes.[9] Because of its extensive trade networks, Venice was also a center for the dissemination of imported perfumes such as musk that were used in scenting the caskets.

Caskets or coffers of various types, including painted *Minnekästchen* and examples of inlaid wood or metal, were popular wedding or betrothal gifts, and from the late Middle Ages were associated with courtship and love. Like the *pastiglia* boxes, they featured images of illustrious women and mythological and chivalric motifs, and may have been used to store jewelry or other personal objects (see cat. no. 40). The form of white-lead *pastiglia* employed here was used in the fifteenth and sixteenth centuries and may have been designed to mimic more costly ivory or bone boxes carved in Florence and Venice by the Embriachi workshops between the late fourteenth and early fifteenth centuries.[10] However, the addition of animal essences

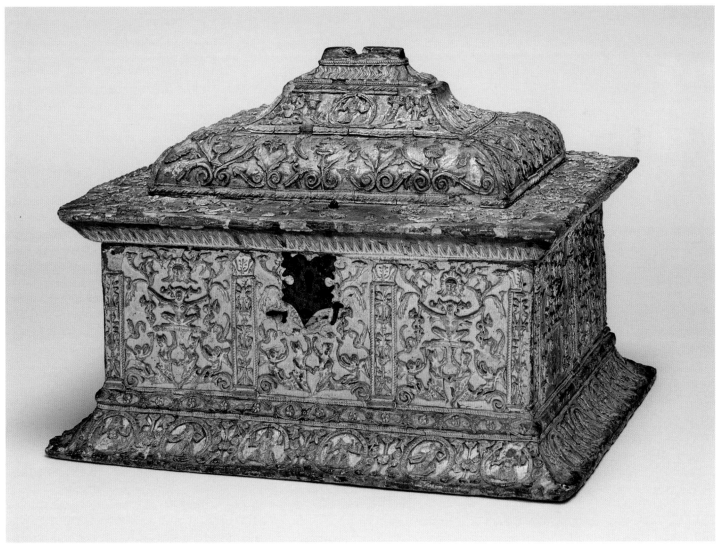

Cat. 39

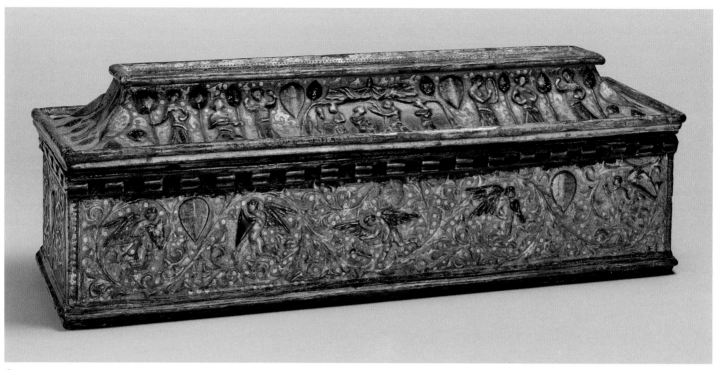

Cat. 40

such as musk or civet was probably unique to what we now call *pastiglia* caskets. The scents were considered to have aphrodisiacal properties, thus adding to the caskets' practical as well as symbolic value as marriage gifts.

DLK

1. The method for obtaining white-lead paste is described in Pliny's *Natural History*, cited in Winter 1984, p. 11.
2. Winter 1984, p. 21.
3. Ibid., p. 33.
4. Pommeranz 1995, p. 59.
5. Winter 1984, p. 16.
6. Pommeranz 1995, p. 93.
7. Manni 1993, p. 11.
8. Pommeranz 1995, p. 209ff., publishes these payments. For a discussion of Tura's involvement, see Syson 2002, p. 35.
9. Winter 1984, p. 21.
10. Ibid., p. 15.

SELECTED REFERENCES: Winter 1984, p. 33, no. 85; Pommeranz 1995, p. 176, no. 191, p. 292, fig. 96 (with incorrect accession number)

40. *Coffer*

Siena (?), 15th century
Walnut, leather, gesso, painted and gilded, 8⅛ ×
24¾ × 8 in. (20.6 × 63 × 20.2 cm.)
Inscribed: *ONESSTÀ FA BELLA DONNA*
The Metropolitan Museum of Art, New York, Gift of
George Blumenthal, 1941 (41.100.188)

Like a cassone in miniature, this coffer is in shape ultimately derived from antique sarcophagi. The top of the coffer slopes upward to a flat, narrow plane which bears

the inscription *ONESSTÀ FA BELLA DONNA*, or "Honesty [or Virtue] makes a woman beautiful," in Gothic capitals (see fig. 51). A series of relief figures in painted and gilded gesso, called *pastiglia*, animate the highly reflective textured surface. This coffer and similar examples have been identified as Sienese.[1]

The many scenes depicted on the coffer make use of the visual vocabulary common to late medieval and early Renaissance Europe for illustrating courtly love in its various guises. Similar imagery is found in the model books that circulated among artisans' workshops in the period, such as the so-called Morgan Model Book.[2] In the central zone of one side of the cover, a lady crowns a knight while a second man looks on. To either side, musicians and dancers, interspersed with trees and blank armorial medallions, serenade the men and lady. On the lower part of the coffer, float five putti—one with a shield that may have been silvered, and one with a musical instrument—surrounded by a meandering pattern of scrolled vines and tendrils. The surface of the coffer is delicately textured throughout, the lower section topped by a pronounced cornice with large dentals that were once highlighted with deep blue to increase the contrast with the gold. The putti and the naturalistic decoration on the lower part of the coffer are in higher relief than the ground decoration on the cover.

On the other side of the cover, four women in two groups sit before a gaming table beneath a canopy. Two pairs of jousting knights on horseback, one to each side of the central scene, clash lances. Beneath, on the lower zone of the coffer, a boar is the central

focus as it embraces its fate by walking in the direction of a hunter brandishing a very large arrow and accompanied by a herald with a horn and a dog. The boar is followed by other animals of the hunt, perhaps a stag and a hunting hound. Armorial medallions, which were once presumably emblazoned with the arms of the owner, appear at regular intervals on the coffer.

Coffers such as this, called *forzerini* or *cofanetti* in contemporary documents, were probably intended as betrothal gifts and may have been used to hold precious dowry objects associated with women, such as cosmetics, personal grooming implements, or sewing tools. They are similar in function to painted German *Minnekästchen* and to *pastiglia* caskets made in northern Italy, one of which is shown in this volume (cat. no. 39). The word *onesstà*, which would be spelled *onestà* in more standardized Italian of the period, was a synonym for "chastity," one of the primary virtues of married women. A similar inscription appears on a coffer at the Victoria and Albert Museum, London, dating from the late fourteenth century: *ONESTA E BELLA* (honesty is beautiful).[3] The conjunction of these two qualities, honesty and beauty, recalls a verse of Petrarch's in which the poet praises his great love, Laura, by explaining that "Two great enemies, Bellezza and Onestà, / Had been brought together with so much concord, / That her holy soul felt rebellion no more."[4] As Paul Watson explained, the notion that the two were inimical was expressed in the writings of the Dominican theologian Bartolomeo da San Concordio (d. 1347), who concluded in

his *Ammaestramenti degli antichi* (Teachings from the Ancients) that "Beauty is often the enemy of honesty."[5] As with so many small luxury objects created as wedding or betrothal gifts in this period, subtle echoes of Petrarchan poetry reinforced the amorous context of the coffer and placed it within a particular literary and social milieu.

<div align="right">DLK</div>

1. Pommeranz 1995, p. 128, no. 35, p. 250, fig. 16, where it is identified as having once been in the Spitzer Collection. Pommeranz is evidently unaware that it has been at the Metropolitan since 1941, and its location is not indicated.
2. This model book has been dated about 1360 and comes from central Italy. See Scheller 1995, pp. 256–64, with bibliography. Some of the illustrations are reproduced in P. F. Watson 1979. See Watson's plate 75, which is folio 8r from the Morgan Model Book, featuring hunters, boars, spears, stags, and hounds.
3. For an illustration of this coffer, see Schotmuller 1921, pl. 64, fig. 142; and P. F. Watson 1979, no. 74. There was also another variant of this coffer, apparently without an inscription, formerly in a private collection in Florence but currently missing (Pignatti 1962, p. 47). A photograph of this coffer appears in Pommeranz 1995, p. 121, no. 13, p. 251, fig. 18, where it is identified as having once been the property of Antichità Bellini, Florence. I have contacted Bellini and been told that this coffer was stolen.
4. P. F. Watson 1979, p. 92. The passage is from the *Rime* (297.1–4), in Watson's translation.
5. P. F. Watson 1979, p. 57. *Ammaestramenti* 1.1.10, 10. Both Petrarch and San Corcordio derived their imagery from Juvenal.

Selected references: Molinier 1890–93, vol. 5, p. 245, pl. 1, no. 1; Pommeranz 1995, p. 128, no. 35, p. 250, fig. 16

41. Case (Étui) with an Amorous Inscription

Italian, 1450–1500
Leather (*cuir bouilli*) over a wooden core, red cord, case only: 8¼ × 3⅛ × 3¼ in. (20.9 × 8 × 8.2 cm)
Inscribed: *A BONA FEDE TE AMO DEL BON [CUORE]*
The Metropolitan Museum of Art, New York, Rogers Fund, 1950 (50.53.1)

Fashioned of tooled leather over a wooden core in a technique known as *cuir bouilli* (boiled leather), this case may once have held writing tools or other personal implements. A faded red cord, perhaps a modern replacement, is knotted under straps on either side

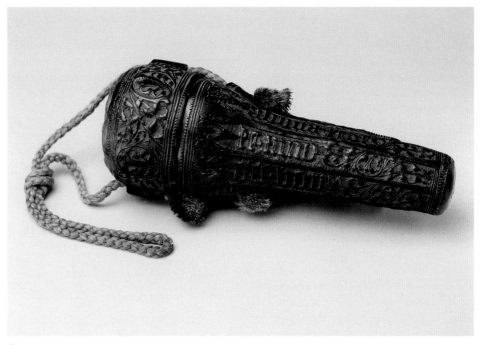

Cat. 41

so that the case could be suspended for storage. An unidentified monogram and coat of arms are located on the cover. The inscription *A BONA FEDE TE AMO DEL BON [CUORE]* (In good faith, I love you with a true heart [the word "heart" is represented by a heart shape]), in Gothic letters, indicates that the case was a love token or betrothal gift. Elaborate curving tendrils and other naturalistic details fill the surface. Triangles thrust vertically like flames from the lower part of the case,

drawing the eye to comparable ornament at the border where the cover meets the lower section. The cylindrical cover is decorated with a horizontal rinceau motif.

Stiffened leather was used from the early Middle Ages throughout Europe to make all sorts of cases, boxes, armor, and bookbindings. It was commonly called *cuir bouilli*, though the precise techniques varied and are probably impossible to reconstruct for any one example. The term is found in English

Fig. 67. Designed by Francesco di Giorgio Martini (1439–1501), executed by Giuliano da Maiano (1432–1490), *Studiolo* from the Gubbio Palace of Duke Federigo da Montefeltro (detail), ca. 1478–82. Walnut, beech, rosewood, oak, and fruitwoods in walnut. The Metropolitan Museum of Art, New York, Rogers Fund, 1939 (39.153)

literary sources between the fourteenth and sixteenth centuries, then reappears at the end of the nineteenth century. Generally, scraped and tanned leather was wrapped around a wooden core. A second layer of leather, perhaps impregnated with wax or resin, was stretched over the first layer, forming a thicker surface that could be punched, modeled, embossed, or stamped to create the desired ornamentation. Small incisions made with wood or metal tools were widened before the object was subjected to heat in the form of a heated tool or hot water, and the leather shrank. Heating bonded the two layers of leather and made them rigid.[1]

A similar case is in the collection of the Virginia Museum of Fine Arts, Richmond.[2] The cases are also found in Renaissance painted images depicting environments for study or scholarship such as the *studioli*, or studies, of church doctors and evangelists or of secular humanists. A pen case, with its accompanying inkwell, hangs on a shelf above Saint Jerome's desk in Domenico Ghirlandaio's fresco of the saint's study, dated 1480, in the church of Ognissanti, in Florence. This set may have been meant for travel, since in the fresco Jerome is using two inkwells, one black and the other red, which are attached to his desk and therefore not portable.[3] In the study from the Gubbio palace of Duke Federigo da Montefeltro (1444–1482), which has been reconstructed at the Metropolitan Museum, a pen case is nestled in one of the illusionistic intarsia panels (fig. 67), suggesting that this was a common accessory. An inkwell in a matching case is suspended nearby. A pen case and inkwell can be seen in use in a small panel by Fra Angelico (ca. 1400–1455), in San Marco, Florence, which depicts the Naming of Saint John the Baptist. According to the Gospel of Luke (1:63), Zacharias, John's father, asked for a tablet to write out his son's

name. The panel shows a woman, perhaps John's mother, Elisabeth, holding a pen case by the cord in one hand and an inkwell in the other while Zacharias writes. The outdoor setting of this scene confirms that these accessories were for peripatetic writing rather than use in a permanent setting.

DLK

1. Bliss 1989, p. 23.
2. Ibid., p. 17ff., figs. 1, 5, 6.
3. See D. Thornton 1997, p. 40. Thornton (p. 144) also mentions a 1450 inventory from Siena that refers to such a set as "un pennaiuolo col calamaio"; she cites (p. 204) the inventory of the estate of Giovanni di Pietro di Fece, February 28, 1450, Archivio di Stato, Siena, Archivio Notarile, K=DCCCIII, and Mazzi 1911.

SELECTED REFERENCE: *Secular Spirit* 1975, p. 81, no. 89, ill.

42. Five Spindle Whorls

Faenza (?), 16th century
Maiolica, ½–⅞ in. (1.3–2.3 cm)
Inscribed: *[C]HIARA.B[ELLA]; LODE.CA[TERINA?].B[ELLA]; POLISENA.B[ELLA]; SOBASTIANA.B[E]LLA*
Philadelphia Museum of Art, The Howard I. and Janet H. Stein Collection, in honor of the 125th Anniversary of the Museum, 1999 (1999.99.15–.19)

After raw fibers were wound on a distaff for safekeeping, they needed to be spun on a spindle. The act of spinning would transform them into thread and eventually into the cloth that was the basis for all textile production in the Renaissance, whether domestic or commercial. Spindles were wooden shafts with a whorl on one end that both stopped the thread from falling off and added a necessary weight to the device that helped it spin evenly.

Moralists such as the Franciscan Saint Bernardino of Siena and the humanist Francesco Barbaro encouraged women to tend to domestic duties such as spinning for the good of their households.[1] In a sermon of 1427, Bernardino lists the tasks of a good wife; he notes that "she causes the flax to be spun and the linen to be woven," while also cleaning the granary, filling the oil jars, salting the meat, and repairing broken wine barrels. Unlike those other, potentially messy tasks, however, spinning could be made at least somewhat enjoyable with special tools, which often arrived in the home as part of the new bride's dowry or counter-dowry. The needle case in this volume, for instance, was an inherently practical object, but the niello inlay made it a pleasure to use (cat. no. 44). The same could be said for ornamented spindle whorls. The vast majority of these were probably made of nothing more than plain clay or roughly carved stone. Yet some were blown glass,[2] and still others, such as the present examples, were fashioned of maiolica and painted with a woman's name or initials along with the initial *B* or the full word *bella*, or "beautiful." This kind of personalization indicates that such objects were specially purchased and presented.

Maiolica whorls may have been stock productions for ceramicists, who could have made them from small bits of clay left over from larger, more lucrative projects. Whorls could be formed and fired, then painted with basic ornament, leaving a reserved strip. When a buyer wanted a whorl personalized, a name could be painted in the reserved area and then the whorl would be fired the second, final time, bonding clay and ornament so that they would retain the vivid colors admired in maiolica today. A great number of these whorls have been excavated in prominent maiolica-producing regions on the Italian peninsula. The examples here,

Cat. 42

originally presented to a Chiara, a Caterina, a Polisena, and a Sobastiana, offer some surprising insights into naming practices in the Renaissance.[3] JMM

1. Bernardino of Siena, *Le prediche volgari*, 1936 (ed.), p. 418; Kohl and Witt 1978, p. 216.
2. Musacchio 1999, p. 165.
3. Bellucci 1898, pp. 8–13.

SELECTED REFERENCE: W. M. Watson 2001, p. 210, no. 84a–e

43. Spindle Whorl

Florence, Medici Porcelain Workshop, ca. 1575–87
Soft-paste porcelain with underglaze blue ornament,
Diam. 1 in. (2.5 cm)
The British Museum, London, Presented by A. W. Franks (1885.0508.102)

Cat. 43, view 1

Cat. 43, view 2

Grand Duke Francesco de' Medici (1541–1587) was always more interested in furthering his scientific experiments—and his relationship with his mistress and later wife, Bianca Cappello (see cat. no. 126)—than he was in governing the Florentine state. Much of his effort and money went into the various workshops he supported at the Uffizi, the Casino at San Marco, and elsewhere for the production of luxury objects such as crystal, hardstone, and tapestry. This spindle whorl was made by his porcelain manufactory, run by the multifaceted architect Bernardo Buontalenti, whom Francesco put in charge of the quest for porcelain in the 1560s.

The Medici, like many European princes, sought out the elusive recipe for the delicate, translucent, yet strong blue-and-white wares they otherwise had to import, at great expense, from China. Despite that expense, the Medici porcelain collection was vast. By the middle of the sixteenth century, the family had more than four hundred pieces of Chinese Ming and Islamic wares, and Francesco was keen to produce his own porcelain to compare, and compete, with them.[1] Although Vasari forecast the success of this enterprise a bit prematurely in the 1568 edition of his *Lives of the Artists*,[2] by 1575 the Medici workshop was recognized as the first European porcelain manufacturer. Its product, what is now called soft-paste porcelain, was translucent like true, or hard-paste, porcelain, but the materials used were different and the kiln temperatures lower.[3] Yet even these lower temperatures damaged many of the experimental wares and limited the output.

According to the inventories of the grand ducal holdings, in the middle of the eighteenth century there were more than three hundred pieces of Medici porcelain scattered throughout the various family residences, a number that probably represented most of the successful pieces, minus those given away as diplomatic gifts to promote Francesco's achievement.[4] However, the end of the family dynasty in the eighteenth century and the auction of many of its holdings resulted in significant losses: today, fewer than seventy pieces of Medici porcelain are known, although more do appear occasionally on the art market. Most of these are flat plates, which were relatively easy to mold, paint, and fire, but some are more complexly shaped ewers and flasks that are impressive in both their manufacture and their survival.

This whorl, however, is unique. The very existence of such a functional object is fascinating, since all the other known pieces of Medici porcelain seem to have been for display, to make a grand statement on ceremonial occasions. Medici women did not need to spin, of course, and their servants would have been supplied with more practical, inexpensive whorls for use in their household tasks. This whorl, now transformed into a precious object of considerable value, must have been intended as a love token, similar to the maiolica examples in this volume (cat. no. 42). The same precious but functional designation may be granted to other documented (but now lost) pieces of Medici porcelain: inventories indicate that the workshop

also made salts, water bottles, and even bird feeders, all of which could have been found in cheaper materials.[5]

In this case, the potter paid particular attention to the whorl's inherent function. The sleek, balanced shape is ideal for use with a spindle. While the coloring is the blue-and-white typical of most Medici porcelain, the ornament is neither Chinese nor Islamic. Nor is it the sort of more popular ornament found on maiolica whorls (cat. no. 42). Instead, the paint was applied carefully and evenly to create a radiating geometric motif around the hole. When the whorl was placed on a spindle, the fast rotation needed to create thread blurred it into an attractive blue streak. The damage to the fired surfaces indicates that it was indeed used in this manner, making a fascinating statement on the presumed exclusivity of early porcelain production.[6] JMM

1. Spallanzani 1994.
2. Vasari, *Le vite*, 1568/1906 (ed.), vol. 7, p. 615.
3. Cora and Fanfani 1986.
4. Spallanzani 1990, p. 319.
5. Spallanzani 1994, p. 190.
6. D. Thornton and T. Wilson 2009, no. 472.

SELECTED REFERENCES: Cora and Fanfani 1986, p. 62; Spallanzani 1994, p. 130; D. Thornton and T. Wilson 2009, no. 472

44. Needle Case with a Woman Holding a Distaff

Florence, ca. 1500
Silver with niello inlay, H. 2 in. (5 cm), W. ⅜ in. (1.1 cm)
Inscribed: *HARIA DI ARCANZOLI*
The British Museum, London (1845.0825.66–71)

This small, surprisingly heavy case must have held practical sewing tools such as needles and pins. The body is a sturdy metal pyramid, the corners, top, and bottom gilt, and the three sides inset with silver niello plates. Two sides have representations of putti, one standing and the other seated, entwined within curving vegetal forms. The third bears a standing female figure in profile who strides to the left, holding a distaff in the crook of her arm that trails a long length of fiber. A scroll reading *HARIA DI ARCANZOLI* unfurls from the figure's mouth, as if she is speaking her name (the *H* must be a stylized *M* for "Maria"). Indeed, the function of the case as a holder of Maria's domestic tools is implied by the inclusion of the distaff, essentially a smooth stick that held raw fibers during the spinning process, keeping them neat and making it quicker

and easier to transform them into threads with the use of a spindle and whorl (see cat. nos. 42, 43). In the Renaissance, this sort of tedious, relatively unskilled task was often done by low-paid, or unpaid, women working in the home. Although cloth production was the staple of the economy in cities such as Florence, this most basic part of the process was not given much recognition or remuneration. But the distaff itself had been recognized as a symbol of wifely duty since antiquity, when it appeared on Greek vases with some regularity. Even the modern use of the word acknowledges this connection to women and their lives: "the distaff side" is understood as the maternal line.

Spinning and sewing both provided for the household and occupied idle hands. The Virgin Mary was often cited as a good model for these occupations. In the early fourteenth century, for example, the Dominican friar Giovanni Dominici advocated representations of the sewing Madonna as devotional aids for young children.[1] The dowries and counter-dowries of many women contained the tools necessary to conduct these tasks. For instance, the Florentine Violante Strozzi, who married in 1486, went to her husband with seven needle cases, an assortment of wool in various colors, a silver thimble, a pair of shears, a thousand small pins (presumably divided among those seven needle cases), a distaff, and thirty spindles.[2]

Although a practical object, the present needle case was executed with great care and skill. The small but fine niello plates are one indication of this, as is the lid, which sockets snugly onto the body, reflecting considerable effort in its assembly. The vegetal ornament continues on two sides of the lid, while the third has a shining sun with a human face. A hole through the center of the case made the middle of the four narrow interior compartments useless for storage. However, a cord could be run through this hole, to suspend the case from the owner's girdle. Industrious women moved from chamber to chamber, following the daylight with their needlework tasks, and such cases kept their smallest tools within reach. In fact, the top and bottom of this case have applied ornament, so it cannot stand independently and had to hang suspended in such a manner.

JMM

1. Dominici, *Education of Children*, 1927 (ed.), p. 34.
2. Archivio di Stato, Florence, Carte strozziane III, vol. 138, fol. 134r: "7 agoraiuoli . . . 2 libre di refe di piu colori, uno anello da cucire d'ariento . . . uno paio di forbice, 1000 spilletti . . . uno aspo i rocha, 30 fuse."

SELECTED REFERENCES: Hind 1936, p. 34, nos. 89–94, pl. XIII; Syson and D. Thornton 2001, p. 48, fig. 28; Musacchio 2008, p. 187, fig. 192

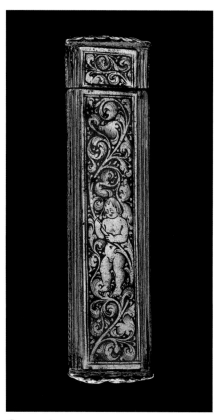

Cat. 44, view 1

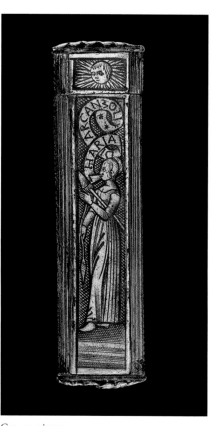

Cat. 44, view 2

Cat. 44, view 3

45. Mandora or Chitarino

Northern Italy, Milan (?), ca. 1420
Boxwood, rosewood, 14⅛ × 3¾ × 3⅛ in. (36 × 9.6 × 8 cm)
The Metropolitan Museum of Art, New York, Gift of Irwin Untermyer, 1964 (64.101.1409)

This small and opulently carved boxwood instrument from the early fifteenth century once held four or five strings. Strangely shaped to the modern eye, the instrument, with its round body, wide finger board, and tonguelike lower extension, recalls experimental stringed instruments seen in the works of artists such as Fra Angelico (ca. 1395/1400–1455), Agostino di Duccio (1418–after 1481), and Gaudenzio Ferrari (1475/80–1546). Scholars have long debated the name and musical nature of this instrument, which has features of both plucked and bowed instruments. It has variously been called a *mandora,* mandola, chitarino, gittern, or *rebecchino.* Its round body, accommodating a Gothic rosette, and a carving on the pegbox of a woman plucking an instrument, much like the one she adorns, suggest that this was a plucked instrument. However, its overall shape, like that of a swollen cucumber, the sickle-shaped pegbox, and the extended lower section or tail link it with the bowed medieval rebec, an instrument derived from the North African rebab.[1]

No matter how the instrument was sounded, the fine relief work covering the back makes it the most elegant and beautiful of three existing examples.[2] These carvings, featuring familiar medieval symbols set among folding leaves, provide a narrative associated with romance—with marital and spiritual fidelity. Most prominent, on the middle and tail sections, are youthful falconers. A maiden, her hair falling to her shoulders, gazes at her betrothed; her hand folds over his arm, and a faithful dog sits at her feet. The young man returns her glance; his hand clutches a purse containing his falcon's meaty rewards, and his left arm supports the bird of prey. Above the figures, perched in a tree, is Cupid, armed with bow and arrow; below the couple, a stag leaps. On the instrument's neck a robed figure points upward to a threatening dragon. The figures are adorned with eyes of inlaid ivory, and the female figure with inlaid wooden nipples. These images, drawn from medieval tapestries, bestiaries, manuscripts, and church carvings, are open to both sacred and secular interpretations. The couple, tree, robed figure, and dragon suggest Adam and Eve, the Tree of Knowledge, a blessing or pontificating God, and a satanic beast. It can also be asserted that the dog and the falcon denote loyalty

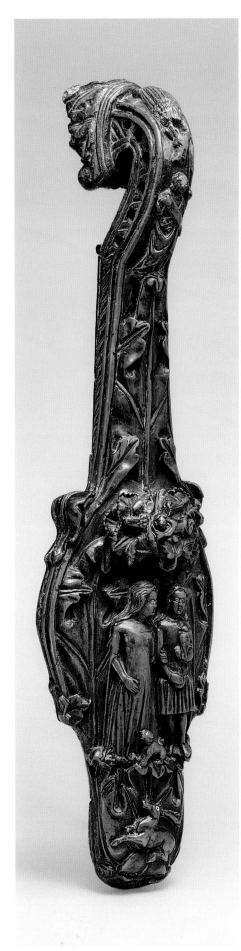

Cat. 45

and trust (for similar iconography, see cat. nos. 121a, b); the purse, a reward and support for the bride, whose wood nipples indicate fertility; the Cupid without a blindfold and with a wound in his left thigh, both noble love and pain and anguish in love; and the stag, a counter to the dragon's malevolent powers, as in the bestiaries and depictions on church furniture that portray the stag as an enemy of vipers.

This exceptional instrument reminds us that belief in the efficacy of music and its instruments as elements of courtship is universal and timeless. Krishna played his flute to seduce dancing milk maidens, whereas youthful Native American men used breathy, sensuous-sounding flutes to articulate amorous intentions. In Europe, at the end of the Renaissance, Shakespeare proposed the overuse of music to remedy lovesickness: "If music be the food of love, play on; / Give me excess of it, that, surfeiting, / The appetite may sicken, and so die" (*Twelfth Night,* 1.1.1–3). Although many uncertainties surround this beautiful and mysterious musical instrument, it is clear that its carving, rich iconography, and musical function unite art and music in the service of romance.

KM

1. Like this instrument, the bowed rebab has a lower extension and a rosette. Similar European examples are seen in the *Cantigas de Santa Maria,* Gerard David's *The Virgin and the Child with Saints* (Musée des Beaux-Arts, Rouen), and a miniature in the Psalter of Alfonso V of Aragon, (fol. 82r).
2. One example (Kunsthistorisches Museum, Vienna, SAM 433) features a female nude, possibly Venus, carved on its back. Another, the Violeta of Santa Caterina de' Vigri, in the monastery of Corpus Domini, Bologna, has a shield-shaped body and an ancient bow, and is considered a relic of the saint. All three instruments are made of a single piece of wood that has been roughly gouged out; the Bologna example alone possesses a solid neck and a lower section supplied with a bridge and tailpiece.

SELECTED REFERENCES: Falke 1929, p. 331, fig. 9; Forsyth 1944; Geiringer 1945, p. 72, p. XII, 1; Hackenbroch 1962, pp. xi–xii, 6, fig. 5, pl. 5; Winternitz 1967, p. 48, no. 4, ill. p. 51; Gómez-Moreno 1968, no. 216, ill.; Laurence Libin in Metropolitan Museum 1975, p. 167, ill.; Libin in *Secular Spirit* 1975, p. 234, no. 242, pl. 13; Libin in *Highlights of the Untermyer Collection* 1977, pp. 150–51, no. 286, ill.; Tiella 1975; P. F. Watson 1979, p. 38, pls. 17, 18; Dixon 1981–82, pp. 147–56, fig. 1, 2; Libin 1983, pp. 63–69, figs. 1–6

46. Wafering Iron

Possibly Umbria, early 16th century
Wrought iron, Diam. of plates, 6½ in. (16.5 cm);
when closed 6½ × 32⅝ × 6¾ in. (16.5 × 83 × 17 cm)
Inscribed on both plates: *NICOLO E PAVLINA LUGLI*;
on one plate: *N, L*; on facing plate: *N, P, L*
Victoria and Albert Museum, London (M.454-1924)

Consisting of two round iron plates fea-turing incised and punched or stamped decoration on each interior surface, the wafering iron displays techniques shared by goldsmiths and other artisans who created dies for coins and medals in Umbria during the fifteenth and sixteenth centuries.[1] On one plate is a central shield with a coat of arms depicting a hand grasping a baton. On either side of the shield are two initials: *N* and *L*. A geometric pattern fills the area between the central medallion and the perimeter, where the following inscription can be read: *NICOLO E PAVLINA LUGLI*.

The facing plate features the same inscrip-tion on the perimeter, but the central field consists of a medallion framing a pointed circular cartouche containing the initials *N*, *P*, and *L*, presumably for Niccolò and Paulina Lugli. A cross tops the cartouche, which has been called a merchant's mark but resembles more closely a stylized heart.[2] The presence of the initials of the couple within this cartou-che suggests that the wafering iron is familial rather than commercial in nature.

Irons such as this were used from the late Middle Ages well into the modern period to create thin wafers to serve at the close of a festive meal along with other sweets such as spiced, fortified wine and candied fruits or nuts. Many irons from this period fea-ture ecclesiastical inscriptions or imagery and were used to make communion wafers. The name of a couple suggests that this iron may have been made to provide personalized

wafers for a wedding feast and then kept to commemorate the event.

Recipes either for, or including, wafers can be found in cookery sources from the late fourteenth century such as the *Ménagier de Paris,* where wafers are served at the end of a meal with sweetened wine called hippocras.[3] Basic ingredients include flour and water, but eggs, sugar, salt, rose water, oil or lard, and various spices appear as well. Wafers must have been made in large quantities for incor-poration into complex recipes such as the Parmesan pie in Chiquart's *Du fait de cui-sine,* a Savoyard culinary treatise of the early fifteenth century, where the author indicates that at least twenty thousand sugared wafers were required for the assembling of the pie, more a theatrical event than an actual dish.[4] Called *cialde* or *cialdoni* in Italian, the wafers were celebrated by Lorenzo de' Medici in his *Canzona de' cialdoni*, a poem penned in the voice of master waferers and included in the *Canti carnascialeschi,* a suite of some-times ribald lyrics dating from the 1470s and 1480s. The *Canti* celebrated the trade guilds of Florence, among other topics, and were performed during the annual Feast of San Giovanni, patron saint of the city. A recipe is woven into the clever verse. Contemporary listeners would have delighted in the thinly veiled erotic double entendres present in the seemingly innocent but perhaps overly ath-letic description of wafer making:[5] "Metti nel vaso acqua, e farina drento / quanto ve n'entra, e mena a compimento: / quand'hai menato, e' vien come un unguento, / un'acqua quasi par di maccheroni" (You place water in the bowl, and then as much flour as will fit, and beat vigorously until it is ready: when you have beaten it until it becomes like an unguent, a liquid almost like *maccheroni*). After sugar is added, the instructions continue: "Conviene, in quel menar, cura ben aggia, / per menar forte, che di fuor non caggia, / fatto l'intriso,

Fig. 68. Bartolomeo Scappi (ca. 1500–1577), *Opera di M. Bartolomeo Scappi, cuoco secreto di Papa Pio V* (detail of a *ferro da cialdoni*), 1570. Printed book with engraved plates, 8⅛ × 6¼ × 2⅛ in. (20.7 × 16 × 5.5 cm). The Metropolitan Museum of Art, New York, The Elisha Whittelsey Collection, The Elisha Whittelsey Fund, 1952 (52.595.2)

poi col dito assaggia: / se ti par buon, le forme a fuoco poni" (Be careful as you beat that you don't beat so hard that the batter splashes out. When it is finished, taste it with your finger and if it seems ready, place the irons in the fire.) Wafers are also mentioned in documen-tary sources from the period such as the reg-isters of payments in the Florentine Opera del Duomo, or Cathedral Office of Works, where they are on the menu for festive occasions

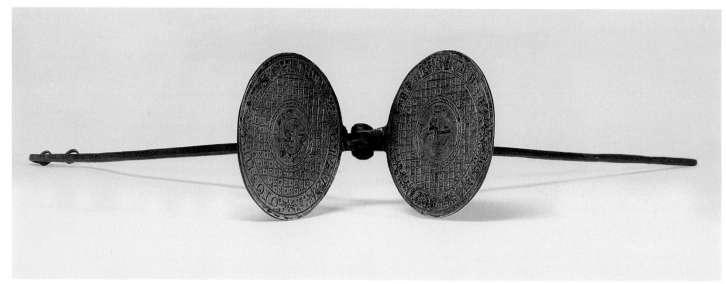

Cat. 46

such as a meal served to the consuls of the Wool Guild when they came to visit the Opera in 1417, or as refreshments to celebrate the Feast of San Giovanni.[6]

Wafers retained their appeal, appearing in the aristocratic cookery manuals of the sixteenth century by Cristoforo da Messisbugo and Bartolomeo Scappi. Messisbugo, steward and master of ceremonies at the Este court in Ferrara, included 1,500 wafers in a banquet served to a group of illustrious dukes, duchesses, marquesses, ambassadors, and prelates in January 1529.[7] Bartolomeo Scappi includes *ferri da cialdoni* in a list of essential kitchen tools and even illustrates one in his 1570 *Opera*, which was reprinted through the middle of the seventeenth century (fig. 68).[8] Scappi's wafering iron takes the same form as the iron under consideration here and is clearly labeled as such: "p[er] fare cialde." The faint outlines of an unidentifiable coat of arms can be seen on the inner surface of the iron, suggesting that it was customary to imprint the wafers with personal arms or insignia.

Though wafers are ubiquitous in Italian Renaissance recipe collections, they were apparently such a basic dish that there was no need for professional stewards or chefs such as Messisbugo or Scappi to list the ingredients. In some cases, the wafers may have been made by specialized craftsmen who were not part of the court or palace kitchens in which these cooks and stewards labored.[9]

DLK

1. Hildburgh (1914–15), in what remains the most comprehensive discussion of the genre, believes that many of the surviving irons were created in Perugia.
2. Ibid., p. 191, fig. 8, nos. 27a, 27b.
3. One of many examples is *Le Ménagier de Paris* 1846 (ed.), p. 92.
4. Chiquart, *On Cookery,* 1986 (ed.), p. 52.
5. *Trionfi e canti carnascialeschi* 1986, p. 8. The translations here are mine. The verb *menare* (to beat vigorously) carried overt sexual associations.
6. An example of this, from the year 1417: "A dì detto per confetto, vino, pane e cialdoni per una collazione per onorare i consoli de l'Arte della Lana che vennono a vicitare l'Opera lire quattro soldi dodici," recorded in *Years of the Cupola* 2004. For the San Giovanni refreshments, see *Years of the Cupola* 2004.
7. Messisbugo, *Libro novo . . . di vivanda,* 2001 (ed.), p. 18v. The first edition of this text is *Banchetti compositioni di vivande et apparecchio generale* (Ferrara, 1549).
8. Scappi, *Opera,* 2002 (ed.), vol. 2, p. 228v. "Ferri da cialdoni" are mentioned as part of the arsenal of the traveling kitchen. The illustrations are unpaginated.
9. Thirteenth-century French guild regulations list specialized wafer bakers, or *oubliers,* who were expected to produce a thousand wafers per day; see Chiquart, *On Cookery,* 1986 (ed.), p. 52.

SELECTED REFERENCES: Chiquart, *On Cookery,* 1986 (ed.), pp. 49–53; Messisbugo, *Libro novo . . . di vivanda,* 2001 (ed.), p. 18v; Scappi, *Opera,* 2002 (ed.), vol. 2, p. 228v; Hildburgh 1914–15, pp. 191–92, nos. 27a, 27b, fig. 8

47. Two Boys with a Bowl of Fruit

Florence, ca. 1500
Polychrome terracotta, 19⅞ × 22½ × 7 in. (50.5 × 57 × 17.9 cm)
Yale University Art Gallery, New Haven, Gift of Elisabeth M. Drey (1982.74)

This terracotta statuette represents two nude boys on either side of a fruit bowl overflowing with bunches of grapes, grape leaves, and ripe pomegranates. The boy on the left stands and raises his right arm to throw a pomegranate while reaching into the bowl with his left hand for another one. The boy on the right sits, a bunch of grapes in one hand, and leans over to bite the first boy's reaching fingers. The additional fruit (and the large, upright pickle) scattered on the base at their feet must imply ideas of abundance similar to those seen in the roughly contemporary statuette *Dovizia* (cat. no. 48). Some traces of original paint still remain on the statuette: the naked flesh is colored with yellow ocher, highlighted in red on nipples and navels; the hair and eyes have vestiges of brown paint; and the green leaves in the bowl are juxtaposed against the red of the bursting pomegranates. Originally these colors would have been both more vivid and more consistent; they now seem dulled by what may be a later brownish wash, perhaps an attempt to make the inexpensive terracotta look bronzed or gilt.

Statuettes such as this one have puzzled art historians. Stylistically they seem to be Florentine, despite some affinities to works from other geographical locales, and they seem to date to about 1500. Thermoluminescent tests conducted in 1977 reveal that this piece was last fired sometime between 1452 and 1512, which accords well with stylistic evidence. Similar statuettes, with equally rambunctious children, are attributed to the aptly named Master of the Unruly Children, an anonymous artist, or more likely artistic workshop, active in the late fifteenth and early sixteenth centuries. As a group, these works appear to be charming genre compositions. Although there is a tradition of representations of battling children in ancient art, the boys here do not seem to have the elevated aura of those earlier examples. In iconographic terms they have much in common not only with the *Dovizia* but also with the images painted on the backs of childbirth trays and bowls and on the sides of marriage

Cat. 47

chests. Also noteworthy in this regard is the general interest in representations of putti so prevalent throughout the Renaissance in paintings, sculpture, and illuminated manuscripts for both sacred and secular audiences. The connection to fertility and fecundity, evident in many of these other images, must be part of the purpose behind these statuettes, too. The antagonism visible in this example, with fruit-tossing and finger-biting, is also common to the group as a whole.[1] Although these gestures seem indecipherable today, during the Renaissance they may well have illustrated popular sayings recognizable to all.

Their inexpensive materials, small size, and secular iconography indicate that these statuettes were intended for the domestic sphere. And, in fact, similar statuettes were cited in Florentine household inventories from this period.[2] They probably withstood multiple installations and changes in ownership after they were made and have suffered accordingly; in this case, breaks in the base and extended limbs have been repaired and reconstructed. But the work was treasured enough by past owners to be worthy of these repairs. Unlike small bronzes, which also enjoyed a certain popularity at this time, these statuettes did not depict ancient gods or heroes. And they are too unwieldy to lift and admire from all sides. The present work may have been meant for an elevated position on a mantel or over a door. Viewed from below, the pudgy faces and bodies of the slightly tilted figures form a stable pyramid around the overflowing bowl. From that angle, or from a position somewhat above the statuettes, if they were placed on a tabletop, a viewer could still see the figures' genitalia and recognize both their gender and, by extension, their potential role as heirs in their household. But the careful details of leaves and fruit on the base suggest an immediate and personal interaction with their original audience, wherever their placement.

JMM

1. Pope-Hennessy 1964, vol. 2, pp. 407–8, no. 426.
2. Musacchio 1999, p. 127.

SELECTED REFERENCES: *Children and Flowers* 1958, p. 11, no. 90; Musacchio 2008, p. 233, fig. 243

Workshop of Giovanni della Robbia
Florentine, 1469–1529/30

48. Dovízia

Florence, late 15th–early 16th century
Glazed terracotta, H. 28 in. (71.1 cm)
The Metropolitan Museum of Art, New York, From the Collection of James Stillman, Gift of Dr. Ernest G. Stillman, 1922 (22.16.6)
New York only

This statuette is a domestic reinterpretation of one of the most recognizable public monuments of fifteenth-century Florence, Donatello's statue of Dovizia, or Abundance, which by 1430 stood on an ancient column in a corner of the city's Mercato Vecchio. Donatello represented Dovizia in the guise of a beautiful woman wearing long, flowing draperies and carrying a basket of fruit and a cornucopia. There is no record of either the statue's commission or its patrons, although it was certainly sponsored by the city itself. Donatello's sculptural work on behalf of various civic and religious groups made him a logical choice for the task. His Dovizia was based, in part, on Roman representations of civic charity.[1] When transplanted to the Renaissance, however, this new Dovizia, with her burden of fruit, clearly linked the ancient concepts of Charity and Abundance with Florence's sprawling marketplace below. A symbol of both mercantile success and civic prosperity, it served as a sign that the government was ready to assist its citizens in the achievement of these goals.

The patrons of Donatello's Dovizia proved remarkably shortsighted in one respect. Despite its intended exposed location, the statue had been carved from *pietra serena*, a locally quarried sandstone that could not withstand the impact of weathering. By the early eighteenth century Dovizia was in such poor condition that it was taken down and replaced with a copy by Giovanni Battista Foggini (Palazzo della Cassa di Risparmio, Florence). Although the column itself is still standing near its original site, now the renovated nineteenth-century Piazza della Repubblica, the statue atop it is yet another copy, from the late nineteenth century. Donatello's original is lost and must have been destroyed by the elements. But the Foggini version is considered a reliable interpretation of its appearance. Further evidence occurs in paintings and other sculptures from the Renaissance; Donatello's statue was adapted for a variety of places and purposes, a sure indication of its great importance and recognizability well beyond its creation and installation.

The statuette in this volume is an excellent example of the potent afterlife of Donatello's invention. It belongs to a group of at least ten examples—and certainly many more were made originally—that demonstrate a keen interest in the adaptation of this civic symbol for a domestic setting. The group is sufficiently diverse in pose, costume, accessories, and coloring to indicate a certain freedom in production. Although parts of each statuette were cast with molds (the cascading draperies, sandaled feet, and upturned arm are similar in many of the examples), others were executed freehand, allowing for the inclusion of particular elements desired by either artist or patron. The statuettes were produced in the workshop of Giovanni della Robbia, grandnephew of the more famous Luca della Robbia, and the son of Luca's nephew Andrea. Heir to the family's workshop, Giovanni utilized a wider range of glazes than his predecessors, producing sculptures that were notably more colorful. These skillful coloristic effects are evident in the Metropolitan's statuette, which contrasts the stark whiteness of Dovizia's figure, much like the original marble, with the richly painted purples, yellows, and greens in her bouquet and basket.

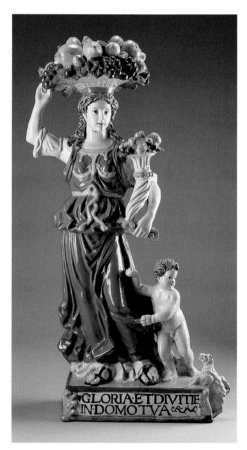

Fig. 69. Giovanni della Robbia (1469–1529/30), *Dovizia*, 16th century. Glazed polychrome terracotta, 27¼ × 14¾ × 8¼ in. (69.2 × 37.5 × 21 cm). Minneapolis Institute of Arts, The William Hood Dunwoody Fund

Cat. 48

your home" (see fig. 69).[4] The Metropolitan's statuette may have been meant to include a similar inscription; it has the same kind of base, but it is unadorned except for the all-over white glaze. The addition of the small lizard clambering up the base is unique in the group; its meaning is unclear, although it may have been merely an entertaining detail. The other two statuettes with bases have small white dogs (symbols of fidelity) or perhaps ermines (symbols of both marital chastity and fertility) in the same location.

Like the *Two Boys with a Bowl of Fruit* (cat. no. 47), these Dovizia statuettes are too large to be easily portable and must have been installed in secure locations, where they would be visible but spared from the accidents of daily life. Ironically, the Della Robbia workshop's use of glazed terracotta, rather than the friable sandstone of Donatello's original, resulted in objects sufficiently durable for prolonged outdoor placement, and some of these statuettes may have stood in the interior courtyards that served as light wells in many Florentine palaces. But most would have been inside the home, where family members could regularly view them. It is there that they are cited in later inventories. For example, in 1551 Piero Benintendi had one in the main ground-floor chamber of his palace, a room his family and visitors would have frequently used.[5]

JMM

1. Wilkins 1983; Wilk 1986.
2. Randolph 2002b.
3. See Wilkins 1983, p. 410, figs. 10–13.
4. For these, see ibid., figs. 11, 12.
5. Archivio di Stato, Florence, Magistrato dei Pupilli del Principato, vol. 2650, fol. 48v: "1ª Dovizia di terra della Robbia con sua basa messa a oro."

SELECTED REFERENCES: Breck and Burroughs 1922, p. 55, ill.; Wilkins 1983, p. 409, fig. 15; Randolph 2002a, p. 36, fig. 1.10; Randolph 2002b, fig. 9.3

Throughout the long history of the Della Robbia workshop—Luca began working in glazed terracotta by the 1440s, and his heirs continued this production well into the sixteenth century—it created a great number of statuettes and reliefs that met the domestic needs of the Florentine public. These objects were produced in multiples to meet the demand. However, since the Dovizia was a domesticated version of a prominent civic sculpture, its appearance and subsequent meaning changed accordingly. Civic abundance became domestic abundance, or fertility: the statuettes as a group deliver the promise of both economic prosperity and procreative success on a domestic, personal level.[2] The Florentine emphasis on children and the importance of continuing the lineage, evident in the contemporary proliferation of childbirth trays and marriage chests from this period, made this a logical development. To further enforce this ideal, many of these statuettes included a naked boy (or in one case boys), a detail absent in Donatello's original (fig. 69).[3] In fact, the Metropolitan's statuette must have also had one of these boys, which would have been attached in the area indicated by the unglazed breaks on the base and draperies.

Two statuettes from this group make the connection to domestic abundance even more explicit: the fronts of their bases are painted with the phrase "Gloria et divitie in domo tua," or "May glory and riches be in

49a. Portrait Medal of Gaspare Fantuzzi (obverse) and Dorotea di Niccolò Castelli (reverse)

Bologna, ca. 1510–30
Bronze, Diam. 3¼ in. (8.1 cm)
Inscribed on obverse: *GASPAR.ELEPHANTVTIVS*; on
reverse: *ΔΩPON.ΘEOY.ΔAMAP.* [modified: see below]
The British Museum, London (1923.0611.55)

Attributed to Antonio Lombardo

Ferrarese, ca. 1458–1516

49b. Eurydice

Ferrara, ca. 1510–16
Marble, 14⅞ × 8⅝ in. (37.8 × 21.9 cm)
Inscribed on lower edge of relief: *BACCIVS
BANDINELIVS FECIT*
The Metropolitan Museum of Art, New York, Gift of
J. Pierpont Morgan, 1917 (17.190.737)

Gaspare Fantuzzi (ca. 1465/70–1536) and his wife, Dorotea Castelli, were members of two of the leading patrician families in late fifteenth-century Bologna. As a boy, Gaspare received a humanist education, which was to prove fundamental. Although he played a minor role in the political life of Bologna, Gaspare was overshadowed as a statesman by his more famous brother Francesco (1466–1533). He seems instead to have been principally driven by a lifelong passion for the worlds of learning and classical antiquity. His eighteenth-century descendant Giovanni Fantuzzi wrote of how Gaspare was "as a young man a great lover of study and desirous of becoming as learned as he could about literature, and thus he cultivated the friendship of the writers of his own day."[1] Fantuzzi corresponded with a number of contemporary humanists, but his most important friendships seem to have been those with the Bolognese historian Leandro Alberti (1479–ca. 1552) and the Imolese humanist Giovanni Antonio Flaminio (1464–1536), to whose celebrated school at Serravalle (today's Vittorio Veneto) Fantuzzi sent his sons for their education. Flaminio not only dedicated several of his writings to Fantuzzi but also encouraged him to maintain with him "a continuous correspondence in Latin to give him practice in writing elegantly in that language."[2] Their correspondence, published in the eighteenth century,[3] is the most important surviving literary evidence for Gaspare Fantuzzi's humanist interests.

Fantuzzi was also an art collector, described by Leandro Alberti as among the leading *antiquari,* or collectors, of his day in the city of Bologna.[4] However, the only surviving evidence for his collection is a small group of sculptures almost certainly commissioned by Gaspare Fantuzzi himself.[5] These consist of a double medal of himself and his wife and three sculptures, two in marble and one in bronze, to which Gaspare had cryptic inscriptions added in places normally concealed from view.

In 1502 Gaspare married Dorotea di Niccolò Castelli, a member of another Bolognese noble family allied to the Fantuzzi, in part through the families' shared loyalty to the Bentivoglio rulers of Bologna. The double-sided medal of Gaspare and Dorotea (cat. no. 49a) may have been commissioned to celebrate their marriage, but is more likely to have been made a little later. Despite its fine quality, no convincing attribution has yet been suggested, and it has generally been regarded as the work of an anonymous Bolognese medalist.[6] The inscription on the obverse is conventional, simply recording Gaspare's name with the surname in the latinized form commonly used by members of the Fantuzzi family. However, the Greek inscription on the reverse, depicting Dorotea Castelli, is both self-consciously learned and, for those who could understand it, a tender statement of a husband's love for his wife. Slightly altered on this example and on most other surviving versions, the inscription in its original form, seen on examples in Bologna and Saint Petersburg, reads *ΔΩPON.ΘEOY.ΔAMAP.,* which can be translated literally as "A wife the gift of God" but also read phonetically as *DORON.THEOS.DAMAR,* thus a clever play on Dorotea's name.

Gaspare Fantuzzi's love for his wife is even more explicitly referred to on a marble relief of *Eurydice* in Naples,[7] a second version of which is shown here (cat. no. 49b).[8] The first decade of the sixteenth century was a difficult time for Bologna, in particular for the Bentivoglio family and its supporters, expelled from the city in 1506 and again, after their brief return in 1511, in September 1512. On the latter occasion Gaspare and his brother were captured and imprisoned in Ferrara, the city to which the Bentivoglio had gone in final exile. During the few months he spent in Ferrara, until his ransom in January 1513, Gaspare is likely to have met the Venetian sculptor Antonio Lombardo, who had left Venice in 1506 to settle in Ferrara, where he spent the remainder of his life, working principally on the celebrated *camerino di alabastro* of Duke Alfonso I d'Este.[9] Antonio Lombardo created during this period a series of small rectangular reliefs featuring exemplary figures from mythology or from classical history, including a depiction of Eurydice, the faithful wife of Orpheus, as she is bitten by the snake that will cause her death and descent to Hades. The Naples *Eurydice* relief carries on the reverse a beautifully lettered inscription *GASP FANT BON/SVAVISSIMO/CONIVGII/FOEDERI/AMORI/QVE/.D.,* translatable as "Gaspare Fantuzzi of Bologna dedicates this to the most sweet alliance of marriage and to conjugal love" (fig. 70). The subject, one of the great classical stories of enduring love between husband and wife, and the inscription make this relief an extraordinarily touching and personal expression of Gaspare Fantuzzi's affection for his wife, Dorotea. It may well have been made about the time when Fantuzzi was held in Ferrara, between 1512 and 1513, and if so, could have been made to commemorate the tenth anniversary of their marriage.

The attribution of this series of mythological reliefs to Antonio Lombardo has been much discussed. In particular, Leo Planiscig and, more recently, Anne Markham Schulz have argued that most of the reliefs, including both versions of the *Eurydice,* are not by Antonio Lombardo but are instead the work of the Venetian sculptor Giovanni Maria Mosca (ca. 1493/95–ca. 1574).[10] Although some of the mythological reliefs are certainly the work of Mosca, the attribution of the *Eurydice* reliefs to him is more problematic. Both versions are close in style and quality and are on balance more likely to be products of Antonio Lombardo's workshop. The purported signature of the sculptor Baccio Bandinelli (1493–1560) on the New York relief is a later addition. J W

1. Fantuzzi 1781–94, vol. 3, p. 289.
2. Ibid., pp. 289–90.
3. Capponi 1744, books 7–9, letters 271–374.
4. L. Alberti 1541, colophon Gii.
5. Warren 2007.
6. Hill 1930, no. 623; Attwood 1991, p. 7, figs. 10, 11.
7. Museo Nazionale di Capodimonte, IC 4651; Anne Markham Schulz in Ceriana 2004, pp. 258–61, no. 63.
8. Ibid., no. 64.
9. Ceriana 2004.
10. Planiscig 1921, pp. 268–69; Schulz 1998, pp. 61–82.

SELECTED REFERENCES: *49a.* Hill 1930, no. 623; Attwood 1991, p. 7, figs. 10, 11; Warren 2007

49b. Planiscig 1921, pp. 268–69; Schulz 1998, pp. 61–82; Anne Markham Schulz in Ceriana 2004, pp. 258–61, no. 64

Cat. 49a, obverse

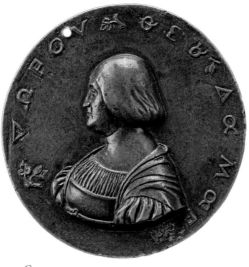

Cat. 49a, reverse

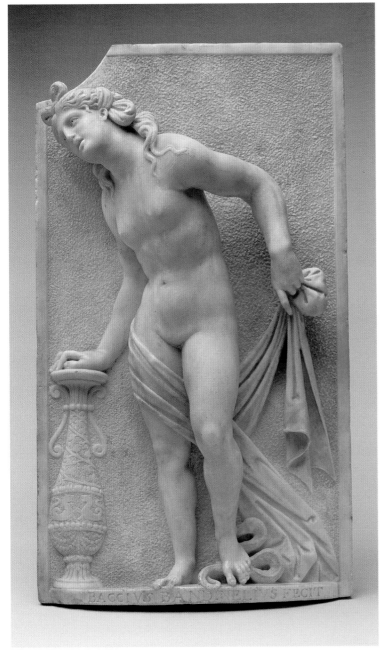

Cat. 49b

Fig. 70. Attributed to Antonio Lombardo (ca. 1458–1516), inscription from reverse of *Eurydice*, 1520–29. Marble, 16 × 10¼ in. (40.7 × 26.1 cm). Museo di Capodimonte, Naples

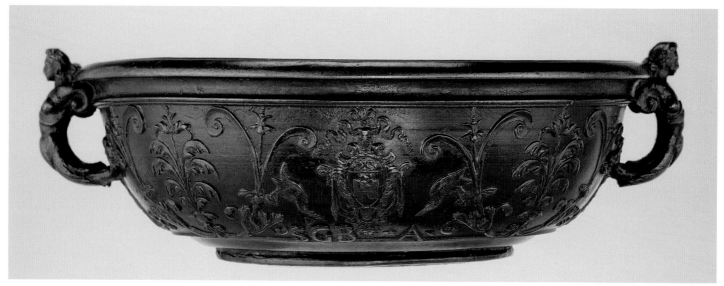

Cat. 50

50. Annoni–Visconti Marriage Bowl

Milan, 1569–71
Bronze, H., excluding handles, 4½ in. (11.3 cm),
Diam., excluding handles, 13⅛ in. (33.2 cm)
The Ashmolean Museum, Oxford (WA 1997.81)

This deep bowl has a molded rim, shal-low foot, and two handles in the form of sirens, below which are grotesque masks. The body is extensively decorated with foliate and scrolling decoration, and in the center of each side is a coat of arms. The arms in one shield are those of the Annoni family: a twin-towered castle with a duck between the tur-rets, a single-headed eagle in the chief, with the initials *S.G / B.A.*, for Signore Giovanni Battista Annoni, below. The other coat of arms is that of the Visconti: a shield charged with the *biscione*, a crowned serpent swal-lowing a child, with the initials *S.S / V*, for Signora Silvia Visconti, below. Each coat of arms is flanked by a pair of bowing storks.

The bowl[1] commemorates the marriage of members of two of the leading families in Renaissance Milan. Giovanni Battista Annoni (ca. 1545–1590) belonged to one of the city's most prominent mercantile fami-lies, heavily involved in import-export trade with northern Europe. His father, Giovanni Angelo Annoni, spent much of his career based in Antwerp, which, like Milan, was at that time a Spanish possession. The Visconti, by contrast, formed part of the city's old aristocracy, Silvia Visconti being the daugh-ter of Pier Francesco Visconti and a mem-ber of the Brignole branch of the family. Silvia was first married to Count Alfonso Cicogna, who died in 1567, leaving his widow with two daughters, Antonia and Ippolita Teodora. Giovanni Battista Annoni and Silvia Visconti are unlikely to have been married in 1569, when Giovanni Battista

received his share of his inheritance from his father, but certainly were by 1571, when their first child, Giovanni Angelo II, was born. They went on to have three daughters, two of whom would become nuns.

It is probable that the bowl was a wed-ding gift from Antonia and Ippolita Teodora Cicogna to their mother and future step-father. *Cicogna* is the Italian word for a stork, a well-known symbol of filial piety.[2] The pair of bowing storks flanking each coat of arms on the bowl are almost certainly intended, therefore, to symbolize the daughters and their acceptance of their mother's new union. Large bowls, more often made of precious metal than of bronze, were an important ele-ment in marriage ceremonies in Renaissance Italy, being used both in the marriage cer-emony itself and during the wedding festivi-ties. Just such a bowl can be seen in Titian's *Sacred and Profane Love*, almost certainly painted to commemorate the marriage of Nicolò Aurelio and Laura Bagarotto in 1514 (fig. 93). The principal function of such bowls seems to have been to contain water for the washing of hands, and they were also used by the coiners of emblems as a symbol for concepts such as marital harmony or inno-cence, often illustrated through the ancient formal act of marriage, the joining of right hands (*dextrarum iunctio*), carried out in conjunction with the cleansing of the hands in a bowl (for the joining of hands, see cat. nos. 16–18).[3]

In 1571, the same year in which his son was born, Giovanni Battista was forced to seek a pardon after having murdered a rival in a fight over a prostitute. Nonetheless, his marriage to Silvia appears to have lasted and may even have been relatively happy. In a letter written in 1584 to a correspon-dent in Mantua,[4] Giovanni Battista praised a ring he had received from Mantua, with

a Crucifixion and Agnus Dei within it. He added that a lady who had come to visit his wife had nearly carried away the ring, and concluded charmingly: "I swear to you that I have never seen a more beautiful thing in my life. Signora Silvia is amazed by it and can-not imagine how it is possible to make such a thing." Silvia was still alive in 1605, when Giovanni Angelo II, by now in charge of the family business, mentioned in a letter that he had brought his mother back to Milan from the country.[5]

The Annoni–Visconti Marriage Bowl is not only a rare piece of documentation for a specific Renaissance marriage; it is also one of the finest small bronzes to survive from Renaissance Milan. Its sophisticated form and decoration link it to the hardstone and rock-crystal vessels for which Milan became celebrated during the sixteenth cen-tury, notably through the work of Annibale Fontana (1540–1587) and the Miseroni and Sarachi families. Together with two other, slightly smaller, bowls in the Victoria and Albert Museum, London,[6] and in the Musée des Arts Décoratifs, Paris,[7] it was evidently made in one of the leading bronze-casting workshops of Milan and was designed by an artist familiar with the prestigious objects in precious materials being produced in Milan at that time. Closer in style to Fontana than to the other great contemporary Milanese sculptor, Leone Leoni (ca. 1509–1590), it may be the work of a member of the Busca family, a distinguished dynasty of Milanese sculp-tors and bronze founders who worked with Fontana on the decorations of the church of Santa Maria presso San Celso and who also cast a series of superb works in bronze for the cathedral of Milan. JW

1. Warren 1999, no. 33; Warren forthcoming, no. 61.

2. Alciati, *Emblematum Libellus,* 1985 (ed.), emblem 30, showing a stork carrying food to its young.
3. Valeriano, *Hieroglyphica,* 1575, p. 251.
4. Piccinelli 2003, pp. 138–39, doc. no. 230.
5. Ibid., p. 362, doc. no. 839.
6. Motture 2001, p. 178, no. 58.
7. Metman and Vaudoyer 1910, p. 4, nos. 123, 124, pl. XI.

SELECTED REFERENCES: Warren 1999, no. 33; Warren forthcoming, no. 61

51. Velvet Fragments with Medici Arms

Florence or Venice, 1440–1500
Silk, metal thread, 31 × 21 in. (78.7 × 53.3 cm)
The Metropolitan Museum of Art, New York, Fletcher Fund, 1946 (46.156.118)

This cut voided velvet is a well-known example of a textile created for a specific family who could afford to commission fabrics bearing their personal insignia. A repeating pattern of stylized six-petaled flowers in crimson, green, and light blue velvet is highlighted, in the central zone of each rosette, with the seven red Medici *palle,* or balls, against a shimmering background of brocaded gold thread. The seven *palle* were used by various members of the Medici family, including Cosimo de' Medici (r. 1434–64), as they rose to prominence during the fifteenth century through their patronage of politics and the arts in Florence and its territorial state.

A Medici connection is reinforced by comparison with Medici artistic monuments such as the private chapel in the Palazzo Medici (now Palazzo Medici-Riccardi) in Florence. A similar pattern of seven *palle* is found on the bridle of Cosimo's horse depicted in one of the frescoes by Benozzo Gozzoli (ca. 1421–1497) which decorate the chapel's walls.

Textiles were among the most significant material goods associated with marriage celebrations, as we know from the letters of Alessandra Strozzi (see my essay "Marriage as a Key to Understanding the Past" in this volume) and from the many surviving inventories of trousseaux that list garments made from luxury woven fabrics as well as lengths of cloth ready to be made into clothing. Inclusion of heraldic devices, including mottoes, on costly garments to be worn on special occasions was one of the ways families such as the Medici and Strozzi signaled their preeminence among the ruling dynasties of the Italian peninsula. Several examples survive. A number of damasks from the end of the fifteenth century woven with the symbol of a dove surrounded by a golden sunburst have been linked to members of the Visconti family;[1] and arms of two families, the Della Scala and the Pamphili, are found on a piece of damask from the first half of the sixteenth century.[2] (See also the discussion of the heraldic symbolism of the textile in cat. no. 53.) A piece such as this one might once have been part of an ecclesiastical garment worn by one of the many Medici prelates or their minions; the dynastic symbolism is nevertheless integral to the fabric. Costly textiles, especially those identified with the patron, were frequently reused in different contexts.

Pieces of this textile are also in the collections of the Art Institute of Chicago; the Bargello, Florence; the Cleveland Museum of Art; the Museo del Tessuto, Prato; and the Musées Royaux des Beaux-Arts de Belgique, Brussels.[3] DLK

1. *Tessuti serici italiani* 1983, pp. 124–35, no. 30.
2. Ibid., p. 123, no. 29.
3. Bunt 1962, fig. 20 (for a chasuble made of this pattern at the Art Institute of Chicago); *Tessuti serici italiani* 1983, pp. 118–19, no. 27, with bibliography (Florence); Weibel 1952, p. 123, no. 147 (Cleveland); Bonito Fanelli 1981, pp. 66–67, fig. 12 (Prato); Errera 1927, p. 129, no. 126 (Brussels).

SELECTED REFERENCES: Serra 1937, p. 31, no. 82, pl. XIII; *Tessuti serici italiani* 1983, pp. 118–19, no. 27

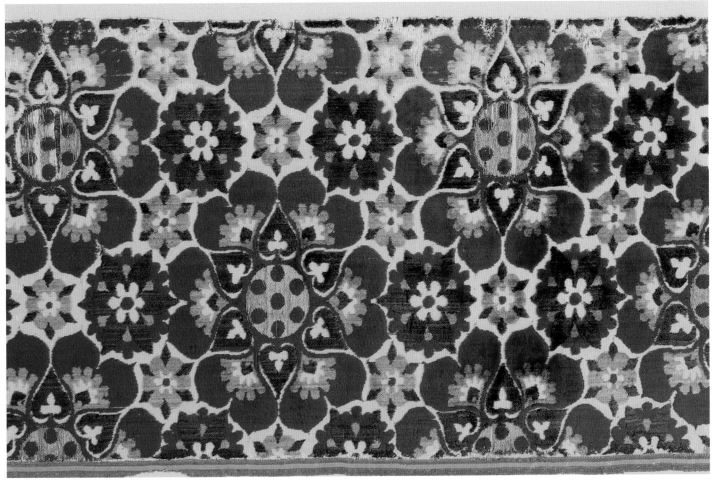

Cat. 51 (detail)

52. Woman's Cap

Venice, 1500–1525
Linen, silk, metal thread, glass beads, 9 × 7¾ in.
(22.9 × 19.7 cm)
The Metropolitan Museum of Art, New York, Rogers
Fund, 1916 (16.154.14)

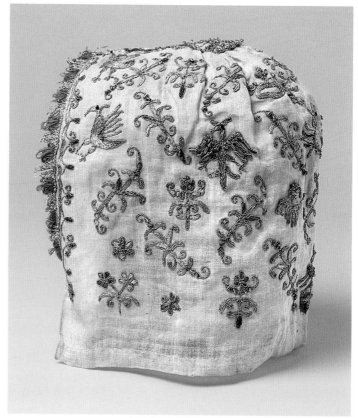

Cat. 52

This cap is fashioned of fine white linen. It is embroidered in gold and silver metallic thread, and in pink, blue, black, red, and green silk thread, with some small glass beads that provide added texture and depth. A fringe of red silk and gold metallic thread frames the front rim of the cap, which was meant to fit closely on the head of a woman. The exquisite detail of the embroidered flowers, phoenix, scrolls, and small putti heads gently padded for relief, and the rich materials employed, suggests that the cap was intended to be worn on a special occasion or by a bride. A delicate casing is incorporated into the lower edge, presumably for ties that would pass under the chin to help position the cap on the head. At the crown of the cap, there is a central embroidered rosette that recalls the hat brooches popular in the period.

Caps or bonnets such as this, called *cuffie*, are mentioned frequently in records of bridal trousseaux from several different regions of Italy during the fifteenth and sixteenth centuries. The 1474 trousseau of Caterina Pico, of Carpi, had at least twelve caps made from different types of linen—from Florence; from Cambrai, in Flanders; and from Reims, in France—some of which included lace.[1] The trousseau of Ghostanza Minerbetti, a Florentine who married in 1511, contained at least twenty-two caps, from simple ones of linen, described as "house caps," to "eight embroidered house caps of very soft fabric," which might match the cap illustrated here.[2] Bona Sforza (1494–1557), who married Sigismund I of Poland in 1518, had sixty caps in her trousseau.[3]

Though archival sources indicate *cuffie* were ubiquitous, there are few painted illustrations of the caps without other headpieces over them, perhaps because Renaissance portraiture reflects occasional rather than typical moments in the sitter's life. This embroidered *cuffia* can be compared to that worn by the sitter in a painting attributed to Paolo Uccello, from the 1460s (fig. 71); or in the anonymous Florentine *Portrait of a Lady in Red* (National Gallery, London). Caps were made of silk brocade or wool as well as linen and could be ornamented with pearls and topped by veils of embroidered silk, as can be seen in Fra Filippo Lippi's double portrait of a man and a woman (cat. no. 118).

Close-fitting caps or bonnets were also worn by men underneath hoods or helmets. In the fifteenth century, Florentine cap makers, or *cuffiai*, were generally part of the Arte dei Medici, Speziali e Merciai, the guild of doctors, apothecaries, and mercers. The Metropolitan Museum acquired this cap

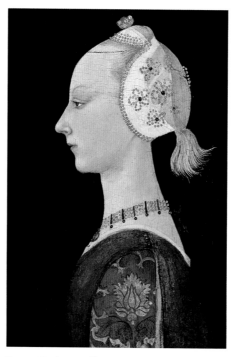

Fig. 71. Paolo Uccello (1397–1475), *A Young Lady of Fashion*, ca. 1460–65. Tempera on panel, 17⅜ × 12⅜ in. (44.1 × 31.5 cm). © Isabella Stewart Gardner Museum, Boston

from the collection of Elia Volpi, a collector and dealer in Florence, who, like Stefano Bardini, held several sales in New York in the early twentieth century that helped to shape taste among Americans for Italian decorative arts of the Middle Ages and Renaissance.[5]

DLK

1. Morselli 1956, p. 100.
2. Frick 2002, pp. 233–39.
3. See the discussion in Levi Pisetzky 1964–69, vol. 3, p. 90. She lists several other *corredi* (trousseaux) in which caps are listed.
4. Frick 2002, p. 48.
5. On this phenomenon generally, see Ferrazza 1994.

SELECTED REFERENCE: American Art Association 1916, lot. 1126

53. Heraldic Textile with the Emblems of Two Families

Italy, 1500–1550
Silk, 26 × 23 in. (66 × 58.4 cm)
The Metropolitan Museum of Art, New York, Fletcher Fund, 1946 (46.156.116)

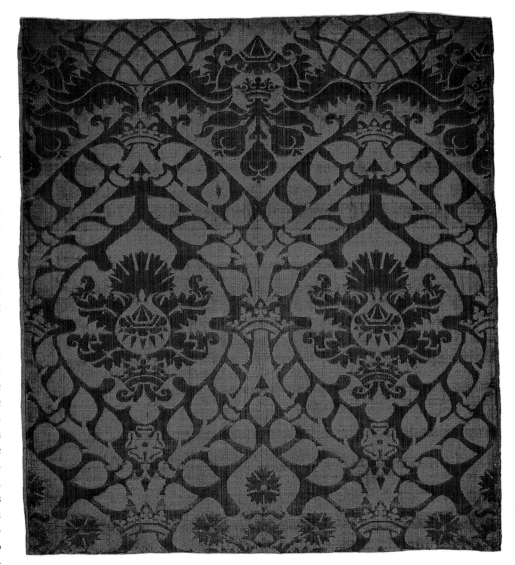

Cat. 53

This silk damask in a vibrant shade of green features a pattern of pointed ovoid forms framed by a garland of leaves that resemble those of ivy or caper. The repeat consists of three separate fields: one with a large diamond ring emerging from a crown from which three pears hang; another with a smaller diamond in the central zone; and a pineapple or pinecone motif that emerges from the top of the pointed oval containing the diamond.

Many variants of this pattern are documented by textile historians, as well as in paintings from the period. There has been speculation about the heraldic significance of the diamond ring and the pears, but the ubiquity of the pattern makes definitive conclusions impossible.[1] The decorative motifs of the rings and pears may hold clues to the function of the fabric, as well as help explicate paintings in which the textile appears, but the heraldic symbolism is by no means transparent. The diamond ring appears in several contexts as a Medici symbol, including on the reverse of the birth tray of Lorenzo de' Medici (cat. no. 70), where it is accompanied by three feathers and the motto *SEMPER* (always).[2] However, as Adrian Randolph and others point out, the diamond ring was also used by other families, both in and outside Florence, such as the Rucellai, the Strozzi, the Sforza, and the Este.[3] The ring was both a symbol and an object with a widely recognizable practical meaning. It was, in Randolph's words, "the most visible sign of legitimate, consensual matrimony."[4]

Pears have been associated with the Peruzzi family of Florence based on the similarity of the Italian for "pears" (*pere*) to the family name, and indeed several branches from the early sixteenth century have either six or eight pears, though not three, on their coat of arms. In his book on Italian families, Pompeo Litta mentions a Medici–Peruzzi marriage. He includes in a genealogical table Laudomia de' Medici, the youngest daughter of Tanai de' Medici, who married Varano Peruzzi, but does not give a date for this wedding.[5] Allan Marquand describes a terracotta medallion depicting Varano's coat of arms, from the workshop of Giovanni della Robbia, that he saw in a provincial castle, with an inscription dating it to 1510. It is probable that the marriage took place in the early sixteenth century. The arms are described as including six pears.[6] The damask was possibly created to mark the union of Laudomia de' Medici with Varano Peruzzi, though in that case one would expect to find six rather than three pears per ring. Yet another hypothesis is that the pears connect the pattern to a group of families who did have three of these fruits on their family devices: the Perini of Pisa, the Perdodini of Prato, or the Peri and Perotti of Florence.[7]

Whereas Donata Devoti attributes the Metropolitan's textile to Venice and identifies the diamond as that of the doge of Venice,[8] Giovanna Galasso more convincingly asserts that the fabric must be Florentine in origin: it is worn, albeit in a deep red hue, by a woman in a portrait by Andrea del Sarto, dated about 1516, and the Florentine painter followed the pattern of the actual damask with "maniacal exactitude" (fig. 72).[9] Both diamond and pear motifs appear prominently on the voluminous right sleeve of the sitter, whose identity is uncertain. Alessandro Cecchi writes that the Peri family commissioned del Sarto to decorate a chapel in the church of San Gallo,[10] and (though this leaves the Medici connection unresolved) it follows that the

Fig. 72. Andrea del Sarto (ca. 1487–1530), *Lady with a Basket of Spindles*, 1510–20. Oil on panel, 29⅞ × 21¼ in. (76 × 54 cm). Galleria degli Uffizi, Florence

artist may have been asked to paint a member of this family as well. A second, more plausible suggestion tentatively put forth here is that the woman with spindles, which allude to domestic virtue, may be Laudomia de' Medici, whose marriage with Varano Peruzzi is cited by Litta.

The contemporary function of textile pieces from the Renaissance is often difficult to establish, since many fabrics were used in both secular and ecclesiastical contexts. In two recent cases, historians have been able to document the use of damasks related to the Metropolitan's in surviving garments recovered from tombs. One of the variants of the pattern cited by Mary Westerman Bulgarella and others is found on a damask skirt (*gonnella*) from 1524 that belonged to Isabelle of Aragon, Duchess of Milan and Bari (1470–1524), and is now conserved in the sacristy of the church of San Domenico Maggiore, in Naples.[11] A similar pattern appears on a *cappotto*, or cloak, in which Don Garzia de' Medici was buried in the church of San Lorenzo, in Florence, together with his mother, Eleonora di Toledo, after their sudden deaths from malaria in Pisa in 1562. A painstaking restoration has revealed the shape of the garment and the pattern of the damask.[12]

The range of dates for the group of related damasks suggests that the pattern was a very successful one and was produced over a long period. The list of paintings that feature representations of related textiles extends the dates during which the pattern was significant well into the seventeenth century.[13] The pattern could be adapted in various ways, including the doubling or halving of the size of the repeat.[14] An indication of the pattern's broad diffusion is provided by a rare surviving drawing in the Florentine State Archives of a related, but not identical, pattern. The fabric was apparently requested by a Florentine textile agent in Frankfurt in 1555, who commissioned a Florentine textile merchant, one Francesco Carletti, to have it ready in time for the Frankfurt fair of the following year.[15] With an international clientele, weavers in northern Europe might also see fit to produce versions themselves.[16] The polyvalent nature of the symbol of the ring, called by Randolph a "meta-heraldic image," explains the many masters that this pattern served.[17] The weavers could presumably personalize it with devices of the patrons for special occasions such as weddings. Though the many variants of the pattern make a conclusive identification of the Metropolitan's piece difficult, its broader context provides a fascinating window into the material culture of the period. DLK

1. For a description of many of the related textiles, see Westerman Bulgarella 1996–97. Her drawings of the group suggest that though the textiles share basic motifs and technique, there are subtle differences, including color. She has located patterns related to the Metropolitan's damask in Cologne (Kunstgewerbemuseum), Naples (the church of San Domenico Maggiore), Munich (Residenz Depot), and Florence (Fondazione Arte della Seta Lisio). Several variants are identified by her in painted images: Bronzino's *Portrait of Cosimo I* (National Gallery of Canada, Ottawa), an anonymous *Portrait of Eleonora di Toledo* (Pinacoteca Sabauda, Turin), and Cristofano Allori's *Judith* (Palazzo Pitti, Florence). Giovanna Galasso (1993, p. 235ff.) identifies several other painted representations of related fabrics, from a *Madonna* in Prato once attributed to Neri di Bicci to a *Sacra Conversazione* by Antonio Campi at the Brera, Milan. A cope now in the Basilica di San Clemente ai Servi, Siena, features the ring with crown but lacks the pears (Roberta Orsini Landini in Acidini Luchinat et al. 2002, p. 287, no. 144). In addition, in a church in Sweden there are pieces featuring the diamond ring (Branting and Lindblom 1932, vol. 1, pp. 142–43); and one piece with both the pears and the diamond ring (Branting and Lindblom 1932, vol. 2, pl. 212).
2. For an extended discussion of the symbolic and heraldic meanings of the wedding ring in Renaissance Florence, see Randolph 2002a, p. 108ff.
3. Ibid., pp. 117–18, with references.
4. Ibid., p. 110.
5. Litta 1819–83, vol. 7, pl. VIII.
6. Marquand 1919, p. 185. The arms were in the courtyard of the Castello di Lari, which is in the Pisan hills. The Florentines had officials stationed there from 1406, when they conquered Pisa and integrated it into the expanding Florentine territorial state. Varano Peruzzi served as vicar and commissary there in 1510, according to the inscription on the terracotta.
7. Westerman Bulgarella 1996–97, p. 7.
8. Devoti 1974.
9. Galasso (1993, p. 236) identified the creator of the painting as Pontormo, but its attribution is hotly contested, and it is now given to Andrea del Sarto. For a discussion of the attributional controversy, see Antonio Natali's entry on the painting in Cecchi and Natali 1996, p. 264, no. 88, with references.
10. *Andrea del Sarto* 1986, pp. 42–47, 55–56, cited by Westerman Bulgarella 1996–97, p. 7.
11. D'Arbitrio 2006, pp. 97–99. She was buried in the garment, which was removed from her tomb in the same church and restored in the 1980s, and this is presumably how the precise date of the skirt was established.
12. For an illustration of this pattern, see Westerman Bulgarella 1993.
13. Westerman Bulgarella 1996–97, p. 13.
14. Ibid., p. 3.
15. This drawing is reproduced in *Il potere e lo spazio* 1980, p. 203; see also p. 206, no. 2.25.

Further information is supplied by Bonita Fanelli 1981, pp. 125–27, where a note from the agent in Frankfurt to his colleague in Florence, found on the back of the drawing, is published. The agent starts by critiquing the drawing and then goes on to describe the pattern verbally, including the color, which is tan, though there were apparently samples included with the drawing, to which he refers. The names of two weavers who might be able to make the fabric based on their past record in weaving this pattern are given. The note ends with a typical reminder to his Florentine colleague to use diligence in serving him. The drawing is also cited by Galasso 1993, p. 236, and Boccherini and Marabelli 1993, p. 49, in connection with the Metropolitan's piece.
16. A related pattern is illustrated in Van Ysselsteyn 1962, p. 126, no. 233, pl. 81. The author claims that the fabric comes from Courtray, in present-day Belgium, though she incorrectly identifies it as linen.
17. Randolph 2002a, p. 115.

SELECTED REFERENCES: Bunt 1962, pl. 25; Devoti 1974, fig. 97; Galasso 1993, pp. 229–48, fig. 11; Westerman Bulgarella 1996–97, pp. 2–6, fig. 8

54. Woven Border with Emblems of the Strozzi Family

Italy, possible dating ranges from 1480 to 1600
Silk, linen, 139 × 19¼ in. (353.1 × 48.9 cm)
Inscribed: *SIC ET VIRTUS EXPECTO*
The Metropolitan Museum of Art, New York, Rogers Fund, 1951 (51.75)

Woven of silk and linen, this long, narrow border may once have been installed high on a wall below an ornamental cornice, or used as a valance for a bed, or *lettiera*, in a nuptial *camera* such as the one created for the Borgherini, discussed by Andrea Bayer in her essay "From Cassone to *Poesia*" in this volume.[1] The design, which unfolds horizontally, features two alternating motifs, both of which are associated with the Strozzi family of Florence. In one, three yellow half-moons are at the center of a field framed by branches of a bush upon which blue and white roses blossom. Red flames dart out from between the half-moons. A banderole with the words *EXPECTO SIC* frames this image. The other motif consists of a molting or grooming falcon, also framed by a banderole, which winds circuitously along the border and bears the words *ET VIRTUS*. Between each iteration of the motifs, the banderoles are linked, allowing the full motto—*SIC ET VIRTUS EXPECTO*—to be read. The motto can be translated as "I wait, and so does virtue." Lively colors of brown, yellow, green,

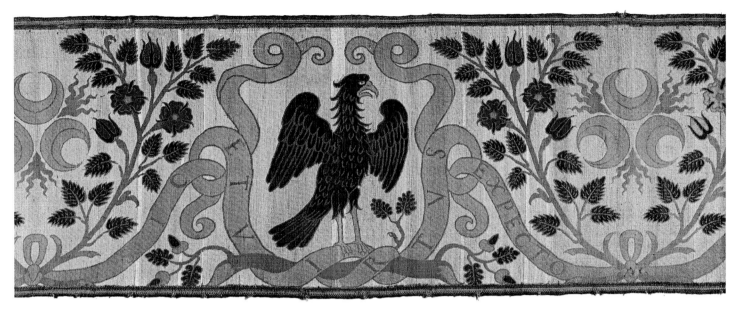

Cat. 54 (detail)

and blue stand out against the neutral off-white ground.

The figure of the falcon losing its feathers is familiar from two other works associated with the Strozzi in the Metropolitan Museum's

Fig. 73. Workshop of Giuliano da Maiano (1432–1490) and Benedetto da Maiano (1442–1497), attributed to, *Chair (Sgabello)*, ca. 1489–91. Walnut, maple, ebony; ebonized wood, and fruitwood; traces of gilding and paint, 58 × 16¾ × 16½ in. (147.3 × 42.5 × 41.9 cm). The Metropolitan Museum of Art, New York, Fletcher Fund, 1930 (30.93.2)

collection: the *Sgabello* chair (fig. 73) and the *Trebizond* cassone (cat. no. 56). During the Italian Renaissance, playful combinations of words and images were frequently used to suggest multiple layers of meaning and were known as *imprese*. In this case, the word for "falconer" in Italian is *strozziere*, a pun on the family name of Strozzi.[2]

The motto's reference to waiting may reflect the sentiments of Filippo Strozzi the Elder (1426–1491), who spent several key years in exile in Naples. (It was in letters to Filippo that his mother, Alessandra Strozzi, described in minute detail the wedding clothing of her daughter, Filippo's sister Caterina. (See my essay "Marriage as a Key to Understanding the Past" in this volume.) When Filippo the Elder returned to Florence from Naples in 1466 he continued to amass his fortune, and by 1474 the demolition of houses and workshops in the area of the future Palazzo Strozzi, which was to be the grandest private palace in Renaissance Florence, had begun.[3] Construction of the palace did not start, however, until 1489, just two years before Filippo the Elder's death. The project was continued by his son, also called Filippo, who rose to prominence in the turbulent political climate of Florence at the turn of the sixteenth century but who died in prison in 1538, after leading an unsuccessful struggle for power against the Medici.

The identification of this border with the Strozzi family, who rank among the most important patrons of arts and architecture in Renaissance Florence, has not been questioned, but the particular patron for whom it was created is disputed, based on differing datings of the piece. According to Beatrice Paolozzi-Strozzi, the border was made toward the end of the fifteenth century, in celebration of the Strozzi family's triumphant return to Florence, when Filippo the Elder acquired

numerous works of art, including *cristallo* and *calcedonio* Venetian glass, Chinese porcelains, Flemish tapestries, and illuminated manuscripts.[4] An identical piece, presumably a fragment of the same border, is in the collection of the Bargello, Florence, and is dated to the end of the fifteenth century.[5] According to Edith Standen, however, the border was created at the end of the sixteenth century; she cites as evidence a medal dated 1593 featuring Alessandro di Camillo Strozzi (b. 1565) with the motto EXPE[C]TO and a spread-winged bird.[6] The history of the Strozzi family is one of serial exile and return, so in any case the motto could have retained its relevance over several generations, perhaps helping to explain its survival to this day. DLK

1. Peter Thornton (1991, p. 129ff.) discusses the various types of valances that appear above four-poster beds beginning in the early sixteenth century. In illustrations of grand beds, the valances were often embroidered or figured in some way.
2. For a discussion of Strozzi emblems, see Nickel 1974; and the entry for cat. no. 56 in this volume. See also Koeppe 1994, p. 29, where the falcon losing its feathers is not only a metaphor of renewal but also an allusion to the falcon's unique capacity to molt only partially, so that it can be ready for flight at any time and is thus always prepared.
3. Paolozzi-Strozzi 2005, p. 65.
4. Ibid., p. 64.
5. *Tessuti italiani del Rinascimento* 1981, p. 80, no. 28.
6. Standen 1951, p. 126. For the medal, see Vannel and Toderi 2003, vol. 1, p. 109, nos. 1021, 1022, pl. 203.

SELECTED REFERENCES: Standen 1951, p. 126, ill. p. 125; *Tessuti italiani del Rinascimento* 1981, p. 80, no. 28, ill.; Paolozzi-Strozzi 2005, pp. 64–65

55. Belt or Girdle with a Woven Love Poem

Italy, 16th century
Tapestry-weave band with silk and metal thread, 66 ×
2½ in. (167.6 × 6.4 cm)
The Metropolitan Museum of Art, New York, Fletcher
Fund, 1946 (46.156.73)

This woven belt or girdle features a lively green ground that serves as the field for a series of diagonally oriented alternating gold and silver cartouches outlined in red and continuing throughout the length of the belt. A floral design executed in gold and silver thread decorates the field above and below the cartouches. At either end is a white phoenix on its pyre that is edged in brilliant vermilion. The entire belt is edged in silver galloon. Though finished off now, the ends may once have been completed with a gilded or silvered buckle (*fibbia*) and metal tip (*puntuale*).[1] (See the discussion of girdle ends in cat. nos. 36a, b.) The green silk backing is not original to the piece. A comparable but earlier belt is in the collection of the Victoria and Albert Museum, London, and features an unidentified coat of arms and an amorous inscription as well as intact metalwork.[2]

Inside each cartouche are words woven in black thread that together form the text of a love poem. Inscribed: AL FOCO DE'TUOI BACI QUAL FENICE INCENERISCO E MORO E AL SOFFIO DEI TUOI SOSPIR RIPRENDO VITA, E COLLE FILA CHE TESSESTI STRINGO AMORE QUANTO TU CON LACCI TUOI ME STRINGI AL CUORE QUANDO PERÒ SARAI FEDEL AMMÉ. A rough translation reads:

> I will burn even as a phoenix
> With the fire of your kisses,
> And I will die.
> Life will return with
> The breath of your sighs.
> Even as the net woven
> With the cords of love,
> Do you tie me to your heart
> As long as you will be faithful to me.[3]

Belts or girdles were both fashion accessories and tokens of affection in Renaissance Italy. As early as the fourteenth century, belts were treasured possessions, and were unique as ornaments that even women from the countryside might have owned.[4] Often part of dowries or among gifts to expectant mothers, they could also be symbolic of love in other, less savory, contexts. Belts or girdles of this sort even appear in Italian literature. The amorous language of the poetry woven into this object suggests that it was a gift from lover to beloved, as in the following example. In the third tale recounted on the third day

Cat. 55

of Giovanni Boccaccio's *Decameron,* a belt plays an important role as a multivalent love token. The story, recounted by Filomena, tells of a woman who uses an unwitting friar to intercede in an adulterous romance. At one point in the complex tale, she claims that her object of desire has given her a purse and a belt as a token of his affections, seemingly a common occurrence. Bringing them to the friar, she protests that she does not need them, saying: "I have brought them here to you so that you yourself may return them to him, telling him for me that I have no need of his things, for, thanks be to God and my husband, I've got enough purses and belts to

drown in."[5] The friar gives the goods to the lover, who takes them as a token of affection and encouragement from her, not admitting to the friar that he did not in fact give them to her in the first place. Thus the belt's symbolic meaning is transformed: It comes to embody the adulteress's illicit desire for her lover, just as it had once served to manifest the husband's legitimate love for his wife. One way or another, the lover got the message and the two eventually consummated their illicit desire, thanks to the friar's intervention.

There are a number of clues which allow one to speculate about the maker of this piece. A pattern first published in 1530 in Giovanni Andrea Vavassore's *Esemplario di lavori,* one of the earliest Italian books that offered instructions for sewing, embroidery, and lace making, must have provided the basic idea for this belt.[6] In the illustrated pattern, an identical procession of diagonal cartouches marches across lengthwise, with very similar flowers hanging above and below. The text is not, however, a poem; the word *liberta* (freedom) is simply repeated in each cartouche.[7] A related piece of embroidery in the Metropolitan Museum's collection replicates Vavassore's pattern exactly, suggesting that his instructions, which, to quote the book's subtitle, were designed to "teach women the method and order for working [textiles]," were sometimes followed precisely.[8]

The belt shown here, however, presents another reality. Its maker was inspired by the pattern, but elected to fill the cartouches with a text of his or her own choosing. This individuality is borne out by the technical evidence: whereas the weaving of the belt, flowers, and general shape is quite accomplished, the areas for which there was no pattern—namely, the words of the poem—are awkward and amateurish. The poetic strophes are not respected in the way the text is broken up to fit into each cartouche, as if the weaver had not planned carefully and was working this feature out as he or she went along. Another personal addition are the two phoenixes, found at either end of the belt, that illustrate the poem. These birds are somewhat awkward in execution and suggest that, as with the text, no pattern was followed. Graphic images of the phoenix were easily accessible since they were used by several sixteenth-century Venetian printers, including Gabriel Giolito de' Ferrari and Guglielmo Fontaneto, in their emblems, and thus appeared on many frontispieces.[9]

The text on the belt is characteristic of Petrarchan lyric poetry from the mid-sixteenth century and may be Venetian or Florentine, though it has eluded precise identification and may be a popular verse that was well known to contemporaries. The theme of

the phoenix is pervasive in medieval literature, from the troubadors to Petrarch, where it is developed in various ways and figures in several of the *canzoniere*.[10] The language is comparable to that of Giovan Battista Strozzi (1504–1571), who wrote one of the intermezzi for the wedding of Cosimo I de' Medici and Eleonora of Toledo in 1539. Strozzi was best known for writing madrigals, many of which remain unpublished.[11] The choice of text for the belt is perfectly calibrated to the function of the object: the voice of the lover refers to weaving, binding, and tying, incorporating the creation of the belt as well as its function, both actual and symbolic. This kind of clever interplay of text and object is parallel to the form of the madrigal, where musical effects are often dictated by the words of the poetry being sung—a musical device sometimes

called madrigalism. Expressive texts were often set to music and reached a large audience through madrigals. Perhaps the maker, or at least the commissioner, of this love token was adapting the words of a favorite song to send a special message.

<div style="text-align:right">DLK</div>

1. Frick 2002, p. 127.
2. Ajmar-Wollheim and Dennis 2006, p. 362, no. 155, pl. 7.4. This belt has similar dimensions.
3. The translation was found in the files of the Department of the European Sculpture and Decorative Arts, Metropolitan Museum, and is unsigned.
4. Frick 2002, p. 46.
5. Boccaccio, *Decameron*, 2002 (ed.), p. 211.
6. See Daniels 1933, p. 23.
7. Giovanni Andrea Vavassore, called

Guadagnino, *Esemplario di lavori: che insegna alle donne il modo e ordine di lavorare* (1530). Several editions, through 1552, are listed in Lotz 1963, pp. 123–25. There is also a facsimile of the 1530 edition: Vavassore, *Esemplario di lavori*, 1910 (ed.). See also Witcombe 2004, p. 291.
8. MMA 18.138. On Vavassore, see Ajmar-Wollheim 2006a, pp. 162–63.
9. Zambon 2004, pp. 60–62.
10. Ibid., p. 36ff.
11. See *Poesia italiana del Cinquecento* 1978, p. 102. A first line of Giovan Battista Strozzi comparable to the poem on the belt can be found in F. Carboni 1982, no. 413: "Al foco de' begli occhi." The poem, unpublished, is in a manuscript in the Vatican Library, which was closed at the time of researching and writing this volume.

CASSONE PANELS AND CHESTS

Marco del Buono Giamberti

Florentine, 1402–1489

and

Apollonio di Giovanni di Tomaso

Florentine, 1415/17–1465

56. *Cassone with The Conquest of Trebizond*

Florence, 1460s
Tempera, gold, and silver on wood; distemper on inner lid, 39½ × 77 × 32⅞ in. (100.3 × 195.6 × 83.5 cm)
Inscribed at left, on city walls: *GO[N]STANTINOPOLI* (Constantinople); at left, within city walls: *S FRA[N]CES/CO* ([church of] San Francesco); upper left, within city walls: *S. SOFIA.* ([church of] Santa Sophia) *DEILO.PER . . . ORI* ([undeciphered]); at left center, on city walls: *PERA.* (Pera [formerly Galata]); on Bosporus: *LOSTRETTO.* (strait); at center, on city walls: *LOSCUTARIO* (Scutari [present-day Üsküdar]); farther back: *CHASTEL NVOVO* (new fortress [Rumeli Hisari]); at right, on city walls: *TREBIZOND[A]* (Trebizond [present-day Trabzon]); next to conquerer: *TAN[B]VRLANA* (Tamerlane)
The Metropolitan Museum of Art, New York, John Stewart Kennedy Fund, 1914 (14.39)
New York only

This cassone, or marriage chest, has until now been considered one of the few to survive largely intact from the fifteenth century. However, technical examination carried out by conservators and research scientists at the Metropolitan Museum as this volume was being prepared has revealed

several anomalous features in its construction that suggest the front panel may in fact come from another contemporary cassone.[1] Inspired by the shape of ancient sarcophagi and called *forzieri*, or strongboxes, during the Renaissance, cassoni were widely imitated during the nineteenth century; as they became highly valued collectibles, all but the best-preserved were reconstructed.[2] The original elements of this cassone may have been created in the workshop of Apollonio di Giovanni and Marco del Buono, who also made the *Story of Esther* panel (cat. no. 57) and who were certainly the painters of the principal narrative scene.

The painted decoration here is not confined to the front panel. The exterior of the lid has been coated with gesso and painted and gilded, then delicately punched with a pattern imitating a cloth draped over the top. Its inner surface has been painted with matte distemper in a colorful imitation of velvet brocade. A stencil appears to have been used to create the pattern, which features the motif of a pomegranate, symbol of prosperity and fertility, and is reminiscent of those found on the period textiles that would have been stored in the chest (cat. no. 56, open).[3] A similar faux-textile pattern is painted on the back of the cassone, though its colors are more subdued and it seems to have been drawn freehand, rather than with a stencil, and is left unfinished (cat. 56, back). Since some cassoni, especially examples from earlier in the fifteenth century, may have been carried through the streets of Florence

during wedding processions, it would have been important to decorate all the exterior surfaces; however, chests of this size and weight may in fact have been too ponderous to go on parade.

Acquired by the Metropolitan Museum in 1913 from the well-known collector, antiquarian, and art dealer in Florence Stefano Bardini (1836–1922), the chest has been linked to the important Florentine family, the Strozzi, on the basis of Bardini's undocumented assertion that he acquired it directly from the Strozzi.[4] A Strozzi connection is supported by the imagery on the two side panels. Although much darkened and difficult to see, these panels feature the device of a hawk or falcon standing on a caltrop (a spiky metal weapon thrown to the ground during battle to destabilize an enemy's horses) atop a banderole on which is written *ME[Z]ZE*, now very faded. The same bird of prey is also found on the Metropolitan Museum's *Sgabello* chair from the Palazzo Strozzi (fig. 73); on a medal depicting Filippo Strozzi, the well-known patron of the massive palace in Florence;[5] and even on a piece of silk-and-linen brocade that may once have adorned a Strozzi *camera* (cat. no. 54). The initials, spelling the word *mezze*, which means "half" in Italian, probably refer to the half-moons that were also Strozzi emblems.

Since the cassone's appearance on the market in the early twentieth century, there has been much speculation concerning the significance of the imagery on its densely figured, lavishly painted and gilded front panel.

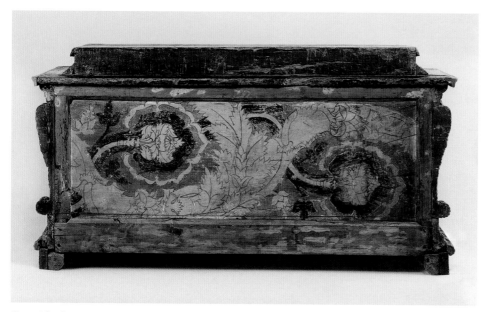

Cat. 56, back

Leaving aside for the moment the question of whether this panel was originally paired with the two on the sides, a detailed exploration of the many inscriptions on the front panel suggests that the subject—unlike many of the biblical or mythological ones commonly found on other painted cassoni—might not have been readily comprehensible to the viewer. Despite the presence of names of people and places that would presumably dispel any doubts, disagreement persists among scholars as to the date and identity of the scene because the inscriptions seem to present contradictory information.

The painting depicts two cities: Constantinople, on the left, and Trebizond, on the right. The few boats shown plying the waters around Constantinople testify to its importance as an entrepot for trade between Europe and Asia. A battle is taking place, with groups of soldiers, both mounted and on foot, wearing a colorful variety of costumes highlighted by elaborate detail and heavy gilding. The traditional view, first put forth in the early twentieth century, was that the panel depicted the 1461 conquest of Trebizond by the Ottoman Sultan Mehmed II.[6] Doubts were raised beginning in 1980 by Keith Christiansen and John Pope-Hennessy based on the presence of the name *TAN[B]VRLANA*, or Tamerlane (cat. 56, detail)—now difficult to see without magnification and raking light—next to the triumphal chariot drawn by two white horses at the far right of the panel (cat. 56, front).[7] The Mongol emperor Tamerlane was the victor in the battle of Angora (modern-day Ankara), which took place in 1402 against the opposing army led by the Ottoman Turk Sultan Bayezid I. Trebizond, the present-day Trabzon, lies on the Black Sea coast near the border with Georgia. The Empire of Trebizond, established as the Byzantine

Empire fragmented after the Fourth Crusade in 1204, was the last of the Byzantine Greek holdouts in the Ottoman sweep that included the conquest of Constantinople in 1453. Ankara lies inland to the southwest, nowhere near either Constantinople or Trebizond. So why Tamerlane in Trebizond? This question has lead to several articles exploring the cultural politics of the 1450s and 1460s in Italy and Asia Minor. Though these are full of fascinating detail and thoughtful analysis, no clear conclusion emerges, which suggests that faithfulness to historical sources was not among the primary motivations of either the painters or the patrons of this panel. Rather, the chest's imagery attests

Cat. 56, detail of inscription on front (enhanced)

to the curiosity and topical interest that its Florentine patrons had regarding the transitional politics of the Anatolian peninsula in the fifteenth century.

Building on the suggestion made by Christensen and Pope-Hennessy[8] that the conflict represented was in fact the 1402 battle of Ankara, or at least that the imagery referred to that event, Andrea Paribeni proposed that political events of the 1460s around Constantinople, as well as farther east in Anatolia, and presumed Florentine responses to them, may explain the seeming contradictions in the panel's iconography.[9] Though the inscription clearly identifies the occupant of the chariot as Tamerlane, Paribeni, followed by Cristelle Baskins, explores the hypothesis that he is instead the Turkmen prince Uzun Hasan, whose exploits were well known at the time.[10] After the Ottoman conquest of Constantinople in 1453, Mehmed II continued to expand his territories. By 1461 he was attempting to subjugate the remaining independent regions along the Black Sea coast. At this time, Trebizond, far to the east of Constantinople, was controlled by the Byzantine emperor David Komneni. It was also an important prize for the Turkmen, led by Uzun Hasan, who were in competition for the area with the Turks. As the Ottoman forces advanced along the coast, Hasan, who alone could have organized a military challenge to the Ottomans, negotiated a truce, agreeing not to help the Byzantine army defend Trebizond if the Ottomans proceeded peacefully. The bloodless fall of Trebizond, the last independent

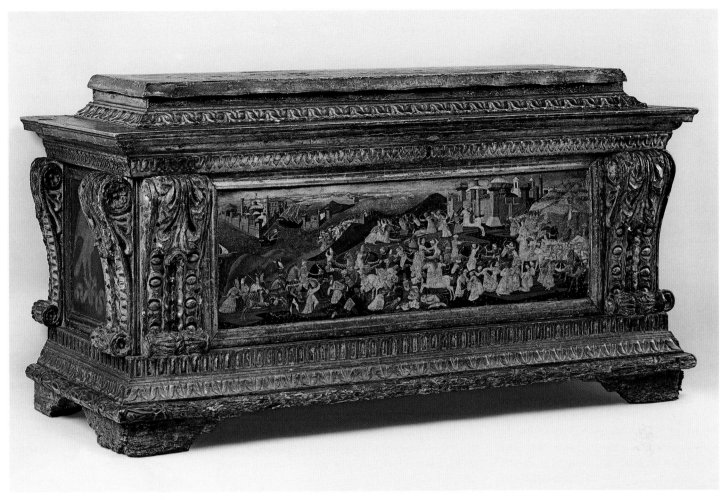

Cat. 56, front

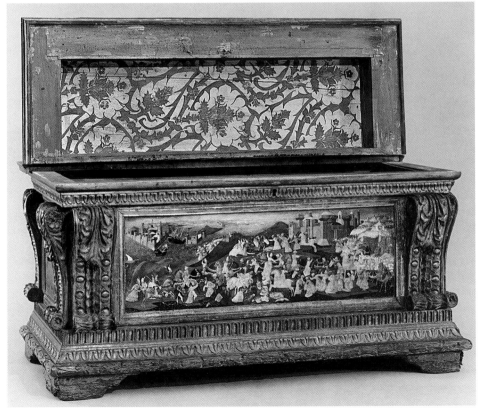

Cat. 56, open

Christian outpost on the Anatolian penin-
sula, took place on August 15, 1461.[11] Uzun
Hasan was known at the time as the "New
Tamerlane," after his ancestor who had origi-
nally prevailed over the Ottomans in 1402.
However, while elements of the story of
Hasan's capitulation in Trebizond may have
informed the iconography on the cassone, he
was not actually victorious in the 1461 skir-
mish (such as it was) and the suggestion fails
to be completely convincing.

While the soldiers depicted fighting on
both sides of the conflict wear similar robes,
their headgear distinguishes them. One
group, moving from the left, presumably from
Constantinople, wears hats with tall shafts
topped by a folded flap that identify them as
the Janissaries, the elite standing army of the
Ottomans. The opposing side sports conical
hats anchored by a white band that makes
them appear to be turbans.[12] Baskins, after
Ellen Callmann, has identified the one fig-
ure in Western dress on horseback wearing a
bell-shaped hat as David Komneni.[13]

Some of the confusion regarding the
imagery may be addressed by examining
the unfolding of the fall of Trebizond. Its
distinction as the last Byzantine outpost on
the Black Sea may explain why a Florentine
patron would have chosen to commission an

image of what was certainly a dark day for Latin Christendom, if that is in fact what is depicted.[14] Though Trebizond did eventually fall to the Ottomans in August 1461, the cassone panel may have been commissioned before this, as an expression of the hope that it, unlike Constantinople, would be saved. The presence of Constantinople in the composition can be easily explained, since Florentines were in fact dedicated to the idea of maintaining a Christian foothold there and, at least during the mid-fifteenth century, supported Pope Pius II's plans for a crusade to take back the city.[15] As Paribeni outlines, Florentine merchants, unlike the Genoese and Venetians, had been slow to enter into the Black Sea trade. Only in December 1460 did they sign a treaty arranging to set up a *fondaco* in Trebizond and a consul to administer it, negotiated through David Komneni's ambassador, the Florentine merchant Michele degli Aldinghieri. Even at this late date, as Mehmed II advanced steadily eastward along the Black Sea coast, there must have been high hopes for maintaining a strong Florentine presence in Trebizond. The positive expectation that the Byzantines would triumph might indeed be an acceptable subject for a marriage chest.[16] But if the cassone was then completed *after* the fall of Trebizond, the identification of Hasan as Tamerlane—a winner rather than a loser who held back the Ottomans in 1461, as had his predecessor in the 1402 battle of Ankara—might have "saved" the panel's imagery from complete obsolescence.

Other elements may also have been at work. It has been proposed that the contemporary conflict between Ottomans and Byzantines may have been viewed as parallel to the legendary enmity in antiquity between Trojans and Greeks. With a little help from the humanists, Florentines traced their lineage to Aeneas, a Trojan, who was also considered an ancestor of the Turks.[17] On the other hand, Paribeni argues that Trojan forces, prefiguring the Ottomans, threatened to unseat the Greek empire, which was viewed in the fifteenth century as allied with Christian Europe. In this vein, Tamerlane was celebrated in later accounts as a great hero for repulsing the Ottomans in 1402.[18] Paribeni cites two cassoni with Greek triumphs that were commissioned from Apollonio, probably in 1461.[19] If the victor of the battle portrayed here was ultimately the Christian West or a regime favorable to it (Byzantines or even the Mongols, at certain moments), this would have resonated powerfully with contemporary interests. The outcome of the bloodless 1461 "conquest of Trebizond" may have been Ottoman domination of this formerly Byzantine port, but

savvy Florentine businessmen were aware of the need for tolerance to allow their mercantile interests to flourish.

Contemporary cartographic sources for Constantinople and its surroundings confirm that the city portrayed on this chest corresponds to a post-1402 view. By the mid-fifteenth century, trading colonies were well established, and there were several maps and descriptions of the city that might have been accessible to the cassone painters in Apollonio's workshop. Pope-Hennessy and Christiansen, followed by Paribeni and Baskins, suggest that a map from Cristoforo Buondelmonti's *Liber Insularum Archipelagi* of about 1420 was an important source for the painters.[20] Patricia Lurati proposes that sketches by Cyriac of Ancona (1391–1452), or copies of them, may also have played a role.[21] The building described in an inscription as the CHASTEL NVOVO is the new fortress, Rumeli Hisari, built by Mehmed II in 1452.[22] But other monuments featured in the portrait of the city, including a Franciscan church and a Byzantine flag flying from the ramparts, underline the importance of depicting the Christian legacy of Constantinople despite its fall to the Ottomans in 1453.[23] While Paribeni argues that the topography of Trebizond, on the other hand, is more generic and is reminiscent not of contemporary maps or sketches but of manuscript illuminations by Apollonio di Giovanni,[24] Baskins presents a couple of descriptions of Trebizond from earlier in the fifteenth century that might have provided a basis for the representation of the city.[25] Trebizond was well known, at least in name, to Florentines, through Greek scholars such as George of Trebizond (1395–1486) and Cardinal Bessarion (1403–1472), who was a native of the city.

Until now, the interpretation of the cassone as an ensemble has hinged on the assumption that the front panel was somehow linked to the Strozzi family, an assumption that the recent technical examination has called into question. Though most scholars agreed that the commission came from a member of the Strozzi family, opinions differed as to which one. Helmut Nickel suggested that the cassone was commissioned in 1462 for the wedding of Caterina Strozzi and Jacopo degli Spini, for whom Apollonio's shop made a pair of cassoni.[26] Paribeni proposed instead Vanni di Francesco Strozzi, who traveled on a Florentine galley to Constantinople, Trebizond, and Caffa, on the Crimea, in 1462. Vanni also appears in the extract of Apollonio di Giovanni's workshop records as a client, commissioning a cassone for his brother's marriage to the daughter of Bertoldo Corsini.[27] Baskins added two other Strozzi family members

to the list of potential patrons: Strozza di Messer Marcello degli Strozzi, in 1459, and Benedetto di Marco degli Strozzi, in 1462.[28] Following a suggestion by Beatrice Paolozzi-Strozzi, who proposed that the cassone was created for Filippo Strozzi, Lurati suggested that it was commissioned for his wedding to Fiammetta degli Adimari, which took place soon after Filippo's return from exile in Naples, in 1466.[29] These Strozzi marriages can be added to the growing list of patronage hypotheses but cannot be conclusive, since precise documentation is lacking and physical evidence suggests otherwise. In any case, attempts to locate the imagery of the cassone within the global ambitions of the Florentine merchants who likely commissioned it are surely not misplaced.

The question of why any of these distant events would have been meaningful to a Florentine patron during the fifteenth century is tied to the ambivalence Europeans may have felt about the Ottoman takeover of Asia Minor. While opportunistic traders had their commercial interests in the long-distance Asia trade to worry about, there was also a desire to maintain a Christian presence in the area and to accommodate to the new diplomatic reality of Ottoman rule. Constantinople, which is prominently represented and named on the cassone, was a fundamentally important trading post for merchants, including Florentines, as they traveled between Europe and Asia. A definitive interpretation of the activity on the panel, whether it is the 1402 battle of Ankara or the 1461 battle of Trebizond with a fairytale ending, will surely continue to be the object of speculation until a foolproof explanation can be put forth. At the very least, this narrative provides a fascinating window into the changing balance of power on the Anatolian peninsula, which was so critical for Italian commercial interests throughout the fifteenth century. DLK

1. The technical examination of the *cassone* will be the subject of a forthcoming publication by Mechthild Baumeister, George Bisacca, Silvia Centeno, Michael Gallagher, Pascale Patris, and Mark Wypyski.
2. On the destruction of cassoni, the sale of orphaned panels, and their reuse in "new" pieces, see Callmann 1999b.
3. Wolfram Koeppe in Kisluk-Grosheide, Koeppe, and Rieder 2006, p. 12.
4. According to Everett Fahy, Bardini purchased a number of important paintings from Prince Ferdinando Strozzi in 1878. Whether or not this cassone was among those purchases is not known, though there are several photographs of the chest in Bardini's archive. See Fahy 2000, pp. 9, 188, photograph no. 293.

5. For discussions of the falcon or hawk in connection with the Strozzi family, see Nickel 1974; and Koeppe 1994.

6. Weisbach 1913.

7. Pope-Hennessy and Christiansen 1980, p. 13.

8. Ibid.

9. Paribeni 2001, p. 260ff.

10. Callmann (1974, p. 50) first suggested that Uzun Hasan was important for understanding the panel's iconography, though as Baskins points out, she assumed that he was an ally of Mehmed II rather than a rival. In a forthcoming publication, Baskins—not convinced of the existence of the Tamerlane inscription, which she has not been able to see—argues that the panel depicts the 1461 Ottoman conquest of Trebizond. Her argument, though flawed by her disavowal of the inscription, contains several ingenious suggestions for a potential bride's interpretation of the story, focusing on the role of Theodora Komneni, daughter of John IV of Trebizond and niece of his brother, David Komneni, who became Uzun Hasan's fourth wife in 1458. Baskins further suggests that Hasan is piloting the victorious chariot on the right, with his older brother Jahangir seated below him. See Baskins forthcoming.

11. Paribeni 2001, p. 265.

12. Ibid., p. 268ff. Though the Florentines were generally quite knowledgeable about Greek costume, owing to the large number of Eastern prelates who visited Florence and Ferrara in 1439 for the council, this would not have been the case for Mongol costume of the early fifteenth century, so the hats worn by this faction resemble those found elsewhere in the oeuvre of Apollonio and his shop.

13. Callmann 1974, p. 49; Baskins forthcoming.

14. This question was first posed by E. H. Gombrich (1955, p. 29, n.2).

15. Paribeni 2001, p. 273–74.

16. Ibid., p. 272.

17. Callmann 1974, p. 51. See also Bisaha 2004.

18. Paribeni 2002, p. 432. Among the accounts Paribeni cites are those of Paolo Giovio and Marin Sanudo.

19. Paribeni 2001, pp. 277–78; see also Callmann 1974, pp. 56–57. Made for the marriage of the daughter of Giovanni Rucellai to Piero di Francesco di Pagolo Vettori, these depict Xerxes' invasion of Greece (Allen Memorial Art Museum, Oberlin) and the triumph of the victorious Greeks (destroyed in World War II).

20. Pope-Hennessy and Christiansen 1980, p. 19.

21. Lurati 2005, p. 105.

22. Paribeni 2001, p. 260.

23. Ibid., p. 279ff. and p. 289ff.

24. Ibid., p. 263.

25. One of these is by a Spanish traveler named Ruy González de Clavijo, who visited the court of Tamerlane at Samarkand about 1403–6. See Baskins forthcoming.

26. Nickel (1974, p. 232, n. 9) bases this on the caltrap on the side panels, which in Italian are called *spine*, and might be a pun on the groom's name. The commission is listed in the fragmentary copy of the workshop's account book, discovered by Aby Warburg and first published in Schubring 1915, p. 437. See also Callmann 1974, p. 81.

27. Schubring 1915, p. 436; Callmann 1974, p. 80. Paribeni suggests this was in 1458, but Schubring gives the date of 1459 for this commission.

28. Baskins forthcoming.

29. Lurati 2005, p. 109; Paolozzi-Strozzi 2005, p. 58. This dating also conveniently explains why the chest is not listed in the extract of the workshop accounts of Apollonio: the book ends in 1463, when Apollonio himself died, although workshop production continued.

SELECTED REFERENCES: Gombrich 1955, p. 25, n. 1, p. 29, n. 2; Callmann 1974, pp. 49–51, 63–64, pls. 125, 128, 129, 133, 134, 139, 142, 218, 221, 223, 225, 247; Nickel 1974, pp. 229, 232, figs. 4, 5; Pope-Hennessy and Christiansen 1980, pp. 12, 13, 19, figs. 7, 11, 12; Callmann 1999b, pp. 338–43, 346, 348, fig. 13; Paribeni 2001, pp. 255–304, figs. 1–3, 5, 7, 13; Paribeni 2002, pp. 427–41, figs. 1, 2; Wolfram Koeppe in Kisluk-Grosheide, Koeppe, and Rieder 2006, pp. 10–12, figs. 2–4; Lurati 2005, pp. 101–18, figs. 1, 2, 4–7; Baskins forthcoming

Marco del Buono Giamberti
Florentine, 1402–1489

and

Apollonio di Giovanni di Tomaso
Florentine, 1415/17–1465

57. Cassone Panel with The Story of Esther

Florence, 1460–70
Tempera and gold on wood, 17½ × 55⅜ in.
(44.5 × 140.7 cm)
Inscribed beneath the figure of Esther: ESTER
The Metropolitan Museum of Art, New York, Rogers Fund, 1918 (18.117.2)

This panel once adorned the front of a cassone, or wedding chest. It depicts an episode from the biblical story of Queen Esther and King Ahasuerus (Esther 2:17–19). Esther, a Jewess, came to Shushan to compete with other virgins of the kingdom for the privilege of marrying King Ahasuerus. She was accompanied by her uncle Mordechai, who had adopted her after the death of her parents. To prepare to meet the king, the virgins underwent rituals of purification for many months in a harem. In secret, Mordechai contrived to gain news of Esther, making sure that she was well looked after. When the king saw Esther, he decided to make the beautiful young woman his queen, and he held a great feast for her, with all his princes and servants.

The painter has transposed this biblical tale to the streets of contemporary Florence. The king and his ministers ride on lavishly caparisoned horses. An imposing palace, complete with rusticated arches and reminiscent of the Palazzo Medici, designed by Michelozzo in the mid-fifteenth century, rises behind this procession. A three-aisled Gothic church with a round, domed apse, looking much like the Duomo of Florence, occupies the middle background. The banquet and marriage take place in a loggia, a private portico built as an extension to a palace for celebrations and other events, which would also have been familiar to a contemporary viewer.

As in the *spalliera* panel depicting the marriage of Cupid and Psyche (cat. no. 136), the action in the right foreground of this cassone panel centers on the giving of the ring, emphasizing the nuptial import of the story. The loggia is set for a lavish feast, complete with a tiered sideboard well stocked with gold serving dishes. A richly patterned gilded textile decorates the walls of the loggia, which has pilasters at the corners and features classicizing roundels lined with clam shells above Roman arches. Mordechai, who continues to play a crucial role in the story, passing on to Esther information that she relays to Ahasuerus, is tellingly placed between the two architecturally articulated zones of the panel: he lurks at the threshold of the loggia with a foot literally in each camp. (One of the riders in the procession at the left, who holds up an object that may be a signet ring, is perhaps also a representation of Mordechai. For valuable services later rendered to Ahasuerus, including the revelation of a plot against his life, Mordechai is honored in a magnificent pageant, and later the king gives him his ring.)

Despite the clearly legible inscription ESTER at the feet of the heroine as she offers her hand in marriage, there were once doubts about the subject of the panel. One of the first scholars of cassoni considered the panel to be a depiction of the story of Dido and Aeneas.[1] Another suggested that the inscription was added by an owner rather than by the artist.[2] Since 1940, however, it has been accepted that the subject is the story of Esther. Moreover, comparison of the inscription with the numerous inscriptions on the front panel of the *Conquest of Trebizond* cassone (cat. no. 56) provides convincing support for the idea that the ESTER inscription is contemporary with the creation of the picture.

The panel is divided into specific dramatic zones based on the architectural settings. This spatial organization is reminiscent of that of woodcut illustrations in the printed texts of *sacre rappresentazioni*,

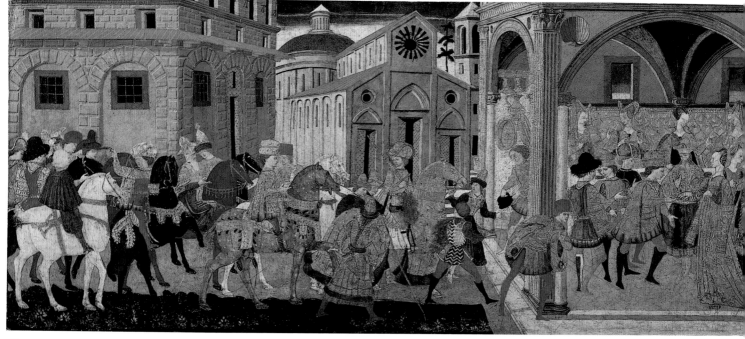

Cat. 57

or mystery plays, a form of popular the-
ater dating from the late Middle Ages. The
plays were performed in public squares or
in churches, the scenery consisting of repre-
sentations of separate buildings, sometimes
called *maisons* (from the French version of
these spectacles), before which the action
took place. The *Rappresentazione della Regina
Ester* was among the few plays dramatized
with a subject from the Old Testament.[3]
The anonymous text of the play recorded in
fifteenth-century incunabula emphasizes the
importance of virtue in making and main-
taining a good marriage.[4] Given fifteenth-
century Florentines' likely acquaintance with
this text, the intended message of the cassone
painting could not have been in any doubt.

First documented in a French collec-
tion in 1885, this panel was, like several
other cassone panels, then attributed to
Dello Delli (ca. 1404–1469),[5] whom Giorgio
Vasari singled out in his 1568 edition of the
Lives of the Artists as particularly skilled in
painting the kinds of small figures required
by cassone panels. (See my essay, "Rites of
Passage," in this volume.) The Metropolitan
acquired the panel in 1918, but only when the
comprehensive catalogue of the Museum's
Italian paintings was published in 1971 was
the panel linked to the productive and rela-
tively well-documented workshop of Marco
del Buono and Apollonio di Giovanni.[6] It is
likely that there was a companion panel, for
a second cassone, illustrating other episodes
from Esther's story.[7] DLK

1. Schubring 1915, p. 266, no. 191, pl. XLI.
2. Burroughs 1919.
3. D'Ancona 1891, p. 435.
4. D'Ancona 1872, vol. I, pp. 129–66.

5. Alexandre 1904, pp. 7, 9.
6. Zeri 1971, p. 101.
7. Wehle 1940, p. 41.

SELECTED REFERENCES: Alexandre 1904,
ill. pp. 7, 9; Burroughs 1919, pp. 6–8, ill.;
Schubring 1915, p. 266, no. 191, pl. XLI; Wehle
1940, pp. 41–42, ill.; Zeri 1971, p 101, ill. p. 102;
Callmann 1974, pp. 40, 42, 66, pls. 161, 245, 254;
Pope-Hennessy and Christiansen 1980, pp. 13, 16,
24–27, figs. 18–20

Marco del Buono Giamberti

Florentine, 1402–1489

and

Apollonio di Giovanni di Tomaso

Florentine, 1415/17–1465

58a. Inner Lid from a Cassone Celebrating a Marriage between the Pazzi and Borromei Families

Florence, 1463
Tempera on panel, 21⅛ × 72 in. (53.6 × 182.8 cm)
Indiana University Art Museum, Bloomington (75.37)

Paolo di Stefano Badaloni, called Paolo Schiavo

Florence, 1397–Pisa, 1478

58b. Inner Lid from a Cassone with Venus Reclining on Pillows

Florence, 1440–45
Tempera on panel, 20 × 67 in. (50.8 × 170.2 cm)
Museo Privato Bellini, Florence (182)

Both of these panels were created to deco-
rate the inner lids of cassoni, or marriage
chests. Though few inner-lid images survive
in comparison with the number of exterior
panels, Ellen Callmann has identified at
least seventeen, dividing them into distinct
subject categories: putti, textile patterns, and
reclining figures.[1] Examples of all three are
included in this volume. The Metropolitan
Museum's Strozzi cassone (cat. no. 56) fea-
tures a textile pattern on the interior of the
lid and demonstrates clearly this type of
decoration in context. The pattern, probably
based on a stencil, imitates the luxurious silk
damasks that were in contemporary produc-
tion and that may in fact have been kept in
the chest for storage.

A number of surviving cassone lids fea-
ture more elaborate figurative images. The
Bloomington lid (cat. no. 58a) is one of sev-
eral panels where putti interact playfully
with heraldic imagery designed to signal the
intended owners of the chest. Another group
of inner lids features full-length reclining fig-
ures, both male and female, in various stages
of undress, such as the enigmatic panel by
Paolo Schiavo (cat. no. 58b). As an important
anchor in the Renaissance interior, a cassone
was meant for display as well as for storage.
But the chest's interior was accessible only to
its owners, whose privileged gaze was per-
mitted to fall on the private imagery on the
inside only when the cassone was temporar-
ily open. Though the Strozzi cassone has a
support that can be used to prop it open, this
may not be original to the piece and in any
case does not allow a full frontal view of the
inner lid.[2]

Lids featuring playful young boys such as
the putti on the Bloomington panel may be

linked to imagery on birth trays, maiolica, and other objects associated with childbirth where male children engage in frivolous games, perhaps to encourage the conception of male offspring.[3] The more suggestive scantily clad or nude adults, while functioning generally to aid in conception, may also have had erotic overtones similar to those found in contemporary mythological imagery. Ernst Gombrich, who first called attention to the suggestive powers of inner-lid

images, points out that some of these nude figures were even labeled "Paris" and "Helen," paragons of beauty and passion, if not virtue.[4] Sandro Botticelli's painting *Venus and Mars,* from about 1485 (fig. 91), depicts Mars, having been disarmed by the charms of Venus, fast asleep in a reclining position similar to that of male nudes on the inner lids of cassoni. Probably once installed in a bedroom, the Botticelli painting would also have served to stimulate behavior resulting in the creation of children. If the cassone's public function was to store precious textiles in a luxurious manner, its private function was to encourage the success of the marriage for which it was created, and there was no better mark of this than the production of male children.

The narrow, elongated form and heraldic subject matter of the Bloomington panel support the hypothesis, first formulated by Callmann in 1977, that it was created to adorn an inner lid.[5] The imagery on this panel comprises two putti who ride dolphins. The commission for the cassone to which this lid once belonged, identified through the heraldry, is documented in the extract of the account book from Apollonio di Giovanni's workshop in Florence. He received an order in 1463 for a pair of chests for the marriage of Beatrice di Giovanni di Buonromeo de' Borromei to Giovanni di Antonio de' Pazzi.[6] Though no price is given for the commission, Callmann suggests that the order must

have been very important because Apollonio did not generally paint the interior surfaces of the chests himself. Both the Pazzi and the Borromei were prominent bankers in Renaissance Florence. The Pazzi are infamous still for their partially successful plot to murder Giuliano and Lorenzo de' Medici in 1478. Giuliano was stabbed as he attended Mass in the Duomo, but Lorenzo escaped, taking refuge in the sacristy. The Pazzi conspirators were executed.

The putto on the left holds the reins of his dolphin in one hand while grasping with the other a long trumpet from which hangs a dark-colored flag emblazoned with the arms of the Pazzi: two dolphins on a blue ground with six crosses. The second putto faces in the opposite direction and holds his trumpet with two hands; the arms hanging from it are those of the Borromei di San Miniato: six vertical stripes in red and green with a crosswise stripe in silver.[7] The dolphins frolic in a swirling, aquamarine ocean that occupies the bottom third of the picture. A blue sky dotted with wispy clouds serves as a backdrop for the mounted putti, the standards, and one dolphin's wide-open jaws, revealing an abundance of pearly white teeth.

Adelheid M. Gealt has suggested that the heraldic imagery on the panel survives only because it was hidden inside the cassone and was not subject to the destruction that later met other imagery tied to the Pazzi.[8] The Pazzi and the Medici were rivals of

Cat. 58a

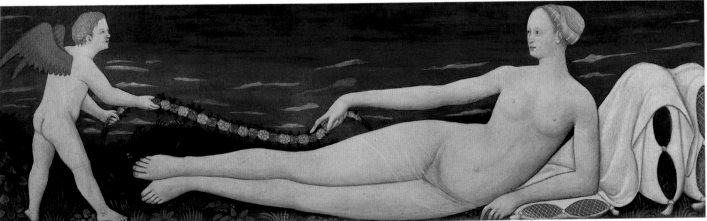

Cat. 58b

long standing. After Giovanni de' Pazzi and Beatrice Borromei married early in the 1460s, Lorenzo de' Medici enacted a law, effective retroactively, that deprived daughters of large inheritances if they had no brothers but did have male cousins, with the result that the vast Borromei inheritance which Giovanni stood to receive from his wife's family was lost.[9] The Bloomington inner lid, with the well-known Pazzi dolphins prominently displayed on one of the banners, depicts the innocence and hope of the union. Moreover, in the wake of the 1478 Pazzi conspiracy against the Medici (described above), of which Giovanni's uncle Jacopo was the ringleader, Lorenzo issued an edict that aimed to erase all physical traces of the Pazzi from Florence, and required family members who survived to change their names and coats of arms; he even imposed fines on any artisan who created a representation of the Pazzi escutcheon. A powerful political instrument, marriage was part of the Medici revenge as well. Lorenzo decreed that any man who married a Pazzi woman would become an official "suspect," losing rights for himself and his male descendants to hold public office in Florence. This effectively removed the Pazzi from the marriage market for several years at least. Finally, in a vivid demonstration of the power of images, Botticelli was hired to paint lifesize portraits of the Pazzi traitors on the walls of a public building in Florence, replacing the arms and banners of honor with defamatory caricatures.[10]

The Pazzi–Borromei panel was previously installed in a chest assembled from unrelated cassone panels during the nineteenth century by the notorious dealer William Blundell Spence, whose panels and reconstructions stoked the English market for secular "Italian Primitives" beginning in 1858.[11] The chest that had the Bloomington heraldic putti mounted as its back panel was among the first to be sold as an integral unit. Spence sold it to Thomas Gambier-Parry in 1859.[12] The Gambier-Parry collection was dispersed in 1971, and the Indiana University Art Museum acquired it soon thereafter, in 1975.

The panel depicting a nude woman, presumably Venus (cat. no. 58b), can be compared with a group of inner lids painted with reclining nudes such as the extraordinary pair by Giovanni di Ser Giovanni Guidi, called Lo Scheggia, now in the Statens Museum for Kunst, Copenhagen. Like the Bloomington panel, catalogue number 58b is long and narrow. Against a rich blue skyscape dotted with wisps of clouds, Venus reclines on three pillows which seem somewhat out of place among the flowers of the field. These are pillows that would be found on a bed, as in Apollonio di Giovanni's miniature

depicting the Ghost of Sichaeus visiting Dido, and add to the intimate aura of the image.[13] A length of linen draped over the pillows provides domestic overtones despite the pastoral setting. Venus is covered only by the barest suggestion of a translucent veil, her sole adornment a filament of seed pearls that swirl around the long, blond tresses coiled atop her head. She holds, rather awkwardly, one end of a garland of pink and red flowers; the other end is held by a winged putto, perhaps Cupid, who playfully attempts to wrest it from her grasp. The two gaze at each other in an oddly dispassionate manner. Though the garland is composed of flowers rather than woven or embroidered, it is reminiscent of marriage belts such as those described elsewhere in this volume (see cat. nos. 36a, b, and 55). Venus's pale complexion and exaggerated forehead are consonant with contemporary images of *belle donne,* or "beautiful women," such as those discussed by Luke Syson in his essay "*Belle:* Picturing Beautiful Women" in this publication.

Paolo di Stefano Badaloni, called Paolo Schiavo, was born in Florence in 1397. As was customary for many painters in fifteenth-century Florence, he matriculated in the Arte dei Medici e Speziali, the guild of doctors and apothecaries, in 1429. He appears in connection with the stained-glass windows for the cupola of the Florentine Duomo in 1436.[14] Vasari indicates that he was a follower of Masolino.[15] In addition to painting altarpieces, frescoes, and cassoni, Schiavo illuminated manuscripts and created cartoons for embroidery and stained glass, demonstrating facility across a range of media typical of fifteenth-century Italian artists who were trained in a variety of two- and three-dimensional techniques.[16]

The *Venus* panel entered the collection of the J. Paul Getty Museum, in Malibu, in 1972, and was sold from it in 1992. At that time, the attribution to Paolo Schiavo was confirmed by Everett Fahy.[17] It was also suggested that the lid belonged to a chest that featured a front panel depicting the story of Callisto, now at the Springfield Museum of Fine Arts.[18] The measurements of the panels are consistent, and there are formal similarities between the two, but no further evidence for the connection has emerged.

DLK

1. Callmann 1977, p. 178, n. 12.
2. Peter Thornton (1991, p. 195, pl. 219) illustrates such a support holding up the lid of a chest.
3. This concept is elaborated in Musacchio 1997a.
4. Gombrich 1955, p. 27.
5. Callmann 1977, p. 177.
6. Callmann (1974, p. 81) does not provide a date, but as published by Schubring, the

"Bottega-Buch" (as Schubring calls it) of Marco del Buono and Apollonio di Giovanni (Biblioteca Nazionale Centrale, Florence, MS, Magliabechiano XXXVII, 305) lists the marriage as taking place in 1463 (Schubring 1915, p. 437). Callmann (1977, p. 178, nn. 19, 20) indicates that the first child was born in 1465.
7. Callmann 1977, p. 178, n. 17.
8. Adelheid M. Gealt in Gealt et al. 2007, p. 230.
9. For an extended discussion of the Pazzi conspiracy, see Martines 2004, p. 130ff.
10. Ibid., pp. 133–36.
11. On this phenomenon, see Callmann 1999b.
12. This information is cited by Callmann from Fleming 1979, p. 504, n. 72. Callmann (1999b, p. 340) explains that it is not known who actually crafted the chests in Florence, but that they all must have been made in a few workshops for dealers.
13. Peter Thornton (1991, p. 165) tells us that these pillows were called *intimelle*. See Apollonio di Giovanni, *The Ghost of Sichaeus Visits Dido, Aeneid,* fol. 67v, ca. 1460, Biblioteca Riccardiana, Florence; illustrated in P. Thornton 1991, p. 195, pl. 219.
14. Thieme and Becker 1907–50, reprint 1992, vol. 30, pp. 46–47.
15. Vasari, *Lives,* 1568/1912–14 (ed.), vol. 2, p. 166. Ellen Callmann (1999a, p. 43) does not believe this was possible.
16. For additional bibliography, see Boskovits 1995. Boskovits (1995, p. 335) dates the Schiavo panel 1440–45.
17. Christie's, New York, *Important and Fine Old Master Paintings,* sale cat., May 21, 1992, p. 50.
18. The May 21, 1992, sales catalogue (ibid.) states that this information was related "in verbal communication to the Getty before 1972" by Federico Zeri. The Springfield *Story of Callisto* was acquired in 1962 as Schiavo. Though it was attributed to "Masolino and assistants" by Ellen Callmann (1999a), Everett Fahy has reaffirmed that it is by Schiavo rather than Masolino (verbal communication, April 2008). The Springfield panel measures 15⅛ × 59¼ inches (38.4 × 150.5 cm). On its iconography, see Simonneau 2007.

Selected references: *58a.* Callmann 1977, pp. 174, 178, 181, figs. 18, 23; Callmann 1999b, pp. 340, 348; Adelheid M. Gealt in Gealt et al. 2007, pp. 230–31, ill.

58b. Christie's, New York, sale cat., May 21, 1992, p. 50; Boskovits 1995, p. 335

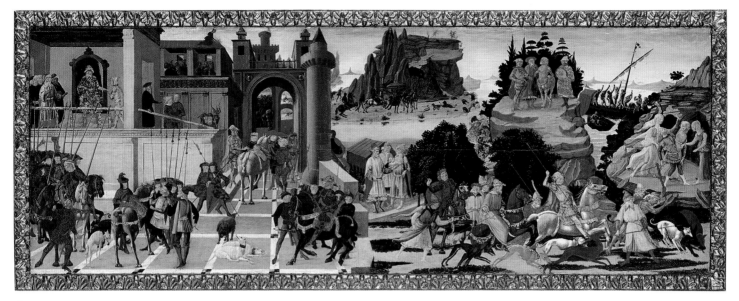

Cat. 59a

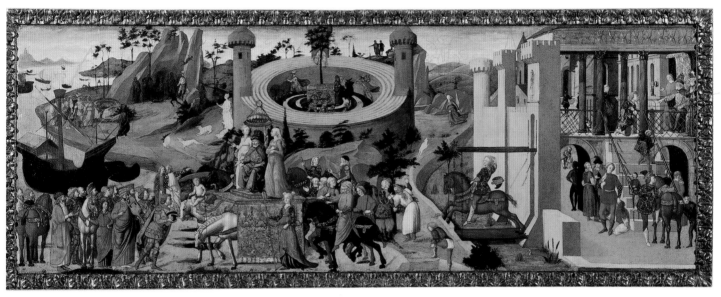

Cat. 59b

Biagio d'Antonio

Florentine, act. fourth quarter of 15th century

and

Master of the Argonauts

59a, b. Two Panels with Scenes from The Story of the Argonauts

Ca. 1465

Tempera on wood, gilt ornaments, each overall 24⅛ × 60⅜ in. (61.3 × 153.4 cm), painted surface 19⅝ × 56 in. (49.8 × 142.2 cm)

The Metropolitan Museum of Art, New York, Gift of J. Pierpont Morgan, 1909 (09.136.1, .2)

These two panels recount episodes from the story of Jason and the Golden Fleece in vivid detail. They have been considered both cassoni fronts and *spalliere*, or wainscoting, panels. Though their dimensions are consonant with those of many cassoni panels, they are in better condition than would be expected of cassoni, which were often damaged in use, and thus presumably were *spalliere* (though they are smaller than Biagio d'Antonio's *spalliera* panel with the *Story of Joseph*; see cat. no. 138).[1] The engaged frames surrounding both panels are original.

Keith Christiansen and John Pope-Hennessy first pointed out the parallels in spatial construction between Lorenzo Ghiberti's *Story of Isaac,* from his second set of bronze doors for the Baptistry in Florence, designed in the 1430s, and the *Story of the Argonauts* panels.[2] Definition of space is especially effective in the articulation of the many subplots in the epic tale of Jason's travels and tribulations in procuring the fleece. Like Ghiberti, who attempted to depict a narrative that unfolds over time through the illusionistic manipulation of space, the artists here treat the panels like a stage on which several episodes take place at varying distances from the viewer. Setting up architectural and landscape settings for the characters to inhabit is an essential element in this sophisticated narrative strategy.

Many, but not all, of the episodes depicted on these panels come from the classical versions of the story: the epic poem *Argonautica* by Apollonius of Rhodes, written in the third century B.C., which would have been available in its Latin paraphrase by the Alexandrian poet Valerius Flaccus as well as in numerous Greek manuscript versions that were in Florence by the second half of the fifteenth century and were being studied and translated in Medicean circles, in which the unknown patrons of these panels likely traveled.[3] Thus, a Latin translation may well have

been available about the time that the panels were created.[4] Valerius's *Argonautica* was first printed in 1474, and Apollonius's text in 1496.[5] However, the makers of these panels probably did not depend solely on the classical sources, but most likely had access to vernacular versions. Caroline Campbell has suggested that a parallel ensemble of paintings, created for the Albizzi–Tornabuoni marriage (cat. nos. 140a–c), made use of an array of narrative sources, including medieval chivalric adaptations of the Jason story current in the Burgundian court as well as the classics, filtered through the works of Ovid and the Italian trecento poets.[6]

The story begins in the upper left of catalogue 59a, with the charge of King Pelias to Jason, his nephew, to retrieve the Golden Fleece from a heavily guarded cave in distant Colchis, on the Black Sea. Easily recognizable as he navigates the many obstacles in his path decked in golden armor, a pink cloak, and a winged helmet, Jason is shown in the next scene rounding up adventurers to join him on his quest. The architectural background on the left of the panel yields to the more naturalistic landscape of shoreline and islands on the right. Jason and Orpheus, holding his viol, consult the centaur Chiron atop Mount Pelion. To the right, Jason's ship, the *Argo,* sails along the Mysian coast. Hercules' squire, Hylas, goes in search of fresh water, but he is pulled into a pool by a nymph and never seen again. After Hercules and Polyphemus set off to find him, the Argonauts depart without them. The scene in the right foreground may be the Calydonian boar hunt, in which Jason takes part in Ovid's *Metamorphoses,* though the story does not appear in the epic of Jason and the Argonauts.[7]

Jason's arrival at Colchis is featured on the left side of the second panel (cat. no. 59b). He is greeted by King Aeëtes, who rides a triumphal chariot flanked by his two daughters, Medea and Chalciope. The king explains that in order to obtain the Golden Fleece, Jason must plow the grove of Ares with fire-breathing bulls, sow the fields with dragon's teeth, and slay the warriors who spring from the teeth. Without the magical aid of the sorceress Medea, who has fallen hopelessly in love with Jason thanks to divine intervention, he would not be able to do this. In exchange for Jason's promise to marry her, Medea provides ointments to protect Jason from the fire-breathing bulls. Orpheus then serenades him on his lyre, enabling Jason to nab the Golden Fleece, which hangs on an oak tree at the center of the labyrinth. He flees with Medea and the fleece. Upon realizing what has happened, Aeëtes dispatches Medea's brother in pursuit; the youth astride his horse, hat flying off as he rides in haste across the castle's moat, may be he.

The nuptial significance of these panels is elusive. Jason's marriage to Medea, unhappy as it was, is not represented. Other works featuring elements of the story of Jason and the Argonauts focus on a moralizing and utterly sanitized version in which Medea and Jason wed and presumably live happily ever after, which is not true to the ancient sources. The narrative on the two panels here ends with the pursuit of the ill-fated Jason and Medea as they escape with the fleece, rather than following the Apollonian story which recounts the trials endured on the their return journey to Iolcus and the tragic outcome of their marriage. It is possible that the intended audience for the *Argonauts* panels was familiar enough with the modified story to project the happy ending that graces the panels in the Albizzi–Tornabuoni series (cat. nos. 140a–c), or perhaps there was a third panel to complete the story, depicting the return and the marriage, that has been lost.

There has been almost constant controversy about the panels' authorship since they appeared on the art market in the first years of the twentieth century. Sold by the dealer and collector Stefano Bardini in 1899 as by Pesellino, they retained that attribution, as Everett Fahy recounts, when J. Pierpont Morgan presented them to the Metropolitan Museum in 1909, though they had also been attributed to Jacopo del Sellaio, author of the two panels devoted to the story of Cupid and Psyche (cat. no. 136). Neither attribution stuck, and in 1932 Bernard Berenson suggested that the works were by Giovanni Battista Utili da Faenza, whose oeuvre eventually became associated with the name of Biagio d'Antonio.[8] Fahy illuminated matters further by calling attention to the fact, first noted by Harry B. Wehle in 1940, that the two panels are not by the same artist. Though some scholars believe that the artist of the second panel designed, but did not execute, the first, this is not universally accepted.[9] Based on the comparison of underdrawings viewed with the aid of infrared reflectography, the artist of the first panel is generally called the Master of the Argonauts, perhaps to be identified with Francesco Rosselli (1448–before 1513), brother of the better-known Cosimo.[10] Since panels such as these, whether destined for chests or other decorative locations in domestic settings, were often the product of workshop collaborations,variations in design and execution within what was presumably a single commission are not surprising.

DLK

1. Fahy 1989, p. 285.
2. Pope-Hennessy and Christiansen 1980, p. 16.
3. For a discussion of the various manuscript sources available in fifteenth-century Italy, see Papanghelis and Rengakos 2001,

pp. 40–43. Apollonius's text was in wide circulation as early as late antiquity, and there are some fifty-five surviving manuscripts dating from the period between the tenth and sixteenth centuries. One manuscript was purchased from Giovanni Aurispa, in Constantinople, in the 1420s by the Florentine humanist Niccolò Niccoli, ending up in the Laurentian Library.
4. Papanghelis and Rengakos 2001, pp. 46–47. Apollonius's epic was first translated from Greek into Latin by Andronikos Kallistos (d. 1487). Kallistos's pupil Bartolomeo Fonzio is credited with copying some of this translation in the 1470s. Caroline Campbell (2007, p. 5) notes that Fonzio gave lectures about the two texts at the Florentine *studio* in the 1480s. See also Fahy 1984, p. 247, n. 10, citing Sabbadini 1905, p. 46.
5. Papanghelis and Rengakos 2001, pp. 48–49.
6. On the role of earlier vernacular moralizing adaptations of the tales of the Argonauts in the later fifteenth century and their use as source material for other painted versions of the story, see C. Campbell 2007.
7. This detail, as well as Orpheus (rather than Medea, as described by Apollonius) serenading the dragon in the sacred grove in the companion panel, contradicts Campbell's assertion that the two Metropolitan panels follow the classical versions of the story (C. Campbell 2007, p. 6). The Calydonian boar hunt was probably known in fifteenth-century Florence through Ovid's *Metamorphoses,* but does not appear in either the Apollonian or Valerian texts.
8. Fahy 1989, p. 285.
9. Ibid., p. 286: "In short, the design of the second panel is accomplished, whereas that of the first is feeble."
10. Ibid., p. 296, citing Oberhuber 1973, p. 53, n. 22. Roberta Bartoli, in her monograph on Biagio di Antonio, identifies the Master of the Argonauts with Bernardo di Stefano Rosselli (1450–1526), nephew rather than brother of Cosimo, but Everett Fahy (personal communication, January 12, 2008) confirms that this is an error; see Bartoli 1999, pp. 147, 173, n. 28.

Selected references: *Catalogue des objets d'art . . . Bardini* 1899, p. 62, no. 360, p. 64, no. 364, pl. 20; Logan 1901, pp. 334–35; Weisbach 1901, pp. 120, 122–25; Schiaparelli 1908/1983, vol. 2, p. 83, n. 251; Burroughs 1914, p. 206; Schubring 1915, pp. 116, 286, nos. 296, 297, pl. LXXI; Berenson 1932, p. 585; Wehle 1940, pp. 35–37, ill.; Zeri 1971, pp. 143–45, ill.; Pope-Hennessy and Christiansen 1980, pp. 16, 29, 33, 35, figs. 21–30; Fahy 1984, pp. 236, 241, 244, fig. 240; Fahy 1976, p. 207; Fahy 1989, pp. 285–300, figs. 2, 4; Roberta Bartoli in Gregori, Paolucci, and Acidini Luchinat 1992, p. 243, under no. 9.6; Barriault 1994, pp. xi, 69, 71, fig. 23.2; Bartoli 1999, pp. 147, p. 173, n. 28; C. Campbell 2007, pp. 5–6, figs. 4, 5

60a, b. Cards from a Tarocchi (Tarot Pack): Love and Charity

Milan, 1428–47
Tempera and gold leaf on paper, each 7½ × 3½ in.
(19 × 9 cm)
Beinecke Rare Book and Manuscript Library, Yale
University, New Haven (ITA 109)

Although card games in general have a long history dating back to antiquity, these two fifteenth-century cards come from what may be the earliest known *tarocchi*, or tarot pack. *Tarocchi* have been associated primarily with divination since at least the eighteenth century. However, in the Renaissance they were used for trick-taking games. These were presumably played like the modern game of Crazy Eights, in which each player tries to discard his or her hand first by matching suits or numbers in turn. The typical *tarocchi* pack of seventy-eight cards is composed of fifty-six minor arcana: four suits (swords, batons, cups, coins), each with cards numbered one through ten as well as court cards representing a male page, a male knight, a queen, and a king. It also contains twenty-two major arcana, or trick or trump cards, represented by figures or allegories whose original meanings are lost. These trump cards allowed players to change the course of the game for their own benefit; for example, if the last discard was a baton, but the player had no batons, he or she could play a trump and call for a change of suit. But rules—and no complete set of rules survives for this period—seemed to vary widely and no full pack is known, so it is difficult to understand exactly why each trump had such an individual appearance and what each one could do in a game situation.

The cards here, representing Love and Charity, are two of the eleven known trumps from the so-called Cary-Yale pack, which has been dated to anywhere between 1428 and 1447. Like many of the hand-painted packs from the Renaissance, it is associated with the court of Filippo Maria Visconti, who was duke of Milan from 1412 until his death in 1447. Each of the trumps in this pack has a gold diaper background patterned with Filippo Maria's sunburst device. On the baldacchino of the Love card, his coiled-viper arms alternate with the Savoy cross of his second wife, and his phrase, "A bon droyt," or "By legitimate rule," is inscribed on the youth's hat. Other cards in the pack have additional devices related to the duke, such as the impression from a Milanese florin struck

during his reign used as the image of the coin in most of the cards in that suit. There thus seems little reason to question Filippo Maria's connection to the pack, particularly because, although best known as an able politician and soldier, he was also interested in the arts and especially in card games.

Between 1410 and 1425, according to his biographer Pier Candido Decembrio, Filippo Maria paid the painter Michelino da Besozzo the sizable sum of fifteen hundred gold ducats for an elaborate pack of cards, almost certainly a *tarocchi*, decorated with gods, court figures, animals, and birds.[1] Although no further purchases were recorded, some 271 cards, representing perhaps as many as fifteen different packs, can be linked to the Visconti or their successors, the Sforza, in fifteenth-century Milan.[2] In fact, the majority of Italian *tarocchi*, both the hand-painted packs and the earliest printed examples, as well as most of the documentary evidence for their production and use, come from the North Italian courts of Milan, Ferrara, and Bologna. The cost associated with these cards—with their fine silver and gold leaf, elaborate punchwork, and carefully composed and painted fronts—indicates that card playing was primarily a cultured courtly

pastime, particularly before printing made it much cheaper to produce packs in multiples for wider dissemination. The Cary-Yale pack was particularly extravagant; the condition of the delicate paint and gilding reveals that the cards were handled rarely and carefully, and the tiny holes in the top margins of each imply that they were strung together for safekeeping when not in use. This would have kept them in a particular order, which may have been a way to teach a new player the rules of the game.

Tarocchi were not standardized during this early period.[3] A total of sixty-seven cards survive from the Cary-Yale pack, but there is no agreement on the original number, which must have been at least eighty-six or perhaps eighty-nine. Instead of the more usual four court cards per suit, the Cary-Yale pack has six: along with the male page, male knight, queen, and king, it also has a female page and a female knight. Since no other pack has those additional characters, these cards may be an indication that this pack was intended for a female member of the court. The Cary-Yale trumps may have been more numerous overall. Among its eleven known trumps are the Theological Virtues of Faith, Hope, and Charity, which no other pack has, as well

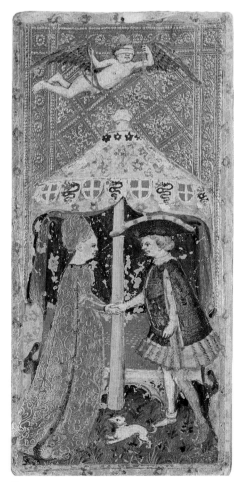

Cat. 60a

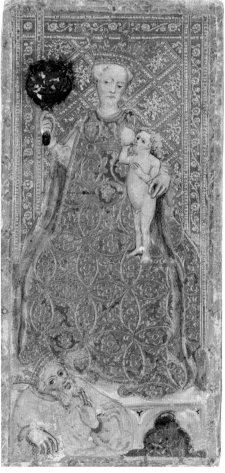

Cat. 60b

as the Cardinal Virtue of Fortitude, which implies that the remaining Virtues of Justice, Temperance, and Prudence were also once present. Of course the trumps vary across all packs, and the vagaries of survival obscure what exactly is missing in every case. Despite these mysteries, the two cards shown here are excellent examples of the great richness and variety of the Cary-Yale pack as a whole. The image of the game as it was played—the courtiers dressed as magnificently as the characters on the cards, and the reflections of the punched silver and gold in the candle-lit gaming room—offers a vivid picture of fifteenth-century court life.

These players also needed a reasonably learned background to understand the complex representations on the trump cards. The Love card depicts a couple wearing rich contemporary dress clasping hands in a marital gesture under a baldacchino. A blindfolded Cupid, preparing to drop his arrows on each, flies above them, and a small dog, perhaps a miniature greyhound (a symbol of fidelity and a popular breed in Renaissance courts), scampers at their feet. As with so many objects in this exhibition, the heraldry and handclasp seem to signify a marriage, perhaps indicating that the pack originated as a marriage gift. The Charity card is a simpler composition, dominated, as many of the court and trump cards were, by a single large-scale figure. The crowned Virtue is seated on a dais, her luxurious fur-lined mantle gilt and punched in a floral pattern. One of her hands holds a now-tarnished silver bell or censer, while the other supports the small naked boy she nurses. An older male figure in a rose-colored robe under the dais looks out at the player as if commiserating. Although he is not part of the traditional iconography of the Virtue, it has been suggested that he may be King Herod, symbolizing the Vice of Disdain, subdued and crushed by Charity above him.[4]

Scholars are divided on the interrelated issues of attribution and dating. Some date this pack early, as part of the celebrations surrounding Filippo Maria's own marriage to Maria of Savoy in 1428; if so, the cards may well be a product of the artists associated with the Zavattari, a prominent family of painters who enjoyed court favor in Milan. History reveals that Filippo Maria and his wife needed all the help they could get. Their arranged marriage was never consummated, and there is considerable evidence that the couple were deeply unhappy. In this way, the romantic iconography of the Love card might have been meant as a sort of talisman for a successful marriage. Alternately, the pack may have been made later, at some point prior to Filippo Maria's death in 1447.[5]

The most likely occasions were the marriage of his illegitimate daughter and only heir, Bianca Maria, to Francesco Sforza in 1441,[6] or the marriage of Francesco's son Galeazzo Maria Sforza and Bona of Savoy in 1468.[7] If indeed they do date to one of those later marriages, they may instead be associated with Bonifacio Bembo, to whom other, similar *tarocchi* have been attributed. Bembo's work for the Sforza court is well documented, and his training as a miniaturist would have been a great help in the planning and execution of the Cary-Yale pack. Regardless of authorship, the Visconti and Savoy references on the Love card put this pack in the Milanese courtly ambient, which was known throughout the fifteenth century to have a great interest in cards and card playing.

JMM

1. Pratesi 1989.
2. *Visconti Tarocchi Deck* 1984, pp. 4–6.
3. Dummett 1986, p. 15.
4. R. Decker and C. Decker 1975, p. 28.
5. Toesca 1912, pp. 523–25.
6. Kaplan 1978.
7. Algeri 1981, p. 72.

SELECTED REFERENCES: R. Steele 1900; Parravicino 1903; Toesca 1912, pp. 522–25; Moakley 1966, p. 77; R. Decker and C. Decker 1975; Jane Hayward in *Secular Spirit* 1975, p. 214, no. 225, pl. 10; Cahn and Marrow 1978, pp. 227–28; Kaplan 1978; Algeri 1981, pp. 64–85; Mulazzani 1981; *Visconti Tarocchi Deck* 1984; Dummett 1986, pp. 12–15; Pratesi 1989; Bandera 1999, pp. 52–63

Bonino Mombrizio

Milanese, ca. 1424–after 1478

61. *Epithalamium de nuptiis Petri Comitis et Helisabeth Vicomercatae* (*Epithalamium on the Wedding of Pietro Conte and Elisabetta da Vimercate*)

Milan, ca. 1450–64
Parchment, 10 fols., 9¼ × 6¾ in. (23.5 × 17 cm)
The Morgan Library and Museum, New York. Purchased as a gift of Professor Mervin R. Dilts, 2006 (MS M. 1148)

Fifteenth-century Italy witnessed renewed interest in classical rhetoric on the part of humanist scholars. An important element of this turn toward antique forms was the revival of the ancient genre of the epithalamium (wedding poem) as the new standard

for wedding orations.[1] This brief manuscript, consisting of only ten leaves, contains the text of an epithalamium in Latin verse composed by the Milanese humanist Bonino Mombrizio.[2] Mombrizio also wrote epithalamia for the marriages of two illegitimate sons of Francesco Sforza, duke of Milan.[3]

The heading of this manuscript's opening page, written in red, identifies the dedicatee as Gaspare da Vimercate (or Vimercati). Gaspare, a prominent condottiere in the service of Francesco Sforza, is best known for his donation of land and money for the founding of the Milanese convent and church of Santa Maria delle Grazie.[4] The bride and groom are also named as Elisabetta da Vimercate (apparently the niece of Gaspare) and Pietro Conte. For unknown reasons, the coat of arms at the bottom is not that of the Vimercate but instead contains emblems of the Sforza family. The manuscript, though undated, was probably made between 1450 and 1464, the period in which Gaspare was count of Valenza but had not yet become the governor of Genoa.[5]

A brightly colored miniature depicting the betrothal of Pietro and Elisabetta dominates the first page (the only leaf with decoration). In the center Cupid, winged and blindfolded, links the hands of the bride and groom. A blonde Venus appears in a radiant blue cloud above the gold frame that surrounds the scene. She showers the couple

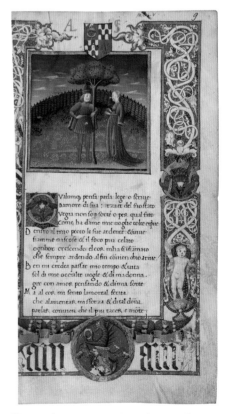

Fig. 74. Anonymous artist, miniature from Petrarch, *Canzoniere*, third quarter of 15th century, Ms. Ital. 561, fol. 9r. Bibliothèque Nationale de France, Paris

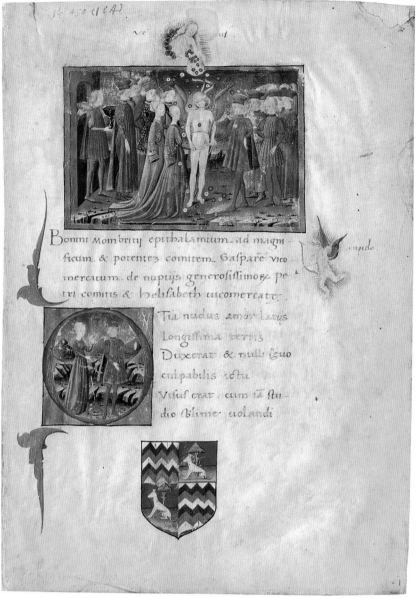

Cat. 61

with flowers—"roses mixed with violets," according to the text—which spill over the frame. Given the poem's dedication, it is not surprising that the artist has awarded pride of place to Gaspare's niece: Elisabetta and her female attendant are the figures closest to the viewer, and both bear emblems of the dukes of Milan on the ornamental sleeves of their garments. The devices are a dog seated under a pine tree (Elisabetta) and a multicolored brush (her attendant). The figures in the bridal party are shown with greater individuation than those on the groom's side. The last two figures in line, who are emerging from the building at far left, bear gifts of silver and gold that refer to Elisabetta's material contribution to the union. Farther down the page, Cupid reappears, hovering alone in the right margin and pointing his golden bow and silver arrow toward the historiated initial *O* (marking the first line of the poem), where the bride and groom are shown alone in a landscape. Their gestures call attention to the tiny arrows that have pierced their hearts.[6]

The miniaturist responsible for this decoration was previously identified as the Master of Ippolita Sforza (active in Milan, 1450–75).[7] The work of this master, known for his service at the Sforza court, is characterized by bright colors, stylized landscapes, and decorative, symmetrical compositions. A legal document issued by Francesco Sforza in 1462 provides evidence of a link between the artist and Gaspare da Vimercate; this elegantly illuminated ducal privilege, granting taxation exemption to Gaspare, has been attributed to the Ippolita Master.[8] However, the decoration in the present manuscript is closer to that of an anonymous artist whose work appears in a collection of poems copied for Alessandro Sforza (fig. 74).[9] The similarity of the images in the epithalamium and in the poems for Alessandro Sforza is especially evident in the faces and hands of the figures, as well as in the costumes. In fact, the treatment of the ladies' gowns in the two miniatures is nearly identical, both with flattened drapery folds trailing behind the garment and

a long ornamental sleeve with embroidered borders delicately painted in gold. The main scribe responsible for the text can be identified as Pagano da Rho, best known for his elegant copy of a treatise on the art of dancing written by Guglielmo Ebreo of Pesaro and dedicated to Galeazzo Maria Sforza in 1463 (Bibliothèque Nationale de France, MS Ital. 973).[10]

SC

1. On the revival of the epithalamium in the Renaissance, see D'Elia 2004.
2. Acquired by the Morgan Library and Museum in 2006; for further details on the manuscript, see the unpublished entry by Dominique Stutzmann on file at the Morgan Library. On Mombrizio, see Frazier 2005.
3. For these sons, Sforza Secondo and Tristano, see Frazier 2005, p. 127.
4. On Gaspare, see most recently Mauri 2002, pp. 43–67.
5. Stutzmann (see note 2 above).
6. Many details of the imagery here, such as the blindfolded Cupid, the strewn rose petals, and the arrows piercing hearts, are found elsewhere throughout this volume. See, for example, cat. nos. 23, 25, 148, and 153.
7. Stutzmann (see note 2 above).
8. See ibid., as well as Voelkle and Wieck 1992, pp. 202–3, no. 78. On the Master of Ippolita Sforza, see Zanichelli 2004.
9. On this manuscript, see *Dix Siècles d'enluminure italienne* 1984, pp. 146–47, no. 127; and more recently Maria Cristina Castelli in Dal Poggetto 1992, pp. 328–29, no. 67.
10. See *Dix Siècles d'enluminure italienne* 1984, pp. 153–54, no. 135.

SELECTED REFERENCES: *Phillipps Manuscripts 1837–71*, p. 149, no. 9396; P. O. Kristeller 1989, p. 231 (Robinson Trust); Bonhams & Butterfields, San Francisco, sale cat., November 14, 2005, lot 1013

Francesco Colonna

62. Hypnerotomachia Poliphili (The Strife of Love in a Dream of Poliphilo)

Venice: Aldus Manutius, December 1499
Printed book with woodcut illustrations; design of woodcuts attributed to Benedetto Bordone (Padua, ca. 1455/60–Padua, 1530)
Bound volume: 11⅜ × 8½ in. (29 × 21.5 cm)
The Metropolitan Museum of Art, New York, Gift of J. Pierpont Morgan, 1923 (23.73.1)
New York only

Often called the most beautiful incunabulum, the *Hypnerotomachia Poliphili* was published by Aldus Manutius (ca. 1449/50–1515), famed for his handsome editions of the

Greek classics and for his introduction of typefaces that are still in use today, including the refined Roman font that made its first appearance in this book.[1] For more than five hundred years the identities of the book's author and of the designer of its exquisite woodcuts, as well as the meaning of the complex narrative, have been the subject of controversy. The book is made even more enigmatic by the peculiar language in which it is written, perhaps intended, as suggested in the dedication letter, to conceal the mysteries of the text from unworthy eyes.[2] This version of the vernacular, elevated through an infusion of Latin and a sprinkling of Greek, may have represented the author's contribution to contemporary debates about the fitness of the Italian language for literature. If so, his example was never followed; in Baldasarre Castiglione's *Courtier*, published in 1528, one of the participants in the dialogue mocks those lovers who adopt pretentious, "Poliphilian" words. This offhand reference testifies, nonetheless, to the book's currency. The book was certainly familiar to artists and their learned advisers, who drew on it for iconographic programs and the development of new subjects.[3]

A clue to the book's authorship is provided by an acrostic formed by the capital letters at the beginning of each chapter: "Poliam Frater Franciscus Columna peramavit" (Friar Francesco Colonna desperately loved Polia). This Francesco Colonna has been convincingly identified with a Dominican friar residing at the monastery of SS. Giovanni e Paolo, in Venice. Everything about this man, from his onetime presence in Treviso, where part of the narrative takes place, to his later activities in Venice, where he taught Latin in the monastery, dabbled in architecture and metalwork, and borrowed money for the printing of books, accords perfectly with our expectations about the author of the *Hypnerotomachia Poliphili*. His monastic affiliation explains, moreover, why his authorship was disguised.[4] However, the identification of Fra Francesco as the book's creator has not prevented several other candidates from being proposed, including a Roman Francesco Colonna, Lord of Palestrina,[5] and the Renaissance author and architect Leon Battista Alberti.[6]

As for the designer of the handsome woodcuts, identified at times with such famous artists as Andrea Mantegna or the young Raphael, a plausible argument has been advanced for the miniaturist Benedetto Bordone. First suggested by Guiseppe Biadego,[7] this attribution seemed convincing to Martin Lowry,[8] who noted the proximity of Bordone's workshop in Venice to the Aldine press, the miniaturist's documented

Cat. 62, Book 2, Biii

Cat. 62, Book 2, C5v

Cat. 62, Book 2, C7v

interest in printing, and the fact that he appears to have illuminated some Aldine editions. This hypothesis has been strengthened in recent years by Helena Szépe and Lilian Armstrong,[9] who have discovered further links between Aldus and Bordone and made specific comparisons between miniatures by Bordone and the woodcuts of the *Hypnerotomachia Poliphili*.[10]

It is unlikely that there will ever be complete consensus on the meaning of this deliberately obscure work, but there can be no doubt that the basic narrative is a love story, divided into two books. The first and longest book, devoted to the dream of the hero, although intensely erotic in parts, contains lengthy descriptions of the buildings and other antiquities encountered by Poliphilo during his quest to be united with his beloved Polia. The second book, probably written earlier but framed as an account of the lovers' history told within the dream, is more in the tradition of the vernacular romance. Here contemporary courtship rituals are documented, such as when Polia embroiders a silk heart with her lover's name or Poliphilo sends off desperate love letters by messenger. The illustrations depict fifteenth-century interiors in which Poliphilo labors over a letter at a handsome writing desk, with a painting of Christ on the wall behind him—startling in a story where only pagan gods rule!—and Polia reads it in a cassone-lined room, with her pet dog at her feet.

There are echoes of Giovanni Boccaccio in the strangest episode in the second book. Afflicted with the plague, Polia had taken a vow of chastity and devoted herself to the virgin goddess Diana. Therefore when Poliphilo approached her as she prayed in the temple she rebuffed him coldly and left him for dead. Her indifference to love was punished when she was forced to watch two nude women, harnessed to the chariot of Cupid, being whipped by the infant god and then cut into pieces by him and fed to the beasts (opposite page, top). The origin of this motif in the *Decameron* is signaled by Polia's statement that the cries of the women were worse than those heard by the nobleman of Ravenna; that nobleman is Nastagio degli Onesti, who figures in the eighth story of the fifth day (see cat. no. 139). Here Boccaccio's story is transposed to a pagan realm, where Cupid himself, not a spurned lover, is the avenger. Later, after shifting her allegiance from Diana to Venus and reviving Poliphilo with kisses (opposite page, center), Polia fearfully observed the icy chariot of the angry Diana enter her window and was relieved when Cupid followed in his mother's chariot, to drive away the virgin huntress with his huge torch and leave Polia's room strewn with flowers (opposite page, bottom).

The battle between chastity and love was often depicted on marriage furniture; there, as in Petrarch's *Triumphs*, love was made a captive to chastity (see cat. no. 72).[11] In Colonna's narrative, chastity is vanquished by love, a more logical prelude to marriage.[12] As Giovanni Pozzi has pointed out,[13] the most neglected aspect of the monk's tale—and perhaps the most disturbing to the ecclesiastical hierarchy—is its exaltation of marriage. Despite the eroticism of the book, the only illicit aspect of the love affair is that Polia appears to have taken vows as a nun; both she and Poliphilo are unmarried, and Poliphilo's heroic struggle (his *erotomachia*) consists in remaining faithful to Polia and delaying his gratification—in spite of severe temptation—until after marriage. Both books conclude with a recognizable marriage ceremony, albeit a pagan one. In the first book, elaborate rites worthy of a mystery religion are culminated when Poliphilo pierces the curtain inscribed ΥΜΗΝ (the Greek word for "marriage") with Cupid's golden arrow, revealing Venus herself, who distributes rings to the couple and solemnizes their pledge. In the second book, a simpler ceremony unfolds in a temple, presided over by a priestess of the Holy Mother (Venus), who confirms the vows that the lovers seal with a kiss.

WT

1. Barolini 1992, pp. 72–84.
2. Colonna, *Hypnerotomachia Poliphili*, 1999 (ed.), p. 2.
3. For the book's artistic legacy, see Blume 1985, pp. 178–82; Bredekamp 1985a; Bredekamp 1985b; and Rowland 1998, pp. 63–64.
4. Casella and Pozzi 1959.
5. Calvesi 1996. Calvesi's claims were disputed by Pozzi 1980, pp. 3–16. See also Fortini Brown 1996, pp. 287–90, for an analysis of the controversy.
6. Lefaivre 1997. Lefaivre's arguments were refuted by Curran and Grafton 2000, and dismissed by Bulgarelli 1998, p. 93.
7. Biadego 1900–1901, pp. 711–12.
8. Lowry 1979, p. 122.
9. Szépe 1991; Szépe 1995; Armstrong 2003.
10. Szépe and Armstrong are currently writing a book on Bordone.
11. Baskins 1999.
12. For the tensions implicit in artistic, poetic, and carnival representations of the battle of Cupid and Chastity, see S. J. Campbell 2004, pp. 169–90.
13. Pozzi 1980, pp. 8–9.

SELECTED REFERENCES: Colonna, *Hypnerotomachia Poliphili*, 1980 (ed.); Colonna, *Hypnerotomachia Poliphili*, 1999 (ed.); Lowry 1979, pp. 118–26; Szépe 1991; Barolini 1992; Calvesi 1996; Lefaivre 1997; Rowland 1998, pp. 59–67; Armstrong 2003, pp. 651–52

Sigismondo Fanti

Ferrara–act. 16th century, Venice

63a. Triompho di Fortuna (Triumph of Fortune)

Venice: Agostino Zani for Giacomo Giunta, 1526
Printed book with woodcut illustrations (some printed in black and red), 13¾ × 9½ × 1 in. (35 × 24 × 2.5 cm)
The Metropolitan Museum of Art, New York, Gift of Paul J. Sachs, 1925 (25.7)

Francesco Marcolini

Forlì, ca. 1500–Venice, after 1559.

with verses by Lodovico Dolce

Venice, 1508–Venice, 1568

63b. Le Sorti . . . intitolate giardino di pensieri (The Fates . . . Entitled Garden of Ideas)

Venice: Francesco Marcolini, October 1540
Printed book with woodcut illustrations, 12¼ × 8⅝ × ⅞ in. (31 × 22 × 2.3 cm)
The Metropolitan Museum of Art, New York, Harris Brisbane Dick Fund, 1937 (37.37.23)
New York only

The first Italian fortune-telling book, Lorenzo Spirito's *Libro della ventura* of 1482, had gone through numerous editions when Sigismondo Fanti, a Ferrarese math teacher, engineer, and astrologer,[1] decided to publish his own fortune-telling book. Important artists played a part in the design of the numerous woodcuts, including Baldassare Peruzzi (1481–1536), author of the elaborate title page, and the Ferrarese Dosso Dossi (ca. 1486–1541/42), who has plausibly been credited with the design of the eight alternating woodcuts that frame the fortune-telling wheels.[2] These frames depict artists, writers, scientists, musicians, and rulers, labeled differently at each appearance.[3] The figure labeled "l'Unico Aretino" who appears below the wheel of Luxuria, or lust (xxvi), is not the poet and pornographer Pietro Aretino—as appropriate as he would be in the context—but Bernardo Accolti (1458–1532), also from Arezzo; famed for his extemporaneous verse, he features in Baldassare Castiglione's *Courtier*.[4] (Aretino is discussed elsewhere in this volume. See the essays by Linda Wolk-Simon and James Grantham Turner; see also cat. nos. 99, 100, 113a, b.)

Fanti makes impressive claims for the basis of his fortune-telling method in natural science and the stars, but the results are ultimately determined, as in Spirito's book,

Cat. 63a, fol. xxv verso

Cat. 63b, title page

by a single throw of the dice. The interlocutor, having passed from his or her selected question through pages illustrating the various winds of fortune and the royal houses of Italy, arrives at one of the wheels, where all the possible combinations of two dice are illustrated. In case there are no dice available, Fanti offers a second wheel on the same page that uses the hour of the day to determine the result. Each of the seventy-two questions, which cover everything from planning a war and building a palace to philosophical and religious issues, is associated with a particular woodcut representing a wheel. Of these questions, seven relate to love and marriage and another four to childbirth.

On the page illustrating the Wheel of the God of Love (Cupid), the question addressed is whether the lover is equally loved by his beloved (above left). The text following this question promises that signs of love will be revealed and types of love discussed, but the quatrain responses delivered by an astrologer or sibyl at the end of the book devote two lines to spurious astrological explanations, leaving little room for elaboration. Most answers provide assurance of reciprocal love. A few offer advice, such as to proceed slowly

but with determination, or to placate your lover with talk if you want to come to the end of your torments. More revealing are the responses to the question dealt with on the facing page.

This wheel addresses the issue of how many husbands a woman will have, one of the few questions specific to women. In the text following the question, Fanti advises that a woman not have more than two or, if it cannot be avoided, three husbands, for numerous marriages imply wantonness and look especially bad if a wife abandons her young children. Fanti editorializes further that men love their children more and never leave them, as a mother does, "to satisfy her dishonest appetites." Multiple marriages for women must have arisen in large part from the discrepancy in age between husband and wife, meaning that the woman often outlived her husband. Authors of advice books generally recommended that women marry between eighteen and twenty-five, and men between twenty-five and thirty-seven,[5] and the age difference was often much greater. Fanti's belief in women's "dishonest appetites" helps to explain why this question is associated with the Wheel of Luxuria—here a satyr

rather than Cupid is depicted approaching a seminude woman—and also accounts for the tenor of many of the answers. In keeping with his own advice, Fanti never predicts that a woman will have more than three husbands, and he allows three husbands in only two of his answers; two husbands are the most common response, twice as frequent as one. A woman may find a single husband who will "triumph in the battle of love," or perhaps two who both "know how to drive away the frost, using Cupid's arts," or are "capable and inclined to satisfy [her] nocturnal desires." One answer even foretells three husbands who are all "very expert and capable at the nocturnal trials." These suggestive answers may have been intended in part to embarrass women players, as their blushes and giggles would have made the game more fun.

Although most of Fanti's questions seem geared to men, the frontispiece to a 1557 edition of Spirito's similar book shows a mixed company gathered around a table, with one woman throwing three dice and another holding the book. In a letter that the author Andrea Calmo (ca. 1510–1571) sent with such a fortune-telling book, he described it as a game to be enjoyed with family or with "a

company of ladies and gentlemen."[6] Further confirmation of women's participation is found in the third Italian fortune-telling book to be published, Francesco Marcolini's *Le Sorti* of 1540, which made use of a deck of cards rather than dice, for this book opens with thirteen questions specific to men, thirteen specific to women, and twenty-four of relevance to both sexes.

As in Fanti's book, the title page to *Le Sorti* consists of a handsome full-page woodcut (opposite page, right). Although copied from an engraving by Marco Dente da Ravenna (b. late 15th century, act. in Rome from 1515, d. 1527),[7] the cut is signed by Giuseppe Porta Salviati (ca. 1520–ca. 1575), who probably had a hand in the series of allegories and philosophers that illustrate the book. A few of these designs have also been attributed to Porta's teacher Francesco Salviati (1510–1563).[8] Marcolini, a specialist in vernacular literature—he was the publisher of Pietro Aretino and Antonfrancesco Doni, among others[9]—hired the prolific Lodovico Dolce, author five years later of a popular advice manual for women,[10] to pen the rhyming responses in his book.

If Dolce takes advantage of this early opportunity to instruct, he does so in a playful manner. The astrological apparatus has been stripped away, and Dolce addresses the questioner as "brother" or "little daughter," employing phrases like "as I see it" or "in my opinion." In a response to the question of how many wives a man will have, he writes, "Marcolini . . . has put in this book of fates that you are not the kind of person to have a wife." In his answers to the question of whether a woman should change lovers, Dolce generally thinks they can do better. The lack of any hint of scandal and the recommendations, for example, to choose one who is "neither too young nor too old but from that middle range that is praised," one who "loves you from the heart," or one whom "you love from the heart, as is fitting" suggest that his intended audience consists of maidens of marriageable age rather than adulterers.[11] In one response, Dolce advises leaving a womanizer to find a man who "non sia vago di mangier le pesche" (does not delight in eating peaches; see Linda Wolk-Simon's essay "Rapture to the Greedy Eyes" in this volume), and in another he urges the woman to "get rid of that madman" and find a lover who gives solace. In his responses to how many husbands a woman may have, Dolce does not stop at three but goes as high as ten, with the average about four. The intention to make women blush is particularly evident in one of his responses: "You will have five, rose-faced one [*volto di rose*], and with all of them you will enjoy equally that which spouses like to enjoy."

Fanti, we recall, had advised women against having more than two or at most three husbands. When it comes to the number of wives a man will have, Fanti seems to believe that sauce for the gander is sauce for the goose, for he counsels men not to have more than two, or at most three, wives unless they want to be reputed "ruffians" and "merchandisers of women." For men as for women, two marriages is Fanti's most frequent response. Dowries feature prominently in Fanti's answers, and the multiple wives are often portrayed as having opposing personalities, with one, for example, making the man's days pleasant, whereas the other makes his life worse than death. In Dolce's responses to the same question, an occasional answer allows for four or even seven wives, but the vast majority predict a single marriage. The issue of dowries is not entirely lacking in *Le Sorti*, but most responses define the nature of the wife, which ranges from a woman so sharp you could cut wood on her, or so annoying and bestial that "being a cuckold will be the least of it," to one who is "the sweetest in the world and the most dear," "a column of every goodness," or "one of those rare ones who are neither obstinate nor proud and know both how to do and how to command." This last answer seems to pay tribute to the active and praiseworthy role a woman can play in a marriage.

WT

1. Ernst 1994; Bolzoni 2001, pp. 110–17.
2. Tietze and Tietze-Conrat 1937, p. 87; Byam Shaw 1976, no. 358; McTavish 1981, pp. 77–78.
3. See Johnson 2001.
4. Unglaub 2007, p. 16.
5. Bell 1999, pp. 212–14.
6. Fortini Brown 2004, p. 136.
7. Witcombe 1983.
8. McTavish 1981, pp. 95–108; Cecchi 1998, p. 71.
9. Quondam 1980; Bolzoni 2001, pp. 117–19.
10. See Bell 1999, pp. 216–19.
11. For the importance of love in marriage at this time, see Cozzi 1980, pp. 48, 61; Bell 1999, pp. 215–19.

SELECTED REFERENCES: Casali 1861, pp. 119–30; Eisler 1947; McTavish 1981, pp. 64–122; Witcombe 1983; Bolzoni 2001, pp. 110–19; Johnson 2001; Fortini Brown 2004, pp. 136–40

Cesare Vecellio

Pieve di Cadore, ca. 1521–Venice, 1601

64. De gli habiti antichi et moderni di diverse parti del mondo libri due . . . (Of Ancient and Modern Dress of Diverse Parts of the World in Two Books . . .)

Venice: Damiano Zenaro, 1590
Printed book with woodcuts by Christoph Krieger (Cristoforo Guerra; b. Nuremberg–d. Venice, ca. 1590), 6⅝ × 5⅛ × 2 in. (16.7 × 12.5 × 5.2 cm)
The Metropolitan Museum of Art, New York, Rogers Fund, 1906, transferred from the Library (21.36.146)

Cesare Vecellio joined the Venetian workshop of his cousin Titian sometime before 1548 and seems to have remained there until the master's death in 1576. Even while assisting his famous relative, Vecellio carried out independent painting commissions in his native Pieve di Cadore and in Belluno and other nearby towns, where he remained in demand throughout his life. By the 1570s he was active as a publisher,[1] issuing in 1572 a large woodcut of the battle of Lepanto by Christoph Krieger.[2] Perhaps the German woodcutter had begun cutting the 420 blocks for the costume book by this time, but the book was not published until 1590, when the author was seventy. Vecellio (p. 155) lamented that Krieger's death prevented him from including as many woodcuts as he had intended—the privilege had stipulated 450.[3] In 1598 a second edition appeared with an additional eighty-eight costumes but a shorter text, printed in Latin as well as Italian to make the book accessible to a broader European public.[4]

Vecellio's costume book is the culmination of a trend that began in the mid-sixteenth century, with a series of costume engravings by Enea Vico (1523–1567). Vico received a privilege in 1557 to publish books of costume,[5] and in 1558 an edition of the incomplete series appeared.[6] The influential images seem to have circulated mainly as loose prints, however, furnishing models for most subsequent series, from the first true costume book, published in Paris in 1562, right to Vecellio's volume.[7] It has been suggested that Vico's costume project was initiated by a trip in 1550 to the court of Charles V in Augsburg, where he could have seen the early manuscript costume book of Christoph Weiditz (ca. 1500–1559).[8] Together with Titian, Vecellio had traveled to Augsburg two years earlier.[9] Neither Vico nor Vecellio copied Weiditz directly, but it is

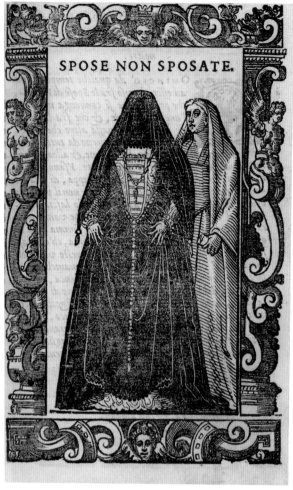

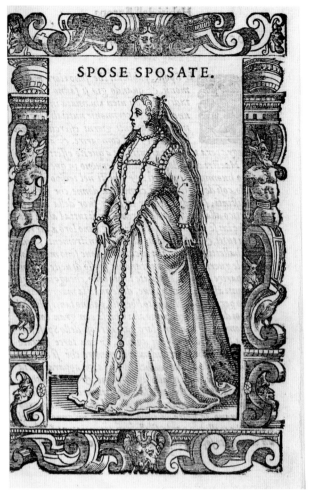

Cat. 64, Book 1, 125

Cat. 64, Book 1, 126

possible that Weiditz's collection of costume drawings and the emperor's enthusiasm for the subject provided a spur to both artists.

In the decades between Vico's engravings and Vecellio's costume book, at least ten costume books were published in Europe, and Vecellio drew on all of them.[10] His volume is distinguished from its predecessors, however, by a lengthy commentary that relates dress to political, religious, economic, and social factors. Only Nicolas de Nicolay's account of his travels among the Turks, first published in Lyon in 1567,[11] presents a comparable richness of ethnographic information alongside the numerous costume illustrations. What Nicolay does for the Ottoman Empire, Vecellio does for the society he knew best, that of Venice and the Veneto. Although he aimed for universality, Vecellio's main focus was Venice, and his most important contribution was his description of Venetian costume of the past and present, to which fully one fourth of his illustrations are devoted.

Vecellio's value as a chronicler of Venetian society is evident from his description of how each stage of a girl's life was marked by a change of dress. The daughters of Venetian nobles were raised in such strict seclusion that between puberty and marriage not even their closest relatives saw them; when

they left the house to attend church, they had to wear a veil. Young adolescents wore one of white silk that covered both face and breast, whereas girls of marriageable age hid their face behind an ample but shorter black veil of costly silk that was fixed in place. Francesco Sansovino, writing in 1581,[12] tells us that marriages were arranged by a third party and the bride was not seen by the groom or his family until after the contract was signed, but Vecellio describes a new custom of well-chaperoned visits between the future spouses, including excursions, prior to the signing. On these occasions the woman would wear a black veil, no longer tightly attached, that covered her face but not her loosely laced bodice, which, along with her sleeves, would usually be of white silk (above left). She would wear valuable pearls and golden jewelry, which she had not worn prior to the engagement (*sposate a parola*), along with perfumed gloves and a long belt of jeweled gold that extended to the ground. Her outer garments would be black with a short train.

After the signing of the marriage contract came the *parentado,* or display of the bride to the extended family, which Patricia Fortini Brown has aptly likened to a coming-out party.[13] On alternate days, groups of male

and female relatives would come to the bride's house, where they would be seated in the portico. Finally revealed in her full splendor, the bride would emerge from her room, escorted by an elderly dance master hired to instruct and assist her (see cat. no. 65), and to the accompaniment of musical instruments she would perform a few dances, bow to her visitors, and return to her room, where a group of women waited to adjust her hair and change her dress. The visiting days would be concluded by a splendid procession of the bridal party to the church, preceded by musicians and including servants carrying torches, which would be lit during the Mass. The church ceremony was followed by a great feast at the home of the groom.

The mode of dress adopted by the bride for the *parentado* would be worn, Vecellio tells us, for nearly a year. The most distinctive feature of the bride's appearance was her hair—blond either through nature or "through the exquisite diligence of art"—spread loose over her shoulders, interlaced with golden filaments, and adorned with a circlet of jeweled gold or, toward the end of the century, a jeweled tiara. In Vecellio's first illustration of the married bride (above right), we see how curls were used to frame the face and how the bridal dress of white satin was adorned at neck and

shoulders with a few small ruffles. However, Vecellio tells us, "for the past six years" brides have adopted a new style, curling their hair in horns to resemble the crescent moon of the chaste goddess Diana—a hairstyle soon taken up by all fashionable Venetian women, including courtesans (see cat. no. 65 and figs. 36, 37). The dress, though still white, was richly embroidered and adorned with lace attachments at the shoulders and neck. The padded bodice swelled at the stomach and defined the contours of the body. All brides were bedecked in precious pearls and golden jewelry, but those who married during the fifteen days of the Feast of the Ascension went all out, since, as Vecellio notes, they would be seen not only by Venetians but by foreigners of all nations, who flocked to witness the splendid celebration. Each of these brides strode through the streets with her attendants, heavily perfumed, carrying a fan with a silver handle, wearing a long train, and with a long transparent veil attached to her hair (Book 1, 128). The splendid Venetian brides whom Franco (see cat. no. 65) had likened to goddesses were compared by Vecellio to so many suns. W T

1. M. Bury 2001, p. 235; Conte 2001, p. 17.
2. This woodcut includes the first instance noted to date of the appearance of Vecellio's address, "Appresso Cesare Vecelli in Frezzaria." See Bassenge Kunst- und Buchauktionen, Berlin, sale cat., November 29, 2007, pp. 30–31, lot 5059.
3. Witcombe 2004, p. 292.
4. Guérin Dalle Mese 2001, p. 125.
5. B. Wilson 2005, p. 292, n. 3.
6. The Metropolitan Museum of Art possesses photographs of a series of thirty-three that included a title page dated 1558 but without Vico's name; a similar edition of 1558 was cited by Ghering van Ierlant 1988, p. 12.
7. Olian 1977.
8. Chen 2000.
9. Conte 2001, p. 13.
10. See Wendy Thompson in S. Carboni 2007, p. 318, no. 63.
11. Gomez-Géraud and Yerasimos 1989.
12. Sansovino, *Venetia*, 1968 (ed.), p. 401.
13. Fortini Brown 2004, p. 141.

Selected references: Olian 1977; Timmons 1997, pp. 28–33; Guérin Dalle Mese 1998; Guérin Dalle Mese 2001; B. Wilson 2005, pp. 70–104; Wendy Thompson in S. Carboni 2007, p. 318, no. 63

Giacomo Franco
Venice or Urbino, 1550–Venice, 1620

65. Habiti delle donne venetiane (Costumes of Venetian Women)

Venice: Giacomo Franco, n.d. (ca. 1591–1609)
Printed book with engraved plates, 11 × 8¼ × 1 in.
(28 × 21 × 2.5 cm)
The Metropolitan Museum of Art, New York, Harris Brisbane Dick Fund, 1934 (34.68)

Giacomo Franco was the illegitimate son of the painter and printmaker Battista Franco, who died when Giacomo was only eleven. Initially Giacomo made his living engraving topical prints, maps, frontispieces, and book illustrations, including those for Anguillara's translation of Ovid's *Metamorphoses* (Venice, 1584) and Torquato Tasso's *La Gerusalemme liberata* (Jerusalem Delivered; Genoa, 1590). In the 1590s he began to publish his own illustrated books, issuing a writing treatise in 1595 and a lace manual and collection of portraits of contemporary rulers in 1596.[1] In the seventeenth century Franco was active mainly as a publisher, and did little engraving of his own.

Franco's *Habiti delle donne venetiane* has always been dated close in time to his *Habiti d'huomeni et donne venetiane* (Costumes of Venetian Men and Women),[2] which first appeared in 1609,[3] although most copies are dated 1610. Yet despite the similarity in titles and the use of the same title page, modified in the case of the *Habiti d'huomeni et donne*, the two books are entirely different.[4] The former consists of twenty numbered plates of splendidly attired women engraved by Franco, each accompanied by a page of letterpress description in Latin and Italian, whereas the latter, which focuses more on Venetian festivals and buildings than on costumes, is made up of unnumbered plates by a variety of hands with engraved inscriptions. Franco's application on November 16, 1591, for a privilege to publish "il libro delli habiti alla venetiana intagliato da lui" (the book of costumes worn by Venetian women engraved by him) suggests that the plates for the *Habiti delle donne* were completed by that date. The inclusion on the title page of a vignette of the "new Rialto Bridge," completed in 1591, also accords with this dating. Publication may have been impeded, however, by the denial of Franco's request.[5]

Franco must have been inspired to create a costume book by the success of Cesare Vecellio's treatise of 1590 (see cat. no. 64) and by his own contributions to Pietro Bertelli's *Diversarum nationum habitus* of 1591.[6] Yet in comparison with other examples of the genre,

including Franco's own *Habiti d'huomeni et donne venetiane,* Franco's *Habiti delle donne* exhibits a surprising lack of diversity. As Franco notes in the text to plate 3, the women of the four Venetian classes—nobles, citizens, merchants, and artisans—"vanno vestite quasi ad un modo" (dress almost in the same style), distinguished only by the quantity and value of their jewels. In the text to plate 11, illustrating "a famous courtesan," Franco explains that wealthy prostitutes dress as splendidly as the other classes of women, although they are required by law to cover their faces when attending church. Vecellio had likewise observed that Venetian courtesans often imitated the mode of dress of married women or even widows.[7] The interchangeability of courtesans and respectable Venetians is evident from a 1614 edition of Franco's *Habiti d'huomeni et donne venetiane*, which includes a licensing statement indicating that it had been approved by the censors. Here the dress of the woman playing the harpsichord, identified in the 1609/1610 edition as that of the "cortegiane principale," is represented as characteristic of the "donne venetiane," and the word "courtesans" has also been replaced by "women" in the plate showing how Venetians arrange their hair (Pierpont Morgan Library 76229).

There is no indication that Franco ever received a privilege for his *Habiti delle donne*; the only "cum privilegio" is on the engraved title page, which is printed separately from the title and could have been approved separately. The fact that nearly half the plates represent courtesans may explain the denial of his 1591 request. A clue to Franco's intended audience is provided by plate 15, illustrating "an enamored youth," susceptible to the lures of the courtesan, and by plate 17, which portrays a representative of the foreign merchants (shown with a prostitute) who, "after making great gains, give themselves some pleasure." The true function of the book would seem to be not that of a costume book but rather that of a souvenir of one of the city's most famous tourist attractions—a collection of Venetian beauties. Bronwen Wilson noted that the friendship albums carried by traveling students and tradesmen often included costume drawings of Venetian women, particularly the veiled virgin and the courtesan.[8] Among the glories of Venice were also her brides, to whom Franco devotes three of his plates.

Of plate 6 Franco tells us that noble brides, with their gold-embroidered dresses, pearls fit for a foreign princess, crowns set with jewels, and hair interwoven with filaments of gold, appeared like goddesses. In another plate (p. 148, top left) Franco portrays the manner in which such brides were displayed to their relations during the ritual viewing known as the *parentado* (see also cat no. 64).

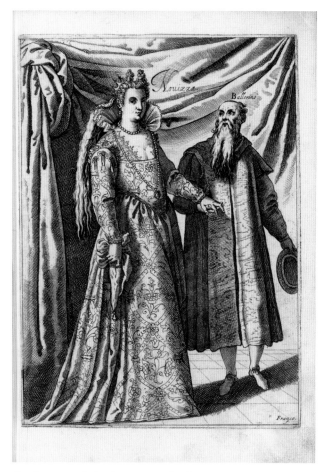

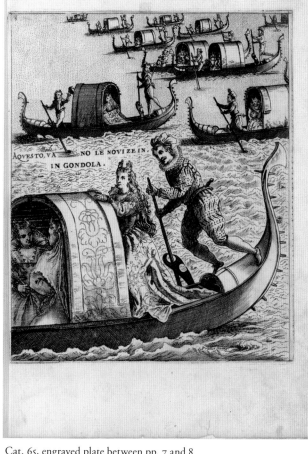

Cat. 65, engraved plate between pp. 6 and 7

Cat. 65, engraved plate between pp. 7 and 8

His illustration of the bride supported by her *ballerino* makes it clear that the main purpose of this elderly dance master was to keep the bride from toppling over as she performed her ritual dances and curtsies in high platform shoes (see cat. no. 117). After two days of receiving relatives at home, the bride would travel by gondola to visit those confined to monasteries. Franco illustrates the earlier custom, as described by Francesco Sansovino in 1581,[9] which required the bride to sit behind the gondola's roof so that everyone could see her clearly (above right). This tradition is also illustrated in Jost Amman's large woodcut that depicts Venice at the time of the Feast of the Ascension,

when the activities included the ritual of the Doge's symbolic marriage to the sea and many weddings were celebrated (fig. 75). At the time of Franco's writing, the practice was for the bride to sit inside the gondola, with only her hair on display, as depicted in a plate to his 1609/1610 costume book. He tells us that a crowd of onlookers would converge to view the spectacle, often joining the family procession in their own gondolas. Sansovino praised this tradition of private and public display of the bride, for he believed that not only the extended family but the entire city of Venice shared a concern in the successful marriage and it was fit that they serve as witnesses.

WT

1. Stefani 1998, p. 182; Wendy Thompson in S. Carboni 2007, p. 319, no. 65.
2. Colas 1933, vol. 1, p. 384; Pasero 1935, p. 354; Nienholdt and Wagner-Neumann 1965, vol. 1, p. 294; Stefani 1998, p. 183.
3. See M. Bury 2001, pp. 186–87.
4. Franco received a privilege for the "*Habiti de huomeni, et Donne Venetiane, con la processione della S. N. et altri particolari . . . da lui intagliati, et fatti intagliar in Rame,*" on October 8, 1609 (cited by B. Wilson 2005, p. 293, n. 3). Pasero (1935, p. 354) and Stefani (1998, p. 183) believe that the *Habiti delle donne* represents a later edition of this book, but the two contain none of the same plates.
5. Witcombe 2004, p. 293; B. Wilson 2005, p. 293, n. 3.
6. Stefani 1993, pp. 271–72.
7. Vecellio, *Degli habiti antichi*, 1590, fol. 137.
8. B. Wilson 2005, pp. 104–14.
9. Sansovino, *Venetia*, 1968 (ed.), p. 401.

SELECTED REFERENCES: Pasero 1935, p. 354; Nienholdt and Wagner-Neumann 1965, vol. 1, p. 294; Stefani 1998, p. 183; Fortini Brown 2004, pp. 161–62; Witcombe 2004, p. 293

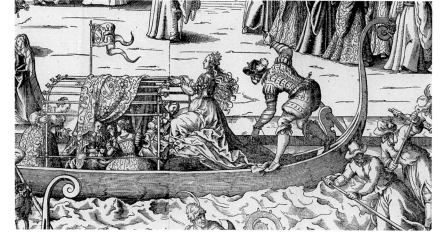

Fig. 75. Jost Amman (1539–1591), *Procession of the Doge to the Bucintoro on Ascension Day, with a View of Venice, ca. 1565* (detail), 1697. Woodcut (posthumous third state), image: 29¾ × 73½ in. (75.6 × 186.7 cm). The Metropolitan Museum of Art, New York, The Elisha Whittelsey Collection, The Elisha Whittelsey Fund, 1949 (49.95.5)

Master of Charles of Durazzo
(Francesco di Michele?)

Florentine, late 14th century

66. Birth Tray (Desco da Parto) with The Triumph of Venus

Florence, ca. 1400

Tempera on panel, painted surface 19¼ × 19⅛ in.
(49 × 48.5 cm); with frame 21⅛ × 20⅞ in. (53.5 × 53 cm)
Inscribed on costumes: *ACHIL, TRISTAN, LANCIELOT, SANSON, PA[RIS], TRIOLOL[US]*
Musée du Louvre, Département des Peintures,
Donation de la marquise Arcanati-Visconti, 1914,
Paris (R.F. 2089)

This is an early, and anomalous, painted birth tray. Only the front of the dodecagonal tray survives; the back may have been painted, as was typical at this date, with a gaming board or a field of flowers. Even without the back, however, it is obvious that this tray was a luxury object. It has been attributed to the so-called Master of Charles of Durazzo, named for the cassone panel representing the conquest of Naples by Charles of Durazzo, now in the Metropolitan Museum.[1] Both Miklós Boskovits and Everett Fahy have identified this painter as the Florentine Francesco di Michele, who was responsible for some of the earliest Renaissance marriage chests and birth trays but also executed monumental sacred work, such as the altarpiece for the church of San Martino a Mensola, outside Florence.[2]

The artist used his knowledge of the sacred iconographic types popular for altarpieces to good advantage here. The composition of the tray comes directly from scenes of Christ Triumphant and the Assumption of the Virgin, in which the main figure is elevated and enclosed in a mandorla, connected by rays of light to the devout below.[3] On this tray, however, the subject is distinctly pagan rather than Christian: the main figure is a dainty nude winged Venus, hovering in a brilliant glow, and the rays of light joining her to six male devotees originate from her genitals. These devotees—heroic lovers from ancient, biblical, and medieval literature, conveniently identified by inscriptions on their tunics—stare up at her in awe and make gestures of humility. They kneel in a flowering garden whose great abundance is a traditional sign of Venus and her fertility. The men are struck not only by the rays of light but also by arrows aimed by two cupids in the sky. The little boys hover on feathered wings, kicking their birdlike feet to draw attention to their talons, symbolizing the ferocity of love.[4]

It is difficult to understand this image as an offering appropriate to a newly married woman and future mother. Certainly Venus's fertility—the flowering plants and trees that set the scene—accords well with childbirth iconography and the talismanic role of *deschi da parto*. However, a depiction of the obviously sexual power of the goddess, and her ability to control the six warriors by the force

Cat. 66

of that sexuality, seems an inappropriate message for a husband to send to his young wife.[5] Although birth trays were objects meant for women, this particular tray relies on such a complex series of associations, and such a familiarity with learned texts, that relatively few women would have completely understood its warning about the perils of Venus. Instead, their generally more educated husbands were likely the ones who most enjoyed a tray such as this. Moreover, although the admonitory aspect of some cassoni and birth trays seems most often to be addressed to the wife, the lesson here was intended for the husband. JMM

1. Pope-Hennessy and Christiansen 1980, pp. 20–23, figs. 13–15; Fahy 1994.
2. Boskovits 1991; Fahy 1994, p. 239.
3. Cantelupe 1962, p. 239.
4. Panofsky 1939, pp. 115–21.
5. Camille 1998, p. 33.

Selected references: Schubring 1915, p. 319, no. 24; Cantelupe 1962, pp. 238–42, fig. 1; P. F. Watson 1979, pp. 80–85, pl. 67; Jacobson-Schutte 1980, pp. 481–82, fig. 6; Brejon de Lavergnée and Thiébaut 1981, p. 201; Boskovits 1991, p. 47; Fahy 1994, p. 239, fig. 237; De Carli 1997, pp. 74–75, no. 6, ill.; Camille 1998, pp. 32–33, fig. 23; Däubler-Hauschke 2003, pp. 219–21, no. 17, fig. 86; Randolph 2004, pp. 553–54, pl. 4.10

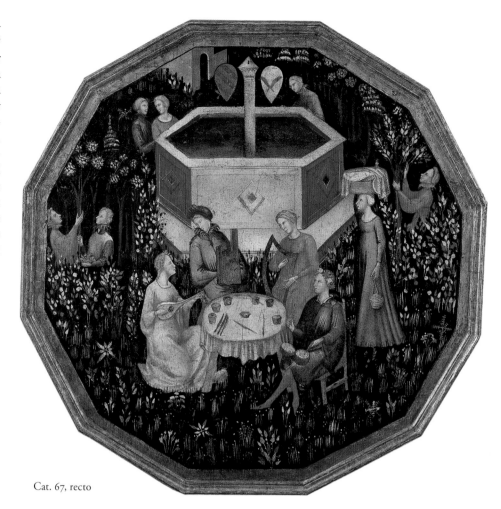

Cat. 67, recto

Master of Sant'Ivo
Florentine, act. late 14th–early 15th century

67. Childbirth Tray (Desco da Parto) with A Garden of Love (recto) and Flowering Field (verso)

Florence, ca. 1410
Tempera on panel, Diam. 24½ in. (62.2 cm)
Private collection

The style of the figures painted on this tray, as well as their very particular costumes with high waists and collars and flowing skirts, would seem to date it to the early fifteenth century.[1] Yet the attribution has been a matter of some debate. When the tray first appeared on the art market, in 1965, it was assigned to Mariotto di Nardo, a Florentine artist active during the first three decades of the fifteenth century who spent much of his career executing frescoes, panel paintings, and illuminated manuscripts for religious institutions in his native city.[2] More recently, the anonymous Master of Sant'Ivo has been suggested. A contemporary and apparently a close colleague of Mariotto, this

Cat. 67, verso

artist is also primarily associated with sacred paintings, but the tray indicates that he was not averse to working in what was by then the profitable market for domestic art.[3]

This childbirth tray is one of four known examples, all dating before the mid-fifteenth century, that represent a popular theme in vernacular literature: the idyllic Garden of Love, where men and women engage in amorous activities surrounded by flowering vegetation and bubbling fountains.[4] The most famous manifestations of this subject were the pleasant country settings in Boccaccio's *Decameron* (ca. 1353) to which a group of Florentine ladies and their male companions escaped during the outbreak of the plague. Somewhat surprisingly, no known tray represents the garden of that storytelling group or any of their one hundred tales. Boccaccio's *Teseida* (ca. 1340) did, however, provide the impetus for two trays with garden settings, both dominated by a foreground image of the heroine, Princess Emilia, and her companions seated in a flowering field while two Theban knights battle for her love in the background.[5] The representations of Emilia's garden are very similar to the one on this tray: in all three, the ground is strewn with bunches of flowers and vegetation in varied shapes and sizes to imply a diverse and abundant bounty. Such allusions to fertility and fecundity were, of course, appropriate for objects associated with childbirth.

If the garden represented on this tray does have a literary source, it has not yet been identified. The image should instead be understood in an evocative sense, as a composition that not only incorporates references to vernacular literature with marital ideals but also includes details that activate all the senses—the smell of flowers, the touch of hands, the sight of the beloved, the sound of music, and the taste of food—to create a stimulating, unabashedly sensual experience.[6] By the middle of the fifteenth century, this kind of iconography would give way to subjects of a decidedly more humanist origin, with stories of heroic accomplishments from ancient texts dominating the production of secular art for the home.[7] But in the early fifteenth century, a representation of a Garden of Love celebrated love and chastity within a marriage and heralded the arrival of the union's anticipated offspring.

The musical party near the center of the tray encourages such a reading. Seated at a draped round table laden with knives and cups or bowls, two men and two women play a lute, a psaltery, a harp, and a set of drums. They look at each other, as if following musical cues, and their gazes unify the composition, echoing the forms of the hexagonal fountain behind them and the dodecagonal

tray itself. A simply dressed woman, perhaps a servant or attendant, walks toward the group from the right, bringing them food in a basket covered in linens balanced on her head and drink in a raffia-wrapped flask. Scattered throughout the scene are six more figures, shaking blossoms or fruit down from trees, gazing into the fountain, or, in the case of the couple at the top left, engaging in potentially more intimate behavior: the hand of the youth reaches around his lady's shoulder as they gaze into each other's eyes. Both setting and subject draw attention to the garden as a site for love, and the two unidentified coats of arms at the top of the composition must have been those of the married couple it originally celebrated.

This tray is particularly important because the reverse still retains its original painting, the only known example with a flowering field empty of both people and objects. The close view of nature at its fertile peak must be another reference to the Garden of Love theme. But the same motif was also popular on imported tapestries from north of the Alps, known in the Renaissance as *verdure* and now more commonly described as *millefleurs*. These tapestries were highly sought-after items in middle- and upper-class households, and their imitation on the reverse of this tray should also be understood within the more general context of Renaissance material culture.

JMM

1. Herald 1981, pp. 43–65.
2. A. Bury 1965.
3. De Carli 1997, pp. 84–85, no. 11; C. Baldini 2004, pp. 94–95.
4. De Carli 1997, pp. 62–65, no. 1, pp. 78–79, no. 8, and pp. 102–3, no. 16.
5. Ibid., pp. 76–77, no. 7, and pp. 82–83, no. 10.
6. P. F. Watson 1979.
7. Callmann 1979.

SELECTED REFERENCES: A. Bury 1965, p. 255, ill., p. 264; P. F. Watson 1979, p. 64, pls. 53, 54; De Carli 1997, pp. 84–85, no. 11, ill.; Musacchio 1999, p. 66, fig. 48; Garrard 2001, p. 81, fig. 46; Sotheby's, New York, sale cat., January 25, 2001, pp. 60–63, lot 27, ill.; Däubler-Hauschke 2003, pp. 213–15, no. 14, figs. 81, 82; C. Baldini 2004, pp. 94–95, no. 39; Musacchio 2008, pp. 119–20, fig. 116

Master of 1416
Florentine, act. early 15th century

68a, b. Recto and Verso of a Birth Tray (Desco da Parto) with Scenes from Boccaccio's "Commedia delle ninfe fiorentine"

Florence, ca. 1410
Tempera on wood, each panel 21⅛ × 22⅛ in. (53.7 × 56.2 cm)
The Metropolitan Museum of Art, New York, Rogers Fund, 1926 (26.287.1, 26.287.2)

These panels, separated from each other today, likely formed the front and back of a single birth tray. The tray is the only known example with a story that continues from one side of the object to the other. Florentines were used to looking across and around paintings in order to grasp their meanings. They did so with large fresco cycles, which could extend across great expanses of wall interrupted by doors and windows, and even more important in this context, they did so with paired marriage chests, on which the story flowed from the front of the first chest to the front of the second. The frequency of this sort of composition for birth trays is not clear, however, because of the poor survival rate of these relatively fragile domestic objects.

This is an early tray, probably by a master in the prolific workshop of Lorenzo di Niccolò (documented 1371–1420), a Florentine painter better known for his production of large-scale altarpieces for churches in and around Florence.[1] Altarpiece production required competent workshop organization to succeed, and some of Lorenzo's associates had recognizable styles of their own. One of these associates, the Master of 1416 (so named for an altarpiece of that date now in the Galleria dell'Accademia, Florence), has been shown to be the artist responsible for this tray.[2]

In 1975 the painted scenes, long considered generic courtly romances, were identified as the earliest known representations of events in Giovanni Boccaccio's novel *Commedia delle ninfe fiorentine* (The Comedy of the Florentine Nymphs; ca. 1342), which tells the story of the hunter Ameto's discovery in the Tuscan countryside of a group of nymphs who teach him about love and ultimately lead him to a virtuous life.[3] To understand the narrative, the viewer must follow the actions of the figures, several of whom can be recognized by their costumes and hair styles, across the two compositions. The front of the tray (cat. 68a) shows two episodes: in the foreground, Ameto, wearing a red, high-collared tunic, finds the nymphs hunting, bathing, and singing in the

Cat. 68a

Cat. 68b

landscape; in the background, Ameto hunts with the nymphs. Lithe hunting dogs, which sleep, play, run, or attack, serve as foils for the figures in this busy composition. The reverse of the tray, however, focuses on a single incident, the competition between leisure, represented by the shepherd Alcesto, and industry, represented by his companion Acaten. This competition, before an audience composed of Ameto and two of the nymphs, is a critical prelude to Ameto's embrace of the virtuous life.

The coats of arms on the reverse of the tray (cat. 68b) have been damaged, but the arms on the right (the bride's side) seem to be those of the Di Lupo Parra family of Pisa. We can assume that the tray celebrated a birth, or the hope for a birth, in a household with a Di Lupo Parra wife. This tray and many other birth trays with similar literary subjects have been referred to as marriage trays, but documentary evidence indicates that no such objects existed. Even when trays were presented at marriage, and even when, as in this case, they illustrated complex texts that seem to have no relationship to childbirth, they were considered birth trays by those who made and bought them. This is indicative of the close relationship between marriage and childbirth in the Renaissance mind, and it helps to explain the presence of birth trays in contemporary households for extended periods of time.[4] JMM

1. Sirén 1920.
2. Pope-Hennessy and Christiansen 1980, p. 6.
3. P. F. Watson and Kirkham 1975.
4. Musacchio 1999, pp. 67–68.

SELECTED REFERENCES: Zeri 1971, pp. 54–56, ill.; P. F. Watson and Kirkham 1975, pp. 35–50, figs. 1, 2; P. F. Watson 1979, pp. 95–98, pl. 79; Pope-Hennessy and Christiansen 1980, pp. 6, 7, 9, figs. 1–3; Miziołek 1996, pp. 103–5, pl. 59b; De Carli 1997, pp. 86–89, no. 12, ill.; Musacchio 1999, p. 71, fig. 55; Däubler-Hauschke 2003, pp. 226–30, no. 20a, b, figs. 91, 92; Weppelmann 2007, pp. 116, 121, figs. 22, 23, pl. XI

Bartolomeo di Fruosino
Florentine, 1366/69–1441

69. Childbirth Tray (Desco da Parto) with a Confinement-Room Scene (recto) and Urinating Putto (verso)

Florence, 1428
Tempera on panel, 23¼ in. (59 cm)
Inscribed on front: *QUESTO SI FE A DI XXV DAPRILE NEL MILLE QUATTROCENTO VENTOTTO* (This was made on the 25th of April, 1428); on reverse: *FACCIA IDDIO SANA OGNI DONNA CHFFIGLIA EPADRI LORO . . . RO . . . ERNATO SIA SANZA NOIA ORICHDIA ISONO UNBANBOLIN CHESULI . . . A DIMORO FO LAPISCIA DARIENTO EDORO* (May God give health to every woman who gives birth and to the child's father . . . may [the child] be born without fatigue or danger. I am a baby who lives on a [rock] . . . and I make urine of silver and gold)
Private collection (on loan to The Metropolitan Museum of Art, New York [L.1995.17])

Although relatively few works by Bartolomeo di Fruosino are known today, surviving documentation indicates that he was a very successful miniaturist who also executed panel paintings for the profitable domestic market.[1] This tray, first identified as a work by Bartolomeo in 1974,[2] is a good example of a popular type of *desco da parto*: the front represents the activities that took place in a bedchamber after the birth of a child, and the back has a talismanic image relevant to family life. In certain aspects, the tray resembles Bartolomeo's manuscript illuminations, indicating that he was capable of revising and reusing his compositions, both in whole and in part, to suit his immediate needs. He may, in fact, have been in particular demand for that skill; another tray with very similar iconography is also attributed to him.[3] On both trays, Bartolomeo included small shields that could be painted at the time of purchase with the necessary heraldry to personalize the object. Furthermore, on the tray in this volume, he added an inscription, discreetly placed on the riser of the step leading into the bed chamber on the front; it gives the exact date of April 25, 1428, certainly the birthday of the child who occasioned this object.

The front provides a wealth of information about the material culture of daily life and the activities surrounding childbirth. The chamber is dominated by a large bed on a platform, with bright red sheets complemented by the mother's red *mantello da parto*, or birthing cloak, an example of the special clothing women wore following childbirth.[4] Here the cloak is secured by a glittering jeweled brooch. The chamber is crowded with attendants and visitors: three women supply food and drink, another sits on the floor

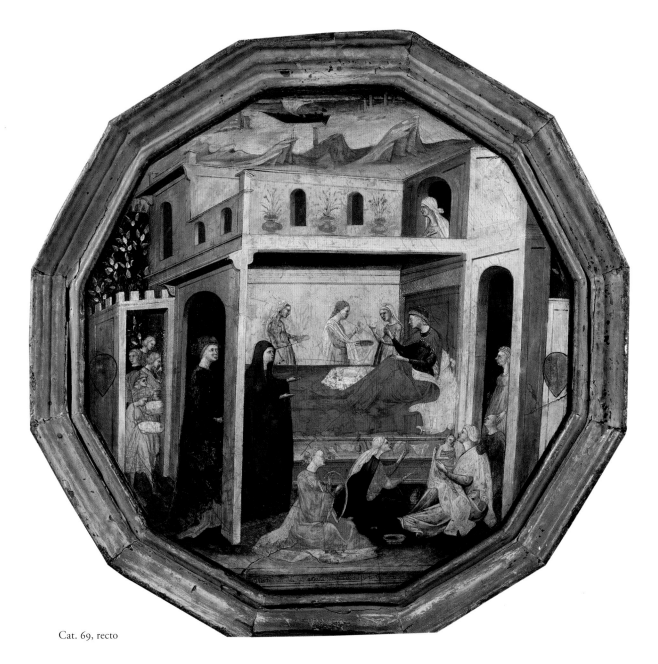

Cat. 69, recto

playing a harp, and two more bathe and dress the newborn with the swaddling rolls unfurling on the chest beside them. Visitors come through the door on the left, followed by five gift-bearing male attendants, and a couple watches from the door on the right. This mother is actually using a birth tray, which rests on her bed, draped in a white cloth that protects its painted surface from the assortment of foodstuffs it bears. And, in fact, this inherent functionality is one reason childbirth trays were so popular for such an extended period. In the sixteenth century, Giorgio Vasari described a drawing by Francesco Salviati as something that would be painted on "one of those trays on which one carries foods to the birthing woman."[5] A wood molding around the front of these trays, still intact here but lost on many others, served as a raised ledge that secured those foods and other objects when the tray was carried to the mother in her bed.

Although this tray seems to represent the activities of the confinement chamber with a high degree of realism, Bartolomeo based his composition on the conventions for sacred scenes of the birth of the Virgin or John the Baptist. His model in this instance was a drawing of the birth of the Baptist by his contemporary Lorenzo Monaco to which he added some of these specific details to make the scene more immediate to his viewers.[6]

The reverse (fig. 54) is in stark contrast to the bedchamber represented on the front. It is painted with a single, large-scale figure of a naked boy in a landscape. Naked boys, sometimes in strikingly similar poses, appear in various manuscript illuminations by Bartolomeo and other Florentine artists from this period, but none has the specific attributes of this one. Squatting on a rocky outcropping just past a forest of blooming trees, he wears a coral branch suspended from his neck, protecting him from assorted ailments and dangers, and holds a whirligig and hobbyhorse for entertainment. Most notably, he urinates a gold-and-silver stream toward the viewer and seems to recite the invocation for successful childbirth that appears around the edge of the tray. Although the heraldic shields on the front seem effaced, those on the back survive almost intact. The arms on the right, the father's side, have been identified as those of the Montauri family of Siena; Tommaso di Paolo Montauri was a goldsmith during this era, and the precious-metal stream of urine may be a clever reference to his profession.[7] Alternatively, the urinating child may have illustrated a now-lost adage related to fertility and fecundity, especially when considered in relation to similar representations on the back of the Apollonio di Giovanni tray shown here and on other works with comparable imagery (cat. nos. 72, 148).

JMM

1. Levi D'Ancona 1961; Levi D'Ancona 1962, pp. 44–48.
2. P. F. Watson 1974a.

3. Everett Fahy in Natale 2006, pp. 96–99, no. 1.
4. Musacchio 1999, pp. 37–38.
5. Vasari, *Le vite*, 1568/1906 (ed.), vol. 7, pp. 20–21.
6. Degenhart and Schmitt 1968, pt. 2, pp. 298–300, no. 198, pl. 217a; and Eisenberg 1989, p. 166.
7. Laurence Kanter in Kanter et al. 1994, p. 312.

SELECTED REFERENCES: P. F. Watson 1974a, pp. 4–9, figs. 1, 2; Pope-Hennessy and Christiansen 1980, pp. 6, 9, 10, figs. 4, 5; Eisenberg 1989, pp. 85, 134, 178, fig. 324; Laurence Kanter in Kanter et al. 1994, pp. 311–14, no. 43, ill.; Sotheby's 1995, lot 161, ill.; De Carli 1997, pp. 98–101, no. 15, ill.; Musacchio 1999, p. 1, figs. 2, 3; Daübler-Hauschke 2003, pp. 170–75, no. 1, figs. 51, 52; Johnson 2005, pp. 102–3, fig. 30; Everett Fahy in Natale 2006, p. 98, under no. 1, figs. 1, 2

Giovanni di Ser Giovanni Guidi, called Lo Scheggia

Florentine, 1406–1486

70. Childbirth Tray (Desco da Parto) with The Triumph of Fame (recto) and Medici and Tornabuoni Arms and Devices (verso)

Florence, ca. 1448
Tempera, silver, and gold on panel, Diam., overall, 36½ in. (92.7 cm); recto, painted surface, 24⅝ in. (62.5 cm); verso, painted surface, 29⅝ in. (75.2 cm)
Inscribed: SEMPER
The Metropolitan Museum of Art, New York, Purchase in memory of Sir John Pope-Hennessy: Rogers Fund, The Annenberg Foundation, Drue Heinz Foundation, Annette de la Renta, Mr. and Mrs. Frank E. Richardson, and The Vincent Astor Foundation Gifts, Wrightsman and Gwynne Andrews Funds, special funds, and Gift of the children of Mrs. Harry Payne Whitney, Gift of Mr. and Mrs. Joshua Logan, and other gifts and bequests, by exchange, 1995 (1995.7)

Lo Scheggia was a prominent artist in fifteenth-century Florence. Although not as well known today as his older brother, Masaccio, Lo Scheggia lived almost sixty years longer and was astonishingly productive. His domestic panels—childbirth trays, marriage chests, wainscoting, and devotional paintings—enjoyed great popularity with the Florentine citizenry throughout his career. Indeed, Lo Scheggia seemed to concentrate on domestic art, being second only to Apollonio di Giovanni in terms of his output in this profitable genre. He was also a member of the Arte di Pietra e Legname, the guild of stoneworkers and woodworkers, and executed several objects in intarsia for both ecclesiastical and individual clients; his nickname, which

means "splinter," may refer either to his status as Masaccio's younger brother or to his own reputation as a woodworker. Unlike those painters who had to purchase panels or chests ready-made, Lo Scheggia could construct them himself and probably saved considerable money as a result.

Among the highlights of Lo Scheggia's career was his work for the Medici family. This tray—the largest and most elaborate of the surviving examples and the only one that can be situated in such a complete historical context—was made to mark the birth of Lorenzo de' Medici, the de facto ruler of Florence from his father Piero's death in 1469 until his own in 1492. Lo Scheggia had the singular distinction of painting not only for Lorenzo's birth in 1449 but also for his marriage in 1469; the inventory of Lorenzo's estate cites a set of three *spalliere*, or wainscoting, panels by Lo Scheggia depicting the joust in front of the church of Santa Croce during the celebration of Lorenzo's marriage to the Roman noblewoman Clarice Orsini.[1] Unfortunately now lost, this set is described as thirteen *braccia* long (approximately twenty-four feet), with gilt moldings and colonnettes.

There is no known commission document for the Medici–Tornabuoni birth tray, but Piero de' Medici must have bought it as a gift for his wife, Lucrezia Tornabuoni, who gave birth to Lorenzo on January 1, 1449. The commission can thus be dated to late 1448 or perhaps even earlier, since the couple had married in 1444. After Piero's death, and Lucrezia's in 1482, the tray apparently passed to Lorenzo and is described in the 1492 inventory as "a round childbirth tray painted with the Triumph of Fame," then hanging in Lorenzo's own chambers.[2] The value assigned in the inventory was ten florins, considerably higher than that of other birth trays from the period. But this is not surprising given its size and complexity. Most childbirth trays measure between twenty and twenty-four inches in diameter, but this one is more than thirty-six inches across, including its elaborate molding. Many trays were executed as stock items, according to model drawings, with no more than the addition of coats of arms to personalize them at purchase. Piero de' Medici, however, was a very demanding patron, and the particular details of this tray indicate that it was commissioned directly from the artist.

This tray is the only known example representing the Triumph of Fame, an eminently appropriate subject for a child destined from birth to be the leader of the city of Florence. The iconography is based largely on Boccaccio's *Amorosa visione* (The Amorous Vision, 1342) and Petrarch's *Trionfi*

(Triumphs, 1354–74), two popular vernacular poems of the period. Petrarch relates how Chastity triumphed over Love, Death over Chastity, Fame over Death, Time over Fame, and, finally, Faith over Time. Artists interpreted these Triumphs as a series of parade carts surrounded by the various characters cited in Petrarch's poem. Piero de' Medici, who was particularly fond of the poem, commissioned an illuminated manuscript copy sometime in 1441,[3] as well as a pair of marriage chests painted with all six Triumphs for his own wedding; this pair, listed in Lorenzo's chambers in 1492, is often identified with two panels by Francesco Pesellino.[4] However, unlike marriage chests, which had long front panels to accommodate several Triumphs in a row, childbirth trays were usually painted with individual Triumphs, particularly those of Love and Chastity (cat. no. 72).

Lo Scheggia's Fame is a winged woman, a sword in her right hand and a statuette of a cupid in her left, standing on a globe placed atop a complexly constructed pedestal; behind her stretches a distant landscape of walled cities, craggy mountains, winding roads, and calm seas. Twenty-eight men on horseback pledge their allegiance with raised right arms below her. They are dressed in extravagant contemporary costumes, their armor reflecting the sunlight and their fur-lined brocade robes. In Petrarch's text, these men include celebrated heroes of the past such as Caesar, Hannibal, Achilles, Noah, King Arthur, Plato, Aristotle, and Herodotus. But Lo Scheggia focuses solely on the warriors from Petrarch's list and arranges them in an anonymous frieze across the center of the composition, so that the only recognizable figure is Fame herself, starkly outlined against the clear sky. The painting is set off by its original gilt molding, painted with a garland of red, green, and white feathers, the colors of the Three Theological Virtues, a device associated with Piero de' Medici.

This was the main side of the tray, and the one all visitors to the Medici Palace would see. Remains of a broken hook at the top of the reverse molding, and the lack of anything similar on the front, imply that the tray was usually hung against the wall, with the representation of Fame visible, when not in use. The 1492 inventory, for example, describes only the Triumph, indicating that it was hanging in this manner at the time of Lorenzo's death. The reverse was also painted, however, and it marks the first usage of Piero de' Medici's complete device: a diamond ring, three feathers, and a scroll inscribed with the motto "Semper," or "Always."[5] On either side of the device are two coats of arms: the eight red *palle*, or balls, of the Medici on the left and the rampant lion of the Tornabuoni on

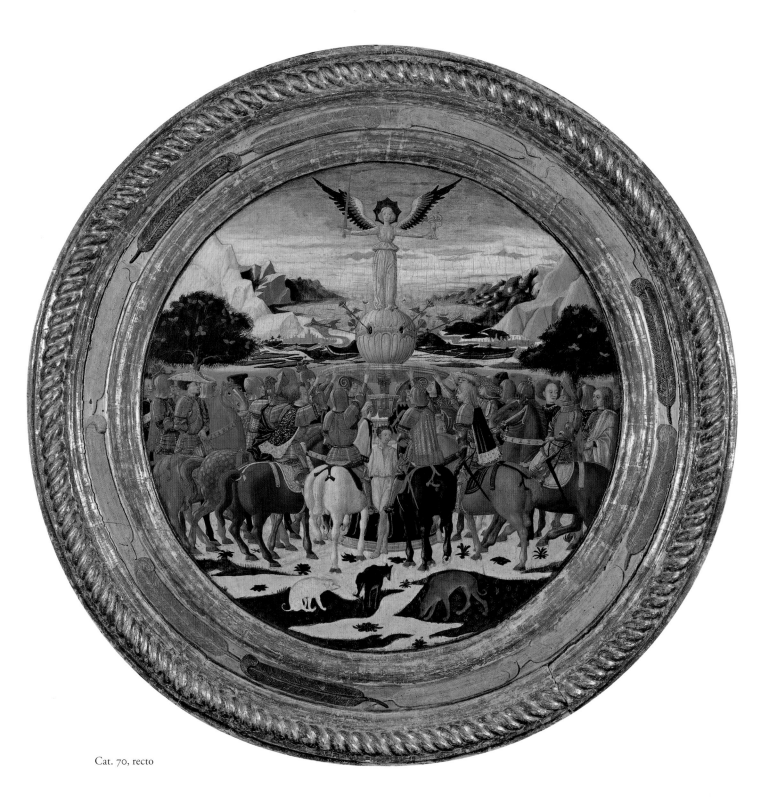

Cat. 70, recto

the right. The scroll and ring were originally silver, which would have made a brilliant contrast to the original blue ground. But now the painted surface is abraded, and the silver has oxidized.

Despite these very particular Medici references and symbols, the tray left the family a few years after Lorenzo's death. These were difficult times for the Medici. Lorenzo's son Piero tried to take his father's place in the city but had few of his father's skills, and the sermons of the Dominican friar Girolamo Savonarola fueled popular animosity against the Medici. In 1494, after a series of disastrous decisions, Piero and his family were

exiled. A year later, the new Florentine government held several sales of confiscated Medici property, and records of these sales indicate that the tray was bought by a certain Ser Bartolomeo di Banbello for slightly more than three florins.[6] In the three years since Lorenzo's death, and in the chaos following the Medici exile, it had depreciated by more than two-thirds.

Although many of the objects bought at these sales were recovered for the family when the Medici returned from exile in 1512, this tray was not. Instead, it remained in Ser Bartolomeo's household. When he died in 1543, his estate was handled by the Magistrato

dei Pupilli, a government agency charged with administering estates. The Pupilli consigned the tray, described only as "a round painted birth tray," to Ser Bartolomeo's widow, Lucrezia.[7] By this date, almost fifty years after the Medici sale, the tray had lost its immediate identification with that family. And, since it was most probably hanging when the Pupilli officials conducted their inventory, they would not have seen the prominent Medici device on the reverse.

The Medici–Tornabuoni tray remained in Ser Bartolomeo's family for at least another generation, passing to his son Jacopo, perhaps at Lucrezia's death or Jacopo's marriage.

Cat. 70, verso

con cornicie e colonnette messe d'oro, divisa in 3 parte, di mano dello Scheggia . . . f. 60."

2. Ibid., p. 27, "uno descho tondo da parto, dipintovi il Trionfo della Fama . . . f. 10."

3. Milanesi 1869.

4. Spallanzani and Gaeta Bertelà 1992, p. 26, "uno paio di forzieri messi d'oro di br. 3½ l'uno, dipintovi dentro e Triomfi del Petrarcha . . . f. 25." For the possible Pesellino panels, see Hendy 1974, pp. 176–78.

5. Ames-Lewis 1979, p. 137.

6. Archivio di Stato, Florence, Mediceo avanti il Principato, vol. 129, fol. 357r, "A Ser Bartolomeo di Banbelo. 1 tondo da parto dipintovi su il Trionfo della Fama . . . fiorini 3.6.8."

7. Archivio di Stato, Florence, Magistrato dei Pupilli del Principato, vol. 2663, fol. 336r, "10 tondo da donna di parte dipinto."

8. Archivio di Stato, Florence, Magistrato dei Pupilli del Principato, vol. 2647, fol. 594v, "uno tondo da donna di parto dipintovi una caccia."

9. Montor 1811, pp. 80–82, no. 57.

10. For more on Bryan's collecting, see Chong 2008.

SELECTED REFERENCES: Montor 1811, pp. 80–82, no. 57; Einstein and Monod 1905, pp. 416–17, ill.; Warburg 1905, p. 5, n. 1; Longhi 1926, pp. 113–14; Ames-Lewis 1979, p. 137, pl. 39a; Pope-Hennessy and Christiansen 1980, pp. 9, 10, 11, fig. 6; Maria Sframeli in Ventrone 1992, pp. 155–57, no. 2.7, ill.; Sotheby's 1995, lot 69, ill.; De Carli 1997, pp. 126–29, no. 28, ill.; D. Thornton 1997, p. 6, fig. 5; Musacchio 1998, pp. 137–51, figs. 1–4, 8; Bellosi and Haines 1999, p. 89, ill.; Laura Cavazzini in Cavazzini 1999, pp. 50–53, no. 10; Musacchio 1999, pp. 73–79, figs. 57, 58; Däubler-Hauschke 2003, pp. 85–124, 262–66, no. 32, pl. 5, figs. 31, 113, 114; Musacchio 2003b, pp. 317–18; F. W. Kent 2004, p. 19; Ajmar-Wollheim and Dennis 2006, pp. 365–66, no. 213; Musacchio 2006, p. 132, pl. 8.12; Fulton 2006, pp. 289–90; Chong 2008; Musacchio 2008, pp. 255–57, fig. 265

When Jacopo died in 1579, Pupilli officials listed the tray in his estate inventory as "a round birth tray painted with a hunt."[8] By the late sixteenth century, painted trays were rare; Florentines increasingly preferred *tafferie da parto* (cat. no. 74) or maiolica birth wares (cat. nos. 76–85). Pupilli officials were probably intrigued by this unusual object and attempted, albeit inaccurately, to identify its iconography. Their error is understandable, since the armored figures on horseback and the dogs do suggest a hunt, particularly to an audience no longer familiar with Boccaccio and Petrarch. A member of Jacopo's family would have been present when the inventory was conducted, but this was no guarantee that either the subject or the origin of the tray would have been revealed. After all, more than a century had passed since its production, and more than eighty years since Jacopo's father purchased it at the Medici sale.

Despite its great size and detailed painting, the Medici–Tornabuoni tray seems to have disappeared from written accounts between Jacopo di Ser Bartolomeo Banbello's death and 1801, when it was recorded in the Florentine collection of a certain Abbé Rimani. By 1811 it had passed to Alexis-François Artaud de Montor, a French diplomat and prolific writer. Artaud de Montor

lived for part of his career in Florence and Rome, where he had the resources to collect a sizable cache of fourteenth- and fifteenth-century Italian panel paintings, known then as "primitives." He published a study of these paintings in which he attributed the Medici–Tornabuoni tray to Giotto, an indication of the state of scholarship regarding early Italian paintings at the time.[9] After Artaud de Montor's death in 1849, his collection was sold in Paris, and Thomas Jefferson Bryan, a wealthy Philadelphia art collector then resident in Paris, bought some eighteen paintings at the sale, including this tray.[10] For several years Bryan exhibited his collection in New York, at his Bryan Gallery of Christian Art and elsewhere; in 1867 he donated it to the New-York Historical Society. When the Historical Society's mission changed in more recent years, a number of Bryan's paintings, along with other works by old masters, were deaccessioned. At the 1995 auction of these paintings, the Medici–Tornabuoni tray was purchased by The Metropolitan Museum of Art.

JMM

1. Spallanzani and Gaeta Bertelà 1992, p. 73, "una spalliera di br. xiii lunga e altra br. una e ½ sopra a' detti forzieri et chassone, dipintovi drento la storia della giostra di Lorenzo

Cat. 71, recto

Giovanni di Ser Giovanni Guidi, called Lo Scheggia

Florentine, 1406–1486

71. Childbirth Tray (Desco da Parto) with Youths Playing Civettino (recto) and Battling Boys (verso)

Florence, ca. 1450
Tempera on panel, Diam. 23¼ in. (59 cm)
Palazzo Davanzati, Istituti Museali della Soprinten-
denza Speciale per il Polo Museale Fiorentino,
Florence (1890.488)
New York only

The identity of the artist responsible for this tray, as well as for a group of sty-listically similar marriage-chest panels and birth trays, has been contested ever since the late nineteenth century, when many of these objects first appeared in the scholarly litera-ture. For years he was anonymous, identified only as the Master of the Adimari Cassone or the Master of Fucecchio, after his best-known paintings; nevertheless, a sizable and distinc-tive body of work was assigned to him. These anonymous names were merged in 1969 and linked to the documented Florentine artist Giovanni di Ser Giovanni Guidi, bet-ter known as Lo Scheggia, the younger and much longer-lived brother of Masaccio.[1] The careful representation of costumes and physiognomy on this tray, and its vivid and oftentimes amusing details of everyday life, all point to Lo Scheggia, a prolific and suc-cessful artist who seemed to focus on domes-tic work. In addition to this childbirth tray, he is represented in the exhibition by two of his most important panels, the so-called Adimari Cassone (cat. no. 134) and the Medici–Tornabuoni *desco da parto* (cat. no. 70). This trio of paintings affords a par-ticularly clear understanding of Lo Scheggia's mature style about 1450.

This is the only known childbirth tray painted with a scene of Renaissance urban life, and the details are quite specific. The rusti-cated palace on the left, with rough stones on the lower floor but smoother ones above, as well as built-in benches around the exte-rior, is similar in style to the Palazzo Medici and other contemporary palaces. Indeed, Lo Scheggia's familiarity with the Medici—judg-ing from his apparent commissions to paint a tray for Lorenzo il Magnifico's birth and a *spalliera* set commemorating Lorenzo's famous joust at his marriage some twenty years later—may have prompted him to represent a variation on their palace, designed by Michelozzo, which was still under con-struction at this time. Many of the palaces framing this street scene have large windows sealed with studded wooden shutters, their smaller internal openings left ajar to let in light and air. Upper floors expand into the street with the help of *sporti*, sturdy wooden struts that buttress those overhanging spaces. Several palaces have poles across the windows, resting on metal hooks on the facades, which allowed inhabitants to hang textiles or rugs for celebrations or airing. These details were both recognizable and undoubtedly appeal-ing for viewers wanting to see their lives mir-rored in contemporary paintings.

Lo Scheggia composed the scene carefully, choosing the moment when the youth in the center lunges forward at one of his sparring partners. This opens the view to the vanishing point through the fortified gate, which resem-bles those that punctuated the fourteenth-century circuit of defensive walls surrounding the city of Florence. Similar architectural details and compositional devices appear in the Adimari Cassone. In fact, both panels utilize the urban backdrop as a stage for a frieze of meticulously costumed foreground figures, posed beneath a cloud-streaked sky and set back from the viewer behind either a tapestry-draped barrier or a lush strip of lawn. Whether in horizontal or circular format, Lo Scheggia replicated this composition, which pulled viewers into the scene, on many dif-ferent objects.

The game represented on the front was identified as early as 1781, when the tray entered the collection of the Florentine gal-leries.[2] In *civettino*, which translates as "little owl," the players had to remain in close prox-imity while deflecting each other's playful punches; the middle youth here stands on the feet of his fellow combatants. To facilitate their rather strenuous activity, the three play-ers have removed their outer garments and

Cat. 71, verso

wear only padded, close-fitting doublets with hose and drawers. The lower edges of the doublets have laces for attaching the hose, which were more like two hip-length socks with eyelets at their top edges, leaving the drawers visible at the crotch. The six other men, strolling through the neighborhood in three groups of two, wear loose gowns and capes as well as the distinctive *cappucci*, or headgear, of the upper classes. These groups are balanced in the foreground by a dog and two cavorting, partially nude infants.

This panel has the size and shape of a childbirth tray, but until very recently there was fictive marbling painted on the reverse. This complicated its identification, since no other tray was similarly painted. The marbling was determined to be a later addition, however, almost certainly added before the tray entered the city's collections.[3] Its removal has revealed a representation of two battling boys, a nice link to the playful infants and sparring youths on the front. The difference in ages seems deliberate; it has been suggested that the groups of figures on front and back represent the Three Ages of Man.[4] But the battling boys carry additional meaning; boys engaged in various activities appear on the backs of other trays (cat. no. 72), as well as on the side panels of marriage chests and even as terracotta statuettes (cat. no. 47). So many representations, on objects meant for domestic settings, indicate a certain universality, perhaps as a reference to an adage now long forgotten.

The boys on this tray are closely related to a similar battling pair on Vittorio Ghiberti's bronze frame for the South Doors of the Florentine Baptistery.[5] They are likely meant to symbolize the fertility and fecundity of both the city of Florence and its individual families and, of course, the hope for male children in what was a self-consciously patriarchal society.[6] The boys here battle by grabbing each other's hair and penises, the latter gesture perhaps accounting for the prudish eighteenth-century overpainting. Fortunately this additional paint layer helped preserve the image. The boys themselves are in good condition, although the background and the left heraldic shield have sustained some damage, which could be the result of abrasion from contact with a wall or some other surface prior to the overpainting.

Barring the discovery of a very specific commissioning document, which would be highly unusual, the damage to the shield makes it impossible to determine the original owner of the tray. Although it may have been made for the open market, with the heraldry added at purchase, the tray may also have been a special commission, with the carefully executed urban scene representing a recognizable, albeit idealized, view of the patron's neighborhood. JMM

1. Bellosi, Lotti, and Matteoli 1969, pp. 56–57, no. 42.
2. Maria Sframeli in L. Berti and Paolucci 1990, p. 240.
3. Francolini and Vervat 2001.
4. Ibid., p. 55.
5. Musacchio 2008, pp. 233–35.
6. Ferretti 1992; Musacchio 1999, pp. 125–37.

SELECTED REFERENCES: Schiaparelli 1908, pp. 272–73, fig. 30; Schubring 1915, p. 237, no. 85, pl. XIII; Bellosi, Lotti, and Matteoli 1969, pp. 56–57, no. 42; L. Berti 1972, p. 216, no. 242, pl. 173; Brucker 1984, p. 232; Maria Sframeli in L. Berti and Paolucci 1990, pp. 240–41, ill.; Joannides 1993, p. 450, no. L7; De Carli 1997, pp. 130–31, no. 29, ill.; Bellosi and Haines 1999, p. 82, ill.; Stefano Francolini in Cavazzini 1999, pp. 72–75, ill.; Strehlke 1999, pp. 314–15, fig. 76; Francolini and Vervat 2001; Musacchio 2008, p. 233, fig. 242

Apollonio di Giovanni Workshop
Florentine, 1415/17–1465

72. Childbirth Tray (Desco da Parto) with The Triumph of Chastity (recto) and Naked Boys with Poppy Pods (verso)

Florence, ca. 1450–60
Tempera and gold leaf on panel, 23 × 23¼ in. (58.4 × 59.1 cm)
North Carolina Museum of Art, Raleigh, Gift of the Samuel H. Kress Foundation (60.17.23)

With the growing interest in Tuscan vernacular literature, Petrarch's *Trionfi* (Triumphs, 1354–74) was increasingly popular in fifteenth-century Florence. Several hundred manuscript versions of this allegorical poem are known today, and after 1470 printed versions began to circulate it to an even wider readership.[1] This popularity is somewhat surprising, since the text is by no means easy. It describes the spiritual journey undertaken by the poet, who is accompanied by scores of figures from history, literature, and the Bible. During the course of the journey, Petrarch witnesses six successive Triumphs, beginning with Love, which conquers all humankind, and progressing to Chastity (in the guise of Petrarch's own beloved Laura), Death, Fame, Time, and finally Faith, which triumphs over all. Although the text itself is not necessarily visual, there was a strong tradition of illustrating each episode with an elaborate triumphal cart, similar to those described in classical texts. Actual carts, designed by prominent artists and filled with costumed actors and talented musicians, paraded through the streets of Florence as part of the celebrations surrounding Carnival, certain saints' days, and civic feasts.[2] Representations of these carts, whether in manuscripts or printed texts, entertained readers with a combination of familiar but still fantastic elements. Owing to this familiarity, all of Petrarch's Triumphs, and particularly Love and Chastity, were represented on a number of marriage chests and childbirth trays.

Four illuminated manuscripts of Petrarch's *Triumphs* are associated with Apollonio di Giovanni.[3] But he is best known today as a partner in the popular and productive workshop he owned with Marco del Buono Giamberto. The activities of this workshop are documented in the so-called *bottega* book, a later, incomplete record of the sale between 1446 and 1462 of 166 pairs of marriage chests, as well as a portrait, a fresco, a birth tray, and a painting of the Madonna, to some of the most prominent Florentine families.[4] Additional documents indicate that the artist also painted a bed, its canopy, and a clothes rack.[5] Apollonio is considered the painter responsible for the workshop style, which has been identified through a complex series of connections between documents, painted panels, and illuminated manuscripts. His awareness of classical and contemporary texts, both requisite sources of iconography for Florentine Renaissance domestic art, was a great asset in his work.

Apollonio drew upon his knowledge of Petrarch's *Triumphs* for the painting on the front of this tray, although he does not represent the exact text in every detail. He paints the moment following the battle between Love and Chastity, with Cupid as a bound and kneeling captive at the front of the cart, one of his precious gold wings bent awkwardly and broken from his fight. Chastity stands in a mandorla behind him, holding aloft a palm of victory. Her cart is pulled, appropriately, by unicorns—animals that can be tamed only by virgins, according to contemporary bestiaries—and accompanied by twenty-one women conversing in four groups. Though surely meant to represent those celebrated for their chastity in Petrarch's poem—Lucrezia, Penelope, and Virginia, to name only a few—these women wear Renaissance costume and have no distinguishing attributes. In fact, they display a rather startling homogeneity: all are blonde, with plucked foreheads and extravagant gowns in a red, gold, and black color scheme. In their role as Chastity's defenders, their unity is appropriate. They hold Cupid's attributes; one woman has his quiver, and another

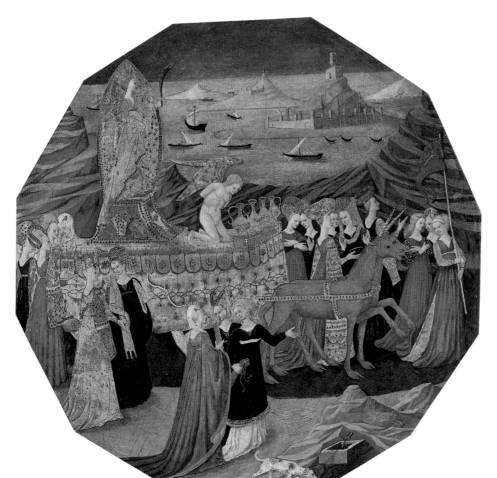

Cat. 72, recto

1. Feo 2004.
2. Eisenbichler and Iannucci 1990.
3. Callmann 1974, pp. 52–53, 57–58.
4. Ibid., pp. 76–81.
5. Callmann 1988.
6. Musacchio 1999, pp. 130–31.

SELECTED REFERENCES: Shapley 1966–67, vol. 1, p. 98, no. K491; Callmann 1974, pp. 14, 36, 59, no. 16, pls. 107, 110; Callmann 1980, pp. 5–6, no. 4; Bowron 1983, no. 179; Christiansen 1986, p. 170, fig. 8; De Carli 1997, pp. 144–45, no. 35, ill.; Musacchio 1999, pp. 55, 130–31, figs. 39, 122; Däubler-Hauschke 2003, pp. 254–58, no. 29, figs. 108, 109; Musacchio 2008, p. 251, fig. 263

auguries and associated them with marriage imagery and poetry (cat. no. 148).

JMM

Workshop of Francesco del Cossa
Ferrarese, ca. 1430–ca. 1477

73. Childbirth Tray (Desco da Parto) with The Meeting of Solomon and the Queen of Sheba

Ferrara, ca. 1470–73
Tempera, gold, oxidized silver leaf on panel,
Diam. 36⅜ in. (92.3 cm)
The Museum of Fine Arts, Houston, The Edith A. and Percy S. Straus Collection (44.574)

The attribution of this childbirth tray has wavered since it was first published in 1894.[1] Early scholars tried to associate it with one of the Florentine artists responsible for other known trays and marriage-chest panels. More recently and plausibly, however, it has been assigned to the workshop of the Ferrarese court painter Francesco del Cossa,[2] best known for the complex astrological frescoes at the Palazzo Schifanoia, executed in collaboration with Cosmè Tura on the occasion of Borso d'Este's elevation to duke of Ferrara in 1471. Those frescoes were the subject of considerable angst for Francesco, who wrote to Borso to complain that he was being paid based on the square footage of wall space he covered rather than his artistic efforts.[3] Such compensation was typical of the time period, when painters were still grouped with other craftspeople who worked with their hands. Francesco's painting style, recognizable for its complex and oftentimes eccentric detail, was both popular and influential. He was productive enough to employ an extensive workshop, and one product of it seems to be this tray, which is based on his designs but probably painted by a close collaborator.

carries his bow. The cart moves across the tray from left to right, led by a woman holding a banner blazoned with a white weasel. Several species of weasels inhabited the less settled reaches of the Italian peninsula, and some, like the ermine, grew white coats in colder climates to blend in with their snowy surroundings. This white fur was in great demand for elite clothing. But medieval and Renaissance bestiaries also cited the weasel's willingness to die rather than risk besmirching its pristine coat, making it a perfect symbol of marital chastity, the key virtue of all Florentine Renaissance brides, as well as a fitting herald for Chastity's Triumph. Other

objects in this volume associate weasels with fertility; it was owing to this complex web of meanings that, for example, two of the Della Robbia workshop *Dovizia* statuettes included a white weasel as the companion to the household goddess (cat. no. 48).

The reverse of the tray emphasizes the result of marital chastity: the birth of children, particularly boys, to continue the lineage. This critical concern was emphasized by civic legislation, humanist authors, and moralists alike. The unidentified coats of arms here—a puzzling three rather than the usual one or two—help to reinforce these interconnections. Technical examination indicates that all three were apparently repainted in the Renaissance. The naked boys below the arms play with poppy seed pods, which can contain hundreds or even thousands of seeds, depending on the variety. One of the boys leans forward, a pod in each hand, and the second urinates on top of, or over, the pod he offers. These seed pods, with their implications of future fertility and abundance, likewise appear on other birth trays and bowls.[6] Similar boys are painted on the side of a near-contemporary marriage chest, and others are represented on the back of birth trays by Bartolomeo di Fruosino (cat. no. 69) and Lo Scheggia (cat. no. 71). Renaissance viewers recognized these fertility

Cat. 72, verso

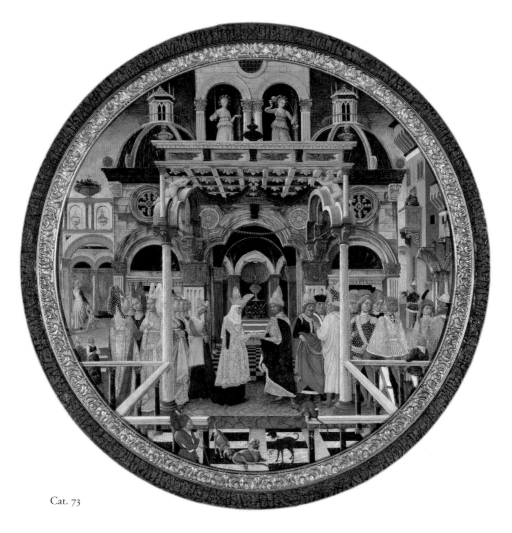

Cat. 73

The crowded compositions of the Schifanoia frescoes are echoed in the extraordinarily detailed scene on the surviving front of this tray. Extensive underdrawings and incisions helped establish the complicated architecture and perspective lines that focus attention on the handclasp between Solomon and the Queen of Sheba and on the precious covered goblet on the altar behind them. The meeting of Solomon and the Queen of Sheba is recounted in 1 Kings 10:1–13 and 2 Chronicles 9:1–12, as well as in various apocryphal sources and later vernacular Italian texts. Literary and archaeological evidence indicates that Solomon was a king of Israel in the tenth century B.C. and was responsible for the construction of the Temple at Jerusalem. His great wisdom attracted the Queen of Sheba, who traveled a great distance to meet him, most likely from the area of modern Yemen in southwestern Asia, bringing gifts of spices, gold, and jewels.

In the Renaissance, this meeting was understood as a marital allegory alluding to the union of Christ (Solomon) and the church (the Queen of Sheba).[4] Furthermore, because both Solomon and the Queen of Sheba were perceived as distant, foreign personages, their meeting became a metaphor for the union of the eastern and western churches, the much-celebrated but short-lived outcome of the ecumenical council that took place in Basel,

Ferrara, and finally Florence (there under the patronage of the Medici family) between 1431 and 1439. Eastern church officials attended the council in all three cities, and these men, and their native costumes, fascinated contemporary artists and writers.

The evocative story of Solomon and the Queen of Sheba naturally incorporated a wide range of peoples, costumes, and architecture to comment on both marital and sacred accords. Its popularity on Florentine marriage chests owed much to the influence of Lorenzo Ghiberti's representation on one of the lowest, and therefore most visible, gilt-bronze panels of the East Doors of the Florentine Baptistery, which were installed in 1452.[5] The details of Ghiberti's panel, particularly the emphasis on the concord between the two rulers and the costumes of some of the figures in their entourages, have been associated with the influence of the ecumenical council itself.[6] The same elements appear both on marriage chests and on a childbirth tray of a related subject, *The Judgment of Solomon*, by the prolific painter Lo Scheggia.[7] Other trays with this subject must have been made, including one cited in Apollonio di Giovanni's *bottega* book as commissioned in 1453 for the rather high sum of nine florins by Giovanni di Amerigo Benci, a general manager of the Medici bank.[8] The association of Solomon and the Queen of

Sheba with the Medici-sponsored ecumenical council and its appearance on Ghiberti's East Doors must have influenced Benci's choice of subject.

Although Ferrarese in origin, this tray—and one other example with the same iconography, now at the Museum of Fine Arts, Boston[9]—has some basis in that Florentine tradition. The compositional details have a similar fantastical element; the architecture of Solomon's court, for instance, is neither fully ancient nor truly Renaissance. The coffered vault of the loggia is accented by gilt rosettes and golden vessels. The niches above contain personifications of the Cardinal Virtues Justice (with sword and scale) and Temperance (with wine and water pitchers), identifying Solomon as a just and moderate ruler. But other details refer to the text even more directly. According to the Old Testament, Solomon's fleet brought back apes and baboons from foreign lands, and in fact two simian members of his menagerie appear in the foreground, their movements controlled by gilded collars. One picks the hair of his human keeper, apparently a court jester, while the other mischievously eyes a group of three dogs from his safe perch on a balustrade.

This wealth of engaging detail extends to the figures. The foreign heritage of the king and queen is signaled by their rich costumes,

including their unusually shaped hats, and further emphasized by the pseudo-Kufic lettering between the moldings. Despite these allusions to what was then considered the exotic East, Sheba's women are dressed in strictly Renaissance costume made of luxurious cloth-of-gold accented by punchwork and *sgraffito*. Several wear the two-pointed *sella* so popular (and so often condemned by sumptuary legislation) among Florentine women in imitation of styles north of the Alps. Solomon is accompanied by a group of older men wearing similarly foreign hats, as well as by a group of stylish youths in the cloaks and colored tights of the fashionable Renaissance elite. Further quotidian details—the departing mother and child, the falconer, and the man watching the events from his perch on a balcony above the crowd—show the artist's interest in filling the scene with eye-catching elements.

Although the use of childbirth trays was popular in Tuscany, and especially in Florence, they seem to have been less common in Ferrara, where their presentation may have been limited to the highest levels of society, such as the Este and their relations. Ferrara and Florence were in close contact, exchanging artists and objects as well as letters and diplomatic envoys, so there is ample reason to believe that Ferrarese patrons and artists knew of this Florentine tradition. In its large size and engaged moldings, the Houston tray is very similar to the one made for the birth of Lorenzo de' Medici in 1449 (cat. no. 70), further evidence, perhaps, of an Este connection. Indeed, the Houston tray has been associated with the union of Rinaldo d'Este, an illegitimate son of Niccolò III d'Este, and Lucrezia Palaeologus, the illegitimate daughter of Guglielmo, Marchese of Monferrato, and by marriage the niece of the Byzantine emperor (and ecumenical council participant) John VIII Palaeologus.[10] Rinaldo and Lucrezia married in 1472, and her entry into the city the following year was marked by an elaborate ceremony at the Ferrara gate attended by local luminaries and Duke Ercole d'Este himself. Some aspect of that ceremony may well be reflected in the extravagant scene on this childbirth tray, but the evidence to prove an Este connection may be lost forever. When the tray was in the Foulc collection, before it was acquired by the prominent New York collector Percy Straus, the back was painted with unidentified heraldry in a double escutcheon within a ribboned garland.[11] Unfortunately, the panel was thinned and cradled about the time of its sale in 1930, and no description or photographic record of the heraldry is known.[12]

JMM

1. Müntz 1894, pp. 220–21, fig. 1.
2. Giovanni Sassu in Natale 2007, p. 462, no. 148.
3. Gilbert 1992, pp. 9–10.
4. P. F. Watson 1974b.
5. Krautheimer 1956, p. 182; Callmann 1974, pp. 43–44.
6. Krautheimer 1956, pp. 180–88.
7. Ahl 1981–82.
8. Callmann 1974, p. 79.
9. Uguccioni 1988, pp. 55–62, fig. 3.
10. Ibid., p. 42.
11. Müntz 1894, p. 221.
12. C. C. Wilson 1996, p. 214.

SELECTED REFERENCES: Müntz 1894, pp. 220–21, fig. 1; Uguccioni 1988, pp. 25–54, fig. 1; C. C. Wilson 1996, pp. 214–29, no. 19, ill.; Giovanni Sassu in Natale 2007, p. 462, no. 148

Jacopo Pontormo
Florentine, 1494–1557

74. Childbirth Bowl (*Tafferia da Parto*) with The Naming of John the Baptist (interior) and Della Casa and Tornaquinci Arms (exterior)

Florence, 1526–27
Oil on panel, Diam. 21¼ in. (54 cm)
Inscribed: *IO*
Galleria degli Uffizi, Istituti Museali della Soprintendenza Speciale per il Polo Museale Fiorentino, Florence (1890 n. 1532)
New York only

This low, turned-wood bowl belongs to a small group of similar objects, known as *tafferie da parto*, or childbirth bowls, that were a phenomenon primarily of the late fifteenth and early sixteenth centuries in Tuscany. Although the origin of these objects is not certain, both documentary sources and surviving examples indicate that painted wood trays, or *deschi da parto*, had declined in popularity by that date.[1] In many cases, historiated maiolica wares, many of them imported from central Italy, took the place of painted wood trays in the rituals of childbirth. Physically, of course, maiolica had advantages over wood, since its virtually indestructible fired-on ornament allowed for a wider range of uses. It could hold both liquids and solid foods, as well as various objects to aid in the care of the confined mother, without the risk of damaging its finely painted surfaces. Even at this late date, however, some people still preferred wood childbirth objects, particularly intarsiated trays (of which there are documentary references but apparently no surviving examples) and *tafferie da parto*.

In the early seventeenth century, the physician and collector Giulio Mancini stated that the Sienese artist Sodoma made "low things," which to Mancini apparently meant decorative and domestic objects. During Mancini's time, art for the home was not considered as important, in hierarchical terms, as monumental paintings and sculptures. This attitude was already evident by the mid-sixteenth century, when Giorgio Vasari described the earlier practice of painting furniture in general, and chests in particular, as something his contemporaries would be ashamed to do.[2] Mancini listed some of these "low things" for his readers, including "bowls for birthing women to eat from in bed."[3] Although no *tafferia* can be attributed to Sodoma, a birth tray by him, now in the Louvre, indicates that he was familiar with the genre overall.[4] And despite Vasari's comments, many artists did indeed paint objects for childbirth in the sixteenth century. This *tafferia*, for example, is by Jacopo Pontormo, better known for painting sacred altarpieces, frescoes, and portraits for some of the most important and influential patrons of Florence. His recognizable style, characterized by brilliant colors, attenuated figures, and complex compositions, is much in evidence here.

Unlike the earlier birth trays, all known *tafferie da parto* are painted with sacred scenes; this one, for example, represents the Naming of John the Baptist, taken from the Gospel of Saint Luke (1:11–13, 57–63). The naming of John the Baptist took place eight days after his birth. Pontormo paints John's mother, Elizabeth, in her large platform bed, covered in green and white sheets and surrounded by five women who seem to care for her and the newborn John. The child squirms in the arms of the woman nearest to the picture plane, his head close to the center of the composition and one foot about to kick out into the viewer's space. A half-concealed, darkly veiled woman who stands in the background is quite different in costume from the others, with their bright dresses and kerchiefs; her sober attire and spectral appearance suggest she may be a personification of Elizabeth's formerly childless state.

Elizabeth's husband, Zacharias, sits near her bed. He had been struck mute for not believing his wife would finally bear a child after their long and barren marriage. When asked the child's name, Zacharias wrote "John"; the first two letters of this name, *IO*, appear on the paper in his lap. As soon as Zacharias wrote the name, he regained his speech. This *tafferia,* then, represents the actual miracle as it is occurring, a miracle that emphasizes the power of belief. Such an image would be appropriate for the new parents, who in this case are identifiable by the heraldry on the exterior. The

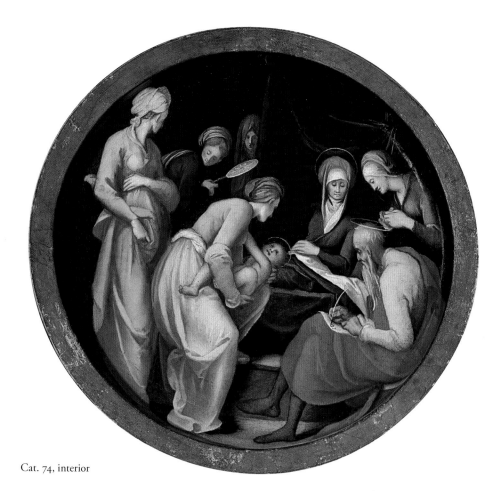

Cat. 74, interior

7. Vasari, *Le vite*, 1568/1906 (ed.), vol. 6, p. 278.
8. Bruschi 1992, n.p.
9. American Art Association 1916, no. 996.

SELECTED REFERENCES: American Art Association 1916, under no. 996; Clapp 1916, pp. 57, 140–41, no. 1198, fig. 114; Becherucci 1944, p. 18; Cox-Rearick 1964, pp. 273–74, fig. 282; L. Berti 1973, pp. 100–101, no. 89, pl. XLII; Bruschi 1992, n.p.; Costamagna 1994, pp. 281–82, no. A30, ill.; Carlo Sisi in Cecchi and Natali 1996, pp. 276–77, no. 94, ill.; De Carli 1997, pp. 186–87, no. 53, ill.; Musacchio 1999, pp. 83–85; Olson 2000, pp. 27, 276, n. 303, fig. A115; Däubler-Hauschke 2003, pp. 197–202, no. 10, pl. 8, figs. 71, 72; Ajmar-Wollheim and Dennis 2006, p. 362, no. 160; Musacchio 2006, p. 125, pl. 8.2

Circle of Battista Franco
Venice, ca. 1510–1561

75. Childbirth Platter with The Infancy and Life of Hercules (recto) and Grotteschi (verso)

Urbino (?), mid-16th century
Oil on panel, Diam. 21 in. (53.4 cm)
Inscribed: *ALCMENA, LUCINA, HERCULES, CALANT*
Victoria and Albert Museum, London (917-1875)

This apparently unique shallow platter conflates the three traditions for childbirth-related objects evident in this volume, the trays (*deschi*), bowls (*tafferie*), and maiolica sets (*schudelle da impagliata*). While the iconography and compositional devices are similar in all three traditions, the material of this platter reflects that of the wood *deschi* and *tafferie da parto*. Its shape is closer to that of a *tafferia*, but the rim unfurls outward, with an undulating form more typical of maiolica wares. It must have been made with knowledge of these three traditions, but it seems to be more experimental. And, judging from the finely detailed, carefully composed painting on both front and back, it was certainly meant to be treasured as a precious object.

The platter has been attributed to Battista Franco, a Venetian by birth who worked in several cities on the Italian peninsula and was especially celebrated for his skill as a draftsman. He was also a maiolica painter, and many of his surviving drawings are composed in the roundels expected for maiolica designs, with obvious demarcation between concavity and surrounding rim. According to Vasari, during the 1540s Duke Guidobaldo II della Rovere of Urbino commissioned a number of these drawings to be used as

elaborate heraldic escutcheon is framed by fanciful half-bird, half-human *grotteschi* and set against a fictive porphyry surround that lends a note of richness. It bears the arms of two prominent Florentine families, the della Casa and Tornaquinci. Girolamo della Casa and Lisabetta Tornaquinci married in 1524 and had their first son in early 1527,[5] a date that accords well with the style of Pontormo's work, particularly his now-ruined frescoes at the Certosa del Galluzzo outside Florence. This birth was likely the impetus for the purchase of the bowl.

This *tafferia* is particularly interesting because it is one of two nearly identical examples. The second bowl, now in a private collection, is slightly smaller, and unfortunately somewhat abraded, but the painting is obviously from the same workshop. However, the back of the second bowl has the arms of two other important Florentine families, the Ughi and Antinori. Mariano di Giorgio Ughi married Oretta di Amerigo Antinori in 1523, and their first son was born in 1525.[6] Pontormo must have known the Antinori rather well; Vasari relates that he painted a portrait, now unidentified, of Oretta's father.[7] The fact that the two families had such similar bowls is no coincidence, since Girolamo della Casa and Mariano Ughi were distant cousins.[8] These two bowls indicate that Pontormo and his workshop made *tafferie da parto* for stock, personalizing them with the appropriate coats

Cat. 74, exterior

of arms at purchase time. In fact, a lost preliminary drawing defining the overall composition of these two *tafferie da parto* may well have been used by the workshop to facilitate their production.[9] JMM

1. Musacchio 1999, p. 83.
2. Vasari, *Le vite,* 1568/1906 (ed.), vol. 2, pp. 148–49.
3. Mancini, *Considerazione sulla pittura,* 1956–57 (ed.), vol. 1, p. 77.
4. For Sodoma's tray, see most recently De Carli 1997, pp. 202–3, no. 61; and Daübler-Hauschke 2003, p. 352, no. A12.
5. Becherucci 1944, p. 18.
6. Bruschi 1992, n.p.

models by the maiolica artists working for him in the town of Castel Durante.[1] And a letter of 1550 from the writer Pietro Aretino to Battista Franco refers to a young Camillo, likely Camillo Gatti (a nephew of the well-known maiolica artist Guido Durantino), whom Battista trained to paint on maiolica.[2] Many of Battista's drawings, and a few of the maiolica wares based on them, have ancient subjects, including two plates from a presumed service representing the Labors of Hercules, which would have been related in their iconography to this platter.[3]

Battista's interest in Herculean imagery is especially obvious in this platter. The center is painted with a scene from the infancy of Hercules. According to Ovid's *Metamorphoses* and other sources, Juno's hatred of Jupiter's offspring with other women delayed, and almost completely prevented, the birth of Hercules; a maiolica tray in this volume illustrates that part of the story (cat. no. 77). But even after his birth, Juno was still determined to harm him. She sent two serpents into his cradle, but the infant miraculously killed them with his bare hands and played with their limp bodies. This platter shows the dramatic moment of their discovery: Hercules's mother, Alcmena, is still confined to bed, attended by her companions, whose gazes and raised arms direct the viewer to the small, naked Hercules in his carved-wood rocking cradle (see cat. no. 86), the dead serpents twined around his arms. Though Alcmena's servant Galanthis is in human form here, the artist has taken liberties with the text, since Juno had transformed her into a weasel when she aided Lucina, the goddess of childbirth, at Hercules's delivery. Alcmena's great canopied bed, the colorful tiled floor, and the display of precious plate and practical utensils in the background locate the scene in a comfortable Renaissance interior.

The painting around the curving rim is a continuous frieze of later episodes in the life of Hercules, set against a winding landscape of hills, trees, and water with tufts of grass, rocks, and flowers in the immediate foreground. Hercules himself appears thirteen times and is identifiable by his powerful body, usually draped in lion skins, and his olive-wood club. That straining, almost naked body is a strong, muscular echo of the frailer, smaller form in the cradle. Although some of the episodes are difficult to identify, many seem to represent his Twelve Labors; at Juno's instigation, he killed his wife and children and had to perform those labors as penance. The platter includes Hercules killing the Nemean Lion and the Lernaean Hydra, cleaning the Augean stables, capturing the Cretan bull and Cerberus, herding Geryon's cattle, and stealing the apples of the

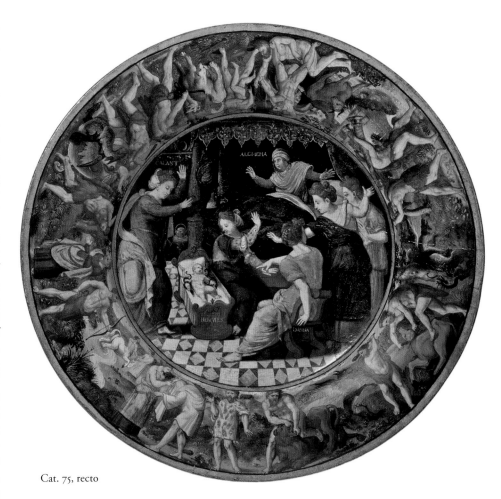

Cat. 75, recto

Hesperides. Other tales from the Hercules legend, such as his battle with Antaeus, his enslavement under Omphale, and his fight with Nessus over Deianera and ensuing death from wearing a shirt soaked in Nessus's poisonous blood and semen, also appear on the frieze. The overall composition of the platter—with densely packed figures in the surrounding frieze and a more focused scene in the central roundel—closely resembles that of the drawings and maiolica associated with Battista Franco.

The reverse of the platter is painted with two bands of antique-inspired gold *grotteschi*, representing foliage, vases, drapery swags, satyrs, and terms, against a dark blue ground. These surround a central roundel displaying an entirely different sensibility that may be a later overpainting or an unfinished composition. Certain elements of the roundel resemble those found on the back of a contemporary maiolica dish attributed to the anonymous Painter of the Coal-Mine Dish (Victoria and Albert Museum), which is also painted on the front with the birth of Hercules.[4] But the relationship between the two cannot be determined with certainty. Little vignettes of unexpected charm are captured in Franco's *grotteschi*. One has a satyr couple terrorizing three children they swing between them in a drapery; another involves a satyr family, the father pulling the

child, who rides a goat that, in turn, pulls the mother on a wheeled cart. While these children may have been understood as fertility talismans, similar to the naked boys on the backs of birth trays and bowls, their importance as lively ornament—represented on this anomalous object with great invention and attention to detail—cannot be denied. A platter such as this, with its refined painting of detailed ancient iconography and motifs, required a sophisticated viewer to truly appreciate it. JMM

1. Vasari, *Le vite,* 1568/1906 (ed.), vol. 6, pp. 581–82.
2. Campori 1871, p. 43; and Mallet 1987, pp. 292–93.
3. Clifford and Mallet 1976, pp. 395, 409–10, nos. 26, 27.
4. Mallet 1991, p. 63. On this dish, see also Shapiro 1967.

SELECTED REFERENCES: Mallet 1991, p. 63; Musacchio 1999, pp. 87–89, 95, figs. 70, 71; Däubler-Hauschke 2003, pp. 63–65, figs. 27, 28

76a. Childbirth Salt (Saliera) with Grotteschi

Urbino or Castel Durante, ca. 1535
Tin-glazed earthenware (maiolica), H. 4½ in.
(11.5 cm), Diam. 4⅞ in. (12.5 cm)
Victoria and Albert Museum, London (7142&A-1861)
New York only

76b. Childbirth Bowl (Scodella) with Child-Care Scene (interior) and Grotteschi (exterior)

Urbino or Castel Durante, ca. 1535
Tin-glazed earthenware (maiolica), H. 4.3 in. (11 cm),
Diam. 7 in. (17.8 cm)
Petit Palais, Musée des Beaux-Arts de la Ville de
Paris (ODUT01074)

Cat. 76a

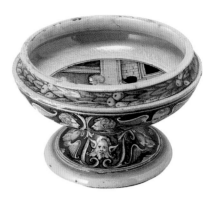

Cat. 76b

This footed bowl and covered salt are reunited here for the first time since their separation, which, judging from their respective provenances, must have occurred sometime before the mid-nineteenth century. Their similar color and exterior ornament, as well as their shapes, confirm the original relationship between the two: they were once part of a five-piece *scodella da parto*, or child-birth bowl. Although no complete set from the period is known, there are a great many separated wares, as the diverse examples in this volume attest.

Evidence for Italian maiolica production in general, and the production of *scodelle da parto* in particular, comes from a manuscript treatise entitled *I tre libri dell'arte del vasaio* (The Three Books of the Potter's Art, ca. 1557–79) by the courtier, engineer, and humanist Cipriano Piccolpasso. Commissioned by the French cardinal François de Tournon, perhaps as a handbook for ceramists in his native country, the manuscript contains a wealth of information about contemporary techniques, glazes, ornaments, and shapes. In one section, Piccolpasso describes two types of *schudelle da impagliata,* or bowls for birthing women. *Impagliata* was the term used in certain regions of the Italian peninsula to designate a woman in childbed,[1] perhaps because she rested on a mattress filled with *paglia*, or straw,[2] or because the drafty cracks in her bedchamber were stopped up with straw.[3] The derivation of the term may never be determined, but its meaning was understood not only in the most prolific maiolica-producing regions but also further afield, in Florence and elsewhere.

According to Piccolpasso, the first type of *schudelle da impagliata* was a simple lidded bowl. The much more complex second type consisted of five or nine wares stacked to form a vaselike assemblage, which Piccolpasso also illustrated in a labeled drawing showing each piece separately and the assembled whole (fig. 55). He wrote:

> You must know then that the five pieces that make up the bowl for a birthing woman all have their function and all five are put together to make a vessel. But to be better understood we will look at the drawing. These are all the five pieces of the bowl. The way to make a complete bowl is this: the tray is turned upside down on the bowl, that is, the flat piece numbered 2 goes upside down on the hollow of the bowl marked number 1, the hollow of the low bowl goes upside down on the feet of the tray, the salt is put on the foot of the low bowl, above which goes its cover, as can be seen here. See how all together they make one vessel like this, a thing of no small ingenuity. There are others who make them of nine pieces, keeping always the same order, and these are called bowls of five or nine pieces.[4]

Although most scholars do not believe that Piccolpasso was a ceramicist himself, he was strikingly accurate about many aspects of the field.[5] In this case, his description and diagram of the childbirth bowl accord well with surviving maiolica and documentary evidence. The bowl here is Piccolpasso's *schudella*, the base of the assemblage he described; a tray would have rested on top of it, secured by the narrow lip that went around the top edge of the bowl. A low bowl would have been put upside down on top of the tray, no doubt also secured by a lip. Then the salt would have been placed on the foot of the overturned bowl, its cover forming a finial for the entire assemblage. Even with the interlocking lips, however, the assembled *schudella da parto* must have been a rather precarious object. It was probably put together only when not in use or at its initial presentation; each piece was intended to hold a type of food considered necessary for the new mother, so each was used individually. This bowl, for example, could hold a broth, while the salt, of course, stored the vital ingredient that acted as both a flavoring and a preservative.

By the time of Piccolpasso's manuscript, this genre was firmly established and had been for some time. The bowl and salt exhibited here are among the earliest known examples, but they are nevertheless finely painted and fully developed in terms of shape and ornament. They are neither signed nor dated—relatively few maiolica wares were during this period—and their attribution is difficult to determine. They seem, however, to be from either Castel Durante (a small town now known as Urbania) or Urbino. The maiolica wares made in these two towns share many of the same characteristics: the buff-colored paste, visible in areas of loss on both pieces, the emphasis on a rich yellow pigment, and the fantastic *grotteschi*.

The exteriors of both pieces feature *grotteschi* in the shape of cherub heads, masks, and harpies, as well as curving foliage and ribbons, all executed in a modulated *bianca sopra bianca* technique to look like carved stone. A garland of leaves and fruit goes around the lip of the bowl, and the corresponding tray probably had a similar garland that served as a key for its placement. The less visible area of each piece was given particular attention. Although the underside of the salt would not be seen during regular use, it has concentric rings of unfurling ribbons and yellow and blue bands surrounding a slightly concave central roundel painted as if to resemble an architectural dome. The interior of the bowl is painted with a scene of childcare. A woman, either the mother herself or perhaps a very well-dressed wetnurse, is shown wearing a fashionable blue dress

and black snood despite her bare feet. She sits on a tiled floor, her legs in front of her to support the swaddled infant, while a naked boy holds up a cloth to be warmed at the hearth. As with many of the bowls in this volume, the interior would be seen only by a small, select audience consisting of the mother herself, who ate the food delivered in the bowl, and her attendants, who filled it. The positive image of childcare, set in a recognizable contemporary interior, would have served as a sort of talisman for the mother, giving her hope that her delivery, too, would be as successful.

JMM

1. Rovere 1939, p. 17.
2. Guasti 1902, p. 4.
3. Cioci 1982, p. 256.
4. Piccolpasso, *Three Books of the Potter's Art,* 1980 (ed.), vol. 1, fols. 10v–11r ("e dunque da sapere che gli cinqui pezzi de che si compone la schudella da don[n]a di parto tutte 5 dico fan[n]o le sue operationi e poste tutta 5 insieme formano un vaso. ma per essere inteso meglio veremo al dissegnio. questi sono tutta 5 gli pezzi della schudella. lordine di farne tutto un vaso e questo il taglieri si riversa su la schudella, cio e quel piano dove il numero 2 va volto sopra al concavo della schudella al nº. 1, il concavo de l'ongaresca va volto sul piedi del taglieri la saliera va posta cossì impiedi nel pie de longaresca, sopra la quale va il suo Coperchio come qui si vedera. ecovi che tutte fano un sol vaso come il presente cosa no di poco ingegnio. altri sono che le fan[n]o di 9 pezzi tene[n]do sempre il medsmo ordine e queste si chiamano schudelle de 5 pezzi o vero di 9").
5. Wharton 2005.

SELECTED REFERENCES: *76a.* Rackham 1940, p. 188, no. 561, pl. 88; Musacchio 1999, pp. 101, 103, fig. 89

76b. Join-Diéterle 1984, no. 49; Bandini and Piccolo Paci 1996, pp. 94–95; Musacchio 1999, pp. 101, 103, fig. 90; Barbe and Ravanelli Guidotti 2006, pp. 61–62, no. 3

77. Childbirth Tray (Tagliere) with The Birth of Hercules

Urbino, ca. 1525–30
Tin-glazed earthenware (maiolica), Diam. 11 in. (28 cm)
Victoria and Albert Museum, London, Mrs George Colwell Bequest (C.755-1925)

Although the artist responsible for this tray cannot be identified, he was clearly a skilled painter. The weighty bodies beneath flowing draperies, the measured movement back into space via the receding pillars, and the realistic interactions of the women hovering around the agitated Alcmena as she delivers Hercules are all strong evidence of his abilities. The coloring and expert paint handling seem to indicate an origin in one of the many productive maiolica workshops established in Urbino during the early sixteenth century. Most of these produced childbirth maiolica to help meet the continuous demand, and both shape and iconography reveal that this piece is indeed one of the childbirth *taglieri,* or trays, described by Cipriano Piccolpasso in his *Three Books of the Potter's Art* (see cat. nos. 76a, b). While the back is painted with simple blue bands on a white ground, the side has a repeating white-palmette pattern on a deep blue ground that probably corresponded to a similar pattern on the exterior of the footed bowl on which the tray rested. The rough band around the side marks the location of the original lip, now shaved off to reveal the clay beneath, that secured the tray in the assembled childbirth bowl, or *schudella da impagliata.*

When this tray was painted, the representation of recognizable scenes from literature, history, and mythology on maiolica wares was particularly popular. These *istoriato,* or "story-painted" wares, were executed by many of the major workshops in Urbino and Faenza. This tray is no exception. Despite its wealth of details common to Renaissance-era interiors, the subject is the birth of Hercules. According to Ovid's *Metamorphoses* (9.273–323), one of Jupiter's many mortal conquests was Alcmena, who became pregnant with his child. But Jupiter's angry wife, Juno, called on Lucina, the goddess of childbirth, to prevent Alcmena's delivery. Alcmena endured a week of painful labor, her delivery blocked by Lucina, who sat nearby with crossed legs and clasped hands. Eventually, Alcmena's devoted servant Galanthis tricked Lucina into believing the birth had already occurred by calling out her congratulations; when Lucina heard this, the surprised goddess relaxed her pose for a

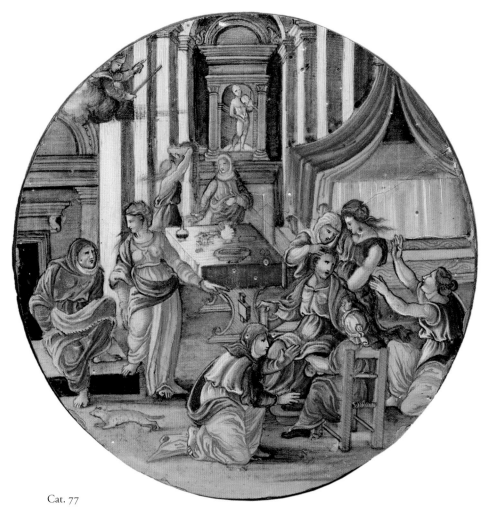

Cat. 77

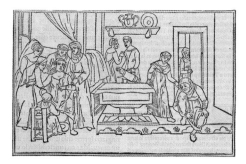

Fig. 76. Benedetto Bordone (ca. 1455/60–1530), design of some woodcuts attributed to, *The Birth of Hercules*, from Ovid (43 b.c.–a.d. 17), *Methamorphoseos vulgare* (Venice, 1501), fol. 72v. Printed book with woodcut illustrations, 11¾ × 8 in. (29.7 × 20.3 cm). The Metropolitan Museum of Art, New York, Rogers Fund, 1922 (22.16)

moment and Alcmena immediately delivered Hercules. As punishment, Juno transformed Galanthis into a weasel and condemned her to give birth through her mouth, because her words had, in effect, given birth to Hercules. Many bestiaries cited Ovid to explain the fantastic belief that weasels gave birth in this miraculous way.[1] Weasels therefore became a type of talisman for pregnant women. Given their related role as symbols of chastity (cat. no. 72), it is easy to see why these animals appear on so many objects related to marriage and childbirth.

Like many maiolica painters, the anonymous artist of this tray used easily accessible prints as compositional inspiration. In fact, Piccolpasso's treatise illustrates a group of ceramists seated around a table, painting wares in front of a wall covered in the prints and drawings they employed as models.[2] The source for this tray was a popular illustrated Venetian edition of the *Metamorphoses* first printed in 1497 (fig. 76). Its woodcut of the birth of Hercules contains almost all the same elements: Lucina crouches at the left, Juno hovers above her wielding a baton, an attendant carries a dish of food in the background, a covered table in the middle holds a platter, pitcher, and various other objects, and the canopied bed at the right is the backdrop for Alcmena and her attendants, including a midwife seated on a low stool reaching under her skirts. Galanthis seems to appear twice in each image, once standing next to Lucina and gesturing to trick her, and then running across the room after being transformed into a weasel. The maiolica painter extended the composition vertically, adding architectural elements to create interest throughout the composition, but his only significant change is the addition of the tiny upside-down head of the newborn Hercules, just peeking out

from under the midwife's arm. The different functions of the two images seem to account for this discrepancy. The woodcut, illustrating an ancient text, needed to convey the plot to a relatively educated, and in most cases male, audience. The tray, however, was intended for a female audience, women who would appreciate a positive representation of what was oftentimes the most traumatic event in their own lives.

JMM

1. Topsell, *Foure-Footed Beastes*, 1967 (ed.), p. 564; Moczulska 1995, pp. 81–85.
2. Piccolpasso, *Three Books of the Potter's Art*, 1980 (ed.), vol. 1, fol. 57v.

SELECTED REFERENCES: Rackham 1940, pp. 207–8, no. 624, pl. 98; Bandini and Piccolo Paci 1996, pp. 73–74; Musacchio 1999, p. 116, fig. 105; Musacchio 2001, p. 181, fig. 7

78a, b. Childbirth Bowl (Scodella) and Tray (Tagliere) with Confinement-Chamber Scenes and Landscape

Castel Durante, ca. 1525–30
Tin-glazed earthenware (maiolica), bowl H. 4⅛ in. (10.5 cm), Diam. 6⅞ in. (17.6 cm); tray H. 1½ in. (3.7 cm), Diam. 8 in. (20.2 cm)
The Walters Art Museum, Baltimore (48.1333.a, b)

No intact example of the five- or nine-piece *schudella da impagliata* described by Cipriano Piccolpasso in his manuscript on maiolica production (see cat. nos. 76a, b) is known from the Renaissance. There are, however, a great many childbirth bowls and trays from the major maiolica-producing cities on the Italian peninsula that are now scattered in public and private collections in Italy and elsewhere. Occasionally, and fortuitously, pieces from one *schudella* have remained together over time. In this case, close examination reveals that another piece was meant to rest on top of the tray: the slightly raised lip around its central scene served as both a compositional frame and a way to secure the overturned bowl that Piccolpasso described. The strong blues, greens, oranges, and yellows that dominate this set are typical of wares from the Metauro River valley around Urbino, specifically from Castel Durante (now Urbania), which was an early center of maiolica production in part because of the high quality of natural clay deposits along the Metauro's banks. Piccolpasso, a native of

Castel Durante, praised this clay as ideal for maiolica.[1]

The exteriors of both bowl and tray are painted with a flowing landscape of fields, hills, and trees, set in front of clear sky and marked by a sense of atmospheric perspective that renders more distant features in a blue tint. In contrast, the interior of the bowl and the top of the tray depict intimate scenes of daily life in the Renaissance home. Although there seems little doubt that these pieces were originally together—the consistent exterior imagery and their close fit demand this—they represent two different but equally well-appointed bedchambers with curtained beds, tile floors, leaded-glass windows, and heavy carved hearths. In the bowl, the woman making the bed pulls the sheets and coverlet up to the large white pillow, having twisted the bed curtains around the four posters to air out the space. Another woman sits on the tiles, a swaddled infant on her legs, while a young boy warms linens at the fire. A distaff, wound thick with flax, hangs on the wall alongside other household implements. The artist made his work a bit easier by limiting this scene to the concavity of the bowl. He then painted a simpler *bianco sopra bianco* design on its curving walls. The flat surface of the tray was easier to paint, and its composition is more detailed. The mother, wearing an embroidered cap (see cat. no. 52), is sitting up and eating in her curtained bed. Two women and a young boy bring her food and drink, while another woman warms more food by the fire. The baby, again swaddled, rests in a rocking cradle on the floor (see cat. no. 86). Among the charming details are the low chair and stool in the foreground, which were used respectively by the midwife and mother during the delivery, and a striped cat that sits on a chest watching the proceedings. The room has a coffered ceiling illusionistically supported by pilasters carved from blue-and-red porphyry, similar to the material used for the mantelpiece; the door and window frames are instead carved from a yellow-green stone. The images on both the bowl and the tray imply a healthy birth, in comfortable and affluent surroundings, and would have been comforting for the woman who was served food and drink from these wares following delivery.

The contrast between the exterior and interior imagery is a vivid reminder that these wares enjoyed a long afterlife in the Renaissance home. Although they would be acquired prior to birth and used by the mother after her delivery, when she was still confined to her bed, they were then kept as a treasured reminder of the birth itself. If

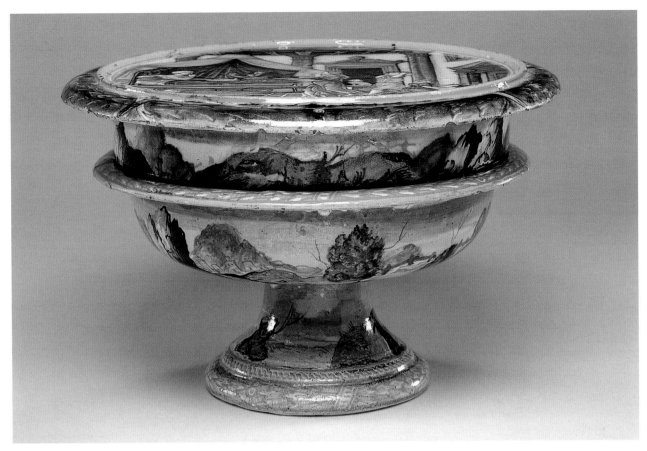

Cats. 78a, b, stacked

they were then assembled into the elaborate vaselike *schudella* Piccolpasso described, the more intimate interior scenes were hidden from view, though they would certainly be remembered by the mother for a long time after the birth itself.

JMM

1. Piccolpasso, *Three Books of the Potter's Art*, 1980 (ed.), vol. 1, fols. 1r–1v, vol. 2, pp. 13–14.

SELECTED REFERENCES: Erdberg and Ross 1952, p. 20, no. 41, pl. 26; Musacchio 1999, pp. 25, 103, figs. 17, 88

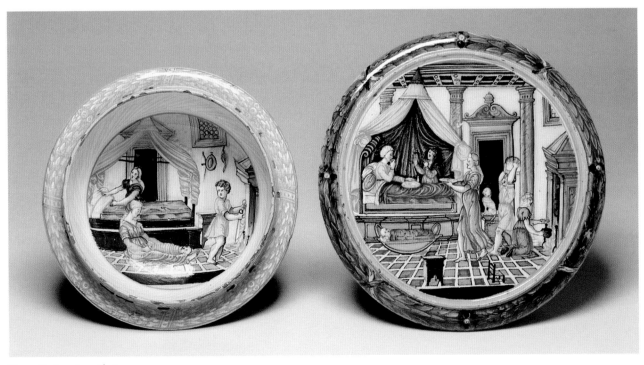

Cats. 78a, interior; 78b, top

Cat. 79

79. Bowl with a Putto Holding a Pinwheel

Gubbio, workshop of Maestro Giorgio Andreoli,
ca. 1530
Tin-glazed earthenware (maiolica), with luster, Diam.
9⅞ in. (25.2 cm)
The Metropolitan Museum of Art, New York, Robert
Lehman Collection, 1975 (1975.1.1107)

This kind of small luster bowl with a cupid or putto playing in a landscape or against a bold lustered ground was a typical Gubbio product of the 1520s and 1530s.[1] The meaning, if any, of this winged putto's pointing with his left forefinger and of his playful smile is mysterious. Similar imagery, including the pinwheel toy, can be found on birth trays (deschi da parto) as well (cat. no. 69). The ribbons decorating the border were scratched through the blue ground to the white tin glaze beneath, a technique typical of Gubbio wares in the 1530s. DT

1. Rasmussen 1989, p. 212, no. 130.

SELECTED REFERENCE: Rasmussen 1989,
p. 212, no. 130

80a, b. Childbirth Bowl (Scodella) with Aeneas Fleeing Troy (interior) and Grotteschi (exterior); and Tray (Tagliere) with Pyramus and Thisbe (top) and Hercules and the Nemean Lion (bottom)

Faenza, Baldassare Manara (documented 1529–46/47),
ca. 1530–40
Tin-glazed earthenware (maiolica), bowl H. 4⅛ in.
(10.5 cm), Diam. 4 in. (10 cm); tray Diam. 7¾ in.
(19.7 cm)
Inscribed around rim of bowl: *IDIO-CHON-LE-SVE-MAN-VE-CREO-TALLE-CHE-APRESSO-ALI-MORTALLI-SIETTE-I-PIV-PCIO-DE-QVAL-SE-VALI-GEMMA-ORIENTALLE-* (God with his hands created you so fair that now to mortal eyes you appear more precious than any oriental gem); on front of tray: *QVEL-CHE-VOLSSE-EXPVGNARE-IL-PARADISO-QVEL-CHE-CACHO-AMAZZO-DE-FVRIA-ACESSE-/QVEL-CHE-QVAL-SALAMANDRA-LA-VIA-PRESSE-IN-MEGIO-AL-FOCHO-COL-IVLIO-ET ANCHISO* (He who wanted to conquer Paradise, he who slew Cacus, who was possessed by the fury/He who made his way through the fire like a salamander with Julius and Anchises); on reverse of tray: *VIRTV-BELTA-FORTESA-IN-SIGVLLARE-PERSONA-VNITA-VISERBBE-EQVALLE-COMO-VN-MINIMO-RIVO-A-VN-APLO-MARE* (Virtue, beauty, and bravery united in a single person; it is as if an enormous sea flowed into a little brook)
The Metropolitan Museum of Art, New York, Robert
Lehman Collection, 1975 (1975.1.1043a, b)
New York only

This matching childbirth bowl (*scodella*) and tray (*tagliere*) must have been part of a set of five or nine pieces, as described in Cipriano Piccolpasso's treatise on maiolica, *I tre libri dell'arte del vasaio* (The Three Books of the Potter's Art, ca. 1557–79) (see cat. nos. 76a, b). The top of the tray has a raised lip to secure additional wares in place, but if these survive, they have not been identified. Baldassare Manara is one of the few ceramists known by name from this period. He was active in a busy—and notably well-documented—family workshop in the town of Faenza, in what is now the Emilia-Romagna region of Italy. Faenza was among the most important centers for maiolica production in the Renaissance. In fact, the term *faience*, used by many later authors to denote tin-glazed earthenware, comes from a transliteration of the town's name. Although Manara's birth date is uncertain, he was cited in documents by 1529, and certainly painting by 1532 or 1534; he died in 1546 or 1547. He was one of the first Faentine ceramists to sign a significant number of his wares—indeed, thirteen signed pieces are known today—so scholars can identify his oeuvre with confidence. This is especially important because his style varied a great deal during his relatively short career, perhaps indicating that he was assisted by a number of workshop hands.

Manara did not sign these two wares, but they can be attributed to him on the basis of comparisons with his known works. Their intense colors and the inventive *grotteschi* on the exterior of the bowl rank them among his best. A special commission may account for their high quality; the arms on the exterior have been identified as those of the Viarini

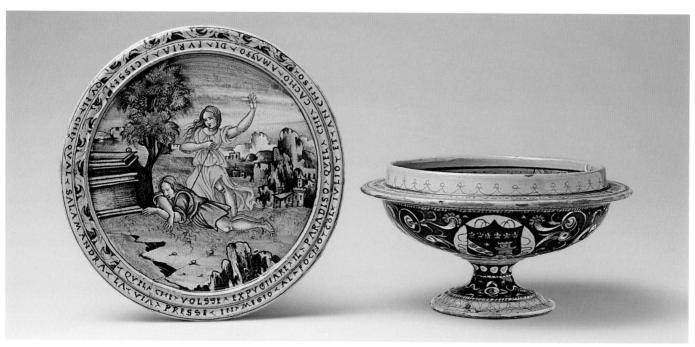

Cats. 80b, top; 80a, exterior

and Benini of Faenza, although no record of a specific marriage between these families has been found.[1] The iconography is unusual for childbirth wares because all three scenes illustrate stories from classical literature. By way of comparison, most childbirth wares, including the other examples in this volume, represent scenes from daily life and especially the activities surrounding childbirth and confinement. Furthermore, the scenes painted on these wares come from different literary sources—Virgil's *Aeneid* (2.671–729), Ovid's *Metamorphoses* (4.55–166), and Pseudo-Apollodorus's *Bibliotheca* (2.5.1)—and seem completely unrelated. But it has been suggested that each was deliberately chosen to comment on marriage. In this interpretation, the Aeneas scene, in which the hero, accompanied by his wife and son, carries his father out of burning Troy, demonstrates family solidarity; Pyramus and Thisbe stand for the power of love; and Hercules killing the Nemean Lion foretells the future virtues of the newborn child.[2] However, relatively few women would have had the humanist training in classical texts (not to mention the literacy) to fully grasp such references, a fact that brings into question the intended audience for this learned and complex object.

Manara may have been somewhat confused as well. While the inscriptions on both wares enforce some of these ideas, none of them come directly from a known text and two do not even describe the scenes they surround. The bowl's laudatory verse, surely referring to the charms of the wife and mother who received the maiolica, seems incongruous alongside the Aeneas iconography. And the text with Pyramus and Thisbe relates instead to Hercules, who appears on the opposite side of the tray, and to Aeneas, who appears in the bowl. Perhaps Manara misunderstood the patron's instructions; the inscriptions seem to be in his own hand.[3]

JMM

1. Ravanelli Guidotti 1996a, p. 154.
2. Däubler-Hauschke 1994, p. 34.
3. Rasmussen 1989, p. 48.

SELECTED REFERENCES: Raggio 1956, p. 197, ill.; Rasmussen 1989, pp. 45–48, no. 28, ill.; Däubler-Hauschke 1994, pp. 26–38, figs. 1–4; Ravanelli Guidotti 1996a, pp. 150–54, no. 15, ill.

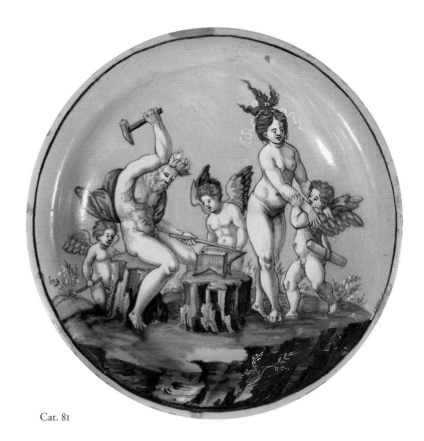

Cat. 81

81. Dish with Venus, Vulcan, and Cupids

Urbino, attributed to Francesco Xanto Avelli (Rovigo, ca. 1486–Urbino, ca. 1582), dated 1539
Tin-glazed earthenware (maiolica), Diam. 6¾ in. (17.1 cm)
The British Museum, London, bequeathed by John Henderson in 1878 (1878, 12-30, 373)

This shallow bowl is painted on both sides. On one side, on a brilliant yellow ground, is the nude figure of the Roman god Vulcan forging an arrow. He is accompanied by his wife, the goddess Venus, and three putti. This scene is taken from a print by Marco Dente da Ravenna.[1] On the other side of the bowl is a continuous scene of heavy clouds with two chariots: Apollo's sun chariot drawn by horses, and Saturn's drawn by dragons. The composition excerpts two woodcuts from a set of seven in Gabriele Giolito de' Ferrara's 1533 *The Seven Planets*.[2] The dish is dated in Roman numerals at the center: *.M.D. XXXVIIII.*[3]

The decoration of the bowl on both sides and the iconography of the painted scenes suggest that it was part of a set made to commemorate the birth of a child. The dish is probably a shallow form of an *ongaresca*, which was stacked upside down on top of a plate (*tagliere*), which in turn covered the deep bowl (*scodella*) at the base of the set. On top of the *ongaresca*, set into the ridged foot, would have been a small lidded salt cellar

(*saliera*) for seasoning the food presented to a new mother. (For a drawing of these interlocking wares stacked, see fig. 55.)

The yellow ground is highly unusual and links this dish with a *tagliere* in Milan that appears to be part of the same sophisticated set. The Milan piece is painted on one side with a musical party, after the woodcut of the children of the planet Venus in Giolito's *Seven Planets* series. On the other side, a putto holds a basket of flowers on his head, in an image adapted from a print by Gian Giacomo Caraglio.[4] The putti on the Milan and London pieces, used as symbols of fertility and abundance, would have been revealed by the new mother only when the set was in use.

These dishes are attributed to Francesco Xanto Avelli da Rovigo, one of the most idiosyncratic and prolific maiolica painters of the Urbino school (see cat. nos. 109, 110). Although he was born in Rovigo, he is known from documentary evidence and from a series of signed pieces to have been in Urbino from 1530. His inscriptions on the reverses of his pieces, in which he names or quotes the sources for his subjects, display his ambitions as a moralist, poet, and political commentator and demonstrate his reading of the classics and his knowledge of Italian poetry. Xanto's pieces also reveal his knowledge of contemporary prints of the Raphael school, from which he borrows in interesting and unusual ways, particularly in his political allegories.[5] This bowl, although it is unsigned, appears to be a relatively late work

in his career and has long been attributed to him on stylistic grounds.[6] Xanto used one of the Giolito woodcuts, *The Planet Venus*, as a source on a plate dated 1542, which is also unsigned.[7] The writing on this plate, which is in the Victoria and Albert Museum, London, appears to be the same as that on certain pieces dated 1541 and 1542 that bear the *X* signature of Xanto Avelli and are almost certainly by him.[8] DT

1. Bartsch XIV.227.
2. Lippmann 1895, pls. Fi, Fiv.
3. T. Wilson 1987, no. 78; Syson and D. Thornton 2001, pp. 218–19; D. Thornton and T. Wilson 2009, no. 169.
4. Julia Triolo in *Museo d'Arti Applicate* 2000, p. 208, no. 215; Mallet 2007, p. 160.
5. The literature on Xanto is large, complex, and contradictory on key issues. Recent accessible accounts in English include T. Wilson 1993, pp. 119–217; Poole 1995, nos. 385, 396; Mallet 2007; D. Thornton and T. Wilson 2009, nos. 154–70 (prefaced by a biography of Xanto).
6. Robinson 1863, pp. 431–32, no. 5,250.
7. Mallet 2007, pp. 41, 160–61, no. 56.
8. T. Wilson and Sani 2006–7, vol. 1, no. 34.

Selected references: Robinson 1863, pp. 431–32, no. 5,250; T. Wilson 1987, pp. 58–59, no. 78; Poole 1995, under nos. 385, 396; Julia Triolo in *Museo d'Arti Applicate* 2000, p. 208, under no. 215; Syson and D. Thornton 2001, pp. 218–19; Mallet 2007; T. Wilson and Sani 2006–7; D. Thornton and T. Wilson 2009, no. 169

82. Childbirth Bowl (Scodella) with Confinement-Chamber Scene (interior) and Diana and Actaeon (exterior)

Urbino, circle of Francesco Xanto Avelli (Rovigo, ca. 1486–Urbino, ca. 1582), ca. 1530s
Tin-glazed earthenware (maiolica), H. 3¾ in. (9.5 cm), Diam. 7⅛ in. (18.1 cm)
The Metropolitan Museum of Art, New York, Samuel D. Lee Fund, 1941 (41.49.2)
New York only

This footed bowl, or *scodella*, was once part of a multipiece stacking set of the sort described by Cipriano Piccolpasso (see cat. nos. 76a, b). It would have formed the base of that set, and the top edge, with its horizontal flange, shows signs of wear where the interlocking tray would have rested securely on top of it. If that tray or any other pieces from the original set survive, they have not been identified. However, the distinctive figural style and unusual combination of interior and exterior iconography on this bowl might make it possible to identify those additional pieces eventually.

The interior is painted with an intimate, idealized scene in a bedchamber following childbirth, of the type found in many maiolica birth bowls. This makes a distinct contrast to the exterior, which depicts the story of Diana and Actaeon set against a vivid landscape. Although many early sixteenth-century childbirth bowls were painted with landscapes on the exterior (cat. nos. 78a, b), those landscapes were unpopulated. When the wares that made up Piccolpasso's typical five- or nine-piece sets were stacked on top of each other, the mountainous crags, tree limbs, grassy knolls, and cloud-streaked skies provided a natural barrier to the more

intimate figural scenes painted within. While the new mother was the principal audience for the interior scene, visible only when she used the individual wares in the disassembled set, the family and friends who visited her saw the more generic exterior. In the case of this bowl, however, a mythological narrative unfolds against the landscape, an especially impressive accomplishment because the curving surface was difficult to paint without considerable distortions.

The tragic story of Diana and the hunter Actaeon was best known through Ovid's *Metamorphoses* (3.138–252), a first-century-A.D. compilation of transformative tales of love from various ancient sources. On one side of the bowl, the goddess and three of her companions, naked but for a few flowing draperies, are surprised by Actaeon as they bath in a sacred stream. As punishment for his inadvertent transgression, Diana changes Actaeon into a stag. He is shown in the midst of that transformation, his head already lengthened and topped by a heavy rack of antlers. The next instant, his dogs mistake him for prey and set upon him; as they pursue him across the surface of the bowl, his face changes back, and he looks down at the dogs in fear. The goddess, now wearing a flowing orange dress but standing in the same pose as in the sacred stream, watches from a distance, bow and arrow in hand. If there are other pieces from this set, they might have further Ovidian scenes painted around their exteriors.

The painting technique, colors, and figure style of this bowl indicate an origin in Urbino, almost certainly within the circle of Francesco Xanto Avelli, who was among the most prolific and popular ceramicists of the early sixteenth century and the head of an extensive workshop organization. Xanto was also a poet and courtier of Francesco Maria I della Rovere, Duke of Urbino. Forty-four

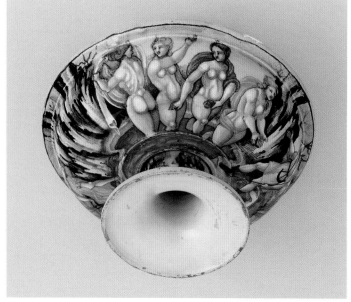

Cat. 82, view 1

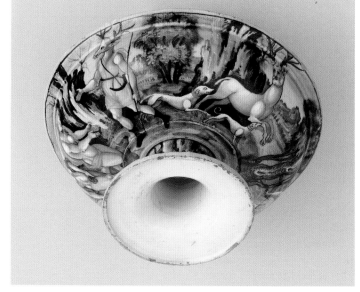

Cat. 82, view 2

of his sonnets praising the duke survive, as well as the shorter verses primarily based on ancient sources that he painted on the reverse of his maiolica wares. As a ceramicist, however, Xanto is best known for his ability to assemble coherent compositions by combining motifs from print sources, and this bowl is no exception to that practice. The two representations of Diana on the exterior use Marcantonio Raimondi's *Quos Ego* engraving as inspiration. In the concavity, the seated attendant with the child is an adaptation of the Muse Erato from Raimondi's engraving after Raphael's *Parnassus* fresco in the Stanza della Segnatura, the child propped on the attendant's knee substituting for Erato's lyre. The striding attendant in classical dress, with the fabric falling loose around her exposed limbs (very similar, in fact, to Diana's dress on the exterior), is copied in part from the representation of Terpsichore in the same engraving and in part from Marcantonio's *Charity*, also after Raphael. All these were prints that Xanto employed in various combinations with considerable success throughout his career.

The reclining nude mother, who has presumably just given birth to the surprisingly alert child seated in the attendant's lap, is especially recognizable in the context of this exhibition. She is based on the engravings of sexual positions executed by Marcantonio Raimondi after drawings by Giulio Romano and known as *I modi*. Because of their explicit sexual content, the engravings were censored by the papacy in 1524, and Raimondi was jailed for his role in their production and dissemination. Their resulting destruction was strikingly thorough: only a few early copies of Raimondi's engravings, and none of Giulio's original drawings, seem to survive (cat. nos. 99, 100). But their immediate reinterpretation in different media by a wide range of sixteenth-century artists gave them a long life. Xanto himself must have owned copies of many of the compositions, or at least drawings or tracings of the most useful parts of them. His frequent inclusion of *I modi* motifs, oftentimes in otherwise innocuous scenes such as this one, was a clever nod to this infamous case of papal censorship (see cat. no. 109). Given the almost complete destruction of both Raimondi's engravings and the early copies after them, however, it is doubtful that many of Xanto's clients would have recognized the visual source for his inventively posed figures.[1] And they certainly would not have expected it here; *I modi* engravings are an unlikely inspiration for a representation of domestic tranquility. But the placement of the mother's arms, one on her head and the other across her torso, combine details of the

women found in two of these compositions, one representing a pair engaged in reversed coitus and the other an acrobatic standing and reclining couple. Both ultimately derive from the popular ancient statue of a sleeping Ariadne—thought to be a dying Cleopatra in the sixteenth century—in the papal collection in Rome.[2]

Xanto's creative combination of these varied sources makes for a striking composition overall. The theatrically draped, flowing canopy above the stable bed frames the figural group, while the simple lines of the architecture situate it in a domestic interior. The success of this composition is evident by the fact that it is one of six bowls with similar interiors: the Victoria and Albert Museum[3] and the Museo Correr[4] each have one, another has appeared on the Florentine art market,[5] and two were formerly in the famed Pringsheim collection in Munich.[6] All feature a color scheme dominated by blues and oranges. In five of the six, the concavities represent nude mothers, propped on one arm, reclining in canopied beds parallel to the picture plane, with two attendants catering to their needs; the sixth bowl has a similar architectural setting but omits the mother in her bed in favor of the activities of three attendants. In five of the bowls, the attendants also care for the needs of a rambunctious newborn, by either holding the child or warming swaddling by a fire. And finally, in one of the Pringsheim bowls and in the Metropolitan example, one of the attendants strides forward carrying a tray with food for the mother.

Four of the six bowls in this group have fanciful early *grotteschi* around the exterior. But one of the Pringsheim bowls, like the Metropolitan bowl, has a mythological scene, in its case the story of the abduction and rape of Europa (*Metamorphoses* 2.833–75). The more complex iconography on these two bowls may indicate that they were commissions, while the others were made for stock. In either case, this type of childbirth bowl must have been in significant demand to warrant the survival of so many examples.

JMM

1. Mallet 2007, p. 41.
2. Bober and Rubenstein 1986, pp. 113–14, no. 79.
3. Mallet 2007, pp. 112–13, no. 32.
4. Petruzzellis-Scherer 1988, p. 123, nos. 1, 2.
5. Bellini and G. Conti 1964, no. 144a.
6. Sotheby's, London, sale cat., June 7–8, 1939, lots 258, 259.

SELECTED REFERENCE: Avery 1941, pp. 230–31

83a, b. Childbirth Bowl (Scodella) with a Confinement-Chamber Scene (interior) and Landscape (exterior); Childbirth Tray (Tagliere) with a Confinement-Chamber Scene (top) and a Cupid (bottom)

Urbino(?), Francesco Durantino (Urbino and elsewhere, documented 1543–75), mid-1540s
Tin-glazed earthenware (maiolica), bowl H. 3¾ in. (9.6 cm), Diam. 6⅞ in. (17.6 cm); tray H. ⅜ in. (1 cm), Diam. 8¾ in. (22.3 cm)
Philadelphia Museum of Art, The Howard I. and Janet H. Stein Collection, in honor of the 125th Anniversary of the Museum (2000-154-4, 2000-154-5)

Francesco Durantino, a prolific and fortuitously well-documented maiolica painter, signed and dated a significant number of his wares, making his personal style more recognizable than those of many of his contemporaries.[1] Although he did not sign these two pieces, certain characteristics, particularly the painting of the eyes and open mouths and the rather bulbous musculature, point to his hand.

The shapes and iconography reveal that this bowl and tray were part of a multipiece *schudella da impagliata*, as described by Cipriano Piccolpasso (see cat. nos. 76a, b). These are the only known examples of childbirth wares by Francesco Durantino, but he likely painted a great many others, now unfortunately lost.[2] The tray (cat. no. 83b) fits onto the footed bowl (cat. 83a) and is held in place by its inner lip. The rim of the tray curves down gently, hiding the join and framing the detailed figural scene on the top with a garland of green leaves and orange and white flowers. In its original configuration, that scene too would have been hidden by another overturned bowl, likewise secured by a slightly raised lip. The figural scenes would be visible only when the mother used the disassembled pieces of her *schudella da impagliata*. When the pieces were assembled, their unified exterior gave no hint of the intimacy of the images inside and underneath.

These figural scenes are executed in a sophisticated painterly style. Both the interior of the shallow bowl and the top of the tray represent bedchambers following childbirth. As in the set from Castel Durante in this volume (cat. nos. 78a, b), there are similarities between the two chambers but also subtle differences in their furnishings. The scene inside the bowl is expertly painted to flow with the curve of the walls, a difficult task that required careful planning and great precision in paint application. Since the maiolica technique did not allow an artist to change a

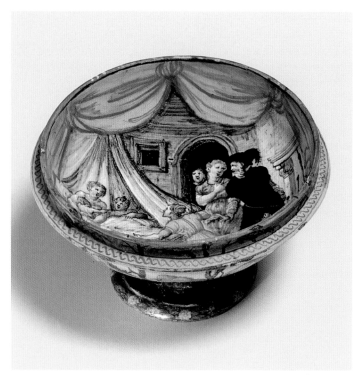

Cat. 83a, interior

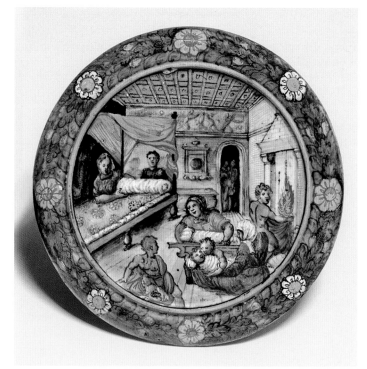

Cat. 83b, top

composition or paint over an error, such an accomplishment is impressive indeed. The mother reclines in a curtained platform bed, nursing her infant, with another child alongside her. The room has a glowing fire and an elegant three-legged table laden with various foods and drinks, as well as what seem to be the disassembled parts of a *schudella da impagliata*. A small boy, naked except for a loose drape, kneels in the foreground and turns to look at four people entering the chamber. Three of the visitors are women, but the fourth is a well-dressed man, his blue stockings decorated with black stripes and his rich black tunic matching his feathered hat. During the Renaissance, childbirth and the confinement period following it were the domain of female midwives, attendants, and relations. Male doctors were called in only under dire circumstances, and husbands would stay away in separate rooms. In light of this division between the genders, the identity of the stylish man in this scene is unclear.

The tray is similarly detailed. The front represents a room with a coffered ceiling and a painted or sculpted frieze across the back wall, on which is hung a convex mirror in a tabernacle frame. The platform bed is empty, the curtains are pulled back, and two women fix the sheets and pillow. The coverlet has a festive floral design that echoes the flowers around the rim of the tray itself. The swaddled baby rests in the lap of a woman who sits by the fire, her back to us; another woman tidies the cradle, and a naked boy warms a sheet by the fire. A second boy, wrapped in an orange cloth, sits in the foreground, while a third hugs the baby. Two figures standing in

the doorway are so hastily painted that they cannot be identified. On the reverse of the tray, a naked Cupid hovers on his colorful feathered wings against a yellow sky filled with clouds. He holds a bow in one hand and an arrow in the other, and his quiver is slung around his waist. This figure resembles the boys painted on the backs of wood childbirth trays, and he must have been painted for similar, presumably talismanic, reasons.

JMM

1. Lessmann 1979, pp. 183–87, and T. Wilson 1993, pp. 223–25.
2. W. M. Watson 2001, p. 201.

SELECTED REFERENCES: Musacchio 1999, pp. 112–13, 126, figs. 101, 117; W. M. Watson 2001, pp. 201–2, no. 60a, b

84a–c. Childbirth Bowl (Scodella), Tray (Taglieri), and Low Bowl (Ongaresca) with Child-Care Scenes, Putti, and Grotteschi

Urbino, workshop of Orazio Fontana, ca. 1565–70
Tin-glazed earthenware (maiolica), bowl 4 × 5½ in.
(10.2 × 14 cm); tray: Diam. 6⅞ in. (17.5 cm); low bowl
Diam. 8½ in. (21.6 cm)
The Detroit Institute of Arts, Founders Society Purchase, Mr. and Mrs. Henry Ford II Fund (59.124a–c)

The hill town of Urbino became particularly prominent in the field of maiolica production about 1520 because of its emphasis on *istoriato*, or story-painted, wares. Many of these wares were made in the prolific and highly successful workshop of the master potter Guido Durantino (d. ca. 1576).[1] Both the shape and the decoration of maiolica grew increasingly elaborate as the sixteenth century progressed. This was partly owing to the demand for detailed *istoriato* scenes on an increasing variety of complexly shaped yet inherently functional wares.[2] It was also the consequence of a new aesthetic, best exemplified by a new generation of maiolica artists.

In the second half of the sixteenth century, perhaps the best known of these artists was Guido Durantino's son Orazio (ca. 1510–1576). After learning the trade from his father (who by 1553 had adopted the surname Fontana), Orazio started his own workshop in Urbino in 1565. He may have concentrated more on shop management than on the actual production of maiolica, but the maiolica created in

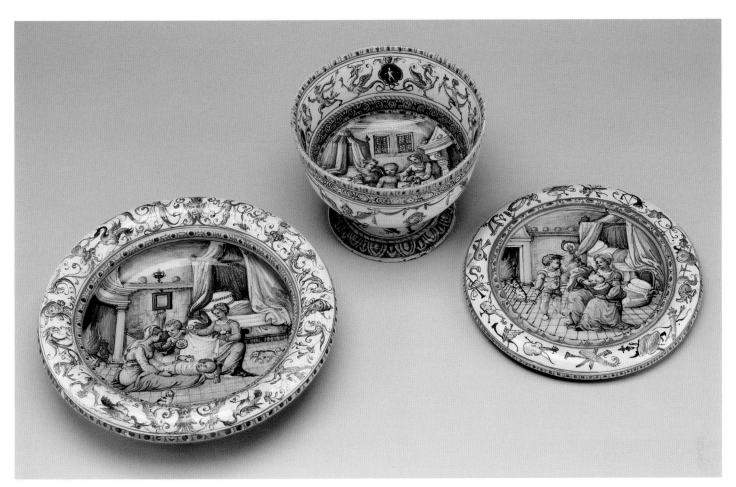

Cats. 84c, interior; 84a, interior; 84b, top

Cats. 84c, 84b, undersides

his shop, even when painted by others, was remarkably consistent in style. Orazio's shop focused on luxury wares with surprisingly sculptural, sometimes even fantastic, shapes.[3] These wares were carefully painted both with *istoriato* scenes and, increasingly, with fanciful ornaments, or *grotteschi*, executed on a white ground. *Grotteschi* were inspired by the frescoes painted by Raphael and his workshop in the loggie of the Vatican in the early sixteenth century, and Raphael's frescoes, in turn, imitated the then recently rediscovered wall paintings in the so-called Domus Aurea, or Golden House, of the emperor Nero in Rome.[4] The Domus Aurea fascinated Renaissance artists, and particularly maiolica painters; they copied the complex ornaments painted on its ancient walls, which they called *grotteschi* because the partially excavated palace seemed like a cave, or grotto.[5] Some early sixteenth-century maiolica incorporated motifs from these ancient wall paintings, but only in the mid-sixteenth century, in the work of artists in and around the Fontana family workshops, did *grotteschi* decoration flourish. To find models for *grotteschi*, Orazio and his fellow painters relied not only on what they knew of ancient paintings—and on their own imaginations—but also on popular prints, especially Jacques Androuet I Ducerceau's *Petites grotesques*, a compilation of several dozen etchings first published in France in 1550.[6] In most cases, maiolica *grotteschi* are unrelated to the figural scenes they surround; they were meant to provide an interesting frame and to delight their original audience with a clever reference to antiquity.

These three wares, once part of the famous nineteenth-century maiolica collection formed by Baron Nathaniel Mayer Anselm von Rothschild in Vienna, are from a particularly beautiful *schudella da impagliata*, or set of interlocking, functional maiolica wares used by new mothers. They are the only known set to survive in three pieces, and they show great unity in composition, color scheme, and style, indicative of a single painter or a unified shop aesthetic. Indeed, they are excellent examples of the high-quality production typical of Orazio Fontana's workshop, combining the three characteristics most closely associated with his work: inventive shapes, skilled *istoriato*, and fantastic *grotteschi*. These inventive shapes are modified from those illustrated in Cipriano Piccolpasso's manuscript treatise *Three Books of the Potter's Art* of about 1557–79 (see cat. nos. 76a, b): both the tray and the low bowl have a curving rim, and all the *istoriato* scenes and edges are bordered in either a fine bead-and-dart motif or some other type of ornament. On the top and bottom of the tray, and on the exterior of the low bowl, these borders provide a raised lip

to secure the additional pieces. The lid fits on the footed bowl, but the low bowl cannot rest upside down on top of it: the curving rims of both tray and low bowl would have made for a very insecure placement. Thus the original complete set must have been slightly modified from Piccolpasso's type; the raised lip on the top of the tray indicates that the set had at least one additional piece, now lost. The astonishingly complex *grotteschi* covering the exteriors and curving rims are among Orazio's best; their imaginative forms and the delicate handling of the paint give the set great energy. Like the landscapes painted on the exterior of earlier childbirth wares (see cat. nos. 78a, b), these *grotteschi* provide a disguise for the more intimate *istoriato* scenes within and underneath.

These *istoriato* scenes were most important to the mother who received and used the set. The insides of the two bowls, and the top of the tray, are painted with well-appointed Renaissance interiors, each slightly different but all with an empty curtained bed and a blazing hearth. The scenes illustrate the activities following a safe and healthy childbirth, and in both bowls they are painted deep in the concavities where the surface is flattest to diminish distortion; *grotteschi* are painted around the walls. The inside of the footed bowl shows two women bathing a standing child. On the tray a seated woman nurses a swaddled infant while a boy shakes a rattle nearby. Finally, inside the low bowl, two women swaddle an infant, with a boy watching and waving his rattle. If the mother is one of the women tending to the newborn, she is not identified as such in any of the scenes.

The undersides of the tray and low bowl are each painted with a naked winged putto standing on billowing clouds; he waves branches on the tray and floral bouquets on the low bowl. The similarities between these small boys and the putti or naked boys on the backs of painted wood childbirth trays (see cat. nos. 69, 71, 72, and fig. 54) are striking, and the figures must have had a related purpose: they can all be considered fertility talismans, meant to encourage the conception and delivery of boys.

JMM

1. Mallet 1987.
2. Syson and D. Thornton 2001, pp. 215–28; and Musacchio 2004, pp. 31–33.
3. Mallet 1987, pp. 287–88.
4. Dacos 1969.
5. There were some dissenters from the enthusiasm for *grotteschi*. In the 1550 edition of his *Lives of the Artists*, Giorgio Vasari mocked: "Grotesques are a type of licentious and ridiculous painting, made in Ancient times for the decoration of empty spaces, where

nothing else could go; they made monsters out of nature and the fantasies of the artists, who ignored all rules, hanging an impossible weight from a slender thread, a horse with legs of leaves, a man with a crane's legs, and the strangest things one can imagine" (Vasari 1550/1986 [ed.], p. 73: "Le grottesche sono una specie di pittura licenziosa e ridicola molto, fatte dagl'antichi per ornamenti di vani, dove in alcuni luoghi non stava bene altro che cose in aria; per il che facevano in quelle tutte sconciature di monstri per strattezza della natura e per gricciolo e ghiribizzo degli artefici, i quali fanno in quelle cose senza alcuna regola, appiccando a un sottilissimo filo un peso che non si può reggere, a un cavallo le gambe di foglie, a un uomo le gambe di gru et infiniti sciarpelloni e passerotti; e chi più stranamente se gli immaginava, quello era tenuto più valente").

6. Poke 2001.

SELECTED REFERENCES: Grigaut 1958–59, pp. 85–89, ill.; Detroit Institute of Arts 1979, p. 157, no. 131; *Triumph of Humanism* 1977, pp. 65, 89, no. 165; Bandini and Piccolo Paci 1996, pp. 91–93; Musacchio 1999, pp. 126–27, figs. 116, 119; Musacchio 2004, p. 51, fig. 39

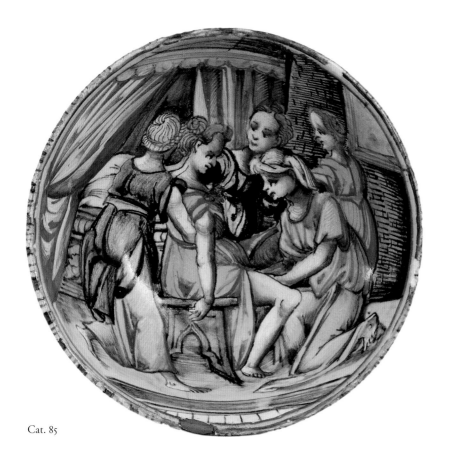

Cat. 85

Selected references: Ravanelli Guidotti 1987, pp. 205–7, no. 84; Crainz 1986, pp. 30–31, no. 7; Bandini and Piccolo Paci 1996, pp. 70–71; Musacchio 1999, pp. 4–5, fig. 3

85. Bowl (Scodella) with Childbirth Scene (interior) and Grotteschi (exterior)

Urbino, workshop of the Patanazzi family (Urbino, ca. 1580–1620), ca. 1580
Tin-glazed earthenware (maiolica), Diam. 13¾ in. (34.9 cm)
International Museum of Ceramics in Faenza—Foundation (6154)

The Patanazzi family of ceramicists operated the most prolific and popular maiolica workshop in late sixteenth-century Urbino. Although the circumstances are not completely clear, the Patanazzi were related to the Fontana and inherited that family's workshop in about 1580.[1] They then continued making and painting wares based on the Fontana's earlier output, refining and frequently elaborating the shapes and ornament, until at least 1620.

The exterior of this childbirth bowl is painted with the elaborate decoration known in the Renaissance as *grotteschi*. This fine ornament—composed of antique-inspired hybrid figures, drapery swags, foliate tendrils, and geometric patterning—would be visible to all when the bowl rested on a shelf or table in a sixteenth-century home. It provides a contrast to the childbirth scene hidden in the concavity of the bowl, in which four women assist another in labor. The laboring woman wears a loose dress and sits on a low chair, her legs akimbo to accommodate

the kneeling midwife, who reaches up under the dress to deliver the infant. The heads and bodies of the women turn solicitously toward the laboring mother, directing viewers to the most compelling and intimate part of the scene. One of the women stands with her back turned, supporting the mother under the arms in a gesture that hints at the positive environment created by this group, engaged in an everyday yet extraordinary event. The curtained bed, the window, and the bricked walls in the background situate the scene inside a comfortable bedchamber and contribute to its intimate feel. Such a personal representation would have been visible only to the woman who used the bowl, perhaps for a meal of nourishing broth before or after childbirth.

Representations of actual childbirth such as this one were relatively uncommon, but when they did appear, they were obviously idealized. These scenes celebrated childbirth as a pleasant experience for the mother, who was surrounded by women who took care of her needs. The reality of Renaissance childbirth, of course, was often completely different; high maternal and infant mortality made it a risk for most women, regardless of their socioeconomic level. The encouraging images painted on childbirth maiolica indicate an awareness of the need for positive reinforcement to counter the often grim reality.

JMM

1. Negroni 1998, p. 106.

86. Cradle

Italy, 16th century
Carved walnut, gilding, polychromy, 35 × 41 × 22 in. (88.9 × 104.1 × 55.9 cm)
Philadelphia Museum of Art, Purchased with the John D. McIlhenny Fund (2000.117.1)

In the Italian Renaissance, children of privileged families were welcomed into the world with a variety of ritual objects that commemorated their birth. *Deschi da parto*, or birth trays, such as that created for the arrival of Lorenzo de' Medici in 1449 (cat. no. 70), and maiolica *impagliata* sets (cat. nos. 76–85), helped to enliven the mother's first days or weeks of convalescence after delivery. These objects were preserved in the family and were probably treasured by the offspring whose birth they celebrated. We know that Lorenzo eventually came into possession of his birth tray, which was hanging in his chambers when an inventory was taken at his death in 1492.[1]

A fine cradle such as this was probably used over several generations. Coats of arms of two families have tentatively been identified on it, though given the longevity of cradles, one or both of the arms may postdate the object's creation. The arms on the sides are impaled, or split down the middle of the field, meaning that they represent two families, presumably those of the mother and father of the child. The left side shows three six-pointed stars over a wavy design and a triple mountain; on the right, a single flower is placed over a triple mountain. Traces of blue and red are discernible on the abraded surface, but these were common colors and do not help in identification of the arms.[2] The arms on the head of the cradle may be a later addition since they are applied rather than carved of a piece.[3]

Deeply carved rinceaux and scroll patterns decorate the gently sloping sides of the cradle. Two rampant unicorns with swirling horns cavort on the front of the cradle, their long forelegs joining in the center to hold up a seven-pointed star, perhaps part of a family *impresa*, or armorial. A triple mountain, another armorial element, is carved on the top front, echoing the mountains on the impaled arms on the sides.

The baby for whom this cradle was created may have slept at night in a smaller, cozier cradle and used this for appearances in public.[4] Two cradles were made for the son born

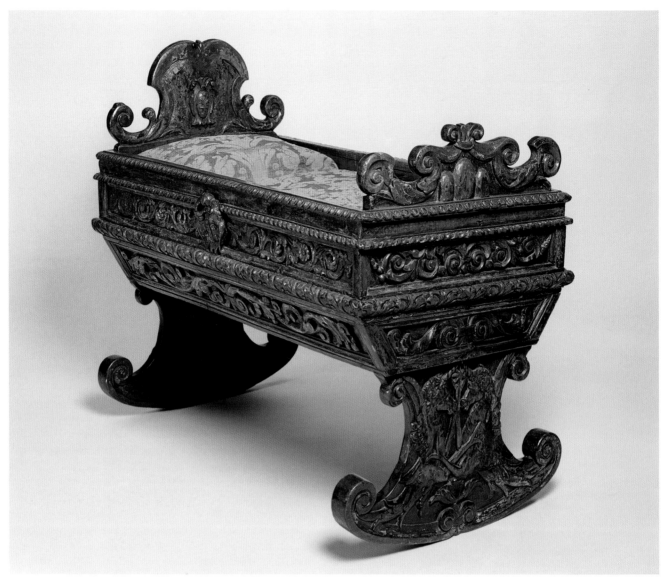

Cat. 86

in 1493 to Ludovico Sforza, Duke of Milan (r. 1481–99), and Beatrice d'Este; one was a gilded state cradle with four columns and a canopy of blue silk with gold trimmings. Like the gilded Sforza cradle, this cradle may have been created to be displayed beside a matching bed in which the mother would receive visitors during her confinement.[5]

Images of cradles in paintings and on ceramic birth wares (cat. nos. 75, 129) typically include a baby, who is usually asleep. This suggests that the true purpose of the cradle was to provide a gentle rocking motion that would, most of the time, lull the infant, probably very uncomfortable in tightly bound swaddling, to sleep, and thus provide some peace for the mother or caretaker. The curling feet of this cradle would have allowed a person to rock it with one foot, leaving the hands free for other tasks. Wealthy families engaged servants to rock the cradle continuously, whereas in less affluent settings members of the family were charged with the task.[6] DLK

1. See Musacchio 1998.
2. Professor Francesco Fumi Cambi Gado, in Florence, has suggested that the arms on the head of cradle may be those of the Fabbrini della Scala family of Florence, and those on the sides may belong to a cadet branch of the Orsini family, but he offers no dates. Curatorial files, Philadelphia Museum of Art.
3. This escutcheon is present in a photograph in Pedrini 1925 but is missing from the 1948 and 1969 editions of the book. According to Pedrini, the cradle was once in the collection of Stefano Bardini. In 1925 it is described as already in the collection of R[aoul] Tolentino.
4. Peter Thornton cites a letter that refers to the need for two cradles, a nighttime and a daytime version, for the child of a Burgundian duchess (P. Thornton 1991, p. 253, citing Eames 1977, pp. 93–107, which presents several sources from northern Europe describing preparations in the thirteenth and fourteenth centuries for baptism and room decor following a child's birth).
5. This description is from a letter written by one of the grandmother's ladies-in-waiting who had come to Milan from Ferrara for the birth (P. Thornton 1991, p. 253, n. 2). Thornton also cites other examples of expensive cradles.
6. Kevill-Davies 1991, p. 106ff.

SELECTED REFERENCES: American Art Association 1924, lot 767; American Art Association 1925, lot 523; Pedrini 1925, pp. 125–26, 283, fig. 304; Pedrini 1948, p. 148, fig. 380; Pedrini 1969, p. 149, fig. 379; Currie 2006a, p. 58; Musacchio 2006, p. 127

Profane Love

Profane Love: The Challenge of Sexuality

James Grantham Turner

Painting moves the senses more readily than poetry does. . . . Painters have depicted libidinous acts, so lustful that they have incited the spectators to play the same party game; poetry will never do this.

—*Leonardo da Vinci,* Paragone, *early 1490s*

I believe that the most rare master Jacopo Sansovino will adorn your chamber with a *Venus* so true and so alive that it fills with lust the mind of everyone who beholds it.

—*Pietro Aretino, letter to Federigo Gonzaga, August 6, 1527*

After I obtained from Pope Clement the freedom of Marcantonio of Bologna, who was in prison for having made copper engravings of the 16 ways [of making love], I felt the wish to see the figures, and having seen them I was touched by the spirit that moved Giulio Romano to design them. And because poets and sculptors ancient and modern often write and sculpt lascivious things to amuse the mind—as proved by the marble satyr in the Chigi palace trying to violate a boy—I dashed off the sonnets on them that you see below. What's so bad about seeing a man mount on top of a lady? Should the animals be more free than us?

—*Pietro Aretino, letter to Battista Zatti, December 11, 1537*

Erotic art flourished in the Renaissance, though in theory it should never have existed. Church and state condemned every kind of sex outside wedlock, and forbade all experiments in the marriage bed. Husband and wife were thought to commit adultery if they desired each other too intensely, pursued pleasure for its own sake, or even looked at each other naked. Modesty made it impossible to visualize even the legitimate, procreative act of love. Birth trays and cassone panels celebrated betrothals, weddings, and childbirth—as did representations of those ritual moments in the life of the Virgin Mary—but the physical reality of sex and procreation remained taboo.

And yet explicitly erotic themes *did* engage the best artists and produce a serious body of art. This essay is intended to better orient the reader about its development and about the images in the following section. Multiple experiments with sexual content were launched by many artists independently. The best-known designs, soon disseminated in engravings, were produced by Raphael (1483–1520) and his students for the decoration of private spaces such as the villa and love nest (later known as the Villa Farnesina; see fig. 31) of the papal banker Agostino Chigi, and Cardinal Bernardo Dovizi da Bibbiena's bathroom in the Vatican (commissioned about 1516; see Linda Wolk-Simon's essay "Rapture to the Greedy Eyes" in this volume). According to the famous 1537 letter by the satirist Pietro Aretino (1492–1556) quoted above, Raphael's illustrious student Giulio Romano (1499?–1546) designed the notorious engravings known as *I modi* (usually translated into English as *Ways* or *Positions*, both in reference to sexual acts), now lost but recorded in contemporary copies (cat. nos. 99, 100). Giulio continued to dramatize sexual encounters on a larger scale, as in the monumental painting *Two Lovers* (fig. 38), of about 1524. Here Giulio provides an almost-lifesize study of the throes of passion

and a portrait of the illicit-sex world: explicitly sexual scenes are carved into the furniture, a disreputable bawd interrupts (or spies on) the couple, and her sniffing dog points to an outrageous visual pun on keys and locks.[1] Nevertheless, this composition was esteemed by the ruling family who probably commissioned it, the Gonzaga of Mantua, and extravagantly praised by Giorgio Vasari (1511–1574).

Tuscan and northern Italian artists also contributed to this remarkable "sex-positive" moment in the High Renaissance. The Bolognese engraver Marcantonio Raimondi (ca. 1470/82–1527/34) experimented with erotic subjects, including female masturbation (fig. 45), even before he collaborated on the *Modi*.[2] Correggio (1489?–1534) made sumptuous erotic paintings of mythological subjects, which were so highly valued that the duke of Mantua presented several of them to Emperor Charles V. Parmigianino (1503–1540) introduced touches of unconventional eroticism in frescos (fig. 77), etchings, and especially drawings (cat. nos. 96, 97), which include the earliest interpretations of the *Modi*.[3] Rosso Fiorentino (1494–1540) initiated the influential series of twenty *Loves of the Gods*, augmented by Perino del Vaga (1501–1547) and engraved in 1527 by Gian Giacomo Caraglio (ca. 1500–1570) (cat. nos. 101a–g). Titian's resplendent Venuses often draw attention to the genital area (cat. no. 152; fig. 87). Even Michelangelo (1475?–1564) burst into this field with his large-scale designs for *Venus and Cupid* and *Leda and the Swan*, executed in the early 1530s but now known only through copies.[4]

EROS IN PHILOSOPHY AND ART

Philosophers imposed a different kind of barrier between "sacred" and "profane" love. Plato and his followers distinguished between two contrasting kinds of desire (*erōs*), lower and higher. The "Vulgar" Aphrodite rules the earthly realm of physical desire

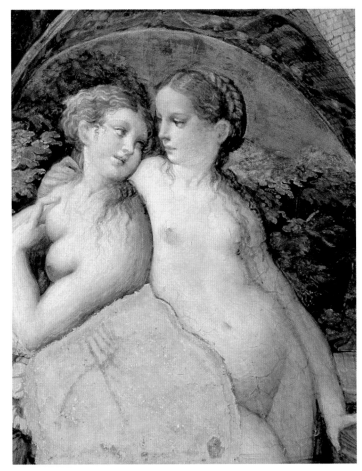

Fig. 77. Parmigianino (Francesco Mazzola) (1503–1540), *Diana Transforming Actaeon into a Stag* (detail), ca. 1523–24. Fresco. Museo Rocca Sanvitale, Fontanellato

and biological reproduction, whereas the "Celestial" Aphrodite ascends to the pure realm of "ideal forms" by steps, shedding the body entirely. Sex and marriage belong to the lower goddess (always called by her Roman name, Venus, in the Renaissance), so she must be rejected by anyone seeking the higher beauty, according to philosophers like Marsilio Ficino (1433–1499) and Giovanni Pico della Mirandola (1463–1494): the ethereal Venus, "chaste, orderly, superior, divine and spiritual," is the cause of all good things; the other Venus, "inferior, disorderly, variable, lascivious, animal, obscene," is the root of all evil.[5] This theory of the two Venuses influenced Renaissance artists—and twentieth-century art historians. Michelangelo, for example, committed himself to the higher Love advocated by Socrates in Plato's *Symposium*, homoerotic but not homosexual, despising physical sex and the lower bodily organs but also excluding the opposite sex: in one sonnet Michelangelo declares that women are "too dissimilar" to partake in the Celestial Venus.[6] In this climate, treating physical sexuality with high artistic seriousness would be a contradiction in terms. Art strives for beauty, but "Cupid is ugly."[7]

Theories of love and the body had begun to change, however. Though the Platonist Ficino taught that lovers should communicate through gazing alone, he recognized that the soul imprints images while men and women are "making babies," and describes

eyesight in quite sexual terms: a stream of "sanguine spirits" penetrates the heart like sperm.[8] Later thinkers developed these hints, admitting that the "higher" Eros could be found in physical, even procreative desire.[9] By aspiring to nobility and beauty, sex became compatible with art. Of course, these theories were voiced mostly by elite males, but important contributions to this "sensuous turn" were made by a Jewish intellectual (Judah León Abravanel, ca. 1465–1530) and a courtesan (Tullia d'Aragona, 1510–1556). Abravanel (Leone Ebreo) recognized sex between man and woman as a natural effect of sacred Love, and traced parallels between the penis and the tongue, ejaculation and verbal expression.[10] Tullia d'Aragona drew on her own "experience" to argue that corporeal, sexual union is *necessary* to achieve the highest stage of love, the fusion of two bodies and two souls; in this way the "lascivious" can become virtuous and honorable. A fictional character based on Tullia applies this vision to art and literature, especially praising Titian's "paradisial" transformation of the body.[11]

For a brief period, before the Counter-Reformation, arousal could be interpreted as a positive experience that yielded new ways of seeing and producing art. In this stimulating culture artists' discoveries and writers' ideas fed each other. Patrons and critics who valued "profane" Eros more highly also encouraged sensuous intensity and sexual subject matter in the work they commissioned or promoted. Giorgio Vasari loved the "grace" and "naturalness" of Giovanni da Udine's genital puns in Agostino Chigi's villa, where a squash with aubergine scrotum splits open a ripe fig (not to mention the peach hanging close to Cupid's shapely bottom) (see fig. 32).[12] Pietro Aretino's letters to powerful rulers equate sexual stimulation and aesthetic quality, whereas we would undoubtedly separate them into good "art" and bad "pornography." In the letters quoted at the beginning of this essay, we see that Aretino defends "lascivious things" and recommends a statue of Venus by Sansovino because it will stir "lust" in all who see it at the Mantuan court—in the same rooms where Giulio painted Jupiter with a highly realistic erection, and where the emperor received Correggio's melting erotic fantasies. This way of talking about art encouraged further experiments, such as Bronzino's provocative *Allegory with Venus and Cupid* (National Gallery, London; probably 1540–50) and the sixteenth-century Florentine painter Francesco Salviati's *Triumph of the Phallus* (discussed below; for a print after Salviati, see cat. no. 102), which takes its cue from another famous letter of Aretino's, in which he asks: Why should we be ashamed of the organs Nature has given us? Surely they should be celebrated in art and public ceremonies? [13]

"LIBIDINOUS ACTS"

Some of the key ideas that potentially encouraged erotic art can already be found in the writings of Leon Battista Alberti (1404–1472). In his architectural treatise, he proposed that beautiful images should be placed in the bedroom, because the child will be shaped by whatever forms in the mind's eye at the moment

of conception and during pregnancy. Alberti's treatise on painting—which interprets the mythic lover Narcissus as the inventor of that art, because he embraced the beautiful image on the surface of the pool—began the association of "embracing" with artistic creation. His *De pictura* raised the status and scope of art by insisting that it should capture all the "motions" that express all the human passions, including "desiderium," or desire. And yet one very important passion must be excluded from representation. Though images enter the soul at the moment of orgasm, they should not themselves be erotic; instead, bedrooms should be hung with "portraits of men of dignity," presumably clothed. Decorum overrides exploration, for artists must exercise perfect modesty and eliminate indecent body parts.[14]

Fifteenth-century writing about art gradually adopted the language of sexual passion, but the art itself remained somewhat inhibited. The finest illustrated book of the 1490s, Francesco Colonna's *Hypnerotomachia Poliphili* (The Strife of Love in a Dream of Poliphilo; Venice, 1499; cat. no. 62), describes the effect of sculptures in words such as "incite," "provoke," and even "masturbate," and its influential woodcuts show a sculpted phallus (used in the ancient worship of Priapus), a "pissing boy" fountain, and an excited satyr with an erection, watching a sleeping nymph. But in scenes that the text calls "lascivious" the lovers are depicted fully clothed, as is Leda coupling with the swan, though impregnation certainly happens: in a charming lying-in scene, Leda receives a birth tray (a customary part of the Italian Renaissance childbirth ritual), while her puzzled husband is presented with two large eggs.[15] Priapic realism, with normal human figures, would have to wait for the next generation of graphic artists.

What we might call the "arousal model" of aesthetic value can be seen emerging in the writings of Leonardo da Vinci (1452–1519), especially when he is comparing the different art forms. The amorous power of visual art, for Leonardo, is one proof of the superiority of painting over poetry. In drafts of an unfinished treatise of about 1492, the artist's power of direct representation is said to "move lovers towards the *simulacri* of the object loved, to speak to imitated pictures," and consequently the *giudicatore innamorato*, or "judge in love," has the best response to art. The master painter "overpowers the mind" of men so that they not only "kiss and talk to" portraits of an actual beloved, but also fall in love with images of ideal female beauty ("amare et innamorarsi"). Sight is already "the most noble of the senses" (as Leonardo insists ad infinitum), but a painting of the mistress generates, paradoxically, a new and even higher "sense," a "stupendous admiration and incomparable delight, superior to all the other senses." The art object itself seems to take the active role and actually "makes you fall in love" (*t'innamora*) by kindling all those senses with a desire to "possess" its beauty. Love becomes the original motive of art as well as its immediate effect: "If the painter wants to see beauties that make him fall in love [*lo innamorino*], he is lord of their generation."[16] This much-cited passage is not always properly translated: phrases such as "to fall in love with" (for *innamorare*) or "production" (for *generare*) fail to convey the procreative imagery and the complex interchange between artist and beauty. Leonardo's anecdotes about falling in love with art evoke the story of Pygmalion, but that artist never intended to create an image that would take the active role and *make him* fall in love with it.

"Love" in this Renaissance context might mean the higher, platonic eros that spurns the low desires of the body. But Leonardo, much as he values the "movement of the mind," makes it very clear that the generative passions and movements inspired by art are not merely cerebral or spiritual. When he challenges the poet's claim to "inflame men to love," he chooses intense, physical words like *accendere* and *incitare*, and specifies that the "love" in question is "the principal concern in all animal species"—that is, sexual and procreative. Painting does all that, and more. Leonardo boasts that the purchaser of one of his religious paintings experienced such "lust" (*libidine*) for the female subject that he begged the artist to remove all sacred iconography, so that he could kiss it "without suspicion." Leonardo then invokes a kind of picture known to antiquity but not yet realized in the Renaissance: the explicit representation of sexual acts. To glorify rather than to denigrate or burlesque his art, and to drive home the specifically physical form of *amore* that he means, he claims that "painting moves the senses more readily than poetry does." Specifically, painters "have depicted libidinous acts, so lustful that they have incited the spectators to play the same party game [*festa*]; poetry will never do this."[17]

Clearly the *Modi* designed by Giulio Romano and engraved by Marcantonio Raimondi partake of this same outlook and bring it up to date, just as the sonnets that comment on these lustful images pick up Leonardo's challenge to poetry (cat. no. 100). But Leonardo himself never depicted *atti libidinosi* in a form that could "incite" the viewer. His anatomical-section drawing in Windsor is probably the least erotic image of copulation in art (fig. 78). Though the standing-up posture might suggest pleasure-driven libertine experiment, the butchered midsection—filled with traditional errors of anatomy—quells any desire to identify or draw closer. Leonardo's

Fig. 78. Leonardo da Vinci (1452–1519), *Coition of Hemisected Man and Woman*, ca. 1492. Pen and ink on paper, 10½ × 8 in. (26.7 × 20.4 cm). The Royal Collection © 2007 Her Majesty Queen Elizabeth II

intention may have been to demonstrate what he wrote on another anatomical drawing at Windsor: coitus is so repulsive that were it not for the beauty of the face the human species would die out.[18]

How differently the vertical posture is treated in the next generation. Leonardo's student in Milan Cesare da Sesto (1477–1523) made two vivid little sketches of a standing man with a woman lying backward on a ledge (cat. nos. 90a, b). The same blond, nude couple is depicted in a kind of stop-frame–motion study, once kissing, once on the brink of penetration. Though some of the images in these sketchbook sheets are taken from drawings that the artist would have seen in Raphael's workshop in Rome, Cesare seems to compose these particular scenes afresh, trying different positions for the arms and legs just as the lovers do; his technique captures the presumed feelings of the actors, delighted yet tentative. The Catholic Church continued to denounce this standing position as atrociously wicked, and how-to books warned that it destroyed the feet. But it was celebrated in literature and art. One contemporary sex manual gives it a classical name, the "Combat" or "Lifting of Antaeus."[19] A similar standing man, bowed over and gazing at his partner's genitals, appears among the engraved copies of the *Modi* (fig. 79), and a somewhat more rustic version was added to the woodcut reprint (cat. no. 100). The most brilliant variant was executed in bronze, probably by a sculptor active in Padua, Desiderío da Firenze (cat. no. 112). The satyr and satyress can be lifted apart and joined again, the realistic genitalia slotting together to form the fulcrum; the female balances perfectly, her extended legs serving as both an expression of pleasure and a counterweight.[20]

It should come as no surprise that explicit representations of coitus in the Renaissance involve satyrlike creatures: their classical pedigree made them a fit subject for art, and their hybrid human-animal nature licensed a free exploration of "lower" urges otherwise masked by shame and decorum. When Jupiter takes a satyr guise, as in Caraglio's *Loves of the Gods*, both the design and the genital realism reach a high point.[21] Similarly, graphic artists could depict the sexual organs detached from the body and writhing with a life of their own, in playful "grotesques" and ingenious composite heads—well illustrated in this volume by a medal associated with Aretino (cat. no. 113a) and a remarkable majolica plate, apparently related to a lost engraving (cat. no. 110). The giant winged

phallus appears already in a fifteenth-century engraving, looking down at peasants who couple sitting upright (fig. 46).[22] In an engraving after Parmigianino the penis mutates into a strange steed ridden to a witches' Sabbath, and in a drawing by or after Salviati (see cat. no. 102) it becomes a vast effigy carried in triumph, like a victorious Roman general, toward the female "arch."[23] This astonishing composition, *The Triumph of the Phallus,* is over five feet in width; it combines grotesque satire and classical monumentality, articulating dozens of elegant figures into an animated procession. Renaissance artists created obscene yet brilliant counterparts to the objects that celebrated marriage. The phallic plate in this volume (cat. no. 110) parodies the plates with the profiles of beautiful women or facing couples (see cat. nos. 9–14), and, in its dimensions, *The Triumph of the Phallus* emulates the painted cassone panel (see cat. nos. 56–59a, b, 134, 136, 138). It is even closer to the cassoni of Salviati's own day, whose decoration had evolved from painting to monochrome relief carving.[24]

When the genital organs were isolated from human anatomy, reanimated or transferred to the animal satyr, artists felt free to treat them with brilliant invention and bawdy wit. In this period, the word "satire" was thought, mistakenly, to come from the word "satyr." A greater challenge was to reattach these organs to the body, to reintegrate sexuality and its "motions" into the full human figure—the body treated not as comic or grotesque but as idealized and heroic. The most striking example was the *Modi*, where the figures are nude and modeled like classical sculpture (in an age when couples normally wore nightshirts or kept their clothes on). In less clandestine publications, some illustrations of the so-called Vitruvian Man—the ideally proportioned human figure stretched out in a circle and a square—give him a full erection.[25] Leonardo's drawing of the Vitruvian Man conjures up the Renaissance in most twenty-first-century minds, even appearing on the Italian one-euro coin. But these phallic versions, if less appealing, express the period just as directly.

EXPERIMENTS IN ANTIQUITY

The visual and the erotic would not have been so closely linked without the influence of classical antiquity. Renaissance artists and thinkers conceived the ancient Romans as free from shame, glorifying the nude body and sanctifying explicitly sexual subjects.[26] Though they never saw the paintings of Pompeii (still buried under volcanic ash), they read avidly in erotic literature and mythology, while gleaning what they could from newly discovered sculptures, coins, gems, and pottery fragments.

The gods of antiquity were powerful but not remote from human feelings. They represent the passions in their sublime aspect: Venus and Priapus stood for sex itself, while most Olympian deities and mythological creatures were famous for both hetero- and homosexual affairs (Ganymede and Hyacinth fascinated Renaissance artists; see cat. nos. 91, 93b). Classical myths encapsulated characters and temperaments (we still refer today to a narcissistic or oedipal personality), blurred the boundaries of sacred and profane, raised the status of sex, and brought it closer to art. Venus, for example—the goddess and the planet—stimulates all kinds of creativity and visual awareness. This was well understood by the Florentine writer Giovanni Boccaccio (1313–1375), the influential author of the *Decameron* and the *Genealogy of the Pagan Gods*. When

Fig. 79. Anonymous Italian artist, Reversed copy of Marcantonio Raimondi's *Modi* 2 or 11, numbered II (It I 22, fol. 49), undated. Engraving. Albertina, Vienna

he draws up a list of everything that Venus means, Boccaccio joins together qualities that the present-day reader might not connect: Venus signifies not only "all genres of fornications and *lasciviae* and multiplicity of coitus" but "mastery in statues and pictures, the composition of garlands and costumes embroidered in gold and silver." In short, sexual desire inspires an interest in "the design of everything," or *rerum omnium decor* in Boccaccio's Latin phrase.[27]

The Church may have confined sex to a single proper form (married, procreative) and condemned every position but the "natural" one as mortal sin, but antiquity enjoyed "multiple" kinds and collected them like statues and pictures. In Latin literature educated Renaissance men (and some women) could read about different sexual practices and techniques, collected into *Kama Sutra*–like books by famous courtesans and illustrated in paintings by major artists. Clever allusions to these variations, with boys as well as girls, were bandied about at glittering occasions such as the 1519 staging of a comedy, *I suppositi* by the great poet Lodovico Ariosto, in the Vatican, for which Raphael designed the sets and Aretino's friend Maestro Andrea the costumes. The jokes about sexual "suppositions"—or "sub-positions"—may have shocked the French ambassador, but they amused Pope Leo X and surely stimulated the invention of Giulio Romano and Aretino, both almost certainly in the audience. The next edition of that play updated the puns to refer explicitly to the new *Modi* engravings. For Ariosto, these were the modern equivalent of the ancient sex manuals, *carte più belle che honeste*—printed sheets that, if not strictly decent, were undeniably beautiful.[28]

A famous passage in Terence's comedy *The Eunuch* describes a young man and woman who look at a painting of Jupiter about to make love with Danae and feel inspired to do likewise.[29] Renaissance depictions of the "Loves of the Gods" call on the same identification and projection. Caraglio's superb engravings quite openly invite the viewer's sexual involvement. Aretino whips up interest in Michelangelo's *Leda* by insisting that "you can't look without envying the swan, who enjoys her with such realistic emotion that he seems, reaching out his neck to kiss her, to be breathing into her mouth the spirit of his divinity."[30]

In Rome, these ways of talking about sex and art were reinforced by freshly excavated objects, whose astonishing beauty threw old certainties into doubt. As early as 1420, the sculptor Lorenzo Ghiberti marvels over the "mastery" and the erotic tenderness of a recently unearthed *Sleeping Hermaphrodite*. He understands that great art not only demands sensuous response (he calls the finer points of the sculpture "sweet") but engages *all* the senses—especially touch, which the Platonists despised. After caressing the nude *Hermaphrodite,* Ghiberti concludes that "the sight would have discerned none of these sweet things, if the hand by touching had not found them."[31] In Aretino's letter of 1537 quoted above, the satirist cites an actual classical statue as his justification for the *Modi*, indeed for all erotica in art and literature. This response was already anticipated in the *Modi* engravings themselves, where several figures echo—or reanimate—ancient sculptures with which Giulio and Marcantonio were intimately familiar.

Artists learned about erotic seeing from antiquity, not only by encountering sculptures, but also by heeding stories about humans who burn with desire for statues—myths like that of Pygmalion, anecdotes like that of the youth so obsessed with Praxiteles' statue

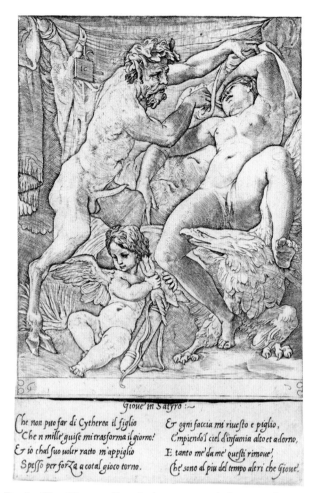

Fig. 80. Gian Giacomo Caraglio (ca. 1500–1570), *Jupiter and Antiope* (*Loves of the Gods,* no. 6, state ii/ii), 1527. Engraving, 17¾ × 12¾ in. (45 × 32.5 cm). Szépművészeti Múzeum, Budapest

of Aphrodite that he copulated with it, leaving his mark behind. As retold in the Renaissance, these are no longer cautionary tales but wholly positive examples of art's ravishing power. Benedetto Varchi, a major theorist of the 1540s, crows that in antiquity "men fell in love with marble statues, as happened to the Venus of Praxiteles," while today "the very same happens all day long in the Venus designed by Michelangelo."[32] (Varchi's phrasing is deliberately provocative, for where we would expect "*with* the Venus" he unmistakably uses "alla Venere" or "nella Venere"—as if the love-struck viewer launches something *at* the sculpture yet is captivated *within* the picture.) The poet Anton Francesco Doni declares that Michelangelo's sculpture *Aurora* "makes you leave the most beautiful and divine woman you could ever see, in order to embrace and kiss" the statue itself.[33] Lodovico Dolce, a disciple of Pietro Aretino, goes even further in his famous 1554 letter describing the *Venus and Adonis* that Titian had just sent to King Philip II of Spain:

> There can be no one so chilled by age or so hard in his makeup that he does not feel himself growing warm and tender, and the whole of his blood stirring in his veins. And no wonder; for if a marble statue could, as it were with the goads of its beauty, penetrate to the marrow of a young man so that he left the stain there, then what should this figure do which is flesh, which is beauty itself, which seems to breathe?[34]

The sexual softening and stirring of the *viewer*—a whole-body experience common to women and men, not narrowly phallic—become direct evidence that the *painting* is alive.

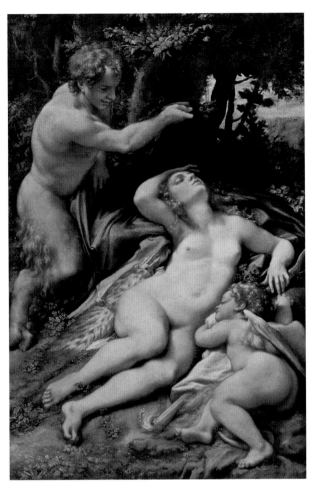

Fig. 81. Correggio (Antonio Allegri) (1489–1534), *Venus, Satyr, and Cupid* (wrongly titled *Jupiter and Antiope*), ca. 1524. Oil on canvas, 74 × 49¼ in. (188 × 125 cm). Musée du Louvre, Paris

In the art world, then as now, a hint of unorthodox sexuality denoted creativity and experiment. Renaissance "artspeak" borrowed from antiquity a pose of easygoing bisexuality and associated sophisticated gender-bending with ideal beauty and virtuosity. Ghiberti's appreciation of ancient sculpture was inspired by a hermaphrodite, seductively "turning so as to show both the male and female nature"—confirming Boccaccio's assumption that "mastery in statues" is inseparable from "multiple" sex. Ancient bisexuality directly influenced the life of the modern studio, as captured in a famous anecdote from Benvenuto Cellini's autobiography. Asked to bring a beautiful courtesan to a party that included Giulio Romano and Michelangelo, Cellini selects and cross-dresses the handsome youth Diego—who can pass as the ideal of *female* beauty because he already resembles "the statue of Antinous," the emperor Hadrian's male lover.[35]

Aretino's letter about the *Modi* offers two justifications that might strike us as contradictory. One is based on nature—all animals do it, so why should we be ashamed?—and the other on classical art. Ironically, his touchstone for the heterosexual *Modi* is a strikingly homosexual statue, an erect satyr "trying to violate a boy."[36] Naturalism and classicism could belong together, as long as both remained true to sexual experience. Aretino also praised Michelangelo for designing Venus "with the muscles of the male in the woman's body, just as she is moved by male and female feelings"—an opportunity to show his "marvellous rotundity of line" and "elegant vivacity of artifice."[37] This extraordinary passage of eroticized art criticism mingles elements of what we now

call homo- and heterosexuality, and grants equal importance to men's and women's natural feelings of arousal. Dolce's description of Titian's *Venus and Adonis* likewise praises the bisexual combination of masculine and feminine beauty in the "lascivious" Adonis—"a difficult, pleasurable mixture"—and the turning posture of the nude Venus, which shows her buttocks and face at once, and proves that painting can outdo sculpture by modeling figures in the round: "The Venus has her back turned, not for lack of art as with some painters, but to demonstrate double art."[38] (This composition can be appreciated in the Metropolitan Museum's own *Venus and Adonis* by Titian, closely related.)[39] Titian himself, recommending his work to his royal patron Philip II, seems to suggest that "double" sexuality means double artistry: "Because the *Danaë* that I already sent Your Majesty showed herself entirely from the front viewpoint, I wanted in this other *poesia* to play variations, and make it show the contrary part."[40]

The word Titian uses is *variare*, and "variety" defines one of the principal challenges to the Renaissance artist. Bette Talvacchia, in the most important study of the *Modi*, shows how deeply Giulio Romano was committed to *varietà*, generating fresh and inventive compositions from a core of classical models by varying the posture, the angle of vision, the gesture of the limbs, the age, and the sex; his designs for erotic engravings fit perfectly into this pattern.[41] Artistic "variety" and sexual virtuosity fed into each other. Experiments such as the *Modi*, the *Loves of the Gods*, and Cesare da Sesto's sketches of standing coupling came about, in fact, because antiquity approached sexual pleasure in much the same way Renaissance artists approached sculpture, painting, and engraving: as a set of complex formal variations constituting an "art" to be mastered. This is nicely captured in a poem by the Florentine painter Bronzino, who praised the paintbrush for its ability to perform "diverse acts and extravagant modes, in front or behind, diagonal, foreshortened or in perspective"—but the word he uses for the brush, *penello*, also means "little penis" (see Linda Wolk-Simon's essay).[42] Bronzino defines the compositional techniques most valued in his day: complex diagonals, sinuous *contrapposti* that show front and rear beauties in the same plane, virtuoso feats of foreshortening (*iscorcio*) and perspective (*prospettiva*). The same design principles inspired the *Modi*, which applied them to figures caught in the act, focusing attention on the vanishing point of the genitals. Caraglio clearly rose to the challenge posed by Marcantonio's more athletic postures: to combine torque and foreshortening without loss of clarity (cat. no. 101a, g).

The *Modi* and the *Loves of the Gods* can thus be seen as laboratories of mainstream taste rather than pornographic sideshows. The "arousal model" fostered by Aretino increasingly influenced the taste of patrons like the Gonzaga in Mantua and King Francis I of France, and in effect weakened the distinction between the supposedly "dishonorable" engraving and the prestigious painting. If we compare Correggio's Paris *Venus, Satyr, and Cupid* (fig. 81) with Caraglio's *Jupiter and Antiope* (fig. 80) we find a remarkable similarity. There seems to be a direct dialogue between them, though the circumstances and direction of the influence remain a mystery. Taken together, they exploit to the full the resources of the serpentine, foreshortened, and rotated nude, scrutinized by an openly desiring observer. Along with Titian's *poesie*, they sum up what Lodovico Dolce meant by "double art."

Epigraphs: Leonardo, *Paragone*, 1949 (ed.), pp. 65–66, "Move più presto i sensi la pittura, che la poesia. . . . [Pittori] hanno dipinto atti libidinosi e tanto lussuriosi, che hanno incitati li risguardatori alla medesima festa, il che non farà la poesia"; Aretino, letter to Federico Gonzaga, Marquis of Mantua, August 6, 1527, in Aretino, *Lettere*, 1995–98 (ed.), vol. 1, pp. 38–39, "Credo che messer Iacopo Sansovino rarissimo vi ornarà la camera d'una Venere sì vera e sì viva che empie di libidine il pensiero di ciascuno che la mira"; Aretino, letter to Battista Zatti, December 11, 1537, in Aretino, *Lettere*, 1995–98 (ed.), vol. 1, pp. 654–55, "Dapoi ch'io ottenni da papa Clemente la libertà di Marcantonio bolognese, il quale era in pregione per avere intagliato in rame i XVI *modi ecc.*, mi venne volontà di veder le figure . . . e vistele, fui tocco da lo spirito che mosse Giulio Romano a disegnarle. E, perché i poeti e gli scultori antichi e moderni soglion scrivere e scolpire alcuna volta per trastullo de l'ingegno cose lascive, come nel palazzo chisio fa fede il satiro di marmo che tenta di violare un fanciullo, ci sciorinai sopra i sonetti che ci si veggono ai piedi. . . . Che male è il veder montare un uomo adosso a una donna? Adunque le bestie debbono essere più libere di noi?" All translations are mine.

1. Kustodieva 1994, no. 113; Barolsky 1978, pp. 132–33; Talvacchia 1999, p. 43. Vasari describes and praises a composition identifiable as this painting, and links it to Gonzaga patronage, in his "life" of Giulio Romano; Vasari, *Le vite*, 1568/1912–14 (ed.), vol. 6, p. 162. For erotic drawings associated with Giulio, see Gombrich et al. 1989, p. 280; Talvacchia 1999, fig. 24; and Wallace, Kemp, and Bernstein 2007, p. 64.
2. Landau and Parshall 1994, fig. 313.
3. Ekserdjian 2006, p. 110.
4. J. K. Nelson 2002.
5. Pico delle Mirandola, *Cabalistarum Selectiora*, 1549, fol. 85v. See Plato, *Symposium*, 1975 (ed.), pp. 106–23, 172–209 (but compare pp. 132–47, for a different account of Eros, much more friendly to sex of all kinds); and Panofsky 1969, pp. 114–16.
6. Quoted in J. K. Nelson 2002, p. 48, "Donna è dissimil troppo."
7. As argued in Frezzi, *Il quadriregio*, 1506, despite the beautiful woodcut illustrations (MMA 21.4.1). Cupid or Amor (Greek Eros) was of course the son of Venus (Greek Aphrodite), but moralists use their names interchangeably to refer to kinds of love.
8. Musacchio 1999, p. 129; Perlman 2000, pp. 114, 123, n. 24.
9. Rossoni 2002.
10. Turner 1987, p. 68; Ruvoldt 2004, pp. 74, 200, n. 34.
11. Turner 2003a, pp. 38–41; the Tullia character, in Sperone Speroni's 1537 *Dialogo d'amore*, is discussed in Pardo 1993, pp. 55–59.
12. Morel 1985.
13. Aretino to Battista Zatti, December 11, 1537, in Aretino, *Lettere*, 1995–98 (ed.), vol. 1, pp. 655–56. This letter to the otherwise obscure Zatti may have accompanied a now-lost woodcut edition of the *Modi* and the poet's sonnets from 1537—the ancestor of the pirated version (cat. no. 100).
14. L. B. Alberti, *Della pittura*, 1950 (ed.), pp. 77–78, 92–95; L. B. Alberti, *On Painting*, 1956 (ed.), pp. 64, 76–79; Musacchio 1999, p. 130.
15. Colonna, *Hypnerotomachia Poliphili*, 1499, fols. d4-v, d8-v, e7, k6v, k7v, m6, C5v.
16. Leonardo, *Paragone*, 1949 (ed.), pp. 51, 53–54, 56, 59, 61, 65; all passages from the "Prima parte" of the Codex Urbanas, a manuscript treatise redacted by a sixteenth-century scribe (the title *Paragone* was added only in the nineteenth century). Note that landscape, the other main instance of the artist's ability to create according to his desires, is also described as an amorous scene where the lover can visualize himself with his beloved (p. 63). Scholars are now paying more attention to Leonardo's claims for the power of art to "arouse desire in the beholder," as Linda Wolk-Simon reminds us in this volume (see "Rapture to the Greedy Eyes," n. 19).
17. Leonardo, *Paragone*, 1949 (ed.), pp. 65–66.
18. *Leonardo da Vinci* 1977, no. 32b (Royal Library, Windsor, 19009v).
19. *Il piacevol ragionamento de l'Aretino* 1987 (ed.), p. 97; Brundage 1984, pp. 86–87; Lawner 1984, p. 55; Bell 1999, p. 34; Talvacchia 1999, p. 120.
20. See Turner 2008.
21. See Turner 2007a, fig. 188, for a hypothetical reconstruction of the lost first state.

22. Konrad Oberhuber in Levenson, Oberhuber, and Sheehan 1973, App. A., pp. 526–27. Though hundreds of impressions must have been made, judging from the condition of the plate, only the copperplate survives and no paper copy.
23. Ekserdjian 2006, p. 116; Monbeig Goguel 2001, p. 24; Turner 2007c.
24. See, for example, MMA 41.190.255.
25. See, for example, Cesare Cesariano's Italian translation of Vitruvius (Como, 1521), fol. 50.
26. Valeriano, *Hieroglyphica*, 1575, quoted in Steinberg 1983, p. 21.
27. Boccaccio, *Genealogie*, 1998 (ed.), pp. 338–40.
28. Ariosto, *I suppositi*, 1551, fol. A3v; Ariosto, *Lettere*, 1887 (ed.), pp. clxxviii–clxxx; Ariosto, *Commedie*, 1933 (ed.), pp. 85–86; Frommel 1984; Shearman 2003, pp. 439–42. For illustrated sex manuals by the courtesan-author Elephantis, mentioned in Ariosto's prologues, see, for example, Suetonius *Tiberius* 43.1 (*Suetonius* 1997–98 [ed.], vol. 1, pp. 370–71); *Priapea* 1988 (ed.), no. 4; and Martial *Epigrams* 12.43 (Martial, *Epigrams*, 1993 [ed.], vol. 3, pp. 124, 125).
29. *Terence* 2001 (ed.), vol. 1, pp. 378–81.
30. Aretino to Guidobaldo, Duke of Urbino, in Aretino, *Lettere*, 1995–98 (ed.), vol. 2, p. 14, "Non si può mirar senza invidiare il cigno, che ne gode con affetto tanto simile al vero che pare, mentre stende il collo per basciarla, che le voglia esalare in bocca lo spirito de la sua divinità." This 1542 letter accompanied copies of Michelangelo's *Venus* and *Leda*, procured for Guidobaldo (see n. 37 below).
31. Ghiberti, *I commentarii*, 1998 (ed.), p. 108, "Era moltissime dolceze; nessuna cosa il viso scorgeva, se non col tatto la mano la trovava." See also Pardo 1993, pp. 62–64. For unearthed sculptures, see also Barkan 1999.
32. Quoted in J. K. Nelson 2002, p. 44. The fullest account of responses to Praxiteles' Aphrodite of Cnidus is Lucian of Samosata, *Affairs of the Heart*, 1967 (ed.).
33. Emison 1997, p. 155.
34. Letter to Alessandro Contarini, 1554/55, in Roskill 1968/2000, p. 216, "Niuno cosi affredato da gli anni, o si duro di complessione, che non si senta riscaldere, intenerire, e commoversi nelle vene tutto il sangue. Ne è maraviglia, che se una statua di marmo pote in modo con gli stimoli della sua bellezza penetrar nelle midolle d'un giovane, ch'ei vi lasciò la macchia: hor, che dee far questa, che è di carne; ch'è la beltà istessa; che par, che spiri?" This painting, dispatched to "il Re d'Inghilterra" (that is, Philip II, married to Mary Tudor), is almost certainly the one now in the Museo del Prado, Madrid.
35. Cited, for example, in Jacobs 2000, p. 60. For statues identified as Antinous, see Haskell and Penny 1982, no. 4.
36. Aretino to Battista Zatti, December 11, 1537, in Aretino, *Lettere*, 1995–98 (ed.), vol. 1, pp. 654–56. For the sculpture itself (in the "palazzo chisio," or Villa Farnesina), see Bober and Rubinstein 1986, p. 109.
37. Aretino to Guidobaldo, Duke of Urbino, in Aretino, *Lettere*, 1995–98 (ed.), vol. 2, p. 14, "Contornata con maravigliosa rotondità di linee: e . . . [Michelangelo] le ha fatto nel corpo di femina i muscoli di maschio, talché ella è mossa da sentimenti virili e donneschi con elegante vivacità d'artifizio." Aretino's letter accompanies two paintings by Vasari (now lost) after Michelangelo's *Leda* and *Venus* cartoons; the *Leda* can be reconstructed from engravings and a cartoon attributed to Rosso Fiorentino (Royal Academy, London) and the *Venus* from the version that Vasari praises ("colored by Pontormo"; *Le vite*, 1550/1986 [ed.], p. 91), now in the Accademia, Florence.
38. Quoted in Roskill 1968/2000, pp. 212–14, "Vezzi lascivi & amorosi," "mistura difficile, aggradevole," "La Venere è volta di schena, non per mancamento d'arte, come fece quel dipintore, ma per dimonstrar doppia arte." See cat. no. 100 in this volume for a striking example of this turning posture in the *Modi*.
39. MMA 49.7.16.
40. Cited, for example, in Hope 1980a, p. 114, and Ginzburg 1990, pp. 80–81, "Perché la Danae, ch'io mandai già a Vostra Maestà, si vedeva tutta dalla parte dinanzi, ho voluto in quest'altra poesia variare, e farlo mostrare la contraria parte."
41. Talvacchia 1999, pp. 35–38.
42. Bronzino, *Rime in burla*, 1988 (ed.), p. 24, "Diversi atti e modi stravaganti . . . o dirieto o davanti, / a traverso, in iscorcio o in prospettiva."

Giulio Pippi, called Giulio Romano
Rome, ca. 1499–Mantua, 1546

87. *Woman with a Mirror*

Ca. 1520–24
Oil on canvas, transferred from wood, 43¾ × 36¼ in.
(111 × 92 cm)
Pushkin State Museum of Fine Arts, Moscow (2687)

Believed in the seventeenth century to be by Raphael, this painting of a nude woman seated beside a mirror is now regarded as the work of his principal pupil, Giulio Romano. Patently derived from Raphael's *Fornarina* (a presumed portrait of the artist's mistress; fig. 33), though lacking the myriad poetic and symbolic allusions that invest that complex image with its compelling ambiguity (see cat. no. 88), it depicts an unknown sitter in a darkened interior that looks out onto the open courtyard of a Bramantesque High Renaissance palazzo in which a maidservant

Cat. 87

leans over a balustrade.[1] Whatever her historical identity, the subject's "overtly erotic" treatment and the presence of a sculpture of Venus, goddess of love, in a niche in the background leave little doubt that she is a courtesan.[2] Essentially high-class prostitutes, such women were mainstays of Roman society in the sixteenth century—the cultivated consorts and companions of the significant population of high-ranking prelates whose nominal vows of celibacy proscribed conjugal liaisons but not carnal pleasures.

The established pictorial conventions for courtesan portraits are all faithfully observed in Giulio's painting, notably the woman's state of undress; her inviting, seductive body language (the presentation of her breast to the implied visitor whom she welcomes to her private chamber with her upraised right hand);[3] and the array of luxury items, in this case a mirror and a cosmetic or jewel box that were the tools of the courtesan's trade, on the table beside her. (A rare surviving example of such an object, decorated with appropriately profane imagery, is included in this volume; cat. no. 114.) The expensive jewels with which the woman is adorned further signal her status as a courtesan. Pearls, rubies, and other gems were among the valuable trinkets that successful courtesans and high-class prostitutes received, not only as payment for the "carnal commerce" they practiced but also as tokens cementing the relationships they entered into with their clients and patrons: just as the woman "made a 'gift' of her body, [so was] the man 'naturally obliged' (but also legally required) to honour this gift with a counter-gift" of jewelry and other luxury objects.[4] (Sixteenth-century documents describe such items and the transactions surrounding them in rich detail.) Giulio's sensuous nude is the very paradigm of the prosperous Renaissance courtesan.

Mistress portraits in the Renaissance were often covered by shutters or curtains. (Pietro Aretino referred to a portrait of a mistress by Titian that was kept behind a curtain, and Raphael's *Fornarina* was once outfitted with a shutter.) This device served to conceal the illicit image from all but its intended audience, while heightening its erotic aspect by engaging the observer as an active participant who must remove the cover to behold the object of his desire. Acknowledging this convention for the display of mistress portraits, Giulio incorporates precisely such a curtain into the painting itself, to the sitter's left: pulled off to one side and flowing as though still in motion, the drapery, he suggests, has just been parted to reveal the woman who returns the viewer's wanton gaze. There could be no more efficacious demonstration of the truth of Aretino's observation on the power of an erotic image "to fill with lust the thought of anyone who gazes at it."[5] LW-S

1. Suggestions for the sitter's identity, all without foundation, have included Beatrice d'Este, Lucrezia Borgia, and Raphael's mistress, La Fornarina.
2. Rogers 2000, pp. 92–93, itemizes the specific characteristics of Renaissance courtesan portraits though without reference to Giulio's painting; "overtly erotic" is her apt formulation for describing the distinctive manner of portraying courtesans. The seemingly self-evident identification of Giulio's sitter as a courtesan has escaped comment in the literature.
3. So ubiquitous is this gesture in profane imagery (see cat. nos. 107 and 112) that it should be added to the "slung leg" and "chin chuck" in the stock repertoire of erotic motifs.
4. Storey 2006, pp. 71–72.

5. Aretino, *Lettere*, 1957–60 (ed.), vol. i, p. 17, no. ii, referring to a sculpture of Venus.

SELECTED REFERENCES: Vittoria Markova in Gombrich et al. 1989, p. 274, ill. p. 275; Markova 2007, pp. 34–36, no. 5, ill.

Raffaellino del Colle

Borgo San Sepolcro, ca. 1490–1566

After Raphael (Raffaello Sanzio)
Italian, 1483–1520

88. *Portrait of a Nude Woman (The Fornarina), Copy after Raphael*

Ca. 1520
Oil on panel, 32⅝ × 22½ in. (83 × 57 cm)
Borghese Gallery, Rome (355)

In a judgmental aside, the biographer Giorgio Vasari spoke disapprovingly of Raphael's amorous nature, ascribing his sudden and premature death at the age of thirty-seven to a fever contracted after a night of intemperate carousing. He further reported that the painter summoned to his deathbed the *innamorata* of his last years (presumably the mistress who distracted him when he was supposed to be working at Agostino Chigi's surburban villa in Rome), whose care he consigned to his friend the print dealer Il Baviera after making provisions for her in his will. Later known as La Fornarina (the baker's wife or daughter), she may have been the Margarita Luti from Siena referred to in contemporary documents and is probably the subject of Raphael's sensuous portrait of a nude woman painted around 1518 (fig. 33).[1] The present work is a nearly contemporary and exceptionally faithful replica of the painting by one of Raphael's followers, Raffaellino del Colle, who joined his workshop in or around 1519 and remained an assistant to Giulio Romano in Rome after Raphael's death in 1520.

Images of poetic beauty that had the capacity to stir the physical passions of the privileged viewer, mistress portraits were at once real and ideal, Platonic and erotic, evocations of Petrarch's chaste beloved, Laura, and of sensual Venus, goddess of love. That duality informs the portrait of the Fornarina. Despite the occasional claim in the literature to the contrary, the painting presumably does represent Raphael's mistress; his proprietary claim to her is indicated by the armband inscribed with his name to which she points (the signature inscription is absent in this version), an intimate "branding" that would have been inappropriate for a sitter who had no personal connection to the artist.[2] Yet it is

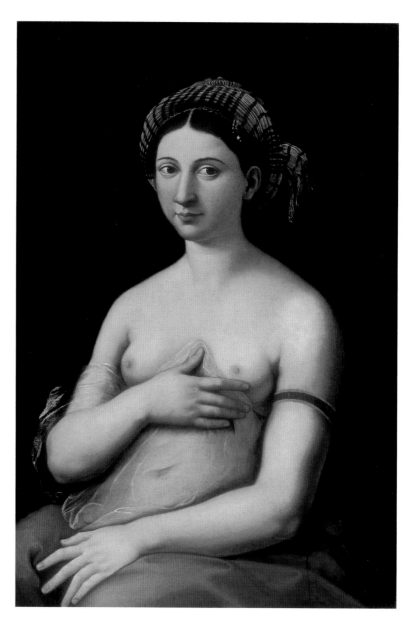

Cat. 88

also an image of perfect beauty, an analogue of Raphael's poetic and cerebral formulation of a "certa Iddea" that was not based on a single individual but was instead a synthesis of the best features of many.[3] That "certain idea" is symbolized by the single pearl adorning her hair, a jewel whose opalescent white sheen was regarded as the equivalent of perfect female beauty. Pearls also connoted "purity, virginity and marital chastity,"[4] virtues that are imputed to the sitter.

Precisely this duality—the tension between the Platonic ideal and the carnal real—is lost in Giulio Romano's portrait (cat. 87), even with its obvious derivation from Raphael's portrait of the Fornarina. If Raphael's work evokes the Petrarchan poetics of Pietro Bembo, for whom contemplation of beauty could lead to an apprehension of a higher truth, Giulio's enticing sitter instead conjures the sensibility of the self-avowed "anti-Petrarch" and satirist Pietro Aretino, who declared that an erotic image had the capacity to arouse the viewer's lust.

LW-S

1. The possible historical identity of Raphael's mistress is discussed in D. A. Brown and Oberhuber 1978, pp. 49–50. Margarita Luti was the widowed daughter of Francesco Luti of Siena who entered a convent for fallen women in Rome four months after Raphael's death. The posthumous nickname "La Fornarina" carried punning erotic associations. Pietro Aretino's courtesan-interlocutor Nanna, for example, frequently refers to ovens and the contents baked inside them as metaphors for heterosexual intercourse: "One thing's clear," she expounds to her disciple Antonia, "for every two people who bake their bread at home, there are seven hundred who want theirs from the baker's: it's whiter" (Aretino, *Secret Life of Wives*, 2006 [ed.], p. 64); and the Florentine academician Giovanni della Casa penned a burlesque verse, *Capitolo del Forno*, in praise of "the warm baker's oven, in which the soft bread rises and gets hard" (quoted by D. A. Brown and Oberhuber 1978, p. 50, who note that the nickname "Fornarina" was not attached to Raphael's mistress in published sources before the eighteenth century).

2. In addition to the inscription, the replica lacks the small ring on the fourth finger

of the sitter's left hand as well as the foliate backdrop, the symbolic connotations of which are discussed above (see my essay). Technical examination of the Borghese portrait would perhaps reveal if its present uniform dark background is original.

3. On Raphael's conception of a "certa Iddea" of ideal beauty, a poetic conceit probably formulated by his friend Baldassare Castiglione, see my essay. For the duality inherent in Renaissance mistress portraits and much of what follows, see also my essay and Luke Syson's essay "*Belle*" in this volume.

4. Matthews Grieco 2006, p. 110.

SELECTED REFERENCE: Della Pergola 1955–59, vol. 2, pp. 121–22, no. 172, ill.

Eugenio Cajés (?)
Madrid, 1575–1634

After Francesco Mazzola, called Parmigianino
Parmese, 1503–1540

89. Cupid Carving His Bow

Late 16th century (1580s?)
Oil on canvas, 58¼ × 25⅝ in. (148 × 65 cm)
Museo Nacional del Prado, Madrid (P00281)

*C*upid Carving His Bow, executed in the 1530s, was one of Parmigianino's most celebrated and widely replicated inventions. It was painted for the artist's friend and patron in Parma, the Cavaliere Francesco Baiardo, whom Vasari in the second edition of the *Lives* described as Parmigianino's "molto familiare amico" (very close friend). A detailed inventory of Baiardo's collection compiled in 1561, the year of his death, attests to the wealth of works by Parmigianino, both paintings and drawings, in his possession. Many of the images, including the *Cupid*, as well as some of his sculptures had erotic subjects suggesting if not a homosexual orientation at least "a taste for the homoerotic" on the part of the Cavaliere, and perhaps of the artist as well.[1]

Parmigianino departs from Renaissance pictorial conventions in showing the god of love not as a cherubic, mischievous young child but rather as a fleshy nude adolescent. The particular subject, Cupid carving a piece of wood to fashion his bow, is also unheralded.[2] Gazing seductively over his shoulder at the privileged viewer (originally the Cavaliere Baiardo) to whom he presents his shapely and ample rear end, Cupid wields between his thighs a large, erect knife—a seemingly mundane object that carried overt erotic and specifically phallic connotations in the burlesque humor and visual imagery of the day.[3] The punning allusion certainly must have been

appreciated by contemporaries, among them the poet and publisher Antonfrancesco Doni, author of a mock-pedantic treatise on the key, another favorite erotic metaphor (for which, see my essay in this volume), who hailed Parmigianino's *Cupid Carving His Bow* as a "must-see" painting for the visitor to Parma.[4]

Enacting the topos *amor vincit omnia* (love conquers all), Cupid delicately tramples underfoot two books signifying wisdom and learning: intellectual pursuit is vanquished by omnipotent Love. Not only is carnal love all-powerful, it is also perilous, with the capacity to inflict pain. This is conveyed by the grimacing putto struggling against his baleful companion's effort to force him to touch the god's flesh—a detail described at some length by Vasari, who observed that he cries from fear of being burned by the "fuoco d'Amore" (fire of love).[5] To resist temptation or succumb to it—that is the conundrum of Parmigianino's alluring tableau, even if wily Cupid's triumph seems inevitable.

Instantly famous, Parmigianino's *Cupid* was also highly coveted, the demand for the image satisfied by the numerous copies that were produced beginning in the later sixteenth century.[6] At an unknown date in the 1560s or 1570s, the original entered the collection of Antonio Pérez, secretary to Philip II of Spain, which was confiscated by the king following Pérez's arrest for murder in 1578. After futile decades of pursuit, Rudolf II of Prague succeeded in acquiring the *Cupid* in 1605. This early, faithful copy, ascribed to the Spanish court painter Eugenio Cajés (or Caxes) was made sometime before the work left the royal collection, perhaps on the basis of a tracing of the original.[7] LW-S

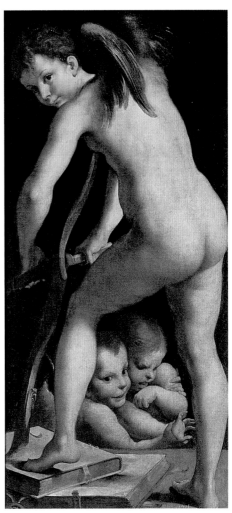

Cat. 89

1. Discussed by David Ekserdjian (2006, pp. 12–13, 99), who notes that contemporary evidence of heterosexual proclivities on the part of Baiardo and Parmigianino also exists, although of the former he says that "it is not unreasonable . . . to assume that . . . the Cavaliere Francesco Baiardo must have been homosexual" (ibid., p. 99). As Rocke (1995) and others have demonstrated, sexual behavior was fluid in the Renaissance, and distinctions between heterosexual and homosexual orientation were largely meaningless. Many males practiced relations of both types, despite the censorious attitude of both the church and civic governments toward sodomy. That said, the homoerotic component of Parmigianino's *Cupid Carving His Bow*—like Caravaggio's even more blatant *Amor*, a prepubescent winged boy who entices with his exposed flesh and inviting grin (Gemäldegalerie, Berlin)—is inarguable and must have been intended expressly to appeal to the patron.

2. The unprecedented subject is commented on by Ekserdjian 2006, p. 98. Wald 2002, p. 167, and Ferino-Pagden and Wald 2003,

pp. 23–26, posit the influence of various antique sources for Parmigianino's unusual treatment of Cupid. The homoerotic overtones of the painting are discussed by Saslow 1986, pp. 129–31.

3. The erotic symbolism of the knife is discussed in Wind 1976, p. 95 and n. 10.

4. In a letter of 1552 Doni advises "andando a Parma fate di vedere il Cupido del Parmigianino," which was then in the Baiardo collection; quoted in Vaccaro 2002, p. 181.

5. Vasari, *Le vite*, 1568/1906 (ed.), vol. 5, p. 230. These two winged children may be a playful allusion to Raphael's two similarly placed winged angels—sacred beings to Parmigianino's profane pair—leaning on a ledge at the bottom of the *Sistine Madonna,* which Parmigianino could easily have seen in nearby Piacenza. Ferino-Pagden and Wald 2003, p. 26, suggest a Platonic interpretation of the two putti as Himeros and Pothos, representing physical and ideal love; Ekserdjian 2006, p. 98, conjectures that "the putti struggling hint at the combat of Eros and Anteros."

6. See Ferino-Pagden and Wald 2003, p. 26ff.

7. Wald 2002, p. 181, n. 57, posits that Cupid and the putti were based on a tracing.

SELECTED REFERENCES: Wald 2002, pp. 180–81, n. 57, fig. 7c; Ferino-Pagden and Wald 2003, pp. 18–32, ill. pp. 25, 26; Ekserdjian 2006, pp. 98–99

Cesare da Sesto

Sesto Calende, 1477–Milan, 1523

90a. Studies of an Amorino Riding a Monster; a Female Seated on an Urn; a Couple Embracing; and Figures of Christ and Saint John the Baptist

Ca. 1510–14

Pen and brown ink over black and red chalk, framing lines in black chalk, 7½ × 5⅝ in. (192 × 143 mm)

Inscribed at upper right in pen and brown ink: *31*

The Pierpont Morgan Library, New York, Purchased by Pierpont Morgan, 1909 (II, 57, recto)

90b. Studies of Saint John the Baptist; Mercury; an Erotic Scene; a Grotesque; and Various Figures, possibly for a Calvary Scene

Ca. 1510–14

Pen and brown ink over red chalk, 7½ × 5⅝ in. (190 × 142 mm)

Inscribed at upper left in pen and brown ink: *14*

The Pierpont Morgan Library, New York, Purchased by Pierpont Morgan, 1909 (II, 40, verso)

90c. Studies of Mars, Venus, and Cupid; Adam and Eve; a Grotesque; and Other Figures

Ca. 1510–14

Pen and brown ink, framing lines in black chalk, 7¾ × 5½ in. (196 × 141 mm)

Inscribed at upper right in pen and brown ink: *11*

The Pierpont Morgan Library, New York, Purchased by Pierpont Morgan, 1909 (II, 37, recto)

Cesare da Sesto was among the most gifted followers of Leonardo da Vinci in Milan. By 1508 he had relocated to Rome, where he collaborated for some years with the Sienese-born painter and architect Baldassare Peruzzi, one of the city's preeminent artists during the pontificates of Julius II (1503–13) and Leo X (1513–21). There Cesare assiduously studied the work of Raphael, whose style profoundly influenced his own. As scholars have long observed, his manner both as a painter and a draftsman reflects his enduring, two-fold debt to Raphael and Leonardo.

Most of the drawings in a now-dismembered sketchbook by Cesare, preserved in large part in the Pierpont Morgan

Cat. 90a

Library in New York, were executed during the artist's years in Rome. In addition to iterations of Raphael's frescoes in the Vatican Stanze and elsewhere and devotional paintings by him such as the *Alba Madonna* (National Gallery of Art, Washington, D.C.), the sketchbook pages also contain drawings after Michelangelo and the antique. These are interspersed with fluid ideas for figures, decorative motifs, and compositions of Cesare's own invention, some of which have been connected (with varying degrees of persuasiveness) with paintings by the artist.

Two of the pages now in the Morgan show amorous scenes (cat. nos. 90a and 90b). The bluntly erotic subject matter, the absence of mythological accoutrements attending the figures, and even the specific postures of the respective pairs of lovers all call to mind the *Modi*—the notorious series of erotic prints designed by Giulio Romano and engraved by Marcantonio Raimondi in 1524 (cat. nos. 99 and 100). Particularly close to that paradigm is the copulating couple at the lower left of cat. no. 90a, who enact in reverse the pose of the protagonists in Giulio and Marcantonio's Position 15 (cat. no. 100, fol. B4v), although the pair at the upper left of

cat. no. 90b loosely recall, again in reverse, their counterparts in another of Giulio's designs, Position 11. An obvious, if precipitous, assumption would be that the sketches were inspired by those celebrated and widely copied inventions; however, such a scenario is virtually impossible, given that Cesare almost certainly could not have known the *Modi*, as he died the year before the prints were published and had been absent from Rome for a decade before that. Like other drawings in the sketchbook, these jottings almost certainly were done during his years there, in which case they cannot have been executed later than about 1514 (the exact date of Cesare's departure from the Eternal City is unknown, but it was in or before that year).

An intriguing question thus arises. Were these erotic musings in pen and ink the product of Cesare da Sesto's own imagination, or do they, like other drawings in the sketchbook, reflect works that he saw in Rome? If the latter, might these sketches derive from material circulating at the time in Raphael's workshop (Cesare's privileged access to which is attested in other drawings in the same pages),[1] and, if so, might that material have served as the heretofore unknown

Cat. 90b Cat. 90c

model and progenitor for Giulio's salacious images of a decade or so later whose figures and poses so closely recall those in Cesare's sketchbook? No such drawings by Raphael are now known, but erotically charged late paintings by him, like the *Portrait of the Fornarina* (fig. 33; see also cat. no. 88) and a lost nude portrait of the courtesan Olimpia, as well as the frescoes in the Psyche Loggia of the Villa Farnesina and the *stufetta* of Cardinal Bibbiena (for which, see my essay "Rapture to the Greedy Eyes" in this volume and figs. 31, 32), confirm that such subject matter was part of his vast repertoire.

Ample precedent existed in ancient Roman art for the explicit depiction of sexual activity, its appropriation but one more reflection of the Renaissance enthrallment with the *maniera all'antica*. Source material also existed in the form of erotic prints, which had been widely circulating since the later fifteenth century and were undoubtedly known to Raphael and his followers as well as to Cesare da Sesto: an engraving of a copulating couple, a record of which survives only in the copperplate (see fig. 46), presumably because effective censorship eradicated all traces of the actual prints, is particularly close to one

of the drawings of lovers from the Morgan sketchbook (cat. no. 90a).

In addition to Raphael, the antique, and erotic prints, Cesare da Sesto may also have had in mind the example of Leonardo, who, according to the late sixteenth-century Milanese painter and theorist Giovanni Paolo Lomazzo, produced erotic drawings. No such work is today known—further victim, perhaps, of the zealous censor's hand and as such another witness in absentia to the one-time prevalence, if not ubiquity, of a genre of Renaissance imagery that "has a tendency . . . not to survive"[2]—but a third page from the Morgan sketchbook (cat. no. 90c) whose principal figures are Venus and Mars (or possibly Roxanne and Alexander) may provide some reflection of Leonardo's lost drawings in this vein. (Certainly, the grotesque head at the lower left recalls Leonardo's caricatures.) What appears to be the head of a lion or other beast at the center of the sheet is seen at second glance to be the buttocks and scrotum of an exceedingly limber boy, his upside-down head framed by his splayed legs as he engages in obscene acrobatics. Witty and lewd, this erotic *grotesquerie* epitomizes Renaissance burlesque humor.

Whether Cesare's two "modi" (cat. nos. 90a and 90b) are his own inventions, echoes of erotic prints or of lost drawings by Raphael that he would have seen in Rome, or recollections of unidentified ancient sources remains for now an unresolved question. Striking in any event is their fluid *mise-en-page*—the seamlessness with which the erotic scenes and classicizing *grotteschi* flow into studies for standing saints on the same pages. It is perhaps not taking too much license to see in this continuum a reflection of the duality and coexistence of the sacred and the profane in the culture of Renaissance Rome.

LW-S

1. Nova 1997, p. 484, notes that "Cesare must have had privileged access to Raphael's workshop because his sketches record inventions for paintings that were not visible in Rome."
2. T. Wilson 2005a, p. 24, in a discussion of Renaissance erotic imagery. Leonardo's lost erotic drawings were more burlesque and humorous than pornographic.

SELECTED REFERENCES: Bean and Stampfle 1965, pp. 36–37, no. 39; Carminati 1994, p. 253, no. D30, ill., p. 256, no. D33, ill., p. 274, no. D50, ill.

Giulio Pippi, called Giulio Romano
Rome, ca. 1499–Mantua, 1546

91. Apollo and Cyparissus OR Apollo and Hyacinth

1520s
Pen and brown ink, brown wash, 11⅜ × 9⅛ in. (289 × 231 mm)
Nationalmuseum, Stockholm (347/1863)
New York only

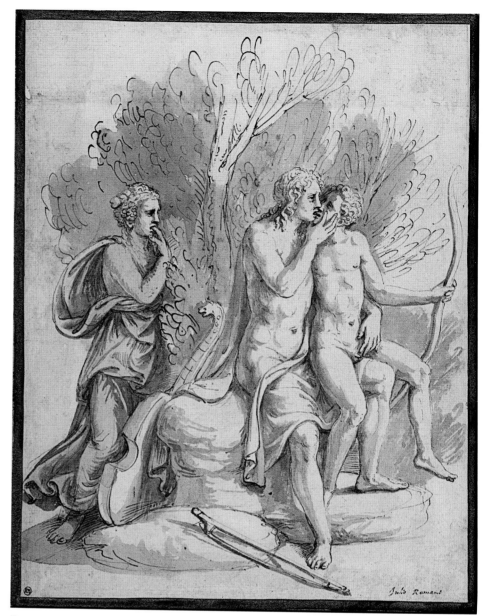

Cat. 91

Was it Giulio Romano's penchant for erotic imagery that led Shakespeare, in *The Winter's Tale,* to anoint him, with singular if surprising praise, "that rare Italian master"? Certainly such subject matter (an understandable source of infamy) occupies a place of exceptional prominence in Giulio's graphic oeuvre, witnessed in his designs for the notorious series of prints known as the *Modi* (cat. no. 99) and in his numerous drawings of erotic encounters (see also cat. no. 92). The present example, unusual in being a scene of homoerotic rather than heterosexual love, depicts either Apollo and Hyacinth (a subject treated in a roughly contemporaneous drawing by Perino del Vaga, Giulio's fellow *garzone*, or apprentice, in the Raphael workshop; cat. no. 93b) or Apollo and Cyparissus. Ovid's *Metamorphoses* tell of both ill-starred adolescent loves of Apollo: Hyacinth, the doomed youth beloved by the sun god, from whose dying blood the crimson hyacinth grew; and the comely Cyparissus, who grieved inconsolably after accidentally killing his cherished stag until his longed-for death was granted by a sorrowful Apollo, who turned him into a cypress tree. In the story of Cyparissus, Ovid describes Apollo as "that god who strings the lyre and strings the bow."[1] As Giulio's compact tableau expressly includes not only the god's string instrument but also his bow, it seems likely that this is the narrative represented.[2] And although the tree that provides the backdrop to the lovers' encounter is clearly not a cypress, its prominence in the composition may have been intended as a further reference to the Cyparissus legend.

Giulio's drawing shows an "explicit scene of sexual activity, as Apollo bestows an open-mouthed kiss on his young companion and fondles his genitals."[3] This candid presentation contrasts markedly with Perino del Vaga's more chaste rendition of a similar Ovidian subject (cat. 93b) and is typical of Giulio's approach to erotic imagery. *Apollo and Hyacinth* from the series the *Loves of the Gods* (cat. nos. 101a–g) engraved by Gian Giacomo Caraglio, while still not as graphic in its depiction of a homoerotic encounter, is

closer in spirit to Giulio's drawing; not coincidentally, the similar pose of the entwined protagonists in the print recalls this composition. It is entirely possible that the author of this design, perhaps Perino del Vaga, had recourse to this source or, conversely, that Giulio knew the Caraglio print. (As the precise date of Giulio's drawing is unknown, the question of chronological priority remains unresolved.)[4]

In *Apollo and Cyparissus* (the identification of the drawing's subject accepted by the present author), Giulio borrows from an established repertoire of coded visual motifs to expound on the sexual theme of the narrative. The "slung leg" pose enacted by Cyparissus was a long-established artistic convention signifying copulation (see also cat. nos. 101a–g, 112),[5] and the lewd gesture of the spying woman at the left—encountered in other of Giulio's erotic drawings—carried an analogous obscene meaning. Indeed, the very presence of a voyeur—one who

witnesses the sexual encounter unobserved—is itself a staple of the erotic culture of the Renaissance, both visual and literary. Voyeurs were fixtures in the racy dialogues of Pietro Aretino (for which, see my essay "Rapture to the Greedy Eyes" in this volume), spying and eavesdropping on the sexual antics of others, and they frequently figured in erotic imagery as the literal, or implied, audience (see cat. nos. 99, 103), their presence heightening the titillating aspect of the illicit encounters they witness.

The function of Giulio's drawing is unknown. It may be a design for a fresco of Apollo and Hyacinth (a subject closely related, as noted, to Apollo and Cyparissus) that the artist conceived for the suburban villa of Baldassare Turini da Pescia on the Janiculum in Rome—lost but mentioned by Vasari and reproduced, according to the biographer, in a series of now unrecorded and perhaps censored prints. Or, it may represent an early idea for the engraved series of the *Loves*

of the Gods commissioned by the print dealer Baviera, the designs for which were realized by Rosso Fiorentino and Perino within a few years of Giulio's departure from Rome for Mantua.[6] Given that erotic drawings appear to have been produced in some number as independent works for private pleasure, particularly in Rome, it is also not impossible that Giulio's drawing was executed for that express purpose. LW-S

1. Ovid *Metamorphoses* 10.107–8 (English trans., Ovid *Metamorphoses*, 1994 [ed.], vol. 2, 1976, p. 73).
2. Talvacchia 1999, p. 269, n. 7, suggests that the ambiguity of subject is deliberate and that the specific mythological narrative is secondary to the primary purpose of showing Apollo with a young male lover.
3. Ibid., p. 129.
4. The similarities were noted in Saslow 1986, p. 113.
5. Talvacchia 1999, p. 129.
6. Ibid., p. 128, although the author stops short of proposing that Giulio's drawing might represent an early, unrealized design for the *Loves of the Gods*. If the possible connection with the lost fresco in Turini's villa proved true, the correct subject of Giulio's drawing would be Apollo and Hyacinth.

SELECTED REFERENCES: Saslow 1986, p. 113; Bette Talvacchia in Gombrich et al. 1989, p. 283, ill.; Talvacchia 1999, pp. 128–29, fig. 31

Giulio Pippi, called Giulio Romano
Rome, ca. 1499–Mantua, 1546

92. Lovers

Ca. 1525–28
Pen and brown ink, brown wash, over black chalk, traces of squaring grid at the sides, 5⅛ × 8⅞ in. (130 × 226 mm)
Szépmüvészeti Múzeum, Budapest (2419)
Fort Worth only

The amorous exploits of the Olympian gods provided Renaissance artists with a rich pictorial repertoire. By offering a veil of decorum, however flimsy, mythological themes afforded them a license to depict erotic subject matter that would otherwise be considered egregiously racy or scandalous. Raphael, whose frescoes of nude gods and goddesses on the vault of the Psyche Loggia of the Villa Farnesina in Rome are among the most sensuous images of the sixteenth century (see figs. 31, 32), observed the rules of propriety; his disciples Giulio Romano and Marcantonio Raimondi did not. Their

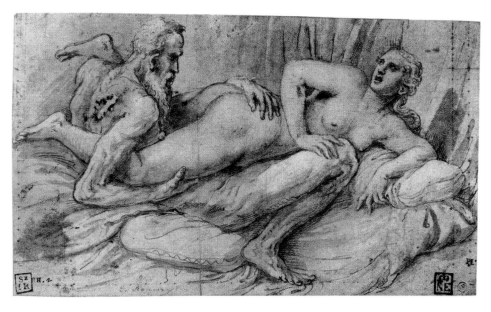

Cat. 92

notorious series of erotic prints showing sixteen different positions for copulation, known as the *Modi* (see cat. nos 99, 100), does not have ancient deities as protagonists; the actors are instead mere mortals. And because the images were reproduced as engravings, their audience could not be regulated and was potentially limitless. Punishment for this transgression was swift and severe: the engravings were censored, the plates destroyed, and one of the unlucky perpetrators, the engraver Marcantonio Raimondi, was thrown in prison.

Not surprisingly, the fame of these illicit images was only enhanced by the scandal that attended their reception. Individual figures and motifs from the *Modi*, as well as entire compositions, were widely copied in a variety of media across Italy and beyond (see cat. no. 109). In addition, silhouetted fragments of early copies of some of the original prints—clandestine relics that escaped the censor's obliterating hand—survive (see cat. no. 99). The most complete record of their appearance is a series of woodcuts after the engravings, published in Venice in or sometime shortly after 1527 (cat. no. 100), in which the images are reproduced together with the suitably profane sonnets Pietro Aretino had penned to accompany the *Modi* when they first circulated in Rome in 1524.[1]

Though not a study for any of the prints in the series, this drawing by Giulio Romano of a pair of lovers, executed in the later 1520s, soon after the artist's removal to Mantua, is of the same tenor and in the same spirit as the *Modi* and is particularly close to the print representing Position 16. Like the couple in Giulio's monumental painting *Two Lovers* (fig. 38), not to mention the pairs in the censored engravings, the trysting figures lack any attributes that would identify them as

deities. Nor is there anything to signal that this is a mythological scene. With the coupling of an old man and a young woman, an improbable pair, the invention presents a "witty irony"[2] that Giulio's contemporaries would have lauded. That irony—the conjoining of antitheses into an integral rhetorical or poetic formulation—is the essence of the burlesque paradox, a satiric mode epitomized by the poet Francesco Berni's conception of "grotesque beauty" (for which, see my essay "Rapture to the Greedy Eyes" in this volume). Giulio's composition, then, is a sort of visual *facetia*—a witty jest of the type narrated by Poggio Bracciolini, whose anecdotes frequently involve unlikely lovers, including old husbands and young wives,[3] or Pietro Aretino, whose racy dialogues narrated by the courtesan Nanna recount the indiscretions of debauched clerics and duplicitous wives with their servants, neighbors, doctors, and sundry others of all ages.

While some of Giulio's erotic drawings, like those of Parmigianino and Perino del Vaga, were conceivably executed as autonomous inventions (see cat. nos. 93a, b, 96, 97), the partially realized squaring grid, which would have been used to transfer the composition to another surface, suggests that this sheet may have been a design for a painting or fresco, though no such work by the artist is known. LW-S

1. The dating of Aretino's sonnets is discussed in my essay in this volume.
2. Zentai 2003, p. 62.
3. See, for example, Facetiae LXXXVII and XCIII (*Facetiae* 1928).

SELECTED REFERENCES: Konrad Oberhuber in Gombrich et al. 1989, p. 280, ill. p. 281; Zentai 2003, pp. 62–63, no. 23

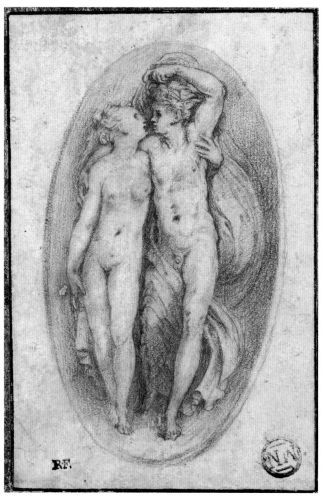

Cat. 93a

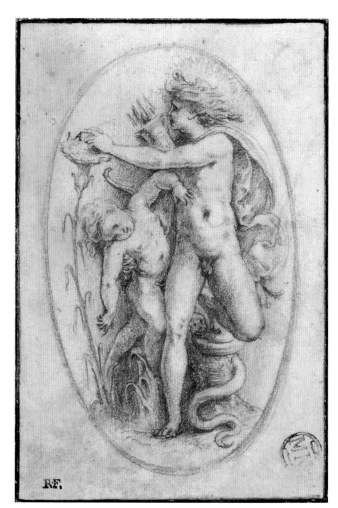

Cat. 93b

Perino del Vaga

Florence, 1501–Rome, 1547

93a. Couple Embracing

Ca. 1525–27
Red chalk, 4¾ × 3 in. (120 × 77 mm)
Musée du Louvre, Paris (10.383)
New York only

93b. Apollo and Hyacinth

Ca. 1525–27
Red chalk, 4⅝ × 3 in. (117 × 75 mm)
Musée du Louvre, Paris (10.383bis)
New York only

L ike Giulio Romano, his fellow *garzone* (apprentice) in Raphael's workshop, Perino del Vaga treated erotic subjects in his drawings and designs for prints, though he eschewed the prurience of Giulio's more salacious essays on the theme (see cat. nos. 91, 92, 100). Perino's most monumental effort in this vein is the *Fall of the Giants* in the Palazzo Doria in Genoa (see fig. 41), commissioned by Admiral-Prince Andrea Doria, for whom he worked as court artist for a number of years following the Sack of Rome in

1527. Vanquished by the superior might of the Olympian gods, the defeated Titans litter the ground, deployed in a web of artfully contrived and suggestively interwoven postures that allows them to display to the fullest advantage their muscular nude physiques. It is not a reach to suppose that this particular treatment of the mythological subject, like Parmigianino's *Cupid Carving His Bow* (see cat. no. 89), was expressly tailored to appeal to the homoerotic tastes of the patron[1] (although a witty parody of heterosexual intercourse occurs in the same fresco, where Mercury's pointing index finger is poised to penetrate the clenched fist of Ceres, a passage recalling the punning encounter of a zucchini and a fig in the lush swags of the Villa Farnesina in Rome, painted by Perino's collaborator Giovanni da Udine some years earlier (see my essay "Rapture to the Greedy Eyes" in this volume).

The lovers in Perino's erotic drawings engage in sterile, stylized, and passionless pas de deux. Such is the case with *Vertumnus and Pomona* (cat. no. 94), *Apollo and Hyacinth* (cat. no. 93b), and the embracing pair whose specific identities, if any were intended, remain ambiguous (cat. no. 93a). The latter two drawings share the same format, technique, and scale as well as a highly finished,

refined, and precious aspect that invokes the aesthetic of ancient gems or cameos.[2] They were perhaps produced as models for prints, as has been proposed,[3] although their oval format and the unnuanced, shadowy background of the *Couple Embracing* in particular (which would be difficult for the etcher or engraver to coherently translate) seem incompatible with that function. It is more likely that the designs were conceived as independent works intended for private consumption by a cultivated patron or collector, one whose erotic sensibilities were more poetic than pornographic.

No mythological subject has been discerned in the *Couple Embracing* (cat. no. 93a), but the related drawing, *Apollo and Hyacinth* (cat. no. 93b), does have a literary source—Ovid's *Metamorphoses*, which relates the story of their amorous but doomed liaison (Book X). Hyacinth was a beautiful youth beloved not only by the sun god but also by Zephyrus, god of the wind. In a jealous rage Zephyrus caused him to be struck on the head and killed during a game of quoits.[4] As the boy expired, blood issuing from the wound stained the earth; from that spot sprang the hyacinth—"that sanguine flower inscribed with woe," as the English poet Milton, invoking its mythological origins, described the

crimson bloom.[5] Perino deftly encapsulated the essentials of the legend: Apollo is shown with his conventional attributes, a bow and quiver of arrows, balancing on a support around which coils a serpent, an allusion to the great snake that the young Apollo slew at Delphi, seat of his cult.[6] Clutching the mortally wounded Hyacinth, (who resembles a struggling toddler more than a sensuous adolescent), the god reaches for the eponymous flower that has sprouted from the ground, his distress conveyed by his windswept hair and billowing drapery, while the pain of his grief is signaled by the sharp thorn on which he is about to prick his finger.

Apollo and Hyacinth and *Couple Embracing* were perhaps meant to illustrate two aspects of carnal love, sodomitic and heterosexual, while a related drawing by Perino of a standing man with a cornucopia[7] may subtly allude to a third mode of carnal pleasure, autoeroticism, a theme taken up in one of Parmigianino's erotic drawings:[8] the horn that is the source of the cornucopia carries phallic connotations that would have been immediately recognized in the sixteenth century, and, in contrast to the other two designs, the protagonist is shown alone rather than with a lover. Whatever their intended meaning, these refined and graceful images display little of the salacious carnality of Parmigianino's and Giulio's erotic drawings (see cat. nos. 96–97 and 91–92, respectively) and Pietro Aretino's lewd sonnets and dialogues. *Apollo and Hyacinth* is nothing like Giulio's graphic depiction of an analogous homoerotic encounter culled from the annals of ancient mythology (cat. no. 91),[9] recalling instead the ethos of Raphael's Cupid and Psyche cycle in the Villa Farnesina (figs. 31, 32). The homage may even extend to Perino's use in these drawings of red chalk—the medium favored by Raphael in his preparatory studies for those frescoes. LW-S

1. Andrea Doria's presumed homoerotic proclivities, reflected in the portrait of him in the guise of Neptune by Bronzino, are discussed above in my essay.
2. Davidson 1966, p. 22, under no. 14, suggests that the source for *Couple Embracing* (cat. no. 93a) is an antique cameo now in the Museo Archaeologico, Florence.
3. Bacou 1983, under nos. 78–79.
4. A game similar to horseshoes employing flat stone or metal disks with holes in the centers.
5. John Milton, *Lycidas*, (1637), in *The Oxford Book of English Verse, 1250–1900*, ed. A. T. Quiller-Couch (Oxford, 1909), line 106.
6. Perino's composition may have been inspired by ancient sculptures of Apollo balancing against a tree trunk with an encircling snake, numerous iterations of which were known in the Renaissance.

7. Musée du Louvre, Paris, 33446; see Bacou 1983, p. 79, no. 89. The figure may have been inspired by genii on the reverses of ancient Roman coins. It shares similarities with a drawing by Parmigianino of Silenus, the possible subject of Perino's drawing (Royal Collection, Windsor; see Wald 2002, p. 170, fig. 5c).
8. Discussed and illustrated in Ekserdjian 2006, p. 115, fig. 117.
9. The same subject is accorded a different, more overtly erotic rendering in an engraving by Gian Giacomo Caraglio from the *Loves of the Gods* (cat. no. 101a–g). That Apollo and Hyacinth design has been attributed to Perino, but his authorship is not indisputable, nor is it clear that the composition was part of the series as originally conceived by Caraglio and Baviera, perhaps having been added on as the number of prints in this successful venture expanded. See the discussion under cat. no. 101.

SELECTED REFERENCES: *93a.* Davidson 1966, p. 22, no. 13, fig. 14; Bacou 1983, pp. 78–79, no. 88, ill.; Elena Parma in *Perino del Vaga* 2001, pp. 188–89, no. 76, ill.

93b. Davidson 1966, p. 22, no. 14; Bacou 1983, pp. 78–79, no. 87, ill.; Elena Parma in *Perino del Vaga* 2001, pp. 188–89, no. 77, ill.

Perino del Vaga
Florence, 1501–Rome, 1547

94. Vertumnus and Pomona

Ca. 1527
Red chalk, outlines finely drawn in ink and incised, 6⅞ × 5⅜ in. (176 × 137 mm)
The British Museum, London (5226-96)

One of Perino del Vaga's most beautiful drawings, this red chalk study of *Vertumnus and Pomona* was among the designs reproduced by Gian Giacomo Caraglio in the series of engravings known as the *Loves of the Gods* (cat. no. 101a–g). The subject is taken from Ovid's *Metamorphoses* (14:623ff.). Pomona was a minor Roman deity, the goddess of *poma*, or tree-borne fruit, such as apples. She eschewed the wild fields of untamed nature, preferring instead the locked confines of her carefully cultivated garden, which all men, whose lascivious intentions she feared, were forbidden to enter. There, having no "care for Venus," Pomona faithfully tended her plants with a pruning hook, her emblem. Yet Pomona's

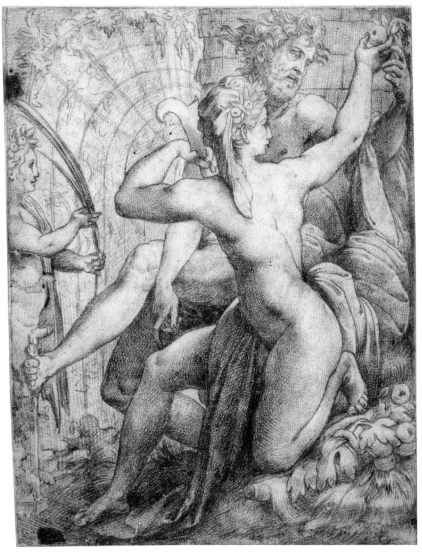

Cat. 94

beauty aroused the desire of all who saw her, most of all Vertumnus, who repeatedly visited her in different rustic disguises. Eventually he appeared to her in the aspect of an old woman, who revealed to the cold-hearted Pomona Vertumnus's deep love for her, but in vain, for she remained unmoved. Shedding his disguise, he was "ready to force her will, but no force was necessary; and the nymph, smitten by the beauty of the god, felt an answering passion."[1]

As in his contemporaneous drawing of *Apollo and Hyacinth* (cat. 93b), Perino deftly renders, in a dense composition, the salient, identifying elements of the narrative—the protective wall of Pomona's *hortus conclusus* (enclosed garden); the vine-covered pergola signifying the order imposed on wild nature through her attentive labors (and the evidence Vertumnus in disguise adduces to persuade Pomona that an icy heart is barren, while only love yields fruit); the apples sacred to the goddess; and her attribute the pruning hook, which she holds in her left hand in a pose artfully emulating Michelangelo's gracefully contorted Libyan Sibyl in the Sistine Chapel. The animated statue of Priapus, ithyphallic god and guardian of gardens, who appears at the left, watches approvingly as Vertumnus achieves his long-hoped-for conquest of Pomona—a conquest indicated by Pomona's gift to him of one of her prized fruits; by the aroused state of Priapus, whom Vertumnus, unseen by Pomona, caresses with his extended foot; and by the victor's palm that Priapus awards Vertumnus.

The story of Vertumnus and Pomona is uncommon in Renaissance art. (Two rare depictions are Pontormo's slightly earlier fresco of 1521 in the lunette of the Medici Villa of Poggio a Caiano outside Florence, where the subject was chosen for its aptness to the physical setting, a working villa-farm,[2] and a woodcut in the late fifteenth-century *Hypnerotomachia Poliphili*, cat. no. 62, which shows the triumph of Vertumnus and Pomona.) Unlike other tales narrated by Ovid—Apollo's burning love for the nymph Daphne, for example—Vertumnus and Pomona did not have an established iconographic or pictorial tradition (Perino's composition shares no similarities either with Pontormo's fresco or the woodcut in the *Hypnerotomachia Poliphili*) and would not necessarily have been immediately recognized by the kind of broad audience that reproductive prints were intended to reach. It therefore stands out as something of an anomaly in the *Loves of the Gods*, which otherwise portray the major Olympian deities, among them Jupiter, Venus, Neptune, Apollo, and Mercury, engaged in amorous encounters more overtly erotic and lewd

than the graceful, chaste ballet enacted here. Given these departures from the spirit and tone of the rest of the series, it is possible that the drawing was not originally executed as a model for the engraver but was produced by Perino as an independent work in the manner of *Couple Embracing* and *Apollo and Hyacinth* (cat. nos. 93a, b), then subsequently adapted as the model for the print (all three are datable to roughly the same period, executed in the same medium and technique, and share a decorously erotic subject matter). The highly finished character of *Vertumnus and Pomona*, and the fact that the other extant design by Perino for the *Loves of the Gods*, Venus and Cupid (cat. no. 95), is executed in a different technique, do not contradict this conjecture.

If the mythological subject of Perino's drawing was rather obscure, the coded erotic symbolism of numerous details of the composition was not. Fruits and vegetables carried widely recognized erotic meaning in the imagery and burlesque poetry of the day: the lush swags of vegetation in the Psyche Loggia of the Villa Farnesina in Rome (figs. 31, 32) are the most monumental and amusing demonstration of this in painting, and the poet Franceso Berni's encomium to a peach (a coded metaphor for the male buttocks) is a perfect literary counterpoint. Consonant with the fruit imagery, the garden—sacred grove of the insatiable, lusty Priapus—was celebrated in mock-humanist dialogues, epistles, and verses, in emulation of equally salacious antique exemplars by Ovid and his followers, as a locus rife with lascivious carnal excess—a fertile space to be penetrated and conquered.[3] Were this exquisitely refined drawing produced as an independent work for private consumption, as the erotic drawings of Salviati and Parmigianino certainly were (see fig. 42 and cat. nos. 96a, b, 97), its learned and playful eroticism would have found an appreciative audience among elite humanist and curial circles in Rome in the years before the Sack.

LW-S

1. Ovid *Metamorphoses* 14.623–772 (English trans., Ovid *Metamorphoses*, 1994 [ed.], vol. 2, pp. 344–55; quotations on pp. 345, 355).
2. Cox Rearick 1984, p. 120ff.
3. All discussed in my essay "Rapture to the Greedy Eyes" in this volume.

SELECTED REFERENCES: Pouncey and Gere 1962, pp. 95–96, no. 163, pl. 130; Davidson 1963, p. 23, pl. 18; *Perino del Vaga* 2001, p. 190, no. 78, ill.

Perino del Vaga
Florence, 1501–Rome, 1547

95. Venus and Cupid

Ca. 1527
Pen and brown-gray ink, contours incised with stylus, possibly retouched by another hand in darker brown ink, 6¼ × 5⅜ in. (159 × 138 mm)
Inscribed at lower edge in a 16th-century hand: PERINO
Galleria degli Uffizi, Gabinetto Disegni e Stampe, Florence (13552 F)
Fort Worth only

Two drawings by Perino del Vaga for the *Loves of the Gods,* the series of prints commissioned by Raphael's friend Il Baviera and engraved by Gian Giacomo Caraglio in 1527, are known—a red chalk study of *Vertumnus and Pomona* (cat. no. 94) and this *Venus and Cupid,* executed in pen and ink. The incised contours of both designs indicate that they served as models for the engraver, even though the composition of *Venus and Cupid* is in the same sense as the print rather than reversed, as is more typically the case with reproductive prints (including *Vertumnus and Pomona*).

Unlike all the other images comprising the *Loves of the Gods* (cat. no. 101a–g), this design does not depict an Olympian deity engaged in an amorous dalliance; rather, the nude Venus appears alone and asleep, accompanied only by her slumbering son Cupid. The image belongs to a Venetian-inspired pictorial tradition epitomized by Giorgione's *Sleeping Venus* (which originally included the figure of Cupid) of about 1510 (fig. 88) and reprised by Poussin in his numerous iterations of sleeping nymphs and goddesses that drew on Venetian models for inspiration.[1] In all those works, as in Perino's drawing, the sensuous female nude, lost in an erotic reverie, is displayed for the viewer's delectation.

Perino's Venus may have been inspired by an antique model. Her pose loosely recalls that of the sleeping Ariadne (alternatively identified as Cleopatra), a widely admired ancient Roman sculpture discovered in Rome in the first years of the sixteenth century and installed by Pope Julius II in 1512 in the Vatican Belvedere.[2] The artist reprised the essentials of the composition (omitting Cupid) in the right half of a design for a tapestry representing *Mercury, Aglaurus, and Herse,* one of the panels from the lost *Furti di Giove* (Secret Loves of Jupiter) series commissioned by his Genoese patron Andrea Doria in the early 1530s.[3] The sleeping Herse in Perino's *modello*[4] is nearly identical to the sleeping Venus in the present sheet; Perino may have reused this drawing when designing the tapestry.

LW-S

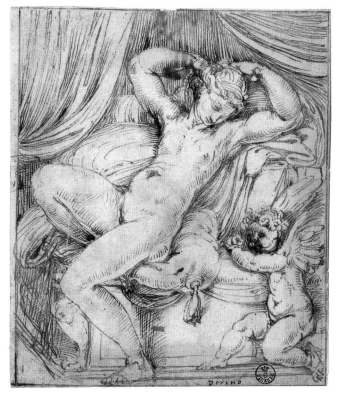

Cat. 95

on a sarcophagus that was in the Massimi Collection in Rome since at least the 1540s and probably earlier; Bober and Rubinstein 1986, p. 115, no. 80.

3. For which see Davidson 1988.

4. Staatliche Graphische Sammlung, Munich, 2543. The *modello*, now divided in two, represented *Mercury, Aglaurus, and Herse*; see *Perino del Vaga* 2001, pp. 253–54, nos. 131, 132.

SELECTED REFERENCES: Davidson 1966, pp. 23–24, no. 16, fig. 15; Parma Armani 1986, p. 70, ill. no. 67; Archer 1995, pp. 112–13; *Perino del Vaga* 2001, p. 190, no. 79, ill.

1. On Giorgione's Venus, see Andrea Bayer's essay "From Cassone to *Poesia*" in this volume. Relevant works by Poussin include *Sleeping Venus and Cupid* (Staatliche Kunstsammlungen, Gemäldegalerie Alte Meister, Dresden, 721); *Nymph and Satyrs* (National Gallery, London, inv. no. NG 91); and *Venus or a Nymph Spied on by Satyrs* (Kunsthalle, Zurich, inv. no. 2480); see Rosenberg and Christiansen 2008, nos. 11, 12, and fig. 65, respectively.

2. Haskell and Penny 1981, pp. 184–87, no. 24 (Cleopatra); Bober and Rubinstein 1986, pp. 113–14, no. 79 (Ariadne). Perino's figure is also close to the sleeping Ariadne in a relief representing the Discovery of Ariadne

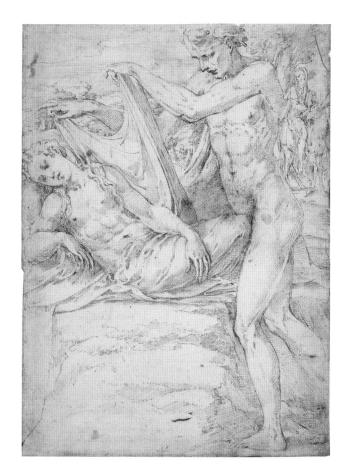

Cat. 96a

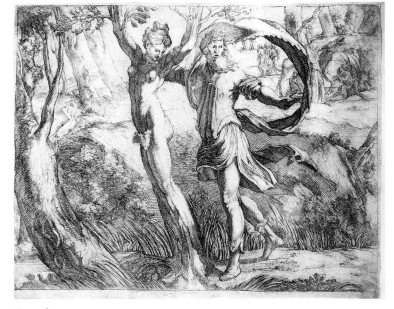

Cat. 96b

Francesco Mazzola, called
Parmigianino

Parmese, 1503–1540

96a. *Priapus and Lotis*

Ca. 1530–40
Pen and brown ink, over black chalk, 12⅝ × 9¼ in.
(321 × 234 mm)
The British Museum, London (5210-48)

Unidentifed Sixteenth-Century Etcher (Jacopo Bertoia?, Parmese, ca. 1530–1575)

*After Francesco Mazzola, called
Parmigianino*

96b. *Priapus and Lotis*

Etching, 7⅞ × 10¾ in. (200 × 273 mm)
The Metropolitan Museum of Art, New York, The
Harris Brisbane Dick Fund, 1927 (27.78.1 [26])

Ithyphallic god of gardens and fertility and
the incarnation of unbridled carnal lust,
Priapus was a favorite character in the erotic
poetry of antiquity and the Renaissance.[1]
Parmigianino shows him attempting to rav-
age the slumbering Lotis (whose pose recalls
classical depictions of the sleeping Ariadne),
only to have his lecherous designs thwarted
by the ass of Silenus, seen in the background
with ears alertly pricked, whose braying
alarm roused the nymph and allowed her
to flee.[2] The subject is taken from Ovid's
Fasti—elegiac verses commemorating the
rustic rituals and celebrations of the ancient
Roman calendar. The drawing depicts the
moment in the narrative when the rebuffed
Priapus, consumed by desire, silently creeps
up on the beautiful Lotis and, finding her
in an insensate, wine-induced languor, pulls
off her sheet.

The composition, in which a libidinous
male lifts the drapery from a sleeping nude
female, recalls a number of Perino del Vaga's
designs from the series of erotic prints known
as the *Loves of the Gods*. Engraved by Gian
Giacomo Caraglio, these were mostly pro-
duced in the immediate aftermath of the Sack
of Rome in 1527 (see cat. nos. 101a–g), though
the commission predated by some months
that catastrophic event, and the first designs
are by Rosso Fiorentino. Parmigianino may
well have intended to recall those apposite
models, which he conceivably saw before he
abandoned Rome and which he certainly
could have known later when they were cir-
culated in print form.

The hard, angular contour line and chiseled
cross-hatching of the *Priapus and Lotis* (cat.

no. 96a) are characteristic of Parmigianino's
late drawings, suggesting a date for this sheet
in the last decade of his career, when he was
active in his native Parma. The patently
erotic subject matter has led to the informed
conjecture that the drawing may have been
made for Francesco Baiardo, an important
patron and friend of the artist whose passion
for erotica is amply documented in many of
the works of art that he owned, including the
seductive *Cupid Carving His Bow* (see cat.
no. 89).[3] That it has the finished character of a
"presentation drawing" is consistent with the
idea that the *Priapus and Lotis* is an autono-
mous invention, perhaps made as a gift, as
has been recently suggested,[4] although the
particular style and technique, as well as
the exceptionally finished composition, also
raise the alternative possibility that the work
was created as a design for a print. No corre-
sponding etching or engraving is known, but
other erotic inventions of Parmigianino were
reproduced as prints,[5] and a rare etching asso-
ciated with him represents another moment
in the Priapus and Lotis story—the fleeing
nymph's transformation into a tree to avoid
the rapacious god's advances (cat. no. 96b).[6]
Whatever the drawing's original function,
the oversized phallus of Priapus was later
obliterated—an act of censorship suffered
by other of Parmigianino's erotic composi-
tions (among them, cat. no. 97 as well as the
Priapus and Lotis etching)—though the orig-
inal, prodigious proportions of the offending
member may still be discerned.

LW-S

1. See my essay "Rapture to the Greedy Eyes" in
 this volume.
2. The drawing's subject is discussed by Hugo
 Chapman in Bambach et al. 2001, p. 185, no.
 134; and in Ekserdjian 2006, p. 115.
3. Chapman in Bambach et al. 2001, p. 185,
 no. 134.
4. Ekserdjian 2006, p. 115.
5. See ibid., fig. 120.
6. Previously thought to represent Apollo and
 Daphne, the correct subject was recently
 identified by Thompson 2008, who tenta-
 tively proposes the Emilian artist Jacopo
 Bertoia as a candidate for its authorship.
 The print relates to a damaged drawing in
 the Albertina, Vienna, which, according
 to Thompson, is accepted as a late work of
 Parmigianino by Achim Gnann and David
 Ekserdjian.

SELECTED REFERENCES: *96a*. Hugo Chapman
in Bambach et al. 2001, p. 185, no. 134, ill.;
Ekserdjian 2006, p. 115, fig. 116; Thompson 2008,
pp. 186–89, fig. 40

96b. Thompson 2008, pp. 186–89, fig. 37

Francesco Mazzola, called
Parmigianino

Parmese, 1503–1540

97. *Erotic Scene*

Mid-1520s or 1530s
Pen and brown ink, 7¼ × 4 in. (185 × 100 mm)
Private collection

A gifted and exceptionally prolific
draftsman, Parmigianino produced a
number of erotic drawings that until recently
have been largely ignored in the literature
because of their illicit subject matter.[1] Erotic
prints based on his designs also exist. Most
of the works have a mythological theme,
with Venus, goddess of love, a predictably
frequent participant. The drawings do not
form a cohesive group and were not designed
as a series, and none can be precisely dated.
Nor were they studies for paintings. One or
two such drawings—*Priapus and Lotis* (cat.
no. 96a), for example—are fully worked up,
carefully finished compositions and may
have been ideas for unexecuted prints in the
vein of Giulio Romano and Marcantonio
Raimondi's *Modi* (cat. no. 99) or Perino del
Vaga, Rosso Fiorentino, and Gian Giacomo
Caraglio's *Loves of the Gods* (cat. nos. 101a–g),
though this suggestion is conjectural.
Certainly the more informal erotic draw-
ings, including the present example, must

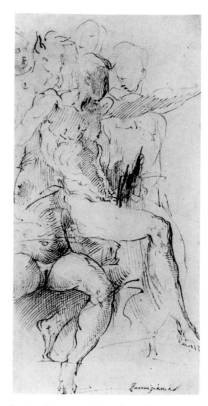

Fig. 82. Francesco Mazzola, called
Parmigianino (1503–1540), *Erotic Scene*
(cat. no. 97), prerestoration

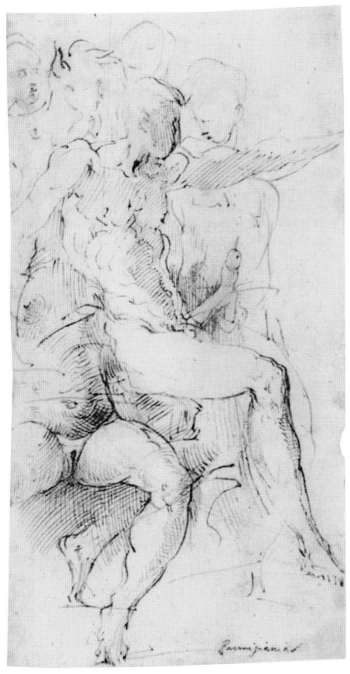

Cat. 97

him originally displayed conspicuously large erections, details obliterated at some later point by the pen of a prudish censor (fig. 82) and partly recovered during a recent restoration. The possible presence of a satyr notwithstanding (the quickly sketched visage at the upper left has an ambiguously goatlike aspect), this composition is unusual among Parmigianino's surviving erotica in eschewing all pretense of a classical or mythological theme, a distinction it shares with a more graphic and overtly homoerotic scene of two nude, aroused men embracing; the same subject with an expanded cast was taken up in an erotic drawing by Francesco Salviati (fig. 41). The drawing is in this respect close in spirit to Giulio Romano's designs for the *Modi*, which delighted—and offended—precisely because of the utter lack of literary or mythological artifice accorded to the variegated cast of copulating couples. Indeed, the central figure of the gesturing male is loosely based, in reverse, on the seated male in Position 10 from the *Modi*, a composition whose appeal for Parmigianino is elsewhere documented in a faithful copy he made of it.[4] What remains of the exposed female with splayed legs, in turn, appears to derive—again in reverse—from another, contemporary erotic image, Perino del Vaga's *Jupiter and Antiope*, part of the series of the *Loves of the Gods* engraved by Caraglio (fig. 80) in 1527. That both quotations are in reverse of the respective prints, and therefore presumably in the same sense as the preparatory designs, raises the possibility that Parmigianino had seen drawings by both Perino and Giulio in Rome.

LW-S

1. Recently discussed as a group by Ekserdjian 2006, pp. 109–17, who notes that Parmigianino "does not confine himself to soft core, but explores the realm of the hard core too" (p. 109).
2. Ekserdjian (ibid., p. 110), remarking on the absence of erotic subject matter in Parmigianino's early work, speculates that the artist's "personal road to erotic Damascus was the journey to Rome at exactly the moment when Giulio Romano and Marcantonio Raimondi were engaged on the *Modi* [i.e., ca. 1524]."
3. Ekserdjian 1999, pp. 38–39, no. 72, fig. 90.
4. Parmigianino's quotation from Giulio's design was pointed out by Ekserdjian (2006, p. 110, fig. 106).

SELECTED REFERENCE: Ekserdjian 2006, pp. 115–16, fig. 118

have been produced for the private pleasure of their unrecorded recipients.

It is known that this type of subject matter held an exceptional appeal for Francesco Baiardo, Parmigianino's patron and intimate friend in Parma for whom the artist painted the sensual and homoerotic *Cupid Carving His Bow* (cat. no. 89): the detailed inventory of his collection drawn up in 1561 (which records a singularly large number of paintings and drawings by Parmigianino) reflects Baiardo's predilection for erotica. Some of Parmigianino's surviving drawings of this type conceivably belonged to Baiardo, in which case they were likely executed during the artist's last decade in Parma (1530–39)—a supposition supported in some cases by stylistic evidence. Not to be ruled out, though, is the possibility that at least a few were

produced during Parmigianino's years in Rome in the mid-1520s—an equally plausible scenario, given the presence there of a large, attentive, and sophisticated audience for erotic imagery and poetry, culled from the most cultivated ranks of the humanist, clerical, and curial elite, and an obliging group of artists (many of whom would become Parmigianino's friends or acquaintances) happy to satisfy the demand.[2]

A recent addition to Parmigianino's graphic oeuvre,[3] this drawing of a dense group of nude male and female protagonists has no recognizable literary theme, and depicts what may be rather succinctly described as an orgy. (The sheet has been cropped along the left edge, abbreviating the reclining female figure.) Both the seated man in the center and the companion standing behind

Enea Silvio Piccolomini

Corsignano (now Pienza), 1405–Ancona, 1464

98. Hystoria di due amanti (Tale of Two Lovers)

Translator, from the Latin original: Alessandro Braccesi
(1445–1503)

Dedicated to Lorenzo di Pierfrancesco de' Medici
(1463–1503)

Florence: Piero Pacini da Pescia, [ca. 1500]

Printed book with woodcut illustrations, 8⅛ × 5¾ × ⅜ in. (20.5 × 14.5 × 1 cm)

The Metropolitan Museum of Art, New York, Harris Brisbane Dick Fund, 1925 (25.30.17)

The rather melancholy and cynical tale of adultery written by Enea Silvio Piccolomini, which ends with the death of the woman and the marriage of the man to a wealthy and beautiful young girl, seems bound up with the author's own regrets; no stranger to love in his youth, Piccolomini wrote the account soon after he had fathered a second child out of wedlock and two years before he took holy orders and entered on the path that would lead to his election as pope in 1458.[1] (He ruled as Pope Pius II from 1458 to 1464.) Written at the request of a Sienese friend, the narrative is believed to be based on an affair that took place between a young married noblewoman of Siena and a visiting German in the service of the emperor Sigismondo.[2] Piccolomini's extensive use of examples and quotations from earlier literature—from Ovid to the church fathers, to classical comedy and Giovanni Boccaccio—has been accounted for as an erudite game for the enjoyment of an elite audience[3] or as a demonstration of the inadequacy of ethical instruction based on *exempla*,[4] among other interpretations. None of this is relevant, however, to the Italian translation here, in which the tone has been altered and the ending changed to provide an amusing and joyful celebration of illicit love that culminates in a splendid marriage—after the convenient death of the aged husband—and the birth to the couple of eight handsome sons.

Composed in 1444, the Latin text *(De duobus amantibus historia)* circulated widely in manuscript—as evident from the expressed regret of Pope Pius II that his tale was read more for the lascivious love story than for the lesson it taught[5]—but was published only in 1468, four years after the pope's death. Of the two Italian translations produced in the fifteenth century, the first and by far

the most popular was that of Alessandro Braccesi (1445–1503), a Florentine notary and diplomat as well as a writer.[6] Braccesi's first version, which survives in manuscript in the Biblioteca Riccardiana, in Florence, has been dated by Viti[7] to 1478–79, based on Braccesi's reference to the plague that threatened Florence in those years as among his reasons for making the story more cheerful. (In the published edition, the reference to "tempi noiosi e gravi"—troublesome and sorrowful times—is more general.) In his dedication to the young Lorenzo di Pierfrancesco de' Medici, Braccesi acknowledged that the original unhappy ending was meant to demonstrate the perils and suffering caused by love, yet since none of the many tales that teach that lesson had ever dissuaded lovers from their course, the translator has decided to go ahead and adapt the tale so that it will bring only pleasure to his readers (a2 recto). About 1480 Braccesi put the text through a thorough edit, probably with an eye to publication.[8] The result, though it still retains long passages that are a fairly direct translation from Piccolomini, is an independent work in which Braccesi likely took considerable pride—he even inserted several of his own sonnets into the love letters.

Braccesi's translation was first published in 1481; subsequent editions appeared in 1485, 1489, 1491, and 1492. This edition, which dates to about 1500, appears to be the first to receive illustrations. Paul Kristeller[9] noted that the publisher, Piero Pacini da Pescia, "took a special interest in the artistic printing and in the illustration of the books he published." Pacini was responsible for many of the most splendid illustrated Florentine books of the quattrocento, including the *Epistole e Evangeli* (Epistles and Gospels),[10] the poet Luigi Pulci's chivalric epic *Morgante*, and Federico Frezzi's novel *Quattriregio* (Four Realms).[11] All of the illustrations exhibit the characteristics of fifteenth-century Florentine woodcuts—a bold use of black and white pattern, parallel hatching, and ornamental frames—yet the variance in style and scale and the fact that few fit the text exactly suggest that most of them were created for other books. Kristeller has identified four that appeared elsewhere,[12] but of these only two appear in a dated publication, Pulci's *Morgante*, published by Pacini in 1500. It is evident that one of the woodcuts (fol. C8r, opposite) illustrates a scene from the first tale of the fourth day of Boccaccio's *Decameron*, in which old Prince Tancred, who kept his beloved daughter, Ghismonda, unwed, has fallen asleep behind a curtain in her room

and awakens to discover her in the arms of his page Guiscardo. Another cut shows Cupid aiming his bow at the couple—the man can be identified by his hat, lying on the bed in the other scene, and the woman wears the same dress. No editions of the *Decameron* with fifteenth-century Florentine illustrations are known, but the tale of Guiscardo and Ghismonda was also published independently in a rhyming version. Of the three recorded editions, only one was illustrated and that with a single block which does not correspond to either of these.[13] The two woodcuts prove that another illustrated Florentine edition existed or at least that Pacini planned to publish one. It is possible that some blocks used in the *Storia* were created expressly for Braccesi's book, such as the illustration of the procuress delivering the letter (fol. B2r, opposite) or that of the lovers under the covers (fol. D8r, opposite).

Pacini normally used a mixture of old and new blocks in his publications, yet the availability to him of so many appropriate blocks to illustrate this tale shows how common such love stories were in fifteenth-century Florence. Today they are so rare that this is the only copy of this illustrated edition in an American collection, and only three others are known.[14] The efforts of the influential preacher Girolamo Savonarola, who in the mid-1490s urged Florentine citizens to throw their licentious books and pagan artworks into bonfires, may have played a role in destroying such literature. But a more likely cause is that such inexpensive, popular books, the paperback novels of their day, were passed around and read until they fell apart. WT

1. In the year he wrote the story, Piccolomini confessed in a letter to having loved many women of whom he tired after possessing them, an attitude not too different from that of his "hero." See the letters quoted by Glendinning 1996, p. 101, and examined by Martels 2003.

2. See, for example, Glendinning 1996, who argues that the tale was meant as a rehabilitation of Piccolomini's friend Kaspar Schlick, who is believed to have been the model for the adulterous German visitor.

3. Pirovano 2006.

4. O'Brien 1999.

5. Letter cited ibid., p. 14.

6. Braccesi played an active role in Florentine politics. As an author, he is best known for translating Appian into Italian, but he also wrote Latin poems dedicated to Lorenzo de' Medici, Marsilio Ficino, Angelo Politian, Ginevra de' Benci, and others. For Braccesi's life, see Perosa 1971.

Cat. 98, fol. C8r

Cat. 98, fol. B2r

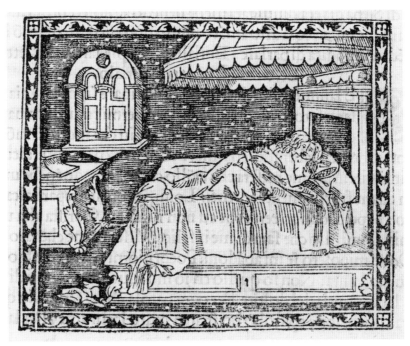

Cat. 98, fol. D8r

7. Viti 1982, p. 54.

8. Ibid., p. 61.

9. P. Kristeller 1897, vol. 1, pp. xviii–xix.

10. See Armstrong 2004, pp. 29–35; and Daniel De Simone in De Simone 2004, pp. 107–10, no. 18.

11. Van der Sman 1989.

12. P. Kristeller 1897, vol. 1, p. 129.

13. The Incunabula Short Title Catalogue (ISTC hereafter), a database at the British Library available online, lists two editions, one published in Brescia (copy in Chapel Hill) and one in Venice (copy in Wolfenbüttel); P. Kristeller (1897, vol. 1, p. 86, no. 218) describes the block that illustrates a third edition, in the Trivulzio Library, Milan.

14. The ISTC lists three additional copies, all in Italy. The one in Siena is incomplete and is probably Kristeller's 330a, which he describes as a variant with many of the same illustrations. Four copies of fifteenth-century editions of Braccesi's translation without illustrations survive in U.S. collections. The texts of the 1485 (Pierpont Morgan Library, New York) and 1489 editions (University of Pennsylvania Rare Book Library) appear

to be identical to that of the Metropolitan Museum's edition.

SELECTED REFERENCES: Piccolomini, *Tale of Two Lovers*, 1929 (ed.); Piccolomini, *Tale of Two Lovers,* 1999 (ed.); P. Kristeller 1897, vol. 1, pp. 129–30; Viti 1982; Glendinning 1996; Pirovano 2006

Attributed to Agostino Veneziano (Agostino dei Musi)

Venice, ca. 1490–Rome(?), after 1536

And assistants, copying engravings by Marcantonio Raimondi

Argini, near Bologna, 1475/80–Bologna 1527/34

After drawings by Giulio Pippi, called Giulio Romano

Rome, 1499(?)–Mantua, 1546

99. Nine Fragments from "I modi"

Rome(?), before 1531
Pieces cut from seven engravings, mounted on board and made up with pen and black ink, within ruled border, 8⅝ × 10⅛ in. (217 × 256 mm)
Each fragment numbered in pencil on mount by Jean-Frédéric Maximilien Waldeck, ca. 1860
The British Museum, London (1972.U.1306-1314)

The satirist Pietro Aretino (1492–1556) tells us that the infamous images of sexual acts in *I modi* (translatable as *Ways* or *Positions*) were designed by Giulio Romano (1499?–1546) and engraved by Marcantonio Raimondi (ca. 1470/82–1527/34), who was then jailed by the powerful papal official Gian Matteo Giberti.[1] No independent evidence corroborates this episode, which apparently happened in 1524 or 1525, but Bette Talvacchia's comprehensive study finds many reasons to attribute the original compositions to Giulio, as far as they can be reconstructed from copies. The engravings seem to have been destroyed, but these nine fragments (and a

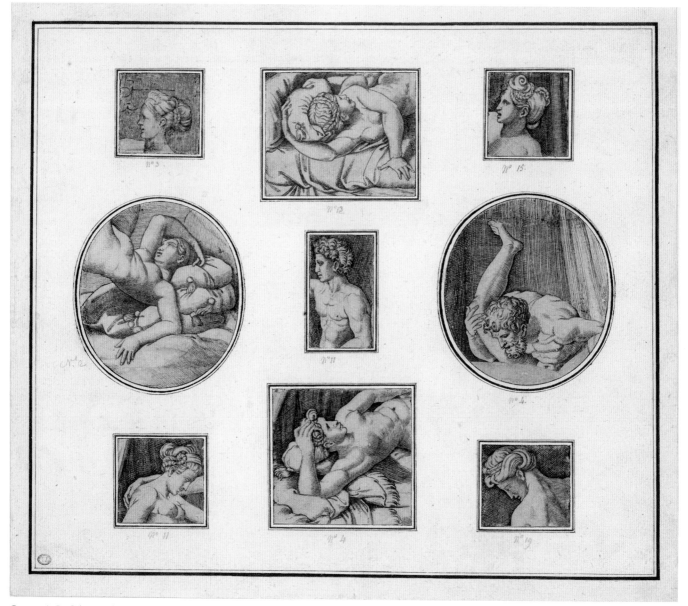

Cat. 99, A, B, C (top row), D (middle row, left), E (middle row, center, and bottom row, left), F (middle row, right, and bottom row, center), G (bottom row, right)

few single sheets) survive from early engraved copies, which can be compared to looser freehand copies in the small woodcuts of the "Toscanini volume" (cat. no. 100) and to the historiated maiolica of Francesco Xanto Avelli (cat. no. 109). We do not know the precise number and order of these erotic scenes, but they must have constituted an impressive series of at least fourteen multi-figure compositions, uniform in format and execution, by Giulio and Marcantonio—the acknowledged leaders of design and technique. The influence of the *Modi* can be felt in Parmigianino (1503–1540; see fig. 77), in the monumental engraving series *The Loves of the Gods* (cat. nos. 101a–g), and further afield.

No drawings survive for these *Modi*, but a sheet of *Lovers* from slightly later in Giulio's career (cat. no. 92), after he moved to Mantua, gives us a glimpse of the design process. In this drawing Giulio invents an ingeniously perverse composition and builds it up in layers of chalk, ink, and wash, bringing out the contrast between the smooth perfection of the female nude and the bony,

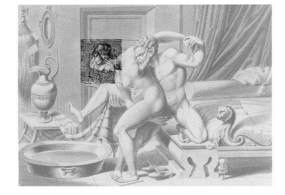

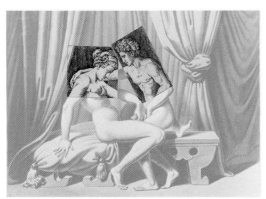

Fig. 83. Three composite views: Fragments from *I modi* (cat. no. 99) superimposed on wash drawings by Jean-Frédéric Maximilien Waldeck, recording the original compositions

wrinkled older man. As in many of the *Modi,* the lovers lie not face to face but in a sinuous interlocking position that juxtaposes the man's face and the woman's buttocks. This posture exemplifies three kinds of rotation or inversion—woman on top, head to toe, and the sideways torsion that brings both breasts and buttocks into view, showing what Titian called "contrary parts" at once.[2] Sexual and artistic virtuosity combine here, for it was exactly this dramatic variety of posture, this inventive mastery of serpentine contrapposto and foreshortening, that High Renaissance artists most valued.

Giulio's sources were both classical and contemporary. Antique tokens, sculptures, and reliefs provided many of the figures, whereas the idea of illustrating the "art of love" in serial images came from Latin literature, which often alluded to books of sexual positions: these had become topical during the glittering (and shocking) Vatican performance of Ariosto's comedy *I suppositi* in 1519, in which Giulio must have been involved as the leader of Raphael's workshop. (For this

performance, see my essay "Profane Love" in this volume.) Artists in that workshop evidently liked to sketch what Leonardo da Vinci had called "libidinous acts," and visitors like Cesare da Sesto (1477–1523) emulated them.[3] The copyist of a well-known Renaissance sketchbook now in Fossombrone preserved three of these drawings, and though a later owner obliterated them with heavy inking, some of their original lines can still be made out; significantly, they are not direct copies of the *Modi*[4] but similar, parallel studies of intercourse *all'antica*.

These nine fragments were already cut and pasted when the sheet was bought in 1812 by the painter Sir Thomas Lawrence, from whose collection it passed to the British Museum in 1830. The collector Pierre-Jean Mariette (1694–1774) lamented that he could find only "fragments" of the compositions already reduced to "little more than heads," which at least saved him "red faces" when he showed them.[5] The London collage displays the ornate hairstyles of the women, suggestive of skillful sexual interlacing, and includes some well-formed upper bodies, while trying to eliminate signs of contact between the sexes. Nevertheless, other body parts can still be seen, such as a leg rising into the air beside one man's cheek—arguably more erotic in this isolated form than in the uncut scene.

By comparison with other partial copies, these London fragments can be located in seven of the *Modi*, identified here as A–G (following the order of the collage, from upper left to bottom right). In most cases the original compositions were recorded in wash drawings by Jean-Frédéric Maximilien Waldeck (Vienna [?], 1766–Paris, 1875), based on tracings that preserved the outlines of engravings now lost. What John Gere called the "impersonal neo-classic" modeling[6] is Waldeck's own invention.

A ("No. 3"). This small and flatly engraved head has been turned ninety degrees from the original as Waldeck reconstructs it. Talvacchia and Raymond B. Waddington[7] both observe that this posture cleverly reworks a detail in one of Marcantonio's own engravings (*Bacchanal,* The British Museum, London), which in turn re-creates an antique bacchic sarcophagus now in Naples. The magnificent modeling and chiaroscuro of Marcantonio's *Bacchanal* allow us to imagine what the original *Modi* looked like. In the classical model, a satyress presents her rump to a priapic herm and reaches down to find his phallus, which is conspicuously limp; in Marcantonio's print, the situation has been wittily refigured, with a satyr-eared male now the responsive object of desire. Not just the persons but the furnishings continue the

double play of ancient and modern, animate and inanimate. A rustic-looking door hinge behind the woman's head can still be made out in the fragment. A large ornament on the bed—a *grottesco* combination of architectural leaf volute and animal head, very similar to the foot of the couch in Giulio's painting *Lovers* (fig. 38)—seems to have come alive, swiveling around to leer at the satyr-man and his partner.

B ("No. 12"). Waldeck's reconstruction of this scene is unreliable, so it must be inferred from the related woodcut in the "Toscanini volume" (cat. no. 100, fol. B2r), which inverts one of the woman's legs but otherwise captures the reversed coitus described in Aretino's accompanying sonnet. The mass above her shoulder in the fragment is thus revealed as the muscular calf and thigh of a kneeling man, dramatically foreshortened. Her reclining posture and S-shaped arms derive from an ancient sculpture of the sleeping Ariadne or dying Cleopatra, which Giulio surely saw in the Vatican Belvedere; a similar figure appears in the Naples sarcophagus and Marcantonio's *Bacchanal*. Now, however, she is fully awake, flexing her torso and arms to look around at the incongruous proceedings—as in Giulio's Budapest drawing.

C ("No. 15"). This configuration (see fig. 83, top) derives from an antique gem of *Leda and the Swan*, also reprised in an engraving closely related to the *Modi*[8] and to the copulation scene depicted on the foot of the couch in Giulio's *Lovers* (fig. 38). The related woodcut (cat. no. 100, fol. A2v) places the lovers incongruously in the open air, but the fragment and the Waldeck wash drawing show the background as drapery. The sexes have been separated by tearing of the sheet rather than cutting, though the nose and lip of the man (called "caro vecchione" in Aretino's sonnet) can still be seen at the left.

D ("No. 2"). A later, reversed copy in Vienna (fig. 79) records the entire composition from which this splendid oval fragment was cut. The standing posture—a "libidinous act" that had already intrigued Leonardo (fig. 78) and Cesare da Sesto (cat. nos. 90a, b)—recurs throughout the *Modi*, for example, in the satyr-man (see the discussion above, under fragment A) and in the vivid scene captured in a woodcut of Cupid pulling a captured cart (cat. no. 100, fol. B4v). Aretino's sonnet printed below the woodcut interprets the frenzied male as trying to see the front and back erogenous zones at once, very much the concern of contemporary painters; gazing at the anus and vulva, he will, according to Aretino, "achieve Paradise" and feel "more

beautiful than Narcissus." The bawd figure at the window, who interrupts this reverie, recurs on a larger scale in Giulio's *Lovers* (fig. 38).

E (two fragments numbered "11"). The seated or horse-riding position (fig. 83, middle) is recommended by Ovid in *Ars amatoria* and appears frequently on Roman tokens and ceramics, some of which Giulio may have known. Here he combines it with the reaching-down gesture already seen in the satyr-woman (see the discussion above, under fragment A). Though the sheet of lovers has been cut into two fragments, the man's affectionate arm and hand can still be seen on the woman's shoulder. The facial features are somewhat coarse and angular, and the breasts awkwardly placed, suggesting that some of these replacement copies were assigned to assistants.

F (two fragments numbered "4"). The uninked zone at the bottom of the oval piece precisely matches the curvature of the woman's arm in the rectangle, confirming the accuracy of Waldeck's reconstruction. Enough survives of this beautiful sheet to venture an attribution to Agostino Veneziano (Agostino dei Musi), the talented follower and occasional rival of Marcantonio. The woman is another variant of the animated *Ariadne* statue while the man's heroic torso and downward-leaning head derive from the *Hercules Resting*, a statuette of which was known in Raphael's workshop.[9] No "Toscanini" woodcut exists for this vibrant image, but it almost certainly appeared on the missing folio A4, and a sonnet attributed to Aretino describes it quite accurately. Xanto borrowed the female figure to represent "lascivious Rome," on a plate dated 1534 (State Hermitage Museum, Saint Petersburg).

G ("No. 19"). This fragment preserves the woman's hard, sculptured profile and dramatically lit shoulder, the apex of the original composition (fig. 83, bottom). Here the seated posture of fragment E has been reversed, as recommended in Ovid and described in sixteenth-century sex manuals.[10] Parmigianino's fascinating pen-and-ink drawing after this engraving (private collection) deemphasizes the woman's head—perhaps to suggest a boy— and brings the man into greater prominence, though eliminating his erect penis.[11] JGT

1. Aretino to Battista Zatti, December 11, 1537, in Aretino, *Lettere*, 1995–98 (ed.), vol. 1, p. 655: "querele Gibertine."
2. Titian to King Philip II of Spain, quoted in Hope 1980a, p. 114.

3. See cat. nos. 90a, b; Nova 1997 (for Cesare's access to Raphael's studio); and Leonardo, *Paragone*, 1949 (ed.), pp. 65–66 (discussed in my essay in this volume).
4. This claim is made in Nesselrath 1993, pp. 180–81, 183.
5. Mariette to Giovanni Bottari, May 30, 1756, in Bottari 1764, p. 330. Delessert (1853, p. 24) recalls an "English amateur" who saw them "mutilated with scissors" at the time of Ralph Willett's 1812 sale, where Lawrence paid forty-five pounds for the sheet; by 1830 its price had sunk to eleven guineas.
6. John Gere to Walter Toscanini, June 9, 1958, carbon copy kept with the Waldeck materials, German XVIII-century, box 67, Department of Prints and Drawings, British Museum. He comments on a set of Waldeck's drawings in the British Museum; another set is in the Bibliothèque Nationale de France, Paris.
7. Talvacchia 1999; Waddington 2004.
8. Turner 2007b.
9. See Nesselrath 1993, pp. 182–83, fol. 80, fig. 58. For a detailed assessment of Agostino's possible role in these engraved copies, see Turner 2004; for a sonnet describing this composition, see Lawner 1984, p. 72.
10. Ovid *Ars amatoria* 3.786: "the Parthian horse" (Ovid, *Art of Love*, 1985 [ed.], pp. 172, 173); *Il piacevol ragionamento de l'Aretino*, 1987 (ed.), p. 99: the "bella sedia."
11. Ekserdjian 1999, p. 38, no. 71, fig. 91; Ekserdjian 2006, p. 110, fig. 106.

SELECTED REFERENCES: Delessert 1853; Foxon 1963; Dunand and Lemarchand 1977; Gombrich et al. 1989, pp. 276–81; Talvacchia 1999; Richard Aste in Cox-Rearick 1999, pp. 50–57, no. 7, ill.; Turner 2003b; Turner 2004; Camarda 2005

100. The "*Toscanini Volume*"

Possibly northern Italy: publisher unknown, ca. 1550–60
Printed book with woodcut illustrations, image size: ca. 2⅜ × 2⅝ in. (60 x 66 mm)
Private collection, Milan

This unique little book is a fragmentary edition of sonnets (lacking the title page), some probably by Pietro Aretino (1492–1556), with reversed copies of details from the engravings by Marcantonio Raimondi (ca. 1470/82–1527/34) for *I modi*. Brought together here with the engraved fragments in the British Museum (cat. no. 99) for the first time, it provides the fullest evidence for the dissemination of the *Modi* in conjunction with sonnets by, or in the manner of, Aretino. Even with folios A1 and A4 missing, it contains fourteen small woodcut images above matching poems, plus a final page of verse commentary. This quarto pamphlet is bound at the end of a book of obscene poems, some likely by a younger

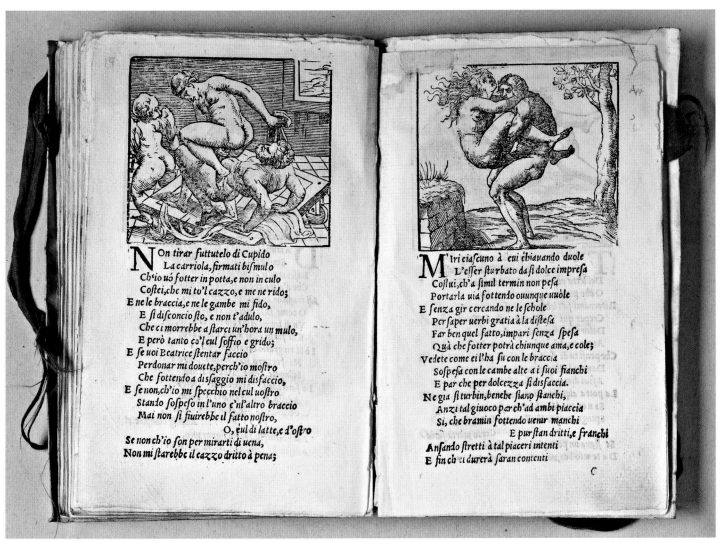

Cat. 100, fols. B4v–C1r

Cat. 100, fol. B2v (detail)

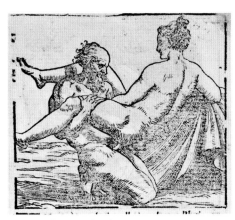

Cat. 100, fol. C1v (detail)

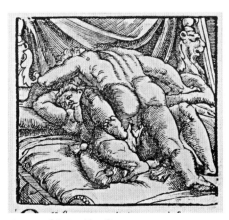

Cat. 100, fol. A3r (detail)

Cat. 100, fol. B3r (detail)

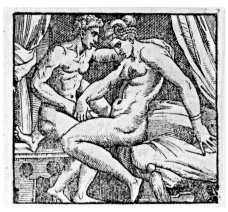

Cat. 100, fol. A3v (detail)

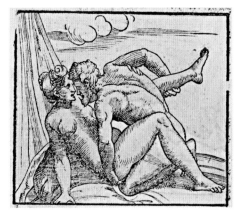

Cat. 100, fol. A2v (detail)

203

protégé of Aretino, probably published in Venice in the 1530s—but it was produced using lower-quality type and paper. This composite volume is sometimes cited by the name of former owner Walter Toscanini, the son of the conductor.

Scholars have been tempted to link this booklet to a note of Aretino's dated 1527, in which he sends a friend "the book of sonnets and *figure lussuriose*."[1] But this more plausibly refers to a presentation set of the original engravings, much larger in format, with sonnets written below them. In 1541 Niccolò Franco, first Aretino's secretary and then his bitterest enemy, jeered at him for publishing "a little booklet [*picciolo Libretto*] where are all the modes of screwing, / And each one displays its own sonnet"—adding that the author's sister had tested them all.[2] A small-format edition from about 1540, based on the replacement copies rather than the long-vanished Marcantonio engravings, could well have been the immediate ancestor of the "Toscanini" pamphlet—though it appears to be a piracy, made by a block cutter less skillful than those in Aretino's circle in Venice, where he collaborated with the publisher Francesco Marcolini (ca. 1500–after 1559) to produce splendid illustrated books. The woodcuts here, barely one-sixth of the surface area of the engravings, efficiently crop and compress the figures into an almost square aperture. The furnishings and accessories that distinguish Marcantonio's images are sometimes retained but more often truncated or omitted.

Aretino, who appears as a love-sick swain in Marcolini's frontispiece for his 1537 *Stanze* (cat. no. 113c), prided himself on his expertise in every kind of eros, from the profane to the celestial. In 1537 he wrote in a famous letter that he was "touched by the spirit that moved Giulio Romano to design" the *Modi*—some dozen years earlier, after helping to release Marcantonio from jail and seeing the images themselves—and so wrote obscene sonnets "at their feet." Aretino's letter invited the reader to "consider how naturally my verses portray the attitudes of the jousters," and justified his deliberately rude poems as both a cultured intellectual game and an expression of "natural" sexuality.[3] Long dismissed for their grossness, some of Aretino's sonnets (printed in the "Toscanini" booklet) are now recognized for their vital exploration of the interplay of arousal and observation. They strive to meet Leonardo da Vinci's challenge to poets to capture, as painters can, the excitement of "libidinous acts." (For Leonardo, see my essay "Profane Love" in this volume).

The spectacular composition on folio B4 verso, which may have formed the finale of the original *Modi*, sums up the variations on the *figura serpentinata* that fascinated and challenged artists, producing what the theorist Lodovico Dolce called "difficult mixtures" and "double art."[4] The woman's downward-reaching gesture becomes a precarious balancing act; as the accompanying sonnet explains in the man's speaking voice, "I'm trusting to my arms and legs . . . suspended on both arms." Her upper body corresponds to the slumped-over dying Cleopatra in an engraving by Marcantonio or Agostino Veneziano (Bartsch XIV.161.198), but the torso and legs have been reanimated with a twisting contrapposto. The lighting in the engraving must have been dramatic, as the faint line of shadow thrown by the woman's raised arm here is much more emphatic in copies of the figure painted on maiolica wares by Francesco Xanto Avelli (1486/87?–?1542).[5] Hints of classical mythology appear in other scenes, but here Cupid takes an active part, pulling a humble truckle bed in a parody of the Petrarchan *Triumph of Love*.[6] The seductive rear view and over-the-shoulder gaze of this hard-working Cupid are reprised in Parmigianino's great *Amor Carving His Bow* in Vienna (for a contemporary copy, see cat. no. 89).

David Ekserdjian asserts that the sonnets inject "a much needed dose of admittedly obscene humour" into the "heavy-handed" *Modi*,[7] but a burlesque wit clearly runs through the original designs. Here the strained athletic posture seems to reinforce the parody, perhaps illustrating Leon Battista Alberti's warning against contorting the figure in an attempt to show multiple sides.[8] The accompanying sonnet (plausibly by Aretino himself) brings in another technique for displaying doublesidedness, the mirror. The male admits that "if it weren't that I mirror myself in your ass [*mi specchio in cul vostro*], this act of ours could not go on; if it weren't that I long to gaze at your milk-white and shell-pink ass, my prick would scarcely stand upright." This plaintive monologue reflects not so much "(male) sexual power"[9] as the fragility of male performance, something also recognized in the advice manuals of the period.[10] Aretino compares the bottom to the small circular mirrors known as "spheres," concealed behind fabric like a painting and shining brightly when revealed.[11] His sonnet parodies (yet endorses) a key concept of the earlier Renaissance theory of images, the idea that religious paintings and sculptures should be placed in the nursery because the child will "mirror himself" in them (*si specchi*).[12] The *Modi* bring down to earth the Neoplatonic notion that "the lover engraves the figure of the beloved on his own soul, and so the soul of the lover becomes a mirror in which the image of the loved one is reflected."[13]

Classical artifacts often depict this reversed "riding" position, and though the closest parallels to this *Modi* image were not recorded in the Renaissance, Giulio might have known others. In the silver Warren Cup (British Museum, London), from the early first century A.D., the younger man lowers himself backward onto his bearded lover using a strap, just as here the woman steadies herself with a taut bedsheet (misrepresented in the woodcut but visible in the reconstruction by Jean-Frédéric Maximilien Waldeck). In one fragment of red *sigillata*, or Arretine ware (Museum of Fine Arts, Boston), of the same period, the female is uncannily similar. In antiquity, however, the elite male reclined luxuriously; now, he himself becomes the couch.

Standing copulation, as shown in folio C1r, intrigued artists as well as connoisseurs of sexual experiment, who compared it to the combat of Hercules and Antaeus.[14] Cesare da Sesto's sketches (cat. nos. 90a–c) and the bronze satyrs and satyresses attributed to Desiderío da Firenze (cat. no. 112) or to Riccio (fig. 85) resemble this woodcut only generically, however. The poem, which exists in some collections of "Aretino" sonnets but not others, describes the action accurately but does not explore the psychology of the gaze, or speak in the lovers' own voices. Instead it delivers a lecture on how steadily they keep at it, without interruption.

Engaging as they are, neither text nor woodcut on folio C1r belongs convincingly to the *Modi*.[15] The image is not corroborated by any other copyist, and differs in characters and setting—unkempt rustics standing under a blank sky in a minimal open-air setting, rather than statuesque and elaborately coiffed sexual athletes in draped, ornamented interiors, as glimpsed in the engraving fragments (cat. no. 99). Their upright position suggests an original in vertical rather than horizontal format. It is difficult to imagine Giulio designing such an anatomically insupportable composition, where the female body floats in the air. JGT

1. Aretino to Cesare Fregoso, November 9, 1527, in Aretino, *Lettere,* 1995–98 (ed.), vol. 1, pp. 40–41.
2. N. Franco, *Rime,* 1541, fol. 128v: "picciolo Libretto . . . Dove son tutti i modi del chiavare, / E ciascun modo mostra il suo sonetto."
3. Aretino to Battista Zatti, December 11, 1537, in Aretino, *Lettere,* 1995–98 (ed.), vol. 1, pp. 655–56, also discussed in my essay in this volume.
4. Quoted in Roskill 1968/2000, pp. 212–14; and see my essay in this volume.
5. For example, *Circe and Glaucus* (Wallace Collection, London, C91).
6. Waddington 2004, p. 28.
7. Ekserdjian 2006, p. 110.

8. L. B. Alberti, *Della pittura*, 1950 (ed.),
 pp. 96–97; L. B. Alberti, *On Painting*, 1956
 (ed.), p. 80.
9. Findlen 1993, p. 69.
10. Bell 1999, pp. 35, 41–57.
11. P. Thornton 1991, pl. 267; Musacchio 1999,
 fig. 41. Renaissance sodomitical literature
 describes the *culo* as "the mirror of the *cazzo*"
 and praises its spherical form as *il tondo* (see
 La cazzaria del C. M., Bibliothèque Nationale
 de France, Paris, fols. A2, A4; N. Franco,
 Rime, 1541, p. 110).
12. Dominici, *Regola*, 1860 (ed.), p. 13.
13. Ficino, *Commentary*, 1944 (ed.), p. 57.
14. See Talvacchia 1999, p. 222; and my discus-
 sion of Cesare and the "Antaeus" posture in
 my essay in this volume.
15. The damage and water-staining on this page
 (but not on the opposite page) suggest that
 this last gathering may have circulated sepa-
 rately before the whole collection was bound.

SELECTED REFERENCES: Aretino, letter to
Battista Zatti, December 11, 1537, in Aretino,
Lettere, 1995–98 (ed.), vol. 1, pp. 654–56; Aretino,
Sonetti, 1992 (ed.); M. Sander 1929; Foxon 1963;
Lawner 1984; Zentai 1998, pp. 74–75, under
no. 27; M. Bury 1999; Talvacchia 1999; Barolsky
2000; *Eros invaincu* 2004, no. 1; Turner 2004;
Turner forthcoming

Gian Giacomo Caraglio
Verona or Parma, ca. 1500–Kraków, 1565

After Perino del Vaga
Florence, 1501–Rome, 1547

and Rosso Fiorentino
Florence, 1494–Fontainebleau, 1540

101a–g. The Loves of the Gods

a. Neptune and Doris (JGT, no. 7; Bartsch XV, 11 [73])

b. Pluto and Proserpina (JGT, no. 8; Bartsch XV, 22 [73])

c. Apollo and Daphne (JGT, no. 11; Bartsch XV, 18 [75])

d. Mercury, Aglaurus, and Herse (JGT, no. 14; Bartsch XV, 12 [73])

e. Bacchus and Erigone (JGT, no. 15; Bartsch XV, 14 [74])

f. Vulcan and Ceres (JGT, no. 17; Bartsch XV, 13 [73])

g. Vertumnus and Pomona (JGT, no. 18; Bartsch XV, 16 [74])

1527
Engravings, each (within its own frame) 17¾ × 12¾ in.
(45 × 32.5 cm)
Rijksmuseum, Amsterdam (RP-P-OB-35.611, 612, 613,
615, 616, 618, 621)

Scandalous, instantly famous, and swiftly censored by Pope Clement VII and his irate minions in Rome, the *Modi*—six-teen prints of fornicating couples designed by Giulio Romano and engraved by Marcantonio Raimondi in 1524 (cat. nos. 99, 100)—spawned a number of progeny. Earliest and most notable among those lascivious offspring is the *Loves of the Gods*, a series of some twenty images designed primarily by Perino del Vaga and Rosso Fiorentino and engraved by Gian Giacomo Caraglio in 1527. Its narrative, long clouded and convoluted in the literature, has been considerably clarified by James Grantham Turner, who has estab-lished the original numeration (used in the heading above), configuration, and prob-able content of the series and demonstrated that the anonymous verses that accompany many of the extant impressions (the work of two distinct calligraphic hands), while not integral to the images, were introduced early in the production process.[1] Such mat-ters fall for the most part outside the nar-row focus of the present discussion, which is concerned primarily with a single aspect of the prints—their subject matter—although brief comment will be made about the origi-nal scope of the series.

In contrast to the *Modi*, which depict patently quotidian (and therefore, in the eyes of sixteenth-century guardians of public morality and decorum, objectionable) figures engaged in a fulsome variety of sexual acro-batics, the protagonists of the *Loves* are not lowly mortals surrendering to their carnal appetites. Rather, they are the lofty inhab-itants of Olympus, whose amorous adventures, recounted by Ovid and other ancient Roman poets, were a mainstay of classical myth and Renaissance secular imagery. As many schol-ars have postulated, the choice of ancient deities as subjects was probably calculated to preempt the criticism that the notori-ously nonmythological *Modi* immediately attracted: like Raphael's artistically refined but undeniably sensual frescoes in the Psyche Loggia of the Villa Farnesina, a gloss of anti-quarian erudition, however meretricious, attaches to the baldly erotic *Loves* by virtue of their antique subject matter, thereby impart-ing a patina of decorum. Mythology, in other words, provided a convenient pretext for the portrayal of lewd imagery.[2] The strategy was evidently effective, for the perpetrators of the *Loves* were spared the punitive indigni-ties suffered by the printmaker Marcantonio Raimondi, who was thrown in jail for his part in the *Modi* enterprise (the other major player, Giulio Romano, conveniently left town shortly after the *Modi* were published), though the lack of retribution was probably owing more to the chaotic political climate of the moment than to any clever deception on the part of the publisher, printmaker, or artist. Reeling from the utter devastation of Rome wrought by the cataclysmic Sack of May 1527 by rampaging imperial troops—a horrific event that contemporary observers described in near-apocalyptic terms—the pope, who had had to flee the Vatican for fear of his life, undoubtedly had more press-ing matters to deal with than another epi-sode of scabrous printmaking.

Vasari gives vague and not entirely con-sistent accounts of the *Loves* in his biogra-phies of Rosso, Perino, and Marcantonio (where Caraglio is discussed). His descrip-tion—"quando gli Dei si transformano per conseguire i fini de' loro amori" (when the gods transform themselves in order to con-summate their loves)[3]—misleadingly implies that the subjects are all drawn from Ovid's *Metamorphoses*, a literary source that some do not share. (The non-narrative *Venus and Cupid* [JGT, no. 20; see cat. no. 95] has no obvious textual source; and *Cupid and Psyche* [B. 20], the subject of another print, is based on *The Golden Ass* by the late antique poet Apuleius). His accounting of the genesis of the series is presumably accurate in its essen-tials: however, the commission to design the *Loves* first went to Rosso, with whom Caraglio had profitably collaborated on the recent *Hercules* and *Gods in Niches* series;[4] the temperamental artist produced two drawings before having an altercation with the publisher, Baviera, who then enlisted Perino—desperate after the personal travails he endured during the Sack—to resume the project. Rosso's two designs are *Pluto and Proserpina* (cat. no. 101b) and *Saturn and Philyra* (B. 23). Most of the other scenes are inventions of Perino, who worked on the *Loves* until he departed for Genoa in late 1527 or early 1528.[5]

That the *Loves of the Gods* was something of an ad hoc and ongoing enterprise, fueled and expanded by its own success, rather than a suite of images whose content was fixed from the outset, is suggested by the random and uneven representation of the Olympian deities: Jupiter is the subject of no fewer than five prints (a sort of miniseries within the *Loves* that anticipates the *Furti di Giove* [*Loves of Jupiter*] tapestries that Perino designed a

few years later for his great Genoese patron Andrea Doria);[6] Juno is absent (aside from a single print, where she is cast as an antagonist of Jupiter), while Hercules, a half-mortal interloper, is included; the rarely represented, minor deities Vertumnus and Pomona—not Olympians at all—make an appearance; and the engraving of Venus and Cupid departs entirely from the "loves of the gods" theme, and from all the other prints in the series, in showing the goddess alone. Moreover, the uneven quality of the designs suggests that in addition to Perino and Rosso, at least one other unidentified draftsman provided Caraglio with drawings, probably after both those artists had left Rome following the Sack.[7]

Reconsidering Vasari's confusing discussion as the backdrop to these particulars, we may wonder whether the *Loves of the Gods* evolved as an amalgam of a smaller, circumscribed series devoted to the Ovidian *Loves of Jupiter* with other erotic mythological scenes, which were added by the enterprising publisher and/or printmaker in order to enlarge what was obviously a commercially successful venture.[8] Perhaps Vasari had the *Jupiter* subset in mind when he described the *Loves* as images of the gods changing form in order to consummate their passions, a characterization that applies only to those five scenes.[9]

The *symplegmae* (erotic groups) portrayed in the *Loves of the Gods* are predominantly heterosexual, but one scene, *Apollo and Hyacinth* (JGT, no. 12), is a homoerotic encounter of the type both practiced and elegized in poetic verses at the numerous humanist academies that sprang up in Rome and elsewhere during the sixteenth century.[10] (It is amusing to observe that Apollo offers a defensive *apologia* for his change in preference from the female Daphne to the adolescent male Hyacinth in the accompanying text.)[11] Although two of the images, *Jupiter and Antiope* (B. 10) and *Mercury, Aglaurus, and Herse* (cat. no. 101d), are surprisingly graphic—Turner characterizes them as "two of the most sexually explicit images in the series, indeed in Western art"[12]—and three of the *Jupiter* scenes represent the paired figures *in flagrante delicto*, as in the *Modi*, the majority of the designs, with their elegant, stylized poses and gracefully interwoven figures, eschew the overtly lascivious tone of Giulio Romano's designs in favor of the chaste, sterile eroticism that infuses Perino's drawings of similar subjects (see cat. nos. 93–95).

Indeed, other than in the Jupiter scenes, erotic meaning in the *Loves* is not so much expressly illustrated as it is signaled through quotations from an established lexicon of coded symbols and gestures. Most conspicuous, and repeated throughout the series like a refrain, is the "slung leg"—a pose that

contemporaries would have recognized as an analogue of sexual intercourse.[13] The quiver and strategically placed arrows of Cupid, who appears throughout the *Loves* as an observer or participant, take on a playful phallic aspect in some of the scenes (*Jupiter and Antiope* [B. 10]; *Mars and Venus* [B. 15]; *Saturn and Philyra* [B. 23]). Reprising one of Giulio Romano's favorite lewd gestures, Mars inserts a finger in the mouth of Venus. The keys held by Janus in a print that probably does not belong to the *Loves,* but was certainly inspired by those designs in any case, was a well-known, punning symbol of sexual intercourse (fig. 39),[14] while fruits of the type seen in *Vulcan and Ceres* (cat. no. 101f) and *Vertumnus and Pomona* (cat. no. 101g) provided an endless font of material for burlesque poetry and mock-humanist encomia extolling both heterosexual and homosexual love (see my essay "Rapture to the Greedy Eyes" in this volume). That artists of the period spoke this particular dialect of coded language is most famously attested in the beautiful garlands of fruits and vegetables painted by Giovanni da Udine, a collaborator of both Giulio Romano and Perino del Vaga in Raphael's workshop, in the Psyche Loggia of the Villa Farnesina, where a ripe fig and a suggestively shaped zucchini enact a parody of sexual intercourse (fig. 32).[15]

If the *Loves of the Gods* took its immediate inspiration from the *Modi*, that iconic model was only the most recent and notorious installment in a long tradition of profane erotic imagery. Ancient Roman art—the object of keen study and emulation by Raphael and his followers, including Perino and Giulio—abounded with such subject matter, as did fifteenth- and sixteenth-century Italian prints. Like the *Modi* and Marcantonio's thematically related *Woman with a Dildo* (see fig. 45), such images were typically suppressed or censored, but not before they were circulated and collected. Devoid of any classical overlay, the *Modi* are in fact closer to this type of ribald popular imagery (and its literary counterpart in the work of Pietro Aretino and other burlesque poets of the age) than to any of the ancient sources that have been adduced for them. Imagining the licentious Arcadia of Ovid's *Metamorphoses* or Apuleius's *Golden Ass*, the *Loves of the Gods*, in contrast, conjures both the subject matter and the spirit of ancient Roman mythology.

LW-S

1. Turner 2007a (source for the "JGT" numbers listed in the heading) sweeps away many of the more egregious errors and misconceptions advanced by most of the authors who have written about the *Loves*, beginning with Giorgio Vasari in the sixteenth century.

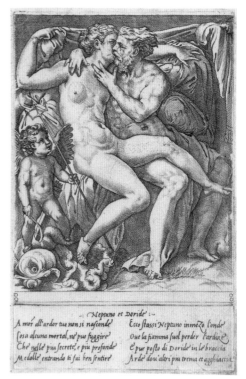

A mor all'ardor tue non si nasconde'
cosa alcuna mortal, ne' piu fuggire'
Che' nelle' piu secrete', e piu profonde'
Medolle' entrando ti fai ben sentire'

Ecco stassi Neptuno in mezo l'onde'
Oue la fiamma suol perder l'ardire'
E' pur posto di Doride' in le' braccia
Arde' dou'altri piu trema et agghiaccia'

— Neptuno et Doride' :—

Cat. 101a

The joining of lewd words and image was almost certainly not the innovation of Baviera, the publisher of the series, or his collaborators; like the subject matter of the prints, this format reprises the successful formula used earlier in the *Modi*. For this reason I concur with those scholars who believe that Pietro Aretino's sonnets were not joined to the *Modi* only in the second, woodcut, edition but were already circulating in tandem with Marcantonio's prints in Rome in 1524.

2. As Archer 1995, p. 98, observes, "The Caraglio series veils its eroticism in the humanistic gloss of mythological narrative." The point is also made, inter alia, by Talvacchia 1999, pp. 126–27. Despite the possible presence of a satyr or faun in Position 7, and Cupid in Position 14, I do not believe that any of the copulating figures in the *Modi* are deities or mythological protagonists.

3. Vasari, *Le vite*, 1568/1906 (ed.), vol. 5, p. 611.

4. For *Hercules*, see Carroll 1987, pp. 75–87, nos. 9–14; and Oberhuber and Gnann 1999, p. 350ff. For *Gods in Niches*, see Carroll 1987, pp. 100–125, nos. 21–40; and Oberhuber and Gnann 1999, p. 390ff.

5. Vasari says that Perino designed ten scenes and Rosso two; if his accounting is accurate, another artist (or artists) was responsible for designing the remaining eight prints. Turner 2007a, p. 368, states that Perino "certainly [did] not [design] the entire series as commonly assumed" (the two compositions by Rosso notwithstanding), though with one exception no alternative attributions are proposed. The designs of lesser quality are by and large those omitted from the series by Bartsch (*Peintre-graveur* [Vienna, 1803–21]). All the designs can aptly be characterized as

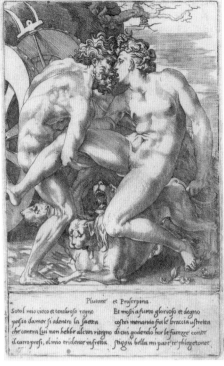

Plutone et Proserpina.

Sotto'l mio cieco et tenebroso regno Et mossi a furto glorioso et degno
passo d'amor si adentro la saetta costei menai no fra le braccia ristretta
che contra lui non hebbi alcun ritegno di cui godendo hor le farezze conte
il carro presi, el mio tridente in fretta stiggiu bella mi pare te phlegetonce

Cat. 101b

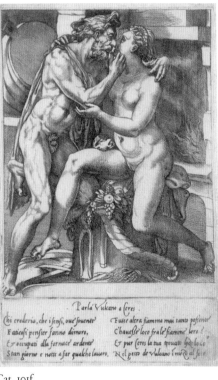

Apollo a Dapne.

Inuidiosa scorza a che t'affretti cosi dicendo et frondi et rami schietti
chiuder il chiaro uiso et desiato In uece strinse del bel corpo amato
Perche piu tosto pia non aspetti Di cui gustando il frutto ch'se serua
ch'io ne furi alcu bacio in questo stato lusato amaro anchor questa proterua

Cat. 101c

ercurio parla a Silauros

Poi che sei fatta per inuidia un sasso In sasso trasformata qui ti lasso
Ne uedi, u, l'empia uoglia ti trasporte, Eterno esempio di si iniqua sorte,
E chiuder pensi, a chi non chiude il passo Ma inuidia piu di me ti uince'e sforza
Virtude Re e de le tartaree porte'. Ch'ella quel dentro cangia, et io la sorza

Cat. 101d

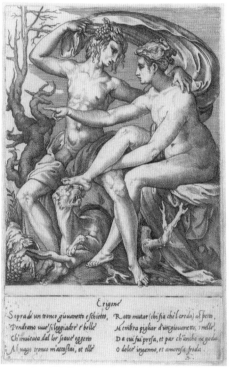

Erigone.

Sopra di un tronco giouanetto e schietto, Rato mutar (chi fia chi l'creda) aspetto,
Pendeano uue si leggiadre' et belle' Membra pighar d'in giouanetto, snelle',
Chi inuitasa dal lor soaue oggetto Da cui fui presa, et par ch'anche ne goda,
Al uago tronco m'accostai, et elle' O dolce inganno, et amorosa froda.

Cat. 101e

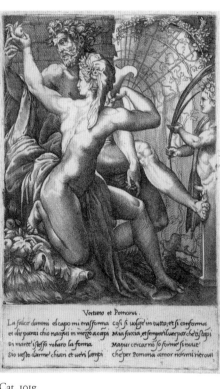

Parla Vulcano a Ceres.

Chi crederia, che i sensi, oue souente' Fusse altra fiamma mai tanto possente'
Fancesi pensier farino d'amore, C'hauesse loco fra le fiamme' loro!
Et occupau dlla fernace ardenti' Et pur Ceres la tua trouati hor loco
Stan giorno e notte a far qualche lauoro, Nel petto de Vulcano i mezo al foco

Cat. 101f

Vertuno et Pomona.

La falce d'anni, el capo mi trasforma cosi si uolge in tutto, et si conforma
et dir potrai ch'io nacqui in mezzo a capi Mia faccia, et sempre l'huer par che ti stapi
Di marte' i stesso robaro la forma Mapur cercar no so forme si noue
Sio uesto d'arme' chiari et ueri lampi che per Pomona amor richmi ritroui

Cat. 101g

"Perinesque," though they are uneven, and some of the compositions are superior to others.

6. For the tapestry series, see Davidson 1988; and Elena Parma in *Perino del Vaga* 2001, pp. 232–54, 248–54, nos. 126–32.

7. Talvacchia 1999, p. 139, describes "Baviera's process of insistently working with different artists over a period of several years until a sufficient group of models had been compiled" and the "piecemeal" history of the scenes. See also Turner 2007a, p. 376. The print identified in note 9 below (Turner 2007a, p. 378, no. 3) as *Jupiter and Callisto*, the design of which Turner ascribes (wrongly, in my opinion) to Rosso, appears to me to be by an inferior hand; Perino's responsibility for the *Apollo and Hyacinth* (Turner 2007a, p. 379, no. 12) should also be questioned if not dismissed outright. See also note 14 below.

8. See cat. no. 94, where it is suggested that the composition of *Vertumnus and Pomona* (here, cat. no. 101g) may have originated as an independent invention in the manner of Perino's other red chalk drawings of erotic subjects and only later been incorporated into the *Loves of the Gods*—a suggestion consistent with the idea posited here that the content of the engraved series was ad hoc and additive rather than fixed at the outset. A fluid genesis would also account for the anomalous image of Venus alone; conceivably, that design is a discarded first idea for the more lascivious *Mercury, Aglaurus, and Herse* print (cat. no. 101d)—a possibility suggested by the nearly identical figure of Herse in one of Perino's slightly later *Loves of Jupiter* tapestries, lost but known through his *modello*—which the publisher and printmaker may have decided to include for its undeniable erotic appeal. See also cat. no. 95.

9. Of the Jupiter prints, I believe that the composition identified as Jupiter and Io with Juno (Turner 2007a, p. 378, no. 3, and p. 370, fig. 183) in fact depicts Jupiter and Callisto, one of the *furti* (encounters) illustrated in Perino's lost *Loves of Jupiter* tapestries (Davidson 1988, p. 433). Jupiter and Io are unmistakably the subject of another print in the series (Turner 2007a, p. 378, no. 4; B. 9; Talvacchia 1999, p. 142, fig. 37), making a second representation of the same subject inexplicably redundant; moreover, in his seduction of the nymph Callisto, Jupiter assumes the form of the goddess Diana, who appears in the composition in question. The verse appended below the image is presumably the source of the misidentification.

10. See my essay in this volume.

11. "Nesun min colpi, se del mio donzello / Le guance io prezzo piu che gemme et oro / Da poi che mi fu amor si curdo, et fello / Per quella onde ver deggia il uago allor / Pero son fatto a quell desio ribello, E tardo sol per questo, et discoloro / Et si mi piace ognhor lanoua salma? Chio le concede dogni honor la palma" (It is no fault of mine if I appreciate / the cheeks of my lad more than jewels and gold, / since love was so cruel and mean to me. / By the side of that river the pretty laurel [i.e., Daphne] grows green / but I am made a rebel against that desire, / and I linger only for this, and I grow pale, / and I like his young skin so much / that I concede to him the palm of every honor). English trans., Archer 1995, p. 205.

12. Turner 2007a, p. 370. The enlarged phallus of Jupiter as a satyr in the *Jupiter and Antiope* (B. 10) was censored in most of the surviving impressions. The pose of the sleeping female figure exposing herself in both prints recalls antique models like the *Barberini Faun* (Glyptothek, Munich; Haskell and Penny 1981, no. 33); that particular work had not yet been discovered, but Perino must have known other ancient examples in the same vein.

13. The erotic meaning of the pose is discussed by Steinberg 1968 and occurs in the following prints: *Neptune and Doris* (cat. no. 101a), *Vulcan and Ceres* (cat. no. 101f), *Bacchus and Erigone* (cat. no. 101e), *Mars and Venus* (B. 15), *Cupid and Psyche* (B. 20), *Pluto and Proserpina* (cat. no. 101b), and *Hercules and Deianira* (B. 19). (According to Matthews Grieco 1997, pp. 66–67, the latter subject, familiar from popular prints, spoke to contemporary audiences of the "erotic power of women over men.") To cite only one example in another medium as evidence of its ubiquity, the slung-leg pose is seen in Riccio's *Satyr and Satyress* in the Victoria and Albert Museum, London (fig. 85).

14. The print representing *Janus* (B. 17; see Archer 1995, p. 109; fig. 39), which Talvacchia 1999, pp. 155–56, and Turner 2007a, p. 370, have excluded from the *Loves*, may well have been one of the late "add-on" images, stylistically idiosyncratic because it, too, is by a different hand but thematically consistent with the rest of the series and of the same dimensions. The platform in this composition, which is a departure from the beds used in the other designs and is cited by Talvacchia 1999, p. 156, as one of the reasons for excluding the *Janus* from the *Loves*, is a *ponte*, or bridge, appropriate to the god of portals and gateways; like the crossed keys (a familiar papal emblem as well as an erotic metaphor), it may also have been intended as a punning allusion to the then much-beleaguered pope, the Pontifex Maximus.

15. A cornucopia, one of which is suggestively placed below Ceres's outstretched leg in *Vulcan and Ceres* (cat. no. 101f), probably also carried lascivious connotations; see discussion under cat. no. 93 with regard to a related drawing by Perino.

SELECTED REFERENCES: Archer 1995, p. 97ff.; Talvacchia 1999, pp. 126–58; Achim Gnann in *Perino del Vaga* 2001, pp. 190–94, nos. 80–90; Turner 2007a

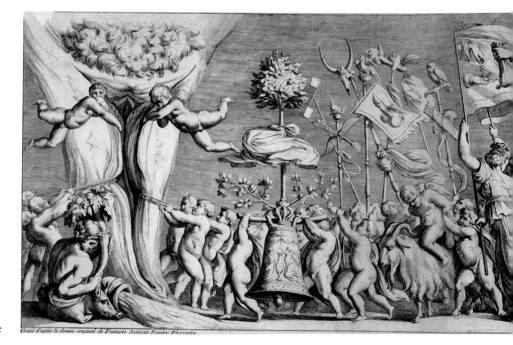

Gravé d'après le dessein original de François Salviati Peintre Florentin.

Monogrammist CLF
French, 17th century (?)

After Francesco Salviati
Florence, 1510–Rome, 1563

102. The Triumph of the Phallus

Engraving and etching, 15⅛ × 63⅜ in. (38.3 × 161 cm)
The British Museum, London (2002, 1027.55)

Striking as much for its exceptional size as for its licentious subject matter, this monumental print (composed of three joined sheets, it is more than five feet wide) was an imposing if anomalous specimen among the phalanx of "phallic artifacts," predominantly antiquities, assembled by George Witt (1804–1869) in the mid-nineteenth century. A physician, banker, and politician, Witt gained a certain renown in London society for the Sunday morning lectures he delivered on his unusual collection, which was bequeathed to the British Museum and, perhaps surprisingly given the prudish tastes of the day, accepted by the trustees.[1] Most of the works were then immediately consigned to a newly designated *museum secretum*, modeled after the infamous *gabinetto segreto* of the Museo Archeologico in Naples, and furtively locked away—some for decades, others for more than a century. In 1991 the contents of "cupboard 55" (a restricted repository housing the remnants of the *museum secretum*) were revealed to an astonished public, though the press at the time was forbidden to take photographs of the curiosities.[2] Precisely when this singular piece of erotica was liberated from the *museum secretum* is unrecorded, but only recently it was unearthed in the "pornography cupboard" of the British Museum's print room and published for the first time in 2007.[3]

A priapic satire of a Roman triumph, whose iconographic conventions are faithfully observed, the design depicts an enormous phallus enthroned beneath the honorific canopy of an *all'antica* chariot. Crowned by a flying nike with a laurel wreath, the victor is propelled by a frenetic retinue of nymphs and putti toward a triumphal arch in the form of female pudenda. Acolytes wave standards embellished with images of the victorious hero and brandish as trophies the clothing—monks' and nuns' habits, elegant gowns, tunics, and trousers—of the vanquished, those from all stations of life who yielded to the ineluctable power of carnal love: *amor vincit omnia* (love conquers all). The erotic subject recalls a woodcut, the *Worship of Priapus*, from the enigmatic late fifteenth-century *Hypnerotomachia Poliphili* (cat. no. 62); here, the ithyphallic rustic deity is transformed into his most distinguishing attribute, and the composition assumes the form of an ancient relief with the worshippers deployed in a friezelike procession. Indeed, in both size and composition the design approximates carved Roman sarcophagi, particularly representations of the *Triumph of Bacchus,*[4] important examples of which were well known and widely copied in Renaissance Rome.[5]

An inscription at the lower left of the print credits the sixteenth-century Florentine painter Francesco Salviati with the invention of the *Triumph of the Phallus*. (A drawing of this subject from the circle of Salviati, presumably a faithful copy of a lost original by the artist, dated to the 1540s, appeared on the art market in 1999).[6] Although hidden from view in recent times, the composition was evidently of some repute in the eighteenth century. In December 1728, during a trip through Italy, the French jurist and writer Baron de Montesquieu recorded having seen in Florence in the Gaddi collection what was without doubt this image: "a sketch by Salviati of a huge Priapus on a chariot led with great force by some women toward a [*blank*]. They carry picks on which are many monks' habits and form a kind of procession."[7] Not long after, the design was reproduced in an etching and, in condensed form, on a carved gem by Felice Antonio Maria Bernabé, which was itself copied in various iterations. The learned Italian theologian and scholar Antonio Francesco Gori mentioned Bernabé's gem in his *Dactyliotheca Smithiani*, published in 1767, and stated that it was based on an obscene drawing by Francesco Salviati, which at that time was in the gallery of the Gaddi family, testimony consistent with Montesquieu's earlier statement.

The information gleaned from these mutually corroborating written accounts—that the *Triumph of the Phallus* was based on a drawing by Salviati and that the drawing in question was owned in the eighteenth century by the Gaddi family—fits well with the earlier historical record. Salviati is known to have produced erotic designs (see fig. 41),

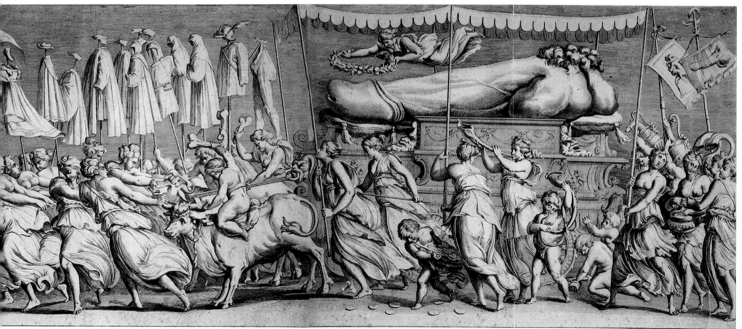

Cat. 102

and his network of patrons in Rome brought him into the orbit of Giovanni Gaddi, powerful Clerk of the Apostolic Chamber, and Cardinal Niccolo Gaddi, whose descendants later owned the drawing. They and other cultivated and libertine aristocratic members of Salviati's circle, who shared a predilection for "erotic games" and a particular tolerance for homosexuality, formed the audience for such images as the *Triumph of the Phallus*.[8]

Like the mock-humanist burlesque poetry and dialogues of the period, which skillfully appropriated the literary conventions of the ancients in emulation of intellectually elevated humanist tracts but cast them in the service of profane and even lewd themes, Salviati's invention parodies all the pictorial and iconographic conventions of archaeologically inspired Renaissance *trionfi* celebrating great military deeds and noble civic virtue—Mantegna's heroic *Triumphs of Caesar* is an iconic exemple[9]—and transforms the heroic ritual into an apotheosis of lust. Informed by the spirit and language of the self-avowed "anti-Petrarch" and indefatigable champion of carnality, Pietro Aretino,[10] the composition is a visualization of his pronouncement that "we should allocate to [the phallus] its own ferial days and consecrate special vigils and feast-days in its honor."[11]

LW-S

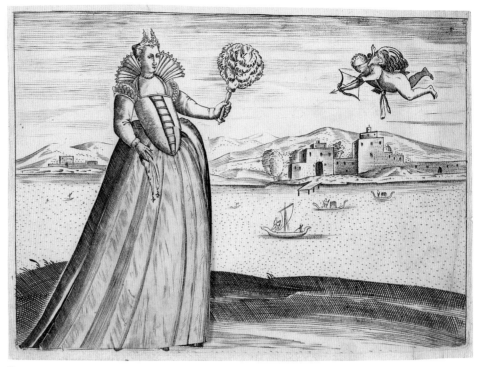

Cat. 103

1. On George Witt and his collection, see Johns 1982, pp. 28–30.
2. As reported in Bailey 1991; this article was kindly brought to my attention by Geoffrey Woollard.
3. Turner 2007c. Another impression is in a private collection in Stockholm, and a smaller etching of this subject is in the Bibliothèque Nationale de France, Paris; for which, see respectively Turner 2007c, p. 285, and Philippe Costamagna in Monbeig Goguel 1998, p. 252, under no. 97, ill.
4. Compositional parallels with sarcophagi reliefs are noted by Turner 2007c, p. 286.
5. Bober a)nd Rubinstein 1986, pp. 111–13, nos. 76–78.
6. Ascribed to the circle of Salviati, the drawing is now in a private collection; see Monbeig Goguel 2001, p. 36, fig. 9.
7. Montesquieu, *Oeuvres*, 1949–51 (ed.), vol. 1, pp. 656–57 (author's translation).
8. The foregoing is synopsized from Monbeig Goguel 2001, pp. 26–30.
9. On the ancient and Renaissance literary sources of Mantegena's *Triumphs* imagery, see the essay and entries by Charles Hope on "The Triumphs of Caesar" in Boorsch et al. 1992, pp. 350–72.
10. Parallels with Aretino are noted by Monbeig Goguel 2001 and Turner 2007c; the former suggests that artist and poet may have encountered each other in Venice in the early 1540s.
11. Letter to Battista Zatti, December 1537,

in Aretino, *Lettere*, 1957–60 (ed.), vol. 1, pp. 110–11, no. LXVIII; quoted in Waddington 2004, p. 115; T. Wilson 2005a, p. 20.

SELECTED REFERENCES: Monbeig Goguel 2001, p. 24ff.; Turner 2007c, pp. 284–86, fig. 162

Pietro Bertelli

Act. Padua, late 16th–early 17th century

103. Courtesan and Blind Cupid (Flap print with liftable skirt)

Ca. 1588
Engraving and etching, 5½ × 7½ in. (14 × 19.1 cm)
The Metropolitan Museum of Art, New York, The Elisha Whittelsey Collection, The Elisha Whittelsey Fund, 1955 (55.503.30)

The Bertelli family oversaw an industrious print and book publishing operation in Venice, Padua, and elsewhere in Italy that flourished for nearly a century beginning in the 1560s. The most notable member of this modest dynasty was Pietro Bertelli, who about 1588 published a series of prints of courtesans with flaps that lifted to offer glimpses of the seductive pleasures for which Venice was famed by its admirers and reviled by its detractors. Revealing the carnal secrets that the seemingly innocent pastimes of secular daily life masked, these clever and amusing "interactive" works have been aptly described as "flap erotica."[1] In this example—one of the most replicated images from the series—an elegantly garbed courtesan holding a plumed fan (a symbol of sensuality)[2] and sporting the coiffed horns that became popular in the later sixteenth

Cat. 103 with flap lifted

voyeur is not merely a passive viewer but a physically engaged participant: through the very motion of lifting the courtesan's skirt he becomes implicated in a carnal act. In addition to the sense of sight (and in the case of Aretino, sound, for his eavesdroppers both watch and listen through cracks in the walls), another sense—touch—is thus enlisted in Bertelli's courtesan print, whose erotic content is only revealed by a viewer willing to commit the "transgression" of "groping the sheet to find the elusive edge," then "probing beneath the skirt."[4] Physicality, yet another defining characteristic of the erotica of Giulio and Aretino, whose energetic and agile actors demonstrate it in abundance, thus also obtains in the flap print. While not an attribute of Bertelli's placid and graceful courtesan, it is instead required of her "client" or audience. It is through this transfer of physicality from image to spectator that the print achieves a heightened erotic content.

LW-S

1. S. K. K. Schmidt 2006, vol. 1, p. 329. I am grateful to Wendy Thompson for bringing this source to my attention.
2. Fortini Brown 2004, p. 264, with reference to the fan held by a courtesan in a painting by Giovanni Cariani, and p. 162, fig. 185, for a reproduction of an illustration of a courtesan holding a fan from Giacomo Franco's *Habiti delle donne venetiane*, an image in cat. no. 65.
3. S. K. K. Schmidt 2006, vol. 1, p. 326. Citing impressions that were mounted to a backing presumably in order to be hung on a wall, the author suggests that "the prints would have been perfect for a humanist's private *studiolo*, with familiar themes unthinkable in uncovered paintings" (S. K. K. Schmidt 2006, vol. 1, p. 335).
4. Schmidt (ibid., p. 338), who analyzes the manner in which Bertelli's flap prints require the active physical touch of the viewer to be fully appreciated.

SELECTED REFERENCES: Fortini Brown 2004, pp. 184–85; S. K. K. Schmidt 2006, vol. 1, p. 329

century (see fig. 37) stands beside the banks of a river or canal as a blindfolded Cupid hovers in the air nearby. Here, the flap is the skirt, which lifts to present to the viewer her undergarments and chopines, the impossibly high platform shoes that Venetian ladies wore to keep their feet dry. (A pair of sixteenth-century Venetian chopines is included in the exhibition; see cat. no. 117, fig. 36.)

Bertelli's courtesan, whose costume and hairstyle as well as incriminating pearls and fan all closely resemble the courtesans in Giacomo Franco's *Habiti delle donne venetiane* (cat. no. 65), partakes of a number of the pervasive conceits of Renaissance erotica. Like a portrait of a mistress or lover hidden behind a closed curtain or on the unseen back of a maiolica plate (cat. no. 111), or a clandestine image kept behind a secret shutter of a covered mirror (see cat. no. 115), the flap print's illicit content could be either concealed or revealed depending on the audience. The act of lifting the skirt, analogous to removing the cover from a mistress portrait, could only be performed by its privileged private viewer, who in so doing effectively contrived to "lift the curtain obscuring the object of his desire."[3]

Voyeurism—a recurring theme of Giulio Romano's erotic images and Pietro Aretino's salacious dialogues, both of which feature unseen observers witnessing the protagonists' sexual antics—also comes into play with the flap-skirt print. In this case, however, the

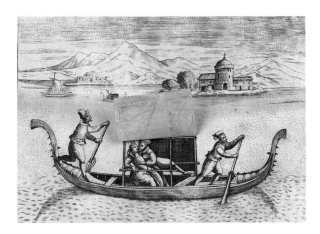

Fig. 84. Donato Bertelli (act. 1568–74), *Vere imagini et descritioni delle piv nobilli citta del mondo,* 1578. Engraving. New York Public Library, New York

Pietro Bertelli (?)

Act. Padua, late 16th–early 17th century

104a–f. Costumes of Roman Women

a. *La Citella Romana (Maiden)*

b. *La Sposa Romana (Bride)*

c. *La Maritata Romana (Matron)*

d. *La Vedova ala Baronessa (Widowed Baroness)*

e. *La Vedova Romana (Widow)*

f. *La Cortigiana di Roma (Courtesan)*

Ca. 1600
Engravings, each 9 × 6¼ in. (22.9 × 15.9 cm)
The Metropolitan Museum of Art, New York, Bequest of Randolph Gunter, 1962 (62.676.31.1), Estate of Randolph Gunter, 1962 (62.676.31.2–6)

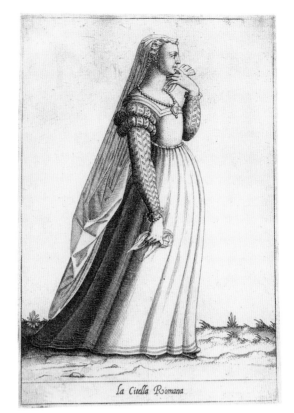

Cat. 104a

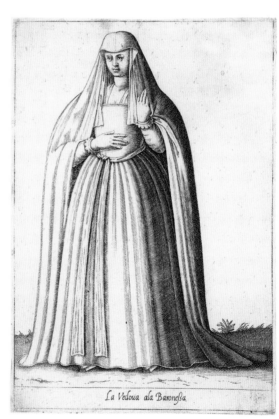

Cat. 104d

These six engravings depicting the costumes of Roman women recall the more elaborate and ambitious series by Cesare Vercellio and Giacomo Franco illustrating the attire and customs of Venetian women (cat. nos. 64 and 65). They were probably created, in a manner similar to those examples, as book illustrations, although the expedient Bertelli was known to reuse his inventions in a number of different contexts and formats. In Rome, as in Venice, courtesans were a fixture in contemporary society, their intractable (if intermittently rued) presence reflected in the inclusion of a *cortigiana* among Bertelli's cast of Roman women. Documentary accounts from the sixteenth century record that courtesans in Venice were often indistinguishable from "honest women"—a deliberately misleading semblance they cultivated by dressing in the same attire (see cat. nos. 64 and 103), and a ruse that civic authorities at times attempted to combat through legislation (see my essay "Rapture to the Greedy Eyes" in this volume). The same was undoubtedly the case in Rome, although their presence in that city populated by ostensibly celibate clerics was more benignly tolerated than it was in La Serennissima. Judging by these costume prints, the Roman courtesan's attire differed little from that of a matron or widow: all wear a heavy veil. Of those categories (as distinct from the newly betrothed and the bride, both of whom wear jewels but not the heavy veil), only the courtesan sports pearls—a jewel that was frequently given in exchange for "carnal commerce," as accounts of sixteenth-century Roman legal proceedings demonstrate, and which thus had a particular association with courtesans and high-class prostitutes (see cat. no. 87).

LW-S

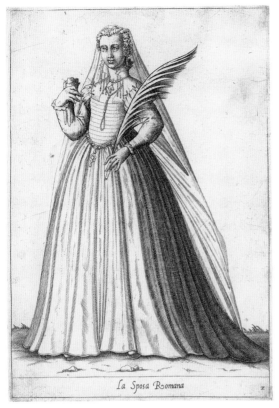

La Sposa Romana

Cat. 104b

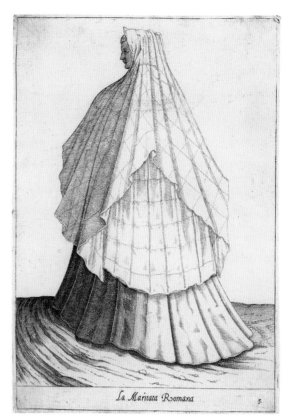

La Maritata Romana

Cat. 104c

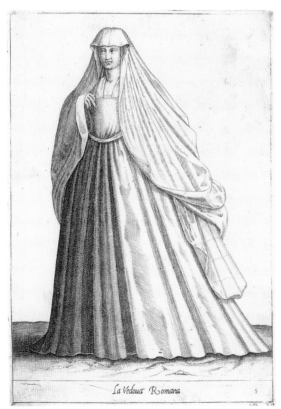

La Vedoua Romana

Cat. 104e

La Cortigiana de Roma

Cat. 104f

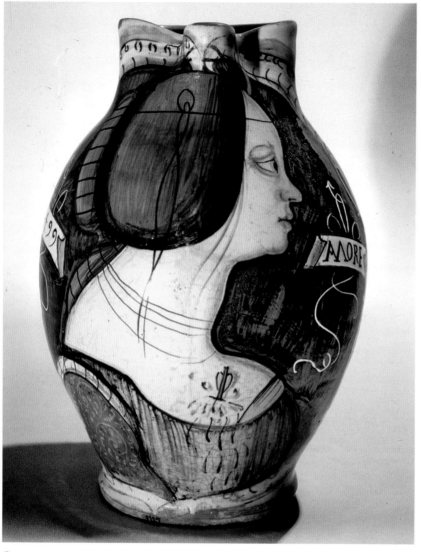

Cat. 105

105. Boccale (Jug): Woman Wounded by Love

Faenza, 1499
Tin-glazed earthenware (maiolica), H. 12⅜ in.
(31.5 cm), Diam. (base) 5¼ in. (13.5 cm)
Inscribed: AMORE
Musei Civici d'Arte Antica, Bologna (1115)

Recent scholarship has highlighted the existence of a considerable body of Renaissance maiolica decorated with lewd and bawdy subject matter, of which the "Phallic Head" plate now in the Ashmolean Museum, Oxford (cat. no. 110), is the most singular example.[1] Recalling (in spirit, if not in form or manner of decoration) ancient Greek ceramics embellished with overtly erotic scenes, these pieces belong to a tradition that extended back to antiquity.[2] What exactly Renaissance artists would have seen of such work is uncertain. Examples of Greek pottery,

though rare, were not entirely unknown in fifteenth- and sixteenth-century Italy (Vasari refers to Greek vases, judging them inferior to the painted earthenware of his own day), and Aretine ware, of more local provenance, was certainly familiar.[3] The impetus behind the manufacture of these objects remains a puzzle, but given their illicit imagery it seems probable that, like erotic paintings and drawings, they were meant for the private enjoyment and amusement of a select few, shared and exchanged among friends.

In a rare early reference to a specific, traceable piece of maiolica, this jug is expressly mentioned in Lorenzo Legati's 1677 publication *De vasi delle terre vulgara*. His description of "a profile portrait bust of a woman of gentle bearing, almost naturalistic, with clothes and hairstyle demonstrating the fashion of that time . . . her hair . . . gathered in a little golden-yellow veil, . . . tied with a fine ribbon seemingly of black silk" accords perfectly with its subject, as does his additional

exegesis that "the painter makes her appear as if she had been wounded by an amorous dart, by placing a dagger in her breast and blood spill[ing] from the wound. And there is a white cartouche as if from her mouth which seems, sighing, to pronounce the word LOVE."[4] What Legati neglected to note is the sketchily rendered, graffito-like motif of a flying phallus, its trajectory indicated by the incised arrow pointing to the woman's head.

Love is not merely alluded to, as Legati's excursus suggest, but is expressly represented by the phallus, as the word *amore*, emblazoned on its *cartellino* like a name tag, conveys. (The winged penis as a symbol of carnal love is a familiar erotic motif, seen, for example, in a print of a copulating couple now known only through the engraver's plate; see fig. 46.) The very literal tableau may be a pedantic and unironic illustration of the time-honored topos of the pain associated with the travails of love (a theme also expressed in a lubricious scene of a woman exposing her genitalia on an albarello now in the Museum für Kunst und Gewerbe, Hamburg),[5] for which the jug's original contents served perhaps as an elixir. Alternatively, this image may be a parody of the *bella donna* type—an irreverent and salacious depiction of a *brutta donna,* or woman of questionable virtue akin to the "insatiable Swallower of Parsnips" derisively referred to by Pietro Aretino's whore Nanna, whose colorful language adduces one of the many vulgar phallic metaphors from the burlesque vegetal repertoire of the day.[6] Whatever its intent, there can be little doubt that the ribald detail of the flying phallus—which Legati either overlooked or abstained from mentioning—would have sounded a humorous refrain for its original audience.

LW-S

1. G. Conti 1992; Hess 2003; T. Wilson 2005a.
2. Numerous examples are discussed and illustrated in Johns 1982.
3. Syson and D. Thornton 2001, pp. 214–15.
4. Cited and quoted in Ajmar-Wollheim and D. Thornton 1998, pp. 143–44. An image of a woman holding a dagger and a winged heart on a fluted bowl (cat. no. 25) likewise takes up the theme of the pain of love (see as well cat. nos. 21–24).
5. For which, see Rasmussen 1984, pp. 83–86, no. 52. This example is very similar to cat. no. 108.
6. Aretino, *Ragionamenti* (English trans.: Aretino, *Secret Life of Wives*, 2006 [ed.], p. 58). Such *brutte donne* seem to have provided the subject matter for some of the floor

tiles in the Vaselli Chapel in San Petronio, Bologna; see Ravanelli Guidotti 1988, kindly brought to my attention by Dora Thornton, and cat. no. 107.

Selected references: Ravanelli Guidotti 1985a, no. 32; Ajmar-Wollheim and D. Thornton 1998, pp. 143–44

106. Plate with a Woman and a Basket of "Fruits"

Deruta, first quarter of 16th century
Tin-glazed earthenware (maiolica), Diam. 13⅝ in. (34.5 cm)
Inscribed in banderole: *AIBO FRVTI DONE* (Come get your good fruit, women)
Musée du Louvre, Paris (O.A. 1256)

Rife with erotic overtones, fruits and vegetables communicated myriad prurient meanings and innuendos to a sixteenth-century audience conversant with the ribald and scabrous literary conventions of burlesque poetry and its echoes in the visual arts (see my essay "Rapture to the Greedy Eyes" in this volume). Thus, when included in depictions of a seductively beautiful woman (fig. 44), a handsome youth,[1] or a leering satyr (cat. no. 111), a basket of fruit would immediately have been understood as a carnal attribute of the subject or sitter. An admirably witty inversion of the pictorial theme of a woman with a basket of fruit is this plate, in which the "fruits" are transformed into phalluses—the literal objects they often metaphorically represent.

Although it has been suggested that this image is in some manner associated with the theme of fertility (according to one recent interpretation, the woman's basket contains *frutti di cera*, wax phalluses that were offered to Priapus in the hope of obtaining real-life, flesh equivalents),[2] it fits squarely within the framework of burlesque imagery. In the *Ragionamenti*, Pietro Aretino's *puttana* Nanna recounts the excitement with which a company of monks and nuns, as though heeding the invitation of the woman on this dish to "come get your good fruit," rushed to pluck the contents of a basket of "fruits" that were in actuality the glass dildoes "shaped like a man's testimonials," known as *pastinache muranese*, or "parsnips of Murano."[3] (Their use is demonstrated in a rare erotic print by Raphael's collaborator Marcantonio Raimondi; fig. 45). Parsnips, like cucumbers, green beans, and other suggestively shaped botanical specimens, were coded metaphors for phalluses of flesh as well as glass: elsewhere in the *Ragionamenti*, the same Nanna lewdly describes a promiscuous wife as "the insatiable Swallower of Parsnips."[4] In its parody of an established pictorial theme, the image of a woman with a basket of "parsnips" is at once witty and salacious. Indeed, so perfectly consonant is it with the conventions of the burlesque that a supposed apotropaic or medicinal meaning, or allusion to an obscure fertility ritual—interpretations that each fail to take into account the scene's bawdy, humorous aspect—seems improbable if not irrelevant.

LW-S

1. An iconic example of the latter is Carvaggio's *Boy with a Basket of Fruit* (Borghese Gallery, Rome).
2. G. Conti 1992, p. 110. (Such votive wax phalluses from eighteenth-century Isernia exist;

see Johns 1982, p. 25.) Hess 2003, p. 73, also suggests an allusion to the theme of fertility. A similar interpretation has been proposed for a curious mural above a public fountain in Massa Maritima that depicts women plucking phallus-shaped fruits from trees (fig. 43); for which see Ferzoco 2005. The subject of a woman holding a basket or container of one-eyed phalluses is a recurring theme in ancient Greek vase painting, based on the different examples noted in Hess 2003, p. 72, and T. Wilson 2005a, pp. 30–31; whether the loose similarity of subject with this plate is coincidental or historically significant remains uncertain.
3. Aretino, *Secret Life of Nuns*, 2004 (ed.), pp. 15–16. No such objects from the sixteenth century are known to survive, but fragments of seventeenth-century English examples have been excavated; see Telfer 2006, p. 194. I am grateful to Dora Thornton for this reference.
4. Aretino, *Secret Life of Wives*, 2006 (ed.), p. 58.

Selected references: G. Conti 1992, pp. 110–11; Hess 2003, ill. p. 73; T. Wilson 2005a, p. 30, fig. 19

107. Dish with an Allegorical Subject

Castelli, workshop of Orazio Pompeii, ca. 1520–40
Tin-glazed earthenware (maiolica), H. 1⅝ in. (4 cm), Diam. 9¼ in. (23.5 cm)
Inscribed on banderole: *PIGLI /A•E•NO•PENETIRE• PEGIO / NO PO: STARE•CHE / ARESTITV / IRE*
Corcoran Gallery of Art, Washington, D.C., William A. Clark Collection (26.308)

A notable example of "erotic earthenware," as it has aptly been described, this dish depicts a woman holding a bird as she displays her left breast.[1] In both form

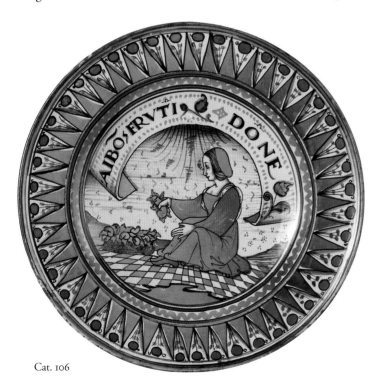

Cat. 106

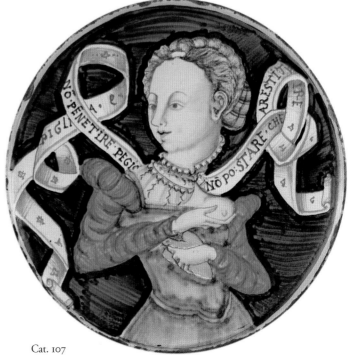

Cat. 107

and imagery, it is related to *coppe amatorie* (love cups), maiolica ware that was given as betrothal gifts.[2] Such works were frequently embellished with *belle donne* (idealized female heads) accompanied by tags or inscriptions naming the beauty or extolling her virtues (see, for example, cat. nos. 9 and 12). While the present piece appropriates those conventions, this particular *donna* is almost certainly a courtesan or high-class prostitute rather than a chaste paragon of virtue or beauty. Such an identification is posited on the basis of her carnal offerings (the bird, or *uccello*, is an ancient and ubiquitous vulgar metaphor for the penis and carried expressly homoerotic connotations in the Renaissance burlesque lexicon; see my essay "Rapture to the Greedy Eyes" in this volume) and is not inconsistent with her elegant attire. (Courtesan portraits often show the sitter garbed in this type of fancy costume [see figs. 36, 37]; such women frequently received expensive clothing, as well as jewels and trinkets, from their male admirers as payment for their services or to seal their carnal contracts.)[3] Indeed, the woman's lewd gesture of grasping an exposed breast is a stock motif in Renaissance burlesque imagery; it is enacted, for example, by the female member of the pair of copulating satyrs in a bronze attributed to Desiderío da Firenze (cat. no. 112). There is no doubt that it carries lascivious associations here.

The female subject represented on the Corcoran dish, then, is closer in type not to the "Beautiful Pulisena" (cat. no. 9) and her ilk—images informed by contemporary literary modes praising local beauties[4]—but to the local beauties of questionable virtue unflatteringly commemorated in the floor tiles from the Vaselli Chapel in San Petronio in Bologna.[5] Like those glazed earthenware pasquinades, the Corcoran dish appropriates and subverts an encomiastic formula, transforming it into a satirical and comic idiom. Such images are the artistic counterparts of the burlesque literary trifles that flowed from the pens of countless Renaissance poets in learned and playful mockery of humanist pedantry.

The specific meaning of this prurient image remains a puzzle, but it seems to represent an allegory of sexuality, the breast and bird signifying, respectively, female and homoerotic pleasures. Like Hercules at the Crossroads, the viewer-recipient is confronted with a conundrum or choice: which rival temptation of the flesh will prove the most seductive? Holding, or perhaps restraining, the bird tightly against her chest as she extends her breast like an offering, the woman undoubtedly hopes that her feminine charms will triumph. That hope seems to be the essence of the inscription in the

banderole fluttering over her head, words of encouragement that accompany her oblation of flesh, chosen to sway a hesitant or undecided client: "Take and don't regret it. The worst that can happen is that you'd have to give it back." LW-S

1. The nearly identical subject occurs on an ancient Greek red-figure vase in the British Museum, London, which shows a nude woman holding a bird as she lifts the cover off a basket of phalli (Johns 1982, p. 67, fig. 5; interestingly, the latter subject, a woman with a basket of phalli, is also seen on another Renaissance maiolica plate included in the present catalogue, no. 106).
2. Thornton, discussed under cat. no. 9 of the present publication.
3. See my essay in this volume; see also cat. no. 87.
4. Thornton, under cat. no. 9, notes that these "*belle donne* should be viewed within the literary tradition of praising local beauties, one which was well-established in different regions of Italy from the late fifteenth century." On this, see also Ajmar-Wollheim and D. Thornton 1998, p. 140. This tradition in turn is based on classical rhetorical modes of praise.
5. See Ravanelli Guidotti 1988.

Selected references: W. M. Watson 1986, no. 18; Musacchio 2004, p. 48, fig. 36

108. Albarello with a Woman (Shepherdess?) Lifting Her Skirt

Central Italy, Deruta (?), ca. 1500–1520
Tin-glazed earthenware (maiolica), H. 8⅛ in. (20.7 cm)
The Walters Art Museum, Baltimore (48.2234)

Maiolica vessels of this shape, known as albarelli, were produced as apothecary jars. The original medicinal contents—and the precise maladies those herbs, balms, and oils were intended to treat—are often signaled by identifying inscriptions as well as the particular pictorial decoration. However, few such clues are present on this albarello, which lacks an inscription and is embellished with an erotic but enigmatic image of a woman lifting her skirt. Her vaguely *all'antica* tunic and sandals and the whip that she holds suggest that she is an ancient shepherdess, but no precise narrative subject has been recognized. An albarello now in the Museum für Kunst und Gewerbe, Hamburg, is decorated with a similar scene,[1] although that woman wears contemporary rather than classical dress and lifts her skirt in the presence of a winged phallus that must

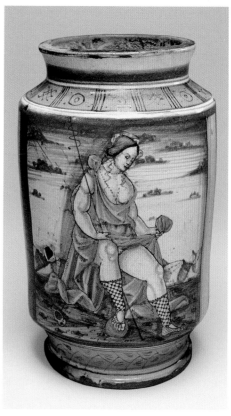

Cat. 108

signify love or, more specifically, fertility—an explanatory detail absent here. While the Hamburg jar also lacks an inscription, its more explicit imagery points to the likelihood that it was made to contain an aphrodisiac or a fertility tonic. By extension, this albarello may also originally have contained some sort of "love potion"—a function consonant with the poetic yet titillating image.[2]

LW-S

1. Rasmussen 1984, pp. 83–86, no. 52.
2. The function suggested for both albarelli, with due caution, by Catherine Hess (2003, p. 74).

Selected reference: Hess 2003, p. 74, ill. p. 76

109. Plate with The Death of the Woman of Sestos

Urbino, Francesco Xanto Avelli (Rovigo, 1486/87?–Urbino, ?1542), dated 1532
Tin-glazed earthenware (maiolica), Diam. 16 in. (40.6 cm)
Inscribed on reverse: *.MDXXXII. / A' L'USO ANTICO U[N] V[ER]GI[N] CORPO ARDE[N]DO / UN' AQUILA DA QUEL NUTRITO, ANCH'ELLA / UOLSE PARTECIPAR DIL FUOCO HORRE[N]DO. / NEL .X. LIBRO D[EL] CAIO PLINIO SECO[N]DO, AL CAP: V /. FRA[NCESCO]. XANTO. A. DA ROUIGO. T / URBINO* (1542. According to the antique custom, the body of a virgin being burned / an eagle nourished by her also / wishes to participate in the horrid fire / From chapter 5 of Pliny's Book X / Francesco Xanto Avelli da Rovigo in / Urbino)
The Metropolitan Museum of Art, New York, The

The subject of this plate by the ambitious maiolica painter Xanto (see also cat. no. 81) comes from Pliny (Natural History 10.6 [in modern editions]). In the city of Sestos, according to Pliny, an eagle was reared by a young girl. The grateful eagle brought the girl birds and prey, and when she died it perched itself on her funeral pyre, so deeply did it love her. Here Xanto depicts the final act of the story. The plate, also decorated with the Pucci arms, is one of thirty-seven known to survive from the large Pucci dinner service.

Xanto owned a partial set of the *Modi* (cat. no. 99) in early, second-generation copies, and frequently quoted figures from these erotic engravings, designed by Giulio Romano. Xanto's oeuvre is a valuable source for reconstructing the appearance and influence of Giulio's erotica, because, as here, Xanto inscribed his works both with a precise date and with interpretive verses and literary references. The naked man stoking the fire on this plate is borrowed from the muscular male whose knotty leg is glimpsed in one of the London fragments of the *Modi* (cat. no. 99B). The left hand of the man in the fragment, which (in other early copies) appears below his right shoulder holding a kind of belt, has been transformed by Xanto into a piece of firewood. Xanto's appropriated image bears witness to the strong impression made by this foreshortened, kneeling nude seen from an indecent rear view—itself related to a figure in an important engraving by Agostino Veneziano or Marcantonio Raimondi, the *Carcass*, whose design is variously given to Giulio, Raphael, or Parmigianino. Such a virtuoso composition, recorded imperfectly in a volume of the *Modi* with woodcut illustrations in place of engravings (cat. no. 100), surely inspired Bronzino's bawdy tribute to the "extravagant modes . . . foreshortened or in perspective" made possible by the phallic paintbrush, *il penello*.[1] The propped-up position of the corpse, taken by Xanto from the *Dying Cleopatra* engraved by Marcantonio or Agostino (Bartsch XIV.161.198), also resembles the upper body of the female sexual acrobat in the "Cupid's cart" scene (see cat. no. 100, fol. B4r), another figure that he often borrows.

Scholars sometimes argue that Xanto's reuse of *Modi* figures is merely formal, even mechanical, since knowledge of their original sexual context vanished when the series was suppressed (supposedly by papal authority in 1524). This may have become the case with workshop repetitions, but in Xanto's signed and dated pieces we can detect witty

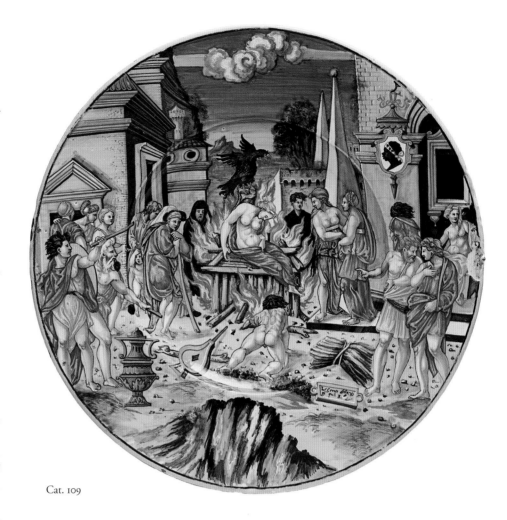

Cat. 109

allusions to the libertine originals—familiar from the numerous copies if not from Marcantonio's own plates. The bold woman in catalogue number 99E reappears in Xanto's work as "lascivious Rome," and the reclining lady who couples with the kneeling man, in the print cited here, features in several Xanto compositions as a breast-feeding mother.[2] In the Metropolitan plate, the precipitous fornicator now stokes a different kind of fire, but one still connected to an unusual form of love.

Xanto's adaptations of the *Modi*, especially those on wares designed for weddings and childbirth festivities, construct a visual and conceptual bridge between the illicit culture of "profane love" and the marital, domestic sphere. JGT

1. Bronzino, *Rime in burla*, 1998 (ed.), p. 24; for the corresponding woodcut, see Talvacchia 1999, p. 210.
2. See, for example, the maiolica plate entitled by Xanto *Roma lasciva dal buon Carlo Quinto partita a mezzo* (State Hermitage Museum, Saint Petersburg) and those illustrated in Musacchio 1999, pp. 118–19; and Mallet 2007, no. 35.

SELECTED REFERENCES: Woodford 1965; Talvacchia 1994; Musacchio 2004, pp. 18, 48, figs. 8, 12; Mallet 2007; Sani 2007, pp. 195–96

Attributed to Francesco "Urbini" (Urbino)

Urbino, Gubbio, and Deruta, act. 1530s

110. Phallic-Head Plate, 1536

Gubbio, Workshop of Maestro Giorgio Andreoli (?), 1536
Inscribed in reverse on banderole: *OGNI HOMO ME GUARDA COME FOSSE UNA TESTA DE CAZI* (Every man looks at me as if I were a dickhead); on back: *1536 / EL BREVE DENTRO VOI LEGERITE COME I GUIDEI SE INTENDER EL VORITE* (If you want to understand the meaning, you will be able to read the text like the Jews do); also inscribed with painter's mark *FR* and a pair of scales
Tin-glazed earthenware (maiolica), Diam. 9⅛ in. (23.2 cm)
The Ashmolean Museum, Oxford. Purchased (France, Madan, and Miller Funds) with the assistance of The Art Fund, the Resource / V & A Purchase Grant Fund, and numerous private donors, 2003 (WA2003.136)

Ascribed to the elusive Francesco "Urbini," an enigmatic personality so christened by Timothy Wilson, this astonishing plate—singularly "unlike that of any other piece of maiolica"—depicts a male head in profile rendered entirely of phalli.[1] According to the "hypothetical biography" constructed by Wilson, the artist was

active in Urbino (his possible birthplace), Gubbio, and Deruta in the 1530s, first in the orbit of Francesco Xanto Avelli, known as Francesco Xanto da Urbino (for whom see cat. nos. 81, 82, and 109), and subsequently in the workshop of Maestro Giorgio Andreoli in Gubbio—two of the preeminent maiolica painters of the sixteenth century. He was probably a journeyman with no workshop of his own, the itinerant career and lack of proprietorship providing some explanation for the apparent lack of any reference to him in contemporary documents. Even more obscure than its author are the circumstances leading to the production of this unique object, the patron who might have commissioned it, the possible identity (if any) of the sitter so dubiously commemorated, and its intended recipient, all of which remain a mystery.[2]

Like the dish with a woman and a bird (cat. no. 107), the satiric *testa dei cazzi* subversively appropriates the conventions of the *bella donna* and its male equivalent—a bust-length, idealized head accompanied by an inscription or motto (see cat. nos. 13a, b, 14a, b)—and recasts the formula according to the vulgar lexicon of the burlesque. Although no other maiolica pieces with an analogous subject are known, the phallic head was evidently a stock motif in the widely disseminated repertoire of erotic imagery, as its reappearance in other media confirms. The reverse of a medal of Pietro Aretino shows a phallic-headed satyr (cat. no. 113a)—a dual allusion to that consummate satirist's infamous carnality on the one hand and to the etymology and intentionally crude, unpolished nature of his barbed literary invectives on the other. Leonardo da Vinci created similar phallic *capricci*, according to the late sixteenth-century Milanese theorist Giovanni Paolo Lomazzo (now lost, but echoed perhaps in Cesare da Sesto's vulgar drawing of an erotic grotesque; cat. no. 90c); a similar head is the subject of a drawing attributed to Francesco Salviati.[3] And a print of this very subject, no impressions of which are now known (an unsurprising lacuna, given what Wilson has termed the tendency of such material not to survive), is documented in the sixteenth century in the collection of Ferdinand Columbus, son of the explorer Christopher Columbus.[4]

The *testa dei cazzi* plate partakes of the satirical sensibility and bawdy humor imprinted in the burlesque writings of Aretino and other distinguished practitioners of the genre such as Niccolò Franco, Francesco Berni, and Francesco Maria Molza. Carnal subject matter, described in blunt and literal detail or by means of thinly veiled, coded erotic metaphors, provided endless inspiration for those

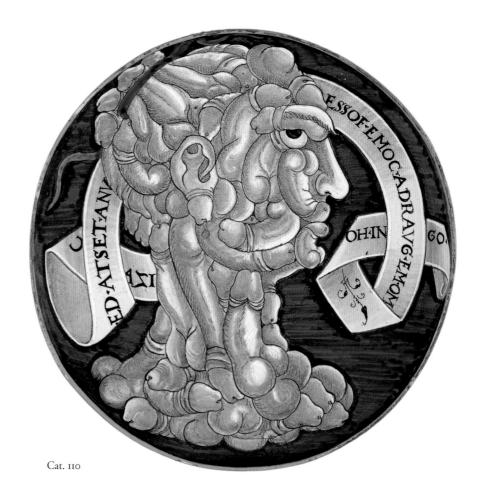

Cat. 110

salacious wits and their legions of fellows and cohorts in their more frivolous moments. The most apposite poetic counterpart is the mock-humanist dialogue *La cazzaria* (The Book of the Prick) by the Sienese academician Antonio Vignali, whose interlocutors expound at length, and with learned rhetorical flourishes, on the myriad virtues of sodomy.[5] Their earnest discourse shows the same lack of irony (in itself an ironic subversion) manifest in this phallic Arcimboldo's wonderment that "every man looks at me as if I were a dickhead," which is communicated, in a literal transcription of the subject's *moti mentali*, in the banderole fluttering around his head.[6] The script, read from right to left in emulation of Hebrew as an inscription on the reverse explains, underscores the image's satiric nature and intent: unlike that ancient and arcane language, which only a handful of distinguished scholars and humanists could probe and decipher, no real learning was required to read this parodic text—just faux erudition.[7]

Although we may only speculate about its origins, there is no doubt that the *testa dei cazzi* plate would have been an amusing presence at gatherings of Vignali's Accademi degli Intronati (Academy of the Deaf) and other fellowships of its kind that sprang up in Rome, Florence, and elsewhere in Italy in the sixteenth century (for which see my essay "Rapture to the Greedy Eyes" in this

volume). Private sodalities of like-minded initiates, these academies were incubators for erotic and homoerotic literary trifles, as well as loci for the consumption of lewd images. The learned but lewd mock-humanist dialogues, epigrams, and poems that issued from their pens find an iconic counterpart in the satirical image and text of the *testa dei cazzi* plate. LW-S

1. T. Wilson 2005a, pp. 13–14. The artist's presumed monogram appears on the back.
2. Wilson (ibid., p. 18) suggests that "the *testa de cazi* dish may be seen as a satirically emblematic portrait of an individual" whose identity has been lost to posterity. That at least some of the *belle donne* on maiolica plates and vessels are not idealized types but rather painted paeans to "local beauties," that is, representations of living people, has been discussed by Ajmar-Wollheim and Thornton 1998, p. 140; see also cat. nos. 9–13.
3. Monbeig Goguel 2001, fig. 9.
4. T. Wilson 2005a, p. 24.
5. Ibid., p. 20, adduces this, as well as the writings of Aretino and Franco, as the backdrop to the *testa dei cazzi* plate, but with no discussion of the subject matter or content of such texts, which are discussed at length in my essay in this volume.
6. This reference is to the late sixteenth-century Milanese painter Giuseppe Arcimboldo (1527?–1593), who is famous for his "portraits"—likenesses fashioned from a composite of fruits, flowers, and sea creatures,

among other nonanthropomorphic elements (for which see, most recently, Ferino-Pagden 2007). The composite phallic head of the *testa dei cazzi* plate anticipates his inventions, while employing a different, deliberately vulgar vocabulary. *Moti mentali*, or "movements of the mind," is Leonardo's term for the inner thoughts that animate and are expressed in gesture and expression.

7. Because it is deaf to the bawdy, humorous, and overtly erotic aspects of the *testa dei cazzi* conceit, the interpretation of the image proposed by Biscarini and Nardelli 2006, according to which the head of uncircumcised phalli and the right-to-left writing in emulation of Hebrew (as noted by the inscription on the reverse) indicate that the subject is an "Ebreo" (Jew), is in my opinion unconvincing. As suggested here, an alternative parodic and burlesque explanation for the right-to-left writing is to be found in the context of the mock-humanist "manifestos" in which the many literary academies and sodalities of the day specialized.

SELECTED REFERENCES: Parronchi 1991, fig. 2; G. Conti 1992, pp. 102–3; T. Wilson 2005a, figs. 1, 2; Biscarini and Nardelli 2006; Alexander Wied in Ferino-Pagden 2007, p. 60, no. II.9, ill. p. 61

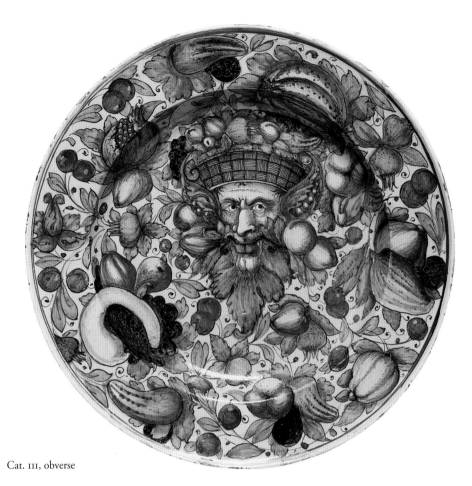

Cat. III, obverse

111. Dish with a Satyr Head and Fruit (obverse) and Standing Woman in Contemporary Dress (reverse)

Venice, ca. 1540–50
Tin-glazed earthenware (maiolica), Diam. 17⅞ in. (45.5 cm)
Victoria and Albert Museum, London (1768-1855)

Bestial creatures imprisoned by their carnal appetites, satyrs are often portrayed in Renaissance art as incarnations of lust (see cat. no. 112; fig. 85). The leering satyr head at the center of the design on this Venetian dish thus immediately signals its lewd meaning, which is iterated in the succulent, suggestively shaped fruits and vegetables arrayed around the rim and piled in his basket headdress.[1] The specimens, which include cucumbers, gourds, peas, melons, peaches, and pomegranates, are all drawn from the established lexicon of sixteenth-century burlesque poetry, which imputed punning, sexually suggestive, erotic, and homoerotic meaning to these innocuous and seemingly innocent crops (see my essay "Rapture to the Greedy Eyes" in this volume). The literary paradigm for such prose is Francesco Berni's encomium to a peach—a stand-in for the male buttocks (the aspect perhaps assumed by the two ambiguous fruits to the right of

the satyr's basket and at the bottom edge of the plate)—whose delights, the poet rhapsodized, can be enjoyed at any time. Less lyrical but in the same tenor is Pietro Aretino's conjuring of a "cucumber fully ripe" as a phallic metaphor. In painting, the effulgent swags framing the sensuous frescoes by Raphael's workshop in the Psyche Loggia of the Villa Farnesina in Rome serve as a veritable illustrated handbook of the salacious alter egos of Renaissance fruits and vegetables (see fig. 32). The thinly veiled scabrous allusions of both word and image were widely comprehended, including, no doubt, by the original owner of this amusing dish.

Sketched on the reverse, and therefore seen only by its intended private audience, is a contemporary *bella* (beauty, in this case a mistress or courtesan), the secret object of the satyr's—and owner's—lascivious desire. Like the miniature, presumably of his *innamorata*, that Bronzino's Ludovico Capponi coyly shields from all but his own gaze (fig. 34), or a mistress portrait obscured behind a curtain that only a lover could draw back (a manner of display mentioned by Aretino), the conceit of concealment heightens the erotic content of this image of forbidden, carnal love.

LW-S

1. The latter detail recalls the basket of fruits held by the sitter in Sebastiano del Piombo's beautiful portrait of a young Roman woman (fig. 44; see most recently Roberto Contini

in *Sebastiano del Piombo* 2008, pp. 144–47, no. 22). Despite attempts to identify the subject as Saint Dorothy, she is more likely a courtesan, in which case the basket of fruits was meant to convey, like that in Caravaggio's patently erotic *Boy with a Basket of Fruits* (Borghese Gallery, Rome), carnal rather than marital associations. A recent suggestion, advanced during the Sebastiano del Piombo exhibition in Rome and Berlin (2008), is that the portrait represents Agostino Chigi's mistress and eventual wife, Francesca Ordeaschi.

SELECTED REFERENCE: T. Wilson 1987, p. 110, no. 178, ill. p. 111

Cat. III, reverse

Attributed to Desiderío da Firenze

Florentine, documented in Padua 1532–45

112. *Satyr and Satyress*

After 1524 (?)
Bronze, H. 10⅝ in. (27 cm)
Musée National de la Renaissance, Château d'Écouen
(E.Cl. 2752a, b)

This pair of satyrs copulating surfaced in the later twentieth century after having been secreted in the "reserve" collection of the Musée Cluny, Paris, presumably because of its illicit subject matter, for over a hundred years, its reemergence paralleling that of the monumental print *Triumph of the Phallus* (cat. no. 102). At the time of its acquisition in 1858, the group—described as a "sujet lubrique"—included a third satyr; recent scholarship has not only proven that figure to be a later addition of inferior quality but has also recovered the original arrangement of the two then-separated principals.[1] Upon its rediscovery, the work was ascribed to the Paduan sculptor Andrea Riccio (1470–1532), who produced many bronze statuettes of satyrs, both singly and in pairs, and who also populated his most important work—the Paschal Candlestick in the Santo of Padua (1507–16)—with a myriad of such mythical creatures. A subsequent attribution to Riccio's follower, the shadowy Desiderio da Firenze, whose oeuvre and artistic personality have come into increasing focus over the past decade, has gained widespread if not universal acceptance.[2]

The sexually explicit theme of the sculptural group recalls the *Modi,* the iconic series of erotic engravings by Giulio Romano and Marcantonio Raimondi (suppressed but nonetheless exceedingly influential) published in 1524 (cat. no. 99).[3] The satyrs' position does not correspond particularly closely to any of Giulio's sixteen poses,[4] however, and other, equally salacious sources of inspiration—both ancient and modern (see, for example, cat. nos. 90a, b and fig. 46)—existed in abundance.[5] Certainly, the satyress's lewd gesture and vulgar expression, both of which recur in works in a variety of media, draw on a stock repertoire of erotic motifs (cat. nos. 87, 101b, and 107) rather than a single, specific model. The parallels with erotic prints are more suggestive in the case of a roughly contemporaneous bronze group by Riccio in the Victoria and Albert Museum, London (fig. 85): the intertwined figures paraphrase in reverse one of Perino del Vaga's designs from

Gian Giacomo Caraglio's *Loves of the Gods* (cat. no. 101a), although a direct link in this case remains speculative.[6] Unlike the pair in Écouen, those satyrs are not depicted *in flagrante delicto,* but the same libidinous spirit characterizes their union: the satyress's slung leg and the satyr's "chin-chuck" gesture both conveyed amorous and sexual meaning to a sixteenth-century audience.[7] Riccio's model may well have inspired his follower's more explicit variation on the theme.

In Venetian art satyrs are often portrayed as the gentle inhabitants of an idyllic, lost Golden Age, fixtures in the pastoral landscape of Arcadia. They also appear as reveling attendants of Bacchus and Dionysus and as personifications of vice. But satyrs are most typically represented, on the authority of the ancients, as incarnations of lust and carnality—primitive creatures prey to their uncontrollable physical appetites whose base character is inalienable from their rustic, uncivilized nature.[8] That maxim is voiced by the sixteenth-century architect and treatise writer Sebastiano Serlio: his description of the appropriate stage set for "satiric" scenes (satire, that is, as opposed to tragedy or comedy) proceeds from the observation that "licentiousness is part of the nature of personages whom we call rustic"—those

Fig. 85. Andrea Briosco, called Riccio (1470–1532), *Satyr and Satyress*, 1515–20. Bronze, 9½ × 6½ × 7 in. (24 × 16.5 × 17.9 cm). Victoria and Albert Museum, London

campestral beings like satyrs who dwell in the untamed, rural countryside.[9] Paduan sculptors created satyrs of both breeds, benign and bestial (indeed, both types occur in Riccio's oeuvre).[10] The copulating satyrs, like Riccio's lascivious pair, conform to the latter, more commonplace typology—one sanctioned by antiquity; embraced by Giulio Romano, Marcantonio Raimondi, Perino del Vaga, and their contemporaries in Raphael's circle; and concomitant with the more prurient (and quintessentially Roman) aspects of the erotic culture of the Renaissance.

LW-S

1. Jestaz 1983 proposed an attribution to Riccio. The satyr was reproduced as an independent standing figure without the satyress, suggesting that the original pair was "uncoupled" at a somewhat early stage of its history; at least two derivative versions of the male figure are known (cited by Anthony Radcliffe in Martineau and Hope 1983, pp. 377–78, under no. S24).

2. For Desiderio da Firenze, see Pellegrini 2001; Franca Pellegrini in *Donatello* 2001, pp. 178–87, nos. 40–45; and Warren 2001. The Écouen satyr group was published as his work by Franca Pellegrini in *Donatello* 2001, pp. 186–87, no. 45 (endorsing an attribution proposed by Jeremy Warren); and Jestaz 2005, pp. 162–65. The attribution debate is summarized in Christie's, London, sale cat., December 7, 2006, under lot 192.

3. Radcliffe in Martineau and Hope 1983, p. 378, under no. S24.

4. "Pose 18," the image cited by Jestaz 1983, p. 43, fig. 17, as the model for the copulating satyrs, was not in fact part of the Giulio-Marcantonio *Modi*, which only numbered sixteen poses, but a later interpolation by the copyist Waldeck.

5. Among countless antique precursors that could be invoked, a relevant example is the fresco of a satyr and nymph copulating from the House of the Faun in Pompeii. Although that particular work was not known in the Renaissance, it is representative of a category of antique subject matter with which Renaissance artists were deeply conversant. Because the connection is tenuous, the *Modi* cannot be adduced as a firm terminus post quem for the satyr group in Écouen (*pace* Jestaz 1983, p. 44; and Radcliffe in Martineau and Hope 1983, p. 378, under no. S24).

6. The proposal that the bronze satyr pair provided the source for three of Perino's designs for the *Loves of the Gods*, including *Neptune and Doris* (Jestaz 1983, p. 52), seems improbable; if there is any relation, the inverse seems more likely, given the widespread influence and circulation of those prints. Whether the post quem for the Victoria and Albert group that such a sequence of influence

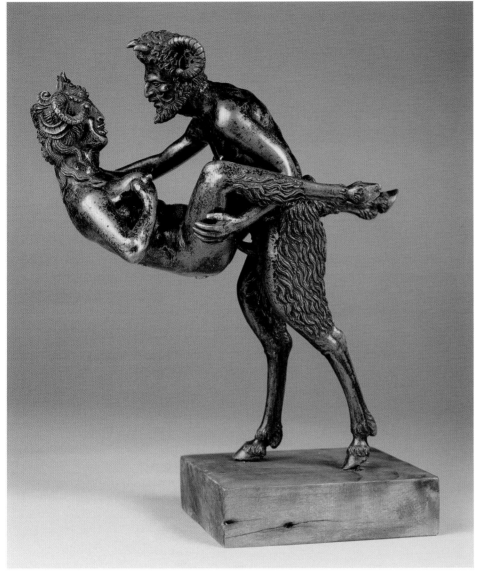

Cat. 112

requires (after 1527) is tenable is a matter to be debated. Another possibility is that the bronze pair and Perino's compositions drew on a common source.

7. Both analyzed by Leo Steinberg, in Steinberg 1968 (slung leg), and Steinberg 1983/1996, pp. 3–6, 110–18 (chin chuck).
8. L. F. Kaufmann 1984, pp. 65–81.
9. "... tal licentia si puo comprendere che fosse concessa a personaggi che senza respetto parlassero, come saria a dire gente rustica"; "Della scena satirica," from *Secondo libro di perspettivo* (Venice, 1560), quoted in Anderson 1974, p. 299.
10. Butterfield 2001, p. 12.

SELECTED REFERENCES: Jestaz 1983; Anthony Radcliffe in Martineau and Hope 1983, pp. 377–78, no. S24, ill.; Franca Pellegrini in *Donatello* 2001, pp. 186–87, no. 45, ill.; Jestaz 2005, pp. 162–65, figs. 71–73; Christie's, London, sale cat., December 7, 2006, under lot 192

Anonymous

113a. Portrait Medal of Pietro Aretino (obverse) and Satyr Head Composed of Phalli (reverse)

Cast copper, Diam. 1⅝ in. (4.2 cm)
Inscribed on obverse: D.PETRVS. ARETINVS. FLAGELLVM. PRINCIPVM (Pietro Aretino, scourge of princes); on reverse: TOTVS. IN. TOTO. ET. TOTVS. IN QVALIBET. PARTE. (All in all and all in every part)
Private collection

Marcantonio Raimondi
Bolognese, ca. 1470/82–1527/34

Probably after a design by Sebastiano del Piombo
Venice, 1485–Rome, 1547

113b. Portrait of Pietro Aretino

Ca. 1517–20 or 1524–25
Engraving, 8⁷⁄₁₆ × 5¹⁵⁄₁₆ in. (21.5 × 15.1 cm)
The Metropolitan Museum of Art, New York, Purchase, Joseph Pulitzer Bequest, 1917 (17.50.40)

Design attributed to Tiziano Vecellio, called Titian
Pieve di Cadore, ca. 1488–Venice, 1576

Woodblock attributed to Giovanni Britto
Italian, act. Venice, 1536–50

113c. Frontispiece for Pietro Aretino's "Stanze" (Signature a1)

Author: Pietro Aretino (1492–1556)
Venice: Francesco Marcolini, January 23, 1537
Printed book with frontispiece printed as a chiaroscuro woodcut from two blocks, 7⅝ × 5¹³⁄₁₆ × ⁵⁄₁₆ in. (19.4 × 14.7 × .8 cm)
The Metropolitan Museum of Art, New York, Harris Brisbane Dick Fund, 1937 (37.37.2)

With a presciently modern aptitude for personal aggrandizement, Pietro Aretino engineered his own soaring fame and cult of celebrity. His principal vehicles for self-promotion were his writings, notably his letters (many of which were self-consciously composed with public dissemination and consumption in mind)—first published in 1537—and his portraits. An exceptionally large number of images of Aretino were produced during his lifetime, many at their subject's behest. The work of some of the leading artists of the day—Titian (cat. no. 113c), Sebastiano del Piombo, Marcantonio Raimondi (cat. no. 113b), Jacopo Sansovino, Leone Leoni, and Alessandro Vittoria—these include painted, carved, engraved, woodcut, and medallic portraits of the sharp-tongued satirist whose merciless pen led the poet Ariosto to admiringly pronounce him "the scourge of princes" (*flagellum principum*), an epithet Aretino proudly appropriated as a motto, and which appears on the portrait medals by Leoni and Vittoria as well as on this anonymous derivation.

Six different portrait medals of Aretino are known.[1] One type, of which cat. no. 113a is an example, has an obscene image on the reverse—a satyr's head formed entirely of phalli. It is accompanied by the motto TOTVS IN TOTO ET TOTVS IN QVALIBET PARTE (All in all and all in every part), a Neoplatonic

formulation concerning the indivisibility of the soul and its integral presence in every aspect of the body.[2] Early writers shied away from describing the scabrous subject: an eighteenth-century biographer of Aretino says only that modesty prevents him from mentioning it ("la modestia non ci permette di dire"). Slightly more descriptive is a late nineteenth-century account, which notes decorously that the satyr head was formed of "emblèmes obscènes."[3] Only in 1960 was the medal's reverse accurately described and reproduced, dispelling all doubt about its content.[4]

Various proposals concerning the patronage and subject matter of this curious portrait medal have been advanced. Interpreting the reverse as a defamatory image, some scholars have maintained that it was commissioned as anti-Aretino propaganda, either by the poet Pietro Bembo, in retaliation for Aretino's libelous epigram calling him a hermaphrodite, or by his erstwhile secretary and sworn archenemy Niccolò Franco, who, in a clever play on Ariosto's *flagellum principum* tag, branded Aretino the *flagello de' cazzi* (scourge of pricks)—a possible exegetical "caption" for the phallic-head medallic portrait.[5] Rarely were Renaissance medals enlisted for such a scurrilous or derisive purpose, however, and despite (or in this case, because of) its lewd aspect, a laudatory function can be surmised for the phallic-head satyr. An object of praise, the medal was almost certainly intended—whoever commissioned it—to proclaim Aretino's fame as the most admired, and feared, satirist of his day.

In emulation of ancient satirical authors like Juvenal, Renaissance satirists, sparing no one, considered it their singular mission to expose vice wherever it existed and in so doing to reveal the truth. Etymological forerunner (or so sixteenth-century poets and philologists wrongly believed) and archetype of the satirist was the satyr.[6] Uncivilized, brazen creatures consumed by lust, captive to their crude, aggressive, and base instincts but possessing an innocence that exempted them from sin or evil (see cat. no. 112), satyrs were reputed on the authority of ancient satirical authors to be prone to harsh and abusive attacks on humans. The two traits—carnality and the "innocent truth-telling and exposure of vice"—were indelibly linked,[7] and in the barbed attacks of satyrs lay the justification for the "defamatory, vituperative quality of satire" as practiced by Aretino and his contemporaries.[8]

If the obverse of the portrait medal portrays Aretino as the distinguished man of letters he aspired to be (somewhat improbably, given his feeble command of Latin), sporting one of the gold chains he received in homage from a roster of royal admirers

Cat. 113a, obverse

Cat. 113a, reverse

(or more accurately, extracted as a form of blackmail in exchange for staying his venomous pen), the reverse reveals him for what he really is—a modern-day satyr, champion of physical passions and carnal lust, relentless unmasker of vice and hypocrisy. Like the priapic satyrs of antiquity, Aretino is, as the motto and image jointly convey, pure *cazzo* (prick) in both body and soul—the venerable persona his legions of emulators and admirers, as well as detractors and victims, would most immediately have recognized.

LW-S

Contrary to Vasari's improbable assertion that it records an invention of Titian, this engraved portrait of Aretino (cat. no. 113b) by Raphael's printmaker, Marcantonio Raimondi, was probably designed by the Venetian painter Sebastiano del Piombo, although Giulio Romano's name has also been proposed. Sebastiano's first patron following his permanent removal to Rome around 1511 was Agostino Chigi, the wealthy papal banker who would hire the ambitious

but unknown Aretino upon his arrival in the Eternal City later in the decade (see my essay "Rapture to the Greedy Eyes" in this volume) and for whom Giulio and other members of Raphael's workshop executed the gloriously sensual frescoes representing the myth of Cupid and Psyche. According to some scholars, this portrait dates from that early moment of Aretino's Roman career; others maintain that it was executed around 1525 as an expression of gratitude by Marcantonio to Aretino, who had negotiated the engraver's release from prison following the publication of the *Modi* (cat. nos. 99 and 100).

If Aretino's bearded visage, *beretta* (cap), and other elegant attire all recall Raphael's sober and restrained portrayal of the learned humanist and diplomat Baldassare Castiglione (Musée du Louvre, Paris)—an allusion that the ambitious and bombastic satirist would have encouraged heartily—his prominent hat badge invokes the prurient sensibility (entirely alien to the dignified Castiglione) that resonates in his transgressive pronouncement that the phallus should be venerated and displayed as proudly "as a medal in one's hat."[9]

LW-S

The frontispiece to Aretino's *Stanze*, a volume of poetry praising the beautiful and gifted Angela Tornimbena, wife of Giannantonio Sirena and a poet in her own right, is the only known chiaroscuro woodcut used to illustrate an Italian book (cat. no. 113c). The design of the woodcut is usually attributed to Aretino's close friend Titian. In support of this attribution is Aretino's dedicatory letter to the empress Isabella, which extols the talents of the painter and commends his desire to paint the portrait of Isabella's husband, Charles V (fol. A2r). David Rosand and Michelangelo Muraro attribute the cutting of the blocks to Giovanni Britto,[10] a German craftsman working in Venice, who in 1536 had illustrated another book for the publisher of the *Stanze*, Francesco Marcolini, and who in 1550 created a large woodcut based on a self-portrait by Titian. Both works are signed, and Aretino, at the insistence of the cutter, penned a laudatory sonnet about the Titian likeness. Neither the controlled hatching, somewhat reminiscent of engraving, nor the somewhat haphazard highlights suggest that Titian drew the design directly on the block. More likely, as Rosand and Muraro have suggested, the painter supplied the cutter with no more than a rough sketch.[11] The book also contains a sonnet addressed to Angela by the respected poet Veronica Gambara (fol. D2r).

Perfectly illustrating the conceit of the poem, the woodcut depicts Aretino as a rustic shepherd singing to his love, Angela Sirena,

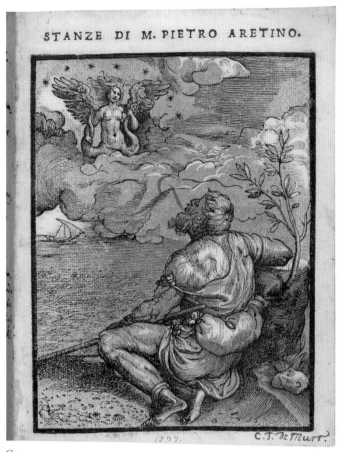

PETRVS ARRETINVS ACERRIMVS VIRTVTVM AC VITIORVM
DEMOSTRATOR
NON MANVS ARTIFICIS MAGE DIGNVM OS PINGERE NON OS
HOC PINGI POTERAT NOBILIORE MANV
PELLÆVS IVVENIS SI VIVERET HAC VOLO DESTRA
PINGIER HOC TANTVM DICERET ORE CANI

Cat. 113b

Cat. 113c

who appears as a winged siren in the heavens. Aretino's celebration of the "chaste Siren," as he identifies Angela in the dedicatory letter (fol. A2r), was not well received, for although Aretino insisted that his admiration was untainted by lust, Angela's husband and family felt that even his protestations brought shame upon the young woman; her death in 1540 has been blamed on this notoriety.[12] The line block for this chiaroscuro was later printed independently in Antonfrancesco Doni's *I mondi*, published by Marcolini in 1552. In the accompanying text (fols. 70v, 71v), a dialogue between Momus (god of satire) and the Soul, the Soul briefly takes on the identity of the deceased woman, who explains that the shepherd who remained on earth (Aretino) sent the fame of her beauty and her bitter death as far as the stars and that she will have eternal life through his writings. Perhaps Doni was trying to assuage the guilt of his friend Aretino.

WT

1. Enumerated in Waddington 1989, p. 657ff. Two variants with the phallus-head reverse exist; according to Waddington (ibid., p. 679), the smaller medal is a copy of the larger.
2. Ibid., p. 679.
3. The notices of Mazzuchelli and Armand, respectively, are quoted in ibid., pp. 678–79.
4. Aretino, *Lettere*, 1957–60 (ed.), vol. 3, pls. 20, 21.

5. These arguments are summarized in Waddington 1989, p. 679.
6. The false etymology, universally accepted in the Renaissance, is discussed in Reynolds 1983, p. 5ff.
7. Waddingon 2004, p. 111.
8. Waddington 1989, p. 662. On the subject of satire in the Renaissance, see also Reynolds 1983, passim. Aretino's particular aptitude for that "genre" of literary invective is also discussed in Reynolds 1997, pp. 119–42.
9. Aretino to Battista Zatti, December 1537, penned in a retrospective accounting of the spirit that prompted him to compose the salacious sonnets accompanying the Giulio-Marcantonio *Modi*, which are contemporaneous with this print; Aretino, *Lettere*, 1957–60 (ed.), vol. 1, pp. 110–11, no. LXVIII, quoted in translation in Waddington 2004, p. 115.
10. Rosand and Muraro 1976, p. 191.
11. Ibid., p. 195.
12. Casali 1861, p. 38.

SELECTED REFERENCES: *113a*. Waddington 1989, p. 678ff.; Waddington 2004, p. 109ff.; Woods-Marsden 1994, p. 290 ff.

113b. Innis H. Shoemaker in Shoemaker and Broun 1981, pp. 150–52, no. 46, ill.

113c. Doni, *I mondi*, 1552, fols. 70v–71v; Casali 1861, pp. 37–39; Mortimer 1974, vol. 2, pp. 32–34; Rosand and Muraro 1976, pp. 191, 194–95, no. 14, ill.; Paul Needham et al. in Sotheby's, New York, sale cat., December 8, 1994, lot 14

114. Casket with Venus and Cupid

Northern Italy, late 16th century
Bronze, 8 × 5½ × 4¾ in. (20.4 × 14 × 11.6 cm); casket only L. 5⅞ in. (14.8 cm), W. 3½ in. (8.9 cm)
The Ashmolean Museum, Oxford, Given by C. D. E. Fortnum, 1888 (WA1888.CDEF.B1137)

This rectangular casket is supported at each corner by a Nereid. Its sides are decorated with foliated scrollwork, springing on the long sides from a roundel containing a blank asymmetrical scrolled escutcheon, and on the short sides from roundels containing a satyr's mask. There is matching scrollwork on the sloping sides of the cover, with rosettes in the central fields and acanthus at the corners. The cover is surmounted by a figure of Venus, reclining naked on drapery, resting her head in her right hand and touching her pudenda with her left hand. The naked figure of Cupid lies on top of her, looking upward and grasping Venus's right breast. Inside the casket is one large lengthwise compartment, balanced by four smaller rectangular compartments.

The casket has been published only once previously, by Anthony Radcliffe in his discussion of a triangular inkstand from the same workshop in the Thyssen collection, the body of which is made from panels identical in form to the long side panels of the Ashmolean casket.[1] Radcliffe suggested that the two bronzes were the product of a

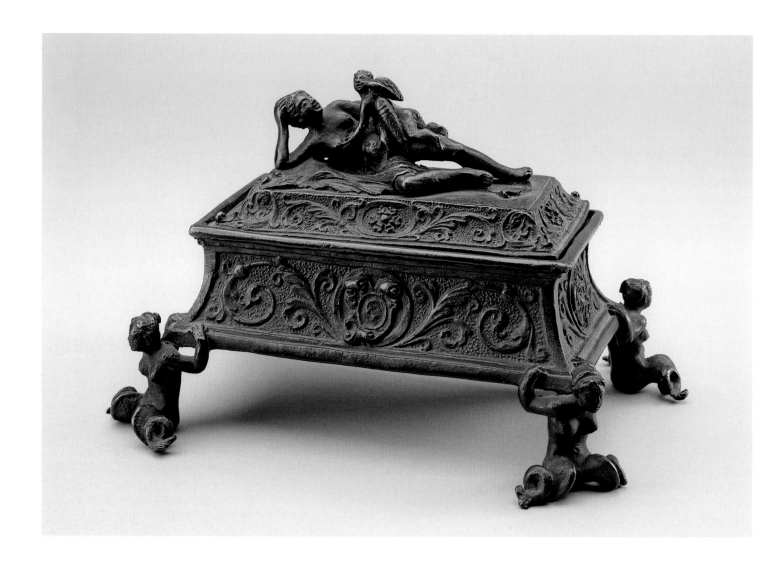

northern Italian workshop, and he dated them to the early seventeenth century. They may in fact date from a little earlier, as both the exuberant foliate decoration and the Nereids have some analogies with later sixteenth-century bronzes, including the Annoni–Visconti Marriage Bowl (cat. no. 50).

It has hitherto been assumed that the internal divisions within the casket were used to store ink and pens. However, the four subsidiary compartments are too small to accommodate the separately made ink-wells and sand pots usual in Italian writing caskets, so it is most unlikely that it was conceived as a writing casket. Any consideration of its original status and function must take account of the blatantly erotic figural group on the cover, which depicts Cupid lying across the naked body of his mother, Venus, who seems to be pleasuring herself in response to Cupid's caressing of her breast. Cupid looks upward with a pert expression, as if consciously inviting the spectator's approval and participation.

The casket appears, therefore, to be one of very few bronzes of pornographic subject matter from the Renaissance to have survived the moral censure of later centuries unbowdlerized. We can only speculate as to who its first owner might have been. It could have been made for the private amusement and titillation of a male owner, but it might also conceivably have belonged to a female owner, specifically a courtesan. The smaller internal compartments certainly seem to be the right size for cosmetics, in which case the larger compartment might have held tools for their application. JW

1. Radcliffe, Baker, and Maek-Gérard 1992, pp. 240–43, no. 43.

Selected references: Radcliffe, Baker, and Maek-Gérard 1992, pp. 240–43, no. 43; Warren forthcoming, no. 62

115. Tabernacle Mirror Frame with Sliding Covers

Florence, mid-16th century
Walnut, overall 16¼ × 15⅛ in. (41.3 × 38.4 cm); frame
opening 7⅜ × 5⅞ in. (18.7 × 14.9 cm)
The Metropolitan Museum of Art, New York, Robert
Lehman Collection, 1975 (1975.1.2090)

M irrors appear frequently in represen-
tations of interiors and in household
inventories from the fifteenth and sixteenth
centuries in central Italy. A 1436 inventory
from the household of Nicolas III d'Este,
in Ferrara, mentions mirrors in frames of
gilded wood with coats of arms painted on
them, though frames were also made of ivory
or *pastiglia*.[1] More commonly fashioned of
polished steel, the mirrors themselves could
also be made of glass with a silvered back-
ing. By the sixteenth century, the Venetian
glass-mirror makers were dominant, though
inventories still specify that a mirror was "of
glass" until the mid-sixteenth century.[2]

Because the glass was subject to dam-
age from light, scratching, or corrosion, it
was frequently covered, concealed behind a

Cat. 115, with shutters closed

Cat. 115, with shutters open

Fig. 86. Neroccio de' Landi workshop, Mirror frame, ca. 1480–1500. Painted and gilded papier-mâché, 18 × 16 in. (45.7 × 40. 6 cm). Victoria and Albert Museum, London

protective curtain or a shutter. This handsome example belongs to that tradition, but is exceptional in having not one but two movable shutters: the mirror is mounted on a second, inner shutter, which also opened. Both shutters were grasped from the right, the shells and volutes on the sides serving as handles.[3] (A surgery manual dated 1596 features a mirror with a similar handle for the shutter, which is shown pulled out to the right.)[4] The walnut frame was probably once highlighted with parcel-gilt that has been lost with the original surface, and the blank cartouche might once have been painted with the owner's coat of arms.

Since mirrors were associated with female beauty and virtue, they were an ideal marriage or betrothal gift. Some even incorporated images of beautiful women, such as a papier-mâché example in London, from the workshop of the Sienese painter Neroccio de' Landi, where a small, steel convex mirror was installed beneath the image of a woman in bridal finery (fig. 86).[5] Mirrors had many symbolic meanings in the visual vocabulary of the Italian Renaissance: they were attributes of beautiful women, but they could also symbolize vanity, voluptuousness (as in Giulio Romano's *Woman with a Mirror* [cat. no. 87]), deceit, prudence, humility, and pride.[6] The association with beauty is crystallized by the entry under the term *Bellezza Feminile* (Feminine Beauty) in Cesare Ripa's *Iconologia*, first published in 1593, where one of the attributes is a mirror.

The shallow rebate behind this mirror's secret shutter undoubtedly contained an illicit image, either a portrait of a mistress or lover or an erotic scene, that only the mirror's owner was privileged to behold.[7] Painted mistress portraits were frequently concealed behind a shutter or curtain in the

sixteenth century, and could be revealed only by an actively engaged voyeur—a convention that served to heighten the erotic content by arousing desire and underscoring the forbidden aspect of the subject. The maker of this frame transferred that conceit to this otherwise innocent household object, whose unknown owner went to unusual lengths to safeguard his secret. DLK AND LW-S

1. P. Thornton 1991, pp. 234–35.
2. Ibid., p. 236.
3. Newbery, Bisacca, and Kanter 1990, pp. 54–55, no. 26; Newbery 2007, p. 56, no. 31.
4. P. Thornton 1991, p. 236, pl. 270.
5. Syson and D. Thornton 2001, p. 52. John Pope-Hennessy (1950, p. 291) cites other examples of the same form of mirror in the Lanz collection and in Paris.
6. Mirrors were also found in *studioli* and artists' studies. See the thorough discussion in D. Thornton 1997, pp. 167–74.
7. Both authors arrived at this conclusion, independently, although it was first proposed by Linda Wolk-Simon in the course of preparation of the 1990 exhibition "Italian Renaissance Frames" at The Metropolitan Museum of Art. The illicit image may also have been of a suspect religious nature, such as a portrait of Savonarola, though this seems less likely, given the conventional associations of mirrors with vanity, *luxuria*, and other sins.

SELECTED REFERENCES: Newbery, Bisacca, and Kanter 1990, pp. 54–55, no. 26, ill.; Newbery 2007, pp. 56–57, no. 31, ill.

116a–c. Three Ornamental Glass Hairpins or Hatpins

Probably Venice or Innsbruck, late sixteenth century (?)

a. Colorless nonlead glass, copper (?) wire, lampworked, trailed, and gilt, scrollwork applied over a layer of fused leaf gilding, L. 4⅝ in. (11.7 cm), Diam. of ball ⅝ in. (1.5 cm)
The Metropolitan Museum of Art, New York, Robert Lehman Collection, 1975 (1975.1.1525)
New York only

b. Colorless nonlead glass, copper (?) wire, lampworked, trailed, and gilt, scrollwork applied over a layer of fused leaf gilding, L. 5⅛ in. (12.9 cm), Diam. of ball ⅝ in. (1.6 cm)
The Metropolitan Museum of Art, New York, Robert Lehman Collection, 1975 (1975.1.1527)

c. Colorless and transparent green and ruby red nonlead glass, copper (?) wire, and sheet metal, lampworked, trailed, and gilt, ball covered with fused leaf gilding, L. 6⅛ in. (15.7 cm), Diam. of larger ball 1 in. (2.6 cm)
The Metropolitan Museum of Art, New York, Robert Lehman Collection, 1975 (1975.1.1526)

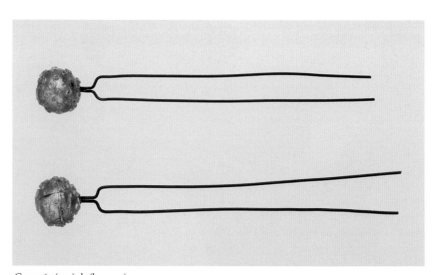

Cat. 116a (top), b (bottom)

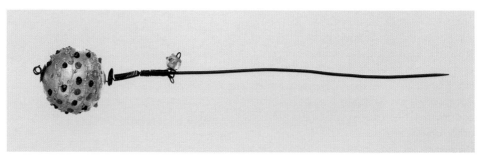

Cat. 116c

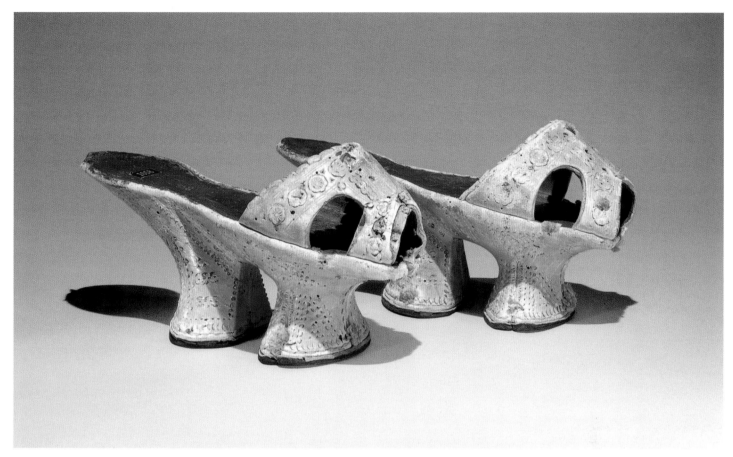

Cat. 117

These ornamental glass pins, designed in imitation of gold jewelry, were embellishments for a woman's hat or, more probably, hair. (The sitter in Botticelli's portrait of a young woman, possibly Simonetta Vespucci, in mythological guise wears such ornaments in her elaborate coif; see fig. 21.)[1] Presumably because of its exceptional fragility, almost no Renaissance glass jewelry has survived to compare with these examples, but it is known that lampworked glass objects were produced in the late sixteenth century both in Venice and Innsbruck, the two alternative, probable places of manufacture of these three objects. While the two smaller balls are solid, the larger and more elaborately decorated example is hollow, undoubtedly to keep it from becoming too heavy for the wearer. The red dots on that pin were probably meant to emulate rubies. A formula for producing imitations of those prized gems, which instructed the reader how to achieve the desired *rosso trasparente di rubino* (transparent red of a ruby) was published by Antonio Neri in his 1612 treatise *L'arte vetraria*.[2] Common prostitutes frequently owned such cheap imitation jewels, known as *bigiotteria*, as contemporary documents record, and both prostitutes and courtesans routinely received jewelry and other objects for personal adornment from their male clients as payment for "carnal

commerce"[3]—though whether or not these hairpins originally comprised such an offering is unknown. LW-S

1. Städelsches Kunstinstitut, Frankfurt am Main, ca. 1480–85.
2. Neri 1612, book 7, chap. 129, pp. 108–9 (English trans., Merret 1662); quoted in Lanmon and Whitehouse 1993, p. 238, n. 2, under no. 86.
3. Storey 2006, passim; for *bigiotteria*, see p. 76.

Selected reference: Lanmon and Whitehouse 1993, pp. 236–38, nos. 84–86, ill.

117. Chopines

Venice, ca. 1600
Beige leather, silk, and wood, decorated with stamped and pierced designs and small silk-floss pompoms,
L. 8¾ in. (22.2 cm)
The Metropolitan Museum of Art, New York,
Purchase, Irene Lewisohn Bequest, 1973 (1973.114.4 a,b)

The high platform shoes known as chopines came into fashion in Venice in the sixteenth century. Awkward yet practical, they served not only to keep the wearer's precariously perched feet from getting wet or soiled in the perpetually damp lagoon city but also signaled her elevated social status. Like expensive jewels and silk gowns, chopines

were favored both by patrician women and by the successful courtesans who contrived to emulate their appearance (see fig. 36).[1] Such fancy footwear thus does not unequivocally signal that its owner was a courtesan or prostitute, although the chopines-shod woman in Pietro Bertelli's erotic flap print undoubtedly represents that niche of society (cat. no. 103), and the idle, emotionally detached ladies in Carpaccio's famous *Two Women on a Balcony* (in which a pair of discarded chopines appears at the lower left) may well do so.[2] The ambiguity that has attended their identification as one or the other mirrors the confusion that courtesans deliberately cultivated by their expensive and luxurious attire, until sumptuary laws and other official prohibitions forbade them from donning the finery of honest noblewomen. LW-S

1. See the discussion of chopines and of courtesans as their primary, though by no means exclusive, wearers in *Il gioco dell'amore* 1990, p. 169, under no. 100.
2. On this painting and the discovery that it once formed part of a single composition with Carpaccio's *Hunting on the Lagoon* (J. Paul Getty Museum, Los Angeles), see Szafran 1995.

Selected references: Koda 2001, p. 145, ill.; Koda 2002, ill.

The Paintings of Love and Marriage

From Cassone to Poesia: Paintings of Love and Marriage

Andrea Bayer

When Guidobaldo della Rovere, soon to be duke of Urbino, wrote to his agent in Venice in March 1538 about Titian's now-iconic painting known as the *Venus of Urbino* (fig. 87), he called the picture simply "la donna nuda" (the nude woman). He was short of funds and worried that the painting might be sold to someone else; two months later he wrote again, asking his agent to provide a guarantee to the artist that he was good for the payment for this object he so greatly desired.[1] In these terse, serviceable letters there is absolutely no mention of the painting's meaning or of the motivation behind its commission. Guidobaldo's extreme lack of specificity can be understood metaphorically, as a symbol of how difficult it is for the modern viewer to grasp precisely the meaning of many comparable sixteenth-century paintings, meanings that almost certainly must have been clear to the original owners. Consider the following interpretations of this beloved image: the subject is just a sexy, nude woman lying on her bed; she is a courtesan (hence Manet's reinterpretation of her as *Olympia*); she is the mythological goddess Venus; she is a Venus indulging in an obscene gesture; she was created as a marriage painting; she was painted

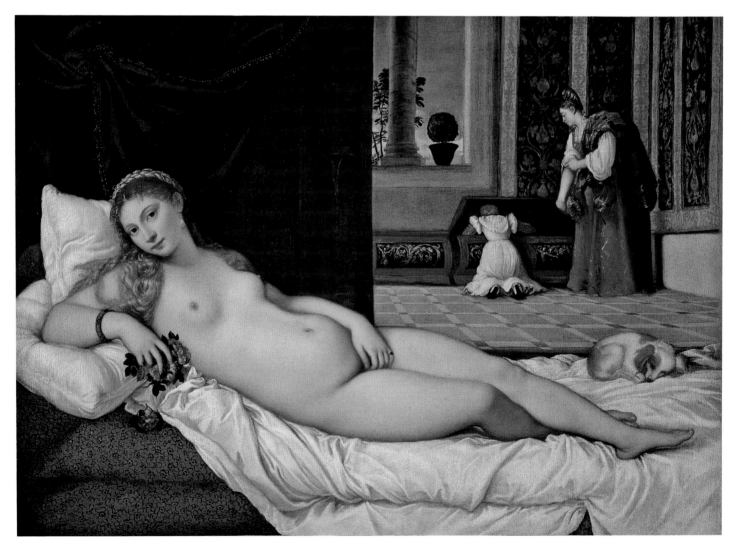

Fig. 87. Tiziano Vecellio, called Titian (ca. 1488–1576), *Venus of Urbino*, 1538. Oil on canvas, 46⅞ × 65 in. (119 × 165 cm). Galleria degli Uffizi, Florence

Fig. 88. Giorgione (1477/78–1510), *Sleeping Venus*, ca. 1510. Oil on canvas, 42¾ × 68⅞ in. (108.5 × 175 cm). Gemäldegalerie, Staatliche Kunstsammlungen, Dresden

Fig. 89. Jacopo Negretti, called Palma il Vecchio (1479/80–1528), *Venus and Cupid*. Oil on canvas, 46½ × 82¼ in. (118 × 209 cm). Fitzwilliam Museum, Cambridge

specifically to commemorate della Rovere's marriage to the prepubescent Giulia da Varano (which had taken place some four years before the picture was executed, in 1534).[2] Each of these views has its ardent supporters, although they are not necessarily mutually exclusive. Perhaps the painting's ambiguity would matter less if a whole line of wonderfully beautiful paintings were not pulled into its wake. These begin with its older cousin, Giorgione's *Sleeping Venus* (fig. 88), executed some twenty-five years earlier and completed by Titian, according to the contemporary observer Marcantonio Michiel, and are followed by works by Palma il Vecchio (fig. 89), Domenico Beccafumi, Lorenzo Lotto (cat. no. 148), and Paris Bordon (cat. no. 150), among many others.

We probably will never know exactly what Guidobaldo believed the meaning of the *Venus of Urbino* to be. However, historians have painstakingly built an argument that relates elements in all of the paintings mentioned here to nuptial imagery and to the decoration of bedrooms (*camere*) that often accompanied or was carried out in the years following a wedding. The poetic figure of a resting or sleeping Venus plays an important role in epithalamia, the marriage songs in poetry or prose invented by the Greeks (above all, Sappho), adopted by the Romans (Catullus, Statius, and others), and revived on a grand scale during the Renaissance (cat. no. 61).[3] In these songs or orations, Venus is described as reclining in a bower, while Cupid—sometimes armed with his arrows—rouses her to come to a wedding as *pronuba,* or patroness, of marriage. Other details in these paintings are taken directly from the evolving language of the Renaissance epithalamium and are associated with the celebration of weddings. For example, there

is considerable circumstantial evidence that Giorgione's *Sleeping Venus* was commissioned by one of the artist's principal patrons, the Venetian Girolamo Marcello, perhaps on the occasion of his marriage to Morosina Pisani in October 1507, and that the picture was inspired by a Roman poem. Domenico Beccafumi's *Venus* (The Barber Institute of Fine Arts, Birmingham), from another region of Italy, was an element of the decorations this artist created for Francesco Petrucci's bedchamber in Siena about 1517–19. Although commissioned some years after Petrucci's marriage to Caterina Piccolomini, in 1512, the paintings installed in the bedroom were each imbued with significance relevant to a wedded couple, and all derived from classical sources (for these, see cat. no. 141).[4]

Titian's *Venus* includes many significant details related not only to epithalamia but also more generally to contemporary marriage imagery: servants packing or unpacking the sumptuous gowns stored in the two cassoni in the background; the myrtle bush; Venus's rose petals; her pearl earring; and her faithful dog. Even the way in which Titian uses Venus's gesture and the geometry of the composition to draw our attention to the goddess's pubic area could contribute to the themes of maritally sanctioned sexuality and fertility. In this respect the painting calls to mind Lorenzo Lotto's *Venus and Cupid* (cat. no. 148), in which Cupid directs a spray of urine onto Venus's rose-petal–covered pubic area.[5]

When Giorgio Vasari saw Titian's painting in Pesaro in 1548 it was hanging along with other works by the artist in the duke's *guardaroba*, or wardrobe. However, there is evidence that horizontal paintings of female nudes were often installed directly over beds or, at least, in a bedroom. (Indeed, in the seventeenth century the *Venus of Urbino* hung again in a bedroom—that of Vittoria della Rovere in Florence, where she had brought it around 1631.) Beccafumi's *Venus* was installed over a bed in the Petrucci palace, and—closer to home for Titian—the important Venetian collector Andrea Odoni placed a full-length nude by Savoldo over his bed in 1532, when Marcantonio Michiel saw and recorded it.[6] Numerous contemporary authors wrote about the efficacy of such images in stimulating married couples hoping for children, as well as about the belief that a couple's having visual beauty before their eyes could influence the appearance of their offspring.[7]

But we must not be misled into thinking that the meanings of such paintings were entirely innocent or domestic. A letter written in 1544 to Cardinal Alessandro Farnese in Rome describes a scene in Titian's workshop that touches on this subject. On Titian's easel was a painting of "una nuda," the sumptuous *Danae* now in Naples, that was meant for the cardinal. The author of the letter, the humanist Giovanni della Casa, compares the unfinished *Danae* to the earlier *Venus of Urbino* and concludes that next to *Danae* the *Venus* seems like "a Theatine nun" (indeed, X-radiographs of the *Danae* reveal a version of the *Venus of Urbino* on the canvas below). He relished the impact that the *Danae* would have on viewers, especially a particular member of the Roman curia, and Titian joked that he could give her the face of a certain "Angela," a famous Roman courtesan who was favored by the Farnese.[8] Jesting aside, it is clear that the content of both paintings was understood to have an erotic charge. The Dominican preacher Savonarola's understanding of this aspect of painting was revealed when he complained that people had "near their beds and *lettucci* images of naked men and women doing indecent things."[9]

What, if anything, did love have to do with the commissioning of the *Venus of Urbino*? In this connection some family history is revealing. To shore up the dynasty—that is, for political reasons—Guidobaldo della Rovere was coerced by his family to marry the ten-year-old Julia da Varano, daughter of the duke of Camerino, whose neighboring estate would therefore pass into the hands of the Urbino dukes. Before this occurred, the young Guidobaldo had fallen in love with his cousin, Clarice Orsini, the daughter of Felice della Rovere Orsini, Pope Julius II's illegitimate daughter (see cat. no. 8). Guidobaldo wrote a heartrending letter to his father begging to be allowed to marry her: "For two years now I have spoken at length, begging you that in giving me a wife, it would seem that in this act the principal matter is to satisfy me, given that I carried, and still carry such a love for the lady Clarice, due to her qualities, and her manners. To let me have her would give me such extreme happiness, and not to have her would cause me such infinite sadness, so I beg you with all my heart, if you have any regard for my sanity and health, satisfy and concede me this favour, knowing that in her is my all."[10] The answer from Duke Francesco Maria della Rovere was a resounding no, nor was his kinswoman Felice della Rovere interested in a marriage between her daughter and Guidobaldo. The young people were prevailed upon to marry others, and the ravishingly beautiful *Venus* probably appeared as *pronuba* in the service of a conventionally arranged Renaissance marriage.

"I CAN DRESS HER AND I CAN MAKE MY CHAMBER"

How did such allusive and evocative paintings make their way into the nuptial bedroom? Kent Lydecker has amply demonstrated that Florentine husbands took pains to embellish the spaces their brides would come to inhabit in their fathers' homes.[11] Many opened ledger accounts specifically for this purpose; the account opened by Lorenzo Morelli when he married Vaggia di Tanai Nerli in 1472 was labeled: "Spese per me nello sottoscritte chose quando menai la donna" (My expenses for these things below when I took my wife home). As we have already learned (see Deborah L. Krohn's essay "Rites of Passage" in this volume), the decorations included great chests (cassoni, or *forzieri,* which in the fifteenth century were almost always painted), an elaborately carved bed and daybed (*lettiera* and *lettuccio*), sometimes surmounted by a hat rack (*cappellinaio*), a bench (*cassapanca*), mirrors, tapestries, and hangings. In addition, a devotional work—either painted or carved—was an essential element of a complete bedroom in fifteenth-century Italy.

By the later decades of the fifteenth century artists were producing important cycles of paintings for the walls of these *camere* (see cat. nos. 136–141) and panels specifically meant to hang over beds. Some of the imagery seems to have migrated from its original location on the lids of cassoni to these more prominent places, as Kenneth Clark suggested in 1956, in his consideration of Giorgione's *Sleeping Venus*. Unable to find an antique source for the pose (we now believe it may have been inspired by ancient gems), Clark observed that it "seems so calm and inevitable that we do not at once recognize its originality." This led him to speculate whether, "perhaps after all her real predecessors were those figures of naked brides which were traditionally painted on the inside of the

Fig. 90. Botticelli (Alessandro di Mariano Filipepi) (1444/45–1510), *Primavera*, ca. 1481. Tempera on panel, 79⅞ in. × 10 ft. 3⅝ in. (203 × 314 cm). Galleria degli Uffizi, Florence

fifteenth-century marriage chests" (cat. no. 58b).[12] The connection to the figures painted on the inner lids of these chests (we are no longer so confident that they were meant to portray actual brides) is indeed striking. Clark might have reacted similarly to Botticelli's *Fortune* (private collection), now badly damaged, which may have hung over the bed in the *anticamera* in the Medici Palace reserved for Piero de' Medici, Lorenzo's son.[13] With its simple composition and strong graphic design, it is easy to imagine as a refined offshoot of earlier paintings on furniture.

Paintings that hung over the massive daybeds were also part of the furnishing of the *camera*. The most tantalizing of all such paintings in Florence is Botticelli's *Primavera* (fig. 90), likely painted for Lorenzo the Magnificent's cousin Lorenzo di Pierfrancesco de' Medici (1463–1503). In a 1498 inventory of the Casa Vecchia, a Medici townhouse on the Via Larga near the Medici Palace, this masterpiece is recorded in an inventory as hanging over a daybed in the room adjacent to Lorenzo's principal *camera* on the ground floor.[14] There it is described as "uno quadro di ligname apicato sopra el lettuccio, nel quale è dipinto nove figure de donne ch'omini" (a painting on wood hung over the *lettuccio* in which nine figures, both men and women, are depicted). The rest of this characteristic piece of furniture is also described. It included a predella, or step, a built-in cassone, and a *cappellinaio*. (The nearby *camera bella* was furnished with two large painted *forzieri* or cassoni and fitted with *spalliere*, panels hung at shoulder height.) However, when Vasari saw the *Primavera* in the following century, it was hanging in the Medici villa at Castello, outside Florence. Some scholars have argued, therefore, that it was commissioned in the late 1470s by the adolescent Lorenzo, in close colloquy with his older cousin, and that it reflects their shared interest in poetry and studies of antiquity; furthermore, they propose that it was always meant for the rustic environment of the villa at Castello.[15] According to this theory, its arrival at a family palace in Florence in the 1490s would have been unplanned, attributable

to the turmoil that followed Lorenzo the Magnificent's death, in 1492.

Another possibility is that the *Primavera* may always have been meant for the room alongside Lorenzo di Pierfrancesco's bedchamber, for it may have been commissioned at about the time of his marriage to Semiramide Appiani, the daughter of the ruler of the small but strategically important state of Piombino. As was so often the case, this marriage was a drawn-out affair, contractually underway in 1480, but with the final *nozze* taking place in the Medici Palace only in 1482. Cousin Lorenzo was Lorenzo di Pierfrancesco's *mezzano* (go-between), a function he would fulfill in many important Florentine marriages (see cat. nos. 139, 140). He wrote a letter to Semiramide's grandmother in which he declared that he would think of the girl as his own daughter;[16] under the circumstances, he could easily have concerned himself with the content of the works of art that decorated the young couple's chambers in the palace. According to numerous contemporary accounts, including that of Leon Battista Alberti, husbands and wives often had separate rooms; if this were true of Lorenzo di Pierfrancesco and his wife, the *Primavera* may have hung in Semiramide's bedchamber. The room with the *Primavera* also included Botticelli's splendid so-called *Pallas and the Centaur* (described in the inventories as a Camilla, rather than Pallas; Galleria degli Uffizi, Florence), generally believed to have been commissioned for the wedding, perhaps as a gift from the older Lorenzo. It would be absurd to reduce the imagery of either of these great works, in particular the *Primavera*, to more ordinary nuptial subjects, but scholars have identified references in both paintings to sources whose themes include the marriage union, chastity, and fidelity.[17]

Some of the most interesting paintings commissioned for the private rooms of young Tuscan couples are *spalliere* paintings. The term *spalliera*, related to the Italian word for "shoulder" (*spalla*), covers a bewildering variety of paintings and hangings, all of them

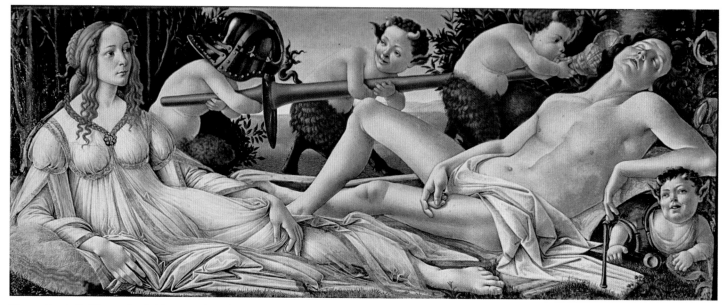

Fig. 91. Botticelli (Alessandro di Mariano Filipepi) (1444/45–1510), *Venus and Mars*, ca. 1485. Tempera and oil on panel, 27¼ × 68¼ in. (69.2 × 173.4 cm). National Gallery, London

installed at shoulder height or higher. Decorations called *spalliere* ranged from the painted backrests of daybeds and wood paneling or wainscoting, sometimes with intarsia work, to tapestries hung above benches (as in cat. no. 139).[18] Recently, scholars have suggested that we underestimate the height at which *spalliere* panels (and other domestic works, such as devotional tondi) may originally have hung. Analysis of contemporary documents describing the disposition of paintings in a room, and visual analysis of the compositions of the paintings themselves, indicates that these works were often meant to be seen above eye level.[19] It may well be that the viewer had to look up at the narratives that ornamented the upper parts of the walls of the *camera,* even if the height now sometimes suggested by researchers may be exaggerated.

Paintings commissioned to be inserted in the wainscoting of rooms, or hung independently at that height, could treat the most disparate subject matter (including the lives of saints) and could suit many varieties of patronage, including civic commissions. Yet, a surprising number of the fifteenth- and early sixteenth-century paintings that fit the general definition of *spalliere* panels can be associated with marriage and the preparation of a *camera,* and depict narratives chosen from ancient texts or contemporary literature.[20]

Botticelli's *Venus and Mars* (fig. 91), for example, demonstrates that commissions for nuptial *spalliere* paintings could inspire artists to exercise great wit and inventiveness. Mars and Venus recline side by side, Mars in such a state of postcoital exhaustion that his hand hangs limply and even the blowing of a conch shell into his ear does not rouse him. The two figures are linked by a group of young satyrs who have stolen Mars's armor, but he is in no condition either to wear it or to contest them. An ancient source, the description in Lucian's *Herodotus* of a painting (hence an ekphrasis) depicting the wedding of Alexander the Great and Roxana, inspired this motif. In the relevant passage cupids play with the great warrior's arms—Love has completely vanquished War. Ernst Gombrich was the first to note the wasps (*vespe* in Italian) buzzing in Mars's ears and thus to associate the painting with commissions executed for the Vespucci (although it has been

difficult to determine for which couple from this many-branched family).[21] Despite the brilliance of the painting's invention and the beauty of many details, Botticelli was casual about elements of its composition, neglecting to indicate adequately Venus's right leg and leaving the background ill defined.[22] These oversights suggest that Botticelli was concerned primarily with the overall impression of this rather lighthearted work.

Vasari described other *spalliere* paintings made by Botticelli for the same family, concentrating on their installation, rather than their subjects: "Round an apartment [*camera*] of the house of Giovanni Vespucci, now belonging to Piero Salviati, in the Via de' Servi, he made many pictures which were enclosed by frames of walnut-wood, by way of ornament and paneling [*per ricignimento e spalliera*], with many most lively and beautiful figures."[23] These are usually thought to be the panels *Virginia* (Accademia Carrara, Bergamo) and *Lucretia* (Isabella Stewart Gardner Museum, Boston), depicting virtuous Roman women (a theme often used on cassoni), possibly painted on the occasion of the wedding of Giovanni Vespucci and Nanna de' Nerli, in 1500.[24] Vasari's descriptions make clear that these paintings were very much parts of ensembles, meant to be seen as unified wholes.

Of ensembles made to decorate the Florentine *camera*, the most elaborate seems to have been the paintings commissioned by Salvi Borgherini on the occasion of the wedding of his son Pierfrancesco (1480–1558) and Margherita Accaiuoli, in 1515. The great woodworker and architect Baccio d'Agnolo designed the walnut furniture, including a *lettuccio* and two cassoni, and the paneling of the room. (Impressive stonework for the palace, some still in situ, probably carved by Benedetto da Rovezzano, gives us an idea of the extraordinary quality of the commission executed for the Borgherini).[25] A consortium of painters led by Andrea del Sarto, alongside Jacopo Pontormo, Francesco Granacci, and Francesco Bacchiacca, was hired to paint fourteen panels with scenes from the Old Testament narrative of the Life of Joseph (now divided among the National Gallery, London, the Borghese Gallery, Rome, the Galleria Palatina, Florence, and the Galleria degli Uffizi, Florence); two devotional paintings by these artists

probably also hung in the bedroom with this series. Allan Braham has studied Vasari's lengthy discussion of this bedroom in his *Lives* and has suggested how the works may have been installed in it. Recently, Brenda Preyer has tried to identify the suite of rooms in the Palazzo Borgherini (now Roselli del Turco) that would have included Pierfrancesco's *sala, camera,* and *anticamera* and consequently to judge where the furniture must have been placed and the view a visitor would have had upon entering the room.[26]

The disposition of these works constituted a veritable encyclopedia of the possible locations of paintings within such a chamber: they were inserted as panels in cassoni, as *spalliere* above cassoni and elsewhere, and perhaps above a *cassapanca,* above the *lettuccio,* around the sides of the bed (*tornaletti*), and possibly over a door and the fireplace. We do not know why the family commissioned such an extensive cycle on the theme of Joseph, but the story's intense interplay of fathers, sons, and brothers may have played a part in their choice. Salvi Borgherini's daughter, Maria, and her husband, Zanobi Girolami, had also commissioned Andrea del Sarto to paint a Story of Joseph for them, and the family may have thought of Joseph's important role as a prefiguration of Christ the Savior (Salvatore) as a subtle allusion to Salvi himself.[27] The total effect of the decoration must have been stupendous, as it included such iconic Mannerist works as Pontormo's *Jacob and Joseph in Egypt* (fig. 92). The pains Pontormo took with its subtle design are revealed in the extensive compositional changes from the original drawing on the panel to the final painted surface.[28]

Vasari singled out Pontormo's painting for praise in a passage that is one of the great set pieces of his *Lives of the Artists.* In 1529, some years after the completion of the room, when the Medici partisan Pierfrancesco was in exile in Lucca during the siege of Florence, a representative of the anti-Medicean Republican government, Battista della Palla, asked Margherita Accaiuoli to give up the Joseph paintings for sale so that the city could present them to his party's supporter, the king of France. Margherita lashed out at the "cheap salesman" who made the request, declaring, "This bed, which you want for your private interest and greed for money—although you cloak your malevolence in false piety—this is the bed of my nuptials in honor of which my father-in-law Salvi made all this magnificent and regal decoration, which I revere in memory of him and for the love of my husband, and which I intend to defend with my very blood and life."[29] What was the meaning of this speech that Vasari puts in the mouth of the offended wife? Through the metaphor of her bed, Margherita defended the honor of her home, her husband's family, and of her city as she saw it. In 1530 the siege of Florence ended; the Republicans were defeated; and Margherita's nemesis, Battista della Palla, was thrown into a Medicean fortress, where he soon died.

EPITHALAMIA AND THE POETRY OF MARRIAGE

While the relevance of certain cassone and *spalliera* subjects to nuptial themes is not always clear, paintings that respond to the poetic imagery of epithalamia are direct statements of the pleasures and hopes of marriage. As mentioned earlier in this essay, epithalamia, written in praise of marriage in song, prose, or verse, were usually composed for specific occasions. They have a complex history, but in short we can say that many were inspired by great examples by Catullus (84–54 B.C.), especially three of his poems known as Carmen 61, 62, and 64; Statius, who wrote about

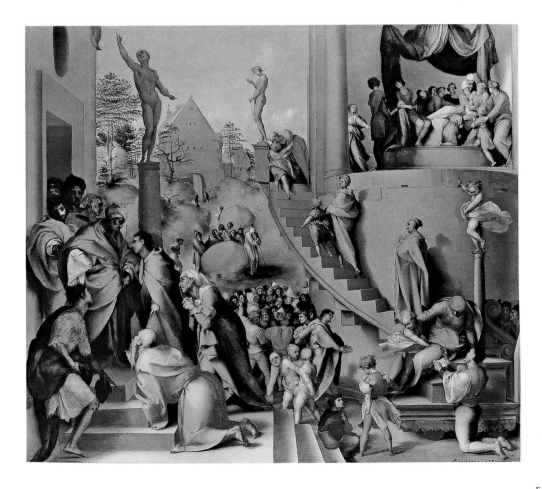

Fig. 92. Jacopo Pontormo (1494–1557), *Jacob and Joseph in Egypt,* probably 1518. Oil on panel, 38 × 43⅛ in. (96.5 × 109.5 cm). National Gallery, London

90 A.D.; and Claudian, who was active at the end of the fourth century A.D.[30] Greek prose examples were also of longstanding importance. The revival of epithalamia in the Renaissance is now well documented; Anthony D'Elia has identified hundreds from the fifteenth century alone, and more could be added to his list (see cat. no. 61).[31] Examples come from all over Italy, although in the fifteenth century they were most numerous at the courts of Ferrara, Naples, Milan, and Rimini, where they were delivered as Latin or Italian orations at weddings. They often commented at length on the virtues and qualities of the bride and groom, as well as those of their families. Later such Italian poets as Torquato Tasso and Marino wrote poems for marriages in the vernacular, which they often called "Per le nozze di. . . ."

Keith Christiansen recognized that Lorenzo Lotto's great, hitherto enigmatic *Venus and Cupid* (cat. no. 148) was created with the imagery of the epithalamium in mind.[32] It was in the poetry of Statius that the goddess Venus came to play the primary role in the celebration of marriage, replacing Hymen. As another scholar writes, she "unites the couple, sanctions the passions that brought them together, and increases their amorous desires."[33] Cupid comes to the bower where Venus is resting and escorts her to the wedding, where she adorns the bride and prepares the bridal bed. Lotto (and most likely his patron) also found inspiration in the beautiful language of Catullus's poetry; the influence of Catullus was such that in 1538 the Venetian author Ludovico Dolce freely translated one of his epithalamia.[34] It is in Catullus's Carmen 61 that we read of the bridal wreath and the "glossy-leaved myrtle," of the beauty of the bride as compared to Venus, and her delicacy to myrtle's tiny flowers. Catullus twice uses the metaphor of a vine clinging to a tree to describe a married couple. In the same poem he indulges in ribald jests that were meant to help ward off evil; in Lotto's painting the ribald content is contributed by the "giocoso" (jesting) Cupid. Significantly, a laughing Cupid appears again in a nuptial poem by Claudian. An emphasis on illicit, somber, or threatening aspects of love is an important element of Carmen 64, conveyed in the story of Theseus and Ariadne—a tale of illicit love and abandonment. This darker aspect may be reflected in Lotto's sinister depiction of a snake beneath the blue cloth upon which Venus reclines and the nearby rod with which she might chastise Cupid. To this deep stratum of antique inspiration Lotto added contemporary Italian and Venetian references to marriage: the bridal tiara and pearl earring, the veil, and the Cupid who urinates as a symbol of fertility (see cat. nos. 64, 69).

Although Lotto's painting may be the paradigmatic expression of this subject, other works of the period clearly belong in the same tradition. Giorgione's sublime *Sleeping Venus,* referred to above (fig. 88), which was probably commissioned for a wedding, reflects the imagery of a late Roman epithalamium written by Claudian in 399, which begins with a vision of Venus asleep in a landscape in the heat of the sun.[35] Other reclining nude Venuses with a Cupid, for example Palma il Vecchio's *Venus and Cupid* (fig. 89), probably respond to the same poetic inspirations; in particular the emphasis on Cupid's arrow in the Palma il Vecchio may refer to Claudian's second epithalamium, in which the boy dips his arrows in both honey and poison.[36] The genre was not limited to Venice. In Florence Botticelli's workshop created a large *Venus with Putti Gathering Roses* (National Gallery, London), which very likely was originally installed in the woodwork of a couple's *camera.* The motif of the flowers here may allude to Claudian's "couches . . . piled with roses . . . as befits a marriage."[37]

Epithalamia were written to celebrate marriages, and therefore were required to be positive about the institution. There were many excellent reasons that marriage was important for society, which were voiced in these orations and poems. But these orations also express the personal satisfactions that marriage could bring. Addressing himself to the guests at the extravagantly grand wedding of Costanzo Sforza and Camilla of Aragon in 1475—the description of which is preserved in a manuscript now in the Vatican Library (fig. 63)—Pandolfo Collenuccio began his oration with a reference to oft-expressed antimarriage sentiments: "I am amazed at how many men are hostile to marriage, since they believe that wives are an impediment to work, studies, and the contemplation of the truth." The author was absolutely against such an approach to life: "There can be no happiness without a wife and no one should be judged wise, as Aristotle says, who spurns so great a good of nature, so great a pleasure of friendship, and the usefulness of so great a gift. . . . God established marriage; nature beckons us to use and enjoy it; peoples agree upon it; and individual cities have founded rites and solemn ceremonies for it."[38] The paintings created to celebrate marriage in one way or another express these same sentiments, encouraging young couples to enter into the "blessed bond of board and bed" that Shakespeare named in *As You Like It.*

1. Gronau 1936, pp. 93, 94, doc. nos. XXXI, XXXV.
2. As, ultimately, just "una donna nuda"; see Hope 1980a, pp. 117–19; Hope 1980b, p. 82; and Zapperi 1991, pp. 163–64. Zapperi notes that the painting continued to be called "the nude woman" or "a recumbent woman," or "recumbent nude" in local sources well into the seventeenth century. Mark Twain was outraged by the figure's gesture; see Rosand 1997, p. 38, a theme picked up in more measured tones in Goffen 1997a, pp. 77–79. An overview of the interpretations focusing on marriage can be found in Goffen 1997a, pp. 79–82; and Goffen 1997b, p. 155.
3. Christiansen 1986; Anderson 1997, pp. 222–24; D'Elia 2004.
4. Roberto Bartalini in *Beccafumi* 1990, pp. 132–35, no. 14; Marilena Caciorgna in *Siena e Roma* 2005, pp. 130–34, nos. 1.8, 1.9; Carol Plazzotta in Syson et al. 2007, pp. 323–33, nos. 102–7.
5. Arasse 1997, esp. p. 98; Rosand 1997, p. 49.
6. It is sometimes suggested that this painting is identical to a *Sleeping Venus* now in the Borghese Gallery, Rome (Della Pergola 1955–59, vol. 1, , pp. 126–27, no. 229); for the original text written by Michiel on his visit to Odoni's house, see Michiel, *Notizia d'opere del disegno,* 2000 (ed.), pp. 17, 52. Paintings with other sensual subjects were placed above beds; for example, a painting inspired by Leonardo's *Leda* is described in Giovanni Rucellai's play *Oreste,* written between 1515 and 1520, as "sopra il capezzal del letto," as discussed by J. K. Nelson 2007a, p. 7, and appendix.
7. In his *De re aedificatoria* Leon Battista Alberti recommended "dignified" (or honorable) and "handsome" (or beautiful) paintings for the bedroom, "for they say that this may have a great influence on the fertility of the mother and the appearance of future offspring;" while Giulio Mancini, writing in the early seventeenth century in his *Considerazione sulla pittura,* advised that more provocative works be hung

in the bedroom, "because once seen they serve to arouse one and to make beautiful, healthy, and charming children." The tradition is an ancient one; see Rosand 1997, pp. 48, 60, nn. 40, 41.

8. Hope 1977; Rosand 1997, pp. 50–51; Wald 2008, pp. 125, and 128, ill. no. 2a, for the X-radiograph.

9. Lydecker 1987a, pp. 172–73.

10. Murphy 2005, p. 272.

11. See Klapisch-Zuber 1982/1985, esp. p. 222, n. 31, who quotes Agnolo Bandini, who was marrying Nanna Tornaquinci in 1453 with the hope of some financial help from his father-in-law; Lydecker 1987a, chap. 2.

12. Clark 1956, p. 115.

13. Everett Fahy in Barocchi 1992, pp. 131–32, no. 27.

14. W. Smith 1975; see also Shearman 1975, pp. 17–18, 25, nos. 37, 38.

15. Dempsey 1992, pp. 22–24; Cecchi 2005, p. 148.

16. Rohlmann 1996, p. 127.

17. See Levi D'Ancona 1983, pp. 71–95, for the identification of the plants in the painting and the frequency with which their symbolic readings related to love and, more specifically, marriage; Zirpolo 1991–92; Rohlmann 1996; Zöllner 1997.

18. For an overview, see Motture and Syson 2006, pp. 274–75.

19. Ibid.; J. K. Nelson 2007.

20. For the most complete compilation, see Barriault 1994.

21. Gombrich 1945/1972, pp. 68–69.

22. Nicholas Penny in Rubin and Wright 1999, p. 332.

23. Vasari's original text and the English translation by Gaston du C. De Vere, 1912–14, can be found in Barriault 1994, p. 12.

24. Cecchi 2005, p. 342, provides information about the family.

25. Cecchi 1990, p. 41, and figs. 20–23.

26. Braham 1979; Preyer 2006, p. 42.

27. Braham 1979, p. 761; Alessandro Cecchi in *Andrea del Sarto* 1986, p. 105, nos. X, XI.

28. Carol Plazzotta in Bomford 2002, pp. 148–55, no. 12.

29. Vasari 1568/1906 (ed.), vol. 6, p. 259ff. On this situation, see Barolsky 1991, pp. 65–79; for Della Palla's involvement vis-à-vis the French king, see Elam 1993.

30. Tufte 1970, chaps. 1–4.

31. D'Elia 2002; D'Elia 2004.

32. Christiansen 1986.

33. Tufte 1970, p. 58.

34. Anderson 1997, pp. 224–25, 335, n. 63.

35. Ibid., p. 222; Anderson points out that the artists make no attempt to illustrate these complex poems in all their detail.

36. Tufte 1970, p. 61.

37. Christiansen 1986, p. 172.

38. D'Elia 2004, p. 84.

Picturing the Perfect Marriage: The Equilibrium of Sense and Sensibility in Titian's "Sacred and Profane Love"

Beverly Louise Brown

Rebecca Mead's recent best seller, *One Perfect Day: The Selling of the American Wedding*, puts forward the notion that the modern wedding is a product of our consumerist society: a ceremony in which the bride wears the perfect dress, entertains her family and friends with a spectacular production worthy of Hollywood celebrities, and ensures a happily married life by securing every single item on her bridal registry list. We have no trouble imagining this perfect bride, or "Bridezilla," as Mead calls her. A white dress, a veil, a bouquet of flowers, a euphoric couple holding hands as they emerge from a church door being pelted by rice can mean only one thing. Just as we embrace this largely Victorian image of nuptial celebration, early sixteenth-century viewers would have easily recognized Titian's *Sacred and Profane Love* (fig. 93) as a visual epithalamium, a poem about marriage. Every element in this lyrical masterpiece,

from the jeweled belt and silver bowl to the sculpted fountain and hunted hare, speaks of marital bliss and idyllic love.

On the surface, *Sacred and Profane Love* is a straightforward picture dominated by two competing yet related beauties, whose radiant and seductive grace seems effortless. They could be sisters, if not twins. They sit on either end of a classical sarcophagus that has been transformed into a fountain, one dressed in a shimmering white satin gown with magnificent red undersleeves, the other's nudity accentuated by a flowing crimson mantle. Between them, a pudgy Cupid leans over the fountain's edge, rippling the water. In the distance is a sparsely populated landscape bathed in the glowing yellow light of dawn; a few men gather around the village gate, three riders gallop across the hills, a lone shepherd tends his flock, and two idle lovers steal a kiss. All of these figures are subordinate to the seductive magnetism of the two women and

to the perfect equilibrium maintained between the sensual appeal of the one's voluptuous drapery and the other's unblemished flesh. The essence of the picture lies in this point-counterpoint, yet the ambiguous identity of these two scintillating beauties has fueled a prolonged debate over the picture's meaning.[1]

We have no idea what Titian or his patron might have called the painting. In fact, one of the most perplexing aspects of its history is the veil of silence that shrouds the canvas until the early seventeenth century, when it is recorded in the collection of Cardinal Scipione Borghese in Rome.[2] We do know, however, a surprising amount about the picture's patron. The coat of arms on the center of the fountain has been identified as that of Niccolò Aurelio (1463–1531), a secretary to the Venetian Council of Ten, who would obtain and then tragically lose the coveted position of Grand Chancellor.[3] According to the Venetian diarist Marin Sanudo, Aurelio married Laura Bagarotto on May 17, 1514.[4] The wedding was a cause célèbre; as Sanudo put it, "Everyone was talking about it." Laura was the daughter of Bertuccio Bagarotto, an eminent Paduan lawyer, and the widow of Francesco Borromeo, a Paduan nobleman related to the famous Milanese family.[5] Her father (and presumably her husband) had been executed in 1509 for supporting the imperial forces against Venice during the War of the League of Cambrai. Not only were the rebels hanged in public for their disloyalty, but their estates were confiscated by the Venetians.[6] In 1510 the Council of Ten had decreed that the dowries of the Paduan rebels' widows be restored, but Laura was still petitioning for the return of hers in January 1514. The petition

Fig. 93. Tiziano Vecellio, called Titian (ca. 1488–1576), *Sacred and Profane Love*, ca. 1514–15. Oil on canvas, 46½ in. × 9 ft. 1⅞ in. (118 × 279 cm). Borghese Gallery, Rome

had been sent on her behalf by Aurelio and, on the day before their marriage was publicly announced, Laura's dowry was finally returned.[7] It included a white satin dress, twenty-five pearls, and a respectable amount of property in the Paduan territory, including a villa in Lissaro near Cittadella. The dowry was valued at just over 2,100 ducats, a sizable sum considering that the dowry limitation act of 1505 had set the official rate for patrician families at 3,000 ducats.[8]

Stylistic considerations coupled with the evidence supplied by Sanudo's diary seem to confirm that Titian's picture was commissioned around 1514 in celebration of Nicolò and Laura's marriage. Even without knowing the particulars of their nuptial arrangements, it is clear that the picture is about marriage. Its rectangular shape is reminiscent of cassoni, the traditional Italian wedding chests whose decoration extolled uxorial virtues and dynastic generation. Central to any discussion of marriage is love, and love has always been acknowledged as the key to unlocking the picture's inherent meaning. The 1650 Borghese inventory listed the painting as "the Three Loves of Titian." Later archivists described it as "Divine Love and Profane Love, with Cupid Fishing in a Basin," "Heavenly and Earthly Love," or by the title that we now use, "Sacred and Profane Love."[9] Few doubted that the nude was Venus, the goddess of Love, but her companion's identity remained elusive. By the end of the nineteenth century, scholars had begun to scour classical texts for narratives that might explain the painting's subject.[10] Perhaps it was Venus urging Medea to follow Jason, or Venus telling her half-sister Helen to take the beaten and disgraced Paris back to her bed. Contemporary texts were also advanced as sources for the theme, including Giovanni Boccaccio's *Elegia di madonna Fiammetta* or Francesco Colonna's *Hypnerotomachia Poliphili* (cat. no. 62).[11] In the latter case, it has been suggested that Polia, the chaste heroine of the romance, meets Venus at the tomb of Adonis. More recently, a group of scholars has suggested that the clothed figure is an idealized portrait of Laura Bagarotto, dressed as the quintessential sixteenth-century bride. Some suggest she is being given marital advice by Venus, while others maintain that as a mortal figure she is unaware of Venus's divine presence.[12] It is doubtful, however, that a sixteenth-century viewer would have specifically recognized Laura, for the features of the clothed figure (as well as those of the nude Venus) resemble any number of Titian's female subjects in his secular and religious paintings of the period.

Others, taking the title *Sacred and Profane Love* as a starting point, have read the picture as an allegory of two contrasting aspects of love. Basing his thesis on the writings of Marsilio Ficino and Giovanni Pico della Mirandola, Erwin Panofsky saw the picture as a conscious tribute to the Neoplatonic concept of Geminae Veneres, or twin Venuses.[13] In this interpretation, the clothed Venus, personifying Earthly Love, is the generative force that creates all tangible beauty, while the nude Venus, personifying Heavenly Love, is the elevated state that allows the intellect to comprehend the eternal beauty of God. Ficino and Pico, however,

were referring to a type of homoerotic love, in which the soul's spiritual ascent is fueled by the love between men.[14] Furthermore, to accept Panofsky's interpretation demands a bit of mental gymnastics, in which the Heavenly and Earthly Venuses are reversed in relation to how we read the picture, from left to right.

Like their counterparts in Plato's *Symposium*, Ficino and Pico's twin Venuses represent intellectual concepts without physical attributes. Heavenly Venus presides over a perfect intellectual state devoid of all physicality, while Earthly Venus rules over the positive aspects of sexual intercourse that ensure procreation. By returning to the original Platonic notion, the writers overturned a strong medieval tradition in which Celestial or Heavenly Venus represents the positive, procreative aspect of marital sex while Earthly or Vulgar Venus has the negative connotation of carnal desire.[15] The pictorial portrayals of these two Venuses also survived intact. One of the most popular mythological sources of the period was Boccaccio's *Genealogiae*, which was published in 1472 in Venice and appeared in seven other editions by 1511. In it, Boccaccio gives a richly detailed account of the characteristics of both Venuses, characteristics that we can readily identify as the defining attributes of the two female figures in Titian's *Sacred and Profane Love*.[16]

According to Boccaccio, Earthly Venus is the mother of Cupid and the goddess of lust, who pertains to sexual excitement and fornication of all kinds. She is, therefore, nude. As one medieval mythographer explained, "Venus is painted nude either because the sin of lechery is least hidden, or because the naked do come together."[17] With every inch of her tantalizing flesh on view, this Venus is the one most frequently represented during the Renaissance

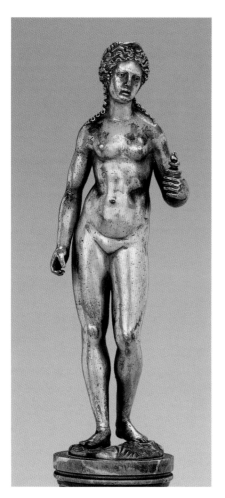

Fig. 94. Attributed to Tullio Lombardo (ca. 1455–1532), *Venus with a Burning Urn*, ca. 1500–1520. Gilt bronze (hollow cast), H. 7¼ in. (18.3 cm). © The Cleveland Museum of Art, John L. Severance Fund (1948.171)

and the one most easily recognizable today. This beautiful and naked goddess was born of the sea, but her morals are suspect. In his fifteenth-century treatise on architecture, Filarete recommended her image as an appropriate decoration for a "House of Vice."[18] In Titian's painting, the nude holds a smoldering oil lamp, for which there is no classical precedent. By the thirteenth century, however, Venus was frequently depicted holding a flaming torch or oil lamp as a symbol of the all-consuming heat of sexual passion.[19] This theme reoccurs in a number of early sixteenth-century works such as prints by Marcantonio Raimondi and small bronzes by Antico and Tullio Lombardo (fig. 94).[20] On January 19, 1503, Isabella d'Este sent Pietro Perugino a detailed program for the *Battle of Chastity and Lasciviousness* (Musée du Louvre, Paris), in which the chaste Diana's drapery was to be burnt by the torch of a scantily clad Venus.[21]

Earthly Venus's celestial counterpart rules over Spring, that time of year when a young man's fancy turns toward love. Boccaccio described Heavenly Venus at length. She wears a girdle called a cestus and is accompanied by swans and doves. Surrounding her is the sweet scent of roses and myrtle, the latter a plant specifically associated with matrimony. As the goddess of marriage, Heavenly Venus presides over sexual love that leads to procreation. Images of this marital Venus are most commonly associated with triumphal scenes or astrological cycles. She appears, for example, in a fresco cycle attributed to Nicolò Miretto and Stefano da Ferrara in the Palazzo della Ragione in Padua, where she stands in an enclosed garden representing the month of April. She is dressed in a high-belted white gown with red sleeves and carries a bouquet of roses in each hand.[22] In Francesco del Cossa's *Month of April* in the Palazzo Schifanoia in Ferrara, Venus rides in a triumphal cart drawn by a pair of swans (fig. 95).[23] Doves flutter above her head and a large myrtle plant grows on the shore nearby. Her long flowing locks are crowned with a wreath of red and white roses and she wears a golden girdle, decorated with a picture of Cupid aiming his arrow at a pair of embracing lovers. Kneeling before her is the fettered Mars, to whom she offers a quince, a fruit whose juices were thought to enhance a bride's sweet voice and pleasant speech on her wedding night.[24] In her other hand, she holds a golden apple from the Garden of the Hesperides, a symbol of perpetual fruitfulness and fecundity.

The clothed figure in Titian's *Sacred and Profane Love* is strikingly similar in appearance to Cossa's Heavenly Venus. Not only does she wear a similar red and white gown fastened by a jeweled belt, but her long flowing tresses are crowned with a wreath of myrtle and she holds a bouquet of red roses in her lap. These attributes suggest that she too is Heavenly Venus, the goddess of honest and licit marital love. Ironically, as the bound Mars in Cossa's fresco reminds us, Venus was not a very good wife. Nevertheless, throughout the Renaissance she was strongly associated with becoming one. It was Venus who united the couple, sanctioned the passion that brought them together, and increased their amorous desires.[25] She prepared the bridal bed and adorned the bride. That a bride's beauty might rival Venus's is a recurrent theme in the classical epithalamia of Statius and Claudian.[26] They recounted how Venus herself parts a bride's hair and beautifies her face so that on her wedding day she might assume the goddess's own sweet image. In Titian's painting, the clothed Venus

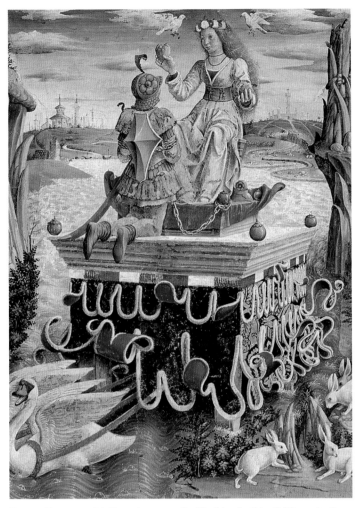

Fig. 95. Francesco del Cossa (1435–1478), *The Month of April: Triumph of Venus and Astrological Symbols* (detail), 1469. Fresco. Palazzo Schifanoia, Ferrara

is dressed as the perfect contemporary bride, since each bride's beauty was but a reflection of the goddess's.

We know that during the sixteenth century some Venetian brides did wear luxurious white satin gowns similar to that pictured in *Sacred and Profane Love*. In his description of Venetian wedding practices, Francesco Sansovino specifically mentions that, according to an antique custom, a bride was presented in a white dress, with her hair falling loosely to her shoulders and entwined with threads of gold.[27] Among the items listed in Laura Bagarotto's dowry is a white satin dress, which she must have worn during her first marriage in Padua and presumably again when she married Aurelio. In 1497, when Davide Freschi and Maria Bianco's wedding was blessed in the church of San Basso, the bride wore a long white silk dress with open sleeves reaching to the ground, similar perhaps to the deep crimson-violet (*pavonazzo*) dress illustrated in Cesare Vecellio's *Habiti antichi* and described as "The Antique Dress of Women and Brides" (cat. no. 65).[28] As Vecellio clearly indicates, not all wedding dresses were white. In fact, the color of choice in Venice and elsewhere seems to have been red.[29] In 1525 Doge Andrea Gritti's granddaughter Viena wore a special rose-colored gown (*ruosa secha*) meant to match his ceremonial robes.[30] In 1504 Samaritana Freschi wore a crimson velvet dress with gold sleeves and, two years later, so did her sister Giustina. Both wore a crownlike bonnet set with gems and pearls and were further adorned with necklaces and chains.[31] The long

gold necklace draped over the shoulders of women, seen in many contemporary portraits, was commonly known as a *vinculum amoris*, or chain of love.[32] In Lorenzo Lotto's celebrated wedding portrait of Marsilio and Faustina Cassotti (fig. 7), the bride is dressed in red and adorned with pearls and a gold *vinculum amoris*, as well as an antique cameo of her namesake, Faustina the Elder.[33] This humorous look at the burdensome yoke of marriage is also a prime indicator of the couple's status and wealth; it is, in essence, an inventory of Faustina's dowry. When it came to choosing a dress, it was not the color that mattered, but the opulence. Clothing was a financial asset, the visual encapsulation of a bride's social status and rank.[34]

In 1505, when Marco Antonio Altieri described the public pomp and splendor of a wedding procession in Rome, he did not mention the color of the bride's dress, although he did remark that the white horse pulling the carriage symbolized her purity. More important was her jewelry: the pearls and precious gems, gold chains, and especially her crown.[35] The garlands of pearls in the mock procession of Venus and Mars depicted on a maiolica plate (cat. no. 6) are a lighthearted parody of the ostentatious displays that marked a bride's public presentation. Of course, as Giacomo Franco reminds us, in Venice these horse-drawn processions were replaced by gondola rides (cat. no. 65). For Franco, the elegance of a Venetian bride surpassed even that of a foreign princess. She was dressed in gold and wore a diadem of pearls and precious stones. Her hair was long and hung loosely behind her shoulders, interwoven with threads of gold, her beauty rivaling that of Venus.[36]

By comparison, Titian's Heavenly Venus is austerely dressed, her only ornament a ruby-studded belt buckle. Venus's cestus or girdle was the sign of a chaste and honest marriage. During her many dalliances, the goddess is purported to have left it behind, as her incestuous behavior broke the sacred bonds of matrimony. After a marriage contract had been finalized between two families, in the presence of witnesses, the groom would have presented his betrothed with a ring. He then might offer her a number of courtship gifts or *contrados*: small chests filled with ribbons, pearls and gold jewelry, as well as fabric for new dresses, belts, gloves, and bonnets. For instance, on the morning of her betrothal, Doge Gritti's niece received a silver casket containing a small stuffed animal with a jeweled head and gold chain.[37] Many of the caskets were elaborately decorated with *pastiglia* (cat. no. 39), while some, like the one overflowing with colored ribbons, rings, and gold chains in Palma Vecchio's *La Bella*, were less ornate (fig. 96).[38] In the story of Griselda, Boccaccio explains how a groom put together "girdles and rings with a costly and beautiful crown and all the other paraphernalia of a bride."[39] The acceptance of these gifts publicly announced one's consent to marriage. One young girl in Bologna refused to wear "the coral necklace, silver-studded black velvet belt, and white bonnet interwoven with gold thread" that her fiancé sent her, because she did not wish to wed him.[40] Symbolically, the fastening of a belt represented the unification of the couple, whose idealized profiles might be depicted on the belt-ends (cat. no. 36b).[41] A girdle was also a sign of the bride's chastity. On the night that a marriage was consummated, she might return it to her husband as proof of her virginity.[42]

Although not specifically linked to Venus, the gloves worn by the clothed figure in *Sacred and Profane Love* also might denote a

bride's virginity. Like belts, they were a betrothal gift, given as a token of the groom's serious intentions and worn until the marriage night.[43] In Paris Bordon's *Lovers* (fig. 104), a groom tenderly helps his bride display her newly received ring, belt, and gloves. His honorable conduct is assured by the presence of his trusted friend, the *compare dell'anello* or ring bearer.[44] Uncovered hands might arouse passion or even sexual desire. Petrarch's timorous heart was wrung when the pure gentle fingers of his love's hand were hidden within a glove.[45] For Baldassare Castiglione, the desire to see beautiful and delicate hands was increased "especially if covered with gloves again."[46] A groom might also give his prospective bride a white handkerchief of the type draped across Heavenly Venus's right arm.[47] Women, such as the merchant's wife illustrated by Giacomo Franco (cat. no. 65), carried them as a sign of marital fidelity. One recalls only too well the trouble wrought when Desdemona drops hers in Shakespeare's *Othello*. In public, a handkerchief might attest to a woman's faithfulness and humility but, in private, it was a token of love and secret joy. In Ruzante's comedy *La Betía*, first performed in Venice in 1523 for the marriage of Antonio Grimani di Vincenzo, the various levels of a handkerchief's symbolism are clearly spelled out. "It was holy in church, wise in life, and indecent in bed, growing, multiplying, and impregnating the earth on every side."[48] Taken into the marital bed, a handkerchief might facilitate the pleasant seduction that led to procreation, which was, after all, the aim of every marriage.

Although we cannot see what is in the bronze and gilt bowl under Heavenly Venus's arm, this has not prevented scholars from describing its contents. Many have assumed that it is filled with rose petals or jewels, suggesting that it symbolizes the brevity of earthly pleasures. Others think it might be a vase used to collect the fountain's water or an urn containing Laura's father's ashes.[49] Its size and shape are similar to those of the bronze bowl commissioned for the marriage of Giambattista Annoni and Silvia Visconti in the 1570s (cat. no. 50). This bowl carries the coat of arms and initials of the couple and was no doubt prominently displayed during the festive banquets held in celebration of their union. The final panel of Sandro Botticelli's *Story of Nastagio degli Onesti* (cat. no. 139), painted for the marriage of Giannozzo di Antonio Pucci and Lucrezia di Piero di Giovanni di Jacopo Bini in 1483, depicts a lavish wedding feast held under an open loggia.[50] Here the fictional characters of Boccaccio's story are joined by the real-life bride and groom. In the foreground is a sideboard draped with brocade and laden with elaborate bowls and basins in a very public display of the combined Pucci–Bini family assets.

Resting on the edge of the fountain in *Sacred and Profane Love* is a silver fluted basin similar to the ones depicted in Botticelli's panel. It was once believed that the Bagarotto coat of arms could be seen in the center of the dish in Titian's painting. However, after the picture's cleaning in the early 1990s, it is no longer possible to say with certainty that the lines in the dish's center are anything more than random marks.[51] Nevertheless, it should be remembered that similar objects, whether silver or crystal, were often decorated with arms and traditionally given as gifts from the bride's family to the groom.[52] Altieri describes how after the ring ceremony, the bride's mother gave the groom a silver ewer and basin bearing his arms conjoined with those of his future wife.[53] While such dishes might be used for serving

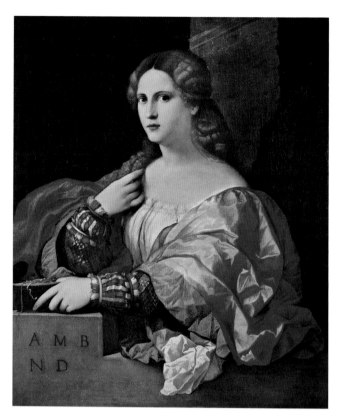

Fig. 96. Jacopo Negretti, called Palma il Vecchio (1479/80–1528), *La Bella*, 1520. Oil on canvas, 37⅜ × 31½ in. (95 × 80 cm). The Thyssen-Bornemisza Collection, Madrid

sweetmeats at the nuptial banquet, they also were employed for cleansing a mother's hands after birth and during the rite of baptism, hence the three fish found in the center of one silver basin (fig. 97).[54] Such gifts were generative talismans and it seems clear that the placement of the basin just above the Aurelio coat of arms alludes to the hoped-for fertility of Laura and Niccolò's union, even if the Bagarotto arms are not present. Cupid stirs the fountain's water, encouraging its flow from the spout placed directly below the basin and coat of arms. The water nourishes Venus's rosebush, which thrives at the painting's center. As Rona Goffen has explained, "The emission of liquid from a tube, caused by a male figure, however small, represents ejaculation, or its frequent symbolic equivalent, urination."[55] In Lorenzo Lotto's more salacious wedding picture (cat. no. 148), Cupid aims his stream of urine directly through a myrtle wreath onto his mother's stomach. The same generative aspects are expressed by the urinating boy on the reverse of Bartolomeo di Fruosino's childbirth tray (cat. no. 69; fig. 54). The inscription around the edge reads in part, "grant health to every woman who gives birth . . . I make urine of silver and gold," a universal wish for fecundity and prosperity.

On the sarcophagus, here transformed into a fountain, Titian depicted a complex relief, which, while classical in style, cannot be related to any known ancient source. Like an antique fragment, it seems weathered by time. The eroded faces and bodies are perhaps deliberately ambiguous, and parts of the relief are hidden altogether behind the lush folds of drapery or partly obscured by the rosebush. The herm at the left is the lustful Priapus, the son of Bacchus and Venus, who as the god of fertility ruled over gardens. He tugs at the hair of a nude woman, seemingly pulling her from the unbridled horse that a man attempts to tether with the ribbons flowing from the escutcheon that bears the Aurelio coat

of arms. Horses were known for their lustful ways, and the word "horse" itself was used as a euphemism for a phallus.[56] Unbridled horses symbolized man's uncontrollable lust. Such impulsive passion, however, might be assuaged by marriage. In the upper right corner of Palma Vecchio's *La Bella*, a picture that we have already seen reflects early sixteenth-century marriage customs, there is a marble relief of a horseman trampling a naked man (fig. 96). It is a graphic reminder that the bestial aspects of love could be transformed through matrimony. Francesco Barbaro's treatise on marriage, *De Re Uxoria*, written around 1415–16 as a wedding gift for Lorenzo di Giovanni de' Medici and first published in Venice in 1513, reminds newly wed couples that lust and unseemly desire are harmful to a husband's dignity.[57] Lovemaking should be performed in moderation and one's sexual appetite reserved for the procreation of children. In *Sacred and Profane Love*, the implication of tying a horse to the Aurelio coat of arms seems abundantly clear.

If the scene on the left of the painted relief takes place in the fertile garden of Priapus, then that on the right is located in the enchanted garden of Venus, according to Petrarch a place of "fleeting delights and constant weariness."[58] The action is dominated by a man violently flogging a rival.[59] Beyond them a woman stands in shock and a man rushes forward, perhaps in an attempt to stop the brutality. The figures on the left recall the story of Adonis, the legendary lover of Venus, who was punished by the jealous Mars and eventually gored by a boar. In 1499 Francesco Colonna retold the story in the *Hypnerotomachia Poliphili* (cat. no. 62).[60] He recounts how when Venus heard the wounded Adonis call for help, she dashed through the forest naked and in her haste pricked her flesh on a rose thorn, her blood turning the white roses red. He goes on to explain that "this little tale could be seen perfectly carved on one of the long sides of the tomb." Indeed, the accompanying woodcut shows Adonis's tomb transformed into a

fountain decorated with the tale of love's misfortune (fig. 98). The story of Venus and Adonis was often interpreted as a moral allegory in which Adonis paid for enjoying the pleasures of sensual desire and neglecting the duty of true devotion. Lust, like a beautiful rose, could prick with the sting of sin. In Titian's *Sacred and Profane Love*, the imagery on the relief, bifurcated by the water spout, echoes the moralized division between the twin Venuses sitting above. Heavenly Venus, the goddess of marriage, sits at the left above the scene, reminding us that sexual desire must be restrained and harnessed for the greater good of the family. Earthly Venus, in all her corporeal beauty, presides at the right over a tale in which the dangers of carnal concupiscence become palpably apparent.

While the sarcophagus may allude to the tomb of Adonis—a lone rose placed on its rim as a poignant reminder of love's sorrows—it is also the Fountain of Love strewn with roses whose sweet smell perfumes the air.[61] Behind it lies a sun-drenched landscape, whose imagery, like that of the relief, is split into two contrasting halves. Behind Heavenly Venus on a rich and fertile hillside are two white rabbits or hares, animals known for their sexual prowess and fecundity.[62] Both were associated with Venus and used euphemistically for the female pudenda. Rabbits appear at the foot of Venus's triumphal cart in the Palazzo Schifanoia (fig. 95) and a group of cupids try to catch a hare in Titian's *Worship of Venus* (Museo del Prado, Madrid).[63] This latter picture was based on Philostratus the Elder's *Imagines*, which explains that while a female hare suckles her young, she bears another litter to share the same milk. In fact, there is no time at all when she is not carrying young.[64] If the creation of "bunnies" was seen as a positive female attribute, the hunting of them by men was considered an amatory pursuit propelled by lust. Behind Titian's nude Venus, a hound chases after a hare and an amorous couple embrace. But the self-indulgent pursuit of sexual pleasure could only lead to a

Fig. 97. Silver fluted bowl, Venice, early 16th century. Victoria and Albert Museum, London

Fig. 98. Attributed to Benedetto Bordone (ca. 1455/60–1530), *Scene of the Tomb of Adonis*, woodcut illustration from Francesco Colonna (ca. 1453–1517), *Hypnerotomachia Poliphili*, book 1, Z7r (detail of cat. no. 62)

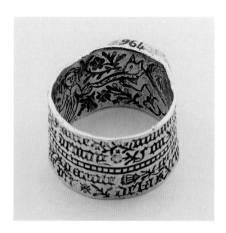

spiritually barren life, as the dry riverbed and tree stump at the extreme right suggest.

Only through marriage can man's baser instincts be channeled and true happiness be found. The theme of venery, an allusion to courtship, frequently decorates betrothal gifts, including ivory combs (cat. no. 37), small caskets, and prints.[65] These images hold out the promise that, like a hunted hare or stag, the bridegroom will suddenly turn and submissively offer himself to the hunter. As a fifteenth-century gold ring (fig. 99) so cleverly illustrates, in the chase of love the tables would turn and the hunted lady would triumph. An inscription on the outside of the ring states that it is being given to a lady despite her objections, but on the inside is a more secretive message. Next to an image of a lady holding a tethered squirrel with one hand and a bunch of acorns in the other, it reads "love is infinite for her relative," implying that in marriage her pursuer will become a member of her family.[66] The penis was sometimes referred to as a squirrel, and here the lady has it on a leash, where it might feed on a meal of nuts within the infinite circle of marital love. The sexual implication of this hidden squirrel is similar to that of the sleeping one in Lorenzo Lotto's *Portrait of a Married Couple* (cat. no. 124). In Lotto's picture, the husband points to the squirrel with one hand while holding in the other a piece of paper that reads "Homo numquam" (man would never do this). Unlike the inattentive squirrel, this husband will not fail to carry out his familial duties. The chase of love, which starts from the negative connotation of lust, finds a happy resolution

in the legitimate pleasure of conjugal sex. In the hunt, we are brought full circle back to the Fountain of Love, an allegory for how love begins and how love may end.

Depictions of two Venuses in the same picture are extremely rare. Just before his death in 1506, Mantegna was working on a painting for Isabella d'Este's *studiolo*, which was described by one of her courtiers as containing "two Venuses, one dressed and the other nude."[67] The commission was taken up by Lorenzo Costa, whose *Comus* (Musée du Louvre, Paris) includes an Earthly and a Heavenly Venus thought to personify the conversion of natural desire into the acceptable actions of civility.[68] Titian's reference point, however, may have been a subject traditionally used to decorate *cassoni* panels: the struggle between Chastity and Love, or prudent sense and heedless sensuality. Like Neroccio de' Landi's *Battle of Chastity and Love* (fig. 100), in which the twin images of *virtù* (chaste Christian love) and *lussuria* (erotic love) vie for supremacy, Titian's twin Venuses embody two contrasting aspects of love.[69] Yet, unlike the cassone panel, in which *virtù* triumphs, since her companion's arrow is the first to reach the target, in *Sacred and Profane Love* an equilibrium is maintained between the forces of love: an equilibrium necessary for marital success.

Titian reinterpreted traditional marriage imagery in a new classical style. With chromatic bravura, he harmonized the purity of white with the passion of red, carefully interweaving the identities of the two Venuses. In doing so, he went beyond the medieval view that carnal love was merely lustful. Like the early sixteenth-century dialogues on the nature of love in Pietro Bembo's *Gli Asolani* and Leone Ebreo's *Dialoghi d'amore*, Titian sought to reconcile love's sensual and spiritual aspects.[70] As Bembo and Ebreo both realized, the two sides of love could find a common ground in marriage. Playing upon conventions firmly embedded in common knowledge and nuptial custom, Titian created a poem about marriage whose overall structure may be complex, but whose component parts would have been easily deciphered by his sixteenth-century audience. For Laura Bagarotto and Niccolò Aurelio, Titian presented a visual epithalamium on the sense and sensibility of love and marriage. He has, in short, pictured the perfect marriage, in which the raging passions of the heart are subsumed by the generative power of marital bliss.

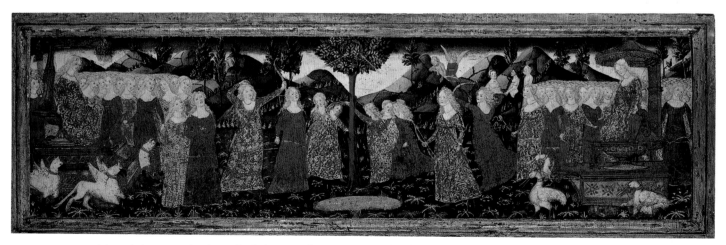

Fig. 100. Neroccio de' Landi (1447–1500), *The Battle of Chastity and Love*, ca. 1475. Oil and tempera on panel, 13½ × 50¼ in. (34.3 × 127.6 cm). Private collection, London

The research for this essay was supported by a grant from the Institute for Mediterranean Studies. I am grateful to Caroline Elam and Charles Hope for making several helpful suggestions.

1. For the substantial literature on the picture, see *Tiziano* 1995. To this one should add B. D. Steele 1996; Bertelli 1997; Barolsky 1998; Borggrefe 2001; Dal Pozzolo 2001; and Joannides 2001, pp. 185–93.

2. The picture is likely to have been bought from Cardinal Paolo Emilio Sfondrato in 1608; see Staccioli 1995, pp. 54–55.

3. On Aurelio, see Mayer 1939; Wethey 1969–75, vol. 3, p. 177; Neff 1981; Neff 1985, pp. 211–52, 361–63; and Robertson 1988, pp. 272–73.

4. Sanudo, *I diarii*, 1879–1903 (ed.), vol. 18, col. 199: "Non voglio restar di scriver una cossa notanda: come Nicolò Aurelio secretario dil Consejo di X è maridado in una fi[gl]a fo dil Bertuzi Bagaroto, che fo apichato, vedoa, fo moglie di Francesco Lombardo, qual à bona dota, et par habi auto licentia dal Principe, consieri e Cai di X; *tamen* di questo molto se parloe."

5. Goffen 1993, p. 123, pointed out that Sanudo refers to Francesco by his place of origin and not his family name.

6. On Bagarotto, see Wethey 1969–75, vol. 3, p. 177; Robertson 1988, p. 272; and Goffen 1993, p. 123.

7. Archivio di Stato, Venice, Consiglio de' Dieci, Miscellanea codici, reg. 83B, cc. 38v–40v. I would like to thank Charles Hope for providing me with a transcription of the document. It is referred to, but not transcribed, by both Neff 1985, p. 252, and Goffen 1993, p. 130.

8. Chojnacki 2000, pp. 67–72.

9. See Della Pergola 1964; and Staccioli 1995, pp. 56–58; the latter points out that the title "Beltà disornata e Beltà ornata" (Beauty Unadorned and Beauty Adorned), quoted from Scipione Francucci's 1613 poem "La galleria dell'Illustrissimo e Reverendissimo Signor Scipione Cardinale Borghese cantata," does not refer to *Sacred and Profane Love*. For the relevant lines from the poem, see Herrmann Fiore 1995, pp. 392–95.

10. Many of the various proposals are discussed at length in Wethey 1969–75, vol. 3, pp. 178–79; Bernardini 1995; and Kilpatrick 1999.

11. The possible connection with the *Hypnerotomachia Poliphili* has been explored by a number of scholars, including Friedlaender 1938; Wischnitzer-Bernstein 1943; Cantelupe 1964; E. Fry 1979; and Calvesi 1989.

12. Hope 1980a, pp. 116–17, suggested that the picture be retitled *Laura Bagarotto at the Fountain of Venus*; he thought that Laura was unaware of Venus. E. Fry 1979, Ost 1980, Rogers 1988, Ricciardi 1986, and Borggrefe 2001 all think she meets Venus.

13. Panofsky 1967, pp. 129–69; and Panofsky 1969, pp. 109–38.

14. Kraye 1994.

15. See Hollander 1977, pp. 158–60, n. 44; and Rubin 2000. See also the comments of Holberton 1985, p. 34.

16. Boccaccio, *Genealogiae*, 1494 (ed.), book 3, chaps. 22–23.

17. Vatican Mythographer III (12th century); see Brumble 1998, p. 342.

18. Filarete, *Trattato di architettura*, 1972 (ed.), vol. 2, pp. 549–50.

19. Those in favor of a Neoplatonic reading have suggested that the flaming vase represents divine love and have related the figures to Christian images of Caritas. However, these images are of clothed, not nude women; see Freyhan 1948, pp. 85–86; and Pincus 1969.

20. For Marcantonio Raimondi, see Marzia Faietti in Faietti and Oberhuber 1988, pp. 132–34, no. 22. For the bronzes, see *Natur und Antike* 1985, pp. 420–25.

21. See S. J. Campbell 2004, pp. 172–74.

22. Anna Maria Spiazzi in Aliberti Gaudioso 1996, pp. 182–85.

23. See Previati 2000; and the essays in Varese 1989.

24. See Barbaro, *De Re Uxoria*, 1915 (ed.), p. 61.

25. See, for example, the poems of Neapolitan humanist Giovanni Gioviano Pontano, cited in D'Elia 2004, p. 103.

26. Statius, *Silvae*, 2003 (ed.), pp. 40–61; Claudian, *Works*, 1922 (ed.), vol. 1, pp. 242–67. See also Tufte 1970, pp. 57–66.

27. Sansovino, *Venetia*, 1581, p. 149.

28. For the Freschi-Bianco wedding, see Morelli and Gennari 1819, pp. 20–21. See also Vecellio, *Habiti antichi*, 1598, fol. 67v: "le spose et donne di quel tempo usavano le maniche alla dogalina lunghe quasi fino in terra, riversate sopra le spalle, et alcune di color pavonazzo." On the color of Venetian fabric, see Hills 2003, pp. 44, 312.

29. Murphy 1997, p. 118; Pinchera 2003, p. 240.

30. Sanudo, *I diarii*, 1879–1903 (ed.), vol. 37, col. 475. See also Labalme and Sanguineti White 1999, p. 56.

31. Morelli and Gennari 1819, pp. 22–29.

32. Ripa, *Iconologia*, 1603, p. 80, lists it as an attribute of "Concordia Maritale" (marital harmony), which denotes that a couple has been chained together by love. See also Brevaglieri 1995, p. 158.

33. For the significance of the cameo, see B. L. Brown 2009.

34. See Allerston 1998.

35. Altieri, *Li nuptiali*, 1995 (ed.), pp. 67–68.

36. G. Franco, *Habiti*, 1610, fol. 6.

37. Sanudo, *I diarii*, 1879–1903 (ed.), vol. 37, col. 475.

38. For the picture, see Sylvia Ferino-Pagden in D. A. Brown and Ferino-Pagden 2006, pp. 230–31, no. 44.

39. Boccaccio, *Decameron*, 1976 (ed.), p. 944: "e oltre a questo apparecchiò cinture e anella e una ricca e bella corona e tutto ciò che a novella sposa si richiedea."

40. Ferrante 2001, p. 341.

41. See Fingerlin 1971, p. 431, no. 384; and Syson and D. Thornton 2001, pp. 53–56.

42. Economopoulos 1992, p. 112.

43. Dal Pozzolo 1994, pp. 30–34. For the popularity of gloves in this period, see Welch forthcoming.

44. Economopoulos 1992, p. 105.

45. Petrarch's so-called sonnets of the glove are nos. 199–201; see Petrarch, *Rerum Vulgarium Fragmenta*, 1995 (ed.), pp. 246–49.

46. Castiglione, *Il libro del cortegiano*, 1964 (ed.), p. 155: "Il medesimo è delle mani; le quali, se delicate e belle sono, mostrate ignude a tempo, secondo che occorre operarle, e non per far veder la lor bellezza, lasciano di sé grandissimo desiderio e massimamente revestite di guanti."

47. Gazzola 2006, pp. 148–62.

48. Ruzante, *La Betía*, 1967 (ed.), p. 424 (act 5, lines 184–88): "Qui dentro c'è un fazzoletto; che siate santa in chiesa, savia per la via e scorretta in letto per crescere e moltiplicare . . . e riempir la terra da ogni lato."

49. See Borggrefe 2001, pp. 349–53; and Robertson 1988, p. 274.

50. For a detailed analysis of the picture, see Rubin 2007, pp. 229–71.

51. Bernardini and Spezzani 1995, p. 357.

52. Dal Pozzolo 2001, p. 51.

53. Altieri, *Li nuptiali*, 1995 (ed.), p. 51.

54. Musacchio 1999, p. xi, lists "un bacino d'ottone liscio da parto." See also the comments in Klapisch-Zuber 1982/1985, p. 239, n. 83.

55. Goffen 1993, p. 131.

56. Panofsky 1969, pp. 118–19; and Santore 1997, p. 192.

57. Barbaro, *De Re Uxoria*, 1915 (ed.), pp. 28, 57.

58. Petrarch, *Triumphs*, 1962 (ed.), p. 32. See also Giamatti 1966, pp. 122–28; and P. F. Watson 1979, pp. 30–31.

59. The prone figure has also been identified as a woman by Joannides 2001, p. 192, and as a satyr by Borggrefe 2001, p. 353.

60. Colonna, *Hypnerotomachia Poliphili*, 1999 (ed.), pp. 372–75. See also n. 11 above.

61. On the scent of roses and its symbolism, see Quiviger 2004.

62. Brumble 1998, p. 343.

63. For *The Worship of Venus*, see Miguel Falomir in Falomir 2003a, pp. 162–65, 358–59, no. 11.

64. Philostratus, *Imagines*, 1969 (ed.), pp. 26–29.

65. For caskets and prints, see Swarzenski 1947.

66. Camille 1998, pp. 103–04. The outside of the ring reads "*UNE FAME NOMINATIVE A FAIT DE MOY SON DATIFF PAR LA PAROLE GENITIVE EN DEPIT DE L'ACCUSATIFF*" and on the inside "*TM[ON] AMOUR EST INFINITI[V]E GE VEU ESTRE SON RELATIF.*"

67. See S. J. Campbell 2004, p. 205: "doi Veneri una vestida laltra nuda."

68. Ibid., pp. 213–15. Although Campbell relates these two Venuses to Boccaccio, he prefers a Neoplatonic reading in which the nude Venus is heavenly and the clothed one is earthly.

69. For Neroccio de' Landi, see Toledano 1987, pp. 73–78; and Callmann 1995, pp. 26–27, and p. 61, no. 103. For the suggestion that the cassoni might represent Diana's Hunt, see Boccaccio, *Diana's Hunt*, 1991 (ed.), p. 61.

70. *Gli Asolani* was begun in 1497 and published in Venice in 1505. For its possible influence on Titian, see Quondam 1995, pp. 74–77. *Dialoghi d'amore* was written in 1501–2 and published in 1535; see Vila-Chã 2006. See also J. C. Nelson 1958, pp. 84–107; and Rossoni 2002, pp. 48–57.

Belle: Picturing Beautiful Women

Luke Syson

The discreet rustle of brilliantly colored silks, the evanescent fragrances of flowers and perfumes, fur's soft embrace, pristine linens framing glimpses of pearly flesh, the cool fire of precious stones, and, in the middle of all this, a young woman, her face studiedly blank, her clothes cunningly disarranged, her long fair hair falling in graceful tendrils about her bare shoulders. Here are the ingredients (some of course implied rather than experienced) of many of the half-length pictures of women, of the type known as *belle* (female beauties—a usefully neutral term), by painters such as Titian (ca. 1488–1576) and Palma Vecchio (1479/80?–1528; see cat. nos. 146a, b) and by their followers on the Venetian terra firma. These pictures were made for clients in early cinquecento Venice and, perhaps a little later, for an aristocratic elite elsewhere in Italy and Europe.[1] Men are sometimes represented—often in supporting roles rather than as full-fledged protagonists. At other times, absent from the picture, they are present as viewers (though it cannot be assumed that the audience for these works was exclusively male), meeting the woman's bold gaze, or acknowledged by her demurely, perhaps coyly, averted eyes. These are beautiful pictures of beautiful women—lovely because of their subject matter and because of the way in which the creamy paint is laid down. And they contain this plethora of sensory invitations, baits for the erotic imagination. But these paintings are wholly suggestive; there is nothing explicit about them. All this sensual delight remains, moreover, tantalizingly out of reach.[2] The woman is alluring but, because pictured, is unscented, untouchable, and therefore ultimately remote and ideal.

Pictures of *belle* have been understood according to various—astonishingly various—notions of love and desire: pure adoration, inspired emulation, yearning and out-and-out physical lust, to which we might add covetousness and ownership. Some, though not all, of these concepts conflate the desirability of the picture and that of the woman it represents. Scholarly interpretations have thus run the gamut from the frankly celebratory to the profoundly moralistic and have generally been oppositional, based on certain prior assumptions—about the nature of desire or the proper place of the erotic in art and life, upon readings of the "symbolic" messages contained in the pictures and analyses of the social contexts of their making. In many instances, the pictures contain narratives that are implied rather than spelled out, offering extra scope for divergent readings, abetted by the lack of firm documentary evidence regarding these pictures. In particular, much of the discussion has been flawed by the widespread supposition that once a functional or iconographic category is defined, all such pictures will fall into it. In essence, the debate turns on two key issues: Are these women real or ideal? And are they virtuous (chaste before and after marriage, according to the limited expectations of women in this period) or the contrary? Are they, that is, golden-haired maidens or brassy blondes?[3]

These divisions are highlighted by the differing evaluations of Giorgione's *Portrait of a Woman (Laura)* (cat. no. 145), of 1506, often seen as the prototype of this kind of painting in Venice and surely the earliest surviving example of its type. (For the varying interpretations of *Laura*, see the discussion under cat. no. 145.) The meaning of many other *belle* pictures containing similar "symbols"—such as the several images of a woman dressed (or semidressed) in her chemise holding out flowers, sometimes identified as Flora (in her several roles), by Bartolomeo Veneto (1502–1531), Titian, and Palma Vecchio—has likewise been much disputed.[4] Given that it has proved impossible to agree on single interpretations, it might be suggested the point of pictures like these is precisely that they should contain a range of possibilities, that they would have been open to several overlapping, rather than contradictory, readings.[5] Their "symbols" are therefore deliberately multivalent.

COURTESANS

Nonetheless, there has been one dominant strand in the discussion of pictures of *belle* in recent years. Many scholars have presented arguments that they are portraits of courtesans, largely founded on a view of female nudity (even partial nudity) as entirely transgressive. Images that seem so candidly sexual must depict professional women whose trade was sex, and there was of course no lack of prostitutes in Venice. For any other women, it is opined, even the limited state of undress usually seen in these pictures would have been considered indecorous. These assumptions are not new. *Belle* pictures were called portraits of courtesans from the end of the cinquecento, and this tendency increases from the beginning of the century following. However, it should be remembered that by then the post-Tridentine legions of decency were on the march. Chronology is important, and the moral atmosphere in Italy was very different after the Catholic Church's reaffirmation of dogma and discipline at the Council of Trent (1545–63).

There can be no doubt that artists did paint pictures of courtesans in the first decades of the sixteenth century, though it is

usefully underlined that only one picture has been firmly identified as such, and this is very unlike a typical *bella*.[6] Some of the paintings that we know about were made to adorn the residences of the women themselves. The inventory of the goods of the courtesan Elisabetta Condulmer made after her death in September 1538 includes, for example, her own portrait under a curtain.[7] This work, however, may have differed very little from conventional portraits of more obviously virtuous women. In his *Lives,* Giorgio Vasari mentions a portrait of the Florentine singer-courtesan Barbara Raffacani Salutati painted by Domenico Puligo (1492–1527). It is very likely that this is his *Portrait of a Woman,* of about 1525, showing a lady with a music book (fig. 35).[8] If this work can be taken as indicative, it appears that courtesans chose to have themselves portrayed in images that are less obviously sexualized than any of the pictures under discussion. Barbara's dress (and she is fully dressed) is completely proper. And this fact correlates with our understanding of how courtesans all over Italy wished to be perceived. Differentiating themselves from common whores on streets or in brothels, courtesans sought a veneer of respectability. Although Condulmer owned a bed that was, according to the inventory, "alla cortesana" (in a courtesan style), the paintings in her bedchamber were religious. Thus it seems unlikely that any of the surviving Venetian paintings of *belle* are veristic portraits of real courtesans.

Are they images, nonetheless, of "the courtesan" rather than "a courtesan"? The suggestive eroticism of these pictures evokes much Renaissance literature describing encounters with these professional women. Take, for example, the description by Pietro Fortini of his visit to a courtesan in 1520s Rome, an account of their first decorous meeting and of her subsequent dishabille as she strips down to her chemise (it was a warm spring day, he explains) and "a little hair-band embroidered with different sorts of flowers and golden stars."[9] This parallel might be thought to provide corroborative evidence that the paraphernalia—mirrors, combs, perfume jars, and other so-called tools of Venus—with which these women are depicted may have indicated their sexual availability, and that so, too, did their loose blond—sinfully bleached—hair.[10] It has also been pointed out that the aliases adopted by prostitutes—Violante, Flora, even Laura (the name of the chaste beloved in Petrarch's poems)—are suggested by the flowers and leaves included in a number of these pictures (though most of these names were also, of course, given to perfectly reputable women). On this basis, when men are included, they are assumed to be clients, and when older women appear, they perforce are procuresses. The argument might continue thus: These were depictions of courtesans made for bachelors as arousing "pinups." Such images have been related to a "culture of single men" that arose from the decreasing incidence of marriage in sixteenth-century Venice.[11] There is indeed some evidence that prostitutes were employed as models by painters like Titian.[12] If this was generally known, the practice might have colored reactions and interpretations by some owners and viewers, charging the pictures in a particular way.

It remains the fact, however, that there is only a single, isolated example of a *belle* picture that was seemingly identified at the time as representing a prostitute (though not one of very high caste). This work appears in another posthumous inventory, of the belongings of the recently deceased Palma Vecchio (who died in 1528), which included the paintings left, some unfinished, in his workshop (see cat. no. 146b). Philip Rylands argues that the term *cara.a* used in the inventory for the subject of this painting is an abbreviation of the word *carampana,* the name given to those Venetian prostitutes obliged by law to live in the neighborhood of Ca' Rampani, in the parish of San Cassiano. However, the same notary chose to label another five "ritratti" ("portraits," the word used here probably to indicate a head-and-shoulders format rather than a true likeness) of women left behind by Palma in a strikingly more neutral manner. The description of "1 quadro de *una dona* retrata che tien una parte de cavelj in man de ca. braza 1 quasi finida" (one painting of *a woman,* portrayed, who holds a part of her hair in her hand, about 1 braccia tall, almost finished [emphasis added])[13] is typical. This was the standard way in which such pictures are recorded. Marcantonio Michiel saw, for example, at the house of Girolamo Marcello, "La tela della *donna* insino al cinto, che tiene in la mano destra el liuto e la sinistra sotto la testa, fu de Iacomo Palma" (the canvas of *the woman* seen to the waist, who holds the lute in her right hand and rests her head on the left, by Jacopo Palma [emphasis added]).[14] The inventory of Palma's goods further suggests that these pictures of beautiful women were not generally commissioned, but instead were made as stock to be bought off the peg. For certain painters, this was a lucrative bread-and-butter production for the open market, a secular counterpart of Madonna and Child painting.[15] Indeed, there is repetitiveness in this production that becomes unsurprising. Titian and his workshop painted several versions, for example, of his composition of a *Young Woman at Her Toilet,* varying in quality and in the choice of accessories in the foreground (fig. 101).[16]

There was, then, a sound commercial reason for painters to maintain an openness of meaning that matched the openness of their market. These women could not be just courtesans. Indeed, for them to be always identified as such would severely have distorted the meanings of other subjects treated by the same artists. These *belle* are idealized in ways that make them very similar to these painters' images of other women—chaste Diana or exemplary Lucretia, female saints and the Virgin Mary herself. If courtesans modeled for pictures of *belle,* their features were also used elsewhere. This is even true for hectically flushed maidens in pictures by Paris Bordon (1500–1571), pictures that are particularly susceptible to vulgar interpretation. Some, it is true, were declared erotic. According to Vasari, Bordon sent a "portrait" of a "donna lascivissima" (most lascivious woman) from Venice to the Genoese Ottaviano Grimaldi—with a portrait of Grimaldi himself.[17] But she was still not identified as a prostitute or courtesan. It is even possible that for some clients a picture might have gained in erotic appeal if the subject was not identified in this

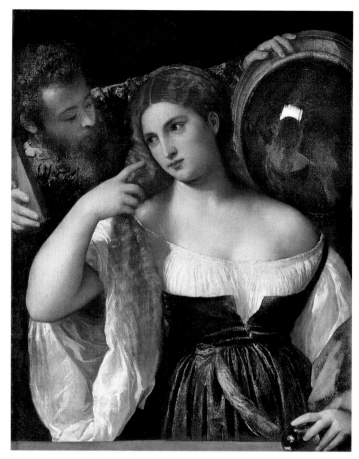

Fig. 101. Tiziano Vecellio, called Titian (ca. 1488–1576), *Young Woman at Her Toilet*, 1512–15. Oil on canvas, 36⅝ × 29⅞ in. (93 × 76 cm). Musée du Louvre, Paris

way.[18] As we have already seen, the internal evidence of the pictures themselves suggests that these images of beautiful women were designed to operate on several levels. Bachelors might be higher-minded than Grimaldi, as (or more) interested in poetry than in sex. They might also be more sophisticated, recognizing the essential unavailability of the women depicted. And of course bachelors got married. Thus the same image might need to function in different ways, even after its initial purchase. *Belle* might therefore be presented by artists according to the expectations of various possible consumers and could perhaps be subtly adapted to meet those expectations. The market for *belle* would have been unnecessarily limited if all these women were specifically identified as courtesans, or even if the erotic was their only appeal.

DISHES

There is another category of image that art historians have dubbed *belle*, one that provides a suggestive parallel for these Venetian paintings and, though likewise largely undocumented, offers another, more seemly context for understanding them. From the beginning of the sixteenth century, flourishing therefore at much the same moment, ceramic vessels—maiolica jugs, dishes, and plates (see cat. nos. 9–15) decorated with head-and-shoulder images of beautiful women were manufactured all over Italy. Although some were elite objects, which might be elegantly and expensively lustered, many others were more basic, produced more quickly and cheaply; this is a notably democratic genre,

suggesting that the vessels' visual ingredients were widely understood. Indeed, the female profile was a long-standing ornamental feature of ceramics, but these sixteenth-century examples develop the type by the addition of text.[19] Some have moralizing inscriptions and the women depicted remain anonymous, the moral message associated simply with their female loveliness. Several of these mottoes were well known and some derive from Petrarch's poetry. Others of the heads are given names—though only first names—and are in addition lauded as "bella," or sometimes "diva" (divine), "unica" (unique), or "pulita" (chaste).[20] They are generally fully clothed, but some are garbed in a kind of *all'antica* (classicizing) fancy dress and a few have a breast uncovered. Many maiolica *belle* make considerable play of elaborately dressed hair or ample bosom. Those produced in the Umbrian town of Deruta have a standard head type that was repeated ad infinitum, seemingly based on an ideal of female beauty derived from paintings by Perugino (ca. 1450–?1523) and his immediate followers. In Faenza, where maiolica *belle* were produced in especially large numbers, the types are more various. The images of the women do not, however, change with the names. The heads on two almost identical jugs made in Faenza have, for example, the same features and costume but are inscribed, respectively, LA IACOMA and LAURA B[ELLA].[21] The painter has given a remarkable amplitude to the women's chests by exploiting the bulge of the jug. These are not therefore true portraits; they take no account of the individualized likenesses of the named women (such a consideration was in any case always somewhat limited in female portraiture).

We await a systematic survey of the names found on these pieces. It has been suggested that the use only of forenames is paralleled by the fictitious designations given to women in many amatory Renaissance sonnets.[22] Some of these seem rather highfalutin, but Marta Ajmar-Wollheim and Dora Thornton have demonstrated that though they may be poetic, most were also in common usage. Buyers may therefore have been able to choose a standard design and then personalize it by the choice of name. Alternatively, potters may have made pieces already inscribed with those names that were encountered most often—variations on Giovanna or Elisabetta, Giulia, or Maria, for instance—or ones that might function in themselves as tribute to a lady's reputation even if she was not so christened: Laura, again after Petrarch's idealized beloved, or Faustina, after Faustina the Elder, almost the only Roman empress whose character remained unimpugned in the Renaissance. All these names appear repeatedly.

These, in other words, were art objects that, like the Venetian pictures of *belle*, were intended for the open market. They are described in rather similar terms in one extremely rare mention. On January 4, 1548, a large quantity of pottery was confiscated from the "appoteca et magazeno" (pharmacy and shop) of Ser Francesco da Venezia, in Ravenna, to satisfy his debts. The list of pieces includes eleven "piatelli grandi con depinture de volto de donna" (large plates with paintings of the face of a woman).[23] This is as fuzzy a description as we have come to expect. But that even such generalized images were (or at least could be) associated with living women is proved by a rather peculiar poem written by Andreano da Concole, of Todi, in 1557 (see also cat. no. 9):[24]

Master potter, take my advice. If you wish to sell your wares fast,
you should depict on them the women whom I honour here,
who have come down to us from heaven. In truth I tell you,
and not hastily, that, in Todi, there are not, nor will there ever
be, women more beautiful than those listed here, for all of them
are as lovely as Narcissus. . . . The first selected . . . should be
Colonna Perugina alma Baldesca, Messer Fabio's wife, Madonna
Francesca, and apart from these women, it should not displease
you to include also, painted by your fine hand, Franceschina wife
of Bartolaccio, nor should it be troublesome to paint Ortentia,
Celidonia and Filomena, Orsina, Betta, Figenia and Filena,
Dorotia and Madalena . . . and I am hunting out more lovely
ladies for you.

This poem gives a clue as to one of the several traditions that inform this production: the beauty of local women linked to pride in place.[25] Catalogues of the beautiful women to be found in particular cities had become enormously popular by the mid-cinquecento, but this kind of publication has older roots. They are in spirit vernacular and localized derivations from Giovanni Boccaccio's much-read biographies of ancient heroines. The genre has been blended with what had probably become a well-known expression of civic pride. In the fifteenth century the republic of Siena, for example, had found many ways of celebrating the much-vaunted loveliness of its women. And by the first decade of the sixteenth century a correlation between female beauty (and virtue) and city had been asserted on a small group of portrait medals of women identified only by their first name and the place of their birth, pieces like the *Magdalena Mantuana* medal of 1504, sometimes attributed to Moderno (1467–1528).[26]

The tag "diva" (the exemplary Magdalena is so described)—as well, of course, as the profile format itself—also comes from *medaglie*: ancient coins of deified empresses and their Renaissance medallic equivalents. Once again, the same head could be used to represent ancient heroine or contemporary beauty. Almost exactly the same profile appears on two plates now in Berlin (Kunstgewerbemuseum).[27] In one, the woman is crowned and labeled *CORNELIA REGINA*—the daughter of Scipio Africanus, the adored wife of Tiberius Gracchus, and the devoted mother of the Gracchi. Here, in other words, is a virtuous woman of history who, along with others whose biographies were related by Boccaccio, was represented in pictures made to decorate nuptial bedchambers and to provide inspiration to young married women. On the other Berlin plate, the head, now minus crown, represents one *LANDREA BE[LLA]*. The plates' decorative borders differ, and some small details of costume are changed, but perhaps the most noticeable divergence is the inclusion on Landrea's torso of lines drawn to indicate her cleavage. Do we detect here another faint whisper of the erotic?

It is noteworthy that the first of the women listed by the excitable Andreano da Concole were married. This fact seems to provide the last and perhaps most important context for the interpretation of these pieces. Frustratingly, there is apparently no surviving documentary information on the precise social function—or functions—of these jugs and dishes (and it may be that no very precise utility was ever determined). But it has regularly been argued that they should be related to the various phases or rituals of courtship

and marriage.[28] They may therefore have been bought as cheaper and still more idealized equivalents of the portraits of women commissioned in some places, such as Florence or the northern Italian courts, during marriage negotiations. They may have been used as one of the many kinds of objects employed as material declarations of love. They may even have featured as props during one or another of the many feasts for betrothals and weddings that are so richly documented, since, like silver, they could be both eaten off and displayed. This is all necessarily speculative but, once again, such theories are lent weight by additional imagery and inscriptions found on these vessels and plates, and by the iconography of other ceramics made in the period where the message is more straightforward. The themes are explicitly those of love and virtue. We find maiolica decorated with hearts, some held in the hand of the lover, some pierced by arrows (cat. no. 25). Plates were made with the clasped hands of faith that are such an important element of nuptial iconography or with a hand pointing to the inscription *AMORE* (cat. nos. 17, 18).[29] Other pieces, such as a Deruta plate in the Museo Regionale della Ceramica, are inscribed simply *VIRTVS*.[30]

Evidence that the woman depicted could be taken to represent the love interest of a particular man is found when the identifying inscription mentions not just the name of the woman but also, as in Concole's poem, that of the man to whom she "belongs." It is likely that the woman called on a Deruta dish (probably of the 1550s; Louvre, Paris) "the beautiful Giovanna of handsome Bellardino" had received the piece from Bellardino himself.[31] Some maiolica pieces depict couples (with some kinship therefore to Titian's composition of a *Young Woman at Her Toilet,* in which a young man holds up mirrors for his beloved). One fairly representative example is the mid-sixteenth-century plate (fig. 102), also made in Deruta (probably in the workshop of Giacomo Mancini, called Il Frate), with a richly dressed (and unnamed) man kissing a woman

Fig. 102. Dish on a low foot inscribed *DVLCE.EST.AMARE.* Deruta, probably workshop of Giacomo Mancini, called Il Frate, mid-16th century. Tin-glazed earthenware (maiolica), Diam. 10⅜ in. (26.5 cm). Victoria and Albert Museum, London

and holding a flower, doubtless a pink or carnation, to her breast, with the Latin inscription DVLCE EST AMARE (To love is sweet). Sara Matthews Grieco has sensibly written: "This type of plate is relatively common and constitutes a visual evocation of the types of amorous dalliance expected of betrothed couples, and an acknowledgement of the physical intimacy that the new couple was expected to share."[32]

In short, what we have here are idealized images of female beauty and virtue that are demonstrably to be associated with real women, images that were framed by reference to literary—both poetic and biographical—tropes and numismatic conventions. Both the women depicted and the ceramic pieces themselves are unequivocally objects of love. Some even evince a cautious eroticism. And lurking in the background are the notions that the representations of virtuous women could be employed as models for emulation[33] and that the women's beauty was, to some degree, the product of their birthplace.

POETIC BEAUTY

Although we can probably assume that the audience for the pictures of all the many anonymous *belle* painted in Venice was more sophisticated, more visually literate, than that for the vast majority of ceramic beauties, the frame of reference for both categories is surprisingly alike. This kind of painting was, for example, a distinctly local phenomenon across northern Italy. Are we therefore seeing in the Venetian *belle* paintings an expression of a shared pleasure in the beauty of the women of the Serenissima?

Even if this was the case, another context remains more important. The heads of women on dishes and jugs were, as we have seen, material demonstrations of the love induced by female beauty and could therefore function as appropriate tributes to particular beloveds. Many of these maiolica pieces were made in or for centers, like Perugia (the main market for Deruta's wares), where conventional female portraits, likenesses on panel or canvas, are unusual. Venice was another city where there was a dearth of portraits of women, at least before the middle of the sixteenth century.[34] So should it be additionally argued that these pictures were similarly personalized, to stand for the beloved and the wife, their elements supplied with specific meaning, by this context?

According to Neoplatonic principles, love should be disinterested—and chaste (like the women who inspired it). Baldassare Castiglione, in his *Courtier* (published in 1528), gave popular voice to an attitude that was already widely held. "Love," he says, "is defined as nothing other than a certain desire to enjoy beauty." Elsewhere he writes:

Again, one cannot in any way enjoy beauty or satisfy the desire it excites in our souls through touch, but without that sense of which beauty itself is the true object, namely the faculty of sight. He must therefore detach himself from the blind judgement of the senses and relish with the eyes the radiance, the grace, the loving conversation, the smiles, the habits and all the other attractive enhancements of beauty. Similarly, with his hearing, her sweetness of voice, the harmony of her words, the melody of her music, if the beloved is musical. Thus he will graze on the sweetest food for the soul by means of these two senses, which have little

connection with the corporeal and are servants to reason, without desire for the body stimulating any appetite less than chaste.[35]

This response to woman's beauty would have been utterly familiar to viewers of art; they were accustomed to look at images of women with an uncontaminated love. This, after all, was how they were supposed to see images of the Virgin Mary. Like Giorgione's and Palma's *belle*, some of these loved images might even contain some degree of nudity without any (intentional) breach of decorum. There was an established iconography for pictures of the Virgin nursing the infant Christ, the *Madonna lactans*. Indeed, female nudity might actually signal a woman's chastity. On the reverse of Pisanello's 1447 portrait medal of the notably virtuous Cecilia Gonzaga, a daughter of the ruling household of Mantua who had refused marriage and taken holy orders, is an image of a beautiful maiden taming a unicorn, a well-known representation of virginity. She may be pure but she also, like Giorgione's Laura, has one of her breasts revealed.[36]

Castiglione's declaration accords with the poetic tradition of love for the chaste beloved, one that is correctly traced back to Petrarch's famous sonnets of the mid-fourteenth century devoted to his own Laura. In these poems, Laura's outward loveliness reflects her inner beauty, the beauty of her soul, and both could be captured (to some extent) by a painter. The portrait of Laura purportedly painted by Simone Martini (ca. 1284–1344), if it ever existed, does not survive. However, Elizabeth Cropper and others have conclusively demonstrated how Petrarch's two sonnets with this image at their heart were crucial for artists of the later fifteenth and the sixteenth centuries as they formulated their own pictures of beautiful women.[37] And in one case, a painter chose to represent the ideal beloved naked to the waist, causing much subsequent confusion. It has convincingly been argued that Piero di Cosimo's celebrated image of a bare-breasted young woman (fig. 103), her hair threaded with pearls and her neck encircled by a snake, is not, as Vasari thought, the depraved Egyptian queen Cleopatra but, as the inscription below her (formerly considered spurious) states, Simonetta Vespucci, the poetic beloved of Giuliano de' Medici.[38] Like Petrarch's (and Simone's) Laura, Simonetta was already dead by the time her image was painted, and her nudity was perhaps intended to evoke the unadorned beauty of her soul as well as her chastity (if the Cecilia Gonzaga medal is a precedent). The picture certainly has a wonderful innocence.

There was a Petrarchan strand in Venetian art and literature as well.[39] A painting by Jacopo Bellini (ca. 1400–1470/71), said to be of Petrarch's Laura and possibly indirectly derived from a fresco at Avignon, was celebrated in a poem in Latin by Girolamo Bologni. His *In archetypa Laurae effigies in pictura Jacobi Bellini* (On the Archetype of Laura, A Painted Portrait by Jacopo Bellini), of about 1509–16, predictably enough, explores the connection between the beauty of the depiction and that of the depicted. It starts with these words:

If the girl was with such a face as the marvellous tablet reports: by you, Petrarch, she was hardly sufficiently praised. But if Laura herself was such as you praise her in your poetry, Petrarch, the picture is the lesser, and a long way short.[40]

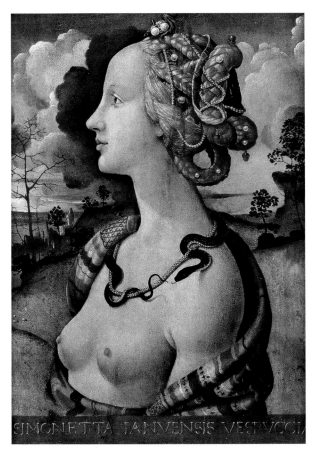

Fig. 103. Piero di Cosimo (1462–1521), *Portrait of Simonetta Vespucci,*
ca. 1480. Tempera on panel, 22⅜ × 16½ in. (57 × 42 cm). Musée
Condé, Chantilly

It is not surprising, therefore, that Venetian painters were called
upon to depict the poetic loves of writers like Pietro Bembo
(1470–1547), who took the portrait by Giovanni Bellini (real or
invented?) of his own chaste mistress as the subject of a sonnet.
We cannot know what either of these pictures looked like, but it
is important to realize that these Neo-Petrarchan poems—and
there were many (though very few mention pictures)—have cer-
tain standard components that are echoed in many Venetian pic-
tures of *belle*, and can become, therefore, another tool for their
full interpretation.

One of the most important of these tropes is the fetishization
of objects that could be linked directly to the physical beauty
of the beloved, including just those things that, it has been pro-
posed, were unambiguously the attributes of courtesans: perfume
jars, suggestive of the delicate aroma of the maiden, and mirrors
(see cat. no. 115).[41] Artists were assuredly aware of their poetic
meanings. To take just one example, a medalist working in 1470s
Rome, who styled himself Lysippus the Younger, made what is
almost certainly a self-portrait medal (British Museum, London),
which he inscribed *DI LA IL BEL VISO E QVI IL TVO SERVO MIRA*
(Admire on one side your own beautiful face, and on the other
that of your servant).[42] Unlike most quattrocento medals, the
piece is one-sided, and its reverse was polished up to be used as
a mirror by the lady who had received his gift. When depicted,
mirrors, combs (see cat. no. 37), and perfume jars could therefore
become visual prompts in pictures that could function as "secular
devotional images"[43] pertaining to earthly love, with the same

role as the pomegranates, veils, or little books in paintings of
the Virgin, concerned with the heavenly. There is even a degree
of communality.

Even the bared breast was, it has been argued, an element that
could be given a Petrarchan reading—standing for the exposed
heart and soul.[44] But this was also an ingredient that, though
containing no lascivious intention, might give the viewer pause
for thought. This proper recognition of the range of response a
naturalistic image could induce finds, once again, a parallel in
contemporary poetry. It is recognized that Pietro Bembo was
responsible for injecting a novel erotic frisson into the Petrarchan
tradition. In his poetry and prose, women's bodies take on a new
voluptuous fascination. Sabinetta, for example, is Gismondo's
innocent object of desire in Bembo's dialogue *Gli Asolani* (1505).
Yet Gismondo gazes on "the form of her two little breasts, round
and firm," revealed by the gauzy fabric of her summer dress.[45]
Agnolo Firenzuola's *Dialogo delle bellezze delle donne* (Dialogue
on the Charms of Women), of 1541, is likewise deeply indebted
to Petrarchan ideals, but also views women in a way that is less
than saintly. His hero, Celso, is aroused by the slippage of the
veil that should conceal the bosom of Selvaggia, the woman in
the dialogue with whom he conducts the most obvious flirtation:
he spouts a little paean of praise to "the breasts, like two hills
of snow and roses in full bloom, with those two little crowns of
cut rubies on their summit, like little spouts of a beautiful and
functional vase; which besides their usefulness in providing the
nourishment for little babies, endow [a woman] with a certain
splendour, with such a fresh appeal, that in spite of ourselves, but
with great pleasure, we are forced to hold our gaze, as I do myself
when I look at the pure white breast of one of you. . . . but now
we cover these altars, for if you don't fix your veil in place, I won't
be able to continue."[46] These are similes—flowers and vessels and
precious stones—that again recall *belle* paintings. Celso's man-
ner of looking at women is far from pure Platonic contempla-
tion. Mary Rogers has written perceptively: "Paintings may well
reveal certain disjunctions, parallel to the contradictions we have
observed in Firenzuola . . . between the theoretical moral stance
the artist might take towards his subject, and his actual practice
when approaching it in detail. There is also the danger of erect-
ing too simple a polarity between a modest, virtuous beauty who
stimulates only chaste, distant aesthetic admiration, and a wanton
siren arousing voluptuous animal passions."[47] In other words, the
fact that these women are erotically stimulating does not mean
that they sacrifice their virtue. These texts show that the women
so described can remain morally uncompromised.

MARRIAGE

This inherent quality of *belle* pictures—the combination of desir-
ability and unavailability—made them suitable belongings for the
lovelorn votary of a chaste lady. But they could also stand meta-
phorically, and perhaps still more appropriately, for the bride,[48]
owned and attainable but properly chaste within marriage. The
idealized women, like those depicted on maiolica, could have
functioned as substitutes for all those missing portraits of brides.
Husbands, after all, could be regarded as the most ardent of all
lovers. Naturally enough, it was considered important that young

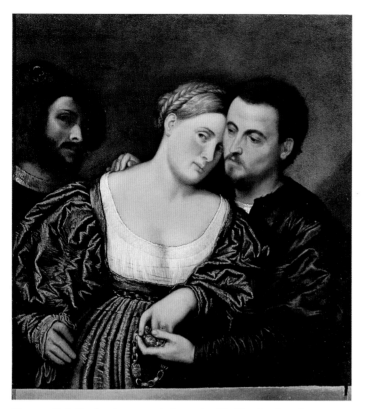

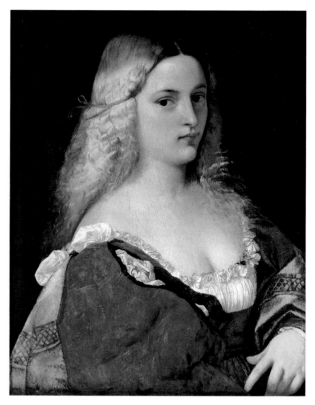

Fig. 104. Paris Bordon (1500–1571), *Lovers* (or *The Venetian Lovers*), ca. 1530. Oil on canvas, 37⅜ × 31½ in. (95 × 80 cm). Pinacoteca di Brera, Milan

Fig. 105. Attributed to Jacopo Negretti, called Palma il Vecchio (1479/80–1528), or Tiziano Vecellio, called Titian (ca. 1488–1576), *Violante*, ca. 1515–18. Oil on panel, 25⅜ × 20 in. (64.5 × 50.8 cm). Kunsthistorisches Museum, Vienna

married women should be sexually active and alluring. How else would the husband acquire his much-longed-for progeny? Marriage was the key moment when a young woman crossed the threshold from virgin to matron. This was certainly a possible reading of the Venetian images of the fecund Flora, transformed from the wintry Chloris after her marriage to Zephyr.[49] Brides' sexual behavior was, however, vigilantly circumscribed.[50] It was right, therefore, that the erotic appeal of these pictures should be somewhat muted.

Just as we know there existed portraits of courtesans, so we can be sure that pictures were executed that pertain directly to marriage. The *Lovers*, an early work by Paris Bordon (fig. 104), is regularly misconstrued as the depiction of a *ménage à trois* or something still more debased. Almost certainly, however, this is a scene of gift-giving between groom and bride, with a designated witness, the ring sponsor.[51] Bordon based his composition on a prototype by Titian, likely the severely damaged picture in the Royal Collection, London.[52] There is, nonetheless, an amorous loucheness about both these pictures, as the lady leans into the body of her betrothed.

This mood accords with a frankness about sexuality in marriage that is encountered elsewhere. The diarist Marin Sanudo (1466–1536), for example, records that many engaged couples had sexual intercourse before marriage (though he did not approve); couples on their wedding night were ribaldly accompanied to their beds. The artistic reflections of this sexual candor are sometimes equally forthright. In Giovanni Bellini's so-called *Feast of the Gods* (National Gallery of Art, Washington, D.C.), a woman puts her arm around the shoulders of a saturnine youth, who has his right hand between her legs. That she is a bride is indicated by

the fact that she has selected a quince from the fruit bowl in the foreground; Plutarch (and Francesco Barbaro, in his 1416 *De Re Uxoria* [On Wifely Duties]) informs us that Solon had advised Attic brides to nibble on a quince to foster their desire.[53]

Another plant—a flower—that may have had a particular meaning in the context of marital consummation is the violet that features regularly in pictures of *belle*. Women in pictures attributed to Palma (fig. 105) and Giovanni Cariani (Szépművészeti Múzeum, Budapest) are usually called Violante because of the violets tucked into their chemise or golden hair. The latter painting was copied with the addition of a *V* inscription (the use of just an initial giving scope for different readings: "Violante," "Virtus," or even "Venetia").[54] Sometimes, certainly, the violet signaled female virtue; in pictures of the Virgin Mary violets stood for modesty or humility. Firenzuola discussed the wearing of flowers: "They [women] also used sweet violets, for the short time they lasted. . . . And they called them *viole mammole* as if to say violets for young girls (*mammole*), and for this reason [Poliziano] called them virginal little flowers (*mammolette verginelle*), as if he wished to imply that they were flowers, that is, violets, to decorate young virgins."[55] But violets were also associated (by reference to Nicander of Colophon) with the loss of virginity.[56] Though this meaning has been associated with professional sexuality, it is obvious that courtesans hardly needed deflowering.

The multivalent attributes already discussed in relation to courtesan iconography and to pure poetic love are susceptible to one further reading. Many of the objects represented were strictly related to the material culture of ritualized wedding ceremonials. Others were well-known courtship gifts.[57] It is remarkable, for example, how many of these Venetian *belle* wear rings on their

fourth finger.[58] And the precious stones set into them were also said to have had precise meanings within marriage.[59] Fur also seems to have had specific associations with sexual union. As far back as 1447, the Florentine mother of Caterina Strozzi summed up the material appeal of her future son-in-law, Marco Parenti, making a distinction between his gifts presented before marriage and those made after. In the latter category comes "some crimson velvet . . . lined with marten, for her to wear when she goes to her husband's."[60] Sanudo gives a detailed account of the ceremonies in 1525 accompanying the wedding of Vienna, the granddaughter of Doge Andrea Gritti, to Paolo Contarini. On the day after the consummation of the marriage, the ring sponsor sent the bride a large silver basket: "In it was a lovely sable wrap with a beautiful head and a little chain about its neck."[61] In this context, it is interesting that the fur coat draped over Giorgione's Laura is rather like the garment worn by the woman depicted in Sebastiano del Piombo's so-called Dorothea (fig. 44); among Dorothea's other attributes are quinces.[62] We do not need, moreover, to assume that scenes of personal beautification had negative connotations. Brides were expected to care for their appearance and, though undoubtedly condemned by strict moralists, cosmetic self-adornment was actually regarded as a perfectly acceptable way of ensuring a husband's continuing affection and erotic interest.[63] One later sixteenth-century writer, the physician Giovanni Marinelli, intended his collection of beauty treatments, Degli ornamenti delle donne (On Women's Ornaments; Venice, 1562), for respectable women, including wives, assisting them to embody a Neo-Petrarchan ideal. He even gives the secret of "un'acqua virtuosa molto" (a very virtuous water) for lightening the skin.[64] Flowing blond hair may sometimes have been deemed unacceptable, but it was celebrated at a key betrothal ritual—when the bride-to-be was led out by her dancing master with her hair loose around her shoulders (and dressed in white; see cat. no. 65). And we can find yet another potential meaning of the single exposed breast, associated, as it was with the Virgin Mary, with the nurturing of a child.

Throughout this discussion, I have sought to make a proper distinction between the phrases "these mean" and "these could have been taken to mean." There are no simple solutions to these pictures of belle. Some may have been purchased by rapacious or romantic bachelors. Others were bought to mark marriages. And even in this latter, narrower context, the paintings could communicate in several ways, none contradicting the other. They may have helped to arouse a husband to respectful desire, while ensuring that consummation was sought elsewhere—with his wife. They could be read as the image of the ideal beloved—linked by their ownership and display with a real woman on the point of, or just after, marriage. It is also plausible that they retained their exemplary character, employed to give lessons to new brides on appropriate sexuality. Their joy lies (and lay) in their numerous possibilities, teased out by their repeated and prolonged viewing.

1. In the large and tortured literature on these pictures, the most sensible, open, and indeed open-minded accounts are those by Tinagli 1997, pp. 98–104; and Ferino-Pagden 2006.
2. In this, the paintings are unlike more obviously pornographic images, which achieve a kind of fulfillment by their explicitness.
3. J. Sander 2004, p. 319, suggests a rather mechanistic distinction between those women who are pictured making eye contact with the viewer (in which case they are offering themselves and thus are probably courtesans) and those whose gazes are averted (in which case they are chaste and may be read as brides).
4. There is substantial literature on these works. See, for example, the different interpretations in Held 1961; Mellencamp 1969; and Goffen 1997b, pp. 72–79.
5. This is essentially the point made by Schäpers 1997, p. 236.
6. Schuler 1991.
7. Fortini Brown 2004, pp. 173–81, esp. p. 175.
8. Vasari 1568/1906 (ed.), vol. 4, p. 465; Rogers 2000; Elena Capretti in Domenico Puligo 2002, pp. 122–23, no. 27.
9. Rogers and Tinagli 2005, pp. 283–85.
10. Santore 1997. Many strict moralists (some theologians), from Saint Bernardino of Siena onward, condemned women for artificially making their hair more blond than nature had intended. However, their strictures were widely ignored, and other authors gave recipes for how women might lighten their hair (see below).
11. Herlihy 1980.
12. Hope 1980b, p. 58.
13. Rylands 1992, p. 350, no. 17.
14. Ibid., p. 341.
15. This impression is confirmed by records of the acquisition of such pictures painted by Titian. In December 1522, Alfonso I d'Este, Duke of Ferrara, was informed that Titian would soon be arriving in Ferrara with the Bacchus and Ariadne (National Gallery, London) and something described simply, in now familiar terms, as "uno quadro d'una donna" (a picture of a woman, possibly the Uffizi Flora). Hope 1980b, p. 62; Goffen 1997b, p. 295, n. 104.
16. Wethey 1969–75, vol. 3, pp. 162–63, no. 22. The primary version, of surpassing beauty, is in the Louvre, Paris. Other versions are to be found in Barcelona and Prague. In the latter the male lover is replaced by a maidservant.
17. Vasari 1568/1906 (ed.), vol. 7, p. 465; Bailo and Biscaro 1900, pp. 128–29; Mariani Canova 1964, pp. 48–49; Penny 2008, p. 49.
18. The portrait of a chaste young woman might be meaningfully converted into something less pure. This is probably what had happened when, in July 1551, the little-known (and distinctly shamefaced) painter Francesco Terzo wrote to Pietro Aretino, that notorious connoisseur of the erotic: "Signor Pietro per non haver soggetto più accomodato per hora vi mando il presente Ritratto d'una honestissima Giovane, e perchè non sia conosciuta holle mutato l'habito, e celatole il nome, non volendo che si sappia quelli che m'introdussero a far tal cosa" (Signor Pietro, since I don't have a more fitting subject, I send you for now the present portrait of a most chaste young woman, and so she should not be recognized I have changed the costume and hidden her name, not wanting it known that I have been tempted to do such a thing). Hirst 1981, p. 94, n. 15.
19. These are most intelligently discussed by Ajmar-Wollheim and D. Thornton 1998.
20. For the last, used particularly in Deruta, see Busti and Cocchi 2004, pp. 106–8, nos. 20, 21, for plates (both with the same head) in the Bargello, Florence, and the National Gallery of Art, Washington, D.C., inscribed, respectively, LA FIANBETTA BELLA PVLITA and FAVSTINA PVLITA E BELLA.
21. Ravanelli Guidotti 2000, pp. 284–85, no. 69a, b.
22. T. Wilson 1987, p. 144.
23. Ravanelli Guidotti 2000, p. 12.
24. F. Briganti 1903, pp. 13–15. This translation appears in Ajmar-Wollheim and D. Thornton 1998, p. 140.
25. This is rightly stressed by Ajmar-Wollheim and D. Thornton 1998, pp. 140–42, followed by Ravanelli Guidotti 2000, pp. 33, 363–73.
26. Douglas Lewis in Scher 1994, p. 81, no. 18.
27. Hausmann 1972, pp. 148–52, nos. 112, 113; Ravanelli Guidotti 2000, p. 46.
28. This is sometimes denied. See, for example, Mallet's account of a dish

probably made, painted, and lustered at Gubbio in the workshop of Maestro Giorgio Andreoli, dated 1537, and inscribed *CAMILLA. B[ELLA]:* "It is unlikely that dishes like these were intended as portraits, and there seems no contemporary evidence to support the belief that they were commissioned as love-gifts. The dish was probably a fruit-dish but its low foot has been ground off, probably in order to frame it and hang it on the wall" (J. V. G. Mallet in Mallet and Dreier 1998, p. 134, no. 15). Mallet comes to this conclusion despite the fact that the woman depicted wears a heart-shaped pendant.

29. Ravanelli Guidotti 2000, pp. 345–59.

30. Busti and Cocchi 2004, p. 103, no. 17. Such an inscription would not, of course, pertain simply to the relationships of men and women.

31. Giacomotti 1974, p. 155, no. 518; Ajmar-Wollheim and D. Thornton 1998, p. 148.

32. Matthews Grieco 2006, pp. 114, 116, fig. 7.14.

33. There is a notably coy depiction of a bare-shouldered Lucretia dated 1537, another product of the workshop of Maestro Giorgio Andreoli in the collection of the Petit Palais, Paris. See Carmen Ravanelli Guidotti in Barbe and Ravanelli Guidotti 2006, p. 121, no. 50.

34. This point is made insufficiently frequently in considering these works. But see Luchs 1995, p. 22; Humfrey 1995, p. 103; and esp. Ferino-Pagden 2006, pp. 190–91. Siena is another example. See Luke Syson in Syson et al. 2007, pp. 208–12, nos. 51, 52, for the only surviving female portrait.

35. These passages are much cited, but see, most recently, Rogers and Tinagli 2005, pp. 38–39 (their translation).

36. This was noted by Dal Pozzolo 1993, esp. p. 271.

37. Cropper 1976; Cropper 1985.

38. Vasari 1568/1906 (ed.), vol. 4, p. 144; Geronimus 2006, pp. 55–66. I am grateful to Duncan Bull, with whom I discussed this problem. He confirms that the inscription, much disputed, is certainly old and may well be original. An X-ray of the picture shows certainly that nothing was ever painted underneath the inscription. He has also kindly drawn my attention to an important piece of evidence, apparently not known to Geronimus (though it corroborates his argument), published by Donati 2001. On the back of a sheet of drawings for medals by Francesco da Sangallo, who owned the picture, is this brief note from that great collector of portraits Paolo Giovio (in Florence from 1550 to 1552), in which he writes, "Maestro Francesco honorando, jo mandai hier Sereno per la Simonetta, et non fusti in casa. Siate contento, se vi piace, di darla a questo messo, perché non servirà ad altri che a me" (Honored Master Francesco, yesterday I sent Sereno for the Simonetta, but you were not at home. If it pleases you so to do, give her to this messenger, because [to see her] would serve no one more than me). He must surely be referring to the painting.

39. Bevilacqua 1979; Dal Pozzolo 1993, esp. pp. 260–64.

40. Holberton 2003, p. 41.

41. Goodman-Soellner 1983.

42. See Luke Syson in Scher 1994, p. 121, no. 36. The choice of an inscription in the vernacular surely links the medal to the Petrarchan tradition of poetic tributes to women, making it unlikely that it was made for a male object of desire, as suggested by Waldman 2000, and supported by Wesche 2008.

43. Schäpers 1997, p. 236.

44. Dal Pozzolo 1993, esp. pp. 278–79.

45. Goffen 1997b, p. 79.

46. "Le mammelle, come due colline di neve e di rose ripiene, con quelle due coroncine di fine robinuzzi nella loro cima, come cannelluzze del bello e util vaso; il quale oltre all utilità di stillare il nutrimento a' piccioli fanciullini, dà un certo splendore, con si nuova vaghezza, che forza ci è fermarvi su gli occhi a nostro dispetto, anzi con gran piacere: come fo io, che guardando il bianchissimo petto d'una di voi . . . Eccoci a coprir li altari: se voi non racconciate quel velo come si stava, io non seguirò più oltre." Cited by Rogers 1988, p. 70.

47. Ibid., p. 73. Joanna Woods-Marsden has written of Titian's portrait of the mistress of the Duke of Ferrara, Laura Dianti (Kisters Collection, Kreuzlingen) in a similar vein. She points out that it contains a number of visual markers of the sitter's virtue (more propagandist than actual)—but that Titian has "subverted the very purity implied by these markers by eroticizing other features, so that the overall impression

is one of 'easy' virtue or, perhaps, 'unvirtue,' rather than its opposite." See Woods-Marsden 2007, esp. p. 64. It might be thought that pictures of the nursing Madonna or of female saints such as Mary Magdalen would have been immune from carnal fantasy, but even in this religious context there were apparently problems. Leonardo da Vinci, seeking to demonstrate the special power of paintings, tells a revealing tale: "And if the poet claims that he can inflame men to love . . . the painter has the power to do the same, and indeed more so, for he places before the lover's eyes the very image of the beloved object, and he often engages with it, kissing it, and speaking with it; which he would not do were the same beauties placed before him by the writer; and so much the more [does painting] conquer the minds of men, to love and fall in love with [a] painting that does not portray any living woman. And once it happened to me that I made a painting which represented a sacred subject, which was bought by one who loved it, and he wanted me to remove the symbols of divinity, so that he could kiss it without impropriety. But, in the end, his conscience overcame his sighs and his physical passion, and he had to remove it from his house." See Leonardo, *Paragone*, 1949 (ed.), p. 65. This translation combines features from Rogers 1986, p. 299; and Shearman 1992, p. 118. Leonardo's story has a ring of truth, and the passionate owner's change of heart may have been caused by his recognition of the futility of his Pygmalionism. Indeed, as pictorial naturalism increased, worries about the established *Madonna lactans* imagery emerged, and this Marian category became ever more unusual in the late fifteenth and sixteenth centuries. See Holmes 1997, esp. p. 178; and Penny 2008, p. 268. For some devout viewers these pictures would retain their chaste allure. But it is even possible that some erotic undertone was intended, given the centrality of the Song of Songs to the iconography of the Virgin and Child. Worries might be more acute, but eroticism was still more appropriate if the "devotional image" was about the love of earthly women.

48. This is the position forcefully argued by Gentili 1995; and Bertelli 1997. Worryingly, however, Bertelli writes (1997, p. 12) of the several paintings usually thought to represent Flora: "Ritengo infatti si sia di fronte a veri e propri ritratti fisiognomici di promesse spose" (Indeed I maintain that what we have here are true and physiognomically accurate portraits of brides-to-be). This assertion somewhat undermines the rest of his argument.

49. See Zirpolo 1992.

50. Berriot-Salvadore 1993, pp. 79–85; Matthews Grieco 1993, esp. pp. 69–73; Sommerville 1995, pp. 126–34; Bell 1999, pp. 17, 37–39.

51. Giordana Mariani Canova in *Paris Bordon* 1984, p. 54, no. 2. For this interpretation, see the intelligent article by Economopoulos 1992. This interpretation is, however, judged unconvincing by Humfrey 1995, pp. 172–73.

52. Lucy Whitaker in Whitaker and Clayton 2007, pp. 191–93, no. 60.

53. For the quince, see Panofsky 1939, p. 163, n. 117; and Levi D'Ancona 1977, p. 324.

54. The letter *V* is also found on the handle of a celebrated jug made in Faenza in 1499 (cat. no. 105)—an interesting insertion in the light of what has now become a prolonged debate about the meaning of the *V* inscriptions on so many Venetian pictures of both women and men. By analogy with the Deruta plate mentioned above, it is difficult to resist the conclusion that in this instance it signals the woman's "Virtus."

55. Firenzuola, *On the Beauty of Women*, 1992 (ed.), pp. 53–57 (Second Dialogue), 80, n. 29.

56. Levi D'Ancona 1977, pp. 398–401.

57. Syson and D. Thornton 2001, pp. 53–61.

58. For which, see Randolph 2002a, pp. 119–24.

59. Matthews Grieco 2006, esp. p. 110.

60. Quoted in Matthews Grieco 2006, p. 118.

61. Labalme and Sanguineti White 1999, p. 59.

62. There is surely no need to see Laura's garment as a coat specifically made for a man, as argued by Junkerman 1993. For Sebastiano's picture, see Hirst 1981, pp. 96–97.

63. Matthews Grieco 1993, esp. pp. 59–63; Laughran 2003, esp. pp. 47–61; Rogers and Tinagli 2005, p. 37.

64. Woods-Marsden 2007, p. 59.

Fra Filippo Lippi

Florence, ca. 1406–Spoleto, 1469

118. *Portrait of a Woman and a Man at a Casement*

Ca. 1440–44
Tempera on panel, 25¼ × 16½ in. (64.1 × 41.9 cm)
Inscribed on edge of woman's cuff: *LEALT[A]*
The Metropolitan Museum of Art, New York,
Marquand Collection, Gift of Henry G. Marquand,
1889 (89.15.19)

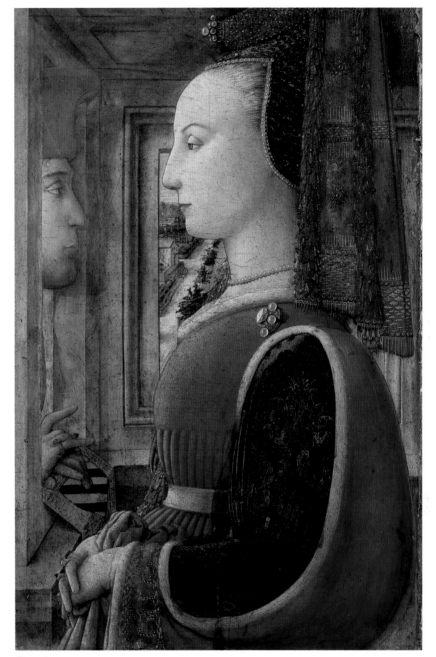

Cat. 118

This important portrait of a woman and a man by Filippo Lippi has inspired a large number of studies offering different interpretations of its meaning. In 2004 Keith Christiansen summarized the artist's innovations: "It is, indeed, the first surviving Italian portrait with an interior setting, the first Italian portrait with a landscape background, and the first double portrait in Italian art."[1] The young woman's luxurious dress and jewelry are associated with the bridal gifts of a newlywed. At left, a man wearing a red cap (*berretta*) of a shape that designates high rank leans through a window opening and rests his hands with gesticulating fingers on a coat of arms. Nearly a century ago, Joseph Breck identified the arms as those of the Florentine Scolari family and the sitters as Lorenzo di Ranieri Scolari and Angiola di Bernardo Sapiti, who married in 1436. At that time, however, the Scolari arms consisted of black bands on a yellow field. Since the bands in the present painting are dark blue, Breck's identification—and an alternative one to a branch of the Ferraro family of Piedmont, suggested by Dieter Jansen—cannot be confirmed.[2] Noting the secondary position of the man, Jansen proposed that the painting showed the declaration of allegiance of the military captain Giacomo Ferraro d'Ormea to Yolande, Duchess of Savoy, who was of superior rank; he dated it late in Lippi's oeuvre. On the basis of style, the painting may be dated to about 1440–44, although it has been dated as early as 1435–36.[3]

The clothing and jewels worn by the young woman are extraordinarily sumptuous. Although very few such luxury items have survived the centuries, the extant logbooks (*libri di ricordanze*) and inventories of Florentine patricians provide diligent records of the purchases they lavished on their young

brides, who typically married in their midteens.[4] A bridegroom might spend on wedding finery for his bride a sum that equaled a sizable part of the dowry paid by the bride's father. Here, the bride wears an overdress (*cioppa*) of heavy red wool with deep folds, belted at the waist and lined or trimmed with fur. The baglike sleeves (*a gozzi*) are cut to show her underdress (*gamurra*) of deep green velvet brocade, an extremely costly fabric with woven loops of gold (*alluciolato*) of a type produced in Florence. A saddle-shaped headdress (*sella*) rests on a feather-covered

cap trimmed with pearls. This elaborate structure supports a swathe of fabric—with one shorter length and the other falling below the waist—ornamented with a rich array of patterns, from scaling to fringes, and studded with tiny pearls and metallic spangles. The woman wears a large brooch beset with gems on her left shoulder, another on her headdress, a necklace of oversized pearls, and at least four rings over what appear to be light silk gloves. With her fingers she gathers up her heavy dress, calling attention to its luxurious volume and weight. The

gold- and pearl-embroidered letters on the wristband of her overdress spell *LEALT[À]*, meaning loyalty.[5] Under Florentine sumptuary law, unless the bride was exempt as the wife of a foreigner, knight, or doctor, such costly attire would have been permitted only for a restricted period; she would have been required to simplify her wardrobe and reduce the number of jewels she wore in the years following her nuptials. The sumptuary laws were regularly broken, however, and a husband could also choose to sell costly items or return them to their lenders at any time.[6]

The complex setting of Lippi's double portrait, the disparity of scale between the man and the woman, and their poses have elicited numerous interpretations. Robert Baldwin contends that the couple's mutual gaze through the window can be related to poetic expressions of love, both sacred and secular, and especially to a passage from the Song of Solomon (2:9) that is commonly read as an allegory of the mystical marriage of Christ (the bridegroom) and Mary/the Church (the bride): "Behold, he standeth behind our wall, he looketh forth at the windows, shewing himself through the lattice."[7] A simple and persuasive explanation for Lippi's innovations of setting is his exposure to Northern art—including manuscript illuminations that showed gesticulating figures in complex architectural spaces.[8] (Lippi's profound interest in perspectival settings is also apparent in his religious paintings.) Apart from any metaphorical meaning, Lippi exploits the possibilities of the window to create fictive space.[9] Whatever the pictorial inspiration for this portrait, the male figure appears as an adjunct of the woman, who is clearly the focus of attention.

Whereas considerable documentation exists for commissions in Renaissance Florence for clothing, jewelry, and other nuptial gifts, no records are known of expenditures on profile portraits of young women, such as this one. It has been plausibly argued that they were commissioned by a bride's husband (or her father-in-law) to hang in the couple's new home—perhaps in the marital chamber—to commemorate the wedding, to honor the young woman's new role as wife, and to serve as a reminder to her descendents of her beauty, virtue, and honor. Some portraits were possibly commissioned by the bride's family for display in her childhood home—as a continued reminder of their departed daughter, dressed in a manner in keeping with her family's wealth and status—but probably not Lippi's Metropolitan panel, since the single coat of arms is associated with the male figure. Jeffrey Ruda proposed that the painting commemorated the woman's death.[10] Christina Neilson's suggestions that the

couple are "a knight and the lady to whom he has devoted himself" and that the fact that their eyes do not meet alludes to the courtly ideal of unrequited desire deserve consideration.[11] Although the woman's conspicuous adornment marks her as a bride, a married woman could be the object of a platonic love affair. This proposition could explain the disparity in size between the sitters, but the declaration of loyalty that appears on the woman's garment seems more appropriate for her role as a wife. Other questions remain, including whether the person who commissioned such a portrait displayed it in his residence, to show his devotion to his beloved, or presented it to her as a gift. In any case, the profile poses respond to this chivalric idea, which enshrines the woman in her own virtue.[12] NE

1. See Keith Christiansen in Christiansen 2005, p. 150.
2. Breck 1913, p. 49; Jansen 1987–88. See also Christiansen in Christiansen 2005, p. 150.
3. See Christiansen in Christiansen 2005, pp. 150–53, no. 4, for a discussion of dating the work to about 1440–44, and Ruda 1993, p. 385, for the earlier date. Pope-Hennessy and Christiansen (1980, p. 57) suggest that the portrait commemorates the birth of the Scolari's first child in 1444, following the proposal by Frank Mather (1914, p. 169) that the Scolari bride is pregnant.
4. See Herald 1981, pp. 242–45, for documents of such purchases.
5. For the woman's dress, see Orsi Landini and Westerman Bulgarella 2001, pp. 93–94; and Woods-Marsden 2001, pp. 65–67. For an overview of Florentine Renaissance clothing, see Frick 2002.
6. See Orsi Landini and Westerman Bulgarella 2001, pp. 94–95; Klapisch-Zuber 1982/1985, pp. 225–28; Craven 1997, p. 216.
7. Baldwin 1986a; Baldwin 1986b.
8. See Ringbom 1985; Nuttall 2004, p. 212.
9. Nygren 2006 discusses Lippi's double portrait as a pictorial meditation on the metaphor of the open window to denote perspectival space.
10. Ruda 1993, p. 385.
11. Neilson 2008, p. 44.
12. For a discussion of the profile format, see Wright 2000, especially pp. 94–96.

SELECTED REFERENCES: Breck 1913, pp. 44–55, fig. 1; Zeri 1971, pp. 85–87, ill.; Ringbom 1985, pp. 133–37, fig. 1; Baldwin 1986a, pp. 30–34; Baldwin 1986b, pp. 7–12, fig. 1; Jansen 1987–88, pp. 97–121, fig. 1; Tietzel 1991, pp. 17–42, fig. 1; Ruda 1993, pp. 85–88, 385–86, no. 16, pls. 45, 217; Craven 1997, pp. 215–23; Holmes 1999, pp. 129, 134–35, fig. 113; David Alan Brown in D. A. Brown et al. 2001, pp. 106–9, no. 3, ill.; Keith Christiansen in Christiansen 2005, pp. 150–53, no. 4, ill.

Francesco Laurana
Vrana, near Zara (now Zadar, Croatia), ca. 1420–Avignon, ca. 1502

119. Portrait Bust of Beatrice of Aragon

Ca. 1474–75
Marble, 16 × 15⅞ × 8 in. (40.6 × 40.4 × 20.3 cm)
Inscribed on tablet: *DIVA BEATRIX / ARAGONIA*
The Frick Collection, New York (1961. 2. 86)

Francesco Laurana's female portrait busts—a core group of nine works—have been admired as iconic representations of feminine beauty from the time of their rediscovery in the mid-nineteenth century, even before the artist's authorship was established. Ever since, their dating and the identification of the sitters have been subject to debate; more recently, the authorship or authenticity of some of these busts has been questioned. These issues have been complicated by the poverty of documentation and because the artist moved so frequently between Naples, the south of France, and Sicily. The present portrait representing Beatrice of Aragon (1457–1509), daughter of Ferrante I of Aragon, king of Naples, and Isabella of Chiaramonte, is one of two busts by Laurana bearing an inscription. The other is a posthumous portrait of Battista Sforza, Duchess of Urbino (Museo Nazionale del Bargello, Florence), probably also made in 1474. Additional busts attributed to Laurana are in the Staatliche Museen zu Berlin, Bode-Museum (largely destroyed); National Gallery of Art, Washington, D.C.; Frick Collection, New York (a purchase by Henry Clay Frick; the present work was bequeathed to the Frick by John D. Rockefeller, Jr.); Galleria Nazionale, Palermo; Musée du Louvre, Paris; Musée Jacquemart-André, Paris; and Kunsthistorisches Museum, Vienna.[1] Laurana's authorship of some of these sculptures has been challenged by Chrysa Damianaki, and the identities of the sitters (variously considered to represent Isabella of Aragon, Ippolita Maria Sforza, and Eleonora of Aragon) continue to be debated.[2] Only Peter Fusco has questioned in print the autograph status of the Frick's *Beatrice of Aragon*.[3]

In 1888 Wilhelm von Bode attributed the group of stylistically related busts to Francesco Laurana by associating them with the artist's *Madonna della Neve,* signed and dated 1471 (Chiesa del Crocifisso, Noto, Sicily), and other documented works.[4] The abstracted facial type of Laurana's Madonnas—an oval head with full, smooth cheeks and slanting, downcast eyes—has Franco-Flemish precedents. The same idealized beauty informs

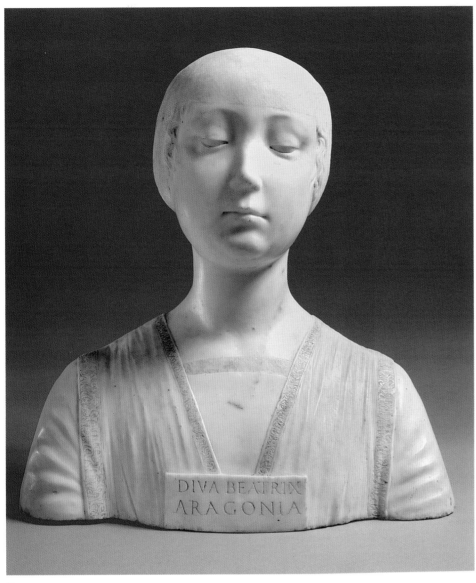

Cat. 119

Cat. 119, detail of bodice

Laurana's portrait busts, each of which, however, is more individualized than the Madonnas.

Originally *Beatrice of Aragon* must have been colored—perhaps like Laurana's bust in Vienna—and the remains of polychromy were likely removed before the sculpture came on the market in the mid-nineteenth century. Notwithstanding the loss of the original surface, the bust is today in very good condition.[5]

The inscription DIVA BEATRIX ARAGONIA (Diva Beatrice of Aragon) indicates that the Frick bust was created before Beatrice's marriage by proxy in Naples on September 15, 1476, to Matthias Corvinus, king of Hungary (see cat. no. 3). Ferrante had previously negotiated several other matches for his daughter. Her 1463 betrothal to Giovanni Battista Marzano, the young duke of Sessa, was annulled. A decade later, a potential match with Filiberto, Duke of Savoy, was discouraged by his uncle Louis XI, so that his own three-year-old son, the future Charles VIII of France, could be proposed as Beatrice's fiancé—even though she was sixteen years old. In the meantime, Ferrante engaged in intermittent negotiations with Corvinus, who in 1465 had rejected the Neapolitan king's offer of his eldest daughter, Eleonora (who in 1473 was married to Ercole d'Este, Duke of Ferrara). Her appearance was allegedly at issue; it was reported from Venice that King Ferrante's daughter was not beautiful, and the king of Hungary wanted "una bellissima" for his queen.[6] A baronial threat supporting René d'Anjou's claim to Naples may also have deterred Corvinus. His rivals subdued, Ferrante later proposed his more beautiful daughter, Beatrice. Following further negotiations, the betrothal was contracted in 1474.[7]

Beatrice's adolescent appearance—conveyed by a smooth, fresh face, full cheeks, and flat chest—supports a date of about 1474–75. Portraits were exchanged during marriage negotiations among princely families, often to appraise the prospective spouse's appearance. In 1472, probably just before Laurana sculpted Beatrice's bust, her sister Eleonora received a portrait of her future husband, Ercole d'Este, Duke of Ferrara (actually, a double portrait with his illegitimate daughter Lucrezia), by Cosmè Tura. Tura painted other Este portraits, all untraced, including a portrait of Lucrezia on the occasion of her betrothal to Annibale Bentivoglio in 1479 and portraits of Isabella d'Este (1480) and Beatrice d'Este (1485) to be sent to their future husbands.[8] If the Frick bust was commissioned to show to a prospective bridegroom, Corvinus was the likely recipient, although it is also possible that the portrait was created

for a member of Beatrice's family in antici-pation of her move to a faraway kingdom. For example, Ippolita Maria Sforza, who was married to Beatrice's brother Alfonso II, wrote her mother, Bianca Maria Sforza, the duchess of Milan, from Naples in 1466 to request portraits of her parents and all her brothers and sisters to provide her consola-tion and pleasure.[9]

Despite its elegant abstraction, the Frick bust is an individual portrait, established by the details of Beatrice's physiognomy and dress. Her broad face with rounded fea-tures and a soft double chin are consistent with her marble relief portrait in Budapest (Szépmüvészeti Múzeum) and her likeness in a medal attributed to the circle of Gian Cristoforo Romano (National Gallery of Art, Washington, D.C.), which is inscribed *DIVA BEATRIX HVNGARIAE REGINA* (Diva Beatrice, Queen of Hungary).[10] Beatrice wears a finely textured cap (*cuffia*) that reveals the shape of the plaits of hair wound around her head. A few meandering locks escape at the temples and at the nape of the neck. Her overdress or tunic (*giornea*) made of a fine, pliant fabric has an incised border of pseudo-Kufic deco-ration, similar to that decorating the robes of some of Laurana's Madonnas. These bor-ders are discontinued in the back, suggest-ing that the bust may have been intended for display in a niche. The clothing was prob-ably originally colored, gilded, and perhaps bejeweled to suggest the sumptuous attire of a princess, possibly in a manner similar to Laurana's Vienna bust, whose cap is gilded and decorated with colored wax flowers. When visiting her sister Eleonora in Ferrara on her journey to Hungary, Beatrice wore a crimson and gold gown trimmed with fur and a mantle embroidered with gold and pearls; her hair was wrapped with a very fine veil laden with large pearls and diamonds.[11] In the Frick bust, the fall of the drapery sug-gests silk, perhaps summer attire.

The neckline band of Beatrice's dress (*cotta*) is chiseled in very low relief on a punched ground to suggest embroidered decoration. The motifs, now abraded, were described by Wilhelm Rolfs as "two wea-sels or ermines, on either side of a hill with bird (?), as well as two lilies, each with three blossoms," emblems of Beatrice's father.[12] Photographs dating from before 1930, when the bust was in the Gustave Dreyfus collec-tion, show this imagery (see detail of bodice on p. 257). An ermine hung as a pendant on the collar of the Order of the Ermine, which Ferrante founded in 1465. It was featured on his coins (*armellini*) with the legend *DECO-RUM* and used as a personal *impresa*. Another of Ferrante's devices was the mount of dia-monds (*monte dei diamanti*), which is in all

probability the central motif on Beatrice's neckband. The lilies above each of the ermines (only visible at right) may refer to the older Aragonese Order of the Stole and Jar (also known as the Order of the Lily), to which Ferrante had been elected when he was a prince, and whose device was three lil-ies in a jar, alluding to the vase of lilies often depicted in Annunciation scenes.[13] Reputedly an animal of moderate temper, the ermine was a popular emblem among the European nobility, adaptable for political purposes. The statutes of the Order of the Ermine explain that by adopting as their emblem "the pur-est beast, we signify to our companions that only what is decent, just, and honest must be done."[14] Ferrante's adoption of the ermine and the motto *DECORUM* have been under-stood to allude to his suppression of the bar-ons' rebellion against his rule in Naples.[15] The ermine and the mount of diamonds also appear in the margins of the dedication page of Diomede Carafa's *De Institutione Vivendi* (Ms. Parm. 1654, Biblioteca Palatina, Parma), which was presented to Beatrice at the time of her marriage.[16] Long associated with chastity—the foremost feminine vir-tue—the ermine could also represent the honor of a prospective bride. In his poem *Trionfi*, Petrarch describes the Triumph of Chastity, whose chariot was accompanied by a procession of chaste maidens bearing a ban-ner with an ermine (see cat. nos. 72, 137b). The lily also symbolized purity and chastity, and its depiction on Beatrice's dress further underscored her honor and virtue. A similar use of devices is found in Gian Cristoforo Romano's exquisite marble bust of Beatrice d'Este (Musée du Louvre, Paris), a niece of Beatrice of Aragon.[17] It was likely executed shortly before her marriage in January 1491 to Ludovico Sforza called il Moro, ruler of Milan. The base is inscribed with the words *DIVAE / BEATRICI / D.HERC.F* (To the diva Beatrice, daughter of the duke Ercole), and the device of a diamond ring entwined with foliage and a flower, an emblem of the sit-ter's father, is carved in relief on her bodice. Within the ring is an *impresa* of Ludovico, a cloth held on each side by two hands.[18] With this juxtaposition of emblems, the cloth appears to function as a sieve to water or pollinate the flower—imagery that cleverly alludes to fertility and dynastic succession in a marital context.

Like many other Renaissance images of women, Laurana's marble busts defy easy categorization as portraits—observed or imagined, made during life or after death. Petrarch was a pervasive influence for imag-ery of female beauty, and it is noteworthy that Laurana's Vienna bust, whose subject is often claimed to be Isabella of Aragon, appears to

have been the prototype for later representa-tions of Petrarch's beloved, Laura.[19] In creat-ing a likeness of Beatrice of Aragon, Laurana would have responded to courtly ideals of decorum that described the princess's beauty as an expression of her virtue, her downcast eyes a sign of her chaste modesty. In his description of the nuptials of Beatrice and Corvinus, the humanist courtier Antonio Bonfini praised Beatrice's splendid fore-head, lofty eyebrows, blushing cheeks, and merry eyes. He asserted that she possessed the beauty of Venus, the modesty of Diana, and the wisdom and eloquence of Pallas.[20] Having captured with exquisite understate-ment Beatrice's individual features, Laurana conjured superhuman perfection with pure, abstracted form. N E

1. For illustrations of Laurana's female portrait busts, see Kruft 1995, pls. 26–29, 69–93.

2. Damianaki 2000, pp. 92–113, 168–87.

3. P. Fusco 1996, p. 12, n. 10.

4. Bode 1888; Giovanni C. F. Villa in Lucco 2006a, pp. 316–17, no. 61.

5. *Beatrice of Aragon* was shown at the 1865 exhibition *Mostra del Medio Evo* at the Bargello, Florence, as a work by Desiderio da Settignano, for which see Barocchi and Gaeta Bertelà 1985, p. 89, n. 86. Alessandro Foresi (1868, p. 114) wrote that Charles Timbal "paid 4,000 francs for a marble bust (ancient nonetheless) since he believed it to be a portrait of 'la Diva Beatrix Aragoniae [*sic*]," and commented on the "barbaric" treatment of the bust, probably referring to the application of a substance to artificially age the marble. For the condition of the bust (which was undoubtedly cleaned by Duveen before he sold it to Rockefeller) and Foresi's remarks, see Damianaki 2000, pp. 77–79, 185–86, n. 147; see also John Pope-Hennessy and Bernice F. Davidson in Frick Collection 2003, p. 423.

6. Domonkos 1989, p. 55, n. 2.

7. For the political events with a bearing on Beatrice's betrothals, see Berzeviczy 1909 and Clough 1992, p. 140; for her nuptials, see Domonkos 1989 and Honemann 2005. Damianaki 2000 (p. 81) contends that Beatrice's title as queen was confirmed before July 30, 1475.

8. For Tura's portraits, see Manca 2000b, pp. 212, 223–26, 229; and Stephen J. Campbell in S. J. Campbell 2002, pp. 247–49. For examples of portrait exchange during nuptial negotiations, see L. Campbell 1990, pp. 197–98, and Warnke 1992, pp. 220–23, who, however, infers with-out documentation that portraits of Beatrice of Aragon by Laurana were sent to her fiancés.

9. Letter dated January 6, 1466, Archivio Sforzesco, Archivio di Stato, Milan, 16.S.215, cited by Damianaki 2000, p. 129, n. 81.

10. Pollard 2007, vol. 1, p. 143, no. 126, ill.

11. Damianaki 2000, pp. 80, 161, n. 167.

12. Rolfs 1907, vol. 1, p. 340.

13. For these knightly orders, coinage, and emblems, see Boulton 1987, pp. 330–38, 402–26; and Grierson and Travaini 1999, pp. 13–14, 20, 125, 369, 374.

14. Boulton 1987, p. 424.

15. Clough 1992, pp. 158–59.

16. See Silvia Scipioni in Bono et al. 2002, pp. 184–85, no. 16.

17. For the bust of Beatrice d'Este, see Norris 1977, pp. 21–25; and Andrea Bacchi in Bentini 2004, p. 248, no. 42, ill. p. 249.

18. For this *impresa,* which Ludovico himself wore on his clothing and which also became a personal emblem of Beatrice, see Welch 1995, pp. 198, 313, n. 93.

19. See Götz-Mohr 1993, whose conclusions should be reconsidered in regard to the comprehensive study of images of Petrarch's Laura by Trapp (2001), who did not discuss the Vienna bust.

20. See Rolfs 1907, vol. 1, p. 335.

SELECTED REFERENCES: Rolfs 1907, vol. 1, pp. 339–43, vol. 2, pl. 49, nos. 1–3, pl. 50, no. 1; Valentiner 1942, pp. 283–87, fig. 1; Kennedy 1962, n.p.; Hersey 1969, p. 33; Kruft 1995, pp. 127, 136–39, 375–76, no. 15, ill. p. 127, fig. 101, p. 375, fig. 2, pls. 66–68; P. Fusco 1996, p. 12, n. 10; Bernice F. Davidson in Ryskamp et al. 1996, p. 124, ill.; Damianaki 2000, pp. 76–83, 159–63, pls. 117–21; John Pope-Hennessy and Bernice F. Davidson in Frick Collection 2003, pp. 423–27, ill.

Ercole de' Roberti

Ferrarese, ca. 1455/56–1496

120a. *Portrait of Giovanni II Bentivoglio*

Ca. 1474–77
Tempera and oil on panel, 21¼ × 15 in. (54 × 38.1 cm)
National Gallery of Art, Washington, D.C., Samuel H. Kress Collection (1939.1.219)

120b. *Portrait of Ginevra Sforza Bentivoglio*

Ca. 1474–77
Tempera and oil on panel, 21⅛ × 15¼ in. (53.7 × 38.7 cm)
National Gallery of Art, Washington, D.C., Samuel H. Kress Collection (1939.1.220)

This important pair of portraits dates to the period of Giovanni II Bentivoglio's ascendancy to power in Bologna. Most recent scholars have supported Roberto Longhi's 1934 attribution to Ercole de' Roberti, dating the works between 1474 and 1477, when the artist's manner was close to that of his master, Francesco del Cossa. The portraits no doubt depend on Piero della Francesca's celebrated pendant portraits of Battista Sforza and Federigo da Montefeltro (Galleria degli Uffizi, Florence), which were probably painted shortly after Battista's death, in 1472, and before Federigo was named duke of Urbino, in 1474. The natural daughter of Alessandro Sforza, lord of Pesaro, Ginevra (1452–1507) was Battista Sforza's half-sister. Piero's portraits are perhaps the earliest to place their subjects against a landscape backdrop inspired by Netherlandish examples, and their general prototype may be found in hieratic profile portraits of the Burgundian and northern Italian courts, which were in turn inspired by ancient medals that carried connotations of rulership.[1]

A noteworthy precedent for the Bentivoglio paintings that predates Piero's pair is the lost diptych by Niccolò Teutonico representing Francesco Sforza, Duke of Milan, and Bianca Maria Visconti, which was presented to Borso d'Este, Duke of Ferrara, in 1455.[2] Two profile portraits of the splendidly attired Sforza couple now in Milan (Pinacoteca di Brera) are arguably posthumous paintings datable to the 1470s, but they may give an idea of the earlier untraced diptych.[3] Francesco Sforza, who was Ginevra's uncle, had usurped the duchy of Milan and derived legitimacy of rule from his marriage with Bianca Maria, heir of Duke Filippo Maria Visconti, the last direct male descendant of the house of Visconti, which had earlier ruled Milan. Such official portraits were sometimes presented as gifts to consolidate political alliances and proclaim dynastic lineage. Portraits of nobles or other important persons were displayed in the anterooms, chambers, or studies of family palaces, where they might occasionally also be viewed by visitors. A 1494 inventory of the Este Castello at Ferrara, for example, lists fifteen portraits of members of the Este and Sforza families, and the 1500 inventory of the library of Ginevra's nephew Giovanni Sforza in Pesaro records nineteen portraits of family members and contemporary rulers.[4]

As with the Sforza-Visconti union, the marriage of Giovanni II Bentivoglio (whose mother was a Visconti) to Ginevra Sforza was instrumental in establishing the bridegroom's authority. Unlike the city-states of Milan, Ferrara, and Mantua, which were ruled by hereditary lords, Bologna was a territory in the Papal States, but by the mid-fifteenth century had become relatively autonomous. The laws of the city's governing councils, of which the Sedici was the most powerful, in principle required approval by the papal legate, or representative. To maintain a degree of autonomy, the aristocracy encouraged the ascendancy of successive members of the Bentivoglio family as means of protecting Bologna from outside domination and stabilizing their city ravaged by internecine conflicts. Giovanni (1443–1508) was only two years old when his father, Annibale, was assassinated. Annibale's cousin, Sante Bentivoglio, next rose to power in Bologna. Sante's alliance with Milan was cemented by his marriage to Francesco Sforza's niece Ginevra. When Sante died in 1463, young Giovanni was quickly instated as *gonfaloniere* of justice, the highest position in the city. In accordance with the duke's wishes, he wed Sante's widow, Ginevra, in 1464, and the following year was named "president for life" of the Sedici by Pope Paul II.[5]

Although Roberti's pair of Bentivoglio portraits likely postdates Giovanni and Ginevra's marriage by more than a decade, it celebrates their union by proclaiming their virtue, magnificence, and lineage. Giovanni's services as a mercenary commander, or *condottiere,* in the territorial struggles that roiled the Italian peninsula brought status and wealth to both himself and Bologna. About the time the portraits were commissioned, the Bentivoglio sought to ensure dynastic continuity. In 1473 Pope Sixtus IV confirmed the right of succession as head of the Sedici to Giovanni's eldest son, Annibale II, and in 1478 Annibale was betrothed to Lucrezia d'Este, natural daughter of Ercole d'Este.[6] Ties to the other major Italian courts were later consolidated by marriages between the couple's children (eleven of whom survived past childhood) to members of the Sforza, Malatesta, Gonzaga, and Borgia families, among others. When Pope Julius II adopted an aggressive policy to exert authority over the Papal States and reasserted claim to Bologna, however, Giovanni's support had eroded, and he died in exile.

In the Bentivoglio portraits, the couple's dress is no less sumptuous than that of other seigneurial families of northern Italy. Knighted as a boy by Emperor Frederick III, Giovanni would have been expected to dress according to his rank to demonstrate his *magnificenza*.[7] The portraits, which have sustained some abrasion, are painted in a tempera and oil mixture applied with fine strokes,[8] and attention is lavished on minute details of costume. Giovanni wears a costly gown (*vestimento*) of cut velvet with gold thread, trimmed at the neck with white fur, over a red brocaded doublet. His *berretta* (cap) is the same shade of vermilion as his wife's pearl-trimmed girdle. His assertive posture and uplifted chin contrast with the steadfast and discreet demeanor of his wife, whose blond tresses

and complexion epitomized female beauty and virtue. Her hair is dressed *a corni* (with horns), a northern European fashion, and covered with long silk veils held in place by a fine wire understructure and golden pins. Some years earlier, Andrea Mantegna portrayed Barbara of Brandenburg, consort of Duke Ludovico Gonzaga, in the Camera Picta of the ducal palace, Mantua, with her hair dressed in a similar style. Ginevra wears a double strand of pearls and a luxurious brown velvet overdress, its gold borders garnished with large gemstones and pearls, which opens to show the cloth-of-gold sleeve of her underdress. To depict this precious fabric, Roberti used mosaic gold (tin disulphide), a pigment found in Renaissance manuscript illuminations, but fairly rare in panel paintings.[9] Notably, it was employed by Francesco del Cossa on the central panel, depicting Saint Vincent Ferrer (National Gallery, London, ca. 1473–75), of the Griffoni Altarpiece, a work on which Roberti collaborated with his master, as well as in Cosmè Tura's *Pietà* (Museo Correr, Venice; ca. 1460) and Roberti's *Saint Jerome* (J. Paul Getty Museum, Los Angeles; ca. 1470).[10]

To fulfill his ambition to become virtual ruler of Bologna and to demonstrate his magnificence, Giovanni engaged in patronage on a large scale—supporting tournaments and feasts as well as urban renewal and other building projects. The enormous Palazzo Bentivoglio, begun by Sante and continued by Giovanni, brought prestige to Bologna for its beauty and as a splendid setting for the reception of princes and ambassadors.[11] In the present portraits, the dark green curtains that isolate the figures (and connote royalty) are pulled back to show narrow, vertical slices of landscape. In contrast to the serenely unpopulated panoramic background of Piero's portraits of the Montefeltro of Urbino, these views represent the architecture of Bologna itself. In their portraits, Giovanni Bentivoglio and Ginevra Sforza present themselves as "first citizens" of Bologna, and in a magnificent display arguably aspire to parity with the lords of the northern Italian courts. NE

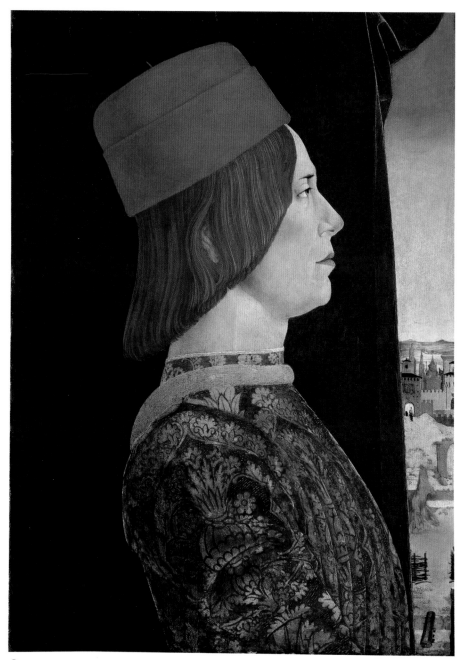

Cat. 120a

1. For Piero's portraits, see Woods-Marsden 2002, pls. 26–29.
2. Warnke 1998, p. 213, n. 12. See also the discussion of this diptych by Everett Fahy in his essay "The Marriage Portrait in the Renaissance" in this volume.
3. See Sandrina Bandera in *Le muse e il principe* 1991, vol. I, pp. 93–97, nos. 18, 19.
4. See Aleci 1998, esp. pp. 74, 208, n. 52.
5. For the Bentivoglio family in Bologna, see Ady 1937; and Drogin 2004.

6. Ady 1937, pp. 98, 68.
7. See Bridgeman 1998 for dress during the Renaissance as an indication of virtue.
8. This was established by Rikke Foulke during conservation treatment of the panels in 2000–2001; Rikke Foulke, Culpeper Fellow in Paintings Conservation, National Gallery of Art, Washington, D.C., conservation report, 2001, files, Painting Conservation Department. See Allen 1999 on the artist's innovative technique.
9. Rikke Foulke, conservation report, 2001 (see note 8 above).
10. For the use of mosaic gold in these works, see A. Smith, Reeve, and Roy 1981, pp. 55–56; Dunkerton 2002, p. 142; and Allen 1999, pp. xvi, xxviii.
11. Clarke 2004; see also Clarke 1999.

SELECTED REFERENCES: Longhi 1934/1956, p. 46ff.; Manca 1992, pp. 34–35, 104–6, no. 5, figs. 5a, 5b; Molteni 1999, pp. 128–29, no. 15, ill.; David Alan Brown in D. A. Brown et al. 2001, pp. 102–5, no. 2, ill.; Angela Ghirardi in Fortunati 2003, pp. 50–51, ill.; Joseph Manca in Boskovits and D. A. Brown 2003, pp. 602–7, ill.

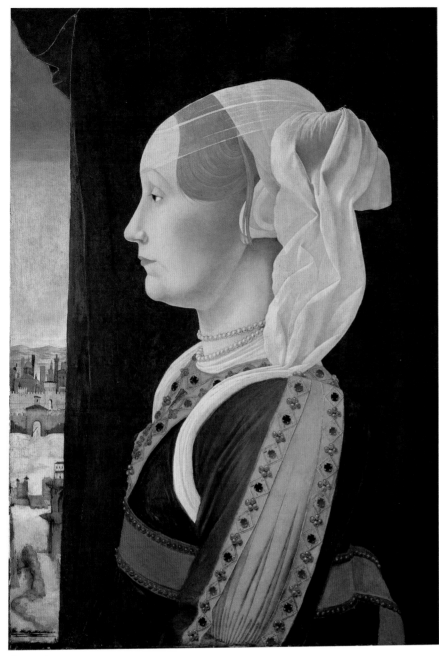

Cat. 120b

Attributed to the Maestro delle Storie del Pane
Emilian School

121a. Portrait of a Man, possibly Matteo di Sebastiano di Bernardino Gozzadini

Ca. 1485–95
Tempera on panel, 20¾ × 14⅝ in. (52.7 × 37.1 cm);
painted surface 19⅜ × 14 in. (49.2 × 35.6 cm)
Inscribed at upper right: *VT SIT NOSTRA*
The Metropolitan Museum of Art, New York, Robert
Lehman Collection, 1975 (1975.1.95)

121b. Portrait of a Woman, possibly Ginevra d'Antonio Lupari Gozzadini

Ca. 1485–95
Tempera on panel, 19¾ × 14⅝ in. (50.2 × 37.1 cm);
painted surface 19⅛ × 14⅛ in. (48.6 × 35.9 cm)
Inscribed at upper left: *FORMA. SVPERSTES*
The Metropolitan Museum of Art, New York, Robert
Lehman Collection, 1975 (1975.1.96)

The two coats of arms suspended on a building that forms part of the continuous landscape background of these pendant portraits belong to the Gozzadini, a prominent Bolognese family. The woman's natal coat of arms is absent, which would indicate her new marital status. It also suggests that the portraits were on display in the Gozzadini palace. This is borne out by the provenance of the panels, which were sold by the Gozzadini family in Bologna at the beginning of the twentieth century. In his fundamental study of the portraits, John Pope-Hennessy has proposed that the sitters are Matteo di Sebastiano di Bernardino Gozzadini (b. 1473) and Ginevra d'Antonio Lupari, based on the evidence of the fragment of a label on the back of the male portrait, presumably copied from an earlier one when the panel was cradled, which reads: *BERNARDINI DI GOT . . . / . . . OS VIGINTI UNO.*[1] Pope-Hennessy suggests that the original inscription could be reconstructed as *MATTEUS SEBASTIANI BERNARDINI DE GOTSADINIIS / AETATIS SUAE ANNOS VIGINTI UNO* (Matteo, son of Sebastiano, son of Bernardino Gozzadini, age twenty-one). If the male subject is indeed Matteo di Gozzadini, who looks to be about twenty-one, the couple would have wed in 1494 (further evidence is needed, however, to confirm these identifications). Members of the bridegroom's family may have been familiar with Ercole de' Roberti's portraits of Giovanni II Bentivoglio and Ginevra Sforza Bentivoglio (cat. nos. 120a, b) or associated lost works, since Italian fifteenth-century double portraits are rarities. Whereas the Bentivoglio pendants evoke paradigms of state portraiture, the present panels—like the Florentine portrait pair of a young man and a young woman attributed to Domenico Ghirlandaio (cat. nos. 122 a, b)—emphasize the marital virtues.

The couple is portrayed as betrothed or married by the objects they hold, the background motifs, and the woman's dress. Offset by the dark void of the window, the woman's profile—with its well-defined aquiline nose and broad jaw—complements the incisive contours of her handsome husband's head against the receding wall of the building. He holds a sprig of pinks, associated with betrothal and fidelity, and his wife holds a fruit—a peach, orange, or apple, all of which signify love and marriage. He wears a bright red *berretta* (cap) and a deep crimson tunic (*giornea*) over a dark doublet. His partner's blue-green gown has red and gold brocaded sleeves, worn with a fine covering of the neckline and shoulders (*coverciere*) and a belt with a nielloed silver buckle, a typical betrothal gift (see cat. nos. 36a, b). Her hair is gathered in a simple chignon, held in place with banded ribbons. The expensive, though unostentatious, dress and jewelry—black beaded necklaces with a jeweled pendant—befit a recently married woman of rank in the last decades of the fifteenth century. Some years earlier, in 1453, the

Bolognese noblewoman Nicolosa Sanuti wrote a spirited treatise imploring Cardinal Bessarion to repeal recently instituted sumptuary restrictions, arguing, "Does not everyone know that gold and such adornments and all decoration are testimonies to virtue and heralds of a well-instructed mind?"[2]

An inscription on the frieze of the building begins at left *VT SIT NOSTRA* and continues in the pendant painting at right *FORMA. SVPERSTES* (note the Byzantine-derived form of the letter *M*). This has been translated by George Szabó "so that our images may survive" and by Pope-Hennessy "in order that our features may survive."[3] The Latin word "forma," however, is perhaps better translated as "beauty," since the multivalent word carries this primary connotation—as it does in Ginevra de' Benci's motto inscribed on her celebrated portrait by Leonardo da Vinci, *Virtutem forma decorat*, or Beauty adorns virtue (fig. 8). The motto on the present panels invokes the Renaissance topos that the painted image will survive its live model and that beyond simple likeness, beauty (*forma*) is an expression of virtue.[4] The desire of the present couple for immortality transcends the mere preservation of physical likeness and beauty to embrace their virtues and their hope for longevity of lineage.

The landscape is replete with human figures and animals that evoke marital virtues, fecundity, and prosperity. The *paysage moralisé* of the male portrait features a falcon-bearer riding on a horse and accompanied by a dog, and a hunter on foot farther behind. Falconers are frequent motifs in chivalric amorous imagery, the bird representing the beloved.[5] On the path is a pelican feeding her young from the blood of her pierced breast—a common symbol of charity. The phoenix on the tree stump stands for regeneration, here undoubtedly referring to the family lineage, as does the tree stump that sprouts a new branch in the foreground of the female portrait. As a counterpart to the falcon-bearer, this landscape features a woman approaching a unicorn. The object in her hands—variously identified as a bridle, mirror, or wreath—is now difficult to decipher, but the motif alludes to the lady's chastity, since legend tells that only virgins could capture the mythical beast. The unicorn appears on the reverse of the portrait medals of Cecilia Gonzaga and Lodovica Tornabuoni, as well as in Leonardo's drawing *Lady with a Unicorn* (Ashmolean Museum, Oxford), which David Alan Brown posits was a preliminary design for the reverse of Ginevra de' Benci's portrait.[6] Additional small animals—birds, rabbits, and a tiny ermine—refer respectively to love, fertility,

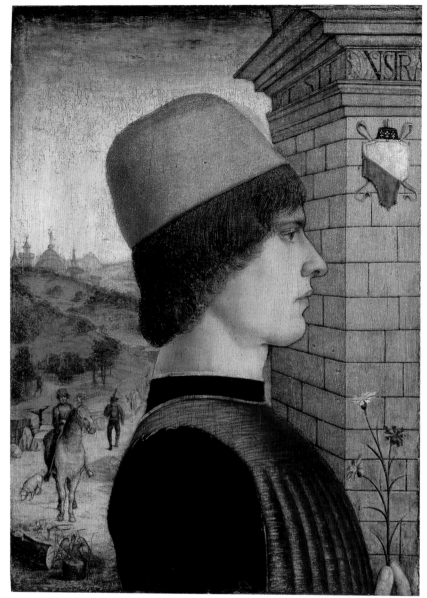

Cat. 121a

and chastity. Similar amorous imagery may be found on betrothal gifts, such as jewelry boxes, mirrors, or combs (see cat. no. 37). The distant landscapes of the pendants are likewise idyllic and complementary. Behind the male figure, on the horizon beyond wooded hills, appears a fantastic city. The more open pendant landscape shows a river wending into a lake teeming with boats and buildings along the shores.

The surface of the paintings is somewhat abraded, and the attribution has been proven somewhat difficult. Attributions to Francesco del Cossa[7] and Lorenzo Costa[8] have not found support in recent scholarship. Carlo Volpe ascribed the panels to the anonymous master known as the Maestro delle Storie del Pane, who in the 1480s painted the fresco cycle at the Castello dei Bentivoglio at Ponte

Poledrano, Giovanni Bentivoglio II's favorite rural retreat, outside Bologna on the route to Ferrara—an attribution that recently has gained support.[9] Landscape details of these rural scenes, as well as the quality of light, bear close comparison to those features of the Metropolitan's panels.

NE

1. Pope-Hennessy 1987, p. 214.
2. Killerby 1999, p. 268.
3. Szabó 1975, p. 56; Pope-Hennessy 1987, p. 214.
4. See Garrard 2006, pp. 45, 53, nn. 112–15, for *forma* and related concepts.
5. Friedman 1989.
6. D. A. Brown et al. 2001, pp. 118–20, 127–29, nos. 7, 10 (entries by Eleonora Luciano), pp. 150–53, and no. 18 (entry by David Alan Brown); see also cat. no. 3 in this volume.

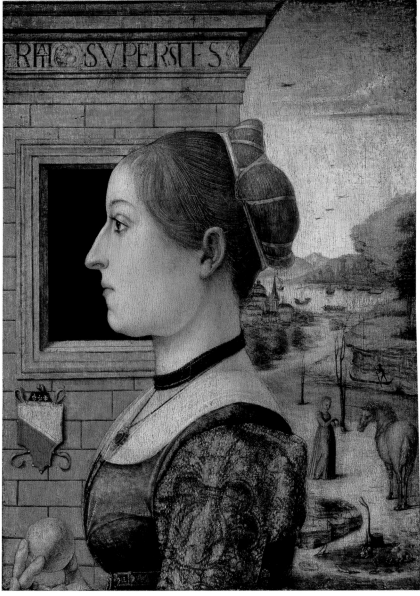

Cat. 121b

7. Venturi 1914, pp. 642–46.
8. Longhi 1934/1956, pp. 54, 105–6, n. 104,
 pp. 143, 170, n. 8, fig. 178.
9. Volpe 1958, pp. 30–31; Sgarbi 1985, pp. 20–22;
 Bacchi 1987; Pope-Hennessy 1987, p. 216;
 Angela Ghirardi in Fortunati 2003, p. 53;
 and Everett Fahy in his essay "The Marriage
 Portrait in the Renaissance" in this volume.

SELECTED REFERENCES: Venturi 1914,
pp. 642–46, figs. 486, 487; Longhi 1934/1956,
pp. 54, 105–6, n. 104, pp. 143, 170, n. 8, fig. 178;
Volpe 1958, pp. 30–31; Szabó 1975, pp. 57–59,
pls. 41, 42; Sgarbi 1985, pp. 20–22, ill.; Pope-
Hennessy 1987, pp. 214–19, nos. 89, 90, ill.;
Bacchi 1987; Angela Ghirardi in Fortunati 2003,
pp. 52–53, ill.

Attributed to Domenico Ghirlandaio

Florentine, 1448/49–1494

122a. *Portrait of a Young Man*

Ca. 1490
Tempera on panel, 20⅜ × 15⅝ in. (51.8 × 39.7 cm)
The Huntington Library, Art Collections, and
Botanical Gardens, The Arabella Huntington
Memorial Collection, San Marino, California (26.92)

122b. *Portrait of a Young Woman*

Ca. 1490
Tempera on panel, 20⅜ × 15⅝ in. (51.8 × 39.7 cm)
The Huntington Library, Art Collections, and
Botanical Gardens, The Arabella Huntington
Memorial Collection, San Marino, California (26.89)

These two paintings in the Huntington Art Collections, San Marino, California, in all probability are portrayals of a married couple by the fifteenth-century Florentine artist Domenico Ghirlandaio. The attribution and identification of the figures are complicated by the existence of a closely related pair of paintings in the Gemäldegalerie, Berlin, which are attributed to Davide Ghirlandaio, as well as to Sebastiano Mainardi.[1] (For one of the Berlin pair, see fig. 106.) The female portrait in the present pair is related to Domenico Ghirlandaio's elegant portrait of Giovanna degli Albizzi Tornabuoni (Museo Thyssen-Bornemisza, Madrid), although its mood is more quotidian. Both portraits show an alcove for the display of marriage gifts. The unidentified woman seen here is less expensively dressed than Giovanna Tornabuoni, whose image is arguably posthumous.[2] The Huntington pair was attributed to Domenico Ghirlandaio at the beginning of the twentieth century, but an attribution to Mainardi—who was a pupil of Domenico and a workshop collaborator of the younger Ghirlandaio brothers, Davide and Benedetto, as well as the brother-in-law of all three—had gained favor by the 1930s. In his essay "The Marriage Portrait in the Renaissance" in this volume, Everett Fahy has returned the attribution to Domenico Ghirlandaio.[3]

Admired in Italy for their detailed naturalism, Netherlandish portraits, especially Hans Memling's half-length portraits placed before a distant landscape, clearly inspired the Huntington pendants.[4] Florentine merchants and bankers who traveled to Bruges, where Memling worked from about 1465, commissioned portraits as well as devotional works from the city's leading master, who in turn influenced Italian artists such as Domenico Ghirlandaio. While employed at the Medici bank in Bruges, Tommaso Portinari commissioned from Hugo van der Goes a monumental triptych with a central panel that featured the Adoration of the Shepherds and wings that included family portraits. The Portinari Altarpiece arrived in Florence in 1483, and two years later Ghirlandaio painted an altarpiece of the same subject for the Sassetti Chapel, Santa Trinita, that responded to its example.[5] Memling painted some of the earliest portraits of married couples in a secular rather than a devotional context. According to the art connoisseur Marcantonio Michiel, in 1521 the Venetian collector Cardinal Domenico Grimani owned likenesses of "a man and wife together in the Flemish manner" by Memling. This portrait may have been a double one rather than a pair, but Memling likely produced conjugal portrait

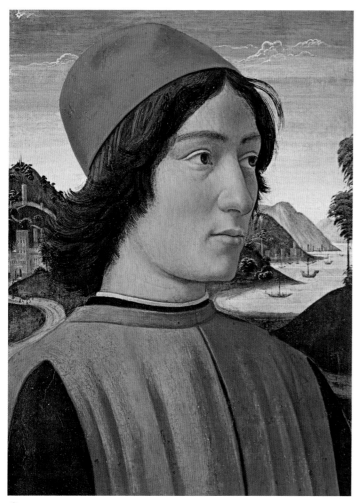

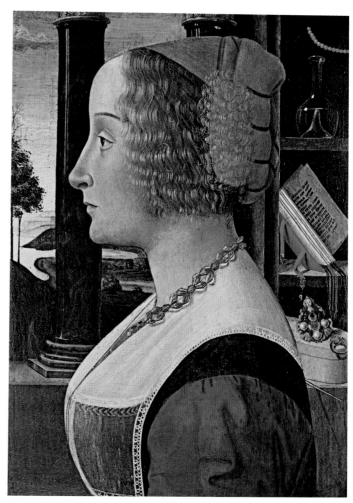

Cat. 122a

Cat. 122b

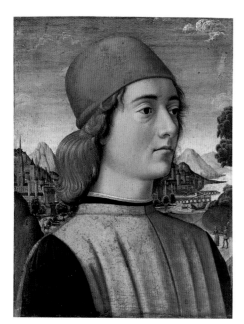

Fig. 106. Davide Ghirlandaio (1452–1525), attributed to, *Portrait of a Young Man*, ca. 1490. Tempera on panel, 17½ × 13½ in. (44.6 × 34.4 cm). Gemäldegalerie, Staatliche Museen zu Berlin

pendants that had found their way into Italy by the late fifteenth century.[6]

The lady in the Huntington pair is placed in an open loggia with marble colonnettes that offset her profile, overlooking a serene landscape with views of water, wending roads, round-headed trees, and distant blue mountains. Although the woman is seen in profile, as is the figure in its fashionable model, the portrait of Giovanna degli Albizzi Tornabuoni, the man is portrayed in a three-quarter view, an innovative Netherlandish portrait type. It is often noted that this setting derives from Memling's *Portrait of a Young Man* in the Metropolitan Museum (fig. 107). Datable about 1475–80, the Metropolitan portrait also inspired a *Virgin and Child* (Musée du Louvre, Paris) once attributed to the workshop of Andrea Verrocchio but more recently to Domenico Ghirlandaio.[7]

The alcove (also a Netherlandish motif) in the Huntington panel displays betrothal gifts that refer to the bride's virtue and honor and her role as wife. At the top hangs a strand of coral beads, which were believed to have propitious effects and were also worn as necklaces and bracelets by infants.[8] The clear glass vase is emblematic of chastity, and the devotional book with page markers and silver-tipped clasps signals the young woman's piety.

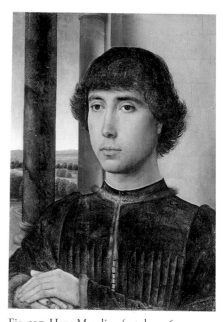

Fig. 107. Hans Memling (act. by 1465– d. 1494), *Portrait of a Young Man*, ca. 1482. Oil on panel, 15¾ × 11⅜ in. (40 × 29 cm). The Metropolitan Museum of Art, New York, Robert Lehman Collection, 1975 (1975.1.112)

On the bottom ledge is a wooden box of the type used to hold bridal gifts, and upon it are a nuptial ring and an ornate brooch with a female figure, gemstones, and three large pearls. These expensive jewels were worn by new brides as emblems of the marriage union and the couple's honor. The foreshortened needle, casting a shadow on the wall, represents wedding gifts of sewing utensils, tokens of domestic virtue (see cat. no. 44).[9]

The modest but refined attire of the woman in the Huntington panel reflects the Florentine sumptuary restrictions imposed in 1472, edicts that were often ignored. According to these laws, a bride could wear only a single brooch and three rings and was forbidden to wear gold or silver jewelry, pearls, crimson cloth, or furs. After three years of marriage had passed, she was forbidden to wear any jewelry.[10] Possibly for this reason (if not simply so that we may see it clearly here), the woman in the painting does not wear her costly brooch. She is clothed in a simple underdress (*gamurra*), and her neckline and shoulders are covered with very fine linen or silk cloth (a garment called a *coverciere*).[11] A small pendant hangs from her crystal-bead necklace. The hair is dressed in a typical Florentine fashion, parted and drawn back to show a high forehead with curly locks falling from the temples over the cheeks, and long tresses wound at the back of the head and secured with ribbons. In this hairstyle the tail end of the plait often escapes in a sort of tassel, but here the ornament may be made of short, light feathers and the chignon of false hair (the subject of much disapproval by the clergy).[12] The vermilion cap (*berretta*) and a red woolen sleeveless tunic (*giornea*) over a black doublet worn by the man in his portrait are likewise standard patrician Florentine attire—the apparent simplicity and uniformity of style are belied by the quality of the fabric and costly dyestuffs.

What can explain the existence of a second version of the Huntington portraits, the ones mentioned above, now in Berlin? Art historians usually surmise that paintings of betrothed or newly married young women, which have survived in greater numbers than pairs, were commissioned by the fiancé or husband or his father for display in the couple's new home. The depiction of betrothal gifts and allusions to marital virtues would serve as daily reminders of status and obligations within the family, as well as new kinship alliances. But no documentation for these pictures survives. Presumably portraits were commissioned by parents as mementos of loved ones—married, called away on business, or deceased—who no longer lived in the natal home. The portrayal of the young woman in the Berlin pair is virtually the same

as that in the Huntington pair, but the man's features—including fair hair—vary enough from the Huntington portrait to suggest he is a different person (fig. 106). The landscape in his portrait is busier and includes a young couple and northern Gothic architecture. Perhaps one pair portrays a married couple and was intended for display in their home, and the other depicts siblings, rather than a married couple, and was commissioned by their parents as a remembrance of their departed son and daughter.

Another possibility is that one of the two pairs was painted later, as a commission or for sale on the art market. By at least the end of the fifteenth century, portraits were collected in Europe not only for genealogical, political, or humanist reasons (for example, famous men [*viri illustri*] as models for conduct, or portraits of friends and professional colleagues) but also for their intrinsic artistic value and interest.[13] The San Marino and Berlin panels would have been valued as innovative portraits of a newlywed couple dressed in the Florentine fashion. One possibility is that Domenico Ghirlandaio's portraits (which were once in the collection of Marchese Gherardi, Florence) were copied by Davide Ghirlandaio in a more detailed manner. The existence of a third version, of inferior quality (Musée Fabre, Montpellier), indicates there was a taste for such novel portraits.[14] The young man in this third version is depicted with a larger nose and dark, bouffant hair. In place of an alcove the female portrait has a landscape. Unlike in the other versions, too, the woman stands in a corner space, and the receding loggia wall is depicted in a perspective view that is closer to that of Memling's *Portrait of a Young Man*. This suggests that the painter (who was probably employed in the Ghirlandaio workshop) was emulating aspects of Memling's painting and not simply copying one of the other versions of the portraits. In any event, without documentation the existence of these different versions remains puzzling.

NE

1. For the attribution, see Everett Fahy's essay in this volume; Bock 1996, p. 74; and David Alan Brown in D. A. Brown et al. 2001, pp. 194–95.
2. See David Alan Brown in D. A. Brown et al. 2001, pp. 190–93, no. 30.
3. For a synopsis of the attributional questions surrounding the portraits, see David Alan Brown in ibid., pp. 194–97, no. 31.
4. L. Campbell 2005, p. 66.
5. Nuttall 2004, pp. 60–69, 148–52, ill.
6. See Nuttall 2005, p. 75; Till-Holger Borchert in Borchert 2005, pp. 155–56, no. 5.
7. See Borchert in Borchert 2005, p. 165, no. 15.
8. Musacchio 2005, pp. 151–53.

9. On Florentine marriage gifts, see Klapisch-Zuber 1982/1985; Randolph 1998; Woods-Marsden 2001, pp. 64–68.
10. For a summary of Florentine fifteenth-century sumptuary laws, see Craven 1997, pp. 182–98. See also Woods-Marsden 2001, pp. 65, 72–74.
11. Orsi Landini and Westerman Bulgarella 2001, p. 90.
12. Levi Pisetzky 1964–69, vol. 2, text, fig. 118.
13. For Italian portrait collections, see Aleci 1998. In Florence, Lorenzo de' Medici owned a portrait of a lady by the Netherlandish artist Petrus Christus; Nuttall 2004, p. 254. Cardinal Grimani's portrait of a man and wife by Memling (see above) was appreciated in Florence for its "Flemish style" and unusual format. On the other side of the Alps, in Mechelen, the cultivated and learned Margaret of Austria was given Jan van Eyck's *Giovanni Arnolfini and His Wife* (National Gallery, London) for her collection; she also owned portraits of Italian merchants as well as a "young lady dressed in the Portuguese fashion"; see Eichberger 1996, p. 268.
14. For this pair, see Anderson 1990, pp. 208–9.

SELECTED REFERENCES: Anderson 1990, pp. 208–9; Simons 1992, p. 52; Craven 1997, pp. 196–97, 298–301; Randolph 1998, p. 196; David Alan Brown in D. A. Brown et al. 2001, pp. 194–97, no. 31, ill.; Woods-Marsden 2001, p. 74

Jacometto Veneziano

Venetian, act. 1472–97

123a. *Portrait of Alvise Contarini (recto); A Tethered Roebuck (verso)*

Ca. 1485–95
Oil on panel, 4⅝ × 3⅜ in. (11.8 × 8.6 cm)
Inscribed on verso: *AIEI*
The Metropolitan Museum of Art, New York, Robert Lehman Collection, 1975 (1975.1.86)

123b. *Portrait of a Woman (recto); Scene in Grisaille (verso)*

Ca. 1485–95
Oil on panel, 4 × 2⅞ in. (10.2 × 7.3 cm)
The Metropolitan Museum of Art, New York, Robert Lehman Collection, 1975 (1975.1.85)

These exquisitely detailed and beautifully preserved miniature portraits in the Metropolitan's Robert Lehman Collection have been of enormous importance to scholars reconstructing the oeuvre of Jacometto Veneziano, who was described shortly after his death as the foremost painter in the world.[1] In 1543 the Venetian collector

and connoisseur Marcantonio Michiel visited the residence of Michele Contarini; he recorded in his notebook that he saw "a little portrait of M[esser] Alvise Contarini son of (q[uondam]) M[esser] . . . who died some years ago. In the same small picture, there is opposite (a l'incontro), a portrait of a nun of San Secondo, and on the cover of these portraits is a small deer (cervetta) in a landscape, and the leather cover of this little picture is decorated with foliage stamped in gold. It is by the hand of Jacometto, a most perfect work."[2] The manuscript's long-disputed reading was recently clarified by Rosella Lauber, who suggested the abbreviation "q[uondam]," an indication of lineage; unfortunately, the name that follows it is no longer legible.[3] The portraits date from about 1485–95.[4] During the late fifteenth century the eminent, extensive Contarini family included several contemporaries named Alvise Contarini, including Andrea il Bello's son, who married Daria Querini in 1481.[5] The portraits are no doubt those recorded in 1565 in the Vendramin collection with an attribution to Giovanni Bellini.[6]

The man—who wears typical Venetian dress, a black robe and a cap—is portrayed against a background that includes views of both land and sea. On the horizon at left is a tiny ship. Michiel's contested identification of the woman as a nun of the Benedictine monastery of San Secondo was recently endorsed by Lauber, who cites Michiel's familiarity with the religious orders in Venice (his sisters were abbesses). She suggests that the small island at left in the background of the woman's portrait depicts the monastery, which was situated between Cannaregio and Mestre. As is often remarked, the lady's unusual attire differs from known images or descriptions of Benedictine dress.[7] Her hair is secured and for the most part covered with fine white veils (and perhaps a cap), one of which is pulled across the forehead. A wimplelike veil covers her neck but leaves the shoulders exposed, whereas nun's wimples serve to cover hair and flesh. Her dark garment reveals a white undergarment or chemise at the neckline and sleeve. Images of Benedictine religious dress typically include a larger black veil worn over white underveils, a dark tunic and scapular, and frequently a mantle to provide coverage. David Alan Brown maintains that "no nun . . . would have chosen to be portrayed in such décolleté," while Angela Dillon Bussi, who attributes the portraits to Alvise Vivarini, contends that this is plausible religious dress. Further evidence may help to resolve the issue.[8] A larger, closely related panel portrait (Cleveland Museum of Art) poses similar questions; the young woman is more modestly covered, and entirely dressed in white,

as was customary for religious novices, but she does not wear an overveil.[9] Instead, could the headdress worn by the woman in the present portrait—possibly inspired by exotic veils and turbans encountered by European travelers in the Near East—have been a short-lived secular Venetian fashion? The subject of Portrait of a Lady attributed to Jacometto in the Philadelphia Museum of Art (John G. Johnson Collection) wears a similar headdress, but her veil covers less hair, trails around her shoulders, and tucks into her bodice.[10]

The imagery on the versos of the Lehman portraits may offer some clues to the subjects' relationship. The reverse of the male portrait depicts a deer resting on a rocky ground, chained by its red collar to a round shield inscribed with the Greek word AIEI (forever), against a fictive porphyry background. Usually misidentified as a hart (male red deer) or hind (female red deer), the animal is clearly a roebuck (Capreolus capreolus), distinguished by its slender build and short antlers from the larger red deer (Cervus elaphus). Since ancient times, the roe has been a familiar image in love poetry (and religious allegory), as in the Song of Solomon: "My beloved is like a roe or a young hart" (2:9); "Make haste, my beloved, and be thou like to a roe or to a young hart upon the mountains of spices" (8:14). The hart or stag was considered to be a lustful animal by such ancient writers as Pliny the Elder. The roebuck, however, was singled out for its monogamous behavior and is therefore associated with chastity or fidelity in marriage. According to Gaston Phoebus's Livre de la chasse (Book of the Hunt), "The roebuck never ruts with more than a single female, and the buck and doe will stay together the whole season. . . . And if you separate them and hunt one of them far from the other, they will rejoin each other as soon as they can, and will seek each other until they are reunited."[11] Although the roebuck shown in the Lehman panel looks young, its image may have been intended to evoke the idea that the deer is an exceptionally long-lived beast. In the first century A.D., Pliny the Elder repeated the legend that stags were captured wearing gold necklaces that Alexander the Great had put on them a hundred years earlier (Naturalis Historia 8.50.119). The circular shield, the inscription AIEI, and the porphyry slab together reinforce the theme of longevity in a marital context; at the same time they may call to mind the perdurability of painted images, as well as the prospect of eternal life.[12]

The imagery on the reverse of the male portrait is most readily explained in the context of conjugal fidelity and the endurance of love even when the couple are separated from each other, perhaps by travel or duty

abroad (which was a frequent occurrence for Venetians), or by death. Citing Marcantonio Michiel's remark that Alvise Contarini "died some years ago" (che morse già anni), Lauber hypothesizes that his portrait may be posthumous (it should be remembered, however, that Michiel saw the portraits about a half century after they were created).[13] If so, the woman's unusual dress may reflect her widowed state. The miniature size of the paintings, and their leather case, made them easily portable, so that the images of beloved ones could be treasured in absentia. As David Brown suggests, the smaller female portrait may have originally nestled in the frame of the larger male one so that the reverses would have been seen when the pair of portraits in their frames were closed, and the portraits displayed side by side when the diptych was opened.[14]

The painting on the back of the female portrait is severely abraded, but it must originally have been quite beautiful and innovative; like the reverse of the pendant piece, which features a display of painted stone, this grisaille seems to be fashioned of a durable material, in this case, gilded bronze. The scene shows a figure in voluminous drapery seated on an islet or high ground at the foot of a cliff. Below and to the left, at the water's edge, is a small, empty boat with an oarlock (forcola), and on the opposite shore is a wooded landscape. In its present state, the scene cannot be deciphered well enough to determine the subject or allegory depicted, but perhaps it also deals with conjugal virtue.

Although he was celebrated as a miniaturist and for his small-scale portraits, there is still no scholarly consensus regarding Jacometto's work as an illuminator.[15] The format of the Lehman portraits—three-quarter profile views of a man and woman against a landscape background, with an emblematic reverse that includes a fictive porphyry backdrop—suggests that Jacometto was influenced by the work of Hans Memling or by other Netherlandish portraitists. Another, slightly smaller version of the Lehman male portrait is in the collection of the Duke of Buccleuch and Queensberry. On its reverse, above the letters AIEI, an additional inscription on the boss is no longer legible.[16] Among several other portraits that have been attributed to Jacometto is Portrait of a Young Man (National Gallery, London) whose reverse bears an inscription from Horace's Odes (1.13.17–18), FELICES TER ET AMPLIVS QVOS IRRVPTA TENET COPVLA (More than triple happiness comes to the couple bound together as one), and a pair of crossed laurel branches tied together.[17] The sentiment is similar to that expressed on the reverse of the Contarini panel, for the laurel, used here in

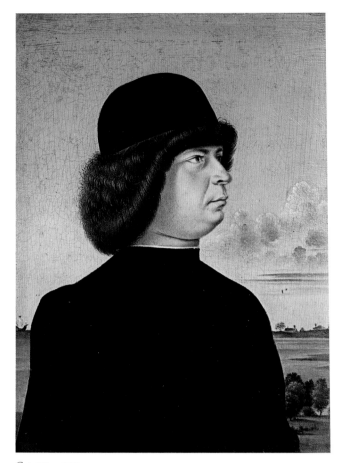

Cat. 123a, recto

Cat. 123b, recto

Cat. 123a, verso

Cat. 123b, verso

a nuptial context, stands for virtue, chastity (that is, marital fidelity), and eternity—the everlasting union of the couple.

<div style="text-align:right">NE</div>

1. For Jacometto Veneziano, see Humfrey 2000, citing the 1497 letter of the humanist Michele da Placiola lauding the artist.

2. Lauber 2005, pp. 97–99, transcribed and analyzed the relevant passage from Michiel's manuscript (Biblioteca Nazionale Marciana, Venice, Ms. It. XI, 67: "Vi è uno ritratto picolo de M[esser] Alvixe Contarini q[uondam] M[esser] . . . che morse già anni, et ne l'instesso quadretto un ritratto a l'incontro d'una monacha da San Segondo, et sopra la coperta de detti ritratti una cervetta in un paese, et nella coperta de cuoro de detto quadretto fogliami di oro maxenato, di mano di Iacometto, opera perfettissima."

3. Lauber 2005, pp. 97–99.

4. See David Alan Brown in Brown et al. 2001, pp. 154–57, no. 19.

5. Lauber 2005, p. 115, n. 195.

6. "Un quadreto de man de Zuan Belin con una figura de dritto et de roverso una cerva. Un altro quadreto con una munega de man de Zuan Belin" (A small picture by the hand of Giovanni Bellini with a figure on the recto and a deer on the verso. Another small picture with a nun by the hand of Giovanni Bellini); Pope-Hennessy 1987, p. 242.

7. On religious dress, see Koslin 1999.

8. David Alan Brown in D. A. Brown et al. 2001, p. 154; Dillon Bussi 1995, p. 41, n. 29.

9. For this portrait, see Lauber 2005, pp. 97, 114, n. 183, fig. 22, pl. VI.

10. See David Alan Brown in D. A. Brown et al. 2001, pp. 160–61, no. 21, ill.

11. Quoted in Cummins 1988, p. 89. For the roebuck, see Friedmann 1980, pp. 131, 205–7; and Cummins 1988, pp. 87–92.

12. On the symbolic use of porphyry, see Mundy 1988; and Dülberg 1990, pp. 116–27.

13. Lauber 2005, p. 99.

14. David Alan Brown in D. A. Brown et al. 2001, p. 154. The objections of Dillon Bussi (1995, pp. 34–35) and Mauro Lucco (in Lucco 2006a, p. 334) that the Metropolitan portraits could not be those described by Michiel as two portraits in a single little picture (*quadretto*) may be rebutted by a similar use

of the singular *quadro* to describe a folding diptych of portraits of Franceso Sforza and Bianca Maria Visconti, for which see the essay by Everett Fahy in this volume.

15. See Lauber 2005, pp. 113–14, n. 180.
16. See Peter Humfrey in Humfrey et al. 2004, pp. 68–69, no. 6.
17. Dülberg 1990, pp. 111, 131, 228, no. 168, figs. 121, 122; David Alan Brown in D. A. Brown et al. 2001, pp. 158–59, no. 20.

SELECTED REFERENCES: Szabó 1975, pp. 54–56, pls. 53–56; Mundy 1977, p. 39, figs. 8, 9; Pope-Hennessy 1987, pp. 240–43, nos. 96, 97, ill.; Dülberg 1990, pp. 33, 41–42, 124–26, 236–37, nos. 183, 184, figs. 75–80; David Alan Brown in D. A. Brown et al. 2001, pp. 154–57, no. 19, ill.; Lauber 2005, pp. 96–99, figs. 19, 20; Mauro Lucco in Lucco 2006a, pp. 334–35, no. 69, ill.

Lorenzo Lotto

Venice, ca. 1480–Loreto, 1556

124. Portrait of a Married Couple

Ca. 1523–24
Oil on canvas, 37⅞ × 45¾ in. (96 × 116.2 cm)
Inscribed on paper in man's hand: HOMO NUM / QUAM
The State Hermitage Museum, Saint Petersburg
(GE 1447)

A brilliant and innovative portrait painter, Lorenzo Lotto was foremost among Italian artists in his use of portraiture to express complex ideas and feelings about the state of matrimony and the relationship between couples. Employing novel formats, such as the double portrait, and clever emblematic motifs, Lotto alludes to his sitters' deepest sentiments and spiritual life. His ingenious, emotive approach to portraiture and his virtuoso physical description are both evident in this picture of a married couple. Lotto's keen appreciation of the couple's luxurious dress and belongings is conveyed by the sheer volume of fabric—from fine white linen to black damask—the intricate patterns of exquisitely embroidered collars and cuffs, the glint of gold rings and entwined necklaces, and the textures of squirrel and terrier fur. Lotto also relishes the rich colors and lustrous pile of the precious Anatolian table carpet, typical of the Uşak region of Turkey.[1]

Scholarly debate has centered on both the identity of the sitters and the interpretation of the emblematic conceit suggested by the squirrel and inscription HOMO NUM QUAM (man never) on the paper held by the husband.[2] The work has been dated to about 1523–24, when Lotto lived in Bergamo. In 1992 Maria Serena Amaglio identified the couple as Antonio Agliardi, an engineer of that North Italian town, and Apollonia Cassotti, daughter of the cloth merchant Zanin, who commissioned, among other paintings, the nuptial portrait of his younger son, Marsilio, and his wife (fig. 7).[3] To support her claim, Amaglio noted that the husband in the present picture wears a sword, in keeping with Agliardi's position in the militia, and his wife wears a fashionable golden cap (*scufia*) with flower motifs identical to the one worn by Agnese Avinatari, the second wife of Paolo Cassotti, Zanin's brother, in Andrea Previtali's *Virgin and Child with Saints Paul and Agnes and Paolo and Agnese Cassotti* (Accademia Carrara, Bergamo; ca. 1520–23). These caps, according to the argument, would have identified the women as members of the Cassotti family. Mauro Lucco refuted Amaglio's identification of the sitters—which is, however, supported by Francesca Cortesi Bosco and Augusto Gentili—because the couple portrayed look younger than the approximate ages of Antonio and Apollonia (perhaps fifty-two and thirty-five) at the time the canvas was painted, and also because such a cap, if a Cassotti family possession, would have passed down the male line and not to a woman (Apollonia Cassotti) marrying into another family (Agliardi).[4] Lucco's alternative hypothesis that the picture represents Zanin's older son, Gian Maria Cassotti, and the latter's recently deceased wife, Laura, has not gained acceptance.[5] Until more compelling evidence is forthcoming (a probable crest on the man's ring is no longer discernible), the identity of the sitters remains uncertain.

The emblematic meaning of the portrait, likewise a topic of discussion, may be deliberately ambiguous. Diana Wronski Galis offered a reading of the inscription, HOMO NUM QUAM (man never), as a conflation of two passages in the marriage ceremony read by the priest.[6] Cortesi Bosco expounds upon this reading, noting the relevant passages from the marriage mass in the Roman Missal (*Missale romanum*).[7] The first, from the Gospel of Saint Matthew (19:6), is recited after the couple exchange vows and the priest joins their hands: "What therefore God hath joined together, let no man put asunder [*homo non separet*]." The second passage follows shortly afterward, when the priest prays, "O God, who . . . didst teach that it should never be lawful to put asunder those whom thou by Matrimony hadst made one [*nunquam liceret disjungi*]." In Galis's oft-repeated interpretation, the inscription alludes to matrimonial fidelity, reinforcing the symbolism of the dog held in the crook of the wife's left arm, as she rests her right hand on her husband's shoulder. Although it should be noted that the precise phrase *homo num quam* is not found in scripture or in the words of the marriage ceremony—which was not standardized in Italy under the authority of the church at this date—the Latin words may indeed have invoked marriage vows. In any event, the conjugal bond between the couple is clearly expressed by such details as the woman's hand near her spouse's heart and the placement of his ring at the painting's fulcrum.

Since the husband, who holds the paper with the inscription, points to the squirrel crouching on the table, the phrase "man never" probably relates to the animal. Marzia Di Tanna ascertained that it is a Eurasian red squirrel (*Sciurus vulgaris*) and linked its lethargic state to a passage in a source well known during the Renaissance, Pliny the Elder's *Naturalis Historia* (8.138,58): "Squirrels also forsee a storm, and stop up their holes to windward in advance, opening doorways on the other side; moreover their own exceptionally bushy tail serves them as a covering. Consequently some have a store of food ready for the winter and others use sleep as a substitute for food."[8] In fact, squirrels do not hibernate, but they do stay in their nests during strong winds and storms unless forced to find food. In the present portrait, the landscape viewed through the window shows two trees bending against a cloudy sky, and Lotto's squirrel arches its tail for protection. Thus, in addition to its diligent gathering of provisions, the squirrel is notable for its prescience, which accounts for its depiction in Lotto's *Madonna and Child with Saints John the Baptist and Catherine* (Palma Camozzi Vertova Collection, Costa di Mazzate, Bergamo; 1522), where a lively squirrel foresees Christ's eventual sacrifice on the cross.[9] In the present picture the squirrel chooses to sleep through the storm, and the inscription can be read as a declaration that the man will not abandon his husbandry—his duty to provide for his family, whatever "storms" may come.[10]

The town of Bergamo experienced various political and religious upheavals in the early sixteenth century. During this period, astrological prognostications—of flooding, bad harvests, epidemics, and so on—were widely disseminated in pamphlets and by other means throughout Italy and Germany. Especially alarming was the prediction of a universal flood resulting from the conjunction of the major planets under the sign of Pisces in February 1524.[11] Although the prediction was deemphasized or dismissed by some pamphlet writers, others viewed it seriously, fearing divine punishment. As the fateful date approached, there was fear and

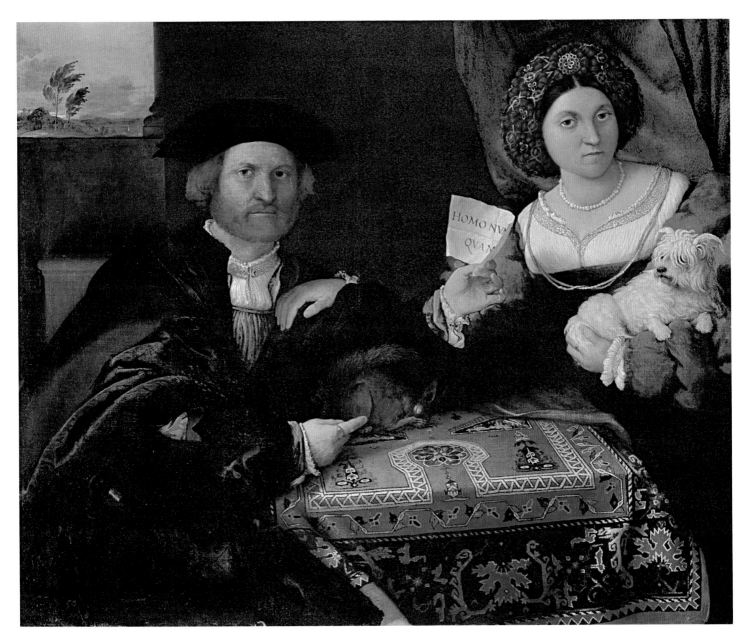

Cat. 124

trepidation throughout Italy, compounded in Bergamo by terrible weather in the summer of 1523, including fierce thunderstorms, overflowing rivers and lakes, and an outbreak of plague in the new year. In January 1524, every family in Bergamo was required, on penalty of a fine, to participate in Sunday processions to invoke God's protection of the city. Cortesi Bosco placed the present painting in the context of these extraordinary meteorological events of 1523–24 and proposed that the inscription refers to the man's refusal to behave like a sleeping squirrel, to react passively in the face of adversity. Although the precise meaning of the inscription and other aspects of the work remain elusive, the portrait nonetheless conveys a touching impression of marital concord and mutual support, perhaps at a moment of civic peril.

The inscription in the Saint Petersburg painting may have been suggested by the Madrid double portrait of Marsilio Cassotti

and his bride, Faustina, painted in 1523. It depicts the central moment in the marriage rite, when the groom places a ring on the finger of the bride and they become man and wife. As mentioned above, the work was a gift of the groom's father, listed in Lotto's account as: "the painting with the portraits, that is Messer Marsilio and his wife with the little Cupid, regarding the representation of those clothes of silk, caps [*scufioti*], and necklaces."[12] In this picture portraying the obligations and rewards of marriage, Lotto plays on the Latin word for wedlock—*coniugium*, or *con giogo* (with a yoke) in Italian, as an impish Cupid lowers a yoke upon the couple's shoulders. Evergreen laurel branches symbolize their virtue and eternal love; sprouting from the yoke, the laurel suggests both chastity and fertility.

Like the Saint Petersburg picture, the Madrid portrait invokes marital harmony, duty or servitude, and faithfulness. Faustina

wears a gold necklace, the *vinculum amoris* that symbolized conjugal chains or ties, hung with a cameo of her namesake, the Roman empress Faustina the Elder, who was well known in the Renaissance from coinage with her image and the inscription CONCORDIAE (Harmony) and who was considered to be an exemplary wife.[13] Lotto was also inspired by ancient Roman representations of a personification of Concordia or Juno Pronuba (sometimes at a later date a cupid) joining a couple in matrimony, which he probably knew from imagery on marriage sarcophagi or other sources. In this portrait, Lotto captures the blithe optimism of newlyweds who have not yet tested their wedding vows, whereas in the Saint Petersburg portrait the older couple appear to have been put to the test and renew their pledge of marital support.

NE

1. On Lotto's carpets, see Mack 1997.

2. Alexander Nagel (1998, pp. 743–44) notes that the symbolic language of Lotto's portraits—including the Saint Petersburg picture—makes them susceptible to radically different readings and cautions against interpretations that do not acknowledge the limitations in understanding them.

3. Amaglio 1992. For the documentation of Lotto's paintings for Zanin Cassotti, see Gentili 1989, pp. 155–56.

4. Mauro Lucco in D. A. Brown, Humfrey, and Lucco 1997, pp. 148–51, no. 25; Cortesi Bosco 1993; Gentili 2000, pp. 14–18, 37, nn. 26, 27. For further discussion of the cap as inconclusive evidence for the identification of the sitters, see B. L. Brown 2009. Luxury objects such as the *scufia* and other items of clothing and jewelry were also loaned, rented, or acquired on the secondhand market.

5. Lucco in D. A. Brown, Humfrey, and Lucco 1997, pp. 148–51, no. 25. Lucco perceives that the husband is weeping. See also Lucco in F. Rossi 2001, p. 136.

6. Galis 1977, p. 238.

7. Cortesi Bosco 1993, pp. 340, 349, n. 54, cites the 1516 edition of the *Missale romanum* published in Venice, fols. 212v–213.

8. Pliny the Elder, *Natural History*, 1966–75 (ed.), vol. 3 (1967), p. 99.

9. Lucco in D. A. Brown, Humfrey, and Lucco 1997, pp. 125–27, no. 18; and Gentili 2000, pp. 7–8.

10. A preparatory drawing (Rijksmuseum, Amsterdam) delineates the general scheme of the painting. The husband holds up a paper and points to a sketchy object that has been identified by Stefano Giani (2005, p. 144) as a crouching squirrel viewed frontally, rather than in profile as in the painting.

11. Cortesi Bosco 1993, pp. 339–40; see also Cortesi Bosco 1980, pp. 3–7.

12. For the Prado portrait, see Van Hall 1976; Galis 1977, pp. 234–36, 397–402; Humfrey 1997, pp. 70–71; Lucco in D. A. Brown, Humfrey, and Lucco 1997, pp. 134–37, no. 21; and B. L. Brown 2009. The Kimbell Art Museum gratefully acknowledges the Prado's very generous loan of this iconic marriage portrait for display in the present exhibition.

13. See B. L. Brown 2009.

SELECTED REFERENCES: Galis 1977, pp. 237–41, 385–92, no. 74, fig. 16; Fahy 1979, pp. 81–88, pls. 23–25; Di Tanna 1990, pp. 47–50, ill. p. 44; Cortesi Bosco 1993, pp. 336–49, fig. 191; Meijer 1995, p. 135, under no. 49; Humfrey 1997, pp. 70–72, pl. 82; Mauro Lucco in D. A. Brown, Humfrey, and Lucco 1997, pp. 148–51, no. 25, ill.; Gentili 2000, pp. 14–23, figs. 10, 11, 14

Bernardino Licinio
Venetian, ca. 1490–after 1549

125. Portrait of a Woman Holding a Portrait of a Man

Ca. 1525–30
Oil on canvas, 30½ × 36⅛ in. (77.5 × 91.5 cm)
Museo d'Arte Antica del Castello Sforzesco, Milan (28)
New York only

In recent discussions, this unidentified Venetian woman has invariably been described as a widow, recognizable as such from her black dress, holding a portrait of her deceased husband. In sixteenth-century Venice, however, black was not worn exclusively by widows, who typically covered their hair with veils and wore little or no jewelry (see the entry for cat. no. 133).[1] Rather, the lady's dress is surely that of a Venetian matron, as can be seen by comparing it with the attire of the female subjects of other portraits by Bernardino Licinio—including examples in the Accademia Carrara, Bergamo, and the Gemäldegalerie Alte Meister, Dresden—and similar portraits by his contemporaries.[2] In fact, the accessories of her dress denote her married status and may well have been betrothal gifts or part of her *donora,* or trousseau. The expensive necklaces of pearls, an allusion to purity, were de rigueur for young Venetian matrons. Her *scufia* (cap) was quite fashionable during the 1520s, as was the so-called paternoster belt of large gold beads around her waist, a piece of jewelry associated with the bonds of marriage.[3] Among foliate motifs stitched in golden thread, dogs and other animals—both running and in repose—decorate the neckline of the woman's delicate *camicia* (undershirt). A bride's trousseau might include *camicie* of the finest linen, which during the sixteenth century were often embellished with exquisite needlework.[4] Several of Licinio's portraits, including the two mentioned above, show ladies wearing gowns with low-cut, square-necked bodices that reveal bands of embroidered floral motifs on the borders of the *camicia* or on the partlet (*bavaro*) covering the breast and shoulders. *A Portrait of a Woman* by an unknown Venetian artist (National Gallery, London; ca. 1510–20) depicts similar embroidery on the neckline of the bodice featuring dogs chasing a hare.[5] Such scenes representing "the chase of love" appear frequently on betrothal objects, among them the ivory comb in this volume (cat. no. 37); the dog, of course, is a common symbol of marital fidelity.[6] In the present portrait, the bearded man in the framed portrait held by the woman wears a stylish doublet with decorative slashing over

a white *camicia* with an embroidered collar. The dress of both sitters is consistent with a date of about 1525–30. In the early nineteenth century the painting was cut into several pieces—one slit ran along the right edge of the frame of the male portrait—but they were reassembled and reattached during a conservation campaign in 1955.[7]

Portraits such as this one or the Venetian painter Giovanni Cariani's half-length *Portrait of a Man* (private collection; ca. 1510–14), which depicts the sitter looking intensely toward the viewer and holding a small framed portrait of a woman in profile, are usually thought to depict the subject with a representation of a deceased spouse.[8] Since the woman in the present portrait is not in mourning, however, it is more likely that her portrait was commissioned because her husband was about to be separated from his family, perhaps for professional reasons. Another possibility is that the portrait of the woman is posthumous and that the presence of her husband's portrait in the picture expresses the conjugal devotion of the couple and also memorializes it for posterity.[9] The impression of vitality conveyed by the two sitters here is not a reliable indicator that either portrait is posthumous, even though Licinio's likenesses are in general somber and psychologically inaccessible. His painting of the family of his brother Arrigo Licinio (Borghese Gallery, Rome), for example, includes a likeness of his sister-in-law, Agnese—who was presumably painted while still alive—with a melancholy expression.[10] A portrait formerly in the collection of the earl of Carlisle, Castle Howard, and attributed to Licinio—possibly created in his workshop—depicts the sitter, Helena Capella, with a comparably sad and remote gaze. Her dress is similar to that of the woman in the present portrait, though it is less luxurious; she wears no jewelry and carries a devotional book. An inscription on a stone parapet indicates that the portrait commemorates her death, after having given birth to six children in seven years of marriage.[11] On the whole, it seems unwise to draw conclusions about the people in Licinio's pictures in the absence of independent evidence about them. The subject of his *Woman with a Musical Score and Two Men* (Koelliker collection, Milan; ca. 1520), though more beautiful than Helena Capella, stands in a pose almost identical to hers, and her male companions in the painting have the look of individuals, yet the picture is probably allegorical and not a portrait at all.[12]

Licinio was much in demand as a portraitist in Venice. His success can be attributed to a sober realism rooted perhaps in his Lombard ancestry, which moderated the poetic temper of his Venetian training.　NE

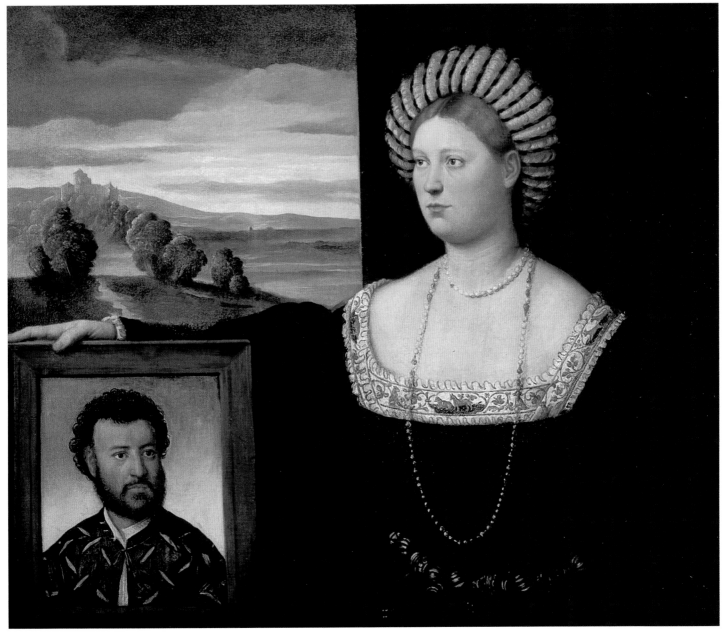

Cat. 125

1. Jane Martineau's assertion to the contrary, the frame of the portrait under her arm is not black and does not indicate that the sitter is deceased. Jane Martineau in Chambers and Martineau 1981, p. 164, no. 113.

2. See Vertova 1980, p. 411, no. 6, ill. p. 387, for the Bergamo portrait, and p. 416, no. 32, ill. p. 454, no. 3, for the Dresden portrait.

3. On the *scufia*, see Penny 2004, pp. 87–88. For the belt, see Levi Pisetzky 1964–69, vol. 3, pp. 97–100; and Economopoulos 1992, pp. 108–12.

4. For *camicie*, see Levi Pisetzky 1964–69, vol. 3, pp. 76–77.

5. Baker and Henry 2001, p. 351, ill.

6. For "the chase of love" theme, see Beverly Brown's essay "Picturing the Perfect Marriage" in this volume; P. F. Watson 1979, pp. 91–102; and Seidel 1994, pp. 36–40.

7. Giorgio Fossaluzza in Fiorio 1997, p. 321.

8. Dülberg 1990, p. 64, fig. 726.

9. It has been suggested that Licinio's *Portrait of a Woman and Her Three Sons* (State Hermitage Museum, Saint Petersburg) includes a posthumous portrait of one of the sons. See Irina Artemieva in Artemieva and Guderzo 2001, pp. 78–79, no. 15.

10. See Andrea Bayer in Bayer 2004, p. 117, no. 26.

11. The work was offered at Christie's, New York, on January 11, 1991, lot 21.

12. See Peter Humfrey in Humfrey et al. 2004, pp. 100–101, no. 23.

SELECTED REFERENCES: Vertova 1980, p. 425, no. 70, ill. p. 454, no. 2; Jane Martineau in Chambers and Martineau 1981, p. 164, no. 113, ill.; Fiorio and Garberi 1987, p. 85, no. 109, ill.; Economopoulos 1992, p. 112, ill. p. 113; Simons 1995, pp. 274–76, fig. 11.1; Giorgio Fossaluzza in Fiorio 1997, pp. 321–23, no. 221, ill.; Levy 2003b, p. 223, fig. 13.4; Marina Santucci in *Tiziano* 2006, pp. 258–59, no. C45, ill.

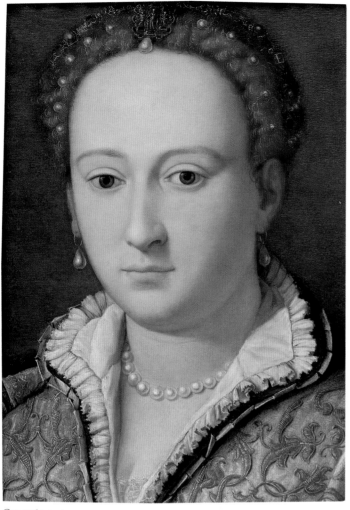

Cat. 126a, recto

Cat. 126a, verso

Alessandro Allori

Florentine, 1535–1607

126a. Portrait of Bianca Cappello (recto) and Michelangelo's "Dream of Human Life" (verso)

Early 1570s
Oil on copper, 14⅝ × 10⅝ in. (37 × 27 cm)
Galleria degli Uffizi, Istituti Museali della Soprinten-
denza Speciale per il Polo Museale Fiorentino,
Florence (1890.1514)

Raffaello Gualterotti

Florence, 1543–1639

126b. Feste nelle nozze del serenissimo Don Francesco Medici Gran Duca di Toscana; et della sereniss. sua consorte la sig. Bianca Cappello (Celebrations for the marriage of the most serene Don Francesco de' Medici, Grand Duke of Tuscany; and his most serene consort Bianca Cappello)

Florence: Stamperia de' Giunti, 1579
Printed book with engravings by Accursio Baldi
(Monte Sansevino, act. 1570–1607) and Bastiano
Marsili, overall 9 × 6⅛ × ⅝ in. (22.8 × 15.5 × 1.5 cm)
The Metropolitan Museum of Art, New York, Harris
Brisbane Dick Fund, 1931 (31.34)

In 1565 Francesco de' Medici married
Giovanna of Austria in a suitably extrava-
gant ceremony. A pious woman who was
daughter and sister to successive Hapsburg
emperors, Giovanna was a valuable asset to
Florentine political ambitions. The Medici
had only become dukes a generation earlier,
with Francesco's father, Cosimo, and they
were keen to enhance their status through
marriages to Europe's more long-standing
political elite. However, this did not stop
Francesco from beginning an affair with
the married Venetian noblewoman Bianca
Cappello in 1564.

This small, two-sided painting by the
prolific court artist Alessandro Allori is a

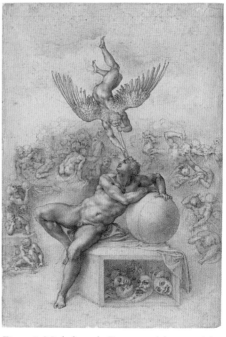

Fig. 108. Michelangelo Buonarroti (1475–1564),
The Dream of Human Life, ca. 1535–36. Black
chalk on paper, 15⅝ × 11 in. (39.6 × 27.9 cm).
The Samuel Courtauld Trust, Courtauld
Institute of Art Gallery, London

product of that affair (cat. no. 126a). Bianca is represented on the front, dressed in expensive silver-and-gold brocade over a bright white shirt, her carefully coiffed hair set with a headdress of gold, gems, and pearls and a delicate brooch representing Venus and Cupid. The painting is not dated, but Bianca, who was born in 1548, seems to be in her mid-twenties; contemporary sources reveal that, only a few years later, her problematic health caused considerable bloating and weight gain and altered her appearance dramatically. The first securely dated portrait of Bianca, a medal by Pastorino de' Pastorini dated to the time of her marriage to Francesco in 1578, showed her with a more aged and matronly appearance.[1] Allori's portrait, on the other hand, was probably commissioned by Francesco shortly after 1572, making it the earliest known portrait of her. In that year her philandering husband was murdered, and Bianca's widowhood gave her considerable freedom to continue her affair with Francesco. This portrait may have been the first time she posed for Allori. The two developed a mutually beneficial professional relationship: Bianca stood as godmother to his son Angelo in 1580[2] and hired him to paint several portraits of herself and her own son Antonio.[3]

But the real mystery is the reverse of the painting, which is painted with a version of Michelangelo's allegorical drawing known as *The Dream of Human Life* (fig. 108). Michelangelo's original represents a young man, sitting on a box and leaning on a globe, who is startled awake by a trumpeting angel. Fragmentary but often explicit vignettes of what seem to be the Seven Deadly Sins—gluttony, lust, avarice, pride, wrath, envy, and sloth—are arranged around him, as if lingering remnants of his dream. In most interpretations, the angel is thought to be calling the youth away from sin, to the virtuous path and divine beauty.[4] This drawing was well known by the 1570s through engravings by the French printmakers Nicolas Béatrizet and Antoine Lafréry and several contemporary painted copies.

Yet it is difficult to reconcile Allori's inclusion of this allegory with Bianca's portrait. Certainly an awareness, and an appreciation, of Michelangelo was part of Florentine court life. Allori was much influenced by Michelangelo, and he was one of the artists who executed paintings for the master's funeral in 1564.[5] And Francesco de' Medici, like his father before him, collected Michelangelo's work. But the potential negative meaning of this allegory—as a commentary on sin, for example—seems inappropriate in relation to Bianca, whose status as ducal mistress already gave her a problematic reputation. But Allori's recasting of certain elements seems to tone down the more sinful details, especially those pertaining to lust, making the painting a statement on the cleansing and purifying force of love, and an appropriate message to celebrate Francesco's lover.[6]

Francesco probably gave this painting to Bianca when he was still married to his first wife, as a token of his devotion. It would have fit well in Bianca's elaborately decorated chambers, where she was known to entertain visiting dignitaries and Florentines alike.[7] Because it is so carefully executed on front and back, both sides must have been visible in its original installation. In fact, it may have been placed into a framework for a box lid, with her portrait on the exterior and the more complex allegory inside, hidden from the casual viewer. Her son Antonio's estate inventory, compiled at his death in 1621, included "a little walnut box with a portrait on copper of Signora Bianca" in his extravagant gallery of paintings.[8] It was one of at least ten paintings of Bianca in his home, many of which must have been deposited there following the sudden deaths of both Bianca and Francesco in 1587 and the subsequent rise of Francesco's brother Ferdinando as grand duke.[9]

Allori's painting was a relatively private object for a limited audience, made at a time when Francesco could not publicize his relationship with Bianca without angering his powerful Hapsburg in-laws. The situation changed, however, when Giovanna of Austria died of a miscarriage in April 1578. Less than two months later Bianca and Francesco secretly married, and in October 1579 they celebrated their marriage publicly and Bianca became grand duchess. Although most Florentines, as well as most members of the prominent European courts, were aware of their marriage, Francesco's vulnerable political position required him to at least attempt to mollify the Hapsburgs by waiting a year after Giovanna's death for those public festivities.

Francesco's second marriage was ostensibly for love: Bianca brought few political assets, and even less money, and was already condemned as a scandalous foreign whore by many Florentines, who disapproved of the long, public affair. As a result, the wedding

Cat. 126b, title page

and its associated events did not celebrate the acquisition of new political connections as much as they tried to promote Bianca's position and reputation. There is little doubt that Bianca planned some of these events herself with this in mind. Beginning on October 4, the Medici celebrated with a ceremonial entrance, tournaments, Bianca's coronation, a hunt, and a theatrical performance, in some of the most important sites of the city. Talented musicians, many of whom were already in the ducal service, such as the composers Alessandro Striggio and Piero Strozzi and the singer Giulio Caccini, also participated, providing entertainment for the court, its official guests, and the curious Florentines.

The festival book exhibited here (cat. no. 126b) records these events. During the Renaissance it was common practice to commission a festival book on the occasion of an auspicious court event such as a marriage, funeral, baptism, or coronation. The books were printed for distribution under the auspices of the court itself, and they served as mementos for those who attended the events and as glorified descriptions for those who did not. Most festival books were self-congratulatory and propagandistic, using the power of both words and images to advance a political agenda. This one, which was dedicated to Bianca herself, was no exception. The author, Raffaello Gualterotti, was a dutiful courtier and amateur astrologer who corresponded with Galileo. His lucid prose style combined with Accursio Baldi and Bastiano Marsili's sixteen engravings of the stage set and the processional carts to describe the exceedingly complex performance in vivid terms.

The key event, and the one Gualterotti described in the most detail, was the *sbarra*, or pageant, in the Palazzo Pitti courtyard on October 14. The venue was a deliberate choice, and one loaded with political significance. The Pitti was a Medici residence, purchased by Francesco's mother, Eleonora of Toledo, in 1539 and connected to the family's other home in the Palazzo Vecchio via a long corridor constructed by Giorgio Vasari. Viewers were arranged under the arches of the Pitti

courtyard and at windows and balconies. An engraving in the festival book (fig. 26) shows the courtyard tented with a large cloth, from which seventy winged putti hang, each bearing a gilt candelabra to help light the scene below. The scenery included various mountains (which hid some of the musicians), huts, fountains, the city of Delphi, and the temple of Apollo, as well as painted perspectival panels that expanded and defined the space. A series of ornate carts, laden with performers and accompanied by automatons, passed through the courtyard to tell the story of a Dalmatian woman whose husband was held prisoner by a sorceress. He could escape only if the crown worn by the fantastic dragon that guarded him was placed on the head of the most worthy princess in the world, who was, of course, Bianca herself. And indeed, at the culmination of the drama the god Apollo retrieved the jeweled crown from the fire-breathing dragon and placed it on Bianca's head. Apollo's appearance as the hero of this story was not surprising, since his traditional connection with medicine had real resonance for the Medici. Their name, of course, means "doctors" in Italian, and they had long associated themselves with the doctor saints and Christian martyrs Cosmas and Damian.[10] Clearly Bianca adopted these important Medici symbols, such as the Pitti and Apollo, to help promote her cause.

The somewhat strained narrative of the imprisoned Dalmatian knight became the excuse for the extravagance to follow. There were ten carts, each with a tableau of astonishing musical, visual, and even pyrotechnical entertainments. Venus appeared twice; the engraving illustrated here represents her second visit, as Anadyomene Venus (Venus Rising from the Sea) in a shell-shaped cart pulled by two doves and accompanied by Tritons, Graces, Furies, and a band of torch-bearing putti. When one of the Graces struck a nearby mountain with Venus's scepter, it opened with great fireworks and revealed Cyclops at Vulcan's forge, singing a madrigal by Maffio Veniero. At the end of the song two Venetian knights strode out, ready to participate in the tournament held later that

day. Fire-breathing automatons interrupted the jousting to draw the spectacle to a close.

These fantastical festivities, said to cost what was then the enormous sum of three hundred thousand ducats,[11] did little to make Florentines embrace their new grand duchess. Although both she and Francesco did everything they could to improve her reputation, Bianca never enjoyed the favor of her adopted city and Francesco's reign represents a low point in Medicean history. But Gualterotti's efforts for Francesco and Bianca did not hurt him when Francesco's brother Ferdinando came to power in 1587. Ferdinando hired Gualterotti to compose the festival book celebrating the entry of his own future bride, Christine of Lorraine, into Florence in 1589, no doubt because he was impressed by what Gualterotti had accomplished, under very different circumstances, for Francesco and Bianca.[12]

JMM

1. Langedijk 1981–87, vol. 1, p. 323, no. 12,18.
2. Lecchini Giovannoni 1991, p. 11.
3. Allori, *I ricordi*, 1908 (ed.).
4. Panofsky 1939, pp. 223–25; and Summers 1981, p. 215.
5. Lecchini Giovannoni 1991, p. 306.
6. Marabottini 1956.
7. Musacchio 2007, pp. 487–88.
8. Archivio di Stato, Florence, Guardaroba Medicea 399, fol. 266r, "uno scatolino di noce da ritratti entrovi un ritratto in rame della Sig.ra Bianca."
9. Musacchio 2007, p. 491.
10. Hanning 1979, pp. 502–3.
11. Nagler 1964, p. 50.
12. Saslow 1996, pp. 189–96.

Selected references: *126a*. Marabottini 1956; Langedijk 1981–87, vol. 1, p. 314, no. 12,8, ill.; Lecchini Giovannoni 1991, pp. 305–6, no. 191, figs. 426, 427; Simona Lecchini Giovannoni in *Magnificenza alla corte dei Medici* 1997, p. 208, no. 162, ill.; Jonathan Katz Nelson in Falletti and Nelson 2002, pp. 221–22, no. 41, pl. XV, 1

126b. Nagler 1964, pp. 49–57; Blumenthal 1973, p. 72, no. 27; Fabbri, Garbero Zorzi, and Petrioli Tofani 1975, pp. 131–35, nos. 9.4–9.19

Domenico Ghirlandaio
Florentine, 1448/49–1494

127. *Francesco Sassetti and His Son Teodoro*

Ca. 1488
Tempera on panel, 33¼ × 25⅛ in. (84.5 × 63.8 cm);
painted surface 29⅞ × 20⅞ in. (75.9 × 53 cm)
Inscribed at top: *FRAN[CISCV]S SAXETTVS THEODORVSQUE. F[ILIVS]*
The Metropolitan Museum of Art, New York,
The Jules Bache Collection, 1949 (49.7.7)

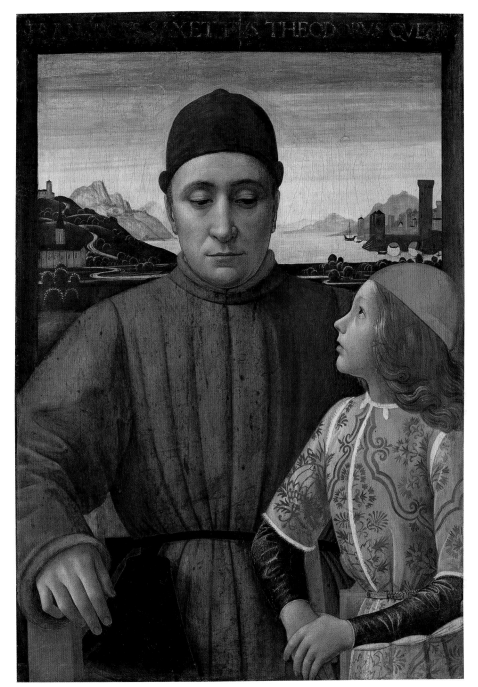

Cat. 127

This intriguing double portrait is one of the earliest Renaissance paintings of a man and child. The full-face presentation of the adult sitter is also unusual. A Latin inscription at the top of the panel identifies him as Francesco Sassetti and the child as his son Teodoro. The inscription is not original and, as Federico Zeri observed, it is written in the window embrasure, flattening the intended perspective.[1] The identification of the subjects, however, is generally accepted. Francesco Sassetti (1421–1490) began his career in the Geneva branch of the Medici bank and rose to become general manager of the banking empire. His firstborn son, Teodoro (1460–1479), died the same year that his youngest son, also named Teodoro, was born. Debate in the last century has focused on the date of the panel and on which Teodoro is represented. Most scholars now accept the Metropolitan portrait as a work by Domenico Ghirlandaio—with the exception of Ronald G. Kecks, who considers it to be by a follower—and date it to the mid- to late 1480s, while at the same time acknowledging that Sassetti looks middle-aged rather than in his sixties.[2] It follows that the child, who looks about nine years old, must be Teodoro II.

The painting, whose early provenance is untraced, was owned in the nineteenth century by the Scottish collector William Graham (1817–1885). He purchased works from dealers on trips to Italy in the late 1860s and early 1870s, and the artist-dealer Charles Fairfax Murray sent him paintings from Florence. When Graham's collection went to auction at Sotheby's in 1886, this painting was one of the most expensive lots, acquired for 510 guineas by Robert Benson, a family friend, through the dealer Colnaghi.[3] In 1927 the Benson collection was purchased en bloc by Duveen Brothers, who sold the Sassetti double portrait the same year to

financier Jules Bache, and he gave it to the Metropolitan Museum in 1944.

In 1971, in the catalogue of the Metropolitan Museum's Italian paintings collection, Zeri wrote that "the age of the man in our double portrait cannot be judged by the present appearance of his face, which has been extensively repainted and is therefore useless as a means of dating the picture."[4] Later, scholars also remarked on the state of the panel. According to Meryle Secrest, Michele Lazzaroni, who overzealously restored many works held by Duveen, repainted Sassetti's face and made other "improvements";[5] however, the surface rather closely follows the underdrawing (fig. 109) revealed in an infrared photograph. This initial drawing

with a brush described the underlying forms and modeling of the face and is fairly close to the present-day appearance of the painting. Certain changes, such as the softening of the figure's crow's-feet and jowls, are attributable to the painting's somewhat worn state. Abraded areas have been integrated with strokes of retouching throughout, but still without changing the character of the portrait.

It is more likely, therefore, that Duveen's restorer, in fact, removed an earlier intervention that likely took place either just before or just after the panel was purchased by Graham. At the 1886 sale, critics such as the art dealer Davis lamented that the pictures "are so loaded with *modern paint* . . . one and

Fig. 109. Infrared reflectogram of Francesco Sassetti's head in cat. no. 127

all have not only been sadly restored, but badly done, and no artistic skill."[6] When the portrait was exhibited at the Royal Academy in 1893 and at the New Gallery in 1893–94, its state of conservation was deplored. Costanza Jocelyn Ffoulkes felt that the picture should not have been exhibited, so clouded was it by restoration that it had lost every impression of individuality.[7] Illustrations of the painting from the early twentieth century[8] show that the intervention (possibly undertaken in Italy or in Britain by Henry Merritt, who worked on many Graham paintings) raised Sassetti's upper eyelids to open his eyes, broadened the contours of his face, and smoothed his features.[9] Much of the abrasion now evident, such as the partial loss of small figures in the landscape, appears to have been sustained by this time. Duveen, probably responding to the widespread criticism, had the repaint removed. A visible pentimento, reducing the size of Sassetti's *berretta*, is Ghirlandaio's own modification.

The background is a much simplified variant of the landscape in *Saint Francis Renouncing His Earthly Goods*, a fresco in the Sassetti chapel in Santa Trinita, Florence, completed by Ghirlandaio in 1485. Eve Borsook and Johannes Offerhaus's oft-cited identification of the location as Geneva and of the church depicted at left as an oratory that Sassetti funded cannot be corroborated.[10] Motifs such as the lakeside quays with towers derive from Netherlandish art and are also common in the work of Sandro Botticelli and other Florentine artists.

Innovative and unusual aspects of the work—the frontal presentation of Sassetti, the idealization of his features, and the presence of his young son—may be considered in the light of Sassetti's career and legacy.

Called back from Geneva to Florence in 1459 to advise Giovanni di Cosimo de' Medici, he married Nera di Piero Corsi, with whom he had five sons and five daughters, and became general manager of the Medici bank in 1463. Having made a great deal of money from his banking assets, he invested in luxury goods and real estate. Testimony to Sassetti's humanist and aesthetic interests are his friendships with scholars such as Marsilio Ficino, his funerary chapel at Santa Trinita, his collections of manuscripts and classical inscriptions, and his magnificent villa, La Pietra—all of which conferred prestige and glory on the house of Sassetti.

Under Sassetti's stewardship, however, the Medici bank went into decline, and most of its branches failed or were liquidated. In 1488 Sassetti determined to travel to France to personally resolve problems at the Lyons branch, which were also imperiling his own fortune and honor. Before his journey he prepared a document, his "ultima volontà," or last injunctions to his sons.[11] Noting that at age sixty-eight "death daily draws closer," Sassetti stated his desire that if he died abroad his body be returned to Florence and buried in his new chapel, and he instructed his elder surviving sons, Galeazzo and Cosimo, to divide his estate equally among them, "including the youngest [Teodoro II] and the priest [Federigo]." This equal division of property among his sons follows the Tuscan custom of *fedecommesso,* which served to preserve wealth for the entire patriline; primogeniture (passing wealth exclusively to the firstborn son) was rare in Italy until a half century later.[12] Sassetti urged his heirs to sell La Pietra, "an expensive luxury," if need be, and, facing an uncertain future, he admonished them further: "I command and require you, if you wish me to depart this world contented, not to refuse my inheritance on any grounds whatever. Even if I were to leave you more debts than assets, I want you to live and die in that same state of Fortune; for this I regard as your duty. . . . Live together in love and charity, most of all taking as much care of those younger than yourselves and for their portions as you do for yourselves."[13]

Sassetti may have commissioned this portrait about the time of his departure for Lyons, as a visual will and testament equivalent to his written one, in the event he died abroad. The iconic, seated frontal pose—deriving from ruler portraits and conveying the idea of authority—suits Sassetti's standing as paterfamilias. His heavy, fur-lined crimson gown (*vesta*) and mulberry-colored *berretta* and Teodoro's brocaded gray tunic trimmed with precious white fur befit the family's position (precarious though it might be) among Florence's wealthiest

citizens. Hanging from Francesco's belt is a *borsa* (purse), which indicates his profession and also suggests his munificence. This article of dress appears frequently in paintings of the period depicting scenes of travel.[14] The church in the background suggests the banker's spiritual investments and his generosity in founding several chapels. Charles M. Rosenberg proposes that the work is posthumous and that the young boy is not a true portrait of Teodoro II but "simply a painting of Francesco Sassetti and 'Son.'"[15] Francesco's idealized countenance (puzzling, given his advanced age and Ghirlandaio's realistic representations of him as an old man of sixty-four in the Santa Trinita chapel) may be commemorative. Circumstances may have prevented the work from being painted from life, leading Ghirlandaio to consult an earlier model, such as the 1464 *all'antica* bust of Sassetti attributed to Andrea del Verrocchio or Antonio Rossellino (Museo Nazionale del Bargello, Florence), although the painted portrait has a different character.[16] Sassetti did, in fact, save the Medici bank in Lyons. He died following a stroke shortly afterward, in March 1490, and within a few generations the family fortune had largely dissipated.

Ghirlandaio adopted a similar composition for his better-known painting in the Musée du Louvre, Paris, datable about 1490, of a young boy and an unidentified old man with rhinophyma—arguably a posthumous portrait because a related drawing (Nationalmuseum, Stockholm) shows him with closed eyes, probably deceased. The Louvre picture is enlivened by the man's three-quarter pose and kind expression and by the child's affectionate embrace.[17] Both portraits accentuate the contrast between youth and age, a gloss on mortality. The gravity of Sassetti's expression accords with his concern for his patrimony and his wish that his sons "emulate the virtues and good habits you have known during my lifetime . . . as I believe that I have lived in such as way that you have no need to be ashamed of your father."[18] NE

1. Zeri 1971, p. 133.
2. Kecks 2000, pp. 110–11, 409.
3. For Graham's collection, see Garnett 2000.
4. Zeri 1971, p. 133.
5. Secrest 2004, p. 251.
6. Quoted in Garnett 2000, p. 184.
7. Ffoulkes 1894, p. 166.
8. L. Cust 1907, p. 26, ill. p. 13; R. Benson and Borenius 1914, p. 51, ill. p. 50; R. Fry 1920, pp. 26–27, no. 23, ill.
9. See Garnett 2000, p. 184, who also mentions Raffaelle Pinti as a restorer of Graham's paintings.
10. Borsook and Offerhaus 1981, p. 27, n. 83; Ames-Lewis 1996, p. 88, n. 27.

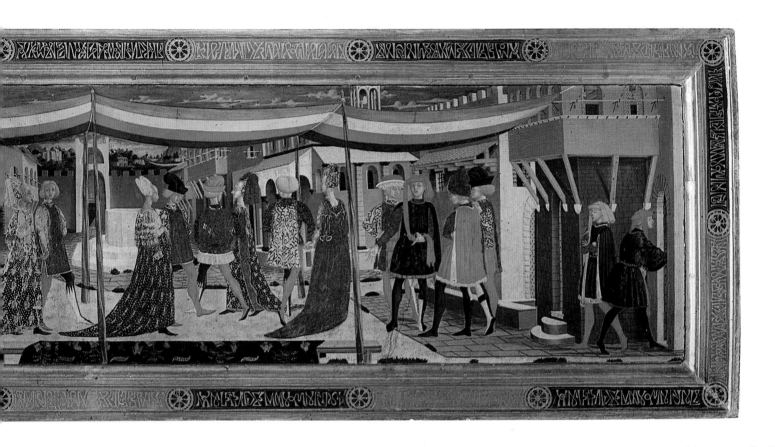

with a slow introductory section, presumably what we see in the present panel. According to Jayne, the *chirintana* was performed in Florence in 1459.[9]

Gombosi also proposed that the last pair in the line, at the left, are bride and groom, the bride wearing a headpiece of peacock feathers.[10] Carole Collier Frick suggests further that this figure is wearing a gown, called a *cioppa*, which could be worn at a wedding.[11] Cavazzini, however, casts doubt on the matrimonial context of the panel, calling the dance a not specifically nuptial *bassadanza*.[12] In any case, it is safe to say that the scene represented is one of celebration, whether of a marriage, engagement, or other important occasion.

Gombosi was the first to identify the instruments the musicians play as three shawms and a slide trumpet, which he says constituted "the favorite dance orchestra of the fifteenth century."[13] More recently, Timothy McGee has pointed out that the combination of instruments suggests that these performers are a particular group of civic musicians called the *pifferi*, who played on both public and private occasions when dancing was to be included. Though the banners hanging from two of the woodwind

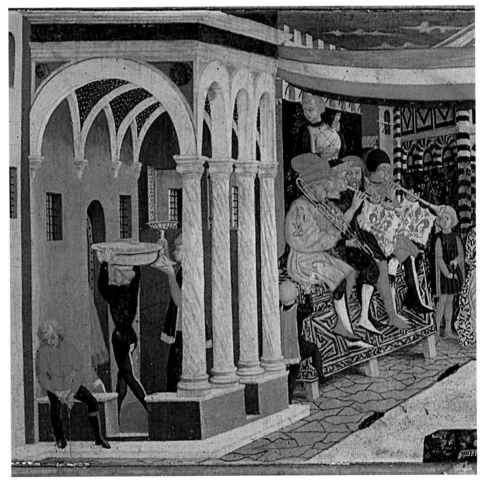

Cat. 134, detail

instruments are emblazoned with the device of the Florentine government (the fleur-de-lis, or *giglio*), Florentine statutes expressly required the *pifferi* to wear enamel emblems on their chests rather than display banners, which were reserved for the ensemble known as the *trombetti*.[14] This inconsistency may be explained as artistic license, since any Florentine would have seen the *pifferi* in action and thus recognize their costume. The slide trumpet became part of the *pifferi* ensemble in 1443.[15] That the musicians were in the service of the civic government underscores the importance of the event shown here. The *pifferi* did not generally play at more than three private events each year.[16]

A clue to the identity of the participants in the ceremony may lie in the coats of arms that appear on the tapestries draped over the benches in the foreground. With two (or perhaps three) red bands on a white ground, they could belong to one of at least two Florentine families.[17] The *verdure* or *verzure* tapestries—what we might call millefleurs—appear to be similar to those first made in the southern Netherlands and later in Italy by northern weavers. They were highly prized by Italian patrons during the fifteenth century.[18] The Visconti, Gonzaga, and Este were buying tapestries from Paris and Bruges, among other cities, beginning in the late fourteenth century. In 1448 the Medici agent in Bruges searched there and in Antwerp for tapestries to decorate the newly built Medici Palace in Florence, but the Medici had him instead commission a specific set, since none of the ones he saw proved suitable.[19] Relatively easy to transport, tapestries were used as festive decoration for banquets, processions, and celebrations of many kinds. Since upholstery was not common in this period, tapestries were also used to cover seating, and this is what we see in the present panel: the tapestries have been draped over a couple of benches arranged underneath the marquee, where the dancing couples presumably will alight after their performance. A series of inscriptions, which read upside-down on the panel, contribute to the authentic look of the textiles. Among images of amorous couples and treetops, several fragmentary words in Gothic letters on banderoles can be made out, but their significance has proved elusive.[20] They are very close to the lower edge of the panel and may have been damaged when it was removed from its original setting or disfigured during a restoration at some point in the panel's history. It is likely that the inscriptions evoked the sort of chivalric romance that would have been illustrated on contemporary tapestries.

Giovanni di Ser Giovanni, called Lo Scheggia, was the brother of Masaccio, who died in 1428. Scheggia had a much longer, if less distinguished, career.[21] Until 1969 the hundred or so works now considered part of his oeuvre were classified under the names Master of the Adimari Cassone and Master of Fucecchio. Luciano Bellosi first made the connection between these two artistic personalities in 1969, and contributed a definitive essay on Scheggia at the time of an exhibition at the artist's birthplace, San Giovanni Valdarno, in 1999.[22] The present panel has been dated by Bellosi, following Jacques Mesnil and Paul Schubring, to 1440–50, based on stylistic evidence as well as costume.[23] McGee suggests that the earliest date for the panel is 1443, since it was in that year that for the first time a mouthpiece instrument such as the slide trumpet in the painting was recorded as part of the Florentine *pifferi* ensemble.[24]

DLK

1. Laura Cavazzini in Cavazzini 1999, pp. 58–61.
2. Lastri 1776–78, vol. 2, pp. 78–81.
3. Salvini 1782 is the published version of the manuscript in which Lastri claimed to have found a mention of the painted panel and an identification of the scene as the Adimari–Ricasoli wedding, but it does not in fact include this information. The book is simply a list of canons and other officials of the cathedral with basic bibliographical information about each person from the year 378 through 1782. Boccaccio Adimari, whose wedding is supposedly represented on the panel, is mentioned on page 287. He became a canon in 1408 but gave up the position in 1411. This discrepancy is discussed in McGee 1992–95, pp. 139–40. Salvini's manuscript may have contained a description of the present panel, since the preface to the published book clearly indicates that it is an abridgment of a more comprehensive account. I have not been able to locate Salvini's manuscript as this volume goes to press.
4. Luisa Marcucci (1963, p. 12) suggests that the panel may have been painted for a wedding between the Adimari and Martelli, which took place about the middle of the century. She cites the following source for this: C. Masselli, "Catalogo . . . della fiorentina Accademia delle Belle Arte," manuscript in the Soprintendenza Gallerie, Florence, 1859, p. 45, no. 46.
5. Barriault 1994, pp. 66–67.
6. Cavazzini in Cavazzini 1999, p. 60, citing Spallanzani and Gaeta Bertelà 1992, p. 10.
7. Cavazzini in Cavazzini 1999, p. 58.
8. Gombosi 1941, p. 291.
9. See Jayne 1990, pp. 193–95. See also Uguccioni 1990, p. 242.
10. Gombosi 1941, p. 291.
11. Frick 2002, p. 117.
12. Cavazzini (in Cavazzini 1999, p. 59) bases her assertion on a citation of an image and a description of a *bassadanza* in Baxandall 1972, pp. 77–78: "Lorenzo di Piero de' Medici, Il Magnifico, had composed a dance, *Venus*, probably in the 1460s: *Bassa Danza called Venus, for three persons*." Gombosi (1941, p. 299) explains that *bassadanza* is a general term for different dances that are varied in their tempo, measure, and steps, and Maurizio Padovan (1987, p. 87) writes further that the *bassadanza* was one of two general categories of dances described in fifteenth-century dance treatises. It would seem possible, then, that the type of dance appropriate to a marriage celebration could fall in the general category of *bassadanze* even though such dances were not exclusively associated with weddings.
13. Gombosi 1941, p. 301.
14. McGee 1992–95, pp. 148–49. The emblem worn by the *pifferi* was called a *smaltum*. See also McGee 1999, p. 730.
15. The one seen here resembles a trombone and has been misidentified in the past as a trombone with a double slide, which was first represented in 1490, in a fresco by Filippino Lippi (McGee 1992–95, pp. 151–52, fig. 7). McGee concurs with Gombosi in identifying the instrument seen here as a slide trumpet and suggests that its shape may have been distorted during a restoration. The gold color of the instrument may also be the result of a restoration (albeit an early one) since mouthpiece instruments such as this would have been represented with silver paint, which would in time blacken and need to be replaced.
16. McGee 1992–95, p. 154, n. 46.
17. Strehlke 1999, p. 314, suggests that the arms belong to the "Tebaldini," but in his book on Florentine families, Roberto Ciabani spells the name "Tedaldini" (Ciabani 1992, vol. 1, p. 294); however, Ciabani illustrates the same arms for the Belfredelli family (vol. 4, p. 932).
18. A. S. Cavallo 1993, p. 71.
19. T. P. Campbell 2002, p. 88.
20. Carl Strehlke (1999, p. 314) suggests that the figures represent the Nine Worthies, but this does not seem probable. Lastri (1776–78, vol. 2, p. 81) claims that on the tapestries "can be read repeatedly written the Latin word *veniam* [I come], which could allude to the desire of the bride to enter the house of her husband." On the engraved illustration of the painting published in Lastri's book, the words VNATIS and VENIAM and perhaps DI VERAM can be made out, but they are right side up rather than upside down, as they would have been on the panel. One of the words is not legible.

Paul Schubring (1915, p. 277) recorded the inscriptions as follows, but simply skipped words that he could not read, and which are indeed impossible to make out: O PICCINA; ODI VERAM; VENATIS; AMORI. Martin Wackernagel (1938/1981, p. 178, n. 172) weighs in on these inscriptions, saying that they include the words *Venatio* and *Orticultura*. One of the inscriptions appears to be a number, but it does not add up.

21. On Scheggia, see Haines 1999, p. 35ff. Scheggia is first documented in an artistic context as a studio assistant of Bicci di Lorenzo in 1420–21. He did not matriculate in the Florentine painters' guild until 1430 (p. 38).

22. Luciano Bellosi in Bellosi, Lotti, and Matteoli 1969, p. 56; Bellosi 1999, p. 7ff.

23. Bellosi 1999, p. 8, n. 4.

24. McGee 1992–95, p. 154.

SELECTED REFERENCES: Mesnil 1906, p. 67; Schiaparelli 1908/1983, vol. 1, pp. 4, 5, 11, 37, 57, 61, 70, 78, 167, 196, 219, 271–74, 299, figs. 2–4; Schubring 1915, vol. 1, pp. 9, 84, 103–4, 115, 277–78, nos. 256–60, vol. 2, pls. LVI, LVII; Wackernagel 1938/1981, pp. 157, 178, n. 172; Gombosi 1941, pp. 291–92; Marcucci 1963; Mingardi 1987, pp. 128, 129, fig. 17; Padovan 1987, p. 97, fig. 34; Jayne 1990, pp. 193–95, pls. 28, 28a, 28b; Uguccioni 1990, pp. 240–42; McGee 1992–95, pp. 139–57, figs. 1, 2; Barriault 1994, pp. 66–67, fig. 21; Bellosi 1999, p. 7ff.; Laura Cavazzini in Cavazzini 1999, pp. 58–61, no. 13, ill.; Strehlke 1999, p. 314, fig. 77; Frick 2002, p. 117

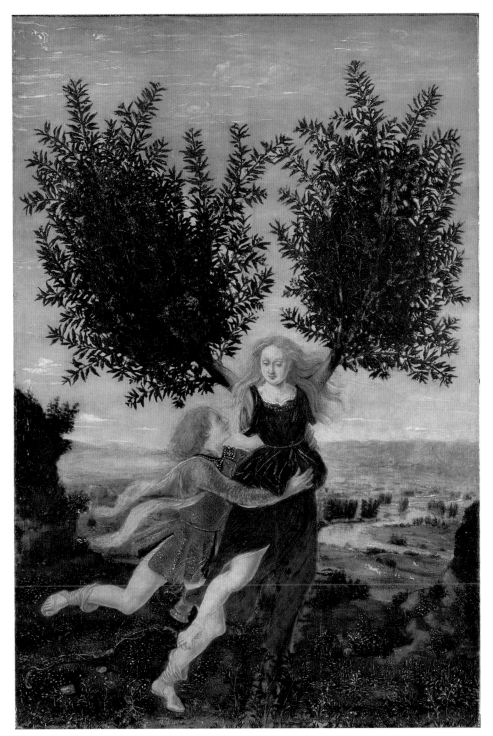

Cat. 135

Antonio del Pollaiuolo
Florentine, 1431–1498

135. *Apollo and Daphne*

Possibly 1460s
Oil (?) on panel (possibly cypress), 11⅝ × 7⅞ in. (29.5 × 20 cm)
The National Gallery, London. Wynn Ellis Bequest, 1876 (NG928)

Exultant at having just killed the great serpent Python, Apollo taunted Cupid about his lesser abilities as a hunter. Cupid took his revenge, kindling Apollo's love for the nymph Daphne with a golden arrow, while frightening Daphne into flight with its antithesis, an arrow blunt and tipped with lead. Having already declared to her father, the river god Peneus, her intention to be as chaste as Diana—despite his pleas for a son-in-law and grandsons—Daphne was all the more intent on escaping the amorous Apollo. She ran, he followed, pleading with her to realize from whom she was fleeing, while she felt rather like a hare running before a hound. Her flight only enhanced her beauty: "The winds bared her limbs, the opposing breezes set her garments a-flutter as she ran,

and a light air flung her locks streaming behind her."[1]

The end of this mythological tale, immortalized by Gianlorenzo Bernini in his 1622 sculpture for Scipione Borghese (Borghese Gallery, Rome), is well known. Peneus granted Daphne her wish to escape pursuit, allowing her to be transformed into a laurel tree. Even then, as her limbs and hair changed to branches and leaves, her feet to roots, and her sides to soft bark, Apollo pressed kisses upon the wood. From that moment, the laurel became Apollo's tree: "My hair, my lyre, my quiver shall always be entwined with thee, O laurel."[2]

Antonio del Pollaiuolo's precious panel painting is the most lyrical interpretation from the fifteenth century of this Ovidian tale. It shows Apollo as a hunter, albeit one dressed in courtly garb, his quiver at his side and his bow cast aside on the ground as he reaches to grasp Daphne. Her transformation is suggested persuasively, but with grace: one leg is already rooted in the ground while the other is free, her hair still flowing although her arms are imagined as vast branches of dark laurel leaves. The two figures are set before an expansive landscape, in which a winding river (the Arno) makes its way back to a hazy distant view of Florence. The river, alluding to Peneus, is punctuated by boats coming and going and by reflections of trees along its banks; on the near side, a minute hunt takes place. The descriptive power of the landscape and the palpably soft, moist air suggest that the artist may have had Northern panel paintings in mind.

Pollaiuolo has most eloquently depicted the rapid motion of the two figures. He similarly attempted to depict the musculature of the legs as the body is propelled forward in his *Hercules and the Hydra,* one of three canvases painted about 1460 that hung first in the Medici Palace and then the Palazzo della Signoria; now lost, these are probably reflected in two small panels in the Galleria degli Uffizi. The same stances and sense of strong forward motion were explored in drawing as well, in the artist's famous print called the *Battle of Nude Men* and in the unusual frescoes of dancing nudes painted in a villa outside Florence (Villa La Gallina, Arcetri). Thus, many of Pollaiuolo's long-term artistic concerns are developed on the modest surface of this panel.

In 1915 Paul Schubring, in his groundbreaking volume on Italian marriage chests, suggested that the *Apollo and Daphne* was a side panel of a cassone.[3] He compared it with other panels depicting the same legend that made up the sides of a cassone dated about 1450.[4] Attilio Schiaparelli had likewise considered it a panel from a nuptial chest,

as did Leopold Ettlinger, who concluded that the "courtly elegance" of the painting made it a "fine example of traditional *cassone* painting, near to the manner of Apollonio di Giovanni."[5] Martin Wackernagel suggested that the panel might not have been set into a large piece of furniture or the wainscoting of a *camera* but into a smaller coffer or cabinet.[6]

Other scholars have questioned these conclusions about the painting's original setting and function, citing not only its miniaturist precision and delicacy but also its fine state of preservation as being contrary to what one might expect of paintings subject to the wear and tear of daily living. Most recently, Alison Wright has argued forcefully that it must have been an independent painting,[7] perhaps treated as a precious object, as comparable Netherlandish paintings were, and stored in a case or a sleeve (an example would be a portrait diptych attributed to Nicolas Froment in the Musée du Louvre, which still has its marvelous red velvet bag).[8] As such, it would be an early example of an independent mythology, meant for the private delectation of a patron interested in Ovidian themes.[9]

The subject could have had various levels of meaning for artist and patron. Above all, the love of Apollo for Daphne and her subsequent transformation became the subject of a whole group of Petrarchan verses on the theme of unattainable love, with the *lauro,* or laurel, therefore an exemplum of perfect chastity.[10] Daphne / *lauro* is evoked as such in many poems and in the moralizing versions of Ovid popular throughout the period. For Petrarch, she became both the ever-fleeing desired woman and, simultaneously, the immutable laurel, whose leaves crown the poet and who is, in that sense, the representation of eternal art and poetry. Pollaiuolo provides a parallel poetic view in his depiction of the modest maiden, eyes downcast, but nonetheless rooted, with the powerful thrust of her uplifted branches already covered with laurel leaves. The extensive and atmospheric landscape likewise captures the mood of Petrarch's poems with its distances a "metaphor for the lover's loss."[11]

For whom might this poetic vision of love and poetry have been created? Although its known provenance does not stretch back before 1845, when the collector William Coningham bought it in Rome, two recent authors have made the appealing suggestion that it may have been painted for Lorenzo de' Medici, whose family Antonio was often working for in the 1460s.[12] Lorenzo associated himself with Apollo in many ways, not least of which was to adopt the laurel as a device, which he used at the games he sponsored in 1469 and where his personal standard also showed a laurel tree with a nymph. One of

Lorenzo's finest works of poetry, the *Ambra* of about 1491–92, celebrated the nymph who was the genius loci of the old house on the property at the site of Lorenzo's great villa at Poggio a Caiano. Ambra's story is related to Daphne's in that she too attempts to flee an unwanted pursuer, the river god Ombrone, and is transformed.[13] Paul Barolsky further conjectured that because of its modest dimensions, the panel might once have covered a portrait of the patron, although the portrait would have had to be exceptionally narrow (the suggestion that the panel might have been the back or cover of a portrait was also made by Angelica Dülberg).[14] Unless further evidence is revealed, we must accept that we cannot know the original function and setting of this most marvelous meditation on love, its pursuit and its loss, and the eternal consolations of poetry.

A B

1. Ovid *Metamorphoses* 1.452–67; for the quotation in English translation, see Ovid, *Metamorphoses,* 1994 (ed.), vol. 1, p. 39.
2. Ovid *Metamorphoses* 1.558–59; English trans., Ovid, *Metamorphoses,* 1994 (ed.), vol. 1, p. 41.
3. Schubring 1915, vol. 1, p. 297, no. 334.
4. Ibid., vol. 1, p. 258, nos. 154, 155, vol. 2, pl. XXXI. Schubring illustrated another panel of Apollo and Daphne, which, with its pair representing Narcissus, certainly formed part of a domestic setting, perhaps as wall panels (*spalliere*). The awkward image depicts Daphne as completely transformed, save for her head. See Schubring 1915, vol. 2, no. 605, pl. CXXXIII. The theme was also explored at about the same date in manuscript illustrations by Francesco di Antonio del Chierico (Florentine, 1433–1484); see Garzelli 1985, vol. 1, pp. 131–32, vol. 2, figs. 305–10.
5. Schiaparelli 1908/1983, vol. 1, p. 286; L. D. Ettlinger 1978, p. 28. Further evidence has shown that Antonio's workshop had experience in executing marriage-related commissions, contributing paraphernalia for the joust held to celebrate Lorenzo de' Medici's wedding to Clarice Orsini in 1469; Wright 2005, p. 13.
6. Wackernagel 1938/1981, pp. 167–68.
7. Alison Wright in Rubin and Wright 1999, p. 336, no. 88; Wright 2005, p. 94.
8. See Dülberg 1990, fig. 114.
9. Like its function, the date of the panel has also been much debated, with suggestions ranging from the early 1460s to the mid-1480s. Given its connections with Pollaiuolo's *Labors of Hercules* (for which see Wright 2005, pp. 75–87), an earlier date is more probable, and the landscape vista is also close to other works of the late 1460s and early 1470s. The attribution of the painting has also been questioned recently by Aldo Galli, who suggests, unconvincingly, that the painting is by Piero del Pollaiuolo (Galli 2003, p. 30; Galli 2005, p. 26 and pl. 22).

10. Marga Cottino-Jones (1975, p. 153) counts some fifty-two compositions of Petrarch's *Canzoniere* in which the myth of Apollo and Daphne or the motif of the *lauro* are used by the poet. See also Stechow 1932; Barkan 1986, p. 209.

11. Wright in Rubin and Wright 1999, p. 336, no. 88.

12. Barolsky 1998, p. 457; Wright 2005, p. 98.

13. Dempsey 1985, pp. 182–89.

14. Dülberg 1990, p. 290, no. 320.

SELECTED REFERENCES: Crutwell 1907, pp. 62–67; Schiaparelli 1908/1983, vol. 1, p. 286; Schubring 1915, vol. 1, p. 297, no. 334; Stechow 1932, pp. 19–20, fig. 17; Wackernagel 1938/1981, pp. 167–68; Davies 1961, pp. 446–47, no. 298; L. D. Ettlinger 1978, pp. 15, 28, 141, no. 9, pls. 11, 28; Dülberg 1990, p. 290, no. 320, fig. 159; Even 1997, pp. 143–59, figs. 1, 3; Barolsky 1998; Alison Wright in Rubin and Wright 1999, pp. 336–37, no. 88, ill.; Ciccuto 2001, p. 16; Poletti 2001, pp. 36, 39, 148, 182–85, ill.; Galli 2003, pp. 27–58, esp. pp. 30, 49, fig. 60; Galli 2005, pp. 26, 89–90, pl. 22; Wright 2005, pp. 94–98, 520, figs. 67, 68, 350

Jacopo del Sellaio

Florentine, 1441/42–1493

136. Panel with The Story of Cupid and Psyche

1470s
Tempera on panel, without frame 23¼ × 70 in. (59 × 178 cm)
Private collection, New York
New York only

This panel, most likely a *spalliera*, may have been painted to adorn the walls of a nuptial chamber. It narrates the intricate myth of Cupid and Psyche as it was recounted in the Roman and late medieval sources available to the educated patron class in Renaissance Florence. Elements from Lucius Apuleius's second-century work *The Golden Ass,* first published in Rome in 1469, as well as Giovanni Boccaccio's fourteenth-century *Genealogia Deorum* (Genealogy of the Gods) are present in the details of the story as interpreted by the painter.[1]

Like many of the narratives, both mythical and biblical, that appear on cassone and *spalliere* panels, as well as on other pieces of furniture associated with the celebration of marriage in Renaissance Italy, the tale of Cupid and Psyche features beauty, love, envy, greed, punishment, and a happy ending with a strong moral message, presumably directed toward a newly formed marriage alliance. Deeply symbolic, the story can be read on many levels, and presumably was by its viewers. On a philosophical plane, the story symbolized the pursuit of the soul (Psyche) to obtain divine love (Cupid).

The story unfolds horizontally across two panels. The early episodes are illustrated on a panel at the Fitzwilliam Museum, Cambridge (fig. 111). As the tale begins, the sun god Apollo descends on Endelechia as she sleeps and impregnates her. She lies upon a lavish blue-and-gold coverlet and is sheltered by a canopy of red-and-gold–patterned velvet, similar to the textiles that would have been part of any wealthy bride's trousseau in Renaissance Florence. The child born from this union is Psyche, who is tended by her sisters at the foot of the bed before emerging as a young woman, in a white flowing dress highlighted with gold, at the edge of the bedchamber. Psyche is admired by suitors, arousing the envy of Venus, who sends her son Cupid to cast a spell on her so that she will fall in love with the most despicable of her admirers. Cupid, winging his way toward Psyche, is himself smitten by her and falls in love, unable to carry out his mother's directive.

Thwarted, Venus makes sure that however much Psyche is flattered, she remains unmarried and alone, a fate that contemporary Florentine girls would certainly have considered a terrible one. Unable to choose a husband for her, Psyche's parents seek the advice of an oracle, whose circular temple they visit; they resolve to have her locked away in a mountaintop castle where she will marry a monster. But gentle breezes blow her off the mountaintop to a bed of flowers, and she awakes to find herself in front of Cupid's palace. She is welcomed by attendants but allowed to have contact with her lover only by night, and thus his identity remains a secret. Psyche asks Cupid (a somewhat anomalous scene, since he supposedly remains invisible to her) to allow her sisters to visit. The jealous sisters convince her to attempt to discover the identity of her loving but mysterious suitor. The scene on the right side of the panel depicts Psyche, carrying an oil lamp, stealing into her lover's bedroom as he sleeps. Awakened by a glancing drop of hot oil, he flies away with Psyche clinging to his leg.

The second panel picks up the narrative as Psyche, having attempted to follow Cupid, lands on the ground. Cupid appears in a cypress tree to reproach her. She flings herself into a river, but is rescued by a hirsute Pan, who comforts her with his pipes. Psyche then visits a small round temple, atop a hill in the middle distance, where she begins to clear and sort through some votive objects found there, when the goddess Ceres appears and enjoins her to depart. She visits an even more lavish temple next, in the left foreground. Inside the temple is a gilded statue of Juno, who appears to Psyche as she kneels before her. However, Juno, like Ceres, will not go against the wishes of Venus and help Psyche regain her lover.

Having resolved to seek out Venus herself, Psyche comes upon one of Venus's servants, who drags her the rest of the way. Venus brandishes an admonishing finger while her minions punish Psyche, hitting her with rods as she kneels in submission. Venus orders Psyche to carry out a series of near-impossible tasks in order to achieve her goal of reunion with Cupid—which she does, successfully, offstage. Directly above this scene, Cupid appeals to Jupiter, who approves the lovers' union. The marriage of Cupid and Psyche takes place in the right foreground, presided over by Jupiter with guests including Diana, Mercury, Neptune, Mars (in full armor, perhaps a portrait of the artist), and of course Venus. Jupiter, wearing a papal tiara, touches Psyche's hand, granting her immortality, while Cupid seals their union with a gesture that would be familiar to the painting's beholders: he places a ring on her finger. It is curious that the chief pagan god, Jupiter, is portrayed with the attribute of a pope. Did the patron aim to demonstrate universal approval for this union, under both pagan and Christian authority? Or could this be a clue to the political orientation of the patron? There is no way to know, but such a clear allusion to the pope would certainly have been intentional.

The episodes chosen by Sellaio are related to those on a set of cassone panels recounting the story of Cupid and Psyche, now in Berlin, by the Argonaut Master, but they do not depend on them. Previously believed to have been painted much earlier,[2] these cassone panels were dated convincingly by Everett Fahy to 1475.[3] This dating makes the Berlin panels roughly contemporary with such other works by the Argonaut Master as one of the Metropolitan's two panels illustrating scenes from *The Story of the Argonauts* (cat. nos. 59a, b). Sellaio was in partnership with Biagio d'Antonio, who painted another of the Metropolitan's *Argonauts* panels as well as *The Story of Joseph* (cat. no. 138).[4] The close relationship between Sellaio and the Argonaut Master suggested by each artist's link with Biagio d'Antonio may clarify the iconographic parallels between the Berlin and Cambridge–New York sets of Psyche panels. Since artists typically collaborated in the creation of panels such as these, it is possible that Sellaio, Biagio, and the Argonaut Master, who may be identified with Cosimo Roselli's brother Francesco, were in partnership during this period.[5]

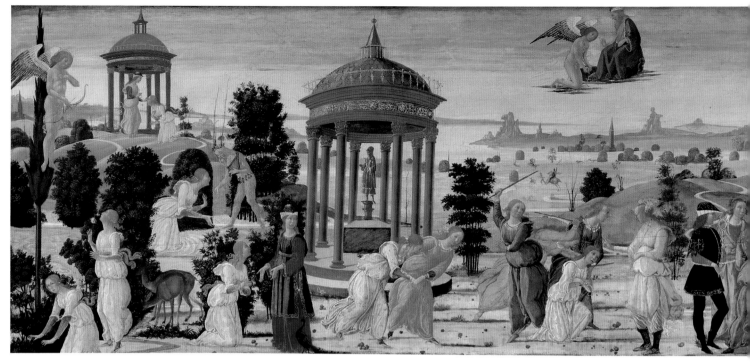

Cat. 136

The Psyche panels in Cambridge and New York were attributed in the early literature to Fra Filippo Lippi (ca. 1406–1469) or his son Filippino (ca. 1457–1504), but have been given unanimously to Sellaio since the 1920s. As a pupil of Filippo Lippi, Sellaio was well situated to learn informally from other contemporary painters such as Sandro Botticelli (1444/45–1510), whose influence is evident in the Psyche panels. Based on three clearly documented works, Sellaio's oeuvre has come into sharper focus in recent years, and he has emerged as a significant painter of small devotional panels as well as narratives such as the Cupid and Psyche. Ellen Callmann believed that Sellaio had a large workshop and was "heavily involved in the expanding private-sector market,"[6] which was, to a certain extent, driven by commissions for interior decoration such as *spalliere* panels, which gradually replaced the pictorial cassone as a locus of narrative in the domestic sphere.

The Psyche panels are first documented in the collection of Cardinal Joseph Fesch (1763–1839), Napoleon's uncle, whose colorful career spanned the tumultuous years of revolution, conquest, and imperial downfall. Both were sold in 1845 and then entered English collections.[7] They were auctioned at Christie's in London in 1863, as Filippo Lippi. The panels were probably split up in the 1870s.[8] The Cambridge panel entered the Fitzwilliam Museum in 1912 as part of the bequest of Charles Brinsley Marlay. The second panel emerged in Amsterdam in 1924 and was subsequently brought to the United States, where it is now in a private collection.[9]

DLK

1. Vertova 1979, p. 104.
2. Vertova (ibid., p. 112), following several others, as given in Fahy 1989, p. 297, n. 19, points to the Medici emblem on Cupid's house and speculates that these two panels may have been created for the 1444 wedding of Lucrezia Tornabuoni and Piero il Gottoso, son of Cosimo de' Medici, *Pater Patriae*, the parents of Lorenzo de' Medici *Il Magnifico*, but the later dating definitively refutes this. The erroneous speculation is repeated in Vertova 1993, p. 28.
3. Fahy 1989, p. 290.
4. Callmann 1998, p. 149, citing Lydecker 1987a, pp. 118–19.
5. Fahy 1989, p. 296, citing the suggestion of Oberhuber 1973, p. 53, n. 22.
6. Callmann 1998, p. 143.
7. Sold in Rome, Cardinal Fesch sale, March 17, 1845, lot 1220. See the entry by Lon de Vries Robbé in Van Os and Prakken 1974, pp. 61–63.

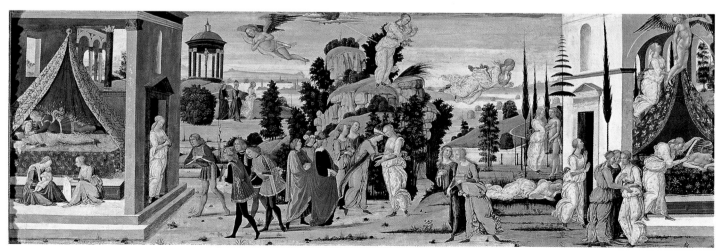

Fig. 111. Jacopo del Sellaio (1441/42–1493), *The Story of Cupid and Psyche*. Tempera with gold on panel, 23¼ × 70⅜ in. (59 × 178.8 cm). Fitzwilliam Museum, Cambridge

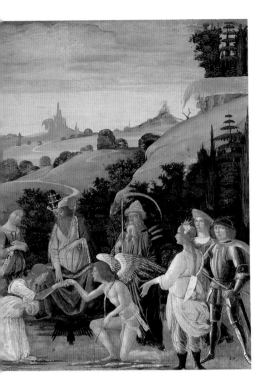

8. For the panels' provenance, see Goodison and Robertson 1967, p. 155.
9. The panel was first noted in Holland by Constable 1925, p. 282, fig. 11G. It was part of the E. Proehl collection.

SELECTED REFERENCES: Waagen 1854, vol. 3, p. 374 (as by Fra Filippo Lippi); Constable 1925, p. 282, pl. 11G; *Lorenzo il Magnifico* 1949, no. 12; Goodison and Robertson 1967, pp. 153–56; Vertova 1979, pp. 114–15, pls. 33d, 34a, 34b, 36b; Fahy 1989; Kanter 1994, pp. 172–73, under no. 50; Callmann 1998, p. 154

Gherardo di Giovanni del Fora
Florentine, 1444/45–1497

137a. The Combat of Love and Chastity

Probably 1480s
Tempera on panel, 16¾ × 13¾ in. (42.5 × 34.9 cm)
The National Gallery, London. Bought 1885 (NG1196)

137b. Chaste Women in a Landscape

Probably 1480s
Tempera on panel, 11¾ × 9¼ in. (29.8 × 23.5 cm)
Private collection

These two fragments, and a third (location unknown), were once joined as parts of a panel depicting *The Battle between Love and Chastity* (fig. 112). Other fragments from the same commission suggest that it originally included three horizontal panels. The narrative began with *Love's Chariot* and was completed with scenes of the *Defeat of Love* and the *Triumph of Chastity* (as suggested in fig. 113). Principally based on Petrarch's *Triumph of Chastity,* a section of his long poem *Trionfi* (*Triumphs*), the panels were painted by the gifted and well-educated Florentine artist Gherardo di Giovanni del Fora, who worked first alongside his brothers Bartolomeo (1442–1494) and Monte (1448–1523) and then with Monte alone (after 1476) at a studio in Piazza San Marco.[1] Extraordinary miniaturists, they were also painters of altarpieces and mosaicists. Giorgio Vasari devoted a "Life" to Gherardo, extolling him as a miniaturist and crediting him with a "cervello sofisticato," a sophisticated mind.[2] This is more than evident in some of Gherardo's greatest miniatures, such as the portrait of Piero di Lorenzo de' Medici that opens a volume of Homer produced in Florence in 1488 (Biblioteca Nazionale Vittorio Emanuele III, Naples).[3] The delicacy of handling of his miniatures may be found in the narrative scenes exhibited here as well.

The reuniting of the various fragments of this charming yet learned group of paintings and their correct identification are due principally to the insights of three scholars: Roger Fry, Everett Fahy, and Federico Zeri. *The Combat of Love and Chastity* (cat. no. 137a) entered the National Gallery in 1885, having previously belonged to a British gentleman in Genoa and before that to the collection of the Marchese Crosa di Vergagni there. As early as 1847 that family had given a related work, *The Triumph of Chastity* (to the right in fig. 113) to the Galleria Sabauda in Turin. Fry recognized that another fragment in a private collection in London, *Chaste Women in a Landscape* (cat. no. 137b), must have been painted by the same artist. Although he saw that their landscapes were very similar, their differing heights made him discount the possibility that they were fragments of the same panel. (*Chaste Women* is cut down at the bottom, and later it was recognized that the picture must have originally been to the right of the *Combat* scene, given the continuous horizon lines and identical background vegetation. As Luke Syson has noted, the fragments were probably not immediately adjacent, and *Chaste Women* would have been rather more in the background, with the *Combat* distinctly in the foreground.)[4] At the time of Fry's writing, the attribution of these two panels was debated, although Fry suggested the name of the Florentine Cosimo Rosselli.[5]

Meanwhile, the painting in the museum in Turin had provided a nomenclature for an anonymous master, the Master of the Triumph of Chastity, who began to have a body of work collected around his name. Roberto Longhi, for example, noted that a painting depicting the Magdalen in the Kress collection (K. 1742), was by the same master. Everett Fahy showed conclusively that the Master of the Triumph of Chastity was Gherardo di Giovanni, the artist described by Vasari.[6] Finally, Zeri, analyzing photographs of paintings that he had discovered serendipitously in New York, realized that the paintings that they reproduced belonged to the same sequence (his reconstructions are illustrated here), which could now be understood almost entirely.[7] The new panels (the three in the photographs he had found, as well as a fourth, known through a description, see below) had been in the Genoese collection of Marchese Agostino Adorno and were studied there by the remarkable Otto Mündler in 1867 and described by the Prince d'Essling and Eugène Müntz in their book *Pétrarque: Ses Études d'art*.[8] Zeri was able to report that the paintings were still in Genoa until 1940 (although he never saw them) but lost track of them during the war. Throughout this period, possible attributions of the four panels in Genoa had ranged widely—from Mantegna to Botticelli—but there was increasing agreement that they represented Petrarchan *Triumphs*. Based on Fahy's earlier work, Zeri was able to attribute all of these panels to Gherardo di Giovanni.

Zeri's reconstruction shows a narrative inventively inspired by a reading of Petrarch's first two *Triumphs,* that of Love (*Amore*) and that of Chastity (*Pudicizia*). It must be considered in conjunction with a somewhat revised one, proposed recently by Cristelle Baskins.[9] The first of the panels, which included the two fragments exhibited here,

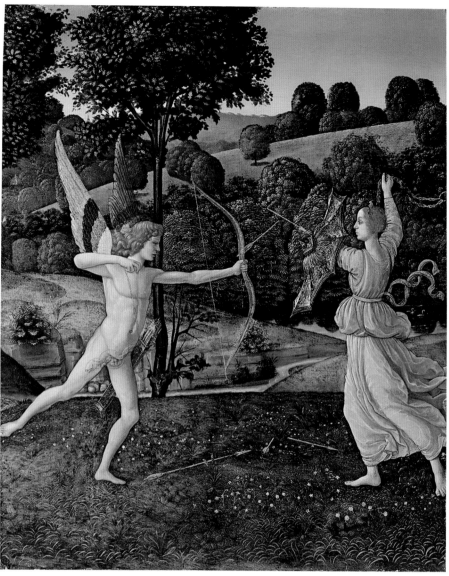

Cat. 137a

shows the chariot of Love pulled, as Petrarch describes, by four white horses, with those under the god's sway captive at the sides and with Jupiter (perhaps Cupid's greatest victim) chained to its front. The car is riderless as Cupid (*Amore*) has already leapt out of it to begin his combat with Chastity. They meet at the center of the panel in a verdant landscape:

> As when two lions roaring in their rage together crash,
> or blazing thunderbolts plunge downward, riving air and earth and sea,
> So I saw Love, with all his armaments,
> Moving to capture her of whom I write.[10]

Cupid has his bow and arrows, while she is armed with a shield decorated with faceted gems and the chainlike whip that Petrarch tells us she will use to bind her opponent. Chastity is accompanied by her followers, the Virtues (Honesty, Modesty, and so forth), who are described as walking hand in hand,

as shown here (cat. no. 137b). Remarkably, although weaponless, they too seem prepared for battle, some sporting helmets.

The second panel, whose precise description by Essling and Müntz underlies Baskins's new reconstruction, began with the scene of *Cupid Chastised or Defeated*.[11] Amore is shown held down to the ground by the young women, including Lucrezia and Penelope, with his arrows broken and even his wings pulled to pieces: "They had plucked the feathers from his wings" (line 135).[12] In the center of the panel a throng of Chastity's followers representing Modesty (*Onestà*), including Judith holding Holofernes' head, follows her glittering triumphal cart (the panel now in Turin), pulled by unicorns and led by a woman holding a standard decorated with an ermine of purity. The cortege moves forward before a great walled city (the del Fora brothers were renowned for their miniature views of Florence) bounded by a river touched by reflections and inhabited by swans, portrayed

with a delicacy almost matching Memling's. Chastity is crowned with a garland of laurel leaves, an allusion to Petrarch's ideal love, Laura, and sits on a throne whose seat would rival the metalwork of the Pollaiuolo. Cupid sits disarmed and bound before her. The final panel is known only through Essling and Müntz's description: along with other details, chained Love is brought into a temple (a comparable scene is to be found in Francesco di Giorgio's *Triumph of Chastity* at the J. Paul Getty Museum, Los Angeles). Thus ends the career of disruptive Love, replaced by the taming virtue of Chastity, as it was understood to exist within marriage.

The Petrarchan *Triumphs*—including *Fame* (cat. no. 70), *Death*, *Time*, and *Eternity*, as well as *Love* and *Chastity* (see also cat. no. 72)—were illustrated in almost every medium throughout the fifteenth century.[13] In Petrarch's progression, Love is defeated by Chastity, who in turn is defeated by Death. Fame then rises, but is surpassed in turn by

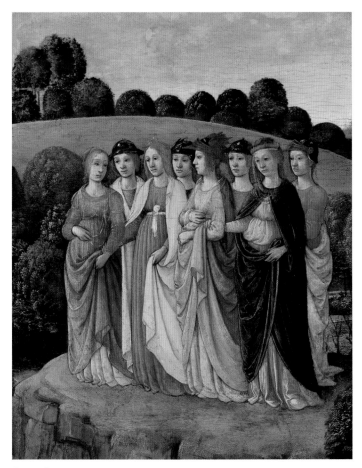

Cat. 137b

Time, Eternity, and Faith. The visual imagery created to illustrate the *Triumphs* tended to follow certain patterns, to which these panels also conform, although both the seamless flow from one *Triumph* to the next and the emphasis on the dramatic conflict between the two allegorical figures are quite remarkable. Many other examples of similar subjects probably decorating nuptial furniture could be cited, such as two panels of identical subjects, framed together, by the Florentine Jacopo del Sellaio (1442–1493) and close in date to Gherardo's (Museo Bandini, Fiesole). Sellaio's panels depict two processions with many similarities—including the banner with the ermine—but the sense of narrative movement and dramatic conflict is lacking. Like Sellaio's, Gherardo's *Triumphs* are often thought to have been elements of cassoni, but it is possible that they were *spalliere,* originally decorating the walls of a Florentine *camera.* The full length of the first panel, with the addition of the fragment known in photographs, must have been almost forty inches, appropriate for either a cassone or a *spalliera,* but the attention to detail, use of gold decoration, and state of preservation make an installation out of harm's way the more likely.

Gherardo's brother Monte di Giovanni also undertook a series of *Triumphs*, in collaboration with the Paduan scribe Bartolomeo Sanvito (ca. 1435–1518), as illustrations for a manuscript of great beauty and strong antiquarian bent (Walters Art Museum, Baltimore, 10.755; ca. 1480). In this work, which Annarosa Garzelli has called "visionary," the *Triumph of Death* includes a highly unusual scene of Laura on her deathbed, surrounded by ladies of a purity and sweetness precisely comparable to the "chaste women" who accompany Chastity in her battle here.[14] A B

Fig. 112. Gherardo di Giovanni del Fora (1444/45–1497), *The Battle between Love and Chastity* (reconstruction by Federico Zeri)

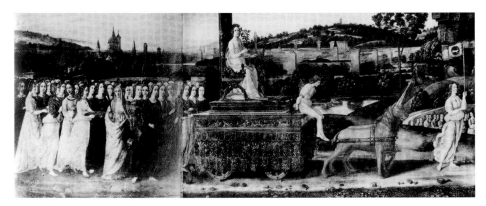

Fig. 113. Gherardo di Giovanni del Fora (1444/45–1497), *The Triumph of Chastity* (reconstruction by Federico Zeri)

1. For an overview of their activity, see Nicoletta Pons in Gregori, Paolucci, and Acidini Luchinat 1992, pp. 106–7.
2. Vasari, *Le vite,* 1568/1878–85 (ed.), vol. 3, pp. 237–43.
3. See Andrea De Marchi in Barocchi 1992, pp. 109–11, no. 21.
4. The author would like to thank Luke Syson for the notes he made in 2007, following an examination of *Chaste Women in a Landscape.*
5. R. Fry 1918.
6. Fahy 1967, p. 132.
7. Zeri 1983/1991. Zeri noted that these paintings had first been described by a Genoese author, F. Alizieri, writing in 1847, who had also seen *The Combat of Love and Chastity* in the Crosa di Vergagni collection.
8. Essling and Müntz 1902, p. 142.
9. Baskins 1999, p. 122, ill.
10. Ibid., p. 120.

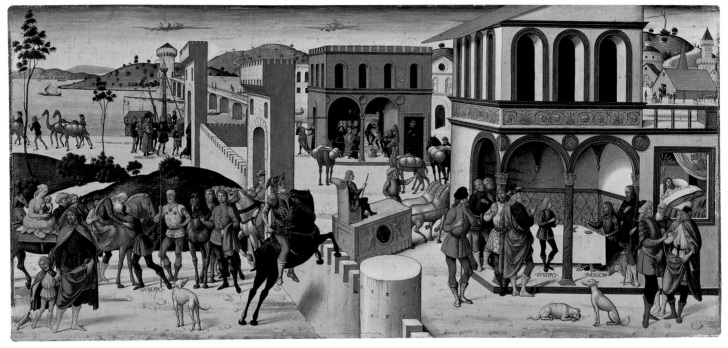

Cat. 138

11. For Essling and Müntz, see Davies 1961, p. 185, no. 3.

12. This is the scene represented on a monumental scale in a fresco (now detached; National Gallery, London) painted by Luca Signorelli for the "camera bella" in the Palazzo del Magnifico, Siena, commissioned by Pandolfo Petrucci at the time of his son Borghese's marriage to Vittoria Piccolomini in 1509; see Philippa Jackson in Syson et al. 2007, pp. 270–75, nos. 80–82.

13. Carandente 1963.

14. Garzelli 1985, vol. 1, p. 270.

SELECTED REFERENCES: R. Fry 1918, p. 201, ill.; Davies 1961, pp. 184–85, no. 1196; Carandente 1963, pp. 70–71, pl. XIV; Fahy 1967, pp. 128–33; Zeri 1983/1991, pp. 155–59, figs. 236, 237; Nicoletta Pons in Gregori, Paolucci, and Acidini Luchinat 1992, pp. 106–7; Baskins 1999, pp. 120–24, ill.; Melli 2007, pp. 38–39

Biagio d'Antonio
Florentine, act. 1472–1516

138. Spalliera Panel with The Story of Joseph

After 1482
Tempera on panel, 27 × 59 in. (68.6 × 149.9 cm)
Inscribed: *GVSEPPO* [repeatedly], *JACOB, MERCATANTI, PULTIFER, MOGLE DIPULTIFER, FARAGON* (Joseph, Jacob, merchants, Potiphar, Potiphar's wife, Pharaoh); on triumphal cart: · *IOS / EF* · (Joseph); at right: *SONGO DIFARAGONE* (Pharaoh's dream)
The Metropolitan Museum of Art, New York, The Friedsam Collection, Bequest of Michael Friedsam, 1931 (32.100.69)

This *spalliera* panel, probably once installed as a wainscoting in a bedroom, tells the story of Joseph from the book of Genesis (37, 39–47). Together with its pendant, now at the J. Paul Getty Museum (fig. 114), it was first documented in the Borghese Gallery in Rome in the early nineteenth century as a Pinturicchio.[1] Like the two panels depicting scenes from the *Story of the Argonauts* (cat. nos. 59a, b), it was later attributed to Utili da Faenza by Bernard Berenson, who eventually identified Utili as the painter Biagio d'Antonio. Its dating after 1482 is based on similarities with the work of Perugino (ca. 1450–1523) and other Umbrian artists who worked together on the frescoes in the Sistine Chapel.[2]

Like several panels painted earlier in the fifteenth century by Apollonio di Giovanni (1415/17–1465) and his workshop, including the cassone panels depicting the *Conquest of Trebizond* (cat. no. 56) and the *Story of Esther* (cat. no. 57), the panel here rewards the viewer with clearly inscribed labels identifying the central characters and locations in the narrative, with some of these central characters named several times. The role of these labels is intriguing. The use of inscriptions on paintings was certainly not new in the fifteenth century, and may derive from medieval pictorial traditions such as manuscript illumination.[3] But in the context of Renaissance humanist culture and its emphasis on literacy, the deployment of inscriptions in depictions of classical subjects or elaborate stories from the Old Testament would have signaled to viewers that the imagery was to be read like a text.[4] The inscribed legends do not only compensate for the potentially confusing juxtaposition of episodes in the nonlinear narrative structure; the lettering on the Joseph panel also documents an interest in Roman epigraphy. Biagio had probably worked in the Sistine Chapel by the time he painted this panel and would thus have witnessed the burgeoning archaeological culture of fifteenth-century Rome. It is tempting to see the many inscribed names as evidence of contemporary classicizing tastes.

The panel depicts seven episodes, from Joseph's arrival in Egypt to his reunion with his brothers. As in Biagio's earlier *Story of the Argonauts* panels, the narrative unfolds in three dimensions rather than simply marching across the horizontal surface. This layered conception of space can be attributed to the influence of sculptors of the fifteenth century including Donatello, Andrea del Verrocchio, and Lorenzo Ghiberti. Ghiberti illustrated the story of Joseph in one of his bronze reliefs

for the so-called Gates of Paradise (Baptistery of San Giovanni, Florence) in the 1430s and is sometimes credited with the reinvention of this narrative style in the Renaissance.[5] In Biagio's Joseph panel, as in Ghiberti's Joseph relief, the architectural setting of the story is given prominence, dramatically dividing the space into distinct zones without formally articulated borders or markers.

The first episode on this panel depicts Joseph newly arrived in Egypt, after having been sold by his brothers to merchants who now proceed to sell him to Potiphar, one of Pharaoh's ministers. In the upper central zone he is shown fleeing from Potiphar's wife, who made advances toward him and later, after he repulsed her, falsely accused him of trying to seduce her. A barred cell on the right of the crenellated structure in the background serves as the prison into which Joseph was thrown. Joseph turns his fate around through his skill as an interpreter of dreams. To illustrate this pivotal scene, the artist simply places the label "Pharaoh's Dream" across the sheets of his bed. Above Pharaoh's head hover the seven sheaves of wheat and seven heifers of his prophetic dream. Afterward, he listens to Joseph's interpretation of this dream at a table in the open loggia of his classicizing palace. Joseph's warning that seven lean years are to follow is heeded, and from a triumphal cart Pharaoh arranges for grain to be stockpiled, shown in a large barn in the upper right. When Joseph's brothers come to Egypt seeking relief from famine, he tests them in various ways, finally by hiding a golden goblet in a satchel carried by his youngest brother, Benjamin. In the end, he reveals his identity and they joyfully embrace, with the satchel, lying open to reveal the goblet, on the ground before them.

The story of Joseph was also at the heart of a grand decorative program for an ensemble

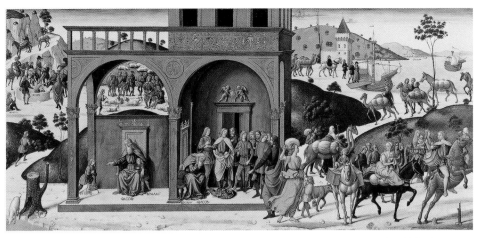

Fig. 114. Biagio d'Antonio (act. 1472–1516), *The Story of Joseph*, ca. 1485. Tempera and gold leaf on panel, 26¼ × 58¾ in. (66.7 × 149.2 cm). The J. Paul Getty Museum, Los Angeles

of pictures commissioned to decorate the bedroom of Pierfrancesco Borgherini and Margherita Acciaiuoli when they married in 1515 (see Andrea Bayer's essay "From Cassone to *Poesia*" in this volume), but the meaning of this story in the nuptial context is somewhat elusive. It is possible that Joseph was celebrated as an example of chastity in his refusal of Potiphar's wife's advances, of constancy in his devotion to family despite being cast out, and of clemency in his reconciliation with his brothers. These values—chastity, clemency, and constancy—appear in prescriptive literature for men and women aimed at preserving the social fabric, such as Leon Battista Alberti's *Della famiglia* (On the Family; see my essay "Marriage as a Key to Understanding the Past" in this volume) wedding poems, and epithalamia. They are echoed visually in narrative pictures and painted furniture as well as on maiolica vessels created to adorn domestic settings in the Italian Renaissance.

DLK

1. Zeri 1971, p. 147.
2. Bernard Berenson, "The Michael Friedsam Collection," pp. 82–83, manuscript completed in 1928, curatorial files, Department of European Paintings, Metropolitan Museum.
3. For a discussion of related conventions, with bibliography, see Matthew 1998, p. 617ff. Berenson (see note 2 above) remarked that the inscriptions, as much as those on Greek vases, "deserve the attention of philosophers."
4. Inscriptions also appear frequently on the reverse of *istoriato* maiolica dishes depicting stories adapted from Ovid or other classical sources that may not have been well known (see, for example, cat. no. 109). In these cases, the inscriptions may have served as a kind of game, enabling viewers to test their knowledge by simply turning the plate over.
5. Barriault 1994, pp. 61–64.

SELECTED REFERENCES: Zeri 1971, pp. 146–48, ill.; Pope-Hennessy and Christiansen 1980, pp. 2, 16–17, 38, 41, figs. 34–36; Fahy 1989, pp. 286–87; Barriault 1994, pp. 64, 74, 121, 142, no. 2.2, fig. 2.2; Bartoli 1999, pp. 163, 224–25, no. 107, ill. p. 166

Botticelli (Alessandro di Mariano Filipepi)

Florentine, 1444/45–1510

and

Workshop, probably Bartolomeo di Giovanni

Florentine, act. ca. 1475–ca. 1500/1505

139. The Banquet in the Pinewoods: Scene Three of The Story of Nastagio degli Onesti

1483
Tempera on panel, 33⅛ × 56 in. (84 × 142 cm)
Museo Nacional del Prado, Madrid (2840)
New York only

In 1483 Sandro Botticelli was commissioned to paint four *spalliere* panels illustrating Giovanni Boccaccio's tale of Nastagio degli Onesti (*Decameron* 5.8) on the occasion of the marriage of Giannozzo Pucci to Lucrezia Bini, probably by the bridegroom's father, Antonio, who was already the artist's patron.[1] Giannozzo had just recently lost his first wife, Smeralda di Ugolino, in August 1482, and this new marriage was organized in some haste, albeit with a certain amount of pomp and preparation. It was promoted by Lorenzo de' Medici (whose role as a broker was also crucial in the marriage of Lorenzo Tornabuoni and Giovanna degli Albizzi; see cat. no. 140); he counted the Pucci family among his most stalwart supporters. Indeed, the bonds between the two families were so strong that earlier in the century, allies of the Medici were known as *puccini*, and Giannozzo was to lose his life in 1497 while attempting to assist the Medici after their expulsion from Florence. The maneuvering of the Pucci as they rose within Florentine society, the role of the Medici and their allies in this regard, and the spate of Pucci marriages in the 1480s recently have been studied in detail.[2] All three coats of arms—Pucci, Bini (Pucci impaling Bini), and Medici—are found on the third and fourth panels; on the fourth, those of the Medici are surrounded by a garland of laurel, which alludes to Lorenzo. In a well-known passage, Giorgio Vasari described the four paintings—"fascinating and very beautiful"—as being in the Palazzo Pucci, along with a tondo of the *Adoration of the Magi* (probably the one by Botticelli of about 1470–75 in the National Gallery, London).[3] This description followed that of other *spalliere* paintings done by Botticelli perhaps for Guidantonio di Giovanni Vespucci and his bride, and including the *Virginia* (Accademia Carrara, Bergamo) and *Lucrezia* (Isabella Stewart Gardner Museum, Boston).

The Pucci panels almost certainly hung in the *camera* (bedchamber) that had been prepared for the young couple and probably would have been installed within wooden surrounds (the Vespucci paintings were said to be "enclosed by frames of walnut-wood, by way of ornament and paneling").[4]

Boccaccio's narrative strikes many modern observers as an odd choice for a wedding decoration to be hung in the couple's *camera,* and there has been much speculation as to its underlying meaning for the patrons. The tale revolves around a wealthy young man from Ravenna, Nastagio degli Onesti, who is rejected—despite his lavish attempts to woo her—by a young noblewoman from the Traversari family. Boccaccio is in no doubt about the cruelty of her rejection, calling her "cruda e dura e selvatica" (cruel, hard, and wild). Encouraged to travel so as to forget her, Nastagio went only so far as the neighboring pinewoods, where he pitched a camp and entertained his friends profusely. There, while making his melancholy way through the woods—poetically delineated in the first two panels (figs. 115, 116) with slender, receding trunks and dark crowns of foliage—he saw a horrifying scene. A naked girl ran toward him, screaming; a knight on horseback followed her, accompanied by dogs that tore at her flesh. The first of the panels captures the moment when Nastagio gathered his wits and caught up a branch to go to her assistance. It is followed in the second by the even more grisly scene in which the knight catches the girl and drives his rapier through her back, tearing out her heart and entrails and throwing them to the dogs. The knight, Guido degli Anastagi, tells Nastagio not to interfere, as both participants are dead and this is their posthumous punishment for their

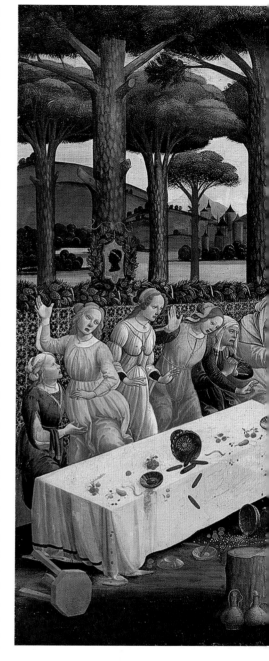

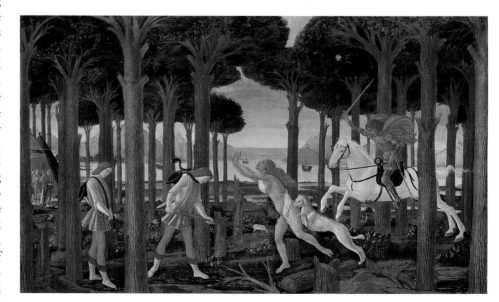

Fig. 115. Botticelli (Alessandro di Mariano Filipepi) (1444/45–1510) and workshop, *Nastagio in the Pinewoods of Ravenna: Scene One of The Story of Nastagio degli Onesti*, 1483. Tempera on panel, 32⅝ × 54⅜ in. (83 × 138 cm). Museo Nacional del Prado, Madrid

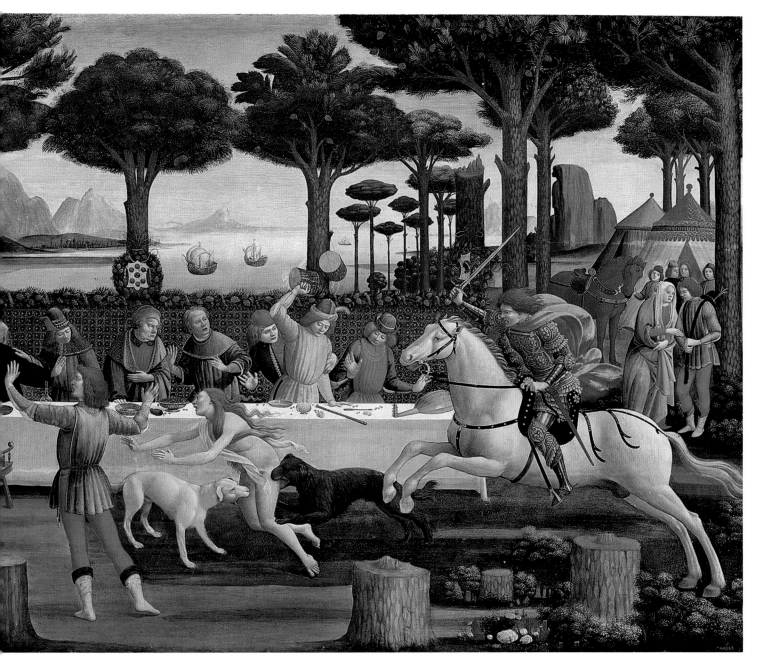

Cat. 139

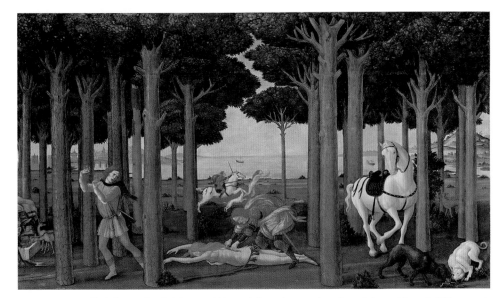

Fig. 116. Botticelli (Alessandro di Mariano Filipepi) (1444/45–1510) and workshop, *Nastagio Witnesses the Punishment of Guido degli Anastagi and His Beloved: Scene Two of The Story of Nastagio degli Onesti*, 1483. Tempera on panel, 32¼ × 54⅜ in. (82 × 138 cm). Museo Nacional del Prado, Madrid

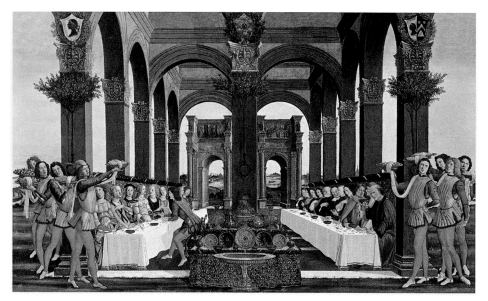

Fig. 117. Botticelli (Alessandro di Mariano Filipepi) (1444/45–1510), *Wedding Feast: Scene Four of The Story of Nastagio degli Onesti*, 1483. Tempera on panel, 33⅛ × 55⅞ in. (84 × 142 cm). Private collection

behavior in life. Hers had been to mock and reject him; his to react to this treatment with suicide. They were condemned to repeat this scene in various places each day; on Fridays they return to the pinewoods.

Nastagio determined to use this macabre scene to his advantage. He invited Traversari, his daughter, and others to a feast in the woods, which Botticelli has depicted in the third scene, shown here. With the guests seated at adjoining tables strewn with wonderfully described metalwork plates containing desserts and fruits, glass decanters, and abandoned musical instruments, and with a festive woven *spalliera* topped by a coniferous garland behind them, the hideous narrative is played out before their eyes (see fig. 48). Nastagio's love rises from her chair in horror, knocking the objects from the table. One of the male guests seems about to strike at the dogs with a tabor. Told the story of the knight and his victim, the young girl quickly determined to avoid this fate herself, and her nurse is seen at the far right of the panel telling Nastagio of her charge's change of heart. Although she was willing to offer herself to him unconditionally, Nastagio desired only honorable marriage.

The written tale then trails off swiftly, while Botticelli instead devotes the last and most sumptuous of the panels (fig. 117) to a grand nuptial feast, in which the figures from the *Decameron* mingle with others from contemporary Florence, possibly including Lucrezia Bini, her father and the groom's, and other family members and friends.[5] The feast is set within an arcade of stone piers, leading back to a triumphal arch.[6] The guests are again being served dessert—they have *tazze* for wine before them (see cat. no. 29) and, as

Herbert P. Horne pointed out, the servants are arriving with *berlingozzi* (cakes), *cialdoni* (wafers; see cat. no. 46), and *zuccherini* (sweetmeats).[7] At the very center of the composition rises a great credenza, covered with metallic vessels and plate. (In a contemporary description of the wedding of Nannina de' Medici and Bernardo Rucellai in 1466, the groom's father mentions "a very rich credenza furnished with worked silver.")[8]

Recent scholars have grappled with this difficult tale, attempting to understand its appeal for patron and artist.[9] At first glance it seems a morality play, in which a young woman is threatened with punishment for attempting to avoid the fulfillment of her societal duty to marry when presented with an eligible candidate (Boccaccio speaks of her becoming more "amenable," and the atmosphere perceptibly lightens when she accepts Nastagio's hand). At the same time, there is also a subtle admonitory message for the bridegroom. The ghostly knight had wasted his life in despair and suicide, while Nastagio is wasting his patrimony and life's energy yearning for the unobtainable young woman. In a way, the young couple are both brusquely forced to mature and accept the constraining, cooperative aspects of society, "the vision of an organised social community which is opposed to chaos, even at the expense of the individual."[10]

At the same time, these somewhat tendentious readings can lose sight of the paintings' close connection to their literary source. There was a formidable revival of interest in Boccaccio's oeuvre in the later decades of the quattrocento, evident, for example, in the writings of Angelo Poliziano and, notably, in the collecting and writings of Lorenzo de'

Medici.[11] Before then, Boccaccio's vernacular works seem to have almost disappeared from important Florentine libraries. Fascinatingly, Botticelli's character seems to have been seen as similar to Boccaccio's: both took delight in lighthearted jokiness and had a notable descriptive ability, each in his own art. As late as 1542, when the Venetian scholar Francesco Sansovino wrote his *Letters on the Ten Days of the Decameron*, the letter he addressed to the Venetian painter Lorenzo Lotto compares a frightening but amusing prank that Botticelli was said to have played on a noblewoman to the story of Nastagio degli Onesti. Was this an indirect allusion to Botticelli's famous paintings of the story?[12]

This particular story of Boccaccio's had additional appeal: it was partially inspired by Dante's *Inferno* (canto 13). There, in the description of the second ring of the seventh circle of Hell, two noted spendthrifts run through the woods as black hounds catch them and tear their flesh. Like Boccaccio's knight and young woman, they too are condemned to suffer this punishment each day. In this same circle of Hell, the reader also finds the souls of those who have committed suicide, who, like the spendthrifts, are considered to embody the vice of profligacy—both acts are wasteful in their own ways.[13] Botticelli was surely thinking of Dante when he considered Boccaccio's story, because our first glimpse of Nastagio as he walks through the pinewoods of Chiasso is similar to the melancholy figure of the poet in the woods in Botticelli's drawing for the very first canto of the *Inferno* (Biblioteca Apostolica Vaticana, Reginense lat. 1896, c. 101v), one of the famous series probably undertaken at about the same time as the Pucci panels. Thus it seems clear that this sequence of four dreamlike paintings was meant to evoke both of the great Tuscan authors, with the satisfying ending representing an escape from the perils of squandering one's youth, riches, and possibilities for the future.

All modern critics who have examined the paintings have noted that while based on designs by Botticelli, they were carried out, in part, by members of his workshop, probably because of the press of time in preparing for a nuptial chamber. The paintings remained together in the Palazzo Pucci until 1868. By then, certain visitors had remarked on their poor condition, although Charles Eastlake, then director of the National Gallery, London, almost bought them, discouraged only by what he considered the horrific nature of the second panel. They were sold instead to Alexander Barker and remained together until the last decade of the nineteenth century, when three went first to Paris and then to the Cambó collection in

Barcelona, before arriving in Madrid, while the fourth stayed in London until 1967. As people examined them, divergent ideas arose as to their relative qualities and authorship.[14] There is now a consensus that the third panel, *The Banquet in the Pinewoods*, was painted by Bartolomeo di Giovanni (see cat. no. 140b), who is better known for his work with Domenico Ghirlandaio but who also collaborated with Botticelli and copied his *Last Communion of Saint Jerome* (the original in The Metropolitan Museum of Art, New York; the copy in the Galleria Pallavicini, Rome).[15] Having recently reexamined the three panels, now in the Prado, Luciano Bellosi and Monica Folchi concluded that the quality of the first panel argued for its having been painted in part by Botticelli himself, that of the second by an unknown assistant but under the artist's direct control.[16] Alessandro Cecchi has hypothesized that the artist who contributed the most to the cycle may have been Jacopo di Domenico di Papi, who is recorded in Botticelli's shop as a trusted assistant in the 1480s.[17] The fourth panel, with its ambitious architecture and perspective, numerous portraits, and descriptive, festive atmosphere, has been considered both the weakest in execution (Horne) and the highest in quality (Cecchi) of all the works.[18] It is certainly a grand affirmation of the ceremonial aspects of the Pucci–Bini nuptials and of the status and accomplishments of all the families involved. It is pleasant to think that there was affection between the bride and groom as well, a hope that is supported by a tender letter written from Lucrezia to Giannozzo at just this time.[19]

AB

1. Horne (1908, pp. 132–33) correctly established the identity of the couple. For biographical information about them and their families, see Cecchi 2005, pp. 202, 279, nn. 53–60; and esp. Rubin 2007, chap. 7, pp. 229–71. Lucrezia's father, Piero, had saved twelve hundred gold florins ("fiorini larghi d'oro") in the Monte delle Doti, or official dowry fund, for this wedding, probably not an easy task in a family with fourteen children. For more on the Florentine system of dowries, see Deborah Krohn's essay "Marriage as a Key to Understanding the Past" in this volume.
2. Rubin 2007, pp. 244–51.
3. "molto vaga e bella"; Vasari, *Le vite*, 1568/1906 (ed.), vol. 3, p. 313. Lightbown 1978, vol. 1, pl. 13, vol. 2, pp. 25–26, no. B11.
4. "chiusi da ornamenti di noce per ricignimento e spalliera"; Vasari, *Le vite*, 1568/1906 (ed.), vol. 3, pp. 312–13. For the English translation and further discussion, see Barriault 1994, p. 12.
5. Rubin 2007, pp. 252–55.
6. Patricia Rubin (ibid., pp. 266–69) identifies the decorations on the triumphal arch as, to

the right, a Roman scene of clemency and, to the left, a contemporary scene from a novella, also showing clemency and a "happy ending."
7. Horne 1908, p. 133.
8. "una credenza fornita d'arienti lavorati molto ricca"; quoted in ibid., p. 132.
9. See, for example, Olsen 1992; and Baskins 1994, pp. 2–16.
10. Tinagli 1997, p. 37. Rubin (2007, p. 257) calls our attention to the fact that these scenes "activate pity through suffering" and "address the intellect through the contemplation of pain," a strategy used in devotional works and transferred here to the profane.
11. M. Rossi 1999, pp. 156, 182, n. 17; and Rubin 2007, p. 263, who highlights Lorenzo's praise of Boccaccio.
12. M. Rossi 1999, p. 153.
13. Olsen 1992, p. 151.
14. On these issues, see Lightbown 1978, vol. 2, pp. 50–51, under no. B38; and Luciano Bellosi and Monica Folchi in *Colección Cambó* 1990, pp. 218–22.
15. See Bellosi and Folchi in *Colección Cambó* 1990, pp. 221–22; and Pons 2004, pp. 30–36, and fig. 28. Bartolomeo di Giovanni's name appeared in connection with the four Pucci *spalliere* panels as early as 1908; see Horne 1908, p. 134. A copy of the composition in the John G. Johnson Collection at the Philadelphia Museum of Art has had various attributions, including one to Bartolomeo di Giovanni; see *John G. Johnson Collection* 1966, pp. 70–71, no. 64.
16. Bellosi and Folchi in *Colección Cambó* 1990, p. 218.
17. Cecchi 2005, pp. 75, 218.
18. Horne 1908, p. 134; Cecchi 2005, p. 218.
19. Rubin 2007, p. 249.

SELECTED REFERENCES: Crowe and Cavalcaselle 1903–14, vol. 4 (1911), pp. 258–59; Horne 1908, pp. 126–35; Lightbown 1978, vol. 1, pp. 69–70, pls. 28A–28C, vol. 2, pp. 47–51, nos. B35–B38; Luciano Bellosi and Monica Folchi in *Colección Cambó* 1990, pp. 211–22, nos. 17–19, ill.; Olsen 1992, pp. 146–70, pls. 9–11; Barriault 1994, pp. 109–13, 142–44, no. 3, pls. II–V; Baskins 1994, pp. 1–36, figs. 1–3; Tinagli 1997, pp. 36–42, figs. 7–10; Massimiliano Rossi in Branca 1999, vol. 2, pp. 214–15, no. 76, ill. nos. 221–24; M. Rossi 1999, pp. 153–58; Nicoletta Pons in *Botticelli e Filippino* 2004, pp. 102–5, no. 1, ill.; Pons 2004, pp. 30–31, fig. 23; Cecchi 2005, pp. 202, 218, ill. pp. 206–13; Rubin 2007, passim, esp. pp. 229–71, 360–62, pls. 213–16

Master of 1487, probably Pietro del Donzello

Florentine, 1452–1509

140a. The Departure of the Argonauts

1487
Oil on panel, 33 × 64½ in. (83.8 × 163.8 cm)
The Mari-Cha Collection Ltd.

Bartolomeo di Giovanni

Florentine, act. ca. 1475–ca. 1500/1505

140b. The Argonauts in Colchis

1487
Tempera (?) and oil on panel, 32¾ × 64½ in. (83.2 × 163.8 cm)
The Mari-Cha Collection Ltd.

Biagio d'Antonio

Florentine, 1446–1516

140c. The Betrothal of Jason and Medea

1487
Tempera on panel, 32⅝ × 64⅜ in. (83 × 163.4 cm)
Musée des Arts Décoratifs, Paris (PE 102)

The marriage of Lorenzo di Giovanni Tornabuoni (1468–1497) and Giovanna di Maso degli Albizzi (1468–1488) took place in Florence in the summer of 1486, with great pomp and magnificence. A cortege of one hundred young noblewomen and fifteen youths in their livery accompanied the bride and groom to Santa Maria del Fiore. The ceremonial "giving of the ring" was presided over by the count of Tendiglia, the Spanish ambassador to the papacy. Notables accompanied the bride to the house of her husband, "whose father [Giovanni Tornabuoni], having set up a stage [*palco*] in the piazza of S. Michele Albertelli for dancing and festivities, put on a great spectacle for the people," as did Giovanna's father, who hosted a sumptuous dinner at his house, entertaining his guests in such a way that the occasion was joyous "beyond any measure."[1] The three days of celebration were described in an epithalamium written by Naldo Naldi (who wrote another for Lorenzo di Filippo Strozzi and Lucrezia di Bernardo Rucellai in 1503).[2]

As was so often the case, the Tornabuoni–Albizzi match had political objectives. It was arranged by Lorenzo de' Medici, who

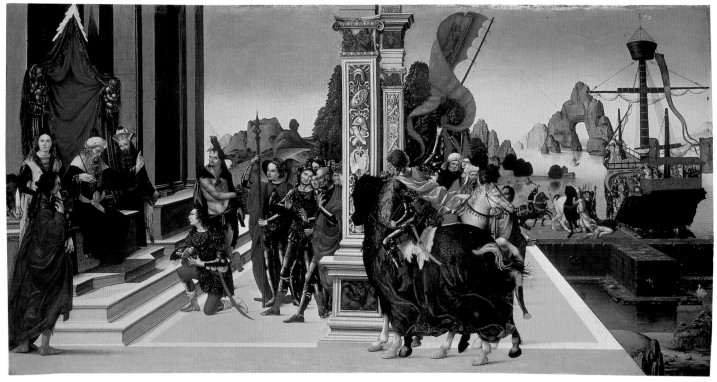

Cat. 140a

Fig. 118. Bartolomeo di Giovanni (act. ca. 1475–ca. 1500/1505), Two panels with Apollo and Venus in niches, 1487. Each 32¼ × 8¼ in. (82 × 21 cm). Private collection, Italy

often assumed the role of marriage broker in the upper echelons of Florentine society (for his role in another marriage, see cat. no. 139).[3] The Tornabuoni were closely allied to the Medici (Giovanni's sister Lucrezia was Lorenzo's mother; Giovanni himself worked as a manager and partner in the Roman branch of the Medici bank, and the two Lorenzos grew up together, studying with the humanist and poet Angelo Poliziano), and this marriage served to pull the Albizzi further into the Medici orbit. Both bride and groom were very young, and only two years later Giovanna died in childbirth, to be immortalized in a sublime, arguably posthumous portrait (fig. 14). The inscription on that work—"Art, would that you could represent character and mind. There would be no more beautiful painting on earth"—and the fact that Lorenzo kept it close to him until his own tragic death in 1497 suggest that this arranged marriage had a basis in affection and respect.[4] There was a precedent for this in his own family, for Lorenzo's father had lamented when his wife, Francesca Pitti, died in childbirth, so oppressed by the bitter loss of his "sweetest spouse" that he did not even know where he was.[5]

The young couple received fine rooms in the Palazzo Tornabuoni; one, Lorenzo's bedchamber (*camera*), was singled out in the laconic text of the inventory taken at his death as "beautiful." It was here that the Tornabuoni family provided a traditional nuptial decoration, consisting of cassoni, *spalliere* wall panels, bed and daybed, and a devotional tondo identified as Domenico Ghirlandaio's *Adoration of the Magi* (Galleria degli Uffizi, Florence; 1487), along with other useful and decorative furnishings.[6]

Five other important paintings can be securely linked to this couple. If these three grand panels of scenes from the Greek tale of Jason and the Argonauts and two panels of Apollo (the god of the Argonauts) and Venus in niches (fig. 118) hung in this room, they were most likely installed as *spalliere*, perhaps near or over cassoni (as described in the inventory).[7] The panels of the god and goddess include putti holding coats of arms of the two families (Apollo over the Tornabuoni's and Venus over the Albizzi's); two of the narrative panels also have these arms, and one bears the date 1487.[8]

The three narrative paintings are by different artists, who took care that their distinctive styles would emerge (although they also made sure that the protagonists of the story were easily identifiable from one scene to the next). The opening scene (cat. no. 140a), in which Jason is ordered by King Pelias of Iolcus to depart with his companions, the Argonauts, and retrieve the Golden Fleece from Colchis, was painted by an artist whom Roberto Longhi dubbed the Master of 1487 and whom Everett Fahy has identified with some certainty as Pietro del Donzello. This lesser-known painter had a highly creative moment in the 1480s, as this dynamic and innovative work demonstrates. Jason appears seven times in the next panel (cat. no. 140b), most prominently at the feast where Aeetes, king of Colchis, greeted him and set out the terms of his challenge. (The architecture of the loggia may be suggestive of the original courtyard of the Palazzo Tornabuoni.)[9] The feats that Jason will have to accomplish, beginning with plowing the field of Ares with fire-breathing bulls—assisted by Aeetes' daughter Medea—are shown farther to the right, as is the hero's meeting with

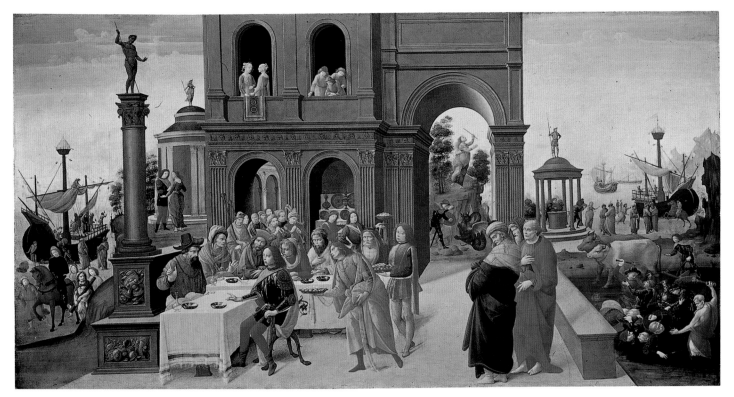

Cat. 140b

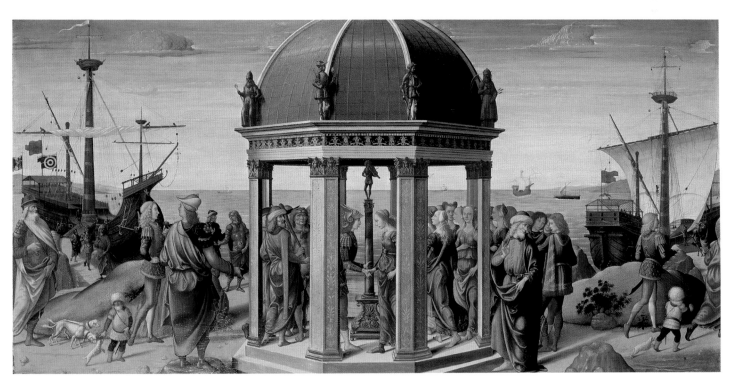

Cat. 140c

Medea in the Temple of Hecate at the center left. This panel was painted by Bartolomeo di Giovanni, an accomplished master who collaborated with both Domenico Ghirlandaio and Sandro Botticelli (see cat. no. 139); he also painted the figures of Apollo and Venus in niches. Finally, Biagio d'Antonio, who had also worked with Ghirlandaio and was the creator of cassoni panels on the same subject

(cat. nos. 59a, b), painted the culminating scene, in which Jason and Medea stand in the Temple of Apollo and Jason vows that in return for her assistance he will wed and not abandon her. To quote from the principal ancient source for the story, Apollonius Rhodius's *Argonautica* (a text to be found in the Medici library), "Thus he spoke, and straightaway clasped her right hand in his."[10]

The imagery is very much like that in other *sposalizio or* betrothal scenes, including that of the Virgin (fig. 3), with its temple and the centrality of the view. In the Renaissance, such consensual vows were the bedrock requirement of any wedding.

In each of these panels a ceremonial scene is the center of the artist's focus. In the *Departure of the Argonauts*, Donzello's

brilliant narrative shows the Argonauts, including Hercules—some standing and others on horseback with swirling banners—clustered around Jason kneeling at King Pelias's throne. In the *Argonauts in Colchis*, Bartolomeo di Giovanni depicts some of the most thrilling moments of the tale, including the events at the field of Ares, but most of the panel is devoted to King Aeetes' banquet. At the center of Biagio d'Antonio's *Betrothal of Jason and Medea* the couple exchange ceremonial vows. This is in accord with the displays of the rituals of marriage that were often part of the decoration of a nuptial *camera*.

What is more difficult to understand is why the subject of Jason and Medea would have been a nuptial decoration, considering the gruesome outcome of the tale. Back in Iolcus, Medea tricks Pelias's daughters into murdering him; later, Jason divorces Medea and she, seeking vengeance, kills first her husband's new bride and then her own children. While the tragic end occurs in both of the two principal ancient sources, Anne B. Barriault has pointed out that in Ovid's account—both in the *Metamorphoses* and in the *Heroides*—Medea's love of, and loyalty to, Jason are emphasized, with poetic language that brings the matrimonial bonds to the fore.[11] Caroline Campbell turns our attention to the great popularity of chivalric texts devoted to the Trojan War and the Voyage of the *Argo* (the latter flourished in association with the Order of the Golden Fleece, founded in 1430 by Philip III of Burgundy to celebrate his marriage to the infanta Isabel of Portugal). In one of these texts, Jason and Medea are actually reconciled: "They ruled and governed their kingdom together, living in love, and giving birth to beautiful children who ruled after them."[12] Details in the paintings suggest that the Florentine patrons and artists may have been aware of these vernacular texts. Finally, of course, Jason's own triumph over the obstacles placed in his way may have been one of the messages uppermost in the patron's mind. His success in stealing the Golden Fleece symbolized the beginning of a new Golden Age.[13]

The present panels are reunited at this exhibition for the first time in recent history. In the nineteenth century the panel now in Paris (cat. no. 140c) was first in the Alessandro Castellani collection in Rome and then in that of Count Castracani Staccoli in Urbino. In 1897 it entered the collection of Guillaume Émile Peyre, who bequeathed it to the Musée des Arts Décoratifs. The panels now in a private collection (cat. nos. 140a, b) were in Ashburnham House, property of the Fourth Earl of Ashburnham, by 1878. They later entered the collection of Sir Joseph

Robinson, Bt., when, having been sold and reacquired, they passed by descent to the collection of Count Natale Labia and were exhibited at intervals in Cape Town, South Africa, and elsewhere before being sold at auction in 1989. A B

1. Ammirato (*Delle famiglie nobili fiorentine*, 1615), quoted in Kress 2003, p. 271, no. 4 (original language Italian). The date of the wedding, given by Ammirato as June 14, 1486, has been questioned by Gert van der Sman (2007, pp. 162–63), who notes that in Naldo Naldi's nuptial poem the wedding is said to have taken place in September.

2. Van der Sman 2007, pp. 174–75; Van der Sman's research on the Tornabuoni–Albizzi couple, including much new archival information concerning, among other topics, Giovanna's trousseau, will be published fully in *Lorenzo e Giovanna: Due vite tra cronaca e arte* (forthcoming). The present author wishes to thank Dr. Van der Sman for sharing the results of his research.

3. Klapisch-Zuber 1979/1985, p. 192; Rubin 2007, pp. 244–49. Fahy 1984, p. 244, has identified the Medici emblems (*palle*) on a pennant flying from the ship *Argo* (cat. no. 140c).

4. See David Alan Brown in D. A. Brown et al. 2001, pp. 190–93, no. 30, for a discussion of the inscription. The portrait hung in a room adjacent to Lorenzo's *camera*, the so-called *camera del palcho d'oro*; see Kress 2003, p. 263.

5. Kress 2003, p. 273, no. 11.

6. Cadogan 2000, pp. 256–58, no. 32, pls. 188, 189; Kress 2003, pp. 269–70, publishes folio 148r of the inventory of the "camera di Lorenzo, bella" in the Palazzo Tornabuoni. Other items in this inventory are relevant to the themes of this exhibition, including the "2 banbini dorati abracciati insieme" (2 gilded children embracing) that brings to mind catalogue number 47, the two vases of Murano glass, and the mirror (cat. no. 115).

7. "2 forzieri da spose dorati e dipin[t]o chon ispalliere dorate e dipinte" (2 painted and gilded marriage chests with painted and gilded backboards, or *spalliere*). There was also another chest, described as a "forziere di nocie chon prospettiva e altri lavori di nocie chon dette spalliere choperto di tela azzura" (walnut chests with perspectives and other work in walnut with *spalliere* covered in blue cloth). Susanna Kress (2003, pp. 254–58) believes the Argonaut panels may have been directly associated with these pieces of furniture. She also suggests that two cassone panels with scenes from the Trojan War by Biagio d'Antonio that currently belong to the Fitzwilliam Museum, Cambridge, but that can be traced to the Albizzi family palace, may have been the front panels of the chests described in this inventory. Van der Sman 2007, pp. 162–64, draws on other folios of the same inventory in discussing another room belonging to Lorenzo, the "chamera di

Lorenzo di sopra," in the Villa Tornabuoni (now Lemmi) in Careggi.

8. For the identification and history of these panels, see Fahy 1984. Earlier contributions to our understanding of their original function include Schubring 1915 and Wackernagel 1938/1981.

9. Kress 2003, p. 256.

10. Fahy 1984, p. 241. C. Campbell 2007, p. 5, has shown that Lorenzo Tornabuoni would have studied both Apollonius Rhodius and the *Argonautica* by the later Roman author Valerius Flaccus at lectures given by the humanist Bartolomeo Fonzio while he was enrolled at the Florentine *studio* in the 1480s.

11. Barriault 1994, pp. 113–16.

12. C. Campbell 2007, esp. p. 11ff.

13. See Kress 2003, pp. 265, 283, nos. 132, 133.

Selected references: Schubring 1915, vol. 1, p. 301, no. 349, and pp. 311–12, nos. 389, 390, vol. 2, pls. LXXXIII, XCII; Wackernagel 1938/1981, p. 158 and n. 120; Fahy 1984, pp. 233–47, figs. 236, 237, 243–45; Sotheby's, London, sale cat., December 6, 1989, pp. 20–29, lots 105, 106, ill.; Barriault 1994, pp. 69–81, 113–16, 144–45, no. 4, pl. 1; Bartoli 1999, pp. 160–61, 211–12, no. 73, ill. p. 158; Kress 2003; Pons 2004, pp. 18–20, fig. 12; C. Campbell 2007, pp. 1–19, figs. 1–3; Van der Sman forthcoming

Domenico Beccafumi

Sienese, 1484–1551

141a. Cerealia, or possibly Cult of Vesta

Ca. 1517–19
Oil on panel, 25⅞ × 49 in. (65.5 × 124.5 cm)
Museo di Casa Martelli, Florence (52)
New York only

141b. Lupercalia

Ca. 1517–19
Oil on panel, 25⅞ × 49 in. (65.5 × 124.5 cm)
Inscribed on lintel of temple: DE STERILI FIERI CVPIENS FECVNDA LVPERCIS / HIS DET COEDENDAS NVPTA PVELLA MANVS
Museo di Casa Martelli, Florence (61)
New York only

About 1517–19, Francesco di Camillo Petrucci (b. 1489), a relative of Pandolfo Petrucci called il Magnifico, who briefly dominated Sienese politics in the early 1520s, commissioned Domenico Beccafumi to decorate his *camera*, or bedroom. The work included a bed with figures and round columns (which had, as well, an additional element also with "figures"); a frieze that wrapped around the room, probably quite

Cat. 141a

Cat. 141b

high on the wall; and a bench, possibly with a backboard. The woodwork was decorated with paintings in fine colors with an emphasis on gold and blue.[1] This description has come down to us in a document recording a complaint that the artist made to the Justice of the Comune of Siena in 1526 and again in 1527 for nonpayment of his fees (he received the balance due in 1528). In the years since the work had been carried out, political circumstances had changed. Petrucci had

been forced from the government by another member of the family in 1523; by 1526 he had been exiled and his goods had been confiscated. Francesco had already, in fact, sold the contents of the room to another cousin, Scipione di Girolamo Petrucci, without having first paid for it in its entirety.

As Francesco Petrucci married Caterina di Niccolò Piccolomini del Mandolo in 1512, the decoration of their bedroom had been put off for a number of years when Beccafumi

began work (both families contributed to its costs). It was probably undertaken at about the time of the birth of their first son, Muzio Romulo Maria, in 1517.[2] The group of paintings installed in it, as suggested by Donato Sanminiatelli and discussed by Roberto Bartalini and now Carol Plazzotta, has themes specifically related both to the state of marriage and to fecundity.[3] It included depictions of three exemplary women of antiquity known for their domestic virtues (*Cornelia*,

Galleria Doria Pamphilj, Rome; and *Marcia* and *Tanaquil*, both National Gallery of Art, London), which were probably installed as a trio, as part of the bench.[4] All have gold-lettered inscriptions that are precisely comparable to the one on *Lupercalia* (cat. no. 141b). A *Venus* (Barber Institute of Fine Arts, Birmingham) reclining in a landscape with a Cupid holding a toy pinwheel, much like the mischievous boys auguring fertility on birth trays (see cat. no. 69 verso), was almost certainly hung above the bed, as was often the case (it may have been the principal element of the "addition" to the bed mentioned in the documents). The two extraordinary narrative panels now in the Museo di Casa Martelli were probably part of the frieze along the upper portions of the wall.[5]

The panels represent two Roman festivals and rely principally on the text of Ovid's long Latin poem the *Fasti*. The identification of the first (cat. no. 141a) has been problematic. In line with the title given in a 1771 Martelli family inventory, it has traditionally been called the *Cult of Vesta*.[6] Described in the *Fasti* (6.249–349), a ceremony in honor of Vesta took place on June 9. On that day, women came to worship at the altar of the goddess Vesta, protectress of the hearth (both of the family and, by extension, of the city or state). As is well known, her priestesses had to be virgins, and their principal role was to keep her flame, seen here burning brightly under the statue in the niche, ever lit (Tuccia was one of these vestals; see cat. no. 144). According to this interpretation, we see the goddess's female devotees approaching her on her feast day; the woman already climbing the steps is barefooted, as Ovid says was required. They surround Vesta's temple, the Aedes Vestae, which was always perfectly circular. This identification of the panel's subject has made it difficult to account for the two children on the steps, but it is possible that they are the founders of Rome, the twins Romulus and Remus, born of Mars and a vestal, Rea Silvia, who therefore broke her vows and was sentenced to death.[7] The hypothesis seemed borne out by the appearance of the twins suckling the she-wolf at the right of the second panel (it should be remembered that when representing their city as the "daughter of Rome," the Sienese often chose to include the wolf and twins in their visual imagery).

In her study of the Petrucci cycle, Carol Plazzotta has rejected this identification of the scene, positing instead that it represents another Roman feast, the *Cerealia*, or the worship of Ceres (*Fasti* 4.393–621), goddess of vegetation and exemplary mother, hence a theme equally appropriate for a *camera*.[8] She notes that Ovid specifically says that Vesta was not represented by a statue in her temple ("Long did I foolishly think that there were images of Vesta [there]: afterwards I learned that there are none under her curved dome").[9] Other interesting details conform to the text for Ceres. The bronze sculpture of the goddess has an ox next to her, and a pig seems set within the blaze at her feet; these beasts may illustrate Ovid's injunction to worshipers to act in conformity with the goddess's wishes: "Take the knives away from the ox; let the ox plough; sacrifice the lazy sow."[10] Likewise, within the parameters of Beccafumi's well-known license with color, the devotees wear pale colors, as they should, and some figures have the cornstalks associated with Ceres in their hair. The artist has had to imagine her temple and has created a scene of a certain ambiguity; indeed, one can readily understand how the title *Vesta* became attached to this panel.

In the other panel we see the unfolding of the Lupercalia, a festival held on February 15 at the Lupercal, the cave or grotto at the foot of the Palatine Hill where the wolf (*lupa*) supposedly fed the two twins (*Fasti* 2.259–281). There, young noblemen known as *luperci* sacrificed goats, eventually winding the animals' skins around their own loins and taking tufts to pelt at women in augury of fertility. This is the idea expressed in the delicate lettering of the inscription on the lintel at left: "Let the bride who wishes to transform herself from sterile to fertile present her hands in submission to these Luperci." The reference to the "hands" in the distich is key to understanding the exact textual source for the painting. As Lisa Barbagli has shown, although Ovid says that the women must turn their backs to be hit by the strips of skin (*Fasti*, 2.445–50), a 1496 edition of the *Fasti* with notes by the humanists Antonio Costanzi and Paolo Marsi added a comment referring to Plutarch's *Life of Caesar*, which records Caesar's presence at one of these festivals and states that the women were meant to hold out their hands. It was also generally thought that the celebrations were dedicated to Faunus (or Pan), god of herdsmen, whom we see at the far right of the panel.

Such scenes of recondite classical imagery were characteristic of Sienese palace decoration at the time, and Beccafumi himself undertook a number of major cycles, most notably the ceiling paintings in the palace usually known as the Palazzo Bindi Sergardi and in the Sala del Concistoro of the Palazzo Pubblico. The first of these was most likely done on the occasion of the marriage of Alessandro Venturi and Bartolomea Luti in 1519.[11] But these decorations were grander, while the Petrucci cycle remains truly domestic in scale and mood. The *Cerealia* is serene, with the elegance of the extraordinary architecture, piers on high plinths and smooth stairs, a setting for the bending, approaching women in their cool colors. The *Lupercalia* is instead all action, the men with their heavily muscled torsos striding in from the right, and the women—aligned along the perspective of the receding walls—hands outstretched to receive them. 　　 A B

1. "una lettiera con fighure e cholonne tonde, con chornicioni intorno a tutta la chamara e chassabancha con quadri di pittura e cholori fini, e tutte le sopradette chose tutte messe a oro et azurro fino, et una agionta alla lettiera con fighure, e tutto a oro et azurro . . ."; see *Beccafumi* 1990, p. 689, doc. no. 131. New information on the *cassapanca,* or bench, can be found in Carol Plazzotta in Syson et al. 2007, p. 324.
2. Plazzotta in Syson et al. 2007, p. 323.
3. Sanminiatelli 1967, pp. 85–86; Roberto Bartalini in *Beccafumi* 1990, pp. 132–35, no. 14. On the Petrucci *camera* as a whole, see most recently the exemplary entry by Plazzotta in Syson et al. 2007, pp. 323–33, nos. 102–7.
4. A closely associated trio can be found in the work of Guidoccio Cozzarelli, whose *Hippo, Camilla, and Lucrezia* of about 1495–1500 is still in its original framework. See Marilena Caciorgna in *Siena e Roma* 2005, pp. 194–95, no. 2.15.
5. Although they were in the possession of Cardinal Ludovico Ludovisi by 1632 and in the Palazzo Martelli, Florence, by 1677, the *Venus* was still in the Palazzo Petrucci along with other works by the artist in 1815. See Bartalini in *Beccafumi* 1990, pp. 132–35, no. 14; Civai 1990, p. 68, n. 73; and Monica Folchi in Torriti (Piero) et al. 1998, pp. 93–94.
6. In the 1632 inventory of the Cardinal Ludovico Ludovisi collection, the panel was called *Sacrifice of Medea*; for both early titles, see Plazzotta in Syson et al. 2007, p. 329.
7. Caciorgna in *Siena e Roma* 2005, p. 132.
8. Plazzotta in Syson et al. 2007, p. 329.
9. *Fasti* 6.295–97. The translation of the passage is from Ovid, *Fasti,* 1996 (ed.), p. 341.
10. *Fasti* 4.412–14; English trans., Ovid, *Fasti,* 1996 (ed.), p. 219.
11. The palace, formerly the Palazzo Agostini, is now known as the Casini Casuccini. Pinelli 1990, esp. pp. 622, 624.

SELECTED REFERENCES: Sanminiatelli 1967, pp. 85–86, no. 16, ill. nos. 16–16c; Civai 1990, pp. 58, 68, n. 73, pls. III, IV; Roberto Bartalini in *Beccafumi* 1990, pp. 132–35, no. 14, ill.; Pinelli 1990; Monica Folchi in Torriti (Piero) et al. 1998, pp. 92–94, no. P28a, b, ill.; Barbagli 1998; Caciorgna and Guerrini 2005, pp. 99–118, figs. 23, 24; Marilena Caciorgna in *Siena e Roma* 2005, pp. 130–33, nos. 1.8, 1.9, ill.; Carol Plazzotta in Syson et al. 2007, pp. 323–33, nos. 102, 103, ill.

Ercole de' Roberti

Ferrarese, ca. 1455/56–1496

142. Portia and Brutus

Ca. 1486–90
Tempera, possibly oil, and gold on panel, 19⅛ ×
13½ in. (48.7 × 34.3 cm)
Kimbell Art Museum, Fort Worth (1986.05)

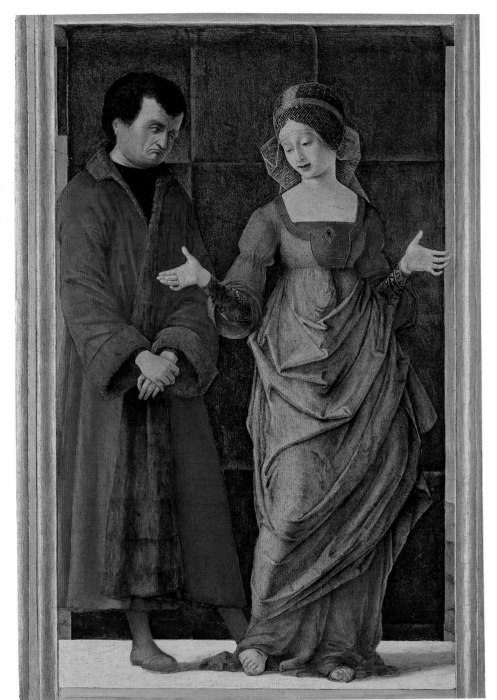

Cat. 142

Portia and Brutus belongs to a series of three panels featuring virtuous women. The others are *The Wife of Hasdrubal and Her Children* (National Gallery of Art, Washington, D.C.) and *Lucretia with Her Husband, Collatinus, and Lucius Junius Brutus* (Galleria Estense, Modena) (figs. 119, 120). The first two themes are rare in visual art, the third, though well known, is depicted in an unusual way. The series relates to a literary genre, Lives of Famous Men and Women, whose subjects' virtuous deeds were considered worthy of emulation—and whose vices were condemned—by ancient authors, including Plutarch and Valerius Maximus, as well as the early Renaissance humanists Petrarch and Boccaccio. The latter's Latin work *De Mulieribus Claris* (On Famous Women; 1361–75) was especially influential for later Renaissance writers. Some men of letters at the North Italian courts, such as Giovanni Sabadino degli Arienti (1481–1510), included contemporary rulers' wives as well as women from antiquity and the Old Testament in their compendiums of illustrious women. By the mid-fifteenth century in Tuscany, female worthies exemplifying such virtues as chastity, fortitude, marital fidelity, and patriotism were being depicted on cassone and other furnishings for nuptial chambers.[1]

The Kimbell Art Museum panel illustrates an occasion when Portia (ca. 70–43/42 B.C.), wife of the Roman politician and general Marcus Junius Brutus, demonstrated her bravery. The strong-minded and intelligent noblewoman had been featured as an exemplar of fortitude in Valerius Maximus's *Factorum et dictorum memorabilium libri IX* (Memorable Doings and Sayings in Nine Books; 3.2.15) and had also been praised in modern times by Boccaccio in *On Famous Women* (book 82). Both of these popular sources were undoubtedly known to the painter of the panels, Ercole de' Roberti, or to his patron or his adviser. Portia's husband, Brutus, had told his wife that he was secretly plotting to assassinate Julius Caesar. The night before the assassination, Portia dropped the razor used to cut her nails and

hurt herself. Her maids called Brutus, who reprimanded Portia for usurping the barber's task, whereupon she explained that the wound was self-inflicted, "to see if I would have the courage to kill myself with a sword and endure death if your enterprise should not succeed as you wish."[2] A cassone panel of about 1485 by Jacopo del Sellaio (Fine Arts Museums of San Francisco) whose lost companion piece probably showed Portia's wounding and Caesar's murder, illustrates the tragic events that followed—Brutus's defeat and death in a battle with Caesar's heirs and Portia's subsequent suicide by swallowing live coals.

As Margaret Franklin recently observed,[3] Roberti must have drawn inspiration for the Kimbell panel from a woodcut in the first printed edition of Boccaccio's *On Famous Women*, which shows Portia pointing to the razor piercing her foot. The artist underscores the psychological relationship between the spouses: Portia—cool and composed—takes the spotlight, openly declaring her resolution and triggering the consternation of Brutus, who draws inward. *Portia and Brutus* showcases Roberti's exquisite use of color, which is particularly notable in the application of delicate crosshatched brushstrokes, the transparent oil glazes, and fine details such as Portia's

Fig. 119. Ercole de' Roberti (ca. 1455/56–1496), *The Wife of Hasdrubal and Her Children*, ca. 1490–93. Tempera on panel, 18⅝ × 12 in. (47.3 × 30.6 cm). Ailsa Mellon Bruce Fund, Image courtesy of the Board of Trustees, National Gallery of Art, Washington, D.C.

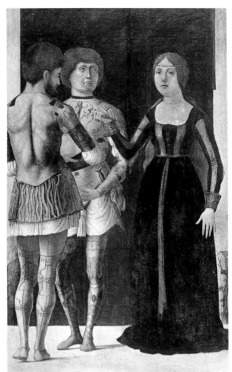

Fig. 120. Ercole de' Roberti (ca. 1455/56–1496), *Lucretia with Her Husband, Collatinus, and Lucius Junius Brutus*, ca. 1490. Tempera on panel, 19⅛ × 14 in. (48.7 × 35.5 cm). Galleria Estense, Modena

gold-threaded veil, brocaded sleeves, and underdress that changes from plum to blue.

The wife of the Carthaginian general Hasdrubal, who is depicted with her sons in the National Gallery panel, was also upheld as an example of fortitude by Valerius Maximus (3.2.8). After her husband surrendered to the Romans, his wife upbraided him for pleading with the enemy for his life, abandoning his troops and family. Taking their two children in hand, she flung herself into the burning ruins of Carthage. Roberti's panel in the Galleria Estense depicts Lucretia, whom Valerius Maximus (6.1.1) chose as a paragon of chastity. Boccaccio's *On Famous Women* (book 48), following ancient sources including Livy, tells how a group of rowdy young Roman officers, including Lucretia's husband, who was named Collatinus, and Sextus Tarquinius, boasted about the honor of their spouses. They visited the wives at home, and found Lucretia to be the most praiseworthy. Incited by lust, Sextus later came to her bedroom and threatened to kill her and accuse her of adultery if she did not submit to him. Roberti depicts the scene following the rape, after Lucretia sent for her husband and Lucius Junius Brutus, as well as other family members. Explaining that she wished to set an honorable example, Lucretia then stabbed herself. In Boccaccio's words, her action "led ultimately to freedom for Rome." According to Livy, Lucius Junius

Brutus avenged her by leading forces to rid Rome of the Tarquin tyrants.

Luke Syson dates the panels to about 1486–90, soon after Roberti left Bologna for Ferrara, and confirms the autograph status of all three. Joseph Manca, who dates the panels to about 1490–93, judges that the Modena panel could have been painted by Roberti himself or with assistance.[4] Recent scholarship also supports the claim that Roberti painted the panels for the duchess of Ferrara, Eleonora of Aragon (1450–1493), wife of Ercole I d'Este. Joseph Manca suggests they were commissioned as part of the decoration for the duchess's suite of rooms in the Castello Vecchio, which was refurbished about 1490–93, and points to the suitability of their theme, given that Eleonora actively participated in the rule of Ferrara during her husband's absence and in times of crisis.[5] Ferrarese courtier Bartolommeo Goggio, moreover, dedicated a Latin treatise, *De Laudibus Mulierum* (In Praise of Women), to Eleonora in 1487, in which he argued the superiority of women and lauded their capacity to take action and their physical courage.[6] In a comprehensive discussion of the three paintings, Franklin underlines how Roberti's unconventionally daring and "masculinized" heroines—chaste, politically loyal, and steadfast in adversity—were appropriate models for the consort of a ruling prince, and she discusses the works in the context

of Eleonora's significant role at the court of Ferrara.[7] In the absence of documentation to confirm that Eleonora commissioned the panels, it should not be ruled out that they were created instead to decorate furnishings for the nuptials of one of her children—most likely Alfonso, who married Anna Sforza in 1491. Since the Modena picture is recorded in the Este collections in the seventeenth century, it is more likely to have been painted for, and remained with, the Este court in Ferrara than for Beatrice, who in 1491 married the ruler of Milan, Ludovico Sforza, or Isabella, who wed Francesco II Gonzaga, Marchese of Mantua, in 1490.[8]

The superiority of women was a topic of interest at this time, not only for Goggio but for other humanists associated with the northern Italian courts.[9] Roberti's panels can be construed as supporting the view that women are superior to men, since his heroines are paragons of virtue—courageous, honorable, and faithful—whereas their husbands behave in cowardly and ill-advised ways. Be that as it may, the themes of the panels typify the genre of Famous Men, which included not only exemplary lives by also disastrous ones, such as that of Hasdrubal.

Creighton Gilbert has noted that Boccaccio included the story of Hasdrubal's wife in *De Casibus Virorum Illustrium* (On the Fates of Illustrious Men, 1355–74; book 5), which recounts the downfall of powerful men due to misfortune or their own disastrous decisions.[10] Although the tale is fully narrated by the Roman historian Appian (*Punic Wars* 8.19.131), the author of the program for Roberti's panels was more likely familiar with Boccaccio's text, which portrays her as a "glorious soul" for acting as her husband should have. The courageous actions of Roberti's virtuous women are direct responses to their husbands' deeds or misfortunes. Gilbert notes that the husbands of Portia and Lucretia seem to express remorse;[11] this reference to their conduct also serves to warn men to make wise and valiant decisions on behalf of their families and their country.[12]

The panels were likely set into wall paneling in a room or may possibly have decorated a piece of furniture. Roberti's series is distinguished from other contemporary sets of illustrations of virtuous women by the inclusion of additional characters from their stories. Unusual, too, is the panels' diminutive size, comparable only to Andrea Mantegna's small grisailles, including *Tuccia* and *A Woman Drinking (Sophonisba?)* (National Gallery, London) and *Judith* and *Dido* (Montreal Museum of Fine Arts), which were possibly influenced by Roberti's example.[13] In late quattrocento Tuscan depictions, virtuous women typically appear either standing in a

niche (for example, Fra Bartolommeo's *Portia* and *Female Warrior* in the Galleria degli Uffizi, Florence, and the Musée du Louvre, Paris, respectively) or before a landscape background (for example, Domenico Beccafumi's *Penelope*; see cat. no. 143). Roberti places his figures in a stagelike space in front of green or red curtains (Este colors), with a narrow sliver of landscape visible on each side, a setting suggestive of the tableaux vivants that were enacted during nuptial festivities such as the 1496 *joyeuse entrée* into Brussels of Joanna of Aragon-Castile, bride of Philip the Fair.[14] Indeed, Roberti's heroines seem to explain their actions with their dramatic body movements and gestures; it is not outside the realm of possibility that the artist's innovative compositions were inspired by similar tableaux. NE

1. On encomiums of famous women in literature, see McLeod 1991; P. J. Benson 1992; Kolsky 2003; and Kolsky 2005. Tinagli 2004 and Franklin 2006 discuss connections between the literary tradition and interpretations of the subject in the visual arts.
2. Boccaccio, *Famous Women*, 2001 (ed.), p. 343.
3. Franklin 2006, pp. 136–37, fig. 4.2.
4. Luke Syson in Allen and Syson 1999, p. xxxii; Joseph Manca in Boskovits and D. A. Brown 2003, pp. 607–11.
5. Manca 2000a; Manca in Boskovits and D. A. Brown 2003, pp. 607–10.
6. For Goggio, see Gundersheimer 1980; P. J. Benson 1992, pp. 45–64; and Kolsky 2005, pp. 172–90.
7. Franklin 2006, pp. 131–48.
8. See Manca 1992, p. 138; and Manca in Boskovits and D. A. Brown 2003, p. 610.
9. See P. J. Benson 1992, pp. 33–64; Kolsky 2005; Franklin 2006, pp. 120–30.
10. Gilbert 2002. See also Boccaccio, *De Casibus Virorum Illustrium*, 1962 (ed.); and Boccaccio, *Fates of Illustrious Men*, 1965 (ed.).
11. Gilbert 2002, p. 195.
12. Ruth Wilkins Sullivan posited that the program of Roberti's panels illustrates the saying *Malo mori quam foedari* (Death rather than dishonor), which she discusses as the motto of Eleonora's father, King Ferrante I of Aragon, who adopted the ermine, a symbol of purity, as a personal emblem; Sullivan 1994. This hypothesis is difficult to sustain since Portia's suicide is not depicted. Moreover, there is no evidence that Ferrante I, who founded the Order of the Ermine, in fact employed the motto *Malo mori quam foedari* (although others did so) in his device of the ermine; rather, he used the mottoes *Decorum* and *Probanda*, for which see Moretti 2001, p. 18, n. 27. These mottoes, which allude to upright behavior, do not invoke death.
13. See Syson in Allen and Syson 1999, p. xxxiii.
14. For the Brussels celebration, which included tableaux of exemplary women, see Wescher 1931, pp. 179–81.

SELECTED REFERENCES: Manca 1986, pp. 154–60, 291–300, no. 17b; Manca 1992, pp. 59–61, 136–39, fig. 17b; Sullivan 1994, pp. 610–25, fig. 1; Molteni 1995, pp. 90–91, 176–77, no. 40, ill.; Allen 1999, pp. xxi–xxii; Luke Syson in Allen and Syson 1999, pp. xxxii–xxxiii, no. VIII, ill. p. xxxv; Manca 2000a, pp. 13–20, fig. 2; Gilbert 2002; Joseph Manca in Boskovits and D. A. Brown 2003, pp. 608–11, fig. 1; Manca 2003, pp. 86–92, fig. 4; Franklin 2006, pp. 131–48, fig. 4.1

Domenico Beccafumi

Cortine in Valdibiana Montaperti, 1484–Siena, 1551

143. *Penelope*

Ca. 1514
Oil on panel, 33¼ × 18⅞ in. (84.2 × 47.8 cm)
Seminario Patriarcale, Venice (70)

The majestic figure in this painting is the Homeric heroine Penelope. In book 40 of his *De Mulieribus Claris* (On Famous Women, 1361–75), Giovanni Boccaccio declared that for married women Penelope "is the most sacred and lasting example of untarnished honor and undefiled purity. The constancy of her virtue was sternly tested by fortune, but in vain."[1] When Penelope believed her husband, Odysseus, to be dead, she vowed to remain in "chaste and perpetual widowhood"—an ideal espoused by Boccaccio and others during the Renaissance. During her husband's ten-year absence, to thwart her many persistent suitors, Penelope said she must finish the cloth she was weaving before deciding whom to marry. As a ruse, the fabric she wove during the day she unraveled at night.

The Sienese artist Domenico Beccafumi has clothed Penelope in a light-catching tunic and undergown that changes from olive to acid green tones, secured with a bejeweled girdle that denotes her marital chastity. The diaphanous sleeves of her chemise are pinned up to expose muscular arms. A diadem crowns her gossamer hair, matching the gold thread she pulls from her weaving onto the spindle in her right hand. She places her left on a narrow upright loom—a fantastic creation with an *all'antica* base adorned with rams' heads, grotesque masks, and foliate feet. The red cloth ornamented with a rinceau that Penelope weaves—and unweaves—is stretched between two natural branches; a pair of shears and floss hang from one side of the loom. The fresh, verdant landscape behind the queen is punctuated by a bare, spiky tree—a signature element in many works by Beccafumi.

Representations of Penelope are surprisingly rare in Renaissance art. She is depicted in Bernardino Pinturicchio's fresco *Penelope with the Suitors* (National Gallery, London; ca. 1509), one of eight subjects commissioned about 1509 by Pandolfo Petrucci for the "camera bella" of the Palazzo del Magnifico, Siena, as part of a suite of rooms prepared for the marriage of his son Borghese to Vittoria Piccolomini. In that fresco Pinturicchio depicts details of Homer's *Odyssey*, including Penelope's "large web"—a grand floor loom. Penelope also appears in Luca Signorelli's *Triumph of Chastity: Love Disarmed and Bound* (National Gallery, London), another fresco in this cycle.[2]

The format of Beccafumi's *Penelope* indicates that it was likely created for a nuptial decorative program, undoubtedly one of a trio of panel paintings of virtuous women, of the type that enjoyed popularity in Siena at the end of the fifteenth century and the first two decades of the sixteenth. A set of panels depicting three paragons of chastity, *Hippo*, *Camilla*, and *Lucretia* (private collection, Siena), attributed to Guidoccio Cozzarelli (1450–1516/17) may still be seen in its original wooden enframement with classicizing pilasters. Such *spalliere* (wall panels) would have been placed above a *lettuccio* (daybed) or *cassapanca* (bench).[3] Among the earliest and most ambitious of such decorative cycles commissioned for a room in a Sienese patrician palace, possibly on the occasion of the double marriage of brothers Antonio and Giulio Spannocchi in 1493, is a group of eight portraits of exemplary men and women from antiquity painted by diverse artists. The set was recently reunited in London for an exhibition of Sienese Renaissance art.[4] Decorative programs for domestic interiors in republican Siena often followed precedents in civic buildings. By choosing moralizing subjects from antiquity to decorate the furnishings and walls of nuptial chambers and other rooms in their palaces, Sienese families not only displayed their humanist learning but also promoted personal and civic values, including chastity and marital fidelity.[5]

The earliest documentation of Beccafumi's *Penelope* is in the Ospedale di Santa Maria della Scala in Siena. It was sold to Marchese Federico Manfredini (1743–1829), who bequeathed it to the Seminario Patriarcale, Venice, as a work by Baldassare Peruzzi. The attribution to Beccafumi, first suggested in 1912 by Giovanni Morelli and Georges Lafenestre, did not gain immediate favor, but it has been confirmed in recent literature.[6] Donato Sanminiatelli published the panel as part of Beccafumi's commission for Francesco Petrucci's *camera* in the Palazzo Magnifico;[7] however, *Penelope* is smaller in scale than the three exemplary women—*Tanaquil*, *Marcia* (National Gallery, London),

Cat. 143

and *Cornelia* (Galleria Doria Pamphilj, Rome)—that belong to this commission of about 1519 and also quite different in style. Familiarity with ancient texts is evident in this sophisticated program, which included *spalliere* panels presented in this volume (cat. nos. 141a, b), and a headboard featuring Venus and Cupid (Barber Institute of Fine Arts, Birmingham.)[8] Alessandro Bagnoli and Marco Torriti have catalogued *Penelope* among Beccafumi's earliest known works, datable around 1514.[9] No other paintings have been identified as part of the same program. A trio of heroines—*Sophonisba*, *Cleopatra* (Museé Bonnat de Bayonne), and *Judith* (Wallace Collection, London)—has been attributed to Beccafumi and dated to about 1508–10, but his authorship is not secure.[10]

Pliny the Elder wrote that the famed artist Zeuxis painted a picture of Penelope "in which one saw morality itself" (*Naturalis*

historia 35.63). Indeed, Beccafumi's *Penelope* embodies the virtues of fidelity, chastity, fortitude, and constancy. The Sienese artist looked to the Florentine masters to fashion his *exemplum virtutis*: Penelope's statuesque bearing seems to have been inspired by Michelangelo's four saints for the Piccolomini Altar in the Duomo of Siena and by the powerful repose of his *David* (Galleria dell'Accademia, Florence), with his mighty right hand. Her beauty invokes the fluid grace of Leonardo's lost painting *Leda and the Swan* and the sublime resolve expressed in Marcantonio Raimondi's engraving after Raphael's *Lucretia*.[11]

The bas-relief on the base of the balustrade on the left side features a stately woman with a companion. The scene on the right has been described as Penelope and a group of young women selecting spindles from an itinerant vendor.[12] Weaving and

its implements—spindles, distaffs, yarn winders, and looms—have been associated since antiquity with virtuous women (see cat. nos. 42–44). Possibly the relief has another meaning. The apocryphal book known as the Gospel of Pseudo-Matthew—based on the Protoevangelium of James, and a source of devotion during the Renaissance—describes how the young Virgin Mary was steadfast in her devotion to prayer and her weaving. After she was betrothed to Joseph, she was given five virgin companions. They cast lots among themselves for colors to spin to make the veil of the Temple in Jerusalem, and Mary received the purple, the color of royalty.[13] Despite the rarity of the legend, the parallels that can be drawn between the ancient Greek heroine Penelope and the Virgin are striking.

NE

1. Boccaccio, *Famous Women*, 2001 (ed.), pp. 158–63.
2. See Philippa Jackson in Syson et al. 2007, pp. 270–75, nos. 80–82.
3. For Cozzarelli's panels, see Marilena Caciorgna in *Siena e Roma* 2005, pp. 194–95, no. 2.15.
4. Luke Syson in Syson et al. 2007, pp. 234–44, nos. 65–72.
5. For Sienese *exempla virtutis*, see Tátrai 1979; Caciorgna and Guerrini 2003; Tinagli 2004, pp. 127–30; and *Siena e Roma* 2005, pp. 157–216.
6. See Alessandro Bagnoli in *Beccafumi* 1990, p. 106; and Marco Torriti in Torriti (Piero) et al. 1998, p. 57.
7. Sanminiatelli 1967, p. 85.
8. For the Petrucci *camera,* see also Dunkerton, Christensen, and Syson 2006; and Carol Plazzotta in Syson et al. 2007, pp. 323–33, nos. 102–7.
9. See Bagnoli in *Beccafumi* 1990, pp. 106–7; and Marco Torriti in Torriti (Piero) et al. 1998, p. 57, no. P3.
10. See Marco Torriti in Torriti (Piero) et al. 1998, pp. 55–57, nos. P2a, b, c.
11. For Leonardo's lost painting of the standing Leda, see Dalli Regoli, Nanni, and Natali 2001, pp. 131–53. For Marcantonio Raimondi's print after Raphael (Bartsch XIV.155.192), see Pon 2004, pp. 96–97, fig. 47.
12. See Sanminiatelli 1967, p. 193, n. 19; and Marco Torriti in Torriti (Piero) et al. 1998, p. 57.
13. Pseudo-Matthew, chap. 8. For the legend of Mary as weaver and spinner, see Gibson 1990.

SELECTED REFERENCES: Pope-Hennessy 1940, p. 115; Sanminiatelli 1967, p. 85, no. 15, ill., and pp. 193–94, n. 19; G. Briganti and Baccheschi 1977, p. 89, no. 30, ill.; Tátrai 1979, pp. 48–49, fig. 21; Sricchia Santoro 1987, pp. 449–50, fig. 12; Fiorella Sricchia Santoro in Sricchia Santoro 1988, pp. 6, 100, under no. 22; Alessandro Bagnoli in *Beccafumi* 1990, pp. 106–7, no. 7, ill.; Torriti (Paolo) 1998, p. 28; Marco Torriti in Torriti (Piero) et al. 1998, p. 57, no. P3, ill. p. 56; Dubus 1999, pp. 30, 88, fig. 7; Caciorgna and Guerrini 2003, pp. 268–71, ill.

Cat. 144

Moretto da Brescia (Alessandro Bonvicino)

Brescian, ca. 1498–1554

144. *The Vestal Virgin Tuccia*

Ca. 1540–44
Oil on panel, 44½ × 33⅞ in. (113 × 86 cm)
Inscribed on tablet: *PVDICITIAE / TESTIMONIV / ALEXADER* [*sic*] */ BRIX. F*
Private collection
New York only

The subject of this painting is easily identified by her attribute—a sieve—as the Vestal Virgin Tuccia, a heroine from ancient Roman history renowned for her chastity. The artist is identified in an inscription at lower right as Alessandro (*ALEXADER*) Bonvicino of Brescia (*BRIX*). Better known as Moretto da Brescia, he was the foremost artist in that town and was active chiefly as a painter of altarpieces and portraits.

Tuccia figures among the women from antiquity who were upheld as moral paragons during the Renaissance. Her story is told by the Greek historian Dionysius of Halicarnassus in *Roman Antiquities* (2.69) and by the Roman author Valerius Maximus in his *Factorum et dictorum memorabilium libri IX* (Memorable Doings and Sayings in Nine Books).[1] As a Vestal Virgin, Tuccia was charged with maintaining the sacred fire of the goddess of the hearth. Valerius tells us that Tuccia was wrongfully accused of unchastity and appealed to the goddess: "O Vesta, if I have always brought pure hands to your secret services, make it so now that with this sieve I shall be able to draw water from the Tiber and bring it to your temple" (8.1.5). She was able to carry out her self-imposed task successfully and reestablish her good name.

In Moretto's panel, Tuccia is richly dressed in a bodice brocaded with gold leaf motifs against a blue ground, a fine cream-colored underdress with white stripes, a diaphanous silk veil tied across her bosom, and a purple-red satin skirt with a gold border. Her elaborate coiffure of braids interlaced with bands of fabric appears in other paintings from the late 1530s and 1540s, such as Moretto's *Portrait of Tullia of Aragon as Salome* (Pinacoteca Civica Tosio Martinengo, Brescia). Here, Tuccia, who is seated with a sieve in her lap, places her elegant hand on a tablet, which in addition to the artist's name is inscribed with the Latin words *PVDICITIAE TESTIMONIV* (in proof of her chastity). This phrase is found not in Valerius Maximus but in Saint Augustine's *De civitate Dei* (10.16.2). In the context of distinguishing pagan, demonic acts from true Christian miracles, Augustine cites Tuccia (whom he does not name): "a Vestal virgin suspected of unchastity removed all doubt when she filled a sieve with water from the Tiber and it did not run out through the holes."[2] In the lines immediately preceding this passage, Augustine mentions another unjustly accused woman who vindicated herself in a wondrous episode. A boat that held an image of the goddess Cybele was mired in the Tiber and could not be moved by man or beast. After praying to the goddess, the Roman matron Claudia Quinta (likewise unnamed by Augustine) alone succeeded in pulling the ship to shore "in proof of her chastity."[3]

A rare secular painting in Moretto's oeuvre, *The Vestal Virgin Tuccia* bears comparison with the artist's representations of the Virgin and female saints, such as Saint Agnes, in his altarpiece of the *Madonna and Child in Glory with Saints* for the church of San Giovanni Evangelista, Brescia. Antonio Vannugli considered the altarpiece to be an early work by Moretto, but it has been dated by Alessandro Ballarin to about 1544, the date he assigns to *Tuccia*.[4] In comparison with the idealized Saint Agnes, the Vestal Virgin displays a robust physicality, which is heightened by the placement of her bare foot on the picture's lower edge to form a support for the sieve on her lap, as well as by the intense illumination from the right that highlights her warm flesh, the textures of her clothing, the glinting brass of the colander-like sieve, and the water shimmering in it. The dramatic lighting and bold foreshortening bring to mind Moretto's painting of about 1544 in the Cappella del Sacramento of San Giovanni Evangelista, Brescia, showing Saint Luke placing a foot on the head of an ox (his symbol) to prop up his tome.[5] Tuccia's muscular frame suggests the virtue of fortitude, as does the column behind her (a common attribute of fortitude), although her characterization as a virago is tempered by such intimate details as the wispy curls on her forehead. The sensuous treatment of the heroine's body has precedents

in Titian's *Salome* (Judith?) (Galleria Doria Pamphilj, Rome; ca. 1515–16) and Gerolamo Romanino's painting of the same subject (Gemäldegalerie, Berlin, ca. 1516–17), in both of which voluminous sleeves are rolled back to expose the heroine's strong arms.

Chastity was upheld as the preeminent feminine virtue during the Renaissance. Accordingly, the husband in Leon Battista Alberti's treatise *Della Famiglia* (ca. 1433–34) advises his young wife: "Nothing is so important for yourself, so acceptable to God, so pleasing to me, and precious in the sight of your children as your chastity. The woman's character is the jewel of her family . . . her purity has always far outweighed her beauty."[6] Chastity—and other conjugal virtues, such as modesty and fidelity—are celebrated in the imagery decorating objects made for a newlywed couple's bedroom, such as painted birth trays and cassone and *spalliere* panels (see cat. nos. 72, 137a, b). *The Triumph of Chastity*, from Petrarch's widely read *Trionfi* (*Triumphs*) was a popular subject.[7] In Petrarch's poem, the triumphal chariot bearing the figure of Chastity is accompanied by exemplars of chastity, including Lucretia, Penelope, Virginia, Judith, and "the vestal virgin who to cleanse herself of ill repute brought water from the Tiber to her temple in a sieve."[8] A *spalliera* panel by Jacopo del Sellaio (Museo Bandini, Fiesole; ca. 1490–93) shows Tuccia dressed *all'antica*, running with a sieve, whereas a panel by Francesco di Giorgio Martini (J. Paul Getty Museum, Los Angeles; ca. 1463–68) depicts her as an Augustinian nun in a white tunic with black scapular and veil, bearing her sieve.

Tuccia was also included in various series of panel paintings of virtuous women that were intended to be set into a bedroom wall or integrated into its furniture. When they have been removed from their original setting and context, it is often not possible to determine the original number of panels in such series devoted to *donne illustre* or fully to reconstruct their programs; however, it is safe to say that the women typically exemplify the virtues of chastity, conjugal fidelity, and fortitude within programs that are more or less complex or nuanced (see entries for cat. nos. 142, 143). Andrea Mantegna's grisaille panels titled *Tuccia* and *A Woman Drinking* (Sophonisba?) (National Gallery, London; ca. 1500) probably formed a series, possibly made for Isabella d'Este in Mantua, together with *Judith* and *Dido*, which are canvases of similar dimensions (Montreal Museum of Fine Arts).[9] An inventory of the Michiel collection, Venice, compiled in 1570 by connoisseur Marcantonio Michiel's son Giulio lists a pair of older paintings ("quadri antichi") representing the chaste heroines

Lucretia Romano (Lucretia) and Tuchea (Tuccia), and the sixteenth-century Sienese artist Bartolommeo Neroni called il Riccio paired Tuccia with Claudia Quinta in a series now in the Victoria and Albert Museum, London.[10] Such series of virtuous women, often in groups of three, were popular in Siena in the late fifteenth and early sixteenth centuries.[11] Girolamo di Benvenuto included *Tuccia* (Sternberk Castle, Czech Republic) in a series with *Cleopatra* (formerly Grassi collection, Florence), and *Portia* (Musée d'Art et d'Histoire, Chambéry), both of the latter seen committing suicide.[12] Jerzy Miziołek has shown that Tuccia carrying her full sieve to the temple, displayed in cassone panels together with scenes of the *Judgment of Solomon* and the *Legend of the Dead King,* also stood as an exemplum of justice, as she does also in paintings made for display in public buildings, such as Pomponio Amalteo's fresco of 1529 in the Palazzo del Consiglio dei Nobili, Belluno.[13]

Giovanni Battista Moroni painted an imposing canvas with Tuccia as its theme (National Gallery, London; ca. 1555) that owes a clear debt to the precedent of his master, Moretto. The Latin inscription on the tablet in Moroni's work is from Valerius Maximus (*Factorum et dictorum memorabilium libri IX,* 8.1.5): "Chastity . . . emerged from an obscuring cloud of ill fame."[14] Moroni's portrayal of this Amazonian Tuccia, who is dressed *all'antica* with exposed breasts, doubtless alludes to "nuda virtualis" or "nuda veritas," signifying innocence and truth, which has nothing to hide.[15] This meaning, and a desire to show that the heroine lived in ancient times, likely informs Moretto's presentation.

The earliest history of Moretto's *The Vestal Virgin Tuccia* is unknown, and no related paintings by the artist have come to light. In 1592 the painting was cited by Paolo Morigia in *La Nobiltà di Milano* as in the Milanese palace of Prospero Visconti (1543/44–1592), a respected scholar, historian, linguist, and collector: "The vestal virgin Tuccia who carries water with the sieve in her hand by . . . Moretto."[16] Nicholas Penny suggested that a family or institution in Brescia, such as a convent, might have commissioned both Moretto and Moroni to paint this relatively rare subject.[17] Antonio Vannugli noted that Moretto's *Tuccia* would have been a fitting nuptial gift.[18] Moretto's inclusion of a Latin phrase from Augustine in the inscription suggests that the subject was proposed by a learned patron—possibly a woman, possibly one who had reason to defend herself from unmerited accusations. Women who engaged in humanist studies could be judged guilty of impropriety for entering this traditionally masculine domain. For instance,

Isotta Nogarola (1418–1466), an unusually learned Veronese noblewoman, was thwarted in her ambition to undertake a humanist career by slurs on her character. In 1439 an anonymous writer accused her "of doing things which little befit her erudition and reputation—although this saying of many wise men I hold to be true: that an eloquent woman is never chaste; and the behavior of many learned women also confirms its truth. . . . let me explain that before she made her body generally available for promiscuous intercourse, she had first permitted—and indeed even earnestly desired—that the seal of her virginity be broken by none other than her brother."[19] Following this unmerited and malicious attack, Isotta took a more acceptable route, devoting herself to religious studies and never marrying. A century later, erudite women were still well advised to closely guard their reputation for chastity.

NE

1. Valerius Maximus, *Memorable Doings*, 2000 (ed.), vol. 2, p. 193.
2. Augustine, *City of God*, 1998 (ed.), p. 416.
3. Augustine also refers to Tuccia's supernatural act in *De civitate Dei* 22.11.3.
4. Vannugli 1988, p. 85; Ballarin 2006, vol. 1, p. 191.
5. For Moretto's painting of Saint Luke, see Ballarin 2006, vol. 1, p. 193, vol. 2, fig. 244.
6. L. B. Alberti, *Family in Renaissance Florence,* 1969 (ed.), p. 213.
7. See Baskins 1999.
8. *Trionfi,* ll. 148–51. See Warner 1985, p. 243.
9. Mauro Lucco in Lucco 2006b, pp. 106–9, nos. 17–20; Franklin 2006, pp. 148–74.
10. See Fletcher 1973, p. 384, n. 28, for the Michiel inventory; Tátrai 1979, pp. 47–48, for the works by il Riccio.
11. See Syson 2007a; Luke Syson in Syson et al. 2007, pp. 234–45, nos. 65–72; Carol Plazzotta in Syson et al. 2007, pp. 323–33, nos. 102–7.
12. Tátrai 1979, pp. 48–49; Pujmanová 1977, pp. 547–48.
13. See Miziołek 2001–2 for this theme and for additional Renaissance artworks representing Tuccia.
14. Valerius Maximus, *Memorable Doings,* 2000 (ed.), vol. 2, p. 193.
15. See Warner 1985, pp. 241–42, 315; Penny 2004, pp. 206–10.
16. "Tuccia Vergine vestale che porta l'acqua col Cribro in mano di . . . Moretto." Quoted in Vannugli 1988, p. 86; author's translation.
17. Penny 2004, p. 209.
18. Vannugli 1988, p. 88.
19. Nogarola, *Writings,* 2004 (ed.), pp. 68–69.

SELECTED REFERENCES: Vannugli 1988, pp. 85–90, pl. x; Antonio Vannugli in *Alessandro Bonvicino* 1988, pp. 128–32, no. 58, ill.; Penny 2004, p. 209, ill. p. 208, fig. 3; Ballarin 2006, vol. 1, p. 191, vol. 2, p. 341, pl. CXXXII

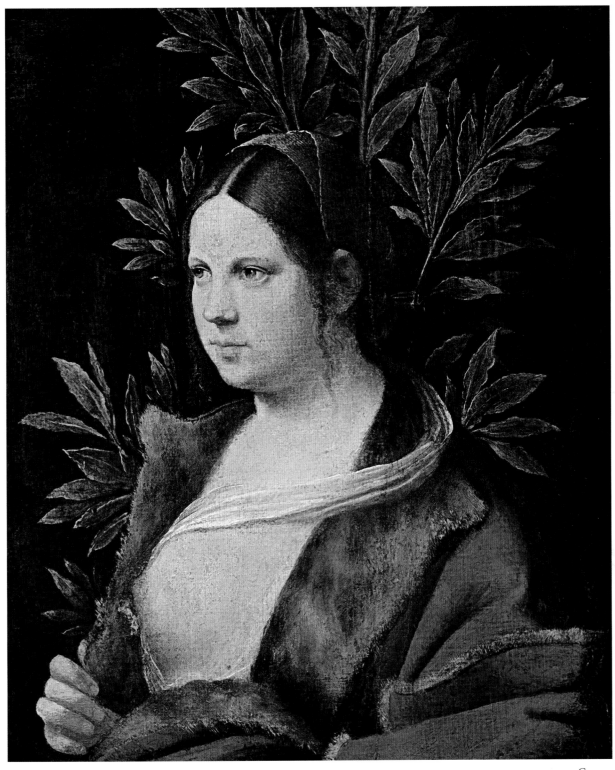

Cat. 145

Giorgione
Castelfranco Veneto, 1477/78–Venice, 1510

145. Portrait of a Woman (Laura)

1506
Oil on canvas mounted on panel, 16⅛ × 13¼ in. (41 × 33.6 cm)

Inscribed on back: *1506 ADI PRIMO ZUGNO FO FATTO QUESTO DE MA[NO] DE MAISTRO ZORZI DA CHASTEL FR[ANCO] CHOLEGA DE MAISTRO VIZENZO CHAENA AD INSTANZIA DE MIS[SER] GIAC[OMO] . . .*
Kunsthistorisches Museum, Gemäldegalerie, Vienna (31)

Giorgione's transfixing portrait of a clear-eyed young woman, who has come down to us as "Laura" because of the laurel branches framing her head, is at once a relatively simple image and a conundrum. She is shown to the waist, her silhouette outlined by the vigorous green leaves, undressed save for a thick, red, fur-lined cloak pulled open to reveal one breast and a transparent veil that delicately covers her hair but then twists provocatively across her torso and wraps around her right breast. She gazes not at the viewer but straight before her and out of the painting to the left. The canvas on

which the portrait was painted is mounted on a fir panel on which there is an informative inscription (now generally accepted to be contemporary with the painting), providing us with the date, June 1, 1506, the painter, "maistro Zorzi da chastel fr[anco]," or Giorgione, and, in less helpful terms, the patron, "Mis[ter] Giacomo. . . ."

Technical studies—beginning with restoration and close examination, including X-radiography supervised by Johannes Wilde in Vienna in the 1930s, and more recently infrared reflectography—demonstrate that the artist made many important changes as he worked, both to the background and to the sitter's attire.[1] The laurel branches were planned from the outset, but the artist at first intended them to be an even wider, denser backdrop for her head, set against a blue sky and possibly a landscape (as cross sections of the paint layer have shown). Then Giorgione painted out the sky and shifted the laurel so that it was visible only at the right side of the composition; he finally settled on the placement we see today, with the leaves on the left painted over the dark background.[2] He also made changes to the veil and cloak, perhaps at one time thinking of covering her chest with a thin chemise, but also of narrowing the fur lining of the cloak, revealing part of her left breast. Finally, it should be remembered that the painting was cut down into an oval shape and then built up again into a rectangle in the eighteenth century, so that the fingers as we see them are largely reconstructions, probably following the original rather closely.

Despite this wealth of information, we cannot answer either of the two interlocking questions that are of great interest in the context of this volume: who was "misser Giacomo," and what relationship did he have with the palpably present woman who sat for this portrait? For, unlike Palma's *belle donne* (see cat. nos. 146a, b), this woman is not an idealized beauty of the period, but most decisively an individual, with brown eyes and hair, a broad face and nose, and a rather plain demeanor—one recent critic has gone so far as to say that she "is not a beauty, she is not seductive, she is not young."[3] Given her appearance, the first mention of the painting as "Petraces Laura" in a list of works in Bartolomeo della Nave's collection about 1636 is all the more ironic, for a woman as unlike Laura as immortalized and idealized by Petrarch—blond, pale, and elusive—would be hard to imagine.[4] Indeed, Giorgione has used all of his skill to convince us of this Laura's independent existence on June 1, 1506, above all in the way that light describes the set of the intelligent, steady eyes in their sockets; the high forehead; and the hint of a smile.

"Laura" has been called variously a courtesan, a courtesan-poet, a mistress, and a bride, each based on the details provided the viewer by the painter. Considering these strongly held positions in turn affords a bracing reminder of the pitfalls of interpretation. Those who believe she must be a courtesan stress that a respectable Venetian woman would not be shown with a breast bared (a pose that denies any proper chasteness), and further note that she may be wearing her lover's cloak rather than her own.[5] The inclusion of the laurel—sacred to Apollo and for Petrarch a metaphor for his art—could suggest that she was the first in a line of Venetian courtesans who were authors and poets as well, the most famous of whom were Tullia d'Aragona and Veronica Franco.[6] Although Renaissance courtesans were generally anxious to be depicted more decorously, this was certainly an arena with evolving and sometimes unique imagery, as Moretto's representation of Tullia d'Aragona as Salomé (Pinacoteca Civica Tosio Martinengo, Brescia; ca. 1540) indicates.

At the same time, one author has argued that "in Venetian painting of the early cinquecento, there were no 'portraits of courtesans,'" and that the paintings thus described should be considered (putting it jocularly) as "promised brides ready to maintain their promises."[7] There are, in fact, various arguments in favor of understanding "Laura" as a bride (or within a marital context). Both the directionality of her glance and the fact that at one stage in the development of the composition the laurel branches were concentrated on the right of the composition suggest that the artist may have been planning it as one half of a portrait pair. Then, the laurel as a symbol of chastity or virtue, is found repeatedly in painting with nuptial themes, including Lorenzo Lotto's *Portrait of Messer Marsilio Cassotti and His Wife, Faustina* (fig. 7), in which the bride and groom are yoked together by a branch of it, and on the reverse of Jacometto Veneziano's *Portrait of a Man* (National Gallery, London; 1475–98), where tied branches of it appear with a nuptial inscription. Numerous examples can be brought forward to show that the single uncovered breast very often indicated virtue rather than vice, and could easily suggest the modest availability of the bride, and her readiness to receive love.[8] Likewise, the veil covering her head is a typical attribute of a bride.

Should she be neither courtesan nor bride, it is possible that this portrait was the memento of a love or was intended as a gift between lovers, possibly even presented in tandem with a sonnet, its poetic equivalent. This hypothetical line of reasoning is interesting if the painting is considered alongside Leonardo's *Ginevra de' Benci* (fig. 8), of some twenty-five years earlier, to which it is often

compared, given that Giorgione's awareness of Leonardo's work may have inspired him to place his own sitter before a screen of foliage that alludes to her name or character. Both the patron and the date of Leonardo's painting are still debated. It is possible that the far more demure Ginevra was portrayed at the time of her wedding to Luigi Niccolini in 1474, or perhaps during a platonic relationship with the Venetian ambassador Bernardo Bembo, who was in Florence in 1475–76 and 1478–80 and whose emblem of a wreath of laurel and palm is represented on the painting's reverse. Bembo could have commissioned the work early in 1475, his decision to fix on a "donna amata" perhaps inspired by a tournament organized by the Medici during which Giuliano de' Medici's admiration for Simonetta Vespucci was celebrated; some scholars have instead dated the work to the later years of the decade. Verses referring to Bembo's chaste feelings for Ginevra were written by the humanist Cristoforo Landino, providing the final ingredient of this Petrarchan affair. A third, related, alternative, that it is a nuptial portrait "updated" with Bembo's emblem has also been suggested, but it is a difficult scenario to envision (it has also been suggested that neither husband nor platonic lover was the patron).[9] Whatever Giorgione may have known about this painting (there is no indication that Bembo's family kept it in Venice, although there is a possibility that Leonardo had it in his possession when he was in the city in 1500), the story behind its making may have been in his mind when he undertook to paint *Portrait of a Woman* (*Laura*).

It remains equally difficult to know why the artist Vincenzo Catena (active 1506–31) is mentioned in the inscription as Giorgione's "cholega," perhaps to be translated as "colleague," and whether this has any bearing on the painting's meaning. This is the earliest mention of the artist to come down to us; in the following decade his own work was much influenced by Giorgione.[10] During that decade he also had numerous acquaintances among Venetian humanists, including Pietro Bembo, Bernardo's famous son. Giles Robertson, in his book about the artist, expressed the belief that Catena was already moving in these humanist circles in 1506 and that he and Giorgione may have met in that context and come to work together.[11] This too remains speculative, but it is wonderful to think that this painting, redolent of the ideas about love expressed by Bembo in his dialogue *Gli Asolani* in 1505, may have been painted in the same milieu.

A B

1. These studies are discussed in detail in Oberthaler 2004, pp. 268–69, and p. 273, figs. 3–6; and Oberthaler and Walmsley 2006, pp. 291–92, no. 38, figs. 7–9.

2. See Oberthaler and Walmsley 2006, p. 292, fig. 9.

3. Anderson 1997, p. 217.

4. See Waterhouse 1952, p. 16, no. 50, for the list; the irony is noted by Sylvia Ferino-Pagden (in D. A. Brown and Ferino-Pagden 2006, p. 210). See also Dal Pozzolo 1993, pp. 260–64, for images circulating in the Veneto believed to represent Petrarch's Laura.

5. See Junkerman 1993, which provides a subtle discussion of both the woman's gesture and her garment; and Anderson 1997, pp. 211, 215–16, which cites Cesare Vecellio (De gli habiti antichi, 1590) on courtesans' winter fur cloaks.

6. See Anderson 1997, pp. 215–16.

7. Gentili 1995, p. 95; and see Gentili's sharp response to the previously mentioned interpretations, pp. 104–5, n. 21.

8. For nuanced readings of both of these details, see Dal Pozzolo 1993, esp. pp. 267–79, with references also to earlier studies along these lines, such as Noë 1960 and Verheyen 1968; as well as Gentili 1995, pp. 96, 99; and Sylvia Ferino-Pagden in D. A. Brown and Ferino-Pagden 2006, p. 210.

9. The connection with Bembo was put forward in Fletcher 1989; see David Alan Brown in D. A. Brown et al. 2001, pp. 142–46, no. 16, for a review of the literature and his own views; on Bembo's stays in Florence and his connections there, see Fletcher 1989 and Walter and Zapperi 2006, pp. 31–44. Garrard (1992, pp. 59–64; and 2006) questions both theories. She suggests (1992, p. 63) that "we take Leonardo's painting at its face value, as an honorific image of a young woman who had achieved recognition as a poet, and whose physical beauty is here presented as coextensive with her intellectual beauty" and that the work may have been commissioned by the sitter herself or by her brother.

10. Mauro Lucco in Le Siècle de Titien 1993, pp. 274–75, no. 7, discussing Catena's Portrait of Giangiorgio Trissino (Musée du Louvre, Paris); and Lucco in D. A. Brown and Ferino-Pagden 2006, pp. 122–25, no. 19, on Catena's Adoration of the Shepherds (Metropolitan Museum, New York; 69.123).

11. Robertson 1954, pp. 5, 12–13.

SELECTED REFERENCES: Wilde 1931, pp. 91–102; Wilde 1934; Waterhouse 1952, pp. 1–23; Noë 1960, pp. 1–35, fig. 1; Verheyen 1968, pp. 220–27, fig. 2; Dal Pozzolo 1993, pp. 257–92, fig. 1; Junkerman 1993, pp. 49–58, fig. 1; Alessandro Ballarin in Le Siècle de Titien 1993, pp. 724–29, no. 27, ill. pp. 41, 295; Gentili 1995; Anderson 1997, pp. 208–17, 299–300, ill.; Giovanna Nepi Scirè and Sylvia Ferino-Pagden in Ferino-Pagden and Nepi Scirè 2004, pp. 197–201, no. 8, ill.; Oberthaler 2004, pp. 268–69; Sylvia Ferino-Pagden in D. A. Brown and Ferino-Pagden 2006, pp. 208–11, no. 38, ill.; Ferino-Pagden 2006; Oberthaler and Walmsley 2006, pp. 291–92, no. 38, ill.

Jacopo Negretti, called Palma il Vecchio
Serina, near Bergamo, 1479/80–Venice, 1528

146a. Young Woman in Blue with a Fan

Ca. 1512–14
Oil on panel, 25 × 20⅛ in. (63 × 51 cm)
Kunsthistorisches Museum, Vienna (63)

146b. Young Woman in Green Holding a Box

Ca. 1512–14
Oil on panel, 19¾ × 16 in. (50 × 40.5 cm)
Kunsthistorisches Museum, Vienna (66)

Palma il Vecchio's oeuvre includes a remarkable group of paintings of *belle donne*, half-length portrayals of lovely young women who are not immediately recognizable either as contemporary portraits or as mythological or historical characters.[1] Both those exhibited here can probably be traced back to the Venetian collection of Bartolomeo della Nave, a list of whose paintings was compiled in the 1630s. Della Nave also owned the marvelous related *Portrait of a Woman*, called *Violante* (a violet is tucked into the girl's bodice), often attributed to Palma but more likely to have been painted by Titian (Kunsthistorisches Museum, Vienna; ca. 1510–15).[2] All the paintings in the group are variations on a theme: a light-haired young woman, lavishly dressed although sometimes in a degree of dishabille, presents herself to the viewer. Specific attributes that might help to identify her are generally lacking, although the *Violante,* for example, was described as a "woman called the faire Catt" in the inventory cited above, implying that in the seventeenth century it was considered the likeness of a specific person with a nickname (Carlo Ridolfi writing in 1648 called it, in Italian, the "Dama detta la Gattina"). Another legend that grew up around that work and circulated in the nineteenth century held that it was a daughter of Palma's named Violante who was portrayed, and that she was the beloved of Titian.[3]

Much variety of expression and effect could be achieved within the narrow limits offered by these compositions. The subject of *Young Woman in Blue* (cat. no. 146a) is carefully coiffed, her pale, smooth skin (the kind of skin that brings to mind S. J. Freedberg's phrase, a "luminous, enamelled sensuality")[4] set off by tiny blue flowers at her left ear; her broad torso and her arms are encased in a magnificent gown of blue with sleeves of green, tied with ribbons across a white chemise, and striped cuffs with almost transparent fringes. Leaning on a plinth, she holds a black fan in one delicate hand while gesturing with the other, and she gazes at the viewer out of the corners of her eyes. The sense of space within the composition is created above all by the suggestion of a nichelike architecture in the neutral gray background. The subject of *Young Woman in Green* (cat. no. 146b) has flesh tones that seem more thinly painted, and both more delicate and more natural. She looks away from the viewer and therefore does not have the provocative gaze of the woman in blue. Yet her clothes suggest a greater state of undressed intimacy. Her outer garment—its sleeves a beautiful green and soft orange—is untied, and the artist lingers over the wonderful twisted braid of the cord, exposing a good deal of her white chemise. She holds a small, round box, from which a thread spills. Each woman wears small rings in the middle of the fourth finger of one hand. Such tender hands were characterized by Crowe and Cavalcaselle as "so obviously kept in lavender as to presuppose absolute abstention from labour, so delicate and undersized as almost to look unreal."[5]

Like that of Giorgione's *Laura* (cat. no. 145), the meaning of these works, once coveted primarily for their sensual appeal and outright beauty, has been much disputed in recent years. Are they portraits, and if so, of courtesans or mistresses or brides? If not, what do they represent? There is no simple answer to these questions, and all interpretation must take into consideration the subtle but unmistakable differences between one work and the next, and the probability that some of the paintings (certainly the *Laura,* in this context) are more personalized and specific than others. Philip Rylands asserted that the subject of *Young Woman in Green* can be positively identified as a prostitute or courtesan. Following an earlier suggestion, he identified the painting with one still to be found in Palma's studio when an inventory was made up in 1528, following the artist's death. The entry describes a portrait "with hair tumbled on the shoulders and dressed in green," as a "retrato de la cara.a. . . . ," an abbreviation that Rylands suggested was of the word *carampana,* a local term given to Venetian prostitutes, who were required to live near the Ca' Rampani, in the parish of San Cassiano—close to the famous Ponte delle Tette.[6] There is a strong probability that some of the women thus depicted would have been considered easily "approachable." In the hands of a less sensitive, more anecdotal artist such as Bernardino Licinio (ca. 1490–after 1549), the elegant women portrayed by

Palma could diminish into blowsy courtesans actually embraced by their suitors (see *Courtesan and Her Cavalier*, formerly Canford Manor, Dorset).[7]

This easy explanation does not do justice to our women, who are of an extraordinary refinement. There can be little doubt that they were representative of the ideals of beauty expressed abundantly in contemporary literature. In an important article analyzing the coincidence of terms of beauty in three sixteenth-century treatises and related paintings, Mary Rogers showed, for example, how in Federigo Luigini's *Libro delle bella donna* (Venice, 1554), the writer's ideal included uncovered hair that was "dorati, crespi, lunghi e folti, in bionde trecce avolti" (golden, curled, long and thick, wound in blond braids), which could certainly describe Palma's treatment of the tresses in these paintings. The mere fact that the hair is not held up in a snood, as was conventional among married women, indicates a strong eroticism, as loose tresses were "capelli di fuori legge." Likewise, in treatises and in the endless examples of love poetry inspired by Petrarch, much was made of the qualities of women's skin, which was considered most beautiful if white, flawless, without pucker or blemish and like marble, ivory, or alabaster.[8]

Interpretations of these *belle donne* have ranged from prostitute to bride to abstract beauty; from the illicitly available, to the *sposa* erotically available only to her husband, to an unreachable ideal. Accessories contribute to this hermeneutic confusion. Does the properly dressed woman in blue hold a fan comparable to that held by the courtesan in a lively print by Pietro Bertelli (cat. no. 103)? Why then is the partially undressed woman in green holding what appears to be a modest sewing box (see cat. no. 44) with a dangling thread? Many other details found in related paintings can be interpreted in either sense: jewels, flowers, boxes, gold chains can equally signify the bride or the courtesan.

In a beautiful recent essay, Silvia Ferino-Pagden cut this Gordian knot by suggesting that we look more closely at the ambiguities built into the literary parallels to the paintings, the poetry and dialogues in which the discourse about the nature of love seemed to capture the imagination of the Venetian public.[9] The beloved could be described in abstract terms, and her qualities could be both arousing and chaste; a bride could also be dreamt of in this double way. The great game of Petrarchan love involved both words—portraits in sonnets and dialogues—and paintings, beginning with Simone Martini's untraced portrait of Laura. Many portraits of real women resulted from the conventions of these love affairs, notably,

Cat. 146a

in this context, that of the Venetian widow Maria Savorgnan, with whom the author Pietro Bembo exchanged sonnets in 1500, and whose painted portrait was commissioned from Giovanni Bellini (unusually, Maria herself commissioned the latter).[10] It is vital to remember that these love affairs themselves could range from the strictly chaste and ideal (such as Lorenzo de' Medici and Lucrezia Donati's) to the sexual and secret (as indeed Bembo's with Savorgnan was).

At the same time, it is relevant to ask whether a "portrait" of a beloved needed to achieve physiological similitude. The literary critic Amedeo Quondam once asked, "Why didn't Petrarch ever talk about Laura's nose?"[11] This odd lacuna was even singled out by one of the participants in the dialogue *Civil conversazione*, written by Stefano Guazzo in 1574, where one interlocutor asks whether the poet's oversight might not be because his lady's nose was somehow unsightly, and by extension indecorous. Quondam showed that in neo-Petrarchan

poetry certain aspects of female beauty were repeated over and over (what another scholar, Giovanni Pozzi, called the "fixed catalogue of privileged anatomical parts"),[12] while others were conspicuously left out. The upshot, of course, was a codification of the ideals of beauty that could be repeated and did not have to precisely refer to an individual's appearance. This did not mean, however, that in writing a sonnet praising the hair, eyes, eyebrows, cheeks, lips, and mouth of one's beloved, the author was not addressing a real love, or at least implying that he did so. Or, as Quondam would express it, that there was not an "io" addressing a "tu" (an "I" addressing a "you"), just that the means of address had been conventionalized. It seems credible to believe that the same language has been adopted and developed by Palma, whose "portraits" of the beloved then parallel all those "portraits" in language, in which the loved one's hair is always of gold; the eyes of amber, surrounded by ivory; the lips of coral and the teeth like pearls; the cheeks like

Cat. 146b

two roses and the forehead serene; the breasts white as snow.[13] A B

1. See Luke Syson's essay *Belle* in this volume.
2. For these three paintings, see Rylands

1992, p. 152, no. 7 (*Young Woman in Green*); pp. 153–54, no. 9 (*Young Woman in Blue*); pp. 172–73, no. 31 (*Violante,* as by Palma). For the paintings from Bartolomeo della Nave's collection, see Waterhouse 1952, p. 16, no. 68 (*Woman in Blue*), no. 65(?) (*Woman in Green*),

and p. 15, no. 29 (*Violante,* as by Titian). Della Nave also owned Giorgione's *Laura* (cat. no. 145).

3. This tale was based on Marco Boschini's claim about the purported relationship between "Violante" and Titian. See Rylands 1992, p. 172, no. 31, for this and the passage from Ridolfi's *Maraviglie dell'arte*; and Joannides 2001, p. 231.
4. Freedberg 1970, p. 106.
5. Crowe and Cavalcaselle 1871, vol. 2, p. 480.
6. On Venetian courtesans, see Linda Wolk-Simon's essay "Rapture to the Greedy Eyes" and cat. nos. 103, 116, 117, in this volume; Rylands 1992, p. 89, and Appendix, p. 350, no. 23; the author's identification of this painting with the 1528 inventory entry was following a suggestion of Gustav Ludwig (1903, p. 77, n. 11). In the inventory, the painting is described as "meza facta," as are a number of other works. If this is to be translated as "half-finished," it leaves the identification of the painting open to doubt.
7. Luisa Vertova in *I pittori bergamaschi* 1980, pp. 414–15, no. 24, ill. p. 467, no. 2.
8. Rogers 1988, pp. 60–63.
9. Ferino-Pagden 2006, esp. pp. 195–96.
10. See the illuminating chapter in Walter and Zapperi 2006, pp. 59–78; the portrait is untraced.
11. Quondam 1989; see also Cropper 1995.
12. Pozzi 1979, p. 5; Quondam 1989, p. 19.
13. See quotations of poetry by Niccolò da Correggio and Bernardo Giambullari in Quondam 1989, pp. 15 and 27. On the issue of "portraits" versus "pictures" in the written descriptions of comparable works, see Santore 2000.

SELECTED REFERENCES: Mariacher 1968, pp. 54, 73–74, nos. 20, 49, ill.; Mariacher 1980, p. 217, nos. 66, 67, ill. p. 225, no. 5, and p. 236, no. 4; Rylands 1992, pp. 89, 97–98, 152–54, nos. 7, 9, ill. p. 98; Goffen 1999, pp. 118, 121, ill. p. 117 (*Young Woman in Blue*)

MYTHOLOGIES AND ALLEGORIES

Attributed to Giovanni Busi, called Giovanni Cariani

San Giovanni Bianco, ca. 1485–Venice, after 1547

147. *Allegorical Wedding Picture*

Ca. 1510–30
Oil on canvas, 29⅞ × 49¼ in. (76 × 125 cm)
Private collection, Switzerland

This enigmatic picture bears neither a definitive attribution nor a widely accepted subject matter. Three half-length

female figures are set against a dark background. The woman in the center is positioned frontally along the picture plane, while the two women flanking her are seen in profile. The central figure unifies the composition by placing the tips of the fingers of her right hand on the right palm of the figure at her right and resting her left hand on the shoulder of the figure at her left. If touch unites in this work, sight introduces an element of discord. The gaze of the central figure, coupled with her open mouth and raised right knee, suggests a desire to communicate with the figure at her right, who meets her

glance in an unwavering manner. The figure at the right looks ahead stoically, seemingly unaware of her companions. These visual cues alert the viewer to the narrative character of the picture without revealing the particulars of the *poesia*.

The composition and the narrative do evolve, however, from the Venetian *sacra conversazione* of the quattrocento as well as from Giorgione's, and later Titian's, enigmatic half-length, three-figure compositions set against dark backgrounds, dating from the first quarter of the sixteenth century.[1] Specifically, the composition finds its origins

in works such as Giovanni Bellini's *Madonna and Child* (Accademia, Venice; ca. 1490), in which the Virgin is flanked by two female saints against a dark background.

Claudia Bertling Biaggini situates the work in the realm of early sixteenth-century Venetian painting and the genre of the wedding picture, attempting to decipher the narrative by way of comparisons with both sixteenth-century and classical literary and pictorial precedents.[2] Biaggini notes that the epithalamic verse of the Roman poets Catullus, Statius, and Claudian introduced the theme of the goddess Venus as adviser to the bride, which was later adopted by Renaissance authors such as Lodovico Dolce (1508–1568). She traces the theme of the bridal adviser to the Greeks, noting parallels between the hand and eye contact in the present work and the narrative depicted on an Athenian red-figure vase by the fifth-century-B.C. Eretria Painter representing the bride Harmonia sitting between Peitho (goddess of persuasion) and a *kore* (handmaiden). Ultimately, Biaggini reads this work as an ambivalent bride seeking assistance from an attendant at her right and Venus—the goddess of love—at her left.[3]

Silvana Seidel Menchi places this work in the context of sixteenth-century Venetian nuptial pictures. She regards the central figure as a virgin displaying the customary reserve at the prospect of matrimony. In Venice a prospective bride was expected to refuse a marriage proposal two or three times before finally accepting it; excessive enthusiasm

for the union was regarded as inappropriate. Although Seidel Menchi incorrectly describes the central figure as in tears, she correctly views the work as a psychologically inflected interpretation of a young woman undergoing a conjugal rite of passage.[4]

Certain examples of the genre of the marriage picture, such as Lorenzo Lotto's *Messer Marsilio Cassotti and His Wife, Faustina*, of 1523 (fig. 7), should be understood as "marriage portraits," in which the figures are meant to represent specific individuals, while at the same time offering additional allegorical meanings. In other examples, such as Titian's *Sacred and Profane Love* (fig. 93), however, the theme of matrimony is presented on a purely allegorical level (see Beverly Brown's essay "Picturing the Perfect Marriage" in this volume). The present painting belongs in the latter category of the allegorical marriage picture. The facial features of the women, unlike those of Faustina in Lotto's *Marsilio Cassotti*, have the generic appearance common to Venetian pictures of *belle donne* by Titian and Palma il Vecchio (see cat. nos. 146a, b). The myrtle crown resting on the head of the figure at the left symbolizes marriage, while the rose affixed to the bosom of the central figure and the carnation in her left hand are unequivocal symbols of love. The pearls adorning the head of the figure at the right symbolize the physical perfection and purity of a bride,[5] while the *dextrarum iunctio*, or joining of two right hands, echoes the ancient Roman marriage rite. All this suggests that the picture represents a young woman seeking

support—emotional, physical, and psychological—from two allegorical figures, most likely before an impending marriage. The bride's central placement implies that a choice is being made between two alternatives—a choice that cannot be fully elucidated without further research. Although the tilt of the bride's body and the joining of hands indicate a marked preference for the option represented by the figure at her right, the bride's uncertain expression leaves the viewer with a feeling of disquietude as to her fate.

The white and red *scuffia*, or cap, worn by the bride here and by other Venetian women and men throughout the sixteenth century, evidently became more fitted as the century progressed (see, for example, the one worn by the central figure in Bernardino Licinio's *Portrait of Arrigo Licinio and His Family*, of about 1535, in the Borghese Gallery, Rome).[6] Her dress and those of her companions have sleeves cut *a comeo*, a style the Venetian state sought to regulate with frequent sumptuary laws. During the first decades of the sixteenth century, these laws decreed that dresses were to be of one color with modest sleeves; gold cloth was a luxury permitted only to women residing in the Palazzo Ducale.[7] The dress worn by the central figure in the present painting clearly violates these precepts. Unless the fashions depicted are *retardataire*, the width of the sleeves and the shape of the *scuffia* worn by the central figure suggest a date in the 1510s or 1520s.

This picture is presently attributed to Giovanni Busi, called Giovanni Cariani

(ca. 1485–after 1547). It was most likely produced by an artist in the orbits of Titian (ca. 1488–1576) and Lorenzo Lotto (ca. 1480–1556), probably by a painter such as Cariani, who worked in Venice and then brought his talents to bear elsewhere, perhaps in Bergamo or Brescia. The contours of the faces have the robustness of those female countenances rendered by Palma il Vecchio and Sebastiano del Piombo (ca. 1485/86–1547), as well as Cariani, without mimicking them. The somewhat damaged condition of the painting, coupled with the lack of definitive modeling of the faces, makes reaching a firmer attribution difficult.[8]

The uncertainties manifest in *Bildsprache* of this type raise questions once again as to whether secular Venetian allegorical iconography of this period should be interpreted on an esoteric or exoteric level.

ES-P

1. In particular, this work derives from compositions such as Giorgione's *The Three Ages of Man* and Titian's *The Concert* (both Palazzo Pitti, Florence).
2. Biaggini (2002–3, p. 98) notes that the theme was explored in works such as Lorenzo Lotto's *Messer Marsilio Cassotti and His Wife, Faustina* (fig. 7) and Paris Bordon's *Lovers* (fig. 104).
3. Biaggini 2002–3.
4. Seidel Menchi 2006, pp. 676–78.
5. Orsi Landini and Westerman Bulgarella 2001, p. 94.
6. For Licino's painting, see Andrea Bayer in Bayer 2004, p. 117, no. 26.
7. Newton 1988, pp. 46–76.
8. Anke Oelerich, Restaurierungswerkstatt Oelerich, Bergisch Gladbach, conservation report, February 2007.

SELECTED REFERENCES: Newton 1988, pp. 46–76; Orsi Landini and Westerman Bulgarella 2001; Biaggini 2002–3, pp. 94–111, figs. 1–3, 8; Seidel Menchi 2006, pp. 676–78, fig. 5

Lorenzo Lotto
Venice, ca. 1480–Loreto, 1556

148. Venus and Cupid

Late 1520s
Oil on canvas, 36⅞ × 43⅞ in. (92.4 × 111.4 cm)
The Metropolitan Museum of Art, New York, Purchase, Mrs. Charles Wrightsman Gift, in honor of Marietta Tree, 1986 (1986.138)
New York only

In this playful and evocative work, the brilliant Venetian artist Lorenzo Lotto has created a paradigmatic marriage painting,

the visual equivalent of a poetic epithalamium. Venus is shown reclining nude in a grassy bower, holding a myrtle wreath with an incense burner suspended from it; she is strewn with rose petals and wears a gem-encrusted tiara and one pendant earring. Cupid, with a bow slung across his shoulder and a myrtle wreath at a jaunty angle across his forehead, gazes at his mother mischievously while sending a gold and silver stream of urine through her wreath and onto her torso. Behind them ivy winds up a sturdy oak, whose branch helps support a great swath of red drapery, while a conch shell hangs above the goddess on a slender tie.

Keith Christiansen recognized that the ancient marriage poems and songs known as epithalamia (for which, see Andrea Bayer's essay "From Cassone to *Poesia*" in this volume and cat. no. 61) were reflected both in the painting's overall composition and in these details.[1] The poems often follow a formula in which Cupid arrives to rouse his mother, urging her to rise from her bower and rush to give her blessing to a couple about to be wed. Her role in the wedding is stressed, for example, in the Roman poet Statius's epithalamium for Stella and Violentilla, where it falls to Venus to praise marriage, giving her blessing to passion within the legitimate union and expressing her hope for a fertile outcome.[2] In a Latin poem by the Alexandrian poet Claudian, several of the details so expertly depicted by Lotto make their appearance: "myrtle wreaths adorn the portals, the couches are piled with roses, while cloth of scarlet dye, as befits a marriage, adorns the bridal chamber."[3] Catullus made use of ivy as a metaphor for the clinging nature of love. Indeed, the traditions reflected in this imagery have an enormously long history, as even early Greek lyric poetry includes epithalamic verse in which bridal processions are strewn with myrtle, roses, and violets.[4] The *strophion*, or white girdle, under the goddess's breast was identified by Renaissance antiquarians as that worn by a Roman maiden on her wedding night, to be untied by her husband.[5]

Lotto, and his patron, would have been aware of this form of poetry because of its widespread revival throughout Italy beginning in the fifteenth century. Epithalamia were written and presented as orations (both in prose and in verse) at hundreds of weddings, where they also served as panegyrics to the, often noble, bride and groom and their families. Lodovico Dolce, a leading Venetian art critic, in 1538 translated one of the most significant and oft-quoted of the ancient poems, Catullus 64, which celebrated the union of the Argonaut Peleus and the sea-nymph Thetis. It is clear that there would

have been widespread recognition of the parallel poetic tradition to which this painting made reference.

Lotto's genius was to wed immediately recognizable contemporary symbols to the underlying classical language. The micturating putto—an augury of fertility and prosperity—is found on birth trays, as on the reverse of one by Bartolomeo di Fruosino (cat. no. 69), which is inscribed, "May God give health to every woman who gives birth and to the child's father . . . may [the child] be born without fatigue or danger. I am a baby who lives on a [rock?] . . . and I make urine of silver and gold." Likewise, Venus is adorned with a Venetian bridal tiara with veil and a pearl earring, as described by Cesare Vecellio in his costume book (see cat. no. 64). Even the more threatening elements of this image—the rod and the serpent (though nonvenomous) in the foreground—have multiple sources, both contemporary and ancient, not least of which are poetic passages that Virginia Tufte called the "anti-epithalamium," that is, the ominous reverse of a joyful bridal scene.[6] Thus, in the epithalamium written by Catullus and translated by Dolce, the joy of Peleus and Thetis is compared to the pain inflicted on Ariadne by Theseus, the poem's other principal theme.

Although Lotto's production of secular painting was limited, his inventiveness in the depiction of marital themes was remarkable, indeed, unique. His great double portrait *Messer Marsilio Cassotti and His Bride, Faustina* (fig. 7), painted in Bergamo in 1523, encapsulates contemporary ritual, elucidating its underlying meaning (for another example in portraiture, see cat. no. 124).[7] The young bridegroom, about whose family we know a good deal, is shown placing a ring on the bride's finger (she is in typical wedding finery), while a cupid—similar to that in the present canvas—is literally yoking the two together, representing *vincla conjugalia*, or conjugal ties. The laurel around the putto's head and between his fingers probably signifies the *virtus* (virtue) that must exist within the marriage. The painting was commissioned by Cassotti's father, who may have considered the couple too young for the responsibilities of marriage (the groom was just twenty-one) and therefore thought out this rather tongue-in-cheek image with its palpable overtones of obdurate permanence.[8]

In a painting closely related to the *Venus and Cupid*, and perhaps also inspired by a marriage, Lotto depicted a *Triumph of Chastity* (fig. 121) that is equally complex in its imagery. A marblelike Venus, based on an antique relief sculpture, and her son are being driven away by an agitated figure of Chastity, who threatens them with Cupid's own bow.

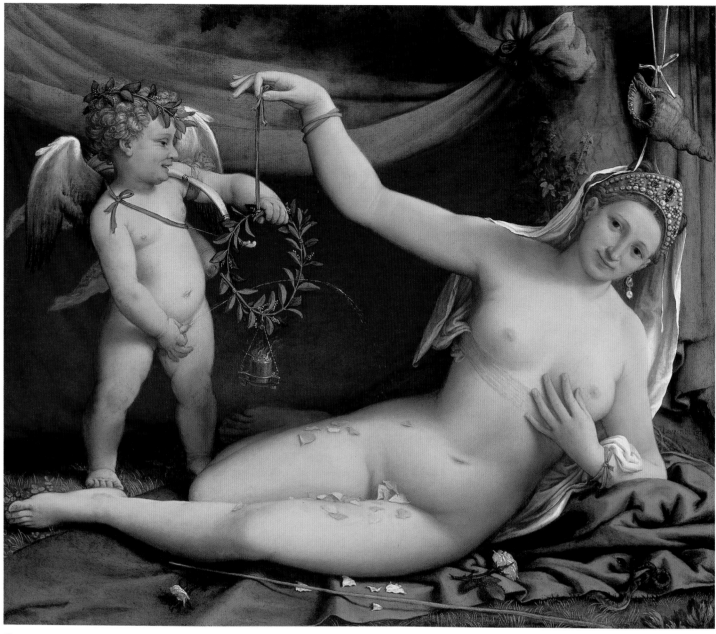

Cat. 148

A small ermine, symbolic of purity, decorates Chastity's bodice. In this case, Venus appears in her more typical role as goddess of love; she holds her toilet accessories, including a beautiful comb, as far away from the attacking, bonneted Chastity as possible. The latter would have been understood as championing the chastity within marriage held as the model by all sixteenth-century authors.

It is very unfortunate that we do not know for whom the *Venus and Cupid* was painted. In recent years it has been suggested that Lotto painted it for his cousin, Mario d'Armano, with whom he lived while working on the *Saint Antoninus* altarpiece for the church of Santi Giovanni e Paolo in Venice, from 1540 to 1542.[9] Lotto kept a list of his contributions to the household expenses, as well as of the paintings he did for the family. One of these was a *Venus*, commissioned in 1540 and supplied with a gilt frame and a black cloth (as a cover?), which had an inscription.

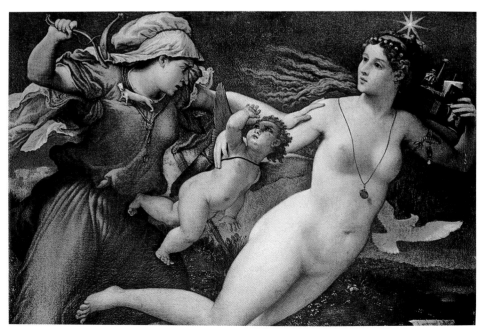

Fig. 121. Lorenzo Lotto (ca. 1480–1556), *The Triumph of Chastity*. Oil on canvas, 28¾ × 44⅞ in. (73 × 114 cm). Private collection, Rome

Although Mario d'Armano himself had long been the father of a family (Lotto often purchased shoes for his daughter, Lauretta, during these years), it is possible that the painting was meant as a wedding gift.

There are two objections to this attractive thesis. First, while it has been argued that the painting is related stylistically to other works of 1540, its brilliant, saturated colors, highly finished surface, and extraordinary attention to details of jewels, flower petals, and so forth make it more akin to paintings of the second half of the 1520s. A comparison of the Cupid in this painting with the one in the portrait of Messer Marsilio and his wife suggests that the two cannot be too widely separated in date. Second, atop Venus's beautifully idealized body is a highly individualized face, with a longish nose, warm brown eyes, and a lovely smile—perhaps the bride herself. It seems more likely that a husband would have commissioned such an intimate portrayal. That might have been in Bergamo, where Lotto was living until 1525, and where, tantalizingly, a "sposalitio d'Amore" (Marriage of Love) was recorded in the Tassi collection in the seventeenth century; or it could have been a few years later in Venice, where Lotto had some of his most sophisticated patrons and the imagery of Venus and Cupid had already been well developed.[10]

AB

1. Christiansen 1986.
2. Tufte 1970, pp. 58–59.
3. *Epithalamium* 29.25–30 (English trans., Claudian, *Works*, 1922 [ed.]), vol. 2, p. 237; quoted in Christiansen 1986, p. 172).
4. Tufte 1970, p. 11.
5. Massi 2006, p. 169.
6. Tufte 1970, chap. 3.
7. The painting has been the subject of a good deal of study. See Van Hall 1976; Mauro Lucco in D. A. Brown, Humfrey, and Lucco 1997, pp. 134–37, no. 21; Miguel Falomir in Falomir 2008, pp. 228, 474–75, no. 37; and B. L. Brown 2009.
8. Lucco in D. A. Brown, Humfrey, and Lucco 1997, p. 136.
9. Humfrey 1997, pp. 139–40.
10. Domenico Tassi was one of Lotto's most important patrons, and the painting is recorded in his family's collection in Ridolfi, *Le maraviglie dell'arte,* 1914–24 (ed.), vol. 1, p. 144. The painting was no longer in the collection by the eighteenth century.

Selected references: Berenson 1956, p. 83, pl. 258; Cortesi Bosco 1980, p. 139, fig. 155, p. 145, n. 69; Christiansen 1986, pp. 166–73, pl. 1, figs. 1–3; Sylvie Béguin in *Le Siècle de Titien* 1993, pp. 494–95, ill. p. 147; Bonnet 1996, pp. 139–40, fig. 92; Humfrey 1997, pp. 139–40, pls. 142, 144; Bayer 2005, pp. 42–44, fig. 36; Massi 2006, pp. 167–70, fig. 1

Paris Bordon
Treviso, 1500–Venice, 1571

149. *Reclining Nude*

Ca. 1537–38
Oil on canvas, 31⅞ × 25⅝ in. (81 × 65 cm)
The Rt. Hon. The Earl of Wemyss and March K.T., Scotland (G 160)

This exquisite painting is a fragment of what must have been a full-length reclining female figure shown in an interior dense with textiles and cushions. She is depicted nude, although covered below the waist by a heavy crimson drapery lined in white silk, and wears various pieces of jewelry, including thin gold chains looped around her wrist (a *laccio d'amore*, or love knot), a necklace, and a brooch on her forehead. The artist, Paris Bordon (or Bordone), educated in his hometown of Treviso, studied briefly with Titian, whose paintings were very influential for the younger artist's early style. This example, with its softly modeled surfaces and flesh tones, probably dates to the late 1530s. It may have been directly inspired by Titian's *Venus of Urbino* (fig. 87), painted in those years, in which the reclining nude was brought into an interior, deviating from Giorgione's *Sleeping Venus* (fig. 88), an earlier depiction of the goddess in a lush landscape. *Two Studies of Women's Arms* (Victoria and Albert Museum, London), a sheet of drawings similarly posed although usually dated somewhat later than the present painting, suggest the care that Bordon took to study the fall of light and the texture of the skin.[1]

Bordon devoted a good deal of his time to painting mythologies and various other subjects peopled by beautiful—albeit often artificially beautiful—women with metallically glittering hair and clothes. Some of his works seem, quite openly, to portray courtesans (for example, *Venetian Women at Their Toilet*, National Gallery of Scotland; ca. 1540–50), but this elegant creature falls into the more indeterminate space occupied by the *Venus of Urbino*. In the past she has been called both a Venus Reposing (by the connoisseur Gustav Friedrich Waagen) and a Courtesan

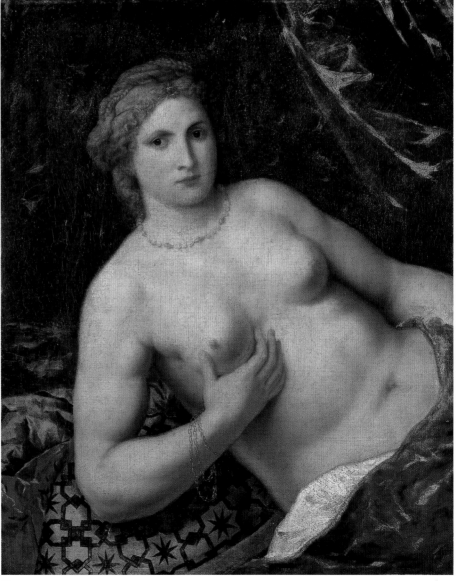

Cat. 149

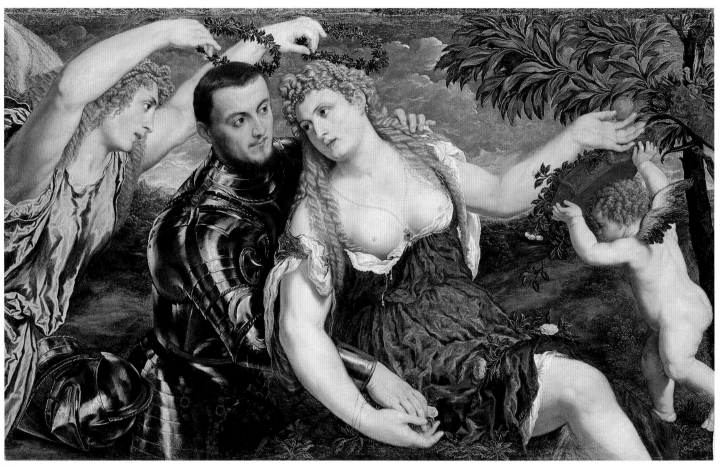

Cat. 150

(by Berenson and, later, Mariani Canova). Waagen, who saw the painting in the 1850s, thought the model's head to be of "uncommon beauty" (although somewhat "marred by an undue space between the right eye and the nose"); and, indeed, in paintings done a few years later, Bordon's women had hardened and become less appealing and more like theatrically made-up performers.[2] Although she rather conspicuously cradles her breast, this does not exclude the possibility that the figure depicted here is a poetically inspired Venus about to officiate at a wedding. The likelihood of this is increased by the gesture's overtones of nuptial fecundity and the inclusion of other marriage-related details, such as the jeweled head-brooch. A comparable painting with possible epithalamic meaning is mentioned by Giorgio Vasari and was one of the commissions undertaken by Bordon during his stay in France in 1558–59 at the court of François, second duc de Guise. For this illustrious patron he painted both a sacred work and "uno da camera di Venere e Cupido" (one of Venus and Cupid for his bedroom).[3] This is probably the painting now in the Muzeum Narodowe, Warsaw, and would have been made for the chamber shared by the duke and Anna d'Este, daughter of the duke of Ferrara, whom de Guise had married in 1549.[4] This full-length reclining Venus roughly suggests what the figure

in the present work looked like before the canvas was cut down.

AB

1. See Rearick 1987, p. 58, fig. 22.
2. See Peter Humfrey in Humfrey et al. 2004, p. 147, no. 47, and p. 434, n. 2 (under no. 47), citing Bernard Berenson and Giordana Mariani Canova, author of a more recent catalogue raisonné, and the quotation from Waagen.
3. Vasari, *Lives*, 1568/1996 (ed.), vol. 2, p. 800.
4. See Waźbiński 1987, p. 109ff. and fig. 2. For arguments dating Bordon's stay in France to 1558–59 (rather than 1538, as stated by Vasari), see as well Béguin 1987; Sylvie Béguin in *Le Siècle de Titien* 1993, pp. 536–37, no. 180; and Penny 2008, p. 58.

SELECTED REFERENCES: Waagen 1857, p. 63; Mariani Canova 1964, pp. 102–3, fig. 84; *Paris Bordon* 1987; Peter Humfrey in Humfrey et al. 2004, p. 147, no. 47, ill.

Paris Bordon
Treviso, 1500–Venice, 1571

150. Venus, Mars, and Cupid Crowned by Victory

Ca. 1550
Oil on canvas, 44 × 68¾ in. (111.5 × 174.5 cm)
Kunsthistorisches Museum, Gemäldegalerie, Vienna
(120)

Venus and Mars are shown side by side in an embrace, their hands touching amid a cascade of roses that falls on Venus's lap from a basket held by Cupid. Victory crowns the couple with myrtle garlands, and Venus, her breasts bared, raises her hand to pluck a quince from a tree. Although Mars is still in his armor—beautifully painted with reflections of Venus's red gown, as if the two are inextricably linked—his helmet is by his side, and it is clear that the painting celebrates "the triumph of Love's peaceful virtues over brute armed force."[1]

By 1643 this painting and five other mythological works by Bordon, some redolent with the imagery of love, and perhaps always meant for display together—although it is difficult to discern an actual coherent program if that was the case—hung at the home

of a paintings dealer in Augsburg, Jerominus Staininger. Their subsequent history has been traced by Klara Garas, who found that some entered the imperial collections and went to Vienna, while others went to Prague and later Dresden.[2] According to Giorgio Vasari and Pietro Aretino, the peripatetic Bordon painted important works for the great Augsburg banking family, the Fuggers, and it is possible that these paintings were undertaken for them. The dates both of a possible trip by the artist to Augsburg and of the paintings under discussion have been much debated. He may have been in that German city in the early 1540s and/or in the early 1550s; Pietro Aretino's letter mentioning Bordon's paintings for Cristoforo Fugger in Venice was written in 1548.[3]

The myrtle garlands, red draperies, and abundance of roses are found as well in Lorenzo Lotto's marriage painting *Venus and Cupid* (cat. no. 148), and a passage from an epithalamium by the late classical poet Claudian associated with that painting is likewise relevant here: "myrtle wreaths adorn the portals, the couches are piled with roses, while cloth of scarlet dye, as befits a marriage, adorns the bridal chamber."[4] The unusual image of the double-crowned figures has led one author to call them "two saints of conjugal virtue."[5] Venus tellingly plucks a quince—*mela cotogna*, in Italian—widely associated in both antiquity and the Renaissance with marriage. It is described as such in the text that appeared below an illustration of Andrea Alciati's emblem "Cotonea" (Quince Tree) in his influential book the *Emblematum Liber* (first published in Augsburg in 1531): "Cydonian fruit [so-named for the ancient belief that they came from that town in Crete] ought to be given to the newly wed, Solon of old is said to have decreed. Because it is conductive to good taste and disposition, and also that their breath might be sweet / and a seductive charm might linger on their lips."[6] A tradition linking the quince to bridal processions may go back as far as the seventh century B.C., the date of a fragment of poetry in which quinces are "cast on the chariot of the prince," the bridegroom.[7] The delicate gold chain looped around Venus's wrist is a *laccio d'amore*, or love knot, symbolic of the strong ties between husband and wife.[8] Another composition in the group mentioned earlier, the so-called *Shepherd and Nymph* (or *Pair of Lovers*), shares the motif of a wreath about to be lowered over the heads of the couple.[9] While Venus has the idealized features, elaborately cascading bleached-blond curls, and pale skin of many of Bordon's beauties, the features of Mars seem quite individualized and could be meant as a portrait; therefore, it is possible

that the painting was done with a specific couple in mind. The painting most closely related to this one in the group, *Venus, Mars, Cupid, and Flora*, also in Vienna, includes a completely different male protagonist.

Józef Grabski has noted the way in which the pictorial organization of this highly artificial composition, with its pronounced rhythms and endlessly overlapping and reciprocal elements (her gown reflected in his armor, his hand resting in hers, both about to be identically crowned), is parallel in construction to many love sonnets of the day. Let one couplet by the sixteenth-century poet Filippo Del Nero stand for them all: "che 'l mio nel vostro e 'l vostro amor nel mio, / Anzi, ch'io in voi, voi in me ci andiam cangiando" (that my love in yours, and yours in mine; / Or rather, I in you, you in me, together we will change).[10]

A B

1. Sylvie Béguin in *Le Siècle de Titien* 1993, p. 537.
2. Garas 1987, pp. 74–78: *Mars Removing Cupid's Bow* (Vienna); the present work (Vienna); *Shepherd with Nymph* (?) (known through a presumptive version in Vienna); *Diana and Nymphs* (formerly Dresden); *Apollo between Marsyas and Midas* (Dresden); two female figures (untraced).
3. For a discussion of the complex issues of dating, and especially the influence of a separate French sojourn on the artist's work, see Béguin in *Le Siècle de Titien* 1993, pp. 535–36; and Penny 2008, pp. 43–45, 58.
4. *Epithalamium* 29.25–30 (English trans., Claudian, *Works*, 1922 [ed.], vol. 2, p. 237; quoted in Christiansen 1986, p. 172).
5. Grabski 1987, p. 210.
6. Woods Callahan 1997, pp. 77–78.
7. Tufte 1970, p. 11.
8. Brevaglieri 1995, p. 134.
9. See the entry for the closely related painting in London in Penny 2008, pp. 56–61.
10. Grabski 1987, p. 211; translation by the author with thanks to Keith Christiansen.

Selected references: Garas 1987, pp. 71–78, fig. 5; Grabski 1987, pp. 203–11, fig. 17; Sylvie Béguin in *Le Siècle de Titien* 1993, pp. 536–37, no. 180, ill. p. 174

Jacopo Robusti, called Tintoretto
Venetian, 1518/19–1594

151. Venus and Mars Surprised by Vulcan

Ca. 1545
Oil on canvas, 52¾ × 78 in. (134 × 198 cm)
Bayerische Staatsgemäldesammlungen, Alte Pinakothek, Munich (9257)
Fort Worth only

In this amusing rendition of the mythological tale of Venus and Mars Surprised by Vulcan, Tintoretto demonstrates the invention and wit for which he was celebrated. An oil painting now in Munich, it offers on a large scale an irreverent view of the relationship between the sexes more often found in prints, literature, and theatrical performances intended for an elite or a private audience. According to classical texts,[1] Venus, goddess of love and beauty, who was married to the lame and elderly god Vulcan, had an illicit affair with Mars, the god of war. The sun god Apollo observed their dalliances and told Vulcan, who forged a net so finely wrought that it was invisible. He placed it on the lovers' bed, and after he had ensnared them *in flagrante delicto* called in all the gods to witness their humiliation.

In a richly appointed interior, the delectable body of Venus is stretched across the left foreground of Tintoretto's painting. One arm casually supporting her body on a pillow propped on the rumpled bed, Venus lifts the draperies with her other arm, cooperating with her husband in his search for signs of illicit activity in the bedclothes. Peeking out from under the table behind Vulcan, Mars faces a yapping dog that threatens to expose him. (Or did the dog alert Mars that Vulcan was about to enter the room, allowing him to hide?) Rather than illustrating an episode from the classical texts, Tintoretto has been inspired by various sources—pictorial and literary— to create a clever narrative that has been termed a "riotous *à la mode* bedroom farce" and a "fractured fable."[2] He presents this tale of adultery and jealousy within a domestic interior space that likewise plays with illusion or deception.

As has been noted, the basic composition of the interior, with its round-paned glass windows, steep perspective, and tiled floor, depends on Eneo Vico's 1543 engraving after Parmigianino of *Venus, Vulcan, and Mars*. Central to Tintoretto's mise-en-scène is the large round mirror propped on a bench against the far wall of the bedchamber in front of the window. Given its impromptu position and size, the mirror, which also

features prominently in the preparatory drawing (Kupferstichkabinett, Berlin), has been reasonably identified as Mars's shield.[3] The stagelike presentation may reflect Tintoretto's method, as described by Carlo Ridolfi, of planning the light effects in his pictures by building little houses or perspective scenes in which he placed wax and clay figures of his subjects and then illuminated with little lamps he made for the windows.[4]

Tintoretto also appears to have been inspired by Jacopo Caraglio's series of engravings of the Loves of the Gods (1527; see cat. nos. 101a–g), adopting both its erotic spirit and certain motifs. Caraglio's *Mars and Venus* shows the couple (nude except for Mars's helmet) sitting on a bed embracing, accompanied by a little dog and by Cupid, who reclines on the floor holding his arrow. Although Venus turns her head to kiss Mars, her hand mirror reflects a full face—no doubt that of Apollo, who has just caught the lovers together. Tintoretto studied another print in the Loves of the Gods series, *Cupid and Psyche*. In a manner similar to Vulcan's, Cupid places a knee on the edge of the bed as he lifts the drapery of Psyche, who is shown in a dorsal view, but in a diagonal pose very like Tintoretto's Venus in the Munich

painting. Titian's *Danae* (Museo Nazionale di Capodimonte, Naples; 1544–46) is often cited as a model for Tintoretto's Munich Venus, and her energized body with its expansive limbs also shows the artist's admiration for Michelangelo's dynamic figures. The Cupid sleeping by the window belongs to a type sculpted by the young Michelangelo that was based on—and passed for—an antique sculpture.[5] Having inspired love with his arrow, still in hand, the dozing Cupid ignores its consequences.

Erasmus Weddigen has proposed that the Munich picture depicts the sun god signaling to Vulcan, by means of concentrated rays of reflected light, his discovery of the adultery of Mars and Venus.[6] Using diagrams and models to reconstruct the miniature stage set that Tintoretto may have built in preparation for working on this painting, Weddigen shows how rays of light would pass through the vase on the windowsill to touch the round mirror and then be deflected to a table mirror on the opposite side of the room—which is not included in Tintoretto's painting, except in a faint reflection visible in the round mirror—and finally strike a wall in the room adjacent to the bedchamber where Vulcan was busy at his forge. A

simpler interpretation of the narrative action in the painting is that the table mirror in the bedchamber (reflected in the round mirror) would allow the lovers to anticipate Vulcan's approach, giving Mars time to hide under the table. As Carla Lord has noted, the use of a mirror as an alarm device may have been suggested by a passage from the late medieval *Roman de la Rose*. At one point in that popular French poem, which was also widely read in Italy, the topic of optics and the magnifying property of mirrors is broached. One of the characters observes that Venus and Mars would have been well advised and forewarned had they used a mirror to detect Vulcan's nearly invisible net. It is amusing to note in this context that in the ensuing dialogue someone observes that even if the mirror ploy failed, Venus would have explained Mars's presence to Vulcan, double-talking and making excuses, "for nothing swears or lies more boldly than a woman, and Mars would have gone off completely cleared."[7] The deceptive properties of mirrors are also discussed in *Le Roman de la Rose*.

Alluding to the *paragone*, a term used in the Renaissance to describe the rivalry for superiority between painting and sculpture, Venetian painters sometimes included

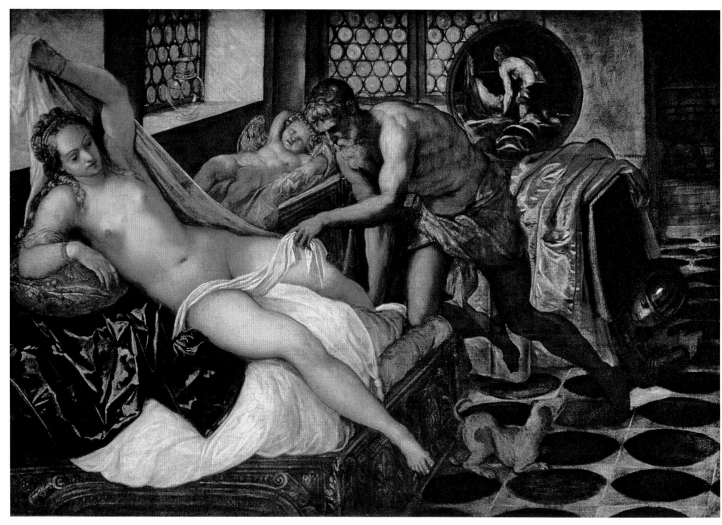

a mirror or two in their pictures, thereby championing the art of painting over that of sculpture, since in painting, multiple views can be presented simultaneously. For example, double mirrors were used to poetic effect by Titian in his *Woman at Her Toilet* (Musée du Louvre, Paris; ca. 1513–15) and by Giovanni Bellini in his *Lady with a Mirror* (Kunsthistorisches Museum, Vienna; 1515). Tintoretto, however shows Vulcan's backside reflected in the mirror in the Munich painting rather than Venus's beautiful nude figure. As Tom Nichols notes, Tintoretto subverts the refined Venetian ideal of aesthetic beauty predicated on both sensual experience and classical antiquity, directing the theme into the farcical mode of popular theater.[8] In a valuable and comprehensive analysis of the Munich painting, Beverly Louise Brown discusses Tintoretto's circle of friends, which included the publishers, or *poligrafi*, among them Anton Francesco Doni, who worked for the popular press and founded the Accademia Pellegrina.[9] The writings of the Venetian *poligrafi*, such as Lodovico Dolce, often dealt with the theme of marital infidelity and the folly of marrying a beautiful young woman. Tintoretto brings a similar spirit to his interpretation of a classical myth—an innovative approach to the genre.

Nothing is known of the painting's whereabouts before it appeared in the 1682 sale of Sir Peter Lely's collection, and several proposals have been made regarding the circumstances of its commission. Whereas Brown, Nichols, Rodolfo Pallucchini and Paola Rossi, and others date the painting to the early 1550s, Robert Franklin Echols and William H. Rearick concur with Detlev von Hadeln's and Erich von der Bercken's stylistic dating of the picture to the mid-1540s. Stella Mary Pearce dates the painting before 1550 on the basis of Venus's hairstyle.[10] As outlined above, the visual sources that inspired the Munich painting also point to a date early in the artist's career. Echols associates the painting's clever intellectualism, eroticism, and theatrical allusions with the artist's early association with Pietro Aretino.[11] Tintoretto had painted two mythological scenes for a ceiling in Aretino's residence about 1544–45, and it is possible the Munich *Venus and Mars* was created at Aretino's instigation or with his help. The cynical antimarriage views of the Venetian *poligrafi*, depending on such ancient writers as Juvenal, were shared by Aretino, as is evident in his 1533 comedy *Il Marescalco*. Regardless of the context of its creation, Tintoretto's *Venus and Mars Surprised by Vulcan* is a highly evocative painting remarkable for its ingenuity.

NE

1. Ovid *Metamorphoses* 4.169–257; Ovid *Ars amatoria* 2.651ff.; Homer *Odyssey* 8.266–366.
2. Nichols 1999, p. 88; B. L. Brown 1996, p. 199.
3. For the drawing, see Frederick Ilchman and Edward Saywell in Falomir 2007, pp. 406–7, no. 58.
4. Ridolfi, *Life of Tintoretto*, 1984 (ed.), p. 17.
5. For Michelangelo's lost sculpture of Cupid and several similar modern and ancient works in the ducal collection in Mantua, see Hirst 1994, pp. 20–28; Brandt et al. 1999.
6. Weddigen 1994; Weddigen 1996.
7. Guillaume de Lorris and Jean de Meun, *Romance of the Rose,* 1995 (ed.), pp. 300–303. Cesare Ripa calls the mirror an emblem of False Love or Deceit in his *Iconologia*; Ripa, *Iconologia*, 1611, p. 154.
8. Nichols 1999, p. 89.
9. B. L. Brown 1996.
10. Pearce 1952.
11. Echols 1996.

Selected references: Hadeln 1922, p. 278, pl. 11, B; Bercken 1942, pp. 41, 117, no. 234, fig. 17; Pearce 1952, pp. 220–21, pl. 7; Lord 1970, pl. 45a; Kultzen and Eikemeier 1971, pp. 133–36, no. 9257, fig. 74; Barolsky 1978, pp. 175–76; Pallucchini and P. Rossi 1982, pp. 44, 163–64, no. 155, fig. 204; Valcanover and Pignatti 1985, pp. 86–87, pl. 11; Beverly Louise Brown in B. L. Brown and Wheelock 1988, pp. 69–72, no. 11, ill.; Echols 1993, pp. 161–67; Weddigen 1994; B. L. Brown 1996, pp. 199–205, fig. 1; Echols 1996, pp. 77–78; Weddigen 1996, pp. 155–61, fig. 1; Nichols 1999, pp. 88–90, ill. no. 74; Rearick 2001, pp. 118–19; Echols 2007, p. 36; Robert Echols in Falomir 2007, pp. 200–203, no. 5, ill.

Tiziano Vecellio, called Titian

Pieve di Cadore, ca. 1488–Venice, 1576

152. *Venus with an Organist and a Dog*

Ca. 1550
Oil on canvas, 54⅜ × 87½ in. (138 × 222.4 cm)
Museo Nacional del Prado, Madrid (420)
New York only

Five closely related versions of Titian's composition on the theme of Venus and a Musician have come down to us. This one and two others depict the reclining female nude with an organist (Museo Nacional del Prado, Madrid, no. 421; Gemäldegalerie, Berlin), while the other two include a lute player rather than the organist (The Metropolitan Museum of Art, New York; Fitzwilliam Museum, Cambridge). Neither the order in which they were been painted nor the extent of Titian's own participation in their execution is certain; both of these issues have been the subject of important research in recent years.[1] It is very possible that the painting discussed here is the first of the group. X-radiographs show that a significant change was made as the artist worked; at first Venus's head was turned so that she gazed toward the musician and only later tilted down so that she regards the lapdog at her side. Also, unlike most of the other versions, the quality of execution never falters throughout the picture. The four other canvases were then derived, in part, by a mechanical means of transfer each from the previous one, not in their entirety but generally in the case of the figure of Venus.[2]

Of the five related works, the present one is to many eyes the most overtly sensuous. This impression is created by the intensity of the musician's gaze toward the woman's completely uncovered torso, a sensual exchange that would have been accentuated if the original idea of having her gaze back at him had been carried out. The portraitlike features of both figures similarly add to the aura of immediacy.[3] The organist's mature face, dark hair, and thin moustache are quite distinctive (the musician in the painting in Berlin bears similarly individualistic features and that one is sometimes said to represent Philip II of Spain), while Venus's soft, delicate features are quite unlike the more regular, highly colored ones of the other versions, some of which may have been brought to this high degree of finish by assistants. Nor is she shown with Cupid, and shorn of the attribute that most firmly identifies her as Venus, she seems even more the lovely woman rather than the distant goddess. These qualities, along with other details of the painting, such as the wedding band worn by the nude on her right hand and the appearance of the lapdog, symbol of faithfulness, as well as the work's early history, all suggest that this canvas may have been carried out in a matrimonial context and for a specific patron.[4]

In 1648 Carlo Ridolfi made a list of works by Titian belonging to the Venetian Pietro Assonica, at the end of which he mentioned that one of the family's paintings, a "femina al naturale, à canto alla quale, stavasi un giovinetto suonando l'organo" (a nude woman, at whose side is a young man playing the organ) had gone to England.[5] He is referring to this painting, which had still been in Venice in 1622, when it was drawn by Anthony van Dyck in his Italian sketchbook (the bottom half of folio 111 in the sketchbook now in the British Museum).[6] It was then sold to Charles I and acquired by Philip IV of Spain following the death of the English king; inventories show it to have been in the Alcázar in Madrid between 1666 and 1734.

Pietro's father, Francesco Assonica, born in Bergamo but living in Venice, was a distinguished patron of Titian's work. Giorgio Vasari calls him the artist's "*compare*," an Italian term that suggests a very old friend. An important lawyer and famed as an orator, Assonica appears in Francesco Sansovino's 1554 treatise *L'avvocato* (The Lawyer) as one of the most eminent practitioners in the city; he was also a member of the prestigious Accademia Veneziana. In 1562 Ludovico Dolce dedicated the second part of his translation of Cicero's orations to Assonica, extolling the paintings with which he had decorated his magnificent home, "which may have come from the divine brush of Titian." This home was presumably one in Venice near Santa Maria Zobenigo, but in the mid-1550s Assonica also built a substantial house and garden in Padua, where he had studied law from 1529 to 1533 and owned some property. He was reputed to have put together one of the most important collections of paintings in the city there, including Titian's *Rest on the Flight into Egypt* (probably the one now in the Escorial). Titian may have assisted the collector in organizing its decoration.[7] It is very interesting that for this *Venus with an Organist*, perhaps the first and most personalized attempt at a composition that was later to be so successful, and one done for a friend, Titian seats the musician at a small organ, an instrument that we know the artist loved and, indeed, owned.[8]

Unfortunately, we do not yet know under what circumstances this painting entered Assonica's collection and whether it had a specific personal resonance for him. The history of his family is less well known than those of his professional life and activities as a collector (although there is probably more to be discovered), and therefore we can only speculate as to whether it may have been a private painting commemorating a wedding or, rather, how it fit into the ongoing life of that particular couple and the decoration of their home. Titian's portrait of Assonica, mentioned by Vasari and Ridolfi, has not come down to us, nor has the present author been able to locate any other depiction of him.[9]

It is well known that Titian's paintings of Venus and a Musician have been subjected to the most various interpretations, ranging from erudite Neoplatonist explanations to proposals that they were examples of simple bedroom decor. All can agree that the addition of a musician to earlier representations of Venus or of Venus and Cupid introduces a new narrative consideration, that of the theme of love and music. Further interpretation has sometimes proven overly dogmatic (as it has in the case of several other paintings in this volume, for example, cat. no. 145).

Cat. 152

Erwin Panofsky and especially Otto Brendel believed that the imagery reflects a debate current among Neoplatonic writers of the period over the relative powers of the senses of sight and sound in the perception, ultimately, of an immaterial Beauty, an explanation that hardly seems to account for the charged qualities of the depiction to modern eyes.[10] Yet it is quite true that writers on the subject of Love—of every stripe—reverted repeatedly to this topic, each from a slightly different angle, as a trope indispensable in comprehending the origin of love. Thus Pietro Bembo said, "The flight of virtuous love has two windows: one is hearing, which sends it to the beauty of the spirit; the other

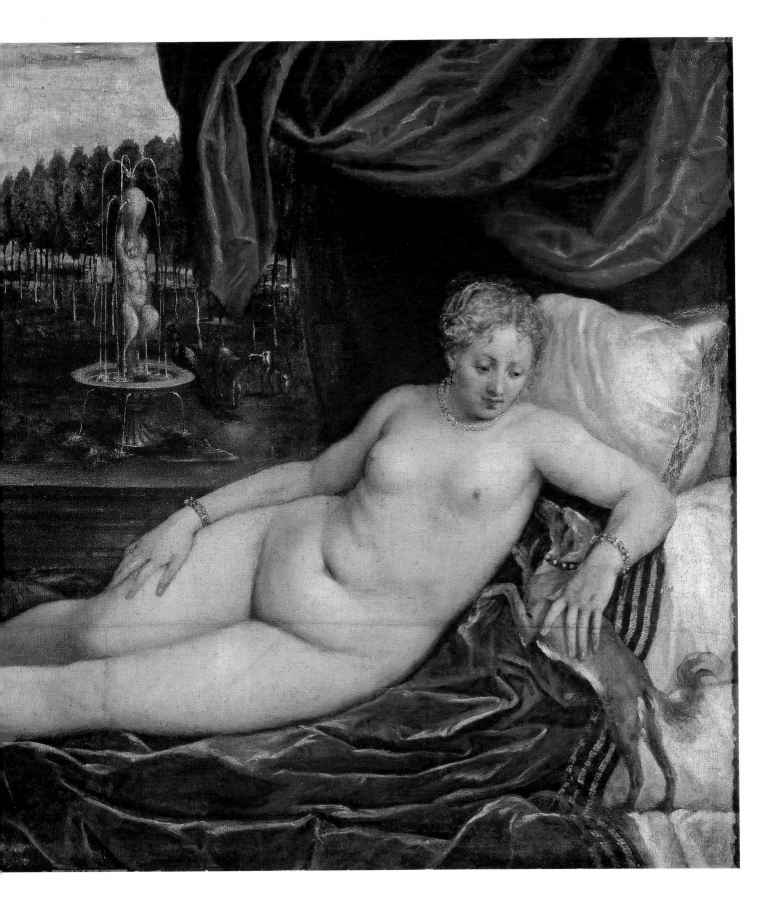

is that of sight, which leads love's flight to the beauty of the body," while in his treatise on the nature of love (*Libro di natura d'Amore,* Venice, 1526) Mario Equicola stressed that the beauty and harmony intrinsic to love could be understood through hearing and, above all, sight.[11] An almost identical thought was expressed close to the date of Titian's

paintings by Ludovico Domenichino (1562), whose opinion it was that "if Love can enter into our souls through the gates of the eyes, it is probable also that it could also enter through the ears."[12] These statements do not preclude sensual love as the goal of author or painter.

Yet, no philosophical treatise can account fully for the expressivity of this painting,

which comes much closer to poetry in its language.[13] In poems and madrigals, the lovesick suitor woos his beloved with song and listens to her music in return (this is particularly relevant for those versions of the composition that include additional instruments placed near Venus). He prefers to do his wooing on a bed, as extolled in a verse in one of Ariosto's

poems, "O letto, testimon de' piacer miei" (O bed, testimony of my pleasure). And the park that spreads behind their loggia was both the scene of amorous encounters and the ideal location for heated discussions regarding the nature of love, as in Pietro Bembo's wildly fashionable *Gli Asolani*.

The sensuality and desire that permeate the painting are reinforced by the details that Titian includes in this garden with its alley of trees and the sun breaking over the horizon. The fountain with a satyr, the peacock, the recumbent deer, and the couple walking down the path all appear in poetry and prose as metaphors of passion. It is difficult to resist quoting the lines from Shakespeare's *Venus and Adonis* that play upon this very imagery:

> Since I have hemm'd thee here
> Within the circuit of this ivory pale,
> I'll be a park, and thou shalt be my deer;
> Feed where thou wilt, on mountain or in
> dale:
> Graze on my lips, and if those hills be dry,
> Stray lower, where the pleasant fountains
> lie.[14]

These details have a certain elasticity of meaning, and can allude as much to the affection between a married couple as to a more informal or illicit relationship.[15] Thus the dog that now absorbs the woman's attention is perhaps the faithful creature found in so many representations of marriage, and at the same time shows a peculiar liveliness that suggests instead sensual pleasure. It is a tribute to a great painter that we can continue to return to an image that we believe we already know well, only to find that its imagery is so open-ended and continues to tease us with its possibilities. A B

1. Miguel Falomir in Falomir 2003a, pp. 248–51, 394–96, nos. 41, 42; Falomir 2003b, pp. 88–89, 330; Keith Christiansen in Ferino-Pagden 2008, pp. 211–15, no. 2.4.
2. See Falomir in Falomir 2003a, pp. 250, 395, fig. 136.
3. As early as their second edition of their monograph on Titian, Crowe and Cavalcaselle (1881, vol. 2, p. 158) wondered if "Titian was furnished with limnings of the persons he was asked to delineate."
4. Fernando Checa in *De Tiziano a Bassano* 1997, p. 98; Falomir in Falomir 2003a, pp. 249, 394; Falomir 2003b, pp. 88, 330.
5. Ridolfi, *Le maraviglie dell'arte*, 1648, p. 175; his text does not identify the figure as Venus.
6. Wethey 1969–75, vol. 3, pl. 111. See Christopher Brown in C. Brown and Vlieghe 1999, pp. 22–23, for a discussion of Van Dyck's stay in Venice in the winter of 1622 and the drawings done in the sketchbook at that time.
7. For this overview of Assonica as a collector, including the quotation, see Mancini 2005,

pp. 102–4, 109–17; for *The Rest on the Flight into Egypt*, see Humfrey 2007, p. 252, no. 186.
8. See Goodman-Soellner 1983a, p. 180 and n. 10, for a reference to Pietro Aretino's 1540 letter documenting Titian's exchange of a portrait for an organ from the instrument maker known as Alessandro "degli organi."
9. Vasari, *Le vite*, 1568/1906 (ed.), vol. 7, p. 456; Ridolfi, *Le maraviglie dell'arte*, 1648, p. 175. Wethey 1969–75, vol. 2, does not mention this portrait.
10. Brendel 1946; Panofsky 1969, pp. 119–25.
11. Bembo's extended metaphor is quoted in Brendel 1946, p. 68; and Goffen 1997b, p. 159. See also Checa in *De Tiziano a Bassano* 1997, p. 99; Falomir in Falomir 2003a, pp. 249, 395.
12. See Checa in *De Tiziano a Bassano* 1997, pp. 98, 101, no. 6.
13. Goodman-Soellner 1983a brings forward many convincing parallels but is rather overly insistent that all the female figures depicted are not Venus but "mortal ladies."
14. As quoted in ibid., p. 184.
15. See Giorgi 1990, pp. 14–16, 103–12, for an exhaustive account.

SELECTED REFERENCES: Ridolfi, *Le maraviglie dell'arte*, 1648, p. 175; Crowe and Cavalcaselle 1881, vol. 2, pp. 157–58; Brendel 1946, pp. 65–75, fig. 2; Wethey 1969–75, vol. 3, pp. 199–200, no. 50, pls. 109, 110, 112, 113; Hope 1980a, pp. 120–24, fig. 33; Goodman-Soellner 1983a, pp. 179–86, fig. 5; Giorgi 1990, pp. 14–16, 103–12, ill. pp. 15, 20–21, 50, 111; Fernando Checa in *De Tiziano a Bassano* 1997, pp. 96–101, no. 14, ill.; Goffen 1997b, pp. 160–63, fig. 92; Gregor J. M. Weber in *Venus* 2001, pp. 130–32; Miguel Falomir in Falomir 2003a, pp. 248–51, 394–96, no. 41, ill.; Humfrey 2007, p. 258, no. 192, ill.

Tiziano Vecellio, called Titian
Pieve di Cadore, ca. 1488–Venice, 1576

153. *Venus Blindfolding Cupid*

Ca. 1565
Oil on canvas, 45⅝ × 72½ in. (116 × 184 cm)
Borghese Gallery, Rome (170)
New York only

In this magnificent "poetic invention" (to paraphrase Jacob Burckhardt), Titian has depicted Venus blindfolding one cupid while another leans behind her and two nymphs (or perhaps Graces) rush in from the right with bows and a quiver full of arrows. The painting was described at length in a poem written in 1613 by Scipione Francucci, which documents its arrival in the Borghese collection by that date. At this same date the painting was also provided with a splendid frame carved with winged *amorini* and shells, an

allusion to Venus. There has been some interesting, albeit inconclusive, speculation as to its owners previous to that time. It may have been part of the group of seventy-one paintings purchased by Scipione Borghese in 1608 from Cardinal Paolo Emilio Sfrondati, but the inventory of that collection has not come down to us. The Sfrondati may have obtained it via the collection of the Spanish grandee Antonio Pérez, who was passionate about Titian's art and who owned a painting of the same subject. There were connections between the Sfrondati family and Madrid, and Paolo Sfrondati, close to the court of Philip II, may have purchased the painting at auction in that city in 1585 and brought it back to Italy.[1] Another suggestion is that Borghese bought it directly from one of the great Venetian collections known to have sold works at the beginning of the seventeenth century.[2] Without further documentation we cannot know whether the painting was made for a specific patron or to mark a specific event, and thus our ability to clarify its original purpose is limited.

It is fascinating that the imagery of both the final painted surface and those earlier details uncovered in an X-radiograph (fig. 122) should reveal that while working on this canvas Titian was reflecting on other works produced in his shop that had themes related to marriage. It has long been recognized, for example, that both the seated Venus and the nymph seen in profile hark back to two figures in an allegory usually called, mistakenly, *The Allegory of Alfonso d'Avalos* (fig. 123), painted about 1530 and now in the Musée du Louvre.[3] Erwin Panofsky showed that this enigmatic work is an allegory of marriage, with the couple (perhaps depicted as Mars and Venus) attended by Cupid and other figures—and in broad outlines this interpretation has been accepted, although there is some dispute as to the details.[4]

The Louvre *Allegory* includes a fragment of a figure at the far right who holds aloft a basket filled with flowers, a motif to which the artist returned, with modifications, on more than one occasion. The X-radiograph and an infrared reflectogram of *Venus Blindfolding Cupid* show that the artist originally intended to include such a figure between Venus and the two nymphs (where we now see the second nymph's bow), and that she likewise would have had her arms raised and apparently held a tray or basket.[5] Although this figure did not ultimately make her appearance in the completed painting, a whole series of other paintings of women lifting up platters of fruit issued out of Titian's studio, the most notable of which is the so-called *Pomona* (Gemäldegalerie, Berlin; ca. 1555). These figures—bedecked with typical Venetian

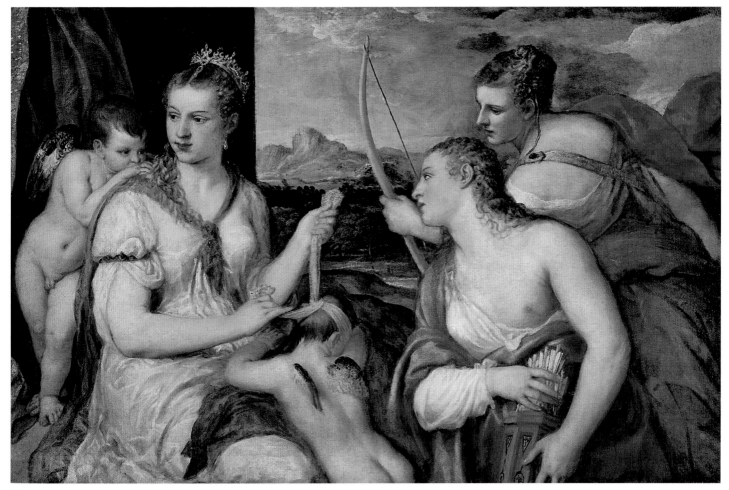

Cat. 153

wedding finery and sometimes even carrying wedding *cassette* (see cat. nos. 39, 40) rather than fruit—were certainly meant as allegories of marriage and probably were sold on the open market to mark such occasions.[6]

But the figure that Titian initially intended did make its appearance in another version of the composition, one not carried out by the artist himself. A fragmentary copy (National Gallery of Art, Washington, D.C.) by a follower includes part of the arm of this additional woman and her platter; it is now cut at the right, but an earlier inventory shows that it originally was completed with figures the compiler believed were the "Elements offering a tribute."[7] This raises the interesting question as to whether the copyist had before him yet another version of this painting by Titian that included the woman holding a platter, or whether the workshop had some record of his original conception, later altered by the

Fig. 122. X-radiograph of cat. no. 153

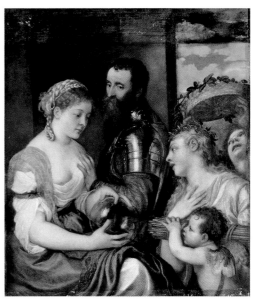

Fig. 123. Tiziano Vecellio, called Titian (ca. 1488–1576), *Marriage Allegory* (sometimes called *The Allegory of Alfonso d'Avalos, the Marquis of Vasto*), ca. 1530. Oil on canvas, 47⅝ × 42⅛ in. (121 × 107 cm). Musée du Louvre, Paris

artist himself.[8] There is another fascinating detail that changes from the composition as recorded in the X-radiograph to that which we now see: originally the Venus was wearing a beret or cap set at a jaunty angle. Kristina Hermann Fiore has noted a suggestive similarity to the hat worn by the French "noble bride" as represented in Cesare Vecellio's costume book *De gli habiti antichi e moderni di diverse parti del mondo* (see cat. no. 64); perhaps she was more specifically a bride in a place where French fashions were popular, such as Bologna, where noblewomen are depicted in "French"-style headwear.[9]

The actual subject of Titian's late masterpiece has been much debated. Interpretations that have questioned the identification of the central figure as Venus or that seek a precise ancient narrative, such as Apuleius's description of Venus punishing Cupid for his love of Psyche, have not withstood closer scrutiny. Although some early sources, such as Carlo Ridolfi, writing in the mid-seventeenth century, called the three women "The Three Graces," they have more generally been considered Venus and two nymphs.[10] In Francucci's 1613 poem they are described as Dora and Armilla, "Due Ninfe nemiche d'Amore" (two nymphs hostile to Love), and he believed them to represent certain virtues—modesty or chastity, beauty, and "*honestate*," or honesty and virtuousness. Panofsky was fascinated by two aspects of the painting's iconography, the figure of the blindfolded cupid and the presence in the scene of two cupids, the second of whom has his eyes uncovered.[11] He demonstrated that the blindfolded cupid evolved as an image in the postclassical period and throughout the Renaissance had mostly negative connotations: Cupid was known to shoot his arrows blindly; thus, like Misfortune and Death, Love struck without regard for age, wealth, or appropriateness. Panofsky believed that the two cupids here represented Eros and Anteros. The blindfolded Eros represented lower, earthy, sensual love, and the seeing Anteros celestial love, or love of virtue, as they were represented in the popular emblem book, the *Emblematum Liber* by Andrea Alciati. Anteros could also represent the awakening of "reciprocal love," and by showing them together here, with Eros under his mother's control, it is likely that Titian was suggesting the conjoining of love and the conjugal chastity proper to matrimony. The crown or tiara that Venus wears, and her pearl drop earring, are proper Venetian marriage

accessories as well, seen for example in the epithalamic painting by Lorenzo Lotto, *Venus and Cupid* (cat. no. 148). Panofsky went one step further, suggesting that the Three Graces are, in a sense, represented here, with Venus as Beauty, and the two nymphs as Chastity and Conjugal Love (or Pleasure). The nymph holding her quiver and handling the clutch of arrows gazes intently at Venus, reminding us that a glance could pierce the heart, just like an arrow.

Returning to Burckhardt's characterization of the work as a "poetic invention," part of the remarkable impact made by this painting rests on the fact that Titian has invented the subject, which does not yield up its secrets readily. Are the nymphs withholding Cupid's own bow and arrows (and if so, what explains their overlarge scale)? Or are they rushing in with them for Venus? Is her act of blindfolding him one of education or punishment (and to what effect, if his actions are "blind" by definition)? One author has noted the irony of the scene: "rendering Love blind, Venus made him all the more dangerous."[12] Spaced rhythmically across the picture plane like the figures from ancient relief sculpture that must have inspired the artist, the protagonists take part in an open-ended drama about love and its effects that alludes to the virtues of marriage. Monumental and grave, yet with the incredible, subdued coloristic richness of Titian's later paintings, the five interlocking figures are set before a view of the mountains of Pieve di Cadore, Titian's hometown. He used their bluish heights and the gathering clouds around them to extend the space behind the figures and to contribute to the work's majesty and sense of drama. Francesco Valcanover noted that the artist rarely returned to his early themes of beauty and love in these years dominated by the Council of Trent and suggested that "the myth of pagan beauty that this painting revived with intensity, for its sublime fusion of nature and the idea, remained almost isolated in Titian's late work."[13]

A B

1. Burckhardt's remark is from *Der Cicerone,* as cited by Herrmann Fiore 1995, pp. 391, 408, n. 21. For Francucci's poem, see Herrmann Fiore 1995, pp. 391–96. Della Pergola (1955–59, vol. 1, p. 131) suggested the Sfrondati provenance for the painting. For the possibility of its having been in Madrid, see Delaforce 1982, p. 750, which publishes Pérez's inventory and suggests that the work listed is a copy now in the Museo de Bellas Artes,

Seville, while Miguel Falomir in Falomir 2003a, pp. 264, 401, discusses the possibility that the painting inventoried was the original, now in the Borghese Gallery.

2. Herrmann Fiore 1995, pp. 389–90.
3. Crowe and Cavalcaselle 1881, vol. 2, p. 356.
4. Panofsky 1939/1972, pp. 160–65; Panofsky 1969, pp. 126–29. For an overview of the literature, see Jean Habert in *Le Siècle de Titien* 1993, pp. 518–20, no. 164.
5. Spezzani 1995, figs. 195, 197. Although Spezzani describes this figure as a man, both the draperies and the facial features, clearly visible in the infrared reflectogram, indicate that it was most likely a woman.
6. In an excellent article published in 1995, Sabina Brevaglieri quotes Lodovico Dolce's influential publication *Dialogo della istitutione delle donne* (1st ed., 1545), in which a well-ordered marriage is compared to a flourishing garden (*orto*) and which provides contemporary textual parallels for the appearance of fruit as symbols in these paintings; see Brevaglieri 1995, pp. 128–30.
7. See Falomir in Falomir 2003a, pp. 265, 402.
8. On this, see Goffen 1997b, p. 140.
9. Herrmann Fiore 1995, p. 400.
10. Ridolfi, *Le maraviglie dell'arte*, 1914–24 (ed.), vol. 1, p. 197. His description of the painting is inaccurate (since it was already in Rome, he may not have seen it), as he calls it "the Graces with Cupids and some shepherdesses." It is called "The Three Graces" in a late-seventeenth-century inventory of the Borghese zcollection. Kristina Herrmann Fiore (1995, p. 397) points out that according to the Roman poet Claudian, Venus was so close to the Graces as to sometimes be considered one of them and that this may account for the back-and-forth of the title in the earlier commentaries. She has also noted that the idea for the composition represented by the image in the X-radiograph, with its three accompanying figures, may have been inspired by Pliny the Elder's description of a painting by Niarkos of Venus between the Graces and Cupids.
11. Panofsky 1939/1972, pp. 95–127; Panofsky 1969, pp. 129–37.
12. Goffen 1997b, p. 145.
13. In *Le Siècle de Titien* 1993, pp. 618–19, no. 258.

SELECTED REFERENCES: Crowe and Cavalcaselle 1881, vol. 2, pp. 355–56; Panofsky 1939, pp. 160, 165–69, fig. 119; Della Pergola 1955–59, vol. 1, pp. 131–32, no. 235, ill.; Panofsky 1969, pp. 129–37, fig. 144; Wethey 1969–75, vol. 3, pp. 131–32, no. 4, pls. 155, 158, 159; Francesco Valcanover in *Le Siècle de Titien* 1993, pp. 618–19, no. 258, ill. p. 236; Herrmann Fiore 1995; Goffen 1997b, pp. 139–45, fig. 83; Miguel Falomir in Falomir 2003a, pp. 264–65, 401–2, no. 49, ill.; Stefan Albl in Ferino-Pagden 2008, pp. 208–10, no. 2.3, ill.

BIBLIOGRAPHY

Acidini Luchinat et al. 2002
Cristina Acidini Luchinat et al. *The Medici, Michelangelo, and the Art of Late Renaissance Florence.* Exh. cat., Palazzo Strozzi, Florence; Art Institute of Chicago; and Detroit Institute of Arts. Detroit, 2002.

Adelson 1984
Candace Adelson. "Three Florentine Grotesques in the Musée des Arts Décoratifs, Paris." *Bulletin de CIETA* (Centre International d'Étude des Textiles Anciens), nos. 59–60, pts. 1 and 2 (1984), pp. 54–60.

Ady 1937
Cecilia M. Ady. *The Bentivoglio of Bologna: A Study in Despotism.* London, 1937.

Ahl 1981–82
Diane Cole Ahl. "Renaissance Birth Salvers and the Richmond *Judgment of Solomon.*" *Studies in Iconography* 7–8 (1981–82), pp. 157–74.

Ainsworth and Christiansen 1998
Maryan W. Ainsworth and Keith Christiansen, eds. *From Van Eyck to Bruegel: Early Netherlandish Paintings in The Metropolitan Museum of Art.* Exh. cat., The Metropolitan Museum of Art. New York, 1998.

Ajmar-Wollheim 2006a
Marta Ajmar-Wollheim. "Housework." In Ajmar-Wollheim and Dennis 2006, pp. 152–63, 377.

Ajmar-Wollheim 2006b
Marta Ajmar-Wollheim. "Sociability." In Ajmar-Wollheim and Dennis 2006, pp. 206–21, 380–81.

Ajmar-Wollheim and Dennis 2006
Marta Ajmar-Wollheim and Flora Dennis, eds. *At Home in Renaissance Italy.* Exh. cat., Victoria and Albert Museum. London, 2006.

Ajmar-Wollheim and D. Thornton 1998
Marta Ajmar[-Wollheim] and Dora Thornton. "When is a Portrait Not a Portrait? *Belle Donne* on Maiolica and the Renaissance Praise of Local Beauties." In *The Image of the Individual: Portraits in the Renaissance,* edited by Nicholas Mann and Luke Syson, pp. 138–53, 227–29. London, 1998.

Albarelli 1986
Giuseppe M. Albarelli. *Ceramisti pesaresi nei documenti notarili dell'Archivio di Stato di Pesaro, sec. XV–XVIII.* Biblioteca Servorum Romandiolae 9. Bologna, 1986.

L. Alberti, *Historie di Bologna*, 1541
Leandro Alberti. *Libro primo della deca prima delle historie di Bologna.* Bologna, 1541.

L. B. Alberti, *Della pittura*, 1950 (ed.)
Leon Battista Alberti. *Della pittura.* [ca. 1435.] Edited by Luigi Mallé. Raccolta di fonti per la storia dell'arte 18. Florence, 1950.

L. B. Alberti, *Dinner Pieces*, 1987 (ed.)
Leon Battista Alberti. *Dinner Pieces: A Translation of the "Intercenales."* [ca. 1430s.] Translated by David Marsh. Medieval and Renaissance Texts and Studies 45. Binghamton, 1987.

L. B. Alberti, *Family in Renaissance Florence*, 1969 (ed.)
Leon Battista Alberti. *The Family in Renaissance Florence.* [ca. 1433–34.] Translated by Renée Neu Watkins. Columbia, S.C., 1969.

L. B. Alberti, *On Painting*, 1956 (ed.)
Leon Battista Alberti. *On Painting.* [ca. 1435.]

Translated and edited by John R. Spencer. New Haven, 1956.

Alciati, *Emblematum Libellus*, 1985 (ed.)
Andrea Alciati. *Andreae Alciati Emblematum Libellus.* [1st ed., *Emblematum Liber*, Augsburg, 1531.] 1985 ed.: *Andreas Alciatus.* Edited by Peter M. Daly, with Virginia W. Callahan, assisted by Simon Cuttler. Vol. 1, *The Latin Emblems: Indexes and Lists.* Index Emblematicus. Toronto, 1985.

Aleci 1998
Linda Klinger Aleci. "Images of Identity: Italian Portrait Collections of the Fifteenth and Sixteenth Centuries." In *The Image of the Individual: Portraits in the Renaissance,* edited by Nicholas Mann and Luke Syson, pp. 67–79, 204–13. London, 1998.

Alessandro Bonvicino 1988
Alessandro Bonvicino: Il Moretto. Exh. cat. by Gian Alberto Dell'Acqua et. al. Monastero di Santa Giulia. Brescia, 1988.

Alexandre 1904
Arsène Alexandre. "La Collection de M. Jean Dollfus." *Les Arts* 3 (January 1904), pp. 6–16.

Algeri 1981
Giuliana Algeri. *Gli Zavaratti: Una famiglia di pittori e la cultura tardogotica in Lombardia.* Rome, 1981.

Aliberti Gaudioso 1996
Filippa M. Aliberti Gaudioso, ed. *Pisanello: I luoghi del gotico internazionale nel Veneto.* Exh. cat., Museo di Castelvecchio, Verona. Milan, 1996.

Alinari 1991
Alessandro Alinari. "The Vulcan Painter and the Fall of Phaethon." In *Italian Renaissance Pottery: Papers Written in Association with a Colloquium at the British Museum,* edited by Timothy Wilson, pp. 80–85. London, 1991.

Alinari 2002
Alessandro Alinari. "Un' indagine archeologica a Cafaggiolo: Notizie preliminari." In *Atti 35, convegno internazionale della ceramica, 2002—Ceramica in blu: Diffusione e utilizzazione del blu nella ceramica, Atti Savona, 31 maggio–1 giugno,* pp. 163–66. Albisola, 2002.

Allen 1999
Denise Allen. "Some Observations on Ercole de' Roberti as a Painter-Draughtsman." In Allen and Syson 1999, pp. xv–xxiv.

Allen and Syson 1999
Denise Allen and Luke Syson, with contributions from Jennifer Helvey and David Jaffé. *Ercole de' Roberti: The Renaissance in Ferrara. Burlington Magazine* 141 (April 1999), suppl., pp. i–xl. [Published in association with an exhibition at the J. Paul Getty Museum, Los Angeles.]

Allerston 1998
Patricia Allerston. "Wedding Finery in Sixteenth-Century Venice." In *Marriage in Italy, 1300–1650,* edited by Trevor Dean and K. J. P. Lowe, pp. 25–40. Cambridge, 1998.

Allerston 2006
Patricia Allerston. "'Contrary to the Truth and Also to the Semblance of Reality'? Entering a Venetian 'Lying-in' Chamber (1605)." *Renaissance Studies* 20 (November 2006), pp. 629–39.

Allori, *I ricordi*, 1908 (ed.)
Alessandro Allori. *I ricordi di Alessandro Allori.* Edited by Igino Benvenuto Supino. Biblioteca della rivista d'arte. Florence, 1908.

Altieri, *Li nuptiali*, 1995 (ed.)
Marco Antonio Altieri. *Li nuptiali di Marco Antonio Altieri.* [1506–13.] Edited by Massimo Miglio and Anna Modigliani. Rome, 1995.

Amaglio 1992
Maria Serena Amaglio. "I ritratti di Antonio Agliardi e Apollonia Cassotti in un dipinto di Lorenzo Lotto." *La rivista di Bergamo* 43 (November–December 1992), pp. 17–19.

American Art Association 1916
Illustrated Catalogue of the Exceedingly Rare and Valuable Art Treasures and Antiquities Formerly Contained in the Famous Davanzati Palace, Florence, Italy. Sale cat., American Art Association, New York, November 21–28, 1916.

American Art Association 1924
Illustratred Catalogue of Gothic and Renaissance Italian and French Art, Gathered by Chevalier Raoul Tolentino, Expert Antiquarian of Rome. Sale cat., American Art Association, New York, April 22– 26, 1924.

American Art Association 1925
The Tolentino Collection: Important Italian Works of Art. Sale cat., American Art Association, New York, January 29–31, 1925.

Ames-Lewis 1979
Francis Ames-Lewis. "Early Medicean Devices." *Journal of the Warburg and Courtauld Institutes* 42 (1979), pp. 122–43.

Ames-Lewis 1996
Francis Ames-Lewis. "Il paesaggio nell'arte del Ghirlandaio." In *Domenico Ghirlandaio, 1449–1494: Atti del convegno internazionale, Firenze, 16–18 ottobre 1994,* edited by Wolfram Prinz and Max Seidel, pp. 81–88. Florence, 1996.

Anderson 1974
Jaynie Anderson. "The 'Casa Longobarda' in Asolo: A Sixteenth-Century Architect's House." *Burlington Magazine* 116 (June 1974), pp. 296–303.

Anderson 1990
Jaynie Anderson. "Giovanni Morelli et la collection Arconati-Visconti." *Revue du Louvre et des Musées de France,* 1990, no. 3, pp. 205–11.

Anderson 1997
Jaynie Anderson. *Giorgione: The Painter of "Poetic Brevity," including a Catalogue Raisonné.* Paris, 1997.

Andrea del Sarto 1986
Andrea del Sarto, 1486–1530: Dipinti e disegni a Firenze. Exh. cat. by Luciano Berti et al. Palazzo Pitti, Florence. Milan, 1986.

Aquino 2005
Lucia Aquino. "La camera di Lodovico de Nobili opera di Francesco Tasso e qualche precisazione sulla cornice del Tondo Doni." *Paragone* 56, no. 659 (3rd ser., no. 59) (January 2005), pp. 86–101.

Arasse 1997
Daniel Arasse. "The *Venus of Urbino,* or the Archetype of a Glance." In *Titian's "Venus of Urbino,"* edited by Rona Goffen, pp. 91–107. Cambridge, 1997.

Archer 1995
Madeline Cirillo Archer. *Italian Masters of the Sixteenth Century: Commentary*. Illustrated Bartsch, vol. 28 (formerly vol. 15, pt. 1). New York, 1995.

Arditi, *Diario*, 1970 (ed.)
Bastiano Arditi. *Diario di Firenze e di altri parti della cristianità (1574–1579)*. Edited by Roberto Cantagalli. Florence, 1970.

Aretino, *Lettere*, 1957–60 (ed.)
Pietro Aretino. *Lettere sull'arte*. [1526–55.] Edited by Ettore Camesasca, with commentary by Fidenzio Pertile and revisions by Carlo Cordié. 3 vols. Vite, lettere, testimonianze di artisti italiani 3. Milan, 1957–60.

Aretino, *Lettere*, 1995–98 (ed.)
Pietro Aretino. *Lettere di Pietro Aretino*. Edited by Francesco Erspamer. 2 vols. Parma, 1995–98.

Aretino, *School of Whoredom*, 2003 (ed.)
Pietro Aretino. *Dialogo*. Venice, 1536. First day, "nel quale la Nanna il primo giorno insegna a la Pippa sua figliuola a esser puttana" (on which Nanna . . . teaches Pippa her daughter to be a whore), translated as *The School of Whoredom*, by Rosa Maria Falvo, Alessandro Gallenzi, and Rebecca Skipwith; foreword by Paul Bailey. London, 2003.

Aretino, *Secret Life of Nuns*, 2004 (ed.)
Pietro Aretino. *Ragionamento*. Venice, 1534. First day ("Giornata prima") translated as *The Secret Life of Nuns*, by Andrew Brown; introduction by Andrew Brown. London, 2004.

Aretino, *Secret Life of Wives*, 2006 (ed.)
Pietro Aretino. *Ragionamento*. Venice, 1534. Second day, "nella quale la Nanna narra alla Antonia la vita delle maritate" (on which Nanna relates the life of married women to Antonia), translated as *The Secret Life of Wives*, by Andrew Brown; foreword by Paul Bailey. London, 2006.

Aretino, *Sonetti*, 1992 (ed.)
Pietro Aretino. *Sonetti sopra i "XVI modi."* [ca. 1524–27.] Edited by Giovanni Aquilecchia. Rome, 1992.

Ariosto, *Commedie*, 1933 (ed.)
Lodovico Ariosto. *Commedie*. Edited by Michele Catalano. Bologna, 1933.

Ariosto, *Lettere*, 1887 (ed.)
Lodovico Ariosto. *Lettere*. Edited by Antonio Cappelli. 3rd ed. Milan, 1887.

Ariosto, *Orlando Furioso*, 1976 (ed.)
Ludovico Ariosto. *Orlando Furioso*. [Ferrara], 1516. 1976 ed.: Edited by Cesare Segre. Milan, 1976.

Ariosto, *Orlando Furioso*, 1999 (ed.)
Ludovico Ariosto. *Orlando Furioso*. [Ferrara], 1516. 1999 ed.: Translated by Guido Waldman. Oxford, 1999.

Ariosto, *I suppositi*, 1551
Lodovico Ariosto. *I suppositi*. Venice, 1551.

Armellini 1882
Mariano Armellini. *Un censimento della Città di Roma sotto il pontificato di Leone X: Tratto da un codice inedito dell'archivio Vaticano*. Rome, 1882.

Armstrong 2003
Lilian Armstrong. "Benedetto Bordon, Aldus Manutius and LucAntonio Giunta: Old Links and New." In Lilian Armstrong, *Studies of Renaissance Miniaturists in Venice*, vol. 2, pp. 644–82. London, 2003.

Armstrong 2004
Lilian Armstrong. "Venetian and Florentine Renaissance Woodcuts for Bibles, Liturgical Books, and Devotional Books." In De Simone 2004, pp. 25–45.

Arslan 1960
Edoardo Arslan. *I Bassano*. 2 vols. Milan, 1960.

Artemieva and Guderzo 2001
Irina Artemieva and Mario Guderzo. *Cinquecento Veneto: Dipinti dall'Ermitage*. Exh. cat. edited by Irina Artemieva. Museo Civico, Bassano del Grappa; and Museu Nacional d'Art de Catalunya, Barcelona. Milan, 2001.

Attwood 1991
Philip Attwood. "An Unidentified Bolognese Medallist." *Medal*, no. 18 (Spring 1991), pp. 3–9.

Augustine, *City of God*, 1998 (ed.)
Saint Augustine. *The City of God against the Pagans*. Edited and translated by R. W. Dyson. Cambridge, 1998.

Avagnina, Binotto, and Villa 2003
Maria Elisa Avagnina, Margaret Binotto, and Giovanni Carlo Federico Villa, eds. *Pinacoteca Civica di Vicenza: Catalogo scientifico delle collezioni*. Vol. 1, *Dipinti dal XIV al XVI secolo*. Milan and Vicenza, 2003.

Avery 1941
C. Louise Avery. "French and Italian Pottery from the Rothschild Collection." *Bulletin of The Metropolitan Museum of Art* 36, no. 11 (November 1941), pp. 229–32.

Bacchi 1987
Andrea Bacchi. "Maestro delle Storie del Pane." In *La pittura in Italia: Il Quattrocento*, edited by Federico Zeri, vol. 2, p. 681. Milan, 1987.

Bacchi 1991
Andrea Bacchi. *Francesco del Cossa*. Soncino, 1991.

Bacou 1983
Roseline Bacou. *Autour de Raphaël*. Exh. cat., Musée du Louvre. Paris, 1983.

Bagnoli 2002
[Alessandro Bagnoli]. *Massa Marittima: L'albero della fecondità*. Massa Marittima, 2002.

Bailey 1991
Martin Bailey. "Cupboard Love: Sex Secrets of the British Museum." *Observer* (London), July 7, 1991.

Bailo and Biscaro 1900
Luigi Bailo and Gerolamo Biscaro. *Della vita e delle opere di Paris Bordon*. Treviso, 1900.

Baker and Henry 2001
Christopher Baker and Tom Henry. *The National Gallery Complete Illustrated Catalogue*. Expanded ed. London and New Haven, 2001.

C. Baldini 2004
Costanza Baldini. *Il Maestro di Sant'Ivo: Ritratto di un pittore fiorentino a cavallo tra XIV e XV secolo*. Scientia. Rome, 2004.

U. Baldini 1988
Umberto Baldini. *Botticelli*. Collana "La Specola." Florence, 1988.

Baldwin 1986a
Robert Baldwin. "'Gates Pure and Shining and Serene': Mutual Gazing as an Amatory Motif in Western Literature and Art." *Renaissance and Reformation* 10 (1986), pp. 23–48.

Baldwin 1986b
Robert Baldwin. "A Window from the Song of Songs in Conjugal Portraits by Fra Filippo Lippi and Bartholomäus Zeitblom." *Source: Notes in the History of Art* 5, no. 2 (Winter 1986), pp. 7–14.

Balla 2008
Gabriella Balla. "The Dowry of Beatrice: Italian Maiolica Art and the Court of King Matthias." In Balla and Jékely 2008, pp. 21–40.

Balla and Jékely 2008
Gabriella Balla and Zsombor Jékely. *The Dowry of Beatrice: Italian Maiolica Art and the Court of King Matthias*. Exh. cat., Iparművészeti Múzeum. Budapest, 2008.

Ballardini 1916
Gaetano Ballardini. "Note intorno ai pittori di faenze della seconda metà del cinquecento." *Rassegna d'arte* 16, no. 3 (1916), pp. 59–72.

Ballardini 1918
Gaetano Ballardini. "Note su Virgiliotto da Faenza." *Faenza* 6 (1918), pp. 34–40.

Ballardini 1925
Gaetano Ballardini. "Una coppa d'amore al Museo Nazionale di Ravenna." *Faenza* 13 (1925), pp. 53–66.

Ballardini 1928
Gaetano Ballardini. *Coppe d'amore nel secolo XV*. Collana di studi d'arte ceramica 1. Faenza, 1928.

Ballardini 1929
Gaetano Ballardini. "Alcuni aspetti della maiolica faentina nella seconda metà del Cinquecento." *Faenza* 17 (1929), pp. 86–102.

Ballardini 1933–38
Gaetano Ballardini. *Corpus della maiolica italiana*. 2 vols. Rome, 1933–38.

Ballarin 2006
Alessandro Ballarin. *La "Salomè" del Romanino ed altri studi sulla pittura bresciana del Cinquecento*. Edited by Barbara Maria Savy. 2 vols. Pittura del Rinascimento nell'Italia settentrionale 9. Florence, 2006.

Bambach 2003
Carmen C. Bambach, ed. *Leonardo da Vinci: Master Draftsman*. Exh. cat., The Metropolitan Museum of Art. New York, 2003.

Bambach et al. 2000
Carmen C. Bambach, Hugo Chapman, Martin Clayton, and George R. Goldner. *Correggio and Parmigianino: Master Draughtsmen of the Renaissance*. Exh. cat., British Museum, London; and The Metropolitan Museum of Art, New York. London and New York, 2000.

Bandello, *Novelle*, 1990 (ed.)
Matteo Bandello. *Novelle*. Edited by Ettore Mazzali. Introduction by Luigi Russo. Milan, 1990.

Bandera 1999
Sandrina Bandera, ed. *I tarocchi: Il caso e la fortuna. Bonifacio Bembo e la cultura cortese tardogotica*. Exh. cat., Pinacoteca di Brera. Milan, 1999.

Bandini and Piccolo Paci 1996
Giovanna Bandini and Sara Piccolo Paci. *Da donna a madre: Vesti e ceramiche particolari per momenti speciali*. Florence, 1996.

Barbagli 1998
Lisa Barbagli. "I *Lupercali* di Domenico Beccafumi tra Ovidio e Plutarco." *Fontes* 1 (1998), pp. 207–19.

Barbargli and Kertzer 2001
Marzio Barbargli and David I. Kertzer. *Family Life in Early Modern Times, 1500–1789*. The History of the European Family 1. New Haven, 2001.

Barbaro, *De Re Uxoria*, 1915 (ed.)
Francesco Barbaro. *De Re Uxoria*. [ca. 1415–16.] Venice, 1513. 1915 ed.: *Francisci Barbari De Re Uxoria Liber, in partes duas*. Edited by Attilio Gnesotto. Padua, 1915.

Barbe and Ravanelli Guidotti 2006
Françoise Barbe and Carmen Ravanelli Guidotti. *Forme e "diverse pitture" della maiolica italiana: La collezione delle maioliche del Petit Palais della città di Parigi*. Exh. cat., Museo Internazionale di Faenza. Venice, 2006.

Barkan 1986
Leonard Barkan. *The Gods Made Flesh: Metamorphosis and the Pursuit of Paganism*. New Haven, 1986.

Barkan 1999
Leonard Barkan. *Unearthing the Past: Archaeology and Aesthetics in the Making of Renaissance Culture.* New Haven, 1999.

Barker, Brigstocke, and Clifford 2000
Nicolas Barker, Hugh Brigstocke, and Timothy Clifford. *"A Poet in Paradise": Lord Lindsay and Christian Art.* Exh. cat. by edited by Aidan Weston-Lewis. National Gallery of Scotland. Edinburgh, 2000.

Barocchi 1992
Paola Barocchi, ed. *Il giardino di San Marco: Maestri e compagni del giovane Michelangelo.* Exh. cat., Casa Buonarroti. Florence, 1992.

Barocchi and Gaeta Bertelà 1985
Paola Barocchi and Giovanna Gaeta Bertelà. "La fortuna di Donatello nel Museo Nazionale del Bargello." In *Omaggio a Donatello, 1386–1986: Donatello e la storia del Museo*, pp. 77–121. Exh. cat., Museo Nazionale del Bargello. Florence, 1985.

Barocchi and Gaeta Bertelà 1993
Paola Barocchi and Giovanna Gaeta Bertelà, eds. *Collezionismo mediceo: Cosimo I, Francesco I, e il Cardinale Ferdinando. Documenti, 1540–1587.* Modena, 1993.

Barolini 1992
Helen Barolini. *Aldus and His Dream Book: An Illustrated Essay.* New York, 1992.

Barolsky 1978
Paul Barolsky. *Infinite Jest: Wit and Humor in Italian Renaissance Art.* Columbia, Mo., 1978.

Barolsky 1991
Paul Barolsky. *Why Mona Lisa Smiles and Other Tales by Vasari.* University Park, Pa., 1991.

Barolsky 1998
Paul Barolsky. "As in Ovid, So in Renaissance Art." *Renaissance Quarterly* 51, no. 2 (1998), pp. 451–74.

Barolsky 1998a
Paul Barolsky. "Sacred and Profane Love." *Source: Notes in the History of Art* 17, no. 3 (Spring 1998), pp. 25–28.

Barolsky 2000
Paul Barolsky. "The Erotic Play of Italian Renaissance Art." [Review of Talvacchia 1999.] *Virginia Quarterly Review* 76, no. 4 (Autumn 2000), pp. 765–70.

Barovier Mentasti 1988
Rosa Barovier Mentasti. *Il vetro veneziano, dal Medioevo al Novecento.* Milan, 1988.

Barovier Mentasti et al. 1982
Rosa Barovier Mentasti et al., eds. *Mille anni di arte del vetro a Venezia.* Exh. cat., Palazzo Ducale and Museo Correr. Venice, 1982.

Barriault 1991
Anne B. Barriault. "The Abundant, Beautiful, Chaste, and Wise: Domestic Painting of the Italian Renaissance in the Virginia Museum of Fine Arts." *Arts in Virginia* 30, no. 1 (1991), pp. 2–21.

Barriault 1994
Anne B. Barriault. *Spalliera Paintings of Renaissance Tuscany: Fables of Poets for Patrician Homes.* University Park, Pa., 1994.

Bartalini 1997
Roberto Bartalini. "Sodoma a Palazzo Chigi." In *Scritti per l'Istituto Germanico di Storia dell'Arte di Firenze*, edited by Cristina Acidini Luchinat et al., pp. 233–38. Florence, 1997.

Bartoli 1999
Roberta Bartoli. *Biagio d'Antonio.* Milan, 1999.

Bartsch
Adam Bartsch. *Le Peintre-graveur.* 21 vols. Vienna, 1803–21.

Baskins 1994
Cristelle L. Baskins. "Gender Trouble in Italian Renaissance Art History: Two Case Studies." *Studies in Iconography* 16 (1994), pp. 1–36.

Baskins 1998
Cristelle L. Baskins. *Cassone Painting, Humanism, and Gender in Early Modern Italy.* Cambridge Studies in New Art History and Criticism. Cambridge, 1998.

Baskins 1999
Cristelle L. Baskins. "*Il Trionfo della Pudicizia*: Menacing Virgins in Italian Renaissance Domestic Painting." In *Menacing Virgins: Representing Virginity in the Middle Ages and Renaissance*, edited by Kathleen Coyne Kelly and Marina Leslie, pp. 117–31. Newark and London, 1999.

Baskins forthcoming
Cristelle L. Baskins. "The Bride of Trebizond: Turks and Turkmens on a Florentine Wedding Chest, circa 1460." In *The "Turk" and Islam in the Western Eye (1453–1832)*, edited James Harper. Burlington, Vt. Forthcoming.

Battie and Cottle 1991
David Battie and Simon Cottle. *Sotheby's Concise Encyclopedia of Glass.* London, 1991.

Baxandall 1972
Michael Baxandall. *Painting and Experience in Fifteenth-Century Italy: A Primer in the Social History of Pictorial Style.* Oxford, 1972.

Bayer 2004
Andrea Bayer, ed. *Painters of Reality: The Legacy of Leonardo and Caravaggio in Lombardy.* Exh. cat. by Andrea Bayer et al. The Metropolitan Museum of Art. New York, 2004.

Bayer 2005
Andrea Bayer. "North of the Apennines: Sixteenth-Century Italian Painting in Venice and the Veneto." *The Metropolitan Museum of Art Bulletin*, n.s., 63, no. 1 (Summer 2005).

Bean and Stampfle 1965
Jacob Bean and Felice Stampfle. *The Italian Renaissance.* Drawings from New York Collections 1. Exh. cat., The Metropolitan Museum of Art. New York, 1965.

***Beccafumi* 1990**
Domenico Beccafumi e il suo tempo. Exh. cat. by Paola Barocchi et al. Pinacoteca Nazionale di Siena. Milan, 1990.

Becherucci 1944
Luisa Becherucci. *Manieristi toscani.* I grandi artisti italiani. Bergamo, 1944.

Béguin 1987
Sylvie Béguin. "Paris Bordon en France." In *Paris Bordon* 1987, pp. 9–27.

Bell 1999
Rudolph M. Bell. *How to Do It: Guides to Good Living for Renaissance Italians.* Chicago, 1999.

Bellavitis and Chabot 2006
Anna Bellavitis and Isabelle Chabot. "People and Property in Florence and Venice." In Ajmar-Wollheim and Dennis 2006, pp. 76–85, 373–74.

Bellini and G. Conti 1964
Mario Bellini and Giovanni Conti. *Maioliche italiane del Rinascimento.* Le arti nella casa italiana. Milan, 1964.

Bellonci 2000
Maria Bellonci. *The Life and Times of Lucrezia Borgia.* Translated by Bernard Wall and Barbara Wall. London, 2000. [1st ed., 1953.]

Bellosi 1999
Luciano Bellosi. "Il Maestro del Cassone Adimari e il

suo grande fratello." In Bellosi and Haines 1999, pp. 7–33.

Bellosi and Haines 1999
Luciano Bellosi and Margaret Haines. *Lo Scheggia.* Florence, 1999.

Bellosi, Lotti, and Matteoli 1969
Luciano Bellosi, Dilvo Lotti, and Anna Matteoli, eds. *Mostra d'arte sacra della diocesi di San Miniato.* Exh. cat. San Miniato, 1969.

Bellucci 1898
Giuseppe Bellucci. *Usi nuziali nell'Umbria.* Perugia, 1898.

Belmont 1982
Nicole Belmont. "The Symbolic Function of the Wedding Procession in the Popular Rituals of Marriage." In *Ritual, Religion and the Sacred: Selections from the Annales—Économies, sociétes, civilisations, volume 7*, edited by Robert Forster and Orest Ranum and translated by Elborg Forster and Patricia M. Ranum, pp. 1–7. Baltimore, 1982.

Beltrami 1907
Luca Beltrami. *Il cofanetto nuziale di Lodovico il Moro e Beatrice d'Este.* Milan, 1907.

Bembo, *Gli Asolani*, 1808 (ed.)
Pietro Bembo. *Gli Asolani.* Venice, 1505. Rev. ed., 1583. 1808 ed.: Opere, vol. 1. Edizione de' classici italiani, ser. 1, vol. 56. Milan, 1808.

Bembo, *Gli Asolani*, 1954 (ed.)
Pietro Bembo. *Gli Asolani.* Venice, 1505. Rev. ed., 1583. 1954 ed.: Translated by Rudolf B. Gottfried. Indiana University Publications, Humanities Series 31. Bloomington, Ind., 1954. [Reprint, Freeport, N.Y., 1971.]

P. J. Benson 1992
Pamela Joseph Benson. *The Invention of the Renaissance Woman: Female Independence in the Literature and Thought of Italy and England.* University Park, Pa., 1992.

R. Benson and Borenius 1914
Robert Benson and Tancred Borenius. *Catalogue of Italian Pictures at 16, South Street, Park Lane, London, and Buckhurst in Sussex, Collected by Robert and Evelyn Benson.* London, 1914.

Bentini 1985
Jadranka Bentini, ed. *Bastianino e la pittura a Ferrara nel secondo Cinquecento.* Exh. cat., Palazzo dei Diamanti, Ferrara. Bologna, 1985.

Bentini 2004
Jadranka Bentini, ed. *Gli Este a Ferrara: Una corte nel Rinascimento.* Exh. cat., Castello di Ferrara. Cinisello Balsamo, 2004.

Bentini et al. 2006
Jadranka Bentini, Gian Pietro Cammarota, Angelo Mazza, Daniela Scaglietti Kelescian, and Anna Stanzani, eds. *Pinacoteca Nazionale di Bologna: Catalogo generale.* Vol. 2, *Da Raffaello ai Carracci.* Venice, 2006.

Berardi 1984
Paride Berardi. *L'antica maiolica di Pesaro dal XIV al XVII secolo.* Florence, 1984.

Berardi 2000
Paride Berardi. *Arte e artisti a Pesaro: Documenti di età malatestiana e di età sforzesca.* Vol. 1, *Pittori* (pt. 2). Pesaro città e contà 12. Pesaro, 2000.

Bercken 1942
Erich von der Bercken. *Die Gemälde des Jacopo Tintoretto.* Munich, 1942.

Bercken and Mayer 1923
Erich von der Bercken and August L. Mayer. *Jacopo Tintoretto.* 2 vols. Munich, 1923.

Berenson 1894
Bernard Berenson. *The Venetian Painters of the Renaissance: With an Index to Their Works*. London, 1894.

Berenson 1932
Bernard Berenson. *Italian Pictures of the Renaissance: A List of the Principal Artists and Their Works, with an Index of Places*. Oxford, 1932.

Berenson 1956
Bernard Berenson. *Lorenzo Lotto*. London, 1956.

Bernardini 1995
Maria Grazia Bernardini. "'L'Amor Sacro e Profano' nella storia della critica." In *Tiziano* 1995, pp. 35–51.

Bernardini and Spezzani 1995
Maria Grazia Bernardini and Paolo Spezzani. "'Amor Sacro e Profano,' Roma, Galleria Borghese." in *Tiziano* 1995, pp. 355–57.

Bernardino of Siena, *Le prediche volgari*, 1935 (ed.)
Bernardino di Siena. *Le prediche volgari inedite*. Edited by Dionisio Pacetti. 2 vols. I classici cristiani 55, 56. Siena, 1935.

Bernardino of Siena, *Le prediche volgari*, 1936 (ed.)
Bernardino di Siena. *Le prediche volgari*. Edited by Piero Bargellini. Milan, 1936.

Berni, *Opere*, 1864 (ed.)
Francesco Berni. *Opere*. 2 vols. Milan, 1864.

Berni, *Rime facete*, 1959 (ed.)
Francesco Berni. *Rime facete*. Edited by Ettore Bruni. Milan, 1959.

Berriot-Salvadore 1993
Evelyne Berriot-Salvadore. *Un corps, un destin: La Femme dans la médecine de la Renaissance*. Paris, 1993.

Bertelli 1997
Sergio Bertelli. "Cortigiane sfacciate e sposi voyeurs." *Paragone* 48, no. 567 (May 1997), pp. 3–33.

F. Berti 1997–2003
Fausto Berti. *Storia della ceramica di Montelupo: Uomini e fornaci in un centro di produzione dal XIV al XVIII secolo*. 5 vols. Montelupo Fiorentino, 1997–2003.

F. Berti 2002
Fausto Berti. *Capolavori della maiolica rinascimentale: Montelupo fabbrica di Firenze, 1400–1630*. Exh. cat., Palazzo Medici Riccardi, Florence. Montelupo Fiorentino, 2002.

L. Berti 1972
Luciano Berti. *Il Museo di Palazzo Davanzati a Firenze*. Gallerie e musei di Firenze. Milan, 1972.

L. Berti 1973
Luciano Berti. *L'opera completa del Pontormo*. Classici dell'arte 66. Milan, 1973.

L. Berti 2002
Luciano Berti. *Il principe dello studiolo: Francesco I dei Medici e la fine del Rinascimento fiorentino*. [New ed.] Varianti 2. Pistoia, 2002.

L. Berti and Paolucci 1990
Luciano Berti and Antonio Paolucci, eds. *L'età di Masaccio: Il primo Quattrocento a Firenze*. Exh. cat., Palazzo Vecchio, Florence. Milan, 1990.

Berzeviczy 1909
Albert Berzeviczy. "Les Fiançailles successive de Béatrice d'Aragon." *Revue de Hongrie* 2 (1909), pp. 146–65.

Bestor 1996
Jane Fair Bestor. "Bastardy and Legitimacy in the Formation of a Regional State in Italy: The Estense Succession." *Comparative Studies in Society and History* 38, no. 3 (July 1996), pp. 549–85.

Bettini 1991
Alessandro Bettini. "Le maioliche della discordia." *CeramicAntica* 1, no. 2 (February 1991), pp. 12–18.

Bettini 1997
Alessandro Bettini. "Sul servizio di Mattia Corvino e sulla maiolica pesarese della seconda metà del XV secolo." *Faenza* 83 (1997), pp. 169–75.

Bevilacqua 1979
Alessandro Bevilacqua. "Simone Martini, Petrarca, i ritratti di Laura e del poeta." *Bolletino del Museo Civico di Padova* 68 (1979), pp. 107–50.

Biadego 1900–1901
Giuseppe Biadego. "Intorno al Sogno di Polifilo." *Atti del Reale Istituto di Scienze, Lettere e Arti* 60, pt. 2 (1900–1901), pp. 699–714.

Biaggini 2002–3
Claudia Bertling Biaggini. "Die unglückliche Braut: Zur Deutung eines mythischen Hochzeitsbildes aus der Zeit zwischen 1520 und 1530." *Georges-Bloch-Jahrbuch des Kunsthistorischen Instituts der Universität Zürich*, 2002–3, pp. 94–111.

Biganti 1987
Tiziana Biganti. "La produzione di ceramica a lustro a Gubbio e a Deruta tra la fine del secolo XV e l'inizio del secolo XVI: Primi risultati di una ricerca documentaria." *Faenza* 73 (1987), pp. 209–25.

Biganti 2002
Tiziana Biganti. *Maestro Giorgio Andreoli nei documenti eugubini (regesti 1488–1575): Un contributo alla storia della ceramica nel Cinquecento*. Florence, 2002.

Bing 1938
Gertrud Bing. "Nugae circa Veritatem: Notes on Anton Francesco Doni." *Journal of the Warburg Institute* 1, no. 4 (April 1938), pp. 304–12.

Birbari 1975
Elizabeth Birbari. *Dress in Italian Painting, 1460–1500*. London, 1975.

Bisaha 2004
Nancy Bisaha. *Creating East and West: Renaissance Humanists and the Ottoman Turks*. Philadelphia, 2004.

Biscarini and Nardelli 2006
Patrizia E. P. Biscarini and Giuseppe M. Nardelli. "Alcune riflessioni sulla coppa erotica dell'Ashmolean Museum di Oxford." *CeramicAntica* 16, no. 10 (November 2006), pp. 48–50.

Blake 2006
Hugo Blake. "Everyday Objects." In Ajmar-Wollheim and Dennis 2006, pp. 332–41, 387–89.

Bliss 1989
Joseph R. Bliss. "A *Cuir Bouilli* Case and Other Decorative Arts from the Italian Renaissance." *Arts in Virginia* 29, no.1 (1989), pp. 16–39.

Blume 1985
Dieter Blume. "Beseelt Natur und ländliche Idylle." In *Natur und Antike* 1985, pp. 173–97.

Blumenthal 1973
Arthur R. Blumenthal. *Italian Renaissance Festival Designs*. Exh. cat., Elvehjem Art Center, University of Wisconsin. Madison, 1973.

Boase 1977
Roger Boase. *The Origin and Meaning of Courtly Love: A Critical Study of European Scholarship*. Manchester, 1977.

Bober and Rubenstein 1986
Phyllis Pray Bober and Ruth Rubinstein, with contributions by Susan Woodford. *Renaissance Artists and Antique Sculpture: A Handbook of Sources*. London and New York, 1986.

Boccaccio, *Decameron*, 1976 (ed.)
Giovanni Boccaccio. *Decameron*. [ca. 1353.] 1976 ed.:

Edited by Vittore Branca. Scrittori italiani e testi antichi. Florence, 1976.

Boccaccio, *Decameron*, 2002 (ed.)
Giovanni Boccaccio. *Decameron*. [ca. 1353.] 2002 ed.: *The Decameron*. Translated by Mark Musa and Peter Bondanella. New York, 2002.

Boccaccio, *De Casibus Virorum Illustrium*, 1962 (ed.)
Giovanni Boccaccio. *De Casibus Illustrium Virorum*. [1355–74.] 1962 ed.: Facsimile reproduction of the Paris edition of 1520. Introduction by Louis Brewer Hall. Gainesville, Fla., 1962.

Boccaccio, *Diana's Hunt*, 1991 (ed.)
Giovanni Boccaccio. *Diana's Hunt / Caccia di Diana: Boccaccio's First Fiction*. Edited and translated by Anthony K. Cassell and Victoria Kirkham. Middle Ages Series. Philadelphia, 1991.

Boccaccio, *Famous Women*, 2001 (ed.)
Giovanni Boccaccio. *Famous Women*. Edited and translated by Virginia Brown. I Tatti Renaissance Library 1. Cambridge, Mass., 2001. [Translation of *De Mulieribus Claris*, 1361–75.]

Boccaccio, *Fates of Illustrious Men*, 1965 (ed.)
Giovanni Boccaccio. *The Fates of Illustrious Men*. Translated and abridged by Louis Brewer Hall. Milestones of Thought in the History of Ideas. New York, 1965. [Translation of *De Casibus Virorum Illustrium*, 1355–74.]

Boccaccio, *Genealogiae*, 1494 (ed.)
Ioannis Boccatii [Giovanni Boccaccio]. *Genealogiae*. Venice, 1494. [1st ed., 1472.]

Boccaccio, *Genealogie*, 1998 (ed.)
Giovanni Boccaccio. *Genealogie Deorum Gentilium*. Venice, 1472. 1998 ed.: *Tutte le opere di Giovanni Boccaccio*. Vols. 7 and 8. Edited by Vittorio Zaccaria. Milan, 1998.

Boccherini and Marabelli 1993
Tamara Boccherini and Paola Marabelli, with Dora Liscia Bemporad. *"Sopra ogni sorte di drapperi . . .": Tipologie decorative e tecniche tessili nella produzione fiorentina del Cinquecento e Seicento*. Exh. cat. Florence, 1993.

Bock 1996
Henning Bock. *Gemäldegalerie Berlin: Gesamtverzeichnis*. Berlin, 1996.

Bode 1888
Wilhelm Bode. "Desidero da Settignano und Francesco Laurana: Zwei italienische Frauenbüsten des Quattrocento im Berliner Museum." *Jahrbuch der Königlich Preussischen Kunstsammlungen* 9 (1888), pp. 209–27. [Reprinted in *Die Kunst der Frührenaissance in Italien*, pp. 134–53. Berlin, 1923.]

Bode 1903
Wilhelm Bode. "Leonardo's Bildnis der Ginevra dei Benci." *Zeitschrift für bildende Kunst* 14 (1903), pp. 274–76.

Bojani 2002
Gian Carlo Bojani, ed. *La maiolica italiana del Cinquecento: Il lustro eugubino e l'istoriato del ducato di Urbino. Atti del convegno di studi, Gubbio, 21, 22, 23 settembre 1998*. Florence, 2002.

Bojani, Ravanelli Guidotti, and Fanfani 1985
Gian Carlo Bojani, Carmen Ravanelli Guidotti, and Angiolo Fanfani, eds. *La donazione Galeazzo Cora: Ceramiche dal Medioevo al XIX secolo*. Museo Internazionale delle Ceramiche in Faenza. Milan, 1985.

Bolzoni 2001
Lina Bolzoni. *The Gallery of Memory: Literary and Iconographic Models in the Age of the Printing Press*. Toronto, 2001.

Bomford 2002
David Bomford, ed. *Underdrawings in Renaissance*

Paintings. Art in the Making. Exh. cat., National Gallery. London, 2002.

Bonfil 1994
Robert Bonfil. *Jewish Life in Renaissance Italy.* Translated by Anthony Oldcorn. Berkeley, 1994.

Bonito Fanelli 1981
Rosalia Bonito Fanelli. *Five Centuries of Italian Textiles, 1300–1800: A Selection from the Museo del Tessuto, Prato.* Exh. cat. Prato, 1981.

Bonnet 1996
Jacques Bonnet. *Lorenzo Lotto.* Paris, 1996.

Bono et al. 2002
Nicola Bono et al. *Nel segno del corvo: Libri e miniature della biblioteca di Mattia Corvino, re d'Ungheria, 1442–1490.* Exh. cat., Biblioteca Estense Universitaria. Modena, 2002.

Bonora 1966/1979
Ettore Bonora. "Il Classicismo dal Bembo al Guarini." In *Storia della letteratura italiana*, vol. 4, *Il Cinquecento*, edited by Emilio Cecchi and Natalino Sapegno, pp. 127–597. Milan, 1979. [1st ed., 1966.]

Boorsch and Spike 1986
Suzanne Boorsch and John Spike, eds. *Italian Artists of the Sixteenth Century.* The Illustrated Bartsch 31 (formerly vol. 15, pt. 4). New York, 1986.

Boorsch et al. 1992
Suzanne Boorsch, Keith Christiansen, David Ekserdjian, Charles Hope, David Landau, et al. *Andrea Mantegna.* Edited by Jane Martineau. Exh. cat., The Metropolitan Museum of Art, New York; and Royal Academy of Arts, London. London, New York, and Milan, 1992.

Borchert et al. 2005
Till-Holger Borchert, with contributions by Maryan W. Ainsworth, Lorne Campbell, and Paula Nuttall. *Memling's Portraits.* Exh. cat., Museo Thyssen-Bornemisza, Madrid; Groeningemuseum, Bruges; and Frick Collection, New York. New York, 2005.

Borenius 1931
Tancred Borenius. *The Leverton Harris Collection.* [London], 1931.

Borggrefe 2001
Heiner Borggrefe. "Tizians sogenannte *Himmlische und Irdische Liebe*: Der Beistand der Venus im Hochzeitsbild der Laura Bagarotto." *Zeitschrift für Kunstgeschichte* 64, no. 3 (2001), pp. 331–63.

Borghini, *Il riposo*, 1584
Raffaello Borghini. *Il riposo.* Florence, 1584.

Borsook and Offerhaus 1981
Eve Borsook and Johannes Offerhaus. *Francesco Sassetti and Ghirlandaio at Santa Trinità, Florence: History and Legend in a Renaissance Chapel.* Doornspijk, 1981.

Boskovits 1991
Miklós Boskovits. "Il Maestro di Incisa Scapaccino e alcuni problemi di pittura tardogotica in Italia." *Paragone*, no. 501 (November 1991), pp. 35–53.

Boskovits 1995
Miklós Boskovits. "Ancora su Paolo Schiavo: Una scheda biografica e una proposta di catalogo." *Arte cristiana*, no. 770 (September–October 1995), pp. 332–40.

Boskovits and D. A. Brown 2003
Miklós Boskovits and David Alan Brown, with Robert Echols et al. *Italian Paintings of the Fifteenth Century.* The Collections of the National Gallery of Art, Systematic Catalogue. Washington, D.C., 2003.

Bottari 1764
Giovanni Gaetano Bottari. *Raccolta di lettere sulla pittura, scultura ed architettura.* Vol. 4. Rome, 1764.

***Botticelli e Filippino* 2004**
Botticelli e Filippino: L'inquietudine e la grazia nella pittura fiorentina del Quattrocento. Exh. cat., Musée du Luxembourg, Paris; and Palazzo Strozzi, Florence. Milan, 2004. [English ed., *Botticelli and Filippino: Passion and Grace in Fifteenth-Century Florentine Painting.* Milan, 2004.]

Boulton 1987
D'Arcy Jonathan Dacre Boulton. *The Knights of the Crown: The Monarchical Orders of Knighthood in Later Medieval Europe, 1325–1520.* New York, 1987.

Bourne 2000
Molly Bourne. "Renaissance Husbands and Wives as Patrons of Art: The *Camerini* of Isabella d'Este and Francesco II Gonzaga." In *Beyond Isabella: Secular Women Patrons of Art in Renaissance Italy,* edited by Sheryl E. Reiss and David G. Wilkins, pp. 93–123. Sixteenth Century Essays and Studies 54. Kirksville, Mo., 2000.

Bowron 1983
Edgar Peters Bowron, ed. *The North Carolina Museum of Art: Introduction to the Collections.* Chapel Hill, N.C., 1983.

Bracciolini, *Facetiae*, 1968 (ed.)
Poggio Bracciolini. *The Facetiae.* Translated by Bernhardt J. Hurwood. New York, 1968.

Bradford 2004
Sarah Bradford. *Lucrezia Borgia: Life, Love and Death in Renaissance Italy.* New York, 2004.

Bradford 2005
Sarah Bradford. *Lucrezia Borgia: Life, Love and Death in Renaissance Italy.* London, 2005. [First published, 2004.]

Braham 1978
Allan Braham, ed. *Giovanni Battista Moroni: 400th Anniversary Exhibition.* Exh. cat., National Gallery. London, 1978.

Braham 1979
Allan Braham. "The Bed of Pierfrancesco Borgherini." *Burlington Magazine* 121 (December 1979), pp. 754–65.

Branca 1999
Vittore Branca, ed. *Boccaccio visualizzato: Narrare per parole e per immagini fra Medioevo e Rinascimento.* 3 vols. Biblioteca di storia dell'arte 30. Turin, 1999.

Brandt et al. 1999
Kathleen Weil-Garris Brandt, Cristina Acidini Luchinat, James David Draper, and Nicholas Penny, eds. *Giovinezza di Michelangelo.* Exh. cat., Palazzo Vecchio and Casa Buonarroti. Florence, 1999.

Branting and Lindblom 1932
Agnes Branting and Andreas Lindblom. *Medieval Embroideries and Textiles in Sweden.* 2 vols. Uppsala, 1932.

Braudel 1949
Fernand Braudel. *La Méditerranée et le monde méditerranéen à l'époque de Philippe II.* Paris, 1949.

Breck 1913
Joseph Breck. "A Double Portrait by Fra Filippo Lippi." *Art in America* 2, no. 1 (December 1913), pp. 44–55.

Breck 1914
Joseph Breck. Letter to the Editor. *Art in America* 2, no. 2 (February 1914), pp. 170–73.

Breck and Burroughs 1922
Joseph Breck and Bryson Burroughs. "An Anonymous Gift." *Bulletin of The Metropolitan Museum of Art* 17, no. 3 (March 1922), pp. 51–58.

Bredekamp 1985a
Horst Bredekamp. "Mythos und Widerspruch." Pt. 2, "Der 'Traum vom Liebeskampf' als Tor zur Antike." In *Natur und Antike* 1985, pp. 139–53, 168–71.

Bredekamp 1985b
Horst Bredekamp. "Mythos und Widerspruch." Pt. 3, "Schonheit und Schrecken." In *Natur und Antike* 1985, pp. 153–66, 171–72.

Brejon de Lavergnée and Thiébaut 1981
Arnauld Brejon de Lavergnée and Dominique Thiébaut. *Catalogue sommaire illustré des peintures du Musée du Louvre.* Vol. 2, *Italie, Espagne, Allemagne, Grande-Bretagne et divers; supplément au catalogue des tableaux flamands et hollandais.* Paris, 1981.

Brendel 1946
Otto Brendel. "The Interpretation of the Holkham *Venus.*" *Art Bulletin* 28, no. 2 (June 1946), pp. 65–75.

Brevaglieri 1995
Sabina Brevaglieri. "Tiziano: Le *Dame con il piatto* e l'allegoria matrimoniale." *Venezia Cinquecento* 5, no. 10 (1995), pp. 123–60.

Bridgeman 1998
Jane Bridgeman. "'*Condecenti et netti . . .*': Beauty, Dress and Gender in Italian Renaissance Art." In *Concepts of Beauty in Renaissance Art,* edited by Francis Ames-Lewis and Mary Rogers, pp. 44–51. Aldershot, 1998.

Bridgeman 2000
Jane Bridgeman. "Dress in Moroni's Portraits." In Peter Humfrey, with contributions by Jane Bridgeman, Nancy C. Edwards, Creighton Gilbert, and Mina Gregori, *Giovanni Battista Moroni: Renaissance Portraitist,* pp. 44–52. Exh. cat., Kimbell Art Museum. Fort Worth, 2000.

F. Briganti 1903
Francesco Briganti. *Le coppe amatorie del secolo XV nelle maioliche di Deruta.* Perugia, 1903.

G. Briganti and Baccheschi 1977
Giuliano Briganti and Edi Baccheschi. *L'opera completa del Beccafumi.* Milan, 1977.

Brock 2002
Maurice Brock. *Bronzino.* Translated by David Poole Radzinowicz and Christine Schultz-Touge. Paris and London, 2002.

Bronzino, *Rime in burla,* 1988 (ed.)
Agnolo Bronzino. *Rime in burla.* [ca. 1530–50.] Edited by Franca Petrucci Nardelli. Introduction by Claudio Mutini. Bibliotheca biographica. Sezione artistico-letteraria. Rome, 1988.

B. L. Brown 1996
Beverly Louise Brown. "Mars's Hot Minion or Tintoretto's Fractured Fable." In *Jacopo Tintoretto nel quarto centenario della morte: Atti del convegno internazionale di studi (Venezia, 24–26 novembre 1994),* edited by Paola Rossi and Lionello Puppi, pp. 199–205. Quaderni di Venezia arti 3. Padua, 1996.

B. L. Brown 2009
Beverly Louise Brown. "The Bride's Jewelry: Lorenzo Lotto's Wedding Portrait of Marsilio and Faustina Cassotti." *Apollo.* Forthcoming [January 2009].

B. L. Brown and Marini 1992
Beverly Louise Brown and Paola Marini, eds. *Jacopo Bassano, c. 1510–1592.* Exh. cat., Museo Civico, Bassano del Grappa; and Kimbell Art Museum, Fort Worth. Bologna, 1992. [English ed., Fort Worth, 1993.]

B. L. Brown and Wheelock 1988
Beverly Louise Brown and Arthur K. Wheelock, Jr. *Masterworks from Munich: Sixteenth- to Eighteenth-Century Paintings from the Alte Pinakothek.* Exh. cat., National Gallery of Art, Washington, D.C.; and Cincinnati Art Museum. Washington, D.C., 1988.

C. Brown and Vlieghe 1999
Christopher Brown and Hans Vlieghe, with contributions from Frans Baudouin et al. *Van Dyck, 1599–1641.* Exh. cat., Koninklijk Museum voor Schone Kunsten,

Antwerp; and Royal Academy of Arts, London. London and Antwerp, 1999.

D. A. Brown 1998
David Alan Brown. *Leonardo da Vinci: Origins of a Genius*. New Haven, 1998.

D. A. Brown and Ferino-Pagden 2006
David Alan Brown and Sylvia Ferino-Pagden, with Jaynie Anderson et al. *Bellini, Giorgione, Titian, and the Renaissance of Venetian Painting*. Exh. cat., National Gallery of Art, Washington, D.C.; and Kunsthistorisches Museum, Vienna. Washington, D.C., and Vienna, 2006.

D. A. Brown and Oberhuber 1978
David Alan Brown and Konrad Oberhuber. "*Monna Vanna* and *Fornarina*: Leonardo and Raphael in Rome." In *Essays Presented to Myron P. Gilmore*, vol. 2, *History of Art, History of Music*, edited by Sergio Bertelli and Gloria Ramakus, pp. 25–86. Florence, 1978.

D. A. Brown, Humfrey, and Lucco 1997
David Alan Brown, Peter Humfrey, and Mauro Lucco, with contributions by Augusto Gentili et al. *Lorenzo Lotto: Rediscovered Master of the Renaissance*. Exh. cat., National Gallery of Art, Washington, D.C.; Accademia Carrara di Belle Arti, Bergamo; and Galeries Nationales du Grand Palais, Paris. Washington, D.C., and New Haven, 1997.

D. A. Brown et al. 2001
David Alan Brown et al. *Virtue and Beauty: Leonardo's Ginevra de' Benci and Renaissance Portraits of Women*. Exh. cat., National Gallery of Art. Washington, D.C., 2001.

K. R. Brown 1992
Katharine Reynolds Brown. "Six Gothic Brooches at The Cloisters." In *The Cloisters: Studies in Honor of the Fiftieth Anniversary*, edited by Elizabeth C. Parker, with Mary B. Shepard, pp. 409–19. The Metropolitan Museum of Art. New York, 1992.

Brucker 1984
Gene Adam Brucker. *Florence: The Golden Age, 1138–1737*. New York, 1984.

Brucker 1986
Gene Adam Brucker. *Giovanni and Lusanna: Love and Marriage in Renaissance Florence*. Berkeley, 1986.

Brumble 1998
H. David Brumble. *Classical Myths and Legends in the Middle Ages and Renaissance: A Dictionary of Allegorical Meanings*. London, 1998.

Brundage 1984
James A. Brundage. "'Let Me Count the Ways': Canonists and Theologians Contemplate Coital Positions." *Journal of Medieval History* 10, no. 2 (June 1984), pp. 81–93.

Bruschi 1992
Alberto Bruschi. *Alberto Bruschi presenta un Pontormo ritrovato: Il desco da parto Ughi-Antinori già della collezione Elia Volpi*. Exh. cat., Loggia Rucellai. Florence, 1992.

Buckley 1932
Wilfred Buckley. "Six Italian Diamond Engraved Glasses." *Burlington Magazine* 61 (October 1932), pp. 159–61.

Bulgarelli 1998
Massimo Bulgarelli. "Albertiniana." *Casabella*, no. 660 (October 1998), pp. 93–94.

Bunt 1962
Cyril George Edward Bunt. *Florentine Fabrics*. The World's Heritage of Woven Fabrics. Leigh-on-Sea, England, 1962.

Burckhardt 1990
Jacob Burckhardt. *The Civilization of the Renaissance in Italy*. Translated by S. G. C. Middlemore. Penguin Classics. London, 1990.

Burke 2006
Jill Burke. "Sex and Spirituality in 1500s Rome: Sebastiano del Piombo's *Martyrdom of Saint Agatha*." *Art Bulletin* 88, no. 3 (September 2006), pp. 482–95.

Burroughs 1914
Bryson Burroughs. *Catalogue of Paintings*. The Metropolitan Museum of Art. New York, 1914.

Burroughs 1919
Bryson Burroughs. "Sienese and Florentine Paintings." *The Metropolitan Museum of Art Bulletin* 14, no. 1 (January 1919), pp. 6–8.

A. Bury 1965
Adrian Bury. "A Florentine Desco." *Connoisseur* 160 (December 1965), p. 255.

M. Bury 1999
Michael Bury. Review of Talvacchia 1999. *Burlington Magazine* 141 (October 1999), p. 625.

M. Bury 2001
Michael Bury. *The Print in Italy, 1550–1620*. Exh. cat., British Museum. London, 2001.

M. Bury 2003
Michael Bury. "Giulio Mancini and the Organization of a Print Collection in Early Seventeenth-Century Italy." In *Collecting Prints and Drawings in Europe, c. 1500–1750*, edited by Christopher Baker, Caroline Elam, and Genevieve Warwick, pp. 79–84. Aldershot, 2003.

Busti and Cocchi 2001
Giulio Busti and Franco Cocchi, eds. *Dulce est amare: Ceramiche tradizionali di Deruta a soggetto amoroso*. Exh. cat., Museo Regionale della Ceramica di Deruta. Perugia, 2001.

Busti and Cocchi 2004
Giulio Busti and Franco Cocchi, eds. *La ceramica umbra al tempo di Perugino*. Exh. cat., Museo Regionale della Ceramica di Deruta. Milan, 2004.

Butazzi 1985
Grazietta Butazzi. "Indicazioni sull'abbigliamento infantile dalle liste della Guardaroba Granducale tra la fine del secolo XVI e il secolo XVII." In *I principi bambini* 1985, pp. 25–32.

Butterfield 1997
Andrew Butterfield. *The Sculptures of Andrea del Verrocchio*. New Haven, 1997.

Butterfield 2001
Andrew Butterfield. "Bronze Beauties." [Review of *Donatello* 2001.] *New York Review of Books*, July 19, 2001, pp. 9–10, 12.

Butters 2002
Suzanne B. Butters. "Ferdinando de' Medici and the Art of the Possible." In Acidini Luchinat et al. 2002, pp. 66–75.

Byam Shaw 1976
James Byam Shaw. *Drawings by Old Masters at Christ Church, Oxford*. 2 vols. Oxford, 1976.

Caciorgna and Guerrini 2003
Marilena Caciorgna and Roberto Guerrini. *La virtù figurata: Eroi ed eroine dell'antichità nell'arte senese tra Medioevo e Rinascimento*. Siena, 2003.

Caciorgna and Guerrini 2005
Marilena Caciorgna and Roberto Guerrini. "*Imago Urbis*: La lupa e l'immagine di Roma nell'arte e nella cultura senese come identità storica e morale." In *Siena e Roma* 2005, pp. 99–118.

Cadogan 2000
Jean K. Cadogan. *Domenico Ghirlandaio: Artist and Artisan*. New Haven, 2000.

Cahn and Marrow 1978
Walter Cahn and James Marrow. "Medieval and Renaissance Manuscripts at Yale: A Selection." *Yale University Library Gazette* 52 (April 1978), pp. 173–284.

Calderai and Chiarugi 2006
Fausto Calderai and Simone Chiarugi. "The *Lettuccio* (Daybed) and *Cappellinaio* (Hat Rack)." In Ajmar-Wollheim and Dennis 2006, pp. 122–23, 375.

Callmann 1974
Ellen Callmann. *Apollonio di Giovanni*. Oxford Studies in the History of Art and Architecture. Oxford, 1974.

Callmann 1977
Ellen Callmann. "An Apollonio di Giovanni for an Historic Marriage." *Burlington Magazine* 119 (March 1977), pp. 174–81.

Callmann 1979
Ellen Callmann. "The Growing Threat to Marital Bliss as Seen in Fifteenth-Century Florentine Paintings." *Studies in Iconography* 5 (1979), pp. 73–92.

Callmann 1980
Ellen Callmann. *Beyond Nobility: Art for the Private Citizen in the Early Renaissance*. Exh. cat., Allentown Art Museum. Allentown, Pa., 1980.

Callmann 1988
Ellen Callmann. "Apollonio di Giovanni and Painting for the Early Renaissance Room." *Antichità viva* 27, nos. 3–4 (1988), pp. 5–18.

Callmann 1995
Ellen Callmann. "Subjects from Boccaccio in Italian Painting, 1375–1525." *Studi sul Boccaccio* 23 (1995), pp. 19–78.

Callmann 1998
Ellen Callmann. "Jacopo del Sellaio, the Orpheus Myth, and Painting for the Private Citizen." *Folia Historiae Artium*, n.s., 4 (1998), pp. 143–58.

Callmann 1999a
Ellen Callmann. "Masolino da Panicale and Florentine Cassone Painting." *Apollo* 150 (August 1999), pp. 42–49.

Callmann 1999b
Ellen Callmann. "William Blundell Spence and the Transformation of Renaissance Cassoni." *Burlington Magazine* 141 (June 1999), pp. 338–48.

Calvesi 1989
Maurizio Calvesi. "Un amore per Venere e Proserpina." *Art e dossier*, no. 39 (October 1989), pp. 27–34.

Calvesi 1996
Maurizio Calvesi. *La 'Pugna d'amore in sogno' di Francesco Colonna Romano*. I saggi 3. Rome, 1996.

Camarda 2005
Antonella Camarda. "*I modi*: Genesi e vicissitudini di un'opera proibita tra Rinascimento e Maniera." *Storia dell'arte*, no. 110 (January–May 2005), pp. 75–104.

Camille 1998
Michael Camille. *The Medieval Art of Love: Objects and Subjects of Desire*. London, 1998.

Campagnol Fabretti 2002
Isabella Campagnol Fabretti. "Mode e tessuti veneziani negli Habiti antichi di Cesare Vecellio." In *Il vestito e la sua immagine: Atti del convegno in omaggio a Cesare Vecellio nel quarto centenario della morte, Belluno, 20–22 settembre 2001*, edited by Jeannine Guérin Dalle Mese, pp. 27–40. Belluno, 2002.

C. Campbell 2007
Caroline Campbell. "Lorenzo Tornabuoni's *History of Jason and Medea* Series: Chivalry and Classicism in 1480s Florence." *Renaissance Studies* 21, no. 1 (February 2007), pp. 1–19.

L. Campbell 1990
Lorne Campbell. *Renaissance Portraits: European Portrait-Painting in the Fourteenth, Fifteenth, and Sixteenth Centuries.* New Haven, 1990.

L. Campbell 2005
Lorne Campbell. "Memling and the Netherlandish Portrait Tradition." In Borchert et al. 2005, pp. 48–67.

S. J. Campbell 2002
Stephen J. Campbell, with contributions by Luke Syson et al. *Cosmè Tura: Painting and Design in Renaissance Ferrara.* Exh. cat. edited by Alan Chong. Isabella Stewart Gardner Museum, Boston. Milan and Boston, 2002.

S. J. Campbell 2004
Stephen Joseph Campbell. *The Cabinet of Eros: Renaissance Mythological Painting and the Studiolo of Isabella d'Este.* New Haven, 2004.

T. P. Campbell 2002
Thomas P. Campbell, with contributions by Maryan W. Ainsworth et al. *Tapestry in the Renaissance: Art and Magnificence.* Exh. cat., The Metropolitan Museum of Art. New York, 2002.

Campori 1870
Giuseppe Campori. *Raccolta di cataloghi ed inventarii inediti di quadri, statue, disegni, bronzi, dorerie, smalti, medaglie, avori, ecc., dal secolo XV al secolo XIX.* Modena, 1870.

Campori 1871
Giuseppe Campori. *Notizie storiche e artistiche della maiolica e della porcellana di Ferrara nei secoli XV e XVI; con una appendice di memorie e di documenti relativi ad altre manifatture di maiolica dell'Italia superiore e media.* Modena, 1871.

Cantaro 1989
Maria Teresa Cantaro. *Lavinia Fontana bolognese: "Pittora singolare," 1552–1614.* Milan, 1989.

Cantelupe 1962
Eugene B. Cantelupe. "The Anonymous *Triumph of Venus* in the Louvre: An Early Italian Renaissance Example of Mythological Disguise." *Art Bulletin* 44, no. 3 (September 1962), pp. 238–42.

Cantelupe 1964
Eugene B. Cantelupe. "Titian's *Sacred and Profane Love* Re-Examined." *Art Bulletin* 46, no. 2 (June 1964), pp. 218–27.

Cantini Guidotti 1994
Gabriella Cantini Guidotti. *Orafi in Toscana tra XV e XVIII secolo: Storie di uomini, di cose, e di parole.* 2 vols. Grammatiche e lessici. Florence, 1994.

Capponi 1744
Domenico Giuseppe Capponi, ed. *Joannis Antonii Flaminii Forocorneliensis Epistolae Familiares.* Bologna, 1744.

Carandente 1963
Giovanni Carandente. *I trionfi nel primo Rinascimento.* Turin, 1963.

F. Carboni 1982
Fabio Carboni. *Incipitario della lirica italiana dei secoli XV–XX: Biblioteca Apostolica Vaticana.* Vatican City, 1982.

S. Carboni 2007
Stefano Carboni, ed. *Venice and the Islamic World, 828–1797.* Exh. cat., The Metropolitan Museum of Art. New York, 2007.

Carew-Reid 1995
Nicole Carew-Reid. *Les Fêtes florentines au temps de Lorenzo il Magnifico.* Florence, 1995.

E. Carli 1950
Enzo Carli, ed. *Mostra delle opere di Giovanni Antonio Bazzi detto "Il Sodoma."* Exh. cat., Museo Borgogna, Vercelli; and Pinacoteca, Siena. Siena, 1950.

G. C. Carli, "Sulle pitture in majolica," 1988–89 (ed.)
Gian Girolamo Carli. "Sulle pitture in majolica del Ducato d'Urbino e specialmente di Gubbio." Ms. 1756. 1988–89 ed.: In Carola Fiocco and Gabriella Gherardi, *Ceramiche umbre dal Medioevo allo storicismo,* pp. 609–28. Edited by Ettore Sannipoli. 2 vols. Catalogo generale del Museo Internazionale delle Ceramiche in Faenza. Catalogo generale delle raccolte 5. Faenza, 1988–89.

Carminati 1994
Marco Carminati. *Cesare da Sesto, 1477–1523.* Milan, 1994.

Caroso, *Il ballarino*, 1581
Fabritio Caroso. *Il ballarino di M. Fabritio Caroso da Sermoneta, diviso in due trattati.* Venice, 1581.

Carroll 1987
Eugene A. Carroll. *Rosso Fiorentino: Drawings, Prints, and Decorative Arts.* Exh. cat., National Gallery of Art. Washington, D.C., 1987.

Cartwright 1903
Julia Mary Cartwright. *Beatrice d'Este, Duchess of Milan, 1475–1497: A Study of the Renaissance.* 3rd ed. London, 1903. [1st ed., 1899.]

Cartwright 1915
Julia Mary Cartwright. *Isabella d'Este, Marchioness of Mantua, 1474–1539: A Study of the Renaissance.* 2 vols. New York, 1915. [1st ed., 1903.]

Casali 1861
Scipione Casali. *Annali della tipografia veneziana di Francesco Marcolini.* Forlì, 1861.

Casazza and Gennaioli 2005
Ornella Casazza and Riccardo Gennaioli, eds. *Mythologica et erotica: Arte e cultura dall'antichità al XVIII secolo.* Exh. cat., Museo degli Argenti, Palazzo Pitti, Florence. Livorno, 2005.

Casella and Pozzi 1959
Maria Teresa Casella and Giovanni Pozzi. *Francesco Colonna: Biografia e opere.* 2 vols. Padua, 1959.

Cassidy 1991
Brendan Cassidy. "A Relic, Some Pictures and the Mothers of Florence in the Late Fourteenth Century." *Gesta* 30, no. 2 (1991), pp. 91–99.

Castiglione, *Book of the Courtier*, 1959/2002 (ed.)
Baldassare Castiglione. *The Book of the Courtier.* Translated by Charles S. Singleton. Edited by Edgar Mayhew. Garden City, N.Y., 1959. Republished with authoritative text and criticism edited by Daniel Javitch. New York, 2002. [Translation of *Il libro del cortegiano.* Venice, 1528.]

Castiglione, *Il libro del cortegiano*, 1964 (ed.)
Baldassare Castiglione. *Il libro del cortegiano.* Venice, 1528. 1964 ed.: *Il libro del cortegiano, con una scelta delle opere minori.* Edited by Bruno Maier. 2nd ed. Classici italiani 31. Turin, 1964.

***Catalogue des objets d'art . . . Alessandro Castellani* 1884**
Catalogue des objets d'art . . . etc. dependant de la succession Alessandro Castellani. Sale cat., Palais Castellani, Rome, March 17–April 10, 1884.

***Catalogue des objets d'art . . . Bardini* 1899**
Catalogue des objets d'art: Antiques, du Moyen Âge et de la Renaissance provenant de la Colletion [sic] Bardini de Florence, dont la vente aura lieu à Londres chez Mr. Christie . . . le 5 juin 1899 Florence, 1899.

A. S. Cavallo 1993
Adolfo Salvatore Cavallo. *Medieval Tapestries in The Metropolitan Museum of Art.* New York, 1993.

S. Cavallo 2006
Sandra Cavallo. "Health, Beauty and Hygiene." In Ajmar-Wollheim and Dennis 2006, pp. 174–87, 378.

Cavazzini 1999
Laura Cavazzini, ed. *Il fratello di Masaccio: Giovanni di Ser Giovanni detto Lo Scheggia.* Exh. cat., Casa Masaccio, San Giovanni Valdarno. Florence, 1999.

Cazzola 1979
Gabriele Cazzola. "'Bentivoli machinatores': Aspetti politici e momenti teatrali di una festa quattrocentesca bolognese." *Biblioteca teatrale* 23–24, no. 1 (1979), pp. 14–38.

Cecchi 1990
Alessandro Cecchi. "Percorso di Baccio d'Agnolo legnaiuolo e architetto fiorentino dagli esordi al palazzo Borgherini." *Antichità viva* 29, no. 1 (1990), pp. 31–46.

Cecchi 1998
Alessandro Cecchi. "Francesco Salviati e gli editori." Pt. 2, "I libri." In Monbeig Goguel 1998, pp. 71–73.

Cecchi 2005
Alessandro Cecchi. *Botticelli.* Milan, 2005.

Cecchi and Natali 1996
Alessandro Cecchi and Antonio Natali, eds. *L'officina della maniera: Varietà e fierezza nell'arte fiorentina del Cinquecento fra le due repubbliche (1494–1530).* Exh. cat., Gallerie degli Uffizi, Florence. Florence and Venice, 1996.

Cellini, *Autobiography*, 1983 (ed.)
Benvenuto Cellini. *The Autobiography of Benvenuto Cellini.* [1558–67; first published, 1728.] Edited by Charles Hope and Alessandro Nova. Translated by John Addington Symonds. New York, 1983.

Cellini, *Autobiography*, 1998 (ed.)
Benvenuto Cellini. *Autobiography of Benvenuto Cellini.* [1558–67; first published, 1728.] Translated and with introduction by George Bull. London, 1956. Rev. ed., New York, 1998.

Ceriana 2004
Matteo Ceriana, ed. *Il camerino di alabastro: Antonio Lombardo e la scultura all'antica.* Gli Este a Ferrara. Exh. cat., Castello di Ferrara. Cinisello Balsamo, 2004.

Chabot 1994
Isabelle Chabot. "'La sposa in nero': La ritualizzazione del lutto delle vedove fiorentine (secoli XIV–XV)." *Quaderni storici* 86 (August 1994), pp. 420–62.

Chambers 1995
David S. Chambers. "The Earlier 'Academies' in Italy." In *Italian Academies of the Sixteenth Century*, edited by David S. Chambers and François Quiviger, pp. 1–14. Warburg Institute Colloquia 1. London, 1995.

Chambers and Martineau 1981
David S. Chambers and Jane Martineau, eds. *Splendours of the Gonzaga.* Exh. cat., Victoria and Albert Museum. London, 1981.

Chambers and Pullan 2004
David S. Chambers and Brian Pullan, eds., with Jennifer Fletcher. *Venice: A Documentary History, 1450–1630.* Oxford, 1992. [Repr., Toronto, 2004.]

Chaucer, *Canterbury Tales*, 1957 (ed.)
Geoffrey Chaucer. *The Canterbury Tales.* In *The Works of Geoffrey Chaucer*, edited by F. N. Robinson. 2nd ed. Boston, 1957.

Chen 2000
Aric Chen. "Enea Vico's Costume Studies: A Source and a Sovereignty." *Art on Paper* 5 (December 2000), pp. 51–55.

Cherry 2001
John Cherry. "Healing through Faith: The Continuation of Medieval Attitudes to Jewellery into the Renaissance." *Renaissance Studies* 15, no. 2 (June 2001), pp. 154–71.

Children and Flowers 1958
Children and Flowers. Exh. cat., Winnipeg Art Gallery. Winnipeg, 1958.

Chiquart, On Cookery, 1986 (ed.)
Chiquart. *Chiquart's "On Cookery": A Fifteenth-Century Savoyard Culinary Treatise*. Edited and translated by Terence Scully. New York, 1986.

Chojnacki 2000
Stanley Chojnacki. *Women and Men in Renaissance Venice: Twelve Essays on Patrician Society*. Baltimore, 2000.

Chong 2008
Alan Chong. "The American Discovery of Cassone Painting." In Cristelle L. Baskins et al., *The Triumph of Marriage: Painted Cassoni of the Renaissance*. Exh. cat., Isabella Stewart Gardner Museum. Boston, 2008. [In press.]

Christiansen 1986
Keith Christiansen. "Lorenzo Lotto and the Tradition of Epithalamic Paintings." *Apollo* 124 (September 1986), pp. 166–73.

Christiansen 1992
Keith Christiansen. "The Art of Andrea Mantegna." In Boorsch et al. 1992, pp. 32–42.

Christiansen 2005
Keith Christiansen, ed. *From Filippo Lippi to Piero della Francesca: Fra Carnevale and the Making of a Renaissance Master*. Exh. cat., Pinacoteca di Brera, Milan; and The Metropolitan Museum of Art, New York. Milan and New York, 2005.

Ciabani 1992
Roberto Ciabani. *Le famiglie di Firenze*. 4 vols. Florence, 1992.

Ciaroni 2004
Andrea Ciaroni, with contributions by Massimo Moretti and Paolo Piovaticci. *Maioliche del Quattrocento a Pesaro: Frammenti di storia dell'arte ceramica dalla bottega dei Fedeli*. Florence, 2004.

Ciccuto 2001
Marcello Ciccuto. "Dalle regioni del mito al tempo dell'uomo: Percorsi dell'arte di Antonio e Piero del Pollaiolo." In Poletti 2001, pp. 13–24.

Cicognara 1813–18
Leopoldo Cicognara. *Storia della scultura dal suo risorgimento in Italia sino al secolo di Napoleone: Per servire di continuazione alle opere di Winckelmann e di d'Agincourt*. 3 vols. Venice, 1813–18.

Cioci 1982
Francesco Cioci. "I Della Rovere di Senigallia e alcune testimonianze ceramiche." *Faenza* 68 (1982), pp. 251–60.

Civai 1990
Alessandra Civai. *Dipinti e sculture in casa Martelli: Storia di una collezione patrizia fiorentina dal Quattrocento all'Ottocento*. Florence, 1990.

Clapp 1916
Frederick Mortimer Clapp. *Jacopo Carucci da Pontormo: His Life and Work*. New Haven, 1916.

Clark 1956
Kenneth Clark. *The Nude: A Study in Ideal Form*. The A. W. Mellon Lectures in the Fine Arts, 1953. Bollingen Series 35, 2. New York, 1956.

Clark 1977
Kenneth Clark. *Animals and Men: Their Relationship as Reflected in Western Art from Prehistory to the Present Day*. New York, 1977.

G. Clarke 1999
Georgia Clarke. "Magnificence and the City: Giovanni Il Bentivoglio and Architecture in Fifteenth-Century Bologna." *Renaissance Studies* 13, no. 4 (1999), pp. 397–411.

G. Clarke 2004
Georgia Clarke. "Giovanni Il Bentivoglio and the Uses of Chivalry: Towards the Creation of a 'Republican Court' in Fifteenth-Century Bologna." In *Artistic Exchange and Cultural Translation in the Italian Renaissance City*, edited by Stephen J. Campbell and Stephen J. Milner, pp. 162–86. Cambridge, 2004.

T. H. Clarke 1974
Timothy H. Clarke. "*Lattimo*: A Group of Venetian Glass Enameled on an Opaque-White Ground." *Journal of Glass Studies* 16 (1974), pp. 22–56.

Claudian, Works, 1922 (ed.)
Claudian [Claudius Claudianus]. [*Works*.] Translated by Maurice Platnauer. 2 vols. The Loeb Classical Library. London, 1922.

Clifford and Mallet 1976
Timothy Clifford and J. V. G. Mallet. "Battista Franco as a Designer for Maiolica." *Burlington Magazine* 118 (June 1976), pp. 387–410.

Clough 1992
Cecil H. Clough. "Federico da Montefeltro and the Kings of Naples: A Study in Fifteenth-Century Survival." *Renaissance Studies* 6, no. 2 (June, 1992), pp. 113–72.

Colas 1933
René Colas. *Bibliographie génerale du costume et de la mode*. 2 vols. Paris, 1933.

Colección Cambó 1990
Colección Cambó. Exh. cat., Museo Nacional del Prado, Madrid; and Museu Nacional d'Art de Catalunya, Barcelona. [Madrid], 1990.

Colnaghi 1986
Dominic Ellis Colnaghi. *Colnaghi's Dictionary of Florentine Painters from the Thirteenth to the Seventeenth Centuries*. Repr., edited by Carlo E. Malvani. Florence, 1986. [First published, London, 1928.]

Colonna, Hypnerotomachia Poliphili, 1499
Francesco Colonna. *Hypnerotomachia Poliphili*. Venice, 1499.

Colonna, Hypnerotomachia Poliphili, 1980 (ed.)
Francesco Colonna. *Hypnerotomachia Poliphili*. Venice, 1499. 1980 ed.: *Hypnerotomachia Poliphili: Edizione critica e commento*. Edited by Giovanni Pozzi and Lucia A. Ciapponi. 2 vols. Medioevo e umanesimo 38, 39. Padua, 1980.

Colonna, Hypnerotomachia Poliphili, 1999 (ed.)
Francesco Colonna. *Hypnerotomachia Poliphili*. Venice, 1499. 1999 ed.: *Hypnerotomachia Poliphili: The Strife of Love in a Dream*. Translated by Joscelyn Godwin. New York, 1999.

Comparetti 1895
Domenico Comparetti. *Vergil in the Middle Ages*. London, 1895.

Constable 1925
W. G. Constable. "Paintings in the Marlay Collection at Cambridge." *Burlington Magazine* 47 (December 1925), pp. 281–91.

Conte 2001
Tiziana Conte. "Note biografiche." In *Cesare Vecellio, 1521c.–1601*, edited by Tiziana Conte, pp. 13–22. Belluno, 2001.

C. Conti 1875
Cosimo Conti. *Ricerche storiche sull'arte degli arazzi in Firenze*. Florence, 1875.

G. Conti 1992
Giovanni Conti. *Nobilissime ignobilità della maiolica istoriata*. Exh. cat. Faenza, 1992.

Cook 1904
Herbert Cook. "Some Notes on the Early Milanese Painters Butinone and Zenale, Part III (Conclusion): Zenale as a Portrait Painter." *Burlington Magazine* 5 (May 1904), pp. 199–209.

Cook 1915
Herbert Cook. "More Portraits by Sofonisba Anguissola." *Burlington Magazine* 26 (March 1915), pp. 228–36.

Cooper 2006
Donal Cooper. "Devotion." In Ajmar-Wolheim and Dennis 2006, pp. 190–203, 379–80.

Cora and Fanfani 1982
Galeazzo Cora and Angiolo Fanfani. *La maiolica di Cafaggiolo*. Florence, 1982.

Cora and Fanfani 1986
Galeazzo Cora and Angiolo Fanfani. *La porcellana dei Medici*. Milan, 1986.

Cordellier 1996
Dominique Cordellier. *Pisanello: La Princesse au brin de genévrier*. Collection solo 3. Paris, 1996.

Corradini 1998
Elena Corradini. "Medallic Portraits of the Este: Effigies ad vivum expressae." In *The Image of the Individual: Portraits in the Renaissance*, edited by Nicholas Mann and Luke Syson, pp. 22–39. London, 1998.

Cortesi Bosco 1980
Francesca Cortesi Bosco. *Gli affreschi dell'Oratorio Suardi: Lorenzo Lotto nella crisi della Riforma*. Bergamo, 1980.

Cortesi Bosco 1993
Francesca Cortesi Bosco. "I coniugi di Lotto all'Ermitage e la loro 'impresa.'" In *Studi per Pietro Zampetti*, edited by Ranieri Varese, pp. 336–49. Ancona, 1993.

Costamagna 1994
Philippe Costamagna. *Pontormo*. Milan, 1994.

Cottino-Jones 1975
Marga Cottino-Jones. "The Myth of Apollo and Daphne in Petrarch's *Canzoniere*: The Dynamics and Literary Function of Transformation." In *Francis Petrarch, Six Centuries Later: A Symposium*, edited by Aldo Scaglione, pp. 152–76. Chapel Hill, N.C., and Chicago, 1975.

Covi 2005
Dario A. Covi. *Andrea del Verrocchio: Life and Work*. Florence, 2005.

Covoni 1892
Pier Filippo Covoni. *Don Antonio de' Medici al Casino di San Marco*. Florence, 1892.

Cox-Rearick 1964
Janet Cox-Rearick. *The Drawings of Pontormo*. 2 vols. Cambridge, Mass., 1964.

Cox-Rearick 1984
Janet Cox-Rearick. *Dynasty and Destiny in Medici Art: Pontormo, Leo X, and the Two Cosimos*. Princeton, 1984.

Cox-Rearick 1999
Janet Cox-Rearick, ed. *Giulio Romano, Master Designer: An Exhibition of Drawings in Celebration of the Five Hundredth Anniversary of His Birth*. Exh. cat., Bertha and Karl Leubsdorf Art Gallery, Hunter College, City University of New York. New York, 1999.

Cozzi 1980
Gaetano Cozzi. "La donna, l'amore, e Tiziano." In *Tiziano e Venezia: Convegno internazionale di studi, Venezia, 1976*, edited by Massimo Gemin and Giannantonio Paladini, pp. 47–63. Venice, 1980.

Crabb 2000
Ann Crabb. *The Strozzi of Florence: Widowhood and Family Solidarity in the Renaissance*. Studies in Medieval and Early Modern Civilization. Ann Arbor, 2000.

Crainz 1986
Franco Crainz. *La tazza da parto*. Rome, 1986.

Craven 1997
Jennifer E. Craven. "A New Historical View of the Independent Female Portrait in Fifteenth-Century Florentine Painting." Ph.D. Diss., University of Pittsburgh, 1997.

Crépin-Leblond and Ennès 1995
Thierry Crépin-Leblond and Pierre Ennès. *Le Dressoir du prince: Services d'apparat à la Renaissance*. Exh. cat., Musée National de la Renaissance, Château d'Écouen. Paris, 1995.

Cropper 1976
Elizabeth Cropper. "On Beautiful Women, Parmigianino, *Petrarchismo*, and the Vernacular Style." *Art Bulletin* 58, no. 3 (September 1976), pp. 374–94.

Cropper 1985
Elizabeth Cropper. "The Beauty of Woman: Problems in the Rhetoric of Renaissance Portraiture." In *Rewriting the Renaissance: The Discourses of Sexual Difference in Early Modern Europe*, edited by Margaret W. Ferguson, Maureen Quilligan, and Nancy J. Vickers, pp. 175–90. Chicago and London, 1985.

Cropper 1995
Elizabeth Cropper. "The Place of Beauty in the High Renaissance and Its Displacement in the History of Art." In *Place and Displacement in the Renaissance*, edited by Alvin Vos, pp. 159–205. Binghamton, N.Y., 1995.

Crowe and Cavalcaselle 1871
J. A. Crowe and G. B. Cavalcaselle. *A History of Painting in North Italy: Venice, Padua, Vicenza, Verona, Ferrara, Milan, Friuli, Brescia, from the Fourteenth to the Sixteenth Century*. 2 vols. London, 1871.

Crowe and Cavalcaselle 1877
J. A. Crowe and G. B. Cavalcaselle. *Titian: His Life and Times. With Some Account of His Family, Chiefly from New and Unpublished Records*. 2 vols. London, 1877.

Crowe and Cavalcaselle 1881
J. A. Crowe and G. B. Cavalcaselle. *The Life and Times of Titian, with Some Account of His Family*. 2 vols. 2nd ed. London, 1881.

Crowe and Cavalcaselle 1903–14
J. A. Crowe and G. B. Cavalcaselle. *A History of Painting in Italy: Umbria, Florence and Siena, from the Second to the Sixteenth Century*. [2nd ed.] 6 vols. London, 1903–14.

Cruttwell 1907
Maud Cruttwell. *Antonio Pollaiuolo*. London, 1907.

Cummins 1988
John Cummins. *The Hound and the Hawk: The Art of Medieval Hunting*. New York, 1988.

Curran and Grafton 2000
Brian Curran and Anthony Grafton. Review of Lefaivre 1997. *Journal of the Society of Architectural Historians* 59, no. 4 (December 2000), pp. 528–30.

Currie 2006
Elizabeth Currie. "Textiles and Clothing." In Ajmar-Wollheim and Dennis 2006, pp. 342–51, 389.

Currie 2006a
Elizabeth Currie. *Inside the Renaissance House*. London, 2006.

L. Cust 1907
Lionel Cust. "La Collection de M. R. H. Benson." *Les Arts* 70 (October 1907), pp. 2–32.

R. H. Cust 1906
Robert H. Hobart Cust. *Giovanni Antonio Bazzi, Hitherto Usually Styled "Sodoma," the Man and the Painter, 1477–1549: A Study*. London, 1906.

Dacos 1969
Nicole Dacos. *La Découverte de la Domus Aurea et la formation des grotesques à la Renaissance*. Studies of the Warburg Institute 31. London, 1969.

Dalli Regoli 1966
Gigetta Dalli Regoli. *Lorenzo di Credi*. Raccolta pisana di saggi e studi 19. Milan, 1966.

Dalli Regoli 1996
Gigetta Dalli Regoli. "Lorenzo di Credi." In *The Dictionary of Art*, edited by Jane Turner, vol. 19, pp. 675–77. New York, 1996.

Dalli Regoli, Nanni, and Natali 2001
Gigetta Dalli Regoli, Romano Nanni, and Antonio Natali. *Leonardo e il mito di Leda: Modelli, memorie e metamorfosi di un'invenzione*. Exh. cat., Palazzina Uzielli, Vinci. Cinisello Balsamo, 2001.

Dal Poggetto 1982
Paolo Dal Poggetto, ed. *Piero e Urbino: Piero e le corti rinascimentali*. Exh. cat., Palazzo Ducale and Oratorio di San Giovanni Battista, Urbino. Venice, 1992.

Dal Poggetto 2004
Paolo Dal Poggetto, ed. *I Della Rovere: Piero della Francesca, Raffaello, Tiziano*. Exh. cat., Palazzo Ducale, Senigallia; Palazzo Ducale, Urbino; Palazzo Ducale, Pesaro; Palazzo Ducale, Urbania. Milan, 2004.

Dal Pozzolo 1993
Enrico Maria Dal Pozzolo. "Il lauro di Laura e delle 'maritate venetiane.'" *Mitteilungen des Kunsthistorischen Institutes in Florenz* 37, nos. 2–3 (1993), pp. 257–92.

Dal Pozzolo 1994
Enrico Maria Dal Pozzolo. "Sotto il guanto." *Venezia arti* 8 (1994), pp. 29–36.

Dal Pozzolo 2001
Enrico Maria Dal Pozzolo. "Il bacile nell'Amor Sacro e Profano di Tiziano." *Critica d'arte* 64, no. 9 (March 2001), pp. 46–55.

Dalton 1912
Ormonde Maddock Dalton. *Franks Bequest: Catalogue of the Finger Rings, Early Christian, Byzantine, Teutonic, Mediaeval and Later, Bequeathed by Sir Augustus Wollaston Franks, K.C.B., in which Are Included the Other Rings of the Same Periods in the Museum*. London, 1912.

Damianaki 2000
Chrysa Damianaki. *The Female Portrait Busts of Francesco Laurana*. Rome, 2000.

D'Amico 1983
John F. D'Amico. *Renaissance Humanism in Papal Rome: Humanists and Churchmen on the Eve of the Reformation*. Baltimore, 1983.

D'Ancona 1872
Alessandro D'Ancona, ed. *Sacre rappresentazioni dei secoli XIV, XV, e XVI*. 3 vols. Florence, 1872.

D'Ancona 1891
Alessandro D'Ancona. *Origini del teatro italiano*. 2 vols. Turin, 1891.

Daniels 1933
Margaret Harrington Daniels. "Early Pattern Books for Lace and Embroidery." *Bulletin of the Needle and Bobbin Club* 17, no. 2 (1933), pp. 3–39.

Dante, *The New Life*, 1896 (ed.)
Dante Alighieri. *The New Life of Dante Alighieri*. Translated by Charles Eliot Norton. 4th ed. Boston, 1896. [Translation of *La vita nuova*.]

Dante, *Rime per la donna pietre*, 1969 (ed.)
Dante Alighieri. *Rime per la donna pietre*. In Dante Alighieri, *Rime della maturità e dell'esilio*, edited by M. Barbi and V. Pernicone, pp. 539–77. Opere di Dante,

new ed., edited by Vittore Branca, Francesco Maggini, and Bruno Nardi, vol. 3. Florence, 1969.

D'Arbitrio 2006
Nicoletta D'Arbitrio. "La 'Veste de' Nobiltà' il potere e l'apparire." In *Tiziano* 2006, pp. 96–103.

Däubler-Hauschke 1994
Claudia Silvia Däubler-[Hauschke]. "La *tazza da parto* nella Collezione Pringsheim." *CeramicAntica* 4 (June 1994), pp. 26–39.

Däubler-Hauschke 2003
Claudia Silvia Däubler-Hauschke. *Geburt und Memoria: Zum italienischen Bildtyp der deschi da parto*. Kunstwissenschaftliche Studien 102. Munich, 2003.

Davanzo Poli 2001
Doretta Davanzo Poli. *Abiti antichi e moderni dei veneziani*. Cultura popolare veneta, n.s., 21. Vicenza, 2001.

Davidson 1963
Bernice F. Davidson. "Early Drawings by Perino del Vaga." Pt. 2. *Master Drawings* 1, no. 4 (Winter 1963), pp. 19–26.

Davidson 1966
Bernice F. Davidson. *Mostra di disegni di Perino del Vaga e la sua cerchia*. Translated by Françoise Pouncey Chiarini. Exh. cat., Gabinetto Disegni e Stampe degli Uffizi. Florence, 1966.

Davidson 1988
Bernice F. Davidson. "The *Furti di Giove* Tapestries Designed by Perino del Vaga for Andrea Doria." *Art Bulletin* 70, no. 3 (September 1988), pp. 424–50.

Davies 1951
Martin Davies. *The Earlier Italian Schools*. National Gallery Catalogues. London, 1951.

Davies 1961
Martin Davies. *The Earlier Italian Schools*. 2nd ed. National Gallery Catalogues. London, 1961.

Dax and Butler 2003
Lionel Dax and Augustin de Butler. *Les lascives: Augustin Carrache*. Paris, 2003.

Dean and Lowe 1998
Trevor Dean and K. J. P. Lowe, eds. *Marriage in Italy, 1300–1650*. Cambridge, 1998.

De Carli 1997
Cecilia De Carli. *I deschi da parto e la pittura del primo Rinascimento toscano*. Archivi di arte antica. Turin, 1997.

R. Decker and C. Decker 1975
Ron Decker and Charlotte Decker. "The Visconti-Sforza Cards in the Cary Collection." *Playing Card* (Playing Card Society) 4 (November 1975), pp. 27–32.

Degenhart and Schmitt 1968
Bernhard Degenhart and Annegrit Schmitt. *Corpus der italienischen Zeichnungen, 1300–1450*. Pt. 1, *Süd- und Mittelitalien*. 4 pts. Berlin, 1968.

Deimling 1993
Barbara Deimling. *Sandro Botticelli, 1444/45–1510*. Cologne, 1993.

Delaforce 1982
Angela Delaforce. "The Collection of Antonio Pérez, Secretary of State to Philip II." *Burlington Magazine* 124 (December 1982), pp. 742–53.

Delessert 1853
Benjamin François Marie Delessert. *Notice sur la vie de Marc Antoine Raimondi, graveur bolonais, accompagnée de réproductions photographiques de quelques unes de ses estampes*. Paris, 1853.

D'Elia 2002
Anthony F. D'Elia. "Marriage, Sexual Pleasure, and Learned Brides in the Wedding Orations of Fifteenth-Century Italy." *Renaissance Quarterly* 55, no. 2 (Summer 2002), pp. 379–433.

D'Elia 2004
Anthony F. D'Elia. *The Renaissance of Marriage in Fifteenth-Century Italy.* Harvard Historical Studies 146. Cambridge, Mass., 2004.

Della Pergola 1955–59
Paola Della Pergola. *Galleria Borghese: I dipinti.* 2 vols. Cataloghi dei musei e gallerie d'Italia. Rome, 1955–59.

Della Pergola 1964
Paola Della Pergola. "L'inventario Borghese del 1693." *Arte antica e moderna*, no. 28 (October–December 1964), pp. 451–67.

Del Lungo 1923
Isidore del Lungo. *Gli amori del Magnifico Lorenzo.* Bologna, 1923.

De Mauri 1924
Ernesto Sarasino De Mauri. *Le maioliche di Deruta.* Milan, 1924.

Dempsey 1985
Charles Dempsey. "Lorenzo de' Medici's *Ambra.*" In *Renaissance Studies in Honor of Craig Hugh Smyth*, vol. 2, *Art, Architecture*, edited by Andrew Morrogh et al., pp. 177–89. Villa I Tatti 7. Florence, 1985.

Dempsey 1992
Charles Dempsey. *The Portrayal of Love: Botticelli's "Primavera" and Humanist Culture at the Time of Lorenzo the Magnificent.* Princeton, 1992.

De Pascale 1998
Enrico De Pascale. "Giovan Paolo Lavagna: Ritratto di gentiluomo con due figli." In *Giovan Paolo Cavagna e il ritratto a Bergamo dopo Moroni*, edited by Enrico De Pascale and Francesco Rossi, pp. 5–20. Exh. cat., Accademia Carrara Pinacoteca, Bergamo. Quaderni dell'Accademia Carrara 14. Bergamo, 1998.

Descatoire 2007
Christine Descatoire. *Trésors de la peste noire: Erfurt et Colmar.* Exh. cat., Musée National du Moyen Âge. Paris, 2007.

De Simone 2004
Daniel De Simone, ed. *A Heavenly Craft: The Woodcut in Early Printed Books. Illustrated Books Purchased by Lessing J. Rosenwald at the Sale of the Library of C. W. Dyson Perrins.* New York, 2004.

De Tiziano a Bassano 1997
De Tiziano a Bassano: Maestros venecianos del Museo del Prado. Exh. cat., Museu Nacional d'Art de Catalunya. Barcelona, 1997.

Detroit Institute of Arts 1979
Detroit Institute of Arts. *Selected Works from the Detroit Institute of Arts.* Detroit, 1979.

Devoti 1974
Donata Devoti. *L'arte del tessuto in Europa.* Arte e tecnica. Milan, 1974.

Di Domenico 2003
Leila Di Domenico. *Per le faustissime nozze: Nuptialia della Biblioteca Braidense (1494–1850).* Cremona, 2003.

Dillon Bussi 1995
Angela Dillon Bussi. "Due ritratti di Raffaele Zovenzoni." *Libri & documenti* 21, no. 1 (1995), pp. 24–42.

Di Tanna 1990
Marzia Di Tanna. "Dal bestiario lottesco: Lo *Sciurus vulgaris.*" *Osservatorio delle arti*, no. 5 (1990), pp. 44–50.

Dixon 1981–82
Laurinda S. Dixon. "Music, Medicine, and Morals: The Iconography of an Early Musical Instrument." *Studies in Iconography* 7–8 (1981–82), pp. 147–56.

Dix Siècles d'enluminure italienne 1984
Dix Siècles d'enluminure italienne: VIe–XVIe Siècles. Exh. cat., Galerie Mazarine. Paris, 1984.

Domenico Puligo 2002
Domenico Puligo (1492–1527): Un protagonista dimenticato della pittura fiorentina. Exh. cat. edited by Elena Capretti and Serena Padovani. Palazzo Pitti. Florence, 2002.

Dominici, *Education of Children*, 1927 (ed.)
Giovanni Dominici. *On the Education of Children.* [ca. 1404.] Translated by Arthur Basil Coté. Washington, D.C., 1927.

Dominici, *Regola*, 1860 (ed.)
Giovanni Dominici. *Regola del governo di cura familiare.* [ca. 1404.] Edited by Donato Salvi. Florence, 1860.

Domonkos 1989
Leslie Domonkos. "A Renaissance Wedding: The Nuptials of the Italian Princess Beatrice of Aragon and Mattias Corvinus, King of Hungary." In *Women in History, Literature and the Arts: A Festschrift for Hildegard Schnuttgen*, edited by Lorrayne Y. Baird-Lange and Thomas A. Copeland, pp. 43–61. Youngstown, Ohio, 1989.

Donatello 2001
Donatello e il suo tempo: Il bronzetto a Padova nel Quattrocento e nel Cinquecento. Exh. cat. by Adriana Augusti et al. Musei Civici. Padua, 2001.

Donati 2001
Gabriele Donati. "Francesco da Sangallo, Paolo Giovio e la 'Simonetta' di Piero di Cosimo." *Prospettiva*, no. 101 (January 2001), pp. 81–85.

Doni, *I mondi*, 1552
Anton Francesco Doni. *I mondi.* Venice, 1552.

Dovizi da Bibbiena, *La calandria*, 1978 (ed.)
Bernardo Dovizi da Bibbiena. *La calandria.* Edited by Paolo Fossati. 3rd ed. Turin, 1978.

Drey 1978
Rudolf E. A. Drey. *Apothecary Jars: Pharmaceutical Pottery and Porcelain in Europe and the East, 1150–1850; with a Glossary of Terms Used in Apothecary Jar Inscriptions.* Faber Monographs on Pottery and Porcelain. London, 1978.

Drogin 2004
David J. Drogin. "Bologna's Bentivoglio Family and Its Artists: Overview of a Quattrocento Court in the Making." In *Artists at Court: Image Making and Identity, 1300–1550*, edited by Stephen J. Campbell, pp. 72–90, 211–16. Boston, 2004.

Dubus 1999
Pascale Dubus. *Domenico Beccafumi.* Translated by Michael Taylor. Paris, 1999.

Dülberg 1990
Angelica Dülberg. *Privatporträts: Geschichte und Ikonologie einer Gattung im 15. und 16. Jahrhundert.* Berlin, 1990.

Dummett 1986
Michael Dummett. *The Visconti-Sforza Tarot Cards.* New York, 1986. [Reproduced from Ms. 630.1-35 in the Morgan Library and Museum, New York, and tarot cards in the collection of the Accademia Carrara, Bergamo.]

Dunand and Lemarchand 1977
Louis Dunand and Philippe Lemarchand. *Les Amours des dieux.* Vol. 1, *Les Compositions de Jules Romain intitulées Les Amours des Dieux, gravées par Marc-Antoine Raimondi.* Lausanne, 1977.

Dunand and Lemarchand 1989
Louis Dunand and Philippe Lemarchand. *Les Amours des Dieux.* Vol. 2, *Les Compositions de Titien intitulées Les Amours des Dieux, gravées par Gian-Jacopo Caraglio, selon les dessins préparatoires de Rosso Fiorentino et Perino del Vaga.* Geneva, 1989.

Duncan 1906
Ellen Duncan. "The National Gallery of Ireland." *Burlington Magazine* 10 (October 1906), pp. 7–23.

Dunkerton 2002
Jill Dunkerton. "Cosmè Tura's Painting Technique." In S. J. Campbell 2002, pp. 107–51.

Dunkerton, Christensen, and Syson 2006
Jill Dunkerton, Carol Christensen, and Luke Syson. "The Master of the Story of Griselda and Paintings for Sienese Palaces" *National Gallery Technical Bulletin* 27 (2006), pp. 4–71. [Issue titled *Renaissance Siena and Perugia, 1490–1510.*]

Eames 1977
Penelope Eames. "Furniture in England, France and the Netherlands from the Twelfth to the Fifteenth Century." *Furniture History* 13 (1977).

Echols 1993
Robert Franklin Echols. "Jacopo Tintoretto and Venetian Painting, 1538–1548." Ph. D. diss., University of Maryland at College Park, 1993.

Echols 1996
Robert Franklin Echols. "'Jacopo nel corso, presso al palio': Dal soffitto per l'Aretino al Miracolo dello Schiavo." In *Jacopo Tintoretto nel quarto centenario della morte: Atti del Convegno internazionale di studi (Venezia, 24–26 novembre 1994)*, edited by Paola Rossi and Lionello Puppi, pp. 77–81. Quaderni di Venezia arti 3. Padua, 1996.

Echols 2007
Robert Franklin Echols. "Tintoretto pintor." In Falomir 2007, pp. 25–62.

Economopoulos 1992
Harula Economopoulos. "Considerazioni su ruoli dimenticati: Gli *Amanti* di Paris Bordon e la figura del compare dell'anello." *Venezia Cinquecento* 2, no. 3 (1992), pp. 99–123.

Eichberger 1996
Dagmar Eichberger. "Margaret of Austria's Portrait Collection: Female Patronage in the Light of Dynastic Ambitions and Artistic Quality." *Renaissance Studies* 10, no. 2 (June 1996), pp. 259–79.

Einhorn 1976
Jürgen W. Einhorn. *Spiritalis Unicornis: Das Einhorn als Bedeutungsträger in Literatur und Kunst des Mittelalters.* Munich, 1976.

Einstein and Monod 1905
Lewis Einstein and François Monod. "Le Musée de la Société Historique de New-York." *Gazette des beaux-arts*, 3rd ser., 33 (May 1905), pp. 414–20.

Eisenach 2004
Emlyn Eisenach. *Husbands, Wives, and Concubines: Marriage, Family, and Social Order in Sixteenth-Century Verona.* Kirksville, Mo., 2004.

Eisenberg 1989
Marvin Eisenberg. *Lorenzo Monaco.* Princeton, 1989.

Eisenbichler and Iannucci 1990
Konrad Eisenbichler and Amilcare A. Iannucci, eds. *Petrarch's Triumphs: Allegory and Spectacle.* University of Toronto Italian Studies 4. Ottawa, 1990.

Eisler 1947
Robert Eisler. "The Frontispiece to Sigismondo Fanti's *Triompho di Fortuna.*" *Journal of the Warburg and Courtauld Institutes* 10 (1947), pp. 155–59.

Ekserdjian 1999
David Ekserdjian. "Unpublished Drawings by Parmigianino: Towards a Supplement to Popham's *Catalogue Raisonné.*" *Apollo* 110 (August 1999), pp. 3–41.

Ekserdjian 2006
David Ekserdjian. *Parmigianino.* New Haven, 2006.

Elam 1993
Caroline Elam. "Art in the Service of Liberty: Battista della Palla, Art Agent for Francis I." In *I Tatti Studies: Essays in the Renaissance* 5 (1993), pp. 33–109.

Emiliani 1993
Andrea Emiliani. *Ludovico Carracci.* Exh. cat. by Maria Silvia Campanini et al. Museo Civico Archeologico and Pinacoteca Nazionale, Bologna; and Kimbell Art Museum, Fort Worth. Bologna, 1993.

Emison 1997
Patricia Emison. *Low and High Style in Italian Renaissance Art.* Garland Studies in the Renaissance 8. New York, 1997.

Engels-de-Lange and Engels 1995
A. E. Engels-de-Lange and A. J. Engels. "A Goblet and Twelve Plates from the Mid-Sixteenth Century." *Annales de l'Association Internationale pour l'Histoire de Verre* 13 (1995; pub. 1996), pp. 381–88.

Ephrussi 1882
Charles Ephrussi. "Les Deux Fresques du Musée du Louvre attribuées à Sandro Botticelli." *Gazette des beaux-arts,* 2nd ser., 25 (May 1, 1882), pp. 475–83.

Equicola, *Libro di natura d'amore*, 1989 (ed.)
Mario Equicola. *Libro di natura d'amore.* Venice, 1526. 1989 ed.: *De natura d'amore. Libro quatro.* Edited by Enrico Musacchio and Graziella Del Ciuco. Biblioteca Capelli. Bologna, 1989.

Erdberg and Ross 1952
Joan Prentice von Erdberg and Marvin C. Ross. *Catalogue of the Italian Majolica in the Walters Art Gallery.* Baltimore, 1952.

Ernst 1994
Germana Ernst. "Fanti, Sigismondo." In *Dizionario biografico degli italiani,* vol. 44, pp. 638–41. Rome, 1994.

Eros invaincu 2004
Eros invaincu: La Bibliothèque Gérard Nordmann. Exh. cat. edited by Monique Nordmann et al. Musée de la Fondation Martin Bodmer, Geneva. Geneva and Paris, 2004.

Errera 1927
Isabelle Errera. *Catalogue d'étoffes anciennes et modernes.* 3rd ed. Musées Royaux du Cinquantenaire. Brussels, 1927.

Essling and Müntz 1902
Prince d'Essling and Eugène Müntz. *Pétrarque: Ses Études d'art, son influence sur les artistes, ses portraits et ceux de Laure, l'illustration de ses écrits.* Paris, 1902.

H. S. Ettlinger 1976
Helen S. Ettlinger. "The Portraits in Botticelli's Villa Lemmi Frescoes." *Mitteilungen des Kunsthistorischen Institutes in Florenz* 20 (1976), pp. 404–6.

H. S. Ettlinger 1990
Helen S. Ettlinger. "The Sepulchre on the Façade: A Re-Evaluation of Sigismondo Malatesta's Rebuilding of San Francesco in Rimini." *Journal of the Warburg and Courtauld Institutes* 53 (1990), pp. 133–43.

H. S. Ettlinger 1994
Helen S. Ettlinger. "Visibilis et Invisibilis: The Mistress in Italian Renaissance Court Society." *Renaissance Quarterly* 47, no. 4 (Winter 1994), pp. 770–92.

L. D. Ettlinger 1978
Leopold D. Ettlinger. *Antonio and Piero Pollaiuolo: Complete Edition with a Critical Catalogue.* Oxford, 1978.

Evans 1931
Joan Evans. *English Posies and Posy Rings.* London, 1931.

Even 1997
Yael Even. "Daphne (without Apollo) Reconsidered: Some Disregarded Images of Sexual Pursuit in Italian Renaissance and Baroque Art." *Studies in Iconography* 18 (1997), pp. 143–59.

Fabbri, Garbero Zorzi, and Petrioli Tofani 1975
Mario Fabbri, Elvira Garbero Zorzi, and Anna Maria Petrioli Tofani. *Il luogo teatrale a Firenze: Brunelleschi, Vasari, Buontalenti, Parigi.* Spettacolo e musica nella Firenze medicea, Documenti e restituzioni 1. Exh. cat., Museo Mediceo, Palazzo Medici Riccardi, Florence. Milan, 1975.

Fabjan 1998
Barbara Fabjan. "In margine all'ermellino." In *Leonardo: La Dama con l'Ermellino,* edited by Barbara Fabjan and Pietro C. Marani, pp. 73–75. Exh. cat., Palazzo del Quirinale, Rome; Pinacoteca di Brera, Milan; and Palazzo Pitti, Florence. Milan, 1998.

Facetiae 1928
The Facetiae of Poggio and Other Medieval Story-Tellers. Translated by Edward Storer. London and New York, 1928.

Fahy 1967
Everett Fahy. "Some Early Italian Pictures in the Gambier-Parry Collection." *Burlington Magazine* 109 (March 1967), pp. 128–39.

Fahy 1976
Everett Fahy. *Some Followers of Domenico Ghirlandaio.* Outstanding Dissertations in the Fine Arts. New York, 1976.

Fahy 1979
Everett Fahy. *The Legacy of Leonardo: Italian Renaissance Paintings from Leningrad.* Exh. cat., National Gallery of Art, Washington, D.C.; Los Angeles County Museum of Art; and M. Knoedler and Co., New York. New York, 1979.

Fahy 1984
Everett Fahy. "The Tornabuoni-Albizzi Panels." In *Scritti di storia dell'arte in onore di Federico Zeri,* edited by Mauro Natale, vol. 1, pp. 233–47. Milan, 1984.

Fahy 1989
Everett Fahy. "The Argonaut Master." *Gazette des beaux-arts,* 6th ser., 114 (December 1989), pp. 285–300.

Fahy 1994
Everett Fahy. "Florence and Naples: A Cassone Panel in The Metropolitan Museum of Art." In *Hommage à Michel Laclotte: Études sur la peinture du Moyen Âge et de la Renaissance,* edited by Pierre Rosenberg, Cécile Scalliérez, and Dominique Thiébaut, pp. 231–43. Milan and Paris, 1994.

Fahy 2000
Everett Fahy. *Dipinti, disegni, miniature, stampe.* L'archivio storico fotografico di Stefano Bardini. Florence, 2000.

Fahy 2007
Everett Fahy. "Ghirlandaio Copying Memling." In *Invisibile agli occhi: Atti della giornata di studi in ricordo di Lisa Venturini, Firenze, Fondazione Roberto Longhi, 15 dicembre 2005,* edited by Nicoletta Baldini, pp. 44–52. Florence, 2007.

Faietti 2007
Marzia Faietti. "*Rebus* d'artista: Agostino Carracci e 'La carta dell'ogni cosa vince l'oro.'" *Artibus et Historiae,* no. 55 (2007), pp. 155–71.

Faietti and Oberhuber 1988
Marzia Faietti and Konrad Oberhuber, eds. *Bologna e l'umanesimo, 1490–1510.* Exh. cat., Pinacoteca Nazionale di Bologna. Bologna, 1988.

Falke 1917
Otto von Falke. "Majoliken von Nicola da Urbino." *Ämtliche Berichte aus den Königl. Kunstsammlungen* (Berlin) 39, no. 1 (October 1917), cols. 1–15.

Falke 1925
Otto von Falke. *Die Kunstsammlung von Pannwitz.* Vol. 2, *Skulpturen und Kunstgewerbe.* Munich, 1925.

Falke 1929
Otto von Falke. "Aus der Sammlung Figdor, I: Kunstgewerbe." *Pantheon* 4 (July 1929), pp. 324–34.

Falletti and J. K. Nelson 2002
Franca Falletti and Jonathan Katz Nelson, eds. *Venere e Amore: Michelangelo e la nuova bellezza ideale / Venus and Love: Michelangelo and the New Ideal of Beauty.* Exh. cat. Galleria dell'Accademia. Florence, 2002.

Falomir 2003a
Miguel Falomir, ed. *Tiziano.* [In Spanish and English.] Exh. cat., Museo Nacional del Prado. Madrid, 2003.

Falomir 2003b
Miguel Falomir. "Tiziano: Réplicas / Titian's Replicas." In Falomir 2003a, pp. 77–91, 326–37.

Falomir 2007
Miguel Falomir, ed. *Tintoretto.* Exh. cat., Museo Nacional del Prado. Madrid, 2007.

Falomir 2008
Miguel Falomir, ed. *El retrato del Renascimento.* Exh. cat., Museo Nacional del Prado; and National Gallery, London. Madrid, 2008.

Fantuzzi 1781–94
Giovanni Fantuzzi. *Notizie degli scrittori bolognesi.* 9 vols. Bologna, 1781–94.

Feo 2004
Michele Feo, ed. *Petrarca nel tempo: Tradizione lettori e immagini delle opere.* Arezzo, 2004.

Ferino-Pagden 2006
Sylvia Ferino-Pagden. "Pictures of Women—Pictures of Love." In D. A. Brown and Ferino-Pagden 2006, pp. 189–99.

Ferino-Pagden 2007
Sylvia Ferino-Pagden, ed. *Arcimboldo, 1526–1593.* Exh. cat., Musée du Luxembourg, Paris; and Kunsthistorisches Museum, Vienna. Milan and Vienna, 2007.

Ferino-Pagden 2008
Sylvia Ferino-Pagden, ed. *Late Titian and the Sensuality of Painting.* Exh. cat., Kunsthistorisches Museum, Vienna; and Gallerie dell'Accademia, Venice. Venice, 2008.

Ferino-Pagden and Nepi Scirè 2004
Sylvia Ferino-Pagden and Giovanna Nepi Scirè, eds. *Giorgione: Myth and Enigma.* Exh. cat., Kunsthistorisches Museum, Vienna. Milan and Vienna, 2004.

Ferino-Pagden and Wald 2003
Sylvia Ferino-Pagden and Robert Wald. "The Fortunes of Parmigianino's *Cupid Carving His Bow.*" *FMR* (International edition), no. 122 (June 2003), pp. 18–32.

Ferrante 2001
Lucia Ferrante. "Gli sposi contesi: Una vicenda bolognese di metà cinquecento." In *Matrimoni in dubbio: Unioni controverse e nozze clandestine in Italia dal XIV al XVIII secolo,* edited by Silvana Seidel Menchi and Diego Quaglioni, pp. 329–62. I processi matrimoniale degli archivi ecclesiastici italiani 2. Annali dell'Istituto Storico Italo-Germanico in Trento, Quaderni 57. Bologna, 2001.

Ferrari 2003
Daniela Ferrari. "'La vita di Leonardo è varia et indeterminata forte': Leonardo da Vinci e i Gonzaga nei documenti dell'Archivio di Stato di Mantova." In *Leonardo, Machiavelli, Cesare Borgia: Arte, storia, e scienza in Romagna, 1500–1503,* pp. 73–79. Exh. cat., Castel Sismondo, Rimini. Rome, 2003.

Ferraro 2001
Joanne M. Ferraro. *Marriage Wars in Late Renaissance*

Venice. Studies in the History of Sexuality. Oxford, 2001.

Ferrazza 1994
Roberta Ferrazza. *Palazzo Davanzati e le collezioni di Elia Volpi.* Florence, 1994.

Ferretti 1992
Massimo Ferretti. "Maestro dei bambini irrequieti: *Due Putti in Lotta.*" In *Per la storia della scultura: Materiali inediti e poco noti, catalogo,* edited by Massimo Ferretti, pp. 33–49. Exh. cat. Turin, 1992.

Ferzoco 2005
George Ferzoco. *Il murale di Massa Marittima / The Massa Marittima Mural.* Toscana Studies 1. 2nd ed. Florence, 2005.

Ffoulkes 1894
Costanza Jocelyn Ffoulkes. "Le esposizioni d'arte italiana a Londra." *Archivio storico dell'arte* 7 (1894) pp. 153–76.

Ficino, *Commentary,* 1944 (ed.)
Marsilio Ficino. *Marsilio Ficino's Commentary on Plato's Symposium.* [1469.] Edited and translated by Sears Reynolds Jayne. Columbia, Mo., 1944.

Filarete, *Trattato di architettura,* 1972 (ed.)
Filarete [Antonio Averlino]. *Trattato di architettura.* [ca. 1465.] Edited by Anna Maria Finoli and Liliana Grassi. 2 vols. Classici italiani di scienze tecniche e arti, Trattati di architettura 2. Milan, 1972.

Findlen 1993
Paula Findlen. "Humanism, Politics and Pornography in Renaissance Italy." In *The Invention of Pornography: Obscenity and the Origins of Modernity, 1500–1800,* edited by Lynn Hunt, pp. 48–108, 345–58. New York, 1993.

Fingerlin 1971
Ilse Fingerlin. *Gürtel des hohen und späten Mittelalters.* Kunstwissenschaftliche Studien 46. Munich, 1971.

Fiocco and Gherardi 1985
Carola Fiocco and Gabriella Gherardi. "Il corredo 'Colonna-Orsini' nella produzione cinquecentesca di Castelli: Proposte per una attribuzione." In *Antichi documenti sulla ceramica di Castelli,* pp. 67–70. Raccolta di studi ceramici dell'Abruzzo 1. Rome, 1985. [Proceedings of a conference held in 1984 in conjunction with the exhibition "Castelli: Ceramiche di cinque secoli" at the Museo delle Ceramiche in Castelli, Italy.]

Fiocco and Gherardi 1988–89
Carola Fiocco and Gabriella Gherardi. *Ceramiche umbre dal medioevo allo storicismo.* 2 vols. Internazionale delle Ceramiche in Faenza. Catalogo generale delle raccolte 5. Faenza, 1988–89.

Fiocco and Gherardi 1992
Carola Fiocco and Gabriella Gherardi. "Alcune considerazioni sull'Orsini-Colonna: Il servizio B°, il servizio T e la 'porcellana colorata.'" *Faenza* 78, nos. 3–4 (1992), pp. 157–65.

Fiocco and Gherardi 1995
Carola Fiocco and Gabriella Gherardi. *Museo Comunale di Gubbio: Ceramiche.* Catalogo regionale dei beni culturali dell'Umbria. Perugia, 1995.

Fiocco and Gherardi 1996
Carola Fiocco and Gabriella Gherardi. "Lustri precoci di Gubbio." *Faenza* 82 (1996), pp. 5–11.

Fiocco and Gherardi 1998
Carola Fiocco and Gabriella Gherardi. "Maestro Giorgio: Il lustro de Gubbio e l'istoriato del ducato d'Urbino." In *Maestro Giorgio da Gubbio: Una carriera sfolgorante,* edited by Gian Carlo Bojani, pp. 15–90. Exh. cat., Palazzo dei Consoli. Gubbio, 1998.

Fiocco and Gherardi 2002
Carola Fiocco and Gabriella Gherardi. "Maestro

Giorgio: Il lustro di Gubbio e l'istoriato del ducato di Urbino." In Bojani 2002, pp. 61–68.

Fiorio 1997
Maria Teresa Fiorio, ed. *Museo d'Arte Antica del Castello Sforzesco: Pinacoteca.* Vol. 1. Musei e gallerie di Milano. Milan, 1997.

Fiorio and Garberi 1987
Maria Teresa Fiorio and Mercedes Garberi. *La Pinacoteca del Castello Sforzesco.* Guide artistiche Electa. Milan, 1987.

Firenzuola, *On the Beauty of Women,* 1992 (ed.)
Agnolo Firenzuola. *On the Beauty of Women.* Translated and edited by Konrad Eisenbichler and Jacqueline Murray. Philadelphia, 1992. [Translation of *Dialogo delle bellezze delle donne,* 1541.]

Fleming 1979
John Fleming. "Art Dealing in the Risorgimento. II." *Burlington Magazine* 121 (August 1979), pp. 492–508.

Fletcher 1973
Jennifer Fletcher. "Marcantonio Michiel's Collection." *Journal of the Warburg and Courtauld Institutes* 36 (1973), pp. 382–85.

Fletcher 1989
Jennifer Fletcher. "Bernardo Bembo and Leonardo's Portrait of Ginevra de' Benci." *Burlington Magazine* 131 (December 1989), pp. 811–16.

Fock 1980
C. Willemijn Fock. "Francesco I e Ferdinando: Mecenati di orefici e intagliatori di pietre dure." In *Le arti del principato Mediceo,* edited by Candace Adelson, pp. 317–63. Florence, 1980.

Foresi 1868
Alexandre Foresi. *Tour de Babel; ou, Objets d'art faux pris pour vrais et vice versa.* Paris and Florence, 1868.

Fornari Schianchi 1988
Lucia Fornari Schianchi. *Ai piedi della Badessa: Un pavimento maiolicato per Maria De Benedetti, Badessa di S. Paolo dal 1471 al 1482, Galleria Nazionale di Parma.* Parma, 1988.

Forster 1969
Leonard Forster. *The Icy Fire: Five Studies in European Petrarchism.* Cambridge, 1969.

Forsyth 1944
William H Forsyth. "The Noblest of Sports: Falconry in the Middle Ages." *The Metropolitan Museum of Art Bulletin,* n.s., 2, no. 9 (May 1944), pp. 253–59.

Fortini Brown 1996
Patricia Fortini Brown. *Venice and Antiquity: The Venetian Sense of the Past.* New Haven, 1996.

Fortini Brown 2004
Patricia Fortini Brown. *Private Lives in Renaissance Venice: Art, Architecture, and the Family.* New Haven, 2004.

Fortnum 1873
C. Drury E. Fortnum. *A Descriptive Catalogue of the Maiolica, Hispano-Moresco, Persian, Damascus, and Rhodian Wares in the South Kensington Museum.* London, 1873.

Fortunati 1994
Vera Fortunati, ed. *Lavinia Fontana, 1552–1614.* Exh. cat., Museo Civico Archeologico, Bologna. Milan, 1994.

Fortunati 2003
Vera Fortunati, ed. *Un Signore allo Specchio: Il ritratto e il palazzo di Giovanni II Bentivoglio.* Exh. cat., Alma Mater Studiorum Università di Bologna, Museo di Palazzo Poggi. Bologna, 2003.

Foxon 1963
David Foxon. "Libertine Literature in England, 1660–1745: II." *Book Collector* 12, no. 2 (Summer 1963), pp. 159–77.

G. Franco, *Habiti,* 1610
Giacomo Franco. *Habiti delle donne venetiane.* Venice, 1610.

N. Franco, *Rime,* 1541
Niccolò Franco. *Rime di M. Nicolo Franco contra Pietro Aretino, e nel fine la Priapea del medemo autore.* Turin, 1541.

Francolini and Vervat 2001
Stefano Francolini and Muriel Vervat. "Il 'Gioco del Civettino' dello Scheggia: Il ritrovamento di un ulteriore dipinto e la tipologia dell'oggetto." *Kermes: La revista del restauro* 14 (April–June 2001), pp. 51–63.

Franklin 2006
Margaret Franklin. *Boccaccio's Heroines: Power and Virtue in Renaissance Society.* Aldershot, 2006.

Frantz 1972
David O. Frantz. "'Leud Priapians' and Renaissance Pornography." *Studies in English Literature, 1500–1900* 12, no. 1 (Winter 1972), pp. 157–72. [Issue titled *The English Renaissance.*]

Frantz 1989
David O. Frantz. *Festum Voluptatis: A Study of Renaissance Erotica.* Columbus, Ohio, 1989.

Frazier 2005
Alison Knowles Frazier. *Possible Lives: Authors and Saints in Renaissance Italy.* New York, 2005.

Freedberg 1970
Sydney Freedberg. *Painting in Italy, 1500 to 1600.* The Pelican History of Art. Harmondsworth, 1970.

Freyhan 1948
Robert Freyhan. "The Evolution of the Caritas Figure in the Thirteenth and Fourteenth Centuries." *Journal of the Warburg and Courtauld Institutes* 11 (1948), pp. 68–86.

Frezzi, *Il quadriregio,* 1506
Federico Frezzi. *Il quadriregio.* Venice, 1506.

Frick 2002
Carole Collier Frick. *Dressing Renaissance Florence: Families, Fortunes, and Fine Clothing.* The Johns Hopkins University Studies in Historical and Political Science, 120th ser., 3. Baltimore, 2002.

Frick Collection 2003
Frick Collection. *The Frick Collection: An Illustrated Catalogue.* Vol. 9, *Drawings, Prints, and Later Acquisitions.* Edited by Joseph Focarino. New York, 2003.

Friedlaender 1938
Walter Friedlaender. "*La Tintura delle Rose* (the Sacred and Profane Love) by Titian." *Art Bulletin* 20, no. 3 (September 1938), pp. 320–24.

Friedman 1989
Mira Friedman. "The Falcon and the Hunt: Symbolic Love Imagery in Medieval and Renaissance Art." In *Poetics of Love in the Middle Ages: Texts and Contexts,* edited by Moshe Lazar and Norris J. Lacy, pp. 157–75. Fairfax, Va., 1989.

Friedmann 1980
Herbert Friedmann. *A Bestiary for Saint Jerome: Animal Symbolism in European Religious Art.* Washington, D.C., 1980.

Frittelli 1922
Ugo Frittelli. *Albero genealogico della nobil famiglia Chigi, patrizia senese.* Siena, 1922.

Frommel 1973
Christoph Luitpold Frommel. *Die römische Palastbau der Hochrenaissance.* Tübingen, 1973.

Frommel 1984
Christoph Luitpold Frommel. "Scenografia teatrale." In Frommel et al. 1984, pp. 225–28.

Frommel et al. 1984
Christoph Luitpold Frommel, Stefano Ray, Manfredo Tafuri, Howard Burns, and Arnold Nesselrath, eds. *Rafaello architetto*. Milan, 1984.

E. Fry 1979
Edward Fry. "In Detail: Titian's *Sacred and Profane Love*." *Portfolio* 1, no. 4 (October–November 1979), pp. 34–39.

R. Fry 1918
Roger Fry. "A Cassone-Panel by Cosimo Roselli (?)." *Burlington Magazine* 32 (May 1918), p. 201.

R. Fry 1920
Roger Fry. *Catalogue of an Exhibition of Florentine Painting before 1500*. Exh. cat., Burlington Fine Arts Club, 1919. London, 1920.

Fuchs 1993
Charles Dominique Fuchs. *Maioliche istoriate rinascimentali del Museo Statale d'Arte Medioevale e Moderna di Arezzo*. Exh. cat., Museo Statale d'Arte Medioevale e Moderna di Arezzo. Arezzo, 1993.

Fulton 2006
Christopher B. Fulton. *An Earthly Paradise: The Medici, Their Collection and the Foundations of Modern Art*. Arte e archeologia 28. Florence, 2006.

P. Fusco 1996
Peter Fusco. "An Image of Saint Cyricus by Francesco Laurana." *Antologia di belle arti*, n.s., nos. 52–55 (1996), pp. 8–16. [Issue titled *La scultura II: Studi in onore di Andrew S. Ciechanowiecki*.]

L. Fusco and Corti 2006
Laurie Fusco and Gino Corti. *Lorenzo de' Medici: Collector and Antiquarian*. Cambridge, 2006.

Gaci, *Sbarra*, 1579
Cosimo Gaci. *Poetica descrizione d'intorno all'inventioni della sbarra*. Florence, 1579.

Gaisser 1995
Julia Haig Gaisser. "The Rise and Fall of Goritz's Feasts." *Renaissance Quarterly* 48, no. 1 (Spring 1995), pp. 41–57.

Galasso 1993
Giovanna Galasso. "Modelli e schemi per la produzione tessile in eta moderna." In *Tessuti nel Veneto: Venezia e la terraferma*, edited by Giuliana Ericani and Paola Frattaroli, pp. 229–48. Verona, 1993.

Galis 1977
Diana Wronski Galis. "Lorenzo Lotto: A Study of His Career and Character, with Particular Emphasis on His Emblematic and Hieroglyphic Works." Ph.D. diss., Bryn Mawr College, 1977.

Galli 2003
Aldo Galli. "Risarcimento di Piero del Pollaiolo." *Prospettiva*, no. 109 (January 2003), pp. 27–58.

Galli 2005
Aldo Galli. *The Pollaiuolo*. Gallery of the Arts 6. Milan, 2005.

Galluzzi 1781
Jacopo Riguccio Galluzzi. *Istoria del Granducato di Toscana sotto il governo della casa Medici*. 5 vols. Florence, 1781.

Garas 1987
Klara Garas. "Opere di Paris Bordon di Augusta." In *Paris Bordon 1987*, pp. 71–78.

Gardelli (Giovanna) 1992
Giovanna Gardelli. *L'universalità dell'amore, dall'umano al divino*. Viterbo, 1992.

Gardelli (Giuliana) 1999
Giuliana Gardelli. *Italika: Maiolica italiana del Rinascimento. Saggi e studi*. Faenza, 1999.

Garnett 2000
Oliver Garnett. "The Letters and Collection of William Graham: Pre-Raphaelite Patron and Pre-Raphael Collector." *Walpole Society* 62 (2000), pp. 145–344.

Garrard 1992
Mary D. Garrard. "Leonardo da Vinci: Female Portraits, Female Nature." In *The Expanding Discourse: Feminism and Art History*, edited by Norma Broude and Mary D. Garrard, pp. 59–86. New York, 1992.

Garrard 2001
Mary D. Garrard. *Artemisia Gentileschi around 1622: The Shaping and Reshaping of an Artistic Identity*. Berkeley, 2001.

Garrard 2006
Mary D. Garrard. "Who was Ginevra de' Benci? Leonardo's Portrait and Its Sitter Recontextualized." *Artibus et historiae*, no. 53 (2006), pp. 23–56.

Garzelli 1985
Annarosa Garzelli, ed. *Miniatura fiorentina del Rinascimento, 1440–1525: Un primo censimento*. 2 vols. Inventari e cataloghi toscani 18, 19, Florence, 1985.

Gavitt 2001
Philip Gavitt. "An Experimental Culture: The Art of the Economy and the Economy of Art under Cosimo I and Francesco I." In *The Cultural Politics of Duke Cosimo I de' Medici*, edited by Konrad Eisenbichler, pp. 205–21. Aldershot, 2001.

Gazzola 2006
Silvia Gazzola. "'Di breve lin facendo eterno laccio': Itinerari simbolici del fazzoletto." *Venezia Cinquecento* 16, no. 31 (2006), pp. 147–87.

Gealt et al. 2007
Adelheid M. Gealt et al. *Masterworks from the Indiana University Art Museum*. Edited by Linda J. Baden. Bloomington, 2007.

Geiringer 1945
Karl Geiringer. *Musical Instruments: Their History in Western Culture from the Stone Age to the Present*. Translated by Bernard Maill. New York, 1945.

Gentili 1989
Augusto Gentili. "Lorenzo Lotto e il ritratto cittadino: Leonino e Lucina Brembate." In *Il ritratto e la memoria: Materiali*, vol. 1, edited by Augusto Gentili, pp. 155–81. Biblioteca del Cinquecento 48. Rome, 1989.

Gentili 1995
Augusto Gentili. "Amore e amorose persone: Tra miti ovidiani, allegorie musicali, celebrazioni matrimoniali." In *Tiziano 1995*, pp. 82–105.

Gentili 2000
Augusto Gentili. "Lotto, Cariani e storie di scoiattoli." *Venezia Cinquecento* 10, no. 20 (2000), pp. 5–38.

Geronimus 2006
Dennis Geronimus. *Piero di Cosimo: Visions Beautiful and Strange*. New Haven, 2006.

Gherardi, *Estense Ducal Galleria*, 1986 (ed.)
Pietro Ercole Gherardi. *Descrizione della pitture esistenti in Modena nell'Estense Ducal Galleria (1744)*. Edited by Giorgio Bonsanti. Transcribed by Orianna Baracchi. Materiali per la storia di Modena medievale e moderna 5. Cultura e vita civile del Settecento in Emilia Romagna, Il Settecento Estense, Studi e ricerche. Modena, 1986. [Transcription of Ms. G.5.18, Italiano 559 in the Biblioteca Estense, Modena.]

Ghering van Ierlant 1988
M. A. Ghering van Ierlant. *Mode in Print (1550–1914)*. Nederlands Kostuummuseum. The Hague, 1988.

Ghiberti, *I commentarii*, 1998 (ed.)
Lorenzo Ghiberti. *Lorenzo Ghiberti: I commentarii. Biblioteca Nazionale Centrale di Firenze, II, I, 333*. Edited by Lorenzo Bartoli. Florence, 1998.

Ghinzoni 1889
Pietro Ghinzoni. "Lettera inedita di Bernardo Belincioni." *Archivio storico lombardo* 6 (June 1889), pp. 417–18.

Ghirardi 1993–94
Angela Ghirardi. "Exempla per l'iconografia dell'infanzia nel secondo cinquecento padano." *Il Carrobbio* 19–20 (1993–94), pp. 123–39.

Giacomotti 1974
Jeanne Giacomotti. *Catalogue des majoliques des Musées Nationaux: Musées du Louvre et de Cluny, Musée National de Céramique à Sèvres, Musée Adrien-Dubouché à Limoges*. Paris, 1974.

Giamatti 1966
A. Bartlett Giamatti. *The Earthly Paradise and the Renaissance Epic*. Princeton, 1966.

Giani 2005
Stefano Giani. "Il ritratto di coniugi di Lorenzo Lotto al Rijksmuseum." *Incontri* 20, no. 2 (2005), pp. 141–50.

Gibson 1990
Gail McMurray Gibson. "The Thread of Life in the Hand of the Virgin." In *Equally in God's Image: Women in the Middle Ages*, edited by Julia Bolton Holloway, Constance S. Wright, and Joan Bechtold, pp. 46–54. New York, 1990.

Gilbert 1980
Creighton E. Gilbert, ed. *Italian Art, 1400–1500: Sources and Documents*. Sources and Documents in the History of Art Series. Englewood Cliffs, N.J., 1980.

Gilbert 1992
Creighton E. Gilbert, ed. *Italian Art, 1400–1500: Sources and Documents*. Evanston, Ill., 1992.

Gilbert 2002
Creighton E. Gilbert. "Lucretia, Portia, Hasdrubal's Wife, and Their Husbands." *Annali dell'Università di Ferrara*, no. 3 (2002), pp. 183–204.

Ginzburg 1976
Carlo Ginzburg. *Il formaggio e i vermin: Il cosmo di un mugnaio del '500*. Turin, 1976. [English trans., *The Cheese and the Worms: The Cosmos of a Sixteenth-Century Miller*. Translated by John Tedeschi and Anne C. Tedeschi. Baltimore, 1980.]

Ginzburg 1990
Carlo Ginzburg. "Titian, Ovid, and Sixteenth-Century Codes for Erotic Illustration." In *Myths, Emblems, Clues*, translated by John Tedeschi and Anne C. Tedeschi, pp. 77–95. London, 1990.

Il gioco dell'amore 1990
Il gioco dell'amore: Le cortigiane di Venezia dal Trecento al Settecento. Exh. cat., Casino Municipale, Ca' Vendramin Calergi, Venice. Milan, 1990.

Giorgi 1990
Roberta Giorgi. *Tiziano: Venere, Amore e il musicista in cinque dipinti*. Rome, 1990.

Glaskunst 1981
3000 Jahre Glaskunst von der Antike bis zum Jugendstil. Exh. cat., Kunstmuseum Luzern. Luzerne, 1981.

Glendinning 1996
Robert Glendinning. "Love, Death, and the Art of Compromise: Aeneas Silvius Piccolomini's Tale of Two Lovers." *Fifteenth-Century Studies* 23 (1996), pp. 101–20.

Goffen 1993
Rona Goffen. "Titian's *Sacred and Profane Love*: Individuality and Sexuality in a Renaissance Marriage Picture." In *Titian 500*, edited by Joseph Manca, pp. 120–44. Studies in the History of Art (National Gallery of Art) 45. Symposium Papers 25. Washington, D.C., 1993.

Goffen 1997a
Rona Goffen. "Sex, Space, and Social History in Titian's *Venus of Urbino*." In *Titian's "Venus of Urbino,"* edited by Rona Goffen, pp. 63–90. Cambridge, 1997.

Goffen 1997b
Rona Goffen. *Titian's Women*. New Haven, 1997.

Goffen 1999
Rona Goffen. "Crossing the Alps: Portraiture in Renaissance Venice." In *Renaissance Venice and the North: Crosscurrents in the Time of Bellini, Dürer and Titian*, edited by Bernard Aikema and Beverly Louise Brown, pp. 114–31. Exh. cat., Palazzo Grassi. Venice, 2000.

Goldthwaite 1987
Richard A. Goldthwaite. "The Medici Bank and the World of Florentine Capitalism." *Past and Present*, no. 114 (February 1987), pp. 3–31.

Goldthwaite 1989
Richard A. Goldthwaite, "The Economic and Social World of Italian Renaissance Maiolica." *Renaissance Quarterly* 42, no. 1 (Spring 1989), pp. 1–32.

Gombosi 1941
Otto Gombosi. "About Dance and Dance Music in the Late Middle Ages." *Musical Quarterly* 27, no. 3 (July 1941), pp. 289–305.

Gombrich 1945/1972
Ernst H. Gombrich. "Botticelli's Mythologies: A Study in the Neoplatonic System of His Circle." *Journal of the Warburg and Courtauld Institutes* 8 (1945), pp. 7–60. Reprinted with revisions in Ernst H. Gombrich, *Symbolic Images: Studies in the Art of the Renaissance*, pp. 31–81. London, 1972.

Gombrich 1955
Ernst H. Gombrich. "Apollonio di Giovanni: A Florentine Cassone Workshop Seen through the Eyes of a Humanist Poet." *Journal of the Warburg and Courtauld Institutes* 18, nos. 1–2 (January–June 1955), pp. 16–34.

Gombrich et al. 1989
Ernst H. Gombrich et al. *Giulio Romano*. Exh. cat. edited by Sergio Polano. Palazzo Te and Palazzo Ducale, Mantua. Milan, 1989.

Gomez-Geraud and Yerasimos 1989
Marie-Christine Gomez-Geraud and Stéphane Yerasimos, eds. *Nicolas de Nicolay: Dans l'empire de Soliman le Magnifique*. Paris, 1989.

Gómez-Moreno 1968
Carmen Gómez-Moreno. *Medieval Art from Private Collections*. Exh. cat., The Metropolitan Museum of Art. New York, 1968.

Goodison and Robertson 1967
Jack Weatherburn Goodison and G. H. Robertson. *Catalogue of Paintings*. Vol. 2, *Italian Schools*. Fitzwilliam Museum. Cambridge, 1967.

Goodman-Soellner 1983
Elise Goodman-Soellner. "Poetic Interpretations of the 'Lady at Her Toilette' Theme in Sixteenth-Century Painting." *Sixteenth Century Journal* 14, no. 4 (Winter 1983), pp. 426–42.

Goodman-Soellner 1983a
Elise Goodman[-Soellner]. "Petrarchism in Titian's *The Lady and the Musician*." *Storia dell'arte*, no. 49 (September–December 1983), pp. 179–86.

Goretti 2006
Paola Goretti. "Pellegrini, gentiluomini, mercanti: Le origini della borsa." In *Dalla testa ai piedi: Costume e moda in età gotica; Atti del convegno di studi, Trento, 7–8 ottobre 2002*, edited by Laura dal Prà and Paolo Peri, pp. 577–603. Beni artistici e storici del Trentino, Quaderni 12. Trent, 2006.

Götz-Mohr 1993
Brita von Götz-Mohr. "Laura Laurana: Francesco Lauranas Wiener Porträtbüste und die Frage der Wahren Existenz von Petrarcas Laura im Quattrocento." *Städel-Jahrbuch* 14 (1993), pp. 147–72.

Grabski 1987
Józef Grabski. "Rime d'amore di Paris Bordon: Strutture visuali e poesia rinascimentale." In *Paris Bordon 1987*, pp. 203–11.

Grafton 1993
Anthony Grafton, ed. *Rome Reborn: The Vatican Library and Renaissance Culture*. Exh. cat., Library of Congress. Washington, D.C., and Vatican City, 1993.

Green 2001
Monica H. Green. *The Trotula: A Medieval Compendium of Women's Medicine*. The Middle Ages Series. Philadelphia, 2001.

Greenblatt 1980
Stephen Greenblatt. *Renaissance Self-Fashioning: From More to Shakespeare*. Chicago, 1980.

Gregori 1979
Mina Gregori. *Giovan Battista Moroni: Tutte le opere*. Bergamo, 1979. [Extract from *I pittori bergamaschi dal XIII al XIX secolo: Il Cinquecento*, vol. 3, pp. 95–377. Bergamo, 1979.]

Gregori, Paolucci, and Acidini Lucinat 1992
Mina Gregori, Antonio Paolucci, and Cristina Acidini Lucinat, eds. *Maestri e botteghe: Pittura a Firenze alla fine del Quattrocento*. Exh. cat., Palazzo Strozzi, Florence. Milan, 1992.

Grierson and Travaini 1999
Philip Grierson and Lucia Travaini. *Medieval European Coinage: With a Catalogue of Medieval Coins in the Fitzwilliam, Cambridge*. Vol. 14, *Italy*, pt. 3, *South Italy, Sicily, Sardinia*. Cambridge, 1999.

Grigaut 1958–59
Paul L. Grigaut. "Two Pieces of Ceramic." *Detroit Institute of Arts Bulletin* 38 (1958–59), pp. 85–89.

Grigioni 1934
Carlo Grigioni. "Documenti: Serie faentina. I Calamelli maiolicari di Faenza." *Faenza* 22 (1934), pp. 50–54, 88–90, 143–53.

Gronau 1936
Georg Gronau. *Documenti artistici urbinati*. Florence, 1936.

Grubb 1996
James S. Grubb. *Provincial Families of the Renaissance: Private and Public Life in the Veneto*. Baltimore, 1996.

Gruyer 1897
Gustave Gruyer. *L'Art ferrarais à l'époque des princes d'Este*. 2 vols. Paris, 1897.

Gualterotti, *Feste nelle nozze*, 1579
Raffaello Gualterotti. *Feste nelle nozze del serenissimo Don Francesco Medici, gran duca di Toscana et della Sereniss. sua Consorte la Sig. Bianca Cappello*. Florence, 1579.

Guasti 1902
Gaetano Guasti. *Di Cafaggiolo e d'altre fabbriche di ceramiche in Toscana*. Florence, 1902.

Gudenrath 2006
William Gudenrath. "Enameled Glass Vessels, 1425 B.C.E.–1800: The Decorating Process." *Journal of Glass Studies* 48 (2006), pp. 23–70.

Guérin Dalle Mese 1998
Jeannine Guérin Dalle Mese. *L'occhio di Cesare Vecellio: Abiti e costume esotici nel '500*. Oltramare 8. Alessandria, 1998.

Guérin Dalle Mese 2001
Jeannine Guérin Dalle Mese. "Abiti di Cesare Vecellio: Venezia e 'il Veneto.'" In *Cesare Vecellio, 1521c.–1601*, edited by Tiziana Conte, pp. 125–56. Belluno, 2001.

Guillaume de Lorris and Jean de Meun, *Romance of the Rose*, 1995 (ed.)
Guillaume de Lorris and Jean de Meun. *The Romance of the Rose*. Translated by Charles Dahlberg. 3rd ed. Princeton, 1995. [Translation of *Le Roman de la rose*.]

Gundersheimer 1980
Werner L. Gundersheimer. "Bartolommeo Goggio: A Feminist in Renaissance Ferrara." *Renaissance Quarterly* 33 (1980), pp. 175–200.

Haas 1998
Louis Haas. *The Renaissance Man and His Children: Childbirth and Early Childhood in Florence, 1300–1600*. New York, 1998.

Hackenbroch 1962
Yvonne Hackenbroch. *Bronzes, Other Metalwork, and Sculpture in the Irwin Untermyer Collection*. The Metropolitan Museum of Art. New York, 1962.

Hackenbroch 1979
Yvonne Hackenbroch. *Renaissance Jewellery*. London, 1979.

Hadeln 1922
Detlev Baron von Hadeln. "Early Works by Tintoretto. II." *Burlington Magazine* 41 (December 1922), pp. 278–88.

Haines 1999
Margaret Haines. "Il mondo dello Scheggia: Persone e luoghi di una carriera." In *Bellosi and Haines 1999*, pp. 35–64.

Van Hall 1976
Mariette van Hall. "Messer Marsilio and His Bride." *Connoisseur* 192 (August 1976), pp. 292–97.

Hankins 1993
James Hankins. "The Popes and Humanism." In *Rome Reborn: The Vatican Library and Renaissance Culture*, edited by Anthony Grafton, pp. 47–85. Exh. cat., Library of Congress, Washington, D.C. New Haven, 1993.

Hanning 1979
Barbara Russano Hanning. "Glorious Apollo: Poetic and Political Themes in the First Opera." *Renaissance Quarterly* 32, no. 4 (Winter 1979), pp. 485–513.

Haskell and Penny 1981
Francis Haskell and Nicholas Penny. *Taste and the Antique: The Lure of Classical Sculpture, 1500–1900*. New Haven, 1981.

Haskell and Penny 1982
Francis Haskell and Nicholas Penny. *Taste and the Antique: The Lure of Classical Sculpture, 1500–1900*. 2nd printing, with corrections. New Haven, 1982.

Hausmann 1972
Tjark Hausmann. *Majolika: Spanische und italienische Keramik vom 14. bis zum 18. Jahrhundert*. Kataloge des Kunstgewerbemuseums Berlin 6. Berlin, 1972.

Hayum 1976
Andrée Hayum. *Giovanni Antonio Bazzi—"Il Sodoma."* Outstanding Dissertations in the Fine Arts. New York, 1976.

Heikamp 1955
Detlef Heikamp. "Agnolo Bronzinos Kinderbildnisse aus dem Jahre 1551." *Mitteilungen des Kunsthistorischen Institutes in Florenz* 7, no. 2 (August 1955), pp. 133–38.

Heikamp 1972
Detlef Heikamp, with contributions by Ferdinand Anders. *Mexico and the Medici*. Quaderni d'arte 6. Florence, 1972.

Heikamp 1986
Detlef Heikamp. "Studien zur mediceischen Glaskunst: Archivalien, Entwurfszeichnungen, Gläser und Scherben." *Mitteilungen des Kunsthistorischen Institutes in Florenz* 30, nos. 1–2 (1986).

Heineken 1753
Carl Heinrich von Heineken. *Recueil d'estampes d'après les plus célèbres tableaux de la Galerie Royale de Dresde*. 2 vols. Dresden, 1753.

Held 1961
Julius Held. "Flora: Goddess and Courtesan." In *De*

artibus opuscula XL: Essays in Honor of Erwin Panofsky, edited by Millard Meiss, vol. 1, pp. 201–18, vol. 2, pp. 69–74. New York, 1961.

Hendy 1964
Philip Hendy. *Some Italian Renaissance Pictures in the Thyssen-Bornemisza Collection.* Lugano-Castagnola, 1964.

Hendy 1974
Philip Hendy. *European and American Paintings in the Isabella Stewart Gardner Museum.* Boston, 1974.

Herald 1981
Jacqueline Herald. *Renaissance Dress in Italy, 1400–1500.* History of Dress Series 2. London, 1981.

Herlihy 1980
David Herlihy. "Popolazione e strutture sociali dal XV al XVI secolo." In *Tiziano e Venezia: Convegno internazionale di studi, Venezia, 1976*, pp. 71–74. Vicenza, 1980.

Herlihy and Klapisch-Zuber 1978
David Herlihy and Christiane Klapisch-Zuber. *Les Toscans et leurs familles: Une Étude du "catasto" florentin de 1427.* Paris, 1978. [English trans., abridged, *Tuscans and Their Families: A Study of the Florentine Catasto of 1427.* Yale Series in Economic History. New Haven, 1985.]

Herrmann Fiore 1995
Kristina Herrmann Fiore. "Venere che Benda Amore." In *Tiziano 1995*, pp. 389–409.

Hersey 1969
George L. Hersey. *Alfonso II and the Artistic Renewal of Naples, 1485–1495.* Yale Publications in the History of Art 19. New Haven, 1969.

Hess 1988
Catherine Hess. *Italian Maiolica: Catalogue of the Collections.* J. Paul Getty Museum. Malibu, 1988.

Hess 2002
Catherine Hess. *Italian Ceramics. Catalogue of the J. Paul Getty Museum Collection.* Los Angeles, 2002.

Hess 2003
Catherine Hess. "Getting Lucky: Renaissance Maiolica." In Paul Mathieu, *Sex Pots: Eroticism in Ceramics*, pp. 64–79. London, 2003.

Hewett 1907
A. Edith Hewett. "A Newly Discovered Portrait by Ambrogio de Predis." *Burlington Magazine* 10 (February 1907), pp. 308–13.

***Highlights of the Untermyer Collection* 1977**
Highlights of the Untermyer Collection of English and Continental Decorative Arts. The Metropolitan Museum of Art. New York, 1977.

Hildburgh 1914–15
W. L. Hildburgh. "Italian Wafering-Irons of the Fifteenth and Sixteenth Centuries." *Proceedings of the Society of Antiquaries of London*, 2nd ser., 27 (1914–15), pp. 161–201.

Hill 1930
George Francis Hill. *A Corpus of Italian Medals of the Renaissance before Cellini.* 2 vols. London, 1930.

Hill, Pollard, and Middeldorf 1930
George Francis Hill. *A Corpus of Italian Medals of the Renaissance before Cellini.* Preface and appendix by John Graham Pollard and Ulrich Middeldorf. 2 vols. 1930. [2nd ed., Florence, 1984.]

Hills 2003
Paul Hills. "El color de Tiziano / Titian's Color." In Falomir 2003a, pp. 33–45, 308–13.

Hind 1936
Arthur M. Hind. *Nielli, Chiefly Italian of the XV Century: Plates, Sulphur Casts and Prints Preserved in the British Museum.* London, 1936.

Hind 1938–48
Arthur M. Hind. *Early Italian Engraving: A Critical Catalogue with Complete Reproduction of All the Prints Described.* 7 vols. London, 1938–48.

Hirst 1981
Michael Hirst. *Sebastiano del Piombo.* Oxford and New York, 1981.

Hirst 1994
Michael Hirst. "The Artist in Rome, 1496–1501." In Michael Hirst and Jill Dunkerton, *The Young Michelangelo*, pp. 13–81. Making and Meaning. Exh. cat., National Gallery. London, 1994.

Hochmann 1999
Michel Hochmann, ed. *Villa Medici: Il sogno di un cardinale. Collezioni e artisti di Ferdinando de' Medici.* Rome, 1999.

Holberton 1985
Paul Holberton. "Of Antique and Other Figures: Metaphor in Early Renaissance Art." *Word and Image* 1, no. 1 (January–March 1985), pp. 31–58.

Holberton 2003
Paul Holberton. "To Loosen the Tongue of Mute Poetry: Giorgione's Self-Portrait 'as David' as a *Paragone* Demonstration." In *Poetry on Art: Renaissance to Romanticism*, edited by Thomas Frangenberg, pp. 29–47. Donington, 2003.

Hollander 1977
Robert Hollander. *Boccaccio's Two Venuses.* New York, 1977.

Holmes 1997
Megan Holmes. "Disrobing the Virgin: The *Madonna Lactans* in Fifteenth-Century Florentine Art." In *Picturing Women in Renaissance and Baroque Italy*, edited by Geraldine A. Johnson and Sara F. Matthews Grieco, pp. 167–95, 283–90. Cambridge, 1997.

Holmes 1999
Megan Holmes. *Fra Filippo Lippi: The Carmelite Painter.* New Haven, 1999.

Honemann 2005
Volker Honemann. "The Marriage of Matthias Corvinus to Beatrice of Aragón (1476) in Urban and Court Historiography." In *Princes and Princely Culture, 1450–1650*, vol. 2, edited by Martin Gosman, Alasdair MacDonald, and Arjo Vanderjagt, pp. 213–26. Brill's Studies in Intellectual History, vol. 118, no. 2. Leiden, 2005.

Honey 1946
William Bowyer Honey. *Glass: A Handbook for the Study of Glass Vessels of All Periods and Countries and a Guide to the Museum Collection.* Victoria and Albert Museum. London, 1946.

Hope 1977
Charles Hope. "A Neglected Document about Titian's 'Danae' in Naples." *Arte veneta* 31 (1977), pp. 188–89.

Hope 1980a
Charles Hope. "Problems of Interpretation in Titian's Erotic Paintings." In *Tiziano e Venezia: Convegno internazionale di studi Venezia, 1976*, pp. 111–24. Vicenza, 1980.

Hope 1980b
Charles Hope. *Titian.* New York, 1980.

Horne 1908
Herbert P. Horne. *Alessandro Filipepi, Commonly Called Sandro Botticelli, Painter of Florence.* London, 1908. [Repr., with an introduction by John Pope-Hennessy. Princeton, 1980.]

Hove 1797
Nicolaas Ten Hove. *Memoirs of the House of Medici, from Its Origin to the Death of Francesco, the Second Grand Duke of Tuscany, and of the Great Men Who Flourished in Tuscany within That Period.* Translated by Richard Clayton. 2 vols. Bath, 1797.

Hoving and Gómez-Moreno 1972–73
Thomas Hoving and Carmen Gómez-Morenzo. "Gold." *The Metropolitan Museum of Art Bulletin*, n.s., 31, no. 2 (Winter 1972–73), pp. 72–120.

Hughes 1986
Diane Owen Hughes. "Representing the Family: Portraits and Purposes in Early Modern Italy." *Journal of Interdisciplinary History* 17, no. 1 (Summer 1986), pp. 7–38.

Humfrey 1995
Peter Humfrey. *Painting in Renaissance Venice.* New Haven, 1995.

Humfrey 1997
Peter Humfrey. *Lorenzo Lotto.* New Haven, 1997.

Humfrey 2000
Peter Humfrey. "Jacometto Veneziano." In *Encyclopedia of Italian Renaissance and Mannerist Art*, edited by Jane Turner, vol. 1, pp. 821–22. Grove Encyclopedias of European Art. London, 2000.

Humfrey 2007
Peter Humfrey. *Titian: The Complete Paintings.* Classical Art Series. Ghent, 2007.

Humfrey et al. 2004
Peter Humfrey, Timothy Clifford, Aidan Weston-Lewis, Michael Bury, et al. *The Age of Titian: Venetian Renaissance Art from Scottish Collections.* Exh. cat., Royal Scottish Academy. Edinburgh, 2004.

Hunt and Revel 1995
Lynn Hunt and Jacques Revel. *Histories: French Constructions of the Past.* Translated by Arthur Goldhammer et al. The New Press Postwar French Thought Series 1. New York, 1995.

Ivanova 2003
Elena Ivanova. *Il secolo d'oro della maiolica: Ceramica italiana dei secoli XV–XVI dalla raccolta del Museo Statale dell'Ermitage.* Exh. cat., Museo Internazionale delle Ceramiche in Faenza. Faenza, 2003.

Jacobs 2000
Fredrika H. Jacobs. "Aretino and Michelangelo, Dolce and Titian: *Femmina, Masculo, Grazia.*" *Art Bulletin* 82, no. 1 (March 2000), pp. 51–67.

Jacobson-Schutte 1980
Anne Jacobson-Schutte. "'Trionfo delle donne': Tematiche di rovesciamento dei ruoli nella Firenze rinascimentale." *Quaderni storici*, no. 44 (August 1980), pp. 474–96.

Jansen 1987–88
Dieter Jansen. "Fra Filippo Lippis Doppelbildnis im New Yorker Metropolitan Museum." *Wallraf-Richartz-Jahrbuch* 48–49 (1987–88), pp. 97–121.

Jayne 1990
Emily Roulette Jayne. "Tuscan Dancing Figures in the Quattrocento." Ph.D. diss., Yale University, 1990.

Jestaz 1983
Bernard Jestaz. "Un Groupe de bronze érotique de Riccio." *Monuments et mémoires* (Fondation Eugène Piot) 65 (1983), pp. 25–54.

Jestaz 2005
Bernard Jestaz. "Desiderio da Firenze: Bronzier à Padoue au XVIe siècle, ou Le Faussaire de Riccio." *Monuments et mémoires* (Fondation Eugène Piot) 84 (2005), pp. 99–171.

Joannides 1993
Paul Joannides. *Masaccio and Masolino: A Complete Catalogue.* London, 1993.

Joannides 2001
Paul Joannides. *Titian to 1518: The Assumption of Genius.* New Haven, 2001.

***John G. Johnson Collection* 1966**
John G. Johnson Collection: Catalogue of Italian Paintings. Philadelphia, 1966.

Johns 1982
Catherine Johns. *Sex or Symbol: Erotic Images of Greece and Rome.* Austin, 1982.

Johnson 2001
Geraldine A. Johnson. "Michelangelo, Fortunetelling and the Formation of Artistic Canons in Fanti's *Triompho di Fortuna.*" In *Coming About . . . A Festschrift for John Shearman,* pp. 199–205. Cambridge, Mass., 2001.

Johnson 2005
Geraldine A. Johnson. *Renaissance Art: A Very Short Introduction.* Oxford, 2005.

Join-Diéterle 1984
Catherine Join-Diéterle. *Catalogue de céramiques.* Vol. 1, *Hispano-mauresques, majoliques italiennes, iznik, des collections Dutuit, Ocampo et Pierre Marie.* Musée du Petit Palais. Paris, 1984.

Jones and Penny 1983
Roger Jones and Nicholas Penny. *Raphael.* New Haven, 1983.

Junkerman 1993
Anne Christine Junkerman. "The Lady and the Laurel: Gender and Meaning in Giorgione's *Laura.*" *Oxford Art Journal* 16, no. 1 (1993), pp. 49–58.

Kanter 1994
Laurence B. Kanter. *Italian Paintings in the Museum of Fine Arts, Boston.* Vol. 1, *Thirteenth–Fifteenth Century.* Boston, 1994.

Kanter et al. 1994
Laurence B. Kanter et al. *Painting and Illumination in Early Renaissance Florence, 1300–1450.* Exh. cat., The Metropolitan Museum of Art. New York, 1994.

Kaplan 1978
Stuart R. Kaplan. *The Encyclopedia of Tarot.* New York, 1978.

L. F. Kaufmann 1984
Lynn Frier Kaufmann. *The Noble Savage: Satyrs and Satyr Families in Renaissance Art.* Studies in Renaissance Art History 2. Ann Arbor, 1984.

T. D. Kaufmann 1978
Thomas DaCosta Kaufmann. "Remarks on the Collections of Rudolf II: The *Kunstkammer* as a Form of *Representatio.*" *Art Journal* 38, no. 1 (Fall 1978), pp. 22–28.

Kecks 2000
Ronald G. Kecks. *Domenico Ghirlandaio und die Malerei der Florentiner Renaissance.* Italienische Forschungen, 4th ser., vol. 2. Munich, 2000.

Keen 1991
Michael E. Keen. *Jewish Ritual Art in the Victoria & Albert Museum.* London, 1991.

Kelly 1977
Joan Kelly-Gabol. "Did Women Have a Renaissance?" In *Becoming Visible: Women in European History,* edited by Renate Bridenthal and Claudia Koota, pp. 174–201. Women in Culture and Society. Boston, 1977. [Reprinted in Joan Kelly, *Women, History and Theory: The Essays of Joan Kelly,* pp. 19–50. Chicago, 1984.]

Kennedy 1962
Ruth Wedgwood Kennedy. *Four Portrait Busts by Francesco Laurana.* Genhenna Essays in Art 1. [Northampton, Mass.], 1962.

D. Kent 2001
Dale Kent. "Women in Renaissance Florence." In D. A. Brown et al. 2001, pp. 25–47.

F. W. Kent 2004
Francis William Kent. *Lorenzo de' Medici and the Art of Magnificence.* The Johns Hopkins Symposia in Comparative History 24. Baltimore, 2004.

Kevill–Davies 1991
Sally Kevill–Davies. *Yesterday's Children: The Antiques and History of Childcare.* Woodbridge, 1991.

Killerby 1999
Catherine Kovesi Killerby. "'Heralds of a Well-Instructed Mind': Nicolosa Sanuti's Defence of Women and Their Clothes." *Renaissance Studies* 13, no. 3 (September 1999), pp. 255–82.

Killerby 2002
Catherine Kovesi Killerby. *Sumptuary Law in Italy, 1200–1500.* Oxford, 2002.

Kilpatrick 1999
Ross S. Kilpatrick. "*Sorella sacra e sorella profana*: Revisiting with Ovid the Borghese Titian." *International Journal of the Classical Tradition* 6, no. 1 (Summer 1999), pp. 30–50.

King 1998
Catherine King. *Renaissance Women Patrons: Wives and Widows in Italy, c. 1300–1550.* Manchester, 1998.

Kirkendale 1993
Warren Kirkendale. *The Court Musicians in Florence during the Principate of the Medici.* Florence, 1993.

Kisluk-Grosheide, Koeppe, and Rieder 2006
Daniëlle Kisluk-Grosheide, Wolfram Koeppe, and William Rieder. *European Furniture in The Metropolitan Museum of Art: Highlights of the Collection.* The Metropolitan Museum of Art. New York, 2006.

Klapisch-Zuber 1979/1985
Christiane Klapisch-Zuber. "Zacharias, or the Ousted Father: Nuptial Rites in Tuscany between Giotto and the Council of Trent." In Klapisch-Zuber 1985, pp. 178–212. [Originally published as "Zacharie ou le père évincé: Les Rituels nuptiaux toscans entre Giotto et le Concile de Trente." *Annales, économies, sociétés, civilisations* 34, no. 6 (November–December 1979), pp. 1216–43.]

Klapisch-Zuber 1980/1985
Christiane Klapisch-Zuber. "State and Family in a Renaissance Society: The Florentine *Catasto* of 1427–30." In Klapisch-Zuber 1985, pp. 1–22. [Originally published as "État et famille dans une société de le Renaissance." *Le Temps de la réflexion,* vol. 1, pp. 243–71. Paris, 1980.]

Klapisch-Zuber 1981/1985
Christiane Klapisch-Zuber. "An Ethnology of Marriage in the Age of Humanism." In Klapisch-Zuber 1985, pp. 247–60. [Originally published as "Une Ethnologie du marriage au temps de l'humanisme." *Annales: Économies, sociétés, civilisations* 36, no. 6 (1981), pp. 1016–27.]

Klapisch-Zuber 1982/1985
Christiane Klapisch-Zuber. "The Griselda Complex: Dowry and Marriage Gifts in the Quattrocento." In Klapisch-Zuber 1985, pp. 213–46. [Originally published as "Le Complexe de Griselda." *Mélanges de l'École Française de Rome* 94, no. 1 (1982), pp. 7–43.]

Klapisch-Zuber 1983a/1985
Christiane Klapisch-Zuber. "The 'Cruel Mother': Maternity, Widowhood, and Dowry in Florence in the Fourteenth and Fifteenth Centuries." In Klapisch-Zuber 1985, pp. 117–31. [Originally published as "Maternité, veuvage et dot à Florence," *Annales: Économies, sociétés, civilisations* 38 (1983), pp. 1097–1109.]

Klapisch-Zuber 1983b/1985
Christiane Klapisch-Zuber. "Holy Dolls: Play and Piety in Florence in the Quattrocento." In Klapisch-Zuber 1985, pp. 310–29. [Originally published as "Les Saintes poupées: Jeu et dévotion dans la Florence du Quattrocento." In *Les Jeux à la Renaissance: Actes du XXIIIᵉ Colloque International d'Études Humanistes, Tours, juillet 1980,* edited by Jean-Claude Margolin and Philippe Ariès, pp. 65–79. Paris, 1983.]

Klapisch-Zuber 1985
Christiane Klapisch-Zuber. *Women, Family, and Ritual in Renaissance Italy.* Translated by Lydia Cochrane. Chicago, 1985.

Knauer 2002
Elfriede Regina Knauer. "Portrait of a Lady? Some Reflections on Images of Prostitutes from the Later Fifteenth Century." *Memoirs of the American Academy in Rome* 47 (2002), pp. 95–117.

Koda 2001
Harold Koda. *Extreme Beauty: The Body Transformed.* Exh. cat., The Metropolitan Museum of Art. New York, 2001.

Koda 2002
Harold Koda. "The Chopine." In *Timeline of Art History.* New York: The Metropolitan Museum of Art. [October 2002]. http://www.metmuseum.org/toah/hd/chop/hd_chop.htm

Koeppe 1994
Wolfram Koeppe. "French and Italian Renaissance Furniture at The Metropolitan Museum of Art: Notes on a Survey." *Apollo* 139 (June 1994), pp. 24–32.

Kohl and Witt 1978
Benjamin G. Kohl and Ronald G. Witt, with Elizabeth B. Welles, eds. and trans. *The Earthly Republic: Italian Humanists on Government and Society.* Philadelphia, 1978.

Kolsky 2003
Stephen Kolsky. *The Genealogy of Women: Studies in Boccaccio's De Mulieribus Claris.* New York, 2003.

Kolsky 2005
Stephen Kolsky. *The Ghost of Boccaccio: Writings on Famous Women in Renaissance Italy.* Late Medieval and Early Modern Studies 7. Turnhout, 2005.

Körner 2006
Hans Körner. *Botticelli.* Cologne, 2006.

Koslin 1999
Désirée G. Koslin. "The Dress of Monastic and Religious Women as Seen in Art from the Early Middle Ages to the Reformation." Ph.D. diss., New York University, 1999.

Kramer and Sprenger, *Malleus Maleficarum,* 1928/1951 (ed.)
Heinrich Kramer and James Sprenger. *Malleus Maleficarum.* [ca. 1486.] Translated and edited by Montague Summers. London, 1928. Repr., London, 1951.

Krautheimer 1956
Richard Krautheimer, with Trude Krautheimer-Hess. *Lorenzo Ghiberti.* Princeton Monographs in Art and Archaeology 31. Princeton, 1956.

Kraye 1994
Jill Kraye. "The Transformation of Platonic Love in the Italian Renaissance." In *Platonism and the English Imagination,* edited by Anna Baldwin and Sarah Hutton, pp. 76–85. Cambridge, 1994.

Kress 2003
Susanna Kress. "Die *camera di Lorenzo, bella* im Palazzo Tornabuoni: Rekonstrukion und Künstlerische Austattung eines Florentiner Hochzeitszimmers des späten Quattrocento." In *Domenico Ghirlandaio: Künstlerische Konstruktion von Identität im Florenz der Renaissance,* edited by Michael Rohlmann, pp. 245–85. Weimar, 2003.

P. Kristeller 1897
Paul Kristeller. *Early Florentine Woodcuts; with an Annotated List of Florentine Illustrated Books.* 2 vols. London, 1897.

P. O. Kristeller 1989
Paul Oskar Kristeller. "Iter Italicum": *A Finding List of Uncatalogued or Incompletely Catalogued Humanistic*

Manuscripts of the Renaissance in Italian and Other Libraries. Vol. 4, *Great Britain to Spain*. London, 1989.

Kruft 1995
Hanno-Walter Kruft. *Francesco Laurana: Ein Bildhauer der Frührenaissance*. Munich, 1995.

Kube 1976
Alfred N. Kube. *Italian Majolica, XV–XVIII Centuries*. [In English and Russian.] Edited by Olga E. Mikhailova and E. A. Lapkovskaya. State Hermitage Collection. Moscow, 1976.

Kuehn 1989
Thomas Kuehn. "Reading Microhistory: The Example of *Giovanni and Lusanna*." *Journal of Modern History* 61, no. 3 (September 1989), pp. 512–34.

Kultzen and Eikemeier 1971
Rolf Kultzen and Peter Eikemeier. *Venezianische Gemälde des 15. und 16. Jahrhunderts*. Gemäldekataloge, Bayerische Staatsgemäldesammlungen 9. 2 vols. Munich, 1971.

Kunz 1917
George Frederick Kunz. *Rings for the Finger, from the Earliest Known Times to the Present, with Full Descriptions of the Origin, Early Making, Materials, the Archaeology, History, for Affection, for Love, for Engagement, for Wedding, Commemorative, Mourning, etc*. London, 1917.

Kustodieva 1994
Tatyana K. Kustodieva. *Italian Painting, Thirteenth to Sixteenth Centuries*. The Hermitage Catalogue of Western European Painting 1. Florence, 1994.

Labalme and Sanguineti White 1999
Patricia H. Labalme and Laura Sanguineti White, with translations by Linda Carroll. "How to (and How Not to) Get Married in Sixteenth-Century Venice (Selections from the Diaries of Marin Sanudo)." *Renaissance Quarterly* 52, no. 1 (Spring 1999), pp. 43–72.

Land 1986
Norman E. Land. "*Ekphrasis* and Imagination: Some Observations on Pietro Aretino's Art Criticism." *Art Bulletin* 68, no. 2 (June 1986), pp. 207–17.

Landau and Parshall 1994
David Landau and Peter Parshall. *The Renaissance Print, 1470–1550*. New Haven, 1994.

Langedijk 1981–87
Karla Langedijk. *The Portraits of the Medici, Fifteenth–Eighteenth Centuries*. 3 vols. Florence, 1981–87.

Lanmon and Whitehouse 1993
Dwight P. Lanmon, with David B. Whitehouse. *The Robert Lehman Collection*. Vol. 11, *Glass*. The Metropolitan Museum of Art. New York, 1993.

Lapini 1900
Agostino Lapini. *Diario fiorentino dal 252 al 1596*. Edited by Giuseppe Odoardo Corazzini. Florence, 1900.

Lastri 1776–78
Marco Lastri. *L'osservatore fiorentino sugli edifizi della sua patria*. 2 vols. Florence, 1776–78.

Lauber 2005
Rosella Lauber. "'Opera perfettissima': Marcantonio Michiel e la *Notizia d'opere di disegno*." In *Il collezionismo a Venezia e nel Veneto ai tempi della Serenissima*, edited by Bernard Aikema, Rosella Lauber, and Max Seidel, pp. 77–116. Collana del Kunsthistorisches Institut in Florenz, Max-Planck-Institut 10. Selection of papers from a conference held in Venice, September 21–25, 2003. Venice, 2005.

Laughran 2003
M. A. Laughran. "Oltre la pelle: I cosmetici e il loro uso." In *La moda*, edited by Carlo Marco Belfanti and Fabio Giusberti, pp. 43–82. Storia d'Italia, Annali 19. Turin, 2003.

Lavinia Fontana 1998
Lavinia Fontana of Bologna, 1552–1614. Exh. cat. by Vera Fortunati et al. National Museum of Women in the Arts, Washington, D.C. Milan, 1998.

Lawner 1984
Lynne Lawner, ed. *I modi, nell'opera di Giulio Romano, Marcantonio Raimondi, Pietro Aretino, e Jean-Frédéric-Maximilien de Waldeck*. Translated by Nicola Crocetti. Marmi 119. Milan, 1984.

Lawner 1987
Lynne Lawner. *Lives of the Courtesans: Portraits of the Renaissance*. New York, 1987.

Lecchini Giovannoni 1991
Simona Lecchini Giovannoni. *Alessandro Allori*. Archivi di arte antica. Turin, 1991.

Lefaivre 1997
Liane Lefaivre. *Leon Battista Alberti's "Hypnerotomachia Poliphili": Re-Cognizing the Architectural Body in the Early Italian Renaissance*. Cambridge, Mass., 1997.

Leonardo, *Paragone*, 1949 (ed.)
Leonardo da Vinci. *Paragone: A Comparison of the Arts by Leonardo da Vinci*. [ca. 1492.] Edited and translated by Irma A. Richter. London, 1949.

Leonardo da Vinci 1977
Leonardo da Vinci: Anatomical Drawings from the Royal Collection. Exh. cat., Royal Academy of Arts. London, 1977.

Le Roy Ladurie 1975
Emmanuel Le Roy Ladurie. *Montaillou: Village occitan de 1294 à 1324*. Bibliothèque des histoires. Paris, 1975.

Lessman 1979
Johanna Lessman. *Italienische Majolika: Katalog der Sammlung Herzog-Anton-Ulrich-Museum Braunschweig*. Brunswick, 1979.

Lessmann 2004
Johanna Lessmann. "Italienische Majolika in Nürnberg." In *Italienische Fayencen der Renaissance: Ihre Spuren in internationalen Museumssammlungen*, edited by Silvia Glaser, pp. 235–64. Wissenschaftliche Beibände zum Anzeiger des Germanischen Nationalmuseums 22. Nuremberg, 2004.

Levenson, Oberhuber, and Sheehan 1973
Jay A. Levenson, Konrad Oberhuber, and Jacquelyn L. Sheehan, eds. *Early Italian Engravings from the National Gallery of Art*. Exh. cat., National Gallery of Art. Washington, D.C., 1973.

Levi D'Ancona 1961
Mirella Levi D'Ancona. "Bartolomeo di Fruosino." *Art Bulletin* 43, no. 2 (June 1961), pp. 81–97.

Levi D'Ancona 1962
Mirella Levi D'Ancona. *Miniatura e miniatori a Firenze dal XIV al XVI secolo: Documenti per la storia della miniatura*. Storia della miniatura 1. Florence, 1962.

Levi D'Ancona 1977
Mirella Levi D'Ancona. *The Garden of the Renaissance: Botanical Symbolism in Italian Painting*. Florence, 1977.

Levi D'Ancona 1983
Mirella Levi D'Ancona. *Botticelli's Primavera: A Botanical Interpretation, including Astrology, Alchemy, and the Medici*. Florence, 1983.

Levi Pisetzky 1964–69
Rosita Levi Pisetzky. *Storia del costume in Italia*. 5 vols. Milan, 1964–69.

Levy 2003a
Allison Levy. "Framing Widows: Mourning, Gender and Portraiture in Early Modern Florence." In Levy 2003b, pp. 211–31.

Levy 2003b
Allison Levy, ed. *Widowhood and Visual Culture in Early Modern Europe*. Women and Gender in the Early Modern World. Aldershot, 2003.

Levy 2006
Allison Levy. *Re-membering Masculinity in Early Modern Florence: Widowed Bodies, Mourning and Portraiture*. Aldershot, 2006.

Libin 1983
Laurence Libin. "A Musical Instrument from the Irwin Untermyer Collection." In *Studien zum europäischen Kunsthandwerk: Festschrift Yvonne Hackenbroch*, pp. 63–69. Munich, 1983.

Lightbown 1978
Ronald W. Lightbown. *Sandro Botticelli*. 2 vols. Berkeley, 1978.

Lightbown 1986
Ronald W. Lightbown. *Mantegna: With a Complete Catalogue of the Paintings, Drawings and Prints*. Oxford, 1986.

Lightbown 1992
Ronald W. Lightbown. *Mediaeval European Jewellery, with a Catalogue of the Collection in the Victoria & Albert Museum*. London, 1992.

Lillie 2005
Amanda Lillie. *Florentine Villas in the Fifteenth Century: An Architectural and Social History*. Cambridge, 2005.

Lindow 2007
James R. Lindow. *The Renaissance Palace in Florence*. Aldershot, 2007.

Lippmann 1895
Friedrich Lippmann. *The Seven Planets*. Translated by Florence Simmonds. London, 1895.

Litta 1819–83
Pompeo Litta. *Famiglie celebri italiane*. Milan, 1819–83.

Locatelli 1867
Pasino Locatelli. *Illustri bergamaschi: Studi critico-biografici*. Bergamo, 1867. [Repr., *I pittori bergamaschi: Studi critico-biografici*. Italica gens 104. Bologna, 1979.]

Logan 1901
Mary Logan. "Compagno di Pesellino et quelques peintures de l'école." *Gazette des beaux-arts*, 3rd ser., 26 (October 1901), pp. 333–43.

Lombardi 2001
Daniela Lombardi. *Matrimoni di antico regime*. Annali dell'Istituto Storico Italo-Germanico in Trento, Monografie, 34. Bologna, 2001.

Longhi 1926
Roberto Longhi [as Andrea Ronchi]. "Primizie di Lorenzo da Viterbo." In *Vita artistica*, vol. 1, pp. 113–14. Rome, 1926.

Longhi 1934
Roberto Longhi. *Officina ferrarese*. Pittura dell'Occidente 1. Rome, 1934.

Longhi 1934/1956
Roberto Longhi. *Officina ferrarese, 1934, seguita dagli ampliamenti, 1940, e dai nuovi ampliamenti, 1940–55*. Edizione delle opere complete di Roberto Longhi 5. Florence, 1956.

Lopez 1976
Guido Lopez, ed. *Festa di nozze per Ludovico il Moro nelle testimonianze di Tristano Calco, Giacomo Trotti, Isabella d'Este, Gian Galeazzo Sforza, Beatrice de' Contrari, et altri*. Milan, 1976.

Lord 1970
Carla Lord. "Tintoretto and the *Roman de la Rose*." *Journal of the Warburg and Courtauld Institute* 33 (1970), pp. 315–17.

Lorenzelli and Veca 1984
Pietro Lorenzelli and Alberto Veca, eds. *Tra/E: Teche, pissidi, cofani e forzieri dall'Alto Medioevo al Barocco*.

Exh. cat., Galleria Lorenzelli, Bergamo; and Antiquaria, London. Bergamo, 1984.

Lorenzo il Magnifico 1949
Lorenzo il Magnifico e le arti: Mostra d'arte antica. Exh. cat. edited by Licia Ragghianti Collobi. Palazzo Strozzi. Florence, 1949.

Lotz 1963
Arthur Lotz. *Bibliographie der Modelbücher.* 2nd ed. Stuttgart, 1963.

Lowry 1979
Martin Lowry. *The World of Aldus Manutius: Business and Scholarship in Renaissance Venice.* Ithaca, N.Y., 1979.

Lucco 2006a
Mauro Lucco, ed. *Antonello da Messina: L'opera completa.* Exh. cat., Scuderie del Quirinale, Rome. Milan, 2006.

Lucco 2006b
Mauro Lucco, ed. *Mantegna a Mantova, 1460–1506.* [Rev. ed.] Exh. cat., Galleria Civica, Palazzo Te, Mantua. Milan, 2006.

Luchs 1977
Alison Luchs. *Cestello: A Cistercian Church of the Florentine Renaissance.* New York, 1977.

Luchs 1995
Alison Luchs. *Tullio Lombardo and Ideal Portrait Sculpture in Renaissance Venice, 1490–1530.* Cambridge, 1995.

Lucian of Samosata, *Affairs of the Heart*, 1967 (ed.)
Lucian of Samosata (attrib.). *ΕΡΩΤΕΣ / Affairs of the Heart.* In *Lucian*, vol. 8, pp. 147–235. Translated by M. D. Macleod. The Loeb Classical Library. Cambridge, Mass., 1967.

Ludwig 1903
Gustav Ludwig. "Archivalische Beiträge zur Geschichte der venezianischen Malerei." *Jahrbuch der Königlich Preuszischen Kunstsammlungen* 24 (1903), suppl., pp. 1–109.

Lurati 2005
Patricia Lurati. "Il *Trionfo di Tamerlano*: Una nuova lettura iconographica di un cassone del Metropolitan Museum of Art." *Mitteilungen des Kunsthistorichen Institutes in Florenz* 49, nos. 1–2 (2005), pp. 101–18.

Luzio 1901
Alessandro Luzio. "Isabella d'Este e la corte Sforzesca." *Archivio storico lombardo*, 3rd ser., 15 (March 1901), pp. 145–76.

Luzio 1915
Alessandro Luzio. *Isabella d'Este e i Borgia.* Milan, 1915.

Luzio and Renier 1890
Alessandro Luzio and Rodolfo Renier. *Delle relazioni di Isabella d'Este Gonzaga con Ludovico e Beatrice Sforza.* Milan, 1890.

Luzio and Renier 1896
Alessandro Luzio and Rodolfo Renier. "Il lusso di Isabella d'Este, Marchesa di Mantova." *Nuovo antologia*, no. 149 (September 16, 1896), pp. 666–88.

Lydecker 1987a
John Kent Lydecker. "The Domestic Setting of the Arts in Renaissance Florence." Ph.D. diss., The Johns Hopkins University, 1987.

Lydecker 1987b
John Kent Lydecker. "Il patriziato fiorentino e la committenza artistica per la casa." In *I ceti dirigenti nella Toscana del Quattrocento*, edited by Donatella Rugiandini, pp. 209–21. Atti del convegno di studi. Monte Oriolo, 1987.

MacClintock 1956
Carol MacClintock. "A Court Musician's Songbook. Modena MS C 311." *Journal of the American Musicological Society* 9, no. 3 (Autumn 1956), pp. 177–92.

MacCurdy 1939
Edward MacCurdy, ed. *The Notebooks of Leonardo da Vinci.* New York, 1939.

Macinghi Strozzi, *Lettere*, 1877 (ed.)
Alessandra Macinghi Strozzi. *Lettere di una gentildonna fiorentina del secolo XV ai figliuoli esuli.* Edited by Cesare Guasti. Florence, 1877.

Macinghi Strozzi, *Letters*, 1997 (ed.)
Alessandra Macinghi Strozzi. *Selected Letters of Alessandra Strozzi.* Translated and edited by Heather Gregory. [In Italian and English.] Biblioteca italiana. Berkeley, 1997.

Mack 1997
Rosamond E. Mack. "Lotto: A Carpet Connoisseur." In D. A. Brown, Humfrey, and Lucco 1997, pp. 59–67.

***Magnificenza alla corte dei Medici* 1997**
Magnificenza alla corte dei Medici: Arte a Firenze alla fine del Cinquecento. Exh. cat., Palazzo Pitti, Florence. Milan, 1997.

Malaguzzi Valeri 1902
Francesco Malaguzzi Valeri. "Ambrogio Preda e un ritratto di Bianca Maria Sforza." *Rassegna d'arte* 2 (1902), pp. 93–94.

Malaguzzi Valeri 1913–23
Francesco Malaguzzi Valeri. *La corte di Lodovico il Moro.* 4 vols. Milan, 1913–23.

Malespini 1609
Celio Malespini. *Ducento novelle, nelle quali si raccontano diversi avvenimenti così lieti, come mesti & stravaganti.* Venice, 1609.

Mallet 1976
J. V. G. Mallet. "Un calamaio in maiolica a Boston / A Maiolica Inkwell at Boston." *Faenza* 62 (1976), pp. 79–85.

Mallet 1981
J. V. G. Mallet. "Mantua and Urbino: Gonzaga Patronage of Maiolica." *Apollo* 114 (September 1981), pp. 162–69.

Mallet 1987
J. V. G. Mallet. "'In Botega di Maestro Guido Durantino in Urbino.'" *Burlington Magazine* 129 (May 1987), pp. 284–98.

Mallet 1991
J. V. G. Mallet. "The Painter of the Coal-Mine Dish." In *Italian Renaissance Pottery: Papers Written in Association with a Colloquium at the British Museum*, edited by Timothy Wilson, pp. 62–72. London, 1991.

Mallet 2007
J. V. G. Mallet. *Xanto: Pottery-Painter, Poet, Man of the Italian Renaissance.* Exh. cat., Wallace Collection. London, 2007.

Mallet and Dreier 1998
J. V. G. Mallet and Franz Adrian Dreier. *The Hockemeyer Collection: Maiolica and Glass.* Bremen, 1998.

Manca 1986
Joseph Manca. "The Life and Art of Ercole de' Roberti." Ph.D. diss., Columbia University, 1986.

Manca 1992
Joseph Manca. *The Art of Ercole de' Roberti.* Cambridge, 1992.

Manca 2000a
Joseph Manca. "*Constantia et Forteza*: Eleonora D'Aragona's Famous Matrons." *Source: Notes in the History of Art* 19, no. 2 (Winter 2000), pp. 13–20.

Manca 2000b
Joseph Manca. *Cosmè Tura: The Life and Art of a Painter in Estense Ferrara.* Oxford, 2000.

Manca 2003
Joseph Manca. "Isabella's Mother: Aspects of the Art Patronage of Eleonora d'Aragona." *Aurora: The Journal of the History of Art* 4 (2002), pp. 79–94.

Mancini, *Considerazioni sulla pittura*, 1956–57 (ed.)
Giulio Mancini. *Considerazioni sulla pittura.* Edited by Adriana Marucchi. 2 vols. Fonti e documenti inediti per la storia dell'arte (Accademia Nazionale dei Lincei) 1. Rome, 1956–57.

Mancini 2005
Vincenzo Mancini. "*Vertuosi* e artisti: Saggi sul collezionismo antiquario e numismatico tra Padova e Venezia nei secoli XVI e XVII.* Numismatica Patavina 5. Padua, 2005.

Manni 1993
Graziano Manni. *Mobili antichi in Emilia Romagna.* Modena, 1993.

Marabottini 1956
Alessandro Marabottini. "Il 'Sogno' di Michelangelo in una copia sconosciuta." In *Scritti di storia dell'arte in onore di Lionello Venturi*, vol. 1, pp. 349–58. Rome, 1956.

Marani 2000
Pietro C. Marani. *Leonardo da Vinci: The Complete Paintings.* New York, 2000.

Marcucci 1963
Luisa Marcucci. *Cassone Adimari.* Milan, 1963.

Marcus 2004
Ivan G. Marcus. *The Jewish Life Cycle: Rites of Passage from Biblical to Modern Times.* The Samuel and Althea Stroum Lectures in Jewish Studies. Seattle, 2004.

Mari et al. 2006
Francesco Mari, Aldo Polettini, Donatella Lippi, and Elisabetta Bertol. "The Mysterious Death of Francesco I de' Medici and Bianca Cappello: An Arsenic Murder?" *British Medical Journal*, no. 333 (December 2006), pp. 1299–1301.

Mariacher 1968
Giovanni Mariacher. *Palma il Vecchio.* Antichi pittori italiani. Collana di studi monografici. Milan, 1968.

Mariacher 1980
Giovanni Mariacher. "Jacopo Negretti detto Palma il Vecchio." In *I pittori bergamaschi dal XIII al XIX secolo: Il Cinquecento*, vol. 1, pp. 171–243. Bergamo, 1980.

Mariani Canova 1964
Giordana Mariani Canova. *Paris Bordon.* Profili e saggi di arte veneta 2. Venice, 1964.

Marinelli, *Gli ornamenti delle donne*, 1562
Giovanni Marinelli. *Gli ornamenti delle donne: Tratti dalle scritture d'una reina Greca.* Venice, 1562.

Marinoni and Pedretti 2000
Augusto Marinoni and Carlo Pedretti, eds. *Il Codice Atlantico della Biblioteca Ambrosiana di Milano.* 3 vols. Florence, 2000.

Mariotti Masi 1986
Maria Luisa Mariotti Masi. *Bianca Cappello: Una veneziana alla corte dei Medici.* Milan, 1986.

Markova 2007
Vittoria Markova. *Pittura italiana nelle collezioni del Museo Puškin dal Cinquecento al Novecento.* Exh. cat., Palazzo della Ragione. Verona, 2007.

Marquand 1919
Allan Marquand. *Robbia Heraldry.* Princeton Monographs in Art and Archaeology. Princeton, 1919.

Martels 2003
Zweder von Martels. "The Fruit of Love: Aeneas Silvius Piccolomini about his Illegitimate Child." In *Pius II, "El più expeditivo pontefice": Selected Studies on Aeneas Silvius Piccolomini, 1405–1464*, edited by

Zweder von Martels and Arie Johan Vanderjagt, pp. 229–48. Leiden, 2003.

Martial, *Epigrams*, 1993 (ed.)
Martial. *Epigrams*. Edited and translated by David Roy Shackleton Bailey. 3 vols. The Loeb Classical Library. Cambridge, Mass., 1993.

Martin, *Roma Sancta*, 1969 (ed.)
Gregory Martin. *Roma Sancta*. [1581.] Edited by George B. Parks. Rome, 1969.

Martineau and Hope 1983
Jane Martineau and Charles Hope, eds. *The Genius of Venice*. Exh. cat., Royal Academy of Arts. London, 1983.

Martines 2004
Lauro Martines. *April Blood: Florence and the Plot against the Medici*. London, 2004.

Marx and Hipp 2005
Harald Marx and Elisabeth Hipp, eds. *Gemäldegalerie Alte Meister Dresden: Illustrierter Katalog*. 2 vols. Cologne, 2005.

Massi 2006
Norberto Massi. "Lorenzo Lotto's New York *Venus*." In *Watching Art: Writings in Honor of James Beck / Studi di storia dell'arte in onore di James Beck,* edited by Lynn Catterson and Mark Zucker, pp. 167–70. Perugia, 2006.

Masson 1975
Georgina Masson. *Courtesans of the Italian Renaissance*. London, 1975.

Masson 1976
Georgina Masson. *Courtesans of the Italian Renaissance*. New York, 1976.

Matchette 2007
Ann Matchette. "To Have and Have Not: The Disposal of Household Furnishings in Florence." In *Approaching the Italian Renaissance Interior: Sources, Methodologies, Debates,* edited by Marta Ajmar-Wollheim, Flora Dennis, and Ann Matchette. Malden, 2007.

Mather 1914
Frank Jewett Mather Jr. "A Double Portrait by Filippo Lippi." [Letter to the Editor.] *Art in America* 2, no. 2 (February 1914), pp. 169–70.

Mather 1922
Frank Jewett Mather Jr. "A Quattrocento Toilet Box in the Louvre." *Art in America* 11, no. 1 (December 1922), pp. 45–51.

Mattei and Cecchetti 1995
Pietro Mattei and Tonina Cecchetti. *Mastro Giorgio: L'uomo, l'artista, l'imprenditore*. Perugia, 1995.

Matthew 1998
Louisa C. Matthew. "The Painter's Presence: Signatures in Venetian Renaissance Pictures." *Art Bulletin* 80, no. 4 (December 1998), pp. 616–48.

Matthews Grieco 1993
Sara F. Matthews Grieco. "The Body, Appearance, and Sexuality." In *A History of Women in the West,* edited by Georges Duby and Michelle Perrot, vol. 3, *Renaissance and Enlightenment Paradoxes,* edited by Natalie Zemon Davis and Arlette Farge, pp. 46–84. Cambridge, Mass., 1993.

Matthews Grieco 1996
Sara F. Matthews Grieco. "Matrimonio e vita coniugale nell'arte dell'Italia moderna." In *Storia del matrimonio,* edited by Michela De Giorgio and Christiane Klapisch-Zuber, pp. 251–98. Storia delle donne in Italia. Storia e società. Rome, 1996.

Matthews Grieco 1997
Sara F. Matthews Grieco. "Pedagogical Prints: Moralizing Broadsheets and Wayward Women in Counter Reformation Italy." In *Picturing Women in*

Renaissance and Baroque Italy, edited by Geraldine A. Johnson and Sara F. Matthews Grieco, pp. 61–87. Cambridge, 1997.

Matthews Grieco 2006
Sara F. Matthews Grieco. "Marriage and Sexuality." In Ajmar-Wollheim and Dennis 2006, pp. 104–19, 374.

***Matthias Corvinus* 1982**
Matthias Corvinus und die Renaissance in Ungarn, 1458–1541. Exh. cat., Schloss Schallaburg. Vienna, 1982.

Mauri 2002
Michele Mauri. *Trittico vimercatese: Gian Giacomo Caprotti detto Salai, Gaspare da Vimercate, Gian Giacomo Gallarati Scotti*. Gente in Lombardia 1. Missaglia, 2002.

Mayer 1939
August L. Mayer. "Niccolò Aurelio: The Commissioner of Titian's 'Sacred and Profane Love.'" *Art Bulletin* 21 (March 1939), p. 89.

Mazzi 1911
Curzio Mazzi. "Libri e masserizie di Giovanni di Giovanni di Pietro di Fece (Fecini) nel 1450 in Siena." *Bullettino senese di storia patria* 18 (1911), pp. 150–72.

McGee 1992–95
Timothy J. McGee. "Misleading Iconography: The Case of the 'Adimari Wedding Cassone.'" *Imago Musicae* 9–12 (1992–95; pub. 1996), pp. 139–57.

McGee 1999
Timothy J. McGee. "In the Service of the Commune: The Changing Role of Florentine Civic Musicians, 1450–1532." *Sixteenth Century Journal* 30, no. 3 (Autumn 1999), pp. 727–43.

McIver 2006
Katherine A. McIver. *Women, Art, and Architecture in Northern Italy, 1520–1580: Negotiating Power*. Aldershot, 2006.

McLeod 1991
Glenda McLeod. *Virtue and Venom: Catalogs of Women from Antiquity to the Renaissance*. Ann Arbor, 1991.

McNab 2001
Jessie McNab. "European Sculpture and Decorative Arts." In "*Ars Vitraria*: Glass in The Metropolitan Museum of Art." *The Metropolitan Museum of Art Bulletin*, n.s., 59, no. 1 (Summer 2001), pp. 45–50.

McTavish 1981
David McTavish. *Giuseppe Porta Called Giuseppe Salviati*. Outstanding Dissertations in the Fine Arts. New York, 1981.

Medici 1913–14
Lorenzo de' Medici. *Opere*. Edited by Attilio Simioni. 2 vols. Bari, 1913–14.

Medici, *Autobiography*, 1995 (ed.)
Lorenzo de' Medici. *The Autobiography of Lorenzo de' Medici the Magnificent: A Commentary on My Sonnets Together with the Text of Il Comento in the Critical Edition of Tiziano Zanato*. Translated by James Wyatt Cook. Medieval and Renaissance Texts and Studies 129. Binghamton, N.Y., 1995.

Meijer 1995
Bert W. Meijer, ed. *Italian Drawings from the Rijksmuseum, Amsterdam*. Exh. cat., Istituto Universitario Olandese di Storia dell'Arte, Florence; and Rijksmuseum, Amsterdam. Florence, 1995.

Meijer 2008
Bert W. Meijer, ed. *Firenze e gli antichi Paesi Bassi, 1430–1530: Dialoghi tra artisti, da Jan van Eyck a Ghirlandaio, da Memling a Raffaello*. Exh. cat., Palazzo Pitti, Florence. Livorno, 2008.

Mellencamp 1969
Emma H. Mellencamp. "A Note on the Costume of

Titian's *Flora*." *Art Bulletin* 51, no. 2 (June 1969), pp. 174–77.

Melli 2007
Lorenza Melli. "Gherardo di Giovanni poliedrico artista alle prese col David del Verrocchio." In *Invisibile agli occhi: Atti della giornata di studi in ricordo di Lisa Venturini, Firenze, Fondazione Roberto Longhi, 15 dicembre 2005,* edited by Nicoletta Baldini, pp. 37–43. Florence, 2007.

***Le Ménagier de Paris* 1846 (ed.)**
Le Ménagier de Paris: Traité de morale et d'économie domestique composé vers 1393, contenant des préceptes moraux, quelques faits historiques, des instructions sur l'art de diriger une maison Edited by Jérome Pichon. 2 vols. Paris, 1846.

Meoni 1998
Lucia Meoni. *Gli arazzi nei musei fiorentini: La collezione medicea. Catalogo completo*. Vol. 1, *La manifattura da Cosimo I a Cosimo II (1545–1621)*. Livorno, 1998.

Merisalo 1999
Outi Merisalo, ed. *Le collezioni medicee nel 1495: Deliberazioni degli ufficiali dei ribelli*. Florence, 1999.

Merret 1662
Christopher Merret. *The Art of Glass, wherein Are Shown the Wayes to Make and Colour Glass, Pastes, Enamels, Lakes, and Other Curiosities*. London, 1662. [Translation of Neri 1612.]

Messisbugo, *Libro novo . . . di vivanda*, 2001 (ed.)
Cristoforo di Messisbugo. *Libro novo nel qual s'insegna a' far d'ogni sorte di vivanda secondo la diversità de i tempi, così di carne come di pesce*. Venice, 1557. Repr., Bologna, 2001.

Metman and Vaudoyer 1910
Louis Metman and Jean-Louis Vaudoyer. *Le Métal: 1ʳᵉ Partie, Le Fer. 2ᵉ Partie, Le Bronze, le cuivre, l'étain. 3ᵉ Partie, Les Métaux précieux: Le Bronze, le cuivre, l'étain, le plomb*. Vol. 1, *Premier Album du Moyen Âge au milieu du XVIIIᵉ siècle*. Paris, 1910.

Metropolitan Museum 1975
The Metropolitan Museum of Art. *Notable Acquisitions, 1965–1975*. New York, 1975.

Michiel, *Notizia d'opere del disegno*, 2000 (ed.)
Marcantonio Michiel. *Notizia d'opere del disegno*. [Edition edited by Theodor Frimmel, Vienna 1896.] Introduction by Cristina De Benedictis. Le voci del museo. Florence, 2000.

Middeldorf 1937
Ulrich Middeldorf. "Medici Pottery of the Fifteenth Century." *Bulletin of the Detroit Institute of Arts* 16, no. 6 (March 1937), pp. 91–96.

Milanesi 1869
Gaetano Milanesi. "Lettere d'artisti italiani dei secoli XIV e XV." *Il Buonarroti*, 2nd ser., 4 (April 1869), pp. 77–87.

Milesi 1991
Silvana Milesi. *Moroni e il primo Cinquecento bergamasco*. Bergamo, 1991.

Milliken 1930
William M. Milliken. "Girdle of the Fourteenth Century." *Bulletin of the Cleveland Museum of Art* 17, no. 3, pt. 1 (March 1930), pp. 35–41.

Mingardi 1987
Maurizio Mingardi. "Gli strumenti musicali nella danza del XIV e XV secolo." In *Mesura et arte del danzare: Guglielmo Ebreo da Pesaro e la danza nelle corti italiane del XV secolo,* edited by Patrizia Castelli, Maurizio Mingardi, and Maurizio Padovan, pp. 113–53. Exh. cat., Palazzo Lazzarini, Pesaro. Pesaro, 1987.

Miziołek 1996
Jerzy Miziołek. *Soggetti classici sui cassoni fiorentini alla vigilia del Rinascimento*. Warsaw, 1996.

Miziołek 2001–2
Jerzy Miziołek. "'Exempla' di giustizia: Tre tavole di cassone di Alvise Donati." *Arte lombarda*, no. 132 (2001–2), pp. 72–88.

Moakley 1966
Gertrude Moakley. *The Tarot Cards Painted by Bonifacio Bembo for the Visconti-Sforza Family: An Iconographic and Historical Study*. New York, 1966.

Mochi Onori 2000
Lorenza Mochi Onori. *Raffaello: La Fornarina*. Exh. cat., Galleria Nazionale d'Arte Antica, Palazzo Barberini. Rome, 2000.

Moczulska 1995
Krystyna Moczulska. "Najpiękniejsza Gallerani i najdoskonalsza ΓΑΛΕΗ w portrecie namalowanym przez Leonarda da Vinci / The Most Graceful Gallerani and the Most Exquisite ΓΑΛΕΗ in the Portrait of Leonardo da Vinci." Translated by Piotr Pieńkowski. *Folia Historiae Artium*, n.s., 1 (1995), pp. 55–86.

Moda alla corte dei Medici 1993
Moda alla corte dei Medici: Gli abiti restaurati di Cosimo, Eleonora, e don Garzia. Florence, 1993.

I modi 1988 (ed.)
I modi, the Sixteen Pleasures: An Erotic Album of the Italian Renaissance, Giulio Romano, Marcantonio Raimondi, Pietro Aretino, and Count Jean-Frederic-Maximilien de Waldeck. Edited, translated, and with commentary by Lynne Lawner. Evanston, Ill., 1988.

Molho 1994
Anthony Molho. *Marriage Alliance in Late Medieval Florence*. Cambridge, Mass., 1994.

Molinier 1890–93
Émile Molinier. *La Collection Spitzer: Antiquité, Moyen-Âge, Renaissance*. 6 vols. Paris, 1890–93.

Möller 1916
Emil Möller. "Leonardos Bildnis der Cecilia Gallerani in der Galerie des Fürsten Czartoryski in Krakau." *Monatshefte für Kunstwissenschaft* 9 (1916), pp. 313–26.

Molteni 1999
Monica Molteni. *Ercole de' Roberti*. Milan, 1999.

Monbeig Goguel 1998
Catherine Monbeig Goguel, ed. *Francesco Salviati (1510–1563), o La bella maniera*. Exh. cat., Accademia di Francia, Villa Medici, Rome; and Musée du Louvre, Paris. Milan and Paris, 1998.

Monbeig Goguel 2001
Catherine Monbeig Goguel. "Francesco Salviati et la *bella maniera*: Quelques points à revoir; interprétation, chronologie, attributions." In *Francesco Salviati et la bella maniera: Actes des colloques de Rome et de Paris (1998)*, edited by Catherine Monbeig Goguel, Philippe Costamagna, and Michel Hochmann, pp. 15–68. Rome, 2001.

Montesquieu, *Oeuvres*, 1949–51 (ed.)
Charles de Secondat, baron de Montesquieu. *Oeuvres complètes*. Edited by Roger Caillois. 2 vols. Paris, 1949–51.

Montor 1811
Artaud de Montor. *Considérations sur l'état de la peinture en Italie dans les quatre siècles qui ont précédé celui de Raphael*. Paris, 1811.

Moore Valeri 2003
Anna Moore Valeri. "Maiolica from Cafaggiolo: New Findings from the Excavation of a Sixteenth-Century Kiln Dump at the Medici Villa." *Apollo* 156 (January 2003), pp. 42–48.

Morel 1985
Philippe Morel. "Priape à la Renaissance: Les Guirlandes de Giovanni da Udine à la Farnésine." *Revue de l'art* 69 (1985), pp. 13–28.

Morel 1991
Philippe Morel. *Le Parnasse astrologique: Les Décors peints pour le Cardinal Ferdinand de Médicis. Étude iconologique*. Vol. 3 of *La Villa Médicis*, edited by André Chastel and Philippe Morel. Rome, 1991.

Morelli and Gennari 1819
Jacopo Morelli and Giuseppe Gennari. *Delle pompe nuziali già usate presso li veneziani e li padovani*. Venice, 1819.

Moretti 2001
Lino Moretti. "Due note carpaccesche: Il 'Giovane Guerriero' Thyssen e la 'Madonna dei Tesseri da Panni di Lana.'" *Arte veneta*, no. 58 (2001), pp. 7–21.

Morselli 1956
Alfonso Morselli. "Il corredo nuziale di Caterina Pico." In *Atti e memorie della Deputazione di Storia Patria per le Antiche Provincie Modenesi*, 8th ser., vol. 8, pp. 81–124. Modena, 1956.

Mortimer 1974
Ruth Mortimer, comp. *Harvard College Library Department of Printing and Graphic Art: Catalogue of Books and Manuscripts*. Pt. 2, *Italian Sixteenth Century Books*. 2 vols. Cambridge, Mass., 1974. [Repr., facsimile ed., San Francisco, 1998.]

Motture 2001
Peta Motture. *Bells and Mortars and Related Utensils: Catalogue of Italian Bronzes in the Victoria and Albert Museum*. London, 2001.

Motture and Syson 2006
Peta Motture and Luke Syson. "Art in the *Casa*." In Ajmar-Wollheim and Dennis 2006, pp. 268–83, 383–85.

Moulton 2000
Ian Frederick Moulton. *Before Pornography: Erotic Writing in Early Modern England*. Studies in the History of Sexuality. Oxford, 2000.

Muir 2005
Edwin Muir. *Ritual in Early Modern Europe*. New Approaches to European History. Cambridge, 2005.

Mulazzani 1981
Germano Mulazzani. *I tarocchi viscontei e Bonifacio Bembo: Il mazzo di Yale*. Milan, 1981.

Mundy 1988
E. James Mundy. "Porphyry and the 'Posthumous' Fifteenth Century Portrait." *Pantheon* 46 (1988), pp. 37–43.

Müntz 1894
Eugène Müntz. "Les Plateaux d'accouchées et la peinture sur meubles du XIVᵉ au XVIᵉ siècle." *Monuments et mémoires* (Fondation Eugene Piot) 1 (1894), pp. 203–32.

Murphy 1997
Caroline P. Murphy. "Lavinia Fontana and Female Life Cycle Experience in Late Sixteenth-Century Bologna." In *Picturing Women in Renaissance and Baroque Italy*, edited by Geraldine A. Johnson and Sara F. Matthews Grieco, pp. 111–38, 272–77. Cambridge, 1997.

Murphy 1999
Caroline P. Murphy. "'In Praise of the Ladies of Bologna': The Image and Identity of the Sixteenth-Century Bolognese Female Patriciate." *Renaissance Studies* 13, no. 4 (December 1999), pp. 440–54.

Murphy 2001
Caroline P. Murphy. "Il ciclo della vita femminile: Norme comportamentali e pratiche di vita." In *Monaca, moglie, serva, cortigiana: Vita e imagine delle donne tra Rinascimento e Controriforma*, edited by Sara F. Matthews Grieco, with the assistance of Sabina Brevaglieri, pp. 14–47. Florence, 2001.

Murphy 2003
Caroline P. Murphy. *Lavinia Fontana: A Painter and Her Patrons in Sixteenth-Century Bologna*. New Haven, 2003.

Murphy 2005
Caroline P. Murphy. *The Pope's Daughter: The Extraordinary Life of Felice della Rovere*. Oxford, 2005.

Musacchio 1997a
Jacqueline Marie Musacchio. "Imaginative Conceptions in Renaissance Italy." In *Picturing Women in Renaissance and Baroque Italy*, edited by Geraldine A. Johnson and Sara F. Matthews Grieco, pp. 42–60, 256–61. Cambridge, 1997.

Musacchio 1997b
Jacqueline Marie Musacchio. "Pregnancy and Poultry in Renaissance Italy." *Source: Notes in the History of Art* 16, no. 2 (Winter 1997), pp. 3–9.

Musacchio 1998
Jacqueline Marie Musacchio. "The Medici-Tornabuoni *Desco da Parto* in Context." *Metropolitan Museum Journal* 33 (1998), pp. 137–51.

Musacchio 1999
Jacqueline Marie Musacchio. *The Art and Ritual of Childbirth in Renaissance Italy*. New Haven, 1999.

Musacchio 2001
Jacqueline Marie Musacchio. "Weasels and Pregnancy in Renaissance Italy." *Renaissance Studies* 15, no. 2 (June 2001), pp. 172–87.

Musacchio 2003a
Jacqueline Marie Musacchio. "The Bride and Her *Donora* in Renaissance Florence." In *Culture and Change: Attending to Early Modern Women*, edited by Margaret Mikesell and Adele Seeff, pp. 177–202. Newark, 2003.

Musacchio 2003b
Jacqueline Marie Musacchio. "The Medici Sale of 1495 and the Second-Hand Market for Domestic Goods in Florence." In *The Art Market in Italy (Fifteenth–Seventeenth Centuries)*, edited by Marcello Fantoni, Louisa C. Matthew, and Sara F. Matthews Grieco, pp. 313–23. Papers from a conference held in Florence, June 19–21, 2000. Ferrara, 2003.

Musacchio 2004
Jacqueline Marie Musacchio. *Marvels of Maiolica: Italian Renaissance Ceramics from the Corcoran Gallery of Art Collection*. Exh. cat., Frances Lehman Loeb Art Center, Vassar College, Poughkeepsie, New York, and other venues. Charlestown, Mass., 2004.

Musacchio 2005
Jacqueline Marie Musacchio. "Lambs, Coral, Teeth, and the Intimate Intersection of Religion and Magic in Renaissance Italy." In *Images, Relics, and Devotional Practices in Medieval and Renaissance Italy*, edited by Sally J. Cornelison and Scott B. Montgomery, pp. 139–56. Medieval and Renaissance Texts and Studies 296. Tempe, 2005.

Musacchio 2006
Jacqueline Marie Musacchio. "Conception and Birth." In Ajmar-Wollheim and Dennis 2006, pp. 124–35, 375–76.

Musacchio 2007
Jacqueline Marie Musacchio. "Objects and Identity: Antonio de' Medici and the Casino at San Marco in Florence." In *The Renaissance World,* edited by John Jeffries Martin, pp. 481–500. The Routledge Worlds. New York, 2007.

Musacchio 2008
Jacqueline Marie Musacchio. *Art, Marriage, and Family in the Florentine Renaissance Palace*. New Haven, 2008. [In press.]

Le muse e il principe 1991
Le muse e il principe: Arte di corte nel Rinascimento padano. [Vol. 1], *Catalogo*. [Vol. 2], *Saggi*. Exh. cat., Museo Poldi Pezzoli, Milan. Modena, 1991.

Museo d'Arti Applicate 2000
Museo d'Arti Applicate: Le ceramiche. Vol. 1. Musei e gallerie di Milano. Milan, 2000.

Nagel 1998
Alexander Nagel. [Book review.] *Art Bulletin* 80, no. 4 (December 1998), pp. 742–47.

Nagel 2005
Alexander Nagel. "Experiments in Art and Reform in Italy in the Early Sixteenth Century." In *The Pontificate of Clement VII: History, Politics, Culture,* edited by Kenneth Gouwens and Sheryl E. Reiss, pp. 385–409. Aldershot, 2005.

Nagler 1964
Alois Maria Nagler. *Theatre Festivals of the Medici, 1539–1637.* New Haven, 1964.

Najemy 1993
John M. Najemy. *Between Friends: Discourses of Power and Desire in the Machiavelli-Vettori Letters of 1513–1515.* Princeton, 1993.

Natale 2006
Mauro Natale, ed. *Capolavori da scoprire: La collezione Borromeo.* Exh. cat., Museo Poldi Pezzoli. Milan, 2006.

Natale 2007
Mauro Natale, ed. *Cosmè Tura e Francesco del Cossa: L'arte a Ferrara nell'età di Borso d'Este.* Exh. cat., Palazzo dei Diamanti and Palazzo Schifanoia. Ferrara, 2007.

Natur und Antike 1985
Natur und Antike in der Renaissance. Exh. cat. edited by Herbert Beck and Peter C. Bol. Liebieghaus Museum alter Plastik. Frankfurt am Main, 1985.

Neff 1981
Mary Frances Neff. "A Citizen in the Service of the Patrician State: The Career of Zaccaria de' Freschi." *Studi veneziani,* n.s., 5 (1981), pp. 33–61.

Neff 1985
Mary Frances Neff. "Chancellery Secretaries in Venetian Politics and Society, 1480–1533." Ph.D. diss., University of California, Los Angeles, 1985.

Negroni 1998
Franco Negroni. "Una famiglia di ceramisti Urbinati: I Patanazzi." *Faenza* 84 (1998), pp. 104–15.

Neilson 2008
Christina Neilson. *Parmigianino's "Antea": A Beautiful Artifice.* Exh. cat., Frick Collection. New York, 2008.

J. C. Nelson 1958
John Charles Nelson. *Renaissance Theory of Love: The Context of Giordano Bruno's "Eroici Furori."* New York, 1958.

J. K. Nelson 2002
Jonathan Katz Nelson. "La 'Venere e Cupido' fiorentina: Un nudo eroico femminile e la potenza dell'amore / The Florentine 'Venus and Cupid': A Heroic Female Nude and the Power of Love." In Falletti and J. K. Nelson 2002, pp. 26–63.

J. K. Nelson 2007
Jonathan K. Nelson. "Putting Botticelli and Filippino in Their Place: The Intended Height of *Spalliera* Paintings and *Tondi.*" In *Invisibile agli occhi: Atti della giornata di studi in ricordo di Lisa Venturini, Firenze, Fondazione Roberto Longhi, 15 dicembre 2005,* edited by Nicoletta Baldini, pp. 53–63. Florence, 2007.

J. K. Nelson 2007a
Jonathan K. Nelson. *Leonardo e la reinvenzione della figura femminile: Leda, Lisa e Maria.* Lettura vinciana 46. Florence, 2007.

Neri 1612
Antonio Neri. *L'arte vetraria distinta in libri sette. Ne quali si scoprono, effetti maravigliosi & insegnano segreti bellissimi, del vetro nel fuoco & altre cose curiose.* Florence, 1612.

Nesselrath 1993
Arnold Nesselrath. *Das Fossombroner Skizzenbuch.* Studies of the Warburg Institute 41. London, 1993.

Newbery 2007
Timothy J. Newbery. *The Robert Lehman Collection.* Vol. 13, *Frames.* Princeton, 2007.

Newbery, Bisacca, and Kanter 1990
Timothy J. Newbery, George Bisacca, and Laurence B. Kanter. *Italian Renaissance Frames.* Exh. cat., The Metropolitan Museum of Art. New York, 1990.

Newby 2000
Martine S. Newby. *Glass of Four Millennia.* Oxford, 2000.

Newton 1988
Mary Stella Newton. *The Dress of the Venetians, 1495–1525.* Pasold Studies in Textile History 6. Aldershot, 1988.

Niccolini di Camugliano 1933
Ginevra Niccolini di Camugliano. *The Chronicles of a Florentine Family, 1200–1470.* London, 1933.

Nichols 1999
Tom Nichols. *Tintoretto: Tradition and Identity.* London, 1999.

Nickel 1974
Helmut Nickel. "Two Falcon Devices of the Strozzi: An Attempt at Interpretation." *Metropolitan Museum Journal* 9 (1974), pp. 229–32.

Nienholdt and Wagner-Neumann 1965
Eva Nienholdt and Gretel Wagner-Neumann, eds. *Katalog der Lipperheideschen Kostümbibliothek.* 2 vols. Berlin, 1965.

Noë 1960
Helen A. Noë. "Messer Giacomo en zijn 'Laura' (een dubbelportret van Giorgione?)." *Nederlands Kunsthistorisch Jaarboek* 11 (1960), pp. 1–35.

Nogarola, *Writings,* 2004 (ed.)
Isotta Nogarola. *Complete Writings: Letterbook, Dialogue on Adam and Eve, Orations.* Edited by Margaret King. Translated by Diana Maury Robin. Chicago, 2004.

Norman 1976
A. V. B. Norman. *Wallace Collection: Catalogue of Ceramics.* Vol. 1, *Pottery, Maiolica, Faience, Stoneware.* London, 1976.

Norris 1977
Andrea Norris. "The Tomb of Gian Galeazzo Visconti at the Certosa di Pavia." Ph.D. diss., New York University, 1977.

Nova 1997
Alessandro Nova. Review of Carminati 1994. *Burlington Magazine* 139 (July 1997), pp. 483–85.

Nova 2001
Alessandro Nova. "Erotismo e spiritualità nella pittura romana del Cinquecento." In *Francesco Salviati et la bella maniera: Actes des colloques de Rome et de Paris (1998),* edited by Catherine Monbeig Goguel, Philippe Costamagna, and Michel Hochmann, pp. 149–69. Rome, 2001.

Nuttall 2004
Paula Nuttall. *From Flanders to Florence: The Impact of Netherlandish Painting, 1400–1500.* New Haven, 2004.

Nuttall 2005
Paula Nuttall. "Memling and the European Renaissance Portrait." In Borchert et al. 2005, pp. 68–91.

Nygren 2006
Barnaby Nygren. "'We First Pretend to Stand at a Certain Window': Window as Pictorial Device and Metaphor in the Paintings of Filippo Lippi." *Source: Notes in the History of Art* 26, no. 1 (Fall 2006), pp. 15–21.

Oberhuber 1971
Konrad Oberhuber. "Raphael and the State Portrait, II: The Portrait of Lorenzo de' Medici." *Burlington Magazine* 113 (August 1971), pp. 436–43.

Oberhuber 1973
Konrad Oberhuber. "Francesco Rosselli." In Jay Levenson, Konrad Oberhuber, and Jacquelyn L. Sheehan, *Early Italian Engravings from the National Gallery of Art,* pp. 47–59. Exh. cat., National Gallery of Art. Washington, D.C., 1973.

Oberhuber and Gnann 1999
Konrad Oberhuber, ed. *Roma e lo stile classico di Raffaello, 1515–1527.* Catalogue by Achim Gnann. Exh. cat., Palazzo Te, Mantua; and Graphische Sammlung Albertina, Vienna. Milan, 1999.

Oberthaler 2004
Elke Oberthaler. "On Technique, Condition and Interpretation of Five Paintings by Giorgione and His Circle." In Ferino-Pagden and Nepi Scirè 2004, pp. 267–76.

Oberthaler and Walmsley 2006
Elke Oberthaler and Elizabeth Walmsley. "Technical Studies of Painting Methods." In D. A. Brown and Ferino-Pagden 2006, pp. 285–300.

O'Brien 1999
Emily O'Brien. "The History of the Two Lovers." In Aeneas Silvius Piccolomini, *The Two Lovers: The Goodly History of Lady Lucrece and Her Lover Eurialus,* edited by Emily O'Brien and Kenneth R. Bartlett, pp. 14–84. Publications of the Barnabe Riche Society 11. Ottawa, 1999.

Ochenkowski 1919
Henryk Ochenkowski. "The Quatercentenary of Leonardo da Vinci, I: *The Lady with the Ermine:* A Composition by Leonardo da Vinci." *Burlington Magazine* 34 (May 1919), pp. 186–94.

Olian 1977
Jo Anne Olian. "Sixteenth-Century Costume Books." *Dress* 3 (1977), pp. 20–48.

Olivi 1887
Luigi Olivi. "Delle nozze di Ercole I con Eleonora d'Aragona." *Memorie della R. Accademia di Scienze, Lettere ed Arti in Modena,* 2nd ser., 5 (1887), pp. 15–68.

Olsen 1992
Christina Olsen. "Gross Expenditure: Botticelli's Nastagio degli Onesti Panels." *Art History* 15, no. 2 (June 1992), pp. 146–70.

Olson 2000
Roberta J. M. Olson. *The Florentine Tondo.* Oxford, 2000.

Oman 1930
Charles Chichele Oman. *Catalogue of Rings.* Victoria and Albert Museum. London, 1930. [Repr., Ipswich, 1993.]

Origo 1962
Iris Origo. *The World of San Bernardino.* New York, 1962.

Origo 1988
Iris Origo. *The Merchant of Prato, Francesco di Marco Datini.* London, 1988.

Orlando Consort 2001
Orlando Consort. *Food, Wine and Song: Music and Feasting in Renaissance Europe.* Los Angeles, 2001.

Orsi Landini 2002
Roberta Orsi Landini. "L'abbigliamento infantile fra Cinque e Seicento." In *Il vestito e la sua immagine: Atti del convegno in omaggio a Cesare Vecellio nel quarto centenario della morte, Belluno, 20–22 settembre 2001,*

edited by Jeannine Guérin Dalle Mese, pp. 143–55. Belluno, 2002.

Orsi Landini and Westerman Bulgarella 2001
Roberta Orsi Landini and Mary Westerman Bulgarella. "Costume in Fifteenth-Century Florentine Portraits of Women." In D. A. Brown et al. 2001, pp. 89–97.

Van Os and Prakken 1974
H. W. van Os and Marian Prakken. *The Florentine Paintings in Holland, 1300–1500.* Maarsen, 1974.

Ost 1980
Hans Ost. "Tizians 'Himmlische und Irdische Liebe.'" *Wallraf-Richartz-Jahrbuch* 41 (1980), pp. 87–104.

Ovid, *Art of Love*, 1985 (ed.)
Ovid. *The Art of Love, and Other Poems.* Translated by J. H. Mozley. 2nd ed., revised by G. P. Goold. Vol. 2 of *Ovid.* The Loeb Classical Library. Cambridge, Mass., 1985.

Ovid, *Fasti*, 1996 (ed.)
Ovid. *Fasti.* Translated by James George Frazer. Reprint (with corrections) of 2nd ed., revised by G. P. Goold. The Loeb Classical Library. Cambridge, Mass., 1996.

Ovid, *Metamorphoses*, 1994 (ed.)
Ovid. *Metamorphoses.* Translated by Frank Justus Miller. Reprint of 3rd ed., revised by G. P. Goold. 2 vols. Vols. 4 and 5 of *Ovid.* The Loeb Classical Library. Cambridge, Mass., 1994.

Ozment 1990
Steven Ozment. *Three Behaim Boys: Growing up in Early Modern Germany.* New Haven, 1990.

Padovan 1987
Maurizio Padovan. "La danza alle corti italiane del XV secolo: Arte figurative e fonti storiche." In *Mesura et arte del danzare: Guglielmo Ebreo da Pesaro e la danza nelle corti italiane el XV secolo,* edited by Patrizia Castelli, Maurizio Mingardi, and Maurizio Padovan, pp. 59–111. Exh. cat., Palazzo Lazzaraini, Pesaro. Pesaro, 1987.

Padovani 2005
Serena Padovani. "I ritratti Doni: Raffaello e il suo 'eccentrico' amico, il Maestro di Serumido." *Paragone* 56, no. 663 (3rd ser., no. 61) (May 2005), pp. 3–26.

Page 2004
Jutta-Annette Page. "Venetian Glass in Austria." In *Beyond Venice: Glass in Venetian Style, 1500–1750,* pp. 20–61, 308–9. Exh. cat. by Jutta-Annette Page, with contributions by Ignasi Doménech, Alexandra Gaba-Van Dongen, Reino Liefkes, Marie-Laure de Rochebrune, and Hugh Willmott. Corning Museum of Glass. Corning, N.Y., 2004.

Page 2006
Jutta-Annette Page, with essays by Stefano Carboni et al. *The Art of Glass: Toledo Museum of Art.* Toledo, 2006.

Paleotti, *Discorso*, 2002 (ed.)
Gabriele Paleotti. *Discorso intorno alle immagini sacre e profane.* Rome, 1582. 2002 ed.: Edited by Stefano Della Torre. Transcribed by Gian Franco Freggula. Vatican City, 2002.

Pallucchini 1981
Rodolfo Pallucchini. *La pittura veneziana del Seicento.* 2 vols. Profili e saggi di arte veneta. Venice, 1981.

Pallucchini and P. Rossi 1982
Rodolfo Pallucchini and Paola Rossi. *Tintoretto: Le opere sacre e profane.* Profili e saggi di arte veneta. 2 vols. Milan, 1982.

Palvarini Gobio Casali 1987
Mariarosa Palvarini Gobio Casali. *La ceramica a Mantova.* Ferrara, 1987.

Panofsky 1939
Erwin Panofsky. *Studies in Iconology: Humanistic Themes in the Art of the Renaissance.* The Mary Flexner Lectures on the Humanities 7. New York, 1939.

Panofsky 1939/1972
Erwin Panofsky. *Studies in Iconology: Humanistic Themes in the Art of the Renaissance.* Icon Editions. New York, 1972. [1st ed., 1939.]

Panofsky 1967
Erwin Panofsky. *Studies in Iconology: Humanistic Themes in the Art of the Renaissance.* New York, 1967. [1st ed., 1939.]

Panofsky 1969
Erwin Panofsky. *Problems in Titian, Mostly Iconographic.* The Wrightsman Lectures 2. New York, 1969.

Paolozzi-Strozzi 2005
Beatrice Paolozzi-Strozzi. "'La nostra casa grande': Il palazzo e gli Strozzi. Appunti di storia dal Quattro al Novecento." In *Palazzo Strozzi: Cinque secoli di arte e culture,* edited by Giorgio Bonsanti, pp. 52–109. Florence, 2005.

Papanghelis and Rengakos 2001
Theodore D. Papanghelis and Antonios Rengakos, eds. *A Companion to Apollonius Rhodius.* Leiden, 2001.

Pardi 1916
G. Pardi. "Disegno della storia demografica di Firenze." *Archivio storico italiano* 74 (1916), pp. 3–84, 185–245.

Pardo 1993
Mary Pardo. "Artifice as Seduction in Titian." In Turner 1993, pp. 55–89.

Parenti, *Lettere*, 1996 (ed.)
Marco Parenti. *Lettere.* Edited by Maria Marrese. Florence, 1996.

Paribeni 2001
Andrea Paribeni. "Iconografia, committenza, topografia di Costantinopoli: Sul cassone di Apollonio di Giovanni con la 'Conquista di Trebisonda.'" *Rivista dell'Istituto Nazionale d'Archeologia e Storia dell'Arte* 56 (2001), pp. 255–304.

Paribeni 2002
Andrea Paribeni. "Una testimonianza iconografica della Battaglia di Ankara (1402) in Apollonio di Giovanni." In *Europa e Islam tra i secoli XIV e XVI / Europe and Islam between Fourteenth and Sixteenth Centuries,* edited by Michele Bernardini, C. Borelli, A. Cerbo, and E. Sanchez Garcia, vol. 1, pp. 427–41. Istituto Universitario Orientale, Collana "Matteo Ripa" 18. Naples, 2002.

***Paris Bordon* 1984**
Paris Bordon. Exh. cat. by Giordana Mariani Canova et al. Palazzo dei Trecento, Treviso. Milan, 1984.

***Paris Bordon* 1987**
Paris Bordon e il suo tempo: Atti del convegno internazionale di studi, Treviso, 28–30 ottobre 1985. Treviso, 1987.

Parker 1997
Deborah Parker. "Towards a Reading of Bronzino's Burlesque Poetry." *Renaissance Quarterly* 50, no. 4 (Winter 1997), pp. 1011–44.

Parma Armani 1986
Elena Parma Armani. *Perino del Vaga: L'Anello Mancate. Studi sul manierismo.* Genoa, 1986.

Parravicino 1903
Count Emiliano di Parravicino. "Three Packs of Italian Tarocco Cards." *Burlington Magazine* 3 (December 1903), pp. 237–51.

Parronchi 1991
Alessandro Parronchi. "Inganni d'ombre." *Achademia Leonardo Vinci* 4 (1991), pp. 52–56.

Pasero 1935
Carlo Pasero. "Giacomo Franco: Editore, incisore e calcografo nei secoli XVI e XVII." *La bibliofilia* 37 (August–October 1935), pp. 332–56.

Pasini 1983
Pier Giorgio Pasini. *I Malatesti e l'arte.* Cinisello Balsamo, 1983.

Passeri 1853
Giambattista Passeri. *Histoire des peintures sur majoliques faites à Pesaro et dans les lieux circonvoisins.* Paris, 1853.

Pearce 1952
Stella Mary Pearce. "Dating on the Evidence of Costume and Hairstyle." In Eric Newton, *Tintoretto,* App., pp. 215–33. London, 1952.

Pedretti 1990
Carlo Pedretti. "La Dama dell'Ermellino come allegoria politica." In *Studi politici in onore di Luigi Firpo,* edited by Silvia Rota Ghibaudi and Franco Barcia, vol. 1, pp. 161–81. 4 vols. Milan, 1990.

Pedretti 1997
Carlo Pedretti. "Gleanings." *Achademia Leonardi Vinci* 10 (1997), pp. 233–44.

Pedrini 1925
Augusto Pedrini. *L'ambiente: Il mobilio e le decorazioni del Rinascimento in Italia.* Turin, 1925.

Pedrini 1948
Augusto Pedrini. *Il mobilio e le decorazioni del Rinascimento in Italia, secoli XV e XVI.* Florence, 1948.

Pedrini 1969
Augusto Pedrini. *Il mobilio e le decorazioni del Rinascimento in Italia secoli, XV et XVI.* Genoa, 1969.

Pellegrini 2001
Franca Pellegrini. "Desiderio da Firenze (Firenze—documentato a Padova dal 1552 al 1545)." In *Donatello* 2001, pp. 173–77.

Penny 2004
Nicholas Penny. *The Sixteenth Century Italian Paintings.* Vol. 1, *Paintings from Bergamo, Brescia and Cremona.* National Gallery Catalogues. London, 2004.

Penny 2008
Nicholas Penny. *The Sixteenth Century Italian Paintings.* Vol. 2, *Venice, 1540–1600.* National Gallery Catalogues. London, 2008.

Perini 1995
Giovanna Perini. "*Ut pictura poesis*: L'Accademia dei Gelati e le arti figurative." In *Italian Academies of the Sixteenth Century,* edited by David S. Chambers and François Quiviger, pp. 113–26. Warburg Institute Colloquia 1. London, 1995.

***Perino del Vaga* 2001**
Perino del Vaga tra Raffaello e Michelangelo. Exh. cat. by Elena Parma Armani et al. Palazzo Te, Mantua. Milan, 2001.

Perlman 2000
Julia Branna Perlman. "Looking at Venus and Ganymede Anew: Problems and Paradoxes in the Relations among Neoplatonic Writing and Renaissance Art." In *Antiquity and Its Interpreters,* edited by Alina Payne, Anne Kuttner, and Rebekah Smick, pp. 110–25. Cambridge, 2000.

Perosa 1971
Alexander Perosa. "Braccesi, Alessandro." In *Dizionario biografico degli italiani,* vol. 13, pp. 602–8. Rome, 1971.

Petrarch, *Canzoniere*, 1985 (ed.)
Petrarch. *Selections from the Canzoniere and Other Works.* Translated and edited by Mark Musa. Oxford, 1985.

Petrarch, *Love Rimes*, 1932 (ed.)
Petrarch. *Love Rimes of Petrarch.* Translated by Morris Bishop. Dragon Series. Ithaca, N.Y., 1932.

Petrarch, *Rerum Vulgarium Fragmenta*, 1995 (ed.)
Petrarch. *Petrarch's Songbook: A Verse Translation of "Rerum Vulgarium Fragmenta."* Translated by James Wyatt Cook. Italian text by Gianfranco Contini. Medieval and Renaissance Texts and Studies 151. Binghamton, 1995.

Petrarch, *Sonnets*, 1966 (ed.)
Petrarch. *Selected Sonnets, Odes and Letters.* Edited by Thomas Goddard Bergin. New York, 1966.

Petrarch, *Triumphs*, 1962 (ed.)
Petrarch. *The Triumphs of Petrarch.* Translated by Ernest Hatch Wilkins. Chicago, 1962.

Petrioli 1966
Anna Maria Petrioli, ed. *Mostra di disegni vasariani: Carri trionfali e costumi per la Genealogia degli Dei (1565).* Florence, 1966.

Petruzzellis-Scherer 1988
Jacqueline Petruzzellis-Scherer. "Fonti iconografiche delle opere dell'Avelli al Museo Correr di Venezia." In *Francesco Xanto Avelli da Rovigo: Atti del convegno internazionale di studi, Accademia dei Concordi, Rovigo, 3–4 maggio 1980,* pp. 121–51. Rovigo, 1988.

Phillipps Manuscripts 1837–71
The Phillipps Manuscripts: Catalogus Librorum Manuscriptorum in Bibliotheca D. Thomae Phillipps, Bart, A.D. 1837. [Middle Hill, Worcestershire], 1837–71. Repr., facsimile ed., London, 1968.

Philostratus, *Imagines*, 1969 (ed.)
Philostratus the Elder, Philostratus the Younger, and Callistratus. *Philostratus, Imagines; Callistratus, Descriptions.* Translated by Arthur Fairbanks. The Loeb Classical Library. London, 1969.

Il piacevol ragionamento de l'Aretino 1987 (ed.)
[Unknown author.] *Il piacevol ragionamento de l'Aretino: Dialogo di Giulia e di Madalena.* [ca. 1540–50.] Edited by Claudio Galderisi. Introduction by Enrico Rufi. Foreword by Giovanni Aquilecchia. Omikron 24. Rome, 1987.

Piccinelli 2003
Roberta Piccinelli. *Le collezioni Gonzaga.* [Vol. 3], *Il Carteggio tra Milano e Mantova (1563–1634).* Milan, 2003.

Piccolomini, *Tale of Two Lovers*, 1929 (ed.)
Aeneas Silvius Piccolomini. *The Tale of the Two Lovers.* Translated by Flora Grierson. London, 1929.

Piccolomini, *Tale of Two Lovers*, 1999 (ed.)
Aeneas Silvius Piccolomini. *The Two Lovers: The Goodly History of Lady Lucrece and Her Lover Eurialus.* Edited by Emily O'Brien and Kenneth R. Bartlett. Ottawa, 1999.

Piccolpasso, *Three Books of the Potter's Art*, 1980 (ed.)
Cipriano Piccolpasso. *I tre libri dell'arte del vasaio.* [ca. 1557–59.] 1980 ed.: *The Three Books of the Potter's Art: A Facsimile of the Manuscript in the Victoria and Albert Museum, London.* Translated and edited by Ronald W. Lightbown and Alan Caiger-Smith. 2 vols. [Vol. 1], facsimile of the original manuscript; [vol. 2], English translation. London, 1980.

Pico della Mirandola, *Cabalistarum Selectiora*, 1549
Giovanni Pico della Mirandola. *Cabalistarum Selectiora.* Venice, 1549.

Pignatti 1962
Terisio Pignatti. *Mobili italiani del Rinascimento.* Le arti nella casa italiana. Milan, 1962.

Pignatti and Pedrocco 1995
Terisio Pignatti and Filippo Pedrocco. *Veronese.* 2 vols. Milan, 1995.

Pillsbury 1980
Edmund Pillsbury. "The Cabinet Paintings of Jacopo Zucchi: Their Meaning and Function." *Monuments et mémoires* (Fondation Eugène Piot) 63 (1980), pp. 187–226.

Pinchera 2003
Valeria Pinchera. "Vestire la vita, vestire la morte: Abiti per matrimoni e funerali, XIV–XVII secolo." In *La moda,* edited by Carlo Marco Belfanti and Fabio Giusberti, pp. 221–59. Storia d'Italia, Annali 19. Turin, 2003.

Pincus 1969
Debra Dienstfrey Pincus. "A Hand by Antonio Rizzo and the Double Caritas Scheme of the Tron Tomb." *Art Bulletin* 51, no. 3 (September 1969), pp. 247–56.

Pinelli 1990
Antonio Pinelli. "Il 'picciol vetro' e il 'maggior vaso': I due grande cicli profane di Domenico Beccafumi in Palazzo Venturi e nella Sala del Concistoro." In *Beccafumi 1990,* pp. 622–51.

Pini 1999
Vittorio Pini. "Vicende del privilegio di Saranno concesso da Ludovico il Moro a Cecilia Gallerani (1491–1513)." *Raccolta Vinciana* 28 (1999), pp. 39–61.

Pinto 1971
Olga Pinto. *Nuptialia: Saggio di bibliografia di scritti italiani pubblicati per nozze dal 1484 al 1799.* Florence, 1971.

Pirovano 2006
Donato Pirovano. "L'arte allusiva di Enea Silvio Piccolomini: Per una lettera dell' *Historia de Duobus Amantibus.*" *Rivista di letteratura italiana* 24, no. 3 (2006), pp. 11–22.

I pittori bergamaschi 1980
I pittori bergamaschi dal XIII al XIX secolo: Il Cinquecento. Vol. 1 by Pietro Zampetti et al. Bergamo, 1980.

Planiscig 1921
Leo Planiscig. *Venezianische Bildhauer der Renaissance.* Vienna, 1921.

Plato, *Symposium*, 1975
Plato. *Lysis, Symposium, Gorgias.* Translated by W. R. M. Lamb. Vol. 3 of *Plato.* The Loeb Classical Library. Cambridge, Mass., 1975.

Pliny the Elder, *Natural History*, 1966–75 (ed.)
Pliny the Elder. *Natural History.* Translated by Harris Rackham. 10 vols. The Loeb Classical Library. Cambridge, Mass., 1966–75.

Poesia italiana del Cinquecento 1978
Poesia italiana del Cinquecento. Edited by Giulio Ferroni. Milan, 1978.

Pohl 1992
Horst Pohl, ed. *Willibald Imhoff, Enkel und Erbe Willibald Pirckheimers.* Quellen zur Geschichte und Kultur der Stadt Nürnberg 24. Nuremberg, 1992.

Poke 2001
Christopher Poke. "Jacques Androuet I Ducerceau's 'Petites Grotesques' as a Source for Urbino Maiolica Decoration." *Burlington Magazine* 143 (June 2001), pp. 332–44.

Poletti 2001
Federico Poletti. *Antonio e Piero Pollaiolo.* Milan, 2001.

Poliziano 1867
Angelo Poliziano. *Prose volgari inedite e poesie latine e greche edite e inedite.* Edited by Isidoro Del Lungo. Florence, 1867.

Pollard 1984–85
John Graham Pollard. *Medaglie italiane del Rinascimento nel Museo Nazionale del Bargello / Italian Renaissance Medals in the Museo Nazionale of Bargello.* 3 vols. Florence, 1984–85.

Pollard 2007
John Graham Pollard, with Eleonora Luciano and Maria Pollard. *Renaissance Medals.* The Collections of the National Gallery of Art. Washington, D.C., 2007.

Pollen 1874
John Hungerford Pollen. *Ancient and Modern Furniture and Woodwork in the South Kensington Museum.* London, 1874.

Pommeranz 1995
Johannes W. Pommeranz. *Pastigliakätschen: Ein Beitrag zur Kunst- und Kulturgeschichte der italienischen Renaissance.* Internationale Hochschulschriften 167. Münster, 1995.

Pon 2004
Lisa Pon. *Raphael, Dürer, and MarcAntonio Raimondi: Copying and the Italian Renaissance Print.* New Haven, 2004.

Pons 2004
Nicoletta Pons, ed. *Bartolomeo di Giovanni: Collaboratore di Ghirlandaio e Botticelli / Bartolomeo di Giovanni: Associate of Ghirlandiao and Botticelli.* Exh. cat., Museo di San Marco. Florence, 2004.

Poole 1995
Julia E. Poole. *Italian Maiolica and Incised Slipware in the Fitzwilliam Museum, Cambridge.* Cambridge, 1995.

Pope-Hennessy 1940
John Pope-Hennessy. "Beccafumi in the Victoria and Albert Museum." *Burlington Magazine* 76 (April 1940), pp. 110–23.

Pope-Hennessy 1950
John Pope-Hennessy. "A Cartapesta Mirror Frame." *Burlington Magazine* 92 (October 1950), pp. 288–91.

Pope-Hennessy 1964
John Pope-Hennessy. *Catalogue of Italian Sculpture in the Victoria and Albert Museum.* 3 vols. London, 1964.

Pope-Hennessy 1966
John Pope-Hennessy. *The Portrait in the Renaissance.* New York, 1966.

Pope-Hennessy 1987
John Pope-Hennessy, with Laurence B. Kanter. *The Robert Lehman Collection.* Vol. 1, *Italian Paintings.* New York and Princeton, 1987.

Pope-Hennessy and Christiansen 1980
John Pope-Hennessy and Keith Christiansen. "Secular Painting in Fifteenth-Century Tuscany: Birth Trays, Cassone Panels, and Portraits." *The Metropolitan Museum of Art Bulletin,* n.s., 38, no. 1 (Summer 1980).

Il potere e lo spazio 1980
Il potere e lo spazio: La scena del principe. Exh. cat., Forte di Belvedere and Palazzo Medici Riccardi. Florence, 1980.

Pouncey and Gere 1962
Philip Pouncey and J. A. Gere. *Italian Drawings in the Department of Prints and Drawings in the British Museum.* Vol. 2, *Raphael and His Circle.* London, 1962.

Pozzi 1979
Giovanni Pozzi. "Il ritratto della donna nella poesia d'inizio Cinquecento e la pittura di Giorgione." *Lettere italiane* 31, no. 1 (January–March 1979), pp. 1–30.

Pozzi 1980
Giovanni Pozzi. "Presentazione." In Colonna, *Hypnerotomachia Poliphili,* 1980 (ed.), vol. 2, pp. 1–20.

Pratesi 1989
Franco Pratesi. "The Earliest Tarot Pack Known." *Playing Card* (Playing Card Society) 18 (August and November 1989), pp. 28–38.

Previati 2000
Elisabetta Previati. "Fonti letterarie ed iconografiche per i 'Trionfi degli Dei' nel Salone dei Mesi a Palazzo Schifanoia." *Musei ferraresi* 19 (2000), pp. 30–56.

Preyer 2006
Brenda Preyer. "The Florentine *Casa*." In Ajmar-Wollheim and Dennis 2006, pp. 34–49, 370–71.

Priapea 1988 (ed.)
Priapea: Poems for a Phallic God. Edited and translated by William Henry Parker. Croom Helm Classical Studies. London, 1988.

I principi bambini 1985
I principi bambini: Abbigliamento e infanzia nel Seicento. Exh cat. edited by Kirsten Aschengreen Piacenti, Silvia Meloni Trkulja, and Roberta Orsi Landini. Galleria del Costume, Palazzo Pitti. Florence, 1985.

Pujmanová 1977
Olga Pujmanová. "Italian Primitives in Czechoslovak Collections." Translated by T. Gottheinerová. *Burlington Magazine* 119 (August 1977), pp. 536–50.

Pulci 1500
Luigi Pulci. *"La giostra" di Lorenzo de Medici messa in rima da Luigi de Pulci anno M.CCCCLXVIII.* Florence, 1500.

Quando gli dei si spogliano 1984
Quando gli dei si spogliano: Il bagno di Clemente VII a Castel Sant'Angelo e le altre stufe romane dei primo Cinquecento. Rome, 1984.

Quiviger 1995
François Quiviger. "The Presence of Artists in Literary Academies." In *Italian Academies of the Sixteenth Century*, edited by David S. Chambers and François Quiviger, pp. 104–12. Warburg Institute Colloquia 1. London, 1995.

Quiviger 2004
François Quiviger. "Fleurs éparpillées dans deux tableaux du *cinquecento* vénitien: Essai d'iconographie olfactive." *Glasgow Emblem Studies* 9 (2004), pp. 155–67.

Quondam 1980
Amedeo Quondam. "Nel giardino del Marcolini: Un editore veneziano tra Aretino e Doni." *Giornale storico della letteratura italiana* 157, no. 497 (1980), pp. 75–116.

Quondam 1989
Amedeo Quondam. "Il naso di Laura." In *Il ritratto e la memoria: Materiali*, edited by Augusto Gentili, vol. 1, pp. 9–44. Biblioteca del Cinquecento 48. Rome, 1989.

Quondam 1995
Amedeo Quondam. "Sull'orlo della bella fontana: Tipologie del discorso erotico nel primo Cinquecento." In *Tiziano* 1995, pp. 65–81.

Rackham 1940
Bernard Rackham. *Catalogue of Italian Maiolica*. 2 vols. Victoria and Albert Museum. London, 1940. [Repr., with additions by J. V. G. Mallet. London, 1977.]

Rackham 1958
Bernard Rackham. "The Ford Collection of Italian Maiolica." *Connoisseur* 142 (November 1958), pp. 148–51.

Rackham 1959
Bernard Rackham. *Islamic Pottery and Italian Maiolica: Illustrated Catalogue of a Private Collection*. London, 1959.

Radcliffe, Baker, and Maek-Gérard 1992
Anthony Radcliffe, Malcolm Baker, and Michael Maek-Gérard. *Renaissance and Later Sculpture with Works of Art in Bronze*. Thyssen-Bornemisza Collection. London, 1992.

Raggio 1956
Olga Raggio. "The Lehman Collection of Italian Maiolica." *The Metropolitan Museum of Art Bulletin*, n.s., 14, no. 8 (April 1956), pp. 186–97.

Rainey 1985
Ronald E. Rainey. "Sumptuary Legislation in Renaissance Florence." 2 vols. Ph.D. diss., Columbia University, 1985.

Randolph 1998
Adrian W. B. Randolph. "Performing the Bridal Body in Fifteenth-Century Florence." *Art History* 21, no. 2 (June 1998), pp. 182–200.

Randolph 2002a
Adrian W. B. Randolph. *Engaging Symbols: Gender, Politics, and Public Art in Fifteenth-Century Florence*. New Haven, 2002.

Randolph 2002b
Adrian W. B. Randolph. "Renaissance Household Goddesses: Fertility, Politics, and the Gendering of the Spectatorship." In *The Material Culture of Sex, Procreation, and Marriage in Premodern Europe*, edited by Anne L. McClanan and Karen Rosoff Encarnación, pp. 163–89. New York, 2002.

Randolph 2004
Adrian W. B. Randolph. "Gendering the Period Eye: *Deschi da Parto* and Renaissance Visual Culture." *Art History* 27, no. 4 (September 2004), pp. 538–62.

Rasmussen 1984
Jörg Rasmussen. *Italienische Majolika*. Katalage des Museums für Kunst und Gewerbe Hamburg 6. Hamburg, 1984.

Rasmussen 1989
Jörg Rasmussen. *The Robert Lehman Collection*. Vol. 10, *Italian Majolica*. Princeton, 1989.

Ravanelli Guidotti 1985a
Carmen Ravanelli Guidotti. *Ceramiche occidentali del Museo Civico Medievale di Bologna*. Cataloghi delle collezioni del Museo Civico Medievale di Bologna, [1]. Bologna, 1985.

Ravanelli Guidotti 1985b
Carmen Ravanelli Guidotti. "Medaglie, placchette, incisioni e ceramiche: Un itinerario iconografico attraverso materiali del Rinascimento." In *Piccoli bronzi e placchette del Museo Nazionale di Ravenna*, pp. liii–lxv. Exh. cat., Cassa di Risparmio di Ravenna. Ravenna, 1985.

Ravanelli Guidotti 1987
Carmen Ravanelli Guidotti. *Donazione Paolo Mereghi: Ceramiche europee ed orientali*. Museo Internazionale delle Ceramiche in Faenza. Catalogo generale delle raccolte 4. Casalecchio di Reno, 1987.

Ravanelli Guidotti 1988
Carmen Ravanelli Guidotti. *Il pavimento della Cappella Vaselli in San Petronio a Bologna*. Bologna, 1988.

Ravanelli Guidotti 1989
Carmen Ravanelli Guidotti. "Maioliche." In *Arti del Medio Evo e del Rinascimento: Omaggio ai Carrand, 1889–1989*, pp. 294–303. Exh. cat., Museo Nazionale del Bargello. Florence, 1989.

Ravanelli Guidotti 1990
Carmen Ravanelli Guidotti, ed. *La donazione Angiolo Fanfani: Ceramiche dal Medioevo al XX secolo*. Museo Internazionale delle Ceramiche in Faenza. Faenza, 1990.

Ravanelli Guidotti 1991
Carmen Ravanelli Guidotti. "Un singolare ritrovamento: Un piatto del servizio di Isabella d'Este-Gonzaga." In *Italian Renaissance Pottery: Papers Written in Association with a Colloquium at the British Museum*, edited by Timothy Wilson, pp. 13–23. London, 1991.

Ravanelli Guidotti 1992
Carmen Ravanelli Guidotti. *MediTERRAneum: Ceramica spagnola in Italia tra Medioevo e Rinascimento / Cerámica española en Italia entre el Medioevo y el Renascimento* [sic]. Exh. cat. Viterbo, 1992.

Ravanelli Guidotti 1996a
Carmen Ravanelli Guidotti. *Baldassarre Manara faentino: Pittore di maioliche nel Cinquecento*. Ferrara, 1996.

Ravanelli Guidotti 1996b
Carmen Ravanelli Guidotti. *Faenza-faïence: 'Bianchi' di Faenza*. Exh. cat., Museo Internazionale delle Ceramiche in Faenza. Ferrara, 1996.

Ravanelli Guidotti 2000
Carmen Ravanelli Guidotti. *Delle gentili donne di Faenza: Studio del "ritratto" sulla ceramica faentina del Rinascimento*. Exh. cat., Palazzo delle Esposizioni, Faenza. Ferrara, 2000.

Ray 2000a
Anthony Ray. "The Rothschild *Alfabeguer* and Other Fifteenth-Century Spanish Lustred Basil-Pots." *Burlington Magazine* 142 (June 2000), pp. 371–75.

Ray 2000b
Anthony Ray. *Spanish Pottery, 1248–1898, with a Catalogue of the Collection in the Victoria and Albert Museum*. London, 2000.

Rearick 1987
William R. Rearick. "The Drawings of Paris Bordon." In *Paris Bordon* 1987, pp. 47–63.

Rearick 2001
William R. Rearick. *Il disegno veneziano del Cinquecento*. Biblioteca Electa. Milan, 2001.

Rebecchini 2002
Guido Rebecchini. *Private Collectors in Mantua, 1500–1630*. Rome, 2002.

Redig de Campos 1967
Dioclecio Redig de Campos. *I palazzi Vaticani*. Bologna, 1967.

Reiss and Wilkins 2001
Sheryl E. Reiss and David G. Wilkins, eds. *Beyond Isabella: Secular Women Patrons of Art in Renaissance Italy*. Kirksville, Mo., 2001.

Reynolds 1983
Anne Reynolds. "Francesco Berni: The Theory and Practice of Italian Satire in the Sixteenth Century." *Italian Quarterly* 24, no. 94 (Fall 1983), pp. 5–15.

Reynolds 1994
Anne Reynolds. "Ambiguities of Apollo and Marsyas: Francesco Berni and His First Published Work." *Studies in Iconography* 16 (1994), pp. 191–224.

Reynolds 1997
Anne Reynolds. *Renaissance Humanism at the Court of Clement VII: Francesco Berni's "Dialogue against Poets" in Context*. New York, 1997.

Reynolds 2000
Anne Reynolds. "Francesco Berni, Gian Matteo Giberti, and Pietro Bembo: Criticism and Rivalry in Rome in the 1520s." *Italica* 77, no. 3 (2000), pp. 307–8.

Ricci 1927
Seymour de Ricci. *A Catalogue of Early Italian Majolica in the Collection of Mortimer L. Schiff*. New York, 1927. [Repr., Ferrara, 1988.]

Ricciardi 1986
Maria Luisa Ricciardi. "*L'Amor Sacra e Profano*: Un ulteriore tentativo di sciogliere l'enigma." *Notizie da Palazzo Albani* 15, no. 1 (1986), pp. 38–43.

Ridolfi, Life of Tintoretto, 1984 (ed.)
Carlo Ridolfi. *The Life of Tintoretto and of His Children Domenico and Marietta*. Translated and edited by Catherine and Robert Enggass. University Park, Pa., 1984. [Translation of Ridolfi's "Vita di Giacopo Robusti detto il Tintoretto" in Carlo Ridolfi, *Le maraviglie*

dell'arte; ovvero, Le vite degli illustri pittori veneti e dello stato, vol. 2. Venice, 1648.]

Ridolfi, *Le maraviglie dell'arte*, 1648
Carlo Ridolfi. *Le maraviglie dell'arte; ovvero, Le vite degli illustri pittori veneti e dello stato.* 2 vols. Venice, 1648.

Ridolfi, *Le maraviglie dell'arte*, 1914–24 (ed.)
Carlo Ridolfi. *Le maraviglie dell'arte; ovvero, Le vite degli illustri pittori veneti e dello stato.* 2 vols. Venice, 1648. 1914–24 ed.: Edited by Detlev Freiherrn von Hadeln. 2 vols. Berlin, 1914–24. [Repr., facsimile ed., 1965.]

Riedel and Wenzel 1765
Jean-Antoine Riedel and Christian Friedrich Wenzel. *Catalogue des tableaux de la Galerie Électorale à Dresde.* Dresden, 1765.

Ringbom 1985
Sixten Ringbom. "Filippo Lippis New Yorker Doppelporträt: Eine Deutung der Fenstersymbolik." *Zeitschrift für Kunstgeschichte* 48, no. 2 (1985), pp. 133–37.

Rio 1856
Alexis-François Rio. *Leonardo da Vinci e la sua scuola.* Milan, 1856.

Ripa, *Iconologia*, 1603
Cesare Ripa. *Iconologia.* Rome, 1603.

Ripa, *Iconologia*, 1611
Cesare Ripa. *Iconologia.* Padua, 1611. [Repr., facsimile ed., *Iconologia: Padua 1611.* The Renaissance and the Gods. New York, 1976.]

Robertson 1954
Giles Robertson. *Vincenzo Catena.* Edinburgh, 1954.

Robertson 1988
Giles Robertson. "Honour, Love and Truth, an Alternative Reading of Titian's *Sacred and Profane Love.*" *Renaissance Studies* 2, no. 2 (October 1988), pp. 268–79.

Robinson 1863
John Charles Robinson. *Catalogue of the Special Exhibition of Works of Art of the Mediaeval, Renaissance, and More Recent Periods, on Loan at the South Kensington Museum, June 1862.* Exh. cat., South Kensington Museum. Rev. ed. London, 1863.

Rochebrune 2004
Marie-Laure de Rochebrune. "Venetian and *Façon de Venise* Glass in France in the Sixteenth and Seventeenth Centuries." In *Beyond Venice: Glass in Venetian Style, 1500–1750*, pp. 142–63, 309. Exh. cat. by Jutta-Annette Page, with contributions by Ignasi Doménech, Alexandra Gaba-Van Dongen, Reino Liefkes, Marie-Laure de Rochebrune, and Hugh Willmott. Corning Museum of Glass. Corning, N.Y., 2004.

Rocke 1995
Michael Rocke. *Forbidden Friendships: Homosexuality and Male Culture in Renaissance Florence.* New York, 1995.

Rodini 1970
Robert J. Rodini. *Antonfrancesco Grazzini: Poet, Dramatist, and Novelliere, 1503–1584.* Madison, Wisc., 1970.

Rogers 1986
Mary Rogers. "Sonnets on Female Portraits from Renaissance North Italy." *Word & Image* 2, no. 4 (October–December 1986), pp. 291–305.

Rogers 1988
Mary Rogers. "The Decorum of Women's Beauty: Trissino, Firenzuola, Luigini and the Representation of Women in Sixteenth-Century Painting." *Renaissance Studies* 2, no. 1 (March 1988), pp. 47–88.

Rogers 1993
Mary Rogers. "An Ideal Wife at the Villa Maser: Veronese, the Barbaros and Renaissance Theorists of Marriage." *Renaissance Studies* 7, no. 4 (December 1993), pp. 379–97.

Rogers 2000
Mary Rogers. "Fashioning Identities for the Renaissance Courtesan." In *Fashioning Identities in Renaissance Art*, edited by Mary Rogers, pp. 91–105. Aldershot, 2000.

Rogers and Tinagli 2005
Mary Rogers and Paola Tinagli, eds. *Women in Italy, 1350–1650, Ideals and Realities: A Sourcebook.* Manchester, 2005.

Rohlmann 1996
Michael Rohlmann. "Botticellis 'Primavera': Zu Anlass, Adressat und Funktion von mythologischen Gemälden im Florentiner Quattrocento." *Artibus et Historiae*, no. 33 (1996), pp. 97–132.

Rolfs 1907
Wilhelm Rolfs. *Franz Laurana.* 2 vols. Berlin, 1907.

Roover 1963
Raymond de Roover. *The Rise and Decline of the Medici Bank, 1397–1494.* Harvard Studies in Business History 21. Cambridge, Mass., 1963.

Rosand 1980
David Rosand. "Ermeneutica Amorosa: Observations on the Interpretation of Titian's Venuses." In *Tiziano e Venezia: Convegno internazionale di studi, Venezia, 1976*, pp. 375–81. Vicenza, 1980.

Rosand 1997
David Rosand. "'So-and-So Reclining on Her Couch.'" In *Titian's "Venus of Urbino,"* edited by Rona Goffen, pp. 37–62. Cambridge, 1997.

Rosand and Muraro 1976
David Rosand and Michelangelo Muraro. *Titian and the Venetian Woodcut.* Exh. cat., National Gallery of Art Washington, D.C.; Dallas Museum of Fine Arts; and Detroit Institute of Arts. Washington, D.C., 1976.

Rosenberg 1993
Charles M. Rosenberg. "Virtue, Piety and Affection: Some Portraits by Domenico Ghirlandio." In *Il ritratto e la memoria: Materiali*, vol. 2, edited by Augusto Gentili, Philippe Morel, and Claudia Cieri Via, pp. 173–95. Rome, 1993.

Rosenberg and Christiansen 2008
Pierre Rosenberg and Keith Christiansen, eds. *Poussin and Nature: Arcadian Visions.* Exh. cat. by Keith Christiansen et al. The Metropolitan Museum of Art. New York, 2008.

Rosenthal 1992
Margaret F. Rosenthal. *The Honest Courtesan: Veronica Franco, Citizen and Writer in Sixteenth-Century Venice.* Chicago, 1992.

Rosenthal 1993
Margaret F. Rosenthal. "Venetian Women Writers and Their Discontents." In *Sexuality and Gender in Early Modern Europe: Institutions, Texts, Images*, edited by James Grantham Turner, pp. 107–23. Cambridge, 1993.

Roskill 1968/2000
Mark W. Roskill. *Dolce's "Aretino" and Venetian Art Theory of the Cinquecento.* Renaissance Society of America Reprint Texts 10. Toronto, 2000. [1st ed., Monographs on Archaeology and Fine Arts 15. New York, 1968.]

F. Rossi 1991
Francesco Rossi. *G. B. Moroni.* Soncino, 1991.

F. Rossi 2001
Francesco Rossi, ed. *Bergamo: L'altra Venezia; Il Rinascimento negli anni di Lorenzo Lotto, 1510–1530.* Exh. cat., Accademia Carrara. Bergamo, 2001.

M. Rossi 1999
Massimiliano Rossi. "I dipinti—Introduzione: La novella di Sandro e Nastagio." In Branca 1999, vol. 2, pp. 153–87.

P. Rossi 1974
Paola Rossi. *Jacopo Tintoretto.* Vol. 1, *I ritratti.* Venice, 1974.

P. Rossi 1994
Paola Rossi. "Die Bildnisse Jacopo Tintorettos." In *Tintoretto 1994*, pp. 12–37.

Rossoni 2002
Elena Rossoni. *Il bianco e dolce cigno: Metafore d'amore nell'arte italiana del XVI secolo.* Appunti d'arte 15. Nouro, 2002.

Rovere 1939
Terisio Rovere. "Arte minore: La ceramica. Il servizio ad 'impagliata.'" *ABC Rivista d'arte*, July 1939, pp. 14–17.

Rowland 1998
Ingrid D. Rowland. *The Culture of the High Renaissance: Ancients and Moderns in Sixteenth-Century Rome.* Cambridge, 1998.

Rowland 2005
Ingrid D. Rowland. *The Roman Garden of Agostino Chigi.* Gerson Lecture 13. Groningen, 2005.

Rubin 1996
Patricia Lee Rubin. "Domenico Ghirlandaio and the Meaning of History in Fifteenth Century Florence." In *Domenico Ghirlandaio, 1449–1494: Atti del convegno internazionale, Firenze, 16–18 ottobre 1994*, edited by Wolfram Prinz and Max Seidel, pp. 97–108. Florence, 1996.

Rubin 2000
Patricia Lee Rubin. "The Seductions of Antiquity." In *Manifestations of Venus: Art and Sexuality*, edited by Caroline Arscott and Katie Scott, pp. 24–38, 177–83. Barber Institute's Critical Perspectives in Art History Series. Manchester, 2000.

Rubin 2007
Patricia Lee Rubin. *Images and Identity in Fifteenth-Century Florence.* New Haven, 2007.

Rubin and Wright 1999
Patricia Lee Rubin and Alison Wright, with contributions by Nicholas Penny. *Renaissance Florence: The Art of the 1470s.* Exh. cat., National Gallery. London, 1999.

Ruda 1993
Jeffrey Ruda. *Fra Filippo Lippi: Life and Work with a Complete Catalogue.* London, 1993.

Ruggiero 1985
Guido Ruggiero. *The Boundaries of Eros: Sex Crime and Sexuality in Renaissance Venice.* New York, 1985.

Ruggiero 1993
Guido Ruggiero. *Binding Passions: Tales of Magic, Marriage and Power at the End of the Renaissance.* New York, 1993.

Ruvoldt 2004
Maria Ruvoldt. *The Italian Renaissance Imagery of Inspiration: Metaphors of Sex, Sleep, and Dreams.* Cambridge, 2004.

Ruzante, *La Betía*, 1967 (ed.)
Ruzante. *La Betía.* In Ruzante, *Teatro*, edited by Ludovico Zorzi. Turin, 1967.

Rylands 1992
Philip Rylands. *Palma Vecchio.* Cambridge Studies in the History of Art. Cambridge, 1992.

Ryskamp et al. 1996
Charles Ryskamp, Bernice F. Davidson, Susan Galassi, Edgar Munhall, and Nadia Tscherny. *Art in the Frick Collection: Paintings, Sculpture, Decorative Arts.* New York, 1996.

Sabar 1986–87
Shalom Sabar. "The Beginning of the *Ketubbah* Decoration in Italy: Venice in the Late Sixteenth to the Early Seventeenth Centuries." *Jewish Art* 13 (1986–87), pp. 96–110.

Sabbadini 1905
Remigio Sabbadini. *Le scoperte dei codici latini e greci ne' secoli XIV e XV.* Florence, 1905.

Salimbeni, *Epitalamio*, 1487
Angelo Michele Salimbeni. *Epitalamio nelle pompe nuziali di Annibale, figlio del principe Giovan Bentivoglio.* Bologna, 1487.

Saltini 1898
Guglielmo Enrico Saltini. *Bianca Cappello e Francesco I de' Medici.* Florence, 1898.

Salvini 1782
Salvino Salvini. *Catalogo cronologico de' canonici della chiesa metropolitana fiorentino, compilato l'anno 1751.* Florence, 1782.

Samuels 1976
Richard S. Samuels. "Benedetto Varchi, the *Accademia degli Infiammati*, and the Origins of the Italian Academic Movement." *Renaissance Quarterly* 29, no. 4 (Winter 1976), pp. 599–634.

J. Sander 2004
Jochen Sander. *Italienische Gemälde im Städel, 1300–1550.* [Vol. 2], *Oberitalien, die Marken und Rom.* Mainz am Rhein, 2004.

M. Sander 1929
Max Sander. "Ein Aretinofund." *Zeitschrift für Bücherfreunde*, n.s., 21 (1929), pp. 50–60.

Sani 2007
Elisa Paola Sani. "List of Works by or Attributable to Francesco Xanto Avelli." In Mallet 2007, App. C, pp. 190–203.

San Juan 2002
Rose Marie San Juan. "The Court Lady's Dilemma: Isabella d'Este and Art Collecting in the Renaissance." In *The Italian Renaissance: The Essential Readings*, edited by Paula Findlen, pp. 317–40. Blackwell Essential Readings in History. Malden, Mass., 2002.

Sanminiatelli 1967
Donato Sanminiatelli. *Domenico Beccafumi.* Antichi pittori italiani. Collana di studi monografici. Milan, 1967.

Sannipoli 2004
Ettore A. Sannipoli. "La ceramica (e le altre arti) a Gubbio nel Rinascimento: Per un repertorio dei decori, dei soggetti, dei temi iconografici." In *La ceramica umbra al tempo di Perugino*, edited by Giulio Busti and Franco Cocchi, pp. 50–65. Exh. cat., Museo Regionale della Ceramica di Deruta. Deruta, 2004.

Sansovino, *Venetia*, 1581
Francesco Sansovino. *Venetia: Città nobilissima et singolare.* Venice, 1581.

Sansovino, *Venetia*, 1968 (ed.)
Francesco Sansovino. *Venetia: Città nobilissima et singolare.* Venice, 1581. 1968 ed.: Repr., facsimile of 1663 ed., with additions by Giustiniano Martinioni and an index edited by Lino Morettii. Venice, 1968.

Santore 1997
Cathy Santore. "The Tools of Venus." *Renaissance Studies* 11, no. 3 (1997), pp. 179–207.

Santore 2000
Cathy Santore. "Picture versus Portrait." *Source: Notes in the History of Art* 19, no. 3 (Spring 2000), pp. 16–21.

Sanudo, *I diarii*, 1879–1903 (ed.)
Marin Sanudo. *I diarii di Marino Sanuto (MCCCCXCVI–MDXXXIII) dall'autografo Marciano ital. cl. VII codd. CDXIX–CDLXXVII.* Edited by Rinaldo Fulin et al. 58 vols. in 59. Venice, 1879–1903.

Saslow 1986
James M. Saslow. *Ganymede in the Renaissance: Homosexuality in Art and Society.* New Haven, 1986.

Saslow 1996
James M. Saslow. *The Medici Wedding of 1589: Florentine Festival as Theatrum Mundi.* New Haven, 1996.

Scappi, *Opera*, 2002 (ed.)
Bartolomeo Scappi. *Opera.* Venice, 1570. Repr., *Opera: Dell'arte del cucinare.* 2 vols. Testi antichi di gastronomia 12. Bologna, 2002.

Scarisbrick 1982
Diana Scarisbrick. "Forever Adamant: A Renaissance Diamond Ring." *Journal of the Walters Art Gallery* 40 (1982), pp. 57–64.

Scarisbrick 1998
Diana Scarisbrick. "The Diamond Love and Marriage Ring." In *The Nature of Diamonds*, edited by George E. Harlow, pp. 163–70. Cambridge, 1998.

Scarisbrick and Henig 2003
Diana Scarisbrick and Martin Henig. *Finger Rings: From Ancient to Modern.* Oxford, 2003.

Schäpers 1997
Petra Schäpers. *Die Junge Frau bei der Toilette: Ein Bildthema im venezianischen Cinquecento.* Bochumer Schriften zu Kunstgeschichte, 21. Frankfurt am Main, 1997.

Scheller 1995
Robert W. Scheller. *Exemplum. Model-Book Drawings and the Practice of Artistic Transmission in the Middle Ages (ca. 900–ca. 1470).* Translated by Michael Hoyle. Amsterdam, 1995.

Scher 1994
Stephen K. Scher. *The Currency of Fame: Portrait Medals of the Rennaissance.* Exh. cat., Frick Collection, New York; and National Gallery of Art, Washington, D.C. New York, 1994.

Schiaparelli 1908
Attilio Schiaparelli. *La casa fiorentina e i suoi arredi nei secoli XIV e XV.* Biblioteca storica del Rinascimento. Florence, 1908. [Repr., 2 vols. Edited by Maria Sframeli and Laura Pagnotta. Florence, 1983.]

Schiaparelli 1908/1983
Attilio Schiaparelli. *La casa fiorentina e i suoi arredi nei secoli XIV e XV.* Edited by Maria Sframeli and Laura Pagnotta. 2 vols. Florence, 1983. [1st ed., Biblioteca storica del Rinascimento. 1908.]

Schlosser 1899
Julius von Schlosser. "Die Werkstatt der Embriachi in Venedig." *Jahrbuch der kunsthistorischen Sammlungen des Allerhöchsten Kaiserhauses* 20 (1899), pp. 220–82.

R. Schmidt 1911
Robert Schmidt. "Die Venezianischen Emailgläser des XV. und XVI. Jahrhunderts." *Jahrbuch der Königlich Preuszischen Kunstsammlungen* 32 (1911), pp. 249–86.

R. Schmidt 1912
Robert Schmidt. *Das Glas.* Handbücher der Königlichen Museen zu Berlin [14]. Berlin, 1912.

S. K. K. Schmidt 2006
Suzanne Kathleen Karr Schmidt. "Art, a User's Guide: Interactive and Sculptural Printmaking in the Renaissance." Ph.D. diss., Yale University, 2006.

Schmitter 1995
Monika A. Schmitter. "Botticelli's Images of Simonetta Vespucci: Between Portrait and Ideal." *Rutgers Art Review* 15 (1995), pp. 33–57.

Schotmuller 1921
Frida Schotmuller. *Furniture and Interior Decoration of the Italian Renaissance.* New York, 1921.

Schrade 1956
Leo Schrade. "Les Fêtes du mariage de Francesco dei Medici et de Bianca Cappello." In *Les Fêtes de la Renaissance*, vol. 1, edited by Jean Jacquot, pp. 107–31. Collection Le Choeur des muses. Paris, 1956.

Schroder 2007
Timothy Schroder. *Renaissance Silver from the Schroder Collection.* Exh. cat., Wallace Collection. London, 2007.

Schubring 1915
Paul Schubring. *Cassoni: Truhen und Truhenbilder der italienischen Frührenaissance. Ein Beitrag zur Profanmalerei im Quattrocento.* 3 vols. Leipzig, 1915.

Schuler 1991
Carol M. Schuler. "The Courtesan in Art: Historical Fact or Modern Fantasy?" *Women's Studies* 19, no. 2 (1991), pp. 209–22.

Schulz 1998
Anne Markham Schulz. *Giammaria Mosca called Padovano: A Renaissance Sculptor in Italy and Poland.* 2 vols. University Park, Pa., 1998.

Scorza 1981
R. A. Scorza. "Vincenzo Borghini and *Invenzione*: The Florentine *Apparato* of 1565." *Journal of the Warburg and Courtauld Institutes* 44 (1981), pp. 57–75.

Scorza 1995
Rick Scorza. "Borghini and the Florentine Academies." In *Italian Academies of the Sixteenth Century*, edited by David S. Chambers and François Quiviger, pp. 137–52. Warburg Institute Colloquia 1. London, 1995.

Scorza 2003
Rick Scorza. "Vasari, Borghini and Michelangelo." In *Reactions to the Master: Michelangelo's Effect on Art and Artists in the Sixteenth Century*, edited by Francis Ames-Lewis and Paul Joannides, pp. 180–210. Aldershot, 2003.

Scott 1988
Joan Wallach Scott. *Gender and the Politics of History.* New York, 1988.

Sebastiano del Piombo 2008
Sebastiano del Piombo, 1485–1547. Exh. cat. by Claudio Strinati, Mauro Lucco, et al. Palazzo Venezia, Rome; and Gemaldegalerie, Berlin. Milan, 2008.

Secrest 2004
Meryle Secrest. *Duveen: A Life in Art.* New York, 2004.

Secular Spirit 1975
The Secular Spirit: Life and Art at the End of the Middle Ages. Exh. cat., The Cloisters, The Metropolitan Museum of Art. New York, 1975.

Segarizzi 1916
Arnaldo Segarizzi, ed. *Relazioni degli ambasciatori veneti al Senato.* Bari, 1916.

Seidel 1994
Max Seidel. "Hochzeitsikonographie im Trecento." *Mitteilungen des Kunsthistorischen Institutes in Florenz* 38 (1994), pp. 1–47.

Seidel Menchi 2001
Silvana Seidel Menchi. "Percorsi variegati, percorsi obbligati: Elogio del matrimonio pre-tridentino." In *Matrimoni in dubbio: Unioni controverse e nozze clandestine in Italia dal XIV al XVIII secolo*, edited by Silvana Seidel Menchi and Diego Quaglioni, pp. 17–60. I processi matrimoniali degli archivi ecclesiastici italiani 2. Annali dell'Istituto Storico Italo-Germanico in Trento, Quaderni 57. Bologna, 2001.

Seidel Menchi 2006
Silvana Seidel Menchi. "Cause matrimoniali e iconografia nuziale: Annotazioni in margine a una ricerca d'archivio." In Seidel Menchi and Quaglioni 2006, pp. 663–703.

Seidel Menchi and Quaglioni 2006
Silvana Seidel Menchi and Diego Quaglioni. *I tribunali del matrimonio (secoli XV–XVIII). I processi matrimoniali degli archivi ecclesiastici italiani 4*. Annali dell'Istituto Storico Italo-Germanico in Trento, Quaderno 68. Bologna, 2006.

Seidmann 1989
Gertrud Seidmann. "Jewish Marriage Rings." In *International Silver & Jewellery Fair & Seminar*, pp. 29–34. London, 1989.

Serra 1937
Luigi Serra. *L'antico tessuto d'arte italiano nella Mostra del Tessile Nazionale (Roma—1937–38-XVI)*. Rome, 1937.

Sgarbi 1985
Vittorio Sgarbi. *Antonio da Crevalcore e la pittura ferrarese del Quattrocento a Bologna*. Milan, 1985.

Shapiro 1967
Maurice L. Shapiro. "A Renaissance Birth Plate." *Art Bulletin* 43, no. 3 (September 1967), pp. 236–43.

Shapley 1966–67
Fern Rusk Shapley. *Paintings from the Samuel H. Kress Collection*. Vols. 1 and 2. London, 1966–67.

Shearman 1975
John Shearman. "The Collections of the Younger Branch of the Medici." *Burlington Magazine* 117 (January 1975), pp. 12–27.

Shearman 1992
John Shearman. *Only Connect . . . : Art and the Spectator in the Italian Renaissance*. Princeton, 1992.

Shearman 2003
John Shearman. *Raphael in Early Modern Sources (1483–1602)*. 2 vols. Römische Forschungen der Biblioteca Hertziana 30, 31. New Haven, 2003.

Shell 1998
Janice Shell. "Cecilia Gallerani: Una biografia." In *Leonardo: La dama con l'ermellino*, edited by Barbara Fabjan and Pietro C. Marani, pp. 51–65. Milan, 1998.

Shell and Sironi 1992
Janice Shell and Grazioso Sironi. "Cecilia Gallerani: Leonardo's *Lady with an Ermine*." *Artibus et historiae*, no. 25 (1992), pp. 47–66.

Shepard 1930
Odell Shepard. *The Lore of the Unicorn*. London, 1930.

Shoemaker and Broun 1981
Innis H. Shoemaker and Elizabeth Broun. *The Engravings of Marcantonio Raimondi*. Exh. cat., Spencer Museum of Art, Lawrence, Kansas; Ackland Art Museum, University of North Carolina, Chapel Hill; and Wellesley College Art Museum, Wellesley, Massachusetts. Lawrence, 1981.

Le Siècle de Titien 1993
Le Siècle de Titien: L'Âge d'or de la peinture à Venise. [1st ed.] Exh. cat., Galeries Nationales du Grand Palais. Paris, 1993.

Siena e Roma 2005
Siena e Roma: Raffaello, Caravaggio e i protagonisti di un legame antico. Exh. cat. by Bruno Santi et al. Santa Maria della Scala, Palazzo Squarcialupi. Siena, 2005.

Signorini 1996
Rodolfo Signorini. "New Findings about Andrea Mantegna: His Son Ludovico's Post-Mortem Inventory (1510)." *Journal of the Warburg and Courtauld Institutes* 59 (1996), pp. 103–18.

Simonneau 2007
Karinne Simonneau. "Diana, Callisto and Arcas: A Matrimonial Panel from the Springfield Museum of Fine Arts." *Renaissance Studies* 21, no. 1 (February 2007), pp. 44–61.

Simons 1985
Patricia Simons. "Portraiture and Patronage in

Quattrocento Florence, with Special Reference to the Tornaquinci and Their Chapel in S. Maria Novella." 2 vols. Ph.D. diss., University of Melbourne, 1985.

Simons 1992
Patricia Simons. "Women in Frames: The Gaze, the Eye, the Profile in Renaissance Portraiture." In *The Expanding Discourse: Feminism and Art History*, edited by Norma Broude and Mary D. Garrard, pp. 40–57. New York, 1992.

Simons 1995
Patricia Simons. "Portraiture, Portrayal, and Idealization: Ambiguous Individualism in Representations of Renaissance Women." In *Language and Images of Renaissance Italy*, edited by Alison Brown, pp. 263–311. Oxford, 1995.

La singolare dottrina di M. Domenico Romoli 1560
La singolare dottrina di M. Domenico Romoli sopranominato Panunto [sic], dell'ufficio dello scalco . . . Venice, 1560.

Sirén 1920
Osvald Sirén. "Lorenzo di Niccolò." *Burlington Magazine* 36 (February 1920), pp. 72–78.

Sitwell 1889
Frances Sitwell. "Types of Beauty in Renaissance and Modern Painting." *Art Journal*, n.s., 1889, pp. 5–11.

Van der Sman 1989
Gert Jan van der Sman. "Il 'Quatriregio': Mitologia e allegoria nel libro illustrato a Firenze intorno al 1500." *La bibliofilia* 91, no. 3 (1989), pp. 237–65.

Van der Sman 2007
Gert Jan Van der Sman. "Sandro Botticelli at Villa Tornabuoni and a Nuptial Poem by Naldo Naldi." *Mitteilungen des Kunsthistorischen Institutes in Florenz* 51, nos. 1 and 2 (2007), pp. 159–86.

Van der Sman forthcoming
Gert Jan van der Sman. *Lorenzo e Giovanna: Due vite fiorentine tra cronaca e arte*. Forthcoming.

A. Smith, Reeve, and Roy 1981
Alistair Smith, Anthony Reeve, and Ashok Roy. "Francesco del Cossa's 'S. Vincent Ferrer.'" *National Gallery Technical Bulletin* 5 (1981), pp. 45–57.

W. Smith 1961
Webster Smith. "Pratolino." *Journal of the Society of Architectural Historians* 20, no. 4 (December 1961), pp. 155–68.

W. Smith 1975
Webster Smith. "On the Original Location of the *Primavera*." *Art Bulletin* 57, no. 1 (March 1975), pp. 31–40.

Sofonisba Anguissola 1994
Sofonisba Anguissola e le sue sorelle. Exh. cat. by Mina Gregori et al. Centro Culturale, Cremona; Kunsthistorisches Museum, Vienna; and National Museum of Women in the Arts, Washington, D.C. Cremona, 1994.

Sommerville 1995
Margaret R. Sommerville. *Sex and Subjection: Attitudes to Women in Early-Modern Society*. London, 1995.

Sotheby's 1995
Important Old Master Paintings: The Property of the New-York Historical Society. Sotheby's, New York, sale cat., January 12, 1995.

Spallanzani 1974
Marco Spallanzani. "Il vaso Medici-Orsini di Detroit in un documento d'archivio." *Faenza* 60 (1974), pp. 88–90.

Spallanzani 1978
Marco Spallanzani. *Ceramiche orientali a Firenze nel Rinascimento*. Florence, 1978. [Repr., 1997.]

Spallanzani 1984
Marco Spallanzani. "Un 'fornimento' di maioliche di Montelupo per Clarice Strozzi de' Medici." *Faenza* 70 (1984), pp. 381–87.

Spallanzani 1986
Marco Spallanzani. "Maioliche di Valenza e di Montelupo in una casa pisana del 1480." *Faenza* 72 (1986), pp. 164–70.

Spallanzani 1990
Marco Spallanzani. "Medici Porcelain in the Collection of the Last Grand-Duke." *Burlington Magazine* 132 (May 1990), pp. 316–20.

Spallanzani 1994
Marco Spallanzani. *Ceramiche alle corte dei Medici nel Cinquecento*. Collezionismo e storia dell'arte, Studi e fonti 3. Modena, 1994.

Spallanzani 1999
Marco Spallanzani. "Maioliche con stemma Pucci e cappello cardinalizio." *Faenza* 85 (1999), pp. 71–83.

Spallanzani 2006
Marco Spallanzani. *Maioliche ispano-moresche a Firenze nel Rinascimento*. Florence, 2006.

Spallanzani and Gaeta Bertelà 1992
Marco Spallanzani and Giovanna Gaeta Bertelà, eds. *Libro d'inventario dei beni di Lorenzo il Magnifico*. Florence, 1992.

Sparti 1996
Barbara Sparti. "The Function and Status of Dance in the Fifteenth-Century Italian Courts." *Dance Research* 14, no. 1 (Summer 1996), pp. 42–61.

Spezzani 1995
Paolo Spezzani. "Le indagini radiografiche e riflettografiche." In *Tiziano* 1995, pp. 440–41.

Spiegel der Seligkeit 2000
Spiegel der Seligkeit: Privates Bild und Frömmigkeit im Spätmittelalter. Exh. cat. by Frank Matthias Kammel, Andreas Curtius, et al. Germanisches Nationalmuseum Nürnberg. Nuremberg, 2000.

Sricchia Santoro 1987
Fiorella Sricchia Santoro. "Il Peruzzi e la pittura senese del suo tempo." In *Baldassare Peruzzi: Pittura scena e architettura nel Cinquecento*, edited by Marcello Fagiolo and Maria Luisa Madonna, pp. 433–67. Biblioteca internazionale di cultura 20. Rome, 1987.

Sricchia Santoro 1988
Fiorella Sricchia Santoro, ed. *Da Sodoma a Marco Pino: Pittore a Siena nella prima metà del Cinquecento*. Exh. cat. by Fiorella Sricchia Santoro, Alessandro Angelini, et al. Palazzo Chigi Saracini, Siena. Florence, 1988.

Staccioli 1995
Sara Staccioli. "'Amor Sacro e Profano' nella Galleria Borghese." In *Tiziano* 1995, pp. 53–59.

Standen 1951
Edith Standen. "The Loom, the Needle, and the Printing Block." *The Metropolitan Museum of Art Bulletin*, n.s., 10, no. 4 (December 1951), pp. 123–33.

Starn and Partridge 1992
Randolph Starn and Loren Partridge. *Arts of Power: Three Halls of State in Italy, 1300–1600*. Berkeley, 1992.

Statius, *Silvae*, 2003 (ed.)
Statius. *Silvae*. Translated by David Roy Shackleton Bailey. The Loeb Classical Library. Cambridge, Mass., 2003.

Stechow 1932
Wolfgang Stechow. *Apollo und Daphne*. Studien der Bibliothek Warburg 23. Leipzig, 1932.

R. Steele 1900
Robert Steele. "A Notice of the Ludus Triumphorum and Some Early Italian Card Games; with Some

Remarks on the Origin of the Game of Cards."
Archaeologia 57 (1900), pp. 185–200.

B. D. Steele 1996
Brian D. Steele. "Water and Fire: Titian's *Sacred and Profane Love* and Ancient Marriage Customs." *Source: Notes in the History of Art* 15, no. 4 (Summer 1996), pp. 22–29.

Stefani 1993
Chiara Stefani. "Giacomo Franco." *Print Quarterly* 10, no. 3 (September 1993), pp. 269–73.

Stefani 1998
Chiara Stefani. "Franco, Giacomo." In *Dizionario biografico degli italiani*, vol. 50, pp. 181–84. Rome, 1998.

Steinberg 1968
Leo Steinberg. "Michelangelo's Florentine Pietà: The Missing Leg." *Art Bulletin* 50 (December 1968), pp. 343–53.

Steinberg 1983
Leo Steinberg. *The Sexuality of Christ in Renaissance Art and in Modern Oblivion*. New York, 1983.

Steinberg 1983/1996
Leo Steinberg. *The Sexuality of Christ in Renaissance Art and Modern Oblivion*. 2nd ed. Chicago, 1996. [1st ed., New York, 1983.]

Storey 2006
Tessa Storey. "Fragments from the 'Life Histories' of Jewellery belonging to Prostitutes in Early-Modern Rome." In *The Biography of the Object in Late Medieval and Renaissance Italy*, edited by Roberta J. M. Olson, Patricia L. Reilly, and Rupert Shepherd, pp. 67–77. Oxford, 2006.

Strauss 1980
Walter L. Strauss, ed. *Sixteenth Century German Artists*. Vol. 10, pt. 1, *Albrecht Durer*. The Illustrated Bartsch 10 (formerly vol. 7, pt. 1). New York, 1980.

Strehlke 1999
Carl Brandon Strehlke. "San Giovanni Valdarno: Scheggia." *Burlington Magazine* 141 (May 1999), pp. 314–15.

Strinati 2004
Claudio Strinati. *Raphael's "Fornarina."* Translated by Eve Sinaiko. Exh. booklet, Frick Collection, New York; Museum of Fine Arts, Houston; and Indianapolis Museum of Art. New York, 2004.

Strocchia 1992
Sharon T. Strocchia. *Death and Ritual in Renaissance Florence*. Baltimore, 1992.

Strong 1984
Roy Strong. *Art and Power: Renaissance Festivals, 1450–1650*. Berkeley, 1984.

Suetonius 1997–98 (ed.)
Suetonius. *Suetonius*. Translated by John Carew Rolfe. 2 vols. Rev. ed. The Loeb Classical Library. Cambridge, Mass., 1997–98.

Sullivan 1994
Ruth Wilkins Sullivan. "Three Ferrarese Panels on the Theme of 'Death Rather than Dishonour' and the Neapolitan Connection." *Zeitschrift für Kunstgeschichte* 57, no. 4 (1994), pp. 610–25.

Summers 1981
David Summers. *Michelangelo and the Language of Art*. Princeton, 1981.

Swarzenski 1947
Georg Swarzenski. "A Marriage Casket and Its Moral." *Bulletin of the Museum of Fine Arts* 45 (1947), pp. 55–62.

Syson 1997
Luke Syson. "Consorts, Mistresses, and Exemplary Women: The Female Medallic Portrait in Fifteenth-Century Italy." In *The Sculpted Object, 1400–1700*,

edited by Stuart Currie and Peta Motture, pp. 43–64. Aldershot, 1997.

Syson 1998
Luke Syson. "Circulating a Likeness? Coin Portraits in Late Fifteenth Century Italy." In *The Image of the Individual: Portraits in the Renaissance*, edited by Nicholas Mann and Luke Syson, pp. 113–25. London, 1998.

Syson 2002
Luke Syson. "Tura and the 'Minor Arts': The School of Ferrara." In *Cosmè Tura: Painting and Design in Renaissance Ferrara*, pp. 31–70. Exh. cat. by Stephen J. Campbell, with contributions by Luke Syson et al.; edited by Alan Chong. Isabella Stewart Gardner Museum, Boston. Milan and Boston, 2002.

Syson 2004
Luke Syson. "Leonardo and Leonardism in Sforza Milan." In *Artists at Court: Image-Making and Identity, 1300–1550*, edited by Stephen J. Campbell, pp. 106–23. Boston, 2004.

Syson 2006
Luke Syson "Representing Domestic Interiors." In Ajmar-Wollheim and Dennis 2006, pp. 86–101, 373–74.

Syson 2007a
Luke Syson. "Heroes and Heroines." In Syson et al. 2007, pp. 220–21.

Syson 2007b
Luke Syson. "Lo stile di una signoria: Il mecenatismo di Borso d'Este." In *Cosmè Tura e Francesco del Cossa: L'arte a Ferrara nell'età di Borso d'Este*, edited by Mauro Natale, pp. 75–88. Ferrara, 2007.

Syson and Gordon 2001
Luke Syson and Dillian Gordon, with contributions by Susanna Avery-Quash. *Pisanello: Painter to the Renaissance Court*. Exh. cat., National Gallery. London, 2001.

Syson and D. Thornton 2001
Luke Syson and Dora Thornton. *Objects of Virtue: Art in Renaissance Italy*. London, 2001.

Syson et al. 2007
Luke Syson et al. *Renaissance Siena: Art for a City*. Exh. cat., National Gallery. London, 2007.

Szabó 1975
George Szabó. *The Robert Lehman Collection: A Guide*. New York, 1975.

Szafran 1995
Yvonne Szafran. "Carpaccio's 'Hunting on the Lagoon': A New Perspective." *Burlington Magazine* 137 (May 1995), pp. 148–58.

Szépe 1991
Helena Katalin Szépe. "The *Poliphilo* and Other Aldines Reconsidered in the Context of the Production of Decorated Books in Venice." Ph.D. diss., Cornell University, 1991.

Szépe 1995
Helena Katalin Szépe. "The Book as Companion, the Author as Friend: Aldine Octavos Illuminated by Benedetto Bordon." *Word and Image* 11, no. 1 (January–March 1995), pp. 77–99.

Tait 1979
Hugh Tait. *The Golden Age of Venetian Glass*. Exh. cat., British Museum. London, 1979.

Tait 1981
Hugh Tait. *The Waddesdon Bequest*. London, 1981.

Tait 1991
Hugh Tait. *Five Thousand Years of Glass*. London, 1991.

Talvacchia 1994
Bette Talvacchia. "Professional Advancement and the Use of the Erotic in the Art of Francesco Xanto."

Sixteenth Century Journal 25, no. 1 (Spring 1994), pp. 121–53.

Talvacchia 1999
Bette Talvacchia. *Taking Positions: On the Erotic in Renaissance Culture*. Princeton, 1999.

Tátrai 1979
Vilmos Tátrai. "Il Maestro della Storia di Griselda e una famiglia senese di mecenati dimenticata." *Acta Historiae Artium* 25 (1979), pp. 27–66.

Telfer 2006
Alison Telfer, with Lyn Blackmore, Caroline Jackson, Jacqui Pearce, Lucy Whittingham, and Hugh Willmott. "Rich Refuse: A Rare Find of Late 17th-Century and Mid-18th-Century Glass and Tin-Glazed Wares from an Excavation at the National Gallery, London." *Journal of the Society for Post-Medieval Archaeology* 40, pt. 1 (2006), pp. 191–213.

Terence 2001 (ed.)
Terence. *Terence*. Edited and translated by John Barsby. 2 vols. The Loeb Classical Library. Cambridge, Mass., 2001.

Tessuti italiani del Rinascimento 1981
Tessuti italiani del Rinascimento: Collezioni Franchetti Carrand, Museo Nazionale del Bargello. Exh. cat., Palazzo Pretorio, Prato. Florence, 1981.

Tessuti serici italiani 1983
Tessuti serici italiani, 1450–1530. Exh. cat., Castello Sforzesco. Milan, 1983.

Thiébaut and Volle 1996
Dominique Thiébaut and Nathalie Volle. "Un Chef-d'Oeuvre restauré: Le *Portrait d'un Vieillard et d'un Jeune Garçon* de Domenico Ghirlandaio (1449–1494)." *Revue du Louvre et des musées de France* 3 (June 1996), pp. 42–53.

Thieme 1898
Ulrich Thieme. "Ein Porträt der Giovanna Tornabuoni von Domenico Ghirlandaio." *Zeitschrift für bildende Kunst*, n.s., 9 (May 1898), pp. 192–200.

Thieme and Becker 1907–50
Ulrich Thieme and Felix Becker, eds. *Allgemeines Lexikon der bildenden Künstler von der Antike bis zur Gegenwart*. 37 vols. Leipzig, 1907–50. [Repr., Munich, 1992.]

Thomas, *History of Italy*, 1963 (ed.)
William Thomas. *The History of Italy*. [1549.] Edited by George B. Parks. Folger Documents of Tudor and Stuart Civilization. Ithaca, N.Y., 1963.

Thompson 2007
Wendy Thompson. "Antonfrancesco Doni's *Medaglie*." *Print Quarterly* 24, no. 3 (September 2007), pp. 223–38.

Thompson 2008
Wendy Thompson. "A Fallacy Exposed: The True Subject of a Rare Print." *Burlington Magazine* 150 (March 2008), pp. 186–89.

D. Thornton 1997
Dora Thornton. *The Scholar in His Study: Ownership and Experience in Renaissance Italy*. New Haven, 1997.

D. Thornton and T. Wilson 2009
Dora Thornton and Timothy Wilson. *Italian Renaissance Ceramics: A Catalogue of the British Museum Collection*. British Museum. London, 2009.

P. Thornton 1991
Peter Thornton. *The Italian Renaissance Interior, 1400–1600*. New York, 1991.

P. Thornton 1998
Peter Thornton. *Form and Decoration: Innovation in the Decorative Arts, 1470–1870*. London, 1998.

Tiella 1975
Marco Tiella. "The Violeta of S. Caterina de' Vigri." *Galpin Society Journal* 28 (April 1975), pp. 60–70.

Tietze and Tietze-Conrat 1937
Hans Tietze and Erica Tietze-Conrat. "Contributi critici allo studio organico dei disegni veneziani del Cinquecento." *La critica d'arte*, no. 8 (April 1937), pp. 77–88.

Tietzel 1991
Brigitte Tietzel. "Neues vom 'Meister der Schafsnasen' Überlegungen zu dem New Yorker Doppelbildnis des Florentiner Quattrocento." *Wallraf-Richartz-Jahrbuch* 52 (1991), pp. 17–42.

Timmons 1997
Traci Elizabeth Timmons. "*Habiti Antichi et Moderni di Tutto il Mondo* and the 'Myth of Venice.'" *Athanor* 15 (1997), pp. 28–33.

Tinagli 1997
Paola Tinagli. *Women in Italian Renaissance Art: Gender, Representation, and Identity*. Manchester, 1997.

Tinagli 2004
Paola Tinagli. "Eleonora and Her 'Famous Sisters': The Tradition of 'Illustrious Women' in Paintings for the Domestic Interior." In *The Cultural World of Eleonora di Toledo: Duchess of Florence and Siena*, edited by Konrad Eisenbichler, pp. 119–35. Aldershot, 2004.

Tintoretto 1994
Jacopo Tintoretto: Portraits. Exh. cat., Galleria dell'Accademia, Venice; and Kunsthistorisches Museum, Vienna. Milan, 1994.

Titien 2006
Titien: Le pouvoir en face. Exh. cat. edited by Patrizia Nitti, Tullia Carratù, and Morena Costantini. Museé du Luxembourg, Paris. Milan, 2006.

Tiziano 1995
Tiziano: Amor Sacro e Amor Profano. Exh. cat. edited by Maria Grazia Bernardini. Palazzo delle Esposizioni, Rome. Milan, 1995.

Tiziano 2006
Tiziano e il ritratto di corte da Raffaello ai Carracci. Exh. cat., Museo di Capodimonte. Naples, 2006.

Toderi and Vannel 2000
Giuseppe Toderi and Fiorenza Vannel. *Le medaglie italiane del XVI secolo*. 3 vols. Florence, 2000.

Toesca 1912
Pietro Toesca. *La pittura e la miniatura nella Lombardia, dai più antichi monumenti alla metà del Quattrocento*. Milan, 1912.

Toesca 1920
Pietro Toesca. "Una scatola dipinta da Domenico di Bartolo." *Rassegna d'arte senese*, no. 13 (1920), pp. 107–8.

Toledano 1987
Ralph Toledano. *Francesco di Giorgio Martini: Pittore e scultore*. Milan, 1987.

Tomory 1976
Peter Tomory. *Catalogue of the Italian Paintings before 1800*. John and Mable Ringling Museum of Art. Sarasota, Fla., 1976.

Topsell, *Foure-Footed Beastes*, 1967 (ed.)
Edward Topsell. *The Historie of Foure-Footed Beastes: Describing the True and Lively Figure of Every Beast* London, 1607. 1967 ed.: *The History of Four-Footed Beasts and Serpents*. New York, 1967.

Torriti (Paolo) 1998
Paolo Torriti. "'Domenico D'Jacomo Pacie Beccafumi detto Mecherino. Pittore, Bronzista, Intagliatore, musaicita, Intarsiatore, Platico, ec.'" In Torriti (Piero) et al. 1998, pp. 27–36.

Torriti (Piero) et al. 1998
Piero Torriti et al. *Beccafumi*. Milan, 1998.

Trapp 2001
J. B. Trapp. "Petrarch's Laura: The Portraiture of an Imaginary Beloved." *Journal of the Warburg and Courtauld Institutes* 64 (2001), pp. 35–192.

Trionfi e canti carnascialeschi 1986
Trionfi e canti carnascialeschi toscani del Rinascimento. 2 vols. Edited by Riccardo Bruscagli. Rome, 1986.

Triumph of Humanism 1977
The Triumph of Humanism: A Visual Survey of the Decorative Arts of the Renaissance. Exh. cat. with contributions by David Graeme Keith et al. California Palace of the Legion of Honor. San Francisco, 1977.

Tufte 1970
Virginia Tufte. *The Poetry of Marriage: The Epithalamium in Europe and Its Development in England*. University of Southern California Studies in Comparative Literature 2. Los Angeles, 1970.

Turner 1987
James Grantham Turner. *One Flesh: Paradisal Marriage and Sexual Relations in the Age of Milton*. Oxford, 1987.

Turner 1993
James Grantham Turner, ed. *Sexuality and Gender in Early Modern Europe: Institutions, Texts, Images*. Cambridge, 1993.

Turner 2003a
James Grantham Turner. *Schooling Sex: Libertine Literature and Erotic Education in Italy, France, and England, 1534–1685*. Oxford, 2003.

Turner 2003b
James Grantham Turner. "Waldeck Continued." *Print Quarterly* 20, no. 4 (December 2003), pp. 387–88.

Turner 2004
James Grantham Turner. "Marcantonio's Lost *Modi* and Their Copies." *Print Quarterly* 21 (2004), pp. 363–84.

Turner 2007a
James Grantham Turner. "Caraglio's *Loves of the Gods.*" *Print Quarterly* 24, no. 4 (December 2007), pp. 359–80.

Turner 2007b
James Grantham Turner. "Leda among the *Modi*?" *Print Quarterly* 24, no. 3 (September 2007), pp. 278–81.

Turner 2007c
James Grantham Turner. "Salviati's Phallic Triumph." *Print Quarterly* 24, no. 3 (September 2007), pp. 284–86.

Turner 2008
James Grantham Turner. "Standing Bronzes, Riccio, and *I Modi*." *Source: Notes in the History of Art* 27 (2008).

Turner forthcoming
James Grantham Turner. "Woodcut Copies after the *Modi*." *Print Quarterly*. Forthcoming.

Uguccioni 1988
Alessandra Uguccioni. *Salomone e la regina di Saba: La pittura di cassone a Ferrara presenze nei musei americani*. Arte e grafica. Ferrara, 1988.

Uguccioni 1990
Alessandra Uguccioni. "La danza nella pittura di cassone." In *Guglielmo Ebreo e la danza nelle corti italiane el XV secolo: Atti del convegno internazionale di studi, Pesaro, 16–18 lugio 1987*, edited by Maurizio Padovan, pp. 235–50. Pisa, 1990.

Unglaub 2007
Jonathan Unglaub. "Bernardo Accolti, Raphael's 'Parnassus' and a New Portrait by Andrea del Sarto." *Burlington Magazine* 149 (January 2007), pp. 14–22.

Uzielli 1896
Gustavo Uzielli. *Ricerche intorno a Leonardo da Vinci*. 2nd ed. Turin, 1896. [1st ed., 1884.]

Vaccaro 2000
Mary Vaccaro. "Beauty and Identity in Parmigianino's Portraits." In *Fashioning Identities in Renaissance Art*, edited by Mary Rogers, pp. 107–17. Aldershot, 2000.

Vaccaro 2002
Mary Vaccaro. *Parmigianino: The Paintings*. Archives of Pre 1800 Art. Turin, 2002.

Valcanover and Pignatti 1985
Francesco Valcanover and Terisio Pignatti. *Tintoretto*. Translated by Robert Reich Wolf. The Library of Great Painters. New York, 1985.

Valentiner 1926
W. R. Valentiner. *A Catalogue of Early Italian Paintings*. Exh. cat., Duveen Galleries, 1924. New York, 1926.

Valentiner 1942
W. R. Valentiner. "Laurana's Portrait Busts of Women." *Art Quarterly* 5 (1942), pp. 272–99.

Valeriano, *Hieroglyphica*, 1575
Giovanni Pierio Valeriano. *Hieroglyphica*. Basel, 1575.

Valerius Maximus, *Memorable Doings*, 2000 (ed.)
Valerius Maximus. *Memorable Doings and Sayings*. Edited and translated by David Roy Schackleton Bailey. 2 vols. The Loeb Classical Library. Cambridge, Mass., 2000.

Vannel and Toderi 2003
Fiorenza Vannel and Giuseppe Toderi. *Medaglie italiane del Museo Nazionale del Bargello*. Vol. 1, *Secoli XV–XVI*. Florence, 2003.

Vannugli 1988
Antonio Vannugli. "Una 'Vestale Tuccia': '*Pudicitiae Testimonium*' del Moretto in Palazzo Taverna a Roma." *Bollettino d'arte* 47 (January–February 1988), pp. 85–90.

Vanzolini 1879
Giuliano Vanzolini, ed. *Istorie delle fabbriche di majoliche metaurensi*. 2 vols. Pesaro, 1879.

Varese 1989
Ranieri Varese, ed. *Atlante di Schifanoia*. Ferrara, 1989.

Vasari, *Lives*, 1568/1912–14 (ed.)
Giorgio Vasari. *Le vite de' più eccellenti pittori, scultori ed architettori*. 2nd ed. 3 vols. Florence, 1568. 1912–14 ed.: *Lives of the Most Eminent Painters, Sculptors and Architects*. Translated by Gaston du C. de Vere. 10 vols. London, 1912–14.

Vasari, *Lives*, 1568/1996 (ed.)
Giorgio Vasari. *Le vite de' più eccellenti pittori, scultori ed architettori*. 2nd ed. 3 vols. Florence, 1568. 1996 ed.: *Lives of the Painters, Sculptors and Architects*. Translated by Gaston du C. de Vere. Edited by David Ekserdjian. 2 vols. New York, 1996.

Vasari, *Technique*, 1568/1907(ed.)
Giorgio Vasari. *Vasari on Technique; Being the Introduction to the Three Arts of Design, Architecture, Sculpture and Painting, Prefixed to the Lives of the Most Excellent Painters, Sculptors and Architects*. [1568.] Translated by Louisa S. Maclehose. London, 1907.

Vasari, *Le vite*, 1550/1986 (ed.)
Giorgio Vasari. *Le vite de' più eccellenti architetti, pittori, et scultori italiani, da Cimabue insino a' tempi nostri*. Florence, 1550. 1986 ed.: Edited by Luciano Bellosi and Aldo Rossi. I millenni. Turin, 1986.

Vasari, *Le vite*, 1568/1878–85 (ed.)
Giorgio Vasari. *Le vite de' più eccellenti pittori, scultori ed architettori*. 2nd ed. 3 vols. Florence, 1568. 1878–85 ed.: Edited by Gaetano Milanesi. 9 vols. Florence, 1878–85.

Vasari, *Le vite*, 1568/1906 (ed.)
Giorgio Vasari. *Le vite de' più eccellenti pittori, scultori ed architettori*. 2nd ed. 3 vols. Florence, 1568. 1906 ed.: Edited by Gaetano Milanesi. 9 vols. Florence, 1906.

Vavassore, *Esemplario di lavori*, 1910 (ed.)
Giovanni Andrea Vavassore, called Guadagnino. *Esemplario di lavori: Che insegna alle donne il modo e ordine di lavorare*. Venice, [1530]. 1910 ed.: Edited by

Elisa Ricci. Libri antichi di modelli riprodotti a fac-simile, ser. 1a, Merletti e ricami 5. Bergamo, 1910.

Vecellio, *De gli habiti antichi*, 1590
Cesare Vecellio. *De gli habiti antichi et moderni di diverse parti del mondo libri due.* Venice, 1590.

Vecellio, *Habiti antichi*, 1598
Cesare Vecellio. *Habiti antichi et moderni di tutto il mondo.* Venice, 1598.

Ventrone 1992
Paola Ventrone, ed. *Les Tems revient, 'l tempo si rinuova: Feste e spettacoli nella Firenze di Lorenzo il Magnifico.* Exh. cat., Palazzo Medici Riccardi. Florence, 1992.

Venturi 1885
Adolfo Venturi. "Relazione artistiche tra le corti di Milano e Ferrara nel secolo XV." *Archivio storico lombardo*, 2nd ser., 2 (1885), pp. 225–80.

Venturi 1887–88
Adolfo Venturi. "L'arte ferrarese nel periodo di Ercole I d'Este II." *Atti e memorie della Regia Deputazione di Storia Patria per le Provincie di Romagna*, no. 6 (1887–88), pp. 350–422.

Venturi 1914
Adolfo Venturi. *Storia dell'arte italiana.* Vol. 7, pt. 3, *La pittura del Quattrocento.* Milan, 1914. [Repr., 1967.]

***Venus* 2001**
Venus: Bilder einer Göttin. Exh. cat., Alte Pinakothek. Munich, 2001.

Verheyen 1968
Egon Verheyen. "Der Sinngehalt von Giorgiones 'Laura.'" *Pantheon* 26 (May–June 1968), pp. 220–27.

Vertova 1979
Luisa Vertova. "Cupid and Psyche in Renaissance Painting before Raphael." *Journal of the Warburg and Courtauld Institutes* 42 (1979), pp. 104–21.

Vertova 1980
Luisa Vertova. "Bernardino Licinio." In *I pittori bergamaschi dal XIII al XIX secolo: Il Cinquecento*, vol. 1, pp. 373–467. Bergamo, 1980.

Vertova 1993
Luisa Vertova. "La fortuna della favola di Psiche da Cosimo Pater Patriae al Gran Principe Ferdinando de' Medici." In *Giuseppe Maria Crespi nei musei fiorentini*, pp. 27–62. Gli Uffizi, Studi e ricerchi 11. Exh. cat., Galleria degli Uffizi. Florence, 1993.

Vignali, *La cazzaria*, 2003 (ed.)
Antonio Vignali. *La cazzaria: The Book of the Prick.* Edited, translated, and with introduction by Ian Frederick Moulton. New York, 2003.

Vila-Chá 2006
João J. Vila-Chá. *Amor Intellectualis? Leone Ebreo (Judah Abravanel) and the Intelligibility of Love.* Colecçáo filosofia 32. Braga, 2006.

***Visconti Tarocchi Deck* 1984**
Cary-Yale Visconti Tarocchi Deck. Introduction by Stuart R. Kaplan. Stamford, 1984.

Viti 1982
Paolo Viti. "I volgarizzamenti di Alessandro Braccesi dell' 'Historia de Duobus Amantibus' di Enea Silvio Piccolomini." *Esperienze letterarie* 7, no. 3 (July–September 1982), pp. 49–68.

Vives, *De l'istituzione de la femina christiana*, 1546
Juan Luis Vives. *De l'istituzione de la femina christiana, vergine, maritata, ò vedova. De lo ammaestrare i fanciulli ne le arti liberali* Venice, 1546.

Vives, *Education of a Christian Woman*, 2000 (ed.)
Juan Luis Vives. *The Education of a Christian Woman: A Sixteenth-Century Manual.* Edited and translated by Charles Fantazzi. The Other Voice in Early Modern Europe. Chicago, 2000. [Translation of *De Institutione Femine Christianae*, 1523; translated into Italian, 1546.]

Voelkle and Wieck 1992
William M. Voelkle and Roger S. Wieck, with the assistance of Maria Francesca P. Saffiotti. *The Bernard H. Breslauer Collection of Manuscript Illuminations.* New York, 1992.

Volpe 1958
Carlo Volpe. "Tre vetrate ferraresi e il Rinascimento a Bologna." *Arte antica e moderna*, no. 1, pp. 23–37. [Reprinted in Carlo Volpe, *La pittura nell'Emilia e nella Romagna: Raccolta di scritti sul Trecento e Quattrocento*, edited by Daniele Benati and Lucia Peruzzi, pp. 152–68. Modena, 1993.]

Waagen 1854
Gustav Friedrich Waagen. *Treasures of Art in Great Britain: Being an Account of the Chief Collections of Paintings, Drawings, Sculptures, Illuminated Mss., &c., &c.* 3 vols. London, 1854.

Waagen 1857
Gustav Friedrich Waagen. *Galleries and Cabinets of Art in Great Britain: Being an Account of More Than Forty Collections of Paintings, Drawings, Sculptures, Mss., &c. &c. Visited in 1854 and 1856, and Now for the First Time Described.* London, 1857.

Wackernagel 1938/1981
Martin Wackernagel. *The World of the Florentine Renaissance Artist: Projects and Patrons, Workshop and Art Market.* Translated by Alison Luchs. Princeton, 1981. [Translation of *Der Lebensraum des Künstlers in der florentinischen Renaissance.* Leipzig, 1938.]

Waddington 1989
Raymond B. Waddington. "A Satirist's *Impresa*: The Medals of Pietro Aretino." *Renaissance Quarterly* 42, no. 4 (Winter 1989), pp. 655–81.

Waddington 2000
Raymond B. Waddinton. Review of Talvacchia 1999. *Sixteenth Century Journal* 31, no. 3 (2000), pp. 885–87.

Waddington 2004
Raymond B. Waddington. *Aretino's Satyr: Sexuality, Satire, and Self-Projection in Sixteenth-Century Literature and Art.* Toronto, 2004.

Wald 2002
Robert Wald. "Parmigianino's *Cupid Carving His Bow*: History, Examination, Restoration." In *Parmigianino e il manierismo europeo: Atti del convegno internazionale di studi, Parma, 13–15 giugno 2002*, edited by Lucia Fornari Schianchi, pp. 165–81. Biblioteca d'arte 3. Milan, 2002.

Wald 2008
Robert Wald. "Titian's Vienna 'Danae': On Execution and Replication in Titian's Studio." In Ferino-Pagden 2008, pp. 125–33.

Waldman 2000
Louis Alexander Waldman. "'The Modern Lysippus': A Roman Quattrocento Medalist in Context." In *Perspectives on the Renaissance Medal*, edited by Stephen K. Scher, pp. 97–113. New York, 2000.

A. Walker 2002
Alicia Walker. "Myth and Magic in Early Byzantine Marriage Jewelry: The Persistence of Pre-Christian Traditions." In *The Material Culture of Sex, Procreation, and Marriage in Premodern Europe*, edited by Anne L. McClanan and Karen Rosoff Encarnación, pp. 59–78. New York, 2002.

J. Walker 1967
John Walker. "*Ginevra de' Benci* by Leonardo da Vinci." *Report and Studies in the History of Art* 1 (1967), pp. 1–38.

Wallace, Kemp, and Bernstein 2007
Marina Wallace, Martin Kemp, and Joanne Bernstein. *Seduced: Art and Sex from Antiquity to Now.* London, 2007.

Walter and Zapperi 2006
Ingeborg Walter and Roberto Zapperi. *Il ritratto dell'amata: Storie d'amore da Petrarca a Tiziano.* Saggi; Arte e lettere. Rome, 2006.

***Walters Collection* 1922**
The Walters Collection. [2nd ed.] Baltimore, 1922.

Warburg 1905
Aby Warburg. "Delle 'Imprese Amorose' nelle più antiche incisioni fiorentine." *Rivista d'arte* 3, nos. 7–8 (July–August 1905), App., pp. 1–15.

Warburg 1907/1999
Aby Warburg. "Francesco Sassettis letztwillige Verfügung." In *Kunstwissenschaftliche Beiträge August Schmarsow gewidmet zum fünfzigsten Semester seiner akademischen Lehrtätigkeit*, pp. 129–52. Leipzig, 1907. Reprinted in translation as "Francesco Sassetti's Last Injunctions to His Sons." In Aby Warburg, *The Renewal of Pagan Antiquity: Contributions to the Cultural History of the European Renaissance*, pp. 223–62, 451–66. Introduction by Kurt W. Forster. Translated by David Britt. Los Angeles, 1999.

Ward 1981
Ann Ward, ed. *The Ring: From Antiquity to the Twentieth Century.* London, 1981.

Warner 1985
Marina Warner. *Monuments & Maidens: The Allegory of the Female Form.* London, 1985.

Warnke 1992
Martin Warnke. *The Court Artist: On the Ancestry of the Modern Artist.* Translated by David McLintock. Ideas in Context. Cambridge, 1992.

Warnke 1998
Martin Warnke. "Individuality as Argument: Piero della Francesca's Portrait of the Duke and Duchess of Urbino." In *The Image of the Individual: Portraits in the Renaissance*, edited by Nicholas Mann and Luke Syson, pp. 81–90, 213–15. London, 1998.

Warren 1999
Jeremy Warren. *Renaissance Master Bronzes from the Ashmolean Museum, Oxford: The Fortnum Collection.* Exh. cat., Daniel Katz Gallery. London, 1999.

Warren 2001
Jeremy Warren. "'The Faun Who Plays on the Pipes': A New Attribution to Desiderio da Firenze." In *Small Bronzes in the Renaissance*, edited by Debra Pincus, pp. 83–103. Studies in the History of Art (National Gallery of Art), vol. 62. Symposium Papers 39. Washington, D.C., 2001.

Warren 2007
Jeremy Warren. "Gaspare Fantuzzi: A Patron of Sculpture in Renaissance Bologna." *Burlington Magazine* 149 (December 2007), pp. 831–35.

Warren forthcoming
Jeremy Warren. *Catalogue of European Sculpture in the Ashmolean Museum: Sculpture, Mainly Up to 1540.* 3 vols. Forthcoming.

Waterhouse 1952
E. K. Waterhouse. "Paintings from Venice for Seventeenth-Century England: Some Records of a Forgotten Transaction." *Italian Studies* 7 (1952), pp. 1–23.

P. F. Watson 1970
Paul F. Watson. "Virtù and Voluptas in Cassone Painting." Ph.D. diss., Yale University, 1970.

P. F. Watson 1974a
Paul F. Watson. "A Desco da Parto by Bartolomeo di Fruosino." *Art Bulletin* 56, no. 1 (March 1974), pp. 4–9.

P. F. Watson 1974b
Paul F. Watson. "The Queen of Sheba in Christian

Tradition." In *Solomon and Sheba*, edited by James B. Pritchard, pp. 115–45. New York, 1974.

P. F. Watson 1979
Paul F. Watson. *The Garden of Love in Tuscan Art of the Early Renaissance.* Philadelphia, 1979.

P. F. Watson and Kirkham 1975
Paul F. Watson and Victoria Kirkham. "Amore e Virtù: Two Salvers Depicting Boccaccio's 'Comedia delle Ninfe Fiorentine' in the Metropolitan Museum." *Metropolitan Museum Journal* 10 (1975), pp. 35–50.

W. M. Watson 1986
Wendy M. Watson. *Italian Renaissance Maiolica from the William A. Clark Collection.* Exh. cat., Corcoran Gallery of Art, Washington, D.C.; and Mount Holyoke College Art Museum, South Hadley, Massachusetts. Washington, D.C., 1986.

W. M. Watson 2001
Wendy M. Watson. *Italian Renaissance Ceramics from the Howard I. and Janet H. Stein Collection and the Philadelphia Museum of Art.* Exh. cat., Philadelphia Museum of Art. Philadelphia, 2001.

Waźbiński 1987
Zygmunt Waźbiński. "'…Un [quadro] da camera di Venere e Cupido' di Paris Bordon per il Duca Francesco di Lorena." In *Paris Bordon* 1987, pp. 109–18.

Weddigen 1994
Erasmus Weddigen. *Des Vulkan Paralleles Wesen: Dialog über einen Ehebruch mit einem Glossar zu Tintorettos "Vulkan überrascht Venus und Mars."* Munich, 1994.

Weddigen 1996
Erasmus Weddigen. "Nuovi percorsi di avvicinamento a Jacopo Tintoretto: Venere, Vulcano e Marte. L'inquisizione dell'informatica." In *Jacopo Tintoretto nel quarto centenario della morte: Atti del convegno internazionale di studi (Venezia, 24–26 novembre 1994),* edited by Paola Rossi and Lionello Puppi, pp. 155–61. Quaderni di Venezia arti 3. Padua, 1996.

Wegner 2008
Susan E. Wegner. *Beauty & Duty: The Art and Business of Renaissance Marriage.* Exh. cat., Museum of Art, Bowdoin College. Brunswick, Maine, 2008.

Wehle 1940
Harry B. Wehle. *A Catalogue of Paintings.* Vol. 1, *Italian, Spanish and Byzantine Paintings.* The Metropolitan Museum of Art. New York, 1940.

Weibel 1952
Adèle Coulin Weibel. *Two Thousand Years of Textiles: The Figured Textiles of Europe and the Near East.* New York, 1952.

Weinstein 2004
Roni Weinstein. *Marriage Rituals Italian Style: A Historical Anthropological Perspective on Early Modern Italian Jews.* Brill's Series in Jewish Studies 35. Leiden, 2004.

Weisbach 1901
Werner Weisbach. *Francesco Pesellino un die Romantik der Renaissance.* Berlin, 1901.

Weisbach 1913
Werner Weisbach. "Eine Darstellung der letzten deutschen Kaiserkrönung in Rome." *Zeitschrift für bildende Kunst,* n.s., 24 (1913), pp. 262–64.

Welch 1995
Evelyn S. Welch. *Art and Authority in Renaissance Milan.* New Haven, 1995.

Welch 2005
Evelyn S. Welch. *Shopping in the Renaissance: Consumer Cultures in Italy, 1400–1600.* New Haven, 2005.

Welch forthcoming
Evelyn S. Welch. "Art on the Edge: Hair, Hats and Hands in Renaissance Italy." *Renaissance Studies.* Forthcoming.

Weppelmann 2007
Stefan Weppelmann. "Lorenzo di Niccolò e la bottega del 'Maestro del 1416.'" In *Intorno a Lorenzo Monaco: Nuovi studi sulla pittura tardogotica,* edited by Daniela Parenti and Angelo Tartuferi, pp. 106–21. Papers presented at the conference "Intorno a Gentile da Fabriano e a Lorenzo Monaco: Nuovi studi sulla pittura tardogotica," held at the Oratorio della Carità, Fabriano, May 31, 2006; the Palazzo Trinci, Foligno, June 1, 2006, and the Kunsthistorisches Institut, Florence, June 2–3, 2006. Livorno, 2007.

Wesche 2008
Markus Wesche. "Lysippus Unveiled: A Renaissance Medallist in Rome and His Humanist Friends." *Medal* 52 (Spring 2008), pp. 4–13.

Wescher 1931
Paul Wescher. *Beschreibendes Verzeichnis der miniaturen Handschriften und Einzelblätter des Kupferstichkabinetts der Staatlichen Museen Berlin.* Leipzig, 1931.

Westerman Bulgarella 1993
Mary Westerman Bulgarella. "Cappotto." In *Moda alla corte dei Medici: Gli abiti restaurati di Cosimo, Eleonora e don Garzia,* pp. 92–96. Exh. cat., Palazzo Pitti. Florence, 1993.

Westerman Bulgarella 1996–97
Mary Westerman Bulgarella. "Un damasco mediceo: Ricerche sulla sua origine, significato, e uso nella pittura fiorentina." *Jacquard* 30 (1996–97), pp. 2–6, 13.

Wethey 1969–75
Harold E. Wethey. *The Paintings of Titian: Complete Edition.* 3 vols. London, 1969–75.

Wharton 2005
Stephen Wharton. "Man, Myth and Manuscript: Towards a Critical Re-Examination of the Work of Cipriano Piccolpasso (1523–1579)." Ph.D. diss., University of Sussex, 2005.

Whistler 1992
Laurence Whistler. *Point Engraving on Glass.* London, 1992.

Whitaker and Clayton 2007
Lucy Whitaker and Martin Clayton, with contributions by Aislinn Loconte. *The Art of Italy in the Royal Collection: Renaissance and Baroque.* Exh. cat., The Queen's Gallery. London, 2007.

Whitehouse 2004
David Whitehouse. Foreword to *Beyond Venice: Glass in Venetian Style, 1500–1750.* Exh. cat. by Jutta-Annette Page, with contributions by Ignasi Doménech, Alexandra Gaba-Van Dongen, Reino Liefkes, Marie-Laure de Rochebrune, and Hugh Willmott. Corning Museum of Glass. Corning, N.Y., 2004.

Wilde 1931
Johannes Wilde. "Ein unbeachtetes Werk Giorgiones." *Jahrbuch der Presussischen Kunstsammlungen* 52 (1931), pp. 91–102.

Wilde 1934
Johannes Wilde. "Über einige venezianische Frauenbildnisse der Renaissance." In *Hommage à Alexis Petrovics,* pp. 206–12. Budapest, 1934.

Wilk 1986
Sarah Blake Wilk. "Donatello's *Dovizia* as an Image of Florentine Political Propaganda." *Artibus et Historiae,* no. 14 (1986), pp. 9–28.

Wilkins 1983
David G. Wilkins. "Donatello's Lost *Dovizia* for the Mercato Vecchio: Wealth and Charity as Florentine Civic Virtues." *Art Bulletin* 65 (1983), pp. 401–23.

B. Wilson 2005
Bronwen Wilson. *The World in Venice: Print, The City, and Early Modern Identity.* Studies in Book and Print Culture. Toronto, 2005.

C. C. Wilson 1996
Carolyn C. Wilson. *Italian Paintings, XIV–XVI Centuries, in the Museum of Fine Arts, Houston.* Houston, 1996.

T. Wilson 1984
Timothy Wilson. "Some Medici Devices on Pottery." *Faenza* 70 (1984), pp. 433–40.

T. Wilson 1987
Timothy Wilson, with the collaboration of Patricia Collins, and an essay by Hugo Blake. *Ceramic Art of the Italian Renaissance.* Exh. cat., British Museum. London, 1987.

T. Wilson 1989a
Timothy Wilson. *Maiolica: Italian Renaissance Ceramics in the Ashmolean Museum.* Oxford, 1989.

T. Wilson 1989b
Timothy Wilson. "Maioliche rinascimentali armoriate con stemmi fiorentini." In *L'araldica: Fonti e metodi; Atti del convegno internazionale di Campiglia Marittima, 6–8 marzo 1987,* pp. 128–38. Florence, 1989.

T. Wilson 1993
Timothy Wilson. "Renaissance Ceramics." In Rudolf Distelberger et al., *Western Decorative Arts, Part 1: Medieval, Renaissance, and Historicizing Styles including Metalwork, Enamels, and Ceramics,* pp. 119–263. Systematic Catalogue of the Collections of the National Gallery of Art. Washington, D.C., and Cambridge, 1993.

T. Wilson 1996a
Timothy Wilson. "The Beginnings of Lustreware in Renaissance Italy." In *The International Ceramics Fair and Seminar: 14, 15, 16, 17th June 1996,* pp. 35–43. London, 1996.

T. Wilson 1996b
Timothy Wilson. *Italian Maiolica of the Renaissance.* Parnassus 1. Milan, 1996.

T. Wilson 1999
Timothy Wilson. "Italian Maiolica around 1500: Some Considerations on the Background to Antwerp Maiolica." In *Maiolica in the North: The Archaeology of Tin-Glazed Earthenware in North-west Europe, c. 1500–1600,* edited by David Gaimster, pp. 5–21. British Museum Occasional Paper, 122. London, 1999.

T. Wilson 2002a
Timothy Wilson. "Italian Maiolica in the Wernher Collection." *Apollo* 155 (May 2002), pp. 35–39.

T. Wilson 2002b
Timothy Wilson. "Il servizio siglato 'S', eseguito nella bottega di Maestro Giorgio negli anni 1524–25." In Bojani 2002, pp. 113–24.

T. Wilson 2003a
Timothy Wilson. "Faenza Maiolica Services of the 1520s for the Florentine Nobility." In *Raphael, Cellini, and a Renaissance Banker: The Patronage of Bindo Altoviti,* edited by Alan Chong, Donatella Pegazzano, and Dimitrios Zikos, pp. 174–86, 393–94. Exh. cat., Isabella Stewart Gardner Museum, Boston; and Museo Nazionale del Bargello, Florence. Boston, 2003.

T. Wilson 2003b
Timothy Wilson. "*Poca differenza . . .*: Some Warnings against Over-confident Attributions of Renaissance Maiolica from the Duchy of Urbino." *Faenza* 89 (2003), pp. 150–75.

T. Wilson 2004
Timothy Wilson. "Il ruolo di Deruta nello sviluppo della maiolica istoriata." In Busti and Cocchi 2004, pp. 38–49.

T. Wilson 2005a
Timothy Wilson. "Un 'intricamento' tra Leonardo ed Arcimboldo." *CeramicAntica* 15 (February 2005), pp. 10–44.

T. Wilson 2005b
Timothy Wilson. "Some *Incunabula* of *Istoriato*-Painting from Pesaro." *Faenza* 91 (2005), pp. 8–24.

T. Wilson and Sani 2006–7
Timothy Wilson and Elisa Paola Sani. *Le maioliche rinascimentali nelle collezioni della Fondazione Cassa di Risparmio di Perugia.* 2 vols. Perugia, 2006–7.

Wind 1976
Barry Wind. "Annibale Carracci's 'Scherzo:' The Christ Church *Butcher Shop*." *Art Bulletin* 58, no. 1 (March 1976), pp. 93–96.

Winspeare 1961
Fabrizio Winspeare. *Isabella Orsini e la corte Medicea del suo tempo.* Florence, 1961.

Winter 1984
Patrick M. de Winter. "A Little-Known Creation of Renaissance Decorative Arts: The White Lead Pastiglia Box." *Saggi e memorie di storia dell'arte* 14 (1984), pp. 7–42.

Winternitz 1967
Emanuel Winternitz. *Musical Instruments of the Western World.* New York, 1967.

Wischnitzer-Bernstein 1943
Rachel Wischnitzer-Bernstein. "A New Interpretation of Titian's *Sacred and Profane Love*." *Gazette des beaux-arts*, 6th ser., 23 (February 1943), pp. 89–98.

Witcombe 1983
Christopher L. C. Ewart Witcombe. "Giuseppe Porta's Frontispiece for Francesco Marcolini's *Sorti*." *Arte Veneta* 37 (1983), pp. 170–74.

Witcombe 2002
Christopher L. C. Ewart Witcombe. "The Chapel of the Courtesan and the Quarrel of the Magdalens." *Art Bulletin* 84, no. 2 (June 2002), pp. 273–92.

Witcombe 2004
Christopher L. C. Ewart Witcombe. *Copyright in the Renaissance: Prints and the Privilegio in Sixteenth-Century Venice and Rome.* Studies in Medieval and Reformation Thought 100. Leiden, 2004.

Witthoft 1982
Brucia Witthoft. "Marriage Rituals and Marriage Chests in Quattrocento Florence." *Artibus et historiae*, no. 5 (1982), pp. 43–59.

Witthoft 1996
Brucia Witthoft. "Riti nuziali e la loro iconografia." In *Storia del matrimonio*, edited by Michela De Giorgio and Christiane Klapisch-Zuber, pp. 119–48. Storia delle donne in Italia. Storia e società. Rome, 1996.

Wohl 1980
Helmut Wohl. *The Paintings of Domenico Veneziano.* New York, 1980.

Wolk-Simon 2004
Linda Wolk-Simon. "Naturalism in Lombard Drawing from Leonardo to Cerano." In Bayer 2004, pp. 45–63.

Wolk-Simon 2005
Linda Wolk-Simon. "Competition, Collaboration, and Specialization in the Roman Art World, 1520–27." In *The Pontificate of Clement VII: History, Politics, Culture*, edited by Kenneth Gouwens and Sheryl E. Reiss, pp. 253–74. Aldershot, 2005.

Wonderful Historyt of Virgilius 1893
The Wonderful History of Virgilius, the Sorcerer of Rome, Englished for the First Time. Mediaeval Legends 2. London, 1893.

Woodford 1965
Susan Woodford. "The Woman of Sestos: A Plinian Theme in the Renaissance." *Journal of the Warburg and Courtauld Institutes* 28 (1965), pp. 343–48.

Woods Callahan 1997
Virginia Woods Callahan. "Alciato's Quince-Eating Bride, and the Figure at the Center of Bellini's *Feast of the Gods*." *Artibus et Historiae*, no. 35 (1997), pp. 73–79.

Woods-Marsden 1987
Joanna Woods-Marsden. "'*Ritratto al Naturale*': Questions of Realism and Idealism in Early Renaissance Portraits." *Art Journal* 46, no. 3 (1987), pp. 209–16.

Woods-Marsden 1994
Joanna Woods-Marsden. "Toward a History of Art Patronage in the Renaissance: The Case of Pietro Aretino." In *Patterns of Patronage in Renaissance Italy: Essays in Honor of John R. Spencer*, pp. 275–99. Issue of *Journal of Medieval and Renaissance Studies* 24, no. 2 (Spring 1994).

Woods-Marsden 2001
Joanna Woods-Marsden. "Portrait of the Lady, 1430–1520." In D. A. Brown et al. 2001, pp. 64–87.

Woods-Marsden 2002
Joanna Woods-Marsden. "Piero della Francesca's Ruler Portraits." In *The Cambridge Companion to Piero della Francesca*, edited by Jeryldene M. Wood, pp. 91–114, 228–36. Cambridge, 2002.

Woods-Marsden 2007
Joanna Woods-Marsden. "The Mistress as 'Virtuous': Titian's Portrait of Laura Dianti." In *Titian: Materiality, Likeness, Istoria*, edited by Joanna Woods-Marsden, pp. 53–69. Turnhout, 2007.

Wright 1999
Alison Wright. "The Pollaiuolo Brothers." In Rubin and Wright 1999, pp. 224–25.

Wright 2000
Alison Wright. "The Memory of Faces: Representational Choices in Fifteenth-Century Florentine Portraiture." In *Art, Memory, and Family in Renaissance Florence*, edited by Giovanni Ciappelli and Patricia Lee Rubin, pp. 86–113. Cambridge, 2000.

Wright 2005
Alison Wright. *The Pollaiuolo Brothers: The Arts of Florence and Rome.* New Haven, 2005.

Yates 1983
Frances A. Yates. *Renaissance and Reform: The Italian Contribution.* Collected Essays 2. London, 1983.

Years of the Cupola 2004
The Years of the Cupola, 1417–1436. Edited by Margaret Haines. Digital archive of the sources of the Opera di Santa Maria del Fiore, Florence. [2004.] http://www.operaduomo.firenze.it/cupola/home_eng.html

Young 1979
Bonnie Young. *A Walk through the Cloisters.* The Metropolitan Museum of Art. New York, 1979.

Van Ysselsteyn 1962
Gerardina Tjaberta van Ysselsteyn. *White Figurated Linen Damask from the Fifteenth to the Beginning of the Nineteenth Century.* The Hague, 1962.

Zafran 1988
Eric M. Zafran. *Fifty Old Master Paintings from the Walters Art Gallery.* Baltimore, 1988.

Zambon 2004
Francesco Zambon. *Il mito della fenice in Oriente e in Occidente.* Venice, 2004.

Zangheri 1987
Luigi Zangheri. *Pratolino: Il giardino delle meraviglie.* 2 vols. 2nd ed. Documenti inediti di cultura toscana 2. Florence, 1987. [1st ed., 1979.]

Zanichelli 2004
Giuseppa Z. Zanichelli. "Maestro di Ippolita Sforza." In *Dizionario biografico dei miniatori italiani: Secoli IX–XVI*, edited by Milvia Bollati, pp. 686–90. Milan, 2004.

Zapperi 1991
Roberto Zapperi. "Alessandro Farnese, Giovanni Della Casa and Titian's *Danae* in Naples." *Journal of the Warburg and Courtauld Institutes* 54 (1991), pp. 159–71.

Zentai 1998
Loránd Zentai. *Sixteenth-Century Central Italian Drawings.* Exh. cat., Szépművészeti Múzeum. Budapest, 1998.

Zentai 2003
Loránd Zentai. *Sixteenth-Century Northern Italian Drawings.* Exh. cat., Szépművészeti Múzeum. Budapest, 1998.

Zeri 1971
Frederico Zeri, with the assistance of Elizabeth E. Gardner. *Italian Paintings: A Catalogue of the Collection of the Metropolitan Museum of Art.* [Vol. 1], *Florentine School.* New York, 1971.

Zeri 1976
Federico Zeri, with condition notes by Elisabeth C. G. Packard. *Italian Paintings in the Walters Art Gallery.* Edited by Ursula E. McCracken. 2 vols. Baltimore, 1976.

Zeri 1983/1991
Federico Zeri. "I frammenti di un celebre 'Trionfo della castità.'" In *Giorno per giorno nella pittura*, [vol. 2], *Scritti sull'arte Toscana dal Trecento al primo Cinquecento*, pp. 155–59. Turin, 1991. [Originally published in Federico Zeri, *Diari di lavoro 1.* Saggi. Turin, 1983.]

Zirpolo 1991–92
Lilian Zirpolo. "Botticelli's *Primavera*: A Lesson for the Bride." *Woman's Art Journal* 12, no. 2 (Fall 1991–Winter 1992), pp. 24–28.

Zirpolo 1992
Lilian Zirpolo. "Botticelli's *Primavera*: A Lesson for the Bride." In *The Expanding Discourse: Feminism and Art History*, edited by Norma Broude and Mary D. Garrard, pp. 100–109. New York, 1992.

Zöllner 1997
Frank Zöllner. "Zu den quellen und zur ikonographie con Sandro Botticellis 'Primavera.'" *Wiener Jahrbuch für Kunstgeschichte* 50 (1997), pp. 131–58.

Zöllner 2005
Frank Zöllner. *Sandro Botticelli.* Translated by Ishbel Flett. Munich, 2005.

PHOTOGRAPH CREDITS

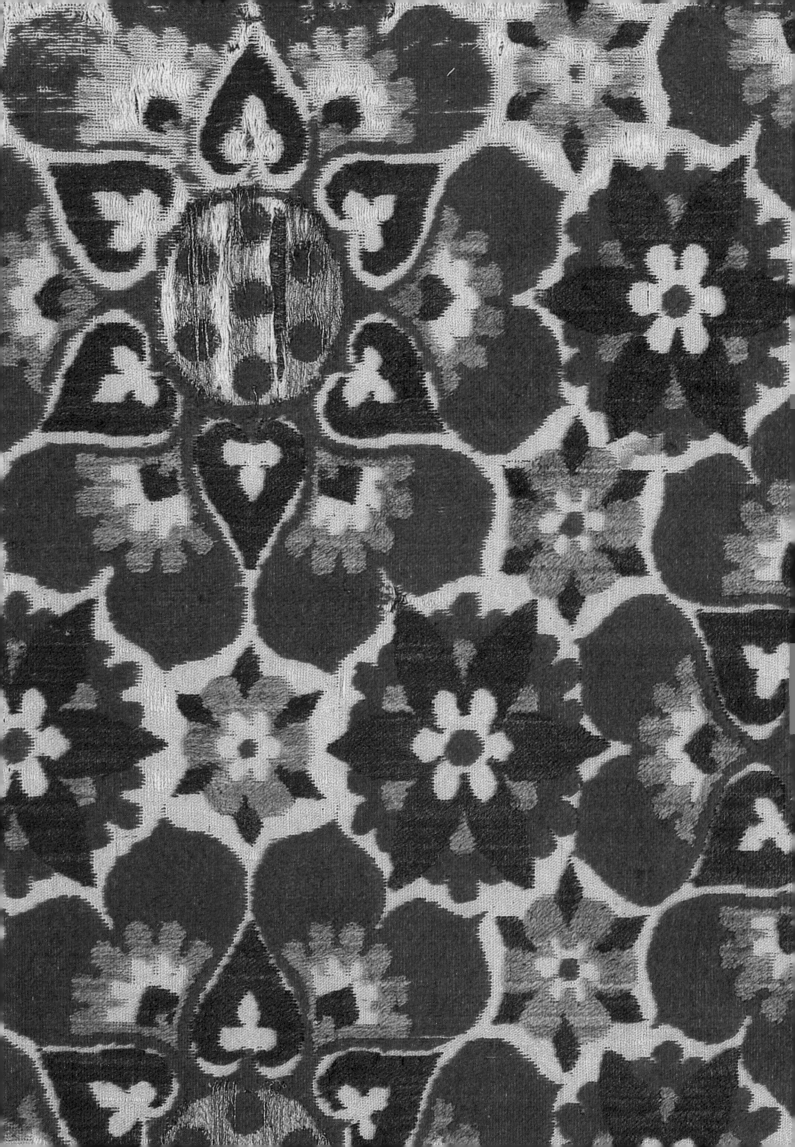